DRAWING AND PAINTING IN THE ITALIAN RENAISSANCE WORKSHOP

Theory and Practice, 1300–1600

Since Vasari, the artists of the Italian Renaissance have been characterized in superhuman terms, suggesting that they were responsible for both the conceptualization and the demanding execution of their creative output. In *Drawing and Painting in the Italian Renaissance Workshop,* Carmen C. Bambach reassesses the role of artists, such as Andrea di Cione "Orcagna," Piero della Francesca, Domenico Ghirlandaio, Leonardo, Michelangelo, and Raphael and their assistants in the creation of monumental painting. Analyzing representative murals, easel paintings, and the many drawings related to the various stages of their production, Bambach convincingly reconstructs the development of workshop practice and design theory in the early modern period. She establishes that between 1430 and 1600, cartoons – full-scale drawings ostensibly of a utilitarian nature – became common practice, and, moreover, moved to the forefront of artistic expression. Her exhaustive analysis of archaeological evidence, found in extant drawings, paintings, and decorative arts by well-known Renaissance masters and anonymous craftspeople, as well as the textual evidence offered by a variety of treatises, patternbooks, dictionaries, letters, inventories, and payment documents, provides a timely and much-needed reassessment of the working methods of artists in one of the most vital periods in the history of art.

Carmen C. Bambach is Associate Curator of Drawings and Prints at the Metropolitan Museum of Art in New York. A "Rome Prize" fellow of the American Academy in Rome, she has held postdoctoral fellowships from the Andrew W. Mellon Foundation (Metropolitan Museum of Art), the John Simon Guggenheim Foundation, and Villa I Tatti, The Harvard University Center for Italian Renaissance Studies in Florence. Dr. Bambach has written widely about Italian Renaissance and Baroque art and has co-authored exhibition catalogues on Neapolitan Baroque paintings, Genoese drawings and prints, and the drawings of Filippino Lippi and his circle.

DRAWING AND PAINTING IN THE ITALIAN RENAISSANCE WORKSHOP

~

Theory and Practice, 1300–1600

CARMEN C. BAMBACH

CAMBRIDGE
UNIVERSITY PRESS

PUBLISHED BY THE SYNDICATE OF THE UNIVERSITY OF CAMBRIDGE

The Pitt Building, Trumpington Street, Cambridge, United Kingdom

CAMBRIDGE UNIVERSITY PRESS

The Edinburgh Building, Cambridge CB2 2RU, UK http://www.cup.cam.ac.uk

40 West 20th Street, New York, NY 10011-4211, USA http://www.cup.org

10 Stamford Road, Oakleigh, Melbourne 3166, Australia

First published 1999

Printed in the United States of America

Typeface Bembo 10.25/12.5 (double column), 10.5/13 (single column) *System* QuarkXPress® [GH]

Library of Congress Cataloging-in-Publication Data

Bambach, Carmen C.
 Drawing and painting in the Italian Renaissance workshop : theory
and practice, 1300-1600 / Carmen C. Bambach.
 p. cm.
 Includes bibliographical references and index.
 ISBN 0-521-40218-2 (hardback)
 1. Art, Italian. 2. Art, Renaissance – Italy. 3. Artists'
studios – Italy. 4. Artists' preparatory studies – Italy. I. Title.
 N6915.B275 1999
 759.5 – dc21 98-51727
 CIP

A catalogue record for this book is available from the British Library.

Publication of this book has been aided by a grant from the
Millard Meiss Publication Fund of the College Art Association. MM

ISBN 0 521 40218 2 hardback

For Albertito, James, Henry, Caroline, and Elisita – the next generation

CONTENTS

PREFACE

This book is in great part about the perspiration behind artistic genius. The designing and execution of monumental paintings often requires a heroic effort. According to Giorgio Vasari, Raffaele Borghini, and Giovanni Battista Armenini, art theorists of the later sixteenth century, the process of preliminary design for a composition culminated in the production of "cartoons," refined full-scale drawings on paper that served to transfer a design onto the working surface. To quote Armenini in 1586, "the cartoon is the last and most perfect manifestation of everything that the art of drawing and design can powerfully express." Despite such vivid testimony in many Cinquecento and Seicento written sources, cartoons as a drawing type have not yet received the attention in modern scholarship that would seem commensurate with their original role in the design process.

By emphasizing how indispensable cartoons were for the difficult medium of fresco painting and by urging that they be prepared even for easel painting, Vasari established the cartoon's practical importance in the design process. With his praise of the beautifully drawn cartoons by the great High Renaissance masters – particularly, Leonardo, Michelangelo, and Raphael – Vasari enshrined the cartoon as a work of art of the highest order. How was it that, between 1430 and 1600, cartoons drawings ostensibly of a utilitarian nature – had not only become common practice but had moved to the forefront of artistic expression? The present book attempts to answer this question by means of a broadly integrated discussion of workshop practice and design theory, based on (1) the physical evidence found in extant drawings, paintings, and decorative arts by well-known Renaissance masters, as well as by anonymous craftspeople, and (2) the textual evidence offered by a variety of treatises, patternbooks, dictionaries, letters, inventories, and payment documents pertaining to the production of both "high style" and "low style" art.

However imperfectly realized, this book is intended as an introduction to both a subject and an archaeological method, which, as I hope to illustrate in the following pages, have broad implications for the ways in which we look at and think about Italian Renaissance art. It was my enormous good fortune to have had access to the scaffoldings erected for the cleaning and restoration of most masterpieces of Italian mural painting treated between 1982 and 1997. In offering a study of cartoons and, particularly, of the techniques by which they were commonly transferred – those of pouncing (in Italian, "*spolvero*") and stylus tracing or incision ("*calco*," "*calcare*," "*ricalcare*," or "*incisione indiretta*") – I wish to draw attention to the complexity of Italian Renaissance workshop practice. From about 1340 onward, the use of *spolvero* – and, probably, from the 1460s to 1470s onward, the use of *calco* – underlay the production of numerous Italian paintings and drawings.

During the last two decades especially, we have begun to recognize just how much the study of artistic technique might help us understand Italian Renaissance art. Explorations of wide diversity in both subject and approach can claim this credit. To single out solely the survey books, whose broad impact will prove perhaps most lasting for our discipline and which have also shaped my own work, we may consider Eve Borsook's *The Mural Painters of Tuscany* (1960, 1980); Francis Ames-Lewis's *Drawing in Early Renaissance Italy* (1981); Paul Hills's *The Light of Early Italian Painting* (1987); Martin Kemp's *The Science of Art: Optical Themes in Western Art from Brunelleschi to Seurat* (1990); the National Gallery's *Art in the Making: Italian Painting before 1400* (1989), as well as *Giotto to Dürer: Early Renaissance Painting in the National Gallery* (1991); Marcia Hall's *Color and Meaning: Practice and Theory in Renaissance Painting* (1992); David Landau and Peter Parshall's *The Renaissance Print, 1470–1550* (1994); and Anabel Thomas's *The Painter's Practice in Renaissance Tuscany* (1995). Moreover, the symposia and museum exhibitions that have accompanied the anniversary celebrations of a number of artists (e.g., Raphael, 1983–1984; Andrea del Sarto, 1986; Piero della Francesca, 1992) have offered unprecedented research on their design techniques. The growing fields of Late Medieval, Renaissance, and Baroque paintings conservation continue to yield a vast quantity of new technical data.

It is still not usual in our discipline, however, to study problems relating to the making of art collectively and within a historical framework. For example, if judged by the sheer frequency of references to them in the art-historical literature, *spolvero* and stylus incision hardly count among the unknown techniques of the Renaissance. Scores of recent articles, catalogues, and books on Renaissance paintings have recorded instances in which such evidence of design transfer has come to light as the result of scientific investigation. And, since the early twentieth century, catalogues of "old master" drawings have rarely failed to note when designs are pricked or stylus-incised for transfer. These vast data have appeared, however, in such complete isolation that there is hardly a context for them in the general bibliography on Italian Renaissance art.

Until the present book, the literature on the functions of cartoons has primarily rested on the pioneering research by Joseph Meder in *Die Handzeichnung* (1919, 1923); Eve Borsook in *The Mural Painters of Tuscany* (1960, 1980); Ugo Procacci in *Sinopie e affreschi* (1961); Millard Meiss and Ugo Procacci in the catalogue that accompanied a traveling exhibition of detached frescos and *sinopie*, *The Great Age of Fresco: Giotto to Pontormo* (Metropolitan Museum of Art, New York, 1968); Bernhard Degenhart and Annegrit Schmitt in the introduction to Parts I and II of their *Corpus der italienischen Zeichnungen* (1968, 1980); Roseline Bacou in her catalogue for an exhibition of cartoons, *Cartons d'artistes du XVe au XIXe siècle* (Cabinet des Dessins, Musée du Louvre, Paris, 1974); Paolo and Laura Mora and Paul Philippot in their encyclopedic survey *The Conservation of Wall-Paintings* (1977, 1984); and the various authors who participated in the proceedings of the symposium on mural painting *Tecnica e stile* (Villa I Tatti, The Harvard University Center for Italian Renaissance Studies, Florence, 1986). Articles on specialized problems by Oskar Fischel on Raphael's "auxiliary cartoons" (1937), Robert Oertel on the origins of exploratory drawing in the tradition of mural painting (1940), Dorothy Miner on medieval pouncing (1968), and Johannes Taubert on the evidence of *spolvero* in Renaissance easel paintings (1975) – to single out significant contributions – have raised important issues, although they have not always necessarily reached conclusions with which we can now wholly agree. As explained in Chapter Ten, just when artists began to employ the *calco* technique to transfer cartoons is still much debated, and, by comparison, the history of the *calco* technique has been much less rigorously explored than that of *spolvero*. Innovative research has been presented in specialized studies on the working procedures of Federico Barocci by

Edmund Pillsbury and Louise Richards (1978) and by Linda Freeman Bauer (1986), and on those of Caravaggio by Keith Christiansen (1986).

The above seminal art-historical literature in turn prompted the author's Ph.D. thesis on the tradition of pouncing drawings in the Italian Renaissance workshop (see Bambach Cappel 1988). By focusing on a selection of drawings, however, my thesis dealt only with a very narrow aspect of the subject surveyed here. The present book can by no means claim to be a complete or definitive study on cartoons. The subject alone is too vast, its history is still unfolding, and too many questions remain unanswerable given the current tools of scientific investigation. Rather, the issues arising in the following pages should suggest both the richness of a contextual approach to workshop practice and the need for further technical research.

Ultimately, however, our primary responsibility as art historians is to the work of art as object. Neither scientific progress, scholarly research, nor aesthetic egotism should be a motive to raise even the slightest possibility of peril to the condition of the work of art.

ACKNOWLEDGMENTS

The type of object-based research that is the backbone of this project would have hardly been possible without the unfailing cooperation of the many academics, museum curators, conservators, and directors of *soprintendenze* in charge of the restoration of murals. They all too often performed miracles on my behalf. Words can only meagerly acknowledge the generosity of my colleagues – their advice and assistance, as well as their encouraging support, over the years. My debts of gratitude, immense, are thus widely scattered. First, readers of the book manuscript must be thanked: Francis Ames-Lewis, Eve Borsook, Kathleen Weil-Garris Brandt, Steven T. Cappel, Yvonne Elet, Creighton E. Gilbert, Martin Kemp, and Patricia Rubin.

At the research stage, the lion's share of gratitude belongs to my mentor and Ph.D. thesis adviser, Creighton E. Gilbert, who first helped me see the possibilities of the topic treated here. He provided steadfast reassurance as well as important criticism long after my graduate studies at Yale University had concluded. Of my professors at Yale, I would also like to single out George L. Hersey, Judith Colton, Vincent J. Scully Jr., and Walter Cahn. With their pioneering research, Leonetto Tintori and Eve Borsook laid the foundation for the study of Italian Renaissance mural painting technique. At all points over the years, Eve's unparalleled knowledge and sage advice have proved indispensable. Martin Kemp has been a providential force behind this project. Chapters Five and Six of the present book would have read quite differently without the benefit of his magisterial *The Science of Art,* published in 1990.

Between 1981 and 1994, the late Fabrizio Mancinelli made the impossible possible to facilitate my research on Italian Renaissance cartoons and mural painting technique, particularly Michelangelo's. As a *"compagno di strada,"* he is sorely missed! Thanks to Fabrizio and to Arnold Nesselrath, I had access to the mural cycles in the Sistine Chapel and Vatican Palace for examination from temporary and restoration scaffoldings. Lisa Venturini repeatedly brought paintings, documents, and bibliography to my attention. Francis Ames-Lewis and Catherine Monbeig Goguel have long encouraged me with their great enthusiasm for research on problems of drawing technique. Annamaria Petrioli Tofani, the late Gianvittorio Dillon, Alessandro Cecchi, Lucia Monaci Moran, Giovanni Agosti, and their welcoming staff enabled my study of the magnificent collection of cartoons in the Gabinetto Disegni e Stampe degli Uffizi, which, as will be apparent, plays a central role in this project. Giorgio Bonsanti generously put at my disposal the rich archives of data and photographic materials at the Opificio delle Pietre Dure e Laboratori di Restauro di Firenze. Maryan W. Ainsworth, Maria Clelia Galassi, Paolo Bensi, and George Bisacca have patiently shared their expertise on easel painting techniques.

Kathleen Friello prepared the index. Nicolò Orsi Battaglini and Antonio Quattrone took a number of the archaeological photographs of Tuscan frescos; and Paolo Nannoni photographed drawings in the Uffizi. I am also indebted to the Photograph Studio at the Metropolitan Museum of Art, under the direction of Barbara Bridgers. A grant from the Samuel H. Kress Foundation has made publication of this book possible. Steven T. Cappel offered moral and practical support for over a decade. He good-naturedly read and incisively commented on many parts of this manuscript. During the last stages of my work, especially Lauri Semarne, Lisa Venturini, Maryan W. Ainsworth, George Bisacca, Sheila O'Connell, Robert Johnson, Jennifer Langham, Charley Miller, Fiorella Superbi Gioffredo, Joseph Connors, Marina Sheriff, Yvonne Elet, Heidi Overing, and the Whalen and Greenfield families were pillars of strength on my behalf.

My family's affection, not to mention their level-headedness and good humor, have meant more than I could possibly express: Maria Luisa, Dan, James, Henry, Elisita, Kathie, Alberto, Albertito, Caroline, Karen, and Guillermo. *Mutti* and *Papo,* it has been a rich journey from Santiago de Chile to New York, and then to Renaissance Italy. Thank you for all the risks you took on our behalf!

New York
May 1999

LIST OF ILLUSTRATIONS

NOTES TO THE READER

A catalogue of cartoons is omitted here, for, as stated in the Preface, this book picks up research at the point where my Ph.D. thesis stopped (see Bambach Cappel 1988, Parts 1, 2) and incorporates substantial new archaeological data on mural cycles. To allow for that discussion and to avoid tedious repetitions of content, cartoons and other types of drawings that I previously catalogued and that are here cited as examples are followed by initials and catalogue numbers within parentheses, as in "(CBC 1)," given in the captions for illustrated works. The reader is referred to Part 2 of my Ph.D. thesis for more extensive descriptions of technique and bibliography. Here, abbreviated technical data are provided in the endnotes, only where revision is necessary. As is standard, dimensions are listed with height preceding width, and an effort is made to distinguish among the media of charcoal, black chalk, and leadpoint (all too often used interchangeably in the literature). In the text, along with the drawing that is illustrated, reference is made to an unillustrated companion work in the same series, as in "(Fig. 224; CBC 282)." In the notes, object-based data and primary sources are favored over the secondary literature. For reasons of space and cost, fewer monuments could be illustrated than are discussed in the text and notes. Photographs often do not appropriately convey subtle archaeological data. Whenever possible, preference has here been given to inaccessible passages of works of art, to details of technique, and to works in a relatively good state of preservation. Roettgen 1996 and 1997 offer useful general photographic surveys in color of fifteenth-century fresco cycles (see Bibliography). In Chapter Six, all folio references to Piero della Francesca's *De Prospectiva pingendi* are to MS. Parm. 1576 (Biblioteca Palatina, Parma). With rare exceptions, citations of documents are based on the transcriptions published in the secondary literature, rather than taken from the original texts. For early treatises, several editions and translations are cited in the notes to cover the nuances of content.

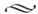

INTRODUCTION: FROM WORKSHOP
PRACTICE TO DESIGN THEORY

They say that knowledge born from experience is mechanical, but that knowledge born
and ending in the mind is scientific, while knowledge born from science and ending in
manual work is semi-mechanical.

Leonardo, *Codex Urbinas Latinus,* fol. 19 recto[1]

Michelangelo at Work on the
Pauline Chapel Frescos

Between 16 November 1542 and 29 March 1546, the papal treasury paid Francesco d'Amadore "Urbino," beloved servant and assistant of Michelangelo, at least 23 scudi, 94½ *bolognini* for helping the master fresco the newly built Pauline Chapel in the Vatican Palace.[2] As the account books state, and they are by no means complete, these sums comprise expense reimbursements as well as "Urbino"'s monthly salary, apparently 4 scudi to Michelangelo's 50 scudi,[3] for: "grinding colors," "ordering one of the walls of the Pauline Chapel to be keyed and plastered with *arriccio,*" "buying six *arcarezzi* of various types and twenty planks of elmwood needed for building the scaffolding."[4]

Rows of black dots outline many of the forms depicted in the composition of both Pauline Chapel frescos, the *Conversion of St. Paul* and the *Crucifixion of St. Peter* (Figs. 1, 2).[5] These dots are called "pounce marks," or *"spolvero* marks." They are minute deposits of charcoal dust (carbon) absorbed into the moist *intonaco,* the thin surface layer of fine plaster on a fresco. These deposits became permanently fixed as the water-based pigments bonded with the setting plaster during the irreversible chemical process of carbonation.[6] On contact with the carbon dioxide in the air, fresh plaster hardens, forming calcium carbonate. As the evaporating water brings the setting lime (calcium hydroxide) of the plaster to the surface, a transparent grid of carbonate crystals forms over the pounce marks and pigments, provided these have been applied while the plaster is moist.

The trapped pounce marks form the underdrawing derived from a pricked full-scale drawing, a "cartoon" that was pounced for transfer.

To reproduce a full-scale drawing exactly on another surface, the drawing's outlines could be pricked with a fine, pointed implement, such as a needle or fine stylus. Next, a small bag or sack of cloth would be filled with pouncing dust ("pounce"), most often powdered charcoal or black chalk, and its mouth would be tied shut. By tapping or smudging the pricked holes on the drawing with the pouncing bag, the artist could obtain a dotted underdrawing on the surface beneath. This entire process is called "pouncing," or *"spolvero."* It served to transfer not only cartoons and other types of drawings but also the designs from tracings, manuscripts, prints, and ornament patterns.

Aspects of the delegation of labor in artists' workshops would remain traditional for a number of centuries. Cennino Cennini's *Libro dell'arte* (MS., late 1390s) lists the manual skills comprising the art of painting for the benefit of the apprentice, who learned the profession in the workshop of a master by assisting him.[7] According to Cennino, pouncing was one of many elementary artisanal skills such as grinding colors, applying size, gessoing, laying *bole,* and gilding to paint in tempera on panels and plastering and trueing up of walls to paint in fresco.[8] A memorandum of 6 June 1572 officially confirmed the terms of Giorgio Vasari's contract and budget to his patron, Grand Duke

Cosimo I de'Medici, for the artist had expected to hire various types of collaborators to help him fresco the dome of Florence Cathedral. Vasari's proposed budget included materials as well as manual laborers *("manouali")* and plasterers *("muratori")* to prepare the scaffoldings, *arriccio,* and *intonaco;* a foreman *("un maestro d'inportanza . . . che stia sempre in sull'opera, massime quando io sarò in terra o a far cartoni . . .");* three competent fresco painters *("maestri pratichi a lavorare a fresco");* three other painters of professional status *("maestri pictori")* to make draperies, skies, backgrounds, and wax and clay models of figures; two other *maestri* to paint ornament, backgrounds, and clouds and to transfer cartoons; and two *garzoni* for grinding colors.[9] Vasari's prospective "cartoon tracers" were practically at the bottom of his pyramid of labor. Much later, Vicente Carducho would also candidly admit in his *Diálogos de la pintura* (Madrid, 1633) that painters delegated to lowly assistants the process of transferring cartoons.[10]

Seen as a whole, such evidence can help us speculate that it was "Urbino," rather than Michelangelo, who pricked the Pauline Chapel cartoons and pounced them onto the fresco surface.[11] It would have been an unremarkable element of his salaried duties for the master, then nearing seventy years of age and failing in health. As Michelangelo complained to his biographer, Giorgio Vasari, in speaking of its strenuous physical demands, "fresco painting . . . is not an art for old men."[12]

The only surviving cartoon for the frescos, without doubt drawn by Michelangelo himself, is a beautiful fragment depicting the lower left group of soldiers in the *Crucifixion of St. Peter* (Figs. 2–4), now in Naples.[13] It portrays the powerful anatomy of the soldiers with carefully calibrated effects of *chiaroscuro* to suggest their *"rilievo"* (relief). Michelangelo drew the cartoon fragment in charcoal and black chalk on multiple, glued sheets of paper, first outlining the forms. Then he finely hatched their areas of shadow, stumping these delicately to blend the individual strokes and modulating the overall intensity of the light effects on the warm buff color of the paper surface. The type of highly rendered cartoon Michelangelo's *Crucifixion of St. Peter* fragment exemplifies may be called a *"ben finito cartone,"* literally, "well-finished cartoon" (see Chapter Seven). The phrase *"ben finito cartone"* occurs in Giovanni Battista Armenini's detailed description of how to draw cartoons in his *De' veri precetti della pittura* (Ravenna, 1586),[14] where the revered cartoons by the great High Renaissance masters are cited as supreme models of the genre. By the 1540s, when Michelangelo was at work on the Pauline Chapel frescos, Central-

Italian artists and theorists had come to regard the production of cartoons as the most important phase in the preliminary design of a composition: in the words of Armenini, "the last and most perfect manifestation of everything which the art of design can powerfully express."[15]

The outlines of Michelangelo's cartoon fragment are, more or less, carefully pricked for transfer by *spolvero.* The *giornate,* the individual plaster patches comprising a fresco surface, record precisely that both Pauline Chapel frescos were entirely painted from *spolvero* cartoons, except for the first *giornata* in the *Conversion of St. Paul.*[16] There, the plaster patch exhibits incisions made with a stylus *("calco," "calcare," "ricalcare," or "incisione indiretta"),* another technique used to transfer cartoons, which was quicker but more destructive than *spolvero.* Vasari's introduction to the *Vite* (Florence, 1550 and 1568) and Raffaele Borghini's *Il Riposo* (Florence, 1584) describe how artists indented the outlines of a cartoon for a fresco or easel painting with a stylus while the cartoon lay on the working surface.[17] In fresco painting, since the *intonaco* is still unset when the cartoon is traced, the procedure usually leaves ridges with relatively broad, soft troughs that are easily visible in raking light.[18]

Importantly for our purpose, however, the area in Michelangelo's fresco of the *Crucifixion of St. Peter,* corresponding to the Naples cartoon fragment, shows only *spolvero* and consists of ten crudely joined *giornate* (Fig. 5). Although the sutures of the *giornate* often coincide with the general outlines of the figures, as they should in *buon fresco,* their extremely inconsistent leveling in some parts suggests that Michelangelo's *muratore* (plasterer) for the *Crucifixion* was not especially accomplished. Plastering was among the tasks in mural painting often delegated.

Whether Michelangelo's *muratore* was "Urbino" or a day-laborer whom "Urbino" contracted is not clear. Cennino's *Libro dell'arte* provides detailed directions for the fresco painter himself to do all the plastering.[19] By contrast, fifteenth- and sixteenth-century payment documents often refer to *manouali* or *muratori* engaged by mural painters to plaster.[20] In 1576, Federico Zuccaro would immortalize his plasterer, Aniello di Mariotto del Buonis, with a portrait – trowel in hand – in the frescos on the dome of Florence Cathedral.[21] Andrea Pozzo's "brief instructions on fresco painting," appended to the *Perspectiva Pictorum* (Rome, 1693–1700), would explain the jobs that usually "pertain not to the painter, but to the *muratore":* the erecting of scaffolding; the laying of the rough, base plaster *("arricciare"),* the laying of the

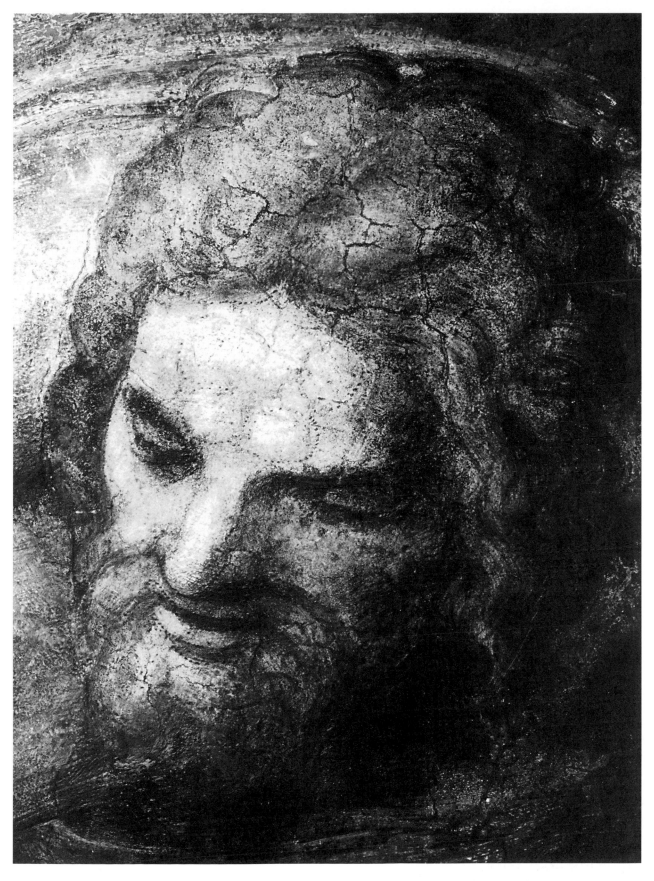

Figure 1. Detail of Michelangelo, The Conversion of St. Paul, *fresco (Pauline Chapel, Vatican Palace). The pouncing or* spolvero *dots are most visible on the forehead, nose, and lips of Christ's face.*

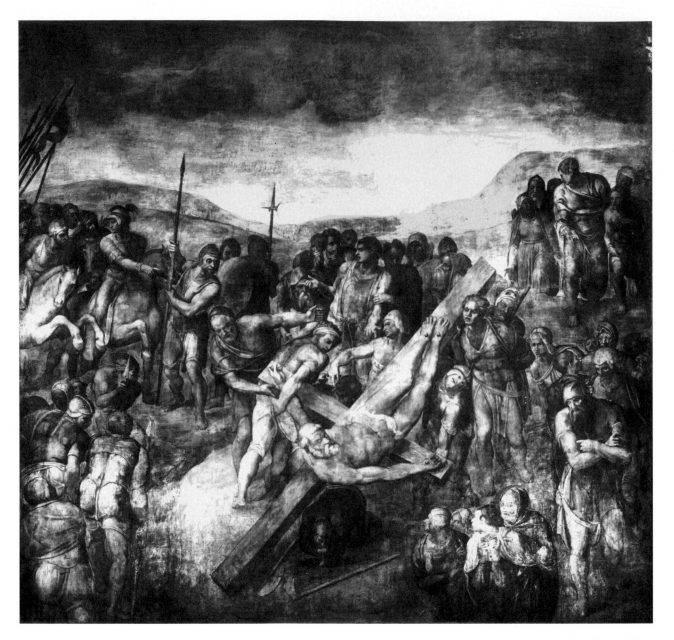

Figure 2. Michelangelo, The Crucifixion of St. Peter, *fresco (Pauline Chapel, Vatican Palace).*

smooth, surface plaster *("intonacare"),* and the integration of sand into the surface of the *intonaco* (*"granire"*; Fig. 6).

Besides grinding colors, purchasing materials, subcontracting manual labor, and pricking and pouncing the Pauline Chapel cartoons, "Urbino" probably assisted Michelangelo in painting the frescos as well (Fig. 7). "Urbino," who served Michelangelo for twenty-six years and who died in 1555 to the master's great anguish, is mentioned in the Pauline Chapel documents only as either Michelangelo's *"servitore"* (ser-

vant) or *"garzone"* (assistant).[22] He was already middle-aged. But, earlier, "Urbino" was specifically called *"pittor[e]"* (painter) in a record of his salary payment on 2 December 1540, when Michelangelo was frescoing the *Last Judgment* on the altar wall of the Sistine Chapel.[23] Moreover, in his service to Michelangelo, as other documents suggest, "Urbino" wore many hats. During the final project of carving the marble tomb of Pope Julius II, he was called *"scultore"* (sculptor), and during the ongoing construction of the new Basilica of St. Peter, he was called *"coadiutore architectorum"* (architectural assistant).[24]

Especially in comparison to the Sistine Ceiling and the *Last Judgment,* the frescoing of the *Crucifixion of St.*

Figure 3. Michelangelo, pricked cartoon fragment for the Crucifixion of St. Peter *(CBC 188; Gallerie Nazionali di Capodimonte inv. 398, Naples).*

Figure 4. Verso of Michelangelo, pricked cartoon fragment for the Crucifixion of St. Peter.

Figure 5. *Approximate diagram showing the disposition of* giornate *and* spolvero *in the portion of Michelangelo's fresco of the* Crucifixion of St. Peter *that corresponds to the Naples cartoon fragment.*

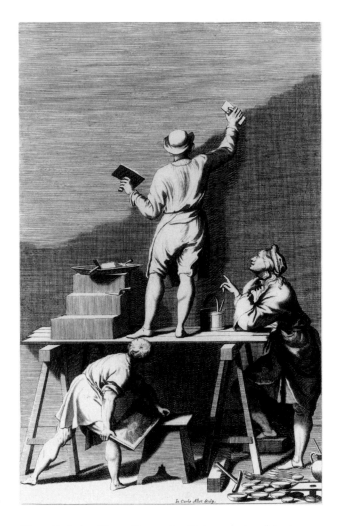

Figure 6. Andrea Pozzo, Perspectiva Pictorum et architectorum, *Rome, 1693–1700, II (Metropolitan Museum of Art, Harris Brisbane Dick Fund, 1947; 47.73 (2), New York). This engraving portrays a master fresco painter directing a plasterer* (muratore) *and an assistant at work.*

eled with sculptural contrasts of chiaroscuro (particularly, those of foreground figures) usually received, on top of the thin base flesh tone, a subtle but dense network of curved hatching in a paler color, applied with a drier brush and built layer upon layer. These pliant but orderly strokes define the forms, like the tracks of a toothed chisel on the surface of a marble sculpture.[26] More accomplished technically, the manner of painting in the *Conversion of St. Paul* conforms better with Michelangelo's earlier handling of the fresco medium.

Regarding the *Crucifixion of St. Peter,* physical evidence in both the Naples cartoon fragment and the fresco indicates that Michelangelo did not transfer the design in the cartoon fragment directly to the fresco surface but used instead the intermediary means of a "substitute cartoon."[27] A passage on the topic of cartoon transfer in Armenini's *De' veri precetti* describes the practice of "substitute cartoons" as follows: "But then to save cartoons from damage, needing afterward to trace the [cartoons'] outlines onto the surface on which one is working, the best way is to prick their outlines with a

Figure 7. Francesco Parmigianino, study of a Young Painter's Assistant Grinding Colors *(Victoria and Albert Museum inv. D.989–1900, London).*

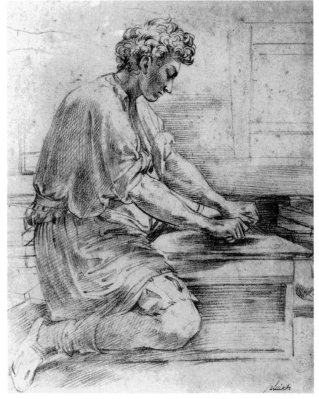

Peter appears somewhat sloppily executed.[25] Admittedly, the *Crucifixion* has suffered from substantial later repainting by restorers and its surface requires cleaning. Nevertheless, it is clear from a close examination of the mural surface that Michelangelo and his assistant(s) generally applied their pigments thickly, largely obscuring the *spolvero* underdrawing from the cartoon and sometimes crudely disregarding the clarity of outlines suggested by the drawing. By contrast, Michelangelo's earlier, *virtuoso* fresco technique included smoothly joined *giornate,* with level transitions in the plaster, and a layering of color of nearly watercolorlike transparency, where the nude, gray *intonaco* was often left visible as tone in background elements. Areas of flesh to be mod-

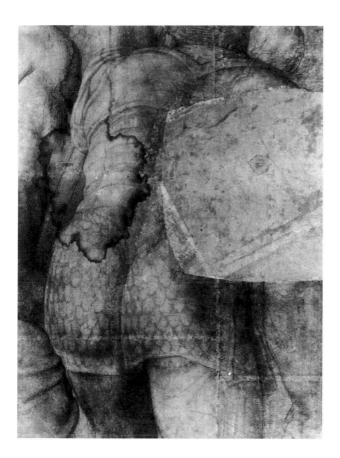

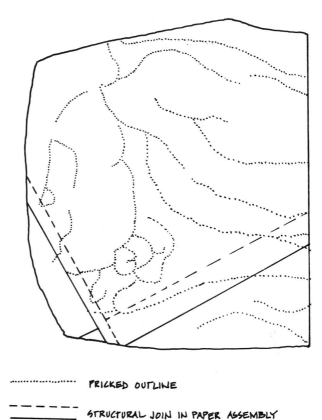

PRICKED OUTLINE

STRUCTURAL JOIN IN PAPER ASSEMBLY

Figure 8. Detail showing the patch with unrelated pricked outlines on the upper right of Michelangelo, pricked cartoon fragment for the Crucifixion of St. Peter (CBC 188; Gallerie Nazionali di Capodimonte inv. 398, Naples).

Figure 9. Approximate reconstruction of the unrelated pricked outlines on the patch of the Naples cartoon fragment, a "substitute cartoon."

needle, having placed another cartoon underneath, which becomes pricked like the one placed on top, [and which] serves later to pounce over and over where one desires to paint, and especially on plaster. . . ."[28]

If evidence left by methods of design transfer on both paintings and drawings can offer a valuable analytical tool, in certain fortunate instances its significance can transcend the history of technique.

A small piece of Michelangelo's actual "substitute cartoon" for the *Crucifixion of St. Peter* survives.[29] It is glued as a patch on the Naples cartoon fragment (Figs. 8–9). As can already be surmised from Armenini's description, a "substitute cartoon" has no drawing.[30] Thus, a "substitute cartoon" is not a duplicate of the carefully drawn master cartoon, or *"ben finito cartone."* It records only the pricked outlines obtained from the *"ben finito cartone"* over which the pouncing dust was rubbed.

The perforated but entirely undrawn design on the piece of Michelangelo's "substitute cartoon" portrays

St. Peter's nude pelvic area, before this portion of the fresco was repainted *a secco* with a white loincloth.[31] The piece of the "substitute cartoon" clarifies the original iconography of the fresco, for it is clear that Michelangelo depicted St. Peter completely nude. Contemporary copies after the fresco – a drawing, two prints, and a small painting – confirm St. Peter's original design.[32]

The total nudity of the saint situates Michelangelo's interpretation of the subject in the same controversial ambit as that of his earlier, more famous fresco of the *Last Judgment* on the altar wall of the Sistine Chapel, in which the total nudity of the figures launched a well-documented cause célèbre. Although not serving the public ceremonial role of the Sistine Chapel, as a manifestation of the *"maiestas papalis,"* the Pauline Chapel was nevertheless built between 1538 and 1540 by Antonio da Sangallo the Younger for Pope Paul III to serve as both Chapel of the Sacrament and Chapel of the

Conclave.[33] Yet without the actual "substitute cartoon" piece, and the supporting evidence of copies after the fresco, the original iconography of the *Crucifixion of St. Peter* would have been lost, for no written sources record its repainting.[34]

This is the type of problem from which the present book grew and to which it will return in subsequent chapters.

Cartoons in the Context of Renaissance Workshop Practice

Michelangelo's use of pouncing and incision techniques, his application of a "substitute cartoon" to spare the Naples cartoon fragment from the ruination of the working process, "Urbino"'s probable role as the cartoon's "pouncer," and the general delegation of labor occurring in the Pauline Chapel frescos, were by no means oddities in Italian Renaissance practice. Such elements form part of a rich tradition in the workshops of Italian artists and craftspeople (Figs. 10–13).

As art history joins science in evaluating the technical data collected during the conservation of the major monuments of Medieval and Renaissance Italy, it has become apparent that the issue of artistic practice is central to any discussion of the broad stylistic and theoretical developments of art in these periods. Yet our difficulties in interpreting and synthesizing the rapidly growing body of emerging technical data suggest how little still we understand the fundamental processes that governed the production of artists, architects, and craftspeople. Their socioeconomic as well as their material and technical world should figure in a reconstruction of the "period eye."[35] The premise that artistic practices can be reconstructed from the material culture pertaining to the workshop remains insufficiently developed in the literature. Moreover, the complexity of Italian Renaissance workshop practice, though all too readily assumed recently, has been little explored. We can begin to frame

some of these issues by investigating the microcosm of a single practice, that of cartoons. In reconstructing the history, functions, and design transfer techniques of cartoons, this study will attempt to demonstrate that an understanding of this complexity is not only possible but is also necessary for the history of Italian Renaissance art.

This approach, in turn, requires a considerably more pragmatic portrait of Italian Renaissance artists at work. As Giorgio Vasari's vastly influential, yet biased, account in *Le Vite de' più eccellenti pittori, scultori ed architettori* (Florence, 1550 and 1568) would have it, the glory that was Italian art culminated in the achievement of Leonardo, Raphael, and, above all, Michelangelo.[36] They brought about a revolution in the pictorial arts that became the cornerstone of what was once considered the most important phase in the history of

Figure 10. Giorgio Vasari, St. Luke Painting the Virgin, *oil on panel (Chapel of St. Luke, SS. Annunziata, Florence). While the painter (a self-portrait) works at the easel, his adult assistant grinds colors in an adjoining room.*

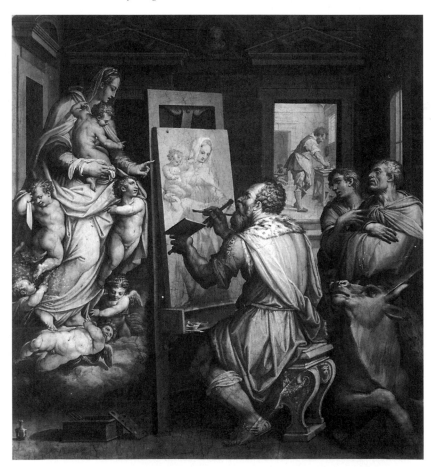

Western art: the High Renaissance (c. 1495–1515), when painting, sculpture, and architecture were thought to have attained a perfection rivaled only by that of Classical Greece and Rome. Although we, as art historians, ceased long ago to view the High Renaissance in such absolute (chauvinistic) terms, acknowledging the overt mythologizing by sixteenth-century art theorists, we have continued to accept, without serious challenge, the corollary that arose from the Cinquecento myth: the notion that the great Italian Renaissance artists were effortless creators of masterpieces.

As unique documents of the gestation of works of art, drawings in particular hold the promise of a glimpse into the private world of genius. But basic questions about many significant Italian artists still await detailed answers: How did they draw? What were the purposes of their drawings? And what do their drawings reveal about their general design methods? Though fundamental to our understanding of the role of drawing in the artistic production of the Italian Renaissance, such questions of function have often remained until relatively recently, and to a great extent by necessity, subordinate to problems of connoisseurship: the authentication, dating, contextualization, and definition of an artist's corpus of drawings. To see revealed the intricate techniques and devices actuating the design processes of the great Italian Renaissance masters is not to deny their genius, but rather to understand how fundamental a tool drawing was to their vision. The study of Italian Renaissance drawings is an integral part of our understanding of artistic practice in this period.

But no less importantly, artists and craftspeople shared more common ground in the practice of drawing than has been supposed (Figs. 10–13). The recognition of painting, sculpture, and architecture as *studia humanitatis,*

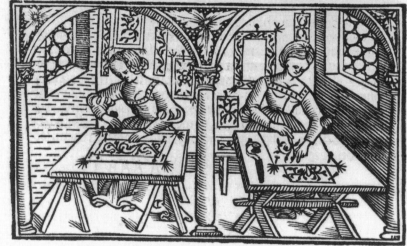

Figure 11. Alessandro Paganino, Libro Primo: De rechami (Il Burato), *Venice, c. 1532, fol. 2 verso (Metropolitan Museum of Art, Harris Brisbane Dick Fund, 1948; 48.40, New York). This woodcut portrays women transferring designs onto the cloth for drawing and embroidery. The woman using the* spolvero *technique is seen in the lower left.*

and their consequent inclusion among the "liberal arts," was one of the principal legacies of the Italian Renaissance. But to argue for the noble status of the arts, Quattrocento and Cinquecento theorists sought insistently to distance the artist from the craftsperson, a rhetorical

dichotomy that we have often accepted too uncritically as fact. The reality was more complex. For instance, within the polemics of the *"paragone"* or comparison of the arts, the distinction between the "science" (i.e., the theoretical or mathematical basis) of painting and the "mechanical" (i.e., the manual) labor of sculpture served as Leonardo's rhetorical strategy in defending the greater nobility of painting.[37] The posthumously compiled *Codex Urbinas Latinus* (fol. 20 recto) records Leonardo's impassioned, if biased, plea: "Sculpture is not a science [*scientia*], but is a most mechanical art [*è arte mecca-nichissima*], because it causes its executant sweat and bodily fatigue, and he need only know the basic measurements of the various members [*le semplici misure de membri*] and the nature of the movements and poses, and this is sufficient to finish his work."[38]

Yet, as we shall observe repeatedly during the course of this book, Leonardo's voluminous notes on the art of painting and drawing teem with advice both "scientific" (i.e., the theory of anatomy, proportion, light and shade, color, and perspective) and "mechanical" (i.e., the recipes for distilling oil, making colors, varnishes, chalks, ink, cardboard, and prepared paper). Seen as a whole, these notes perhaps portray a less familiar Renaissance, that of workshop tradition with its inheritance of cultivated design habits, technical shortcuts, props, gadgets, and its view of drawing primarily as a functional tool rather than as an expressive masterpiece.

Although best known as a means of cartoon transfer used by Italian Renaissance mural painters, the *spolvero* technique would remain among the most enduring, versatile, and universal means of design transfer. Its actual history, albeit with ebbs and flows, spans from at least the tenth-century pricked patterns, discovered in the *"Caves of the Thousand Buddhas"* (Dunhuang, China; see Fig. 127), to the pounced *"stil Liberty"* murals from 1915 to 1916 by Amedeo Bocchi in the *Sala del Consiglio* (Cassa di Risparmio, Parma), to the pricked designs for luster ware by William de Morgan (1839–1917).[39] Designers of Byzantine-style icons, of murals and stage sets, of embroidery and clothing, of ceramic tiles and holloware are only a few of the craftspeople still using the technique today.[40] Modern restorers of murals continue this tradition as well.[41] The history of the *calco* technique (*"calcare," "ricalcare,"* or *"incisione indiretta"*), albeit shorter than that of *spolvero*, also reaches well into the twentieth century – for instance, in the 1930s murals by Ardengo Soffici and Giovanni Tolleri, as well as in contemporary artisanal endeavors.[42] Its origins, on the other hand, are much disputed.[43]

Following its importation into Italy around 1340, and until about 1550, the *spolvero* technique played a highly significant role in the production of paintings (especially in the medium of *buon fresco*) and, to a lesser extent, in that of drawings.[44] In the 1340s to 1360s, Andrea di Cione "Orcagna" and his workshop relied on patterns, repeated by means of *spolvero,* to create the elegant framing ornament in mural cycles originally in the churches of S. Maria Novella and S. Croce, Florence.[45] From the 1430s to the 1460s, Paolo Uccello, Domenico Veneziano, Andrea del Castagno, and Piero della Francesca would pioneer the application of *spolvero* cartoons to paint figural compositions, and from the 1460s to 1470s onward, muralists would begin to combine *spolvero* with *calco* to transfer cartoons more quickly, as is clear from the work by Melozzo da Forlì, Domenico Ghirlandaio, Pietro Perugino, Bartolomeo della Gatta, Luca Signorelli, Bernardino Pinturicchio, and others.[46] Eventually, the use of *calco* led to a further refinement – familiar to us from modern-day "carbon copies" – as we see in drawings from the 1550s by Battista Franco.[47] Before tracing the outlines of a design, the artist would smudge charcoal or black chalk (less commonly, red chalk or graphite) on the verso of the sheet itself, or on the verso of a separate sheet placed underneath. This way, the artist could press less heavily with his hand on the stylus (or other pointed tool) as he more fluently traced on the paper and therefore minimized the damage to the original design. Vasari's *Vite,* Borghini's *Il Riposo,* and Armenini's *De' veri precetti* further confirm that this "carbon paper" procedure became standard for transferring drawings from one sheet to another, and cartoons to both panels and canvases.[48] Examination with infrared reflectography of the underdrawings of many painted panels by Andrea del Sarto (1486–1530) reveals the schematic, somewhat jagged outlines that are typical from such a procedure.[49] Use of this practice also probably explains the fortunate survival of an unusual group of sixty monumental *"ben finiti cartoni"* by Gaudenzio Ferrari (1475/80–1546), his close associate Bernardino Lanino (c. 1512–1583), and their circle of Piedmontese–Lombard artists. Exquisitely rendered in charcoal, these cartoons are exhibited in the Accademia Albertina in Turin.[50] Late Renaissance and Baroque treatise writers on engraving would also recommend this modified *calco* technique to transfer a final design onto the plate.[51]

Yet despite the savings in labor that the *calco* technique could represent, especially in the case of large-scale mural cycles, numerous works from the late

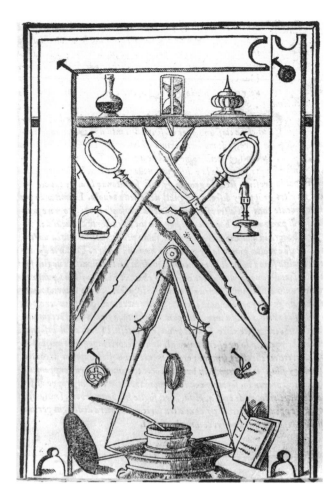

Figure 12. Giovanni Antonio Tagliente, Opera Nuova, *Venice, 1530, fol. 25 recto (Metropolitan Museum of Art 35.75.3L, Harris Brisbane Dick Fund, 1935, New York). This woodcut illustrates the tools necessary for drawing and calligraphy.*

Quattrocento and early Cinquecento attest to the particular utility of the traditional *spolvero* technique. Throughout this period (and well into the Novecento), muralists continued to transfer patterns with *spolvero* in painting complex or repetitive ornament. During the High Renaissance, Leonardo and his workshop sometimes used *spolvero* cartoons to reproduce or paint life-size portraits. Michelangelo and Raphael rarely dispensed with cartoons to paint figural compositions in fresco, transferring them often enough by means of *spolvero,* rather than *calco.* As Armenini's *De' veri precetti* vividly tells, Giulio Romano applied the *calco* technique to produce finished drawings of dazzling virtuosity.[52] Yet until his death in 1546, when it had become particularly unusual for fresco painters to do so, Giulio continued to rely on the *spolvero* tech-

nique extensively. Although the application of *calco* is by comparison more typical, passages of *spolvero* nevertheless recur throughout the figural scenes and ornament of the Farnese Gallery ceiling (Palazzo Farnese, Rome), frescoed by Annibale and Agostino Carracci in 1597–1600 with a team of assistants.[53] The extant cartoons for this project reveal the evidence of both types of design transfer.[54]

A vast corpus of extant drawings can help us document the *spolvero* technique. A group of such drawings was previously gathered by the author – by no means an exhaustive account – but one that was intended to illustrate the extent of the technique's dissemination. Most commonly, such drawings are of two general types. Either they have outlines pricked for transfer onto another surface,[55] or they are drawn freehand over preliminary *spolvero* (pounce marks), which the artists connected dot-by-dot to produce the final design.[56] The former type is by far the more abundant. A few drawings combine both *spolvero* underdrawing and pricked outlines for further transfer;[57] some examples are also drawn on the basis of preliminary pricked outlines.[58] By comparison, it is substantially more difficult to compile a sufficiently nuanced corpus of stylus-indented drawings to study the variations of practice that concern us here: the evidence of incisions on the working surface can often prove extremely ambiguous (see Chapter Ten).

Some of the greatest Italian artists produced drawings utilizing the *spolvero* technique. An incomplete list

Figure 13. Cesare Vecellio, Corona delle nobile et virtuose donne, *Venice, 1600, fol. 30 (Biblioteca Marciana, Venice). This extremely rare woodcut depicts the squaring grids necessary for enlarging and diminishing embroidery patterns, and the pointed instrument for tracing or pricking their outlines.*

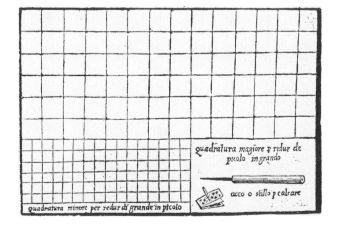

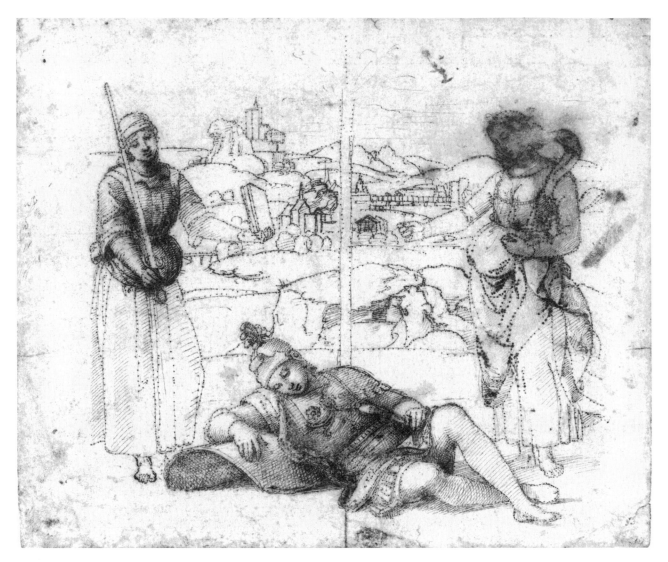

Figure 14. Raphael, pricked cartoon for an allegory, "The Knight's Dream" (CBC 231; British Museum 1994-5-14-57, London), rubbed with black pouncing dust from the recto and verso.

would include Paolo Uccello, the brothers Antonio and Piero Pollaiuolo, Andrea Verrocchio, Domenico Ghirlandaio, the brothers Gentile and Giovanni Bellini, Melozzo da Forlì, Sandro Botticelli, Cima da Conegliano, Filippino Lippi, Leonardo, Lorenzo di Credi, Luca Signorelli, Pietro Perugino, Michelangelo, Fra Bartolomeo, Raphael, Andrea del Sarto, Giulio Romano, Polidoro da Caravaggio, Baldassare Peruzzi, Sebastiano del Piombo, Domenico Beccafumi, Perino del Vaga, Michelangelo Anselmi, Francesco Parmigianino, Niccolò dell'Abate, Annibale and Agostino Carracci, as well as Domenichino. Although this wealth of genius and near-genius may tip the balance of our attention in their favor, the group of drawings here

examined encompasses a nearly equal number of examples by less accomplished draughtsmen, and the number of these still pales in comparison to the vast group of such drawings by anonymous figures. In fact, the overwhelming majority of drawings documenting the *spolvero* technique – well over 1,000 in number, if we were to add up all the individual sheets comprising albums or entire archives scattered in the collections of Europe and North America – were produced by long-forgotten artisans of modest ability.[59]

At least sixty-one of Raphael's drawings, if we include the seven colored Sistine Chapel tapestry cartoons (Victoria and Albert Museum, London), that is, about one-sixth of his surviving corpus, are either pricked for transfer or drawn on *spolvero* marks, a remarkable fact (Plates VI, VII; Figs. 14–15).[60] The tempting explanation for this high number, that the *spolvero* technique was extremely common by the High

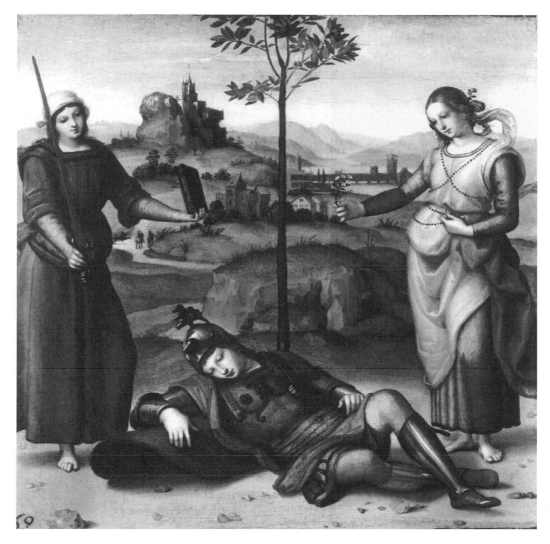

Figure 15. Raphael, "The Knight's Dream," oil on panel (National Gallery, London), painted from spolvero *underdrawing.*

Renaissance, gets the answer only half right. Emerging from his training in Pietro Perugino's *bottega,* which represented a tradition of design reproduction that was particularly strong in the regions of Umbria and the Marches, as we shall see, Raphael realized fully the potential efficiency of *spolvero* as an aid in the creative process of preliminary drawing. He adopted the technique to produce synthetic types of drawings, both before and after the final cartoon stage, pricking and pouncing small-scale and large-scale drawings from one sheet of paper to another. Some artists of the preceding generation had explored the possibilities of the technique as a compositional tool. In their work, however, the surviving evidence is often scant and only becomes intelligible if viewed vis-à-vis Raphael's large

oeuvre. But Raphael's remarkably fluent use of *spolvero* as an exploratory design technique remained relatively exceptional, even during much of the High Renaissance, for artists and craftspeople more commonly used it as a tool for design reproduction and variation.

To speak of the cartoon's history is to argue for patterns of development, for contrasts of functions during the three centuries that concern the present book – broadly speaking, between 1300 and 1600. These are hardly simple or linear developments. As is emerging more clearly from the scientific investigation of underdrawings in panels, the application of cartoons in easel painting and fresco varied greatly. It is the medium of fresco, however, that can claim the greater innovations. We have also alluded to the shared practices of artists

15

and artisans. For the most part, however, art and craft followed parallel courses. Although the *spolvero* technique has enjoyed a fairly continuous use in such decorative arts as embroidery, in the creative work of Italian painters and draughtsmen it experienced an enormously important but comparatively briefer surge in popularity (c. 1370–1520). A survey of the technique's diverse functions reveals at once the practical reasons why it has endured for more than a thousand years in artisanal endeavors, enjoying a widespread application from China to the Western world, but why it also lost ground in the creative process of design.

Chapter Two will illustrate step-by-step the actual procedure of transferring designs, discussing the types of drawing surfaces, media, tools, and technical shortcuts used, as well as the assembly of large-scale cartoons (including costs and types of manual labor). It is clear that to produce the monumental, comprehensive cartoons that began to predominate from the 1450s onward was both costly and labor-intensive. Because of its essential simplicity, the *spolvero* technique was well within the capabilities of not only apprentices and assistants but also of semiskilled craftspeople and unskilled copyists. This is further confirmed by a relatively large Renaissance and Baroque literature of popular how-to craft manuals – "teaching without a master."[61] Chapter Three will then explore the most basic and most common application of *spolvero:* as a means of copying designs exactly and of replicating them manifold. Yet, as pointed out in Chapter Four, the abuse of this basic reproductive function would largely taint the critical reception of this and other techniques of copying in the sixteenth and seventeenth centuries; among reputable artists, this factor must have played a role in the gradual disuse of *spolvero* during the course of these centuries.

Chapters Five and Six will draw a general distinction between the functions of *spolvero* "patterns" and those of *spolvero* "cartoons." Emerging in Italy around 1340, from the Late Medieval tradition of stencil making, patterns enabled the serial reproduction of increasingly elegant and complex ornament. Contrary to frequent assumptions, at least in regard to full-scale drawing, new design types emerged from the Trecento to the Quattrocento, and the functions of old ones evolved substantially. As the fifteenth century unfolded, the steps in the preliminary design process, from initial idea (*"primo pensiero,"* to borrow Filippo Baldinucci's term in 1681 for "quick sketches") to final execution in paint, gradually became more distinct and were explored in increasingly varied drawing types. The

nascent science of perspective would require an increasingly precise design technology during the Quattrocento. Emerging during the 1430s, as a means of perfecting the design of figural compositions, cartoons may be viewed as part of a new Renaissance, Central-Italian tradition of *disegno*.

The Italian term *"disegno"* denotes both "design" and "drawing," as is already apparent in Cennino's *Libro dell'arte* and Leon Battista Alberti's painting treatise.[62] As theorists of the Late Renaissance more expansively explained, the two activities were considered to be inextricably intertwined. "Design" was the abstract manifestation of a highly developed aesthetic cognitive faculty (what Federico Zuccaro would call *"disegno interno"*), whereas "drawing" was the physical product of the hand, guided by the genius of design (what Zuccaro would call *"disegno esterno"*).[63] Vasari, Armenini, Lomazzo, and Zuccaro took it for granted that *disegno* encompassed the very idea already present a priori in the artist's mind, hence the importance of drawing as the foundation of all the arts.[64] Indeed, the concession that *disegno* embodied the common origin of painting and sculpture proved to be a way of settling the dispute of the *"paragone,"* as Jacopo Pontormo shrewdly put it in his reply to Benedetto Varchi's inquiry of 1547.[65]

Chapter Seven will describe the dramatic changes in function and appearance of some late Quattrocento and early Cinquecento cartoons, as an ideal of *disegno* took hold in Central Italy. The emerging practice of "substitute cartoons" (Chapter Eight) would be a direct consequence of this ideal, as would the systematic use of tracing methods in the preparation of preliminary drawings (Chapter Nine). The last two chapters will attempt to clarify the functions of stylus tracing *(calco)* relative to pouncing *(spolvero)*. Based on the testimony of Renaissance and Baroque treatises, we can assess the advantages that kept *spolvero* viable, though in limited contexts, long after *calco* eliminated the old technique's main disadvantage – laboriousness. Such sources also suggest the reasons why painters combined these two design transfer techniques in their murals, especially during the period of transition, between the 1470s and 1520s.

The shifts in working practices that began in the 1470s to 1490s were probably not coincidental, but the outcome of a number of interconnected factors, reflecting the tension between traditional workshop procedures in the Quattrocento and the ideals of design, emerging in the early Cinquecento. An increasing number of monumental architectural spaces to be frescoed would require expedient execution and would entail

complex effects of perspective. Concurrently, the functions and physical appearance of cartoons would evolve, the use of "substitute cartoons" would often become more comprehensive, and, by the first three decades of the sixteenth century, *calco* would gradually displace *spolvero* as the practical method of cartoon transfer.

But throughout the fifteenth and sixteenth centuries, different approaches to the preparation of paintings coexisted in Central Italy and Northern Italy, particularly in the Veneto. In Central Italy, the tradition of mural painting, particularly that of *buon fresco*, had nourished a relatively systematic tradition of design, with more or less clearly defined types of preliminary drawings on paper. In Venice, where easel painting was favored over mural painting (not the least because of the lagoon's salt and damp climate), artists usually produced the underdrawings of their compositions freehand, directly on the panel or canvas (Fig. 16).[66] In his *Vita* of Titian, Vasari famously – if unsympathetically – attempted to explain Giorgione's new, direct approach to painting at the time Titian entered his workshop, around 1507–8. According to Giorgione, who closely imitated nature, "painting only with the colors themselves, without further study in drawings on paper, was the true and best manner of proceeding and was true design" (*"il dipignere solo con i colori stessi, senz' altro studio di disegnare in carta fusse il vero e miglior modo di fare et il vero disegno"*; Fig. 17).[67] Technical examination of Giorgione's and Titian's paintings substantiates at least the spirit of Vasari's claim; extant drawings on paper by these artists are rare (see Fig. 20). Not surprisingly, Venetian easel painters hardly employed *spolvero* except for reproduction: to replicate entire compositions, or individual figures and groups, or isolated decorative motifs in further paintings. This probably explains the presence of *spolvero* in background details of Vittore Carpaccio's *Apotheosis of St. Ursula* (Gallerie dell'Accademia, Venice),[68] as well as those of his *Hunt in the Lagoon* (J. Paul Getty Museum, Los Angeles) and *Two Women on a Terrace* (Museo Correr, Venice), painted in 1490–95.[69] The latter two canvases were originally part of the same composition. Carpaccio and his *bottega* otherwise worked from freehand underdrawings.[70] Of the small corpus of Venetian Quattrocento paintings showing *spolvero*, in fact, the majority have turned out to be workshop pieces, usually depicting such generic subjects as Madonna and Child groupings.[71] Moreover, and also not unexpectedly, few Venetian drawings documenting the *spolvero* technique survive from the period between the 1480s and 1530s, in sharp contrast to the abundance of Central-Italian examples, a reflec-

tion of the general disparity in the quantities of surviving drawings between the two regions, often pointed out in the literature.[72] This disparity therefore does embody fundamental, regional differences in the conception of drawing as a tool.[73] By the Cinquecento, the emphasis in Venice on the act of coloring, *"colorito"* or *"colorire,"* frequently at the expense of *disegno* on paper may have enhanced these differences.[74] Paolo Veronese's frescoes, like those of many of his Central-Italian contemporaries, exhibit *calco*. The pricked drawing of a woman's head (Figs. 18–19), from the 1560s, probably served as a *simile* for replication in a variety of compositions.

Yet, as we can repeatedly observe, even during the era of monumental cartoons in Central Italy, between 1450 and 1750, their preparation was not as commonplace as theorists may have wished, hence their emphasis on the subject. In the introduction to the *Vite,* Vasari conceded – nearly empathetically – that in his day there were many painters of easel pictures who omitted cartoons. But, he insisted that for fresco they "must be done and cannot be avoided."[75] In providing instructions for painting, subsequent writers often treated the preparation of cartoons and freehand underdrawings as equally good alternatives. Since the cleaning of the Sistine Ceiling, it has become well known that Michelangelo frescoed relatively large parts of the ceiling (1508–12) without cartoons, notably the *Ancestors of Christ* on the lunettes (which are dazzling primarily for their arrangements of color).[76] In the Sistine lunettes the master may have reverted to a more traditional use of *sinopia* underdrawings on the *arriccio* – a technique employed by mural painters and mosaicists since Late Antiquity and Early Christian times. When artists omitted cartoons, they also sometimes enlarged the design directly onto the working surface from a finished, small-scale drawing, by constructing grids of proportional squares. In 1596–1602, Giovanni and Cherubino Alberti would transfer large parts of their designs from full-scale cartoons, by means of stylus incision *(incisione indiretta)*, to paint the illusionistic ceiling with the *Apotheosis of St. Clement (Sala Clementina,* Vatican Palace).[77] The muralists, however, would also enlarge numerous drawings for the angels in the prominent central group of the ceiling directly onto the *intonaco* by means of proportional squaring grids, thereby omitting cartoons altogether.[78] The incised squaring grids on the *intonaco* are especially visible in raking light. Andrea Pozzo's *Perspectiva Pictorum* (Rome, 1693–1700) illustrates the application of such proportional squaring grids and

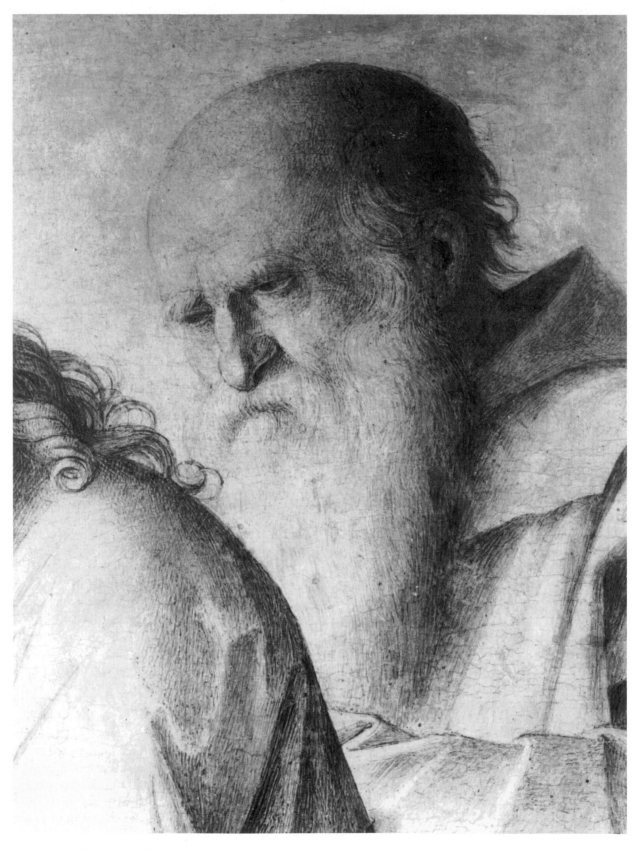

Figure 16. Detail of Giovanni Bellini, The Lamentation over the Dead Christ, *monochrome oil and tempera on panel (Galleria degli Uffizi, Florence). As we can see in this unfinished panel, the graphic quality of the under-painted layers would have made the use of cartoons on paper redundant.*

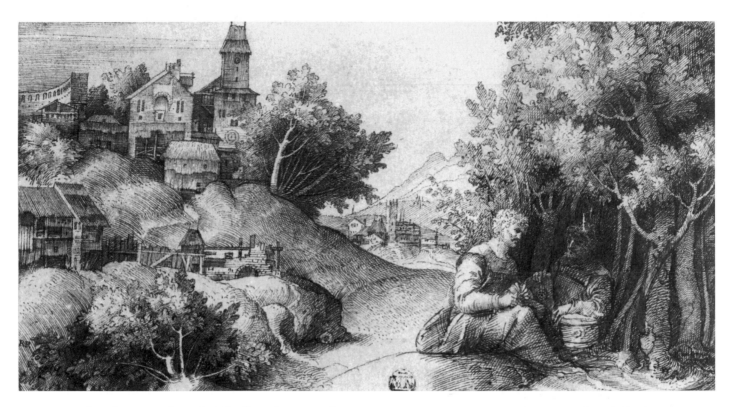

notes that they were intended for frescoing exceptionally large vaults or irregular surfaces.[79]

Some editions of Cesare Vecellio's *Corona delle nobili et virtuose donne,* a Venetian embroidery patternbook first published in 1591, illustrate the use of squaring grids to enlarge and diminish the scale of embroidery designs, along with the instrument used to prick or trace their outlines for transfer, an *"acco"* (needle) or *"stile"* (stylus; Fig. 13).[80] The Central-Italian writers – Giorgio Vasari, Pietro Accolti, Filippo Baldinucci, and Andrea Pozzo – would call the grid *"rete"* or *"graticola,"* whereas the Venetian Cesare Vecellio would call it *"quadratura."* As we shall see, however, the success of this method depended almost entirely on the acuity of the artist's visual judgment, the *"giudizio dell'occhio."*[81] Even at its best, design transfer by means of proportional squaring grids often cannot permit as precise a translation of contours on the working surface as any of the methods involving a 1:1 correspondence of scale between the preliminary design and the final work – either *spolvero, calco,* or *lucido* (tracing with translucent paper).[82] The use of proportional squaring grids is ancient.[83] The practice of squaring was preferred by Venetian painters throughout the Cinquecento and became relatively standard across Europe by the Seicento (Figs. 20–21). Thus, the prominence of the squaring grids in Cesare Vecellio's emblematic diagram apparently reflects this preference.

Figure 17. Here attributed to Giulio Campagnola (probably after Giorgione), pricked composition draft for a Landscape with Two Seated Men *(CBC 39; Département des Arts Graphiques du Musée du Louvre inv. 4648, Paris). This drawing was presumably preparatory for a print and was pricked to reverse the composition.*

Seen as a whole, the reconstruction of cartoons explored in the following pages suggests a complex interaction between theory and practice. For the Italian Renaissance artist, this interaction was more self-evidently reciprocal than we may recognize today. As Leonardo admonished in the *Codex Atlanticus* (fol. 76 recto), in a note dated 23 April 1490, "the painter who copies [*ritrae*] merely by practice [*pratica*] and judgment of the eye [*giuditio d'ochio*], without reason [*ragione*], is like the mirror which imitates within itself all the things placed before it without cognition [*cognitione*] of their existence."[84] Sound theory was the foundation of good practice. Yet, as another of Leonardo's contemporary notes also reminds us in the *Codex Atlanticus* (fol. 221 verso d), "good judgment [*bono giuditio*] is born of good understanding [*bene intendere*], and good understanding derives from reason expounded through good rules [*bone regole*], and good rules are the daughters of good experience [*bona sperientia*], the common mother of all the sciences and arts [*scientie e arti*]."[85]

Though practicality continued to determine the course of the *spolvero* technique's history among crafts-

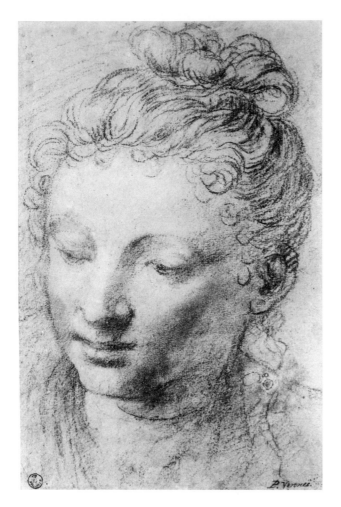

Figure 18. Attributed to Paolo Veronese, pricked pattern for the Head of a Woman *(CBC 335; Gabinetto Disegni e Stampe degli Uffizi inv. 7431 Santarelli, Florence).*

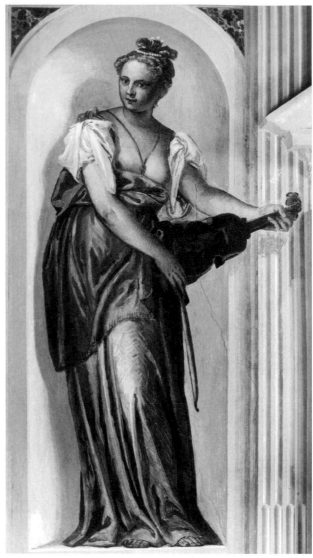

Figure 19. Paolo Veronese, Allegorical Figure, *fresco (Villa Giacomelli, Maser).*

people, it may be argued that among post-Renaissance painters, admiration for the style and technique of the great Italian Renaissance masters, as much as practicality, prompted the sporadic revivals of *spolvero* as a means of cartoon transfer. At a time when it had become customary to trace cartoons with the stylus or even to work from small-scale drawings transferred by means of proportional squaring grids, Domenichino's painstaking use of *spolvero* cartoons to refine drafts of his compositions may have been yet another facet of his emulation of Raphael. This peculiarity is suggested by Domenichino's sequence of design in the cartoons for the *St. Cecilia in Glory* fresco, from 1612 to 1614, on the ceiling of the Polet Chapel (S. Luigi dei Francesi, Rome).[86] The artist's very manner of rendering cartoons in stumped charcoal and white chalk was Raphaelesque.[87] Confirmation of another kind emerges from the 1664 inventory of the collection of

Francesco Raspantino, Domenichino's assistant and artistic heir when the master died in 1641 in Naples. The Raspantino inventory lists almost seventy cartoons by Domenichino (kept in a locked trunk), a bundle of *"spolveri,"* among them one for St. Cecilia, and further on, seven tracings after Raphael.[88] The nostalgic revival of the great art of the masters, ergo a revival of their techniques, was indeed a powerful leitmotif in much post-Renaissance writing on art. Though recast in the more positivistic discourse of the mid–nineteenth century, it was also to serve as the cornerstone for the pioneering investigations of artistic technique begun by Mary Merrifield, Sir Charles Lock Eastlake, and others.

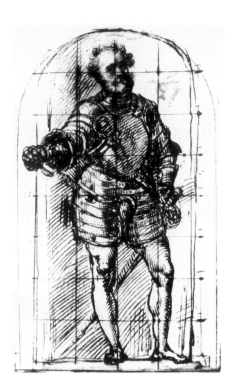

Figure 20. Titian, squared sketch for the Portrait of Francesco Maria della Rovere, Duke of Urbino, in Armor *(Gabinetto Disegni e Stampe degli Uffizi inv. 20767 F, Florence).*

Written Sources

Roughly between 1340 and 1550, as the comprehensive visual evidence suggests, the *spolvero* technique became widespread and then gradually retreated into the background, with relatively little notice in the contemporary written sources.[89] In fact, few texts mention the technique in connection with painting. The reasons are manifold. First, until the sixteenth century, pedagogical writings on art were relatively rare, and, then, arguably, only the atypical procedures merited description. Thus, for example, the references to the *spolvero* technique during the second half of the fifteenth century – a crucially important period for the cartoon's history – are incidental: passing allusions in account book entries, such as that by Alesso Baldovinetti for decorating the Gianfigliazzi Chapel (S. Trinita, Florence), or scattered notes, such as Leonardo's recipe for oil painting. On 28 April 1471, Baldovinetti spent 4 lire to buy 16 *"quaderni"* (quires) of rag paper to make pounced cartoons (*"spolverezi"*) for the prophets and other designs on the vault.[90] In Paris MS. A (fol. 1 recto) in 1490–92, Leonardo's recipe for preparing a wood panel to paint quickly in oils recom-

Figure 21. Workshop of Bernardino Poccetti, squared sinopia *for mural (detached from the* "Chiostro dei Morti," *SS. Annunziata, Florence).*

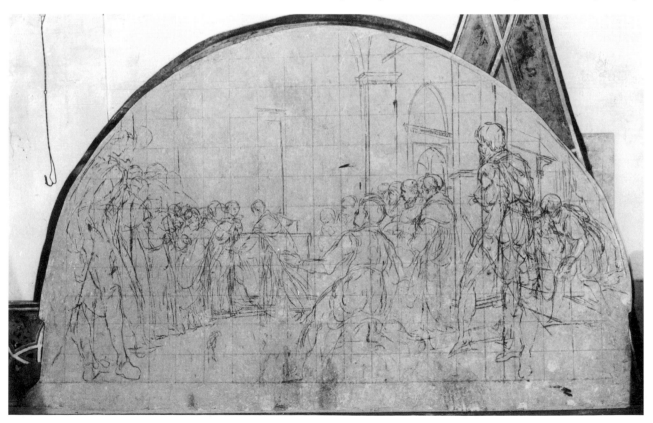

mends that an artist pounce the design of a drawing to transfer it and then outline the forms *("spoluerezza e profila il tuo disegnio")*.[91] The technique was too well known to require explanation. In great contrast to the Raspantino inventory regarding Domenichino, the few early inventories that mention cartoons provide significantly less precise data for our purposes, as in that of Melozzo da Forlì's possessions from 18 May 1493, which merely lists a *"chartone"* ("large paper" or cartoon), portraying the Virgin and another of a St. Sebastian, as well as twenty-two *"charte"* (pieces of paper) with drawings of heads and other motifs.[92]

Second, significant shifts in working practices occurred, as the *calco* technique largely displaced *spolvero* from the 1510s and 1520s onward. Vasari's introduction to the *Vite,* as well as Borghini's *Il Riposo,* are reflections of this change. For the transfer of cartoons to the painting surface, they describe *calco,* rather than *spolvero*.[93] Vasari's own murals reveal the extensive application of *calco;* he and his workshop would employ *spolvero* only in minor, repetitive passages of ornament.[94]

Armenini in his *De' veri precetti,* as well as many treatise writers throughout the seventeenth and eighteenth centuries, attempted to revive earlier Italian painting techniques considered superior to those prevalent in their own time and place, and in so doing, often provided extensive technical descriptions. Andrea Pozzo's appendix to his widely published *Perspectiva Pictorum,* with the "brief instructions on fresco painting," explains the function of the three methods of drawing transfer common in the late Seicento: squaring *("graticolare"),* stylus tracing *("ricalcare"),* and pouncing *("spolverare")*.[95] Acisclo Antonio Palomino's *El museo pictórico y escala óptica* (Madrid, 1715–24) teems with practical hints regarding the *spolvero* technique's application in various media and contexts. Near-contemporaries and famed fresco painters in their lifetimes, both Andrea Pozzo (1642–1709) and Acisclo Antonio Palomino (1655–1726) wrote about their art from firsthand experience, "because one cannot always find practical persons willing to teach much in detail."[96] Such late descriptions can help us fill some of the lacunae of evidence in Italian Renaissance written sources regarding the use and disuse of design transfer techniques.[97] Writings on the craft of embroidery attest to the continuous use of *spolvero* from the sixteenth century to modern times.[98]

In reconstructing techniques of design transfer, the evidence found in a diverse body of written sources may be integrated: art treatises, craft manuals, ephemeral patternbooks, dictionaries, letters, inventories, as well as payment and contractual documents. Texts from Cennino Cennini's *Libro dell'arte* (MS., late 1390s) to Francesco Milizia's *Dizionario delle belle arti del disegno* (Bassano, 1797) permit some of the detailed reconstruction that Chapter Two offers. They describe the tools and materials, often also assigning them names. Because comparison of their contents shows that such processes scarcely changed over the centuries – and the opportunities for verification will arise frequently in Chapter Two – later texts may safely be adduced as evidence in attempting to reconstruct some Renaissance techniques, if not their functions.

Yet the language of artistic practice emerging from this diverse body of written sources also raises its own set of issues. Just how we should interpret both their vocabulary and conventions of writing seems decisive; this question will therefore be among the recurring themes in the present book. Our emphasis here on the evidence from Venetian sixteenth-century embroidery patternbooks serves a twofold purpose (Figs. 11–13). First, Italian Renaissance drawing practice is usually discussed entirely from the testimony of Tuscan writings. Second, the emerging visual evidence regarding the *spolvero* technique in Venice remains fragmentary. Compared to Venetian craftspeople, Venetian painters and draughtsmen appear to have relied on the technique for the limited purpose of design reproduction.[99]

Interpreting the Visual and Textual Evidence

It is a truism that disparities of evidence exist in the survival of Renaissance works of art and texts. These disparities constitute a great impediment to studies that attempt to establish and interpret a broad body of data deriving from such sources. The research presented in this book is, of course, no exception. Three examples can here illustrate the difficulties in distinguishing normative circumstances from accidents of survival. The subtleties of these differences argue for cautious interpretation.

In contrast to the ample evidence of *spolvero* in Michelangelo's frescos, we have only one surviving autograph pricked drawing by the great artist, the Naples cartoon fragment for the *Crucifixion of St. Peter* (Fig. 3), and none drawn on *spolvero* marks. On the one hand, we must allow for the vicissitudes of survival.[100] Vasari's *Vita* of Michelangelo singled out the artist's willful destruction of his own working drawings: "... shortly before he died, he burnt a great number of drawings [*disegni*], sketches [*schizzi*], and cartoons [*cartoni*] made by his own

hand, thus no one would see the toil that he endured and the ways in which he tested his intellect, so as not to appear anything but perfect."[101] There are other recorded instances of Michelangelo's willful destruction of drawings, not least among these the reproach by Pietro Aretino in letters published during the artist's lifetime.[102] Moreover, a letter on 5 February 1518 by Lionardo del Sellaio from Rome to Michelangelo in Florence reports that many *"chartoni"* left behind in the great master's house in Rome were burnt according to his orders.[103] At Michelangelo's death on 18 February 1564, the investigation conducted by the officials gathering the inventory of his possessions apparently revealed that, except for ten architectural and figural *"cartoni,"* no other drawings survived; Michelangelo's nephew Lionardo reportedly stated that the artist had burned everything in two lots shortly before dying.[104] These records of destruction corroborate the facts given in Vasari's *Vita* of Michelangelo, although they have been variously explained.[105] Perhaps we should heed Vasari as well, in his explanation of Michelangelo's motives.[106] At least some of these cartoons must have been pricked.

On the other hand, another explanation might well lie in the artist's design habits. For example, Michelangelo, who considered himself more of a sculptor than a painter and who was thus accustomed to thinking three-dimensionally, may not have used *spolvero* as a reproductive aid in developing preliminary drawings for a composition – unlike Pietro Perugino, Luca Signorelli, Raphael, Girolamo Genga, or Andrea del Sarto (early in his career).[107] Michelangelo may have only employed the technique to transfer cartoons for fresco. Indeed, as noted in Chapter Eleven, statistical evidence shows that he painted progressively greater parts of his frescos from pounced, rather than stylus-incised, cartoons.[108] Contrary to the general trend toward stylus incision, this remains among the notable exceptions in the history of cartoon transfer techniques during the Cinquecento.

Leonardo was especially familiar with the technique of *spolvero*. He wrote about its use in panel painting and applied it in drawings and paintings that are still extant today.[109] Payment documents between 1503 and 1505 chart in relative detail the progress of his cartoon for the lost mural of the *Battle of Anghiari,* intended for *"La Gran' Sala del Consiglio"* (Palazzo Vecchio, Florence).[110] All this would indicate that Leonardo considered cartoons a necessary step in painting panels and murals. Yet infrared reflectography examination confirms the lack of cartoon marks in the unfinished *Adoration of the Magi* (see Figs. 216–17), contracted in

March or July of 1481 and Leonardo's most significant early commission. Full of tonal nuances, the underdrawing of the *Adoration of the Magi* is instead fluently executed freehand, with numerous *pentimenti,* and is frequently altered in the ensuing layers of brownish underpaint.[111] The same is true of the unfinished *St. Jerome* (Pinacoteca Vaticana), from 1480 to 1490. Neither *spolvero* nor *calco* can be discerned in the sparse underdrawings of the *Annunciation* (Galleria degli Uffizi), from about 1472, and the *Baptism of Christ* (Uffizi), painted with his master, Andrea Verrocchio, in 1472–74.[112] Relatively sparse, freehand underdrawing with substantial *pentimenti* also characterizes two fine versions of the *Yarnwinder Madonna* (Duke of Buccleuch, Scotland, and private collection, New York).[113] These panels have been attributed to Leonardo himself and date between 1500 and 1519.

Curiously, infrared reflectography reveals *spolvero* marks only in the *Ginevra de' Benci* (Figs. 22–23), from 1474 to 1476 and the *Cecilia Gallerani* (Czartoryski Museum, Cracow), from 1485 to 1490.[114] It could well be argued that the use of *spolvero* cartoons in these two cases is not unusual, because they are portraits. Portraits, as noted in Acisclo Antonio Palomino's treatise, were considered replicable paintings, and the use of *spolvero* cartoons was therefore practical.[115] As we shall see, the physical evidence in Leonardo's *Isabella d' Este* cartoon (Plate IV) also points in this direction.

Admittedly, in the cases of the *Last Supper* (Refectory of S. Maria delle Grazie, Milan), painted in 1494–97, and the murals in the *"Sala delle Asse"* (Castello Sforzesco, Milan), from around 1499, their ruinous condition, together with their dense, nonfresco painting technique, renders the verification of an underdrawing difficult. These murals, however, seem to lack any signs of having been developed from cartoons. Within the composition of the *Last Supper,* only traces exist of a preliminary perspective scheme for the background architecture and auxiliary lines for the decorative pattern on the tablecloth: all such lines were incised directly on the painting surface.[116] The stratigraphic surveys of the mural surface that were conducted during the recent cleaning and restoration reveal minute traces of a preliminary underdrawing in an aqueous, brick-red earth color, not unlike a *sinopia,* but executed on the *intonaco.*[117] Sparse, direct incisions, as well as dark, freehand underpainted contours, define parts of the *imprese* and garlands within the three lunettes surmounting the *Last Supper;* no incisions can be found in either the west lateral lunette or in the illusionistic architectural decoration.[118]

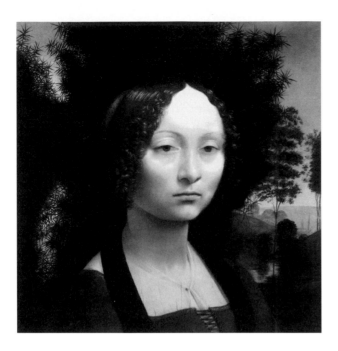

Figure 22. Leonardo, Portrait of Ginevra de' Benci, *oil on panel (National Gallery of Art, Washington).*

Figure 23. Infrared reflectogram detail of the face in Leonardo, Portrait of Ginevra de' Benci. *The* spolvero *dots are most evident in the eye.*

On the walls toward the north corner of the heavily restored *"Sala delle Asse,"* further fragments of the mural decoration were discovered in the 1950s: the roots of the trees, whose branches interlace with knots of gold cord on the ceiling and which grow from amidst plants and rocks.[119] As can readily be confirmed, the underdrawing and underpainting of these roots is entirely freehand. The artist made a precise, tonal brush drawing, cross-hatched diagonally in a brown, aqueous pigment over a loosely sketched preliminary underdrawing of *carboncino* (charcoal). Thus, because Leonardo painted in slow-drying media, he, like many easel painters of the period, may have often dispensed with cartoons. He may have preferred to prepare a complete underdrawing directly on the painting surface, using cartoons for little other than design reproduction.[120] It was laborious and expensive to draw monumental cartoons, especially the *"ben finito cartone"* type. As we shall see in Chapters Seven and Eight, the *Battle of Anghiari* cartoon may, therefore, represent a significant exception in Leonardo's mural painting practice (rather than the norm), because of the delegation of labor and legal obligations attending the commission. There is, however, too little evidence in Leonardo's few surviving paintings for us to reach definitive, statistically responsible conclusions.

Our last example illustrates how we may correlate visual and textual evidence in order to clarify the continuities of specific practices. In the late 1480s, as is demonstrated by his drawings of ornament, architecture, geometry, and anatomy, Leonardo began to use an ingenious method of pricking and pouncing to recreate bilateral symmetry (see Chapters Five and Nine).[121] The method was apparently already known in tenth-century China; it reemerges in a few pages of ornament designs from the dismembered *"Codex Zichy"* by anonymous artisans (c. 1489–1536).[122] Its next unambiguous appearance in drawings occurs in the 1560s to 1580s.[123] But, beyond these drawings, there is considerably more fragmentary visual evidence that could be adduced as testimony to the practice: the disposition of *spolvero* marks in the *grotteschi* of Andrea del Sarto's mural cycle from 1509 to 1524 in the *"Chiostro dello Scalzo"* (Florence), together with the disposition of pricked outlines in a portion of an ornament drawing from 1539 to 1545 by Giulio Romano.[124] Moreover, an embroidery patternbook by the Venetian Giovanni Antonio Tagliente, dated 1527 (republished in 1528, 1530, and 1531), actually explains the practice for the design of ornament.[125] Thus, the text completes the visual evidence, greatly helping us to close the gaps. Tagliente's book is, above all, concerned with the teaching of knotwork and interlacing ornament. It describes in Leonardesque words *"la scienza del far di groppi"* – a subject more brilliantly realized in the famous suite of six engravings of knots, inscribed ACHADEMIA·LEONARDI·VINCI.[126] That the pages of a popular artisan's patternbook present ideas, designs, and methods known to Leonardo, if not actually devised by him, attests to a relatively wide dissemination. No less importantly, Tagliente's reference

occurs at a time of complete silence regarding the *spolvero* technique in higher-minded writings on art.

Such examples can suggest the great difficulty of establishing criteria for a historical consideration of design techniques.

Science Aids Art History

In fresco, insufficient carbonation impedes the bonding between *intonaco, spolvero* deposits, and water-based colors. Moreover, during the actual painting process, the upper layers of pigment usually covered the *spolvero* dots. Especially the latter fact poses a barrier in the examination of not only easel paintings but also – more often than may be realized – in murals, even those executed in a *buon fresco* technique.[127] Most of the original *spolvero* in Michelangelo's *Crucifixion of St. Peter* (Fig. 2) is only very occasionally visible up close on scaffolding. Moreover, the references to Leonardo's murals in our second example above make clear that the fragile state of preservation of many extant Italian Renaissance paintings also poses obstacles. A search for *spolvero* marks is often rendered futile by accretions, abrasions, flaking paint, and *craquelure* (the network of cracks on the paint surface).[128]

The more complex archaeological evidence regarding stylus-incision techniques, both those done through a cartoon and directly on the *intonaco,* will be discussed in Chapter Ten.

Restorers from the eighteenth to the early twentieth centuries sometimes removed the paint layer of deteriorating panel paintings from the original support and transferred it onto canvas in an effort to halt damage. This risky procedure would have eradicated much of the possible evidence of underdrawing, altering not only the texture and structure of the paint layers but also often hastening their degeneration.[129] Similar transfers practiced on deteriorating murals would have obliterated much of the evidence of direct stylus construction as well as of underdrawings on figures.[130] In more modern times, the conservation of murals has included removals by means of *stacco* and *strappo*, methods that were first applied in the eighteenth century and that, although much perfected since, are presently not as widely used as they were a few decades ago.[131] With the *stacco* method, a mural is detached from the wall with its full *intonaco* layer; in the older method of "*stacco a massello,*" the depth of the detachment was greater, as it often included the *arriccio* layer, the coarse base plaster. When the plaster of murals has substantially

degenerated, the *strappo* method serves to remove the paint layer with an uppermost surface layer of *intonaco,* where the lime (calcium hydrate) has bonded with the water-based colors. Greatly refined since World War II, detachment by *strappo* often allows the recovery both of *sinopie* underdrawings on the underlying layer of *arriccio* and of underdrawings on the *intonaco* directly underlying the paint layer.

The *sinopie* for Andrea del Castagno's, Benozzo Gozzoli's and Domenico Ghirlandaio's murals reveal a rich diversity of drawing techniques. A "*secondo strappo*" of Raphael's angel in the *Expulsion of Heliodorus,* from 1511 to 1514, depicts the undersketch on the *intonaco,* directly below the paint layer (Figs. 24–25).[132] The *spolvero* dots from the cartoon, though only sporadically peeking through, are more evident on this small detached "*secondo strappo*" than on the thickly painted surface layer corresponding to this detail in the actual fresco in the *Stanza d'Eliodoro* (Vatican Palace). Three beautifully drawn cartoon fragments for this fresco survive (Fig. 26; CBC 261–62).[133]

The problems of interpretation are further compromised by the limitations of current tools of scientific investigation, their method of application, and the restricted number of objects so examined.[134] Evidence regarding cartoon transfer methods is often more easily discernible on a mural surface. Particularly in fresco, the chemical process of carbonation, due to the interaction of the air with the setting plaster, indelibly fixed the *spolvero* marks together with the water-based pigments. The layers of pigment in tempera and oil painting, however, which are layered more thickly than in fresco, completely conceal the evidence of cartoon transfer in most cases.[135]

Our discussion of painting technique has alluded to the use of infrared reflectography. Infrared reflectography, a video imaging system responsive to infrared light at the higher wavelengths of the electromagnetic spectrum, is among the most promising, nondestructive scientific means currently available of making visible the layers below the surface of a painting.[136] It can deeply penetrate the upper paint layers, often more so than infrared photography, and is especially effective in imaging underdrawing (Figs. 22–23).[137] Unfortunately, the majority of Italian fourteenth- and fifteenth-century panel paintings still remains to be examined with infrared reflectography.[138] This state of research is vexing in comparison to the field of Northern European paintings, in which the application of infrared reflectography has yielded impressive results during the last three decades and the method of investigation has been

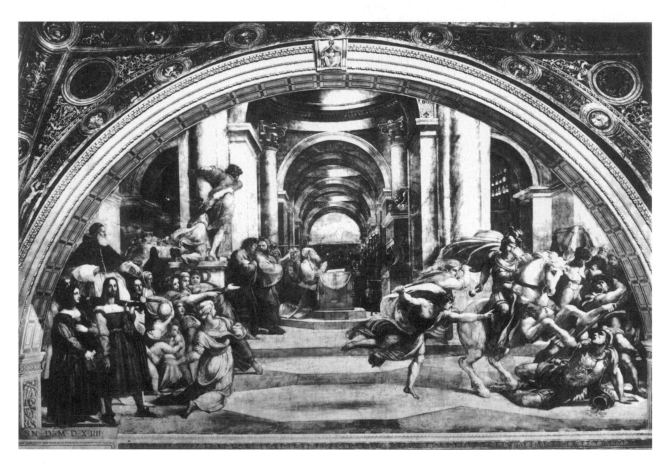

Figure 24. Raphael, The Expulsion of Heliodorus, *fresco (Stanza d'Eliodoro, Vatican Palace).*

significantly refined. The cumulative results from such examination of Italian paintings, dating between 1430 and 1470, will no doubt help us further refine the early history of cartoons in the future.

Infrared reflectography does have limitations, however, for it appears to penetrate the pigment layers unevenly and reveals primarily underdrawings containing carbon black that were executed on a whitish ground.[139] Artists and craftspeople, however, sometimes used non-carbon pouncing dusts and non-whitish grounds, presumably making such underdrawings invisible under infrared radiation.[140] Moreover, as will be discussed in Chapter Two, the underdrawings in nonfresco paintings and in such other media as drawings and embroideries were extremely ephemeral because of how they were made. Infrared reflectography has been successfully applied in the investigation of drawings,[141] and this technology seems also applicable to the study of underdrawings in manuscripts, embroideries, and miniatures.

That infrared reflectography has not revealed *spol-vero* in a number of easel paintings also raises questions, for such negative evidence may lead to hasty conclusions about the omission of cartoons.[142] A telling case is Raphael's panel of *"The Knight's Dream"* (Fig. 15), from 1501 to 1503. In the infrared reflectograms, one can infer, rather than plainly see, the presence of *spolvero* in the short dashes that comprise the outlines of the underdrawing: the dots became deformed as the painter brushed on the underpaint.[143] Here, the survival of the pricked cartoon for the panel (Fig. 14) confirms Raphael's use of the *spolvero* technique.[144] At least three instances exist in Raphael's *oeuvre* where the pricked full-scale drawing survives, although infrared photography or reflectography do not reveal *spolvero* in the underdrawing of the corresponding painting.[145] In such panels, the underdrawing, as distinguished from the painted undermodeling, seems sparse.[146]

Although the evidence of cartoon use is easier to discern in murals, much of it being usually visible to the naked eye, special problems exist. For example, in designs that must have been entirely painted from *spolvero* cartoons, pounce marks can either appear or vanish from sight, depending on the condition of the

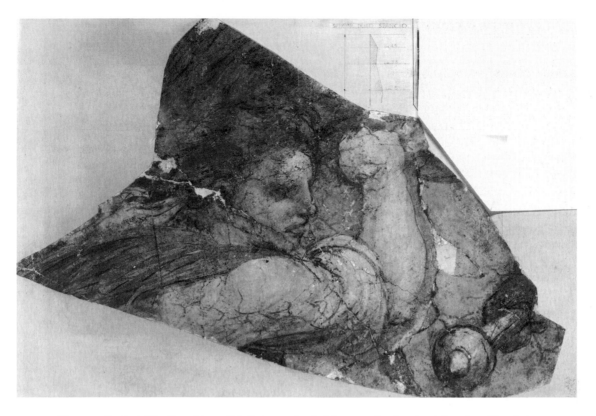

Figure 25. Raphael, The Expulsion of Heliodorus, *detached fragment of underpainted fresco layer* ("secondo strappo"; *Deposit of Pinacoteca Vaticana inv. 2329).*

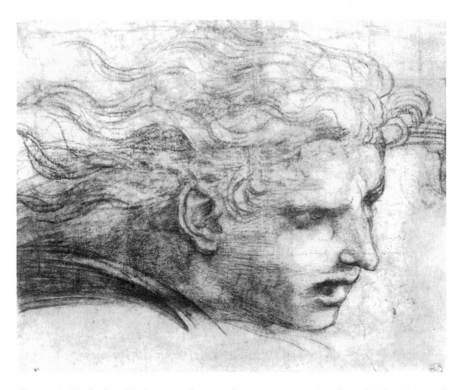

Figure 26. Raphael, pricked cartoon fragment for an Avenging Angel *in the* Expulsion of Heliodorus *(CBC 263; Département des Arts Graphiques du Musée du Louvre inv. 3853, Paris). The lower parts of this drawing were made up on new paper by an early restorer, and the outlines of the restored parts were pricked to harmonize with the original portions of the drawing.*

mural surface (especially if executed or retouched *a secco*), the density of the layers of pigment applied on top, and the relative wetness or dryness of the *intonaco* at the time of pouncing.[147] This problem also usually impedes comparisons between the placement of *spolvero* marks in a fresco and the pricked outlines of a corresponding cartoon. The large scale alone of many Renaissance mural cycles renders a consistent and complete graphic documentation of painting technique difficult, not least because this type of surveying involves complex and expensive computerization. More precise data will no doubt emerge as more easel paintings are examined with infrared reflectography, as methods of scientific investigation are perfected, and as cleaned murals are judiciously documented.

The Renaissance Meaning of "Pouncing"

Although in reconstructing the history and functions of cartoons, we will refer to the technique of pouncing, or *spolvero*, exclusively in its meaning of design transfer, it must be noted that such terms were sometimes used more generally in early written sources, and this can especially complicate the reading of Cinquecento and early Seicento texts. The Medieval painter, draughtsman, and calligrapher, who worked on the sometimes greasy, horny, absorbent surface of parchment, understood "pouncing" – "dusting" or "powdering" – in its most literal sense.[148] Rubbing pounce (powdered pumice, chalk rosin, or colophony) by hand, pad, rag, or hare's foot on the parchment's skin improved its surface and prevented ink from spreading.[149] Cennino Cennini's *Libro dell'arte* instructs, "powdered, like dust or writer's [pouncing] rosin" (*"spolverato, in forma di polvere o di vernicie da scrivere"*).[150] The mid–sixteenth-century calligraphy treatises by Giovanni Battista Palatino and Juan de Yciar also recommend this procedure for sizing writing paper.[151]

Bridging Medieval and Renaissance artistic practice, Cennino is the earliest author to have mentioned pouncing as a technique of transferring patterns, but – making no distinction between it and the above-mentioned practice of preparing parchment – called both *"spolverare."*[152] Like the modern English term "pouncing," *spolverare* in the sense of design transfer is a verbal conflation of the actual technical process.[153] The context for Cennino's use of the term, however, makes the meaning fairly obvious. Of Cennino's eight references to *spolverare* (and variations thereof), only a passage about the preparation of parchment is demonstrably unrelated to the later meaning of pouncing as a draw-

ing transfer method.[154] From Cennino's *Libro* onward, this would become the term's primary meaning in artistic writings and would frequently be featured as such even by Italian and non-Italian lexicographers.[155] For instance, in the 1612 edition of their dictionary, the scholars of the Accademia della Crusca (Florence) explain pouncing as "a term pertaining to painting, that is to derive [a design] with a *spolvero*, which is a sheet of paper containing a drawing that has been pricked with a pin, by letting pass through these holes charcoal or gesso dust, bound in a cloth sack called *spolverezzo*."[156] This earliest dictionary definition of the process would prove authoritative. Despite Filippo Baldinucci's own aspirations as a scholar and art collector in the Florentine court culture of Grand Duke Cosimo III, he would repeat the Crusca's definition verbatim in his *Vocabolario toscano dell'arte del disegno* (Florence, 1681), the first dictionary devoted exclusively to artistic terminology (see further Chapter Two).[157] Giovanni Battista Armenini's *De' veri precetti* only once reverts to the term *"spolverare"* in its narrowest sense to describe a shortcut in rendering the drawing of large cartoons – the artist could dust broadly areas intended to have shadows with a pouncing bag to obtain a gray base tone.[158] Other sources do not allude to a similar practice.

Cennino's, Vasari's, Armenini's, and Pozzo's form of the Italian term for pouncing is *"spolverare."*[159] Leonardo's *"spoluerezzare"* (*"spolverezzare,"* *"spolverizzare"*), appearing in his brief notes from 1490 to 1492 in Paris MS. A (fols. 1 recto, 104 recto), was equally used in the Cinquecento and Seicento.[160] Examples are the Venetian embroidery patternbook by Alessandro Paganino (c. 1532), as well as the dictionaries by the Accademia della Crusca (1612) and Filippo Baldinucci (1681).[161] The words in other Venetian embroidery patternbooks – Giovanni Antonio Tagliente's *"spoluereggiare"* (1527) and Giovanni Ostaus's *"poluereggiare"* (1557) – are variants.[162] The identification of these nuances is important. Often the word alone, fleetingly mentioned, signals the practice, the writer having assumed the reader's familiarity. For instance, Benvenuto Cellini's treatise *Dell'oreficeria* (MS., 1568) barely describes a technique of *"spolverezzare"* or *"spolverezzo"* – literally, a technique of dusting employed in decorative sculpture, rather than pouncing in the sense of design transfer – "because it is universally known by everyone."[163] The introduction to Vasari's *Vite*, in both its 1550 and enlarged 1568 editions, is also revealing in this respect. The word occurs belatedly in Vasari's text, in describing *sgraffito* decoration, rather than in the earlier, thorough descriptions of

cartoons for painting in fresco, panel, or canvas, the more logical places – we might have thought – for such an indication.[164] As explored in Chapters Four and Eleven, Vasari's is therefore a significant and probably conscious elision.

Artisans' Patternbooks

Woodcuts of modest execution in early Venetian embroidery patternbooks visually document at least some techniques of design transfer. (Ephemeral "how to" books were printed and reprinted by the score in sixteenth-century Venice.) The public for embroidery patternbooks consisted primarily of women – the wives and daughters of the nobility and rising mercantile class – as well as youngsters learning the trade.[165] A scene in Alessandro Paganino's *Libro Primo: De rechami,* published around 1532 (Fig. 11), depicts a woman who taps vigorously with a large pouncing bag on a pricked pattern of arabesque ornament to transfer the design by *spolvero.*[166] She works presumably in a room of her house. The pattern is stretched over a cloth and is nailed onto the working table. This is a uniquely early portrayal of a person actually using the *spolvero* technique to work, and the scene is one of four illustrating techniques of design transfer, all performed by women. Two of the other techniques portrayed in the woodcut relied on making the cloth translucent for tracing by placing it against a light source; the third alternative was to exploit the gridlike structure of loosely woven cloth to copy freehand.[167] (Unfortunately, none of Paganino's scenes appears to record stylus incision techniques, which were not easily applied in embroidery.) If the woodcut illustrates the four design transfer techniques as if they were of equal efficacy, the text of Paganino's *"epistoleta"* leaves no doubt that *spolvero* was considered superior, being the most precise and versatile. An array of tools (Fig. 12), first published by Giovanni Antonio Tagliente in 1524 and 1527 – in his calligraphy and embroidery manuals – includes a small pouncing bag hanging from a nail toward the lower right of the image. In Cesare Vecellio's emblematic illustration of the squaring grids (*"quadrature";* Fig. 13), the action of a pricking needle or stylus can be seen on the lower right. The design was transferred directly onto the working surface, after the correct scale had been determined with the help of the grids.

To dismiss these small books – which, as Tagliente's embroidery manual explains, also served as sources for the teaching of draughtsmanship – would impoverish our knowledge of Renaissance drawing practice.[168] If the wide lay audience for such books was at times barely literate, nevertheless the greater availability of patternbooks for the crafts of embroidery, lace, and calligraphy, however meager their textual content, undoubtedly also increased literacy.[169] Moreover, their authors are often related to the mainstream of Renaissance art and culture in ways that deserve more recognition, as in the case of Tagliente's embroidery patternbook, which may well have echoed some of Leonardo's ideas and methods. Giovanni Antonio Tagliente (c. 1465–1527) was among the preeminent calligraphers of his generation and the author of short manuals on a variety of subjects. He was also probably acquainted with the published treatises of Leonardo's friend, Fra Luca Pacioli, the Franciscan mathematician, as well as with the prints of Albrecht Dürer. Leonardo, Pacioli, and Dürer visited Venice during Tagliente's career there as a teacher of the new cursive script – *"el scrivere cancellaresco,"* as it is called in the documents regarding Tagliente's appointment to the post at the Fondaco dei Tedeschi.[170]

Alessandro Paganino (1509–1538), who published the scene of the woman "pouncer," was the owner with his better known father, Paganino Paganini, of a relatively successful press in Toscolano.[171] Since Alessandro wrote the best extant description of the *spolvero* technique, it will often be necessary for us to return to his short informative text, known mostly to specialists in the history of embroidery and printed books of the Venetian Renaissance. Another figure closely involved in the book arts of his day was Cesare Vecellio (c. 1521/30–1602), who illustrated the diagram of the *"quadrature,"* as well as of the tracing instrument. He was the author of a famous costume book, *Degli habiti antichi et moderni* (Venice, 1590) and was Titian's distant cousin. Indeed, he was long employed in the great master's workshop in Venice and accompanied him in his trip to the imperial city of Augsburg in 1548.[172] Cesare came from a family with several generations of painters. Thus, however uncompelling we may consider his paintings to be, his diagram is relevant as a document of Venetian painting and drawing practice.

Users of Cartoons and Design Transfer Techniques

In discussing Michelangelo's late frescos in the Pauline Chapel, we arrived at a hypothetical definition of "Urbino"'s duties as assistant. But our knowledge regarding the organization of labor in Italian Renais-

sance workshops remains frustratingly fragmentary, for unlike the fairly common portrayals of assistants drawing or grinding colors, no such illustrations apparently exist of artists, assistants, or artisans transferring cartoons of monumental size.[173] As noted, the memorandum from 6 June 1572 to Grand Duke Cosimo I de' Medici, about Vasari's contract and budget for many types of collaborators in his large fresco enterprise at Florence Cathedral, refers specifically to laborers who are "cartoon tracers." Vasari obtained a capable foreman, the Bolognese painter Lorenzo Sabatini, who collected payments for making cartoons between July and September 1572 *("a buon chonto de'chartoni e del servizio in chupola")*.[174] We have also seen that Vicente Carducho's *Diálogos* (Madrid, 1633) takes for granted that it was the *"oficial"* (assistant) in a workshop who transferred cartoons *("pasar los perfiles")* and prepared the underpainting before the *"maestro"* (master) intervened to correct and give the painting its finishing touches.[175] The *Diálogos,* although written in the early seventeenth century, are among the few art treatises to acknowledge this division of labor in a painter's workshop. Vicente Carducho (c. 1576/85–1638) succeeded his brother and teacher Bartolomé (1560–1608) as court painter to King Philip III of Spain.[176] Born in Florence, and in Bartolomé's case also trained there, both brothers were direct heirs to that city's workshop tradition.

No less tellingly, Charles Germain de Saint-Aubin's *L'Art du Brodeur* (Paris, 1770) notes that "children or apprentices are the ones who usually prick the designs, for to do this work one needs only patience and [the ability to follow a] routine."[177] Although the treatise by Saint-Aubin is again of a later period, we can entertain the possibility that child labor was indeed sometimes used in the *botteghe* of Italian Renaissance artists for the reason he described.

Cennino recommended a long course of apprenticeship in the *Libro dell'arte,* but the duration of apprenticeships was not entirely standard during the Trecento and Quattrocento. As stated in Neri di Bicci's *Ricordanze,* in 1459–60, Francesco Botticini was among the apprentices who broke his contract after nine months in the Bicci workshop, whereas a memorandum by Leonardo from the late 1490s records that his two pupils, Benedetto and Joditti, only stayed two months and thirteen days, and three months and twenty-four days, respectively.[178] Initiation began at an early age: Cennino himself must have started while still a young boy, for the *Libro* states that he had been Agnolo Gaddi's pupil for twelve years; at least one of Leonardo's rules for learning how to paint (c. 1490–92)

is addressed to *"putti pittori"* (child painters).[179] From 1349 onward, the Florentine statutes for the *"Arte dei medici, speziali e merciai"* (guild of physicians, apothecaries, and haberdashers), to which painters belonged, specifically mandated that apprentices for all professions dependent on the *"arte"* not be older than fifteen years of age.[180] According to Cennino, the first year was spent as a shopboy learning how to draw on erasable tablets, six more years were given to learning the material preparation of panels for painting, and an additional six years to acquiring actual experience in painting and decorating panels, anconas, and murals.[181] Cennino stated, amidst extensive directions on how to paint simulated gold and silver brocades, "and indeed, I advise you, if you want to teach children *(putti)* or boys *(fanciulli)* how to do gilding, have them lay silver, so that they get some practice, because it is less expensive."[182] Of note for our argument, the passage immediately follows the famous description of *"spolverezzi"* (pounced patterns) to portray gold brocade, this being the only context in which Cennino's *Libro* mentions *spolvero* as a method of design transfer.

We can envision that, as young boys, a number of painters who used the technique (early on in their independent careers) first assisted their masters in the workshop by pouncing drawings and patterns. Though not explicitly stated in the Renaissance sources, the production of patterns and cartoons was among the essential skills learned during an artist's apprenticeship, as this was part of the education in drawing. (The visual evidence charted in the following chapters will provide ample opportunities for comparing instances in which a master's design habits recur later in a pupil's work.) On 6 November 1441, the ten-year-old Andrea Mantegna was already listed as *"fiuolo"* (adopted son) of his master Francesco Squarcione; both artists were "pouncers."[183] According to Vasari, Girolamo Genga entered Luca Signorelli's workshop at fifteen years of age; both artists were "pouncers," as well.[184] Earlier, Luca Signorelli had been the *"discipulo"* and *"creato"* of a pioneer of *spolvero* cartoons, Piero della Francesca.[185] A recently discovered document establishes Michelangelo's presence in the Ghirlandaio *bottega* already by June 1487, when he was twelve years old, his apprenticeship probably lasting until 1489/90.[186] During this time, Domenico Ghirlandaio, his brother David, and their relatively large *équipe* of assistants were at work on the frescos of the chancel at S. Maria Novella in Florence.[187] The chapel's figural scenes and spectacular Antique-style ornament (to be examined in Chapters Five and Six) exhibit extensive applications of *spolvero*

and *calco.* Bartolomeo di Giovanni, another artist associated with the Ghirlandaio workshop, was also a frequent "pouncer" (CBC 115–25).[188] Bridging the worlds of the painter and the artisan class, Raffaellino del Garbo was just about the most indefatigable "pouncer" of the Renaissance (CBC 65–107), as a prodigious designer of embroideries and other decorative arts.[189] Andrea del Sarto, a "pouncer" and "stylus tracer" from the following generation, was supposedly seven years of age when, according to Vasari's *Vite,* he began his training in a goldsmith's workshop; he later studied with the painter Piero di Cosimo.[190] The *Anonimo Magliabechiano* (MS., c. 1537–42), on the other hand, written only a few years after Andrea del Sarto's death, lists him as a pupil of Raffaellino del Garbo.[191] As his nickname suggests, Andrea del Sarto was the son of a tailor (and of a tailor's daughter) – tailors were the type of professional artisan who especially depended on the *spolvero* technique.[192] Andrea produced a number of small drawings evidencing the *spolvero* technique (CBC 281–85), crucially those connected with Cardinal Silvio di Rosado Passerini's embroidered altar frontal (see Fig. 224), and throughout his life, he maintained his ties to the class of artisans and small-scale merchants engaged in the garment trade *(farsetti, sarti,* and *berrettai).*[193]

Vasari's carefully constructed *Vita* of Raphael relates somewhat theatrically that the artist was still a child when his father, the painter Giovanni Santi, placed him in Pietro Perugino's workshop, as his mother wept inconsolably.[194] Although the flavor of Vasari's story is moralistic, his facts may well be reliable. Raphael's mother died in October 1491 when Raphael was only eight years old; his father died in August 1494 but must have given the young artist some training. The damaged mural surface of a *Madonna and Child* tabernacle (Casa di Raffaello Santi, Urbino), whether by Giovanni Santi or the young Raphael, reveals *spolvero* dots, as does Giovanni Santi's mural of *St. Sebastian* (Museo Civico, Cagli).[195] When and how Raphael entered Perugino's *bottega* is not known beyond Vasari's narrative, but both Perugino and his studious pupil were prodigious pouncers, and occasional stylus tracers. There are also abundant examples of *spolvero* and *calco* in the drawings and paintings by Perugino's other presumed pupils, Bernardino Pinturicchio and Giovanni di Pietro "Lo Spagna." The same is true, in turn, of the works by Raphael's principal pupils, Giovan Francesco Penni "Il Fattore," Giulio Romano, Polidoro da Caravaggio, and Perino del Vaga.

Although it would be difficult for us to argue a case for the extensive participation of women as painters or as laborers in painters' workshops, it is slowly becoming clear that they, like children, sometimes partook in the artisanal and building trades during this period.[196] (We have seen that the craft of embroidery was largely the domain of women.) Cennino's *Libro dell'arte* singles out the aptness of young girls with dainty fingers in separating the yields for various grades of ultramarine blue pigment to be used in painting.[197] But the gaps in the evidence are simply too enormous for constructive speculation. Although considerably later, Catherine Perrot's informative *Traité de la Miniature de l'Académie Roiale* (Paris, 1625) is a rare source mentioning the *spolvero* and *calco* techniques to have been written by a woman author, dedicated to a woman patron, and intended for an audience largely comprised of women attempting to teach themselves the craft of painting miniatures.

Vasari's mention that one of Filippino Lippi's mediocre pupils, Niccolò Zoccolo, was nicknamed Niccolò "Cartoni" (Niccolò "of the Cartoons"), probably on account of his pedestrian specialty, may be read precisely: the nickname was practically an insult, for copying practices exploiting cartoons had gained an increasingly bad reputation by the sixteenth century.[198] Much in the same spirit, we could call a "pouncer" the person who pounced cartoons and other types of designs for transfer, including patterns, manuscripts, and prints. This term, though not found in the primary sources, would emphasize that frequently the person who pounced a design was neither the artist who made it nor the ranks of assistants employed in his workshop or household: *"garzoni"* (probably, advanced assistants), *"discepoli"* (pupils), *"fattori"* (laborers or helpers), *"fattorini"* (errand boys), or *"servitori"* (servants).[199] Parallel terms might help us designate those who performed other kinds of design transfer – by pricking, stylus incision, tracing with translucent paper, and squaring grids – terms that, if dissonant to the modern ear, would acknowledge the division of labor frequently occurring inside and outside of workshops from the Middle Ages to the Late Baroque.

Although we do not have nearly nuanced enough visual evidence for stylus incisers or tracers, we could classify various pouncers by type. At the one extreme, and the chief object of our interest throughout most of this book, is the kind of pouncer who made the *spolvero* technique a step in the design process, a part of workshop practice. This would include all the painters and their respective assistants cited as examples in this introduction. For the purposes of this classification, whether the masters or their assistants actually per-

formed the task would matter little; this would often be, in any case, difficult to deduce with great certainty. At the other extreme is the kind of pouncer who employed the technique solely for appropriation: mostly, amateurs and fraudulent copyists (to be discussed in Chapters Three and Four). Mediating between these two poles were the craftspeople laboring in decorative arts who adapted the designs of others – for instance, Tagliente's audience of women, youngsters, and artisans who hoped to learn the Leonardesque *"scienza del far di groppi."* Although they often were not the "designers" of the patterns that they pounced, the use of the technique was nevertheless part of their working process. During the course of the following chapters, the visual evidence and the analysis of the written sources will further demonstrate the necessity for making such broad distinctions, for the crux of the problem lies in a definition of artistic "originality" and just how the Renaissance understood it.[200]

Copyists, restorers of drawings, and probably collectors often pricked designs produced centuries earlier – with or without fraudulent motives. Such an instance arises in Raphael's cartoon fragment in the Louvre (Fig. 26), depicting one of the avenging angels in the *Expulsion of Heliodorus* fresco. An eighteenth-century owner and restorer of "old master" drawings, possibly Pierre-Jean Mariette (1694–1774), reconstructed the parts of the original sheet of paper that had been lost because of damage.[201] This, in turn, required that he redraw the bottom and right portions of the drawing. He then repricked the bottom outline of the chin and two folds of the angel's right sleeve to harmonize with the pricked outlines on the autograph part of the design.[202] Curiously, a French nineteenth-century owner of Raphael's small cartoon of the *Annunciation* (CBC 227) had the letters "Raffaello Sanzio" on the lower border of the decorative blue paper mount pinpricked in nearly identical diameter to match the pricking of the cartoon's outlines.[203] Raphael produced the *Annunciation* cartoon to paint the *predella* for the *Coronation of the Virgin* altarpiece (Pinacoteca Vaticana) in 1501–3. It is clear that the pursuit of an ideal of aesthetic uniformity or, plausibly, historical authenticity in these cartoons had led these collectors to put the technique to nonfunctional purposes. The portions of these drawings by Raphael, pricked after the sixteenth century, were naturally never pounced for transfer.[204] Already collectible works of art, the drawings were probably mounted by that time. Similarly, as pointed out in Chapter Three, the pricking of outlines in extant Medieval manuscripts does not exemplify *spolvero* as an original workshop practice but as an appropriation – it is the trail left by scavenging later copyists.

Among the Renaissance users of the *spolvero* technique, some of whom we have already mentioned, were fresco and easel painters, draughtsmen, copyists, designers of *sgraffito*, miniaturists, manuscript illuminators, and embroiderers (as can be ascertained from both textual and visual evidence).[205] Surviving pricked drawings are the sole evidence to suggest that the *spolvero* technique was also probably useful to designers of ceramics, *intarsia* pavements, tapestries, and prints, although not, as might be expected, in directly transferring designs to the working surface. Many such artists and craftspeople applied the technique within the process of preliminary design – printmakers could reverse the designs of their compositions,[206] whereas textile workers could replicate their patterns.

Having suggested who the users of design transfer techniques might have been, let us now analyze more precisely what it was that they did.

PROCESSES, MATERIALS,
TOOLS, AND LABOR

Obstacles of Written Language

We may now explore in greater detail how cartoons, and other types of designs, were made and transferred onto the working surface. The technique of design transfer by means of stylus tracing or stylus incision *("calco," "calcare," "ricalcare," or "incisione indiretta")* is more fully discussed in Chapter Ten, for the sake of greater narrative clarity in the argument this book pursues.

Period writers provide considerable testimony for us to reconstruct what are fundamentally simple processes, yet understanding them is not always possible, as artistic and artisanal practices often lacked a standard vocabulary during the Renaissance and Baroque periods.

On the whole, techniques are better learned by observing and performing them, rather than by reading about them, for they often do not lend themselves to clear verbal description. Cennino commented in a number of asides to this effect in his *Libro dell'arte* (MS., late 1390s).[1] And, in the introduction to his *Vite* (Florence, 1550 and 1568), Vasari balked at describing how to translate a complex perspective construction to a large-scale cartoon, admitting in frustration that it is ". . . a tiresome thing, and difficult to explain, I do not wish to speak further about it."[2] As will be explored in Chapter Four, a general bias against the discussion of technical subjects would also appear as a subtext of many Italian art treatises from the mid-Cinquecento onward. With the ideal of *disegno* gradually emerging during the sixteenth century, this prejudice was fueled by old and new arguments attempting to establish (1) painting as a "liberal art," and (2) drawing as the basis for all the arts. Vasari's statement, however, is more than simply a reflection of a censorious attitude toward technique. It is a sign of genuine consternation with

the nonverbal element of artistic practice. In a note written in 1490–92 in Paris MS. A (fol. 108 recto), Leonardo gave advice to boys learning how to paint. As his young audience is reminded, what is seen is more immediately understood than what is read, for "we certainly know that sight is one of the quickest actions we can perform."[3] This fleeting "visual" element in the transmission of workshop practice, however, remains largely unrecoverable for us.

There are also problems of terminology. For instance, Cennino identified patterns to be pricked and pounced for transfer as *"spolverezzi,"*[4] probably a diminutive suggestive of their small size. In his account book of 1471, Alesso Baldovinetti referred to his cartoons for the prophets to be painted in the Gianfigliazzi Chapel (S. Trinita, Florence) as *"spolverezi."*[5] But such designs to be pricked and pounced would later be called *"spolveri"* (the term used today in modern Italian) by such writers as Giovanni Antonio Tagliente in his embroidery patternbook (Venice, 1527), Daniele Barbaro in his treatise on perspective (Venice, 1569), the anonymous compiler of the 1612 edition of the dictionary by the Accademia della Crusca, and Giovanni Torriano in the earliest Italian–English dictionary definition (London, 1659).[6] Here, a great and further confusion ensued, as is clear from Filippo Baldinucci's *Vocabolario toscano dell'arte del disegno* (Florence, 1681). Although Baldinucci defined *"spolvero"* in the sense of pricked design or cartoon, he inadvertently used both terms – *"spolverizzo"* and *"spolvero"* – to signify the pouncing bag or sack![7] In time, probably between the 1520s and 1580s, the term *"spolverizzo"* came to denote exclusively the pouncing bag, and the diminutive consequently suggested the small size of the bag, which Cennino and Paganino described but did not name.[8] The confusion is noteworthy because it reminds us

that technical processes and equipment familiar in the workshop, and passed from master to apprentice through an oral tradition, could be described, but, to our – and the lexicographer's – annoyance they often lacked a name.

Much contemporary writing about artistic practice derived heavily from earlier writings, and such repetition of information speaks of the continuities of practice. For example, textual comparison demonstrates that Raffaele Borghini's *Il Riposo* (Florence, 1584) follows Vasari closely regarding cartoons, whereas Fra Francesco Bisagno's *Trattato della pittura* (Venice, 1642) nearly plagiarizes the chapters on cartoons and fresco in Armenini's *De' veri precetti della pittura* (Ravenna, 1586). In the case of Filippo Baldinucci (1624–1696) and his *Vocabolario,* we are in a better position to judge because of richer documentation.[9] Although Baldinucci was not really a professional artist,[10] as a youth he frequented the workshop of the Florentine painter Matteo Rosselli (1578–1650) and was, as far as a layperson could be, an authority on drawings, being a distinguished collector himself and the active adviser for Cardinal Leopoldo de' Medici's collections.[11] He certainly knew examples of pricked and stylus-incised drawings.[12] As the *"spolvero–spolverizzo"* muddle already implies, Baldinucci was well aware of, among other books, Cennino's *Libro,* as well as the 1612 and 1680 editions of the Crusca dictionary.[13] In his preface, Baldinucci conceded that he had written the *Vocabolario* hastily, in approximately four months of part-time work, and this partly accounts for his numerous but often incomplete borrowings from previous sources.[14]

A Note on Terminology

For the type of archaeological method explored in the present book, a conclusion may frequently hinge upon the precise description of minute, complex physical evidence. To avoid ambiguity, the term *"spolvero"* will here designate only, and narrowly, the technique of pouncing itself (e.g., *spolvero* technique) and the dots or pounce marks left by it on the secondary surface (e.g., *spolvero* outlines, *spolvero* marks, *spolvero* dots).[15] There has sometimes been a tendency in the Italian literature on technique to designate as *"cartoni"* only cartoons that are stylus-incised, while designating as *"spolveri"* drawings that are pricked and pounced. This distinction seems somewhat artificial. As we shall see, the evidence in the primary sources suggests that the term *"cartone"* refers to the size of such drawings rather than to their

method of transfer. This is the reason why some written sources presumably denote small pricked cartoons for ornament, embroideries, and paintings as *"spolveri"* rather than as *"cartoni."*

Drawing Surfaces of Paper and Parchment

In Cennino's *Libro dell'arte,* the famous passage on the painting of simulated gold brocades recommends that pounced patterns *("spolverezzi")* be drawn on *"carta."*[16] In an earlier chapter, on drawing and shading with washes, Cennino had distinguished between two types of *carta* – *"carta pecorina"* (parchment) and *"carta banbagina"* (paper).[17] This, together with the fact that Cennino wrote at a time when artists still generally drew on both parchment and paper, suggests that the *carta* for pounced patterns refers to a sheet of either support.[18] Pricked Medieval and Renaissance manuscripts on parchment or vellum do survive, although they are problematic (see further, Chapter Three). The treatises on miniature painting by Catherine Perrot (Paris, 1625) and Claude Boutet (Paris, 1676), as well as the anonymous English translation of Boutet (1752), connect the pouncing and stylus tracing of designs to both types of support.[19]

By far the majority of extant cartoons and other types of drawings exhibiting semimechanical means of design transfer were done on linen or cotton-rag paper, called *"carta ba[m]bagina o da straccio"* in Florentine fifteenth- and sixteenth-century records of customs duty.[20] Paper was increasingly available from the Trecento onward. In Florence, no evidence exists for the profession of *cartolaio* (book trader and stationer) before 1292–97: the earliest matriculations of *cartolai* in the *"Arte dei medici, speziali e merciai"* (guild of physicians, apothecaries, and haberdashers), to which painters also belonged, occur only between 1312 and 1320.[21] The statutes of 1314, written in Latin, include *"stationarij"* (book traders and stationers), and the statutes of 1349 in both Latin and the *"volgare"* already provide fairly detailed ordinances for *"cartolarj"* or *"cartolaj."*[22] We can turn to a number of later treatises (Fig. 27) for illustrations and descriptions of how paper was generally manufactured in the West.[23] The statutes of many Italian papermaking cities decreed standards for the prices, quality, weight, and sizes of paper, which was sold to artists, scribes, and printers by *cartolai,* usually in either quires or reams.[24] In case of violation, stiff economic penalties enforced such statutes. The names and four sizes of Bolognese papers, *"imperiale," "reale," "mezzana,"* and *"rezzuta,"* are carved on a late-fourteenth-

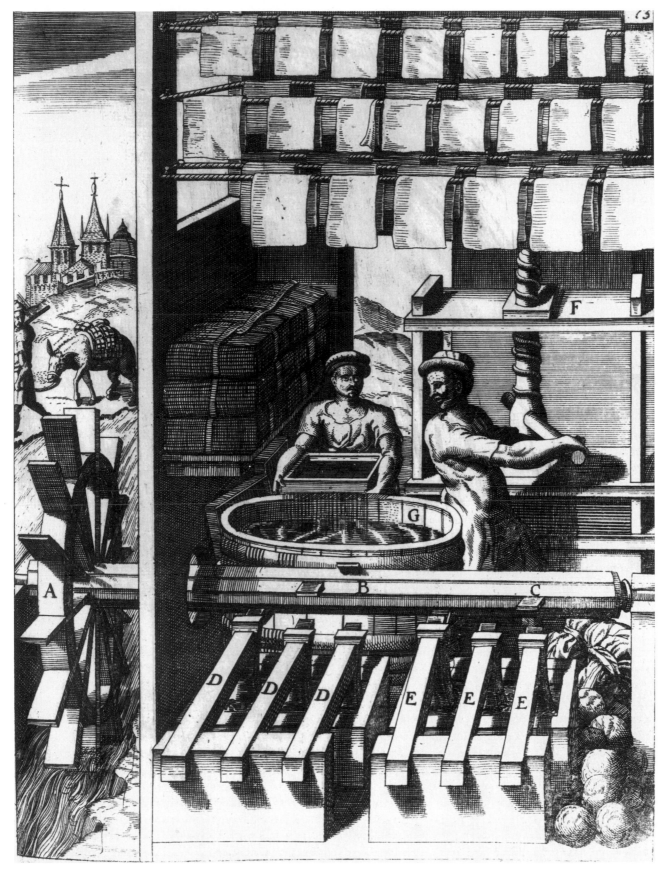

Figure 27. Georg Andreas Boeckler, Theatrum Machinarum novum . . . , Cologne, 1662 (Schlosser Collection of Papermaking inv. 096, New York Public Library).

century marble slab, found in the ancient quarters of the Bolognese *"Arte dei speziali"* to which the city's *cartai* (papermakers) belonged. The slab is now in the Museo Civico Medievale, Bologna (see Appendix One). Quattrocento and Cinquecento records of customs duty for the Florentine *"Arte dei medici, speziali e merciai,"* as well as late Quattrocento account books of Florentine *cartolai* and of the Ripoli printing press reveal that substantial portions of their inventories of paper came not only from Bologna but also from Fabriano, Colle, Prato, and Pescia.[25] Importantly, knowing that a strict quality control existed in Bologna, for instance, helps us interpret extant documents precisely. A case in point are the documents regarding Leonardo's and Michelangelo's cartoons for the large murals planned in 1503–6 for the Council Hall *("La Gran' Sala del Consiglio")* of the Palazzo Vecchio in Florence – the *Battle of Anghiari* and *Battle of Cascina.* Leonardo and Michelangelo bought their cartoon paper for the *Anghiari* and *Cascina* murals in the units of *"lisime"* (reams) and *"quaderni"* (quires), from the stationers.[26] The Bolognese statute of 1389 regulating the paper trade, the earliest of its kind (renewed in 1454), states that a *"lisima"* (*risma,* in modern Italian) was the equivalent of twenty *quaderni.*[27] Each *quaderno* contained twenty-five sheets.[28] As is clear from Renaissance and Baroque treatises on its manufacture, paper was normally starch-sized by the *cartai* before it reached the stationers for distribution.[29]

Artists seem to have favored papers of unassertive color (e.g., buff, beige, ivory, white, tan, light brown), which rendered outlines with contrast and clarity. (We should keep in mind that exposure to light has considerably darkened the original color of the paper on many Renaissance and Baroque cartoons, in extreme cases, to ghastly brown hues; this is a problem of condition independent of artistic intention.[30]) There are relatively few surviving Quattrocento and early Cinquecento pricked or incised drawings on paper prepared with colored grounds. These are usually relatively small in size. The fairly thick preparations used to coat the paper for drawing in metalpoint – made of finely pulverized bone, lead white, earth or vegetable pigments, and glue – were easily chipped around the pricked holes in the *spolvero* procedure or became greatly abraded along the incised contours in the *calco* process.[31] Recent stratigraphic analysis of some large early-sixteenth-century cartoons suggests that their sized paper surface was often very thinly primed with a subtle, neutral color for drawing in charcoal and chalk.[32] This innovative type of ground preparation was

an intrinsic part of the gradually more pictorial manner of rendering cartoons during the High Renaissance. By the third decade of the sixteenth century, a number of artists would increasingly favor blue papers for explorations of nuanced chiaroscuro effects, but a good portion of such examples have faded to deceptively brown hues.[33] Among the examples of cartoons on blue paper *("carta azzurra")* are Giulio Romano's imposing *Head of a Bearded Man* (see Fig. 47), drawn in charcoal with boldly sculptural effects, possibly for one of the apostles in Francesco Torbido's dome fresco of Verona Cathedral; the vast group of small pricked drawings in pen and ink with wash, associated with the commission of embroideries by King Philip II of Spain for the Monastery of El Escorial (see Appendix Three and Fig. 242); as well as the monumental cartoons by the Carracci for the ceiling frescos of the *Galleria Farnese* and *Camerino Farnese* (Galleria Nazionale delle Marche, Urbino; National Gallery, London; British Museum, London; and Royal Library, Windsor).

Descriptions by Leonardo (1490–92), Felipe Nunes (1615), Vicente Carducho (1633), Acisclo Antonio Palomino (1715–24), and Charles Germain de Saint-Aubin (1770) indicate that artists and artisans also traced designs with translucent paper – *"carta lucida,"* *"unta,"* or *"lustra"* – to use as cartoons.[34] Judging from the frequent allusions in written sources, this practice was more common than extant examples might suggest.[35] Cennino's *Libro* indicates that coatings of linseed oil made paper or thin kid parchment translucent and that thin gelatin sheets composed of melted fish and leaf glue also doubled as tracing paper.[36] While repeating much the same, Borghini's *Il Riposo* adds that several sheets of oiled paper could be glued together, cartoonlike, to copy large designs.[37] Candid descriptions of tracing methods, however, become increasingly rare after Leonardo, and even his constitutes a special instance. Artists generally considered such methods as tracing *("lucidare")* to be mechanical and, therefore, harmful to draughtsmanship, not to mention detrimental to professional reputations.[38]

The papers composing cartoons remain largely unstudied. One of the secondary meanings of the term *"cartone"* is cardboard.[39] It is thus often assumed incorrectly that Italian Renaissance cartoon paper had a structure and weight similar to that of cardboard. The paper used for cartoons was, however, essentially the same as that employed for small-scale drawings. For, as Italian Renaissance and Baroque writers on art define it, *"cartone"* designates a large, usually full-scale drawing, constituted of multiple sheets of paper, glued to form a

Figure 28. Enlarged photographic detail in transmitted light of the watermark in Domenico Ghirlandaio, pricked cartoon for the Portrait of a Woman in Bust-Length *(Fig. 214; CBC 113; Devonshire Collection inv. 885 recto, Chatsworth).*

chain lines and laid lines of the medium-weight paper is typical of contemporary Italian handmade papers.[43]

Watermarks

A number of cartoons, as well as "substitute cartoons," exhibit watermarks, and evidence of this type clearly undermines the persistent myth regarding the unique nature of cartoon papers.[44] Drawn on a single, much cut-down sheet and with pricked outlines, Piero Pollaiuolo's head for the figure of *Faith* (Plate II) in the Uffizi is the earliest surviving cartoon related to an extant, documented painting. Its watermark depicts a crossbow inscribed within a circle; the crest element is missing as the result of the sheet's cropping.[45] The earliest document relating to the commission by the *Arte della Mercanzia* of the *Virtues* from Piero Pollaiuolo is dated 18 August 1469.[46] A record of payment to Piero for his panel paintings of *Temperance* and *Faith* on 2 August 1470 offers a *terminus ante quem* dating for his Uffizi pricked cartoon. Although the dating and classification of watermarks proves all too often problematic, at least in the case of Piero's cartoon the crossbow watermark neatly complements the documentary evidence regarding the date of the commission.[47]

Like Pollaiuolo's *Faith*, Domenico Ghirlandaio's Chatsworth cartoon (Figs. 28, 214–15), a portrait for the head of an attendant in the *Birth of the Virgin* fresco (S. Maria Novella, Florence), from 1485 to 1490, is drawn on a single, greatly cropped sheet. Not as easily classifiable, its watermark, which depicts scales, is reproduced in Figure 28.[48] This is among the rare and earliest examples of a watermark in a cartoon that relates to a known mural. Physical evidence, however, confirms that Ghirlandaio transferred this cartoon onto the fresco surface by the intermediary means of a "substitute cartoon," a procedure also probably followed by Piero Pollaiuolo.[49] The paper of the Chatsworth cartoon is thin and of fairly even density.[50]

unit.[40] In this sense, the term *"cartone"* signifies *"carta grande."*[41] It appears in writings on art and documents of payment from at least the late Quattrocento onward. Sources that describe the process of incising cartoons with the stylus speak of fresh plaster yielding to the incision of the paper; this fact confirms that such paper was by necessity relatively thin.[42] Significant data emerged during the extraordinary restoration of Leonardo's unfinished cartoon of the *Virgin and Child with Sts. Anne and John the Baptist* (Plate V), which was blasted with a shotgun in 1987. Examination with betaradiography reveals that the configuration of the

The evidence of watermarks can also be telling in cartoons of monumental size. Lorenzo di Credi's *Enthroned Madonna and Child* (Fig. 29), from the 1490s

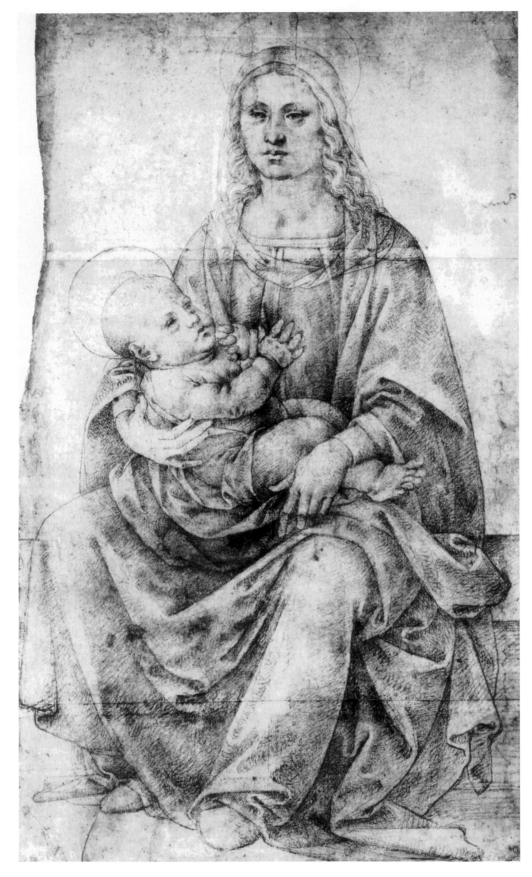

Figure 29. Lorenzo di Credi, pricked cartoon for the Enthroned Madonna and Child *(detail in Fig. 219; CBC 49; Gabinetto Disegni e Stampe degli Uffizi inv. 476 E, Florence).*

and preparatory for an altarpiece that no longer survives, is assembled from three glued sheets, which originally probably were in a *reale* format.[51] Its watermark represents a five-petaled flower.[52] Infrared reflectography examination of Raphael's *"La Belle Jardinière"* cartoon (see Fig. 58) reveals the presence of four examples of the same watermark – one on each of the *fogli reali* comprising the drawing – a three-rung ladder circumscribed by a circle.[53] This watermark type is found on Lucchese paper from 1506 to 1509, and appears to accord perfectly with the date of 1507–8 painted by Raphael on his panel now in the Louvre, for which the Washington cartoon was preparatory.[54] Similarly, at least three of the ten *fogli reali* comprising Fra Bartolomeo's stylus-incised Uffizi cartoon for a kneeling St. Mary Magdalen (see Fig. 36) reveal the identical watermark: a crescent moon,[55] though not as readily visible as we may wish, since this fragile cartoon is glued onto a secondary paper support.

Assembling of Large Cartoons: Premises and Materials

From the scant evidence available we can suppose that artists normally prepared cartoons in their workshop *(bottega)*, often located away from their residence. From artists' tax declarations, a fair amount can be learned about the *botteghe* they kept: their addresses, rent, and even property prices.[56] Various sources note that Leonardo drew his cartoon for the *Battle of Anghiari* in the *"Sala del Papa"* of the *Chiostro Grande* at S. Maria Novella (Florence), presumably because of the large size of this space.[57] On 24 October 1503, Leonardo was to be given the keys to the *sala* and his adjoining apartment, thus beginning the preparation of work on the *Anghiari* cartoon.[58] (Seventy-two years later, Federico Zuccaro would also prepare cartoons in the *"Sala del Papa"* at the convent of S. Maria Novella – to finish the dome frescos of Florence Cathedral, begun by Vasari in 1572.[59]) In the late summer of 1504, Michelangelo would begin drawing his cartoon for the *Battle of Cascina* in the *"Sala Grande"* at the *Ospedale dei Tintori* of S. Onofrio.[60]

As Armenini's *De' veri precetti* instructs, artists began by first carefully measuring the dimensions of the painting surface to assemble a cartoon of the appropriate size.[61] Cennino's *Libro* urges the same in preparing cartoons for stained-glass windows.[62] The production of cartoons for monumental murals, altarpieces, tapestries, and inlaid marble decoration, as well as for stained glass and mosaic, posed unique practical problems because of the large sizes involved. We may consider the dimensions of some surviving pricked cartoons. For instance, at 2.85 by 8.04 meters, Raphael's cartoon fragment for the *School of Athens* (Figs. 30–31) is the largest extant Renaissance example of this drawing type. The sizes of Raphael's seven cartoons for the Sistine Chapel tapestries (Plate VII) range between 3.19 by 3.99 and 3.47 by 5.42 meters. Domenico Beccafumi's largest cartoon for the marble *intarsia* pavement of Siena Cathedral, *Moses Shattering the Tablets with the Ten Commandments* (CBC 16 E), measures 2.68 by 4.20 meters. One of the better preserved cartoon fragments for this project is here reproduced (Figs. 32–33). Michelangelo's cartoon for the fresco of the *Crucifixion of St. Peter* (Figs. 2–3), merely a fragment of the composition, is 2.63 by 1.56 meters.

Only by comparison do cartoons for easel paintings seem relatively small. Raphael's for *"La Belle Jardinière"* (see Fig. 58) stands 0.94 by 0.70 meters. About double that size, Federico Barocci's stylus-indented *Christ Taking Leave from his Mother* (see Figs. 232, 233), which measures 1.87 by 1.62 meters and is relatively complete, is among the largest extant cartoons for an easel painting.

All such cartoons were by necessity assembled from multiple sheets of paper. The largest available commercial size of paper until the late sixteenth century, the *foglio imperiale,* apparently not the size most commonly used for assembling cartoons, was only about 0.50 by 0.73 meters.[63]

It is one of the great tragedies of the history of art that neither mural for the Council Hall of Florence's Palazzo Vecchio – neither Leonardo's *Battle of Anghiari* nor Michelangelo's *Battle of Cascina* – progressed beyond an initial stage of work before being abandoned. Whether Michelangelo ever began painting is even doubtful. Worse, neither of the cartoons survives. Autograph sketches, life studies, and compositional drafts, as well as a relatively large number of copies, provide only incomplete means by which to reconstruct the cartoons' drawing style and composition. At least the documents of payment for the cartoons survive.[64] Although a number of Italian Renaissance documents for important commissions refer to cartoons, the *Anghiari* and *Cascina* cartoon documents are unique in their specificity. Representing the Florentine tradition of notarial bookkeeping at its best, these documents help us reconstruct in relative detail the costs and the process by which such large drawings were assembled. They also provide us with a sense of the division between skilled and unskilled labor that the process entailed, sometimes even enabling us to calculate wages.

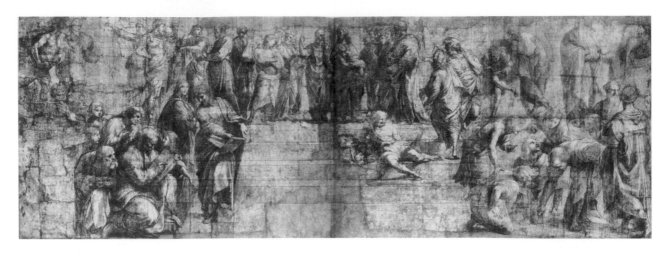

Figure 30. Raphael, pricked cartoon fragment for the School of Athens *(CBC 256; Pinacoteca Ambrosiana inv. 126, Milan). This enormous cartoon was assembled with nearly 200 sheets of paper, glued in an upright (vertical) disposition. Although often differing in size, most sheets measure about 405 × 290 mm. (roughly, a foglio reale cut in half, for the sheets have no creases from the spines of the* quaderni *or quires of paper), and are glued with 10–15 mm. overlapping joins. A number of schematic cuts on the drawing surface, now heavily restored, suggest that for the transfer process onto "substitute cartoons," Raphael's assistants may have sliced the highly rendered Milan cartoon into at least eight large, but manageable portions to work. See Chapter Eight, notes 35–40, for other archaeological data.*

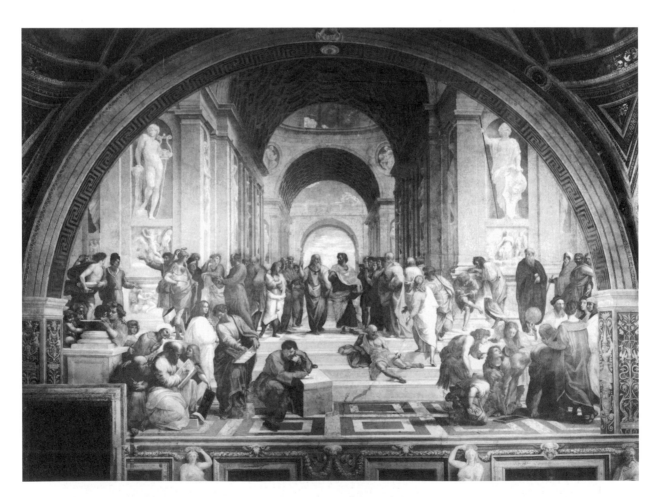

Figure 31. Raphael, The School of Athens, *fresco (Stanza della Segnatura, Vatican Palace). The construction of the architectural setting for the scene was also largely based on cartoons. As pointed out by Arnold Nesselrath, on the fresco surface the upper parts of the temple exhibit extensive passages of spolvero dots (reinforced by both freehand and ruled stylus incisions, done directly on the plaster).*

40

Figure 32. Domenico Beccafumi, pricked cartoon fragment for Aaron and the Israelites Making the Golden Calf *(CBC 17 B; Pinacoteca Nazionale inv. 416, Siena).*

Figure 33. After Domenico Beccafumi, marble inlay (intarsia) *pavement in the crossing of Siena Cathedral. The scene corresponding to the cartoon fragment is seen in the lower left.*

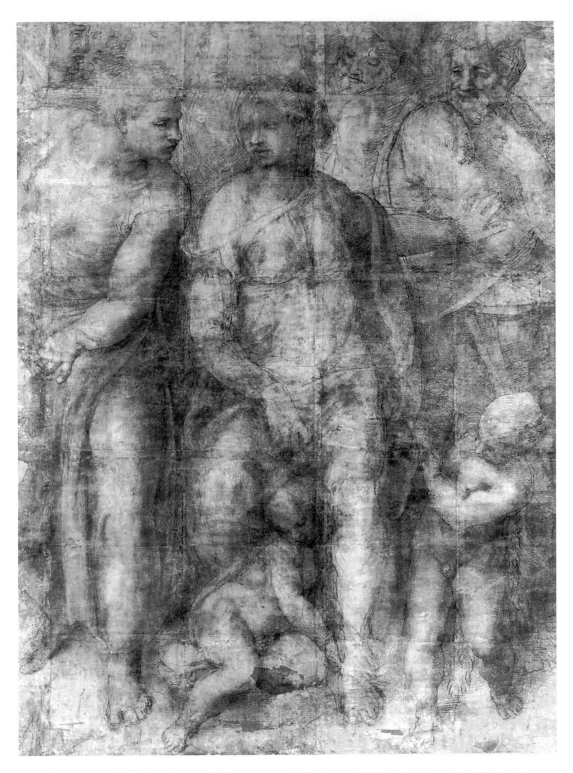

Figure 34. Michelangelo, stylus-incised (?) cartoon for the Virgin and Child with Saints, The "Epifania" *(British Museum 1895-9-15-518, London). Painted by Ascanio Condivi, the corresponding altarpiece in oil on panel is in the Casa Buonarroti, Florence.*

Both Leonardo and Michelangelo apparently used cartoon paper of Bolognese origin and of the *foglio reale* size.[65] (As the late-fourteenth-century marble slab at the Museo Civico Medievale in Bologna indicates, sheets of paper in the *reale* size ranged from 438 by 605 mm. to 452 by 617 mm.) The use of the *reale* format for cartoons had probably long been traditional. An entry on 28 April 1471 in Alesso Baldovinetti's account book for the Gian-

figliazzi Chapel lists the purchase of sixteen *"quaderni"* of *"fogli reali da straccio"* for the pounced cartoons of prophets *("spolverezi de' profeti")* and other designs, and the memorandum from 6 June 1572 recording Vasari's budget for the dome frescos in Florence Cathedral takes into account the *fogli reali* for the cartoons, along with other materials.[66] In fact, sheets of paper approximating either the *reale* size or what the Bolognese marble slab calls the *"rezzuta"* size (the smallest format) are the most commonly found in extant Italian Renaissance cartoons. A *"rezzuta"* is almost exactly one-half of a *reale* sheet. A payment record on 3 April 1521 regarding the purchase of paper for Domenico Beccafumi's cartoons (Figs. 32–33) for the marble *intarsia* pavement of Siena Cathedral lists *"fogli reali"* and *"fogli comuni."*[67] Indeed, as can be confirmed, the two sizes of paper found in Beccafumi's extant cartoons are *fogli reali* and sheets about one-half of a *reale,* the *"comune"* referred to in the document or what the Bolognese marble slab calls *"rezzuta."* North–Italian artists and artisans also used the *reale* format for cartoons, as we can deduce from several entries of payment from 1523 to 1529 for *"foye de papér in forma regal"* in the accountbook *("Liber Fabrice Chori")* kept for the production of the wood *intarsie* in the choir of S. Maria Maggiore in Bergamo. The master craftsman Giovanni Francesco Capoferri da Lovere, who executed the costly wood inlays, worked from tracings of Lorenzo Lotto's carefully rendered cartoons. Jacopo Pontormo's sheet of nude studies in black chalk, from about 1545 to 1550 and preparatory for the destroyed fresco cycle in the choir of S. Lorenzo (Florence), records an uncommon use of *fogli imperiali* for the assembling of monumental cartoons. This drawing bears an autograph inscription on its verso, reading in part *"85 fog[l]i imperiale/nel cartone grande"* and providing measurements for the composition.[68] Like the frescos, however, the cartoon no longer survives. The measurements of the eight sheets comprising Leonardo's cartoon of the *Virgin and Child with Sts. Anne and John the Baptist* (Plate V) suggest an *imperiale* rather than a *reale* format.[69]

The record of payment for the purchase of Leonardo's paper for the *Anghiari* cartoon on 28 February 1504 also includes the *"quadratura"* (literally, "squaring") and *"apianatura"* (flattening) of that paper. In order to assemble a cartoon, the deckled edges of the handmade paper required cropping to ensure that all borders were at right angles to each other. This is what *"quadratura"* means.[70] In their descriptions, Vasari, Borghini, Armenini, Bisagno, and Baldinucci insisted that the sheets of paper for cartoons had to be *"squadrati"* – cropped square – before gluing.[71] Many extant car-

Figure 35. Verso of cartoon for a Male Monastic Saint *by a Cremonese sixteenth-century artist (CBC 353; Philadelphia Museum of Art 1984-56-225). The reinforced horizontal crease from the spine of the* quaderno *(quire) is evident at the center.*

toons confirm the texts, for their glued sheets of paper often have relatively crisp, perpendicular edges.[72] In Michelangelo's cartoon of the *Virgin and Child with Saints* (Figs. 34, 229), the great majority of the borders comprising the *fogli reali* are *"squadrati."*[73] Five of these borders, however, still exhibit the original uncropped, deckled edges of the paper, a minor negligence on the part of the *cartolaio* or the *garzone.*

The *"apianatura"* mentioned in the *Anghiari* cartoon document evidently refers to the flattening of the creases through the center of the *fogli reali,* that is, the spines formed when the freshly produced sheets of wet paper were hung to dry and then folded into the form of a *quaderno,* or quire (Fig. 27). Extant cartoons also confirm this interpretation, for it is common to find creases at, or near, the center of *fogli reali.*[74] The verso of a sixteenth-century Cremonese cartoon in Philadelphia, consisting of a single *foglio reale,* exhibits a readily visible horizontal *quaderno* crease, which the wear and tear of age has reinforced (Fig. 35). Once the sheets of paper were flattened for assembly, the original creases from the spines of the quires became like a series of

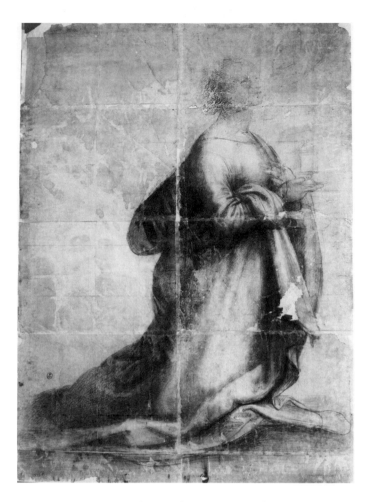

Figure 36. Fra Bartolomeo, stylus-incised cartoon for the Kneeling St. Mary Magdalen *(Gabinetto Disegni e Stampe degli Uffizi inv. 1777 E, Florence). The figure corresponds to that in an altarpiece in oil on panel in the Pinacoteca, Lucca.*

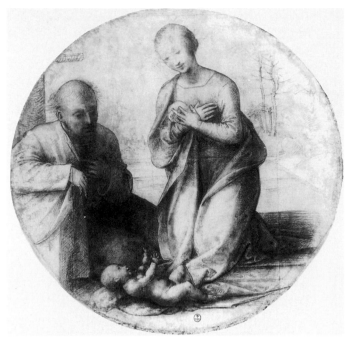

Figure 37. Fra Bartolomeo, stylus-incised cartoon for the Virgin and St. Joseph Adoring the Christ Child *(Gabinetto Disegni e Stampe degli Uffizi inv. 1779 E, Florence). The corresponding oil painting on panel is in the Museo Poldi Pezzoli, Milan.*

minuscule, parallel, slightly buckled striations. As the result of conservation treatment on such large cartoons as Michelangelo's *Crucifixion of St. Peter,* it has become possible to discern more clearly their structure, to differentiate the edges or joins of the glued sheets of paper from the *quaderni* creases (Fig. 3). In Michelangelo's Naples cartoon, the *fogli reali* are glued in a horizontal orientation. Thus, the *quaderni* creases for the most part align vertically. On the cartoon's verso, twelve full-size *fogli reali* can be identified toward the right, in two columns of six each (Fig. 4).[75] The gluing of *fogli reali* in such a horizontal orientation, with the *quaderni* creases aligning vertically, can create a relatively weak structural support for the drawing surface, particularly if the spines of the *quaderni* creases fall on the versos of the sheets. A case in point is Lorenzo di

Credi's beautifully drawn Uffizi cartoon in charcoal or soft black chalk, the *Enthroned Madonna and Child* (Fig. 29). Here, although the length of the *fogli reali* provided an adequate width dimension for the composition, the vertical alignment of the *quaderni* creases weakened the structure of the cartoon's surface sufficiently that Lorenzo (or his *bottega* assistant) glued onto the cartoon's verso vertical strips of the same type of paper, which were 17–30 mm. wide, to flatten the spines of the creases. Later, when the outlines of the cartoon's design were pricked – as the density of the minute holes from the pricking confirms – the pricking needle traversed as systematically over the reinforcement strips as it did on the rest of the cartoon's surface.

Diagrams of the neat structural assembly of Fra Bartolomeo's cartoons (Figs. 36–38) can attest that the *frate* and his *bottega* were fastidiously precise in their construction of such drawings. This is valuable testimony to the late Quattrocento's preoccupation with the craftsmanship of drawing. Some of the artisanal hallmarks of Fra Bartolomeo's cartoon workshop practice are uniform paper sizes (whether in a full *reale* or half-*reale* format), as well as borders of paper perfectly *"squadrati,"* architectural dispositions of joins with careful align-

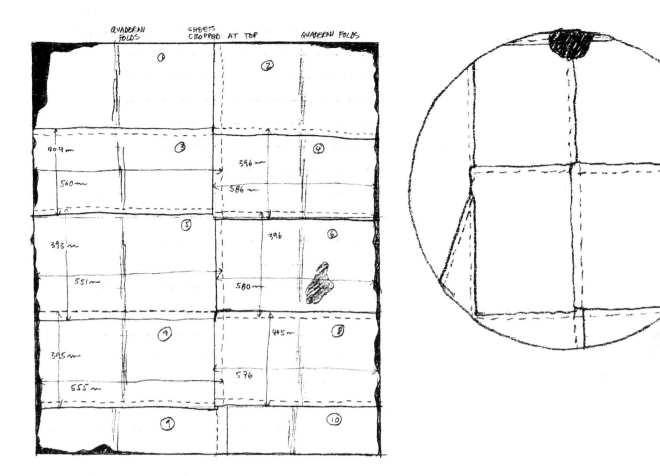

Figure 38. Approximate diagram showing the construction of Fra Bartolomeo's cartoons for the Kneeling St. Mary Magdalen and Virgin and St. Joseph Adoring the Christ Child (Figs. 36, 37).

ments of *quaderni* creases, and very consistent overlaps of paper from join to join. Usually, the joins have narrow overlaps of paper, 3–8 mm., though sometimes they range to 15–20 mm. This orderly method is followed also in the stylus-incised *Virgin and St. Joseph Adoring the Christ Child* (Figs. 37, 38) from around 1500, rendered in black chalk with richly calibrated chiaroscuro. Because of its *tondo* shape, this *"ben finito cartone"* required an ingeniously buttressed join configuration.

The *fogli reali* in Michelangelo's British Museum cartoon of the *Virgin and Child with Saints* (Figs. 34, 229) are glued much less carefully, in a vertical orientation and with *quaderni* creases for the most part aligning horizontally. Seen close up, the paper structure of Michelangelo's cartoon reveals patches, unequally cropped sizes of sheets, and noticeable misadjustments of gluing toward the borders of the composition. Not surprisingly, considering its enormous surface area, still more jarring irregularities of construction abound in Raphael's *School of Athens* cartoon (Figs. 30–31, 39–41). These are, however, the vivid reminders of arduous hand labor. By the end of the sixteenth century, a con-

siderably freer, more economic approach to drawing and painting technique would prevail, as is clear, for example, in Bernardino Poccetti's stylus-incised cartoon fragments from 1582 to 1584, for the mural cycle on the life and miracles of St. Dominic at the *Chiostro Grande* in S. Maria Novella (Figs. 42–43). In these cartoon fragments, the paper sizes are very disparate (apparently, in *imperiale, reale,* and half-*reale* formats), the borders of paper are at times deckled and at others *"squadrati,"* the overlaps of paper in the joins vary greatly in width (from 8 mm. to 49 mm.), the joins change course from sheet to sheet, and there are abrupt diagonal misalignments in the gluing of sheets.[76] Poccetti's *Chiostro Grande* cartoons were purely utilitarian drawings, however, for they were actually dismembered during the fresco painting process (on which, see later discussion).

45

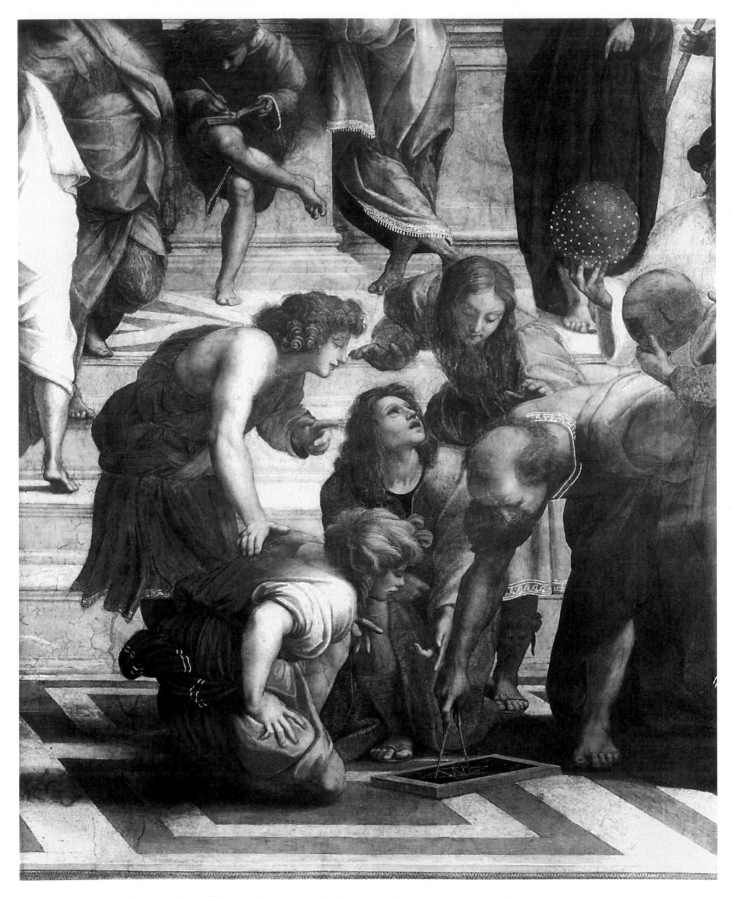

Figure 39. Detail of Raphael, The School of Athens, *fresco (Stanza della Segnatura, Vatican Palace).*

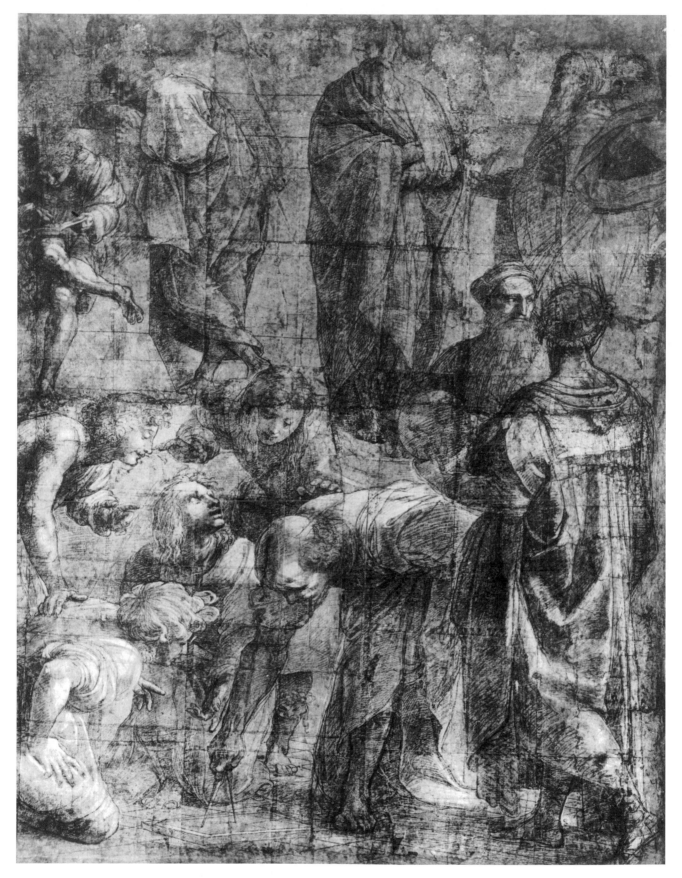

Figure 40. Detail of Raphael, pricked cartoon for the School of Athens *(CBC 256; Pinacoteca Ambrosiana inv. 126, Milan).*

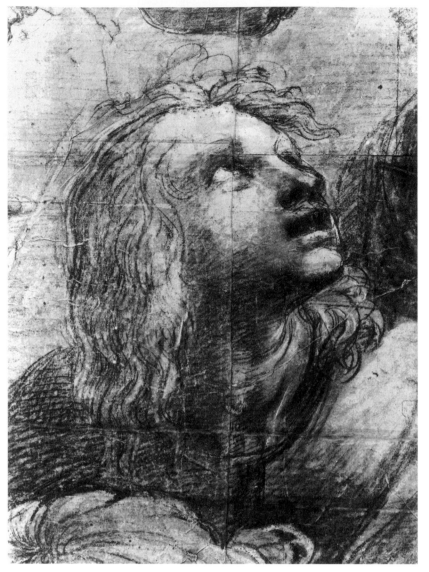

Figure 41. Detail of Raphael, pricked cartoon for the School of Athens.

Manual Labor

A payment on 28 February 1504 regarding Leonardo's *Anghiari* cartoon suggests that both the *"quadratura"* and *"apianatura"* of the paper were the responsibility not of a *garzone*, but of the *cartolaio*.[77] The price difference between the cost of the paper and the sum actually paid to the *cartolaio* indicates the fee for this type of hand labor: 5 lire 8 soldi.[78] The accounts do not record, however, the expenditure of time involved.

As we learn from the records of payment on 31 October and 31 December 1504 for Michelangelo's *Bat-*

tle of Cascina cartoon, the *cartolai* laid out the sheets of the cartoon *("mectere insieme"),* presumably on the floor of the working space, before gluing.[79] The *"mectere insieme"* of Michelangelo's cartoon cost 5 lire for five and a half days of labor, or a daily wage of 18 soldi 2 denari – a larger sum than we might expect.[80] Michelangelo's *garzone,* Piero d'Antonio, whom Michelangelo apparently hired specifically to help with the production of the cartoon, then helped glue the sheets together *("inpastare").*[81] Piero d'Antonio's payment for a journey of five days probably reflects the duration of this menial task. Piero obviously provided significantly cheaper labor than a *cartolaio* – about half-price! He received a daily wage of 9 soldi, only 3 denari higher than the average for an unskilled construction worker in Florence during that year. Tables of wages for skilled and unskilled labor in the Florentine construction industry provide an interesting comparison: skilled construction workers, for example, were being paid about 14.3 soldi daily.[82] Some of the other unskilled laborers *("manuali"),* engaged for the refurbishing of the Great Council Hall of Palazzo Vecchio, were paid similarly to Piero d'Antonio, for they received between 9 and 10 soldi daily.[83]

Unlike Michelangelo, who employed Piero d'Antonio, however, Leonardo may have produced the *Battle of Anghiari* cartoon with little or no help, even from *garzoni.* Assistants do not appear on the payroll until Leonardo actually began painting in the Council Hall.[84] Moreover, the designation of Leonardo's assistants, Raffaello d'Antonio di Biagio and Ferrando Spagnuolo, as *dipintori* may suggest their status to be that of skilled painters in their own right, though probably not matriculated in the guild.[85] And they appear to have been paid accordingly, for Raffaello d'Antonio seems to have collected a high daily wage of 20 soldi.[86] Tommaso di Giovanni Masini, who ground colors, was paid in turn as Ferrando Spagnuolo's *garzone* with a lump sum; neither person's wage rate is specified.[87]

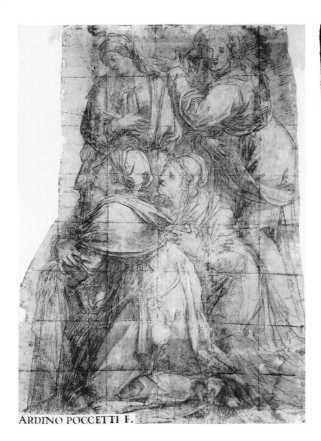

ARDINO POCCETTI F.

Figure 42. Bernardino Poccetti, stylus-incised cartoon fragment for St. Dominic Casting the Demon Appearing to Nine Noble Matrons (Gabinetto Disegni e Stampe degli Uffizi inv. 1788 E, Florence). This and another fragment (Uffizi inv. 1789 E) were preparatory for a mural in the Chiostro Grande at S. Maria Novella, Florence.

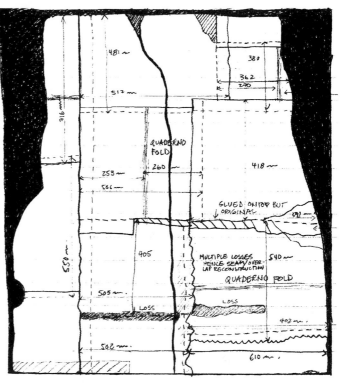

Figure 43. Approximate diagram showing the construction of Bernardino Poccetti's cartoon fragment (Fig. 42). Two types of joins are discernible. Joins from the structural assembly of the paper are generally rectilinear and exhibit overlaps in the paper. Those done to transfer the design onto the plaster are jagged and without overlaps. Here, the artist cut the cartoon fragment into strips to correspond to groups of giornate on the mural surface.

The Gluing Process

According to Vasari, the sheets of cartoons were glued together "with a paste made of flour and water cooked on the fire," advice that Borghini, Armenini, and Bisagno would also later repeat; in fact, Vasari's budget in June 1572 for the dome frescos of Florence Cathedral figures in the flour to make cartoon paste.[88] In the *Libro dell'arte,* Cennino gave the recipe for this paste, which in his time served to paste stencils, books, and cartoons for stained-glass windows (compositional cartoons for paintings were not yet in use): "Take a pipkin almost full of clear water; get it quite hot. When it is about to boil, take some well-sifted flour; put it into a pipkin little by little, stirring constantly with a stick or a spoon. Let it boil, and do not get it too thick. Take it out; put it into a porringer. If you want to keep it from going bad, put in some salt."[89] Indeed, the baker Giovanni di Landino was paid on 30 June 1504 for the enormous amount of 88 pounds *("libbre")* of sifted white flour *("farina stacciata*

biancha"), delivered in two installments, to glue further parts of Leonardo's *Anghiari* cartoon *("rinpastare").*[90] In extant cartoons, the overlaps of paper in the structural joins between glued sheets of paper can range in width from a minimum of 3 mm. to a maximum of 50 mm., but 5–10 mm. is more typical. Apparently, Leonardo's cartoon also required an extensive cloth lining for reinforcement, to judge from an earlier payment record, on 28 February 1504, to the linen dealers Francesco and Lorenzo Ruspoli — *"per uno lenzuolo et 3 teli, dato a decto Lionardo per orlare el cartone."*[91] Thus, in sum, Leonardo's huge expenditure of flour probably encompassed not only the *rinpastare* of the *Anghiari* cartoon but also its *orlare,* as well as perhaps the partial gluing of a "substitute cartoon" (as discussed in Chapter Eight).

After the cartoon was glued together and reinforced, it was necessary to smooth its surface before the artist could draw on it. To do this, Vasari recommended gluing the cartoon "onto the wall with [flour] paste, which is spread two fingers in breadth all around, on

the side facing the wall," advice repeated exactly by Armenini.[92] From Palomino, we learn that the cartoon could also be nailed or tacked onto the wall.[93] Then, as Vasari explained, the cartoon was sprinkled all over with water, and in this moist state it was stretched so that the numerous creases, buckles, or cockles in the paper resulting from the gluing together of sheets could flatten in the process of drying.[94] The treatises by Borghini, Armenini, and Bisagno reiterate much the same.[95] This wetting also helped blend the joins of the overlapping paper from sheet to sheet, to create a more uniform drawing surface.[96]

Drawing Site

To judge from the extant documents for the *Anghiari* and *Cascina* cartoons, they must have been drawn while fastened upright onto a wall, which generally conforms with the practice of cartoon preparation described in Renaissance and Baroque treatises. In a note written in 1490–92 in Paris MS. A (fol. 90 recto), about the portrayal of figures in the *historia*, Leonardo emphasized the importance of studying the height and placement of the figures according to their final execution on a wall.[97] He insisted that preparatory studies be drawn consistently from the same viewing point: one of his extant composition studies in black chalk for the right portion of the *Battle of Anghiari* cartoon documents the viewing angle precisely – *di sotto in sù* (as if seen from below), and in oblique perspective from right to left.[98] It is thus a virtual certainty that in order to draw the *Battle of Anghiari* cartoon, Leonardo placed it at a height corresponding to that planned for the mural in the Council Hall of Palazzo Vecchio. This is confirmed by the documentary sources, which relate Leonardo's invention of a movable scaffolding to draw the large *Anghiari* cartoon – in Vasari's words "a most ingenious edifice."[99] The scaffolding apparently contracted as it rose, and expanded as it lowered; it also included a four-wheeled *"carro"* (wagon), for which various payments exist, but its actual mechanism is still a matter of conjecture.[100]

In his commentary of 1583 to the great architect Giacomo Barozzi da Vignola's treatise on perspective, Egnazio Danti informs us that cartoons could also be drawn flat on the floor: "in the preparation of cartoons [*cartoni*] for façades of similar rooms, the most comfortable thing is to make them on the ground [*in terra nel pavimento*], so that one does not have to climb on scaffoldings, being thus able to plot out [*tirare*]

with threads [*fili*] all the lines which are needed, as experience has shown me many times: and the same we say regarding the making of cartoons for vaults and ceilings."[101] Acisclo Antonio Palomino's recommendation in *El museo pictórico y escala óptica* in 1715–24 complements Egnazio Danti's. If the artist could not draw his cartoon away from the site, he should draw it on the wall before the wall was prepared for painting, so as not to ruin the surface with the holes left by small nails and tacks.[102] Especially cartoons for complex illusionistic frescos on curved surfaces must have often been drawn in situ, in order to calibrate optical distortion. This is partly confirmed by an assessment record on 28 January 1543, regarding Michelangelo Anselmi's cartoons for the apse fresco of the *Coronation of the Virgin* (S. Maria della Steccata, Parma).[103] Originally, the cartoons were to have been drawn by Giulio Romano, who on 14 March 1540 had committed himself to do a small-scale composition drawing in color and at least the three principal figures in cartoon scale, while the rest of the work was to be delegated.[104] Giulio left behind only the colored drawing which was to serve Anselmi as a *modello*, but which rendered forms as if intended for a flat surface, rather than for the actual curvature of the apse (*"p[er] esser il carto[ne] fatto in carta cossa piana et eguale et la nicchia cossa co[n]cava e rotonda"*). This would cause Anselmi considerable delays, and, as is clear from the poignant documents, Anselmi's patience and talents were strained, as he was forced to work out the complex perspectival design adjustments of the cartoons, figure by figure, directly on the unprepared wall, by means of proportional squaring grids (*"sì ch[e] è stato sforzatto far li cartoni sul muro grezo et dissegnare tutte le figure a una p[er] una co[n] l'aiuto dil craticularle sopra detto muro . . ."*).

As Vasari's vivid description of Michelangelo's painting of the Sistine Ceiling attests, the daringly foreshortened pose of Haman in the *Punishment of Haman* was among the most difficult to visualize and to design, because the scene is frescoed on the concave surface of a pendentive (see Plate XII, Fig. 238).[105] Extremely detailed stylus incisions describe the monumental nude body of Haman pushed violently to the foreground, in the central band of the scene. Michelangelo painted Haman comparatively slowly, in four *giornate*, adhering precisely to these cartoon incisions. The profusion of cartoon nail holes around the figure's arms and head, an area done in a single, small *giornata*, attests to the difficulty of holding in place and transferring the cartoon onto the concave surface (Plate XII).[106]

Drawing Aids

The actual process of drawing large cartoons required enormous dexterity, as it could be physically cumbersome and even taxing. Various means to facilitate the effort were devised. It is clear from the descriptions in treatises that the draughtsmanship and quality of design of monumental cartoons were calibrated to be seen from a far viewing distance.[107] Vasari's introduction to the *Vite* mentions that artists employed "a long rod, having a piece of charcoal at the end" to draw cartoons for frescos.[108] This long handle for the charcoal or chalk (a type of *"porte-crayon"*) not only extended the reach of the draughtsman's arm in drawing, but it also helped him in judging proportion *("per giudicar da discosto tutto quello che nel disegno piccolo è disegnato con pari grandezza")*. Curiously, Armenini advocated dusting with a pouncing bag – literally, *"spolverare"* – as a shortcut to achieve a gray base tone in rendering the large areas of shadows in cartoons.[109]

In describing such techniques, the theorists were encouraging the use of a manner of drawing cartoons that was significantly broader than that of small-scale drawings.[110] In a fragment with the head of an angel (Fig. 44), from the 1470s, Andrea Verrocchio boldly hatched over the black chalk drawing in pen and brown ink to deepen the shadows.[111] By contrast, Leonardo and Raphael would usually strengthen the chiaroscuro of their monumental cartoons by varying the handling of the charcoal alone. In technique, Leonardo's grotesque head (Fig. 45), from 1503 to 1505 and sometimes identified with Vasari's description of "Scaramuccia, captain of the gipsies," was probably very close to the lost *Anghiari* cartoon.[112] Raphael used aggressive hatching, only partial stumping, and vigorous reinforcement lines in the cartoon fragments of *God the Father* for the *Disputa* (see Fig. 64) and of a *putto* attendant for *Poetry* (Fig. 46).[113] Both served for frescos in the *Stanza della Segnatura* (Vatican Palace), dating from 1508 to 1509. A similarly bold handling of the charcoal characterizes the *Portrait of Pope Leo X* (Plate VIII), probably drawn around 1520–21 by Giulio Romano, rather than Raphael, as is sometimes maintained, and Giulio's Jovian *Head of a Bearded Man* (Fig. 47), from about a decade later.[114] Monumental compositions more completely suggest a varied, atmospheric treatment of the charcoal medium, as will be discussed in Chapter Seven.[115]

For enlarging a design to the scale of a cartoon, Armenini's *De' veri precetti* would recommend the use of proportional squaring grids on both the small-scale preliminary compositional design and the cartoon, much as is visible in parts of Giulio's cartoon for the *Stoning of St. Stephen* (see Figs. 230–31), which is squared at intervals ranging from 233 to 240 mm.[116] As early an example, as Pietro Perugino's vigorously drawn *Head of St. Joseph of Arimathea* (see Fig. 76), also exhibits the remains of just such a ruled squaring grid underneath the layers of drawing in black chalk.[117] This cartoon fragment was preparatory for a large altarpiece of the *Lamentation* that Perugino painted for the Florentine nuns of S. Chiara, signed and dated 1495 (see Fig. 77). The grid would be calibrated so that a number of lines would coincide with key vertical and horizontal axes through the head and body of the figures. This procedure is frequently seen in figure drawings from the late fifteenth century onward and is prescribed in Leonardo's note from 1490 to 1492 in Paris MS. A (fol. 104 recto).[118] Fra Bartolomeo's monumental stylus-incised Uffizi cartoon for the kneeling St. Mary Magdalen (Fig. 36) is squared in charcoal or black chalk, comprehensively and consistently at intervals of 174–76 mm. Here, the drawing technique of the saint's figure evokes Leonardo, as well, for the artist delicately stumped the charcoal and white chalks to create ineffable *sfumato* effects. Fra Bartolomeo followed this approach also in his Uffizi cartoons for a kneeling *St. Catherine of Siena,* squared at 176–80 mm. intervals, and for a standing *St. Peter,* squared more imprecisely at intervals that range anywhere from 150 mm. to 170 mm.[119] The construction of the squaring grids in Bernardino Poccetti's two stylus-incised Uffizi cartoon fragments from 1582 to 1584, for the St. Dominic mural cycle in the *Chiostro Grande* (S. Maria Novella, Florence) is instructive. Drawn in charcoal, as are the figures, the squaring in Poccetti's cartoon fragment for the left part of the composition is fragmentary and reads faintly against the schematically rendered figures. To produce the squaring grid on the cartoon fragment for the right half of the composition (Fig. 42), however, Poccetti and his *bottega* resolved the problem of the grid's legibility by snapping the lines with cords dipped into dark brown ink, much as fresco painters traditionally did on the surfaces of the *arriccio* or *intonaco* (see Chapters Five and Six).[120] The inked cords left imprints of their weave and their arrested motion often doused the charcoal drawing with tiny ink spots.

Armenini would adamantly defend the efficacy of such squaring grids in the process of drawing cartoons, alleging against "those who say that it is harmful to use the grid" that it was not sufficient to rely on judgment *("giudicio")* alone.[121] This was apparently a point of

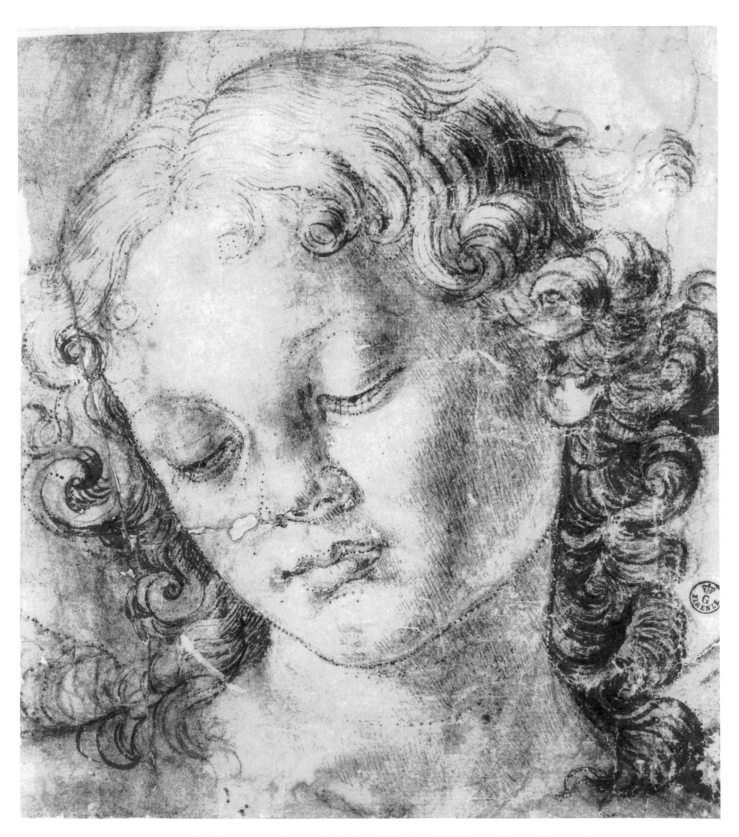

Figure 44. Andrea Verrocchio, pricked cartoon for the Head of an Angel *(CBC 337; Gabinetto Disegni e Stampe degli Uffizi inv. 130 E, Florence).*

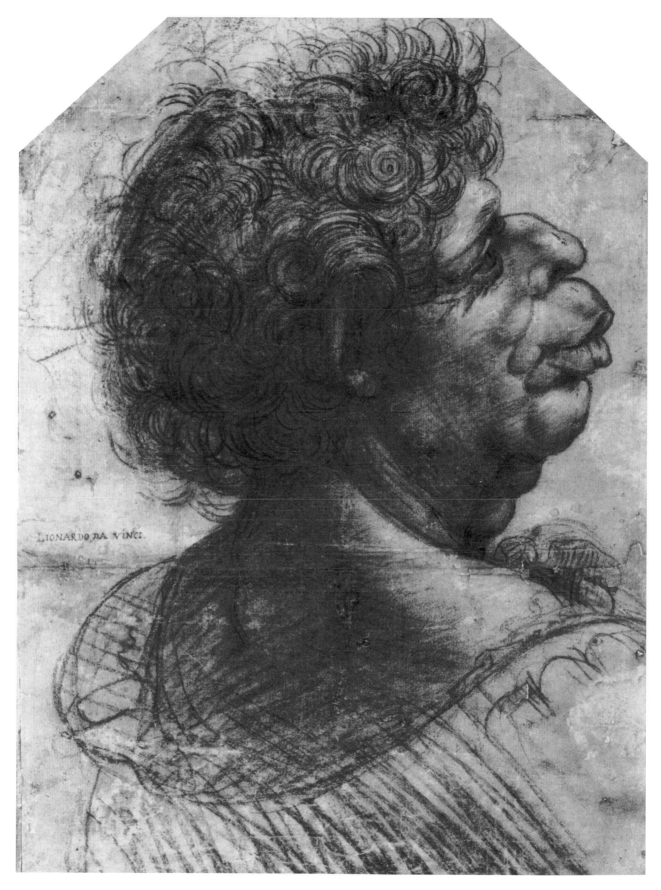

Figure 45. Leonardo, pricked cartoon for the Head of a Grotesque Man, The "Scaramuccia, Captain of the Gipsies?" *(CBC 130; Christ Church inv. 0033, Oxford).*

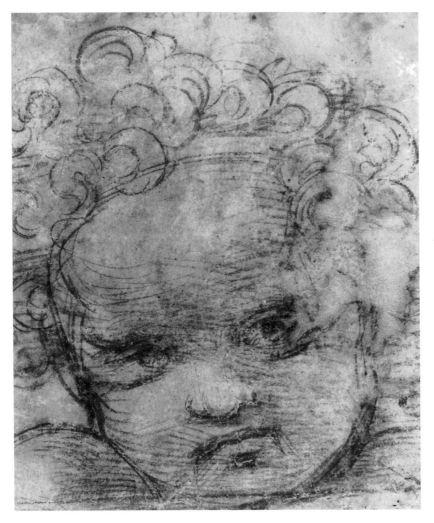

Figure 46. Raphael, pricked cartoon fragment for the Head of a Putto *(CBC 253; British Museum Pp. 1-76, London). The drawing was preparatory for the frescoed vault compartment,* Poetry, *in the* Stanza della Segnatura, *Vatican Palace.*

contention with Vasari, who recommended the use of grids only for such difficult elements as perspective or architectural views.[122] Michelangelo's apparent contempt for the grid may have been at the root of Vasari's prejudice.[123]

Drawing Media

As both texts and extant cartoons can demonstrate, artists drew mural and altarpiece cartoons most commonly in charcoal or black chalk – broad-point media that covered large areas quickly and with relative ease. A layer of size may have been applied as a fixative.[124]

Charcoal was obtained from sticks of willow wood charred in an airtight container, and black chalk from natural carbonaceous shale; both were sharpened to a point with a knife and often tied to a cane for drawing. According to Cennino, a particularly soft variety of black chalk could be found in the mountains of the Piedmont.[125] Vasari's contract and budget in June 1572 for the dome frescos of Florence Cathedral includes willow wood for making charcoal *("salci per far carboni")* to draw his cartoons.[126] The charcoal or chalk drawing was often then highlighted with lead white in either dry or liquid form (mixed with water and gum arabic). For cartoons, Armenini's *De' veri precetti* recommends specifically *"gesso da sarti"* (tailors' white chalk), and Vasari's contract and budget in 1572 for the dome frescos of Florence Cathedral again includes it as such.[127] By the High Renaissance, the exploration of light, and its dramatic power to transform surface, structure, color, and space had become an increasingly important component of Central-Italian design. It probably encouraged the extraordinary refinement of the charcoal and chalk drawing techniques gradually emerging in the most advanced Florentine and Umbrian workshops of the later fifteenth century.[128] The High Renaissance ideal of the *"ben finito cartone"* (literally, "well-finished cartoon") in Florence and Rome was rooted in this exploration of drawing media; more will be said about these developments in Chapter Seven.

The monumental forms in Giulio Romano's early cartoons in charcoal are rendered with a rich, nearly marmoreal tonal definition, highlighted with white chalk (see Plate VIII, Fig. 230). Later, during his Mantuan period, Giulio would develop a considerably more economic means of handling the charcoal, without sacrificing the commanding plasticity of his forms (Fig. 47). Correggio's spirited cartoon for an angel's head (Plate IX) is among the masterpieces of the genre in the sixteenth century.[129] It was calibrated to be seen from a far *"sotto in sù"* perspective, with broad, though exquis-

itely stumped, pictorial effects in charcoal and white chalk. Judging from the granular texture left on the paper throughout the passages of charcoal rendering, Corregio drew this cartoon fragment on the plaster surface of a wall. The angel's head appears on the frescoed squinch portraying St. Joseph, below the enormous *Assumption of the Virgin* on the dome of Parma Cathedral. The Ecole des Beaux-Arts fragment is the only extant, securely autograph cartoon relating to the Parma Cathedral dome, contracted in 1523 and frescoed in 1526–30. In smaller-scale design, an adaptation of Correggio's experiments with *sfumato* emerges in Michelangelo Anselmi's unfinished cartoon, drawn in charcoal, for figures in an unrecorded painting of the *Crucifixion* (Fig. 48).[130] The composition probably dates around the time of Anselmi's early frescos on the apse of the left transept at S. Giovanni Evangelista (Parma), dated 1521; both Correggio and Anselmi seem to have been at work in S. Giovanni at the same time.

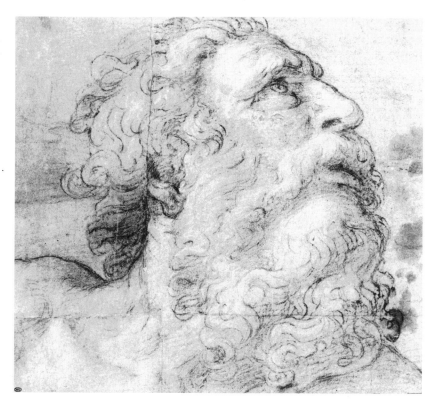

Figure 47. Giulio Romano, stylus-incised cartoon fragment for the Head of a Bearded Man *(Département des Arts Graphiques du Musée du Louvre inv. 3570, Paris).*

Toward the end of the century, Federico Barocci would push Correggio's highly pictorial effects to their limit with a dynamic use of the stumping tool to blend tones softly and seamlessly in monumental compositions. Barocci's cartoon drawing technique would always be closely allied with his painterly approach and study of light, as we see in his monumental *Visitation* (Fig. 49), intended for the altarpiece of 1582 in the "Chiesa Nuova" (Rome).[131] The preparation of full-scale oil sketches of partial details on paper played a prominent role in his working procedure (Fig. 50).[132] A magical quality of light also flickers across agitated contours in his small early cartoon fragment in Chicago, preparatory for the altarpiece of the *Deposition* in the Chapel of St. Bernardino (Cathedral, Perugia), from 1568 to 1569.[133]

In marked contrast to the preference for the dry media of charcoal or chalks, Francesco Parmigianino's cartoon of the *Head of a Bishop Saint* (Fig. 51) is painted broadly with the brush, gray and brown washes, over a charcoal underdrawing. It exemplifies a highly original use of medium within the Renaissance *"ben finito cartone"* tradition, and adapts the painting technique of

sixteenth-century stained glass and tapestry cartoons, but in monochrome. Rendered in a *"sotto in sù"* perspective, the head of the bishop is in a slightly larger than life-size scale and is similar in design to the *Mystical Marriage of St. Catherine* (Pinacoteca Nazionale, Bologna) from 1528, an altarpiece from Parmigianino's Bolognese period. The artist achieved a deeply graded chiaroscuro that is clearly legible from a great viewing distance, and with a remarkable economy of means, pointing in the direction of the painterly cartoons of the Seicento.[134]

For small-scale drawings to be transferred, artists used most commonly pen and ink (over a preliminary underdrawing in leadpoint, charcoal, or black chalk), much less often the tip of the brush or metalpoint.[135] Such media permit complexity of form, offering both a fine quality of line and a precise tonal range, if a harsher one, than either charcoal or chalk.[136] One of the earliest extant pricked drawings from the 1440s to 1460s, Paolo Uccello's soldier riding a horse (Plate I), is in metalpoint with white gouache highlights on olive-green prepared paper, a medium of drawing favored by Cennino, but one that would be largely abandoned by the early six-

teenth century.[137] Renaissance cartoons for embroidery are all invariably drawn in pen and ink with wash and highlights; Saint-Aubin's *L'Art du Brodeur* (Paris, 1770) confirms the practicality of this medium. Ink was available in a variety of brown tones, and the addition of washes and lead white highlights could greatly enrich the tonal range of small *"disegni ben finiti."*

Artists and copyists, however, traced a variety of drawing types (as well as manuscripts and prints) to use as cartoons for transfer, sometimes choosing to do this

Figure 48. Michelangelo Anselmi, unfinished cartoon for saints in a scene of the Crucifixion *(CBC 6; Gabinetto Disegni e Stampe degli Uffizi inv. 7697 Santarelli verso, Florence). Only the outlines on the upper part of the female monastic saint's figure, in the center of the drawing, are pricked.*

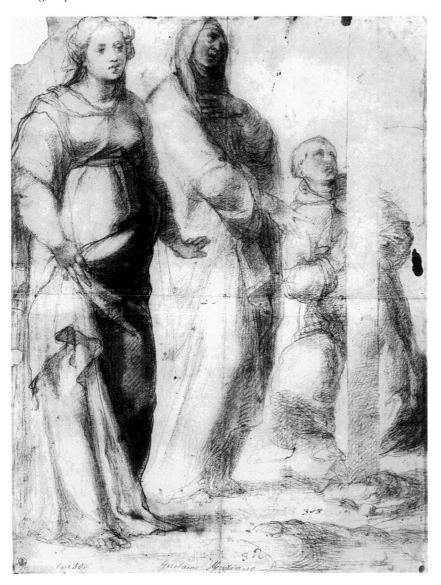

belatedly, and thus the actual range of media for such designs is diverse. Nevertheless, few examples in red chalk exist, as the increasing popularity of this medium coincided with the gradual disuse of the *spolvero* technique. Between 1500 and 1530, artists frequently turned to red chalk for delicate, exploratory studies after life, since its color was ideally suited to the rendering of human flesh; such studies, however, were precisely the drawing type least likely to be transferred. In drawing large cartoons, artists probably avoided red chalk for practical reasons.[138] Viewed from a distance, charcoal and black chalk offer a more legible, sculptural tonal range, and their relative ease of application quickly enabled density of tone. Forms with highlights of white gouache or dry white chalk, enthusiastically advocated in Vasari's and Armenini's discussion of *"rilievo,"* appear more dramatic if rendered in charcoal or black chalk, rather than in red chalk, which can sometimes smear into unattractive pink hues. A relatively large pricked cartoon in red chalk (CBC 222), attributed to Antonio Rimpatta, is a noteworthy exception.[139] For his pricked cartoon of a standing male saint (CBC 289), Luca Signorelli chose the best offered by each medium, rendering the flesh areas in red chalk, but the rest of the figure in black chalk.[140] Piero Pollaiuolo's *Head of Faith* (Plate II) is rendered in charcoal, combined with red chalk on the flesh areas. This two-chalk technique achieves seamlessly blended *"sfumato,"* indicating a high probability that the red chalk drawing is original, rather than the result of retouching by another hand.

Pricking the Designs

Treatise writers used the terms *"bucare," "puntare," "punteggiare,"* or *"forare"* to describe the process of pricking the outlines of a design for transfer.[141] Our discussion of "pouncers" in Chapter One has already indicated that artisans and amateurs often used the *spolvero* technique to appropriate the designs of others. Such

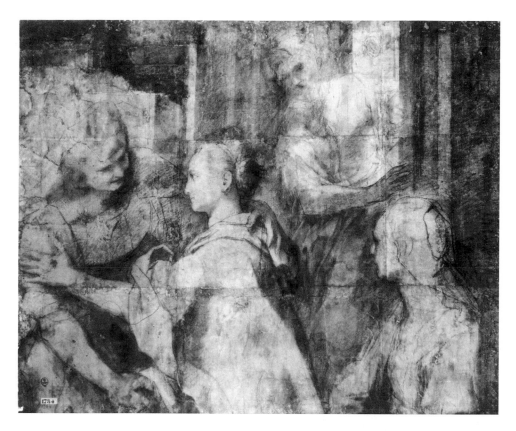

Figure 49. Federico Barocci, stylus-incised cartoon fragment for the Visitation *(Gabinetto Disegni e Stampe degli Uffizi inv. 1784 E, Florence). The corresponding altarpiece in oil on panel is in the "Chiesa Nuova" (S. Maria in Vallicella), Rome.*

copyists avoided the step Renaissance and Baroque art theorists judged to be the most crucial and difficult in the artistic process, that of *"invenzione"* or invention, by resorting to ready-made designs, whether drawings, manuscripts, or prints; they began their work with the actual procedure of transferring the design.

Paganino's *De rechami* describes the procedure as follows: "take a thin needle and prick all the outlines of the drawing, making the hole[s] closely spaced from each other."[142] Cennino's *Libro* cautions that such piercing be done *"gentilmente"* (gently or delicately),[143] and Saint-Aubin's *L'Art du Brodeur* admonishes that "one must hold the needle completely perpendicular in pricking, so that the pouncing dust can [later] pass freely through [the holes of] the paper."[144] Cennino advised further that the design was to be pricked over a buffer for protection: ". . . holding a piece of canvas or cloth under the sheet. Or do the pricking over a poplar or linden board; this is better than canvas."[145] Similarly, Paganino's *De rechami* urges that the artisan place underneath "a cloth of fine wool, which, if new, you will turn on its reverse, because this [prevents] the needle from

passing through too much below [the surface of the sheet of paper], making the holes too big."[146] This is also essentially Saint-Aubin's advice.[147] This method, we may extrapolate from existing drawings and manuscripts, ensured that the paper or parchment did not tear, the holes were evenly sized, and, in the case of patternbooks or sketchbooks, that the pages of drawings underneath were not perforated. As Paganino's *De rechami* cautions, "when you prick, it is enough that only the tip of the needle pass through [the paper]."[148]

Strikingly different styles of pricking are evident in drawings. As examples by Florentine artists working in the same period, we can compare a *Seated Saint* (Fig. 52), possibly by Francesco Botticini, to Antonio Pollaiuolo's presumed study for the *Sforza Equestrian Monument* (Fig. 53).[149] The photographs here illustrated were taken through the microscope under equal magnification.[150] They reveal Botticini's minute, orderly, and closely spaced holes (about 24–27 holes per 10 mm.) and Pollaiuolo's sparse, coarsely pricked holes (about 6–7 holes per 10 mm.), which often overstep the drawn outlines and often fail to perforate the

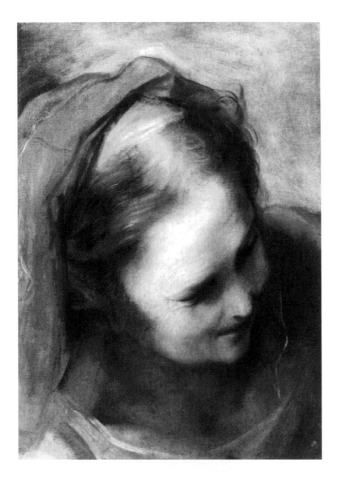

Figure 50. Federico Barocci, Head of St. Elizabeth, *full-scale oil sketch in color on paper (Metropolitan Museum of Art, Harry G. Sperling Fund, 1976; 1976.87.2, New York), prepared after the step of drawing the cartoon.*

paper. By contrast, in large-scale cartoons, such as Piero Pollaiuolo's *Head of Faith* (Plate II), also from this period, the pricking style follows the complexities of the design. The slightly foreshortened face and features, drawn with great precision, exhibit extremely fine, orderly pricking (about 10–13 holes per 10 mm.), whereas the hair and veil, drawn in a loose, impressionistic manner, are much less carefully pricked (about 4 holes per 10 mm.).[151]

Catherine Perrot's *Traité de la Miniature* (Paris, 1625) explicitly states that only "the principal outlines" of the print or design intended for transfer by pouncing should be pricked.[152] In pricking designs, artists, artisans, or *garzoni* occasionally overlooked a small detail here and there, particularly in large or complex compositions. Thus, we often find details, such as halos on saints, folds on draperies, lines on architecture, or vegetation in landscape backgrounds, that were left unpricked; this

type of oversight can naturally occur in the mind-numbing routine of pricking outlines. Yet those who habitually made use of the technique rarely made such mistakes, even in extremely intricate designs.[153] Unfinished cartoons that are only partly pricked are rare (see Fig. 48).

Drawings that are not glued onto mounts help us distinguish the character of perforations, rectos relative to versos. The rectos (i.e., the sides with the drawings), exhibit crisply shaped holes, which when viewed from the versos appear torn and raised, as if the holes were craters. Thus we can see the original direction of pricked designs, even if there is no actual drawing on a sheet – crucial evidence in interpreting the design of "substitute cartoons."[154]

Before the actual process of pouncing began, the holes on the verso of the pricked sheet could be sanded. As Paganino's *De rechami* explains, the holes would thus not obstruct the pouncing dust, if the design was to be pounced from both recto and verso to produce bilaterally symmetrical designs, a common practice among Renaissance painters and craftspeople: "Get a soft pumice stone, and form it like a small slab. Get then the pricked drawing, and turn its faces from obverse to reverse, because in pricking the paper the needle leaves a protruding band [of paper craters]. You will guide this pumice stone mildly over what is perforated, so much that in the end the pumice will have disposed of the excess paper."[155] By sanding the tiny craters of paper, the pouncer improved the extent to which any *spolvero* marks registered on the secondary surface. This was especially necessary if the design was to be repeatedly reused. For, as we shall observe, with each session of pouncing the holes actually closed somewhat when the paper contacted the secondary surface.[156] The practice of sanding described by Paganino also explains the reason why it is sometimes no longer clear whether a drawing was pricked from the recto or verso: the protruding craters of paper were often leveled during the working process.[157]

Pricking and Tracing Tools

The borders encircling the perforations in extant drawings are often colored orange, suggesting that they were pricked with rusty iron implements. Cennino's *Libro* refers to the pricking implement only as *"aghuciella"* (little needle).[158] But the needle may well have been mounted on a small, long wood handle (*"agugella legata in una asticciuola"*), as described regarding various other

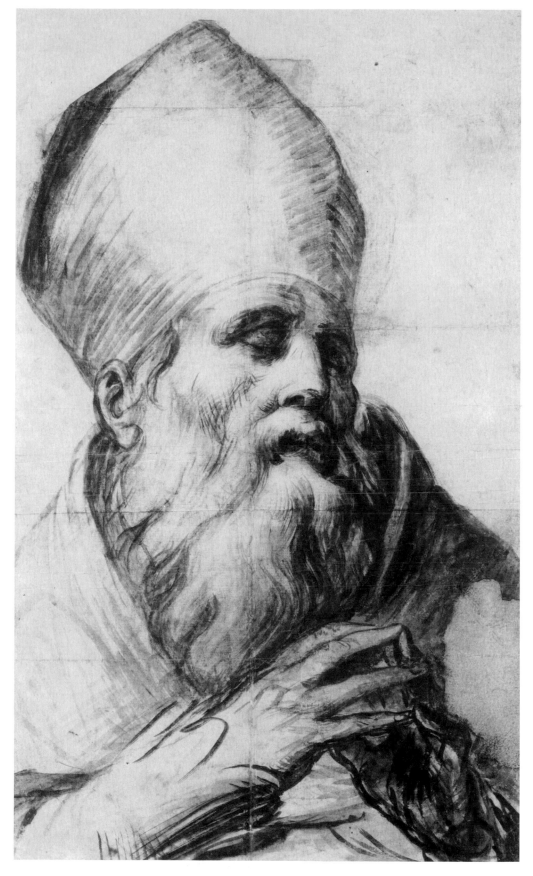

Figure 51. Francesco Parmigianino, stylus-incised (?) cartoon for the Head of a Bishop Saint *(Metropolitan Museum of Art, Van Day Truex Fund, 1995; 1995.306, New York).*

procedures – marking outlines on gilded panels, or *sgraffito* designs on glass.[159] Indeed, this is precisely the way the pricking instrument is portrayed in the woodcut in Cesare Vecellio's *Corona delle nobili et virtuose donne* (Fig. 13) – the *"acco"* (needle) or *"stile"* (stylus). As we have seen, the Accademia della Crusca in 1612, and later Filippo Baldinucci, termed the pricking instrument a small pin *("ispilletto").*[160] Other sources mention a needle *("ago," "aguja," "aiguille")* or lead stylus *("stile di piombo").*[161] We may speculate further, that the same silver and lead styluses used in metalpoint drawing were occasionally used for pricking.[162] Such implements, however, were most efficient in pricking small-scale designs.

Pricking a large cartoon for a mural was inordinately time-consuming, especially because a needle, as recommended in Armenini's *De' veri precetti,* dictated relative fineness of detail. As extant drawings make plain, artists could hardly be expected to comply always with Filippo Baldinucci's and Andrea Pozzo's advice that the outlines of cartoons be "minutely" and "densely" pricked.[163] Ready-found tools in the workshop and household must have also doubled as pricking implements. If early writers are relatively silent on this, it should be remembered that they intended to set paradigms of proper working procedure, not examples of sloppy convenience. Some answers emerge in passages dealing with cartoon transfer by stylus tracing or incision *(calcare),* the later, less labor-intensive, but more destructive method of transferring cartoons. The 1550 and 1568 editions of Giorgio Vasari's introduction to the *Vite* describe "a point made of iron, ivory, or hard wood."[164] Raffaele Borghini's *Il Riposo* (Florence, 1584) essentially agrees with Vasari and notes among others the sharp splinter "of a broom."[165] These household and workshop items recur in Joachim von Sandrart's *Teutsche Akademie* (Nuremberg, 1675).[166] Baldinucci's definition of stylus incision *(calcare)* still partly follows Vasari and Borghini in noting a "stylus [fashioned] of ivory or of hard wood,"[167] while Pozzo's cartoon transfer method of *"ricalcare"* only cites "a point of iron."[168] Less particular painters probably seized upon the pointed handles and splinters of their paintbrushes. Karel van Mander referred to *"stelen van penselen"* in *Den grondt der edel vry schilderconst* (Alkmaar, 1604) and Acisclo Antonio Palomino to *"pedazo de asta de pincel en punta no muy aguda"* (Madrid, 1715–24).[169] Not only nails, hard wires, and compass points must have handily fullfilled this function, but also punches and gravers. These already formed part of the equipment with which Late Medieval and Early Renaissance panel painters tooled cloth patterns, halos, and backgrounds, and sculptors their metal decorations.[170]

Curiously, a popular English treatise on the *"Light Italian Way of Painting"* (London, 1730) also refers to the use of a "porcupine's quill" as a tracing implement.[171] To my knowledge, however, neither descriptions in primary sources nor extant archaeological evidence in drawings (in the form of a recurring diameter, configuration, and spacing of the pricked holes) suggest that outlines could be pricked with such ingenious, time-saving, mechanical devices as single-row spiked roulettes or pinwheels. Yet the probability that such implements were utilized at least to prick nonfigural designs cannot be ruled out. Seventeenth-century printmakers perfected various types of roulettes, or "engines" as they were originally called, in developing the *mezzotint* ("half-tone") process.[172] The extraordinary degree of regularity in the spacing and shape of *spolvero* marks evident particularly in the decorative borders of some Ottocento murals is suggestive of such a mechanized approach.[173] However, in "Late Gothic" and Renaissance murals the state of preservation of *spolvero* outlines is all too often precarious, particularly in ornamental parts, where passages of extensive rectilinear designs could unambiguously provide telltale evidence. This, together with the extensive areas of repainting also common in ornamental parts, greatly obscures further investigation.

Transferring the Designs onto the Working Surface

At this point, we should recognize that writers on ornament and the decorative arts often supply inordinately specific descriptions about technique. Patience-trying quandaries could arise during the process of pouncing ornament designs, especially nonfigurative ones. These were frequently produced "repeat by repeat" on the working surface. (A "repeat" is one complete motif of an overall pattern.) Minutely scaled designs often required manifold repetition in various symmetrical configurations, sometimes within irregularly shaped areas.[174]

Designs, whether figurative or nonfigurative, could be transferred to a variety of working surfaces: wall, panel and canvas, paper and parchment, embroidery cloth, and ceramic. The pricked outlines of the design were tapped or smudged with the pouncing bag – Alessandro Paganino's *De rechami* recommends, "as many times as was necessary" – to obtain a dotted underdrawing on the surface underneath.[175] Saint-

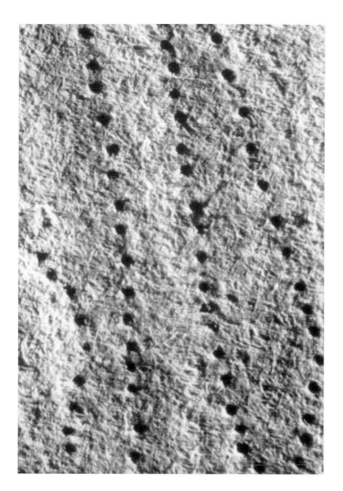

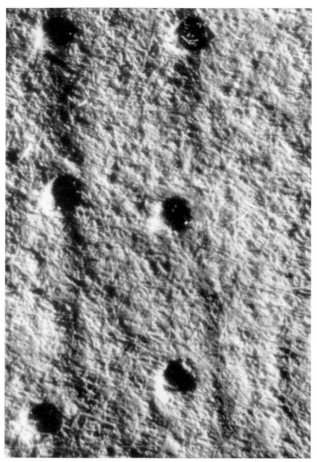

Figure 52. Microscopic enlargement of the pricked outlines in the Seated Saint, *attributed to Francesco Botticini (Fig. 86; CBC 7; Metropolitan Museum of Art, Robert Lehman Collection, 1975.1.409, New York).*

Figure 53. Microscopic enlargement of the pricked outlines in Antonio Pollaiuolo, presumed study for the Sforza Equestrian Monument *(Fig. 278; CBC 213; Metropolitan Museum of Art, Robert Lehman Collection, 1975.1.410, New York).*

Aubin's *L'Art du Brodeur* notes that French embroiderers used the term *"poncer sur le doux"* as a warning to pounce the pricked design on the correct face of the sheet of paper – the side from which the design had been pricked.[176] Saint-Aubin's advice may seem simple-minded until we recall the extraordinary intricacy of some ornament patterns that were pounced a single repeat at a time (see Chapter Five).

Many writers on the *spolvero* technique insisted that the pricked pattern, drawing, print, or cartoon be fixed onto the working surface to prevent slippage of the design during the process of transfer. Just such mishaps recur in Antonio Pisanello's long friezes of twirling banners surmounting the *Tournament Battle* scenes (Palazzo Ducale, Mantua) from 1447 to 1450.[177] Sometimes shifting slightly to the right, sometimes to the bottom, and rubbing against the deposits of *spolvero,* the loose pricked patterns often distorted the dots into

syncopated rows of diagonal dashes.[178] *Spolvero* marks also smear some of Andrea del Sarto's *grotteschi* in the mural cycle on the *Life of St. John the Baptist* ("*Chiostro dello Scalzo,*" Florence) painted between 1509 and 1524.[179] In the detail from Andrea del Sarto's *grotteschi* (Fig. 54), the *spolvero* dots on the right half of the symmetrical design, divided by the stylus-incised centering line, appear larger and readily distinct. On the left half, the dots are much more weakly defined. As actual practice can demonstrate, if a pricked design is pounced from its verso, the pounce marks register more distinctly, than if pounced from the recto.[180] Andrea probably produced his bilaterally symmetrical pattern by folding the sheet of paper along the center and then pricking the design from one half onto the other half of the paper.[181] Thus, on the fresco surface, the right half corresponds to the verso of the paper pattern and the left half to the recto. Great speed of

Figure 54. Detail of Andrea del Sarto (and Andrea di Cosimo Feltrini?), decoration in grotteschi, fresco ("Chiostro dello Scalzo," Florence), showing a greater deposit of carbon dust in the spolvero dots on the right half of the symmetrical figure.

single repeat of the ornamental design and were replicated over and over.[182] Most *spolverezzi* may thus have hardly required more than pinning or holding in place with the hand. In Paganino's illustration (Fig. 11), the embroidery pattern appears nailed onto the embroidery cloth on a working table, and the text of his manual confirms this.[183] Saint-Aubin's *L'Art du Brodeur* prescribes either pinning or placing weights.[184] The traditional method of fixing the corners of translucent tracing paper with warm red or green wax for *lucidare,* which Cennino's *Libro* advocates, probably also served for pouncing small designs.[185]

Easel Painting

Although Vasari and Borghini described the technique of *calco* rather than *spolvero,* they noted that cartoons for panel and canvas paintings were transferred in one piece, without dismembering — *"il cartone tutto d'un pezzo."*[186] The cartoon was secured with small nails,[187] and plumblines often helped center the design. Raphael's cartoon of *St. George and the Dragon* (Fig. 56), from 1505 to 1506, has a pricked plumbline, 41 mm. long, toward the center of the lower border; another pricked plumbline, 61 mm. long, occurs at the center of the top border.[188]

With current scientific means of investigation, it is not always possible to obtain complete, precise data to reconstruct definitively the process by which Italian painters transferred cartoons and patterns onto panel or canvas. The procedure for a small panel can be observed closely in the case of Raphael's *St. George and the Dragon.*[189] Raphael drew the cartoon in the Uffizi (Fig. 56) carefully with a fine pen and medium brown ink over preliminary traces of black chalk underdrawing, which was possibly itself derived from *spolvero.* The economic drawing style of the cartoon confirms that the main foreground elements of the composition had been fully worked out on paper, well before this stage.

execution is vividly apparent in similar types of decorative details in the vast rooms and galleries frescoed by Giulio Romano's workshop at the Palazzo Ducale in Mantua, during the late 1530s and 1540s (Fig. 55).

The pounced patterns *("spolverezzi")* recommended by Cennino in painting gold brocade on both panels and murals were small, as were many other types of patterns employed for ornament painting during the "Late Gothic" and Renaissance. They usually consisted of a

Figure 55. Detail of Giulio Romano and workshop, decoration in grotteschi, fresco (Palazzo Ducale, Mantua), showing smeared and greatly syncopated spolvero *dots from hasty pouncing.*

To suggest chiaroscuro, Raphael hatched in diagonal, parallel strokes; only in the rear end of the horse did he build up any depth of shadow by means of diagonal cross-hatching. The outlines of the main foreground elements are finely and carefully pricked, conforming to the precise drawing style. Much of the background landscape, however, is in less final form. A few deft strokes of the pen suggest rather than describe it, and consequently its outlines are pricked much more sporadically. Infrared reflectography examination reveals traces of the *spolvero* underdrawing in the related panel in Washington (Fig. 57); many of the *spolvero* outlines correspond to the holes in the Uffizi cartoon.[190] Yet the infrared reflectograms do not by any means reveal the full extent of the *spolvero* marks that must have originally existed on the panel. If a tracing on clear acetate, taken from the Washington painting, is placed over the Uffizi cartoon, it can demonstrate the precise degree to which the designs in the painting and drawing correspond.[191] However minor, there are displacements of painted and drawn outlines that are nevertheless noticeable in a composition of such small scale. Inevitable syncopations of outlines must have occurred as the cartoon shifted during the process of transfer onto the painting surface. For example, although the horses's front and rear legs align perfectly, its stomach is

painted 2–3 mm. below the drawing, its tail 2 mm. higher and to the left.[192] Other small alterations inevitably arose during the process of painting. Although St. George's facial profile aligns perfectly, the overall diameter of his head is painted 1.5 mm. larger than drawn. Finally, and not surprisingly, the greatest changes occur in the landscape, which is, after all, more sketchily drawn and only sporadically pricked.

Judging from Vasari's and Borghini's description, the practice of transferring without dismemberment was standard also for large easel painting cartoons comprised of multiple sheets of paper.[193] Recent technical examination of Raphael's *"Belle Jardinière"* (Fig. 58), from 1507 to 1508, establishes that this *"ben finito cartone,"* deeply rendered in charcoal (and some black chalk) with traces of lead white chalk highlights, was a highly functional working drawing, directly used on the final painting surface, the panel in the Musée du Louvre, Paris.[194] The outlines of the design in the Washington cartoon are pricked throughout, as are the plumbline at the bottom and the horizonline on the left, and the cartoon's surface is heavily rubbed with pouncing dust, evident as

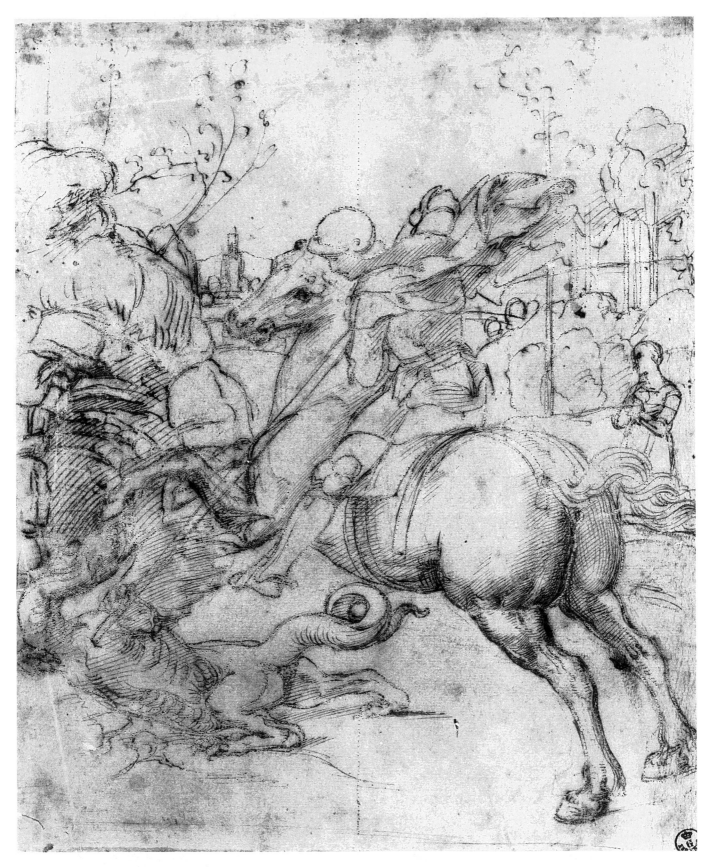

Figure 56. Raphael, pricked cartoon for St. George and the Dragon *(CBC 239; Gabinetto Disegni e Stampe degli Uffizi inv. 529 E, Florence). The plumblines for centering the drawing on the painting surface are seen toward the top and bottom of the sheet.*

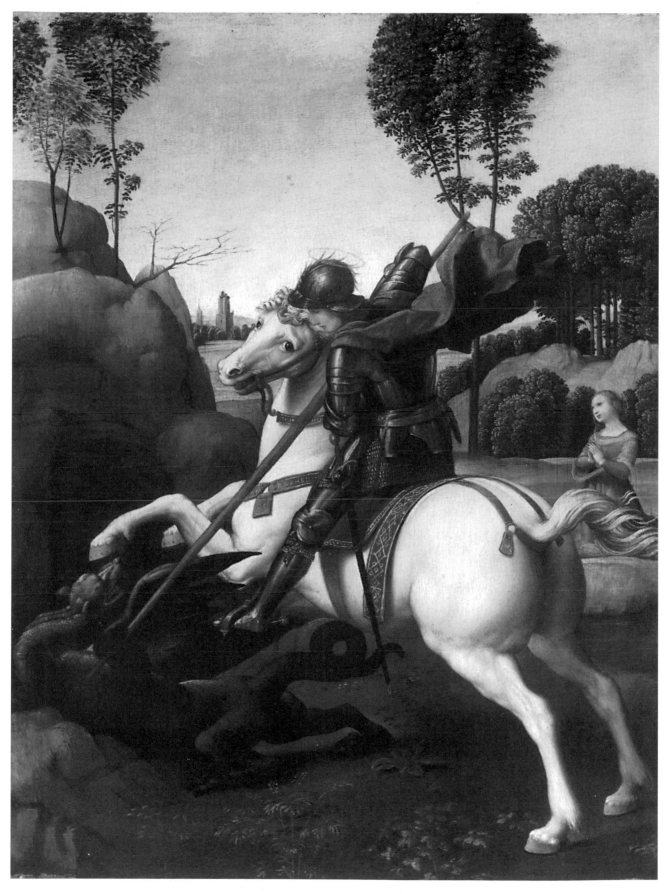

Figure 57. Raphael, St. George and the Dragon, *oil on panel (National Gallery of Art, Washington).*

broad borders of smudged grayish charcoal or chalk along the contours.[195] The artist calibrated the transfer of the composition from the Washington cartoon onto the larger, arched surface of the Louvre panel with great precision, by means of construction lines.[196]

To compose large easel paintings, single figures could also be drawn on separate cartoons, much like Andrea del Sarto's *St. Francis,* which was preparatory for an altarpiece from around 1517 (Figs. 59, 60).[197] Such fragmentary cartoons could be transferred figure-by-figure onto the painting surface, thus saving the artist the labor and expense of materials involved in drawing a large, comprehensive cartoon for the composition. Andrea's *St. Francis* cartoon (Fig. 59) is boldly drawn in charcoal, with hatched strokes that are only lightly stumped to define broad areas of modeling; its drawing surface consisted of three *fogli reali,* joined lengthwise in a vertical orientation. The outlines of the drawing are finely and sharply traced with the stylus. Although the schematic incisions are scarcely the width of a hair, they have rendered the drawing on the saint's facial features especially harsh, deeply excavating the surface of the paper and often imprecisely following the charcoal outlines. Especially in the draperies, divergences of about 3–5 mm. with respect to the drawing are frequent. Conforming exactly with the "carbon copy" method later recommended by Vasari and Borghini for the stylus transfer of easel painting cartoons, the verso of Andrea's *St. Francis* is blackened with curving charcoal strokes and rubbed dust. Seen from the verso, the fine incisions from transfer cause the paper to protrude minutely, relieflike, without actually tearing the paper: the considerable advantage of the "carbon copy" method over plain *calco.* Infrared reflectography examination of a number of Andrea del Sarto's monumental altarpieces from the 1520s reveals the evenly weighted outlines from such "carbon copy" stylus transfer.[198]

In sharp contrast to Andrea's *St. Francis,* Alessandro Allori's large composition cartoon of the *Descent of Christ to Limbo* (Fig. 61) is minutely rendered with black chalk in a technique and figural scale emulating Michelangelo's so-called "presentation drawings" from the 1530s. Allori's cartoon was preparatory for an oil panel dated 1578 (Galleria Colonna, Rome), which reflects a painted composition by Allori's teacher, Agnolo Bronzino (Galleria degli Uffizi, Florence).[199] The nine *fogli imperiali* that comprise Allori's cartoon are glued in a vertical orientation so that the *quaderni* creases align horizontally, three *fogli* to a row, and the joins are entirely unaltered in their structure. The backing of the drawing with a secondary paper support was a later attempt to stabilize the deteriorating condition of the original paper. Allori's cartoon exhibits outlines meticulously incised with a fine, sharp point for transfer. Toward the top of the cartoon's composition, numbered scales in black chalk on both left and right borders probably helped calibrate the reuse of this composition in a different size.[200]

We can explore the actual process of transfer more fully in discussing cartoon reference marks.

Fresco Painting

Transferring a cartoon for a fresco was difficult, by comparison to dry surface media, because it depended on the expert handling of a notoriously treacherous medium. We have already encountered Michelangelo's protest that "fresco painting . . . is not an art for old men."[201] Most writers on painting from Cennino to Milizia pronounced fresco painting supreme, precisely because of its challenge.[202] Vasari regarded its mastery as a matter of virility, "being truly the most manly" of all painting media, as did Gian Paolo Lomazzo in the *Idea del tempio della pittura* (Milan, 1590).[203] By comparison, Lomazzo judged tempera painting, and especially oil painting, "an activity worthy of effeminate young men."[204] Such assertions are not entirely surprising. As we shall see, the dialectical notion of *difficultà–facilità* polarized most discussions of artistic prowess and technique in Italian treatises from the sixteenth to the seventeenth century.

In his diary of 1554–57, Jacopo Pontormo, by then an old and frail man, listed the grueling hardships of frescoing the now destroyed choir of S. Lorenzo (Florence). It is a *giornata*-by-*giornata* struggle, pathetically diminished only by his growing apprehensions of ill health and imminent death: "Wednesday I experienced so much difficulty with the *intonaco,* that I did not think I could make it work; it was full of lumps which made all the sutures [of the *giornate*] visible. . . ."[205] Vasari explained the difficulty of fresco painting in the introduction to the *Vite:*

. . . [fresco] is worked on the plaster while it is fresh and must never be abandoned unless the day's portion is finished. . . . If there be any delay in painting, the plaster forms a certain slight crust, whether from heat, or cold, or wind [drafts of air], or frost, which grows mould on, and stains the whole work. For this reason the wall that is to be painted must be kept continually wet, and the colors to be used must all be of earths, not minerals, and the white of calcined travertine.

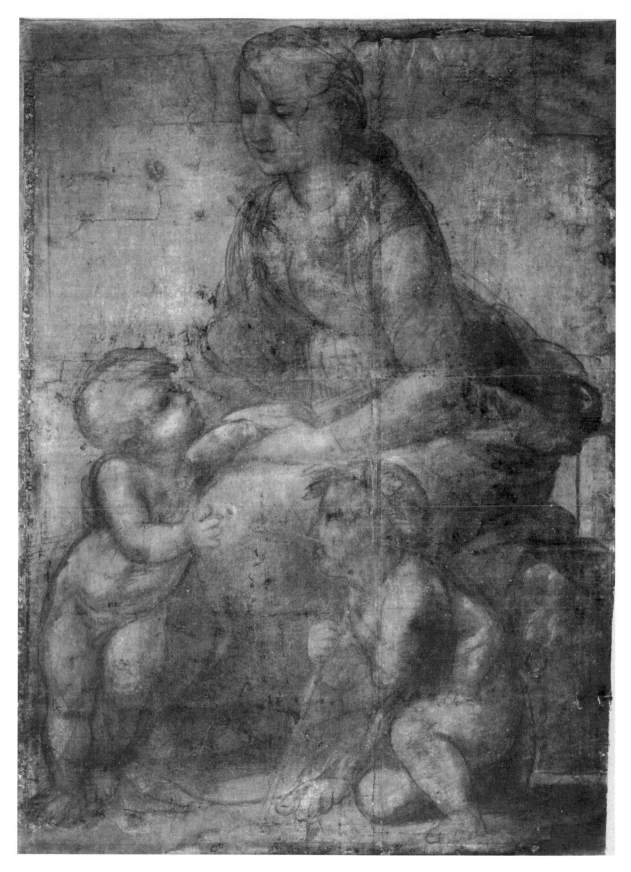

Figure 58. Raphael, pricked cartoon for The Virgin and Child with St. John the Baptist, "La Belle Jardinière" *(CBC 245; National Gallery of Art 1986.33.1, Washington), preparatory for the oil painting on panel in the Musée du Louvre, Paris.*

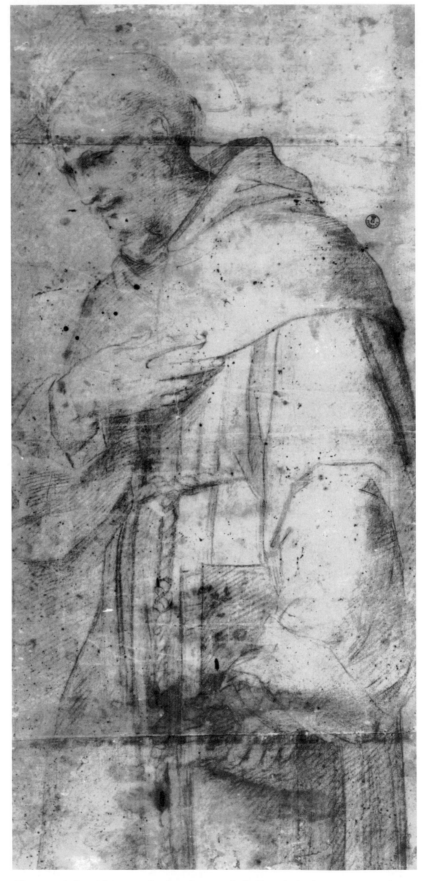

Figure 59. Andrea del Sarto, stylus-incised cartoon for St. Francis (Gabinetto Disegni e Stampe degli Uffizi inv. 6449 F, Florence). The figure of St. Francis is seen at the extreme right in the corresponding altarpiece (Fig. 60), with a change in the viewing angle of his head.

Figure 60. Andrea del Sarto, The Dispute of the Trinity, *oil on panel (Palazzo Pitti, Florence).*

One also needs a hand that is skilled, resolute and quick, but above all a sound and perfect judgment, because while the wall is wet the colors appear one way, which, afterwards when they dry, are no longer the same.[206]

Thus, when Vasari pointedly observed about a fresco cycle in S. Maria Maggiore (Florence) by the young Spinello Aretino (c. 1346–1410), that "this work he executed so carefully that it appears to be the work of one day rather than of many months, as was the fact," the biographer paid him the ultimate compliment.[207] Spinello's *virtuoso* fresco technique had rendered the transitions from *giornata* to *giornata* undistinguishable.

It is an unfortunate loss that the actual process of transferring pricked cartoons onto the *intonaco* went unrecorded by Italian Renaissance writers. Only Acisclo Antonio Palomino described it at length in his *El museo pictórico y escala óptica* (Madrid, 1715–24).[208] Palomino's passages can be supplemented with Vasari's description in the introduction to the *Vite* and Raffaele Borghini's diluted recapitulation in *Il Riposo* (Florence, 1584), which, however, refer to stylus-incised cartoons.[209] Giovanni Battista Armenini's *De' veri precetti della pittura*

(Ravenna, 1586), which Fra Francesco Bisagno's *Trattato della pittura* (Venice, 1642) would repeat in large measure, only recounts the specific practice of *spolvero* "substitute cartoons."[210] If "substitute cartoons" were to be employed, it was at the moment of transfer onto the working surface that they entered the process. The extant, though fragmentary, evidence suggests that cartoons and "substitute cartoons" were transferred in identical fashion.[211] Thus, for the sake of narrative clarity, we need not make a distinction between cartoon and "substitute cartoon" in the description that follows below.

The cartoon was probably centered on the *arriccio,* and then on the *intonaco.* We may deduce this based on analogous examples, in which various types of auxiliary aids in the process of fresco painting were repeated on both *arriccio* and *intonaco* layers. Though writing well before the invention of comprehensive figural cartoons for murals, Cennino's *Libro* advises that the horizontal lines and vertical plumblines of a composition be established by snapping a rope or string, whose ends were tied around nails. This process would be carried out on the *arriccio,* and then later repeated on the *intonaco.*[212] For his fresco of the *Resurrection* (Refectory of S. Apollonia, Florence), painted in 1447, Andrea del Castagno transferred the designs from the *spolvero* cartoons first onto the *arriccio* to draw the *sinopia,* and then onto the *intonaco* to lay in the color.[213] By the late Seicento, the gigantic areas to be frescoed frequently rendered comprehensive cartoons impractical. As a result, Andrea Pozzo's *Perspectiva Pictorum* (Rome, 1693–1700) recommends the use of proportional squaring grids *("graticole"),* relating to the small, squared *modello* drawing, on both the *arriccio* and *intonaco* layers.[214]

The Cutting of Cartoons

According to Vasari, Borghini, Sandrart, and Palomino, fresco painters then cut cartoons into smaller pieces manageable for painting.[215] The sizes of the dismembered cartoon pieces varied. The texts imply that the portions generally corresponded to a *giornata,* the area of a day's work. The disposition of *giornate* appears clearly plotted with outlines on some *sinopie* for murals that we know were painted from cartoons. This is true, for example, of large sections in Andrea del Castagno's mural cycle at the refectory of S. Apollonia (Florence),

Figure 61. Alessandro Allori, stylus-incised cartoon for the Descent of Christ to Limbo *(Gabinetto Disegni e Stampe degli Uffizi inv. 1787 E, Florence), preparatory for the oil painting on panel in the Galleria Colonna, Rome.*

ures.[218] And frequently in the case of monumental figures painted in multiple *giornate,* the first *giornata* would encompass the head down to its neck, shoulders, or bust, the rest of the body being painted subsequently. Thus, in Raphael's Louvre cartoon fragment portraying God the Father in the *Disputa* (Figs. 63–64), the cropping of the cartoon's paper around the upper outlines of the figure may have resulted precisely from this step in the working process.[219] The upper silhouette in Raphael's cartoon fragment follows the corresponding *giornata* in the fresco closely (Fig. 63).[220] A similarly cut silhouette occurs also in Sebastiano del Piombo's pricked *"ben finito cartone"* fragment (CBC 201), preparatory for the head of the apostle St. James in the *Transfiguration* fresco from 1516 to 1524 on the apse of the Borgherini Chapel (S. Pietro in Montorio, Rome).[221] By contrast, the entire figure is silhouetted along the right border in Raphael's monumental cartoon fragment for *Moses before the Burning Bush* (CBC 265), preparatory for the fresco from 1512 to 1514 on the ceiling of the *Stanza d'Eliodoro* (Vatican Palace).[222] Thus, the drawing covered an unusually large area of *giornate* on the fresco surface.[223]

At the end of each day's work, the painter, his *garzoni,* or a *muratore* (plasterer) cut the excess *intonaco* around the *giornata* with a "knife or small, pointy trowel," as recommended by Palomino.[224] (In closed quarters, *intonaco* can take a number of weeks to harden.) To avoid abrupt ridges or depressions in the *intonaco,* the border of the *giornata* was beveled at an angle sloping outward – according to Palomino, *"al soslayo hacia afuera."*[225] This bevel is called a *"scarpata"* in modern Tuscan.[226] More area would have been trimmed than was transferred from the cartoon – again, according to Palomino, "the width of two fingers."[227] This therefore explains the slightly more generous border of paper around the figure in Raphael's *Disputa* cartoon fragment, relative to the suture of the *giornata.*[228]

The general reference in Sandrart's text to the cutting of a cartoon's "piece or *Figur"* does also conform

from 1447.[216] Such referencing must have been done for the benefit of both the *muratore* and the cartoon cutter assisting the painter. In fact, in the *sinopie* for the *Chiostro Grande* cycle at S. Maria Novella (Fig. 62), from 1582 to 1584, many of the detailed *giornate* outlines also bear small inscribed circles and are labeled repeatedly with the word *"qui"* – (here) – to direct assistants.

As Vasari recommended, "each day along the suture [of the *giornata*] a piece [of the cartoon] is cut off and traced onto the wall."[217] Joachim von Sandrart's *Teutsche Akademie* (Nuremberg, 1675) is less equivocal, noting that the painter cut "a piece or *Figur,"* the latter presumably referring to the human figure: fresco painters structured the sutures of *giornate* to coincide as much as possible with the main body outlines of fig-

Figure 62. Artist near Bernardino Poccetti, detached sinopia *for the* Chiostro Grande *mural cycle at S. Maria Novella (Soprintendenza per i Beni Artistici e Storici, Florence), with directions for plastering, as well as for the disposition of* giornate *and the cutting of the corresponding pieces of the cartoons.*

with the placement of cartoon nail holes found throughout Michelangelo's Sistine Ceiling, where holes usually frame the perimeters of large figural groups or individual figures, but rarely occur within figures or groups (Plates XI–XIV), as is sometimes the case in the *Last Judgment* or the *Crucifixion of St. Peter.*[229] Besides a minuscule fragment, no cartoons for the Sistine Chapel survive to clarify the problem.[230] Like the putlog holes sometimes left by scaffolding, cartoon nail holes may have often been filled by the artist, his *garzoni,* or a *muratore.* As Pontormo's diary informs us regarding the S. Lorenzo frescos, "Friday all the holes in the first scene in the choir were replastered."[231]

The configuration of the joins of the paper in a large cartoon is telling. (Cartoon pieces were often later reassembled, either by the artist, his workshop assistants, or by eager later collectors and restorers.) Significantly, few large Cinquecento cartoons for murals exhibit clear signs of having actually been cut into pieces, generally corresponding to individual *gior-*

nate or groups of *giornate.* This physical evidence – of undisturbed joins of paper – often suggests that such cartoons were thus transferred by the intermediary means of "substitute cartoons," a practice that ensured their very survival.[232]

Borders and joins of paper, irregular in shape and with little or no overlap, are often the result of cutting during the working process.[233] Examples are Giulio Romano's pricked cartoon fragment (CBC 204) for the *Battle of Constantine* in the Vatican's *Sala di Costantino,* from 1520 to 1521;[234] the rare group of pricked cartoon fragments (CBC 315–17) by Francisco de Urbino for the ceiling and lunettes of the prior's lower cell at the Monastery of El Escorial from around 1581;[235] and

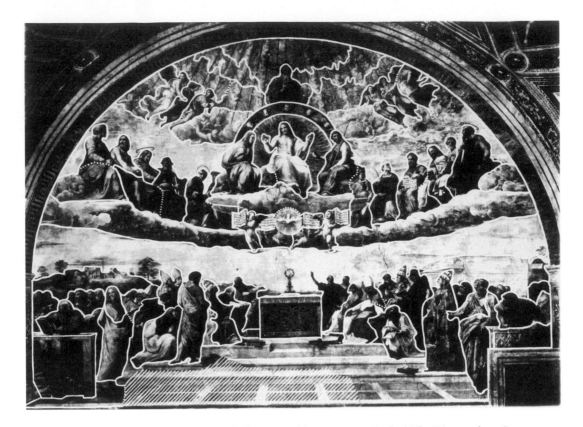

Figure 63. Approximate diagram showing the disposition of the giornate *in Raphael,* The Disputa, *fresco (*Stanza della Segnatura, *Vatican Palace). The figure of God the Father appears on the top of the lunette composition.*

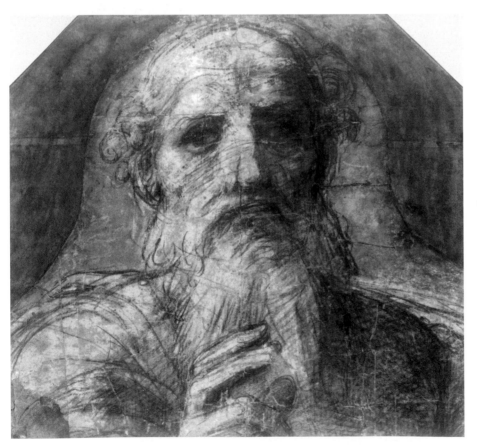

Figure 64. Raphael, pricked cartoon fragment for the Head of God the Father *in the* Disputa *(CBC 252; Département des Arts Graphiques du Musée du Louvre inv. 3868, Paris), silhouetted along the suture of a giornata.*

Bernardino Poccetti's two stylus-incised cartoon fragments (Fig. 42), intended for the *Chiostro Grande* murals at S. Maria Novella and dating from 1582 to 1584.[236] Many of the Escorial cartoon fragments by Francisco de Urbino are not only visibly rubbed with black pouncing dust but are also cropped in the general shape of single *giornate* or groups of *giornate,* remaining today in their original, disassembled state (Fig. 65).

Although by comparison highly refined in its finish, Giulio's cartoon fragment for the *Battle of Constantine* (CBC 204), the fresco in the *Sala di Costantino* at the Vatican Palace, must have also been directly used on the *intonaco.* The fresco surface on this part of the *Battle,* painted relatively thickly, with self-assured rapidity and skill, is entirely and carefully pounced. The outlines of the rendered cartoon fragment (Pinacoteca Ambrosiana, Milan) are pricked, and the painted outlines in the fresco follow the *spolvero* marks precisely. The fresco surface still bears impressions from the tiny paper craters that sank into the moist *intonaco* during the process of pouncing around the cartoon's perforated holes. Giulio's *Battle* cartoon fragment in Milan exhibits two types of paper joins. Most are structural (from the process of *"inpastare,"* or assembly), that is, rectangular, regular, and with paper overlaps, but a few have sharply irregular contours and the paper has little or no overlap. Some of the latter joins, and, more important, the entire irregularly cropped upper border of the cartoon, correspond to the general disposition of *giornate* in this part of the fresco, suggesting that the cartoon must have been cut in the working process.[237] Similarly, the two relatively large, stylus-incised cartoons by Poccetti (Figs. 42–43) also exhibit these two distinctive types of joins – those from the original assembly and those from the transfer process.

The designs of murals painted in *a secco* techniques were also often based on cartoons. In such cases, the cartoons must have been cut into pieces manageable for painting, but in the absence of written and archaeological evidence, we can only speculate regarding the particulars of the design transfer process.

Reference Marks, Centering Marks, Plumblines, and Horizonlines

According to Vasari and Palomino, for each *giornata* of a fresco the pieces of the cartoon resting on the *intonaco* were tacked or nailed, and the borders of the portion transferred from the cartoon were then registered onto the *intonaco* for reference.[238] This minimized the possibility of error. Although Vasari's description in the *Vite* is

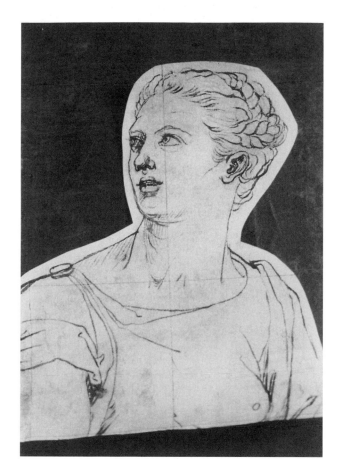

Figure 65. Francisco de Urbino (Francesco da Urbino), outline cartoon fragment for the Head of a Woman *in the* Judgment of Solomon *(CBC 315; Library of the Monastery of San Lorenzo de El Escorial). The drawing is squared in red chalk and silhouetted along the suture of a giornata. Its outlines are pricked and rubbed with black pouncing dust.*

ambiguous (for it does not tell just how the cartoon referencing was done), a few scattered marks and nails have survived on the surfaces of Vasari's own frescos.[239] On the monumental *Battle* scenes in the *Sala dei Cinquecento* (Palazzo Vecchio, Florence), one of Vasari's cartoon reference marks resembles a "V."[240] Different types of small reference marks have been identified in a number of other murals – for instance, in Piero della Francesca's *Sigismondo Malatesta before St. Sigismund* (S. Francesco, "Tempio Malatestiano," Rimini), Luca Signorelli's cycle in the *"Cappella Nuova"* at Orvieto Cathedral, Michelangelo's Sistine Ceiling, and Raphael's *stanze* in the Vatican Palace.[241] The method of referencing explained by Palomino consisted of pouncing around the borders of the particular cartoon piece whose outlines were being transferred, as it lay on the *intonaco.* This slightly blackened silhouette on the *intonaco* became then the guide-

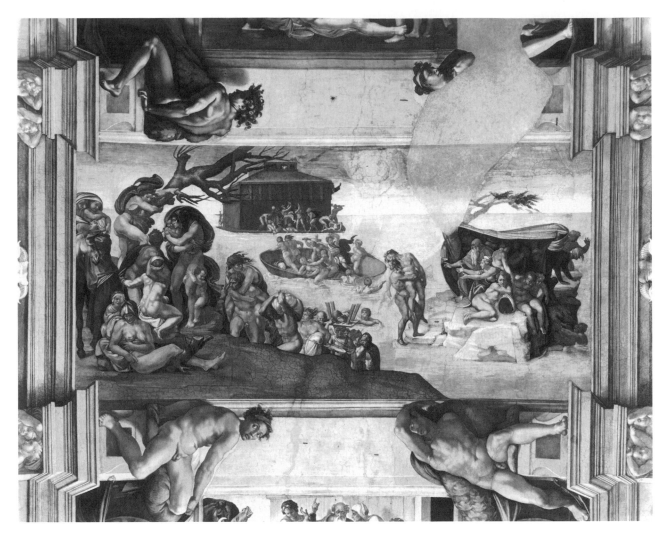

Figure 66. Michelangelo, The Flood, *fresco (Sistine Ceiling, Vatican Palace).*

line by which the *giornata* could be cut and beveled in preparation for joining the *intonaco* from the following session of work.[242]

Abundant signs on the surfaces of many extant murals can help us uncover the ways in which painters adjusted compositions to the exigencies of the painting site: painted crosses, dots, or dashes, incised compass marks, snapped ropes or strings, stylus-ruled plumblines and horizonlines, as well as configurations of *giornate* relative to the evidence of nail holes. The identification of actual cartoon reference marks is more problematic, for they often do not seem to survive in a consistent manner throughout a fresco. (A distinction should be made between marks registering the *giornata*-by-*giornata* transfer of the cartoon's pieces and centering marks serving to align the cartoon's composition before and

after cutting.[243]) If Palomino especially can be relied upon, most day-to-day register marks would have disappeared as the fresco progressed, during the process of *intonacare,* which required that the excess plaster at the suture of each *giornata* be cut away.

A large, sideways "V"-shaped mark on the fresco surface of Michelangelo's scene of the *Flood* in the Sistine Ceiling was apparently meant to remain obviously visible during the process of painting, for it was deeply and directly incised on the *intonaco,* before the layer of paint was added (Figs. 66–67).[244] We can deduce from the primary sources already cited that the piece-by-piece transfer of the cartoon was closely correlated with the laying of the *intonaco* for each *giornata.* The large, sideways "V" in the *Flood* occurs within the lower part of the thirteenth *giornata,* and the mark's point is exactly tangential to the suture separating the thirteenth from the fifteenth *giornata* (Plate XIII). The mark can thus be read as if it were an arrow's head, facing left to indicate the suture.

Figure 67. Detail in raking light of the "V" reference mark directly incised on the plaster in Michelangelo, The Flood. *The mark points to the suture of a* giornata, *along the drapery over the arm of the monumental standing mother (who carries a child) on the left portion of the scene.*

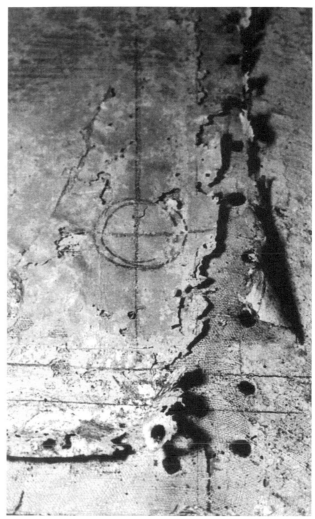

Figure 68. Detail of drawn and pricked circular reference mark in Michelangelo, pricked cartoon fragment for the Crucifixion of St. Peter (Fig. 3; CBC 188; Gallerie Nazionali di Capodimonte inv. 398, Naples).

Based on the clearer evidence presented by similar marks in Raphael's *Fire in the Borgo*,[245] we may hypothesize that Michelangelo's mark in the *Flood* served to align – before and after cutting – a large portion of the cartoon in this general area, encompassing at least the two figures painted on the fifteenth, sixteenth, and seventeenth *giornate,* if not more. Oddities of sequence abound in the twenty-nine to thirty *giornate* of the *Flood,* which may have meant the destruction of important physical evidence. Moreover, the *Flood* marks the beginning of Michelangelo's practical development as a fresco painter, for this was the first scene he painted. The considerable, initial problems with the *intonaco* of the scene, which Vasari vividly explained, prompted partial replastering and repainting.[246] More importantly, these problems led Michelangelo to reconsider his technique, based on the advice of Giuliano da Sangallo and the intervention of collaborators brought from Florence.[247]

Yet other marks seem to refer to the alignment of large, separate portions of the cartoon.[248] Two such marks appear toward the upper and lower right corners

of Michelangelo's cartoon fragment in Naples for the *Crucifixion of St. Peter* (Figs. 3, 68).[249] Each consists of two concentric circles, with their centers intersected by two perpendicular lines, much like the "crosshairs" or alignment marks used today in printing camera-ready designs. The circles are about 43–45 mm. in diameter, but only the crossing lines passing through the centers of these circles are pricked, the perforations having also been presumably done onto the "substitute cartoon." Saint-Aubin's *L'Art du Brodeur* describes an equivalent practice, of making *"retraites,"* which were a type of cross-shaped mark, pricked along with the design to be pounced and which acted as a reference for patterns that needed repetition, shortening, or lengthening.[250]

On Michelangelo's Naples cartoon fragment, the presence of the two centering marks on the top and bottom of the right border establishes that the drawing was probably not meant to be cut into smaller pieces. On the fresco surface of the *Crucifixion of St. Peter* (Figs. 2, 5), two short, inclined, parallel dashes – each about 70 mm. long – that intersect a long, oblique line were directly, but shallowly incised into the almost dry *intonaco*.[251] Although obviously of an entirely different configuration, this probable referencing corresponds relatively closely to the placement of the upper right centering mark on the Naples cartoon fragment.[252]

Although the crosshairs in Michelangelo's *Crucifixion of St. Peter* and the *retraites* mentioned in Saint-Aubin's *L'Art du Brodeur* served to align separate portions of a cartoon or pattern with respect to each other, Raphael relied on reference marks to center the overall composition on the working surface. In his cartoon for the *"Mackintosh Madonna"* (see fig. 97), from 1509 to 1511, a faint and slightly abraded stylus-ruled line runs from the top to the bottom of the composition. It has an exactly vertical pitch – a plumbline – that occurs at about 251 mm. from the original left border of the cartoon (there is a 41 mm. extension strip by a restorer), and at about 231 mm. from the right border. It is thus not precisely centered on the cartoon as it appears today but is so centered with respect to the painted composition.[253] Each mark in the cartoon consists of two incised, wide compass arcs that intersect; they establish precisely the two points of connection from which Raphael constructed his horizonline. As the cartoon is densely drawn and relatively abraded in parts, this horizonline is barely visible even with raking light.[254]

This type of precise and systematic referencing was an integral part of Raphael's design process, as is clear also in the case of *"La Belle Jardinière"* (Fig. 58). A great number of Raphael's small-scale pricked drawings consistently represent short, pricked vertical and horizontal lines, often centered and perpendicular to each of the borders. They appear both in entire compositions[255] and in fragments.[256] Much as in the large *"Mackintosh Madonna,"* the pricked plumbline in the full-scale compositional draft in the Uffizi for the small *"Esterhazy Madonna"* (CBC 247) is centered not with respect to the drawing on the sheet but with respect to the panel painting.[257] Similarly, the pricked plumbline in the full-scale compositional draft in the British Museum for the *Massacre of the Innocents* (see Fig. 258) is centered with respect to the resulting composition on *spolvero* marks in Windsor (see Fig. 260) and, ultimately, the engravings by Marcantonio Raimondi (see Fig. 261).

Centering marks are of ancient origin. For example, two abrupt vertical dashes brushed freehand in black ink can be found on the top and bottom borders of a mid-tenth-century Chinese pricked stencil depicting a seated Buddha (British Museum, London).[258] Such dashes perform the same function as the plumblines of Raphael's small-scale pricked drawings. For bilaterally symmetrical designs of ornament, architecture, and anatomy, Leonardo reused as a plumbline the vertical crease through the center of a sheet of paper, which he had made in order to complete a drawing by pricking it from one half of the sheet onto the other.[259] In the 1580s, Bernardo Buontalenti followed the same pricking and centering procedure to produce his numerous symmetrical architectural drawings (Gabinetto Disegni e Stampe degli Uffizi, Florence). The artisans who compiled and used the *Codex Zichy* (Szépművészeti Múzeum, Budapest)[260] would adopt this shortcut to transfer ornament, as well. To pounce bilaterally symmetrical designs for transfer, ceramicists not only used the crease through the center as the plumbline but also slit the paper around the design, perpendicular to the borders, in order to accommodate it within the concavity of a pot.[261]

The Pouncing Bag and Other Alternatives

We have already referred to the pouncing bag or sack, discussing its inconsistent designation in Filippo Baldinucci's *Vocabolario* relative to other sources, and have noted illustrations of its physical appearance. Baldinucci described it as "the instrument used to contain the powder, that is, a small loosely woven cloth fashioned in the form of a button. . . ."[262] Paganino's woodcut illustrates a fairly large example and Tagliente's a small one (Figs. 11–12). Probably also of ancient origins,[263] the pouncing bags or sacks must have varied in size depending on the size of the area to be pounced and the consistency of their fillings. Most sources indicate that pouncing bags could be filled with powder, already finely ground, which probably implies a fairly small receptacle. Cennino recommended "charcoal powder tied within a rag," Armenini "ground charcoal or black chalk powder," Perrot "charcoal very dry, reduced to powder," Baldinucci and Pozzo "pulverized charcoal," Palomino "sifted ashes," and Saint-Aubin pulverized "carbon from white wood" or the ashes of "thoroughly burned wine dregs."[264] On the other hand, Paganino's direction may explain the large size of the pouncing bag in his woodcut: "get a small amount

of willow tree charcoal and put it in a piece of thin used linen, and tie it, and grind it with a stone."[265] The treatises on miniature painting by Catherine Perrot (Paris, 1625) and Claude Boutet (Paris, 1676), as well as the anonymous English translation of Boutet (London, 1752), confirm that linen was the preferred type of cloth for the sack.[266] Linen is mentioned repeatedly as a material in the *Libro dell'arte,* and thus it may have also been Cennino's choice of cloth for the pouncing bag.[267] Any sturdy rags about the household or workshop, however, presumably sufficed as long as their fibers were loosely woven.

Cennino's *Libro* specifies the color of the pouncing dust according to the color or tone of the working surface to which the design would be transferred. If this ground is white, "pounce with charcoal powder . . . ;" if it is dark, "pounce it with lead white. . . ."[268] Most writers on painting and embroidery techniques would repeat this advice until the late eighteenth century.[269] Other common light-color pouncing dusts consisted of powdered "gesso," "blondish pumice," or "quicklime."[270] Although no primary source seem to mention reddish pouncing dusts, some surviving pricked designs suggest that it was used.[271] Moreover, the three extant Chinese pricked stencils in the British Museum are more or less heavily rubbed with *tuhong,* a red earth-powder found locally in Dunhuang.[272] The actual hue of *tuhong* can vary from almost faint pink to deep brick-red.

Treatise writers are generally silent about alternatives to using a pouncing bag in pouncing designs for transfer. But according to Saint-Aubin, embroiderers could also carefully daub small pricked patterns with a rag of rolled felt that had previously been dipped into a shallow dish filled with pounce. Although this procedure of smudging was cleaner, it was considered less effective.[273] Artists may have similarly rubbed loose pounce with a blunt miniver brush if the design was small, or with the fingers, cotton, wool, or crushed soft paper if the drawing was large – Armenini's *De' veri precetti* recommends such shortcuts in other types of drawing.[274] A further alternative, whereby the pricked outlines were brushed with liquid ink, is found in a Flemish drawing from 1580 to 1600, an *Adoration of the Magi* (CBC 348), of fairly crude execution.[275] Although this technique of "pouncing" with ink or liquid pigment seems exceptional among the drawings here discussed, it may well have been employed by painters more often than we realize. Although modern writers on technique sometimes state that the pouncing dust was blown through the holes, no primary sources appear to mention this.[276]

Fixing the Underdrawings

The shape of *spolvero* marks on a fresco surface frequently indicates whether the painter gauged the appropriate moisture content of the *intonaco* at the time of pouncing the cartoon. Firm and small dots constitute the norm, as is clear in Eve's face in Michelangelo's *Creation of Adam* on the Sistine Ceiling (Fig. 69). Dots with diffused outlines and messy staining suggest that the *intonaco* was too wet, as in the profile of God the Father's face and beard in the *Creation of Eve,* also on the Sistine (Fig. 70). Excessive deposits of dry pouncing dust could easily dirty the plaster if accidentally rubbed. Passages of such inattention sometimes occur in the thinly painted mural fragments of *grotteschi* by Giulio Romano and his *bottega,* detached from a gallery at the Palazzo Ducale in Mantua (Fig. 55). Fresco painters would often carefully go over the *spolvero* underdrawing, connecting it dot-by-dot to form the main outlines of the figures with a thin, watery layer of dark brown or black paint – in the case of murals painted *a secco,* as described by Palomino, "with a point of black chalk, not too sharp."[277]

For ornament, the approach to painting was often by necessity freer and more direct, as is plain on the vast surface areas decorated with *grotteschi* by Giulio Romano and his *bottega* throughout the city of Mantua – in the cycles at the Palazzo Ducale, Palazzo Te, and S. Andrea. There, the muralists all too often ignored the detailed *spolvero* dots with their sweeping strokes of the brush, painting in an impressionistic manner. For architectural features, straight lines were usually drawn with a ruler, either by stylus incising or by painting them against its edge. Before beginning to paint, artists often also retraced elements of the designs, which they had pounced from cartoons, freehand with the stylus. The mural surfaces for the illusionistic marble niches housing Popes Clement and Anacletus, on the upper register of the walls of the Sistine Chapel, by Pietro Perugino and his *bottega,* exhibit a framework of such deeply excavated, direct incisions over, and often paralleling, the faint, sporadic outlines of *spolvero* dots.[278] For the lavishly detailed *all'antica* temple in the background of the *Preaching of the Antichrist* ("Cappella Nuova," Orvieto Cathedral), Luca Signorelli and his *bottega* stylus-ruled over some portions of the fine, comprehensive armature of *spolvero.* A shallower, freer type of retracing of *spolvero* dots, also stylus-incised directly onto the *intonaco* but full of *pentimenti,* much like a quick sketch on paper, emerges in some of the *grotteschi* of both the fictive *dados* and framing elements of Signorelli's Orvieto

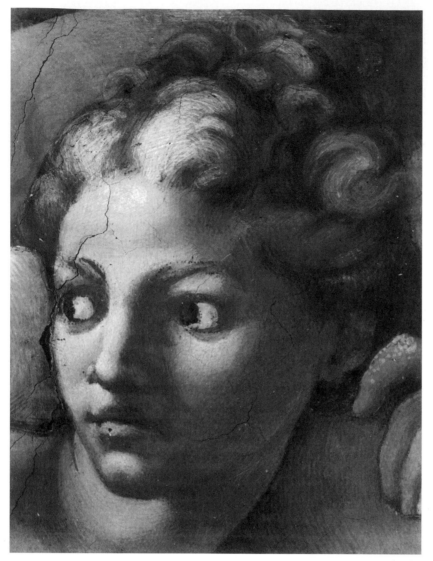

Figure 69. Detail of Eve in Michelangelo, The Creation of Adam, *fresco (Sistine Ceiling, Vatican Palace), showing pouncing on relatively dry plaster.*

cycle, as well as in those adorning the later illusionistic engaged pilasters punctuating the bays of the *Sala di Galatea* (Villa Farnesina, Rome).[279]

These were all attempts, nevertheless, to reinforce ephemeral *spolvero* dots, for, as is recognized in Andrea Pozzo's *Perspectiva Pictorum,* in distinguishing the techniques of *"ricalcare"* and *"spolvero,"* the latter "is apt to leave its traces *[orme]* less visible."[280] All too often, as actual practice can indeed demonstrate, *spolvero* registers faintly on the working surface and disappears easily under ensuing layers of paint – a particular nuisance in modeling dark colors that require a dense layering of pigments.[281] By the early decades of the sixteenth cen-

tury, Central-Italian muralists had come to experiment with a variety of techniques to resolve the problem of chiaroscuro.[282] Incised reinforcements occur repeatedly throughout the Roman projects by Raphael and his workshop – the *Prophet Isaiah* in S. Agostino, the Vatican *stanze* murals, the ceiling of the *Loggia di Psiche* in the Villa Farnesina, and the prophets and sibyls in S. Maria della Pace.[283] The same is true of Andrea del Sarto's mural cycle in the *"Chiostro dello Scalzo"* (Florence). Finally, and no less importantly, direct, freehand stylus retracing could at times serve to correct inexactitudes unforeseen during the preliminary phase of design.[284]

Although the chemical process of carbonation, due to the interaction of the air with the setting plaster, indelibly fixed the *spolvero* marks together with the water-based pigments in fresco painting, only a fixative or the subsequent layering of pigment or drawing medium, made *spolvero* indelible in dry surface media.[285] Here, we may recall Leonardo's note from 1490 to 1492 in Paris MS. A about the preparation of a wood panel for painting in oil.[286] (Not only is this note among the rare fifteenth-century sources to mention the practice of *spolvero* cartoons, but its detailed recipe is also among the valuable documents for the early history of oil painting in Italy.) Importantly for our purpose, Leonardo's note instructs that, after pouncing the pricked design onto the wood panel, the painter should outline *"sottilmente"* (finely) the resulting underdrawing of *spolvero.*[287] Over the finely outlined underdrawing, the painter began the undermodeling of the forms with a "priming of verdigris and yellow."

Most treatise writers on embroidery recommended that artisans draw "with ink and writing pen" over the *spolvero* underdrawing on the cloth.[288] According to Paganino's *De rechami,* if the cloth was colored, this drawing over the dots was done with a fine brush and liquid white pigment – lead white and gum arabic, dissolved in water.[289] This was the same solution used by artists to draw highlights.[290] Upon finishing the under-

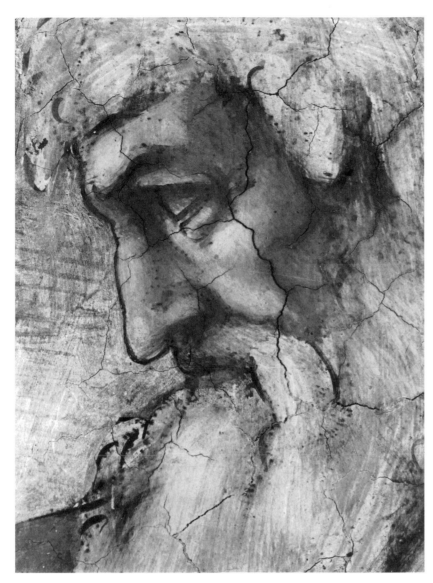

Figure 70. Detail of God the Father in Michelangelo, The Creation of Eve, *fresco (Sistine Ceiling, Vatican Palace), showing smudged pouncing on relatively wet plaster.*

elusive. Vasari recommended "tailors' white chalk" and "willow-tree charcoal" among the media for doing the *"imporre"* (underdrawing) on panels or canvases primed for oil painting.[291] Underdrawings in white chalk on gray or dark grounds, be they freehand or comprised of *spolvero* outlines, are neither visible to the eye nor detectable with infrared reflectography, for white chalk reflects rather than absorbs infrared light.[292] Moreover, infrared reflectography cannot reveal underdrawings in brown or red chalk.[293]

It was common knowledge that once the ephemeral *spolvero* marks settled on the secondary support, they needed reinforcement with a drawing implement. According to Paganino, "after [pouncing], you will lift the pricked design, and with your mouth you will blow very gently, until the superfluous pounce has been removed."[294] Saint-Aubin elaborated, "when [the pounce marks are] slightly blurred or [the process of pouncing] has left too much charcoal on the fabric, one must blow gently on it in order to remove the excess as one draws in the lines. . . ."[295] Raffaele Borghini's *Il Riposo* (Florence, 1584) makes similar points regarding the ephemeral nature of carbon-traced underdrawings on panel paintings, obtained by the modified *calco* method, ". . . Because these lines are not very stable, in the process of painting over them they may be easily erased; it will be good to retrace them with black chalk."[296]

drawing, the artist or artisan went on to execute the design in the medium of his or her choice.

Ephemeral Nature of Underdrawings

In reconstructing the general process of *spolvero* transfer, we have more or less seen just how ephemeral the resulting underdrawings were, except generally on the fresco surface. The use of white or light-colored pouncing dusts, advocated by writers from Cennino to Saint-Aubin, points to another important technical reason why a search for *spolvero* marks in paintings often proves

Deliberate Erasing of Underdrawings

Seen as a whole, the written sources thus indicate a second important technical reason why the evidence of design transfer may no longer be found on the working surface: it could easily be removed. Armenini's *De' veri precetti* tells how Giulio Romano produced *"calchi"* (stylus-traced "carbon copies"), admired as bona fide drawings.[297] Giulio would trace a drawing from one sheet of paper onto another by blackening the verso of the original with charcoal or chalk and then indenting

the outlines with a stylus while the original lay on top of another sheet. He would then redraw the design on the new sheet with pen and ink and would deliberately erase the traces of charcoal or black chalk left from the transfer process by daubing them away with a piece of fine cloth. Giulio thus simulated his *virtuosismo,* giving the appearance of having drawn without a preliminary guide. *Spolvero* marks on drawings were also purposefully erased. As Catherine Perrot's *Traité de la Miniature* (Paris, 1625) describes: "After you have pounced [the pricked design], it is necessary to draw with the silverpoint all the traces which are marked on your vellum, and afterward go over your vellum softly with a small piece of bread *(une mie de pain),* to prevent that your vellum becomes blackened by this carbon powder."[298] Artists commonly rubbed drawings with the soft, moist inside parts of bread to erase or clean a design.[299]

Importantly, the erasing of *spolvero* underdrawings after they had served their immediate purpose was practical, because it helped keep the paint layers clean. The written sources tell us that this was standard procedure for freehand underdrawings. According to Cennino's *Libro,* painters erased until the drawing underneath was practically effaced, "though not so much that you do not understand the strokes that you have made."[300] The design of the freehand underdrawing on the panel was then reinforced with brush and ink

washes, and after this step, it was swept, once more, "clear of charcoal."[301] Like Catherine Perrot, Alessandro Paganino and Charles Germain Saint-Aubin suggested that pouncing dust dirtied the working surface: this was their reason for advising artisans to dispose of excess pouncing dust.[302] Acisclo Antonio Palomino referred to the process of pouncing a cartoon, as "having dirtied it with carbon powder."[303] That *spolvero* marks were easily erased must have been among the technique's advantages for easel painters. (Erasability was, in fact, Vasari's and Borghini's reason for recommending tailor's white chalk and willow-wood charcoal for the underdrawings of oil paintings.[304])

In reconstructing the technical processes by which designs were transferred, we have seen from the testimony by artists, artisans, and amateurs just how little such techniques changed over time, and just how essentially simple they were. Especially in the case of *spolvero,* skilled and unskilled workers could easily perform it, and this is one of the reasons why it facilitated a delegation of labor within the workshop. By reading the period writers on the general subject of design transfer, we have also inevitably encountered the issues of theory that preoccupied them, as well as the prejudices that motivated their pedagogic judgment. Let us now go on to examine the most basic of the various functions which the *spolvero* technique fulfilled.

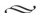
TRADITIONS OF COPYING

Despite three centuries of modern connoisseurship and repeated attempts to resolve the problem methodologically, the distinction between autograph and copy remains among the most complex, elusive problems in the history of art. The replication of works of art during the Renaissance and Baroque was inextricably bound to both the training methods imparted during the process of apprenticeship and the economic demands of the contemporary art market. Our criteria for connoisseurship must, therefore, be sufficiently nuanced to encompass these functional, pragmatic aspects of copying.

In exploring a significantly less creative aspect of copying, the production of technically exact repetitions rather than freehand variants, we should bear in mind that although this practice is nearly as old as freehand copying, it has always had a murky reputation. (This negative reputation will be discussed in Chapter Four.) Mechanically aided copying or tracing implies the use of shortcuts, which, as Filippo Baldinucci would explain in his *Vocabolario toscano dell'arte del disegno* (Florence, 1681), enabled imitation "without the effort of relying on the eye's judgment *[giudizio dell'occhio]*, and the hand's dexterity *[vbbidienza della mano]*."[1] Baldinucci was a savvy drawings connoisseur, collecting in an art market saturated with forgeries, counterproofs, and *calchi*. He probably knew firsthand the weariness that tracings disguised as drawings can inspire.

The tradition of drawing freehand copies after works of art is certainly older than that of exploratory drawing, and such copying was an integral part of artistic training from the Medieval *scriptoria* to at least the early-twentieth-century Beaux-Arts academies.

Medieval Manuscripts
Pricked by Later Copyists

In a tantalizing study on the problem of copies and their relationships to the original models in Medieval and Renaissance manuscripts, it has rightly been pointed out that, for all the emphasis on copying and transmission of motifs in the Medieval art tradition, artists and artisans of the period rarely seem to have copied models exactly.[2] Variations of style and content inevitably entered the copying process, complete Medieval facsimile reproductions being all but nonexistent.[3] The sporadic presence of pricked motifs in Medieval manuscripts, however, has led to the common but uncritical assumption that the *spolvero* technique was an established means of design replication as early as the first half of the eleventh century.[4] This assumption rests on the perceived similarity of design in two figures portrayed in eleventh-century psalters (Bibliothèque Nationale, Paris) and on the fact that one of these designs has pricked outlines.[5] However, the measurements of the pricked design and its supposedly pounced copy by no means correspond,[6] and the copy exhibits no *spolvero* marks at all. This, as well as the tangible differences of details in the figures, suggests that the design of the copy is freehand. As the clear, cumulative evidence of fifteenth- and sixteenth-century pricked drawings and prints can reveal, Medieval manuscripts likewise could have been pricked and pounced centuries after their production, by the same types of copyists we will discuss later.

The corpus of extant early pricked manuscripts is extremely small,[7] and these examples reveal in all cases

selective rather than comprehensive pricking – that is, only parts of a single design, one or two motifs from an entire page, or a few pages from an entire book. This seems precisely the telltale approach of scavenging later copyists. Few of the pricked motifs appear to be rubbed with pouncing dust, which suggests the copyist's "substitute cartoon" procedure, and sometimes even the skill with which the manuscripts were pricked was negligible.[8] Firm proof of the use of *spolvero* for the production of manuscripts is found in a pair of extremely late examples. The "High Gothic" *Alphabet of Marie de Bourgogne* (Musée du Louvre, E. De Rothschild inv. 134–158, Paris) consists of twenty-five pricked sheets. Its copy in Brussels (Bibliothèque Royale Albert Ier inv. II, 845) is the earliest known case of a *spolvero* underdrawing in a manuscript. Based on a study of their watermarks, it has been shown that the Paris manuscript was produced around 1480, whereas the Brussels copy only around 1550.[9] The original was thus pounced seventy years after it was made, and over thirty years after the technique's popularity had crested in Italy. Although investigation of Medieval manuscripts with infrared reflectography continues to yield exciting evidence regarding their underdrawings, no early cases of *spolvero* have emerged.

Finally, and crucially important, no early treatises mention the *spolvero* technique in passages about the art of manuscript illumination.[10] Such silence seems significant. Cennino's reference to *"spolverezzi"* (pounced patterns) in the *Libro dell'arte* (MS., late 1390s) can be ruled out as evidence. It occurs in the limited context of textile ornament for panel and mural painting: *"spolverezzi"* were meant to be used strictly as shortcuts in the serial replication of repetitive ornament (see Chapter Five). Although the *spolvero* technique, therefore, does not seem to have originally been employed by early Medieval manuscript illuminators, it was vastly exploited by copyists from the fifteenth century onward, in marked contradiction with the ideals of design and "originality" emerging during the Renaissance.

The Ideal of Copying in the Quattrocento

From the early fifteenth century onward, and as championed by Leon Battista Alberti's treatise (MS., 1435–36) in a brief comparison between the arts of painting and poetry, fertility of *"inventione"* – or in the Italian translation, *"invenzione"* – would gradually become, at least for the West, the yardstick for measuring artistic cre-

ativity.[11] Since Classical Antiquity, poetry had already been assessed in such terms – "invention" of subject matter and composition, as in Horace's *Ars Poetica*. Yet even within the Classical Latin heritage revived by such Renaissance humanists as Alberti, which valued "originality" above much else, the practice of copying works of art freehand had enjoyed a long, respectable history.[12] Since at least the early Middle Ages, the activity of copying had served as a means of training young artists, of perpetuating significant images or models, and of homogenizing the style of production in a master's workshop.[13] Leonardo, for example, would advocate the same basic mode of instruction that was prevalent in the *botteghe* of Cennino's painter-craftsmen, "the artist should first exercise his hand by copying drawings from the hand of a good master." His statement appears in a note in Paris MS. A (fol. 122 recto), written in 1490–92,[14] and seems to contrast with the efforts of art theorists since Alberti to establish the nobility of painting, and thus its status as a "liberal art"; Leonardo himself served as a major mouthpiece for this cause.

Leonardo, however, spoke from the vantage point of both the teacher and former pupil, for this had been his experience as an apprentice in the workshop of Andrea Verrocchio (c. 1435–1488). In fact, Vasari's *Vita* of Verrocchio mentions his drawings, "made with great patience and knowledge, among which are heads of women, with graceful manner *[con bell'arie]* and hair arrangements that, because of their exceeding beauty, Leonardo da Vinci always imitated."[15] Here, the account by Vasari can reasonably be trusted, for although his attributions are sometimes inaccurate, he based his observations about Verrocchio (and many other Renaissance draughtsmen and their drawing practices) on actual examples of drawings pasted in his *Libro de' disegni*.[16] A few exquisite drawings of women's heads by Verrocchio and his *bottega* survive, of which the autograph cartoon in Christ Church (Plate III) is a nearly life-size example with pricked outlines. Unfortunately for modern connoisseurship, the very practice of precise imitation favored in the workshops of Verrocchio and other artists of the period vastly complicates the problems of drawing attributions between masters and pupils.

Exactly when Leonardo entered Verrocchio's *bottega* is not known. The event is usually thought to have occurred around 1466–69, when his father, Ser Piero di Antonio da Vinci, took the young artist to live in Florence.[17] In 1472, the *"Compagnia e fraternità di San Luca,"* the main confraternity of painters in Florence that

legally depended from the *"Arte dei medici, speziali e merciai,"* recorded in its *"Libro rosso"* the terms of payment for Leonardo's dues, beginning in the month of June of that year.[18] This would have marked the formal beginning of Leonardo's career as a professional painter, although he stayed with Verrocchio until at least 1476, probably as a collaborator.[19]

In a variety of ways, as we shall see, the working habits acquired during the period of apprenticeship were formative. This was especially true of an artist's approach to drawing, as can be demonstrated by comparing freehand studies for figures of infants on a sheet from the 1480s by Verrocchio, to one by Leonardo from 1506 to 1508, that is, nearly thirty years after he probably left Verrocchio's *bottega*.[20] Verrocchio and Leonardo both drew the outlines of the babies' bodies in a fundamentally similar manner. This similarity is especially apparent in the charcoal sketch on the right in Leonardo's Windsor sheet. Leonardo's small, lively sketches for an infant with a lamb, from 1500 to 1504, manifest a similarly Verrocchiesque approach.[21] The same is true of the somewhat stiff studies for figures of infants in the pages from a now dismembered sketchbook, dated 1487–88 and attributed to Francesco di Simone Ferrucci, another assistant in Verrocchio's *bottega*.[22]

Drawing was as basic a tool in the process of design as it was in the training of young artists. Copy drawing was the catalyst. This truism was sufficiently recognized by the end of the Quattrocento, that Girolamo Savonarola (1452–1498), the charismatic Dominican monk and preacher who was famously executed in the Piazza della Signoria (Florence) for his heresy, used it as an analogy in a sermon on the imitation of God. Savonarola's fiery sermon was published in 1493, not long after Leonardo wrote his note in Paris MS. A: "The master draws from his mind an image which his hands trace on paper and it carries the imprint of his idea. The pupil studies the drawing, and tries to imitate it. Little by little, in this way, he appropriates the style of his master. That is how all natural things, and all creatures, have derived from the divine intellect."[23]

In accord with his view of Michelangelo as the supreme master of *disegno* of all ages, Vasari gave an inordinately detailed account of the young genius's education as a draughtsman. Most of it was acquired in Domenico Ghirlandaio's *bottega,* where Michelangelo's apprenticeship is now known to have begun at least a year earlier than Vasari's recorded date of 1 April 1488.[24] Vasari commented admiringly that Michelangelo "also copied *[contrafece]* drawings of the old masters so closely that his copies could not be distinguished from the

originals."[25] This, as is well known, is a *topos* amply grounded in fact.

It should be noted, however, that the endorsement of copying was not unqualified. As we can judge from the analysis of extant paintings and drawings, during the critical period roughly encompassed between 1490 and 1510, a general shift in attitude – away from the traditions of imitation, copying, and reproduction – had begun to take effect at least in the production of mainstream art. It would slowly separate the old generation from the new, emerging during the High Renaissance. Indeed, the chasm widened as the Cinquecento progressed: Leonardo's fragmentary extant writings offer some indication of this change. As we have seen, Leonardo recognized that the practice of copying taught apprentices the rudiments of painting. However, he warned professional painters of its harms. The passage survives only in the posthumously compiled *Codex Urbinas Latinus* (fol. 39 verso): "I say to painters that no one should ever imitate the style *[maniera]* of another, because he will be called a nephew and not a child of Nature with regard to art."[26] He further condemned practicing painters who copied, by giving historical reasons. Painting between Giotto and Masaccio had declined century by century, "because everyone copied the paintings that had already been done," as Leonardo stated in an autograph note in the *Codex Atlanticus* (fol. 141 recto b), around 1490.[27] He considered it a mistake when painters repeated figures, faces, movements, or motifs within the same narrative composition, because exact repetitions of form were not found in Nature.[28]

Production of Copies in the Workshops of Leonardo and Lorenzo di Credi: Florence and Milan

A small fragmentary drawing of an infant's head in the Louvre (Fig. 71) corresponds closely in design and measurements to the detail of St. John the Baptist in the two extant versions of Leonardo's *"Virgin of the Rocks"* (Musée du Louvre, Paris, and National Gallery, London).[29] Probably autograph, the Louvre drawing is greatly reworked and silhouetted not unlike a *giornata,* though its medium – metalpoint, reinforced with pen, brush and brown ink wash, on brownish blue prepared paper – is unusual in a full-scale cartoon for an altarpiece or fresco. Selectively pricked and rubbed with pouncing dust, the Louvre study of the infant's head clearly served as an *exemplum,* or pattern sheet, for the

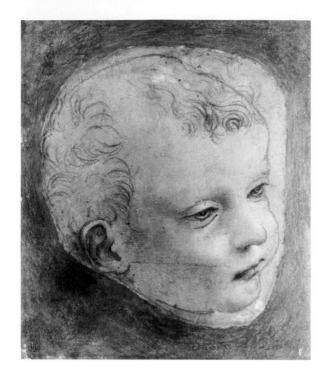

Figure 71. Attributed to Leonardo, pricked cartoon fragment for the Head of an Infant *(Département des Arts Graphiques du Musée du Louvre inv. 2347, Paris), reworked by an early restorer.*

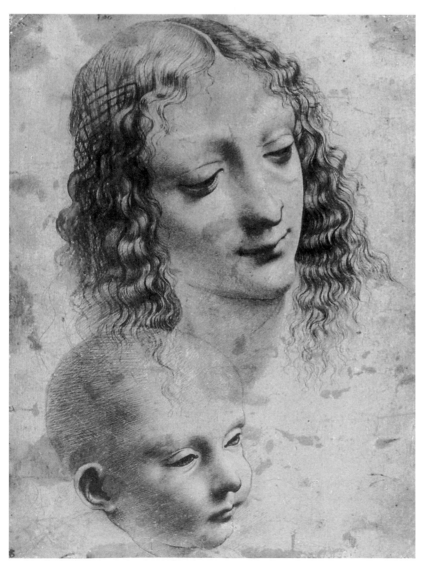

Figure 72. Giovanni Antonio Boltraffio, studies for the Heads of a Youth and an Infant *(Devonshire Collection inv. 893, Chatsworth).*

use of the workshop, and probably also as an aid in the teaching of drawing. This sheet, or a nearly identical version, apparently helped generate a full-scale copy, now in Chatsworth (Fig. 72), probably from the late 1490s.[30] The Chatsworth drawing, also in metalpoint, does not appear to have a *spolvero*-based underdrawing but is of identical dimensions as the Louvre sheet.[31] The Chatsworth drawing is usually attributed to Giovanni Antonio Boltraffio (c. 1466/67?–1516), Leonardo's principal pupil in Milan. He was probably the "Giovan Antonio" whom Leonardo mentioned in a memorandum from 1490 to 1491 as the owner of a silverpoint stylus for drawing, worth 24 soldi and stolen by Gian Giacomo "Salai," the ten-year-old scoundrel then newly arrived in Leonardo's household.[32]

Curiously, a further large-scale pricked drawing, in a similar metalpoint technique (Fig. 73) – either by Boltraffio, or, more probably, by the young Cesare da Sesto (1477–1523), who was yet another of Leonardo's pupils and whose early drawing style would follow closely in Boltraffio's footsteps – renders only the body of an infant.[33] Its head was cut off and its body silhouetted, much as was required for a *giornata;* the scale of the body is commensurate with that of the child's head in the Louvre sheet attributed to Leonardo (Fig. 71). If we were to join the pieces of a figure as a single design – that is, the child's head (as portrayed in Figs. 71 and 72) with the child's body (as represented in Fig. 73) – the total sum of the design is exactly that of the Christ Child's figure in the *Madonna and Child with Donor* fresco (Convent of S. Onofrio al Gianicolo, Rome), a work of disputed attribution.[34] Although old critics often considered Leonardo and Boltraffio as possible authors of the Rome fresco, it was more probably executed by the young Cesare da Sesto, early in his Roman sojourn (c. 1508–13).

We can reasonably conclude that Leonardo was transmitting to his Milanese pupils procedures that he had learned during his training with Andrea Verrocchio. The practices of design reproduction in the *bottega* of Lorenzo di Credi (c. 1458–1537) follow a curiously parallel track in Florence. Lorenzo had been Leonardo's colleague in Verrocchio's *bottega* and is documented to have been there from at least 1480 until Verrocchio's death in 1488, when Lorenzo became the great sculptor's artistic heir; he was in turn influential for a number

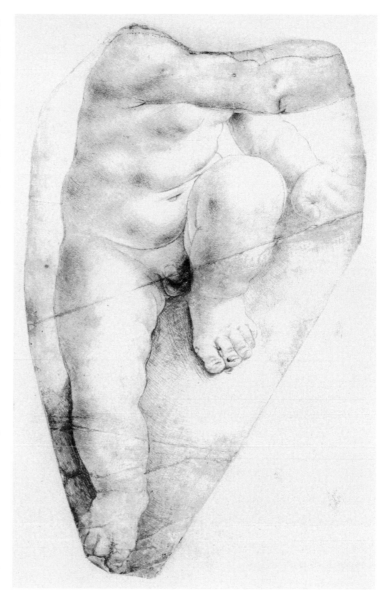

Figure 73. Attributed to Cesare da Sesto or Giovanni Antonio Boltraffio, pricked cartoon fragment for the Body of an Infant *(Département des Arts Graphiques du Musée du Louvre inv. RF 5635, Paris).*

of Florentine painters whose artistic personalities remain yet to be clarified (Fig. 75).[35] (At least one of Lorenzo's innumerable, somewhat repetitive studies of reclining babies is visibly drawn on *spolvero* underdrawing.[36]) In fact, a comparable situation to the Milanese drawings of infants just discussed (Figs. 71–73) turns up in a drawing of modest ability in the Uffizi – yet another infant Christ, but in bust-length (Fig. 75).[37] Dating from 1495 to 1515, this Uffizi sheet can be attributed to an immediate follower of Lorenzo di Credi, and, as it seems closely related in design and scale to a painting (Gallerie dell'Accademia, Venice), the sheet

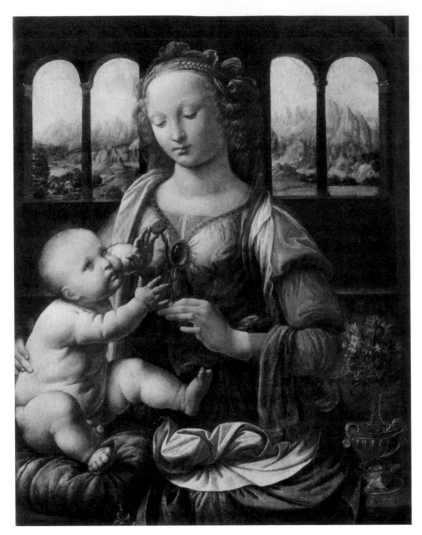

Figure 74. Leonardo, The Madonna and Child, *oil on panel (Alte Pinakothek, Munich).*

toon of the *Enthroned Madonna and Child* (Fig. 29) and resembles generally the design of several other drawings and paintings by Lorenzo and his circle.[40] By contrast, Lorenzo's *Enthroned Madonna and Child* (Fig. 29), a highly rendered *"ben finito cartone"* in charcoal or soft black chalk, is a skillful work. As we can see from both the lack of correspondence in the pricking and the slight divergences of outlines, the relationship between the small drawing and the monumental cartoon is clearly indirect, achieved through the intermediary means of other copy drawings that no longer survive.

In a note in Paris MS. A (fol. 104 recto), from 1490 to 1492, Leonardo observed that young artists could develop the ability to draw well from memory by comparing the accuracy of drawings done from memory against tracings done from actual models.[41] Such precepts demonstrate that the great master tacitly endorsed the use of tracing and copying aids as devices for learning or practicing, what he termed elsewhere the *"giuditio d'ochio"* (called *"giudizio dell' occhio"* by later sixteenth-century theorists) – literally, the "judgment of the eye."[42] We might explain this today as the act of "training the eye to lead the hand." The extent of Leonardo's approval, however, cannot fully be known, since he himself never completed his notes in the form of a painting treatise.[43] Nevertheless, it appears that for Leonardo, these tracing and copying exercises were meant, in turn, only to sharpen the pupils' ability to study after nature. Nature was, ultimately, the sole guide of a painter in his profession.

could well be by the so-called "Master of S. Spirito," now identified with the Del Mazziere brothers.[38] If of inferior quality, the figural type of the infant in the Uffizi sheet is the same as that in autograph studies by Lorenzo di Credi and that in the exquisite panel of the *Madonna and Child* (Fig. 74), from the late 1470s or early 1480s, probably by the young Leonardo.[39] The somewhat mechanical-looking drawing that concerns us (Fig. 75), executed in leadpoint over traces of charcoal on beige prepared paper, has the lifeless, fastidious handling of a copy. The outlines on the child's head and on the top of his arms are pricked, but not those on his shoulders and on the bottom of his right arm. Some traces of rubbed charcoal pouncing dust cover the upper portion of the sheet. The drawing is nearly identical in scale and design to the infant Christ's head in Lorenzo di Credi's monumental, entirely pricked car-

Perugino, "Lo Spagna," and the Umbrian Tradition of Replication

Vasari would reproach Pietro Perugino (doc. 1469–1523) for his repetitions of design, a rebuke often also voiced by modern critics of the artist: "Having worked so much and having always so much excess work to do, he frequently used the same things in different pictures, and his work had become so mannered that he gave all his figures the same air. . . ."[44] According to Vasari, when Pietro Perugino unveiled the painting of the *Deposition* for SS.

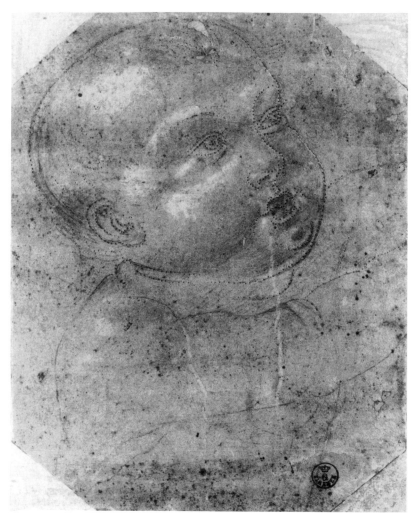

Figure 75. Artist near Lorenzo di Credi and the "Master of S. Spirito" (the brothers Del Mazziere), pricked pattern for the Head and Upper Body of an Infant (CBC 47; Gabinetto Disegni e Stampe degli Uffizi inv. 14507 F, Florence).

Annunziata (Galleria dell'Accademia, Florence), left unfinished by Filippino Lippi at his death in 1504, the younger generation of Florentine artists blamed Perugino for using the same figures over and over again. Pietro replied, "I have painted in this work the figures you formerly praised and admired so much, if they now displease you – what more can I do?"[45] Regarding the composition that was intended for the obverse of Perugino's SS. Annunziata altarpiece, the Assumption of the Virgin (still in situ), it has recently been shown that a good number of the figures are extremely close in design and size to those in the partly autograph S. Pietro altarpiece, the Ascension of Christ (Musée des Beaux-Arts, Lyons).[46] The sum of such data suggests that Perugino systematically reused many of the cartoons for the figures as separate patterns.

None of these cartoons survive, however, and, thus, we must turn to the physical evidence in an earlier project by the artist (Fig. 76). Signed and dated 1495, the altarpiece of the Lamentation was painted for the nuns of S. Chiara in Florence (Fig. 77). In recognizing its beauty, Vasari told that Francesco del Pugliese was apparently willing to pay Perugino three times the price of the original commission.[47] Although the mourning figures are separately recognizable types recurring throughout Perugino's oeuvre, their graceful gestures weave them into a nearly seamless arrangement around the dead Christ. The composition lends them a new context. The artist carefully calibrated the relationships from figure to figure. A fragment from the pricked cartoon in black chalk, the Head of St. Joseph of Arimathea (Fig. 76) is extant.[48] The remnants of a grid can be discerned in the cartoon fragment (as observed in Chapter Two). A vertical line courses through Joseph's face and upper torso. This is the vertical axis aligning the head, shoulders, and knee for the kneeling pose of his figure. Precision of pitch was especially important, as the saint's figure anchors the composition on the left.[49] In the cartoon fragment, a horizontal line also runs through Joseph's right shoulder, providing a point of reference for the placement in space of both of his foreshortened shoulders. If the composition of the S. Chiara Lamentation (Fig. 77) is analyzed, as a whole, from left to right, it will be noticed that this horizontal line extending past Joseph's right shoulder aligns it with Christ, then touches tangentially the upper outlines of the hands of the kneeling young woman, and finally ends in the head of the old woman who clutches Christ's sudarium on the extreme right. If we note the relevance of plumblines and horizonlines for Raphael's design method (as discussed in Chapter Two), although the evidence is significantly more fragmentary in Perugino's case, we can see in his work the origin of Raphael's practice.

It is probable that Perugino employed only partial cartoons to compose the underdrawing of the S. Chiara altarpiece (Fig. 77), considering both the large size and oil medium of the painting.[50] (Unlike fresco, oil painting does not require speed of execution.) Perugino may have shifted cartoons for some of the individual figures, much like a child's cut-out paper dolls, along precisely estab-

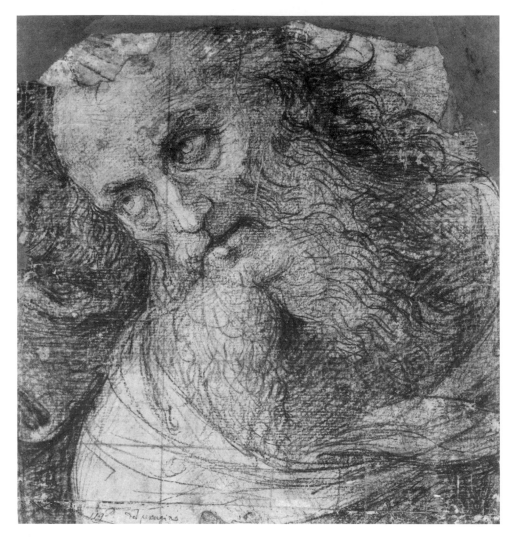

Figure 76. Pietro Perugino, squared and pricked cartoon fragment for the Head of St. Joseph of Arimathea *(CBC 327; Christ Church inv. 0122, Oxford).*

lished points, to work out their alignments. This very practice underlies Raphael's sheet of pricked nude patterns (Figs. 78–79), preparatory for the figures of Christ and his mourners in a *Lamentation,* possibly an early idea for the *"Borghese Entombment"* (Galleria Borghese, Rome), painted around 1506–7 for Atalanta Baglione's chapel at S. Francesco in Perugia.[51] (Raphael's Oxford sheet also demonstrates just how much his initial conception was indebted to Perugino's S. Chiara *Lamentation.*) Other figures in Perugino's S. Chiara altarpiece may have been underdrawn freehand; detailed scientific data about the altarpiece are lacking. Nevertheless, the present state of research indicates that, outside the medium of fresco, for Perugino and his wide circle of associates in Umbria (apprentices, assistants, collaborators, and subcontracted artists), the *spolvero* technique served mainly as a means of design reproduction.[52]

Of Perugino's extant pricked drawings (CBC 325–334), most are noncompositional. They represent either single, isolated figures or heads of figures – types that were replicable from painting to painting. The design of the *Head of a Young Woman* (Fig. 80) resembles a number of *Madonne* and female saints by the artist and members of his circle.[53]

As the most significant painter active in Umbria and the Marches during the late Quattrocento, Perugino was widely imitated by painters from these regions, among them Giovanni di Pietro "Lo Spagna" (c. 1450?–1528). In fact, the carefully rendered Uffizi cartoon by "Lo Spagna" in black chalk, for a panel depicting the *Agony in the Garden* (Fig. 81), illustrates more concretely still the tradition of design replication prevalent among Umbrian and Marchegian artists.[54] The composition for the *Agony in the Garden* by "Lo Spagna" probably dates around

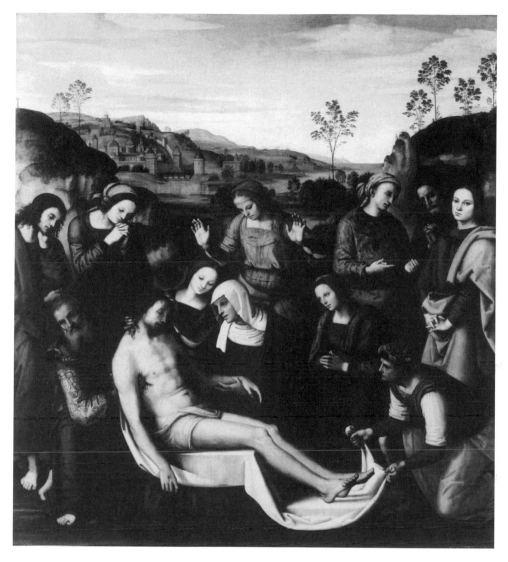

Figure 77. Pietro Perugino, The Lamentation over the Dead Body of Christ, *oil on panel (Palazzo Pitti, Florence).*

1500–10 and derives from a panel of the same subject by Perugino (Galleria degli Uffizi, Florence).[55] The individual figures of Christ and the apostles also recall those in Perugino's panel of the *Resurrection* (Pinacoteca Vaticana) and the small scene of the *Agony in the Garden,* seen in the background of Perugino's fresco of the *Last Supper* (*"Cenacolo di Foligno,"* ex-Convent of S. Onofrio, Florence).[56] The cartoon by "Lo Spagna" survives in the form of four fragments (Fig. 81), which were reconstituted in 1982.[57] Continuities in the stylus ruling of axes and compass construction, as well as of the drawn lines and background elements, confirm that the fragments originally formed a single composition. The cartoon's drawing technique, with dense networks of diagonal cross-hatching and reinforcement lines to suggest deep chiaroscuro, compares closely – if less favorably – with

that of Perugino's *Head of St. Joseph of Arimathea* (Fig. 76). The outlines are pricked painstakingly and appear to be rubbed with pouncing dust. As Vasari and Borghini both noted, Italian Renaissance painters commonly transferred cartoons for easel paintings in one piece, without cutting them up (see Chapter Two).

The fragmented state of the cartoon by "Lo Spagna" (Fig. 81) might not seem unusual, considering the wear and tear common in drawings of such age, were it not for several disquieting facts. First, each fragment encompasses a single and entirely complete figure. It is clear that the overall composition of the corresponding panel painting by the artist (Fig. 82) lacks figural unity, and it almost appears as if he had conceived the composition as a *"montage"* of separate figures. Second, the isolated figure of Christ kneeling in

Figure 78. Raphael, pricked pattern for the dead body of Christ in a Lamentation *(CBC 240; Ashmolean Museum inv. PII 530 verso, Oxford).*

prayer was repeated in yet another panel (National Gallery, London), but one of inferior execution.[58] Moreover, the identical composition of "Lo Spagna"'s *Agony in the Garden,* but in reverse orientation, turns up in a panel (Galleria Nazionale dell' Umbria, Perugia), which Vasari attributed to another of Perugino's followers, Giannicola di Paolo and which was completed in 1530 for S. Francesco in Perugia.[59] Third, the repetition of figures and motifs was a distinct characteristic of the Perugino *bottega.* In sum, it would thus appear that "Lo Spagna" and/or his associates cut up the cartoon specifically to reproduce its figures individually in other compositions, much as was Perugino's practice.

At least to some extent, the especially strong tradition of design replication in Umbria and the Marches reflected the conservatism of patronage in these regions (a subject still awaiting further research). Vasari's vastly influential judgment of Pietro Perugino extended to the Umbrian and Marchigian artists who comprised his wide circle of imitators, apprentices, assistants, collaborators, and subcontractees – *"fece Pietro molti maestri di quella maniera."*[60] Vasari's criticism was a product of its time and place, for by 1550, when the author published the first edition of his *Vite,* the traditions of imitation, copying, and design reproduction typical in earlier Renaissance *botteghe* of the second rank, and quite pervasive in the regions of Umbria and the Marches, were much less appealing, as was the use of the *spolvero* technique. Moreover, Vasari regarded Florence as the

Figure 79. Raphael, pricked pattern for the mourning figures in a Lamentation *(CBC 240; Ashmolean Museum inv. PII 530 recto).*

Figure 80. Pietro Perugino, pricked pattern for the Head of a Young
Woman (CBC 325; Département des Arts Graphiques du Musée du
Louvre inv. 4370, Paris).

birthplace of art, and in his *campanilismo*, he often deni-
grated the achievements of non-Florentine artists.

Patrons, Contracts, and the
Production of Copies

As is clear from surveys of Italian Renaissance artists'
contracts, patrons sometimes required that existing
older models be followed in their iconography, as well
as in their general shape and dimensions, this even in
contracts with established artists.[61] Such clauses exist,
for example, in the following contracts: in 1444, for
Piero della Francesca's extant altarpiece of the
"Madonna della Misericordia" (Museo Civico, Borgo
Sansepolcro); in 1503–5, for Raphael's and Roberto di
Giovanni's altarpiece of the *Coronation of the Virgin,*
which was to have been painted for the Poor Clares of
Monteluce; in 1507, for "Lo Spagna"'s extant altarpiece
of the *Coronation of the Virgin* (Pinacoteca, Todi); and in
1518, for Ridolfo Ghirlandaio's altarpiece, intended for
the Beltramini Chapel in S. Agostino (Colle Val d'Elsa),
which was to imitate an earlier work by his father,

Domenico.[62] Although such stipulations were not gen-
erally used to commission exact copies,[63] the delivered
product sometimes was a copy with only little varia-
tion. For the Franciscans of Todi, "Lo Spagna" pro-
duced a fairly faithful replica of the altarpiece by
Domenico Ghirlandaio and his workshop, which he
finished in 1511 (Figs. 83–84).[64] The Franciscans of S.
Martino in Trevi commissioned "Lo Spagna" in 1522 to
paint another version of the subject, for which the
artist reused the cartoon for the lower register of the
composition, although in reverse (Fig. 85). He most
probably employed a pricked cartoon to replicate the
lower part.

Although more precise research is necessary, it is evi-
dent that also mainstream Renaissance artists from vir-
tually all regions in Italy produced copies specifically to
record their inventions, generally delegating the labor of
execution to members of their *botteghe*. In a letter of 27
March 1501, Isabella d'Este wrote from Mantua to Fra
Pietro da Novellara in Florence that she needed another
version of the portrait drawing *("uno altro schizo del
retracto nostro")* that Leonardo had done, because her
husband had given away the original.[65] The portrait
drawing in question may well have been a cartoon sim-
ilar to that extant in the Musée du Louvre (Plate IV), to
be discussed later. Replying from Florence soon after-
ward, on 3 April 1501, Fra Pietro mentioned in his letter
to Isabella that Leonardo had done little aside from a
cartoon of the *Virgin and Child with St. Anne,* adding
that two apprentices "are making copies" *("fano retrati"),*
which the master occasionally retouched.[66]

As the complex documents on the *"Virgin of the
Rocks"* suggest, the practice of copying even overshad-
owed Leonardo's institutional commissions.[67] On 18
August 1508, Ambrogio de' Predis and Leonardo finally
received permission to remove an altarpiece of the
"Virgin of the Rocks," newly installed in S. Francesco Il
Grande (Milan), to copy it *("retrahere").*[68] Ambrogio de'
Predis was to make the copy under Leonardo's direc-
tion. The concession came amidst a protracted, acri-
monious dispute with the patrons, the Milanese Con-
fraternity of the Immaculate Conception. Because the
painting in question was probably not based on a car-
toon, the artists may have wished to trace its composi-
tion to produce a replica, probably commissioned by
another patron.[69]

On 30 May 1555, the Emperor Charles V wrote
from Brussels to his Ambassador Vargas in Venice to say
that he would soon send "the *patrón* [a term often used
in Spanish sources in the sense of "pricked cartoon"]
with the image of our Lady" for Titian to copy.[70] The
great Venetian artist, well past sixty years of age at that

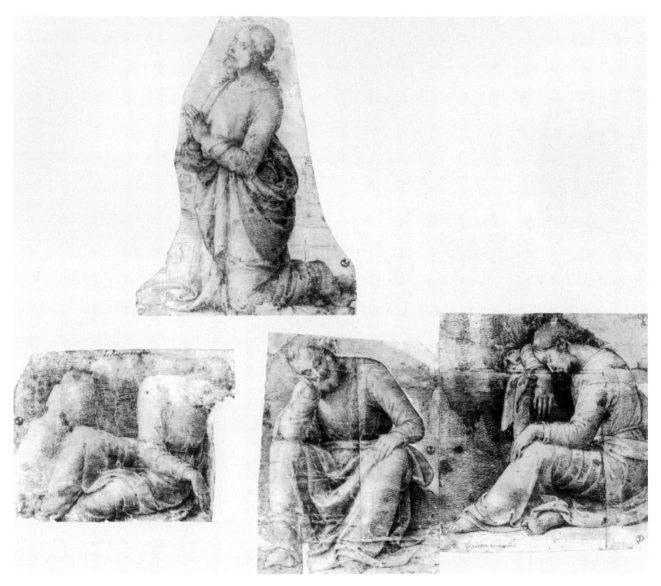

Figure 81. Giovanni di Pietro ("Lo Spagna"), pricked cartoon fragments for the Agony in the Garden *(CBC 303; Gabinetto Disegni e Stampe degli Uffizi inv. 410 E, Florence).*

point, reveled in honors and fame. Investigation of Titian's free, *virtuoso* painting technique reveals that cartoon use was not part of his working practice, even on the rare occasions that he painted in *buon fresco,* as in the *Scuola del Santo* (still in situ, Padua), or the *Fondaco dei Tedeschi* (ruined detached fragments are now in the Museo Cà d'Oro, Venice).[71]

Finally, and also telling of patronal influence, a *ricordo* of work conducted on the right of the high altar at S. Jacopo a Ripoli (near Florence) notes that Alessandro Allori, whose daughter was a nun in that church's convent, frescoed an *Annunciation* in 1589. As the curious document states, for the fresco has all but disappeared,

Allori painted the Virgin from a *"spolverezzo"* that exactly reproduced the design of the Virgin from a famous and much venerated Trecento model in SS. Annunziata (Florence), while taking great liberty in depicting the angel.[72] Allori's extant drawings and paintings confirm that he relied almost exclusively on the *calco* technique for design transfer in his work; thus, here, his practice of *spolvero* was entirely a response to the unusual demand from his patrons to produce an exact replica.

Cartoons and the Politics of Property

Equally surprising written evidence shows that cartoons (along with other kinds of drawings) were, at times, passed on like any other form of property – as bequests, dowries, or gifts. If viewed collectively, such data may further demonstrate that *spolvero* cartoons offered a use-

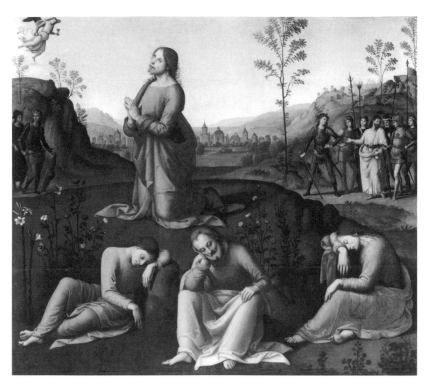

Figure 82. Giovanni di Pietro ("Lo Spagna"), The Agony in the Garden, *tempera and oil on panel (National Gallery, London).*

pintura, su antigüedad, y grandezas (Seville, 1649) would exhort painters to save all their cartoons *("patrones")* and drawings for future reference and reuse in their work.[77] Such advice offers a concrete frame of reference for the evidence in the Renaissance documents that we have been discussing.

Letters yield no less tantalizing bits. On 9 March 1532, Antonio Mini, then in Lyons, proudly announced to Michelangelo, in Florence, that he planned to have three paintings made from the *Leda* cartoon that the great master had given the servant before his departure for France![78] Technical investigation of Michelangelo's early panels reveals that the great master's own method of easel painting was to work entirely from freehand under-drawings.[79] (This was in marked contrast to his common practice of cartoons for fresco, as we shall see.)

Spolvero and the Production of Copies: Broad Conclusions

As Cennino's *Libro dell'arte* (MS., late 1390s) notes, in giving recipes for making translucent tracing papers, any attractively designed "head, or figure, or half figure" was fair game for the copyist.[80] Other attractively designed motifs or compositions were as well. We have seen that it was often scavenging copyists who pricked and pounced the outlines of designs for replication, sometimes even centuries after an artist had invented the original design. Although the *spolvero* technique is best known as a means of cartoon transfer in the work of Italian Renaissance mural painters, its most common use was, in fact, in the production of copies, for, above all, pricked cartoons and other types of pricked designs permitted a manifold repetition of entire compositions, or of their details. Cumulative evidence exists to suggest that most easel painters prepared cartoons, not so much to refine the designs of their compositions but to delegate their execution in paint or, more often, to reproduce them multiple times. The use of *spolvero* cartoons for design replication is especially characteristic of Venetian and Northern European painting practice.

A great part of the cartoon's history from 1440 to 1600 is entangled with this function of design replication.[81] Although we can only finally guess at the full

ful repertory for artists and artisans in the production of copies. In his will of 1498, the virtually unknown painter Bernardin Simondi of Aix-en-Provence bequeathed all his drawings, books of drawings, stencils, and pricked cartoons *("omnes meos patronos vulgariter dictos ponsis")* to his assistant; the same was apparently true of the French stained-glass painter, Guillaume Labbe, in 1493.[73] Similarly, Giovanni Battista Castello "Il Bergamasco" (1509–1569) bequeathed all of his drawings to his pupil, the enigmatic Spanish artist "Joan de Herrera." The inventory taken on 6 June 1569 in Madrid, after "Il Bergamasco"'s death, lists twenty-two *spolveri* (written phonetically in Spanish as *"espulburios"* or *"espulvaros"*).[74] "Il Bergamasco" had gone to Madrid in 1567 to work for King Philip II. When the Brescian painter Lattanzio Gambara (1530–1574) married the daughter of his teacher Girolamo Romanino (c. 1484/87–1562), the leading painter of Brescia then, the dowry included "some pricked cartoons" *("alcuni spolveri").*[75] Romanino often used *calco* in his murals. His *"spolveri"* may have been intended for ornament (he was an eminent painter of Antique-style *grotteschi)* and could presumably be reused to good profit in later work. In his practice, Lattanzio also seems to have stylus-traced cartoons on the rare occasions that he employed them in fresco painting.[76] Much later, Francisco Pacheco's *Arte de la*

Figure 83. Domenico Ghirlandaio and workshop, The Coronation of the Virgin, *tempera on panel (Palazzo Comunale, Narni), dated 1486 and originally painted for the church of S. Giacomo, Narni.*

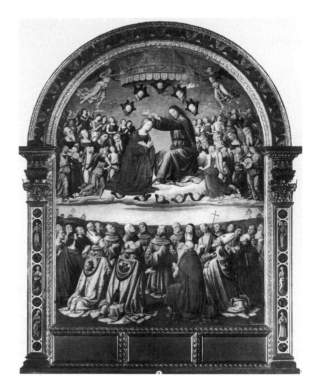

Figure 84. Giovanni di Pietro ("Lo Spagna"), The Coronation of the Virgin, *tempera and oil on panel (Pinacoteca, Todi).*

Figure 85. Giovanni di Pietro ("Lo Spagna"), The Coronation of the Virgin, *tempera and oil on panel (Pinacoteca Comunale, Trevi).*

extent to which the *spolvero* technique served a purely reproductive design function, the complex testimony provided by the written sources further indicates that it was used far more widely than can be confirmed today solely from the extant visual evidence.

Advantages of *Spolvero:*
The Textual Evidence

The common practice of mechanically aided copying would eventually lead to the refinement of specialized techniques by the eighteenth century. Acisclo Antonio Palomino's *El museo pictórico y escala óptica* (Madrid, 1715–24) notes that copyists could minimize the damage inflicted on original designs, by placing a blank sheet underneath the design being pricked, to produce a copy, or "substitute cartoon," which in turn could be smudged with pouncing dust onto the working surface.[82] (The principle of this procedure was essentially the same as that in Giovanni Battista Armenini's description of pricked "substitute cartoons" for mural painting.[83]) We can further estimate the effectiveness of the *spolvero* technique for copies of designs in small scale from the fact that both embroidery and miniature painting treatises would recommend it continuously

from the sixteenth to the nineteenth century. Qualitative evidence emerges in Andrea Pozzo's "brief instructions on fresco painting," appended to the *Perspectiva Pictorum et architectorum* (Rome, 1693–1700), perhaps the most widely read practical treatise of its kind during the Settecento. Pozzo's text instructs that, while stylus tracing (*"ricalcare"*) is the usual and efficient method of cartoon transfer, pouncing (*"spolvero,"* e.g., *spolverare*) serves better for small designs (*"cose piccole"*).[84] Similarly, in defining cartoons (*"cartoni"*) for an academic audience, Francesco Milizia's *Dizionario delle belle arti del disegno* (Bassano, 1797) specifies that *spolvero* should be used if a composition entails numerous figures (*"se le figure sono numerose"*).[85] The resulting precision of detail more than compensated for the laboriousness of the technique.

Claude Boutet's short treatise on miniature painting, first published in 1672, and much reprinted, thoroughly assesses various methods of mechanically aided copying (here, the prominent role of the stylus tracing technique, or *"calquer,"* is an indication of late-seventeenth-century practice).[86] An interpretive reading of this text reveals additional reasons for the effectiveness of the *spolvero* technique. If we were to actually perform the methods described by Boutet — to verify his points — we can deduce, for example, that if a design or motif was particularly small, tracing its outlines with too sharp a stylus or too much pressure might destroy the original by slicing through the paper. The modified *calco* or "carbon copy" technique (described in Chapter One), whereby the artist or copyist rubbed the verso of the original design (or of an interleafed sheet), with charcoal or chalk, before tracing the outlines, lessened the pressure of the hand resting on the stylus. Even this procedure inflicted damage, however, for it left crudely reinforced contours on the original and remnants of smudged chalk on the working surface. Like the pantograph, whose belated invention is published in Christopher Scheiner's *Pantographice, seu ars delineandi* (Rome, 1631),[87] the process of squaring was also enervatingly impractical if the design was small, or if it was to be copied in identical scale. Moreover, small, predominantly tonal drawings could often not be conveniently traced with translucent paper when their chalk was smudged or faded or when their chiaroscuro effects were too subtle or dense. Finally, drawings were generally not easily counterproofed, unless their medium was chalk, charcoal, or graphite.[88] The method of the counterproof (which entailed pressing a damp, blank sheet of paper onto the facing original design) reversed the orientation of the design, also greatly defacing the pigmentation of the original. The offset

that resulted lacked precision of detail and variation of tone.

Such practical considerations help explain both the survival and great abundance of small designs with pricked outlines. The other main advantage of pouncing further explains its use, even at a date when the faster technique of stylus incision was the more common practice. Best of all, as we are told in Palomino's *El museo pictórico y escala óptica*, pouncing (*"estarcir"*) enabled easy, relatively nondestructive, manifold replication and precision of detail: ". . . this [matter] of cartoons is very precise, when things must be repeated on the other side, or in reverse, since the cartoon is already pricked, in flicking it over and pouncing it, [the design] is done without work."[89] Johann Hübner's *Curieuses und Reales Lexikon* (Leipzig, 1762) also notes the use of *spolvero* cartoons to repeat designs.[90]

In the premodern era of photomechanical design reproduction, the possibilities of the technique were relatively vast. Not only could designs be repeated over and over, and in mirror images, but pricked cartoons by the master could also enable assistants to produce copies in the workshop; unrelated artisans and copyists could appropriate the designs of others by tracing, pricking, and pouncing them to produce replicas.

The efficiency of multiple design reproduction made possible by the *spolvero* technique especially suited certain genres of painting — first and foremost, that of ornament (to be explored in Chapter Five). Armenini's *De' veri precetti della pittura* (Ravenna, 1586) mentions in passing that artists could reverse drawings to create variety of design.[91] (Although the phrase in Cennino's *Libro,* "make your repeats so that they register well on each side," which refers to the application of *"spolverezzi,"* or ornament pounced patterns, to replicate brocade motifs in panel painting, is ambiguous, it may well refer to such design reversals, as well as to repetitions.[92]) Not surprisingly, however, the only candid, written confirmation of design reversal by means of *spolvero* in the Renaissance emerges from the humble ranks of the Venetian artisanry — Alessandro Paganino's embroidery patternbook (Venice, c. 1532).[93] More than two centuries later, Charles Germain de Saint-Aubin's embroidery treatise (Paris, 1770) would still repeat Paganino's tradition-sanctioned advice.[94]

Advantages of *Spolvero:* The Visual Evidence

The *spolvero* technique could offer equally useful applications for figural designs. Various types of visual evidence can help us establish this. An example is a

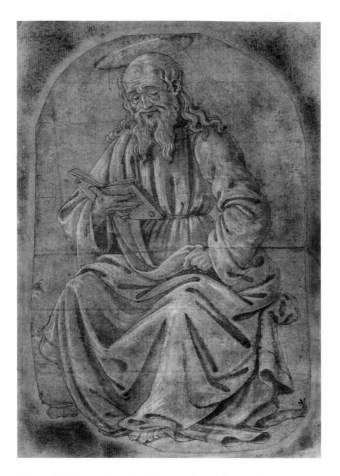

Figure 86. Here attributed to Francesco Botticini, pricked pattern for a Seated Saint *(CBC 7; Metropolitan Museum of Art, Robert Lehman Collection, 1975.1.409, New York).*

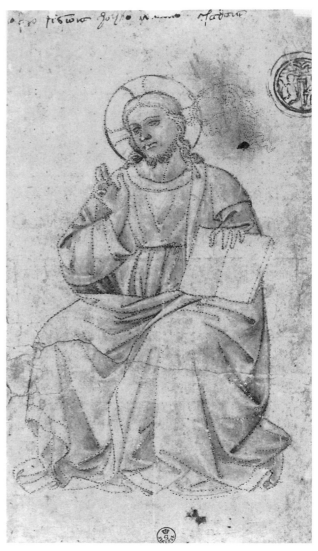

Figure 87. Francesco di Stefano "Il Pesellino," pricked cartoon for a Seated Christ (?) *(CBC 199; Gabinetto Disegni e Stampe degli Uffizi inv. 10 E recto, Florence), with an unrelated pricked outline for the head of another figure on the upper right, and lightly rubbed with black pouncing dust.*

small pricked cartoon of a seated male saint (Fig. 86), probably by Francesco Botticini (c. 1446–1497).[95] Under microscopic enlargement, the drawing reveals traces of rubbed black pouncing dust, which enters into many of the pricked holes. (The sheet is glued onto a mount, preventing analysis of the verso.) The artist drew the saint's halo once straight on as a circle, and another time foreshortened as an oval. Both halo designs are pricked. Such alternative designs seem to suggest that the drawing was used more than once.[96]

With changing attitudes in the field of drawing conservation, more and more "old master" drawings have been detached from the mounts onto which restorers often glued them. When this can be accomplished without risk of damage, the removal of such mounts and adhesive residues stabilizes the surface of a drawing and can enhance the tonal depth of the medium. The new visibility of the versos has frequently yielded data supporting the general arguments this chapter presents. Here, a few examples can speak for scores of others.

Both the recto and verso of a figure design by Francesco di Stefano "Il Pesellino" (c. 1422–1457) is rubbed with black pouncing dust (Fig. 87).[97] This is one of the earliest extant Florentine pricked drawings, probably produced during the last seven years of the artist's life. The seated male figure, who may possibly be Christ, blesses with his right hand and holds a book. The process of pouncing the design from the verso would have reversed the figure's gesture of blessing,

which would have been unsuitable, unless the motif was to be reused in a reproductive print.

Raphael's pricked cartoon in pen and ink, *"The Knight's Dream"* (Fig. 14) probably dates from 1501 to 1503, thus at the very beginning of the artist's short career.[98] As we have seen, it relates closely to an extant panel (Fig. 15). Examination under the microscope confirms that the cartoon's recto was lightly rubbed with charcoal pouncing dust; only faint traces of these particles are now visible. Yet the cartoon's verso is also – and very evidently – blackened with pouncing dust. Thus, the composition of Raphael's cartoon was reproduced at least twice, once in reverse orientation. Similarly, the area of the dragon's figure is heavily rubbed with black pouncing dust from the verso in Raphael's early pen-and-ink *St. George and the Dragon* (see Fig. 249) from 1503 to 1504. Magnification reveals traces of rubbed pouncing dust on the recto, verifying that at least parts of this drawing were also reproduced at least twice, once in reverse. In both these instances, it is difficult for us to ascertain where the artist's functional process of pouncing stopped and the labor of the copyist(s) began. A *Man of Sorrows* (CBC 343), densely rendered in black chalk and with unrelated pricked outlines, also exhibits a recto and verso nearly blackened with pouncing dust.[99] Probably serving for a small devotional panel, this drawing may well be by Timoteo Viti (1469/70–1523), who was a frequent user of the *spolvero* technique. He was Raphael's compatriot and sometime collaborator.

Thus, the uncovered versos of pricked drawings begin to illustrate the degree to which this particular practice was disseminated. In most cases, however, it is not clear whether the pouncing of versos was done by the designer of the drawings or by later copyists.[100] For instance, it must be remembered that the reversal of an image (obtained by pouncing a design from the verso), was essential for reproductive engraving, as we will see later on. This fact would explain the pouncing from both recto and verso in the pricked drawing of a frieze with *grotteschi* (CBC 339), attributed to Enea Vico (1523–1567), the Parmese engraver who specialized in designs of architecture and ornament.

A drawing for a reproductive print, the *Coronation of the Virgin* (CBC 360), from around 1550, is a poorly drawn variant of a famous *inventione* by Raphael.[101] The design is found in a tapestry (Vatican Museums), woven in Brussels from a cartoon by Lambert Lombard after Raphael, and two engravings.[102] The drawing is in the same scale as the engraving by the "Master of the Die," and some of its outlines are very sporadically pricked, whereas the majority of them are stylus-incised. The

artist developed the composition in pen and dark brown ink, brush and washes, partly highlighting the forms in white gouache. He then reinforced the rectangular outlines of the frame with red chalk, as he did for the frame of the composition. The recto of the composition is moderately rubbed with pouncing dust, while the verso is nearly blackened with it. Thus, in his effort to use and reuse the composition, the artist apparently pricked the outlines in those small portions of the design that did not register well with the *calco* technique on the working surface.

Practices in designs of monumental scale follow a parallel course; Pinturicchio's exact repetition of reclining Classical gods succeeds in an elegant ornamental context (Fig. 88). Much has rightly been made of Piero della Francesca's use and reuse of cartoons in his *oeuvre*, from the nearly identical repetition of heads in various scenes in the mural cycle on the *Legend of the True Cross* at S. Francesco (Arezzo), to the bilaterally symmetrical angels flanking the *"Madonna del Parto"* (Cemetery Chapel, Monterchi).[103] Likewise, Benozzo Gozzoli possibly replicated the motif of a daringly foreshortened ox in the Camposanto in Pisa many years after he had painted it in his *"Cappella dei Magi"* murals at the Palazzo Medici (Florence); he may have also repeated the same design of a young boy in the Camposanto at Pisa and in the choir of S. Agostino at San Gimignano.[104] Similar cases of cartoon recycling arise in the paintings by Luca Signorelli and his *bottega*. Among the examples are his repetitions of the figure of St. Jerome in the Bichi Chapel altar wing (Gemäldegalerie, Berlin) and in a later fresco (Palazzo Communale, Volterra), as well as his numerous repetitions of head types in the fresco cycle at Orvieto Cathedral, albeit with variations of designs and executed with *calco*, rather than *spolvero*.[105] The conclusive proof of such cartoon reuses and reversals, however, can often be difficult. Not only is the interpretation of the archaeological evidence complex, but complete data are also rarely available, since the majority of Italian Renaissance cartoons do not survive.

Giulio Romano's *Hermaphrodites*

Exact cartoon reuse can largely be verified for the wall portraying the *Allocution of Constantine* in the *Sala di Costantino* (Figs. 89–90). These murals in the Vatican Palace were painted after Raphael's death in 1520 by his *bottega*, under the joint leadership of his heirs, Giovan Francesco Penni "Il Fattore" (1496?–c. 1528) and Giulio Romano (1499?–1546).[106] The same cartoon

served to depict the heads of the two bilaterally symmetrical hermaphrodites – the one above the allegorical figure of *Moderatio* and the other above *Aeternitas*. A magnificent fragment of Giulio Romano's cartoon survives (Fig. 89). It is drawn boldly in charcoal, with stumping on most areas of deep shadow; the highlights in white chalk are now considerably darkened and smeared.[107] Importantly, the same general outlines in the cartoon are both lightly incised with the stylus and pricked. The stylus incisions are rarely directly on top of the pricked outlines, however, running just slightly above or below them, at times at a distance of as much as 2 and 3 mm. apart. The outlines toward the lower left side of the figure's neck and hair are stylus-incised, but not pricked. The relationship between stylus incisions and pricked holes is such in the general areas of the figure's right eye, chin, hair, and knot on the center of the headdress, that the cartoon appears first to have been traced with the stylus and then to have been pricked for pouncing from the verso, in order to reverse the design.[108] Tracings on translucent acetate,

Figure 88. Bernardino Pinturicchio, Ceiling Decoration of Grotteschi with Reclining Gods, Sphinxes, and Peacocks, *mixed mural technique (Palazzo Colonna, Rome), based on* spolvero *cartoons.*

taken from the two frescoed heads, and then superimposed on the extant Uffizi cartoon, demonstrate that in both cases the outlines of cartoon and paintings correspond closely.[109] The greatest divergences are in the hair and headdress, which Giulio painted about 10 to 11 mm. higher than he drew them, as well as in the left neck outline, which he painted 12 mm. to the right.

Renaissance artists may well have envisioned the replication of certain types of subjects already in the design phase, which possibly guided their preparation of complete full-scale drawings that could be reused to generate copies. The replicable character of certain types of compositions could also explain the predominance of *spolvero*, rather than of other methods of design transfer, particularly for easel paintings, in which infrared reflectography continues to reveal frequent instances of the technique.

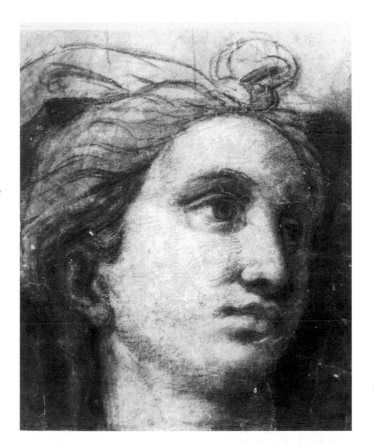

Figure 89. Giulio Romano, pricked and stylus-incised cartoon fragment for the Head of a Hermaphrodite (CBC 205; Gabinetto Disegni e Stampe degli Uffizi inv. 5548 Horne, Florence).

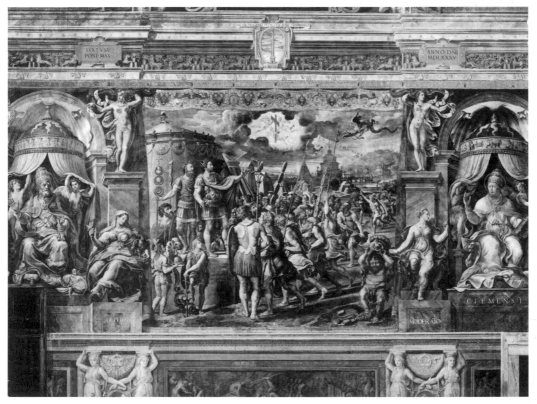

Figure 90. Giulio Romano, Giovan Francesco Penni "Il Fattore," and workshop, The Allocution of Constantine with the Enthroned Popes, Hermaphrodites, Aeternitas, and Moderatio, mixed mural technique (Sala di Costantino, Vatican Palace). The two hermaphrodites whose heads repeat in mirror images stand above the pilasters of the two female allegorical figures.

The *"Madonniere"*'s Practice

As we have seen, Umbrian artists often replicated figures of the Madonna endlessly. We have also already encountered the crude practices of figure replication in portrayals of the infant Christ Child or John the Baptist, by Milanese and Florentine followers of Leonardo and Lorenzo di Credi. That an unusually great number of extant cartoons portray the Madonna and Child, usually as single figures or in the company of angels, is also not surprising, considering that images of the Holy Mother played a central role in Christian devotion during the Middle Ages and the Roman Catholic Renaissance. As in Lorenzo di Credi's two monumental pricked cartoons showing the Madonna in full length (Figs. 29, 91–92, 219),[110] or in Giulio Romano's small pricked cartoon rendering the Madonna in half-length (Fig. 93),[111] such examples rarely portray figures of accompanying saints and usually omit background features. Details of this type tied a composition to a specific context: in omitting them from the cartoons, artists could adapt the Madonna and Child motifs in countless variations on the subject. A number of the monumental cartoons by sixteenth-century Piedmontese–Lombard artists (Accademia Albertina, Turin) also portray the groupings of the Madonna and Child devoid of settings; the large Turin drawings are known to have served in the production of multiple reprises of each composition.[112] Especially Giulio's small pricked cartoon (Fig. 93), broadly drawn in brown ink and wash, over an extensive, sketchy black chalk underdrawing, has the appearance and state of preservation of a much-used working pattern. Not surprisingly, it is also quite rubbed with black pouncing dust.

The practices of *"Madonnieri"* (Giorgio Vasari's derogatory term for painters of the Madonna and Child) attest to the fact that the banal reproduction of popular imagery was a specialized enterprise, particularly in Venice.[113] Throughout the fifteenth century, the

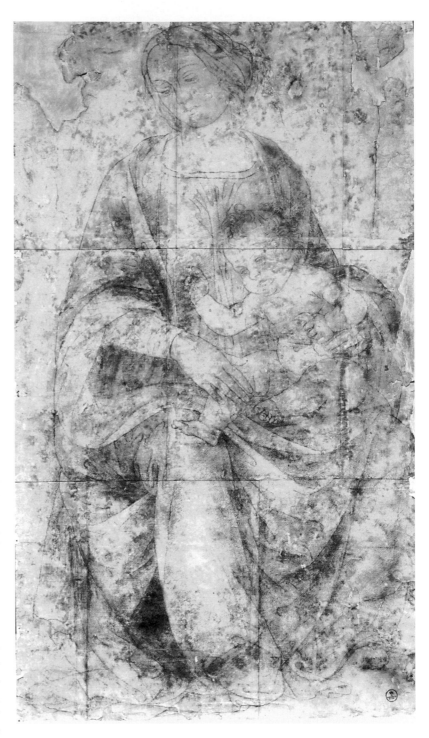

Figure 91. Lorenzo di Credi, pricked cartoon for an Enthroned Madonna and Child *(CBC 50; Gabinetto Disegni e Stampe degli Uffizi inv. 1772 E, Florence).*

mainstay of Venetian artists' workshops, as well as of many Central-Italian workshops of the second and third rank, appears to have been the sale of half-length groups of the Madonna and Child (with angels or

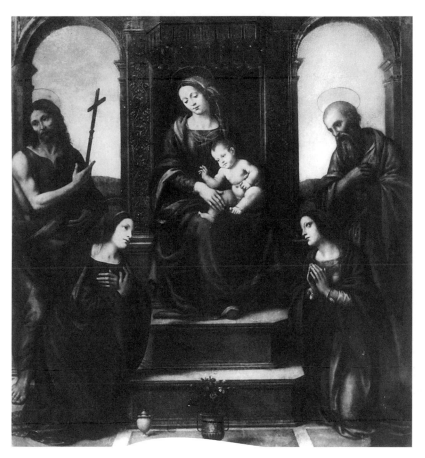

Figure 92. Lorenzo di Credi, Enthroned Madonna and Child with Saints, oil on panel (Museo Civico, S. Maria delle Grazie, Pistoia).

saints) intended for private devotion – Madonne "da camera." The Ricordanze by the Florentine painter Neri di Bicci vividly record the comings and goings of an active Italian Renaissance workshop engaged in such commercial activity: between 1453 and 1475, eighty-one Madonne "da camera" alone were painted, and during those years over a hundred orders were received for cast gesso relief tabernacles of similar subject.[114] The paintings were sold to dealers in Rome and in the region of the Marches, while others were sold locally in Florence.[115] By the 1460s, as Neri's Ricordanze reveal, the demand for painted panels began to pile up in the workshop.[116] In the profitable open market, design replication offered an attractive shortcut, unlike the situation with large-scale altarpiece commissions, which were often elaborate in composition and specific in subject matter.

An early example of a pounced Madonna "da camera" is from Padua, where Venetian practices were current. This Madonna and Child (Verspreide Rijkscollecties, The Hague), attributed to the workshop of Francesco Squarcione and dating from the 1430s to 1440s, is among the earliest Italian panel paintings exhibiting comprehensive spolvero marks.[117] A similar use of spolvero occurs in a canvas from about 1459, the Madonna and Child with Sts. John the Baptist and Paul (S. Francesco, Schio), attributed to Dario da Treviso, who was a follower of Squarcione.[118] Such paintings help us chart the distinction gradually emerging during the Quattrocento, between the use of cartoons for an exploratory purpose, to refine the design of a composition (which is more typical of the Central-Italian tradition of disegno), and the use of cartoons merely serving for design replication. To judge from both the mediocre quality of execution and the commonplace treatment of the subjects, these examples from the Veneto are clearly workshop pieces.

The bottega of Giovanni Bellini was the leading and most active in Venice during the second half of the fifteenth century, and many of the Madonne it produced have long been thought to derive from reused cartoons, though no such drawings are extant.[119] Infrared reflectography confirms that at least some of these workshop products were examples of serial repetition by means of spolvero.[120] Similarly, a number of Madonna and Child compositions by another prolific Venetian bottega of the time, those by Cima da Conegliano and members of his circle, appear to have nearly identical measurements, and, here, infrared reflectography may verify their means of replication.[121]

A rare small drawing (Fig. 94), attributed to the Veronese Antonio Badile (1424–c. 1507), can attest to the "Madonniere"'s practice from the draughtsman's side.[122] This relatively finished, but much used drawing is in pen and ink with washes and white gouache highlights. Its finely pricked outlines are heavily rubbed with black pouncing dust. Clearly a useful pattern, the isolated figures of the seated Madonna and Child could be pounced repeatedly to create devotional images, perhaps in small domestic tabernacles whose compositions could be slightly customized each time with the addition of the requisite saints.

This type of replication was not limited to easel paintings, as is further demonstrated by an earlier Flo-

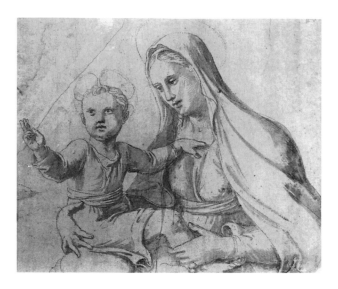

Figure 93. Giulio Romano, pricked cartoon for a small devotional panel of the Madonna and Child Blessing (CBC 203; Graphische Sammlung Albertina inv. 307 [SR 374, R 93], Vienna).

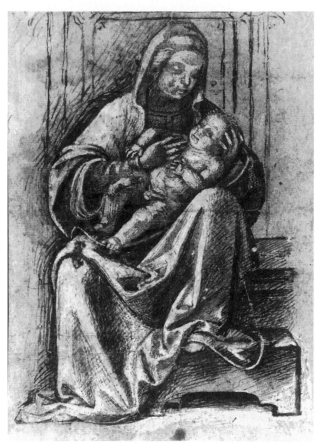

Figure 94. Here attributed to Antonio Badile, pricked cartoon for a small devotional panel of the Enthroned Madonna and Child (Private Collection).

rentine frescoed tabernacle from the 1430s to 1440s (see Figs. 178–79), which will be discussed more fully in Chapter Six. The selective presence of *spolvero* in this example illustrates the routine use of pricked patterns to mass-produce religious imagery. The presence of *spolvero* on a thickly painted detached fresco portraying the Madonna half-length with the Christ Child and two angels (Museo Ospedale degli Innocenti, Florence) verifies the same practice in one of the busiest, most successful late Quattrocento Florentine *botteghe* – that of Domenico Ghirlandaio (1449–1494), who was otherwise among the pioneers of the *calco* technique for cartoon transfer.[123] The small fresco has been also at times attributed to Sebastiano Mainardi, who was Domenico Ghirlandaio's brother-in-law from San Gimignano.[124] A more stunning example of close design replication by the Ghirlandaio workshop is found in the sixteen *tondi* variants of a *Madonna and Child with the Young St. John the Baptist and Angels,* from the 1490s.[125] The version in the Musée du Louvre (Paris) is of the highest quality and may well be an autograph panel by Domenico, whereas some of the others appear to be the work of Mainardi. Although no longer exploited so openly, the practice would nevertheless persist in the Cinquecento. The Florentine Francesco di Cristofano "Il Franciabigio" (1484–1525) probably painted his panels of the *Madonna and Child* in the Birmingham Museum of Art (Alabama) and in the Galleria Nazionale, Palazzo Barberini (Rome), dated 1509, from the same cartoon, but more than a decade later and in reverse.[126]

This is not to say that all Italian Renaissance half-length paintings of the Madonna and Child were based on cartoons, even workshop pieces. While a number of easel pictures with such images seem to exhibit *spolvero,* many do not, even by artists who often seem to have specialized in this genre.[127] As we have seen, cartoons were labor-intensive to draw. If they were produced at all for easel paintings, the *spolvero* technique made reproductions easier.

Raphael's *Madonne*

Raphael's *Madonne* from his Florentine period (c. 1504–8), however, reveal a surprisingly consistent use of *spolvero* cartoons, as is also made plain by recent campaigns of infrared reflectography examination. Among the examples of such paintings on *spolvero* underdrawings are the closely contemporary *"Madonna del Granduca"* (Figs. 95–96) and *"Small Cowper Madonna"*

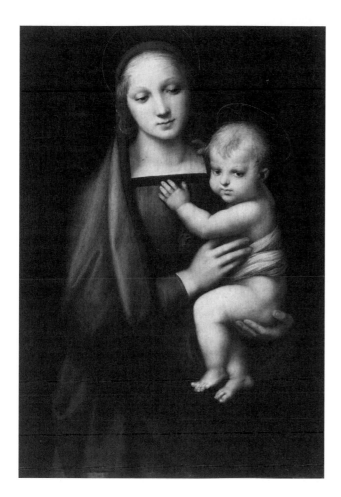

Figure 95. Raphael, The Madonna and Child, "The Madonna del Granduca," oil on panel (Palazzo Pitti, Florence).

1508, appear to have been underdrawn freehand.[130] The use of stylus incision as a means of design transfer seems exceptional in Raphael's Florentine paintings and drawings; it becomes less so during his Roman period.[131]

Seen as a whole, such evidence suggests the importance of developing a corpus of Raphael's underdrawings, for the complex problem of his painted originals and replicas requires rigorous further study with scientific means.[132] The distinctions between *"inventione"* and reproduction in the case of his *Holy Family with the Lamb* are especially subtle. At least four components of the puzzle survive: the pricked cartoon in the Ashmolean Museum, Oxford (CBC 248),[133] though too severely damaged and too heavily rubbed with black pouncing dust for archaeologically precise photographic reproduction; an oil panel of exquisite quality (Museo del Prado, Madrid), usually agreed to be autograph and whose underdrawing appears to show evidence of distorted *spolvero* dots from cartoon transfer; and another two high-quality painted panels (Musée des Beaux-Arts, Angers; and ex-collection of Viscount Lee of Fareham), of identical dimensions to the Madrid version but most often thought to be nonautograph, closely contemporary copies.[134] In the case of the Lee panel, examination with infrared reflectography reveals clearly defined *spolvero* marks, that closely follow the pricked outlines in the Oxford cartoon.[135] This particular fact has been used recently to argue that the Lee

Figure 96. Infrared reflectogram detail of the Christ Child's left hand in Raphael, "The Madonna del Granduca," showing spolvero dots from the cartoon.

(National Gallery of Art, Washington), from 1504 to 1505; as well as the *"Madonna of the Meadow"* (Kunsthistorisches Museum, Vienna), from 1506 to 1507; the *"Madonna del Cardellino"* (Galleria degli Uffizi, Florence), from around 1507; and the *"Large Cowper Madonna"* (National Gallery of Art, Washington), from 1507 to 1508.[128] The Canigiani *Holy Family* (Alte Pinakothek, Munich), painted in 1507 and cleaned in 1983 with spectacular results, may have also been derived from *spolvero*.[129] By contrast, the small *"Madonna dei Garofani"* (on loan to the National Gallery, London) and the monumental, unfinished altarpiece of the *"Madonna del Baldacchino"* (Palazzo Pitti, Florence), both dating around

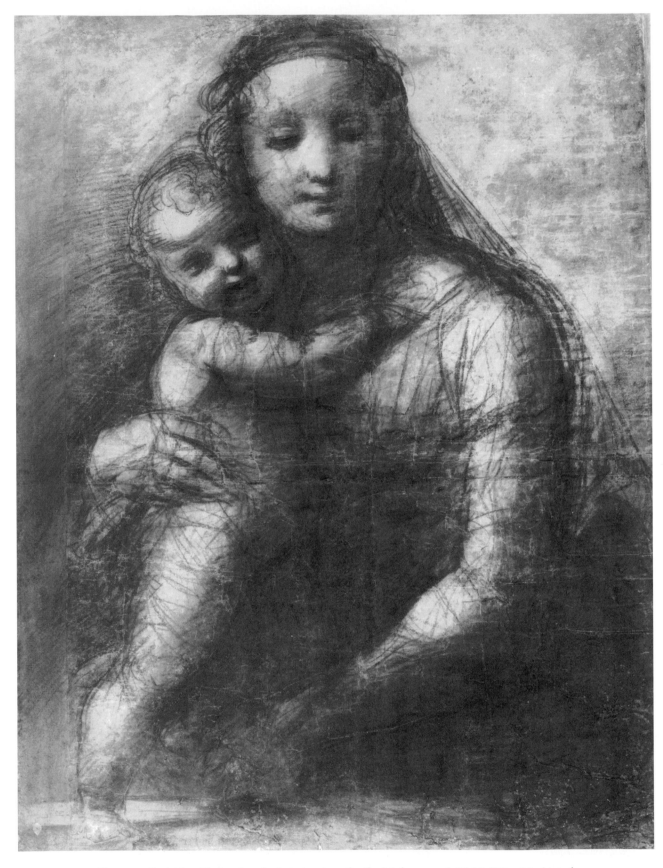

Figure 97. Raphael, pricked and stylus-incised cartoon for the Madonna and Child, "The Mackintosh
Madonna" *(CBC 255; British Museum 1894-7-21-1, London), preparatory for the oil painting on panel, trans-
ferred to canvas, in the National Gallery, London.*

panel is an early autograph version from 1504, and the Madrid panel, a partly autograph copy from 1507.[136] But despite the copious technical evidence marshaled in support of this argument, there is by no means an exact, dot-by-dot correspondence between the *spolvero* marks on the Lee panel and the perforations on the Oxford cartoon.[137] The *spolvero* underdrawing on the Lee panel, therefore, most probably did not derive directly from the Oxford cartoon. Although it is by no means complete, the evidence on the balance still favors the Madrid panel as the original version.

The cartoon for the *"Mackintosh Madonna"* (Fig. 97), drawn densely in charcoal in an exquisitely pictorial manner, probably dates from 1509 to 1511, during Raphael's early years in Rome. Curiously, it exhibits both pricked and stylus-incised outlines but omits a background setting. If the stylus incisions are indeed from transfer, as they evidently are in Giulio's cartoon fragment for the *Sala di Costantino* (Fig. 89), then they would attest that Raphael's *"Mackintosh Madonna"* cartoon was also reused.[138] The composition of the *"Mackintosh Madonna"* is indeed repeated closely, but in a proportionally smaller scale, in an altarpiece by Domenico Alfani (Fig. 98). Around this time, Alfani acted as Raphael's agent in Perugia and received the great master's *"inventioni"* as remuneration for his services.[139] In 1511, Alfani would use a detailed, squared drawing in pen and ink by Raphael, a *Holy Family with Saints* (Palais des Beaux-Arts, Lille), to produce two altarpieces in Perugia; the verso of that drawing contains a business letter by Raphael to Alfani.[140]

Paintings of the *Madonna and Child* largely forged Raphael's early career as an artist and viewed within the broader context of the *"Madonniere"*'s production methods, his practice begins to make sense. But his preference for the *spolvero* technique was also a matter of training passed on by his master, Pietro Perugino, and the Umbrian tradition that Perugino represented. Here, we should further recall two facts. Perugino had already efficiently exploited the reproductive possibilities of *spolvero* cartoons in the 1490s. Also, one of Raphael's earliest cartoons, *"The Knight's Dream"* (Figs. 14–15), from 1501 to

Figure 98. Domenico Alfani, The Enthroned Madonna and Child with Saints, *oil on panel (Galleria Nazionale dell'Umbria, Perugia).*

1503, has rubbed black pouncing dust on both recto and verso. Raphael's consistent use of pricked cartoons for nonfresco paintings can, therefore, be seen as a general response to the practical possibilities for design reproduction that the *spolvero* technique offered. As we shall see in Chapter Nine, this also probably explains the reason why the great master applied the technique to make synthetic types of drawings in the preliminary phase of design. As is demonstrated by his later association in Rome with Marcantonio Raimondi (c. 1470/82–1527/34), another medium of design reproduction, that of engraving, would do justice to Raphael's creative powers by readily disseminating his *"inventioni"* in replicable form.[141] We shall also see in subsequent chapters that the other important advantage of the *spolvero* technique was no less pertinent to Raphael – it more easily enabled a delegation of labor to assistants at the stage of execution.

Portraits

With the rising cult and historical definition of personality during the Renaissance, and for centuries afterward, portraiture would provide one of the steadiest sources of income for European artists. From a practical standpoint, a drawing or a cartoon executed from the living model could often be managed in one sitting, whereas a painted portrait normally consumed several sessions, time and patience on the sitter's part being essential.[142] Technical shortcuts were common. Albrecht Dürer's famous woodcut in Book IV of *Die Underweysung der Messung* (Nuremberg, 1525 and 1538) illustrates how artists could draw the portrait of a seated man onto a pane of glass. Much later, in affirming the efficiency of the *spolvero* technique for manifold replication, Acisclo Antonio Palomino would single out the specific instances of "portraits, which are [regularly] repeated, or an exquisite [design] element that is to be copied precisely, and be repeated many times."[143] As we observed in Chapter One, Leonardo's use and nonuse of cartoons may follow a pattern.[144] Thus, the presence of *spolvero* marks discovered in his portraits, the *Ginevra de' Benci* (Figs. 22–23), from 1474 to 1476, and *Cecilia Gallerani,* from 1485 to 1490, may point to a practice in portraiture similar to that used by *"Madonnieri."*[145]

It is well known that the profile portrait of Sigismondo Pandolfo Malatesta in Piero della Francesca's mural at S. Francesco (*"Tempio Malatestiano,"* Rimini), dated 1451, was reproduced exactly for a bust-length portrait on panel (Musée du Louvre, Paris), probably of workshop execution.[146] The same seems true of Giovanna Tornabuoni's profile portrait in Domenico Ghirlandaio's fresco of the *Visitation* (*"Cappella Maggiore,"* S. Maria Novella, Florence), from 1485 to 1490, and the poignant half-length portrait on panel (Thyssen-Bornemisza Collection, Madrid) that is a *memento mori,* dated 1488. Infrared reflectography reveals *spolvero* in two late Quattrocento portraits painted on panel (Galleria degli Uffizi, Florence), one by a painter close to Domenico Ghirlandaio, the other by a painter near Filippino Lippi.[147]

A great number of extant pricked drawings, at least plausibly portraitlike, as well as the frequent discovery of pounc-ing in Renaissance painted portraits, can confirm Palomino's words that portraits were usually thought worth preserving and replicating by means of the *spolvero* technique.[148] We may also compare a drawing from around 1496, either by Gentile Bellini or his younger brother Giovanni (Fig. 99), a likeness of the middle-aged Gentile Bellini, to a portrait of a young man, from 1488 to 1492, a panel painting by Lorenzo Costa (Fig. 100).[149] Delicately rendered in black chalk, the beautiful Bellini portrait drawing is pricked finely, densely, and uniformly. The outlines on the sheet are not rubbed with pouncing dust, suggesting a "substitute cartoon" procedure – the very practice described by Palomino, which originates in Armenini's precept for mural painting.[150] Oddly, in Costa's panel the mechanical-looking *spolvero* marks are plainly visible on the pigment layer and with the unassisted eye.[151] Neither the Venetian Bellini brothers nor the Ferrarese Lorenzo

Figure 99. Giovanni or Gentile Bellini, pricked cartoon for a Portrait of Gentile Bellini *(CBC 20; Kupferstichkabinett inv. KdZ 5170 recto, Staatliche Museen, Berlin). The nearly identical head turns up in the left foreground of Gentile's* Procession in the Piazza of S. Marco *(Gallerie dell'Accademia, Venice), signed and dated 1496, a date that the watermark on the cartoon generally confirms.*

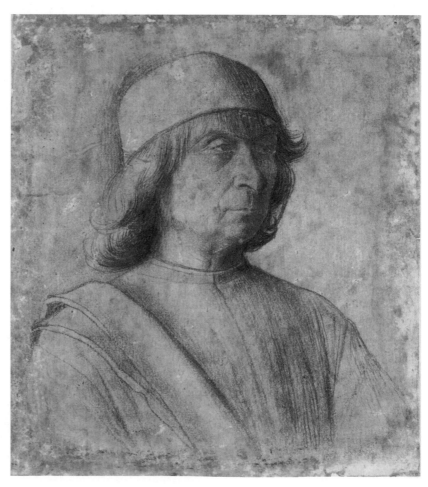

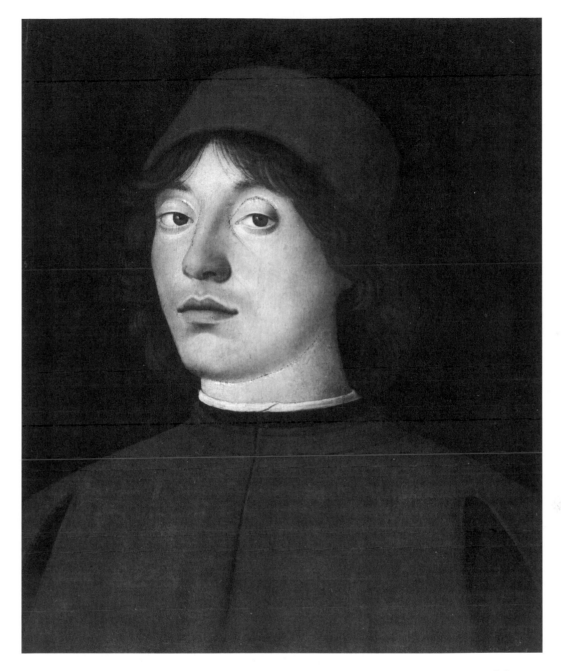

Figure 100. Lorenzo Costa, Portrait of Young Man, *oil on panel (Gemäldegalerie, Berlin), painted from* spolvero *outlines that are evident with the unassisted eye.*

Costa are thus far known to have been "pouncers" in contexts besides portraiture or half-length *Madonne.*

The two nearly identical versions of Raphael's *Portrait of Cardinal Tommaso "Fedra" Inghirami* from 1510 to 1516 may have been painted from the same *spolvero* cartoon: the panel in the Palazzo Pitti (Fig. 101), whose execution is of significantly higher quality than that of the panel in the Isabella Stewart Gardner Museum (Boston), exhibits *spolvero* underdrawing.[152] Confirmation of portrait reproduction by *spolvero* emerges also in French, Nether-

landish, German, and Spanish Renaissance panel paintings, by both minor and distinguished artists.[153] In fact, the complex evidence regarding the full-scale portrait drawings and paintings by Hans Holbein the Younger, who is not known to have used *spolvero* in works other than portraiture, helps fill the gaps in the documentation for earlier Italian examples of the practice.[154] In turn, awareness that this practice had a relatively widespread geographic distribution places in context what could otherwise appear unique to Holbein's method.[155]

Figure 101. Raphael, Portrait of Cardinal Tommaso "Fedra" Inghi-rami, *oil on panel (Palazzo Pitti, Florence).*

Luca Signorelli's Presumed Portrait of Fra Angelico at Orvieto Cathedral

Luca Signorelli's fresco cycle from 1499 to 1504 in the *"Cappella Nuova"* (Cappella della Madonna di S. Brizio) at Orvieto Cathedral provides a representative example of workshop practice that was increasingly common by the end of the fifteenth century. In the interest of rapid execution, Signorelli and his workshop assistants transferred the cartoons for virtually all the *historie* on the walls by means of the efficient *calco* technique; the earlier, more awkward frescos on the vault combine both *spolvero* and *calco*.[156] Curiously, Signorelli's *équipe* pounced only two details of the *historie* on the walls, both in the *Preaching of the Antichrist*. These are the presumed portrait head of Fra Angelico (Fig. 102) and the temple, constructed in daringly foreshortened perspective. (The illusionistic portrayal of the temple posed a particular challenge, as will be evident from our discussion in Chapter Five.) Significantly, the portrait figure, which is often identified by art historians as Fra Angelico, stands on the left of the scene, behind another, who is traditionally recognized as Sig-

norelli's self-portrait, following Vasari's account in the *Vite*.[157] Fra Angelico had been contracted to fresco the chapel in June 1447, and with the aid of Benozzo Gozzoli and other assistants, he had begun to fresco the vault shortly before his departure for Rome to serve Pope Nicholas V; the vault had remained unfinished until Signorelli was hired in April 1499.[158] In Signorelli's frescoed scene, the carefully painted portrait head of "Fra Angelico" exhibits extremely precise, minuscule *spolvero* outlines. By contrast, the face in Signorelli's presumed self-portrait is stylus-incised, albeit finely and exactly. The bodies of both figures are incised as broadly as they are painted. Thus, to pay homage to an important personality, Signorelli may have relied on a received likeness, a portrait drawing of only the head, which was too valuable to destroy by stylus-tracing it. He therefore may have finely pin-pricked and pounced the outlines, using the pattern independently from the compositional cartoon.

Just such an artist's likeness survives in a drawing from nearly a half-century later. Daniele da Volterra's carefully pricked portrait drawing of Michelangelo (CBC 344) provided the design for an onlooker in the right background of his *Assumption of the Virgin* fresco from 1548 to 1553 in the Della Rovere Chapel (SS. Trinità dei Monti, Rome).[159] The drawing appears to have been a bodiless *exemplum,* which Daniele considerably shifted in transferring the design to the largely stylus-incised fresco (it is no longer clear whether the frescoed head shows *spolvero*) and may have been reused in other projects.[160]

Portrait Replicas of Borso d'Este at the Palazzo Schifanoia

From the point of view of the patrons, to have had their likeness multiplied may have meant to amplify for posterity the reach of their socioeconomic status, political power, and personal accomplishment. An extreme case is the repetition of portrait types of the megalomaniac Borso d'Este in the *"Sala dei Mesi"* (Palazzo Schifanoia, Ferrara).[161] This mural cycle was painted around 1467–69 by a team of artists, probably directed by Francesco del Cossa, and is among the largest showing comprehensive *spolvero* from the fifteenth century.[162] One pose for Borso's standing portrait figure is repeated three times, in the scenes allegorizing the months of March, April, and July,[163] and a variant pose, also standing, though in profile, recurs another three times, in the scenes of the months of June, August, and September.[164] A profile version of Borso on horseback appears at least six times in the cycle,[165] and another in three-quarter view, riding a

Figure 102. Luca Signorelli, presumed Portrait of Fra Angelico, *fresco ("Cappella Nuova," or Cappella della Madonna di S. Brizio, Orvieto Cathedral), showing* spolvero *dots from the cartoon.*

sharply foreshortened horse, turns up twice.[166] Borso's persistent presence, always wearing a lavish gold damask tunic, red cap and hose, unifies the mural program visually and advances its propagandistic aims. Although the correspondences of design for each portrait type are close, there are small variations in scale and details in the figures and horses, from instance to instance. This indicates that the artists probably did not pounce the identical cartoons over and over directly on the plaster but reused cartoons as a basis for generating various drawn replicas on paper.[167]

Portrait Replicas of the Sforza Family in Milan

Other Italian Renaissance portraits may have also served as patterns for reproduction, but to a more limited extent than is found in the Palazzo Schifanoia. In Giovanni Donato Montorfano's *Crucifixion* fresco in the refectory of S. Maria delle Grazie, Milan (signed and dated 1495), the now practically effaced portrait figures of Ludovico Sforza "Il Moro," his wife Beatrice d'Este, and their sons Massimiliano and Francesco were added in oil pigments, as donor figures in the foreground of the composition. To judge from their unusual, impermanent painting technique, these additions may well be by Leonardo, who at the time was at work on the *Last Supper* mural on the opposite endwall of the refectory.[168] *Spolvero* marks are evident on the best preserved portrait, that of the boy Francesco, on the right portion of the *Crucifixion*. The *secco* oil technique here facilitated the belated insertion of the portrait, as suggested by the height of the *intonaco*, which is on top of adjoining *giornate*.[169] A profile portrait of the older boy of the Sforza family, Massimiliano, turns up in a pricked metalpoint drawing on blue-green prepared paper (Fig. 103), by the so-called "Master of the *Pala Sforzesca*," an artist in the circle of Leonardo and Ambrogio de' Predis.[170] The portrait of the Sforza boy in the pattern drawing is in the same scale as that in the *"Pala Sforzesca"* (Fig. 104) and in the underpainting in Montorfano's *Crucifixion,* seen on the left in the mural composition. The pattern drawing (Fig. 103)

Figure 103. *"Master of the* Pala Sforzesca," *pricked pattern for a* Portrait of Young Massimiliano Sforza *(CBC 220; Biblioteca Ambrosiana inv. F.290.inf.13, Milan).*

may or may not be from life. The boy's vaguely iconic facial features and fixed gaze are forcefully outlined, contrasting with the sketchiness of his hair and clothes. The numerous *pentimenti* outlines – along the rear of his neck, chin, and ear – confirm that the drawing was conceived as an exploratory study, before being used as a portrait pattern. The facial outline is especially closely and minutely pricked. The drawing was clearly replicated more than once, at least in reverse, because the verso seems to have originally been pounced with red chalk dust.[171] The iconic pairings of the donor portraits of the Sforza family are strikingly similar in both the *"Pala Sforzesca"* and Montorfano's *Crucifixion* mural. Ludovico Sforza "Il Moro," who used portraiture, especially, to further his dynastic ambitions, had commissioned the *"Pala*

Figure 104. Detail of the portrait of young Massimiliano Sforza in "Master of the Pala Sforzesca," The Enthroned Virgin and Child with Saints, Angels, and Donors from the Sforza Family, "The Pala Sforzesca," oil on panel (Pinacoteca di Brera, Milan).

Sforzesca" in 1494 for S. Ambrogio ad Nemus (Milan) and was also the patron behind the decoration of the refectory of S. Maria delle Grazie.[172]

Leonardo's Cartoon for a
Portrait of Isabella d'Este

Leonardo's famous and much reworked Louvre cartoon from around 1500, for a half-length portrait of Isabella d'Este in profile (Plate IV), raises different, yet no less disquieting, questions.[173] Both an exquisite treatment of surface and a highly refined use of medium would seem to confirm the long-standing traditional attribution to the great master, at least for parts of the cartoon.[174] The cartoon's outlines are finely pricked with extremely careful, regularly spaced, and nearly mechanical-looking perforations. Except for problematic areas arising in the drawing iself, there is little variation in the manner of the prick-

ing, from Isabella's face and hands, to her veil and the stripes of her dress. This time-consuming regularity is untypical of Leonardo's pricking style. We may recall the spirited rhythms of perforation – orderly, on facial features, and disorderly on hair and clothing – in his smaller cartoon of a grotesque man (Fig. 45), the figure perhaps to be identified with Vasari's description of "Scaramuccia, captain of the gipsies."[175] Similar contrasts of pricking style exist between facial features and hair in the cartoons by Andrea Verrocchio, Leonardo's master.[176] Upon closer examination, the regularity of pricking in the Isabella d'Este cartoon appears also suspicious if compared to numerous other, larger Italian Renaissance cartoons in which a firm connection to a finished work of art securely documents their function in the creative process of design.[177]

Curiously, in the case of the Isabella d'Este, the overall effect is as if someone had laboriously and reverently translated into pricked outlines a drawing whose design was no longer entirely legible, probably because of its damaged condition. The profile of Isabella's face is pricked consistently 1–2 mm. within the drawn outline. The upper edge of her hairband is unpricked toward its center portion, though its lower edge is completely pricked. There is also a marked divergence between the drawn and pricked outlines of her hair, which could result from the effect of the veil, but, here, the drawing is entirely faded. On her left shoulder and sleeve, the pricked outline runs noticeably within the leadpoint or charcoal outline. The drawing has also all but vanished in the area of her arms: there, the pricked outlines seem to be the only means of reconstructing the original design, if offering a very coarse interpretation.[178] Indeed, on the inside of Isabella's right sleeve, toward the top, the pricking follows no apparent logic at all! As Sir Kenneth Clark wickedly pointed out, Isabella's right arm is portrayed "in a position anatomically false"; the feeble replica in the Ashmolean Museum, Oxford, shows this detail correctly.[179] Although we cannot agree with Clark's harsh conclusion on account of the inaccurately portrayed right arm – "the natural inference is that the Louvre cartoon never was Leonardo's original" – the fact that it was probably a copyist who misunderstood Leonardo's drawing on the cartoon and who probably pricked the cartoon's outlines goes a long way to explain the jarring awkwardnesses of design. The design of the Isabella d'Este was probably transferred by the intermediary means of a pricked "substitute cartoon," as the recto does not seem to be rubbed with pouncing dust. A firm judgment on this matter is not possible, however, in view

of the substantial abrasion and reworking (as well as probable "cleanings" by restorers) of the drawing.

Unlike most large cartoons, the verso of the *Isabella d'Este* is not glued onto a mount, which proves instructive. Remarkably, the verso is rubbed more or less heavily with black pouncing dust, demonstrating that the cartoon was used at some point to produce a mirror image of the drawn composition. Moreover, on the verso, a small rectangular patch of paper was glued onto the corner corresponding to the lower left of the design on the recto to reinforce the original support; it is itself on top of further glued strips of paper framing the borders of the cartoon's verso. This is most probably a post-Leonardo restoration. Crucially significant, the pricked outlines of the cartoon's design extend also to the reinforcements, with little noticeable change in the character of the perforations, as they occur on the original paper of the cartoon and the patch, although the perforations sometimes vary slightly in their diameters. This unnoticed evidence appears to confirm further that the *Isabella d'Este* cartoon was pricked and pounced later, for the purpose of replication, by somebody other than Leonardo.

If we consider Isabella d'Este's letter on 27 March 1501 to Fra Pietro da Novellara, mentioned earlier, about her needing another version of the portrait drawing that Leonardo had executed *("uno altro schizo del retracto nostro"),* we can see that the Louvre cartoon may have been an attempt at such a reconstruction.[180] (Throughout her long life, Isabella was the subject of numerous portraits.[181]) Although they are neither full scale nor of remotely similar quality of execution, at least four large copies survive after Leonardo's *Isabella d'Este* cartoon.[182] Their existence, together with the troubling physical evidence found in the Louvre cartoon, indicates the extent to which Leonardo's famous design must have been imitated. The written sources and extant copies after Leonardo's *"St. Anne"* and *Anghiari* cartoons attest to the great appeal that this particular drawing type of his had in the sixteenth century.

Defining Copies and Variants

Thorny questions face us, therefore, regarding the classification of cartoons and the general role of drawing in the Italian Renaissance *bottega*. Most importantly, if artists and craftspeople used the *spolvero* technique for creative and reproductive purposes, and if they produced relatively finished drawings in both traditions, how can we always distinguish confidently between exploratory drawings and copies? Indeed, how do we define them?

As the *Isabella d'Este* cartoon vividly suggests, an evaluation of the function of pricked drawings must reflect the possibility of pouncing by hands other than the artist's, sometimes much later ones. This greatly complicates any general distinction between "functional" pouncing – an application of the technique in a creative design process that leads to the execution of a final work – and "replicative" pouncing, or use of the technique solely to derive a design from an already existing work, as in a copy.

Although we can recognize that, from at least the 1440s onward, cartoons would gradually serve as a functional step in the creative process, as Giorgio Vasari passionately advocated for the Central-Italian tradition of *disegno,* cases abound of cartoons that were prepared merely to produce copies.[183] The famous (lost) *Venus and Cupid* cartoon that Michelangelo drew in an exquisite charcoal technique *("di carbone finitissimo")* in 1532–33 for Bartolomeo Bettini and that Pontormo executed in paint gave rise to numerous painted and drawn copies.[184] Among the most accomplished of these replicas is a monumental "copy cartoon" in the Gallerie Nazionali di Capodimonte, Naples.[185] A number of extant copy cartoons seem to relate to the production of copies of compositions by Raphael and his workshop. Among such examples are the reprises of the *"Madonna del Divino Amore"*[186] and the *"Madonna of the Veil."*[187]

More striking, however, is the large, pricked copy cartoon after Giulio Romano's *"Madonna della Gatta"* (Fig. 105).[188] At 1.47 by 1.34 meters, it greatly resembles in physical structure any of the large cartoons that we have already encountered in Chapter Two. This copy was highly rendered in charcoal but was then laboriously reworked with brown ink and wash and highlighted with lead white; the drawing surface consists of twelve sheets of paper, whose individual formats measure slightly less than Bolognese *fogli reali*. Moreover, the pricked holes in the copy cartoon of the *"Madonna della Gatta"* are blackened with pouncing dust. Giulio probably painted the original composition for the *"Madonna della Gatta"* (Fig. 106) in the 1520s.[189] A painted copy of unknown date is also extant (Sacristy of S. Maria in Aracoeli, Rome); whether the copy cartoon was preparatory for this or for yet a further version is unclear.[190] Be that as it may, a comparison to any of Giulio's spirited large-scale, securely autograph cartoons exposes, at once, the timidity and lassitude of the copyist's style. Giulio's cartoons for his earliest independent works already reveal a brilliant drawing technique. Stumped passages of vibrant chiaroscuro usually flicker across nebulous webs of reinforcement lines.[191]

Intertwined with the issue of copies is that of variants. Most extant large-scale Quattrocento cartoons

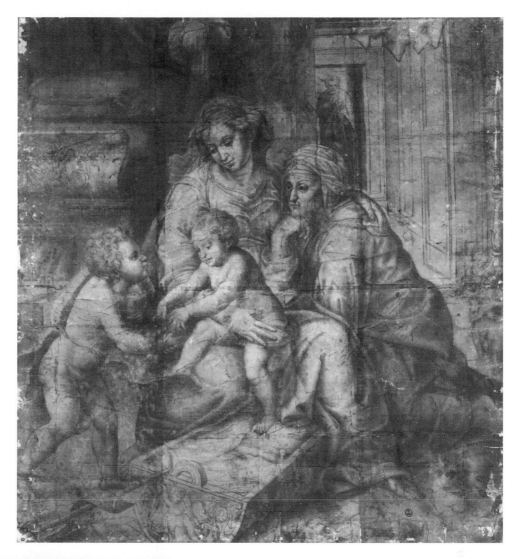

Figure 105. Copyist after Giulio Romano, pricked cartoon for replica of the Virgin and Child with Sts. Elizabeth and John the Baptist, "The Madonna della Gatta" *(CBC 212; Gabinetto Disegni e Stampe degli Uffizi inv. 1776 E, Florence).*

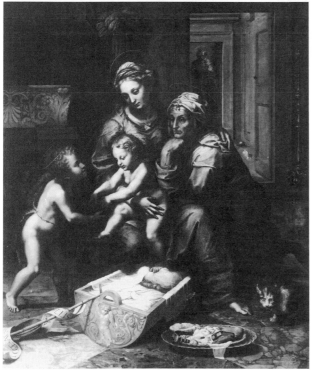

Figure 106. Giulio Romano, The Virgin and Child with Sts. Elizabeth and John the Baptist, "The Madonna della Gatta," *oil on panel (Gallerie Nazionali di Capodimonte, Naples).*

portray heads.[192] Rendered carefully in charcoal or chalk, such large-scale drawings of heads could not only offer valuable *exempla* for training apprentices in the art of drawing, but they could also occasionally be reused in later work.[193] In examining the more unusual case of a brush drawing portraying the head of St. Francis (Fig. 107), we should keep in mind that the artist, Niccolò da Foligno (doc. 1456–1502), also known as Niccolò Alunno or Niccolò di Liberatore di Giacomo, was a prolific, if modestly talented painter working for a large number of private and institutional patrons in Umbria and the Marches.[194] Niccolò reused the St. Francis head type in several painted processional banners and altarpieces from the first half of the 1480s.[195] In the drawing, the main outlines of the head are pricked, and the forms are precisely modeled with ink, washes, and white gouache highlights on olive-prepared paper. The pricked holes are medium-sized and relatively far apart (about six holes per 10 mm.), but there is no rubbed pouncing dust on the sheet. Pricked and drawn outlines diverge slightly, most noticeably in the mouth area.[196] The artist ingeniously reworked the head of St. Francis with quick, schematic strokes of black and reddish brown chalk to transform the head into that of the dying Christ, complete with beard, crown of thorns, and drops of blood.[197] These reworked portions of the drawing are not pricked, which indicates that the artist's somewhat coarse alteration was only meant to suggest the *"reinventione";* he could develop the design *alla prima* on the painting surface or on another sheet of paper.[198] Significantly, another page that Niccolò drew in a similarly finished brush technique but that portrays four heads of angels bears the unrelated pricked outline design from St. Francis's head.[199] The angels are related in design to a processional banner by Niccolò, the *Annunciation* (Galleria Nazionale dell'Umbria, Perugia), which was commissioned on 29 April 1466 by the confraternity of the Annunziata.[200] The sheet with the angels is technically a "substitute cartoon"; its verso lay underneath the *St. Francis,* when the artist perforated the saint's head on top. Both sheets of carefully finished drawings resemble the patternlike appearance of drawings commonly found in modelbooks, and, importantly, if the dating of the repeated motifs is considered as a whole, we can see that the sheets served as models for about twenty years in Niccolò's career.

A great number of the extant pricked, relatively finished drawings from the fifteenth and sixteenth centuries represent single, isolated figures. These could have easily been reused and reworked for different contexts, much like a child's cut-out paper dolls. An instructive case is a very small, selectively pricked drawing (CBC 200) that portrays a graceful, standing female attendant figure – a stock pattern that often turns up in paintings by Pietro Perugino and his circle.[201] This highly finished brush drawing is executed in a range of brown inks and washes over a metalpoint underdrawing on olive prepared paper; dainty touches of red and white gouache accent some of the forms. It may well be a copy after a painting. The figure was later reworked as a nereid, with the addition of a vase on her head, beads on her hips, and a clumsily drawn shell below her feet. The outlines of these details are not pricked. The copyist or the original draughtsman – it is difficult to know which – seems to have first drawn the woman's figure without attributes.

The *"Libretto Veneziano"* in Raphael's Circle

Although it is difficult to discern correctly between autograph, nonautograph, and even "posthumous" pricking, we can easily accept that *spolvero* underdrawings are original. The receipt from transfer, *spolvero* marks are normally the earliest layer of drawing medium on a sheet. Thus, examples of copies drawn on the basis of *spolvero* underdrawings provide the firmest visual proof that artists pricked drawings for the specific purpose of copying or recording individual motifs.

Examination with infrared reflectography reveals that several figures in the so-called *"Libretto Veneziano,"* produced in 1500–10 by a modestly talented Umbrian artist in Raphael's circle, were drawn on *spolvero* underdrawings.[202] The design types are telling: a portraitlike figure of a man kneeling in prayer, who looks as though he might be a donor in an altarpiece (fol. 23 verso); four male heads (fol. 15 recto; Fig. 108); and designs of male nudes that are reminiscent of Antonio Pollaiuolo (fol. 35 recto and verso).[203] A drawing of a child's figure on folio 22 recto is stylus-incised, and its verso is blackened for transfer.[204] Other motifs in the *Libretto* were probably also drawn on top of mechanically reproduced outlines, but the abraded surfaces of the drawings no longer permit confirmation of their means of production. As copies frequently do, these relatively finished drawings appear in awkward isolation on the page, devoid of context. Many of the motifs are closely related to extant compositions by Raphael. The head in the lower left corner of Figure 108 repeats Raphael's delicate study for St. James (Ashmolean Museum, Oxford), although in a reversed design orientation and in smaller scale.[205] St. James stands at the

Figure 107. Niccolò di Liberatore di Giacomo da Foligno, pricked pattern for the Head of St. Francis Reworked as Christ *(CBC 4; Kupferstichkabinett inv. KdZ 5129 verso, Staatliche Museen, Berlin). The artist further pricked this pattern onto the verso of yet another sheet, a pattern for the* Heads of Four Angels *(CBC 5; Kupferstichkabinett inv. KdZ 5107 recto, Staatliche Museen, Berlin).*

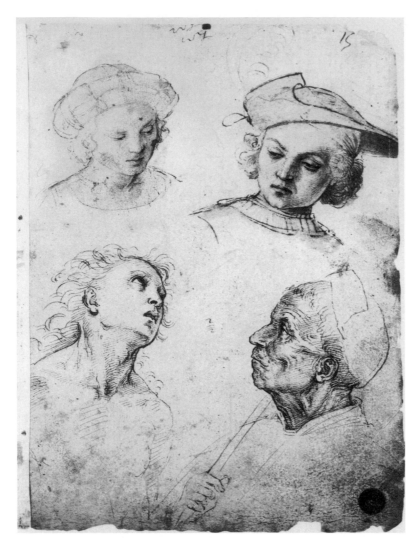

Figure 108. Artist near the young Raphael, patterns for Four Heads, *from the* "Libretto Veneziano," *fol. 15 recto (Gallerie dell'Accademia inv. 55 recto, Venice), drawn from* spolvero *outlines.*

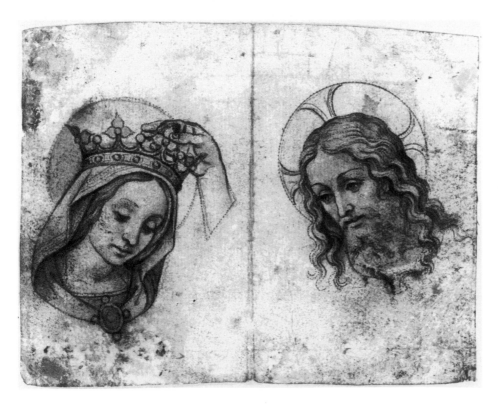

Figure 109. Raffaellino del Garbo, pricked patterns for the Heads of the Virgin and Christ *in a* Coronation of the Virgin *(CBC 78; Istituto Nazionale per la Grafica inv. FC 130466, Rome).*

extreme right in the foreground of the *Coronation of the Virgin* altarpiece (Pinacoteca Vaticana). Three large, full-scale studies on *spolvero* – so-called "auxiliary cartoons" – by Raphael survive for this very project (see Figs. 269–70), including one for the head of St. James.

The evidence of *spolvero* in the *"Libretto Veneziano"* helps us distinguish further between the technique's use for mere design reproduction and its use for more creative studies, as in Raphael's practice (see Chapter Nine). Whether the drawings in the *Libretto* derive directly from originals by Raphael is questionable.[206] Be that as it may, their contrived symmetrical placement on the page, like motifs in a Medieval modelbook, betrays a taste already archaic by the standard of early Cinquecento Florence or Rome.

Artisans and Copyists

A vast, gray realm lies, therefore, between the two extremes of "functional" and "replicative" *spolvero*. The latter was used chiefly by craftspeople producing decorative arts. They supplied an eager market with wares, which adapted popular designs by others and perpetuated cherished models. More than any other means, the *spolvero* technique efficiently enabled the reproduction, adaptation, and wide dissemination of "high style" designs in a variety of media.

Giorgio Vasari snidely commented that Raffaellino del Garbo (c. 1466/70–after 1527), Filippino Lippi's most gifted pupil and a talented draughtsman in his own right, sacrificed his artistic integrity in producing countless drawings for embroiderers.[207] Three such drawings by his workshop (CBC 78–80) in Rome are similarly finished in pen and brown ink, with brush and brown washes, and have finely pricked outlines. They were probably originally part of the same small book of patterns. Rubbed with black (and, possibly, red) pouncing dust, these patterns clearly served to create embroideries but also, and no less importantly, to replicate the motifs multiple times. The largest sheet (Fig. 109), folded vertically down the center, depicts piecemeal the crucial parts for a scene of the *Coronation of the Virgin,* similar in composition, in fact, to Raffaellino's altarpiece originally painted for S. Salvi in Florence (Fig. 110), possibly as late

as 1511.[208] In the drawing, a hand places a crown on the Virgin's head on the left half of the sheet. By looking at the right half, we learn that the hand belongs to Christ, whose head turns toward that of the Virgin. The motifs are entirely isolated from each other. Despite the fact that the drawing of the heads and hand is highly finished, there is, oddly enough, no suggestion of the figures' bodies. These are, however, not exploratory life

Figure 110. Raffaellino del Garbo, The Coronation of the Virgin, *oil on panel (Musée du Louvre, Paris).*

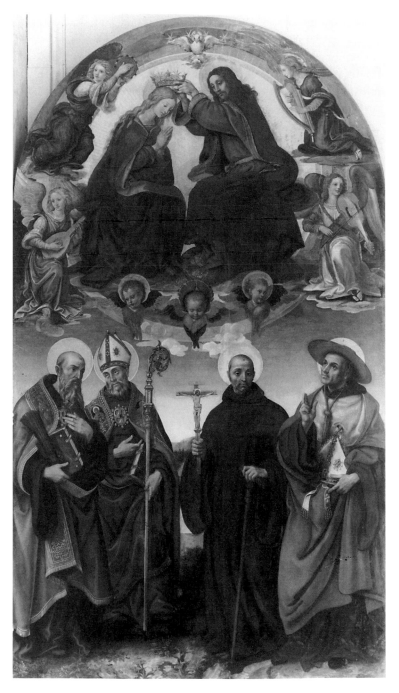

studies but highly synthesized formulas. In fact, the Virgin's jeweled brooch and veil provide a convenient, if abrupt, *terminus* for the design of her figure. The artist even drew Christ's hand with a terminal outline above the wrist – also pricked – marking where his sleeve could be fitted. Thus, craftspeople could provide the filler, assembling the *Coronation of the Virgin* piece by piece, either directly on the working surface, if they trusted their sense of *disegno,* or on another sheet of paper by pouncing the pricked pattern. The same is true of the other two heads of youths (CBC 79–80), which are equally complete, yet devoid of bodies or defining contexts; the designs of their heads are reminiscent of the music-making angels also appearing in the upper register of Raffaellino's Louvre altarpiece, but in reverse.[209] In fact, the users of one of these drawings (CBC 79) rubbed not only the recto but also the verso with black pouncing dust, which indicates that mirror images of the design were indeed produced. Such stock faces could be assigned to supporting figures, either angels or onlookers, depending on the situation, in mass-produced *Annunciations, "Sacre Conversazioni,"* or *Miracles of Saints.* Even their necklines, fashioned with simple collars, could facilitate the adaptation of the basic forms to bodies, garments, and gestures of choice.

To judge from their identical scale, their repeating Gothic-style tracery outlines, as well as their analogous drawing technique, the pair of *St. Paul* and *St. Christopher* (Fig. III; CBC 77) in Rome, as well as that of *St. Nicholas of Bari* (?) and *St. Bartholomew* (CBC 104–5) in Lille, were undoubtedly cartoons for the same set of embroideries.[210] In all four sheets, the distinctive, ornate orphrey outlines framing the figures are painstakingly pricked. Importantly, on the verso of the Rome *St. Christopher,* and hitherto unnoticed, heavily rubbed pouncing dust has nearly effaced an extremely schematic line drawing, no more than a doodle, in pen and dark brown ink: it appears to represent the form of a dalmatic but is too unclear for good photographic reproduction. If identified correctly, this dalmatic has rectangular fields on its left and right borders, with inscribed words, now cropped and partly obscured. This labeled diagram (a type of *modello* or *exemplum*) portrays the design in only general terms and may have served as a means of communicating information between the patron, artist, and embroiderers.[211] In contrast to the Rome *St. Paul,* in which only traces of deposit survive, the recto of the Rome *St. Christopher* and, to a much greater extent, the verso are blackened with pouncing dust. The rectos of the Lille pair are also

thoroughly rubbed with pouncing dust, but of a grayer cast; whether their versos are pounced as well cannot be known, for the drawings are glued onto mounts.

Thick networks of black chalk underdrawing in the Rome *St. Paul* and Lille *St. Nicholas* (?) suggest their character as exploratory drawings in progress, developed entirely freehand. By comparison, the virtual absence of underdrawing in the Rome *St. Christopher* (Fig. III), together with the numerous divergences of design between its drawn and pricked outlines, indicate a semimechanical method of production. Raffaellino probably drew this figure from preexisting pricked outlines, which he derived from an earlier pricked draft (see further, Chapter Nine).[212] The density of black pouncing dust on the Rome *St. Christopher* attests to its frequent, subsequent reproduction, for such figures could be reused over and over in different contexts.[213]

The nebulous realm of anonymous craftspeople offers countless other examples of design replication, as we can judge also from the various pricked and unpricked drawings found among the scattered pages of the *Codex Zichy* (Szépmüvészeti Múzeum, Budapest), an Italian anthology of ornament patterns probably compiled between 1489 and 1536.[214] For Byzantine icons, hundreds of pricked and pounced cartoons survive, together with their corresponding "substitute cartoons" (Byzantine and Benaki Museums, Athens, and St. Mihalarias, London).[215] Dating from the sixteenth to the nineteenth century and of extremely derivative design, the heavily reused Byzantine icon cartoons appear to have been transmitted from generation to generation. Similarly, the archive of papers and designs owned by the Gentili family of potters in Castelli (J. Paul Getty Center inv. 880209, GJPA88-A274, Los Angeles) contains vast numbers of pricked prints and copies after earlier designs, as well as their corresponding "substitute cartoons." These materials in the Getty archive date from around 1620 to 1850 and confirm what we can infer from the frequent recurrence of known print designs in ceramic wares from the early sixteenth century onward, that artisans utilized, almost exclusively, the *spolvero* technique to adapt designs by others to their own work.

Pricked Prints

It seems noteworthy that the gradual development of the *spolvero* cartoon during the second half of the fifteenth century paralleled that of engraving and woodcut as reproductive design media.[216] Indeed, the pre-

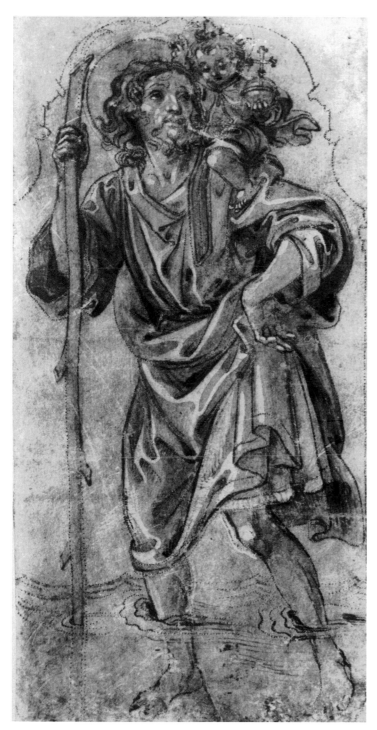

Figure 111. Raffaellino del Garbo, pricked pattern for St. Christopher *(CBC 76; Istituto Nazionale per la Grafica inv. FC 130456 recto, Rome).*

eminent Quattrocento engraver, Andrea Mantegna (c. 1431–1506), was both a "pouncer" and *prospectivo* (master of perspective), closely allied roles in this history.[217] But the phenomenon of pricked prints stretches the notion of design reproduction to extraordinary lengths, as printmaking is itself a precisely reproductive medium. The makers of woodcuts, engravings, or etchings, however, had little reason to prick printed designs, as they were already finished works in and of themselves.[218] Pricked prints, certainly much less plentiful than pricked drawings, present another of the clearest, if least interesting, indications of the copyist's work, since the person who pricked a print often did not have access to the wood block or metal plate from which the impression was pulled.[219] This was almost certainly the case, for instance, with an impression of an engraving of *Hercules and Antaeus* (Figs. 112–13), produced by a follower of Andrea Mantegna probably in the 1490s.[220] (The labors of the titan Hercules were among the most popular *"all'antica"* subjects of the fifteenth century.) In the Metropolitan Museum impression of this engraving, the general outlines of the wrestling figures and much of their interior modeling are finely, carefully, and densely pricked, and the verso of the sheet is rubbed with black pouncing dust throughout to reverse the image. Seen as a whole, such evidence points to the production of yet a further copy.[221]

Printmakers usually pricked the outlines of a design and pounced it from the verso, for transfer onto another sheet of paper, in order to obtain the reversed preliminary design needed to prepare a print (as the process of printing reverses an image).[222] No evidence exists, however, to suggest that *spolvero* played a role in actually transferring the final design onto the wood block or metal plate. To do this, Baroque treatises on printmaking recommend the use of various versions of *calco,* or stylus-tracing techniques, a practice verified by drawings.[223]

Selectivity of pricking also discloses the copyist of prints, as is true of an impression of the posthumous 1553 edition of Giovanni Antonio Tagliente's calligraphy book (Victoria and Albert Museum, London).[224] Only four of the pages containing woodcuts with decorative letters are pricked. Moreover, of the entire alphabet of capital letters in knotwork, only the "A" on folio 16 verso is pricked. The page may thus be regarded as a copyist's attempt to reuse a then fashionable North-Italian form of interlacing ornament.[225] Finally, the archive of papers owned by various families of potters from

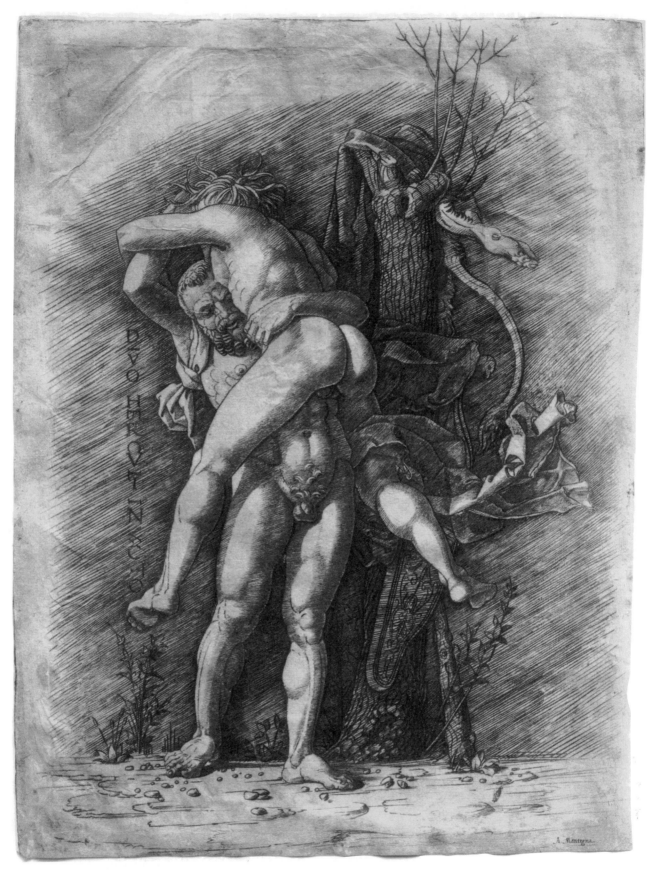

Figure 112. Artist near Andrea Mantegna, Hercules and Antaeus, *engraving, only state (Bartsch XIII.237.16; Hind V.25.17; Metropolitan Museum of Art, Rogers Fund, 1918; 18.65.3, New York), with outlines pricked for transfer.*

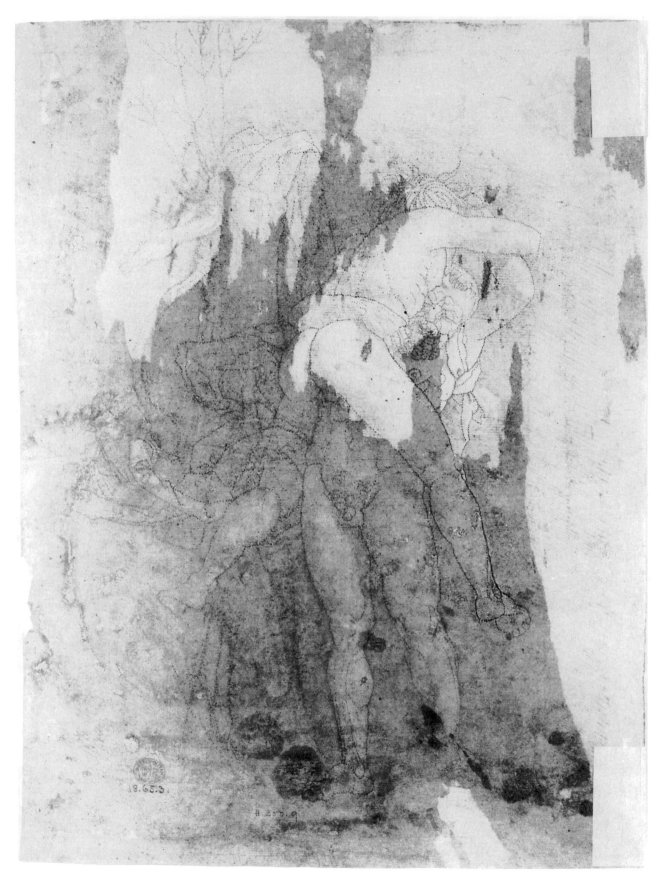

Figure 113. Verso of Hercules and Antaeus *engraving, showing pricked outlines and rubbed black pouncing dust.*

Castelli (J. Paul Getty Center inv. 880209, GJPA88-A274, Los Angeles) includes at least twenty-one pricked engravings and etchings, which date from the mid-sixteenth to the late eighteenth century and which were produced by a wide variety of European artists, not only Italian. In some cases, even their corresponding "substitute cartoons" survive.

Selectively Pricked Drawings

Although it is difficult to deduce when exactly a design was mechanically traced, it is often apparent whether it was the author of a design who did so or subsequent copyists who "transcribed a foreign language which they did not understand," to paraphrase Francesco Milizia's words in 1797.[226] The interpretation of visual evidence, however, is often arguable, and conclusions must therefore remain tentative. Drawings, prints, and book or manuscript pages pricked selectively – that is, isolated motifs transferred, rather than entire designs – generally do seem to betray the hand of the scavenging copyist at work. As noted in Chapter Two, small oversights, whereby a particular detail was left unpricked, naturally arose in the mind-numbing process of pricking the outlines of a design, particularly if it was large or complex. By contrast, the presence of pricked outlines on a motif of a larger composition whose design is otherwise unpricked is usually not accidental. An artist may well have begun pricking a design but may have abandoned the task *in medias res*. A possible example of such a change of plan occurs in an unfinished cartoon fragment from 1520 to 1525 by the Parmese painter Michelangelo Anselmi (Fig. 48).[227] It is nearly the size of a *foglio reale* and portrays the full-length figures of two female saints and a kneeling monk in a scene of a *Crucifixion*. The female saints are in parts highly modeled with charcoal, whereas the figure of the kneeling monk remains relatively sketchy. Only the upper portions of the female monastic saint's figure, standing in the center, are pricked.

The situation is markedly different, however, in Raphael's pen and ink *modello* for the left part of the *"Borghese Entombment"* (Fig. 114), from 1506 to 1507.[228] Its compositional elements are all complete and the design is squared proportionally with two grids – an important factor in our reading. The grid in red chalk over stylus ruling (in squares of 28 mm.) precedes the drawing on the sheet, as it lies underneath all layers of medium, while the grid in pen and ink (in squares of 24 mm.) lies on top of all layers. This demonstrates that the drawing resulted from a synthesis of previous studies, which the artist had probably drawn in a different scale; the *modello's* design was, in turn, enlarged for further elaboration, possibly to the full scale of a cartoon. Despite extensive passages of careful cross-hatching, the technique of pen and ink drawing seems somewhat crude, as is typical for rough, relatively large working drawings in this medium. Only the outlines of the head and a small portion on the top of the right shoulder of one figure – the man bearing Christ's body, who stands on the extreme left – are very finely pricked. Such careful selectivity is unique in Raphael's vast corpus (about 61 pricked and/or pounced drawings). Moreover, the pricking in the *modello* for the *"Borghese Entombment,"* although fine and dense, seems to misunderstand the forms of the face emerging from the chiaroscuro. A view of the sheet from the verso, where there is no drawing to detract attention from the perforated outlines, reveals the incompleteness of the "pricker's" attempt. The left contour of the man's face is slightly jagged, the area of the nose and mouth bordering on the grotesque, and the description of the right part of the cranium appears somewhat haphazard. Raphael's use of the two squaring grids in drawing the composition further establishes that there was little reason for the artist, or a member of his *bottega,* to have pricked this tiny detail of the drawing as part of the creative design process.[229]

Still more obvious examples of the scavenging copyist's work emerge in Francesco Parmigianino's drawings, as in a sheet from around 1522–24, the moment of the fresco decorations in the Rocca at Fontanellato, with compositional studies for an *Adoration of the Shepherds* on the recto, and a group of playing *putti* on the verso (CBC 181).[230] On the upper right of the verso, there is also a separate, relatively finished bust-length study of a *putto* in red chalk. This is the only motif on Parmigianino's entire sheet that has pricked outlines. In design, it is reminiscent of the full-scale study for the Christ Child (Graphische Sammlung Albertina, Vienna), preparatory for the monumental *Madonna and Child with Sts. John the Baptist and Jerome* (National Gallery, London), dated 1527.[231] The area on the sheet's recto, that which corresponds to the pricked drawing of the *putto's* bust on the verso, is heavily rubbed with black pouncing dust. Parmigianino's motif was thus clearly reused in reverse orientation, possibly by a printmaker. Not coincidentally, the smiling head of the *putto* is both a pleasing figure and the most attractively finished drawing on the sheet;

its delicately modeled chiaroscuro contrasts with the roughly sketched compositional drafts.[232] At best, the pricked outlines oversimplify the drawn form; at worst, they betray the artist's intentions.[233]

Determining the function of more creative copies can raise problems of unusual complexity. Parmigianino's Uffizi sheet with two bust-length studies (Fig. 115), placed side by side, portrays one of the sons of Laocoön in the celebrated Hellenistic marble group (Vatican Museums).[234] The artist produced this exquisite freehand copy during his stay in Rome (1524–27). To dramatic effect, he played off the dense, dark brown ink and washes with white gouache highlights, all applied with the tip of the brush, against the blue-gray color of the paper. Only the head and left neck contour of the left figure in the sheet are pricked, so finely as to be nearly imperceptible; curiously, the right neck and shoulder contours of this figure are not pricked.[235] There is no evidence of rubbed pouncing dust on the drawing. An identical head appears in two versions of the artist's etchings of the *Entombment,* dated around 1527–31 (Fig. 116), which are mirror images of each other with small variations; at least twenty preparatory drawings for these etchings survive.[236] In the sheet of studies at the Uffizi, the bust on the left is the more finished of the two, although drawn in a smaller scale; it does not correspond in size to the figure in the etchings, as has been pointed out.[237] Comparison with Parmigianino's other extant studies after the *Laocoön,* which are in red chalk, shows that his choice of a strong chiaroscuro medium for the Uffizi drawing was purposeful. (Sixteenth-century artists commonly used red chalk to draw detail studies after the Antique or the living model.) Thus, based on the medium and the plastic conception of form, we can probably conclude that Parmigianino prepared the Uffizi sheet of studies for a chiaroscuro woodcut, that he either never executed or that is no longer extant.[238] The ideas for the chiaroscuro woodcut, in turn, may have led Parmigianino to the figure in the etchings of the *Entombment.*

Although the exquisitely produced *Entombment* etchings are in mirror images and although printmakers

Figure 114. Raphael, modello *for the* Entombment of Christ, "The Borghese Entombment" *(CBC 243; Gabinetto Disegni e Stampe degli Uffizi inv. 538 E, Florence), partially pricked.*

often pricked drawings to reverse their designs for the printing process, it does not seem likely that Parmigianino pricked one of the heads in the Uffizi drawing (Fig. 115) merely to reverse it. Such a piecemeal approach to the problem of designing a composition seems contrary to the dazzling fluency of invention evident in the artist's preliminary drawings, from early on in his short career.[239] The pricked motif in the Uffizi sheet represents a small portion of a relatively small figure that is treated as a fragment. The artist never intended to make studies of the entire figure of the youth, for, on the sheet, the two studies of him overlap, and the drawing of his forms fades away along the lower border, a quality that is especially evident in the right contours of the left study. Like most artists of his generation, Parmigianino preferred the quicker method of *calco* rather than *spolvero.*[240] Because the pricked motif in the Uffizi drawing portrays a head (rather than a full figure or an entire composition), we may suspect that a scavenging copyist, here as elsewhere, selected the more attractive

Figure 115. Francesco Parmigianino, studies for the Bust of a Youth *(CBC 182; Gabinetto Disegni e Stampe degli Uffizi inv. 743 E, Florence), partially pricked.*

and detailed study on the sheet for pricking.[241] In Rome, Parmigianino had begun to produce finished "presentation drawings," a practice he would continue to refine during the last decade of his life in Parma, where he returned in 1530. His drawings would be much copied in the Cinquecento, and his work much reproduced by printmakers.[242] Vasari indeed restrained his *campanilismo* enough to praise the Parmese artist as one of the most celebrated *disegnatori* of his day: in Rome it was said that "Raphael's spirit had passed into Francesco's body."[243]

Copies after Copies

The use of *spolvero* for replicative purposes, however, did not cease with the doctoring of great "old master" drawings.[244] As extant sheets can show, pricked copies after drawings by famous artists served in turn to generate further copies. A number of fastidiously finished copies with outlines entirely pricked also illustrate a growing taste for "presentation" types of drawings, a genre at which Michelangelo excelled in the 1520s to 1540s.[245] Indeed, the large number of copies after the

great artist's celebrated life studies and "presentation drawings," a subject unto itself, confirms that copies begot more copies. Scientific investigation of such cases may turn up surprising proof of semimechanically produced underdrawings, for the increasing interest of early collectors in Michelangelo's graphic *oeuvre* encouraged the copying of his works.[246] Vasari described how he obtained examples of Michelangelo's draughtsmanship for his *Libro de' disegni;* according to the biographer, Michelangelo produced drawings for Tommaso de' Cavalieri specifically to teach him how to draw.[247] Vasari's *Vita* also records that the great artist drew compositions for the friends of Tommaso, at the latter's request.

An exact copy after Michelangelo's highly rendered red chalk drawing of *Samson and Delilah* is pricked (Fig. 117), whereas the autograph version (Ashmolean Museum, Oxford), which probably dates from the 1530s, is not.[248] In identical scale as the original, the copy imitates Michelangelo's drawing technique to a disturbing degree, even in its use of slight traces of preparatory stylus underdrawing. In the copy (Fig. 117), however, there are inconsistencies between the drawn and pricked outlines, which suggest that the "pricker" partly misunderstood the logic of Michelangelo's original design. For instance, the pricking on the fingers of Samson's right hand is confused and dense; it barely follows the drawing. Not surprisingly, in the Ashmolean sheet, this detail appears only roughly sketched. Further discrepancies of pricking occur in the triumphant figure of Delilah: her head, torso, and right foot. Also, neither the upper portion of Samson's ear nor part of his pubic area was pricked. The copy must have thus been pricked for reuse, hardly surprising considering how much Michelangelo's contemporaries admired his drawings. A small pricked drawing in the *Codex Resta,* after Michelangelo's *Judith and Holofernes* (CBC 345), the fresco on the southeast pendentive of the Sistine Ceiling (1508–12), is a relatively accomplished copy.[249] It similarly attests to the great appeal of Michelangelo's *"inventioni."*

A final, and considerably cruder example is a relatively finished Lombard copy after Raphael's *Death of Ananias* (CBC 280), in which a copyist of the copyist

Figure 116. Francesco Parmigianino, The Entombment of Christ, *etching, second version, second state (Bartsch XVI.8.5, Metropolitan Museum of Art, Harris Brisbane Dick Fund, 1927; 27.78.2(31), New York). The bust of the youth in Fig. 115 can be recognized on the extreme right.*

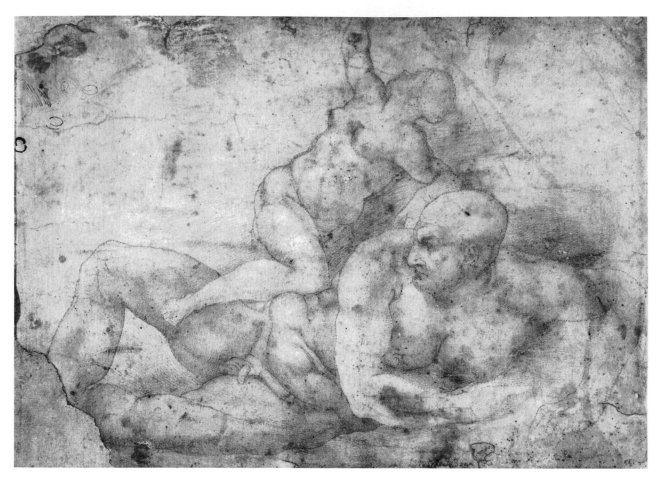

Figure 117. Copyist after Michelangelo, pricked version of Samson and Delilah *(CBC 189; British Museum 1946-7-13-365, London). The original unpricked drawing by Michelangelo is in the Ashmolean Museum (inv. P II 319), Oxford.*

appears to have pricked only the outlines of the foreground figure of Ananias.[250] This anonymous drawing is itself based on the famous small-scale chiaroscuro woodcut by Ugo da Carpi, reproducing Raphael's celebrated and much copied *inventione*.[251] Ugo da Carpi (c. 1480–1520) was among the most skilled reproductive printmakers of Raphael's and Parmigianino's work. Prepared in 1514–16, Raphael's monumental cartoon for the Sistine Chapel tapestry (Victoria and Albert Museum, London) shows the design in reverse with respect to both the much-smaller-scale reproductive woodcut and the Lombard drawn copy; the original tapestry woven from that cartoon in Pieter van Aelst's workshop is in the orientation of both small works but would have been fairly inaccessible to a copyist. In summary, our anonymous Lombard sheet represents a copy after a copy, which in turn was partly pricked by another copyist who hoped to produce yet a further replica.

The visual evidence thus opens a Pandora's box of problems – the troubling extent to which artists, craftspeople, and copyists utilized *spolvero* as the basest means of manifold design reproduction.

THE CENSURE OF
COPYING PRACTICES

A Bad Reputation

A more complete frame of reference may be sought in Renaissance and Baroque treatises. If techniques of mechanically aided copying are placed within the general context of design replication and appropriation, it soon becomes evident that our relative ignorance about a number of mechanical and semimechanical devices appears rooted in a long-standing prejudice against them.

Of note, although art treatises from the period only reluctantly seem to have discussed semimechanical methods of copying designs, popular craft treatises amply recommended them to the self-taught amateur. The striking contrast in attitude that emerges between "high style" and "low style" forms of writing on art suggests that the silence, particularly by Italian art theorists, was high-minded and purposeful. It may well have been a canonical stance, another facet of the rigidly moralistic notions of artistic "decorum" crystallizing during the sixteenth century. For a variety of complex reasons, the discussion of concrete design practices, for instance, does not even merit a place in Federico Zuccaro's long, pedantic exposition on *"disegno esterno."* In Book II of *L'Idea de' pittori, scultori, et architetti* (Turin, 1607), this is the aspect of drawing and design Zuccaro considered practical.[1] By the end of the Cinquecento, the prolific artist and author was the most influential pedagogue of his generation: the elected president of the *Accademia del Disegno* in Rome and Florence and a member of such other *accademie* as the *Insensata* in Perugia and *Innominata* in Parma. At least in this narrow respect, Zuccaro's silence represents the position of mainstream sixteenth-century art theorists. Their premise is neatly summed up by the two interlocutors who are painter's assistants in Gian Battista Volpato's *Modo da tener nel dipinger,* a dialogue on the actual "how

to" practices of painting, known only in manuscript. As Silvio there comments, during the course of a leisurely dinner, after having toasted the *"padroni"* (masters) who employ him and his elder, more experienced colleague, "if *they* discuss painting, *they* would not write about these subjects that pertain neither to art nor to the artist, which would be an indecorous *[indecente]* thing, because our practices [those entrusted to assistants] are base and mechanical *[vili e mecaniche],* requiring no other skill *[arteficio]* than the work of the hands *[lavorar di mani]."*[2] Written in Bassano in 1670–1700, Volpato's *dialogo* offers in a sense a belated, "low style" foil to the mid-sixteenth-century Venetian tradition of *dialoghi* that explore various "noble" aspects of painting – those by Paolo Pino (1548), Michelangelo Biondo (1549), and Lodovico Dolce (1557).[3]

Broadly speaking, the prejudice against semimechanical copying techniques, as it emerges from the written sources, arose from two impulses: (1) the debate about the propriety of such techniques in the artist's *bottega* and (2) the abuse of such techniques by low-skilled artisans, copyists, and amateurs. Seen as a whole, the topic raises significant questions concerning the general status of copies in artistic production and emphasizes how little we understand the manner in which such methods were perceived within the larger context of Renaissance and Baroque design practice. Although a detailed consideration of the problem excedes the scope of this book, we may take the liberty here of sketching out an argument.

Treatise Writers Qualify Methods of Copying

The use of mechanical devices in and of itself was often deemed detrimental, because it developed overdependence. Proponents and detractors, from Leon

Battista Alberti (1404–1472) to Francesco Milizia (1725–1798), heatedly aligned themselves in a debate that apparently lasted more than three centuries and that has hitherto gone unnoticed in the literature. Its sum, however, cannot be known, for the written evidence is sadly fragmentary, and the full history of such devices is yet to be written.

Acisclo Antonio Palomino's *El museo pictórico y escala óptica* (Madrid, 1715–24) explains several methods of copying semimechanically: tracing the outlines of paintings with lake pigment onto translucent paper, *("tomar los perfiles con carmín"),* pouncing designs for transfer *("estarcir"),* and using a black silk veil on a stretcher to trace with gesso *("velo negro").*[4] Palomino qualified especially the usefulness of pouncing in cases "like portraits, which are [regularly] repeated, or an exquisite [design] element that is to be copied exactly, and be repeated many times."[5] Yet it is precisely in this context that Palomino also warned against making the practice of tracing a habit. Tracing is "harmful to those who wish to progress, and thus they must avoid it as much as possible, because it impedes the practice of drawing." Rather, as Palomino urged, artists should use the squaring grid *("cuadrícula").* The Spanish theorist's preference for the squaring grid is most significant.

The Squaring Grid and the *"Giudizio dell'Occhio"*

Although Leon Battista Alberti did not mention cartoons, or their transfer, in his painting treatise (MS., 1435–36), he described how, as an aid in drawing, artists could use the *"velum"* or *"velo"* (veil), which in the earlier Latin version of the treatise he claimed to have invented.[6] In his biography of Alberti, Vasari confirmed the claim.[7] Between the eye and the object to be copied, the artist placed a thin cloth veil, presumably stretched across a frame and with large threads woven in the configuration of squares, to serve as coordinates. According to Alberti, the *"velum"* taught painters to perceive correctly the subtleties of relief, perspective, proportion, and outline. Importantly, however, Alberti felt compelled to defend the veil's use against what were presumably contemporary attacks: "I will not listen to those who say it is not good for a painter to get into the habit of using these things, because, though they offer him the greatest help in painting, they make the artist unable to do anything by himself without them. . . ."[8] As discussed in Chapter Six, the grid became indispensible to *"prospectivi"* (masters of per-

spective), and perhaps the controversy alluded to by Alberti helps explain the reason why there are so few extant squared designs by artists who worked between the 1420s and 1490s, a fact that, although sometimes noticed, has hitherto gone unexplained.

In Paris MS. A (fol. 104 recto), in a passage written in 1490–92, Leonardo recounted a procedure similar to Alberti's but that he intended for drawing a nude male model.[9] At a distance of 7 *braccia* from himself and 1 *braccio* from the model, the draughtsman placed a *"rette"* (net) or *"telaro"* (loom), consisting of a grid of squares woven with threads onto a frame, 3 1/2 *braccia* high by 3 *braccia* wide. The sheet of paper was lightly squared with a corresponding grid. As he visualized the figure through the *"telaro,"* the draughtsman then marked with a pellet of soft wax a vertical thread that passed through the throat, if the model faced frontally, or a vertebra of the spine, if the model posed from the back. This fixed reference point, together with the squares, served to picture the main axis for the body and its horizontal alignments. If the articulation of the limbs was thus correct, the model's pose would appear convincingly portrayed. A number of squared, single-figure drawings after the living model by Florentine artists exist from the last decade of the Quattrocento and the first two decades of the Cinquecento. These drawings confirm the popularity of Leonardo's recorded practice. Here, among the visually compelling examples are Sandro Botticelli's study for *Pallas* (Fig. 118), which, because it relates to a tapestry commissioned in 1491 by Gui de Baudreil, Abbot of Saint-Martin-aux-Bois,[10] must be almost exactly contemporary with Leonardo's passage; Fra Bartolomeo's sheet of studies from around 1512 for a *St. Bartholomew;* and Jacopo Pontormo's study for the *Archangel Gabriel* from 1527 to 1528.[11] Equally important for the dissemination of theory and practice is the complex variation on Leonardo's general exercise illustrated in the 1538 edition of Albrecht Dürer's treatise on measurement (see Fig. 122). Later still, Bernardino Campi's *Parere sopra la pittura* (Cremona, 1584, though probably prepared around 1557) would expand on the principle of Leonardo's exercise, wrapping it neatly with the theory of human proportion. As published and illustrated in Alessandro Lamo's *Vita* of Campi in the *Discorso* (Cremona, 1584), Campi recommended that in drawing, the proportions of a mannequin *("una figura di rilievo di cera"* or *"gesso")* were to be calibrated with respect to both the squaring grid of a *telaro,* through which the figure was seen, and the proportional squaring drawn on the sheet of paper.[12]

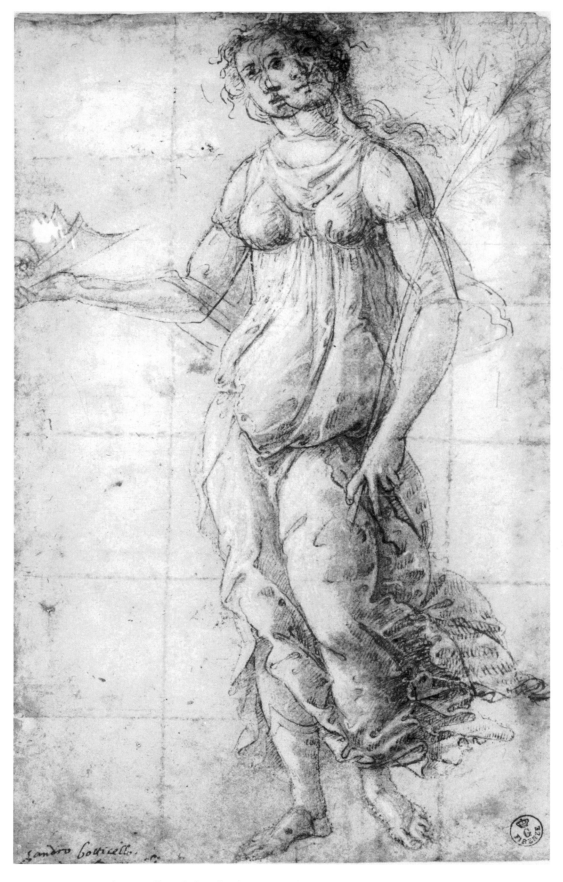

Figure 118. Sandro Botticelli, study for Pallas (CBC 24; Gabinetto Disegni e Stampe degli Uffizi inv. 201 E, Florence), squared twice in charcoal, underneath and on top of all layers of drawing, and outlines selectively pricked.

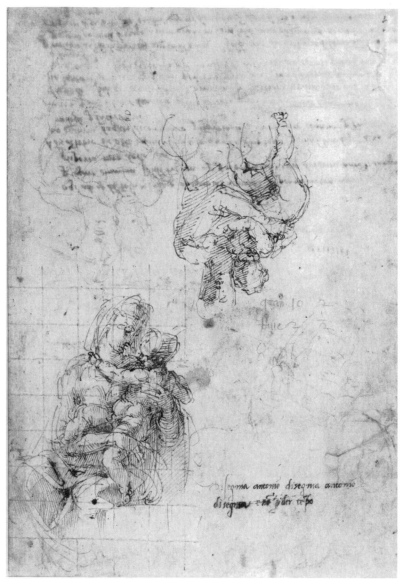

Figure 119. Michelangelo and pupil (probably Antonio Mini), studies for a Madonna and Child (British Museum 1859-5-14-818 recto, London). The lower left pen and brown ink study on the sheet is faintly squared in black chalk, with didactic numbering on the grid. On the lower right, the sheet is inscribed by Michelangelo in the same ink as the studies: "Disegnia antonio disegnia antonio / disegnia e no[n] p[er]der te[m]po." In translation, "draw Antonio, draw Antonio / draw and do not waste time."

In sum, from what can be reconstructed, Leonardo's precepts about copying, together with his "method of drawing a place accurately" in Paris MS. A (fol. 104 recto), show that he sanctioned the use of tracing and copying aids as devices to exercise *"giuditio d'ochio"*; they enhanced the study after nature.[13] For Alberti, as

for Leonardo and a number of later art pedagogues, theoretical rules and practical devices provided the structure that made learning possible.

As a reference aid, the squaring grid was, as we can see, the guiding principle of Alberti's *"velum"* and Leonardo's *"rette"* or *"telaro."* Among methods of copying, the squaring grid was the least mechanical, short of drawing freehand *"a occhio"* (with the unassisted eye). The use of the device required concentrated attention, and by comparison to other methods it developed visual judgment, or eye–hand coordination (Fig. 119). This is the gist of both Alberti's and Leonardo's advice. The squaring grid, called *"rete"* in Filippo Baldinucci's *Vocabolario ... del disegno* (Florence, 1681) and *"graticola"* in both Gian Paolo Lomazzo's *Trattato dell'arte della pittura* (Milan, 1584) and Gian Battista Volpato's *Modo del tener nel dipinger* (MS., 1670–1700), was the most effective device in magnifying or diminishing the scale of designs, before the invention of the pantograph.[14] This is, for example, one of the reasons why, in the sixteenth century, many German and Venetian embroidery patternbooks would depict the designs over reticulation, the other being that the grid helped keep count of stitches. Giovanni Ostaus's description in *La Vera perfettione del disegno di varie sorti di recami* (Venice, 1557) helps document such applications of the grid for artisans.[15]

Most importantly, as is explicit in Bernardino Campi's *Parere*, the squaring grid shared a noble history with the study of proportion and perspective.[16] In the actual practice of Italian artists, this history more or less begins with the early, innovative examples of Masaccio's *Trinity*, from 1425 to 1427, in which the Virgin's figure is incised with a grid of squares and rectangles, and Paolo Uccello's preparatory drawing in color for the *Cenotaph of Sir John Hawkwood*, from 1436, which is squared with the stylus throughout (see Figs. 172, 175). The grid of proportional squares was an integral part of constructing a perspective space, being thus prominently discussed or illustrated, for example, in treatises from Leon Battista Alberti's *De Pictura* and Piero della Francesca's *De*

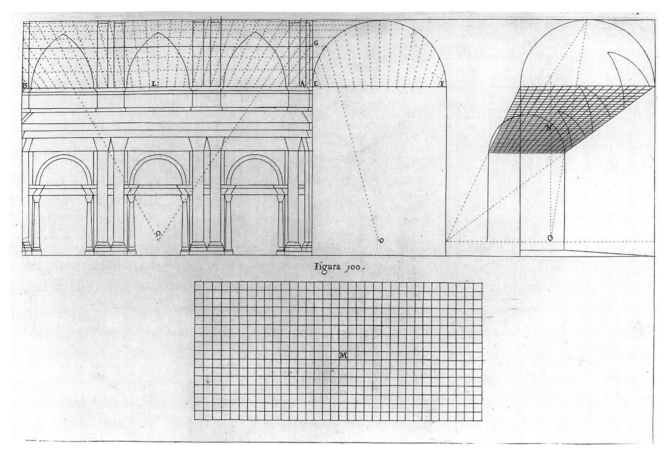

Figura 100.

Figure 120. Andrea Pozzo, Perspectiva Pictorum et architectorum, Rome, 1693–1700, I, plate 100 (Metropolitan Museum of Art, Harris Brisbane Dick Fund, 1947; 47.73 (1), New York). This engraving shows the proportional squaring grids necessary to paint compositions on a curved vault.

Prospectiva pingendi (MS., before 1482) to Pietro Accolti's Lo Inganno degl'occhi (Florence, 1625) and Andrea Pozzo's Perspectiva Pictorum et architectorum (Rome, 1693–1700; Fig. 120). Further, as a crucial auxiliary element in the projection of perspective, the grid of proportional squares would provide the cornerstone for many methods of creating anamorphic images. Such treatises as Daniele Barbaro's La Pratica della perspettiva (Venice, 1569), Gian Paolo Lomazzo's Trattato dell'arte della pittura (Milan, 1584), and Jean François Niceron's Thaumaturgus Opticus (Paris, 1646) and La Perspective curieuse (Paris, 1652) delve into this playground of optical research. And, as already pointed out, regarding Cesare Vecellio's woodcut of "quadrature," the squaring grid became the predominant method of transfer used by Venetian and Baroque painters, key exponents in the tradition of illusionistic painting (Figs. 13, 20–21, 120–21).[17] As Andrea Pozzo explained in his "Breve instruttione per dipingere a fresco:" "when large and irregular areas must be painted, such as churches, rooms, or curved vaults [volte storte], for which cartoons [carte così grande] cannot be made or spread out, it is necessary to utilize squaring [graticola-

tione], which is very useful for transferring from small to large. The perspectival grid [graticolatione prospettica] is likewise necessary especially in vaults and other irregular surfaces, to make architecture portrayed in perspective appear straight, flat, or upright."[18] For "prospectivi," the squaring grid required no justification (Figs. 120–22, 172, 175).

The opposing camp in the debate about the squaring grid appears to be first represented in the Disegno, a short dialogue published in Venice (1549) by the Florentine expatriate writer, Anton Francesco Doni. Doni's narrator objects to the squaring grid, as well as to other aids, "because it makes the practice of the hand lazy, and it very much deceives or delays the eye's true judgment (il vero giudicio dell'occhio)."[19] "Giudizio dell'occhio" is one of the critical notions that both sixteenth-century and modern writers have most

strongly associated with Michelangelo; toward the beginning of Chapter Three, we encountered both Leonardo's and Baldinucci's use of the phrase.[20] Anton Francesco Doni (1513–1574) descended from Angelo Doni, the patron who commissioned Michelangelo's famous *tondo* of the *Holy Family* (Galleria degli Uffizi, Florence), sometime between 1503 and 1506; Anton Francesco's dialogue and letters glow with praise for Michelangelo.[21] Moreover, in his biography of Michelangelo, Vasari attributed to him the dictum that "it was necessary to have the compasses in the eyes *[seste negli occhi]* and not in the hand, because the hands work and the eye judges."[22] In this regard, as well, Vasari saw Michelangelo's master, Domenico Ghirlandaio, as a precursor. Speaking in the *Vite* about Ghirlandaio's drawings after the antiquities of Rome, the biographer praised Ghirlandaio's awesome *"giudizio dell' occhio."* It was so exact *("giusto")* that he produced such drawings merely by eyeing the models *("a occhio"),* without rulers, compasses, or measurements, and afterward, upon comparison of the drawings with their models, the measurements of the drawings proved to be as accurate as if he had in fact measured the models.[23] According to this rhetoric (and in deliberate contrast to

Figure 121. (Above) Jacopo Tintoretto, detail of squared study for a Male Nude in Foreshortening (Gabinetto Disegni e Stampe degli Uffizi inv. 12938 F, Florence).

Figure 122. (Below) Albrecht Dürer, Die Underweysung der Messung, Nuremberg, 1525 (Kupferstichkabinett inv. SMPK, Staatliche Museen, Berlin). This woodcut illustrates how an artist can draw the foreshortened form of a female nude through a frame with a squaring grid of threads onto a drawing surface.

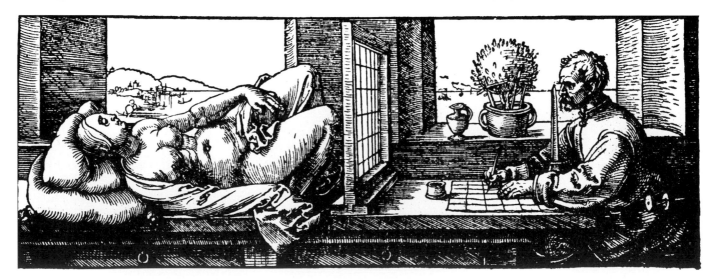

the pedagogic approach of both Alberti and Leonardo), artists were clearly either born with *"giudizio dell'occhio,"* or not. It could be refined, but it could hardly be taught *ex novo*. Even modest, early-sixteenth-century Venetian craftspeople appear to have recognized – if at a rudimentary level – that visual judgment guided the hand's work in this Platonic sense of *"idea,"*[24] for, as Giovanni Antonio Tagliente advertised in his patternbook (Venice, 1527), to a readership consisting almost entirely of women and young boys teaching themselves to draw designs for embroidery, "likewise with these precepts, and by measuring with the compass in hand, or rather with the subtle compass of your eye *[col sesto dell'occhio vostro acuto]*, you can construct and prepare [for embroidery] any type of knot-work."[25]

Seen against this background, it is clear that Giovanni Battista Armenini's championing of the grid was not accidental, and much like Alberti, Armenini felt obliged to justify this method's efficacy in his *De' veri precetti della pittura* (Ravenna, 1586). In recommending proportional squaring grids for enlarging a design to cartoon scale (see Chapter Two), Armenini alleged against those who say that it is harmful to use the grid *("grata")*, that it was not sufficient to rely on judgment *("giudicio")*.[26] Probably through his personal acquaintance with Giulio Romano, Armenini had become familiar with the design practices of Raphael and his workshop, who relied on the squaring grid extensively to enlarge the design of *"modelli,"* as is attested by a substantial corpus of such squared drawings. Another prolific user of the squaring grid was Jacopo Tintoretto, with whose work Armenini was also acquainted but of whose working methods Armenini did not always approve (Fig. 121).[27] Moreover, as has been astutely remarked in an entirely different context, Armenini did not include Michelangelo in a list of exemplary artists who proceeded correctly in preparing cartoons, because of the disagreement regarding the grid.[28] If the source and exact nature of this significant contention must remain largely speculative, it may be added that "where there is smoke, almost certainly there is fire," as a contextual reading of both Doni's and Armenini's treatises can attest. Further, in the introduction to the *Vite,* Vasari had apparently regarded the grid system *("rete")* necessary only to transfer such difficult aspects of a composition as perspective or architectural views.[29] This is the only context in which Vasari briefly alluded to the practice. And, as noted in Chapter Two, he abruptly ended his discussion of perspective designs, claiming

that they were too difficult to describe with words. As usual, Vasari's silences speak volumes. Raffaele Borghini's *Il Riposo* (Florence, 1584) follows the content of Vasari's passage exactly, down to the rhetorical device.[30] Here, it is worthy of our notice that Michelangelo, who claimed that the compass of measurement resided in the eye and who thus accepted only *"il giudizio dell'occhio"* as an aid in drawing, seems to have used squaring grids rarely, if ever, in his own preparatory studies (Fig. 119).[31] Further, by Michelangelo's own account, neither the pictorial rendering of architecture nor the scientific projection of perspectival space much interested him: just about the only attempt by him is the projection of the fictive architectural framework on the Sistine Ceiling (1508–12), rendered from multiple viewpoints. Vasari had published the first edition of his *Vite* when Michelangelo was seventy-five years old, the second edition only four years after the great artist's death. He had enshrined Michelangelo as the consummate *disegnatore* of all time, often looking to him for an authoritative model of theory and practice.

"Corrupt *Disegno*"

In the *Dizionario delle belle arti del disegno* (Bassano, 1771), the influential Neoclassical critic, Francesco Milizia, concluded his definition of *"calcare"* (stylus tracing) by nearly damning this technique: "he who traces [with the stylus] without knowing how to draw, transcribes a foreign language which he does not understand. It is impossible that he shall not commit errors. Wherefore tracing is no good for anything, and of little use to him who knows. Its speed is of use to engravers, but they know the drawing. Therefore, very few should trace."[32] The issue was not that mechanical methods were not to be used. This was often in practice quite unavoidable. Rather, they were to be used advisedly, and only by those who understood their limitations – for instance, Milizia's *Dizionario* concedes that stylus tracing was of service to engravers. Earlier, Baldinucci's *Vocabolario* (Florence, 1681) had provided balanced testimony in describing different techniques of *"lucidare"* – tracing to be done with translucent paper, transparent fish glue resin, mirrors, or black silk veils. There, the author first admonished, "all inventions, which, adopted by those who know little, yield little fruit, because the most exquisite subtleties of outline, which constitute the perfection of *disegno,* one never finds with such instruments." Then he acceded, "I say of those who know lit-

tle, because the excellent artists can usefully resort to them, obtaining from a tracing the [general] outline of a whole, and afterward rendering the parts to perfection with a masterful hand."[33]

Baldinucci understood, as a Florentine reared in the *disegno* tradition would, that the greatest injury to draughtsmanship lay in the corruption of contours.

Techniques of "Lucidare"

During the sixteenth and seventeenth centuries, copyists would shamelessly exploit the practice of *"lucidare"* or *"dilucidare"* (tracing with translucent paper) to produce copies from the paintings by Federico Barocci (c. 1535–1612), an artist famous, not least, because of the expressive force and dynamic *"grazia"* of his figural compositions.[34] As we have seen, the technique of *spolvero,* like that of *lucidare,* was applied to equally reprehensible ends. Repeated references to *spolvero,* in fact, occur within descriptions of tracing designs with translucent paper. The gist of such procedures was that the copyist could trace the desired image onto paper and then could prick and pounce it onto a new working surface. This type of advice turns up, for example, in a note by Leonardo in Paris MS. A (c. 1490–92), as well as in the treatises by Felipe Nunes (Lisbon, 1615), Vicente Carducho (Madrid, 1633), Claude Boutet (Paris, 1676), Acisclo Antonio Palomino (Madrid, 1715–24), and Charles Germain de Saint-Aubin (Paris, 1770).[35] Still more treatises relate the same basic principle, but these substitute the technique of stylus tracing for that of pricking and pouncing.

The specific practices described in these sources merit some attention, because it has proved difficult thus far to identify drawings that appear to exemplify them. Among the procedures offering a greater creative application is that in Leonardo's note in Paris MS. A (fol. 104 recto), from 1490 to 1492, a "method of drawing a place accurately."[36] This is an experiment also recounted in Felipe Nunes's *Arte poetica* (Lisbon, 1615), which includes even an adaptation of the practice for depicting portraits.[37] The use of the practice for portraiture may well have originated with Leonardo, though none of his extant notes records it; a woodcut in Book IV of the 1525 and 1538 editions of Albrecht Dürer's *Die Underweysung der Messung* illustrates it, with the caveat that "such is good for all those who wish to make a portrait *[jemand ab conterfeien],* but who cannot trust their skill."[38] The point of

the exercise was to ensure a precisely proportioned design. According to Leonardo and Nunes, the artist first traced a view of a landscape, city, object, or person onto a pane of glass with paint brush or chalk, then traced this design, again, from the glass onto transparent paper. The design on tracing paper was, in turn, pricked and pounced onto normal drawing paper.

To save labor, Saint-Aubin's *L'Art du Brodeur* would recommend making multiple pricked tracings *("poncifs")* from carefully drawn embroidery designs, to give to the embroiderers for execution.[39]

In sum, the practices mentioned by Leonardo, Nunes, and Saint-Aubin may be regarded as "functional" in the art or craft process, for the *"invenzione"* of the image was either selected from nature or was entirely the product of the designer's imagination.

"Indecent" Practices

By contrast, Carducho in 1633 and Palomino in 1715–24 highlighted the exploitative aspect of tracing.[40] In Carducho's *Diálogos,* in fact, the only allusion to pouncing *("estarcir")* occurs not in the discussion of either cartoons or the techniques of fresco, tempera, and oil painting, but in a passage on *"perfiles"* – "line drawings without shading." According to Carducho, artists could trace a composition or figure from a painting with translucent paper, either by penciling through the outlines directly onto the tracing paper, placed on top, or by first smearing the outlines of the painting with lake pigment *("carmín"),* which, on contact with the tracing paper, left a reversed imprint of the image.[41] The outline design, obtained with either method, could be pricked and pounced for use, in turn, as a cartoon on the primed painting surface. The clear assumption in Carducho's *Diálogos* – unthinkable in mainstream Italian discourse on theory after Leon Battista Alberti's painting treatise (MS., 1435–36) – is that *"perfiles,"* whether traced from another source or the artist's own creation, could function as a cartoon for design transfer; that exact copying was an acceptable shortcut to good design.[42] Especially, the practice of tracing with lake pigment greatly damaged the painted originals. As one of the interlocutors vehemently objects in Gian Battista Volpato's *Modo da tener nel dipinger* (MS., 1670–1700), "such people [tracers] ought to have their hands cut off as punishment for the crime of spoiling such rare gems."[43] By and large, it is

only treatises by painter-craftsmen that recommend making tracings from admired paintings for reuse in a new work – for example, Cennino Cennini (MS., late 1390s), Raffaele Borghini (Florence, 1584), and Dionysius of Fourna (MS., c. 1730–34).[44]

To the high-minded theorist, the reasons for condemning mechanically aided copying were at least twofold. On the one hand, such practices took away the challenge of invention in the art of *disegnare,* and on the other, they were basely market-driven. In a letter from 12 February 1547 to Benedetto Varchi, discussing the relative *difficultà* of various art forms, Giorgio Vasari indeed bitterly lamented the "infinite" number of fraudulent painters who exploit the technique of *dilucidare* to replicate their own works.[45] Not surprisingly, when put in a pedagogic role, Vasari remained completely silent in the *Vite* regarding *lucidare,* nearly so regarding *spolvero,* and discusses *calco* only regarding cartoons for fresco and oil painting. *Spolvero* was to be employed in *sgraffito* façade decoration, in which the repetition of ornament designs was a necessity.[46] Already by 1625, Pietro Accolti thought the practice of *dilucidare* too well known to his Italian audience to merit description in his discussion of illusionistic painting.[47] In his famous letter from 1620 to 1630 to Teodoro Amideni (Dirck van Amayden), Vincenzo Giustiniani ranked a painter who works from a *"spolvero"* (pricked cartoon that was pounced for transfer) at the very bottom of his ideal scale of the painter's talents.[48] The "pouncer" rates even lower than the copyist of paintings! And, adding insult to injury, it mattered little in Giustiniani's mind whether the copyist of paintings copied freehand *("con più lunga osservazione"),* by means of the squaring grid *("graticolazione"),* or traced with translucent paper *("dilucidazione").*[49] As a friend of painters and knowledgeable collector (notably, of Caravaggio's work), the wealthy Genoese-born Marchese Giustiniani was no doubt well acquainted with the conditions of the contemporary art market; he was probably reacting against those who used *spolvero* to appropriate the designs of others. By the late Seicento, Gian Battista Volpato's *Modo del tener nel dipinger* candidly admits to the baser motives of painter-craftsmen who relied on tracings – "I also do this, although I am not a painter, because it requires no skill in painting, but it is properly our business."[50] Works could be traced (the *spolvero* technique, however, is not mentioned) to avoid the tediousness *("fastidio")* of drawing a composition anew,[51] but also to turn a quick profit. The

elder, more experienced painter's assistant in Volpato's *dialogo* attests that a chest owned by his *"padrone"* was full of tracings from paintings by Jacopo Bassano, done by Jacopo's sons and retouched, precisely for this purpose – *"tratti dalle opere del padre, che in tal guisa ritocate da maestri corrono come sue."*[52]

The "high style" miniature painting treatises by Nicholas Hilliard (MS., c. 1600) and Edward Norgate (MS., c. 1648–50) recommended a creative approach, for drawings of the sitters and models to be portrayed were meant to be done *ad vivum.*[53] In great contrast, as proclaimed in the subtitle of his popular treatise, Claude Boutet hoped to teach amateurs the art of miniature painting quickly and "easily without a master" – *"pour apprendre aisément à peindre sans maître."*[54] As the author affirmed in the 1676 edition, those who did not know how to draw, nor had the time to learn the difficult art of design, could resort to semimechanical methods of copying.[55] Boutet described what he considered easy, up-to-date means of design transfer, and appears to have recommended them by the order of his personal preference. Thus, the interested reader could learn how to – trace the outlines of a design with a stylus, after the verso of the sheet or an interleafed "substitute cartoon" was rubbed with red or black chalk *("calquer");* apply grids of proportional squaring *("reduction au petit pied");* trace the outlines of a design with translucent oiled paper *("papier huilé"),* with the thin skin of a pig's bladder *("peau de vessie de cochon"),* or with a pane of glass *("vitre");* pounce the pricked outlines of a design *("se servir de la ponce,"* or *"poncer");* and, last, operate the newly invented pantograph (a type of *"compas de mathématique"* with rulers). Boutet even illustrated this pantograph. But, more importantly for our argument, this treatise bluntly states that miniaturists could use prints or drawings by others as designs to transfer onto the vellum or paper for painting. Though less explicitly phrased, the same assumption underlies Catherine Perrot's *Traité de la Miniature* (Paris, 1625). The design to be painted was obtained from "a print *[estempe]* or drawing *[dessein]"* that was transferred onto the vellum by means of *"calquer"* or *"poncer."*[56] Moreover, as Boutet's treatise notes, designs could even be scavenged from oil paintings, by smearing the main contours of the original with lake pigment and counterproofing them onto translucent oiled paper; then, by pricking and pouncing the outlines of the resulting tracing, the design could be transferred onto the final working surface.[57] These methods are nearly identical to the extremely

destructive practices described in 1633 by Carducho and in 1715–24 by Palomino.

The deliberate silence of many Renaissance and Baroque authors of art treatises on the subject of tracing techniques and mechanically aided copying appears thus justified. It reflects the crude conditions of a contemporary art market at its fringes: apprentices and amateurs who relied excessively on such techniques, rather than learning to draw properly; fraudulent copyists who abused such techniques to seize the inventions of more capable artists; and artisans who utilized such techniques to adapt popular subjects to their craft and repeat patterns over and over.

THE SPLENDORS OF ORNAMENT

"Pattern" and "Cartoon"

To assess the changes in workshop practice occurring from the fourteenth to the fifteenth century, a general distinction must be drawn between what constitutes a *spolvero* "pattern" and what constitutes a *spolvero* "cartoon." "Patterns" belonged to the Late Medieval tradition of stencil making. By contrast, "cartoons" emerged slowly during the 1430s as the most refined type of exploratory drawing in the new Renaissance, Central-Italian tradition of *disegno*. This general distinction between "pattern" and "cartoon" will help us chart the evolution of the *spolvero* technique from its earliest, relatively modest use in Trecento ornament painting to that in the monumental context of the human figure in the Quattrocento, in the *historia* or narrative composition – "the greatest work of the painter," as we are reminded in Leon Battista Alberti's painting treatise (MS., 1435–36).[1] The present chapter will attempt to demonstrate how Trecento ornament painting, particularly in murals, all too often neglected in surveys of Medieval and Renaissance art, formed the basis for much of what is recognized as innovative in Quattrocento design technology. Yet, seen as a whole, a historical analysis of the developments from "pattern" to "cartoon" also largely invalidates claims, sometimes made in the literature, that figural cartoons were employed in Italian painting before the Quattrocento.

Broadly speaking, the function of a pattern, unlike that of a cartoon, is the manifold, piecemeal replication of a design motif, with little or no alteration. From shortly before the mid-Trecento onward, and during much of the early Quattrocento, the *spolvero* technique was used chiefly as a shortcut to replicate repetitive decorative designs of relative intricacy. In its most positive sense, the command of an increasingly rich syntax

of ornament would transform mid- to late Trecento painting, not only in such main Tuscan centers as Florence and Siena but also in much of northern Italy. *Spolvero* would occupy a prominent place within the increasingly sophisticated technology sustaining the extraordinary flowering of "Late Gothic" ornament, along with refined gilding, *pastiglia, sgraffito,* tooling, punchwork, and stencil techniques. Trecento painters, however, prepared the figural parts of their compositions directly on the working surface. This is clear from Cennino Cennini's description in the *Libro dell'arte* (MS., late 1390s) of both mural and panel painting techniques, as well as from the ongoing scientific examination of Trecento and early Quattrocento paintings (Fig. 123).[2] The presence of *spolvero* in the ornamental parts of Italian murals from the 1340s onward firmly documents them as the earliest known examples of the technique's use in the West. Not surprisingly, the evidence in these murals confirms the replicative function that Cennino's *Libro* describes.

State of Preservation of Early Italian Murals

As will become amply evident, our reconstruction of the design technology of fourteenth- and fifteenth-century ornament depends largely on the physical evidence found in paintings, particularly murals. Here, nevertheless, problems arise. Chapter One alluded in passing to the problems of condition in many Italian Renaissance murals that obscure the interpretation of *spolvero* and other surface design techniques. The application of pigments in numerous Trecento murals was predominantly done *a secco* (literally, "dry"), rather than in *buon fresco,* that is, after the *intonaco* had undergone the chemical

Figure 123. Infrared reflectogram detail of the upper right part of St. James's draperies in Nardo di Cione, The Three Saints, *tempera and gold leaf on panel (National Gallery, London). The sparse, aqueous freehand brushstrokes over the charcoal underdrawing are more or less typical of Trecento panel painting technique.*

Francesco, Assisi).[7] On the richly detailed illusionistic tapestries, crisp, minutely pounced outlines complete the faint imprints left by the original lattice of interlacing textile motifs, painted substantially *a secco;* with time the *a secco* pigments have crumbled off the painting surface. Such intermittent areas of loss and modern "reconstruction" recur throughout the nave's *dado. Spolvero* dots also outline small repainted portions of the fictive cornice with modillions surmounting the tapestries, particularly evident on the right wall of the nave at the first bay from the altar.[8] Though the attribution and precise date of the St. Francis cycle in the Upper Church continue to be debated, its execution can safely be placed toward the last years of the thirteenth century, or, at the latest, the early years of the fourteenth.[9] Thus, if these instances of *spolvero* were original, the mural cycle would represent the earliest known example of the technique in Italy.

process of carbonation. This required the addition of a binder or adhesive for the colors. *Secco,* as is well known, is a great deal less durable than *buon fresco.* Passages retouched or executed entirely *a secco* sometimes manifest large areas of pigment loss and flaking, as well as abrasions and deep cracks on the paint surface. Whether in a *buon fresco* or *secco* medium, however, growths of microflora and salt efflorescences, caused by dampness and water damage, also frequently marr the paint layers of ornament on ceilings and on the surrounds of floors, doors, windows, and corners of architectural spaces.[3] These were the areas most susceptible to leaks in buildings.[4] Moreover, the surface texture of deteriorating *intonaci* often becomes porous and rough, a further obstruction in the search for *spolvero* dots.[5]

Related to this problematic state of preservation is a more serious difficulty, which, if unrecognized, may mislead attempts to establish the early chronology of the *spolvero* technique. Apparently, since at least the nineteenth century, mural restorers have used *spolvero* patterns to reconstruct areas of paint losses within the original designs of ornament (Fig. 124).[6] Such nonoriginal *spolvero* occurs, for instance, in small, very sporadic passages of the *dado* below the scenes narrating the *Legend of St. Francis* in the nave of the Upper Church (S.

Evidence of Ornament Patterns on Paper or Parchment

To complicate our reconstruction further, very few firmly documented examples of ornament patterns on paper or parchment survive, fewer still with pricked outlines and rendering a design in full scale. Although such examples are of a relatively late date, they offer evidence that is also probably suggestive of Trecento practices. Among the earliest examples is the famous though problematic sheet by Domenico Ghirlandaio (Fig. 125) in the Uffizi.[10] The pen and ink composition sketch on the recto was preparatory for the *Visitation* in the fresco cycle from 1485 to 1490 in the chancel (*"Cappella Maggiore,"* S. Maria Novella, Florence; see Fig. 286).[11] The fragile and much-abraded sheet also contains a fragment of an Antique-style molding comprised of rows of egg and dart motifs with palmettes, but only as pricked outlines, done from the verso (Fig. 126).[12] The design closely relates to the magnificent frescoed moldings that divide the tiers of scenes on the *Lives of the Virgin and St. John the Baptist* on the walls of the chancel. Similar egg and dart bands also frame some of the artist's earlier fresco cycles – for instance, that on the *Life of St. Fina* (Collegiata of San Gimignano) from 1473 to 1475 and that on the *Life of*

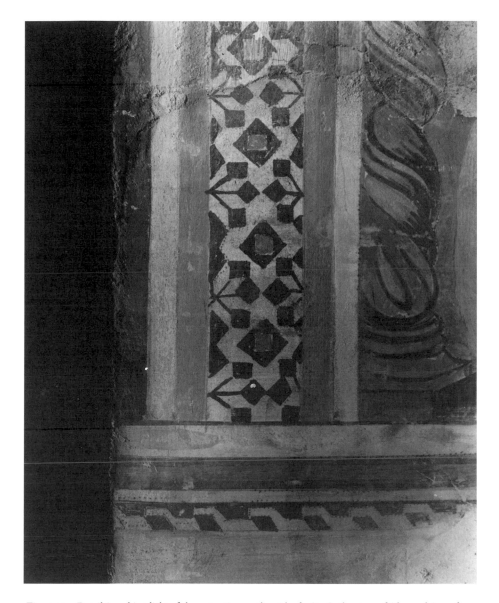

Figure 124. Detail in raking light of the restoration on the niche for St. Catherine of Alexandria, *a fresco by an artist near Andrea di Cione "Orcagna" and Nardo di Cione (S. Miniato al Monte, Florence). A modern restorer made up the losses in the original Trecento fresco by applying a patch of new plaster on top of the old layer and then completing the patterns for the lost parts of the cosmatesque border, podium of the colonnette, and bracketed cornice below, with modern* spolvero *patterns.*

St. Francis in the Sassetti Chapel (S. Trinita, Florence) from 1482 to 1486.[13]

The design in the Uffizi sheet (Fig. 125), however, represents only two bands of the complex trabeation and only a segment of its total length as portrayed in S. Maria Novella. For the egg and dart detail alone, the sheet offers three complete "repeats" (a "repeat" being one complete motif of an overall pattern). The egg and dart motif syncopates imprecisely with the band of palmettes; the latter represents three complete repeats and two halves. Faint vertical creases on the paper at either

end of the design mark the terminus for the overall composite pattern; these creases, or axes, register the period at which the entire pattern begins to recur. As portrayed in the drawing, the pattern is about 15 cm. high and 28.6 cm. long, the sheet's actual size being much larger, approximately 26 by 39 cm.[14] By comparison, the painted trabeations dividing the S. Maria Novella scenes run about 10 meters long. We cannot be sure (1) whether the Uffizi sheet itself was employed on the mural surface or indeed (2) how precisely it functioned, for this pattern is sufficiently generic and

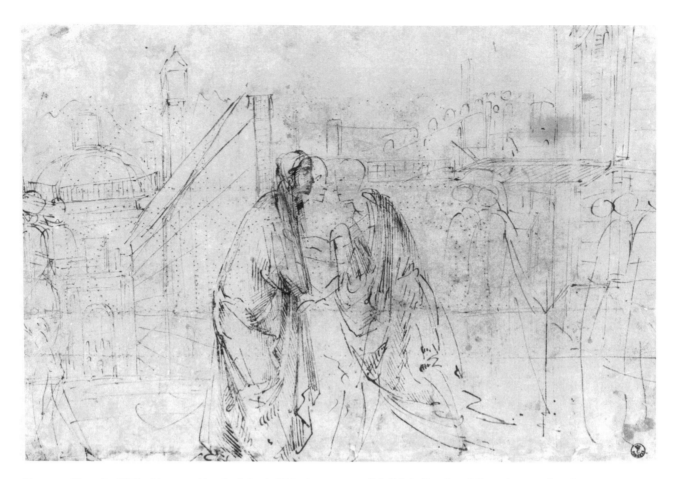

Figure 125. Domenico Ghirlandaio, composition sketch for the Visitation, *with unrelated pricked pattern of a molding done from the verso (CBC 144; Gabinetto Disegni e Stampe degli Uffizi inv. 291 E, Florence).*

fragmentary to have been merely a workshop *exemplum*. Painters generally frescoed the parts of framing elements before the parts of the scenes within them, proceeding from top to bottom more or less in layers; the sequence of *giornate* demonstrates that the S. Maria Novella frescos were no exception.[15] With the guide of stylus-ruled (or cord-snapped) horizontals to align the units, Ghirlandaio and his *bottega* could have serially replicated such pattern fragments, pouncing them side-by-side on the fresco surface, as in Trecento and earlier Quattrocento practice. Or, by pricking and pouncing to produce numerous replicas of the pattern, the *bottega* assistants could have generated larger, glued patterns for actual application on the *intonaco*. Ghirlandaio's pattern sheet still exhibits traces of pouncing dust on the recto (though much abraded as the result of cleaning by restorers), and the raised perforations, though done from the verso, are indeed blackened with pouncing dust, suggesting its use and reuse over and over.[16]

Of all Medieval and Renaissance drawing types, ornament stencils and *spolvero* patterns would have had the lowest probability of survival, since they were used so heavily. To judge from the size of Ghirlandaio's Uffizi paper pattern for the egg and dart molding, for example, it would have required pouncing an enormous number of times to obtain the length necessary to fresco just one rectangular scene at S. Maria Novella – an extremely destructive procedure. Multiple copies of a pattern would have, therefore, been necessary.[17] The patterns that might have survived such intensive use (their purpose and appearance being highly mechanical) probably did not appeal to later collectors of drawings, beyond the immediate heirs of an artist's workshop, unless such patterns, like Ghirlandaio's Uffizi design, appeared on a sheet of brilliantly drawn figural sketches. It is thus not surprising that ornament pattern drawings are extremely rare.[18]

Chinese Origins of *Spolvero* Patterns

Although the argument concerning the early application of *spolvero* in Medieval manuscripts is not persuasive (see Chapter Three), the technique first emerged in the West

Figure 126. Approximate reconstruction of the pricked outlines of the molding on the verso of Domenico Ghirlandaio's Uffizi composition sketch.

during the Late Middle Ages. We have already referred to the three pricked and heavily pounced, mid-tenth-century Chinese patterns, now in the British Museum, which Sir Aurel Stein recovered in 1909 from the *"Caves of the Thousand Buddhas"* at Dunhuang (see Chapters One, Two).[19] One of these ancient patterns exhibits, in fact, an aspect of the "substitute cartoon" procedure, for it has pricked but undrawn outlines that are unrelated to the ink designs on the sheet. The pricking on the Chinese patterns in the British Museum (Fig. 127) is most probably original: their outline designs relate closely to the painted murals found in the cave shrines. Moreover, the virtually unassailable provenance of the patterns is decisive, for they came from the so-called "Library Cave" (Cave 17), sealed with plaster from the early eleventh century until 1900, when it was discovered by a mendicant Daoist priest named Wang Yuanlu.[20] It is not known exactly when pouncing became part of the tradition of replication in Buddhist mural painting or Chinese decorative art; this important issue has not yet been approached with adequate rigor. Nevertheless, there are silk fabrics from the second century B.C. reportedly done from pounced patterns.[21] Lastly, the binome *"fen pen,"* one of whose radical components that signifies "dust" or "powder" and that which Chu Ching-hsüan mentioned in his *T'ang-ch'ao-ming-hua-lu,* written around 850 A.D., apparently designates pounced copies or patterns.[22] Thus, in Chinese, as in most European languages, the very word used to designate the technique alludes in some fashion to "dust" or "powder" – whether

it is the English "to pounce," the Italian *"spolverare"* or *"spolverizzare,"* the French *"poncer,"* the Spanish *"estarcir,"* or the archaic German *"polliren."*[23]

For half a century following Marco Polo's return to Venice in 1295, commerce with China would flourish in Italy. Sometime during the early Trecento, the *spolvero* technique must have been imported from China, along with the better known novelties of gunpowder, spices, and noodles. Pouncing did not form part of the Antique Classical tradition, and the technique's non-Western origins thus open a fascinating avenue of research. More and more, Italian fourteenth-century ornament painting would derive its conceptual structure from the identical repetition and/or reversal of design motifs. *Spolvero* patterns, and cut stencils or templates for more modest designs, allowed a precision of repetitive form that was simply not possible freehand without an enormous expenditure of time and manual labor: even with such considerable efforts, as can be seen in numerous cases of Trecento ornament that is carefully constructed *alla prima,* the results were not perfectly uniform. Yet repetitive and bilaterally symmetrical ornament is an ancient, pervasive mode of expression. Early instances of *spolvero* pattern application could thus emerge in the paintings and decorative arts of China, India, and the Islamic World, or further back in history, even in the ancient Near East and Egypt. Such paths of investigation may in turn clarify the thorny problems regarding the technique's application during the Middle Ages, particularly in Venice, which because of her contact with the Silk Route was probably the technique's main port of entry to the West.

The Italian Textile Trade and Trecento Painting

Chinese silk damasks and brocades, as well as embroideries, were first imported into Europe during the late Duecento, and by the following century the Italian silk industry heavily imitated their elegant designs (Fig. 128).[24] Through the Silk Route, the *spolvero* technique probably made its way into the great textile-producing centers of Italy – primarily Venice, but also Florence and Lucca. Of course, unlike the medium of embroidery, silk-weaving processes do not require per se the

use of *spolvero,* since by crossing the warp with the wefts of filling threads the designs are woven into the cloth support. (For damask, the wefts of silk alternate between a tabby weave and a satin weave to produce dull and glossy designs of one color on the fabric surface. For brocade, wefts of additional contrasting color, not extending from selvage to selvage, are woven in to accent only the raised figurative designs.) The *spolvero* technique, however, is most effective in replicating the figurative paper patterns employed in such weavings. From at least the late fifteenth century onward, Italian artisans pounced pricked patterns on paper directly onto the cloth to produce embroideries and painted designs on silk; although the use of such practices in the Trecento and earlier Quattrocento is assumed, firmly documented examples have not yet come to light.[25]

The occurrence of oriental and orientalizing textile designs in Italian fourteenth-century paintings is today widely recognized.[26] This taste directly reflected the conditions of the contemporary silk trade, central to the economic prosperity of Venice, Florence, Lucca (until the city's fall in 1314), and even Siena, though it was not itself a manufacturing center. The typological classification of textile patterns in Trecento and early Quattrocento panel paintings, much like the study of tooling and punchmarks, sheds light on the complex function of drawn patterns, as well as on the extent of their dissemination in painters' workshops of the Late Middle Ages and Early Renaissance.[27] Not only were the forms that both Italian painters and textile weavers of the period adopted demonstrably oriental, but – we may argue – so probably were some of their production techniques, including the use of *spolvero* patterns. The parallels between orientalizing designs and oriental weaving techniques are usually recognized; similar parallels between form and function have also been made in the case of other Italian decorative arts of orientalizing taste. Our hypothesis may then better explain the reason why Cennino's *Libro dell'arte* (MS., late 1390s), the earliest Western source to mention *spolvero,* describes its use in the context of depicting silk brocades in paintings.

A hypothetical importation of the *spolvero* technique from the East through the commerce routes for silks and other textiles might also help us explain the relatively persistent descriptions of practices utilizing the technique in Cinquecento Venetian embroidery pattern-books, which often illustrate orientalizing patterns.[28] Chinese and Sino-Persian motifs dominated Venetian textile design during the Trecento and Quattrocento.[29]

Cennino's *Sgraffito* Technique

In reconstructing the step-by-step process of pouncing designs for transfer, we have relied repeatedly on Cennino's *Libro dell'arte,* the passage telling how artists pounced small pricked designs *("spolverezzi")* to portray brocade or other patterned textiles in paintings.[30] It should be emphasized, for it has often not been sufficiently understood, that despite Cennino's frequent allusions to design transfer by *spolvero,* they refer only to the painting of repetitive textile patterns.[31] Like many other practices recommended by the author, the point of *spolvero* was to save time and labor. Cennino's most important passage occurs within a description of *"sgraffito,"* then a popular but still relatively novel technique.[32] (In Italian, the verb *sgraffiare* means literally "to scratch away.") Its purpose was to simulate in panel painting the color and texture of the increasingly complex figurative silk damasks and brocades that began to dominate the Italian textile trade between the 1320s and 1350s.[33] It was a taste that in its most flamboyant application in Tuscan and North-Italian panel painting would largely postdate Giotto's death in 1337. Cennino's *Libro* devotes three full chapters to the portrayal of brocaded cloths with this mimetic technique, which was also an important training exercise for assistants, "children or boys."[34]

Cennino described a relatively simple *sgraffito* process (actual practice was more varied). The artisan, or more likely his young helper, laid the entire ground of the cloth to be depicted with *bole* and burnished goldleaf, first incising freehand (directly on the surface) the folds of the cloth and then painting over this ground with egg tempera in the desired color of the cloth. At this stage, the painter-craftsman could model the surface to describe the appearance of three-dimensional form, adding shadows and then highlights.[35] Next, he pounced the pricked brocade patterns drawn on paper or parchment over the matte tempera surface. Such patterns most probably portrayed, at their largest, single repeats, and the fact that Cennino called them by the diminutive form, *"spolverezzi,"* suggests their generally small size. That Cennino referred to them usually in the plural may also be significant, for as we have seen, repetitive pouncing is destructive, and thus multiple replicas of a pattern were probably necessary.

While Cennino did not specifically mention the subject matter of *"spolverezzi"* in the all-important passage about cloths of gold, he later referred to *"o cacciagioni o altri lavorii"* (either game or other motifs) in his rules about the portrayal of other types of cloths.[36]

Actual textiles from the mid-Trecento to the early Quattrocento, as well as fictive designs painted in altarpieces, do indeed abundantly depict deer, birds, and other hunted animals; they also often represent elegant foliage and floral ornament, both naturalistic and fantastic.[37] Such figurative subject matter is especially common in North-Italian modelbooks of the period.[38] Significant examples for this tradition of painted textile ornament are the pages that originally composed a late fourteenth-century Venetian modelbook whose parchment support was reused by Jacopo Bellini (c. 1400–c. 1470) to draw his famous albums.[39] Most of the Trecento patterns now lie underneath Jacopo's compositions, below the ground preparation. A few other loose sheets have also been related to this early modelbook. Among these is a carefully finished pen and brush drawing on parchment (Fig. 129), which on the upper right quadrant renders a leaping dog and a recumbent, chained deer.[40] In the page, only the outlines of the dog and the deer are pricked, though not the deer's chain or other contextual details, but the parchment appears sufficiently soiled and abraded to suggest that it may have been rubbed with pouncing dust. Although the motifs could have been selectively pricked by a much later copyist (as cautioned in Chapter Three), their sizes seem consistent with those of animal and bird textile patterns portrayed in contemporary panels.[41]

Such design motifs could be repeated over and over, by pouncing both in obverse and reverse, along the axial alignments of the overall pattern (see Chapter Two). Cennino's *Libro* instructs, "make your designs, so that they register well on each face."[42] As we shall see, almost as early as Trecento painters began using pricked patterns for ornament, they learned to exploit them to create symmetry. (The flicking over of designs recto-verso to create mirror images was done in the Trecento in an infinitely more repetitive manner than it ever would be in the case of pricked figural cartoons in the Quattrocento and Cinquecento.) After pouncing the patterns onto the painting surface, the artist drew the outlines of the brocade designs, connecting the *spolvero* dot-by-dot by lightly scratching with a stylus – "of birch, or hard wood, or bone; pointed like a stylus for drawing, at one end; and a little edge at the other for scraping."[43] The minutely scratched freehand lines cut through the painted surface to reveal the burnished gold underneath the pigment. With the other end of the stylus, which had the "little edge," the artist then carefully scraped off the excess color. Last, he tooled the brocade designs to heighten the reflectivity of the

gold, stamping them with *rosette*[44] and iron punches, then chasing, stippling, and further scoring them with stylus-incised lines.

Immediately following this description, Cennino explained the procedures for portraying other cloths of "rich" gold, as well as silver, velvet, wool, and silk, adding only what must be done differently with respect to plain gold brocades; *spolvero* patterns were still necessary.[45] Importantly, Cennino considered the general technique of "*spolverezzi*" also useful for mural painting, both in *secco* and *buon fresco*.[46]

Function of Cennino's "*Spolverezzi*"

It is commonly agreed that Cennino's "*spolverezzi*" were forerunners of fifteenth-century *spolvero* cartoons, for the actual process of transferring "*spolverezzi*" and cartoons onto the working surface was identical.[47] As we saw in Chapter Two, the tools, materials, and methods of pouncing to which Cennino's *Libro* alludes resemble those described in later writings on painting, drawing, and the decorative arts: the inherently simple artisanal technique of *spolvero* did not change with time. Conceptually, however, Cennino's *spolvero* ornament patterns – in serving purely for mass replication – were still a leap away from the fifteenth-century figural cartoons that gradually came to serve as aids in exploratory design. The difference is fundamental, and Cennino's famous and much-cited passage on "*spolverezzi*" should be interpreted conservatively within the context of Trecento and early Quattrocento practice.[48]

Another reproductive, semimechanical shortcut, also described in the *Libro dell'arte*, helps us better understand the reproductive design function of Cennino's "*spolverezzi*." This is the block-printing of patterns onto linen cloth ("*lavorare colla forma dipinti in panno*"), a poor person's substitute for woven silk brocade. In fact, it is significant that Cennino's *Libro* brings up both "*spolverezzi*" and block printing in connection with textile ornament, in which the design depends on the uniformity of shape and orderly axial placement of the repeats. Also imported from China, the method of block-printing textiles was considerably less laborious and costly than actually weaving or embroidering brocades.[49] Needless to say, Cennino's method of block-printing cloth did not involve pouncing.[50] The artisan carved the outlines of the design in relief on a block of hard wood, "either nut or pear," dipped the block into a thick, black, ink

Figure 127. (Above) Asian mid-tenth-century pricked pattern for a Buddha Group of Five Figures (British Museum 1919.1-1.072, Ch. 0015, London), obtained by folding the pattern in half, vertically through the center. The two extreme right figures were pricked from the recto. The two extreme left figures, identical to those on the right, but in mirror images, were pricked from the verso and were left only in perforated outline forms.

Figure 128. (Right) Italian fourteenth-century woven silk inspired by Chinese patterns (Metropolitan Museum of Art, Rogers Fund, 1912, 12.55.1, New York).

whose recipe the author precisely described, and printed the design – segment by segment – onto a linen cloth several yards long *("di sei o di venti braccia")*, which was nailed to a stretcher. Thus, whether by block-printing or by pouncing the patterns, the general principle of designing brocadelike ornament was the same. Indeed, Cennino's more discursive passage on block printing helps us bridge the gaps of evidence regarding the actual reproduction of *"spolverezzi"* on the working surface. According to this account, each unit of the design – "animals or figures or foliage ornaments," much like the *"spolverezzi"* – was precisely aligned and registered on the surface of the wood block to be carved and then was printed on the cloth *"con grande ordine."* The same methodical referencing must have been necessary for *"spolverezzi"* on

Figure 129. Late-fourteenth-century Venetian artist, pattern for Motifs of Animals, Birds, and Plants *(Harvard University Art Museums, Fogg Art Museum 1932.291, Cambridge, Massachusetts), selectively pricked.*

Sgraffito Textile Ornament by Andrea, Nardo, and Jacopo di Cione

Although no firmly attributed corpus of paintings by Cennino himself survives to confirm his instructions regarding painting technique, scientific research continues to demonstrate the validity of his precepts particularly in panels from the second half of the Trecento and early Quattrocento.[51] We may turn to the most successful Florentine painters of the period, Andrea di Cione "Orcagna" (1315/20–1368) and his brothers, Nardo (c. 1320–1366) and Jacopo di Cione (c. 1320/30–1398/1400), who presumably ran a single *bottega*. Their altarpieces offer one of the most reliable means of reconstructing Cennino's *sgraffito* technique. As will be discussed below, at least two mural cycles by Orcagna's workshop exhibit *spolvero* in their ornamental borders, establishing it among the earliest practitioners of the technique in Italy.[52] Compared to the *oeuvre* of Orcagna and his brothers, earlier Trecento *sgraffito* designs usually appear to be simpler and less regular, possessing smaller-scale repeats, all of which suggests that such motifs were not pounced from patterns. In fact, Bernardo Daddi (flourished c. 1320–1348), among the pioneers of the new taste for richly ornamented textiles and possibly Orcagna's master, did not use a true *sgraffito* technique in his paintings.[53] A close examination of some panels indicates that Daddi and his *bottega* constructed the geometric framework of small floreated designs directly on the painting surface with the stylus and compass, painting the small units with the aid of stencils or templates.[54] Moreover, although the archangel Gabriel's mantle in Simone Martini's *Annunciation* (Galleria degli Uffizi, Florence), completed in 1333 for Siena Cathedral, is among the early Sienese attempts at true *sgraffito*, he and his assistant Lippo Memmi most probably used a simple perforated metal template or parchment/paper stencil for the floral motif, rather than a *spolvero* pattern.[55]

paper or parchment, as they were transferred onto the cloth or panel. The register marks ensured that in repeated printing (or pouncing), the units would be axially aligned, correlating seamlessly. If the efficiency of reproduction of *"spolverezzi"* is only implicit in Cennino's advice in the *Libro,* it is amply explicit in his discussion of block-printing patterns on cloth. Both shortcuts, like the use of punches, *rosettes,* perforated stencils, and templates to embellish the painted surface of panels and murals, demonstrate the "Late Gothic" artist's reliance on gadgets and devices to produce uniform, serial designs for ornament.

The figurative brocade patterns depicted in the

Figure 130. Detail of Sts. Michael and Catherine of Alexandria in Andrea di Cione "Orcagna," Christ, the Virgin, and Saints, "The Strozzi Altarpiece," tempera and gold leaf on panel (Strozzi Chapel, S. Maria Novella, Florence).

Figure 131. Reconstruction of the recurring "bird and flower" pattern in the painted panels by the brothers Andrea di Cione "Orcagna," Nardo di Cione, and Jacopo di Cione. (Photograph reproduces the scale of the original at 93 percent.)

Figure 132. Detail of tooling and painting in raking light in Andrea di Cione "Orcagna" and Jacopo di Cione, St. Matthew, with Episodes from his Life, tempera and gold leaf on panel (Galleria degli Uffizi, Florence). (Photograph reproduces the scale of the original at 93 percent.).

altarpieces by Orcagna and his brothers have been extensively studied (as have many Trecento textile patterns), and their uses of the *sgraffito* process have been thoroughly reconstructed.[56] What concerns us here are the conclusions regarding the reuse of identical brocade patterns in different altarpieces by the workshop, over a period of time.[57]

For example, we may consider a single pattern (Figs. 130–33), which, when reproduced onto the painting surface as a complete repeat, represents four parrotlike birds flanking a stylized flower: the motif is so distinctive as to represent a hallmark of the *bottega*.[58] This elegant pattern is magnificently realized on the narrow border of St. Lawrence's robe and St. Catherine of Alexandria's dress and mantle in Orcagna's *"Strozzi Altarpiece"* from 1354 to 1557 (Fig. 130). It recurs on the "cloth of honor" in the main panel of Nardo's *Trinity with Sts. Romuald and John the Evangelist* from 1365 (Galleria dell'Accademia, Florence); again as the ground on Nardo's *Three Saints* from around 1365 (National Gallery, London); as the ground on Orcagna's and Jacopo's figure of St. Matthew from 1367 to 1368 (Fig. 132); as the cloth of honor in Nardo's *Enthroned Madonna and Child with Saints* from the 1360s (Brooklyn Museum, New York);[59] as the cloth of honor in Jacopo's *Coronation of the Virgin* from 1372 to 1373 (Fig. 133); and again as the ground on Jacopo's small *Madonna of Humility* from about 1373 (Galleria dell'Accademia, Florence).[60] With its intricately modeled folds and small bodice and sleeves, St. Catherine's gown in Orcagna's *"Strozzi Altarpiece"* (Fig. 130) offers an almost unparalleled tour de force in the illusionistic portrayal of a *sgraffito* pattern. The overall quality of execution for the pattern is particularly precise and consistent in Nardo's *Three Saints* and *Enthroned Madonna*, sloppiest in Nardo's *Trinity with Saints* and Jacopo's *Coronation* (Fig. 133). The base color for the cloths varies from panel to panel; usually it is minium-red, but in Orcagna's *"Strozzi Altarpiece"* it is bluish cream, and in Jacopo's small *Madonna of Humility* it is whitish gray. In all cases, the painters accented the patterns with ultramarine blue before tooling; the pattern in the *"Strozzi Altarpiece"* (Fig. 130) is additionally highlighted with minium-red. Most important, close observation reveals that these tempera accents sometimes differ greatly in treatment not only from panel to panel but also within the same painting, because they were added freehand; nevertheless, they create more delicate overall effects than those Cennino described. The pattern in both Jacopo's *Coronation* (Fig. 130) and Nardo's *Trinity* has little or no tooling.

In the interest of both versatility and better maneuverability, especially within such small, irregularly shaped areas, as in Orcagna's *"Strozzi Altarpiece"* or Jacopo's *Madonna of Humility,* the actual *"spolverezzi"* for the pattern probably represented only one-quarter of the repeat: one bird and a section of the large flower motif (Fig. 131).[61] This quarter would have been pounced in obverse and reverse to complete the design; no register marks seem evident on the surfaces of any of these panels.[62] Tracings on clear acetate taken from the actual paintings, however, confirm that the overall pattern recurs identically in size, and nearly so in design, throughout all seven panels, but only when the unit is one-quarter of the total motif,[63] for, if we compare tracings of large portions of the overall pattern, encompassing one complete repeat or several repeats, we begin to observe minute divergences of outline, which translate into a gradually greater syncopation of the overall pattern toward the periphery. As the comparison of tracings can also confirm, slight variations of design exist in the individual units within the same painting – a bird's belly may be puffier, its crest and beak less curving, its toes angled lower than those of a neighbor, differences readily apparent to the unassisted eye. Although the method of taking tracings on clear acetate from various examples of the pattern can provide a relatively accurate basis for reconstruction and comparison, we must keep in mind that such tracings reflect the outlines of the designs as they were subsequently *sgraffito*ed (Fig. 132) – that is, after they were (1) underpainted, (2) accented, and (3) tooled – rather than as they were drawn and pounced from the paper/parchment patterns.[64]

Although the use of *"spolverezzi"* ensured that the repeats of the overall pattern were uniform in size and shape, the actual tooling, which was done relatively quickly and directly on the painting surface, introduced variations into each repeat. This is inevitable with any process done mostly by hand, but particularly so with one requiring a laborious glyptic technique. An instructive case is the stippled textile pattern of the minium-red cloth for the standing figure of St. Matthew in the Uffizi panel by Orcagna and his brother Jacopo (Fig. 132). On the birds and flower motifs, there are exquisitely realized accents in ultramarine blue, both fine and broad. But, although this is among the more carefully executed panels in our group, the *sgraffito* in the *St. Matthew* still reveals remarkable disparities. Some areas are gilded but not tooled; the *sgraffito* pattern extends substantially under the robes of the saint. The areas of stippling vary in size and often appear imprecise.

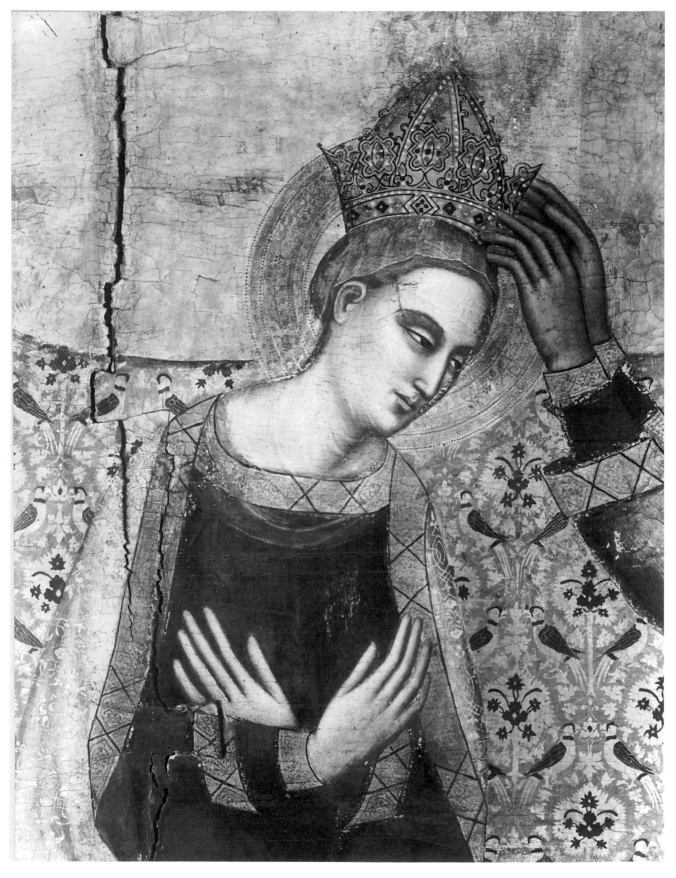

Figure 133. Detail of Jacopo di Cione, The Coronation of the Virgin, *tempera and gold leaf on panel (Galleria dell'Accademia, Florence).*

Although the stippled tail feathers on the birds are usually four in number, there are in some places of the pattern only three feathers, in others as many as five. Another variation occurs in the feet of the birds, sometimes even within the same painting. For instance, the birds' four-toed feet in Orcagna's *"Strozzi Altarpiece"* range from wiry to pudgy. Usually, the feet are fat in Orcagna's and Jacopo's Uffizi *St. Matthew,* as well as in Jacopo's Accademia *Coronation,* but slender in Nardo's paintings – the Accademia *Trinity,* the Brooklyn Museum *Enthroned Madonna,* and the National Gallery *Three Saints.*

Judging from the correspondences of design, but minute divergences of detail, and the enormous number of times that the bird and flower motif must have been repeated throughout panels by the *bottega,* we can reasonably conclude that multiple replicas of the pricked pattern must have existed.[65] Only pricked replicas or tracings could have perpetuated the transmission of the motif in such accurate form for nearly twenty years; such a semimechanical approach offered the possibility of redesigning the motif on the basis of the pricked outlines: this might further account for the small divergences of design.

Yet conclusive proof of the use of *"spolverezzi"* in Trecento panels remains for the most part unverifiable, since the *sgraffito* technique effaced the physical evidence of *spolvero* marks on the painting surface by the process of scraping away the layers of pigment on the gold ground.[66] And, even if, perchance, some *spolvero* underdrawing had withstood the destructive *sgraffito* technique, it would be extremely difficult with current scientific means to verify its presence, for, as discussed in Chapter Two, such underdrawing is by nature ephemeral, particularly that executed with the types of colored pouncing dusts recommended by Cennino – among others, lead white powder. Moreover, noncarbon black pouncing dusts are generally not visible in infrared light, and the burnished goldleaf layer underneath a *sgraffito* passage is nearly impenetrable; its extreme reflectivity could in fact burn an infrared lens.[67] Of note, and in great contrast, infrared reflectography reveals ample evidence of *spolvero* underdrawings in Northern European panels whose textile patterns were painted illusionistically, rather than tooled on goldleaf.[68]

Non-*Sgraffito* Textile Ornament

We have seen that Cennino's *Libro* suggests in passing that *"spolverezzi"* could also serve to portray textiles in mural painting; indeed, this procedure can be documented for non-*sgraffito* ornament. The *dado* of a room at the Castelvecchio in Verona (Figs. 134–35), built in 1354–75 and frescoed in 1360–1400 by a team of anonymous painters from the Veneto, portrays a *trompe-l'oeil* tapestry hung from loops.[69] This tapestry originally ran continuously along all four walls of the trapezoidal space; as an illusionistic device, it is reminiscent of that in the Upper Church (S. Francesco, Assisi), already discussed.[70] But, unlike the painted tapestry on the *dado* of S. Francesco – which appears flat and whose internal motifs were originally painted freehand (usually by means of direct construction on the *intonaco*) – the *dado* at the Castelvecchio attempts to represent the sculptural quality of cloth with deeply projecting folds, whose configuration was reproduced exactly over and over with *spolvero* patterns. The large carbon *spolvero* dots represent the general outlines of the tapestry and its folds only crudely, for the tapestry lacks internal ornament. The dots are spaced relatively far apart – sometimes, at intervals of as much as 10 mm. – and the painted outlines frequently disregard them. Such a crude disposition of *spolvero* and painted outlines exposes the rudimentary function of the patterns, which, unlike Cennino's *"spolverezzi,"* however, would have been monumental (nearly a meter high); they served merely as a shortcut to obtain a uniformity of design throughout the room.[71] Like the painted tapestry on the *dado,* the general framework for the moorish-style tile design covering the main body of the walls is also delineated with *spolvero* (Fig. 135): relatively complex passages exhibit three to four dots per 10 mm., more simple ones one to two dots per 10 mm.

Infrared reflectography examination during the recent cleaning of the Brancacci Chapel frescos (S. Maria del Carmine, Florence) brought to light a much more modest example of the application of *spolvero* patterns in the depiction of drapery.[72] The light-blue gown worn by one of the male onlookers in Masolino's *Resurrection of Tabitha* from 1425 to 1427 is sprinkled with tiny repeating flowers painted *a secco* on the basis of *spolvero* underdrawings.[73] *Spolvero* outlines also define the sumptuous, floral brocade patterns on the pope's cope in Domenico di Bartolo's *Madonna of Mercy* from 1444, part of a detached lunette-shaped mural (Reliquary Chapel, Spedale di S. Maria della Scala, Siena).[74] The general principle of the *spolvero* patterns employed by Masolino and Domenico di Bartolo is identical to Cennino's *"spolverezzi."*

After the 1420s to 1430s, the portrayal of ornate silk and velvet brocade designs in paintings – like the use of

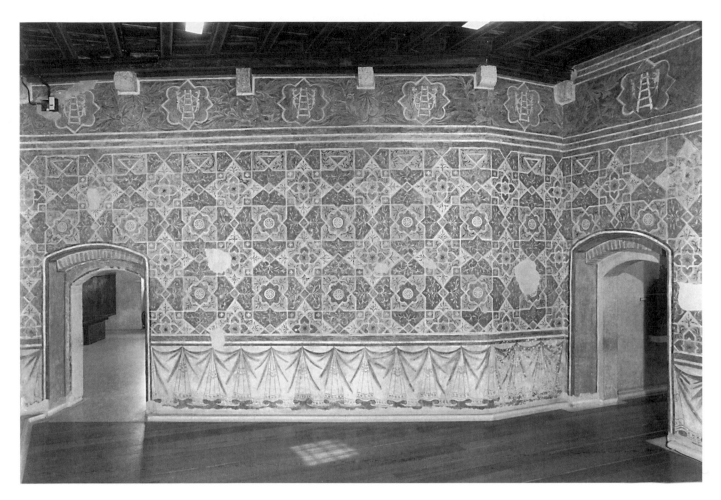

Figure 134. *Veronese or Venetian late-fourteenth-century artists, mural decoration of a room with moorish-style patterns and fictive tapestry (Castelvecchio, Verona).*

Figure 135. *Detail of the moorish-style wall patterns in the room at Castelvecchio, showing* spolvero.

gilding and tooling techniques – would decrease in the main artistic centers of Italy, as preferences for monumental form frequently took hold, and public tastes often came closer to the *"puro sanza ornato"* ideal of Masaccio.[75] Yet actual examples of ornate textile motifs can be found in "progressive" paintings from throughout the century, not only in portraits but also in more public works commissioned by affluent secular patrons – from Gentile da Fabriano's *Adoration of the Magi* altarpiece of 1423 (Galleria degli Uffizi, Florence) for Palla Strozzi, then the richest man in Florence; to Antonio Pisanello's murals of 1433–36 (?) on the *Legend of St. George* (S. Anastasia, Verona) for the Pellegrini family; to Domenico Ghirlandaio's fresco cycle of 1485–95 in the *"cappella maggiore"* (S. Maria Novella, Florence) for Giovanni Tornabuoni; to Vittore Carpaccio's *St. Ursula cycle* of 1490–1500 (Gallerie dell'Accademia, Venice) for the Scuola di S. Orsola, one of the smaller Venetian confraternities, but one that undoubtedly enjoyed aristocratic patronage.[76] As in the floral patterns on the red curtains in the *"Madonna del Parto"* mural (Cemetery Chapel, Monterchi), painted in the 1460s by Piero della Francesca and his *bottega*, artists continued to use small individual *spolvero* patterns to repeat complex textile motifs over and over.[77] This use of small individual ornament patterns remained true, even when the practice of painting figural compositions from large, comprehensive *spolvero* cartoons became common by the middle of the century, and even when *calco* (stylus tracing) replaced *spolvero* as the common technique of cartoon transfer during the last quarter of the century. As can be seen in the female visitor thought to portray Giovanna Tornabuoni in Ghirlandaio's *Birth of the Virgin* (S. Maria Novella, Florence), the delicate profile of her face exhibits *spolvero* (which might be expected in a portrait), whereas the back of her neck is stylus-incised.[78] She wears a dress of rich gold brocade, whose repeating patterns are based on *spolvero;* by contrast, the folds of her dress, as well as its general outlines, are stylus-incised.

Design Technology of Ornament in Trecento Mural Painting

Although Cennino's *Libro* describes the use of *"spolverezzi"* only to depict textile motifs, the presence of *spolvero* marks in various types of decorative designs in mid- to late Trecento murals corroborates that painters used the technique widely for the reproduction of ornament. To understand the improvement the

new reproductive technology of *spolvero* patterns represented, we may now consider how such ornament had traditionally been produced.

For centuries, the underdrawings of murals had most often been prepared on the *arriccio,* the base layer of coarse mortar of lime and sand that underlay the *intonaco.* This practice can be documented from at least Late Antiquity and Early Christian times onward and prevailed until the more widespread use of figural cartoons shortly before the mid-Quattrocento would modify it.[79] According to Cennino's *Libro,* the artist first drew on the rough surface of the *arriccio* a tentative, preliminary sketch of the composition in *carboncino* (charcoal), calibrating the scene and figures within the pictorial space by means of careful measurement.[80] Compass construction helped him situate the points from which he could snap centering lines, plumblines, and groundlines with thin ropes or cords dipped in pigment, whose ends he tied around the heads of nails. The artist then reinforced the figural sketch in *carboncino* by laying in with a fine brush a pale hue of untempered ocher, greatly diluted in water. With a bunch of feathers, he usually brushed the ocher underdrawing clean of any traces of the preliminary charcoal undersketch, probably so that the final design would be clearly legible and the ensuing layers of moist *intonaco* and color would not accidentally soil. He completed this underdrawing by brushing on the water-based, brick-red earth pigment known as *sinopia,* after Sinope, the ancient Greek seaport on the southern shore of the Black Sea, famous as its source. (Any preliminary underdrawing on the *arriccio* layer is now commonly called a *sinopia,* whether done in the eponymous reddish pigment or not.) The last step in the *sinopia* process was the disposition of decorative borders: as Cennino's *Libro* recommends, "then start making your ornaments, or whatever you want to do around the outside."[81] A few extant *sinopie* for figural compositions also include freehand sketches for the ornamental borders.[82] Most of the design process for ornament, however, took place either on the actual painting surface of the mural, or on drawings of patterns on paper or parchment that no longer survive.

In the tradition of Giotto and his immediate followers, muralists constructed the finest painted architectural ornament painstakingly unit by unit, directly on the *intonaco,* by the measured, geometric means of cord snapping, compass sectioning, stylus ruling, and/or ruling with reddish or brownish underpaint. An example is the painted marble *dado* and the colorful ornamental borders in the mural cycle that Giotto and his *bottega*

executed around 1306 for Enrico Scrovegni (Arena Chapel, Padua).[83] On the moist *intonaco,* the painters snapped cords dipped in watery *sinopia* pigment to establish the longitudinal axes for the monochrome bead and reel molding; sometimes, they stylus-ruled these horizontal lines. At measured intervals, the individual beads were then either inscribed freehand with the stylus on the *intonaco,* or, more commonly, drawn freehand *"a occhio"* with the same watery red pigment that served as underpainting for the figures on the *intonaco* layer.[84] The painters usually incised with a compass the outermost circumference of the volutes for the elegant but freer forms of the *rinceaux* on the six painted *grisaille* pilasters articulating the corners and entrance of the chapel. (The nail holes marking the centers of each circle amid the five-petaled flowers are still visible.) The colorful symmetrical arabesques of foliage punctuating the panels on the vertical borders framing the *historie* and articulating the vault appear to have been similarly painted *alla prima;* here, however, perforated stencils or templates may have provided the painters with a general guide for the repetition of the designs. Unfortunately, the dense layers of pigment obscure too much evidence to permit firm conclusions. Be that as it may, minor disruptions of design and symmetry in these free forms are noticeable everywhere. Like other rectilinear architectural detailing throughout the cycle, both within the scenes and without, the patterns for the painted cosmatesque inlay borders were precisely measured, then ruled with stylus or reddish underpaint, directly on the *intonaco.*[85] Snapping with red-dipped cords sometimes also helped to establish the general, structural outlines.

Cennino's *Libro dell'arte* records some of these techniques of direct construction in a passage about the painting of buildings and architectural ornament in murals:

Then make a long ruler, straight and fine; and have it chamfered on one edge, so that it will not touch the wall, and so that if you rub on it, or run along it with the brush and color, it will not smudge anything for you; and you will execute those little moldings with great pleasure and delight; and in the same way bases, columns, capitals, façades, fleurons, canopies, and the whole range of the mason's craft, for it is a fine branch of our profession, and should be executed with great delight.[86]

As far as is presently apparent, these were the elements of construction that defined ornament painting during the late Duecento and early Trecento. This is clear from the murals painted between the 1290s and 1320s by various masters at the *Sancta Sanctorum* (building complex of S. Giovanni in Laterano, Rome), to those in the Upper and Lower Churches (S. Francesco, Assisi), to those in the chapels Giotto and his workshop painted in the 1320s for the Bardi and Peruzzi families (S. Croce, Florence).[87] Artists influenced by Giotto in other regional centers also followed the practice, though often with less precision of construction, as in the mural cycle from 1320 to 1338 by Pietro da Rimini and his *bottega* (S. Chiara, Ravenna).[88]

The practice of direct stylus or cord construction had been applied since at least Classical Antiquity.[89] It would by no means be abandoned while alternative techniques were being explored during the Trecento (see Chapter Ten). Merely to establish the remarkable continuities between Antiquity and the Late Middle Ages, we may compare examples of cord snapping on the interior chambers of the Etruscan fourth-century B.C. *"François Tomb"* and on the *dado* of the fourteenth-century cycle on the right aisle wall of the Collegiata at San Gimignano (Figs. 136–37). In both cases, the technique served to portray fictive, colored marble paneling. In the Montefiore Chapel frescos in the Lower Church (S. Francesco, Assisi), from around 1317–20, Simone Martini and his workshop carefully stylus-constructed most of the architecture and *cosmati* work borders, though for some of the simpler shapes they also painted from stencils.[90] Similarly, in the monumental but much deteriorated murals from the 1340s and 1350s in the Camposanto at Pisa, the modest, coarsely painted frames were all either directly stylus-incised on the *intonaco* or, less commonly, stenciled.

In the North, the traditional technology of direct, measured stylus construction was pushed to its limit in Altichiero da Zevio's and Jacopo Avanzi's mural cycle on the *Life of St. James* from 1376 to 1379 in the Chapel of S. Giacomo (or Chapel of S. Felice, Basilica of S. Antonio, Padua)[91] and especially in Altichiero's nearly scenographic architectural settings for the later scenes in the nearby Oratory of S. Giorgio, probably from 1380 to 1384. Yet, at least in the Oratory of S. Giorgio, it is already unclear whether Altichiero and his *bottega* also sometimes relied on *"spolvero"* patterns to repeat some of the motifs in the magnificent, stylus-constructed ornament and architectural detailing.[92] Certainly, by the following decade, the new practice of *spolvero* had arrived in Padua. Pounce marks appear sporadically on the much-effaced, original decorative borders of the partly detached mural cycle, narrating scenes from the *Life of the Virgin,* in the Oratory of S. Michele (Museo Civico agli Eremitani, Padua), painted in 1397 by Jacopo

Figure 136. Etruscan fourth-century B.C. artist, cord snapping on a frescoed wall of the "François Tomb" (Tarquinia).

sonable reconstruction of working procedures.[94] In the fictive moorish-style tile designs (Figs. 134–35), none of the internal detailing within the color fields was marked out with *spolvero*, demonstrating (as do scores of other fourteenth-century examples of the technique, in which the physical evidence is less explicit) that *spolvero* patterns were used in the Trecento primarily as a shortcut to repeat designs, rather than as a means to refine them. With the guide of centering lines, stylus-incised directly on the *intonaco*, the muralists boldly painted the arabesques of foliage within the color fields freehand, in single, sweeping strokes. The forms of this foliage vary greatly. Decorative circles within the color fields were stylus-incised directly with a compass, whereas the six-lobed star motifs were derived from cut stencils or templates.

Cut Stencils, *Spolvero* Patterns, and Direct Design Construction in the Second Half of the Trecento

We may now further analyze the three general surface design techniques available to painters of ornament during the second half of the Trecento, beyond the underlying *sinopia* on the *arriccio*. A similar red and white cosmatesque inlay design offers a means for us to compare the three types of production: (1) perforated stencils or templates, (2) *spolvero*, and (3) direct stylus construction *(incisione diretta)*. The cosmatesque motif is part of a *genre* that ultimately traces its ancestry back to Etruscan and Roman mural painting.[95] Our examples this time are by closely contemporary painters working at the church of S. Croce in Florence, all within the sphere of influence of Andrea di Cione "Orcagna."[96] Simplest in pattern is the border of squares and triangles framing a detached fragment of a mural attributed to Giovanni del Biondo (doc. 1356–1399), the *Arrival of the Franciscan Friars Minor in Florence* (Fig. 138), from around 1370.[97] Broad, sweeping brushstrokes of red pigment, as well as raised borders of built-up red paint outlining the perimeters of each unit, clearly identify this pattern as having been done quickly with a perforated stencil. The slightly swerving

da Verona, who was probably Altichiero's pupil.[93] Here, the muralists relied on stylus-ruled outlines and compass-incised circles to construct the general outlines of the cosmatesque border – in yellow-and-white hexagon and strap – before pouncing.

By the late Trecento, the *spolvero* technique had also reached Verona, Jacopo's hometown. We may recall the illusionistic tapestry adorning the *dado* of the room frescoed in 1360–1400 by a team of anonymous painters from the Veneto at the Castelvecchio in Verona. As we have seen, this mural program is sufficiently complete and well preserved to permit a rea-

Figure 137. Sienese fourteenth-century artist, cord snapping and pointed compass construction incised on a frescoed dado *panel of the right aisle wall (Collegiata, San Gimignano).*

red forms, corresponding to the hand-cut areas in the stencil, hover – curiously disattached – against the white background of the pattern. In a detail, we can even see the slightly syncopated repetition of a small inverted triangle, a mistake, where the stencil must have slipped. On the other hand, an anonymous painter, the "Master of S. Martino a Mensola," chose *spolvero* to frame his *Enthroned Madonna and Child with Saints,* dated 1387 and located originally in the Cerchi Chapel (Fig. 139).[98] In this detached fresco, the configuration of the border, with its triangles, squares, and eight-lobed stars, is more complex. Small blue-green squares also accent some of the red fields. Yet the painted outlines frequently diverge from the *spolvero* dots, and the border is, on the whole, sloppily painted – minor

defects, however, if we consider the height at which the mural originally stood. Other contemporary cosmatesque borders exhibit passages with worse misalignments of *spolvero* and painted outlines.[99]

By comparison to the stencil or *spolvero* methods, and as the mural cycles by Giotto and his *bottega* so readily demonstrate, measured geometric construction, incised with the stylus directly on the *intonaco (incisione diretta),* promised at least the possibility of crisply defined form.[100] When the anonymous artist set out to paint the borders framing the *historie* in the Rinuccini Chapel at S. Croce, to complete Giovanni da Milano's murals some time after 1369, he carefully stylus-ruled the measured grids of squares and diagonals. These grids, often with jarring corrections, are particularly evident in the quadrilateral panels of small inlaid squares and triangles that punctuate the corners of the frames of many of the scenes (Fig. 140). In the lower reaches of the mural cycle, a precise geometry must have been particularly desirable, as a good deal of the ornament is at the spectator's eye level, or slightly above. But direct stylus construction expended considerably more labor at the moment of painting than either stencils or *spolvero,* an especially problematic factor in *buon fresco,* in which carbonation occurs quickly and speed of execution is thus essential. Therefore, stylus-constructed ornament was frequently reworked *a secco,* with less permanent results. On many of the cosmatesque motifs portrayed in the St. Francis cycle in the Upper Church (S. Francesco, Assisi), as well as in the panels at the Rinuccini Chapel discussed earlier (Fig. 140), much of the *a secco* pigment layer has peeled, revealing the underlying schematic stylus work.[101]

It begins to emerge from our comparisons that the actual quality of execution of ornamental elements was often nearly beside the point, since the low light of many architectural spaces and the viewing distance required for the mural cycles within were surprisingly forgiving of imperfections. As Sir Ernst Gombrich has shown, in grasping the underlying structure of regular, repeating ornament, the eye perceives selectively; the overall sense of order prevails over the perception of individual units or, indeed, of segments of the design.[102]

Figure 138. Detail in raking light of Giovanni del Biondo (attributed), The Arrival of the Franciscan Friars Minor in Florence (Museo dell'Opera S. Croce, Florence). This fresco fragment shows the effects of the slipped stencil pattern in the center of the image. The more thickly built-up paint at the edges of the designs is typical of cut stencil work.

associate with the taste of the so-called "International Gothic" style.

To return to Cennino's *Libro dell'arte,* which the author wrote in the late 1390s during his residence in Padua (possibly while he was in prison), it seems significant with regard to the transmission of practice.[104] Examples of *spolvero* for repetitive ornament can be found in murals dating between the 1340s and 1430s, from a number of geographic centers: Florence, Pistoia, Pisa, Siena, San Gimignano, Urbino, Naples, Milan, Verona, and Padua. This establishes the practice's wide and rapid dissemination. Yet, although Cennino described the Florentine, Giottesque tradition of painting, no evidence of *spolvero* seems to exist in Giotto's murals or in any paintings, in fact, earlier than those by the Florentine *botteghe* of Orcagna, his brothers, and Andrea di Bonaiuto "da Firenze" (active c. 1343–77), or those by the contemporary Sienese painters working at the Collegiata at San Gimignano, which will be examined below. Trecento and early Quattrocento murals in Venice, which might hold an important key to our investigation, are now practically nonexistent, owing to the destructive salts and dampness of the Venetian lagoon.[105]

The eye can therefore easily be tricked in the act of "seeing" pattern, as opposed to "focusing" on it, or "attending" to it – to borrow Gombrich's apt terms distinguishing the phenomena of perception.[103] As Trecento painters particularly understood in the face of increasingly large surfaces to be decorated, what counts most in ornament is precisely regular periodicity. Yet this precision is most difficult to obtain in ornament of a figurative type, as the textile motif of the bird and stylized flower reminds us in the various painted panels by Orcagna and his brothers (Figs. 130–33). Painters from the mid- to late fourteenth century onward focused on the most efficient means of mass-reproducing the regular periodicity of ornament, as they strove for the increasingly elegant complexity that we have come to

Despite the lacunae, the decades of the 1340s and 1350s, when reaction against established Giottesque style and practice gradually occurred, may well turn out to be decisive; they may indeed provide the *a fortiori* argument regarding the importation of the *spolvero* technique into Italy. It could well be that the reason why Cennino's *Libro* mentions *spolverezzi* in such detail, and alludes to their use repeatedly, is because they represented a relatively new practice. Unlike the technology of direct surface construction, which was crucial for "Late Gothic" painters, as far as we know, *spolvero* did not form part of the continuous Western tradition of mural painting since Antiquity.

Moreover, and in sharp contrast to his detailed observations regarding *"spolverezzi,"* Cennino made only passing allusion to perforated stencils *("istrafori"),* a shortcut that – although he did not state it, but as we have seen – Medieval painters typically used to paint simple, repetitive ornament.[106] That Cennino referred to stencils only in a recipe for a flour paste adhesive (of all places!) indicates that he assumed his readers

were too familiar with such patterns to need description. Large stencils were assembled from multiple sheets of glued paper or parchment, as were monumental architectural *spolvero* patterns during the late Trecento, a practice to be discussed shortly. Fourteenth-century mural and panel painters used stencils to achieve delicate decorative effects,[107] but perforated stencils permitted only forms of limited intricacy, and only in positive or negative color fields. They were, nevertheless, in both their design-reproductive function and general method of application, the direct ancestors of *spolvero* patterns. The two techniques clearly overlapped in the production of painted *cosmati* work, for we find examples done from both cut stencils and *spolvero* patterns during the second half of the Trecento (Figs. 138–39).

As Cennino's *Libro* describes them, and as late Trecento and early Quattrocento painters would use them, *spolvero* patterns offered primarily a shortcut to replication, and so in a more precise and versatile manner than perforated stencils. They were ideally suited

Figure 139. Detail of cosmatesque border in "Master of S. Martino a Mensola," The Enthroned Virgin and Child with Saints (Museo dell'Opera S. Croce, Florence), frescoed from spolvero. *The* spolvero *dots are most evident in the bottom center of the image.*

for complex figurative ornament requiring extensive inner detailing. This was precisely the point of their use in the case of the bird and flower textile design in the painted panels by Orcagna and his brothers; contemporary muralists also integrated chiaroscuro modeling for the illusionistic portrayal of architectural ornament. Once the outlines of a design were pricked, the effort necessary to reuse it was negligible; the artist had only to pounce the perforations onto the working surface. A single repeat, or a small group of repeats, could be replicated serially, with considerable opportunity to improvise or to adjust the pattern to the requisites of the site. The process of recreating nongeometric patterns freehand, in contrast, required an inordinate amount of labor, and, as is apparent even in the magnif-

Figure 140. Detail in raking light of cosmatesque podium in "Master of the Rinuccini Chapel," mural cycle on the left wall of the Rinuccini Chapel (S. Croce, Florence), painted from direct stylus construction. The miscalculations in the stylus ruling of oblique lines are apparent.

icent examples of foliage ornament by Giotto and his *bottega* at the Arena Chapel, the overall designs usually lacked precise uniformity.

Painted Architectural Ornament in the Trecento and Early Quattrocento

In discussing the design technology of mural ornament, we have touched on one of the most innovative contributions of the late Duecento and Trecento: the genre of fictive architectural detailing, whose roots in ancient Roman art and architecture had also never been severed.[108] Especially during the later fourteenth century, painted cornices, columns, pilasters, and colored marble inlay panels derived from a Classical vocabulary of form would often seamlessly coexist in the same

mural program with the new fanciful styles of tabernacles and tracery in the French "Gothic" style.[109] In mural painting, the use of *spolvero* for such complex hybrid architectural detailing would be particularly apt, not just because rapidity of execution was an obvious advantage in *buon fresco* but because designs required repetition. Ornamental borders, niches, and tabernacles, which would simulate more and more the surfaces and carving of real stone architecture, framed the scenes or individual figures in large-scale narrative cycles. Primarily through a systematic repetition of form, such ornament unified the separate compartments within a cycle and mediated between the painted narrative and the actual architecture of the site.[110] The gradual use of the "frame" as an illusionistic device would be a remarkable Trecento innovation.[111]

Part of this tradition, and among the earliest examples of the *spolvero* technique in Italy, are the mural fragments from about 1343–50 by the workshop of Andrea di Cione "Orcagna" that originally formed part of the riblike borders on the vault of the chancel ("*Cappella Maggiore*," S. Maria Novella, Florence; Fig. 141).[112] Depicting a series of Old Testament prophets, these damaged murals were discovered in 1958, underneath those painted by Domenico Ghirlandaio and his shop in 1485–90 for Giovanni Tornabuoni and were detached in small fragments.[113] Orcagna's borders once also included panels of symmetrically disposed foliage ornament, like those on the slightly later vault at the "*Cappellone degli Spagnoli*" ("The Spanish Chapel") in the convent of the same church, but which combine *spolvero* and direct stylus construction.[114] This was a decorative device often repeated since Giotto's Arena Chapel. In the mural fragments by Orcagna and his *bottega* (Fig. 141), coarse *spolvero* marks outline only the shape of each quatrefoil and the surrounding white strapwork. The awkwardly disposed geometry of these framing elements appears to have been created mostly "*a occhio*" rather than by measured construction. The quick sweeps made with the trowel to smooth the *intonaco,* and, later, the strokes of the painter's brush, often distorted the *spolvero* marks into long dashes (3–6 mm. long), smearing the subsequent

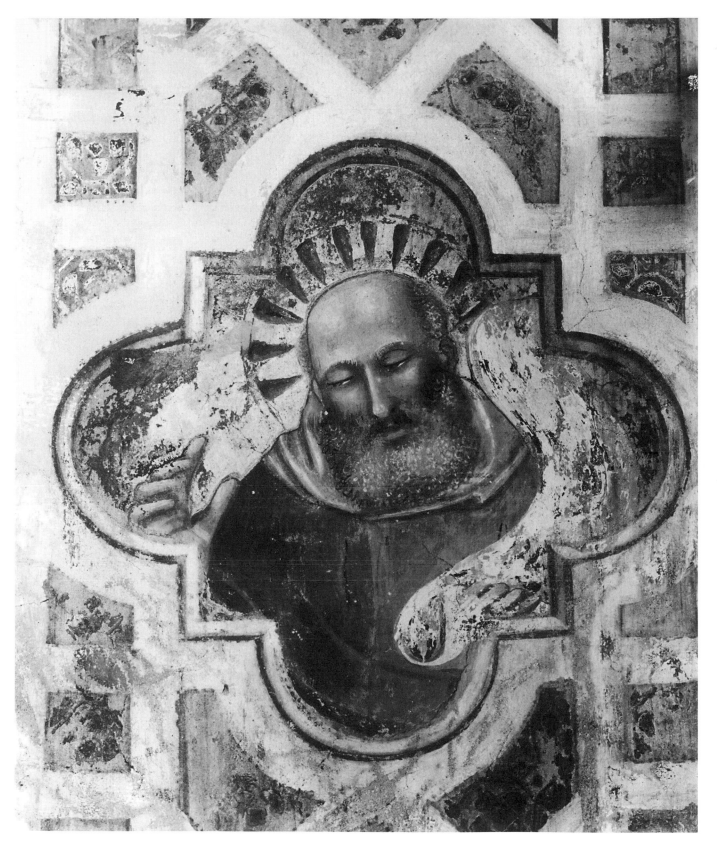

Figure 141. Andrea di Cione "Orcagna" and workshop, Prophet, *mixed mural technique (Museo dell'Opera S. Maria Novella, Florence), with strapwork borders only painted from* spolvero *patterns.*

layers of white pigment with pouncing dust.[115] Rather than laboriously stylus-ruling the interlacing white straps, it seems that Orcagna's workshop snapped cords and painted directly against a ruler's edge to save time, using the *spolvero* marks only as a rudimentary guide. The quatrefoils and strapwork are the units of the design that repeat identically throughout the program. By contrast, as can easily be verified from a number of the detached mural fragments that hang today in the museum at nearly eye level, there is no *spolvero* on the busts of Old Testament prophets contained within the quatrefoils. These busts depict relatively different physical types, seen in profile, frontal, and three-quarter views. The artists painted these nonrepeating elements freehand, probably from *sinopie* underdrawings.

At this early date, *spolvero* served merely to mass-produce the repeats of an ornamental border, whether simple or complex in design. Cycles still in situ, such as those on the aisle walls of the Church of the Collegiata at San Gimignano, are particularly informative (Figs. 142–43).[116] The left aisle wall renders twenty-five episodes from the Old Testament, painted around 1367 by Bartolo di Fredi.[117] The attribution and date of the twenty-seven scenes from the New Testament on the right aisle wall (Fig. 142), however, is not certain. The painter has traditionally been thought to be Barna da Siena (whose life is little documented), based on the mention in the 1568 edition of Giorgio Vasari's *Vite,* but more recent proposals suggest Simone Martini's pupil, Lippo Memmi (doc. 1317–1356), who may have finished the murals by 1343.[118] *Spolvero* delineates the cosmatesque borders framing each of the scenes for both cycles. Throughout the right aisle wall, the painter – Barna or, more probably, Lippo – and his *bottega* pounced relatively neatly, with fine dots, along lines carefully snapped with cords to align the repeats of the eight-pointed star pattern with white, dark blue-gray, and red color fields.[119] By contrast, on the left aisle wall (Fig. 143), although employing a similar pattern for the borders – the eight-pointed stars include yellow fields – Bartolo di Fredi and his *bottega* had proceeded in a less precise manner. There, horizontal lines, stylus-ruled directly but crudely on the *intonaco,* helped align the repeats for pouncing. During the process of painting, however, the muralists often disregarded the guide the dots provided.[120]

A later project by Andrea di Cione "Orcagna" and his *bottega,* the detached murals from 1360 to 1368 originally on the right aisle wall at the Franciscan church of S. Croce in Florence, exemplifies the *spolvero* technique in a more ambitious context.[121] The elaborately detailed borders on the four extant fragments

portraying portions of the *Triumph of Death, Last Judgment,* and *Hell* (Figs. 144–45), imitate the appearance of broad Antique-style friezes,[122] carried on gigantic twisted Corinthian columns. Beyond them, and clashing with their playful elegance, the horrific episodes unfold. Richly colored fictive marble *intarsia,* diminutive interlacing panels of figural scenes, and long panels of graceful foliage arabesques punctuate the borders. Not surprisingly, the *trompe-l'oeil* conception of this frame evokes the actual tabernacle of marble and precious inlay that Orcagna and his *bottega* carved between 1355 and 1359 for Orsanmichele in Florence.

In the frescoed borders at S. Croce, fine, sparse *spolvero* delineates the arabesques of acanthus leaves and highlighted wheat. The dots are by no means discernible throughout the ornamental borders but are particularly evident in one of the small leaves where the thick *a secco* pigment layer has peeled, revealing the bare beige-gray *intonaco* underneath (Fig. 145). Based on what survives of the ornamental border in these mural fragments, we can deduce that the *spolvero* designs of foliage are not only repeated many times but also, within each rectangular unit, the design recurs in mirror images. Here, Orcagna's *bottega* had ruled many of the architectural details of the border – for example, dentils, corbels, straps – with reddish underpainted lines and with the stylus, always directly on the *intonaco.* Yet sporadic areas of *spolvero* also define some passages of the framing rectilinear strapwork, as in the fragments from the S. Maria Novella program.[123] Orcagna's patterns for the borders must have therefore been relatively large (even if we envision that they portrayed only one repeat of the overall design), encompassing most of the framework underlying the foliage arabesques and tiny figural scenes.

Greater technological refinements still are evident in the mural cycle painted around 1366–68 by Andrea di Bonaiuto "da Firenze" and his workshop in the *"Cappellone degli Spagnoli"* ("The Spanish Chapel"; Figs. 146–47), the chapter house of the Dominican convent at S. Croce's rival church, S. Maria Novella.[124] Below the *historie* that glorify the doctrines of the order, a *dado* with fine Antique-style details – a narrow, projecting dentiled cornice, seen in oblique view, over a broad frieze – unifies the perimeter of the architectural space. On the frieze, monumental eight-lobed *tondi* alternate with small squares of painted cosmatesque inlay, rotated on their tips and each flanked top and bottom by two small pairs of bilaterally symmetrical *rinceaux.* Against a background with alternating fields of deep red and green, the white, delicately outlined architectural forms of the motifs appear as shallowly projecting relief. Most

Figure 142. Sienese fourteenth-century artist, mural cycle on the right aisle wall of the Collegiata (San Gimignano). Here, the cosmatesque borders framing each narrative scene were painted from spolvero *patterns.*

Figure 143. Detail in raking light of the cosmatesque border in Bartolo di Fredi, mural cycle on the left aisle wall of the Collegiata (San Gimignano). Here, ruled horizontal lines, stylus-incised directly onto the plaster, helped in the positioning of the spolvero *patterns.*

Figure 144. Andrea di Cione "Orcagna" and workshop, Hell, *mural fragment (Museo dell'Opera S. Croce, Florence), with* rinceaux *and various strapwork motifs painted from* spolvero *patterns.*

Figure 145. Detail in actual scale of spolvero *in Andrea di Cione "Orcagna" and workshop,* Hell.

of this delicately painted *dado* was constructed directly on the *intonaco;* compass-incised circles and precisely measured, stylus-ruled grids guided the construction of the geometric shapes. *Spolvero* emerges only on small portions of the overall pattern, the *rinceaux,* that is, the nongeometric forms of the repeats (Fig. 147).[125] The *spolvero* is particularly crisp in the left portion of the *dado,* below the scene of the *Crucifixion.* The artist applied much of the vermillion, "copper resinate," and white pigments *a secco.* The building has suffered greatly from leaks and flood damage; therefore, the condition of the lower mural surfaces is fragile. In a few intact areas, we can see that the *intonaco* must have still been quite moist at the moment of pouncing the repeating patterns of the *rinceaux.* In some passages, the raised holes from the paper patterns even left tiny impressions in the plaster. In other passages, however, the *intonaco* was excessively wet: the gray-black *spolvero*

dots look diffused and slightly smeared. Here, the *spolvero* patterns offered a precision of design for the free forms of the *rinceaux* every bit the equivalent of that for the measured geometric construction of the regular forms.

In all such cycles from the Trecento and early Quattrocento, *spolvero* marks outline only the intricate frameworks of repeating ornament, as in a *rinceaux* border framing the figure of a male saint by an anonymous artist, on a ruined fragment of a vault (Collegiata, San Gimignano), from 1360 to 1400.[126] The brothers Jacopo and Lorenzo Salimbeni relied on *spolvero* patterns to fresco some of the repeating columns in the Oratorio di S. Giovanni Battista (Urbino), a mural program signed and dated 1416, as did Lorenzo Monaco in 1420–25 to fresco the luxuriant *rinceaux* motifs in the Bartolini Salimbeni Chapel (S. Trinita, Florence). Another example, highly significant because of its

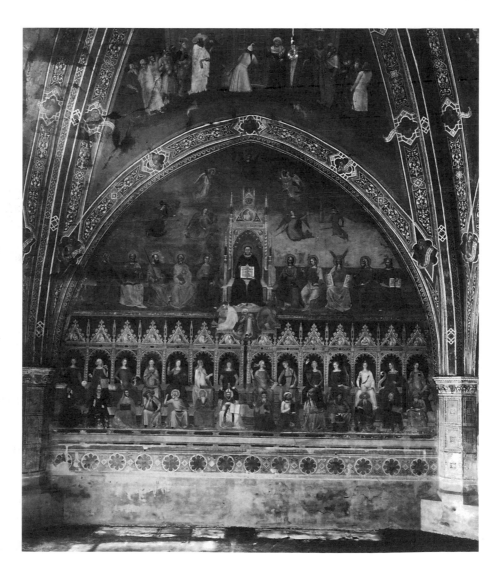

Figure 146. Andrea di Bonaiuto "da Firenze," The Triumph of St. Thomas Aquinas, *mural cycle in the "Cappellone degli Spagnoli" ("The Spanish Chapel," S. Maria Novella, Florence), with view of* dado *decoration. Some of the repeating monumental tabernacles in the main scene were apparently painted from* spolvero *patterns.*

Figure 147. Detail of a repeat of a pattern on the dado *("The Spanish Chapel"). Here, the artist relied on the* spolvero *technique for the* rinceaux *parts of the pattern and stylus-incised the construction for all the abstract geometric forms directly onto the plaster.*

localization, is the exuberant ornament of the cycle completed by Leonardo da Besozzo and Perinetto da Benevento in the Caracciolo del Sole funerary chapel at S. Giovanni a Carbonara (Naples; Fig. 148), a mural decoration probably from the 1430s or 1440s but presenting complex problems of authorship and dating.[127] There, *spolvero* articulates many of the repeating clover motifs, as well as the fictive cornice with modillions, surmounting the *dado*.

Painted Ornament and Transitions of Practice in the Quattrocento

For more complete archaeological evidence, however, we may turn to the mural program, narrating episodes from the *Life of St. Benedict*, in the *"Chiostro degli Aranci"* (Badia, Florence; Figs. 149–50).[128] Payments for the purchase of colors, made between 1436 and 1439, to the enigmatic Portuguese painter, Giovanni di Consalvo, suggest his authorship of the cycle, although some scholars have doubted the attribution in favor of a yet to be identified Florentine painter, the "Master of the *Chiostro degli Aranci.*" The *historie* portrayed in the lunettes offer a penetrating synthesis of the styles of Fra Angelico, Paolo Uccello, and the young Fra Filippo Lippi. These figural scenes exhibit no *spolvero*. On the mural surface, comprehensive passages of scratchy, free-

Figure 148. Detail of spolvero *in the ornamental parts of Leonardo da Besozzo and Perinetto da Benevento, mural cycle in the Caracciolo del Sole Chapel (S. Giovanni a Carbonara, Naples).*

Figure 149. Detail of a figural scene and framing ornament in Giovanni di Consalvo (attributed), mural cycle in the "Chiostro degli Aranci" *(Badia, Florence).*

hand stylus incisions *(incisioni dirette)* articulate the folds of the nearly black habits of the monks, whereas stylus-ruled construction defines most of the architectural forms. It is clear, therefore, that the artist designed in full scale directly on the *intonaco,* without the intermediary means of a cartoon, based on *sinopie.* When the lunette scenes were detached in 1956 by the *strappo* method, the broadly executed *sinopie* on the underlying layer of *arriccio* came to light.[129] In great contrast to the figural scenes, there are detailed *spolvero* outlines on the *intonaco* layer in the area of the *dado,* capitals, and bases of the separating pilasters (Figs. 149–50).[130] Reversed pairs of ornamental foliage designs repeat throughout the program.

At the crossroad of this present history, it is clear that the same basic principle – of *sinopia* for figures, *spolvero* for repetitive patterns – also underlies the recently discovered ornamental borders by Masolino, from 1425 to 1427, behind the altar in the Brancacci Chapel (S. Maria del Carmine, Florence; see the illustration on the back cover of this book).[131] Masolino painted the busts of the figures freehand from *sinopie,* while basing the *rinceaux* on *spolvero* patterns. Similarly, such *spolvero* patterns would enable the repetition of the fictive, *all'antica* corbels surmounting the scenes of the mural cycle (now nearly destroyed) from about 1440 on the upper *loggia* of the cloister at S. Miniato al Monte (Florence), usually attributed to Paolo Uccello or a close follower.[132] Antonio Pisanello relied on monumental *spolvero* patterns to

Figure 150. Detail of spolvero *on the* rinceaux *of the* dado *in Giovanni di Consalvo (attributed), mural cycle in the* "Chiostro degli Aranci."

repeat myriad times the stunningly complex motifs on his elegant frieze of twirling banners above the *Tournament Battle* scenes, from about 1447 to 1450, in the rooms of the Palazzo Ducale (Mantua; Fig. 151).[133] In the two latter cases, the detached *sinopie* can confirm that Uccello and Pisanello still painted the figural parts of the cycles without cartoons, according to the traditional practice of their day. A much more modest application of repetitive *spolvero* occurs in the riblike borders adorning the vault of the chancel *("cappella maggiore")* at S. Francesco in Arezzo.[134] Bicci di Lorenzo undertook this commission in 1447; at his death in 1452, Piero della Francesca succeeded him, painting the famous cycle on the *Legend of the True Cross* below. Between the 1430s and the 1460s, the innovation of the figural cartoon gradually emerged to revolutionize the painting of

the *historia* (see Chapter Six). Among its pioneers would be Paolo Uccello and Piero.

Independent of that development, however, artists would continue to rely on the *spolvero* technique to reproduce ornament with small, intricately detailed, free forms.

Andrea Mantegna's vocabulary of ornament embodies the new *all'antica* taste advocated in Leon Battista Alberti's painting treatise (MS., 1435–36) and *De Re Aedificatoria* (MS., c. 1450). Yet no less intricately detailed than some of the "Late Gothic" ornament that we have discussed, the column with composite capital supporting the temple in the background of his panel, the *Cir-*

Figure 151. Detail of spolvero *on the frieze of twirling banners repeating along the top of Antonio Pisanello,* Tournament Battle, *underpainted mural remains (Palazzo Ducale, Mantua).*

cumcision of Christ (Galleria degli Uffizi, Florence), painted in tempera during the 1460s, also required a *spolvero* pattern, as examination with infrared reflectography reveals.[135] Similarly detailed *spolvero* abounds throughout Mantegna's mural cycle in the *"camera picta"* or *Camera degli Sposi* (Palazzo Ducale, Mantua), from 1465 to 1475, where the repetition and subtle variation of ornamental motifs is layered onto an opulent illusionistic framework evocative of Roman imperial architecture. Melozzo da Forlì also relied on the *spolvero* technique to create the sumptuous moldings, cofferings, capitals, and bases for the architectural setting in his mural, *Pope Sixtus IV Appointing Platina* (Pinacoteca Vaticana), from 1472 to 1481. Like Mantegna, Melozzo usually stylus-constructed the large architectural frameworks directly on the *intonaco,* using *spolvero* for complex or repetitive details. In the mural, which commemorates the founding of the Vatican Library by Pope Sixtus IV, fine *spolvero* articulates the motifs of oak branches facing the monumental foreground pilasters, in a tribute to the pope's family name, *"della Rovere."*

In enabling repetitions and variations of complex design, *spolvero* patterns stimulated the very "copiousness" and *"varietas"* of ornament characteristic of the *all'antica* revival during the second half of the Quattrocento. Domenico Ghirlandaio's *spolvero* pattern for the Classical molding fragment of egg and dart motifs with palmettes, or his mural cycles with archaeologically precise architectural detailing are further examples of this new taste (Fig. 126). The broadly contemporary pen and ink drawings in the *"Codex Escurialensis"* (Library, Monastery of San Lorenzo de El Escorial) record with nearly scientific precision similar motifs from actual Antique remains.[136] Scores of other late Quattrocento and early Cinquecento drawings copying fragments of Roman architecture and sculpture attest to a passionate antiquarianism.

Grotteschi Decoration

Fueled by the rediscovery of Antique mural and *stucco* decoration, particularly in the *Domus Aurea* or "Golden House of Nero" (c. 64–68 A.D.), the painting of *grotteschi* burgeoned into a full-fledged Renaissance genre from about 1480 onward.[137] Yet contrary to Antique precedent, but very much in keeping with the Late Medieval practice that we have been surveying, the delicate and animated figurative ornament of *grotteschi,* usually of bilaterally symmetrical disposition,

was commonly repeated by the efficient and precise means of *spolvero* patterns.[138] A long list of examples can demonstrate the ubiquitousness of this practice and the intricacies of its actual applications in both murals and drawings.[139] At the end of the Quattrocento, Pietro Perugino and Filippino Lippi emerged as the most inspired specialists of this tradition (Figs. 152–53). During the sixteenth century, the taste for *grotteschi,* as well as their reproduction by means of *spolvero* patterns, would rapidly spread throughout Europe, from the library and chapter halls in the Monastery of San Lorenzo Real de El Escorial to the imperial Habsburg palace at Augsburg.[140]

We have seen that in the introduction to the *Vite* (Florence, 1550 and 1568), Giorgio Vasari mentioned *spolvero* only as a means of transferring ornament designs for *sgraffito* façade decoration, a medium that largely depended on the repetition and variation of *grotteschi* motifs.[141] To fresco *grotteschi* more rapidly, painters would attempt to use a variety of techniques *(calco, incisioni dirette,* and painting *alla prima),* besides *spolvero,* though with less effective results. The workshop of Bernardino Poccetti, an unparalled master of the genre of *grotteschi* decoration at the end of the Cinquecento, relied on such a fluent combination of techniques to fresco the stairway leading to the *"Sala di Leone X"* (Palazzo Vecchio, Florence).

Later Ornament Painting

Italian mural painters would use *spolvero* patterns to repeat and reverse ornament designs, more or less continuously from shortly before the mid-Trecento until the end of the Ottocento, albeit with ebbs and flows, whether or not they painted the figural scenes from cartoons and whether or not they pounced or stylus-incised the cartoons for such figural scenes.[142]

Leonardo and the Shortcut to Bilateral Symmetry

Chapter Two discussed the particular configuration of the *spolvero* marks in Andrea del Sarto's *grotteschi* on the pilasters framing the scenes at the *"Chiostro dello Scalzo"* in Florence (Fig. 54), frescoed in 1509–24. As pointed out, on the right half of the symmetrical design, the *spolvero* dots appear larger and readily distinct, whereas on the left half, the dots are much more

Figure 152. Pietro Perugino and workshop, decoration in grotteschi, *mixed mural technique (Collegio del Cambio, Perugia). The bilaterally symmetrical figures were painted from* spolvero *patterns.*

weakly defined, since *spolvero* registers more clearly on a final working surface if a pricked design on paper is pounced from the verso, than if it is pounced from the recto.[143] This example establishes that there was at least one ingenious method to abbreviate the work of constructing such bilaterally symmetrical ornament. Giovanni Antonio Tagliente's embroidery patternbook – published in Venice in 1527, 1529, 1530, and 1531 – describes a shortcut, intended for the production of *"groppi,"* designs of knotwork or interlaces, by then a highly popular form of ornament:[144]

Among the other things . . . that I there explain, that having received and understood the science of making knots and interlaces *["la scienza del far di groppi"],* according to the rules given by me, I say that if you, wishing to make a border, circle, or square, should mark on the paper the size you want, and fold the paper in more parts than you can – in truth, fold it if you can into halves for borders; squares and circles can be folded into eight parts. With the precepts that you have learned and the ruler, you will make with the leadpoint your division according to the work that you wish to make with

the big and small squares, braiding from below and above. And having ably delineated with the pen, and then pricked with the needle, you should notice, that over the fold of the paper you will make half the square (or whatever design you have chosen), because when you open the paper after pricking it as I have said, it will appear whole . . . and you will find the work complete, in proportion, duly divided and accurate. You will then be able to pounce through this pricked design onto anything you desire, whether you want to sew, to embroider, or to paint.[145]

This practice of pricking one-half of a design onto a folded sheet of paper was already known in China by the mid–tenth century (Fig. 127).[146] Renaissance treatises, however, yield neither a precedent for Tagliente's passage, nor subsequent quotations.[147]

Eight drawings by Leonardo, ranging in date between 1487 and 1515, exemplify the two-step shortcut described in Tagliente's patternbook and suggest that this was a fairly common design habit of the great master, after his arrival in Milan in 1482–83.[148] Tagliente's terse passage, however, does not fully

Figure 153. Filippino Lippi, decoration in grotteschi *(Gabinetto Disegni e Stampe degli Uffizi inv. 176 Orn., Florence), drawn from* spolvero *outlines.*

describe the technique's complexity when actually put to practice, as we can see from two of Leonardo's *moreschi* patterns of interlacing stars in the *Codex Atlanticus* (CBC 137–38). In design, the sheets may relate to the decoration of the *"Sala delle Asse"* (Castello Sforzesco, Milan), around 1497–98 and resemble the *"Sixth Knot"* in the famous suite of engravings

inscribed *"Achademia · Leonardi · Vinci,"* as well as the woodcut patterns reproduced on folio 16 verso of Tagliente's embroidery patternbook.[149] One study, possibly a full-scale design for a tile floor (Fig. 154), documents the first part of Tagliente's description: the shortcut for producing bilateral symmetry.[150] Leonardo folded the paper vertically through the center and drew the right half of the six-pointed star first in black chalk and then in pen and ink. The artist then pricked the outlines of the design with a needle or fine stylus and unfolded the paper.[151] But he amended the drawing even after this stage. Judging from evident readjustments along the vertical crease, he seems to have made the two points of the star along the crease too short. Having apparently realized the problem once he unfolded the sheet, Leonardo repricked the outlines by folding it once again. In the end, these two vertical points, though of the right length, were too thin.[152] We may suspect that this was perhaps the reason why Leonardo did not bother to complete the other half of the design with pen and ink, save for a few strokes; he rubbed black pouncing dust only on the right half of the design.

Another possible design for a tile floor (CBC 137), from 1497 to 1498, though its function seems much less certain, depicts variations on interlacing six- and twelve-pointed stars, drawn on *spolvero* underdrawing.[153] This sheet on *spolvero* documents the second step of Tagliente's description, mentioned in passing at the end, of subsequently pouncing the resulting bilaterally symmetrical pricked design for transfer onto another sheet for further elaboration. Although in the case of Leonardo's *Codex Atlanticus* studies, it is plain that the single pricked star (Fig. 154) was not directly pounced for transfer onto the sheet on *spolvero* with more complex composition (CBC 137, since their scales and designs are not exact), we have here a fortunate instance in which a detailed verbal description of an early source finds physical, if fragmentary, proof.

Leonardo's designs from 1487 to 1490 for the *tiburio*

Figure 154. Leonardo, design for Interlacing Star, Codex Atlanticus, *VIII, fol. 701 recto (CBC 138; Biblioteca Ambrosiana, Milan), partly drawn on pricked outlines. These were obtained by folding the pattern in half, vertically through the center, and pricking from right onto left.*

(domed crossing tower) of Milan Cathedral seen in section, also from the *Codex Atlanticus* (CBC 148–49), contain the expected vertical folds through their centers, and the signs of drawing and pricking from right to left; yet here, as well, there is evidence pointing to intermediary lost drawings (Fig. 155).[154] The general dimensions of the architectural elements in the two extant sheets

showing the tower in section are identical, suggesting that Leonardo must have developed a number of studies for this project in the same scale – an economical measure, for the drawings were probably intended to be in the scale of the wood architectural model, which Leonardo prepared with a carpenter's assistant, to compete with a number of other architects, including Donato Bramante, Francesco di Giorgio, and Giovanni Antonio Amadeo, who, along with Giovanni Giacomo Dolcebuono, won the commission in 1490. Both extant designs by Leonardo coincide closely in their outlines, but not precisely, proving that they are not direct prickings of each other.[155]

Figure 155. Leonardo, design for the Domed Crossing Tower of Milan Cathedral, Codex Atlanticus, *X, fol. 851 recto (CBC 149; Biblioteca Ambrosiana, Milan), partly drawn on pricked outlines. These were obtained by folding the pattern in half, vertically through the center, and pricking from right onto left.*

Other drawings by Leonardo produced by this general method of folding the sheet, also from the *Codex Atlanticus,* are a perspective construction of a water wheel[156] and a *mazzocchio,*[157] from 1510 to 1517. These sheets point to the source of the practice in fifteenth-century stereometric exercises. In the case of the water wheel, the technique of pinpricking was used both as a means of plotting the points depicting the wheel, as if it were a measured graph, and for transferring the design. In the drawings of *coppe* and *mazzocchi* traditionally attributed to Paolo Uccello and his circle, the equidistant points were plotted by measurement with stylus ruling, dots, and pinpricks – a method that Piero della Francesca greatly refined in *De Prospectiva pingendi* (MS. before 1482; see Chapter Six).[158] In order to study and produce such effects, Quattrocento illustrators of perspective may have also folded the sheets of drawings along the axis of symmetry. The depiction of only one-half of designs of bilaterally symmetrical *mazzocchio* forms became a convention among illustrators, as seen on folio 128 of Daniele Barbaro's *La Prattica della perspettiva* (Venice, 1569).[159] Artisans, as well, relied on this assumption of bilateral symmetry for their practice. Cipriano Piccolpasso's manuscript on pottery (MS., 1556–59) depicts plates divided on their axes of symmetry into two alternative designs; significantly (in view of Leonardo's *"Sala delle Asse"* and Tagliente's embroidery patternbook), it included designs of *"Groppi con fondi e senza."*[160] More generally, Juan de Alcega's tailoring patternbook (Madrid, 1589), recommends that tailors cut patterns for cloaks, jerkins, cassocks, skirts, and the like, by folding the cloth in two.[161]

Giulio Romano's Mantuan *"Giochi di Putti"*

Much as artists and artisans adjusted the practice of bilateral symmetry in their work, Giulio Romano would use it to produce a monumental ornament design with playing *putti* (Fig. 156), an elaborate conceit on lost inventions by Raphael.[162] Giulio's British Museum sheet and at least four other drawings relate to a series of tapestries (Gulbenkian Foundation, Lisbon; Victoria and Albert Museum, London; and Marquess of Northampton, Compton Wynyates), produced for Cardinal Ercole Gonzaga in the workshop of the Flemish weaver Nicholas Karcher, probably during his stay in Mantua in 1539–45.[163] Giulio's scene portrays *putti* playing with birds and animals as well as climbing on an ingenious armature of arching fruit trees and vine trellises. Many of the outlines on the *putti,* birds, and animals are not pricked, whereas those on the

interlacing trees, branches, and vines are finely so. The extent of their pricking is, in fact, greater than what is actually drawn – there are pricked but undrawn arches, as well as vertical and horizontal lines – which establishes that the pricked outlines preceded the drawing on the sheet. Moreover, there are wide divergences between drawn and pricked outlines, especially evident in a broad area toward the upper center of the design. Most likely, Giulio drew a unit of the arboreal structure, consisting of large and small arches in a rhythm "a b b a," folded a long sheet of paper underneath the drawn part, and pricked through all layers of paper, just as Tagliente's embroidery patternbook recommends. For, unlike Leonardo, Giulio attempted to produce a long sequence of "repeats" side by side. Indeed, a closely related drawing (Collection of the Pouncey Family, London) is about one yard long! When Giulio unfolded the British Museum sheet, he used the resulting pricked outlines to draw with stylus, black chalk, ruler, and pen and ink the repeating interlaced trees and vine trellises, also modeling the forms with wash and creating elegant variety by eliminating and adding details. (This subsequent reworking explains why so many drawn elements are unpricked.)

The pricking technique to create bilateral symmetry was eminently suitable for multiple design repetitions, as we can gather from the four other drawings by Giulio and his circle with variations on the *"giochi di putti"* composition.[164] A similar set of tapestries (Marzotto Collection, Trissino) was also woven for Ercole Gonzaga's younger brother, Ferrante, in the Brussels factory of Willem de Pannemaker.[165] Giulio's murals in the Palazzo Te (Mantua), most notably on the ceiling of the *"Appartamento del Giardino Segreto,"* portray related arboreal motifs, as well. Extant payment documents from 1532 list Benedetto da Pescia "Il Pagni" and "Rinaldo Mantovano," as the mural painters who worked after the preliminary designs by Giulio.[166] The *"giochi di putti"* set in an arboreal *loggia* would become a fashionable form of ornament in Northern Italy, beyond the Gonzaga court, as is suggested by Niccolò d'Aristotile Zoppino's woodcut in his much-reprinted embroidery patternbooks, *Gli Universali de i belli recami antichi e moderni* (Venice, 1537), which is roughly contemporary with Giulio's design.

By the second half of the sixteenth century, the pricking technique to create bilateral symmetry had spread widely; the drawings by the Florentine architect Bernardo Buontalenti (1536–1608) teem with examples.[167] Drawings of *grotteschi* exemplifying the practice were also produced by the followers of Luca Cambiaso, who frescoed the chapter halls of the Monastery of

San Lorenzo de El Escorial, around 1586.[168] Further instances abound among the ornament patterns in the *Codex Zichy* (Szépmüvészeti Múzeum, Budapest), as well as among the designs and papers in the archive on the Gentili family of ceramicists (J. Paul Getty Center inv. 880209, GJPA88-A274, Los Angeles).

The Tradition of Architectural Illusionism

Having noted the purely replicative use of *spolvero* in the design of ornament, let us now partially retrace our steps, to note the substantial number of examples of *spolvero* patterns, as far back as the Trecento, that were used in the illusionistic depiction of architecture. Here, a tradition emerges that, seen as a whole, would have a significant impact on the history of the cartoon in the Quattrocento.

Ornament and Narrative in the Rinuccini Chapel at S. Croce

As we have observed, a "proto-illusionism" emerges in the borders framing Orcagna's scenes of the *Triumph of Death, Last Judgment,* and *Hell* in S. Croce, and, to a lesser extent, in the *dados* of Andrea di Bonaiuto "da Firenze"'s nearly contemporary mural cycle in the *"Cappellone degli Spagnoli"* at S. Maria Novella (Figs. 144–47). Slightly later in S. Croce, in the square space behind the sacristy now known as the Rinuccini Chapel, a more unified approach to the design of ornament would prevail. Between 1365 and 1369, Giovanni da Milano had begun there a cycle of the *Lives of the Virgin and St. Mary Magdalen* for the Guidalotti family.[169] The project was finished during the 1380s for the Rinuccini family by a painter (now known as the "Master of the Rinuccini Chapel"), who is possibly to be identified with Matteo di Pacino and who was greatly influenced by both Giovanni da Milano and Nardo di Cione.[170] Though in parts weakly executed and much restored, the decorative framework of the program offers nevertheless comprehensive, accessible data on the large-scale use of *spolvero* and stencil patterns during the Trecento (Figs. 157–58).[171] The painter used *spolvero* to delineate the fictive *all'antica* marble cornice that surmounts the *dado,* including the *cyma recta* with acanthus leaves, the modillions, and most horizontal lines of the moldings. He rendered these forms obliquely in rudimentary perspective and in detailed chiaroscuro.[172] He relied on stylus-ruled and cord-snapped horizontals, incised directly on the *intonaco,* to

help adjust the patterns side-by-side for repeated pouncing. Each of the three walls of the chapel is about 5.8 meters long, and the *spolvero* patterns, therefore, must have consisted of multiple repeats, like the monumental stencils *("istrafori")* on glued sheets of paper/parchment mentioned in Cennino's *Libro.*[173] Since the *spolvero* marks (which can be seen sporadically through the flaking *a secco* pigments) do not often align with the painted forms, they served only as a general guideline for painting. The execution of this ornament varies considerably from wall to wall; that along the east wall, behind the altar, is a nineteenth-century restoration. Below the illusionistic marble cornice, a flat lattice of bluish-black quatrefoils, based on long strips of perforated stencils or templates (to judge from a number of misaligned registering of the patterns), frames each of the *dado's* square panels of painted colored marbles. On the north and south walls, the cosmatesque columns, which divide each pair of *historie* along the two tiers below the lunette murals, are also repeated, but in mirror images, across the space of the chapel. These repeating columns are pounced throughout.[174]

Because the program is complete, still in situ, and largely unobstructed by church furniture, we can clearly see that the repetition and reversal of the *spolvero* patterns comprising the cornice relate to the square space of the chapel, though in a simple manner. First, the background color for the modillions of the cornice changes from wall to wall: that for the north wall is green, that for the east wall behind the altar is blue-gray, and that for the south wall is red. Second, though portrayed consistently in oblique view, the molding and cornice unify the narrative cycle across the three walls of the chapel, for the orientation of the cornice, and consequently its viewing angle, is in the direction of the altar, from left to right on the north wall, and from right to left on the south wall. Not surprisingly, this is also the general thrust of both narrative and composition in the lowest register of the *historie,* scenes that the "Master of the Rinuccini Chapel," rather than Giovanni da Milano, appears to have painted.[175] The "Rinuccini Master" conceived the cornice on the sidewalls as mirror images across space, and the pattern types he employed on each wall had to be consequently reversed. Moreover, at the midpoint of the east wall, fixed between the two pairs of lancet windows behind the altar, the ornamental cornice above the *dado* runs in opposing directions, right to left on the northeast half of the altar wall, and left to right on the southeast half.[176] This is opposite also with respect to the side walls.

The repetitive modillioned cornice as an illusionistic framing device that unifies groups of scenes had its

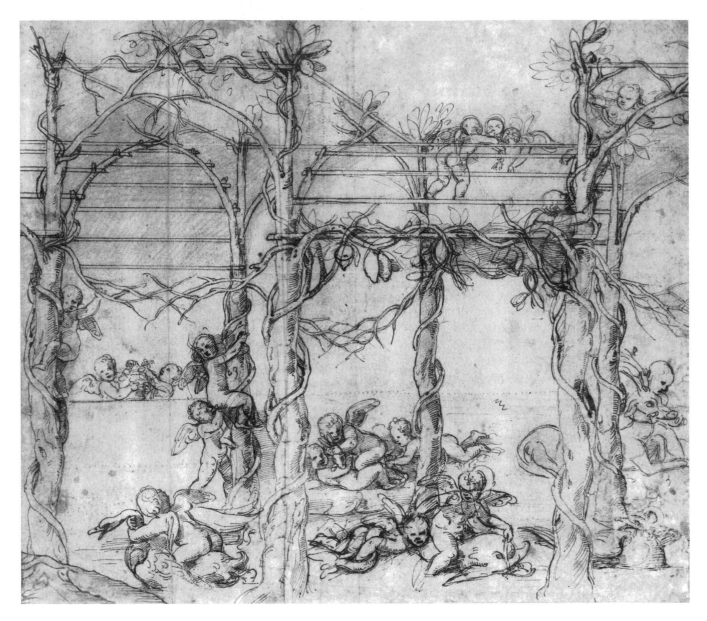

Figure 156. Giulio Romano, design for Ornament of Interlacing Trees and Putti Playing, The Mantuan "Giochi di Putti" *(CBC 207; British Museum 1928-4-17-5, London), partly drawn from pricked outlines.*

roots in ancient Roman wall painting and Early Christian mosaics. The program in the Upper Church (S. Francesco, Assisi) is the most monumental example of its use from the late Duecento and early Trecento.[177] For the St. Francis cycle on the nave at Assisi, the repeating modillions of the *all'antica* cornice were elaborately constructed, probably with the help of some mitering device, but certainly without templates, as has rightly been noted.[178] Yet the disposition of the modillions for the St. Francis cycle can be described as convergent perspective only in a general sense; this aspect of the device is, in fact, absent in the Rinuccini Chapel modillions. In the St. Francis cycle, at the center of each bay and usually (but not always) corresponding with the center of the clerestory window, lies the focus – or more accurately put, the axis of symmetry – from

which the mirror-image repetitions of the modillions depart outwardly. Precisely because this type of design involves more blunt repetition than optical refinement, many mural painters during the last quarter of the Trecento, like the "Rinuccini Master," gradually began to use *spolvero* patterns to create a primitive type of illusionism.[179] As the device of the modillioned cornice demonstrates in the Rinuccini Chapel at S. Croce in Florence and in other contemporary cycles, this was by no means, however, an inexorable march of progress toward Quattrocento *"one-point"* perspective. Many late

Figure 157. Detail of Giovanni da Milano and "Master of the Rinuccini Chapel," The Marriage of the Virgin with Framing Elements, *mixed mural technique, on the left wall of the Rinuccini Chapel (S. Croce, Florence). The twisting column, its podium, and the modillioned cornice below (at the level of the* dado*) were painted from* spolvero *patterns. The quatrefoil motifs were painted from long strips of cut stencils. Their horizontal and vertical joining was not carefully considered, as we can see from the misalignments and cropping of two* quatrefoils *toward the bottom center of the image.*

Figure 158. Detail of spolvero *on the modillions of the cornice in the* dado *on the left wall of the Rinuccini Chapel.*

Trecento painters were unwilling to sacrifice serial production for optical refinement. *Spolvero* appears on the awkwardly oriented, but exquisitely detailed, modillioned cornices by Spinello Aretino and his *bottega* in the sacristy at S. Miniato al Monte (Florence), the cycle narrating episodes from the *Life of St. Benedict* painted after 1387, and on those by Spinello and his son Parri in the *"Sala di Balìa"* (Palazzo Pubblico, Siena), from 1407 to 1410.[180] In the *"Sala di Balìa,"* especially, the "focus modillions" on the fictive cornice surmounting the *dado* correspond with the key points on the piers in the actual architecture of the room, unifying the space overall with a dynamic play of divergent–convergent orientation.

In the tradition of Giotto and his immediate followers, however, such architectural designs had been constructed painstakingly, unit by unit, directly on the mural surface, with the aid of cord snapping, compass sectioning, stylus ruling, and perhaps mitering devices.

Monumental Architectural Patterns
from 1360 to 1450

Increasingly during the fourteenth century, the contractual design specifications for some of the major public monuments being erected throughout Italy would include not only three-dimensional models but also drawings on parchment or paper. The elaborately drafted pen and ink designs relating to the cathedral works in Orvieto, Siena, and Florence are in an unusually large scale and illustrate a wealth of ornamental detail precisely modeled in washes.[181] Though serving a contractual function within particular commissions, such carefully drawn designs played a crucial role in the dissemination in Italy of the "Gothic" style, particularly of its surface embellishments. Between 1370 and the early 1430s, Italian mural painters would emulate this taste, employing *spolvero* architectural patterns, which grew to an unprecedented monumental scale, to the size of "Gothic style" niches, tabernacles, and canopies carved of real wood or stone. A height nearing 2 and 3 meters is not unusual.

Moreover, the precision of pictorial space achieved with such large *spolvero* architectural patterns was sometimes ahead of the description of form realized in the figural parts of the same program. This is true of the *"Cappellone degli Spagnoli"* ("The Spanish Chapel"), from 1366 to 1368, by Andrea di Bonaiuto "da Firenze," where besides the use of *spolvero* on the *dado,* a surprisingly complex direct surface construction was combined with *spolvero* to portray the fourteen repeating tabernacles on the impressive "Gothic"

arcade, seen on the north wall below the enthroned St. Thomas Aquinas (Fig. 146).[182] Moreover, in the monochrome murals from the 1370s, on the *dado* of the Chiesa del Tau in Pistoia (Figs. 159–60), attributed to Niccolò di Tommaso, *spolvero* marks appear only in the richly detailed arcade of niches, which house the figures of the virgins and women martyrs like illusionistic choir stalls.[183] The figures themselves stand slightly less than 1.5 meters tall. The broad, painterly handling of the figures greatly contrasts with the precisely linear treatment of the richly detailed architecture. Because each niche is identical both in its details and oblique setting, it can reasonably be concluded that the artist repeated the same pattern, or copies thereof, multiple times.[184]

A similar decorative system occurs in the interior southeast corner at S. Miniato al Monte in Florence (Fig. 161), where monumental, "Gothic style" tabernacles enclose modest, life-size figures of saints. Greatly influenced by Orcagna and Nardo di Cione, these awkward murals probably date from the 1380s to 1390s and may well be by Pietro Nelli.[185] Six of the fictive niches repeat identically and are at least partly painted from *spolvero.*

Also in Florence, on the arch leading to the chancel (*"cappella maggiore"*) at S. Croce, *spolvero* marks outline the illusionistic brackets, ornament, and monumental niches with saints, especially visible on the right pier. Commissioned by Jacopo degli Alberti and painted between 1388 and 1392 by Agnolo Gaddi, the mural cycle narrates the *Legend of the True Cross:* monumental niches of nearly identical design recur twenty-four times throughout the cycle.[186] Gherardo Starnina's detached murals from around 1404, originally in the Chapel of S. Girolamo (S. Maria del Carmine, Florence; Fig. 162), if only in very fragmentary form, further confirm the function of such "Late Gothic" architectural patterns.[187] In this program, the large, repeating canopies – complete with monumental buttresses, fictive statuary, and carefully detailed tracery – show comprehensive, fine *spolvero,* as do the cosmatesque borders framing the rectangular fields for each of the canopies. A similar treatment is evident in the niches housing saints in the fresco fragments from S. Maria del Carmine, attributed by early sources to the mysterious "Lippo Fiorentino," Lippo d'Andrea (doc. c. 1354–1410).[188] Much later, Fra Angelico's Chapel of Nicholas V at the Vatican Palace, presumably frescoed around 1447–50, offers one of the final stations along this path. There, also, the exquisitely detailed tabernacles housing the saints are based on *spolvero* (Fig. 163), as are other repeating decorative elements.

The primary purpose of such architectural patterns

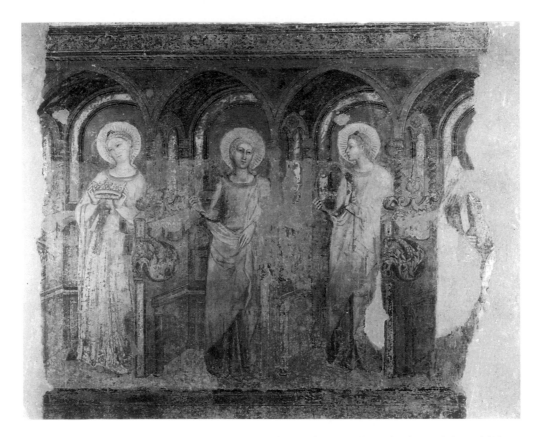

Figure 159. Niccolò di Tommaso, Women Martyrs within Niches, *mixed mural technique (Chiesa del Tau, Pistoia). Only the niches and architectural details are painted from* spolvero *patterns.*

Figure 160. Detail of spolvero *on the colonnettes and tracery in Niccolò di Tommaso,* Women Martyrs within Niches.

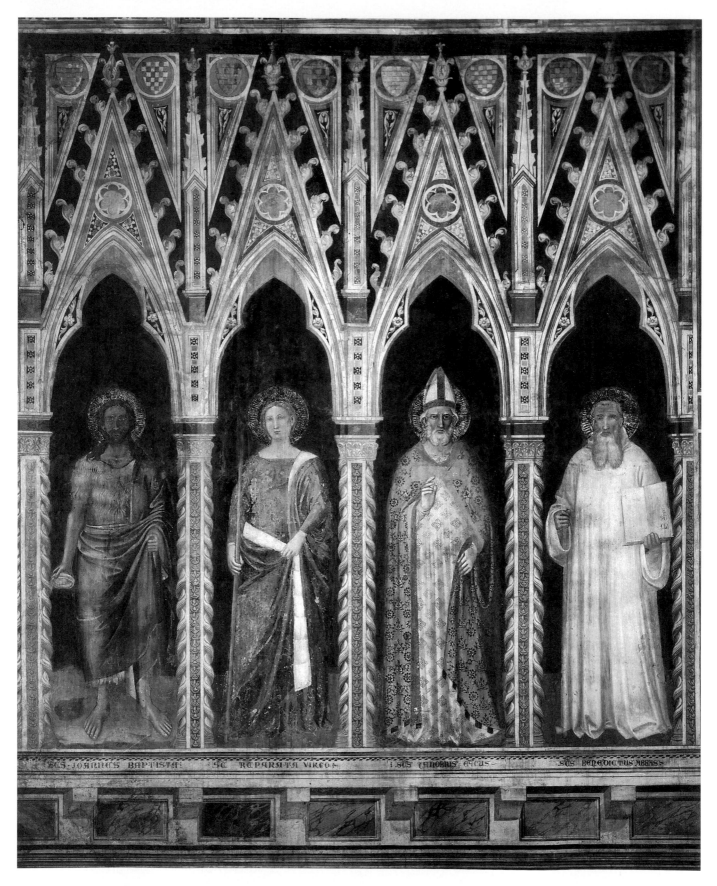

Figure 161. Artist near Andrea di Cione "Orcagna" and Nardo di Cione (Pietro Nelli?), Saints within Tabernacles, *mixed mural technique (S. Miniato al Monte, Florence).*

Figure 162. Detail of the tabernacle housing one of the saints in Gherardo Starnina, mural cycle in the Chapel of S. Girolamo (S. Maria del Carmine, Florence), painted from spolvero *patterns.*

S·AMBROSIVS·

Figure 163. Detail of the tracery and tabernacle in Fra Angelico, mural cycle in the Chapel of Pope Nicholas V (Vatican Palace). The artist relied on stylus ruling and pointed compass construction, directly incised onto the plaster, for the design of the tracery on the fictive frame, and monumental spolvero patterns for the tabernacle within, to repeat its design manifold.

was to replicate designs too complex to improvise anew each time. Yet it is worthy of our notice that, although the figures were painted freehand, without *spolvero,* it is the monumental architectural patterns in perspectival projection that provided the compositional principle for large parts of the overall program.

Some *All'Antica* Temples in the Quattrocento

By contrast, Masaccio's *Trinity* from 1425 to 1427 (S. Maria Novella, Florence), in which the artist carefully constructed both the architectural background and its perspective directly on the *intonaco,* represents a real turning point.[189] As we have seen, especially in non-repetitive architectural backgrounds, Trecento painters had already made use of the basic elements of direct construction on the *intonaco* – *incisioni dirette,* stylus ruling, cord snapping, and compass sectioning. Yet the scope of Masaccio's detailing of the *all'antica* architecture in the *Trinity* and his rationalization of the architecture according to the spectator's point of view for the composition had pushed this design technology to the limit. Such complex construction required the aid of both a detailed preliminary drawing on paper as well as detailed referencing on the *intonaco.* The overall design of Masaccio's architecture was, of course, not meant to be replicated. Yet rarely would such dazzling complexity be attempted again in *buon fresco* without the intermediary means of a full-scale drawing on paper, to be transferred by *spolvero* or *incisione indiretta.* The frescos by Raphael and his *bottega* in the Vatican *stanze* – as is especially clear in the recently cleaned *School of Athens, Fire in the Borgo,* and so-called *"Coronation of Charlemagne"* – offer similar *virtuoso* examples of illusionistic architectural settings constructed partly from cartoons and partly on the *intonaco* with direct compass incision, cord snapping, and stylus ruling.[190] In Masaccio's *Trinity,* small areas of *spolvero* exist only in the minor repetitive, ornamental upper parts of the architecture: the dentils, beaded molding, and the pseudomeander frieze on the monumental pink cornice.[191] This is one of the few aspects of the *Trinity* still reminiscent of fourteenth-century design technology, for the history of this fresco more properly belongs in the following chapter.

The *difficultà* of Masaccio's construction and the late Trecento tradition of *spolvero* architectural patterns begin to explain the gradual, selective integration of the *spolvero* technique into figural compositions during the early Quattrocento. In the *Presentation of the Virgin in the Temple* (Chapel of the *"Assunta,"* Prato Cathedral), which may be dated around 1433–40, by Paolo Uccello or, less likely, a close follower (the "Prato Master"), the only portions within the composition painted from *spolvero* are the four identical columns of the foreshortened, circular temple (Figs. 164–65).[192] The temple's *all'antica* architectural details and its perspectival projection are thoroughly un-Medieval. Yet the means of production from a *spolvero* architectural pattern, at least for the repeating columns, owes much to the tradition of "Late Gothic" design developed by Giovanni da Milano, Gherardo Starnina, Agnolo Gaddi, and their contemporaries. The only other application of *spolvero* in this cycle occurs in the ornamental borders framing each scene, where motifs repeat and reverse essentially in the Trecento manner, and in the white cornice on the lower left of the *Birth of the Virgin.*[193]

The presence of *spolvero* for complex, illusionistic architectural details is welcome confirmation of *difficultà* in many Quattrocento murals, particularly those painted in *buon fresco.* The practice certainly makes sense in the background of Luca Signorelli's *Preaching of the Antichrist* from 1499 to 1504, in the *"Cappella Nuova"* (Cappella della Madonna di S. Brizio, Orvieto Cathedral).[194] In Chapter Three, we alluded to this detail among the exceptional cases of *spolvero* in the *historie* of the fresco cycle, the cartoons for which were otherwise comprehensively stylus-incised. Signorelli constructed the deeply porticoed, central-plan temple in daringly foreshortened perspective. The three-quarter view of the building suggests a vastly receding pictorial space for the scene, and the intricate architectural detailing echoes the brilliant work of Signorelli's elder Sienese colleague, Francesco di Giorgio (1439–1502).

Paris Bordone's Scenographic Courtyard

We may now look forward a half century, to confirm the endurance of this general practice in the Cinquecento. As pointed out, although the use of patterns to replicate ornament details persisted as an uninterrupted tradition, the practice of design repetition was much condemned by sixteenth-century theorists. Despite the negative connotations, however, some artists continued to use patterns in less overtly decorative contexts, as is true of the monumental architectural settings in two oil paintings on canvas by Paris Bordone (1500–1571), which were derived from the same or closely related *spolvero* patterns – the *David and Bathsheba* (Fig. 166) and the *Annunciation* (Fig. 167), signed and dated 1550.[195]

Figure 164. Paolo Uccello (or less likely, the "Prato Master"), The Presentation of the Virgin in the Temple, mixed mural technique (Chapel of the "Assunta," Prato Cathedral).

The architecture of the Baltimore *David and Bathsheba* (Fig. 166) visibly exhibits *spolvero,* and the measurements of both architectural structures correspond, though with some differences of design.[196] In the Caen *Annunciation* (Fig. 167), minor decorative details on the bases and capitals of the columns are more elaborate, and a window replaces a wall in one of the bays on the *piano nobile* of the courtyard.[197] More importantly, however, the units of the overall architectural structure appear shifted: the interior wall of the courtyard begins at the second arch in the *Annunciation,* whereas in the *David and Bathsheba* it begins at the first arch. Yet analysis of the architectural backgrounds in the two canvases reveals that it is not so much that all the elements have been shifted relative to the composition as a whole but that

the design of the arcade is cropped on the left in the *David and Bathsheba* and on the top and right in the *Annunciation.* We may notice that if we cover the first bay of the arcade on the left in the *Annunciation* and add another bay on the right, all elements correspond exactly with respect to each other in both paintings. The manner in which Paris utilized the *spolvero* pattern to paint both architectural backgrounds, therefore, seems to have been relatively simple.[198] We can envision that his drawing depicted five bays in a greatly more detailed, linear, and precise manner than his usually painterly drawing style (Fig. 168).[199] The purpose of his pattern would have been, above all, to provide the correct perspectival relationships of all the elements in the courtyard and of the receding architecture beyond. This pricked architectural design would have been slightly wider and longer than the motif is portrayed in the background of either painting.[200] In pouncing the design onto the primed canvas of the *Annunciation* and the *David and Bathsheba,* the

Figure 165. Detail of spolvero *on the columns of the temple in* The Presentation of the Virgin in the Temple *(Chapel of the "Assunta," Prato Cathedral).*

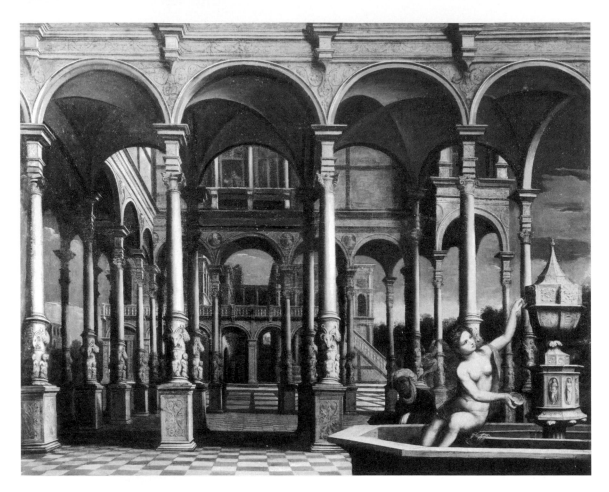

Figure 166. Paris Bordone, David and Bathsheba, *oil on canvas (Walters Art Gallery, Baltimore).*

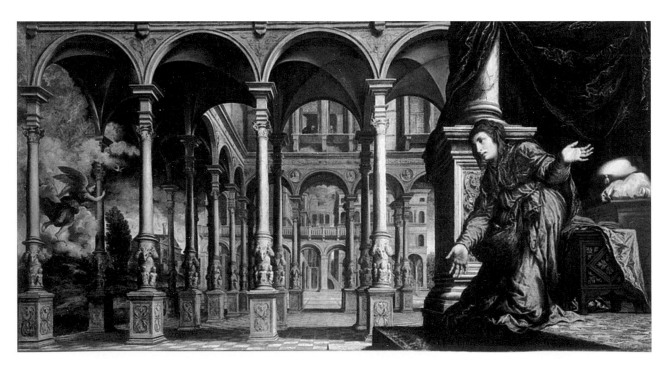

Figure 167. Paris Bordone, The Annunciation, *oil on canvas (Musée des Beaux-Arts, Caen).*

184

artist chose to omit some of the bays of the building. (He may well have used the design on still other occasions than just these two surviving cases.) By folding the unwanted ends of the drawing perpendicularly, the artist could avoid getting pouncing dust in the unused parts of the design.[201] That the pricked pattern was comprehensive, including more than what was represented in either painting, rather than less, seems probable, considering the complex perspectival construction of the architecture.

Paris Bordone's building seen in exaggerated, panoramic perspective evokes the popular scenographic designs for *Comedy* and *Tragedy,* illustrated in Sebastiano Serlio's *Sette libri dell'architettura* (Venice, 1537) and Daniele Barbaro's *La Prattica della perspettiva* (Venice, 1569).[202] Despite its theatricality, however, Paris's design is sufficiently generic to suggest that it was a stock pattern, adaptable to a variety of compositions. The complexity of the perspectival effect, as well as the necessity of repeating the motif, had virtually determined the use of *spolvero* as a means of design transfer.[203]

It was arguably in this last tradition of architectural

Figure 168. Approximate reconstruction of the pricked architectural pattern used by Paris Bordone.

illusionism, which we have charted from the early Trecento onward, that the long association would originate between perspective and techniques of design transfer.[204] Our discussion of the squaring grid and *"giudizio dell'occhio"* in Chapter Four touched on this association in passing. By the early Quattrocento, the scientific study of perspective had gradually emerged from the field of Late Medieval optics.[205] The development of scientific methods in the study of perspective during the Renaissance would demand a precision of drawing technique, both of construction and reproduction, that we are only now beginning to understand, as we attempt to interpret the extensive archaeological evidence found on the surfaces of the paintings and drawings of this period. Now, the implications of these points for the fifteenth century remain to be explored.

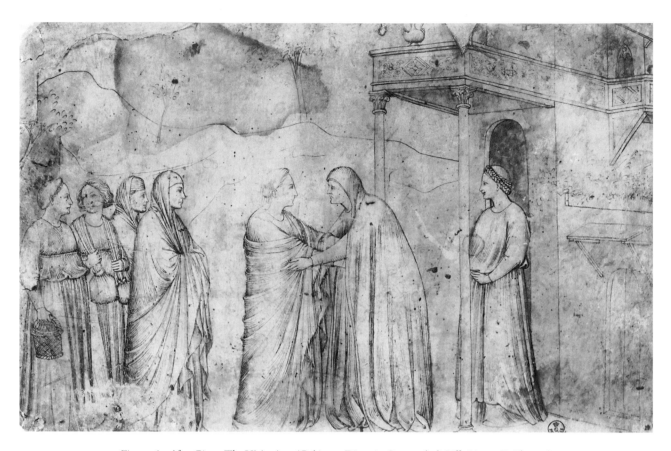

Figure 169. After Giotto, The Visitation *(Gabinetto Disegni e Stampe degli Uffizi inv. 9 E, Florence).*

Without denying the significant pedagogic function of copying, Alberti exhorted artists to draw as a means of thoroughly exploring the *"inventione"* of a composition. Here, in mentioning *"charta"* (paper or parchment) as the support for such exploratory drawings, the Latin text is more explicit than the Italian: "We will work out the whole *historia* and each of its parts by making preparatory studies *in chartis* and take advice on it with all our friends."[14] Creative, exploratory drawing in the modern sense was thus gradually born.[15] The frozen contours of the late Trecento copy after Giotto's *Visitation* (Fig. 169) may be compared with the boldness and *terribilità* of a pen and ink study (Fig. 170), which may well be by Donatello, or at least by an artist closely influenced by the great master. It explores a composition for the *Massacre of the Innocents* and probably dates from the 1440s.[16] Contemporary drawings in a monumental scale suggest a similarly expressive understanding of the figure, as is clear from the Donatellesque plaster fragments with charcoal renderings detached from the walls of the Pazzi Chapel (Museo dell'Opera S. Croce, Florence).[17]

During the course of the Quattrocento, artists would increasingly turn to drawings on paper – rather than to the final working surface – as the principal means of exploring and experimenting with form. The result was an increasingly systematic approach, with an ever more nuanced division of drawing types within the design process.[18]

Alberti's painting treatise goes on to describe the innovative method of squaring preliminary studies on paper with proportional grids for transfer onto the larger scale of a final working surface: "We will endeavor to have everything so well worked beforehand that there will be nothing in the picture whose exact collocation we do not know perfectly. In order that we may know this with greater certainty, it will help to divide our preparatory studies into parallels, so that everything can then be transferred, as it were from our private papers and put in its correct position in the work for public exhibition."[19] The awareness of proportional scale as a conceptual problem arose from two related modes of visualization: (1) the surveying of architecture and (2) the systematic, scientific study of perspective.[20] According to Antonio di Tuccio Manetti's *Vita of Filippo Brunelleschi* (MS., before 1489), the proportional grid of squares was among the methods the

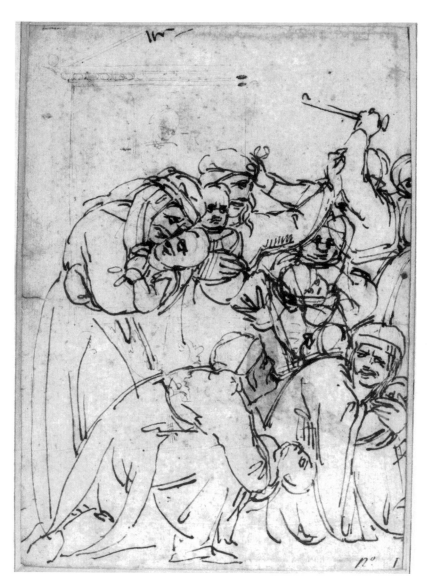

Figure 170. Attributed to Donatello, The Massacre of the Innocents *(Musée des Beaux-Arts inv. 794.1.2501.2, Rennes).*

enlargement until the later fifteenth century.

Masaccio, the Squaring Grid, and the Technology of Direct Construction

Muralists would use mixed media on and off throughout the Quattrocento. Yet, during the first three decades, the shift away from *a secco* painting (more traditional in the Trecento), in favor of a predominantly *buon fresco* execution, quickened the search for an exact surface design technology so that the design notation could be transcribed onto the *intonaco* rather than underneath.

Masaccio's *Trinity* fresco in S. Maria Novella (Figs. 171–74), from 1425 to 1427, confirms that during this period even the most advanced artists still worked out large parts of their compositions directly on the painting surface. There, as is well known, a stylus-incised grid of proportional squares and rectangles is still visible on the Virgin's head and body (Fig. 172).[23] With her pointing right hand and gaze directed at the spectator, Masaccio's monumental figure of the Virgin provides the link between the planes of space separating the worldly from the divine. She is portrayed *"di sotto in sù"* (as if seen from below) and rotated to the right, at an oblique angle to the picture plane. The artist painted her figure quickly, in two *giornate*. The grid in the area of her head is subdivided into smaller squares than is the one in the area of her body, its ratio of smaller to larger squares being 1:16. But the part of the grid covering the central portion of the Virgin's face lacks the vertical line that should divide her head from top to bottom.[24] Thus, technically speaking, in this central passage of the Virgin's face, the grid consists of horizontal rectangles (not squares), in a ratio of 2:1 with respect to the smaller, adjoining squares; the artist probably interrupted the lines so as not to disfigure the Virgin's face.[25] Masaccio (or his *garzone*) incised the greater part of the grid directly on the wet plaster with a stylus, but he also snapped lines with a fine rope, as, for instance, in the horizontal passing above the Virgin's upper lip.[26] Thus, Masaccio's grid served two functions –

famed architect applied in his early survey drawings of ancient Roman buildings *("riquadrare le carte con numero d'abaco e carattere che Filippo intendeua per se medesimo . . . ")*.[21] Alberti had laid a foundation with his thorough discussions of one-point perspective in Book I and of the *"velum"* in Book II, treating these topics with greater clarity in the Latin version of his manuscript; the use of the *"velum"* was controversial, as Alberti would concede.[22] The debate about the veil's merit and its primary application in the work of *"prospectivi"* (Cristoforo Landino's word in 1481 for "masters of perspective") probably explain the infrequent use of squaring grids by artists for mere design

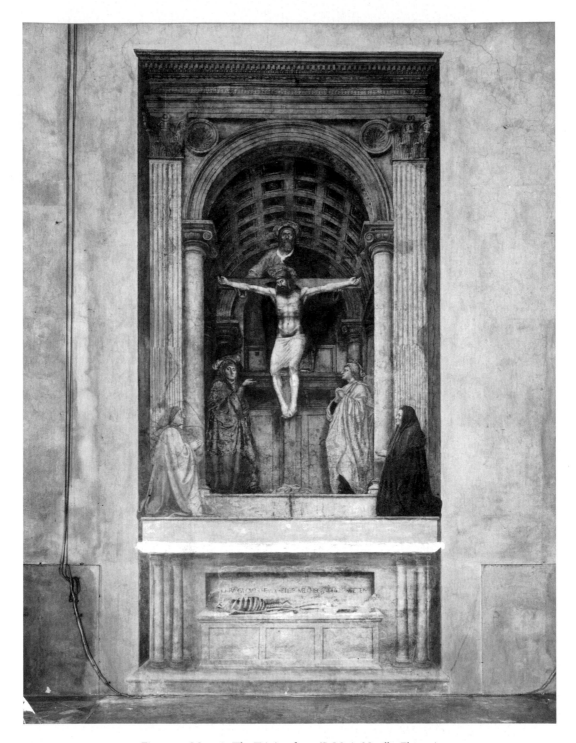

Figure 171. Masaccio, The Trinity, *fresco (S. Maria Novella, Florence).*

to enlarge proportionally the design of the figure and to calibrate the recession in space of her foreshortened pose. These were the twin complementary functions of grids that writers on perspective from Leon Battista Alberti to Andrea Pozzo would recognize (see Chapter Four). In its broadest sense, "perspective" was understood to be a systematic application of proportion to fore-

shorten a form placed in space. Masaccio had presumably prepared a small-scale drawing on paper for the figure, which he marked with a grid of proportionally smaller squares. Although an underlying *sinopia* for the fresco of the *Trinity* has not been found, this does not rule out the possibility that the artist did not produce one, for this monument has had a peripatetic history.[27]

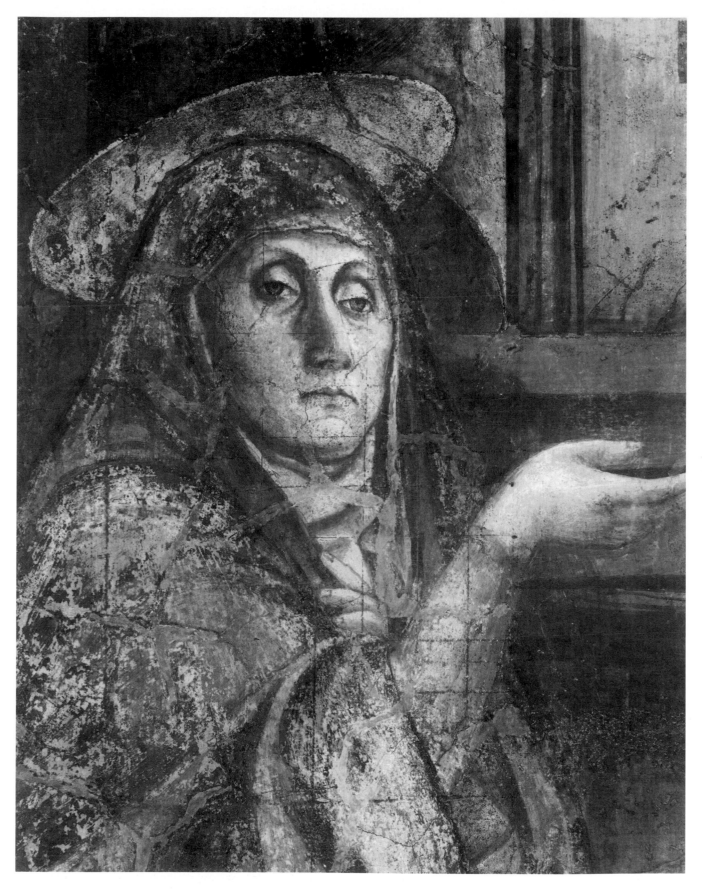

Figure 172. Detail of the Virgin in Masaccio, The Trinity, *with grid of squares and rectangles, directly stylus-incised and cord-snapped onto the plaster.*

Figure 173. Detail in raking light of the right oculus in Masaccio, The Trinity, *with construction directly stylus-incised onto the plaster. The direct surface construction on the symmetrically placed left oculus differs.*

As Masaccio was apparently the first to do for the Virgin's figure, Paolo Uccello also transferred small-scale designs by means of the squaring grid. His colored Uffizi *modello* (Fig. 175), preparatory for the mural cenotaph of *Sir John Hawkwood* in Florence Cathedral, dated 1436, is, in fact, the earliest extant Italian squared drawing on paper and is exactly contemporary with Alberti's description of the *"velo."*[28] In contrast to Masaccio, Paolo squared the drawing with a single grid throughout and consistently ruled it with 25–26 mm. squares.[29] The few lightly incised, stylus-ruled lines on the actual mural surface – most importantly, the vertical centering line – correspond to the squaring grid in Paolo's Uffizi sheet.[30] In this case, the squaring grid probably functioned as the sole means of design transfer.[31] It may have been combined with a *sinopia,* which was probably lost during the mural's detachment by *strappo* in 1841–42. Squaring grids also appear on both the *arriccio* and *intonaco* layers of two scenes, the *Stoning of St. Stephen* and the *Presentation of the Virgin in the Temple* (Figs. 164–65), in the Chapel of the *"Assunta"* at Prato Cathedral.[32] This mural program is often attributed to Paolo Uccello, or, less convincingly,

Figure 174. Detail in raking light of the perspectival projection on the left composite Ionic capital in Masaccio, The Trinity, *directly stylus-incised onto the plaster. A cord–snapped line is seen at the extreme left.*

to a close follower (the "Prato Master"), and may be dated around 1433–40. We cannot be certain whether the artist of the Prato murals relied on a preliminary small-scale drawing on paper before preparing the *sinopia,* yet his practice, like that of Masaccio and Paolo Uccello, illustrates the increasing need that was felt of correlating the layers of design and painting surface systematically.

On the fresco surface of Masaccio's *Trinity,* the extent, precision, and coherence of the design notation for nonfigural parts was extraordinary for its time (Figs. 171–74).[33] For the Virgin's figure (and probably also for portions of the architecture), Masaccio had not only developed the design on a surface other than that of the mural, but he had also attempted to link systematically the scale of his preliminary drawing(s) with that of the resulting painting. Throughout, his composition required consistent and comprehensive marks of reference on the *intonaco.* The complexity of Masaccio's spatial illusion demanded it, and the conventions, as well as the analytical skills involved in constructing a cogent perspective system on paper, must have suggested it.

In the *Trinity,* Masaccio stylus-incised all the construction of the foreshortened Brunelleschian architec-

ture directly on the plaster.[34] He first established the general perspective projection for the pictorial space by means of stylus ruling and cord snapping, then turning to more detailed notation to refine individual passages. This would include diverse partial grids on the capitals of the columns and pilasters (which would follow independent systems from the grid on the Virgin's figure), as well as tangential compass circles to build the subtly receding moldings on the *oculi* of the spandrels (Fig. 173) and freehand sketching of volutes and intricate auxiliary plottings to foreshorten the oval rings on the capitals (Fig. 174). Especially the dense armatures of intersecting stylus ruling and compass work on the two large *giornate* for the coffered barrel vault attest to the arduous method of measurement with which Masaccio labored to refine the architecture, directly on the *intonaco.* He had projected the main forms of the architectural setting before he integrated the figures into the pictorial space: the incised construction often runs through the figures.

Figure 175. Paolo Uccello, squared preparatory modello in color for Sir John Hawkwood *(Gabinetto Disegni e Stampe degli Uffizi inv. 31 F, Florence).*

The fact that Masaccio did not work from a full-scale drawing on paper, or cartoon, is amply clear. (Despite occasional claims to the contrary, all incisions in the *Trinity* were made directly on the plaster, rather than through cartoons, whether entirely freehand or with the aid of ruler and compass.[35]) This explains the extent of direct design notation on the *intonaco*, as well as the variations in the notation of comparable architectural details, not to mention the small but numerous adjustments of the perspective projection.[36] Such variations and adjustments were the result of sensitive artistic decisions, made at the moment of painting. As we have seen, Trecento muralists commonly relied on the basic elements of direct construction on the *intonaco* – *incisioni dirette*, stylus ruling, cord snapping, and compass sectioning. Both the scope of Masaccio's architectural detail and his rational-

ization of the architecture's point of view, however, had pushed this design technology to the limit.

No less importantly, in Masaccio's design of the Virgin's figure (Fig. 172), the squaring grid incised on the mural surface was a mediating step in the development of the full-scale design technology that would emerge in the Quattrocento. It stood between the convention of the *sinopia* underdrawing and the innovation of the *spolvero* figural cartoon. On the north nave wall of Florence Cathedral, the neighboring mural cenotaphs by Paolo Uccello and Andrea del Castagno – the *Sir John Hawkwood* and *Niccolò da Tolentino*, respectively – underscore both the stylistic and technological developments that would distinguish the 1420s to 1430s from the 1440s to 1450s. For by 1456, Andrea del Castagno would rely on *spolvero* cartoons to paint his flamboyantly detailed equestrian monument.

From "Pattern" to "Cartoon"

As the current state of research suggests, the *spolvero* cartoon used in painting the human figure evolved during the 1430s from two general traditions. The first is that of monumental patterns for repetitive architectural features, applied in "Late Gothic" murals. As we have seen, from the 1370s to the 1450s, complex, illusionistic architectural structures, precisely painted from comprehensive *spolvero*, gradually enframed the nearly life-size figures of many programs (Figs. 159–63).

The second tradition emerges in the early pattern-like reproduction of figural designs, which may well be rooted in the practices of tracing already employed by the end of the Duecento.[37] Be that as it may, among the telling examples, for our purposes, are the five pairs of small, crudely painted roundels flanking the top of each pointed arch on the frame of the *"Polyptych of Ognissanti"* (Galleria degli Uffizi, Florence) by Giovanni da Milano, usually dated in the 1350s to 1360s.[38] The left roundels in each pair portray the blessing figure of God the Father identically, with body in three-quarter view and face in profile. The right roundels, however, portray various scenes from the *Creation of the World*. The nearly exact, quintuple repetition of the figure in the left roundels must have been facilitated by a pattern, much like the *"spolverezzi"* employed by

Figure 176. Fourteenth-century stained-glass windows with exactly repeating figures of deacon saints (Museo dell'Opera S. Croce, Florence).

contemporary painters of ornament.[39] More importantly, two Trecento stained-glass windows, portraying the half-length figures of deacon saints (Fig. 176), offer a case of exact cartoon replication in a monumental scale – all the more striking, as the windows are presently mounted side-by-side in the museum.[40] Similarly, the red frieze above the fictive brocade tapestries in Fra Angelico's Chapel of Pope Nicholas V (Fig. 177), which was frescoed presumably in 1447–50,[41] depicts small repeating, bilaterally symmetrical cherub heads, based on *spolvero*.[42] Like Giovanni da Milano with his frame of awkwardly repeating roundel designs, Fra Angelico and his workshop assistants (who, by 1447, in Rome, were four: Benozzo Gozzoli, Giovanni d'Antonio della Checha, Carlo di Ser Lazaro da Narni, and Giacomo d'Antonio da Poli)[43] essentially treated portions of the human figure as ornament patterns, according to traditional Trecento and early Quattrocento practice. Giovanni da Milano, as well as Fra Angelico, belonged to generations of artists who painted figures and *historie* without cartoons, employing *spolvero* only for repetitive decoration.[44]

Figure 177. Detail of ornamental parts in Fra Angelico, mural cycle in the Chapel of Pope Nicholas V (Vatican Palace). Here, many of the repeating cherubs' heads and garlands were painted from spolvero patterns.

The *spolvero* underdrawing in the *Madonna and Child* (Verspreide Rijkscollecties, The Hague), a panel painted in the *bottega* of the Paduan Francesco Squarcione in the 1430s to 1440s, indicates an equivalent step in the evolution of autonomous figural cartoons from the tradition of design replication.[45]

The *Botteghe* of Lorenzo di Bicci and Bicci di Lorenzo

Just how this transition occurred, however, is perhaps best evident in the case of a small Florentine frescoed tabernacle (Figs. 178–79).[46] The *retardataire* style and figural typology of the frescos suggest a date in the 1430s to 1440s, and place this shrine in the ambience of the prolific Bicci di Lorenzo (1373–1452) or a close follower.[47] In the *"Sacra Conversazione"* on the end wall, the hieratic scale of the Madonna and Child dwarfs that of the accompanying, more awkwardly painted saints. A smaller-scale *Annunciation* surmounts the scene. Coarse *spolvero* marks outline the head, arms, and nude upper body of the Infant Christ, and the Madonna's figure in the *"Sacra Conversazione."*[48] In the case of the Infant Christ, the *spolvero* stops neatly at his waist; there are no dots to define his facial features or inner bodily modeling. Nor are there any other *spolvero* dots in the shrine. The evidence thus suggests that this mediocre painter used or reused a pricked pattern, no more individualized than a biscuit cutter, in order to replicate the main devotional image of the Madonna and Christ Child, perhaps in a number of other similar paintings as well. Although not reliable in its facts, Vasari's biography of Lorenzo di Bicci in the 1568 edition, nevertheless, cites numerous painted tabernacles by the artist and his son, Bicci; the *Libro delle ricordanze* by Neri di Bicci (Lorenzo's grandson and Bicci's son) accounts abundantly for such commissions between 1453 and 1475.[49]

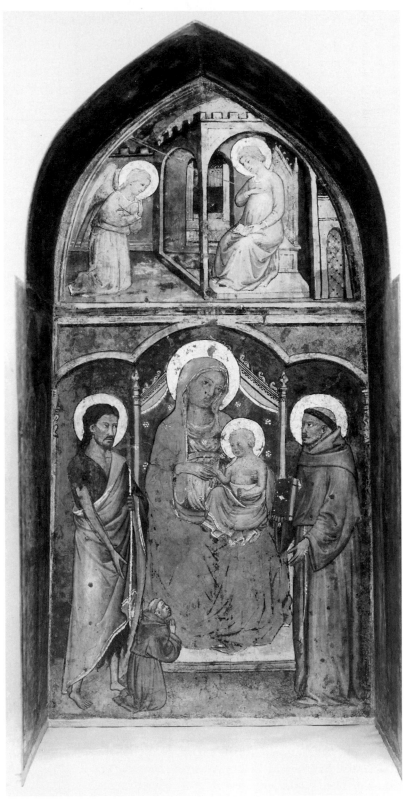

Figure 178. Artist near Bicci di Lorenzo, tabernacle of the Annunciation and the Enthroned Madonna and Child with Saints, *fresco (Museo dell' Opera S. Croce, Florence).*

196

Figure 179. Detail of spolvero *on the Christ Child in the frescoed S. Croce tabernacle.*

plaster rather than on paper. During the summer of 1441, Bicci probably rendered his services as an expert on gilding to Domenico Veneziano for the murals in the choir of S. Egidio.[51] (This important commission would help disseminate the practice of cartoons, as we shall see later. Domenico Veneziano had probably begun using *spolvero* cartoons before this date.) Evident signs of *spolvero* appear on the ornamental borders and in details of the figures of the four seated evangelists in Bicci's vault in the chancel *("cappella maggiore")* at S. Francesco in Arezzo.[52] Bicci took on this project in 1447. At his death in 1452, or possibly earlier, Piero della Francesca succeeded him, painting the famous mural cycle on the *Legend of the True Cross,* which is comprehensively pounced. Piero probably knew Bicci from his work at S. Egidio, for Piero had himself been employed there by Domenico Veneziano in 1439.[53]

Paolo Uccello's *Creation of Adam*

In contrast to the use of *spolvero* by "Late Gothic" painters, Paolo Uccello's practice during the 1430s signals a real turning point. We have already encountered Paolo's innovative application of the squaring grid in the *Hawkwood* cenotaph (Fig. 175), as well as a traditional application of *spolvero* patterns in the ornamental parts of mural cycles closely associated with him. The scenes in the Benedictine cloister of S. Miniato al Monte in Florence are probably autograph;[54] the same is probably true of those in the chapel dedicated to the *"Assunta"* in Prato Cathedral (Figs. 164–65), often unjustly considered to be by his immediate follower, the "Prato Master."[55] Paolo first used a *spolvero* cartoon to paint the human figure in the nearly effaced mural of the *Creation of Adam* (Fig. 180), on the second bay of the east wall of the *"Chiostro Verde,"* flanking the Dominican church of S. Maria Novella.[56] This scene is generally dated in the 1420s or 1430s, because it reflects the so-called "Interna-

The murals produced by the *botteghe* of the father and son, Lorenzo di Bicci (1350–1427) and Bicci di Lorenzo (1373–1452), often overlooked in the literature on Italian Renaissance art and often confused since Giorgio Vasari's account in the *Vite,* may well turn out to be a further missing link in this history.[50] Although Bicci di Lorenzo's pictorial vocabulary and artistic training belonged to the old world of Cennino's "Late Gothic" painter-craftsman, his professional contacts placed him in the new world of the Renaissance. With an extensive charcoal undersketch, his beautifully rendered *sinopia* for the mural commemorating the consecration of the small church of S. Egidio at S. Maria Nuova (Administrative Offices, Hospital of S. Maria Nuova, Florence) is a virtual cartoon drawing, but on

Figure 180. Detail of Paolo Uccello, The Creation of Adam, *mixed mural technique ("Chiostro Verde," S. Maria Novella, Florence).* Spolvero *is evident in small portions of the figure of God the Father.*

tional Gothic" style of Lorenzo Ghiberti (who was one of Paolo's teachers) and of Masolino (who was probably one of Paolo's colleagues in Ghiberti's *bottega*).[57] A date soon after our artist's return from Venice, which he visited from 1425 to 1431, seems most likely.

Paolo Uccello executed the scene of the *Creation of Adam,* like the rest of the *"Chiostro Verde"* mural cycle in an *a secco tempera forte* technique with warm, nearly monochromatic pigments – mostly *"terra verde"* (green earth, hence the nickname of the cloister), ochers, lime

white, and dabs of vermillion on selected details.[58] (This *"terra verde"* technique had become a specialty of the artist; a contractual document from 30 May 1436 for the *Hawkwood* cenotaph specifies it.[59]) It has been debated whether the curving row of evenly spaced, relatively large dots close to the hem on God the Father's robes is indeed a row of *spolvero*.[60] The dots are oddly evident to any spectator viewing the murals from ground level and in most photographs of the scene. Examination of the much-deteriorated *a secco* mural surface suggests that the claims of both detractors and defenders of the *spolvero* theory have been partly correct.[61] Most of the dots indeed resulted from short, brush-applied dabs of tempera in the same dark, blue-green hue as the grass of the flowered meadow on which God strides in the Garden of Eden. Yet underneath these dotted dabs of paint, as is evident toward the central parts of the row, in areas where the blue-green pigment is now lost, there seem to be black deposits of carbon, or *spolvero* marks, that are of a significantly smaller diameter, although difficult to illustrate in detail. The haphazard way in which the *spolvero* emerges in this particular passage and then disappears –

Figure 181. Detail in raking light showing the deterioration of the mural surface in Paolo Uccello, The Creation of the Animals and Adam *("Chiostro Verde"), painted predominantly a secco.*

all too frequent in Late Medieval and Renaissance murals – is not surprising, considering the *a secco* execution of the scene.[62] The *intonaco* surface is fairly rough in texture, especially in comparison to the artist's later *Noah* scenes; there is also substantial *craquelure*, blistering, and flaking of the paint layer (Fig. 181). Further *spolvero* dots are visible around the neckline toward the right shoulder of the figure of God, in a passage of almost naked *intonaco,* between underpainted preparatory outlines in ocher and final dark blue-green pigment.[63] From the presence of *spolvero* in these parts, we can reasonably conclude that the artist must have painted the entire figure from a cartoon.

Paolo Uccello's early application of a *spolvero* "cartoon" for the figure of God differs from that of a "pattern" in ways that would be momentous for the history of creative drawing in the fifteenth century (Fig. 180). The monumental figure of God the Father wears an accurately foreshortened halo, still a perspectival novelty

at this time, and is placed in the foreground of the scene at an oblique angle to the picture plane, with the right foot stepping over the fictive cosmatesque lower border of the composition. Most importantly, this is the only figure in the early scenes of *Genesis* in the *"Chiostro Verde"* whose pose communicates a convincing understanding of motion. We may compare this dynamic figure to that of the rigid, puppetlike striding angel in the *Expulsion from Paradise* on the neighboring lunette of the same cycle – clearly the work of a much less skilled painter. Portrayed in slight *contrapposto* from the rear, Paolo Uccello's sculptural figure of God rushes to Adam, grasping his wrist to coax him to life. The swirl of air-blown draperies defining the underlying body confirm the figure's forceful motion. If measured by the yardstick

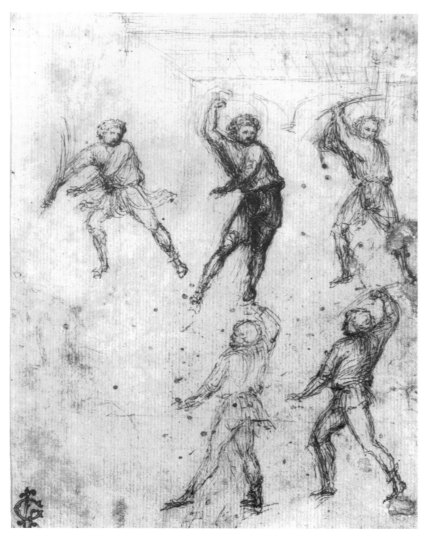

Figure 182. Attributed to Lorenzo Ghiberti, studies for figures in a Fla-gellation of Christ *(Graphische Sammlung Albertina inv. 24409 (R8), Vienna).*

Paolo Uccello's main source of inspiration. With the exception of Masaccio (who died in 1428–29), sculptors rather than painters dominated Florentine art during the 1420s and 1430s. As this generation of sculptors must have gradually understood, perhaps from the surrogate practice of working from preliminary, three-dimensional models, drawings on paper also offered a fresh means by which the live human body in motion could be more precisely visualized. An artist, who may well be Lorenzo Ghiberti, made just such a use of exploratory drawing in pen and ink to study the poses for the aggressors in a *Flagellation of Christ* (Fig. 182); the figures resemble Ghiberti's bronze panel from 1403 to 1424 on the North Doors of Florence's Baptistery.[65]

The portrayal of the human figure in movement was still sufficiently new to painters from the 1420s to 1440s to have needed recording for use in the *bottega*. This is suggested by the copies drawn after Antique reliefs on pages thought to have been part of a small modelbook that was assembled in Rome in Gentile da Fabriano's workshop and that Antonio Pisanello possibly inherited.[66] The stiff and somewhat formulaic poses in these copies make abundantly clear, however, that action poses, more easily than static ones, lose their freshness in the retelling, and with it their persuasive power. Yet, to a lesser extent, this "reduced animation" also permeated the actual process of preliminary design. The point can readily be illustrated if we compare the *sinopia* and the final fresco in the case of the executioner who wields the sword in Masolino's *Decapitation of St. Catherine* in the Chapel of Sts. Catherine and Ambrose at S. Clemente (Fig. 183).[67] Dated around 1428–30, this mural cycle was commissioned by Cardinal Branda Castiglione. (Like Paolo Uccello, Masolino may have been an apprentice in Lorenzo Ghiberti's busy workshop.) Masolino rendered the *sinopia* in charcoal and ocher wash with a remarkably nuanced *chiaroscuro,* considering its function as an underdrawing. It conveys the physical force of the figure's gesture with an immediacy that seems rarely possible without study from life. The searching reinforce-

of later Quattrocento painting, say, the *David* in Andrea del Castagno's ceremonial shield, from 1448 to 1457 (National Gallery of Art, Washington) or the dancing Salome in Fra Filippo Lippi's *Feast of Herod,* from 1452 to 1466, in the chancel of Prato Cathedral, the action pose of Paolo Uccello's God the Father appears perhaps timid. Yet during the 1420s and 1430s, the consistent exploration of such dynamic poses was rare in painting, though common in the great relief sculpture by the Florentines Nanni di Banco, Lorenzo Ghiberti (who may have trained Paolo),[64] and Donatello, as well as by the Sienese Jacopo della Quercia. An early example is the dancing figure of Salome in Donatello's relief, the *Feast of Herod* (Baptistery, Siena), from 1423 to 1427. By the 1440s, Donatello would effectively replace Ghiberti as

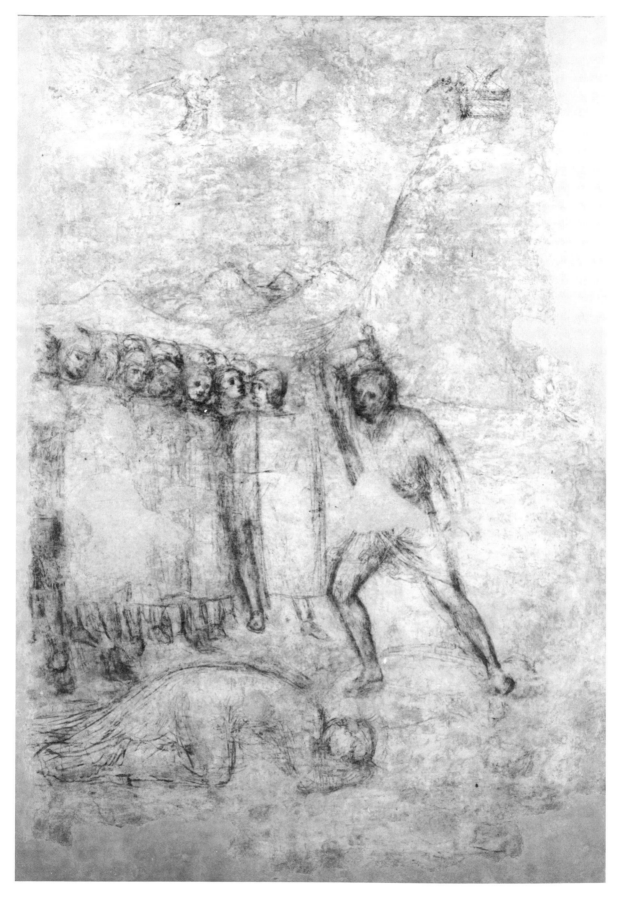

Figure 183. Masolino, detached sinopia *for the* Decapitation of St. Catherine *(S. Clemente, Rome)*.

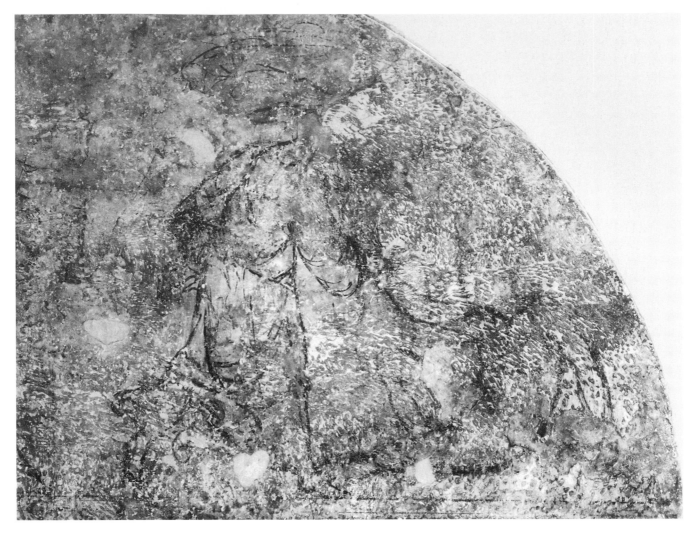

ment lines echo the quivering of the figure's body. In the process of painting, however – and Masolino, like most of his contemporaries, did not use cartoons in this chapel, except to paint repetitive ornament[68] – the figure gains in both descriptive detail and inflection of pose, but the vitality that had characterized his body's movements would mysteriously vanish.

Seen in this context, the technical solution in Paolo Uccello's mural is not surprising. The application of the squaring grid in the preliminary study and mural for the *Hawkwood* cenotaph shows that by 1436 the artist was already at the cutting edge of design technology. The detached *sinopia* for the scene of the *Creation of Adam* (Fig. 184) is mostly an outline drawing, with a relatively extensive, smeared undersketch in charcoal *(carboncino)*. (To judge from an old photograph showing the *sinopia* still in situ, it was on a thin layer of *arriccio* that barely covered the brick masonry wall.[69]) There, the striding legs of God's figure convey only the idea of

Figure 184. Detail of Paolo Uccello, detached sinopia *for the* Creation of Adam *(Museo dell'Opera S. Maria Novella, Florence).*

motion, confused in senseless folds. The hem of his robe, one of the areas showing *spolvero* on the *intonaco*, is in places still an uncertain knot of serpentine outlines. The tentative, rough character of the detail portraying God the Father in the *sinopia* and charcoal undersketch, together with the presence of *spolvero* on the *intonaco*, vividly attest to the nuanced role of exploratory drawing in the artist's working procedure. The cartoon was not only necessary for the resolution of the design problems but also, and equally importantly, for the reproduction of this complex, monumental figure, both in its precise naturalistic details and in its placement with respect to the recumbent figure of Adam. The very methods of design in the mural seem experimental in their eclecticism. In the *sinopia*, the charcoal under-

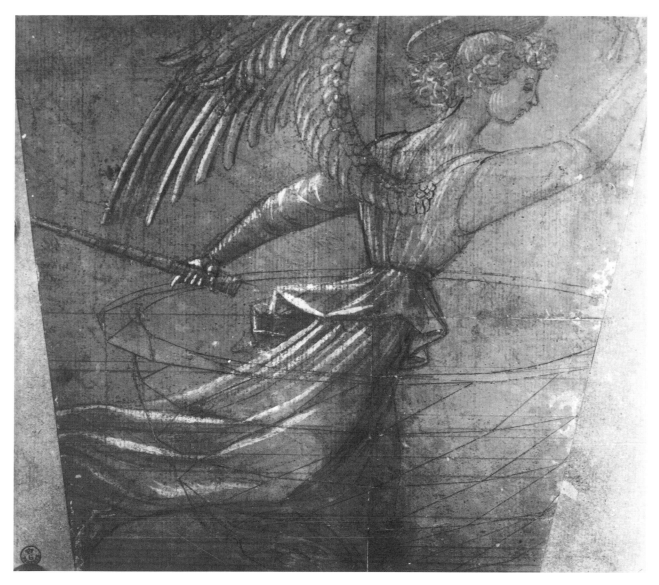

drawing for the static figure of Adam is more substantial than that for God the Father; Adam's blocky head is vaguely oriented. Even at the moment of painting, the artist obsessively searched for the contours of Adam's facial features: an area of reinforcement lines, formed by direct stylus incisions on the *intonaco,* is still visible despite the deterioration of the mural surface.

Paolo Uccello's Pricked Drawing of a Running Angel

The active pose of the angel in a *chiaroscuro* study on brown-green prepared paper, intended for a scene of the *Expulsion from Paradise* (Fig. 185), can help us visualize the emerging significance of exploratory drawings

Figure 185. Attributed to Paolo Uccello, studies for a Running Angel *in a scene of the* Expulsion from Paradise, *vessel in perspective, and other motifs (CBC 313; Gabinetto Disegni e Stampe degli Uffizi inv. 1302 F, Florence), partly pricked.*

on paper in the artist's design process.[70] The attribution of this sheet to Paolo Uccello is often accepted, although it has also been unfairly given to his close followers, the "Carrand Master" and the "Prato Master," based on a perceived weakness in the execution of the drawing. The criterion of "quality" seems in this case inadequate, for this is a strikingly innovative figure study for this period – in fact, few examples in a similarly large scale come to mind. The multiple layers of design on the sheet attest to its functional role in the

artist's workshop. Be that as it may, the angel's spirited running pose echoes the earlier, more restrained one of God the Father in the *"Chiostro Verde" Creation of Adam* (Fig. 180); on the basis of style alone, the Uffizi study (Fig. 185) may be dated anywhere between the 1440s and 1460s.[71] The artist developed the angel's design from sketch to relatively finished study on the same sheet. He first ruled the vertical axis for the angel's running body with the stylus, sketching the figure lightly in metalpoint on the brown-green prepared paper; the oval that originally described the angel's face is still fully apparent. He gradually refined the forms in metalpoint, highlighting them expressively with white gouache and then reworking them with pen and brown ink, as well as with brush and brown wash. He may have traced some of the circular outlines of the wings with the compass, finally pricking the outlines of the angel finely and carefully. No rubbed pouncing dust is apparent, although the surface of the drawing is too abraded and soiled throughout for definitive conclusions.

The Uffizi sheet also combines several layers of unrelated designs. A large-scale pricking covers the sheet almost in its entirety. It portrays a hand (seen on the upper left), portions of a sleeve, and folds of drapery, fastened onto a five-lobed brooch (seen on the lower right).[72] This design probably relates to a mural or large panel by Paolo Uccello, or his followers, and may have been pricked from the verso; the holes are largely covered by the layer of brown-green preparation on the recto.[73] The artist then drew another design on top of the angel (partly obscuring it), portraying the armature for a vessel in transparent, stereometric perspective.[74] He constructed this vessel in metalpoint over stylus ruling and incised compass marks; he later also reinforced some of the forms with pen and ink. Such a systematic use and reuse of the sheet suggests that these drawings were simply exercises.[75]

As we shall see, Paolo Uccello's pricked study of a *Soldier Riding a Horse* and his later scenes in the *"Chiostro Verde"* cycle at S. Maria Novella, which he painted from comprehensive *spolvero*, suggest the extraordinary complexity of his design methods.[76] Exploratory drawing on both paper and plaster played a crucial role, but this can only be surmised from sadly fragmentary evidence.

Domenico Veneziano's Canto de' Carnesecchi Tabernacle

Further confirmation of early cartoon use emerges in a monument no less progressive for its time, which stood

originally not far from S. Maria Novella in Florence: the outdoor tabernacle by Domenico Veneziano, formerly on the Canto de' Carnesecchi, at the intersection of what is today Via dei Panzani and Via dei Banchi. Tiny, but unmistakable passages of *spolvero* dots appear in two of the ravaged mural fragments portraying the heads of male monastic saints.[77] On the head of the beardless saint (Fig. 186), the *spolvero* dots outline almost the entire hairline and parts of the earlobe. This damaged head has suffered from extensive repainting as well as multiple coats of shellac. Yet examination with raking light reveals that, under the shellac, the *spolvero* dots in small sporadic parts of these passages appear to be in their original state, the original fresco pigment layer also appearing to be intact here. Other *spolvero* dots along the hairline were reinforced by restorers with specks of dark paint.[78] The evidence is not nearly as clear in the bearded saint; nevertheless, a few *spolvero* dots can be discerned with certainty on his ear, on his bald cranium, and on the outer contour of his forehead. Although we can reasonably suppose that *spolvero* underdrawing once existed also on the main part of the tabernacle, the large *Enthroned Madonna and Child* with the daringly foreshortened God the Father hovering above, this seems no longer verifiable.[79]

Based on the narrative sequence in Vasari's somewhat muddled biography in the 1550 and 1568 editions of the *Vite,*[80] the Canto de' Carnesecchi tabernacle is often thought to be the earliest work that Domenico painted on his arrival in Florence, after a presumed sojourn in Rome. A date between 1432 and 1437, before his documented stay in Perugia, is often accepted on the basis of style, though less convincing dates into the 1450s have also been advanced.[81] As is sometimes observed, the figural type of the bearded saint closely relates to that of Andrea del Castagno's and Francesco da Faenza's evangelists in the Chapel of S. Tarasio (S. Zaccaria, Venice), signed and dated 1442. The monumentality of Domenico's *Enthroned Madonna and Child,* their placement within the perspectival space of the throne, and the imposing foreshortened figure of God evoke Masaccio and manifest an incipient mastery of the new science of perspective.[82]

Domenico Veneziano's *Sts. John the Baptist and Francis*

Yet to identify clearly the functions of *spolvero* cartoons in the new Renaissance tradition of *disegno* emerging in Central Italy, we must turn to works at least a full

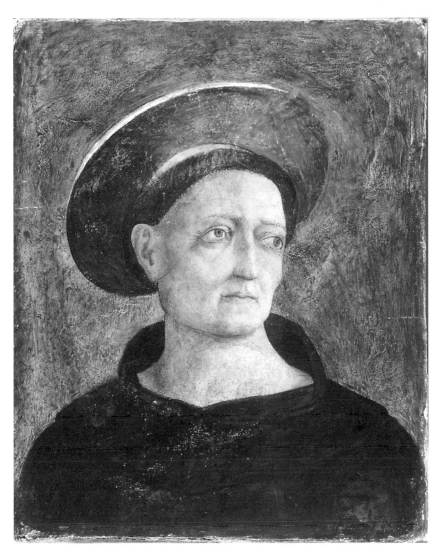

Figure 186. Domenico Veneziano, Male Monastic Saint, *detached mural fragment transferred to tile (National Gallery, London).*

with the spectator's eye level, which would suggest that the fresco stood at about 1.88 meters above the floor of the church.[84]

The unity of Domenico's composition depends on the precise placement of the foreshortened figures of Sts. John and Francis within their pictorial space, based on the spectator's angle of vision. The bare architecture contrasts with the exceptionally descriptive treatment of the figures, where the *"sotto in sù"* perspective of the composition, which also shifts to the right, adds foreshortening to an already complex, naturalistic description of the figures. Painted almost entirely in *buon fresco,* the figures of the two saints are pounced throughout. *Spolvero* marks densely and minutely outline the subtly foreshortened planes and sinuous contours of their faces, hands, and feet. By contrast, passages consisting of simpler outlines, such as the relatively straight folds below the waist in St. Francis's brown habit, reveal sparsely dotted *spolvero.* The marks are relatively large, and their shape becomes increasingly diffused in the lower passages of the composition. Here, the *intonaco* must have been especially wet at the moment of the cartoon's transfer.

decade later, as, for instance, Domenico Veneziano's small fresco of *Sts. John the Baptist and Francis* (Figs. 187–88), from 1450 to 1460.[83] Conceived as if seen from below – *"di sotto in sù"* – the detached fresco was originally situated in the chapel of the Cavalcanti family at S. Croce, on a section of wall in the *tramezzo* (rood screen), which projected from the south wall of the basilica. Within the original walled space of the chapel, it flanked Donatello's tabernacle of the *Annunciation* (still in situ), on the right of the corner. The vanishing point of the perspective scheme in Domenico Veneziano's composition is, consequently, displaced – to 26 cm. below the bottom border, and 55 cm. to the right of the right border – probably also to coincide

The artist portrayed the ascetic figure of St. John the Baptist, patron saint of Florence, with a breathtaking precision of pictorial notation (Fig. 188). The saint stands at an oblique angle to the picture plane, in the role of intercessor, mediating between the space of the spectator and God; he looks in the direction of heaven, his haggard head thrown back and upward. The toes of his right foot, firmly planted on the ground, curl forward and beyond the ledge on which he stands. Because of the complexity of these and similar illusionistic effects, Domenico Veneziano painted the small fresco, which is approximately two meters high by a meter wide, not only from a *spolvero* cartoon but also in nine *giornate* – testimony to a slow, deliberate technique.[85] The disposition of *giornate* suggests that he generally completed the portions relating to one figure separately from those relating to the other, beginning with St. John's head and neck

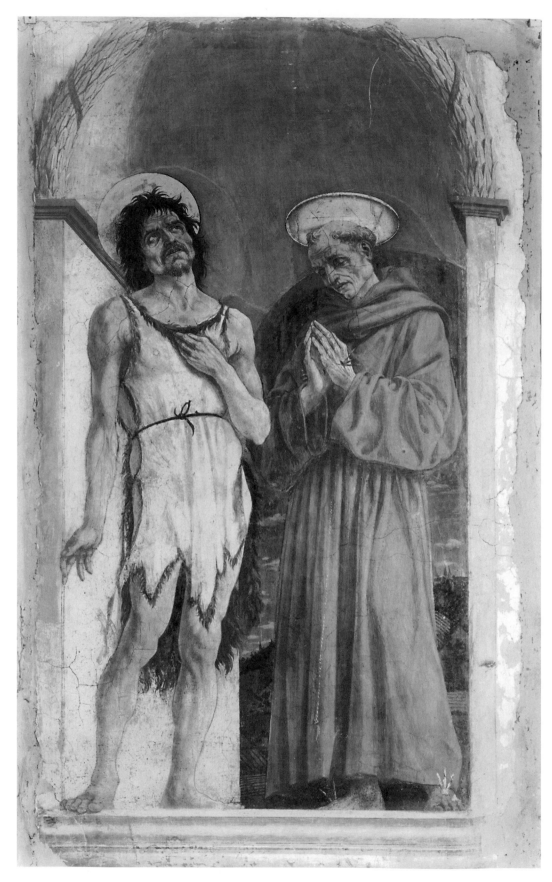

Figure 187. Domenico Veneziano, Sts. John the Baptist and Francis, *detached fresco (Museo dell'Opera S. Croce, Florence).*

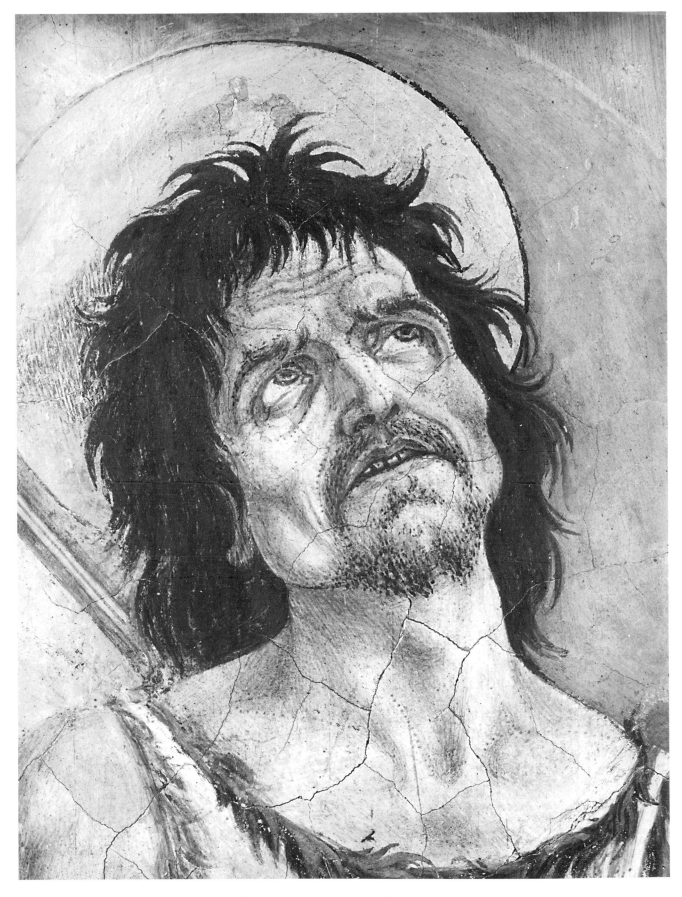

Figure 188. Detail of the head of St. John the Baptist in Domenico Veneziano, Sts. John the Baptist and Francis.

and more or less alternating the sequence of *giornate* from figure to figure as he painted the fresco from top to bottom.[86] The fifth *giornata,* however, integrates the execution of portions from both figures, the right half of St. John's torso along with part of St. Francis's left sleeve, affirming that the artist indeed developed both figures on a single cartoon, rather than on separate fragments.[87]

This cartoon must have also included the sharply foreshortened, barrel-vaulted arch within which the saints stand, but probably not the landscape, painted entirely *a secco* with tempera and visible diagonally behind St. Francis.[88] On the upper left and right of the arch, sporadic areas of *spolvero* bleed through the layers of pigment on the ribbon and on the wreath; dashes or elongated *spolvero* dots, deformed either by the painter's troweling of the *intonaco* or his brushing of color,[89] emerge on the portion of the ledge below the feet of St. Francis. A small area of *spolvero* is also discernible within the ribs of the pink cornice. Domenico must have reconstructed much of the architecture with compass and stylus-ruled incisions directly on the *intonaco,* using as a guide the *spolvero* underdrawing, which was presumably more comprehensive than is evident today. He may have projected the orthogonals for the perspective system – in a synthetic form – on an underlying *sinopia.*[90] This was his procedure in the murals for the choir of S. Egidio, as is clear in the small, extant fragment of the *sinopia* for the *Marriage of the Virgin* (Museo Andrea del Castagno at the Refectory of S. Apollonia, Florence), from 1439 to 1444.[91]

Thus, in sharp contrast to Trecento and early Quattrocento *spolvero* patterns, the primary function of Domenico Veneziano's cartoon was not to replicate the design over and over but to facilitate the transfer of outlines too complex and detailed to improvise either from memory, or from smaller-scale drawings, or even from a *sinopia* underdrawing.[92] In the Renaissance tradition of design that gradually took hold in Central Italy, the cartoon represented the conclusion of an extensive process of preparatory drawings on paper, enlarged to the scale of the final work. Seen as a whole, the illusionism of Domenico Veneziano's composition, the sequence of *giornate* in his execution of the two saints' figures, and the presence of *spolvero* in both architecture and figures confirm that he must have relied on a single cartoon for the entire scene. Thus, the use of a full-scale drawing on paper to synthesize the various elements of a composition constitutes the novelty of Domenico's design approach.

Andrea del Castagno's *Vision of St. Jerome*

Surviving in a more complete state, the contemporary *sinopie* and frescos by Andrea del Castagno concretely illustrate how an increasingly descriptive language of form shaped the search for an equally precise design technology, helping us better understand the technical progress that cartoons brought about in the Quattrocento.[93] By nearly all accounts, Andrea's *Vision of St. Jerome* in the Corboli Chapel at SS. Annunziata (Figs. 189–92) is regarded as a late work, probably from 1450 to 1455.[94] Densely packed *spolvero* delineates all areas of the composition, from the craggy wrinkles, tendons, and muscles of the ascetic, almost toothless St. Jerome (Fig. 191), to the sharp, blood-dripping rock with which he beats his breast and the ferocious snout and teeth of the lion's open jaw.[95]

The crucial improvement with the use of cartoons was that the design could be conveniently outlined on the surface of the *intonaco,* rather than have it, perforce, remain underneath, as was the case with *sinopia* underdrawings on the *arriccio,* or base plaster (Fig. 190).[96] (As a much later treatise would note, *spolvero* cartoons were used in the fresco medium "so that the painting could be made with greater assurance and brevity."[97]) In the traditional technique of fresco (Fig. 6), the painter, his *garzone,* or a *muratore* (plasterer) spread a layer of moist *intonaco* for each *giornata,* obscuring the portion of the *sinopia* that was about to be painted. Thus, with the *sinopia* system, painters worked partly from memory, which required improvisation.

Especially in the rapidly carbonating medium of *buon fresco,* *spolvero* cartoons allowed for an extraordinary complexity and exactness of pictorial notation. Based on the close-up examination of murals from the Trecento to the Seicento, we can broadly conclude that the traditional *sinopia* method without cartoons could, and did, remain viable for figural painting as long as artists stressed light, color, and "painterly" modes of defining form (rather than "linear" ones) – to rely for a moment on the old categories of style coined by Heinrich Wölfflin.[98] But for a *"disegnatore"* of Andrea del Castagno's sensibility, for whom the calibration of outlines turning in space was an all-important design feature, the traditional method was clearly insufficient, not only to reproduce accurately but also to paint – with the promptness imposed by the medium – the minute, naturalistic facial and anatomical details of figures, as well as their intricate passages of foreshortening. Particularly in the case of St. Jerome's foreshortened head (Figs. 191–92), with its strained upward gaze

at the vision of the Holy Trinity, the use of a *spolvero* cartoon on the portable, smooth surface of paper extended at least the promise of perfect design.

The Functions of Andrea del Castagno's *Sinopie*

Most importantly, the coarse, porous surface of the *arriccio* (base plaster), unlike the smooth surface of paper, limited the exactness of line and detail possible in a *sinopia* with charcoal underdrawing. (Compare Figs. 190–92.) At its smoothest, the *arriccio* for a *sinopia* could not be as even and flat as the *intonaco* on top, because otherwise this surface layer of fine plaster could not properly adhere. When the base plaster of a *sinopia* was too smooth to add the *intonaco* layer on top, it was keyed with a hammer *(martellinatura)*.[99] Employed since at least Late Antiquity and Early Christian times for both mural painting and mosaic, the *sinopia* made a significant contribution to the Early Renaissance tradition of exploratory drawing in Italy. As the cartoon entered the design technology of mural painting during the fifteenth century, the *sinopia* continued to play an important, although modified, role well into the eighteenth century.

There is a great variation of texture in the *arriccio* of Andrea del Castagno's *sinopie*.[100] Some of his detached *sinopie* are now conveniently installed in the Museo Andrea del Castagno, at the converted refectory of S. Apollonia, and thus can be studied with particular immediacy. In comparing Andrea del Castagno's fresco of the *Vision of St. Jerome* to the *sinopia* detached in 1967, it is clear that the fresco and *sinopia* greatly differ in composition (Figs. 189–92). It has even been maintained that the *sinopia* – sketchily painted over a comprehensive charcoal underdrawing – is neither by Andrea nor his *bottega*.[101] More likely, as Eve Borsook has suggested, the *sinopia* represents the artist's early idea for the composition, which he later greatly refined in the cartoon.[102] Here, the intervention of the fresco's patron, Gerolamo Corboli,[103] might explain the changes in the figure of his namesake, St. Jerome, for the saint's final penitent gesture and older age, as well as the inclusion of his attributes, the lion and the cardinal's hat, emerge only in the cartoon and final fresco.

Other *sinopie* by Andrea del Castagno – that for the *Pietà with Angels,* as well as those for large portions of the cycle of the *Crucifixion, Entombment,* and *Resurrection* painted on the end wall of the refectory at S. Apollonia in 1447 – are more precisely linear in their designs, because their function was synthetic, rather than explor-

atory.[104] (Compare Figs. 193–94.) When such *sinopie* render the design of the composition primarily in terms of outlines, they are on significantly smoother *arriccio* and exhibit only faint passages of underdrawing in charcoal *(carboncino)* beneath the brushed ocher outlines (Fig. 194). As has been pointed out, traces of *spolvero* dots on the highly modeled angel above the resurrected Christ, as well as on one of the more summarily drawn sleeping soldiers below, suggest that the *sinopia* for the *Resurrection* was itself based on *spolvero* cartoons (Fig. 194).[105] The same appears to be true of the *Entombment,* where, at least on the right foot of the apostle in the left foreground, interrupted dashes of charcoal underneath the reddish strokes suggest the remains of *spolvero.* Andrea may have developed the preliminary design for the composition with charcoal directly on the *arriccio,* and from this he may have drawn the cartoons; in the *Resurrection,* the figures in the mechanical-looking *sinopia* and the final fresco correspond precisely in scale.[106] The artist probably prepared separate cartoons for individual figures, or tightly knit groups of figures, to economize on both materials and manual labor, because the area of the wall containing the *Last Supper, Crucifixion, Entombment,* and *Resurrection* is enormous. He probably painted the architectural elements and most landscape features directly, based on *sinopie* underdrawings and surface contruction on the *intonaco* – *incisioni dirette,* stylus ruling, cord snapping, and compass sectioning. The latter evidence is especially comprehensive in the steeply foreshortened portions of the architectural setting in the *Last Supper.* The decorative detailing on architectural features was probably derived from small separate patterns, to enable a better maneuverability for design repetitions and reversals.

Andrea (and his assistant) may have first pounced the cartoons onto the *arriccio* to plot the disposition of the scenes, figure by figure – or figural cluster by figural cluster – shifting and adjusting the cartoons as necessary. On the *sinopie,* the artist even plotted the disposition of the *giornate* (Fig. 194).[107] This attests not only to his extremely systematic working procedure but also to the synthetic role of his *sinopie,* for it is there that he integrated all design elements. Later, at the moment of painting, Andrea (and his assistant) probably pounced the same (though probably reworked) cartoons onto the *intonaco* to use as guides: the fresco surfaces exhibit detailed *spolvero* throughout. The choice of precisely linear *sinopie,* however, required a comparatively smooth *arriccio.*

By contrast, the bold, pictorially drawn *sinopia* for the *Vision of St. Jerome* (Figs. 190, 192) represents an ani-

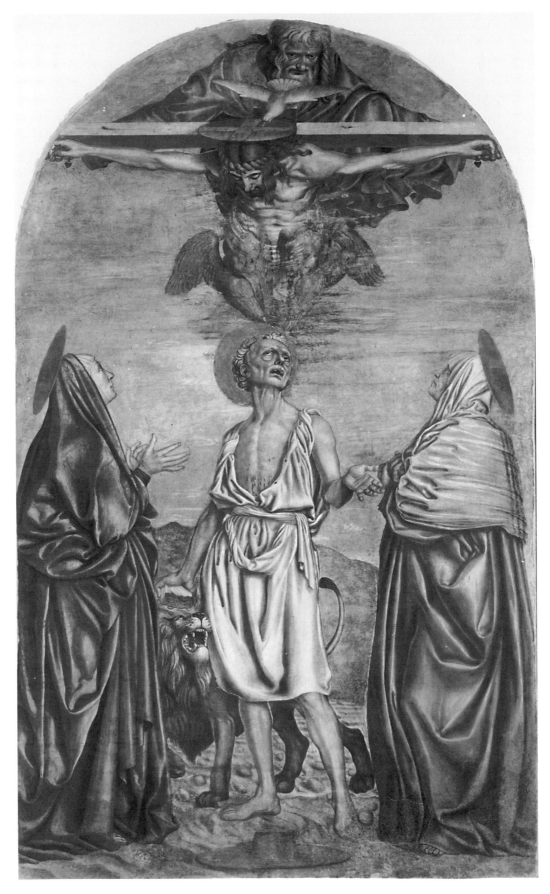

Figure 189. Andrea del Castagno, The Vision of St. Jerome, *mixed mural technique (SS. Annunziata, Florence).*

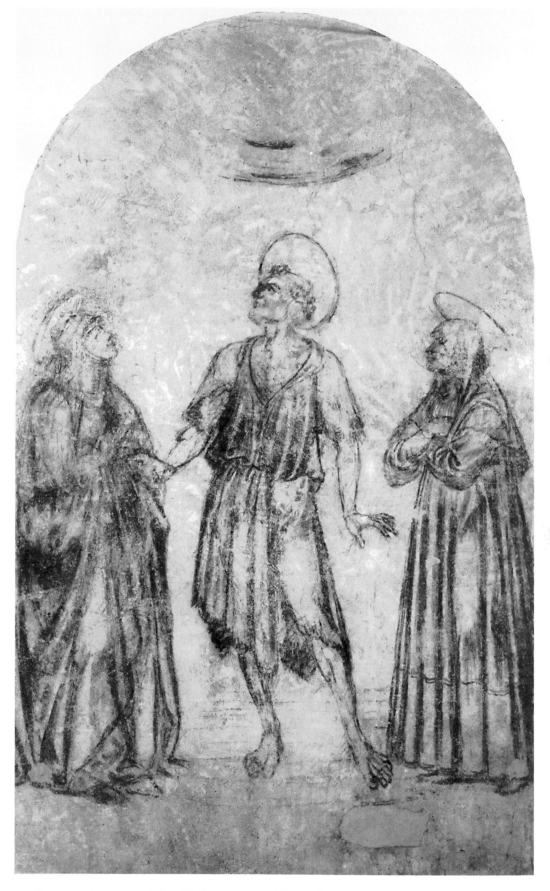

Figure 190. Attributed to Andrea del Castagno, detached sinopia for the Vision of St. Jerome (Museo Andrea del Castagno at the Refectory of S. Apollonia, Florence).

mated exploratory design in progress, fulfilling a much more basic function than either the linear *sinopie* or the cartoons. Although the lighting of the forms – with broad, vibrant tonal modeling – would remain nearly identical in the fresco, the very coarse, bumpy surface of the *arriccio* would have made it virtually impossible to draw meticulously precise outlines. In several passages, in fact, the design of the charcoal undersketch differs substantially from the layer of ocher brush drawing on top. The relative scale of the figures is also somewhat inconsistent, especially that of the female figure on the right (St. Eustochium?), who is slightly smaller and whose undersketching in charcoal is considerably less comprehensive than on the other two figures. Andrea (or his assistant) may have drawn her first. By comparison, more of the monumental female figure on the left (probably St. Paula) remained unresolved even in the ocher brush drawing. Not surprisingly, the charcoal undersketch, nebulous with broad reinforcement lines, is particularly dense in this area of the composition. The artist probably drew this female figure second but left her unfinished, because her relationship to the figure of St. Jerome needed

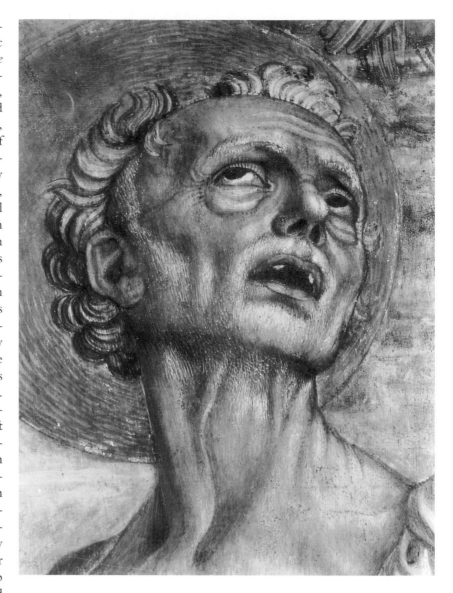

Figure 191. Detail of the head of St. Jerome in Andrea del Castagno's mural, The Vision of St. Jerome.

further definition. In the figure of St. Jerome, probably drawn last, the resolute strokes of vivid crimson ocher and the paler, brown ocher tonal wash have largely tamed the searching charcoal undersketch, which is denser on the left side. At the *sinopia* stage, however, Andrea del Castagno had not sufficiently worked out the composition to introduce any descriptive detail. That function he would leave for the cartoons.

Among the major differences between the *sinopia* and the resulting fresco (Figs. 189, 190) are the precise formulation of foreshortened form and the placement of the figures in space, as well as their consistency of scale. The rotations of their bodies, particularly that of the penitent St. Jerome, as well as his attributes, and the steep perspective of the *Holy Trinity* in the upper register – if cramped and awkward – appear only in the car-

toon. Andrea lowered the placement of the figures, especially that of St. Jerome, in the bottom register of the composition, to enlarge the area necessary for the foreshortened Trinity above. But he had already probably planned to include the Trinity, since in the *sinopia*, the parallel curved lines above St. Jerome's head are a shorthand notation that generally corresponds to the placement of the torso with loincloth of the crucified Christ in the fresco. The design of Christ's foreshortened body required the type of exploration, refinement, and calibration better realized in a sequence of preliminary drawings on paper. They could be under-

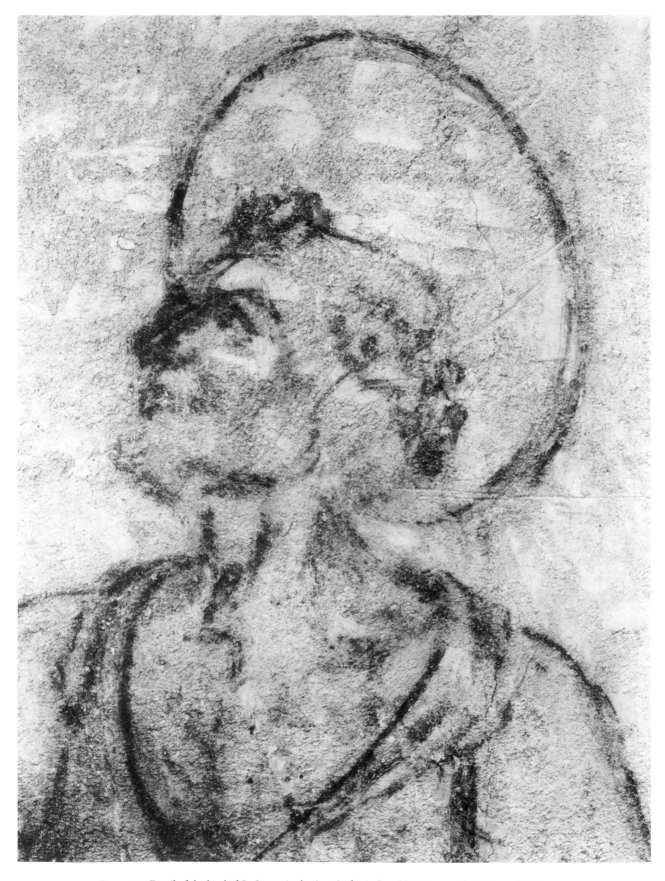

Figure 192. Detail of the head of St. Jerome in the sinopia *for Andrea del Castagno,* The Vision of St. Jerome.

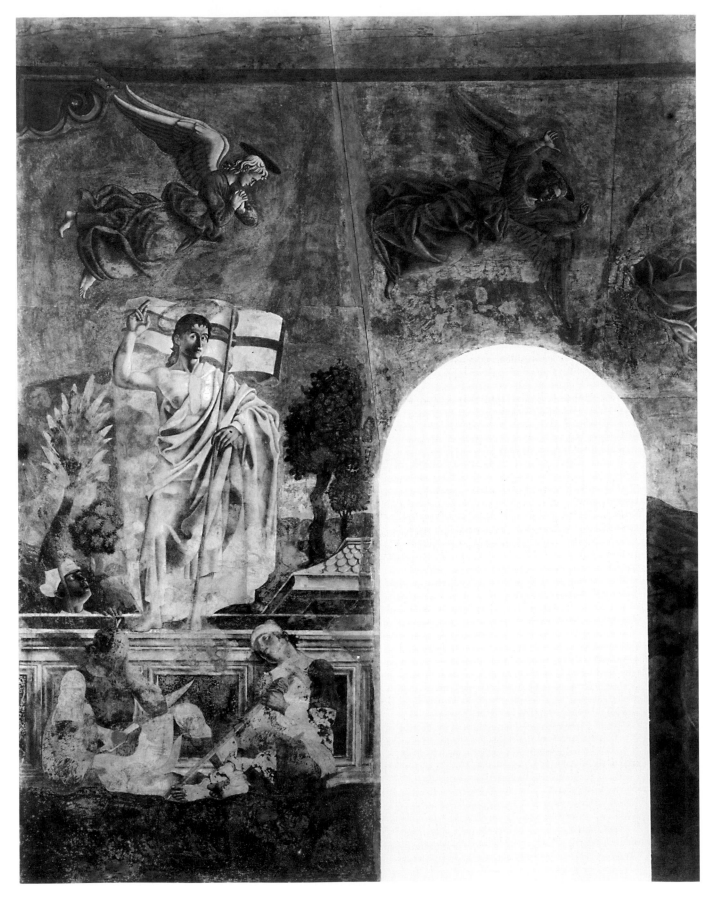

Figure 193. Andrea del Castagno, The Resurrection, *mixed mural technique (Refectory of S. Apollonia, Florence).*

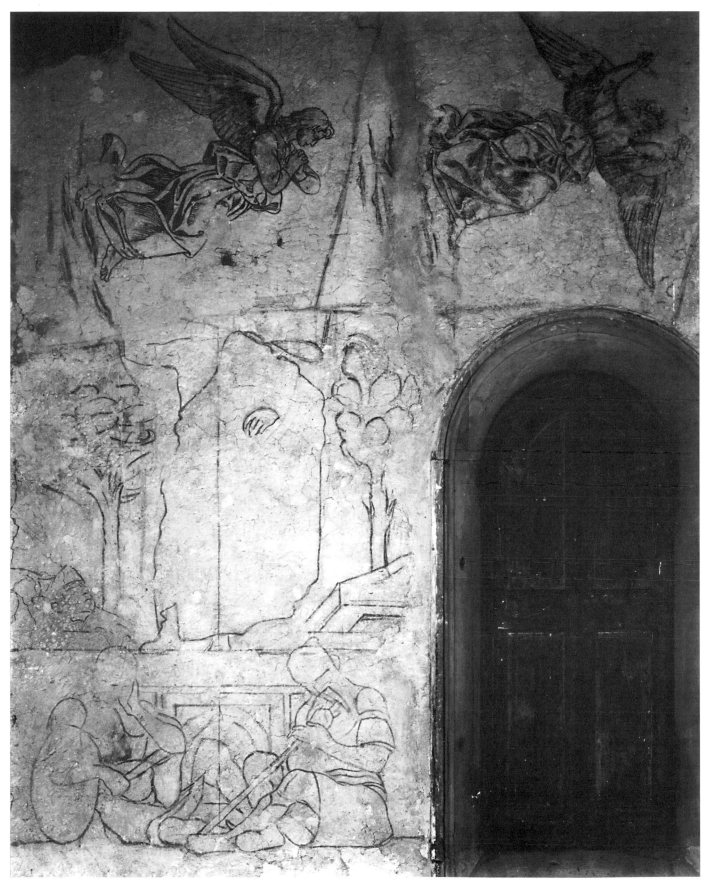

Figure 194. Andrea del Castagno, detached sinopia *for the* Resurrection *(Museo Andrea del Castagno at the Refectory of S. Apollonia, Florence), with plotting of the* giornate *and clearly disparate stages of drawing on the figures.*

taken in the artist's workshop, which offered controllable conditions for the study after the living model, or artfully posed mannequins of clay or wood, as well as a ready supply of props. (Unfortunately, the great losses in the corpus of mid-Quattrocento exploratory drawings make our task of reconstruction difficult.) By shifting the cartoons for each figure back and forth to their appropriate relationship, the problems of space that the positioning of the figures created could be adjusted.

Ultimately, however, the integration of upper and lower registers in the *Vision of St. Jerome* (Fig. 189) is unreconciled: the artist even possibly misjudged the wall's area when he drew the cartoons in his workshop. The perspectival effect of the crucified Christ was originally less disconcerting than it seems today, because the two seraphs originally concealing the legs of Christ have largely crumbled away, as they were added *a secco*.[108] Throughout much of the second half of the Quattrocento (and Cinquecento), the twin functions of *sinopie,* as surfaces for both exploratory large-scale drawing and synthesis for different compositional elements, would often complement the use of cartoons, as we see in Andrea del Castagno's work.

Paolo Uccello's
Sacrifice and Drunkenness of Noah

For the vanguard painters of the 1440s and 1450s, however, the utility of cartoons would transcend the challenge of *buon fresco* as a medium. As the *"Chiostro Verde"* cycle at S. Maria Novella especially demonstrates, Paolo

Uccello often executed murals predominantly or entirely *a secco* (probably on a ground color layer of fresco), since this technique gained him time for a highly refined design and painting process.[109] The later scenes in the *"Chiostro Verde,"* those on the fourth bay of the east wall portraying the story of Noah, have usually been regarded as Paolo's crowning achievement, following Vasari's praise in his *Vita* of the artist.[110] The dates of these later murals remain much disputed (in the absence of documents); stylistically, they fit in the 1440s and 1450s. Possibly the *Deluge and Recession of the Waters* and certainly the *Sacrifice and Drunkenness of Noah* (Figs. 195–96) exemplify yet another turning point in our artist's working practice.[111] In both scenes, monumental figures populate vast and relatively unified pictorial spaces. Each composition depicts two events of the narrative, seen in drastic foreshortening, but with little relation to the viewer's eye level because of the murals' high placement on the wall. Their perspective, with its deliberately inconsistent vanishing points, is a visual rejoinder to the problems of dramatic sequence in the narrative, simultaneously isolating one event from the other and consolidating both into the space of one composition.[112] It could well be argued that the calibration of perspectival effects in these murals was the product of Paolo's increasingly deliberate design process – in Vasari's admiring words, *"tanta fatica . . . tant' arte e diligenza."*[113] As the mural surfaces attest, Paolo developed the designs of his figures with a preci-

Figure 195. Paolo Uccello, The Sacrifice and Drunkenness of Noah, *mixed mural technique ("Chiostro Verde," S. Maria Novella, Florence).*

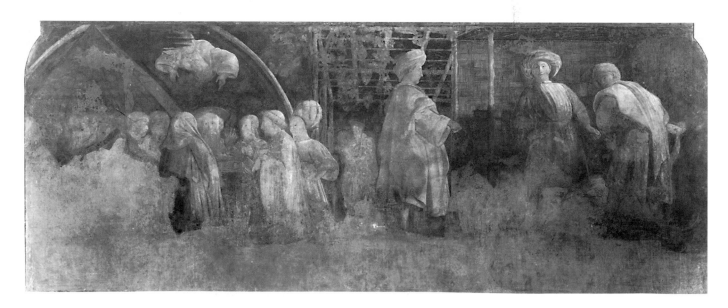

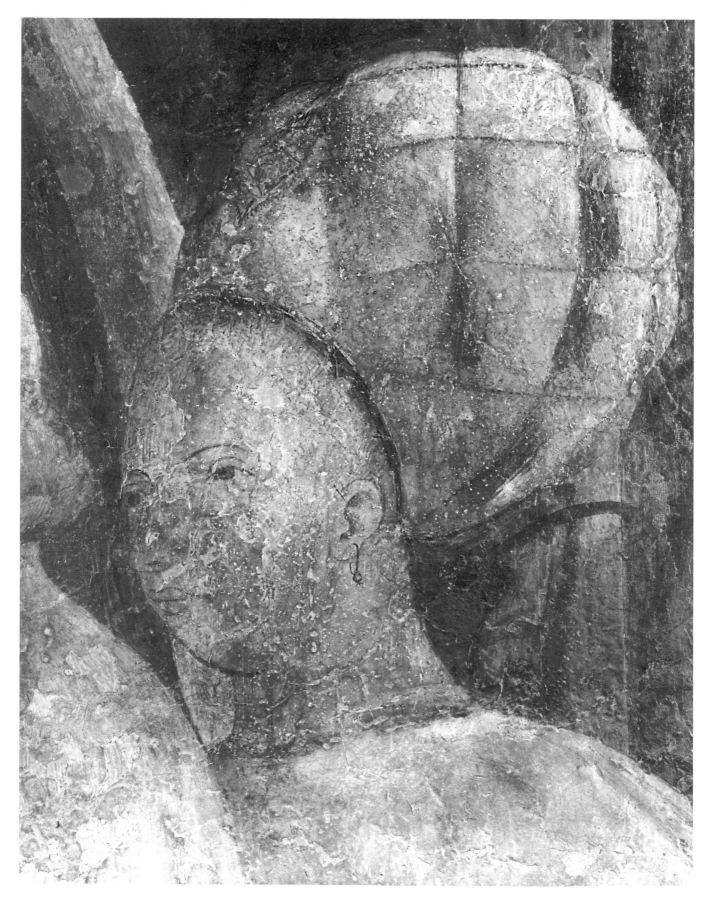

Figure 196. Detail of Paolo Uccello, The Sacrifice of Noah, *exhibiting fine* spolvero.

sion of method we normally recognize in the perspective projections of his pictorial spaces and geometric exercises but to which we rarely concede in his treatment of the human figure.

For Paolo Uccello, much of the process of synthesis in the design of an *"historia"* may have unfolded on the *arriccio,* at the *sinopia* stage. The detachment by *strappo* of some of his murals has brought to light *sinopie* that, above all, reveal a firmly ruled perspective structure underlying his conception of pictorial space. The *sinopia* for the *Nativity* from S. Martino alla Scala (Soprintendenza per i Beni Artistici e Storici, Florence), dating around the 1440s to 1450s, depicts a detailed, bifocal *"costruzione legittima"* without figures.[114] His figural *sinopie* portray perspective constructions already in fully synthesized form, which suggests that our artist had already explored the issues of pictorial space in separate preliminary drawings, either in smaller scale on paper or in full scale on the wall, in successive layers of *sinopia,* deeper within the *arriccio.* This seems generally true of the destroyed *sinopia* for the *Sacrifice and Drunkenness of Noah,* as well as of the extant *sinopie* from the cycle on the Legend of St. Benedict (upper *loggia* of cloister, S. Miniato al Monte, Florence), dating around 1442–47 and sometimes unfairly dismissed as the work of a follower.[115]

The *sinopie* for the *Noah* scenes were destroyed in, or shortly after 1909, when the restorer, Domenico Fiscali, detached the murals by means of a disastrous early *strappo* procedure.[116] Only one of these underdrawings, that for the *Drunkenness of Noah,* seems to have been recorded in a photograph taken during the "restoration" campaign. Although this *sinopia* shows the sharply foreshortened architectural setting in relative detail, the figures remain in a sketchy preliminary phase of design. Examination of the mural surfaces today suggests that Paolo ruled all verticals, horizontals, and orthogonals of the *Noah* scenes with the stylus, incising them directly on the *intonaco.*[117] (Similarly, in the probably contemporary S. Martino alla Scala *Nativity,* the complex bifocal perspective construction developed in the *sinopia* was largely stylus-incised directly on the *intonaco* in the process of painting: the ruling of lines in that *sinopia,* relative to the mural surface, coincides exactly.[118]) After sketching the figures for the *Sacrifice and Drunkenness of Noah* on the *sinopia,* Paolo clearly attended to their study in greater detail. Eugenio Campani, who examined the *Noah sinopie* before their destruction, reported that, in the *sinopia* for the *Drunkenness,* Paolo drew at least three drafts for the standing figure of Noah's son in the rear center of the hut's space, erasing each successive sketch with a thin wash of lime white or plaster.[119] But this figure as it appears in the final layers of the *sinopia,* with head and body turned toward his brother, the mocking son of Noah, still differs substantially from the way he was finally painted in the mural. The revision clearly took place in the cartoon. As finally painted, the figure turns his full face toward the spectator, as does the young man standing next to him on the right, probably Japheth, the dutiful son who covers Noah's nudity. A series of smaller-scale drawings on paper must have refined the naturalistic detailing of many of the figures and animals.

Violent, often disjointed changes of scale in the figural arrangement of the *Deluge and Recession of the Waters* parallel the explosive intensity of the continuous narrative. In the more serene *Sacrifice and Drunkenness of Noah* (Fig. 195), the protagonists of the first event are suspended in the middleground of those in the second event, with subtly calibrated relationships of scale and outline. This shifting of figures in and out of the pictorial spaces required an accurate, overall control of scale. (Judging from the fine *spolvero* dots, the cartoons for the *Sacrifice and Drunkenness of Noah* must have indeed been exquisitely delicate and precise in their rendering of outlines; Fig. 196.) Before the artist transferred the cartoons by *spolvero,* he whitewashed the *intonaco* to smoothen it for painting with tempera. Minuscule *spolvero* dots appear in the better preserved figures: the two women and the man who gather on the right of Noah at the altar in the *Sacrifice,* and the two sons who stand to the left of the sprawled, inebriated Noah in the *Drunkenness* (Figs. 195–96).[120] These *spolvero* marks are densely spaced, about five to eight per 10 mm. (four to six per 1/2 inch), undoubtedly resulting from pouncing the cartoons through such pin-sized holes, as we can see in Paolo Uccello's Uffizi drawings of the *Soldier Riding a Horse* and *Running Angel* (Plate I; Fig. 185). The artist reinforced the armature of *spolvero* with a relatively wet, dark gray-brown outline, before laying in the warm, nearly monochromatic pigments – *"terra verde,"* ochers, lime white, and touches of vermillion. Yet especially on the forehead of the woman standing third to the right of Noah in the *Sacrifice* (Fig. 196), the *spolvero* dots were often smeared into continuous dark outlines.

Passages in the profile of Ham's face in the *Drunkenness,* with their limpidly smooth *intonaco* surface and minute dotting of *spolvero,* enable a breathtaking glimpse into the mural's technique and original condition. According to Vasari (and perhaps we should not be overly skeptical of his account), the monumental figure of Ham was a portrait of Dello Delli, the artist under

whose supervision the *"Chiostro Verde"* cycle of Genesis was begun in 1425 and who was apparently Paolo Uccello's close friend.[121] Dello went to Spain in 1432 but returned to Florence in 1446, which has sometimes been adduced as evidence for dating the murals between 1446 and 1450.[122] Be that as it may, if some figures in the *Sacrifice and Drunkenness of Noah* were portraits, it might further explain the use of *spolvero* to ensure a precise translation of the designs onto the mural surface. We may conclude that all the main figures in the *Noah* scenes, particularly the daringly foreshortened, upside-down figure of God the Father in the *Sacrifice of Noah* that so captivated Vasari,[123] as well as those in the monumental lunette above, the *Deluge and the Recession of the Waters,* were probably painted from *spolvero* cartoons. (The use of the technique in the *Deluge* is not clear, however, for the mural surface is extremely damaged.) The group of figures and animals who surround Noah at the altar in the *Sacrifice* is so tightly intertwined that the cartoon probably included it entirely as a unit, along with the three figures on Noah's right, which actually show *spolvero*. However, the more spacious placement of Noah's sons in the *Drunkenness* does not help us decide whether the figures in this scene were portrayed in a single cartoon or separate cartoons.

"Paolo's labors *[fatiche]* in painting must have been truly great, having drawn so much that he left to his relatives . . . whole chestfuls of drawings *[disegni]."* This, Vasari concluded with mixed admiration in his *Vita* of the artist.[124] The increasingly disciplined approach to drawing as a means of exploring perspective effects in the *historia* was one of Paolo Uccello's greatest achievements.

Influence of Full-Scale Design Practices in the Decorative Arts

The division of labor between design and execution in media other than painting, and the need for design replication, undoubtedly provided a further stimulus in the early development of figural cartoons. The account books of the Ferrarese ducal court suggest that, from the late 1450s until at least 1480, the great painter Cosmè Tura, as well as more minor masters, were fashioning full-scale preparatory designs for tapestries, both on paper and on cloth. The relevant documents use such terms as *"patrone," "desegno,"* and less commonly *"cartone."* Among the earliest mentions, a *Memoriale* of 1457 states that the *cartolaio* Gregorio de Gasperino was to be paid for "six sheets of *fogli reali,"* which Cosmè

Tura employed to paint a *"desegno"* of devices to adorn cantle covers for the horses of his patrons, the Este family. Cosmè's tapestry cartoon – for his *"desegno"* must have been in full scale to judge from the quantity and size of paper purchased – was to be woven by *"maestro* Levino, master tapestry maker," who was none other than the Flemish weaver, Livino Gigli of Bruges, newly returned to Ferrara in July 1457.[125] Designing in full scale for a variety of media would often go hand in hand with delegated execution in the Quattrocento, as it would in the Cinquecento.[126]

The idea, however, of rehearsing a monumental figural composition in full scale on paper before its execution in paint on the wall may well have resulted first from contact with makers of stained-glass windows, mosaics, and wood inlay decoration *(intarsia).*[127] During the 1420s, 1430s, and 1440s work on the stained-glass windows of Florence Cathedral had resumed with renewed energy, and there, as the payment documents make plain, a similar division of labor prevailed between designers and executants.[128] It is fascinating to contemplate the possibility that while Andrea del Castagno was in Venice, after he and Francesco da Faenza had finished the S. Tarasio murals in S. Zaccaria (signed and dated 1442), Andrea helped design mosaics for the Mascoli Chapel in the Basilica of S. Marco, as has repeatedly been proposed.[129] In the mosaic of the *Dormition of the Virgin,* Michele Giambono was probably responsible for the design of the apostles on the right. Soon afterward, on 26 February 1444, Andrea del Castagno was collecting payment for the *"disegni"* of the *Lamentation,* one of the stained-glass windows for the *oculi* in the drum of Florence Cathedral; the actual execution was by the *"vetraio,"* Angelo Lippi or Lorenzo di Antonio.[130] A letter from 23 March 1432 by the administrators of Florence Cathedral to Piero Beccanugi, the Florentine Ambassador to Venice, indicates that in 1425 Paolo Uccello designed a mosaic depicting *St. Peter* for the façade of the Basilica of S. Marco (destroyed).[131] Between 8 July 1443 and 10 February 1444, Paolo was paid for the *"disegni"* of three stained-glass windows in Florence Cathedral – the *Resurrection,* the *Nativity* and the lost *Annunciation.*[132] The two extant windows were executed by the *"vetrai,"* Bernardo di Francesco and Angelo Lippi, respectively.[133] Between 1462 and 1491, we find Alesso Baldovinetti (a frequent user of *spolvero* cartoons) documented as a designer, maker, and restorer of mosaics, as well as a designer of wood *intarsia* and stained-glass windows.[134]

Although we can only speculate about the early use of cartoons in the practice of mosaicists,[135] it is clear

that full-scale designs for stained-glass windows were known since at least the twelfth century, for Theophilus's *De Diversis artibus* (MS., after 1106) describes how to draw them on planks of wood.[136] Cennino's *Libro dell'arte* (MS., late 1390s) relates how large cartoons of glued sheets of paper for stained-glass windows were made, the first treatise reference to this type of drawing on paper and the only early one for a decorative art.[137] According to Cennino's *Libro,* artists drew such cartoons first with charcoal, then with ink, and with as much finish as "you would draw on a panel" to prepare its underdrawing.[138] As Cennino's *Libro* repeatedly attests, painters hired to design for the decorative arts were rarely engaged in the actual labor of execution. The increasing employment of late-four-teenth- and early-fifteenth-century artists as designers, rather than as makers, probably helped evolve clear, standard drawing types, which could be interpreted by craftspeople without the designer's personal guidance. By contrast, however, the labor of execution was less sharply divided in the painter's *bottega,* where masters more or less directly supervised assistants. (This fact may go some way to explain the delayed absorption of the practice of full-scale drawings on paper into the design technology of mural and panel painting.)

In Central Italy, at least as far back as the 1390s, there existed a tradition of artists who designed stained-glass windows but who had no specialized training in this craft. Besides Andrea del Castagno and Paolo Uccello, other such participants were Agnolo Gaddi (Cennino's teacher), Lorenzo Ghiberti, Donatello, Stefano di Gio-vanni "Sassetta," Benozzo Gozzoli, and Alesso Bal-dovinetti.[139] The use of large-scale drawings as a com-mon language between designers and makers probably evolved from such a tradition. Following this, it may have seemed a logical step to integrate two separate techniques — that of *spolvero* and that of cartoons — together into the practice of mural painting. As their extant murals demonstrate, Paolo Uccello, Sassetta, Andrea del Castagno, Benozzo Gozzoli, and Alesso Bal-dovinetti employed *spolvero* figural cartoons. Although no cartoons for stained-glass windows by these early artists survive, to aid in our reconstruction, a cropped pricked outline design, depicting a seated figure of St. Paul (Figs. 197–98), on a sheet of unrelated pen studies from the 1440s to 1460s, by a Paduan artist near Donatello, may point to the common ground shared by the tradition of stained-glass window design and that of exploratory drawing in this period.[140] As has been sug-gested, the seated figure in this mysterious sheet, which, if reconstructed to its full size would measure nearly 70 cm., closely resembles the monumental saints in the stained-glass windows of Florence Cathedral, designed by Donatello in 1434–35.[141]

The Decoration of S. Egidio in Florence: A Web of Workshop Practice

The shared experience of painting the mural cycle on the *Life of the Virgin* in the choir of S. Egidio (S. Maria Nuova, Florence) may go a long way in explaining the nearly coeval use of *spolvero* cartoons by Domenico Veneziano, his young collaborator Piero della Francesca, and Andrea del Castagno.[142] In fact, Florentine painters may have better absorbed the practice of working from cartoons as the result of this ill-fated mural program, which remained unfinished for twenty-three years. Founded in 1286 by Folco Portinari at the Hospital of S. Maria Nuova, the small church of S. Egidio served between 1339 and 1450 as the chapel of congregation for the *"Compagnia e fraternità di S. Luca,"* the main brotherhood of painters in Florence.[143]

Documents reveal that between 1439 and 1445 Domenico Veneziano was painting in the choir of S. Egidio in *buon fresco* and *secco* techniques that included the purchase of a substantial amount of linseed oil.[144] Moreover, Bicci di Lorenzo, who was also a "pouncer" and who, as the architect, had redesigned S. Egidio between 1418 and 1420, continued to render various ser-vices to the Hospital of S. Maria Nuova. On 11 June 1441, he was debited in his account at that institution for the cost of a relatively large quantity of gold leaf.[145] This gold leaf probably served for Domenico Veneziano's mural of the *Birth of the Virgin* at S. Egidio, as has been hypothesized.[146] By 1445, when Domenico inexplicably abandoned the S. Egidio commission, he may have com-pleted the *Meeting at the Golden Gate* and the *Birth of the Virgin* but may have prepared only the *sinopia* for the *Marriage of the Virgin.*[147] A document of 12 September 1439 mentions Piero della Francesca at S. Egidio, appar-ently as Domenico's assistant; a second period of collab-oration between the two artists may have arisen after the mid-1440s.[148] Piero would employ *spolvero* cartoons for large portions of his earliest known fresco, *Sigismondo Malatesta before St. Sigismund ("Tempio Malatestiano,"* Rimini), signed and dated 1451.[149]

Between 1451 and 1453, Andrea del Castagno painted, but may not have completed, the *Annunciation,* the *Presentation of the Virgin in the Temple,* and the *Death of the Virgin* at S. Egidio.[150] Vasari particularly praised Andrea's *Death of the Virgin* as a *tour de force* for its fore-shortening of the bier.[151] At least the Virgin's foreshort-ened figure must have been painted from a cartoon.

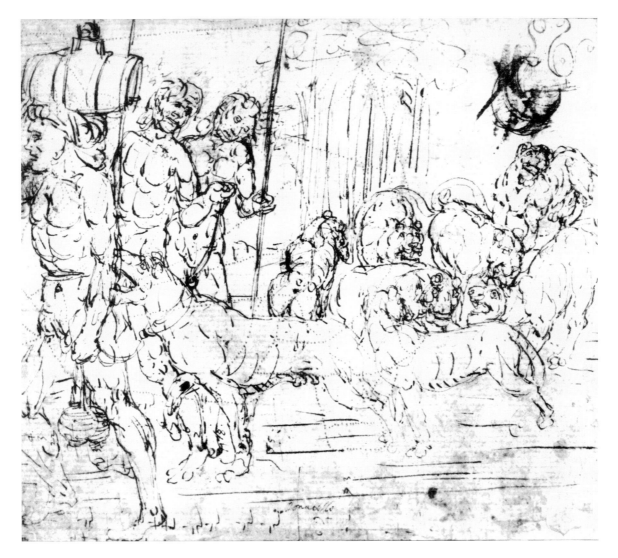

Figure 197. Artist near Donatello, study for a scene with men and dogs (CBC 59; Département des Arts Graphiques du Musée du Louvre inv. 1152, Paris).

Figure 198. Approximate reconstruction of the unrelated pricked outlines on the Louvre sheet.

After all, the artist had used *spolvero* cartoons earlier for equally (or less) taxing displays of illusionistic skill, as in his cycle of the *Last Supper, Crucifixion, Entombment,* and *Resurrection* in the refectory at S. Apollonia, from 1447, and in the series of *Famous Men and Women,* formerly gracing the *loggia* of the Villa Carducci at Soffiano.[152] Portrayed in shallow *"sotto in sù"* perspective, the monumental Villa Carducci frescos have usually been dated 1448–50, on the basis of both style and the extant documentary evidence about the family of the presumed patron, Filippo di Giovanni Carducci. Neither program, however, was easily accessible to Andrea's contemporaries: the refectory because the convent of S. Apollonia was under strict rule of *clausura,* and the villa because it was privately owned.[153]

In 1461–62, Alesso Baldovinetti, who is known to have worked closely with Andrea del Castagno in June 1454 and who may have been Domenico Veneziano's pupil, completed that master's unfinished *Marriage of the Virgin* at S. Egidio.[154] Baldovinetti would use *spolvero* cartoons extensively for many of his figures in the Chapel of the Cardinal of Portugal (S. Miniato al Monte, Florence), a mural cycle painted largely *a secco* around 1466–67.[155] Baldovinetti's account book for the Gianfigliazzi Chapel lists a purchase on 28 April 1471 of sixteen *"quaderni"* of *"fogli reali da straccio"* for the cartoons of prophets (*"spolverezi de' profeti"*) and other designs.[156] Nevertheless, conclusions regarding the importance of the mural program at S. Egidio must remain hypothetical, for it was largely destroyed and whitewashed in 1594.[157] What little may have remained must have been painted over when the choir was redecorated by 1650, and again during the eighteenth century. Domenico Veneziano's *sinopia* for the *Marriage of the Virgin,* together with minor mural fragments depicting ornament, feet, and fictive marble panels were discovered in 1938, and detached in 1955.[158] No *spolvero* has thus far been found on these thickly painted, deteriorated fragments: their attribution is usually debated between Domenico Veneziano, Andrea del Castagno, Alesso Baldovinetti, and even the young Piero.[159]

The Cartoon, Perspective, and the "Second Renaissance Style"

It seems clear that by the mid–fifteenth century, the increasingly analytical modes of visual description in painting paralleled many of the systematic methods employed in the study of perspective. Details in murals exhibiting *spolvero* from the mid-Quattrocento onward

can confirm the point.[160] Yet the contemporaneous use of *spolvero* figural cartoons by this time in the murals by Paolo Uccello, Domenico Veneziano, Andrea del Castagno, and Piero della Francesca seems remarkably sudden in the history of the *spolvero* technique that we have traced since its first uses in the West. Such coincidence of practice requires at least some explanation. The slightly older Paolo Uccello (c. 1397–1475) appears as an unexpected innovator in our history. He is the earliest painter from whom both murals painted from *spolvero* and drawings with pricked outlines are extant.[161] Uccello and Domenico Veneziano (c. 1410, but doc. 1438–1461), as well as the younger Andrea del Castagno (c. 1417/19–1457) and Piero della Francesca (c. 1415/20–1492), adopted the practice of *spolvero* figural cartoons relatively early in their careers. In fact, all extant murals by Andrea del Castagno show substantial evidence of *spolvero,* except possibly his earliest two. These are the *Crucifixion,* from 1440 to 1442, for the convent of S. Maria degli Angeli (reinstalled in the *"Sala della Presidenza,"* Hospital of S. Maria Nuova, Florence), and the program in the Chapel of S. Tarasio (S. Zaccaria, Venice), painted with Francesco da Faenza.[162] The S. Tarasio vault frescos are dated 1442 and are signed by both artists. Without exceptions all extant murals by Piero exhibit substantial evidence of *spolvero* cartoons. His mural cycle on the *Legend of the True Cross* in the chancel at S. Francesco in Arezzo (see Figs. 202–4) demonstrates an especially systematic approach.[163] It is among the most monumental examples of *spolvero* until the murals in the *"Sala dei Mesi"* at the Palazzo Schifanoia in Ferrara (Fig. 199), painted in 1467–69 by a team of artists, probably under the direction of Francesco del Cossa.[164] Andrea del Castagno's and Piero della Francesca's use of *spolvero* is noteworthy, considering both the relatively great number of their extant murals and their combined surface areas. Moreover, the ongoing investigation of Piero's panel paintings continues to reveal significant uses of the technique, as we shall see later.

It cannot be merely coincidental that the vanguard painters of the 1440s and 1450s – the younger generation of the so-called "Second Renaissance Style" – were among the first and most consistent users of *spolvero* cartoons for figural compositions. Because of the nuanced outline notation they allowed, such cartoons could facilitate the exploration of individualized detail, of complex figural groupings, and, above all, of foreshortening and perspective. As the intricately detailed designs in murals from this period can show, it was exactly this increasing naturalism, compositional

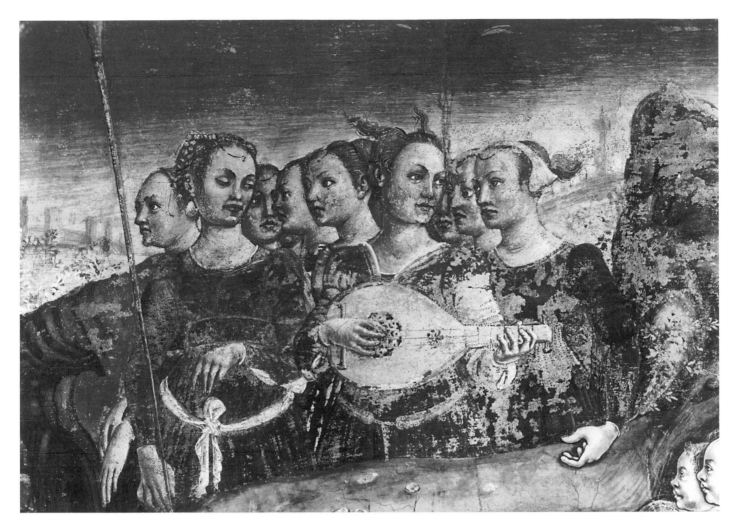

Figure 199. Detail showing spolvero *in Francesco del Cossa and other artists,* The Month of May with the Nine Muses, *mixed mural technique* ("Sala dei Mesi," *Palazzo Schifanoia, Ferrara).*

complexity, and precision of illusionistic effect that set the *oeuvre* of this generation of painters apart from that of their predecessors. The resolution of these new aesthetic concerns was foremost in terms of outline and volume. This is not surprising, as the Tuscan tradition of painting since Giotto had often valued *"disegno"* over *"colore"* – or *"colorare,"* as Piero's *De Prospectiva* designates it – and color was often seen to be subordinate to form. In his painting treatise, Leon Battista Alberti called *"circumscription"* the cornerstone of painting,[165] and in his introduction to the *Vite* (Florence, 1550 and 1568), Vasari defined painting as form modeled in relieflike contrasts of light and shadow, and as color contained within outline.[166] Alberti's early hierarchical definition of painting, in terms of (1) "circumscription," (2) composition, and (3) the reception of light, is but the written confirmation of the highly descriptive

use of line increasingly apparent in paintings from the 1440s and 1450s by the first users of *spolvero* figural cartoons. By the late 1460s, the substance of these developments appears already refined in the pounced, monumental mural cycle in the *"Sala dei Mesi"* at the Palazzo Schifanoia in Ferrara (Fig. 199).[167] Piero had worked in Ferrara, probably in the 1450s, and Alberti had also sojourned there some years earlier.[168]

Until the 1430s to 1440s, the *spolvero* technique had only offered a means of mechanically replicating ornament motifs. The quick proliferation of murals designed with *spolvero* figural cartoons around the mid-Quattrocento confirms that the integration of the technique into the preliminary design process constituted a leap, rather than a smooth transition, from a purely reproductive function to an exploratory one. The increasingly scientific study of perspective must have been a precipi-

tating agent in this change, for it could well be argued that the vanguard painters of the 1440s and 1450s attempted to refine the portrayal of the foreshortened form by methods that in their precision paralleled the complex explorations of pictorial space that had already been under way since the 1420s. The revolutionary Early Renaissance painters of the 1420s and 1430s, who frescoed figural compositions before the practice of cartoons became widespread but who shared an interest in perspective, had pioneered the way.

Despite fragmentary evidence, we can surmise that the development of increasingly scientific methods in the study of perspective had stimulated the refinement of precise drawing techniques, both of construction and replication, from the 1420s onward. As we have seen, during the 1420s and 1430s, it had been *"prospectivi"* who integrated the use of the squaring grid into their design process as a means of both transfer and cal-

ibration, at a time when the figural cartoon had not yet fully emerged.

The "Transformed" Head in Piero della Francesca's *De Prospectiva Pingendi*

We may turn to Piero's work in order to refine further our premise for investigating the role of perspective as a possible agent of change in this aspect of Quattrocento workshop practice (Figs. 200–4). The concrete relationship between the development of exploratory drawing, the figural cartoon, and the study of perspective can indeed be reconstructed, if in fragmentary form, through the evidence provided by Piero's *De Prospectiva pingendi*.[169] After a lifelong preoccupation with perspective and volumetric clarity, which he attained through a rigorous calibration of outline, it is no surprise that Piero would devote a treatise solely to the study of such

Figure 200. Piero della Francesca, De Prospectiva pingendi, *fol. 61 recto (Biblioteca Palatina MS. Parm. 1576, Parma). The diagrams for the sequence on the "transformation" of the head on folios 59 verso, 63 verso, and 65 recto are here omitted.*

Figure 201. Piero della Francesca, De Prospectiva pingendi, *fol. 66 verso (Biblioteca Palatina MS. Parm. 1576, Parma).*

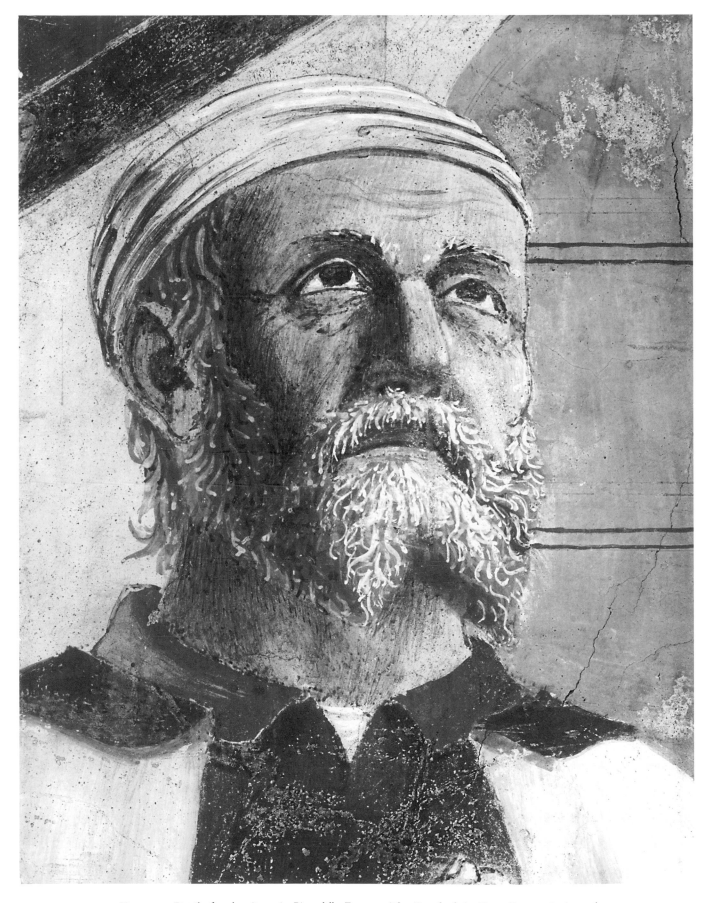

Figure 202. Detail of male witness in Piero della Francesca, The Proof of the True Cross, *mixed mural technique (S. Francesco, Arezzo).*

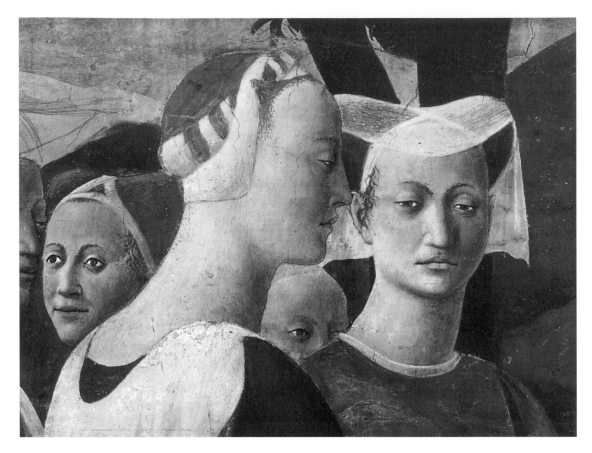

Figure 203. Detail of the women attendants in Piero della Francesca, The Adoration of The Holy Wood, *mixed mural technique (S. Francesco, Arezzo).*

relationships. Indeed, Piero's principle of *"commensura-tio"* – the placement of an object in space, derived from the proportional measurements of a perspective projection – helps explain the general reasons why the use of figural *spolvero* cartoons had been central not only in Piero's painted *oeuvre* but also in that of his fellow *"prospectivi"* working in the 1440s and 1450s.[170]

The Italian manuscript of the *De Prospectiva* (Biblioteca Palatina, Parma), is apparently written in Piero's own hand, whereas the Latin manuscript (Biblioteca Ambrosiana, Milan), the product of an anonymous scribe, seems to have been translated from the Italian by Piero's friend, Matteo dal Borgo, under the artist's direction.[171] The undated manuscripts are thought to have been drafted contemporaneously, certainly before 1482 (the year of Duke Federigo da Montefeltro's death), probably between 1460 and 1480.[172] They include sets of similar illustrations, usually considered to be autograph, that demonstrate in the most literal way the exercises described in the text. Echoing

Alberti, Piero defined the basic elements of painting as *"disegno," "commensuratio,"* and *"colorare,"* but only one – *"commensuratio"* – is the subject of his treatise.[173] Three books treat the diverse proportional systems of measurement by which the outlines of progressively complex forms could be foreshortened – planes, geometric solids, architectural members, and the human head. The subtlest of these methods was that of "transformation," in which the foreshortening of a head could be proportionally constructed by means of measured orthogonal projection.

In section VIII of Book III, Piero explained how artists could project – point-by-point onto a pictorial surface, placed at an established distance from the eye – a head rotated to any position in space by correlating the measurements of the profile and frontal views of the head with those of its views from the top and bottom.[174] The frontal and profile views of the head comprise the "elevations," and the top and bottom views of the head the "plans" (Fig. 200).[175] The measurements

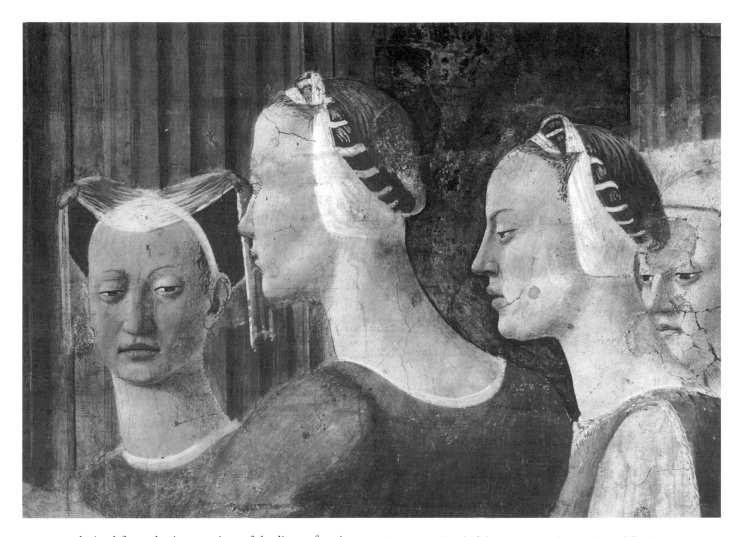

Figure 204. Detail of the women attendants in Piero della Francesca, The Queen of Sheba Meeting King Solomon, mixed mural technique (S. Francesco, Arezzo).

are derived from the intersection of the lines of projection between elevations and plans of the head, at critical nodal points. These coordinates are then systematically transcribed along the various, previously established vertical and horizontal axes of the head, as the coordinates are modified by the angle of view from the fixed point.[176] This is by far the most arduous part of the exercise and it clearly necessitates multiple, exact drafts of the plans and elevations of the head for calculation. Piero greatly simplified this part in his illustration of the profile to make it legible and carried out only one of eight such projections.[177] Finally, in connecting the points, the stereometric cage for the head is obtained, rotated to the desired position in space (Fig. 201).[178]

Renaissance architects and students of perspective were broadly familiar with the general principles of proportionally projecting the relationships between plans and elevations in the case of buildings, architectural spaces, or geometric objects.[179] The stereometric designs of *mazzocchi* and *coppe,* usually attributed to

Paolo Uccello, constitute one general example of such principles.[180] Yet, as has been suggested, even Uccello's construction technique differed substantially from Piero's, which applied the laws of perspective in a highly consistent fashion.[181] The study of proportion, particularly its application to the parts of the human body and face, had provided Piero with another point of departure. The "transformed" heads must have originated in attentive empirical observation, which Piero then standardized by means of proportional measurement. Leonardo's study of facial proportion from 1489 to 1490 in Turin and Fra Luca Pacioli's woodcut published on folio 25 verso of the *De Divina proportione* (Venice, 1509) serve to illustrate this interest, which was undoubtedly more common in the later Quattrocento

than surviving drawings or prints would indicate.[182] It is Piero's systematic application of the laws of perspective to this study of human proportion, however, that makes his contribution appear so highly original.

Seen as a whole, Piero's "transformation" exercises demonstrate *de facto* the significance of the problem for his own design philosphy. There is sufficient evidence, however, to suggest that Piero's method of "transformation" only played a limited role in actual practice, not because of the method's conceptual difficulty but because applying it would have been extraordinarily labor-intensive.[183] Foreshortenings of the human figure, animals, and inanimate objects could certainly be drawn more intuitively, by *"giudizio dell'occhio,"* and generally with more compelling results. Even Piero (like every later Renaissance illustrator of human "transformation") seems to have "eyed" to some extent both the contours and the relationships of the facial features in constructing the projections of the head.[184]

The point of Piero's "transformation" exercises, however, was not that they be a substitute for the study of the foreshortened form after nature,[185] for after all, in actual practice, a "scientific" rule could hardly replace *"giudizio dell'occhio."* Rather, Piero's exercises were a means of teaching spatial relationships by developing visual judgment. By mastering the exercises, painters and artisans may have been able to learn the rudiments of perspective and foreshortening. After painters, *intarsiatori* possibly comprised the largest audience for Piero's treatise; as Fra Luca Pacioli noted on folio 23 recto of his *De Divina proportione,* Piero considered the *intarsiatore* Lorenzo da Lendinara, "dear as a brother."[186] Indeed, from the mid-Quattrocento onward, the art of *intarsia* often became a laboratory for the study of perspective. The underlying assumption of Piero's treatise, however, that foreshortening should be rigorously studied and calibrated, rather than estimated, speaks to his generation of practitioners.

Theory Put to Practice: Piero's Murals at S. Francesco in Arezzo

During the course of Piero's entire career, the practice of *spolvero* figural cartoons would remain central to his design process, and at least in some respects, his use of the technique in his paintings can be understood as an extension of his systematic approach to the study of perspective.[187] Although it seems unlikely that even Piero plotted each and every one of the heads in his paintings according to the method of "transformation"

explained in his *De Prospectiva,* it is clear that he often did so as a means of enhancing the volumetric clarity of his foreshortenings.[188]

Piero's cartoon for the pounced head illustrated in Figure 202, a detail from the *Proof of the True Cross* at S. Francesco, must have already established the angle of view for the face in a preliminary stereometric projection, as is clear from the precise definition of volumes the *spolvero* and *chiaroscuro* articulate. Masaccio, well ahead of his own times, had approached the problem of foreshortening a head in 1425–27, that is, before the reinvention of *spolvero* cartoons for the figure, by incising a grid of squares and rectangles on the wet plaster in order to enlarge the design for the Virgin's foreshortened head in the *Trinity* (Fig. 172). As discussed in our survey of Renaissance and Baroque written sources in Chapter Four, the grid of proportional squares was a method of approximate enlargement, requiring considerable *"giudizio dell'occhio"* and eye–hand coordination. In great contrast to Piero's foreshortened heads (Fig. 202), Masaccio's foreshortening of the Virgin's face in the *Trinity* (Fig. 172) appears approximate – intuitive, rather than rationalized. Masaccio conveyed flat, nearly lopsided diagonal alignments of the facial features – we may note the odd spacing of her eyes, nose, and mouth – rather than the three-dimensional, convex alignments articulated in Piero's paintings and diagrams. In fact, the imprecise foreshortening of the Virgin's head in Masaccio's *Trinity* strikingly contrasts with the precise perspective of that composition's pictorial space. Put another way, although we can easily discern the plan of the *Trinity's* pictorial space, we cannot discern the plan of the Virgin's head. By employing *spolvero* cartoons, Piero and his assistants could transfer exactly, onto the mural surface, outlines that had been drawn in full scale on paper and that had previously been developed in smaller-scale studies. The translation of these outlines from the cartoon onto the *intonaco* was entirely mechanical, and, unlike squaring, required no improvisation. Masaccio's squaring grid had offered an intermediate solution in the history of full-scale figural design, between the traditional *sinopia* and the cartoon pounced on top of the *intonaco*.

Like Domenico Veneziano's small fresco of *Sts. John the Baptist and Francis* (S. Croce, Florence), but on a significantly vaster scale, Piero's mural cycle on the *Legend of the True Cross* at S. Francesco in Arezzo exemplifies a highly unified approach to the design of the *"historia."*[189]

Piero and his assistants[190] painted many of the large-scale architectural elements fairly rapidly, often in enor-

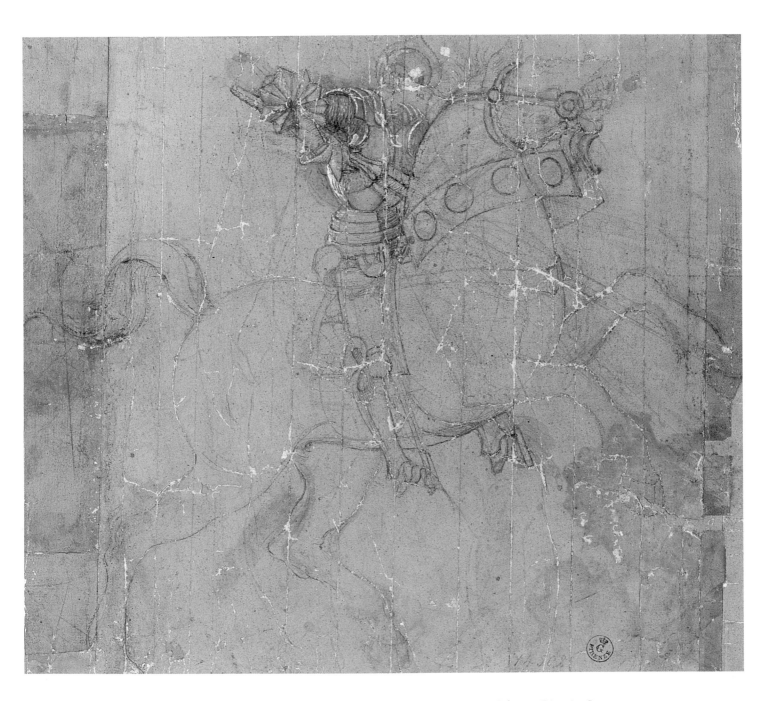

Plate I. Paolo Uccello, *pricked study for a* Soldier Riding a Horse *(CBC 312; Gabinetto Disegni e Stampe degli Uffizi inv. 14502 F, Florence), with stylus-ruled projection lines.*

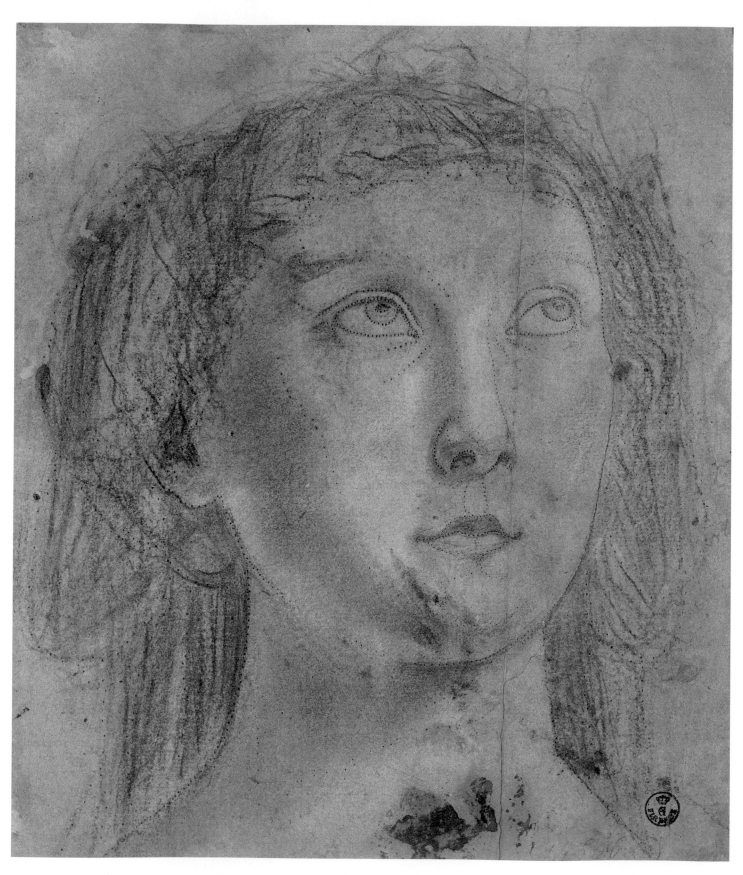

Plate II. Piero Pollaiuolo, pricked cartoon for the Head of an Allegorical Figure of Faith *(CBC 217; Gabinetto Disegni e Stampe degli Uffizi 14506 F, Florence). The corresponding panel painting is illustrated in Figure 210.*

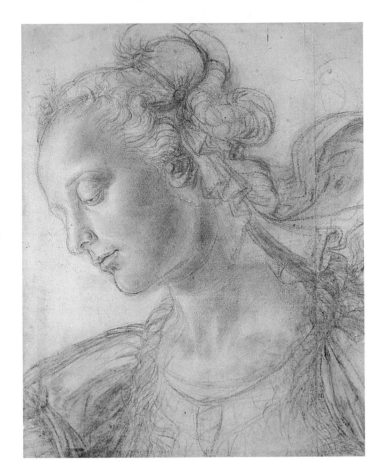

Plate III. Andrea Verrocchio (reworked by the young Leonardo?), pricked cartoon for the Head of a Young Woman *(CBC 338; Christ Church inv. 0005, Oxford).*

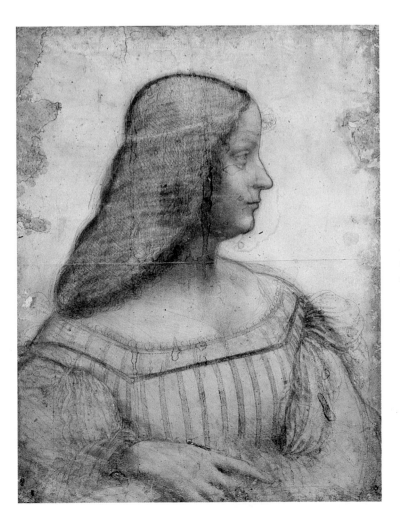

Plate IV. Leonardo, cartoon for a Portrait of Isabella d'Este *(CBC 129; Département des Arts Graphiques du Musée du Louvre inv. MI 753, Paris), pricked by a copyist.*

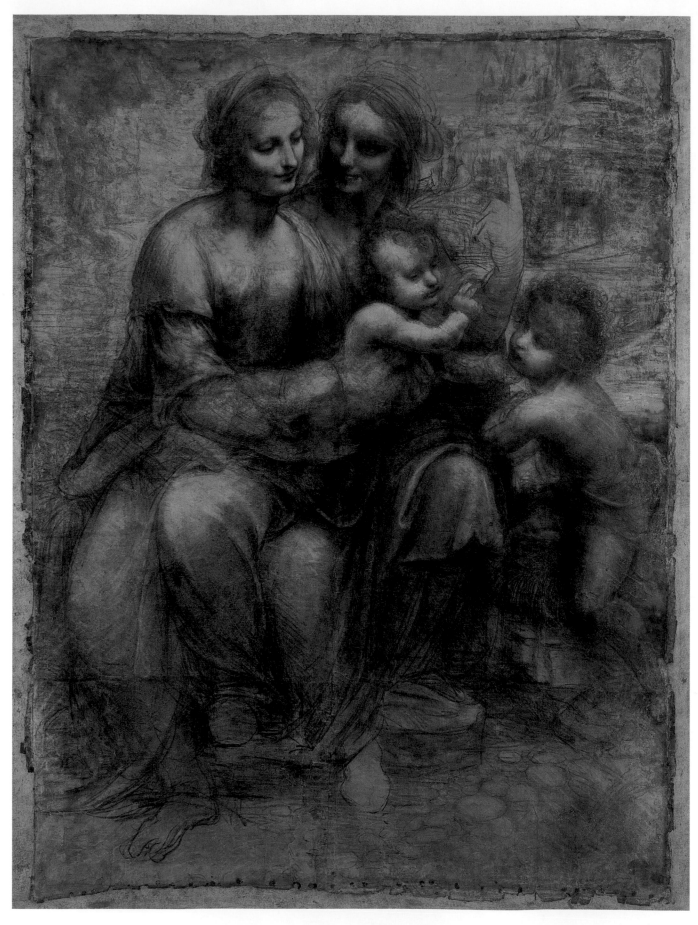

Plate V. Leonardo, cartoon of the Virgin and Child with Sts. Anne and John the Baptist, "The Burlington House Cartoon" *(National Gallery inv. 6337, London).*

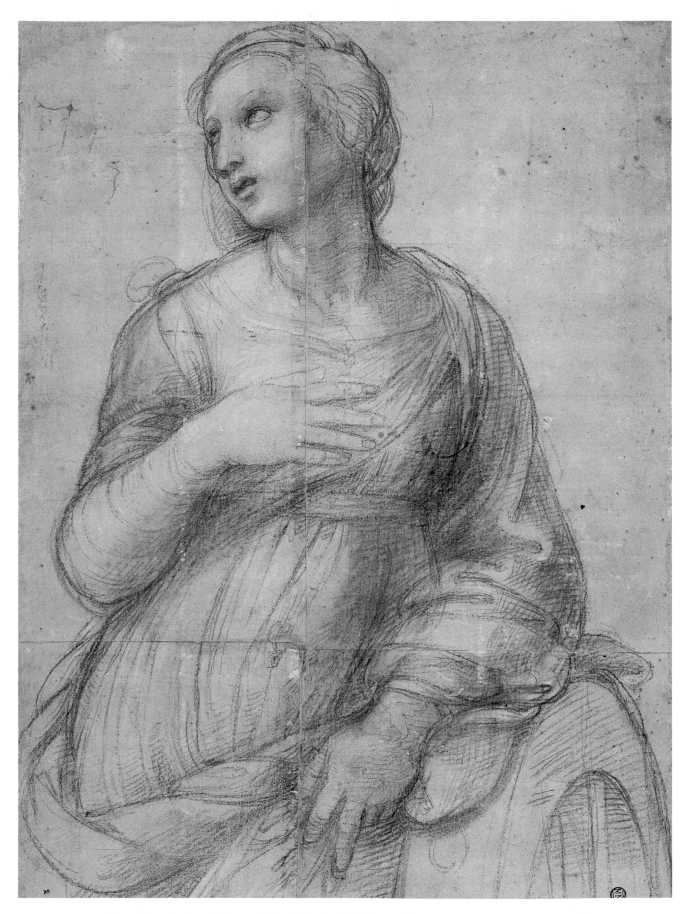

Plate VI. Raphael, pricked cartoon for St. Catherine *(CBC 249; Département des Arts Graphiques du Musée du Louvre inv. 3871, Paris). The corresponding oil painting on panel is in the National Gallery, London.*

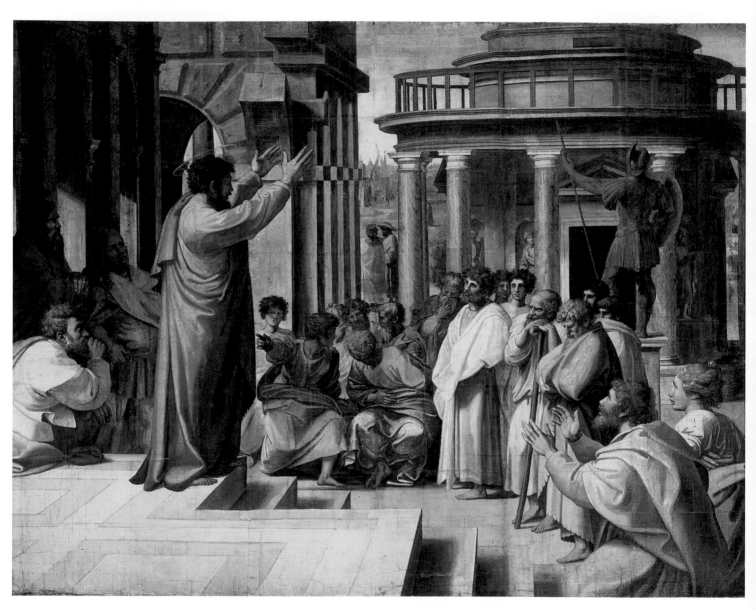

Plate VII. Raphael and workshop, cartoon for St. Paul Preaching in Athens *(CBC 266 G; Victoria and Albert Museum, London), pricked by a copyist. The corresponding tapestry, woven for the Sistine Chapel, is in the Vatican Museums.*

Ritratto di Leon.º x.º

Plate VIII. *Attributed to Giulio Romano, stylus-incised cartoon for the* Portrait of Pope Leo X *(Devonshire Collection inv. 38, Chatsworth). This drawing was intended for the* Enthroned Pope, St. Leo *in the stylus-incised mural painted in the Sala di Costantino, Vatican Palace.*

Plate IX. Antonio Allegri "Correggio," stylus-incised cartoon for the Head of an Angel *(Ecole Nationale Supérieure des Beaux-Arts inv. 109, Paris), preparatory for the squinch of St. Joseph in the dome frescos at Parma Cathedral.*

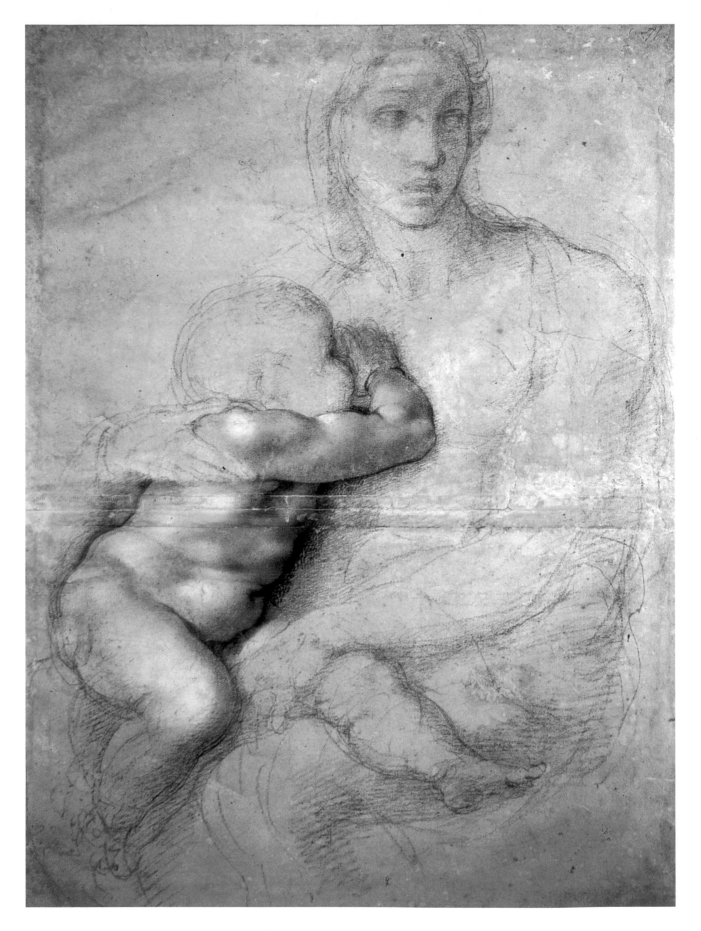

Plate X. Michelangelo, unfinished cartoon for a Madonna and Child *(Casa Buonarroti inv. 71 F, Florence).*

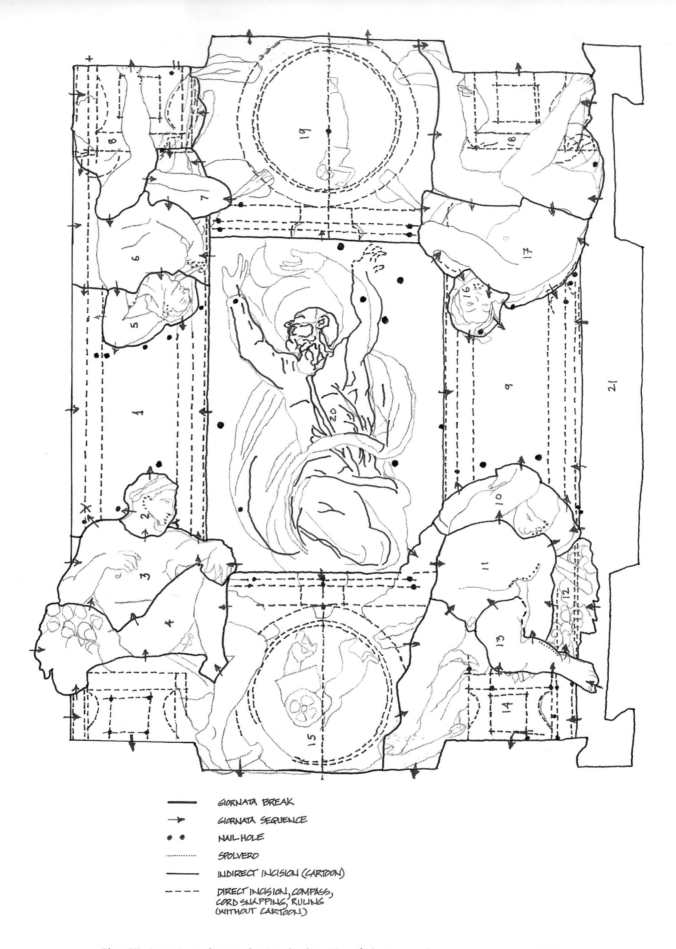

Plate XI. Approximate diagram showing the disposition of giornate, spolvero, incisions, and nail holes in Michelangelo, The Separation of Light from Darkness, fresco (Sistine Ceiling, Vatican Palace).

GIORNATA BREAK

GIORNATA SEQUENCE

NAIL HOLE

SPOLVERO

INDIRECT INCISION (CARTOON)

DIRECT INCISION, COMPASS, CORD SNAPPING, RULING (WITHOUT CARTOON)

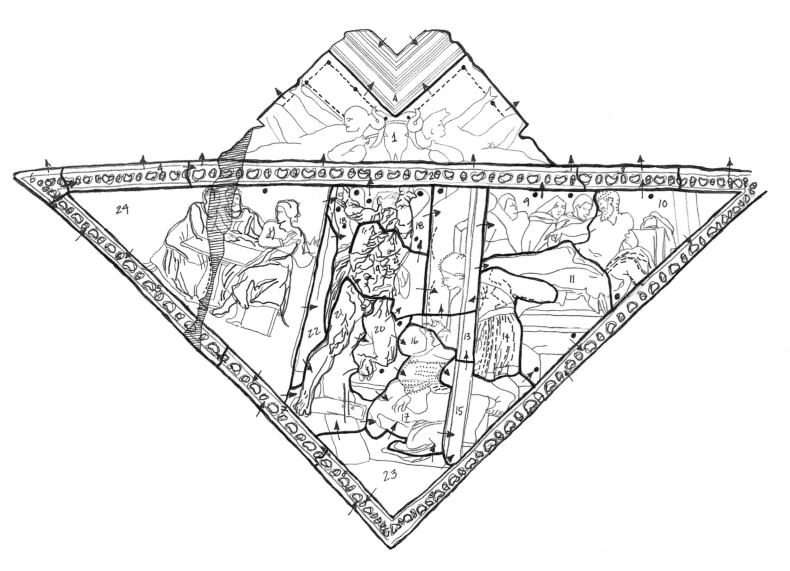

Plate XII. *Approximate diagram showing the disposition of* giornate, spolvero, *incisions, and nail holes in* Michelangelo, The Punishment of Haman, *fresco (Sistine Ceiling, Vatican Palace).*

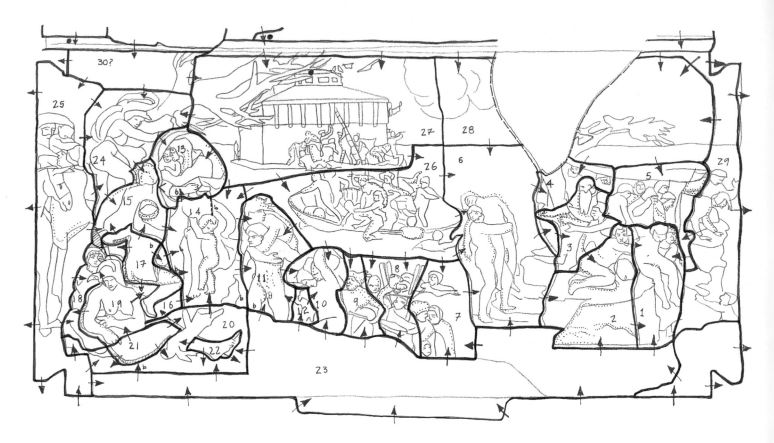

Plate XIII. *Approximate diagram showing the disposition of* giornate, spolvero, *incisions, and nail holes in* Michelangelo, The Flood, *fresco (Sistine Ceiling, Vatican Palace).*

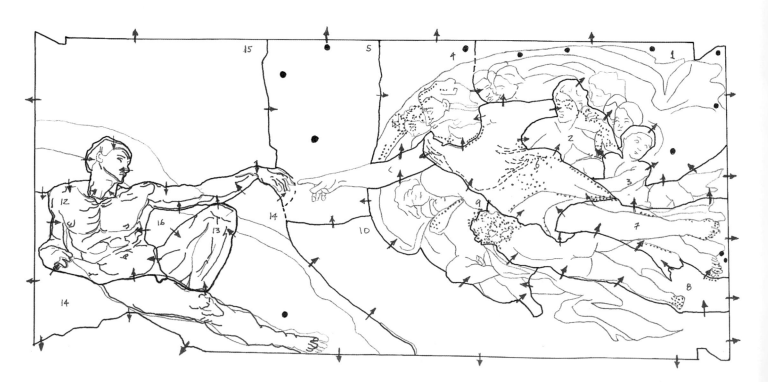

Plate XIV. *Approximate diagram showing the disposition of* giornate, spolvero, *incisions, and nail holes in* Michelangelo, The Creation of Adam, *fresco (Sistine Ceiling, Vatican Palace).*

mous *giornate,* on the basis of direct construction on the *intonaco* – for example, stylus ruling, *incisioni dirette,* cord snapping, and compass sectioning. The artist probably relied on *sinopie* underdrawings to establish the general disposition of such forms, as he did in his mural of *Sigismondo Malatesta before St. Sigismund* ("*Tempio Malatestiano,*" Rimini).[191] For small-scale architectural elements at S. Francesco in Arezzo, Piero and his team relied on separate *spolvero* patterns, as is seen in the small, compact cityscape, on the left part of the middle tier on the left wall, the *Discovery of the True Cross.*[192] For the right part of this tier, the *Proof of the True Cross,* Piero's *bottega* turned to stylus ruling to define the Albertian Temple and the cross, often allowing the lines to run straight into the heads of the pounced figures. In the lowest tier of the left altar wall, with the *Annunciation,* the method of direct construction for the foreground column appears unexpectedly free, especially if we recall the careful projections of bases and capitals that Piero illustrated in the *De Prospectiva.* The artist and his *équipe* painted the composite capital, identical to those in *De Prospectiva,* from a detailed, small *spolvero* pattern; the same is true of the other capital behind it. But in order to suggest the *entasis* of the column, the artists took stunning shortcuts: for the upper half of the shaft they stylus-ruled two mirroring vertical lines that run somewhat obliquely toward the top, whereas for the lower half of the shaft, they stylus-ruled two verticals that run perfectly parallel toward the bottom. Likewise, the perspectival "transformation" of the column's base appears thoroughly convincing when viewed from a distance. Yet, up close, all the moldings of the base are crudely stylus-ruled as straight horizontal lines, well past their profiles, as if seen flatly in elevation. Piero accomplished the slight cylindrical curvature of the rings entirely during the process of painting, by means of an extraordinary, suggestive treatment of light and color.[193] In the middle tier on the right wall, the *Adoration of the Holy Wood* and *The Queen of Sheba Meeting King Solomon,* Piero and his assistants used a more nuanced approach (reminiscent of Masaccio's *Trinity*) to portray the majestic temple. There, they painted the composite capitals seen in frontal view from *spolvero* patterns (for such designs repeat twice in the same tier, and twice in the *Annunciation*), but for the steeply foreshortened capitals, Piero – for he could have hardly delegated this task to assistants – constructed their gradually disappearing perspective by means of a dense armature of lines, stylus-ruled directly on the plaster.[194]

Piero and his team executed the figural parts of the mural cycle from detailed *spolvero* cartoons, often

exceedingly slowly and in small, numerous *giornate.*[195] Probably resulting from several hands at work, the small diversities of technique from scene to scene, however, are such that they render generalizations about the "meaningful" disposition of *giornate* inconclusive. Yet seen as a whole, the wealth of technical evidence brought to light during the recent campaigns of cleaning and consolidation suggests that Piero's cartoons for many of the closely intertwined figural passages of the *historie* were pasted together to encompass at least large sections of each composition.[196] As in the *Victory of Heraclius over Chosroes,* on the lowest tier of the left wall, in a great number of instances throughout the cycle, a single *giornata* combines the *spolvero* outlines of various overlapping parts of figures and objects, as well as the impressions of a raglike texture.[197] These impressions often appear on groups of small, adjoining *giornate,* and although they occur on all three walls, they are more prevalent on the left, especially in the *Victory of Heraclius over Chosroes.* Here, foreshortened forms abound throughout the tightly woven relief of men and horses, and at least ten of the forty *giornate* bear the raglike imprints.[198]

Piero's cartoons were extremely precise; sometimes even the fingernails of the warriors are pounced closely. In the *Dream of Constantine,* on the lowest tier of the right altar wall, there are no raglike imprints and the *giornate* are relatively large. Yet here also, the substantial passages of *spolvero,* scattered throughout the compact composition, confirm that the cartoon spanned the entire area: dots appear on the flying angel, the monumental tent, the bed within it, the sleeping Constantine, and the soldiers standing guard outside. In the *Annunciation,* by contrast, the presence of *spolvero* on the isolated figures of God the Father, the Virgin Mary, and the Archangel Gabriel, as well as on only small, repetitive architectural details – such as the capitals of the columns and the coffers of the door behind – suggests that separate cartoons and ornament patterns were used to assemble the different parts of the scene. Great portions of the repetitive ornament patterns in the upper reaches of the mural cycle are pounced. The imposing building where the *Annunciation* takes place is based on direct construction.

Curiously, the *spolvero* dots on the heads and hands of the figures of the Virgin and Archangel are crisp, minute, and extremely dense (about six to seven dots per 10 mm.) – the *intonaco* bears the tiny imprints from the pricked holes of the cartoon's paper, which sank into the *intonaco* while it was still moist. But the dots are larger in diameter and more dispersed in the areas

of their clothed bodies. No such distinctions characterize flesh and nonflesh areas in the *Victory of Heraclius over Chosroes,* in which the *spolvero* dots are consistently of the larger-diameter type, much as in Domenico Veneziano's S. Croce fresco. Yet, as might be expected, in the *Victory,* the spacing of the *spolvero* dots depends on the complexity of the design – closer together in small, intricate passages (about four to five dots per 10 mm.), and further apart in simple ones (about two to three dots per 10 mm.).

Piero's very approach to color and medium was innovative. The pigments with which he and his assistants painted on the moist plaster at S. Francesco often contain traces of protein tempera, and the "copper resinate" greens have oil, hence their luster and saturation.[199] In view of the mounting technical evidence emerging from Piero's mural surfaces, we can envision that he followed an equally deliberate design approach in his preliminary drawings, in order to resolve a variety of specific details. Throughout the S. Francesco mural cycle, there are a number of demonstrable cases in which a remarkable congruence of outlines in the repetition and/or reversal of head types may point to cartoon reuse.[200] Although it is true that such formal counterpoints shape the rhythm of Piero's compositions, as has often been pointed out, we must emphasize that they appear always thoroughly digested into the whole of the new context. A well-known instance of an exact repetition are the heads of the fallen Chosroes in the bottom tier of the left wall and that of God the Father in the *Annunciation* on the same tier, but on the altar wall.[201] In the middle tier of the right wall, a famous example of a design reversal are the head types of two female attendants – one who wears a horned headdress (Figs. 203–4) and another who is seen in profile (she is only evident on the extreme right in Figure 204) – appearing as mirror images in the *Adoration of the Holy Wood* and the *Queen of Sheba Meeting King Solomon.*[202] In this tier, the sequence of *giornate* establishes that Piero and his assistants generally painted the figures in the scene from right to left; the treatment of the women's bodies differs substantially.[203] In the tightly woven, pounced figural groups of this scene, it seems probable that Piero did not improvise such counterpoints of symmetry directly on the *intonaco,* without previously rehearsing them on paper. He may have already incorporated such repetitions and reversals of figural designs into the cartoons that he drew for the *historia,* by means of intermediate drafts (or tracings) on paper, of the type already amply discussed in Chapter Three.

Paolo Uccello's Foreshortened Soldier Riding a Horse

With the diagrams of the "transformed" heads in Piero's *De Prospectiva* in mind, we may now turn, once more, to the *oeuvre* of Paolo Uccello, to consider one of the earliest extant pricked drawings in the Renaissance tradition of exploratory design – his fully armored *Soldier Riding a Horse* (Plate I).[204] As we saw, Paolo's use in the 1430s of a *spolvero* cartoon for the figure of God the Father in the *"Chiostro Verde,"* and in 1436, of a squaring grid in the preliminary study and mural for the *Hawkwood* cenotaph already distinguished him as an innovator. Often dated in the 1440s to 1460s, the drawing of the soldier riding a horse has been connected to a variety of paintings by Paolo, though none of his compositions provides a precise fit. The relatively careful rendering of the horseman's upper body in *chiaroscuro* – with metalpoint, hatching in pen and ink, gray wash, and lead-white gouache highlights – especially contrasts with the outline drawing of the horse. The horse and rider are in identical scale to those in the squared *modello* for the *Hawkwood* cenotaph (Fig. 175). Our pricked sheet already contained at least three unrelated designs before Paolo drew the horseman. Immediately below the horseman and between the horse's legs are faintly underdrawn remains in brush and gray wash, depicting a human leg in jointed armor. This armor resembles that worn by the horseman, which identifies the faded, slightly smaller-scale motif as a probable detail study for this figure. Underneath the drawing of the horseman, covered by the paper's coating of green preparation, lies a large lightly incised, metalpoint design of a nude.[205] To the left, also underneath a layer of ground preparation, lies a further undecipherable design composed of pricked outlines.

The soldier and horse are seen in three-quarter view and *"di sotto in sù."* Judging from both the extent of *pentimenti* and the relationship of pricking to drawing, the motif of the horseman went through several stages of design on this same sheet, from sketch to more finished study. The drawing was later reinforced with pen and brown ink, and many of the original *pentimenti* covered with a second application of ground preparation, of a slightly more vibrant blue-green tint than the original, but nevertheless close enough to it to suggest that this was done by the artist himself rather than by a later restorer. The lance the horseman brandishes is pricked only on the handle and the tip between the horse's forelegs. Because the drawing's main outlines are pricked, it has generally been

regarded as a cartoon for a painting. It seems more likely, however, that Paolo's drawing represents an exercise in the portrayal of foreshortened form. There is a system of stylus-incised parallel lines, verticals at uneven intervals, as well as incised compass marks, and freehand stylus underdrawing.[206] The stylus-ruled parallels offer a key to the probable function of the drawing (Fig. 205). The general principle resembles Piero's "transformation" exercise for the human head, but since it is apparently of much less consistent application,[207] it may come closer to the way of foreshortening form placed diagonally in space that Piero used for solid objects in Book II of the *De Prospectiva*.[208] Moreover, as can be deduced from Piero's projection of solid objects and the "transformation" of the human head, the majority of nodal points marking his measurements were standardized through the study of proportion. The verticals passing through Uccello's horse are remarkably similar in placement to those Leonardo would later project in his studies of the proportions of the horse, as is evident in his famous elevation drawing (Royal Library, Windsor).[209] Although too much physical evidence is lost in Paolo Uccello's sheet to make any definitive conclusions, the hypothesis of a "proto-transformation" exercise should be considered, in view of the fact that the artist's three panels of the *Battle of S. Romano* (Galleria degli Uffizi, Florence; Musée du Louvre, Paris; and National Gallery, London) devote extraordinary attention to the portrayal of horses and soldiers in different positions of foreshortening.[210] The detail here reproduced (Fig. 206), a foreshortened horse seen from below in "plan" in Paolo Uccello's Uffizi panel, is closely comparable to the "plan" and "elevation" techniques used to illustrate the proportions of the horse in the *Codex Huygens* (Pierpont Morgan Library, New York), by a follower of Leonardo.

In Paolo Uccello's sheet, the apparent presence of rubbed, black pouncing dust in such areas as the hind legs of the horse and the upper body of the soldier, which are redrawn with brush and gray wash, attests to the actual transfer of the design. The drawing was thus probably part of a sequence of exploratory exercises on paper, rather than a cartoon for a painting surface.[211]

Luca Signorelli's Exercise in Foreshortening a Head

A pricked drawing of a man's head in profile, attributed to Luca Signorelli and dating from the 1490s, offers an example of a similar exploratory exercise, projected to a monumental scale (Fig. 207).[212] Judging from its technique, this sheet was also probably not a cartoon for a painting, as has often been thought.[213] The outlines of the design are drawn in an extremely simplified manner and the *chiaroscuro* modeling is curiously reductive. The holes from the pricking do not align consistently with the drawn outlines, and there appear to be no traces of pouncing dust on the sheet. Rather, the pricking of the outlines was done, not as a final step after the drawing was complete but as a preliminary step before the artist began drawing. That is, the artist drew the ink outlines on the basis of already existing pricked outlines, by connecting the holes.[214] Compass work, as well as a system of incised, parallel, horizontal lines, ruled with the stylus directly onto the paper are also apparent.[215] Much like the stylus-ruled verticals in Paolo Uccello's *Soldier Riding a Horse*, the stylus-ruled horizontals in Signorelli's drawing are spaced at uneven intervals.[216] Each incised horizontal is exactly tangential to the point that marks a maximum vertical distance between the outlines forming each of the man's facial features. A stylus-ruled vertical runs also tangentially to the point of maximum protrusion on the man's forehead. This line originally functioned as the plumbline establishing the angle of inclination for the head's profile.[217] Two short, stylus-ruled, parallel diagonals, immediately to the left of the ear, plot the location of the ear's attachment to the head; the ear is inscribed with the letters "x," "j," "v," "p," and "o," clockwise and upside down. The letters mark points through which the stylus-ruled parallels pass, either intersecting or falling tangentially to the drawn outlines of the ear. All the stylus-ruled lines clearly refer only to the head of the figure; the area below the neck was of no consequence.

Among the rare Quattrocento drawings of a parallel projection, Signorelli's sheet evokes the "transformations" in Piero's *De Prospectiva* (Figs. 200–1).[218] The stylus-ruled parallels touch tangentially the points of each facial feature that correspond to the foreshortened frontal view of the head. This portion of the sheet has been lost (Fig. 208).[219] If Signorelli planned to carry out the exercise he began on the Metropolitan Museum sheet through the increasingly complex steps described in the *De Prospectiva*, he would have had to replicate the profile view of the man's head multiple times, for exactitude of outline and cleanliness of draft were crucial to each step in Piero's construction. Signorelli may thus have stacked a number of sheets underneath the original design, including the Metropolitan Museum sheet, and pricked all the sheets simultaneously to have sufficient drafts for each projection.[220]

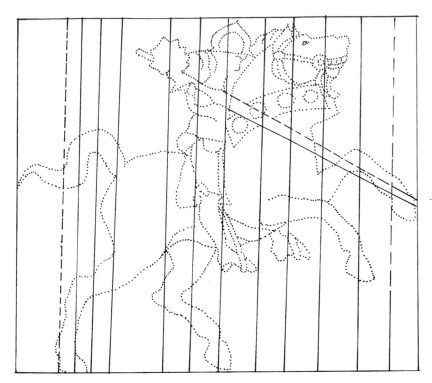

Figure 205. Approximate reconstruction of the parallel projection seen in Paolo Uccello, pricked study for a Soldier Riding a Horse (Uffizi inv. 14502 F; Plate I).

Figure 206. Detail of Paolo Uccello, The Battle of S. Romano, *tempera on panel (Galleria degli Uffizi, Florence).*

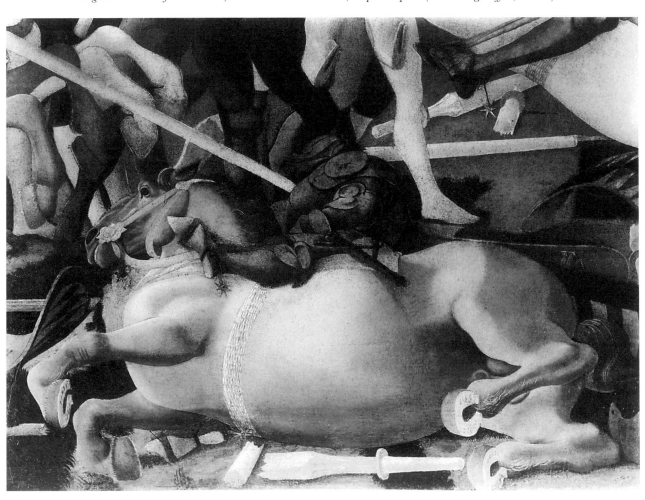

But unlike Piero's theoretical diagrams, Signorelli's drawing appears to be an entirely practical application of a parallel projection (or "transformation") to the likeness of an actual person.

Importantly, Piero may have been developing and applying the principles of "transformation" roughly during the period when Signorelli is most likely to have been apprenticed in Piero's *bottega*.[221] It would therefore not be surprising to encounter the teacher's workshop practice and interest in perspective in a drawing by the former pupil: as we have seen, the working habits acquired during the period of apprenticeship were formative.[222] Piero's exercise in "transformation" may well have sharpened the analytical understanding of foreshortening so evident in the dazzling effects of figural perspective that Signorelli painted throughout his career.

Cartoon Practice and Non-Practice between the 1450s and 1490s

The present state of research suggests that, between the 1440s and 1460s, the use of figural cartoons remained limited, primarily to a circle of associates and pupils generally gravitating around the progressive artists of the "Second Renaissance Style." For example, we may recall that Alesso Baldovinetti, who had worked closely with Andrea del Castagno in 1454 and who had probably been Domenico Veneziano's pupil (completing Domenico's unfinished *Marriage of the Virgin* at S. Egidio), used *spolvero* cartoons extensively about 1466–67 for the mural parts of the Chapel of the Cardinal of Portugal (S. Miniato al Monte, Florence), on which he collaborated with the brothers Antonio and Piero Pollaiuolo.[223] As also noted, Baldovinetti's account book for the Gianfigliazzi Chapel at S. Trinita refers, in 1471, to pounced cartoons of prophets (*"spolverezi de' profeti"*) and other designs.[224] Likewise, Lorentino d'Andrea, who was presumably one of Piero's assistant at S. Francesco and who apparently worked mainly in the town of Arezzo, used comprehensive *spolvero* cartoons around 1463 for the mural cycle narrating the *Legend of the "Fonte Teca"* in the Carbonati Chapel at S. Francesco, and in 1480–90 for the *Enthroned Madonna and Child* at S. Firmina.[225] A similarly comprehensive application of *spolvero* cartoons emerges also in the lunette mural of the *Virgin Handing the Girdle to St. Thomas,* painted in 1470–80, above the altar built by the Quaratesi family in the sacristy (S. Niccolò Oltrarno, Florence). Although this accom-plished fresco has been variously attributed to the followers of Andrea del Castagno, Antonio or Piero Pollaiuolo, and Alesso Baldovinetti, it may more likely be by the young Domenico Ghirlandaio.[226]

In sharp contrast to the *"prospectivi"* of the "Second Renaissance Style," neither Fra Angelico (c. 1399/1400?-1455) nor Fra Filippo Lippi (c. 1406/7–1469) appear to have adopted the new practice in their painting of the human figure. As the most direct artistic heirs to Masaccio, both Fra Angelico and Fra Filippo achieved artistic independence during the 1430s and were working on some of their major commissions in the 1440s and 1450s. The recent cleaning of Fra Angelico's frescos from 1441 to 1450 in the cells of the Convent of S. Marco (Florence) has revealed important data regarding the artist's working methods.[227] Yet, as this and other murals can also demonstrate, Fra Angelico relied extensively on *sinopie* and direct surface construction techniques for the preliminary preparation of compositions, using *spolvero* patterns only for ornamental painting (Figs. 163, 177).[228] It should be emphasized that the incisions in the S. Marco frescos are all freehand *(incisioni dirette),* rather than from cartoon transfer, as has sometimes been suggested.[229]

Fra Filippo omitted both *sinopie* and cartoons in his mural cycle on the *Lives of Sts. John the Baptist and Stephen* in the chancel of Prato Cathedral, from 1452 to 1460, painted predominantly *a secco.*[230] The same is true of his mural cycle at Spoleto Cathedral, from 1467 to 1469.[231] Similarly, infrared reflectography examination of his panels in the Metropolitan Museum of Art (New York) reveals only use of comprehensive freehand brush underdrawings, much of which also being visible with the unassisted eye.[232] Moreover, three of Fra Filippo's extant panel paintings from the 1460s exhibit monumental-scale underdrawings, executed freehand in charcoal and with the brush on the reverse of the wood supports. These are a highly rendered male head and other smaller studies on the back of the *Madonna and Child* (Museo di Palazzo Medici, Florence), a sketchier bust-length rendition of a woman on the back of the *Madonna and Child with two Angels* (Galleria degli Uffizi, Florence), and an outline design for a coat of arms, possibly that of the Martelli family, on the back of the famous *"Pitti Tondo"* (*The Madonna and Child with Scenes from the Life of the Virgin,* Palazzo Pitti, Florence).[233] In many respects, such drawings on the wood, which were never reworked in paint, seem virtual equivalents of cartoons on paper.

Two painters of the following generation, closely associated with Fra Angelico and Fra Filippo, at times

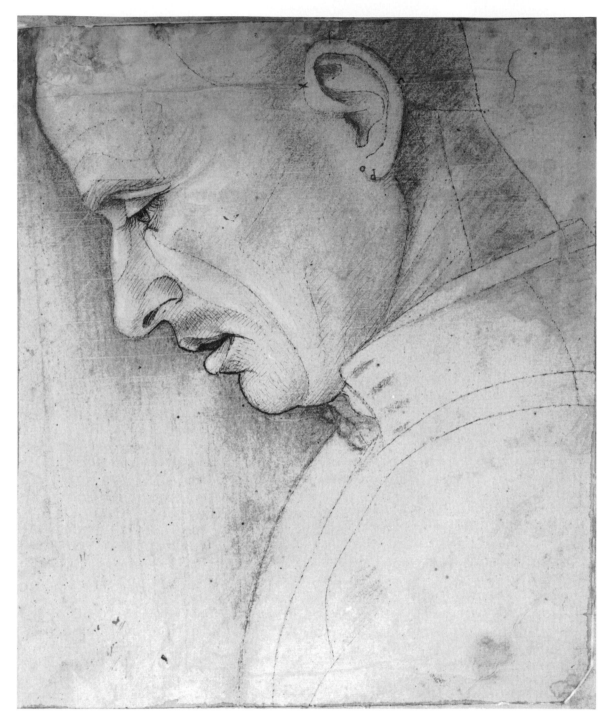

Figure 207. Luca Signorelli, pricked study for the Head of a Man *(CBC 293; Metropolitan Museum of Art, Robert Lehman Collection, 1975.1.420, New York), with stylus-ruled projection lines.*

employed *spolvero* cartoons in some of their mature, independent commissions: Benozzo Gozzoli (c. 1420–1497) and Francesco di Stefano *"Il Pesellino"* (c. 1422–1457). In the late 1440s, Benozzo had assisted Fra Angelico with the lost mural cycles in St. Peter's Basilica (Rome), as well as with the two vault compartments completed in the

"Cappella Nuova" (Cappella della Madonna di S. Brizio, Orvieto Cathedral), and the Chapel of Nicholas V (Vatican Palace). Benozzo, however, would more often than not skip the use of cartoons. His exceptional application of *spolvero* cartoons for the heads of the angels in the choir of *Paradise,* on the left and right of the altar in the

LOST DRAWING, RECONSTRUCTION EXTANT DRAWING

Figure 208. Approximate reconstruction of parallel projection seen in Signorelli's study for the Head of a Man.

"*Cappella dei Magi*" (Palazzo Medici, Florence), possibly meant that he could reuse the motifs of the angels in other projects.[234] None of the other figures in Benozzo's mural cycle at the Palazzo Medici, signed and dated 1459, reveal *spolvero*, although complex uses of the technique are combined with direct surface construction to replicate the magnificent Antique-style ornament patterns on the *dados* of the chapel.[235] Instead, for figural designs, Benozzo appears to have made a highly practical use of the *sinopia*.[236] The *sinopie* for the mural cycle in the Camposanto (Pisa), from 1468 to 1484, demonstrate an extraordinary range of exploratory and synthetic types of drawing, some of which would have made the use of cartoons redundant.[237] Not surprisingly, examination with infrared reflectography reveals only traces of freehand brush underdrawing in four small panels by Benozzo from the 1450s.[238] An artist emerging from Benozzo's workshop in the 1490s, whom Bernard Berenson nicknamed the "*Alunno di*

Benozzo" and Roberto Longhi the "*Maestro Esiguo*" and who is most likely one of the artist's sons (Francesco, or more probably, Alesso), produced a number of pricked drawings.[239] The unfinished, unprimed back of a little-known panel attributed to him (Museo S. Matteo inv. 2153 verso, Pisa) reveals traces of *spolvero* in the fragmentary charcoal underdrawing for the background ornament.

Datable around 1450–57, the small *Mystical Marriage of St. Catherine* (Fig. 209) by Francesco di Stefano "Il Pesellino" is the earliest securely identifiable cartoon extant for a panel painting.[240] The actual painting to which Pesellino's pricked compositional cartoon corresponds no longer survives. But examination with infrared reflectography of a panel of similar size and

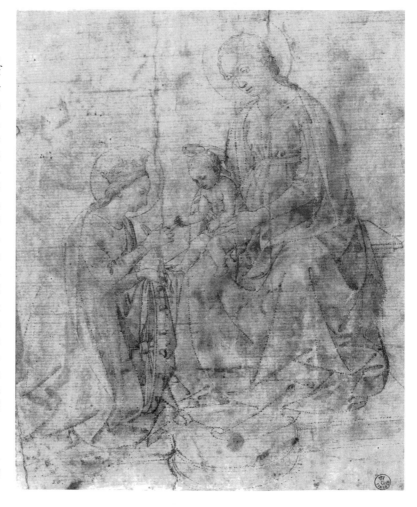

Figure 209. Francesco di Stefano "Il Pesellino," pricked cartoon for The Mystical Marriage of St. Catherine *(CBC 198; Gabinetto Disegni e Stampe degli Uffizi inv. 1117 E).*

type, Pesellino's *Enthroned Madonna and Child with Saints* (Metropolitan Museum of Art, New York), reveals traces of *spolvero*.[241] This confirms the function of the Uffizi drawing. Another, contemporary pricked cartoon by Pesellino is the already mentioned seated figure (Fig. 87).[242] The latter small sheet probably offered a stock pattern for reuse in multiple compositions: the figure is seen in isolation, without a setting, and the verso is heavily rubbed with black pouncing dust to reverse the image. Traces of rubbed pouncing dust are also apparent on the rectos of both of these cartoons by Pesellino.

The 1460s were still a period of transition. The Florentine Antonio di Pietro Averlino "Filarete" offered technical advice about painting and drawing in the books appended to his *Trattato dell' architettura* (MS., c. 1464) but omitted mention of cartoons.[243] Instead, he described the freehand underdrawing techniques for panels and murals that were typical of the older "International Gothic" tradition, often borrowing recipes in fact from Cennino's *Libro dell' arte,* as well as Alberti's painting treatise. Filarete probably wrote his *Trattato* during his years in Milan (1451–65), which may explain the reason why he missed the growing Central-Italian practice. Piero Pollaiuolo's commission from the *Arte della Mercanzia* (Merchant's Tribunal) in Florence for a series of allegorical panels portraying *Virtues* (Galleria degli Uffizi, Florence) helps illustrate the transitional character of workshop practice at this juncture. The earliest document for the project dates from 18 August 1469, and a payment for the panel paintings of *Temperance* and *Faith* (Fig. 210) is entered on 2 August 1470. The reverse of the earliest panel to be painted, the *Charity,* has a full-scale, highly rendered drawing in charcoal and lead white gouache or chalk – a virtual cartoon, but on the unprimed wood rather than paper, that served a contractual purpose (Fig. 211). According to the

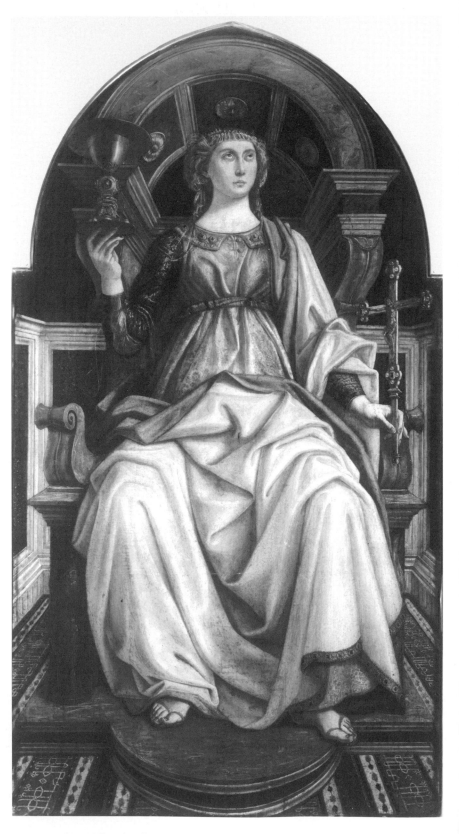

Figure 210. Piero Pollaiuolo, Allegorical Figure of Faith, *tempera and oil on panel (Galleria degli Uffizi, Florence).*

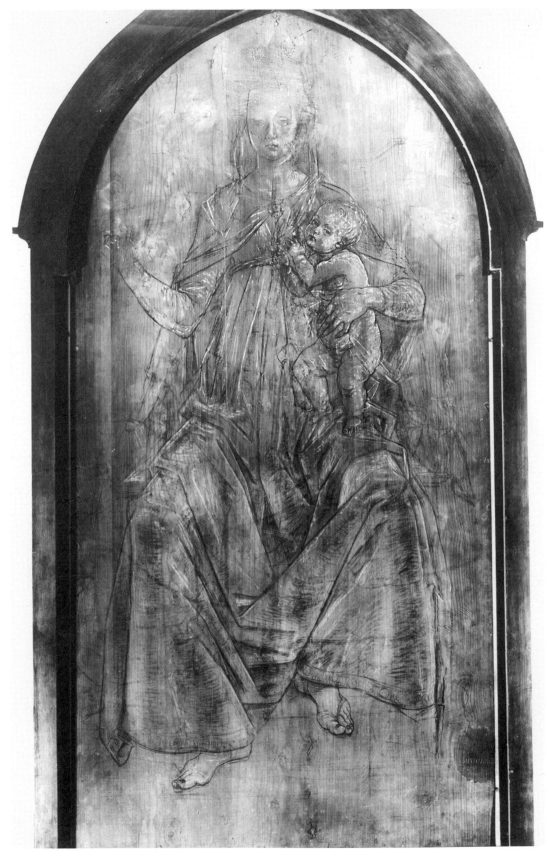

Figure 211. Piero Pollaiuolo, Allegorical Figure of Charity, *freehand drawing in charcoal and lead white gouache or chalk on the verso of the panel painted with the* Allegorical Figure of Charity *(Galleria degli Uffizi, Florence).*

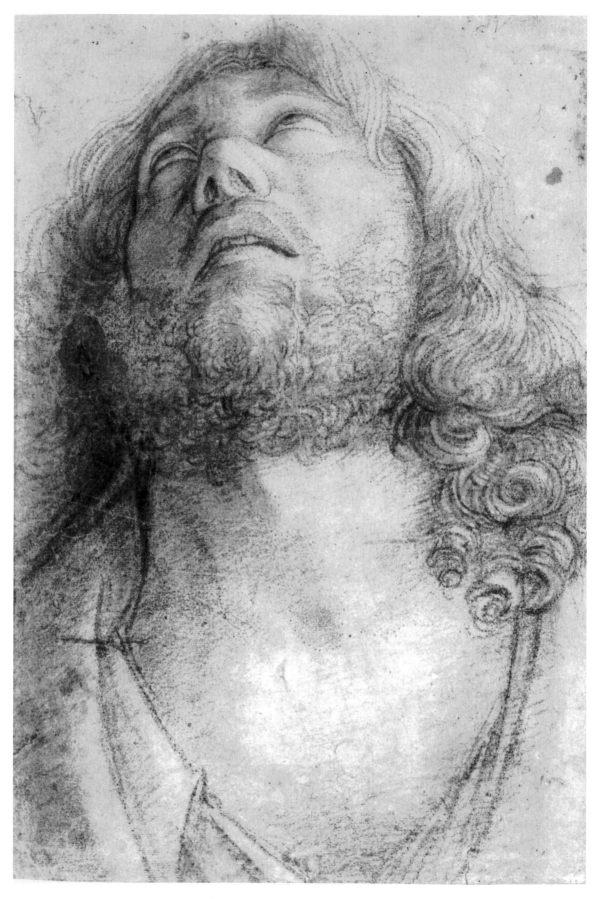

Figure 212. Melozzo da Forlì, pricked cartoon for the Head of a Man *(CBC 187; British Museum 1895-9-15-591, London).*

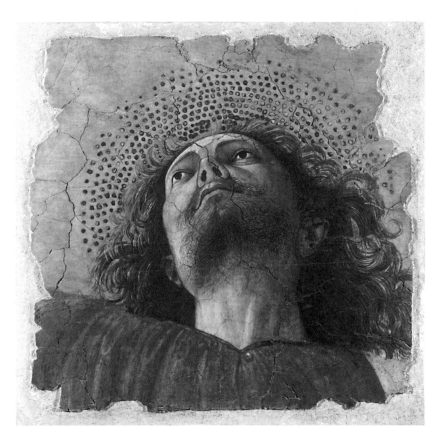

Figure 213. Melozzo da Forlì, Head of an Apostle, *detached fresco fragment (Pinacoteca Vaticana), originally part of the* Ascension *at SS. Apostoli, Rome.*

deliberations on 18 August 1469 by the *Mercanzia* committee,[244] Piero was to follow this design for his painting on the recto of the panel. Piero Pollaiuolo's pricked cartoon on paper for the head of *Faith* in this series (Plate II) can thus be documented better than most such drawings.[245] The artist probably prepared it to refine the difficult *sotto in sù* pose of the head, as comparisons to Piero della Francesca's *De Prospectiva* diagrams can show (Fig. 201). Executed in charcoal, on relatively thick paper, Pollaiuolo's Uffizi cartoon is unusually reworked with brownish red chalk, which is probably original.

By the last quarter of the fifteenth century, a greater variety of painters, from diverse regions of Italy, more or less routinely employed cartoons, transferring them by means of both *spolvero* and *calco* (stylus tracing or *incisione indiretta*). Notable examples of cartoon use arise in the work of Melozzo da Forlì, Andrea Mantegna, Andrea Verrocchio, Antonio and Piero Pollaiuolo, Pietro Perugino, Bernardino Pinturicchio, Francesco di Giorgio, Domenico Ghirlandaio, Filippino Lippi, Vittore Carpaccio, Luca Signorelli, Bartolomeo della Gatta, Girolamo Genga, and Leonardo. As we have seen, Leonardo's allusions to *spolvero,* in notes from about 1490 to 1492, are among the rare written

references to the technique in the Quattrocento.[246] At this point, cartoons had entered the mainstream of Italian workshop practice, as much as they ever would.

Melozzo da Forlì, *"Solenno Maistro in Prospectiva"*

Born into a family of Forlivese artisans and trained locally, Melozzo appears to have found a formative influence in Piero della Francesca.[247] The artists probably met at the court of Federigo da Montefeltro in Urbino during the late 1460s (if not earlier); Piero may have even taught Melozzo perspective during these years,[248] and most contemporary accounts of Melozzo pointedly recognized his excellence as a *"prospectivo."*[249] This aspect of his reputation lasted well into the seventeenth century, even though by then Melozzo's artistic personality would not always be clearly understood.[250] In his *Libro IV* on architecture (Venice, 1537), Sebastiano Serlio spoke about the portrayal of the foreshortened human figure *("scrociar le figure")* as a means of decorating the ceilings of buildings, singling out Melozzo's Sacristy of St. Mark at the Santa Casa of Loreto, probably painted between 1477 and 1480, as a *tour de force* of illusionistic painting.[251]

A finely pricked cartoon most probably by Melozzo, although undocumented, represents a large-scale, bearded head in sharp foreshortening (Fig. 212).[252] It is rendered in soft black chalk, with carefully stumped flesh areas and wiry unblended strokes for the hair and beard. The design is sufficiently close to that of the apostles in the SS. Apostoli fragments (Fig. 213) for us to conclude that the cartoon probably relates to a similar mural but that is no longer extant. As is typical of preliminary detail studies for paintings, the head drawn in the cartoon seems more individualized and more accurately naturalistic than any of Melozzo's painted heads.[253] An inventory of the artist's possessions dated 18 May 1493 lists a *"chartone"* (cartoon) portraying the Virgin and another of a St. Sebastian, as well as twenty-two *"charte"* (pieces of paper) with drawings of heads and other motifs.[254]

Melozzo's mural cycle in the Sacristy of St. Mark (Santa Casa, Loreto) and the mural fragments from the *Ascension of Christ,* originally on the apse of SS. Apostoli

in Rome, datable around 1481–83,[255] can vividly attest to the cartoon's continued significance especially for the tradition of figural perspective pioneered by the vanguard painters of the mid–fifteenth century. The sixteen mural fragments from the apse of SS. Apostoli, destroyed in 1711, are today dispersed between the Pinacoteca Vaticana and Palazzo del Quirinale (Rome); the fragment in the Museo del Prado (Madrid) is of dubious authorship.[256] These are a sad reminder of what must have been the crowning achievement of Melozzo's career, for the SS. Apostoli commission was probably as prestigious as that for the contemporary cycle on the *Lives of Moses and Christ* on the walls of the Sistine Chapel, where Melozzo's contribution is conspicuously absent.[257] In the SS. Apostoli fragments, Melozzo anticipated the economy of cartoon transfer methods that is more completely evident in later murals, still in situ.[258] Sometimes tiny and densely set, *spolvero* dots appear on the faces and hands of the *"sotto in sù"* figures of Christ, cherubim, apostles, and the music-making angels, as well as on some of their more complex foreshortened musical instruments. Especially the draped bodies of the figures and the angels' wings bear broad, supple incisions *(incisioni indirette),* whereas the rectilinear forms reveal networks of stylus ruling and compass marks from direct construction on the plaster. The same is generally true of Melozzo's *Pope Sixtus IV Appointing Platina* (Pinacoteca Vaticana), dating either from 1472 to 1477 or from 1480 to 1481, discussed in Chapter Five.[259] Vasari would especially esteem Melozzo's SS. Apostoli apse mural, for the accomplished forshortenings of the figures.[260]

Domenico Ghirlandaio's *"Maniera Facile e Pratica"* and the Chatsworth Portrait Cartoon

Praise of Domenico Ghirlandaio's "practicality" as a fresco painter figures prominently in Vasari's *Vita* of the artist. Finished on 25 December 1485, the chapel for Francesco Sassetti in S. Trinita (Florence), frescoed with a cycle on the *Life of St. Francis,* is, according to Vasari, *"molto praticamente condotta."*[261] The biographer showed even greater admiration for Ghirlandaio's decoration of the *"cappella maggiore"* (chancel, S. Maria Novella, Florence), commissioned by Giovanni Tornabuoni on 1 September 1485: "a most beautiful, monumental, pleasing thing." There, as he pointed out, the artist had achieved a masterly treatment of color in a fresco technique, with little *secco* retouching.[262] And, as a testimony to the particular permanence of fresco as a painting medium, Vasari

would single out the chapel in the villa of Giovanni Tornabuoni at Casso Macerelli above the Terzole river: "It was exposed for many years, and continuously wetted by the rains and burned by the sun, but it has withstood them as if it had been under cover: it is worth this much to work in fresco, when it is executed well, with judgment, and not retouched *a secco.*"[263] The evidence that continues to pour forth from the examination of Ghirlandaio's drawing and painting techniques reinforces Vasari's expert assessment, which, if not always accurate in its details (for the Ghirlandaio workshop did sometimes employ a *"mezzo fresco"* technique for corrections and applied final touches *a secco*) is in principle true. Not surprisingly, the use of cartoons, efficiently combined with *sinopie* (rendered in a variety of ways), informs Ghirlandaio's practice from his earliest projects onward.[264]

However small in its dimensions if compared to the examples that would follow in the Cinquecento, Domenico Ghirlandaio's pricked, life-size cartoon in Chatsworth (Fig. 214), appears to be the earliest and only extant Quattrocento cartoon securely connected with a figure in a mural (Fig. 215).[265] Domenico Ghirlandaio, his brother David, and their *équipe* of assistants painted the cycle on the *Lives of the Virgin and St. John the Baptist* at S. Maria Novella between 1485 and 1490. With a precisely sculptural articulation of *chiaroscuro,* the Chatsworth cartoon served as a design for the portrait of an attendant in the *Birth of the Virgin.* Vasari regarded this scene especially as *"fatta con diligenza grande,"* probably on account of both, its painting technique and the quantity of Ghirlandaio's preliminary drawings that must have survived into Vasari's own day.[266] As we shall see in Chapter Seven, Vasari would frequently equate *"disegno"* with *"diligenza."* The identity of the middle-aged woman in the Chatsworth cartoon, a member of either the Tornabuoni or Tornaquinci families, remains unknown. Although the Chatsworth portrait cartoon exhibits a remarkably vigorous hatching technique (in charcoal or black chalk), it is probably not directly drawn from life.[267] The verso depicts a faceless figural study for yet another aristocratic member of the same group in the composition.

The Chatsworth portrait cartoon (Fig. 214) is apparently not rubbed with pouncing dust and does not seem to have been a fragment cut from a larger drawing. The fresco surface of the *Birth of the Virgin* (Fig. 215) establishes conclusively that Domenico and his assistants used the intermediary means of a "substitute cartoon," since there are soft, plump stylus incisions made through paper *(incisioni indirette)* in the area of the woman's left shoulder and breasts, passages that in the Chatsworth drawing are pricked, as are all of its other

outlines.[268] In the fresco surface, *spolvero* dots are not readily visible in the woman's face, but the paint layer is dense and the dark painted outlines probably obscured them.[269] Other portrait figures in the scene consistently exhibit *spolvero* in the faces and stylus incisions (*incisioni indirette*) in their bodies, and throughout the cycle, portrait heads are frequently painted in separate *giornate*.[270]

In the case of the Chatsworth cartoon, the "substitute cartoon" practice appears to have been especially justified, considering that it is a carefully drawn portrait, and portraits were usually thought worth preserving and replicating.[271] Since the rest of the woman's figure in the fresco is comprehensively stylus-incised (*incisioni indirette*), it is clear that Domenico's "substitute cartoon" served for the head only. Thus, the cartoon that was actually stylus-incised onto the fresco surface may have been a relatively coarse drawing, with the "substitute cartoon" for the head pasted on or transferred separately. On the fresco surface, the areas of the woman's hands show a relatively consistent divergence between the painted outlines and the cartoon stylus incisions (*incisioni indirette*), which are 5–10 mm. lower, indicating that the cartoon slipped on the plaster surface during transfer. This difference was adjusted in painting.

A sheet in Rome, usually attributed to Bartolomeo della Gatta (CBC 108), possibly exemplifies just such a type of fragmentary "substitute cartoon."[272] Influenced by both Piero and Domenico Veneziano, Don Bartolomeo's fresco of *St. Roch* (Pinacoteca Communale, Arezzo) establishes his use of *spolvero* already in the late 1460s or early 1470s. The sheet in Rome dates between 1480 and 1500. Don Bartolomeo reused it to draw on the recto a heavily rendered study in charcoal and black chalk for one of the apostles appearing in his *Assumption of the Virgin* (S. Domenico, Cortona).[273] On the verso, he drew a study of a male profile, lightly in black chalk. Consequently, the aspect of the sheet that interests us – the pricked outline design, with no drawing to connect the holes, done from what is now the recto – appears considerably obscured.[274]

Extant Large-Scale Cartoons from the Quattrocento

Curiously, like the cartoons by Piero Pollaiuolo (Plate II), or Melozzo da Forlì (Fig. 213), or Domenico Ghirlandaio (Fig. 214), most extant large-scale Quattrocento cartoons on paper consist of portrayals of the human head. These are often life-size or nearly so.[275] As analyses of Italian Renaissance artists' contracts can show, heads were often the parts of an "*historia*" that patrons judged most critically.[276] The contract on 20 August 1490 for Domenico and David Ghirlandaio's altarpiece in the Convento del Palco a Prato required that Domenico, rather than David, paint the heads.[277] In the two contracts drawn up by the committee of patrons for the vault frescos in the "*Cappella Nuova*" (Cappella della Madonna di S. Brizio, Orvieto Cathedral), it is specified that "especially the faces and all the parts of the figures from the middle of each figure upward" be by the artist's own hand. The wording is nearly identical in the clauses pertaining to Pietro Perugino (30 December 1489), who never laid paint on the vault, and to Luca Signorelli (5 April 1499), who inherited the commission.[278] The not unusual stipulation that the cartoons be by the master's hand (a "*mano sua*" clause) was an attempt at quality control. As stated in Signorelli's contract from nearly a year later (27 April 1500), this time for the figural frescos on the walls of the chapel, he was to be paid for his labors in painting, designing, and producing a cartoon ("*cartone*").[279] A similar clause about the autograph execution of his cartoons and murals would also bind Bernardino Pinturicchio in his contract of 29 June 1502 for the Piccolomini Library in Siena Cathedral.[280]

A number of the extant fifteenth-century cartoons of heads relate to identifiable paintings – panels, rather than murals – but it is not entirely clear whether (1) the drawings themselves always constitute fragments of larger drawings depicting the entire figures, and, if this was the case, whether (2) their corresponding bodies would have been rendered in an equally refined drawing technique. Except for Verrocchio's *Head of an Angel* (Fig. 44) and Perugino's *Head of St. Joseph of Arimathea* (Fig. 76), most such full-scale drawings probably did not include bodies.[281] (They may have been used collagelike, as is true of Ghirlandaio's Chatsworth cartoon and of some of the portrait *exempla* discussed in Chapter Three.) The survival and relatively good state of preservation of most such pricked drawings of heads suggests the practice of "substitute cartoons." Only one such cartoon fragment appears obviously rubbed with pouncing dust, indicating that it was transferred directly. This is Biagio d'Antonio's *Head of a Woman* (CBC 318), whose design corresponds exactly to a *tondo* panel of the *Virgin Adoring the Christ Child* (Chigi-Saracini Collection, Siena), probably executed in the late 1470s to early 1480s.[282] Although Biagio d'Antonio's cartoon grows out of the "*ben finito cartone*" tradition so exquisitely pioneered by his master, Andrea Verrocchio, it has the coarser handling of a

working drawing, with an unusually diverse combination of media and techniques – pen and ink, brush with brown wash and white gouache highlights, over stylus, charcoal, and black chalk. The artist stumped and wetted the chalk in some areas; he even corrected a number of outlines with the same white gouache that he used to highlight forms.

Finished drawings portraying the human head have long been collected by artists and nonartists; after their application in the working process, many cartoons depicting the entire human figure may have been dismembered to preserve the precious heads. Because we may all too often regard the *spolvero* cartoons of the Quattrocento exclusively as working drawings for painting, we may also overlook the subtler pattern of evidence they offer as a group: their probable, further role as *exempla* in teaching the art of drawing. Vasari's statement that Andrea Verrocchio drew heads of women with graceful manner and hair arrangements, "which, because of their exceeding beauty, Leonardo da Vinci always imitated," applies to the master's delicately rendered cartoon in Christ Church (Plate III).[283] Many extant fifteenth-century cartoons portray the human head in brilliant *"sotto in sù"* perspective, with facial features carefully rendered in all their naturalistic splendor (Plate II, Fig. 212).

Francesco Squarcione and Andrea Mantegna

A tradition parallel to the Central-Italian one of *spolvero* cartoons had developed more or less concurrently in Northern Italy. The particulars, however, remain still nebulous, as more research is necessary.[284] *Spolvero* patterns for the painting of ornament had been applied in Verona and Padua since at least the late Trecento.[285] We also know that Cennino probably wrote the *Libro dell'arte* in the late 1390s while in a Paduan

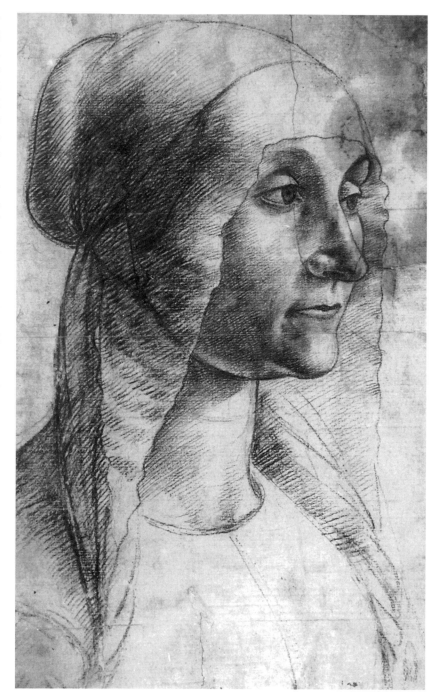

Figure 214. Domenico Ghirlandaio, pricked cartoon for a Portrait of a Woman in Bust-Length *(CBC 113; Devonshire Collection inv. 885 recto, Chatsworth).*

prison. Since at least the 1430s to 1440s, the *bottega* of the Paduan Francesco Squarcione, an antiquarian and *"prospectivo,"* as well as Andrea Mantegna's teacher, probably exploited the *spolvero* technique to reproduce compositions of the *Madonna and Child.*[286]

Figure 215. *Detail of the woman attendant portrayed in the Chatsworth cartoon in Domenico Ghirlandaio,* The Birth of the Virgin, *fresco (chancel of S. Maria Novella, Florence). From the neck down, the figure exhibits stylus incisions from a cartoon.*

A famous teacher in his day (he began as a tailor rather than as a painter), Squarcione contracted on 30 October 1467 to tutor the son of another painter, the obscure "Francesco Guzon," in the study of perspective. Squarcione's contract with the boy's father may allude to the types of perspectival projection thoroughly described in Piero's *De Prospectiva pingendi,* the only surviving fifteenth-century treatise on the subject.[287] The contract specifies that Squarcione would teach the apprentice "to understand a man's head in foreshortening by isometric rendering *(isometria)* ..., and teach him the system of a naked body, measured in front and behind, and to put eyes, nose, mouth and ears in a man's head at the right measured places. . . ."[288] Just how

Squarcione defined *"isometria"* is telling – *"zoè d'un quadro perfecto con el soto quadro in scorzo"* – for these words imply a correlation in the views of the head seen unforshortened (the *"quadro perfecto"*) and foreshortened (the *"soto quadro in scorzo"*).[289] Squarcione promised in the contract to "always keep him [the apprentice] with paper in his hand, to provide him with a model, one after another, with various figures . . . , and correct these models for him, and correct his mistakes so far as I can. . . ." The concluding stipulation in the contract is no less remarkable: "if he [the apprentice] should damage any drawing of mine, the said Guzon is required to pay me its full worth."

Although the new *"scientia"* of perspective was among the important and valuable skills learned during the process of apprenticeship, not all masters were capable of teaching it. Earlier, at least one of Squarcione's contracts with an apprentice (to teach him "perspective and each matter pertaining to the profession of the painter") had ended in a lawsuit. On 21 August 1465, the accusation was that "master Francesco . . . cannot give anything besides promises, but the facts he cannot give, because he does not know them."[290]

Artists in the circle of Andrea Mantegna produced a few pricked drawings, drawings done on *spolvero,* and pricked prints that survive, but these most probably served in the production of copies.[291] Traces of *spolvero* occur in two small, ravaged mural fragments once decorating the funerary chapel of Antonio degli Ovetari at the Church of the Eremitani (Padua), which was all but destroyed in 1944 by Allied bombing. Probably painted in 1449–50 and originally placed within the *intrados* of the arch separating the tribune from the main space of the chapel, the two half-length seraphs, in mirroring poses across the width of the arch, derived from the same cartoon.[292] Their authorship has long been debated between Andrea Mantegna and Niccolò Pizzolo, colleagues in Squarcione's *bottega* and in the Ovetari commission.

In the case of the seraphs, we could well argue that the *spolvero* technique had served merely to reproduce their mirror images, much as "Late Gothic" painters had done for ornamental motifs. Yet substantial evidence survives – if not as complete as we may wish – to document Andrea Mantegna's use of cartoons in composing *historie.* In fact, this innovative drawing type, which he employed in the Central-Italian manner, entered his workshop practice relatively early in his career. Examination with infrared reflectography reveals traces of *spolvero* in parts of the panel portraying the *Adoration of the Shepherds* (Metropolitan Museum of Art, New York), painted in 1450–60.[293] There are

spolvero outlines, along with freehand underdrawing, in various passages of his three small panels from the 1460s – the *Ascension of Christ,* the *Adoration of the Magi,* and the *Circumcision* (Galleria degli Uffizi, Florence).[294] Between 1465 and 1474, it was *spolvero* cartoons that would enable Mantegna to achieve the celebrated *virtuoso* illusionism of his mural program in the *"camera picta"* or *Camera degli Sposi* (Palazzo Ducale, Mantua). There, the signs of pouncing frequently, if sporadically, emerge from the thickly brushed layers of pigment, in both decorative and figural elements of the walls and fictive oculus.

State of the Evidence

Broadly speaking, the functions of Early Renaissance cartoons can be assessed on the basis of three types of evidence, at times divergent and by no means complete: (1) pricked full-scale drawings, (2) *spolvero* outlines or incisions found on the painting surface, and (3) contemporary written sources, both treatises and documents of the type largely mined in the preceding chapters.

Drawings

All too frequently, however, it is not possible to discern whether or not drawings were in fact pricked for transfer onto a final working surface. They were pricked just as often for transfer onto another sheet of paper, to produce either a "substitute cartoon" or yet another drawing for further exploration or variation. Numerous, demonstrable examples of these practices arise during the Cinquecento: the extent to which they mirror those from the second half of the Quattrocento is less easily assessed.

Paolo Uccello, as we have seen, is the earliest painter by whom there are both extant murals painted from *spolvero* and extant pricked drawings, albeit not "cartoons" in the traditional sense. Although this concurrent appearance in paintings and drawings attests to an artist's use of *spolvero,* the evidence of both media remains fragmentary and may raise as many problems as it solves. For example, as noted, Uccello's two fragile pricked drawings (Plate I; fig. 185), from the 1440s to 1460s, were probably exploratory exercises, whose paper was heavily used and reused in the designing of various, unrelated motifs. That the versos of both sheets are unviewable, because they are glued onto mounts, further complicates a reconstruction of their functions. Conversely, although Uccello's murals with *spolvero* survive, the corresponding

pricked cartoons do not. This disparity of evidence between extant drawings and finished works is by no means unique. It remains the Achilles heel in the history of the *spolvero* cartoon until the end of the fifteenth century and the beginning of the sixteenth.

As discussed, surviving large-scale cartoons from the second half of the Quattrocento are fragmentary depictions of the human head, and their very survival and relatively good state of preservation suggests use of "substitute cartoons." The same is probably true of such small cartoons as Pesellino's *Seated Christ(?)* (Fig. 87) and *Mystical Marriage of St. Catherine* (Fig. 209), datable around 1450–57. Yet how representative these cartoons were of the majority produced in the Quattrocento is difficult to say, for conclusions based on extant cartoons are largely compromised by the practice of "substitute cartoons." Only the fresco surface of Domenico Ghirlandaio's *Birth of the Virgin* (S. Maria Novella, Florence) can establish conclusively that his Chatsworth portrait cartoon, from 1485 to 1490, and the earliest surviving cartoon securely identifiable with a mural, was transferred by means of a "substitute cartoon" (Figs. 214–15). More will be said about these problems in Chapters Seven and Eight.

Paintings

Much like that of *spolvero* patterns for ornament, the reconstruction of the early history of figural cartoons derives almost entirely from the evidence furnished by murals. By comparison to murals, however, far fewer easel paintings reveal evidence of cartoon use.[295] Here, the limitations of the scientific tools usually applied to study underdrawing – infrared photography and reflectography – are a complicating factor.[296] A telling example is the examination with infrared reflectography of Paolo Uccello's panel of the *Hunt in the Forest* (Ashmolean Museum, Oxford), from the late 1460s.[297] In the portions that such rays can penetrate, a very slight, freehand underdrawing executed directly on the gesso ground is revealed. There is also a directly drawn and stylus-incised perspective grid of orthogonals; incised, stylus-ruled perspective constructions, however, are ubiquitous in the artist's paintings, as they frequently are in those of his contemporaries.[298] In the Ashmolean panel, a dark underlayer of pigment containing carbon black obscures all of the underdrawing, except in some figures and animals, which the artist painted directly on the gesso ground, leaving them as reserves in white at the initial stages of work.[299] On the faces of Domenico Veneziano's *Madonna and Child* (National Gallery of Art, Washington), from the late 1440s, *spolvero* dots had

long been thought to be evident with the unassisted eye; recent examination with infrared reflectography, however, does not confirm their comprehensive presence.[300] No *spolvero* is discernible in the partly visible underdrawing of Domenico Veneziano's *Madonna and Child* (Berenson Collection at Villa I Tatti, Florence), of the same date.[301] Examinations of Domenico's famous *St. Lucy Altarpiece* (Galleria degli Uffizi), from 1444–45, have been frustratingly contradictory in this regard.[302] The numerous directly stylus-constructed lines of the architecture and perspective are plainly visible on the surface of the panel.

Although the investigation of underdrawings in Italian panel paintings is not yet sufficiently advanced to permit definitive conclusions, it may, nevertheless, be proposed, as a working hypothesis, that in Italy the development of cartoons for easel paintings did not really parallel those for murals, particularly those painted in *buon fresco*. We have seen that Leonardo often painted without cartoons, contrary to the evidence of his note in Paris MS. A (fol. 1 recto), from 1490 to 1492, which recommends a procedure for preparing wood panels in oil painting and which mentions the use of pricked cartoons to pounce designs for transfer.[303] Leonardo's use of *spolvero* in portraiture appears to provide a significant exception.[304] Since the production of cartoons constituted an expense of materials and manual labor, it was probably the need to replicate designs multiple times that often led to the preparation of *spolvero* cartoons for easel pictures. This is especially suggested by the practices of Renaissance *Madonnieri* and portraitists.[305]

The handling their media require greatly defined the differing practices of easel and mural painters. The difficulty of the *buon fresco* medium (see Chapter Two) invites a systematic use of cartoons, timing of steps, and rapidity of execution. By contrast, tempera painting imposes a slow, laborious layering of color. The pigments dry and solidify quickly because of their binder, usually egg yolk (occasionally both the yolk and white of the egg with small additions of other substances). Medieval and Renaissance painters applied the tempera pigments by hatching or stippling carefully with the tip of a brush, building thin layer upon thin layer of finely intertwined brushstrokes.[306] Painters could prepare a freehand underdrawing – that was as elaborate and precise as that of a cartoon on paper – directly on the dry, perfectly smooth *"gesso sottile"* of the panel.[307] The broad, coloristic handling of form possible with the oil medium or emulsions like *tempera grassa* also freed late Quattrocento and early Cinquecento painters from the technical constraint of cartoons.[308] Pigments mixed with oil, most commonly walnut or linseed oil, dry

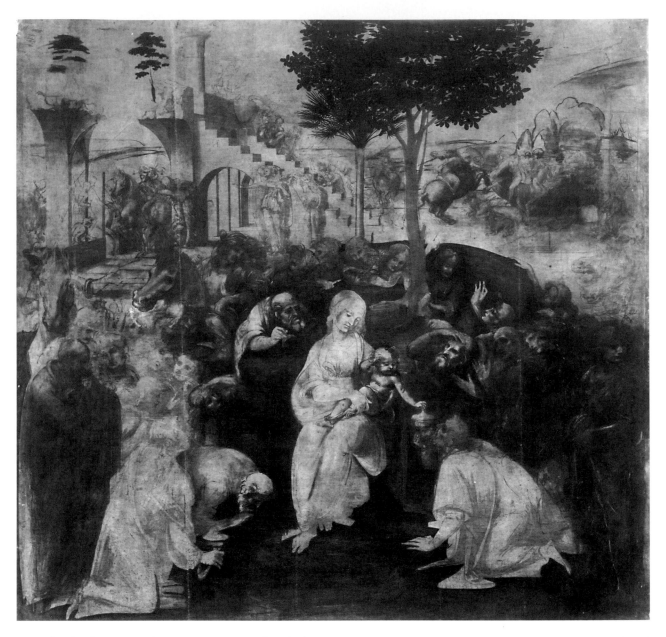

Figure 216. Leonardo, The Adoration of the Magi, *unfinished panel with entirely freehand charcoal underdrawing and oil underpainting (Galleria degli Uffizi, Florence).*

very slowly. By comparison to tempera, oil painting enables a multitude of corrections and "superadding refinements in form, expression, and effect" – to quote Sir Charles Lock Eastlake's apt phrase in 1847, at a time when the oil painting techniques of the Renaissance masters were beginning to be understood historically.[309] Eastlake was referring to Leonardo's unfinished *Adoration of the Magi* in the Uffizi (Figs. 216–17), commissioned in July 1481, a panel that, not surprisingly, as infrared reflectography confirms, exhibits only freehand and extremely nuanced underdrawing. Because in oil painting the priming of the canvas or panel is dry before painting (as in tempera), there is no urgency to produce an underdrawing quickly.[310]

As Eastlake already keenly observed, the traditional medium of *buon fresco* militated at the very least against Leonardo's inconstant pace and endless deliberation in painting. According to Matteo Bandello's eyewitness account of Leonardo at work on the *Last Supper* (narrated in a *novella* in 1497), the artist would at times paint in the refectory of S. Maria delle Grazie (Milan) "from sunrise till darkness, never laying down the brush" to eat and drink.[311] Then, days would lapse in which Leonardo would not touch a brush but would either contemplate what he had painted or labor at the *"Corte Vecchia"* on the monumental clay model for the

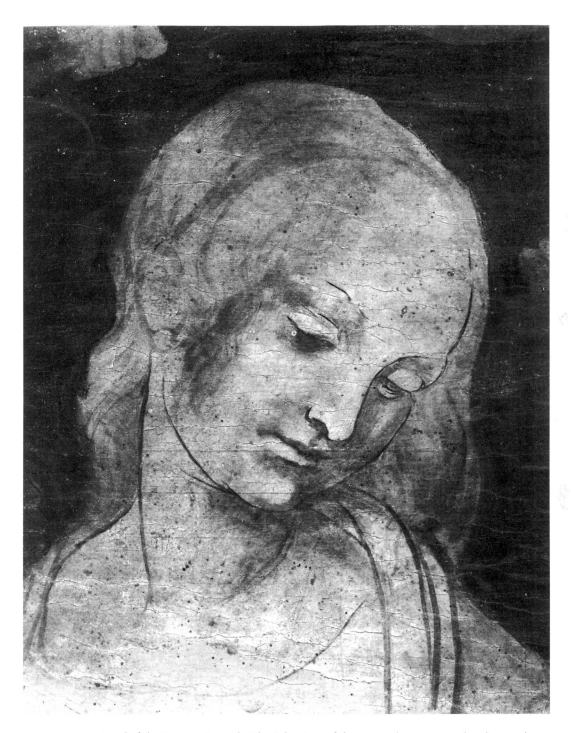

Figure 217. Detail of the Virgin in Leonardo, The Adoration of the Magi, *showing minimal underpainted modeling.*

Sforza equestrian monument, and then, "when the fancy took him . . . he would take a brush and give a few touches to one of the figures; and then suddenly he would leave and go elsewhere." Although again definitive conclusions are not possible, recent stratigraphic analyses of the pigment layers in the *Last Sup-*per suggest that Leonardo painted in a dry *tempera forte* technique, with a protein binder and bits of walnut oil.[312] Seen in this historical and technical context, it is thus not surprising that evidence of cartoon use has not emerged in the mural. It may well have been entirely at the insistence of his patrons, the *"signori"* of

the Florentine Republic, that Leonardo contracted to produce a cartoon at all for his *a secco* mural of the *Battle of Anghiari* in *"La Gran' Sala del Consiglio"* at the Palazzo Vecchio. By 1503, Leonardo had forged a reputation for jilting his patrons with unfinished projects.[313]

From shortly before the mid-Trecento until at least the late Ottocento, painters would employ *spolvero* patterns to replicate decorative details. Renaissance easel painters and many muralists (particularly, those who extensively relied on *a secco* techniques) may have often omitted the use of figural cartoons, unless it was (1) to replicate compositions, figures, or motifs; (2) to delegate the execution in paint whether partly or entirely; or (3) to resolve small, problematic passages. The first two reasons generally explain the practice of Quattrocento Venetian and Northern European painters: *spolvero* is usually found in paintings of inferior quality, done partly or entirely by the workshop as reproductions, rather than in paintings showing the fine autograph hand of the master. More than the design complexities involved, however, it may well have been Piero della Francesca's typically meticulous working habits as a *"prospectivo"* that explain his consistent use of *spolvero* cartoons for panel painting.[314] In all his murals, as we have seen, Piero employed *spolvero* cartoons systematically.

The insistence with which some Cinquecento theorists would urge the use of cartoons to paint on panel or canvas, but the inconsistencies or memory lapses within their narratives regarding this very subject, and the anecdotes admiring the technical virtuosity of artists who painted without cartoons, help us surmise that there must have been enormous laxity in actual practice during the sixteenth century.[315] A similarly unconstrained practicality may have also characterized the fifteenth century.

Documents

Evidence regarding the early use of figural cartoons can also emerge from documents, as is true of the entry on 28 April 1471 in Alesso Baldovinetti's account book for the Gianfigliazzi Chapel, which lists the purchase of sixteen *"quaderni"* of *"fogli reali da straccio"* for the pounced cartoons of prophets *("spolverezi de' profeti")* and other designs.[316] All too frequently, however, documents are more ambiguous and fragmentary than we may realize, because a standard vocabulary did not yet exist. For example, *spolvero* appears throughout the host of music-making angels originally frescoed by Stefano di Gio-

vanni "Sassetta" (doc. 1423–1450), on the arch canopy of the Porta Romana in Siena.[317] The artist secured this commission on 3 May 1447 but left it unfinished at his death on 10 April 1450.[318] The mural was later completed by his presumed pupil Sano di Pietro, who was awarded the project on 12 September 1459. In a petition to the city magistrates of Siena, Donna Giovanna, Sassetta's widow, stated that before he died, her husband had painted *"tutta la volta"* ("the entire vault"), which suggests that the music-making angels were probably entirely executed by Sassetta rather than by Sano. Donna Giovanna also noted in this petition, that, presumably for the parts remaining to be painted, her husband "had already finished and rendered with perfection almost all the design on paper *[disegno in carta]*."[319] As the fortunate recent discovery of complementary documents can prove, this *"disegno in carta"* must have been the cartoon – confirmed by the presence of *spolvero* in the mural – and the document thus represents one of the earliest surviving, verifiable references to a figural cartoon for a fresco.

Solely on the basis of documents, however, it has recently been argued that figural cartoons were used at a significantly earlier date than is suggested in this book – in 1369, by Giovanni da Milano and his *équipe,* in painting the wood ceiling of the *"cappella magna"* at the Vatican Palace.[320] No visual evidence remains, and the design of the decoration is unrecorded. The entries in the contemporary account books (entitled misleadingly, *Expensae pro fabrica palatii Avinionensis*) suggest that the medium of painting may have been egg tempera. They cite a purchase of three *quaderni* of paper in the *reale* size for *"certorum patroneum pro cappella maiore," "pro figuratione evangeliatarum,"* or *"pro patronibus egvanlitarum."*[321] With so many pieces of the puzzle lost, we should not rush to interpret the corrupt Latin words as referring to cartoons for figural scenes, deriving from the gospels. Rather, if we were to rely on the evidence of *spolvero* in extant contemporary murals, we can envision that these documents probably refer to ornament patterns or even to the types of architectural patterns for fictively painted borders, niches, or tabernacles that, between the 1360s and 1450s, would often be of an enormous size and that usually would frame the isolated figures of evangelists, saints, patriarchs, prophets, or other revered holy figures in the mural cycles of chapels and churches (Figs. 159–63).[322] As previously discussed, the present state of archaeological research confirms that Trecento mural and panel painters prepared the figural parts of their compositions directly on the working surface.[323]

THE IDEAL OF THE *"BEN FINITO CARTONE"*
IN THE CINQUECENTO

The Cartoon in the High Renaissance

Writing in his autobiography (MS., c. 1562) about Michelangelo's *Battle of Cascina* cartoon, Benvenuto Cellini would judge that, "although the divine Michel Agnolo in later life finished that great chapel of Pope Julius [the Sistine Chapel], he never rose half-way to the same pitch of power."[1]

Based on the words in Vasari's *Vite*, the public exhibition in Florence of three enormously influential cartoons – which are no longer extant – are rightly credited with having changed the course of art during the first decade of the sixteenth century. These are Leonardo's *Virgin and Child with St. Anne,* as well as Leonardo's *Battle of Anghiari* and Michelangelo's *Battle of Cascina.* These early masterpieces of the Florentine High Renaissance provided the yardstick against which the accomplishment of subsequent *disegnatori* would be measured for a long time to come. Leonardo may or may not have prepared the *Virgin and Child with St. Anne* in connection with a painting planned for the high altar of SS. Annunziata (Florence); the sparse documentary evidence is extremely ambiguous.[2] By contrast, as we saw in Chapter Two, there is considerable, consistent documentary evidence regarding Leonardo's *Battle of Anghiari* and Michelangelo's *Battle of Cascina;* these rival cartoons were meant to culminate in the murals commissioned for the Council Hall *("La Gran' Sala del Consiglio")* at the Palazzo Vecchio. None of these celebrated and much-imitated cartoons resulted in finished paintings. Moreover, it is reasonably clear from both the written evidence and extant preliminary drawings that neither the *Anghiari* nor the *Cascina* cartoons were ever fully completed in their compositions. The momentous impact of these cartoons for the general history of Cinquecento art is too well known to bear repeating

here. Yet, phrased more broadly, the question persists. How was it that cartoons – drawings ostensibly of a utilitarian nature – had moved to the forefront of artistic expression during the High Renaissance?

According to Vasari's admiring *Vita,* the "divine" Michelangelo gave the cartoon for the *Drunkenness of Noah* fresco in the Sistine Ceiling to his friend the Florentine banker Bindo Altoviti as a present.[3] Vasari's *Vita* of Michelangelo also tells us that the heirs of Girolamo Albizzi owned four pieces of cartoons for the Sistine *ignudi* and *prophets,* said to have been given by Michelangelo to his trusted servant Antonio Mini and brought back from France by Benvenuto Cellini.[4] Also according to Vasari's account, Michelangelo's only venture into portraiture was a drawn cartoon representing Tommaso de' Cavalieri, for the great master abhorred the rendering of the living "unless of infinite beauty."[5]

A contextual analysis of cartoon drawing technique, of mural painting technique, and of *disegno* theory from the late Quattrocento to the late Cinquecento intimates possible answers. For in the face of more complete forms of extant evidence from the sixteenth century, our task here, as well as in the chapter that follows, is to attempt to reconcile the facts. To reconstruct the cartoon's early history, we have thus far, by necessity, greatly relied on the archaeological data found in murals and easel paintings, since the overwhelming majority of cartoons produced in the fifteenth century does not survive. By contrast, there exist a large number of cartoons from the sixteenth century, many of which can be connected to extant, finished works of art. This abundance of connected drawings and finished works offers ample opportunities for comparisons of physical evidence. Moreover, if written references to cartoons are scarce for the Quattrocento, a relative wealth of them exists for the Cinquecento, and

these help us establish the cartoon's remarkable role in the development of contemporary design theory.

Leonardo's Lost *"St. Anne"* Cartoon

Shortly after 1500 or 1501, Leonardo returned to Florence following an absence of nearly eighteen years. As Vasari would have it in his *Vita* of the artist, Leonardo regained instant fame by exhibiting in his private quarters at SS. Annunziata a cartoon portraying "the Madonna, St. Anne, and the infant Christ."[6] That cartoon may well have been the one that Fra Pietro da Novellara eagerly described in a letter from 3 April 1501 to Isabella d'Este in Mantua,

He [Leonardo] has done only *a sketch in a cartoon* since he is in Florence: it seems [that] a Christ Child of about a year old who is almost leaving his mother's arms, reaches for a lamb which he appears to squeeze. The mother, half rising from the lap of St. Anne, reaches for the Child to separate him from the lamb [a sacrificial animal] signifying the Passion. St. Anne, rising slightly from her sitting position, appears to want to restrain her daughter from separating the Child from the lamb. [She is] perhaps intended to represent the Church, which would not have the Passion of Christ impeded. And [although] these figures are life-size [they] can fit into the small cartoon, because all are either seated or bending over, and each one is positioned a little in front of the other, and toward the left-hand side. And this *sketch* is not yet finished.[7]

It must be emphasized that what Fra Pietro saw was very much a work in progress, *"uno schiz[z]o in uno cartone."*[8] Considering the extent to which Leonardo modified his solutions for compositions at the preliminary stages of design,[9] the finished cartoon could well have corresponded more closely with Vasari's description.[10] Fra Pietro was acting as Isabella's agent, attempting to secure for her collection a work by the famous artist.[11] He complained to her that Leonardo led a "varied and unpredictable life, seeming to live day to day," doing little else, save for the fact that he was immersed in the study of geometry, and that two apprentices were making copies – Leonardo "puts his hand to one of them from time to time."[12] The closest records of the lost composition, for it is arguable whether these can accurately be termed copies, appear to be an oil painting on panel attributed to Andrea Piccinelli *"Il Brescianino"* (destroyed; formerly, Kaiser Friedrich Museum, Berlin) and a small composition study of disputed authorship, drawn in charcoal over leadpoint (private collection, Switzerland).[13]

Among the significant innovations that Leonardo's lost *"St. Anne"* cartoon probably represented – besides its graceful, monumental pyramidal composition – must have been its exquisite drawing technique. This we can envision from the cartoon in the National Gallery, London (Plate V, Fig. 218), drawn primarily in charcoal, with reinforcements in black chalk and highlights in lead white chalk.[14] The National Gallery cartoon depicts a subject similar to the lost *Virgin and Child with St. Anne*. The overall dimensions may have also been comparable, given the nearly life-size scale of the figures in the National Gallery cartoon and Fra Pietro's comment about the lost composition. The National Gallery cartoon, however, probably dates from 1506 to 1508, during Leonardo's second stay in Milan. The incisive clarity of forms in Domenico Ghirlandaio's Chatsworth portrait cartoon (Fig. 214), from 1485 to 1490, or in Lorenzo di Credi's *Enthroned Madonna and Child* (Fig. 219), from the late 1490s, were achieved by careful hatching, not unlike that in a pen and ink drawing.[15] By comparison, delicately blended pictorial effects characterize Leonardo's approach to rendering (Fig. 218). In the role of teacher, Leonardo would exhort young artists to be diligent and follow proper drawing technique. He remarked in a note in Paris MS. A (fol. 107 verso), from 1490 to 1492: "that your shadows *[onbre]* and highlights *[lumi]* fuse without strokes or marks, as smoke does *[a uso di fumo]*."[16]

From 1490 onward, Leonardo would rely on the medium of drawing as a crucial means of visualizing and recording his scientific research on chiaroscuro.

According to Vasari's *Vita* of Leonardo, the lost *"St. Anne"* cartoon enjoyed the awesome reception normally reserved for finished works of art, for "not only were artists astonished, . . . but for two days the chamber where it stood was crowded with men and women, young and old, as they might do in going to solemn festivals, all hastening to behold the marvels produced by Leonardo."[17] Echoes of the lost cartoon reverberate in countless, more or less contemporary drawings and paintings. Among the notable examples for our purposes is the monumental cartoon for *"La Belle Jardinière"* (Fig. 58), drawn by Raphael in 1506–7, during his stay in Florence.[18] The modeling in charcoal (and some black chalk), with traces of white gouache highlights is considerably less three-dimensional than in Leonardo's National Gallery cartoon.[19] Fra Bartolomeo's cartoons from 1500 onward would more closely reflect Leonardo's technique (Figs. 36–37).[20] Attesting to the dissemination of Leonardo's cartoon-drawing manner in Lombardy during the first

two decades of the sixteenth century are a *Head of the Virgin* (CBC 55), probably by Giampetrino;[21] Andrea Solario's *Madonna and Child with an Angel* (CBC 301);[22] and Giovanni Antonio Bazzi "Il Sodoma"'s virtuoso essay in *sfumato* in the *Mystical Marriage of St. Catherine* (Fig. 220).[23] In Northern Italy, the Leonardesque tradition of the *"ben finito cartone"* would be magnificently realized, later still, in the sixty monumental cartoons at the Accademia Albertina in Turin – by Gaudenzio Ferrari (1475/80–1546), his close associate Bernardino Lanino (c. 1512–1583), and their circle of Lombard-Piedmontese followers.[24] Drawn with deeply graded chiaroscuro, in a stumped, labor-intensive charcoal technique (Fig. 221), many of these beautiful cartoons can be shown to have served for the replication of compositions and individual motifs in a variety of painted versions.[25]

Reception of Cartoons after the *Anghiari* and *Cascina* Commission: Artists, Theorists, and Public

A celebrated reception awaited the cartoons for the murals that were planned in 1503 and 1504 for *"La Gran' Sala del Consiglio"* at the Palazzo Vecchio in Florence. Cellini recollected in his autobiography, "These two cartoons stood, one in the *Palazzo de' Medici,* the other in the *Sala del Papa.* So long as they were displayed, they were the school of the world."[26] Referring to the *Battle of Anghiari* cartoon in his *Vita* of Leonardo, Vasari exclaimed "it is scarcely possible to do justice to the skill of this drawing."[27] In his *Vita* of Michelangelo, Vasari called the *Battle of Cascina* cartoon *"uno studio d'artefici"* ("a veritable school of art"), for "all those who have studied this cartoon and drawn after such a thing . . . have become themselves excellent in art."[28] Michelangelo's drawing technique particularly merited praise: "there were many figures in groups and sketched in a variety of ways *[in varie maniere abbozzate],* some were outlined in charcoal *[contornato di carbone],* some were drawn in hatching *[disegnato di tratti],* and some were in *sfumato* and highlighted with white *[con biacca lumeggiato],* having wished to demonstrate how much he knew that profession."[29] Vasari's list of artists who studied Michelangelo's *Cascina* cartoon reads like a "Who's Who" of Central-Italian *disegno* for the following two generations: Raphael, Bastiano "Aristotile" da Sangallo, Ridolfo Ghirlandaio, Francesco Granacci, Baccio Bandinelli, Alonso Berruguete, Andrea del Sarto, Franciabigio, Jacopo

Sansovino, Rosso Fiorentino, Jacopo Pontormo, Perino del Vaga, "Maturino," "Lorenzetto," and Niccolò "Tribolo."[30] On 2 July 1508, Michelangelo wrote from Rome to his brother Buonarroto in Florence, to say that "the bearer of this letter will be a young Spaniard [Alonso Berruguete], who is coming to Florence to study painting and has asked me to arrange for him to see the [*Battle of Cascina*] cartoon which I began in the *Sala.* So try in any case to arrange for him to have the keys. . . ."[31]

Vasari's lavish praise of cartoons by the great High Renaissance masters – above all, those by Leonardo, Michelangelo, and Raphael – was partly self-serving, as it helped him argue for the theoretical foundation of painting in *disegno.* (Vasari's premise is implicitly taken over in Raffaele Borghini's and Armenini's treatises.) Yet contrary to what the authoritative voice of Vasari's *Vite* might suggest, a survey of sixteenth-century art treatises reveals that theorists rarely mentioned cartoons, let alone explained them as part of painting procedures.[32] Gian Paolo Lomazzo grandly lauded the tradition of fresco painting (as we saw in Chapter Two) but never mentioned cartoons in his actual descriptions of painting technique; he used the term *"cartone"* only when referring to drawings by Leonardo.[33] Here, there must have been several interconnected issues at play. First, narrative consistency was often not a priority for such writers. Second, as pointed out in Chapter Four, mechanical and semimechanical design practices had garnered an increasingly bad reputation. Third, a good number of Cinquecento theorists were *"dilettanti"* of the arts, rather than practitioners, and may have followed from hearsay the practices current in their region. Although conceived as a defense of the noble status of painting, Michelangelo Biondo's *Della nobiltà della pittura* (Venice, 1549) was not above discussing technique, but the author's omission of the topic of cartoons, which might have been relevant to his twenty-third chapter, probably resulted from his acquaintance with Venetian painting practice.[34] Moreover, like Biondo's, many Cinquecento treatises were attempts to reinforce old and new arguments regarding the status of painting as a liberal art. Francesco Lancillotti's *Tractato de pictura* (Rome, 1509), Anton Francesco Doni's *Disegno* (Venice, 1549), and Cristoforo Sorte's *Osservazioni nella pittura* (Venice, 1580) broadly fall under this umbrella.[35] Nevertheless, when read together with Vasari's, Borghini's, and Armenini's emphatic instructions, such conspicuous omissions and the all too common absence of either *spolvero* or *incisioni indirette* on easel paintings from both Northern

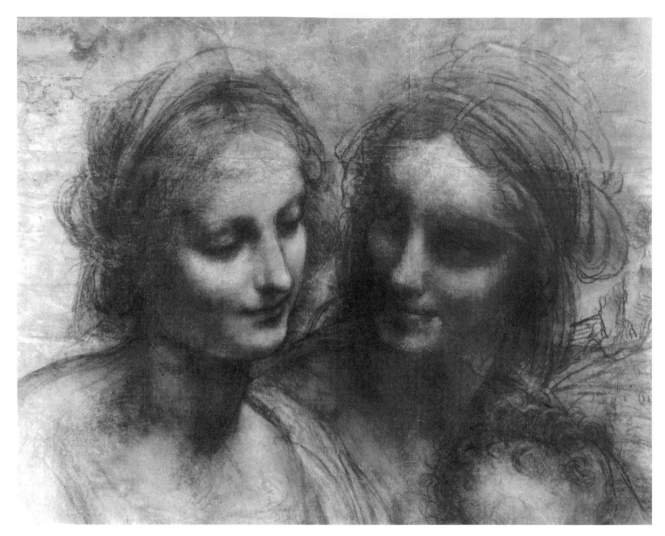

Figure 218. Detail of Leonardo, cartoon of the Virgin and Child with Sts. Anne and John the Baptist, "The Burlington House Cartoon" *(National Gallery inv. 6337, London).*

and Central Italy (except when replicating compositions or delegating the labor of execution) indicate that Cinquecento artists often dispensed with cartoons.

Payment documents, *ricordi,* inventories, letters, and a variety of other types of contemporary written sources do indeed confirm the gist of Vasari's claims regarding the exalted status in the Cinquecento of certain cartoons by the great masters. (Sadly, few, if any, firsthand accounts survive regarding Leonardo's cartoons.) In the famous letter of December 1523 to Ser Giovan Francesco Fattucci, Chaplain in S. Maria del Fiore (Florence), Michelangelo would recall years later the bitter circumstances under which he entered Pope Julius II's service and would reflect on his personal financial loss as a result of leaving the *Battle of Cascina*

commission unfinished: "I had undertaken to execute half the *Sala del Consiglio* [Palazzo Vecchio] of Florence, that is to say, to paint it, for which I was getting 3000 ducats; and I had already done the cartoon, as is known to all Florence, so that the money seemed to me half earned."[36]

An exchange of letters between Michelangelo and Antonio Mini, the artist's former servant, suggests that cartoons by the great master had a commercial value in the contemporary art market. On 27 February 1532, Mini reported from Lyons to Michelangelo in Florence of his scheme to sell to the king of France the precious painting of *Leda,* which Michelangelo had given to Mini as a present.[37] A few days later, on 9 March, the enterprising Mini told Michelangelo that he planned to have three paintings made from the *Leda* cartoon, which Michelangelo had also given him.[38] At about this time, Mini's letters to both Antonio Gondi (who was also then in Lyons) and Michelangelo in Florence

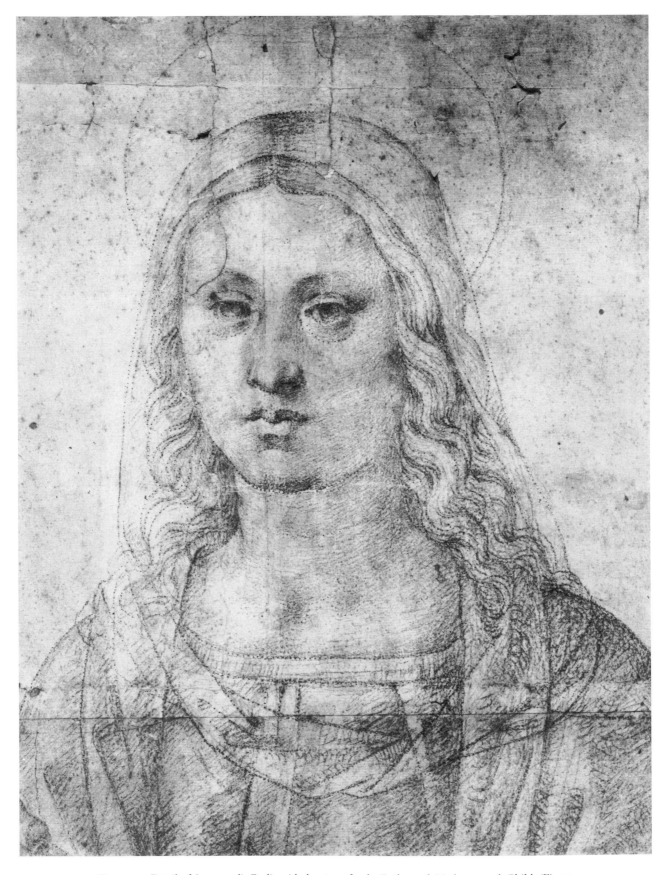

Figure 219. Detail of Lorenzo di Credi, pricked cartoon for the Enthroned Madonna and Child *(Fig. 29; CBC 49; Gabinetto Disegni e Stampe degli Uffizi inv. 476 E, Florence).*

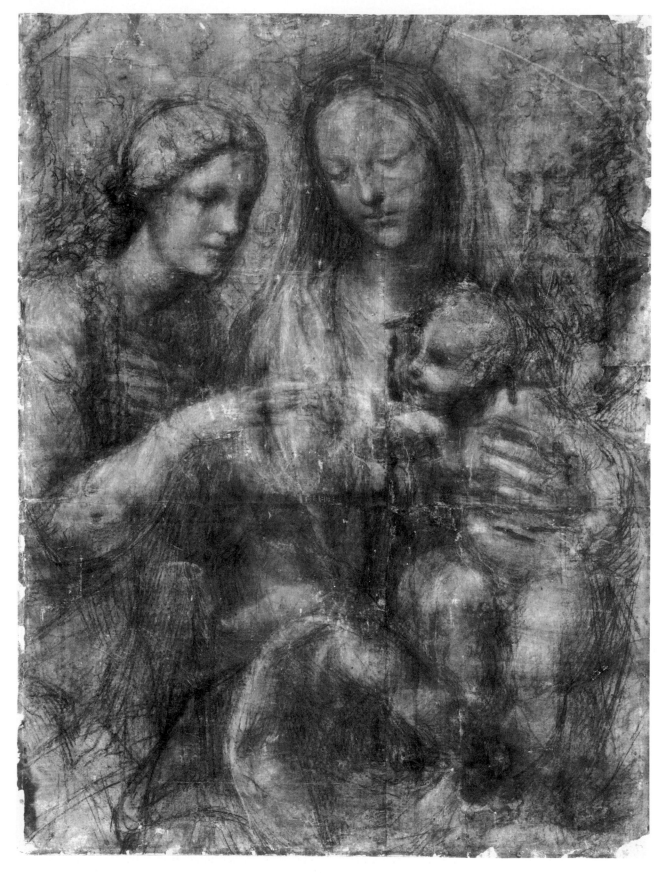

Figure 220. Giovanni Antonio Bazzi "Il Sodoma," stylus-incised cartoon for the Mystical Marriage of St. Catherine *(Staatliche Graphische Sammlung 1907:198, Munich). A closely related oil painting on panel is in the Galleria Nazionale at Palazzo Barberini, Rome.*

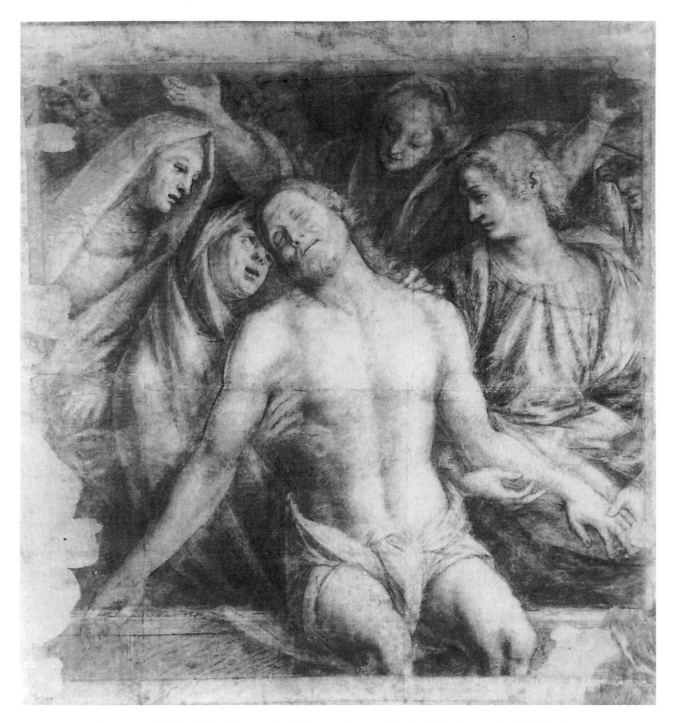

Figure 221. Gaudenzio Ferrari, cartoon for the Lamentation over the Dead Christ *(Accademia Albertina inv. 323, Turin), with outlines retraced with pointed black chalk for the design's transfer. This full-scale drawing served for an extant panel in the Szépmüvészeti Múzeum, Budapest.*

refer to the fact that Jacopo Pontormo had already painted panels from precious Michelangelo cartoons, a *Venus and Cupid* and a *"Noli Me Tangere."*[39] The *Venus and Cupid* cartoon had been executed for Bartolomeo Bettini, whereas the *"Noli Me Tangere"* was presumably

requested by Nicola Schomberg (Archbishop of Capua) on behalf of Alfonso d'Avalos (Marchese del Vasto), who was Vittoria Colonna's relative by marriage.[40] In a somewhat devious way, as he did not wish to anger Michelangelo, Mini now hoped to retrieve

the *"Noli Me Tangere"* cartoon to have it again executed in paint.

Such plotting and planning seem hardly surprising, considering the great demand for Michelangelo as a "cartoonist" in the 1530s. A letter written by Raffaello da Ripa during the last months of 1531 asks Michelangelo the favor of supplying a composition of the *Trinity,* a cartoon that, if the great master wished, could be given out to be executed in paint *("che io lo facessi dipignere").*[41] A similar request came in April of that same year from the Archbishop of Capua, presumably for the *"Noli Me Tangere";* Michelangelo was asked to provide "a cartoon no more finished than a *schizzo."*[42] By 20 January 1538, Pietro Aretino desperately begged for "a scrap of those cartoons which you usually consign to burn in the fire, so that I may enjoy it in life and in death may take it with me to the grave."[43] Michelangelo was then immersed in frescoing the *Last Judgment* on the altar wall of the Sistine Chapel. When *"Il Divino"* did not cave in to the pressure, the eminent, if black-mailing, Venetian man of letters became one of the fresco's most ardent detractors.

The Raphael correspondence also yields some tantalizing nuggets. In November 1517, we hear that the great painter offered his cartoon for *"una historia di Papa Leone iii"* (the *Fire in the Borgo*), a scene already frescoed by him and his *bottega* in the Vatican *stanze,* as a gift to mollify a potential patron, Alfonso I d'Este, Duke of Ferrara.[44] Raphael was putting off Alfonso regarding his request for a painting of the *Triumph of Bacchus.* Like his sister Isabella d'Este, Alfonso was indefatigable in his attempts to procure works by the famous artists of his day. Nearly a year later, the commission of the *Triumph of Bacchus* still postponed, Raphael offered the Duke the cartoon for a *St. Michael,* painted for the King of France![45] On 11 November 1518 the Duke accepted with gratitude, "donating 25 *scudi,"* but hoped that the painting of the *Triumph* would soon follow.[46] Between December 1518 and March 1519, the painting of the *Triumph* was finally said to be under way, but the Duke now requested from Raphael the cartoon for the portrait of Juana de Aragón *("Viceregina di Napoli").* The cartoon was sent with the caveat that "this portrait was made by his assistant *[gargione],"* very likely the precocious Giulio Romano.[47] Throughout the delicate negotiations, the cartoon's safe transport to Ferrara had been a consideration – finally, *"il chartone . . . era pervenuto salvo a Ferrara."*[48] Referring to another treasured but unnamed cartoon by Raphael, Antonio Dosio wrote in a letter on 1 August 1578, "I shall send it immediately and I

will have a case made to accommodate it, so that it does not become damaged."[49]

Contractual and Demonstration Pieces

On his arrival in Florence in 1500 or 1501, Leonardo may well have drawn his cartoon for the *Virgin and Child with St. Anne,* which he prominently displayed at SS. Annunziata, to attract the interest of prospective patrons. Although the written evidence is less than complete, we can speculate that Leonardo, whose steady, nearly seventeen-year employment at the Sforza ducal court had offered comfortable economic stability (which came to an end with the fall of Milan to the French in 1499), probably felt compelled to compete for commissions in the open market of Florence. From the patrons' point of view, once cartoons had entered the mainstream of artistic practice, they could also serve a pragmatic contractual purpose, as is hinted in the document of May 1504 regarding Leonardo's *Battle of Anghiari* (to be discussed later).[50]

A major concern was the control of the quality of execution, and this interest could be greatly protected with the preparation of cartoons. On 11 December 1523, while still residing in Bergamo, Lorenzo Lotto would travel to Jesi, in the region of the Marches, to sign a contract with the members of the Confraternity of St. Lucy to paint an altarpiece (now in the Pinacoteca Civica, Jesi) for their altar in the city's Franciscan conventual church of S. Floriano. Among the requirements, Lotto's contract stipulates that he was to paint the panel according to the cartoon *("per designum . . . in cartone factum")* that he had submitted for approval. (Worthy of some note in this context, Lorenzo Lotto was not a prolific draughtsman, like most Venetian painters of his training and generation.) Although the formal agreement was reached expeditiously, the *St. Lucy* altarpiece and *predella* scenes were finished only in 1532, as is attested by Lotto's signature and date on the main panel. Another concern was the communication between patron and artist, and here the production of demonstration drawings (and sometimes of the cartoons) aided more informal types of discussion. To cite a Central-Italian instance, on 11 February 1565, Cosimo I de' Medici away in Pisa would write to an agent in Florence that he had already advised Agnolo Bronzino to begin making the preparatory drawings for the two episodes from the *Life of St. Lawrence* to be frescoed (S. Lorenzo, Florence), "and that he let us see his cartoons so that we can com-

pletely resolve matters." To return to Lorenzo Lotto, the letters from the great artist to his patrons, the *"Consorzio della Misericordia"* of Bergamo, exemplify an unusually rich back and forth discussion in planning the production of his full-scale designs for the wood *intarsia* (inlay) of the choir in S. Maria Maggiore, Bergamo, between 1524 and 1532. These exchanges were mediated by Lotto's *"designi," "modelli," "lucidi,"* and *"cartoni"* of the Old Testament scenes, allegories, and ornament, which would then be finally translated for use by the wood workers under the master craftsman, Giovanni Francesco Capoferri da Lovere.[51]

Still another concern was the expedient delegation of labor. Greatly more detailed regarding such matters than most painters' contracts, Giorgio Vasari's *allogatione* of August 1572 with his patron, Grand Duke Cosimo I de' Medici, stipulates at the end that, in the event of death, all of Vasari's preparatory materials – drawings, wax models, and cartoons – for the frescoing of the dome of Florence Cathedral were property to be handed to Lorenzo Sabatini (Vasari's foreman in the job) so that he could finish the frescos with the same authority as the master, and if Sabatini were to die, Vasari could find someone else in his place to carry his duties.[52]

The public exhibitions in Florence, of Leonardo's *"St. Anne"* cartoon, and, later, of Leonardo's and Michelangelo's *Battle* pieces for *"La Gran' Sala del Consiglio"* of the Palazzo Vecchio, had marked a turning point in the history of the Italian Renaissance cartoon. These events helped establish what may be termed a new ideal, that of the *"ben finito cartone"* – to rely on Armenini's words. Cartoons had ceased to be regarded as mere working drawings. Their technique of execution was more refined than ever before, and their concomitant function as public demonstration pieces, illustrating work in progress, followed the Classical tradition of criticism revived in Leon Battista Alberti's painting treatise (MS., 1435–36): "Friends should be consulted, and while the work is in progress, any chance spectators should be welcomed and their opinion heard. The painter's work is intended to please the public. . . . So I want our painters openly and often to ask and listen to everybody's opinion, since it helps the painter among other things, to acquire favor."[53] Alberti had invoked Apelles's trick of hiding behind his paintings (so that his critics could speak more freely), as a moral example of diligence and proper conduct, a story originally told in Pliny The Elder's *Historia Naturalis* (MS., first century A.D.). The admonition would also be recast in Leonardo's note in Paris MS. A (fol. 106 recto)

from 1490 to 1492: "certainly while a man is painting he should not refuse anyone's judgment [but] be eager to lend a patient ear to the opinions of others."[54]

Cartoon Drawing Technique in the Second Half of the Quattrocento

The roots of the *"ben finito cartone"* tradition can be traced back to the second half of the Quattrocento. During the last quarter of the century, the new technique of oil painting began to gain ground in Central Italy, bringing with it gradually a more rapid, direct approach to painting; the modeling and glazing techniques that the medium permitted would eventually transform the treatment of light and color.[55] In Venice and Ferrara, where oil painting techniques were commonly used by the 1460s to 1470s, artists had been exploring the possibilities of light and color in remarkably freer ways; artistic exchanges between Northern and Central Italy provided crucial stimuli for change.[56] As a "High Renaissance" style began to emerge in Florence during the last two decades of the Quattrocento, the traditional concern with precision of outline ceded much of its importance to unified chiaroscuro and other types of pictorial effects, such as *sfumato* and atmospheric recession of space. Ultimately, this would be Leonardo's achievement, especially on his return to Florence in 1500 or 1501.[57] His tonal manner of painting would be taken up by the generation of painters working during the first decade of the Cinquecento – especially by Fra Bartolomeo and Raphael.

Thus, if we were to make a very broad distinction, the intricate disposition of *spolvero* outlines in murals by *"prospectivi"* painting between the 1440s and 1460s suggests that their cartoons served as painstakingly accurate models of the compositions to be painted, but the use of cartoons by such artists arose primarily from their preoccupation with reproducing precisely the outlines of complex designs, whether they would delegate the actual execution of the final work or not. As we have seen, in the mid-1430s, Alberti had considered *"circumscription"* one of the three basic elements of painting, though cautioning, "I believe one should take care that circumscription is done with the finest possible, almost invisible lines."[58] However, by the late 1490s, in contrast, Leonardo – already deeply immersed in the study of light, the gradations of shadow, and the perspective of disappearance – repeatedly condemned outlining. His voice emerges with particular clarity in the *Codex Urbinas Latinus* (fol. 46

recto and verso), "Avoid profiles, that is, sharp outlines *(termini)* for objects. . . . Do not make the outlines *(termini)* around your figures of any color other than that of its adjoining background."[59] To Leonardo, the precisely outlined forms in Andrea del Castagno's *Vision of St. Jerome* (Figs. 189, 191), from 1450 to 1455, would have appeared rigid and harsh, the coloring flat, and the use of chiaroscuro lacking in tonal subtlety, unity, and monumentality. Andrea del Castagno's was a *"maniera secca e tagliente"* (a dry and incisive style), to borrow Vasari's later, derogatory words for the mid- to later Quattrocento innovators.[60]

Central-Italian painters of the second half of the fifteenth century increasingly focused on the exploration of light and its dramatic power to transform surface, structure, color, and space as a main compositional element. *Rilievo* (relief), the imitation of three-dimensional form achieved through the disposition of chiaroscuro, had long formed part of the Central-Italian tradition of drawing and painting; according to Vasari, even in the Trecento it distinguished Giotto's manner of painting from that of his less gifted contemporaries. But increasingly during the Quattrocento, a number of Central-Italian painters brought to this *rilievo* an exploration of the physical properties themselves of *lume* (light) and *ombre* (shadows) – to borrow Alberti's and Leonardo's terms – as agents redefining form, color, and space. Near the end of his career, Piero della Francesca (who died in 1492) may have anticipated Leonardo in the scientific study of light. An infinitely nuanced play of light defines the architectural spaces in Piero's *"Montefeltro Altarpiece"* (Pinacoteca di Brera, Milan) and *"Senigallia Madonna"* (Gallerie Nazionali delle Marche, Urbino).[61]

The seeds of a remarkably graded approach to chiaroscuro modeling were already visible in the 1470s to 1490s, when a number of innovative Florentine and Umbrian artists began to translate their thorough, empirical understanding of light and shadow into the medium of drawing by refining the qualities of surface finish.[62] By nature precise and linear, the medium of metalpoint drawing, with white gouache highlights and on papers prepared with color, had been used since Cennino's time.[63] Late Quattrocento Florentine and Umbrian draughtsmen, however, would push the traditional metalpoint tools to their limit to accomplish increasingly nuanced effects of chiaroscuro. Domenico Ghirlandaio would explore the possibilities for veristic graphic description in fairly large-scale silverpoint studies of details, especially portrait drawings after life in the 1480s and 1490s.[64] In great contrast, the

workshop of Andrea Verrocchio had earlier experimented with progressive teaching methods and a pictorial manner of drawing. An example of the innovations of the Verrocchio workshop is the famous but much debated group of detailed studies of draperies, painted with the brush in deeply graded chiaroscuro on linen, prepared with a dark color.[65] Here, real draperies were cast onto clay mannequins to serve as models for the brush drawings. The first examples of this practice date from the late 1460s. Verrocchio's *bottega* had been among the pioneers of the new oil painting techniques in Florence, and it provided a training ground for many of the brilliant draughtsmen of the following generation – Leonardo, Pietro Perugino, Lorenzo di Credi, and Francesco di Simone Ferrucci (and possibly for a brief period, Sandro Botticelli and Domenico Ghirlandaio).

Yet the history of the monumental cartoon in the Quattrocento and the Cinquecento was largely the history of broad-point media – charcoal and black chalk.[66] Especially for large-scale drawing, in which the size of the design required a broader handling, the media of charcoal and chalk could suggest chiaroscuro effects, with even transitions of tone. Among the earliest surviving examples, as we have seen, is Piero Pollaiuolo's cartoon for the head of *Faith* (Plate II, Fig. 210), in the *Arte della Mercanzia* commission from 1469 to 1470, for which the figure is portrayed *di sotto in sù* and in slightly smaller than life-size scale. To suggest her blushing smooth flesh and lips, the artist reworked the charcoal rendering with red chalk, carefully stumping the media to produce a seamless hue.[67] To create a dynamic contrast of texture, he drew the hair and veil somewhat impressionistically in charcoal alone. The selective use of color in the cartoon is analogous to polychromy in sculpture. In the drawing, Pollaiuolo pricked the outlines of the facial features carefully and closely, those of her hair and veil less so.

Late-fifteenth-century artists would explore the tonal range that could be obtained with charcoal and soft black chalks in increasingly pictorial ways. A diversity of handling with the same medium can be seen in two cartoons executed about ten to fifteen years apart – Domenico Ghirlandaio's Chatsworth portrait (Fig. 214), from 1485 to 1490 and only a fragment of a figure, and Fra Bartolomeo's *Virgin and St. Joseph Adoring the Christ Child* (Fig. 37), from around 1500, a comprehensive drawing that was preparatory for a painted *tondo*.[68] Though Fra Bartolomeo's *tondo* cartoon appears more boldly sculptural and its tonal intensity more luxuriantly graded, both artists used a uniform, orderly network of

hatching to model form, even in areas of most intense shadow. An orderly hatching technique also characterizes Lorenzo di Credi's *Enthroned Madonna and Child* (Figs. 29, 219). In comparison, Melozzo da Forlì, Pietro Perugino, Giovanni di Pietro "Lo Spagna" – and the young Raphael in his earliest surviving monumental cartoon, the *Jousting Children on Wild Boars* (CBC 225)[69] – would use denser, more vigorous hatching techniques to suggest tonal gradation but would only lightly blend in the strokes. Their approach was a practical compromise between tonal subtlety and legibility of form at a distance.[70]

Andrea Verrocchio and the Origins of *Sfumato* Drawing

A striking contrast to these drawing techniques is seen earlier, in the cartoons by Andrea Verrocchio (Plate III, Figs. 44, 222–23). Piero Pollaiuolo's cartoon for the head of *Faith* (Plate II) partly anticipates them, if the technique of the sheet in its present state can be trusted to be original, as this author maintains.

Although Verrocchio was apparently among the first Tuscan artists to experiment successfully with effects of *sfumato*, his identity as a painter and draughtsman of cartoons remains nebulous because of sparse documentation.[71] Nevertheless, defining his status seems crucially important, to judge from the evidence alone of his extant cartoons – exquisitely drawn, but in a fragmentary state. Only two paintings can be connected to Verrocchio with any degree of certainty, although their execution was not solely by him. Both the anonymous author of the *Codice Magliabechiano* and Vasari attributed to Verrocchio the *Baptism of Christ* (Galleria degli Uffizi, Florence), commissioned by the monks of S. Salvi. According to Vasari's famous statement, Leonardo's success in painting one of the angels was such that it led to his master's resolution "never to touch the paint brushes again," having been outshone by one so young.[72] In 1474–79, the Pistoia Altarpiece, a *Madonna and Child with Sts. John the Baptist and Donatus,* was commissioned by Donato de' Medici, bishop of Pistoia, for an oratory that was originally adjacent to the Cathedral, the Chiesino della Madonna di Piazza.[73] Still unfinished, the painting occasioned a document in November 1485. Stylistic analysis suggests the extensive participation of Lorenzo di Credi, to whom Vasari indeed attributed the painting;[74] Lorenzo was in Verrocchio's workshop from 1469 until the master's death in 1488 and was his artistic heir. The design of the altar-piece, however, must have been Verrocchio's; the documents attest to the fact that the commission was granted on the basis of a contractual drawing. Frequently linked to this altarpiece, and rightly attributed to Verrocchio, the *Head of a Young Woman* (Fig. 222) must be an unused cartoon, considering its monumental scale.[75] Here, Verrocchio's controlled handling of the black chalk to intensify the tonal depth of the drawing against the warm cream color of the paper combined the techniques of stumping, wetting of the laid-in chalk with the brush, and cool white highlights. This sheet with its delicately calibrated axes for the woman's facial features, and more boldly sketched verso, can only hint at the scope of Verrocchio's innovation, for none of his extant cartoon fragments corresponds precisely with an extant painting, either by him or by the group of artists often associated with his *bottega*.

Verrocchio's earlier bust of an elaborately dressed young woman (Plate III), from around 1470 to 1475, was clearly used.[76] This is perhaps the most beautiful cartoon of the entire Quattrocento. The drawing served as a study for a figure of the Virgin, much as she is represented in one of Verrocchio's panels from the 1470s (Gemäldegalerie, Berlin).[77] Painted and sculpted images of the *Madonna and Child* were a mainstay of the Verrocchio workshop. In the Christ Church cartoon (Plate III), the artist selected for refinement only the areas of flesh, to which he gave a marmoreal luster by carefully stumping the silvery charcoal, the exact technique of *sfumato* rendering that Leonardo would later describe in Paris MS. A (fol. 107 verso).[78] By contrast, Verrocchio treated areas of rough texture impressionistically – the crinkled gauze clothing and veil and the fantastic, braided hair – leaving many of the bold, reinforced strokes virtually untouched or unsmudged. To enrich the intermediate grade of shadows on the flesh areas, the artist then delicately parallel-hatched with a fine-tipped pen and washed light-brown ink passages on the woman's forehead, temple, cheek, and neck. These areas of ink and wash reworking have often been regarded as later retouching, yet their beauty and logic of placement argue that they were functional surface refinements, done probably by Verrocchio himself or a close, brilliantly talented member of his workshop. As we have seen in Chapter Two, artists calibrated the design of cartoons for a far viewing distance. An appropriate viewing distance for studying Verrocchio's sheet would thus be about one to two feet away (30–60 cm.) – the delicate, ink-hatched modeling loses its intrinsic pattern, and is perceived as a golden tone, suggesting the warmth of living flesh that

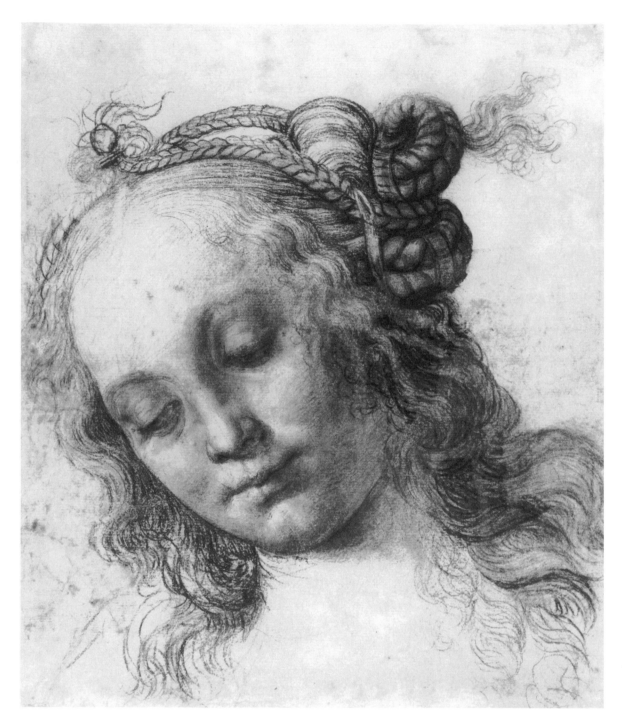

Figure 222. Andrea Verrocchio, unused cartoon for the Head of a Young Woman *(British Museum 1895-9-15-785 recto, London).*

the cool silvery stumped charcoal alone cannot evoke. Fine, gently swelling brushstrokes in brown wash further inflect the turns of outline into space for the nostril, mouth, and chin, a technique recalling Leonardo's advice in drawing: "[regarding] the outlines, [note] which way they go; and [in] the lines, how much is curved to one side or the other, and where they are more or less evident, and if they are broad or fine. . . ." This passage directly precedes the famous note on *sfumato* drawing in Paris MS. A (fol. 107 verso).[79] The delicate reworking with short, left-handed parallel hatching in brush and gray wash unifies the tonal structure

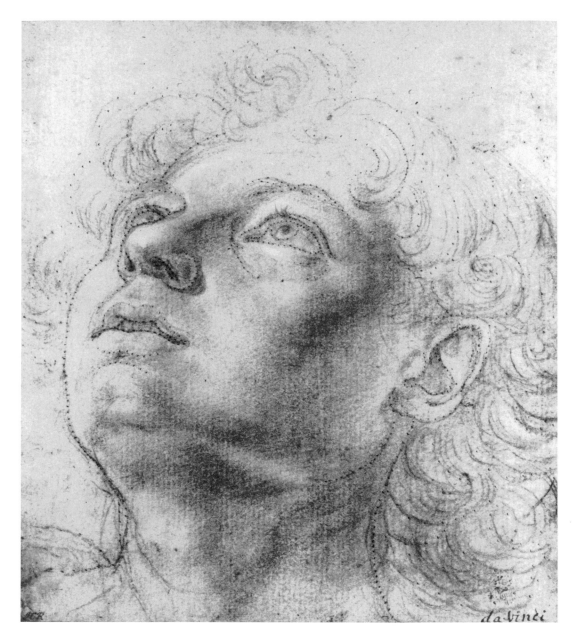

Figure 223. Andrea Verrocchio, pricked cartoon for the Head of an Angel *(CBC 336; Kupferstichkabinett inv. KdZ 5095 recto, Staatliche Museen, Berlin). The fragment of an unfinished drawing on the verso of this sheet, also portraying the head of an angel, is in the scale of a cartoon.*

of the shadows on the woman's temple and cheek. It is entirely possible that this is the hand of the young Leonardo at work. Ultimately, despite the calibrations of chiaroscuro and outline, the overall manner of drawing in Verrocchio's cartoon remains too preciously delicate for the large scale of the design, and the head on the paper appears as if carved in low relief, rather than in the round.

The faintness of the overall effect appears magnified in the cartoon in Berlin (Fig. 223), also from 1470 to 1475, for Verrocchio executed this drawing entirely in silvery charcoal, without reworking it in ink.[80] In rendering the boy's head, probably preparatory for the figure of an angel, Verrocchio varied his handling of the medium to distinguish the qualities of reflected light on changing textures. Even in this finished drawing, numerous reinforcement lines attest to the creative process of exploration. The artist lit the head from the

upper left, as he had the figures in his other cartoons, and as Leonardo would later recommend for life drawing in a note from 1490 to 1492, in Paris MS. A (fol. 33 recto).[81] The planes of the foreshortened facial features are defined architecturally, with exquisitely stumped shadows, rather than with hatching or outlines, as in Ghirlandaio's Chatsworth portrait cartoon (Fig. 214) or Perugino's *Head of St. Joseph of Arimathea* (Fig. 76). Observed close up, Verrocchio's technique appears to capture at once the smoothness of plump young skin and the structure of the underlying bones. Almost imperceptibly, evenly blended shadows build in intensity toward the edges of planes, and smudged charcoal gradually gives way to shining highlight.[82] By contrast, the sketchy curving charcoal strokes articulating the curls of hair and the small fragment of clothing, apparent on the lower left corner of the sheet, stay undisguised. In such a tonal drawing only the bare outlines could be pricked – neatly, with Verrocchio's characteristically large, closely spaced holes, more or less carefully aligned with the drawing.[83] As is typical of Verrocchio's cartoons, the face received the greatest attention; the refined but animated mode of drawing, achieved through careful stumping, matches the precision with which the contours were densely pricked. Less challenging parts of the figure, such as the hair, are suggested sketchily and the outlines are more sporadically pricked.

In yet another cartoon for the *Head of an Angel* (Fig. 44), Verrocchio boldly compensated for the overall effect of the chiaroscuro.[84] The Uffizi angel's head probably also dates around 1470 to 1475, for it relates stylistically to the S. Salvi altarpiece of the *Baptism of Christ* (Galleria degli Uffizi, Florence). Here too the flesh areas shine smoothly stumped, whereas the untouched coarser chalk hatching on the hair appears to diffuse light. But Verrocchio experimented with a denser type of black chalk to produce stronger color, and at this point, the artist or a member of his workshop seems to have pricked the cartoon's outlines. The artist then broke the continuity of his drawing medium specifically to deepen the contrast of shadows. He reworked them with the pen, but this time with a brown ink of much darker color. The areas of flesh received short, brisk parallel hatches over the black chalk drawing, and curving strokes reinforced the chalk modeling on the cascading curls of hair. This general technique of reworking a drawing in black chalk with pen and ink is clearly original and is frequently recognizable in Leonardo's smaller and more inchoate figural studies from the 1490s onward. This, like most of Leonardo's graphic practices, had its roots in the Verrocchio *bottega*. The angel's head

in the Uffizi cartoon resembles that in Verrocchio's panel of *Tobias and the Angel* (National Gallery, London), but the design is larger and in reverse orientation; the scale of the Uffizi cartoon is also much larger than that of the angel in the S. Salvi *Baptism of Christ*.[85] At least in the instance of the Uffizi cartoon (Fig. 44), it is demonstrable that it was a fragment from a larger functional drawing, for in the background toward the upper left and lower right corners, the cropped forms of wings are broadly suggested in black chalk. Verrocchio may have saved his cartoon fragment not only for reuse by the workshop in later compositions, in which the heads of an angel or the Madonna could be inserted and adapted as was required by the new context, but also to instruct his pupils in the art of drawing (see Chapters Three and Four).

Disegno, Rilievo, and Cartoon Drawing Technique in the High Renaissance and Later

Leonardo's early contribution to this aesthetic of a highly refined surface treatment was no less compelling, if today sadly less apparent due to the loss of innumerable drawings. A life study in charcoal, from 1495 to 1497, preparatory for the head of St. Philip in the *Last Supper*, represents one of Leonardo's first extant experiments with *sfumato*,[86] for which his apprenticeship with Andrea Verrocchio had crucially prepared the way. As pointed out in Chapter Three, Leonardo advised that young artists should learn to draw by copying the drawings of their master; indeed, the preparation of cartoons must have been among the essential skills learned during the period of apprenticeship. For instance, Verrocchio's *Head of a Young Woman* (Plate III) shares significant similarities of drawing and pricking technique with Leonardo's *Head of a Grotesque Man* (Fig. 45), from 1503 to 1505, sometimes identified as "Scaramuccia, captain of the gipsies." In both cartoons, the flesh areas have been worked up to simulate a lustrous surface, whereas the hair and clothing remain impressionistically sketchy to suggest the greater opacity of their different textures. (As both of these examples are in the drawings collection of Christ Church, Oxford, they can be compared with particular precision and immediacy.) Leonardo's "Scaramuccia" is probably close to the lost *Battle of Anghiari* cartoon in its spirited handling of the charcoal, as noted in Chapter Two.

Verrocchio's extraordinary understanding of chiaroscuro remained largely intuitive. By 1500, however, Leonardo's derived from an exacting, astonishingly

modern scientific method. Between 1490 and 1492, as Paris MSS. A and C amply attest, Leonardo had begun to study empirically the physical properties of light and the gradations of shadows – their quality, quantity, position, and shape. As later put forth, particularly in Paris MS. E, the observations provided a basis for his theory on the "perspective of disappearance" – the optical phenomena governing the perception of form, translucency/opacity, and distance. The pictorial conventions that Leonardo would adopt to illustrate his conclusions are significant. In earlier diagrams, he rendered the complex tonal effects of shadows on spheres with a meticulously precise system of rigid, parallel hatching in pen and ink.[87] But later, since he would often find the notation of parallel hatching unsatisfactory in suggesting the subtle transitions between grades of shadows, he would often seek the liquid, tonal evenness of ink wash.[88] Leonardo would translate his scientific findings into a nuanced artistic vocabulary, as his painting palette grew increasingly monochromatic, and as his style of drawing gained in expressive force. If we were to compare details from Leonardo's cartoon in the National Gallery (Fig. 218) to some of his diagrams documenting the gradations of shadow on spheres, we can see that the great artist manipulated the monochromatic, dry drawing media in the cartoon – charcoal, black chalk, and white chalk – to achieve mimetic effects remarkably similar to those he had earlier demonstrated in his scientific illustrations.[89]

To gauge the full impact of this contribution, however, we must look to the early work of Fra Bartolomeo in 1499–1500, for Leonardo's technique of *sfumato* drawing appears already fully synthesized in his unusually complete sequence of small-scale figural studies in black chalk for the *Last Judgment* fresco (Museo di S. Marco, Florence).[90] As is suggested by Fra Bartolomeo's roughly contemporary extant cartoons (Figs. 36, 37), the technique of *sfumato* had entered into the vocabulary of Florentine monumental *disegno* with powerful results.

By and large, the drawing technique of monumental cartoons for paintings would increasingly become freer and more pictorial during the course of the sixteenth century.[91] In his *De' veri precetti della pittura* (Ravenna, 1586), Giovanni Battista Armenini would describe a range of techniques enabling suggestive effects of chiaroscuro with charcoal, black chalk, and lead white chalk highlights, based on the examples of cartoons by the great masters he had encountered in his travels.[92] Armenini advocated the techniques of dusting with a pouncing bag as a shortcut to obtain a uniform gray base tone in large areas of shadow. He also explained that artists could create *sfumato* by stumping on passages of charcoal or chalk hatching with their fingers, or with a small piece of wool or linen.[93] The numerous extant cartoons by Bernardino Lanino (c. 1512–1583), his sons, and followers in the regions of the Piedmont and Lombardy (Accademia Albertina, Turin) offer contemporary, independent testimony to such common practices.[94] Areas of light and shadow flicker with great movement in the drawing surfaces of Federico Barocci's cartoons (see Figs. 49, 233), largely because of the artist's control of the stumping tool. The techniques of handling charcoal and chalk in the Cinquecento would often also encompass their wetting or their reinforcement with passages of brush and ink wash: in fact, the tonal scale could be unified seamlessly with translucent layers of wash. The use of colored chalks and pastels, as in Leonardo's *Isabella d'Este* cartoon (Plate IV) and in drawings by Leonardo's Lombard followers, would enter the mainstream of workshop practice only later in the sixteenth century.

In his fragmentary notes, Leonardo favorably associated diligence (*"diligentia"*) with the production of carefully rendered drawings (*"finire con ombre"*).[95] According to the method of rendering cartoons prescribed in the introduction to Vasari's *Vite*, the portrayal of forms in chiaroscuro was to be precisely analyzed from actual figures in the round, "to see the projections, that is, the shadows caused by a light thrown onto the figures, [to see] which projections correspond to the shadows cast by the sun, which more sharply than any [artificial] light defines the figures by shadows on the ground."[96] Only from this study of clay models (*"modelli di terra"*) could the cartoon achieve "the most finished perfection [*fatiche di perfezzione*] and strength [*forza*], and stand out from the paper in relief [*rilievo*]."[97] The type of elaborately drawn cartoon that resulted from this attentive study may well be designated with Armenini's phrase, *"ben finito cartone,"* describing in his *De' veri precetti della pittura* the revered cartoons by Raphael, Perino del Vaga, Daniele da Volterra, and Taddeo Zuccaro. The context for the phrase *"ben finito cartone"* – "well-finished cartoon" – emerges from his comprehensive description of how artists should draw cartoons.[98]

According to Vasari, Raffaele Borghini (who essentially repeated most of Vasari's information), and Armenini, cartoons came to represent the climax of *disegno,* the process of drawing and design. Vasari observed, "at this point the painters go through all the toils [*fatica*] in the art of portraying nudes from life and

draperies from nature, and they trace the perspectives by following all the same rules adopted in small scale in their drawings, enlarging them proportionally."[99] Armenini proclaimed, "The cartoon is the last and most perfect manifestation of everything which the art of *disegno* can powerfully express."[100] The cartoon, as he noted, must reflect the draughtsman's toil *("fatica")* and diligence *("industria")*.

The Renaissance Meaning of *"Ben Finito Cartone"*

However, based on a reading of the primary sources (as we shall see in a moment), the phrase *"ben finito cartone"* should not be taken too literally. As the general context clarifies, Armenini's use of the phrase refers to the refined effects of chiaroscuro and *"rilievo"* achieved in the beautiful cartoons by the great Cinquecento masters, which the theorist held up as supreme models of *disegno*. Regarding Vasari's language in the *Vite*, it has rightly been pointed out that the use of the term *"finito"* often refers to the aesthetic appearance of finish, as with *chiaroscuro*, rather than to the actual state of a design being complete.[101]

Italian Renaissance draughtsmen rarely finished cartoons pedantically to their last detail, unless they were designing for other artists or craftspeople. Shorthand notation in drawings was only viable when the designer was also the artist interpreting the design for execution or when he closely supervised the assistants carrying out the final work. All too often, however, artisans translated drawings into decorative arts with little or no direct supervision (Plate VII, Figs. 109, 111, 224–27).[102] Thus, the absolute precision of design notation in numerous small pricked drawings by Raffaellino del Garbo, Bartolomeo di Giovanni, and their workshops (CBC 65–107, 115–25) may be explained by the fact that these probably served as embroidery cartoons, and hence their labor of execution was entirely delegated.[103] The same seems true of Andrea del Sarto's cartoons from around 1525–26 for the embroidered altar frontal *("palliotto")* commissioned by Cardinal Silvio di Rosado Passerini

(Fig. 224; CBC 282).[104] For the craftspeople interpreting such small cartoons, the wash drawing demarcated the shadows in the modeling without ambiguity, sometimes exaggeratedly so. The outlines of the composition (often, even its framing outlines in the form of rectangles, circles, shields, ovals, and orphreys) were drawn and pricked with painstaking exactitude. *Pentimenti* and traces of preliminary leadpoint, charcoal, or chalk underdrawings were probably erased – they seem frequently faint or nonexistent in extant designs – as they might have proved confusing.

An analogously precise design notation is also typical of small and large pricked preliminary drawings for other decorative arts, as we see in Giulio Campi's delicately rendered *St. Jerome and the Animals* (Fig. 225).[105] The wood *intarsia* bench, for whose ornament this small cartoon was preparatory, was contracted in 1542. Similarly, the dynamic *Battle of the Amazons* (Fig. 226), with strongly chiseled chiaroscuro, is an example of Perino del Vaga's small *"disegni finiti"* (Vasari's term) for the crystal panels of the *"Farnese Casket,"* engraved by

Figure 224. Andrea del Sarto, pricked cartoon for St. Luke *(CBC 283; Istituto Nazionale per la Grafica inv. FC 130467, Rome). This and other full-scale drawings were preparatory for an extant embroidered altar frontal, commissioned by Cardinal Silvio di Rosado Passerini, now in the Museo Diocesano, Cortona Cathedral.*

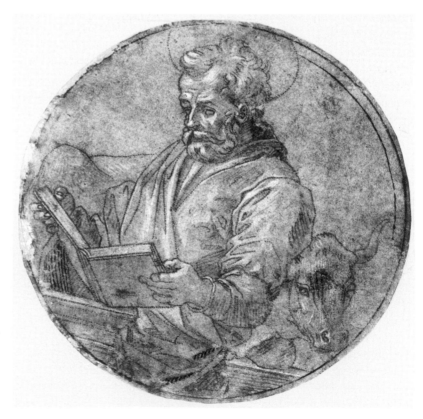

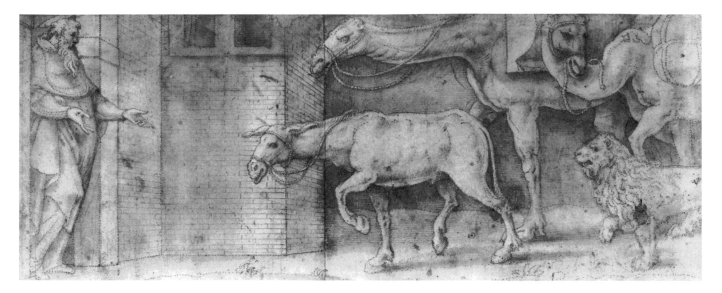

Giovanni Bernardi da Castel Bolognese in 1543–63, thus probably after Perino's death. Also extant are eight of Niccolò dell'Abate's finely pricked cartoons for *Angels Bearing the Instruments of the Passion* (Ecole Nationale Supérieure des Beaux-Arts, Paris), used by Léonard Limousin to produce the Sainte-Chapelle enamels (Musée du Louvre, Paris).[106] Niccolò probably made these finished drawings of starkly brushed chiaroscuro shortly after his arrival in France in 1552. Although offering a dramatic contrast in size, the compositions in the monumental cartoons for the Sistine Chapel tapestries (Plate VII) and *"Scuola Nuova"* tapestries, many of which are now in fragments (Fig. 227), are also completely worked out, down to their smallest-scale background details.[107] These cartoons were brilliantly colored in gouache to guide the Flemish tapestry weavers in their choices of silks, wools, and precious metal threads. Similarly, Domenico Beccafumi's large cartoons for the marble inlay pavement of Siena Cathedral (Figs. 32–33) describe outlines precisely and emphatically, often down to the exact strokes in the hatching that model areas of shadows: the *intarsiatori* would transcribe such outlines as grooves filled with black pitch.[108]

In *"ben finiti cartoni"* of monumental size, the degree of surface refinement is often selective and must have often been a deliberate artistic choice.[109] In Leonardo's National Gallery cartoon (Plate V), among the obviously unfinished passages are St. Anne's pointing hand and the Virgin's and St. Anne's feet, which are only sketchily outlined with lively reinforced strokes. Close examination, however, reveals abundant reinforcement lines also throughout the rest of the composition.[110] Consistently, Leonardo modeled the faces with exquis-

Figure 225. Giulio Campi, pricked cartoon fragment for St. Jerome and the Animals *(Harvard Art Museums, Fogg Art Museum 1994.138, Cambridge, Massachusetts). This full-scale drawing was preparatory for an extant panel of wood inlay (intarsia) on a bench at the church of S. Sigismondo, Cremona.*

ite softness, stumping the charcoal, black chalk, and white chalk to blend them imperceptibly into luminous layers of tone, but sketching the hair and headdresses broadly (see Fig. 218). The infant Christ's legs are only dimly discernible, emanating from areas of smoky chiaroscuro, and their actual pose still needs to be articulated. Here, the appearance of surface finish (a point of drawing technique) is greater than the actual completion or definition of form (a point of design). This approach, however, is entirely in keeping with that of Leonardo's drawings in small scale, as in the sheet of quick composition studies in pen and ink for the *"Madonna of the Cat"* (British Museum, London), from the 1470s, in which a deep chiaroscuro envelopes largely inchoate forms.[111] For Leonardo chiaroscuro was not a "finish" imposed on a completed design but a structural element of the composition growing from its very beginning. The reinforcements of contour, as well as the relative degrees of unfinish, in the highly rendered National Gallery cartoon (Plate V) are meant to evoke the creative flux of gestating form. Leonardo welcomed the "stream of consciousness" solutions arising from the process of exploration itself. A passage on the design of compositions, in the posthumously compiled *Codex Urbinas Latinus,* records the following:

Oh, you composer of *istorie,* do not draw the limbs [on your figures] in such *istorie* with strong outlines, or it will happen

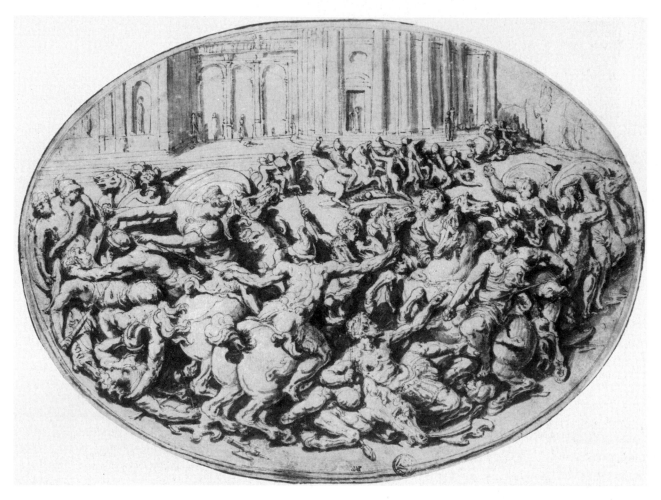

Figure 226. Perino del Vaga, pricked cartoon for the Battle of the Amazons *(CBC 323; Département des Arts Graphiques du Musée du Louvre inv. 594, Paris). This and other full-scale drawings were preparatory for rock crystals on the "Farnese Casket" in the Gallerie Nazionali di Capodimonte, Naples.*

to you as to many different painters who wish every little stroke of charcoal to be definitive . . . Therefore, painter, set down broadly the position of the limbs of your figures and attend first to the movements appropriate to the mental attitudes of the creatures in the *istoria* rather than to the beauty and quality of their limbs. For, you should understand that if such a rough composition turns out to be right for your intention, it will all the more satisfy in being subsequently adorned with the perfection suitable to all its parts.[112]

In design, the National Gallery cartoon does not correspond to any known painting by Leonardo, and it may well lack signs that it was actually transferred onto a working surface.[113] Yet the cartoon's appearance seems hardly that of an "incomplete" work. Had the artist drawn each element with forcible finality, it might have drained the life of the composition.[114]

Already in his painting treatise (MS., 1435–36), Alberti warned against the dangers of belabored execution, by recommending "moderate diligence" and "diligence combined with speed." In Alberti's words, "one should avoid the excessive scruple of those who, out of a desire for their work to be completely free from all defect and highly polished, have it worn out by age before it is finished. The ancient painters used to criticize Protogenes because he could not take his hand off his painting."[115]

As an ideal for the creative aspect of design, however, the actual balance in working practice between diligence and freshness of execution would be difficult to maintain. Although Vasari considered diligence of execution in drawing and painting a most praiseworthy quality, he criticized Lorenzo di Credi for his obsessively refined technique that prevented him from completing his work (Figs. 29, 91–92, 219).[116] In great contrast to Lorenzo di Credi's cartoon, the *terribilità* of Michelangelo's partly unfinished *Madonna and Child* (Plate X) must have come closer to Vasari's ideal of *disegno*.[117] Dating from the 1520s to 1530s, the Casa Buonarroti composition is Michelan-

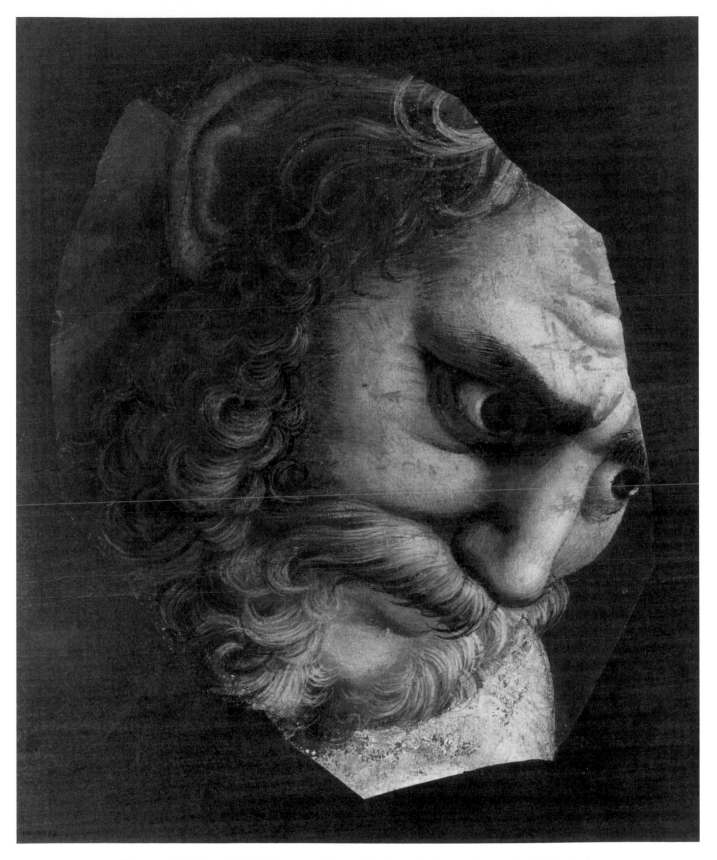

Figure 227. Workshop of Giulio Romano or Tommaso Vincidor, pricked cartoon fragment for the Head of a Shepherd *(CBC 211; Christ Church inv. 1972, Oxford). The extant tapestry of the* Adoration of the Shepherds, *from the "Scuola Nuova" series, is in the Vatican Museums. This is among the few surviving "Scuola Nuova" cartoon fragments that was pricked to produce a full-scale copy of the design.*

gelo's earliest extant modeled cartoon. The artist treated the Madonna's figure as a summary sketch in charcoal but seamlessly stumped the charcoal and red chalk drawing on the body of the suckling infant to cast it in high relief. To amplify the sculptural effect, he added intense white highlights to the baby's figure and reinforced shadows in pen and brush with ink. Without pressing the analogy too far, such dynamic contrasts between a highly refined surface "finish" and "unfinish" also characterize Michelangelo's approach to marble sculpture. As Vasari pointed out regarding Michelangelo's sculpted nursing *Madonna* in the Medici Chapel (S. Lorenzo, Florence) – which is roughly contemporary in date with the Casa Buonarroti cartoon – "although the figures are not yet finished in their parts, one recognizes, that, from the roughly sketched and chiseled [forms], and, from the incompleteness of the sketch, perfection clearly shows."[118] By comparison, the *rilievo* in Michelangelo's cartoon fragment for the *Crucifixion of St. Peter* (Fig. 3), from the 1540s, is more statically descriptive: executed largely with the help of an assistant or assistants, the Pauline Chapel frescos were among the least appreciated of Michelangelo's paintings.[119]

Raphael's close study of Leonardo's pictorial manner of drawing cartoons culminates in his Roman work, as is especially evident in the deep, smoky shadows and flickering highlights of the cartoon for the damaged "*Mackintosh Madonna*" (Fig. 97), from 1509 to 1511. Here, Raphael would adapt his technique to the exigencies of a working drawing. In Leonardo's National Gallery cartoon (Plate V), the delicate atmospheric effects in charcoal and chalk, which were clearly enormously labor-intensive to produce, are somewhat lost when viewed from a distance. This is true of both flesh and drapery areas, and particularly of the background landscape. In comparison, Raphael turned to a blacker charcoal and schematized the chiaroscuro, stumping areas of shadow only selectively – the brisk hatching and bold reinforcement lines vividly suggest the speed of his execution. His drawing style also betrays its origins in the Perugino *bottega*. We may recall that in Perugino's *St. Joseph of Arimathea* fragment (Fig. 76), from 1495, a freer, denser, and more vigorous type of hatching served to control the intensity of the chiaroscuro, which greatly contrasts, for example, with the rigorous, orderly hatching of Ghirlandaio's Chatsworth portrait cartoon (Fig. 214).

Meant to be judged from a distance for a unified effect, the drawing of cartoons is significantly broader than that of small-scale drawings. This we can readily see in the spirited cartoon fragments by Raphael, the

God the Father for the *Disputa* (Fig. 64) and the *putto* attendant for *Poetry* (Fig. 46), both for frescos in the *Stanza della Segnatura* (Vatican Palace), dating from 1508 to 1509 and mentioned in Chapter Two. The drawing style and surface refinement of form in these cartoons reflect the placement of the figures within the pictorial space of the composition. The great differences of handling in Raphael's *Segnatura* cartoon fragments can be explained by the fact that the *Disputa* is placed prominently on a large wall lunette, the foreground figure of God the Father thereby being seen in monumental, deeply contrasting and stumped *rilievo*, and that *Poetry*, by comparison, occupies the less significant place of a roundel high up on the ceiling; thus the *putto*'s figure in the background is coarsely hatched, shows almost no stumping, and has significantly flatter tonal articulation.

Larger compositional cartoons can confirm this point. We may consider Raphael's *School of Athens* (Fig. 228), which at 2.85 by 8.04 meters, is the largest such extant Renaissance drawing; or Michelangelo's cartoon for the fresco of the *Crucifixion of St. Peter* (Fig. 3), which by contrast, at 2.63 by 1.56 meters, is merely a small fragment of the total scene.[120] Because Raphael's monumental *School of Athens* cartoon survives in its nearly complete original width (we do not know how much of the architecture was included on the upper part), it helps us visualize the full range of execution that must have been typical of many such large-scale drawings. Raphael rendered the monumental group of figures aligning in a crescendo from middleground to foreground on the left and right with deep, carefully calibrated chiaroscuro. His diverse handling of the charcoal thoughout the cartoon often helps establish a Leonardesque atmospheric perspective from foreground to background, though in some passages the spatial relationships between figures appears still tentative, as the multiple reinforcement lines attest. The artist achieved a base gray tone of shadow, probably by means of the pouncing bag shortcut described by Armenini and by drawing with the side of the charcoal sticks, repeatedly hatching on top to build up depth. For most figures, the charcoal drawing remains broadly hatched, stumped, and reinforced. For some, however, the rendering approaches Leonardo's delicacy. Yet a few background figures, especially toward the upper left and right, are also crudely sketched in. These background figures – as those in Michelangelo's *Virgin and Child with Saints* (Fig. 229) or in Giulio Romano's brilliant *Stoning of St. Stephen* (Figs. 230–31) – are understood to recede in space and significance, precisely because they are sketchily drawn. Such dynamic contrasts in surface

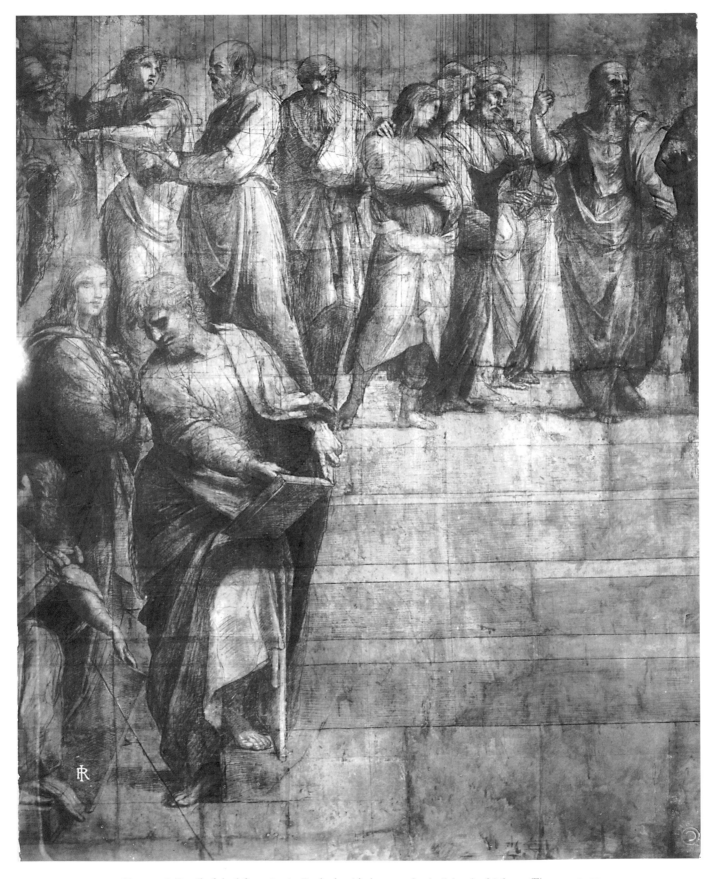

Figure 228. Detail of the left portion in Raphael, pricked cartoon for the School of Athens *(Figs. 30, 40, 41; CBC 256; Pinacoteca Ambrosiana inv. 126, Milan).*

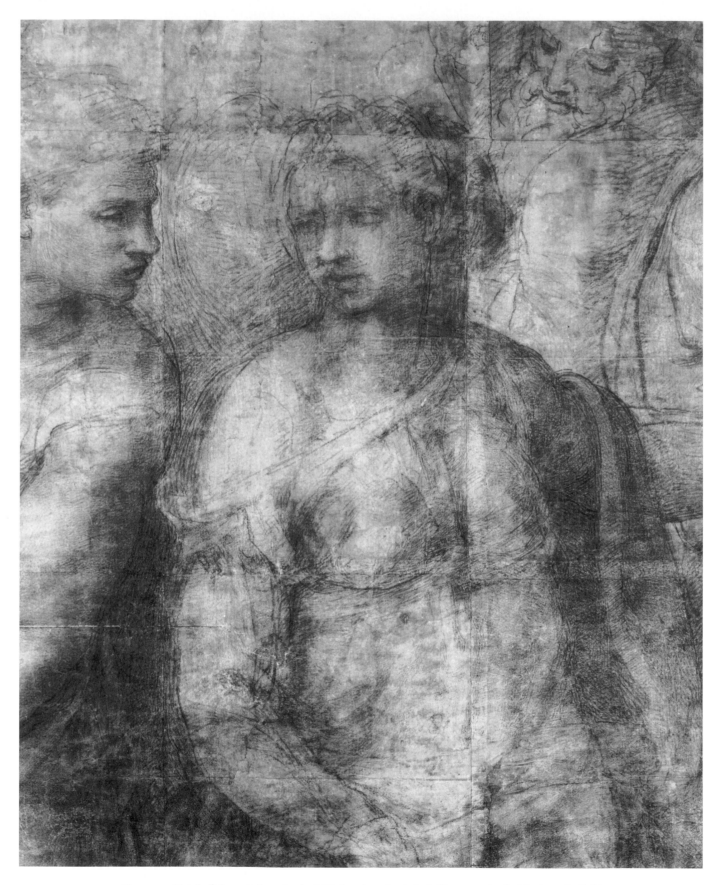

Figure 229. Detail of the central portion in Michelangelo, stylus-incised (?) cartoon for the Virgin and Child with Saints, The "Epifania" *(Fig. 34; British Museum 1895-9-15-518, London).*

"finish" distinguish the important from the unimportant and the foreground from the background. In the hands of Gaudenzio Ferrari, this device of rendering cartoons would offer memorable results (Fig. 221) but would not always translate into paint successfully. Later still, Federico Barocci's mature cartoons (Figs. 232–33) would rely on the magical qualities of light to chisel the forms in receding, angular planes.

Problems in Modern Connoisseurship

Clearly, our criteria of connoisseurship require greater refinement before we can attempt to make distinctions regarding the "quality" of execution of cartoons. The participation of workshop assistants in their production can occasionally be documented. We may recall that Piero d'Antonio received payment on 31 October 1504 for his help in the *"inpastare"* (gluing) of Michelangelo's *Battle of Cascina* cartoon (see Chapter Two); in all probability, however, Piero performed only menial labor, as indicated by the small salary given to him. We have also noted the letters from 29 December 1518 until 2 March 1519 regarding the Duke of Ferrara's request of the portrait cartoon of Juana de Aragón, which turned out to be drawn by a *"gargione"* in Raphael's workshop.[121]

Payments to Raphael, recorded between 15 June 1515 and 20 December 1516, suggest that he produced the cartoons for the Sistine Chapel tapestries (see Plate VII, Fig. 244) at breakneck speed, in about eighteen months time, while engaged in a variety of other projects.[122] Vasari's *Vita* of Raphael tells that the great artist "made in appropriate form and size, of his own hand *[di sua mano]*, the colored cartoons, which were sent to Flanders to be woven."[123] Yet in the *Vita* of Giovan Francesco Penni *"Il Fattore,"* Raphael's principal assistant along with Giulio Romano, Vasari observed that Penni was "of great help to Raphael in painting a great part of the cartoons" for the Sistine Chapel tapestries, "particularly the borders *[fregiature]*."[124] Considering the delegation of labor traditional in the workshops of Medieval and Renaissance artists and artisans, Vasari's differing accounts are not intrinsically incompatible. As a chief assistant in the Raphael *bottega,* Penni undoubtedly intervened in what was still regarded as a product of his master's hand; no doubt, Giulio Romano also made a contribution in the Sistine tapestry cartoons.[125] A division of labor accompanied the production of certain types of preliminary drawings in the Raphael *bottega;* as we shall see later, Giovan Francesco Penni

probably drew the *modello* for the composition of *St. Paul Preaching in Athens* (see Fig. 268, Plate VII), based on a sequence of detailed preliminary studies by Raphael.[126] Overall, the technical investigation of the seven extant cartoons for the Sistine tapestries (Victoria and Albert Museum, London) has revealed a remarkable consistency of materials and production.[127] However, to establish the participation of *garzoni* in the task of drawing monumental cartoons purely on the basis of stylistic analysis is an altogether different problem, much too complex and subjective for reasonable conclusions. A greatly more nuanced understanding of cartoon drawing technique seems necessary.

The Cartoon's Place in the Design Process

As can be observed, and in contrast to the situation for the Quattrocento, a number of the surviving large-scale *"ben finiti cartoni"* from the Cinquecento depict at least substantial portions of compositions; the earliest extant examples date from around 1500 onward. To understand further the innovations the cartoon represented for the High Renaissance, it is necessary to place this drawing type within the process of preliminary design. Unfortunately, however, for the history of Italian drawing in general, and for our argument regarding the role of cartoons in particular, the most complete Renaissance description of the process of preliminary design for a composition is of a much later date. This is Vasari's famous sixteenth chapter in the introduction to both the 1550 and the 1568 editions of the *Vite*. Nevertheless, as corroborated by earlier extant drawings and written sources (chiefly, Leonardo's fragmentary notes between 1490 and 1519), Vasari's text appears to represent essentially the legacy of High Renaissance practice.[128] For our purposes, it remains to be emphasized that Vasari predicated the use of cartoons on an orderly model of design. Most important for Vasari (and for Leonardo, as repeatedly implied in his notes), the design for a composition was to be conceived of as an organic whole in terms of its *"lineamenti"* or *"dintorni"* (outlines), as well as *"rilievo,"* and from the very earliest stages of development.[129]

Although a precedent in the second half of the fifteenth century can be identified for almost every drawing type used in the High Renaissance, Leonardo would expand the nuances of investigation enormously. Compositional unity would become an increasingly dominant artistic concern during the course of his career. To underline earlier practice, we may return,

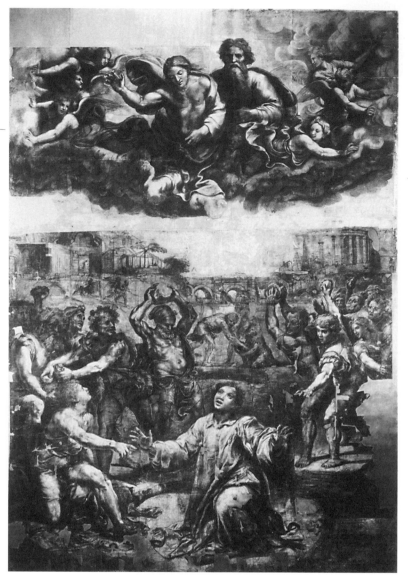

Figure 230. Giulio Romano, stylus-incised cartoon fragments for the Stoning of St. Stephen *(Vatican Museums inv. 753). The corresponding altarpiece in oil on panel is in the church of S. Stefano, Genoa.*

Lorenzo (Figs. 29, 219) is rendered with nuanced chiaroscuro and is better preserved.[132] Importantly for our argument, it has traces of vertical lines, drawn in the same charcoal or soft black chalk as the figures, and these frame the left and right borders of the cartoon's composition. Moreover, the paper structure of the cartoon, consisting of three sheets – the center one, a nearly complete *foglio reale* – is intact. All this confirms that the cartoon's present width is essentially original: the unit of the Virgin and Child shown in the cartoon appears not to have been part of a larger drawn whole. Lorenzo di Credi's fragmented compositional approach is typical of the Verrocchio *bottega*. To a greater or lesser extent, it also speaks for the easel painting practices current during the second half of the Quattrocento. This artist's fragmented approach, however, stands in vivid contrast to the organic whole that evolves from Leonardo's studies, cartoons, and painting on the theme of the *Virgin and Child with St. Anne* after 1500.

Vasari recommended that artists were to begin by drawing sketches, resembling "the form of a blotch" *("schizzi . . . in forma di una mac[c]hia")*. Such sketches offered a rough draft of the compositional idea, "to find the manner of the poses" *("per trovare il modo delle attitudine"),* and were drawn essentially from memory.[133] The *"furia"* of invention prevailed over the precision of pictorial notation.[134] As Leonardo advised in Paris MS. A (fol. 107 verso), "the sketching out of the narratives must be quick and the arrangement of the limbs must not be too finished, only suggestive of their placement."[135] Next, as Vasari instructed – and here, Leonardo's fragmentary notes seem to concur – artists produced *"dissegni"* (Vasari's spelling), properly modeled with relief, and with all possible diligence *("rilevati in buona forma, . . . con tutta quella diligenza che si puo")*.[136] *Disegni* therefore comprised a sequence of more finished drawings, in which the study of carefully graded chiaroscuro played a key role: life studies *("dal vivo"),* as well as synthetic and detailed composition drafts, whose sequence of preparation, however, hinged upon the general resolution of the compositional idea. For such purposes, Vasari recommended the media of

once more, to the two monumental cartoons from the 1490s by Lorenzo di Credi (Figs. 29, 91–92, 219), which served to prepare large altarpieces.[130] Lorenzo pieced together his compositions in collagelike fashion from diverse fragments: one portraying the Virgin and Child for the center, and others for the flanking saints. One of Lorenzo's *Madonna* cartoons (Fig. 91) is virtually an outline drawing, boldly executed in charcoal or a soft black chalk with broad, minimal hatching for areas of modeling; it served for the central group in a *Sacra Conversazione,* originally painted for S. Maria delle Grazie in Pistoia (Fig. 92).[131] The other *Madonna* cartoon by

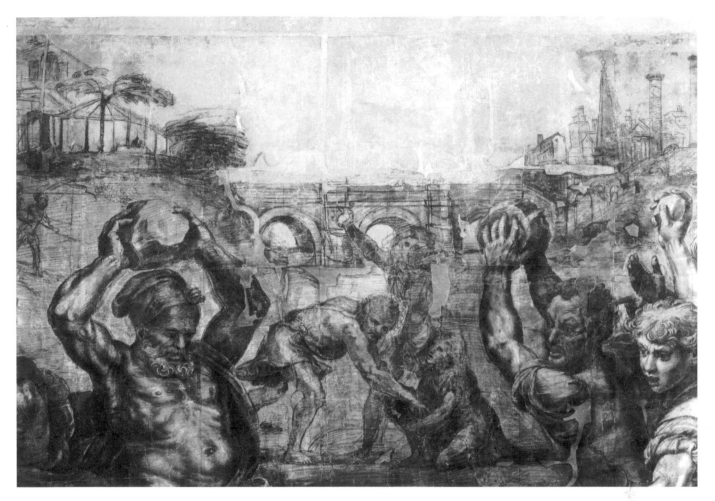

red chalk *("lapis rosso; pietra tenera")*, black chalk *("pietra nera")*, pen and ink *("penna, inchiostro")*, brush and wash with white gouache highlights on colored ground *("tinta dolce che lo vela et ombra; biacca stemperata; fogli tinti")*.[137] A late-fifteenth-century innovation, the latter chiaroscuro medium was an effective means of noting painterly effects, *"questo modo e molto alla pittoresca e mostra più l'ordine del colorito."*[138] In Leonardo's series of composition studies for the *Virgin and Child with St. Anne,* one idea changes fluently into another in an apparently endless progression of studies.[139] The category of *disegni* also included the final composition drawing preceding the cartoon (called a *"modello"* by modern art historians), often squared with a proportional grid. No such squared *"modelli"* survive by Leonardo and Michelangelo;[140] Raphael's are the earliest extant examples in the sixteenth century.[141]

Finally, according to Vasari, artists enlarged the design to full scale by drawing a *"cartone,"* which ensured an exactly calibrated composition on the final working surface *("per compartire, che l'opera venga giusta e misurata")*.[142] Moreover, as the reasoning went – Leon Battista Alberti

Figure 231. Detail of the middleground and background in Giulio Romano, stylus-incised cartoon fragment for the Stoning of St. Stephen.

had already formulated it in his painting treatise (MS., 1435–36) without alluding to cartoons – a drawing in large scale shows more easily errors in design than a drawing in small scale.[143] This point would become a leitmotif of later Cinquecento theory. As we have seen, Leonardo recommended the use of pricked cartoons for painting in oil on panel: his note from 1490 to 1492 in Paris MS. A (fol. 1 recto) is among the rare Quattrocento references to the practice.[144] By emphasizing how indispensable cartoons were for fresco painting and by urging that they even be prepared for easel painting, as well as for a variety of decorative arts, Vasari sought to establish the cartoon's practical importance in the design process. By lavishing almost ekphrastic praise on the cartoons by Leonardo, Raphael, and, above all, Michelangelo, Vasari enshrined the cartoon as a work of art of the highest order. He also frequently cited the exemplary cartoons by lesser sixteenth-century artists.[145]

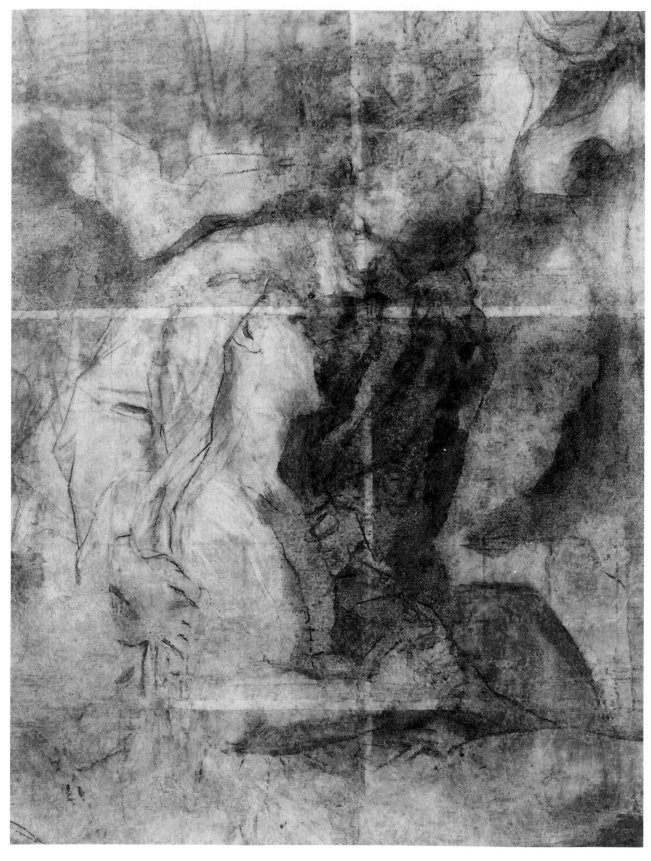

Figure 232. Detail of the Virgin and Attendant in Federico Barocci, stylus-incised cartoon for Christ Taking Leave from His Mother *(Gabinetto Disegni e Stampe degli Uffizi inv. 1785 E, Florence).*

Figure 233. Federico Barocci, Christ Taking Leave from His Mother, *oil on panel (Musée Condé, Chantilly), left unfinished at the artist's death in 1614.*

An orderly model of design was the theorist's desideratum, but we may well wonder whether it corresponded to actual practice.

We have seen that the production of large cartoons entailed an enormous expense of materials and manual labor. That such drawings increasingly acquired the appearance of finished works of art in and of themselves would pose obvious practical problems. First and foremost, how could the investment be protected, particularly in the case of monumental compositions? For fresco painting, the production of *"ben finiti cartoni"* must have seemed particularly impractical, considering the destructive working process that followed.[146] In easel painting, the preparation of elaborate cartoons duplicated the labor and function of creating a detailed underdrawing and underpainting on the final surface of the panel or canvas: here, Leonardo's unfinished *Adoration of the Magi* can help us underline this point (Figs. 216–17).[147] In oil painting especially, as it permitted seamless blendings of tone, the practice of a freehand underdrawing executed directly on the working surface was more efficient, for it became an intrinsic part of the upper modeling in paint. The *"ben finito cartone"* was arguably an ideal of sixteenth-century design theory that all too often proved unrealistic to attain. Leonardo's inconsistent use and nonuse of cartoons throughout his career suggests this was the case, and the ultimately incomplete state of both Leonardo's *Anghiari* and Michelangelo's *Cascina* cartoons probably affirms it. Moreover, examination of panels and canvases with infrared reflectography continues to reveal that even at the heyday of the monumental cartoon in the late Quattrocento and Cinquecento, scores of easel paintings were produced from freehand underdrawings.

We may now attempt to demonstrate how the lofty status of the cartoon as a work of art, so vehemently argued by sixteenth-century theorists, was further reconciled with the realities of Italian Renaissance workshop practice.

The History of Collecting Drawings and the *"Fortuna Critica"* of Cartoons

Tellingly, Acisclo Antonio Palomino's passage about drawing cartoons for fresco in *El museo pictórico y escala óptica* (Madrid, 1715–24) sums up the problem. Palomino explained that artists of the past drew such extremely detailed cartoons for frescos, fully rendered in *chiaroscuro,* which after having been used were much esteemed and collected by painters, "as are today in Italy those for the works by Michelangelo, Raphael,

and Annibale [Carracci]." But, according to Palomino, experience demonstrated that producing such elaborate cartoons consumed so much of the artists's interest and energy that they no longer found the task of painting itself engaging. Thus, the Spanish author concluded, the expense of such labors in drawing was no longer required in his day.[148]

Vasari's praise of *"ben finiti cartoni"* emphasizes how much this type of drawing came to be appreciated and collected, a particularly significant fact, since many of the cartoons he admired never led to finished works of art. When Vasari mentioned a particular cartoon in the *Vite,* he also frequently noted the owner of the drawing by name, reconstructing a form of provenance.[149] For instance, he recorded Leonardo's cartoon of *Adam and Eve,* to be woven as a silk tapestry for the King of Portugal, in the house of Ottaviano de' Medici.[150] Some fragments from Raphael's cartoons for the *Expulsion of Heliodorus* fresco (Fig. 24) were in the house of Francesco Masini of Cesena.[151] Two fragments from the *"ben finiti cartoni,"* portraying the heads of the avenging angels, are now in the Musée du Louvre, Paris (Fig. 26; CBC 262), while another, portraying the head of a horse, is now in the Ashmolean Museum, Oxford (CBC 261).[152] The biographer was even better informed regarding the whereabouts of Michelangelo's cartoons. Besides the artist's heirs, the fortunate owners of his cartoons were Antonio Mini, Bindo Altoviti, Tommaso de' Cavalieri, Grand Duke Cosimo I de' Medici, Bernardo Vecchietti, Uberto Strozzi, as well as the heirs of Girolamo Albizzi.[153]

Inventories help us determine that cartoons, at least by important artists, were collected by laypeople as works of art in and of themselves during the Cinquecento and Seicento.[154] But, as in the traffic of Medieval relics of saints, the overzealous attention of collectors all too often led to the dismemberment of revered cartoons.[155] (In fact, Armenini used the term *"reliquie"* in mentioning the cartoon fragments by Michelangelo, Leonardo, Raphael, Perino del Vaga, and Daniele da Volterra that he had seen during his travels.) Vasari gave conflicting accounts in the *Vite* regarding the deliberate dismemberment of Michelangelo's *Battle of Cascina* cartoon. Whether it was indeed an act of Baccio Bandinelli's jealous arrogance or the destructive working procedures of copyists that damaged the masterpiece in 1516 is no longer clearly discernible from the existing evidence.[156] Nevertheless, the provenance of the *Cascina* cartoon fragments can be traced to Mantua (mentioned by Vasari as being in the collection of Uberto Strozzi) and to Turin during the Seicento.[157]

At least three factors have greatly obscured our

understanding of the functions of Italian Renaissance cartoons: (1) the abusive exploitation of design transfer techniques by artists, artisans, and copyists, which caused the consternation of the high-minded theorists of *disegno* and may have thus provoked their silence regarding the various applications of cartoons; (2) the destructive processes by which artists actually transferred cartoons, which diminished the probability of their survival; and (3) the criterion of draughtsmanly quality by which Italian drawings were collected during (and since) the Renaissance. The survey in Chapter Four regarding the dubious reputation of tracing and design transfer techniques in Renaissance and Baroque writings has attempted to address the first factor. (It should be added that the negative connotations largely postdate the highly efficient utilization of such techniques during the Trecento and Quattrocento.) Chapter Eight will explore the second factor in connection with the practice of "substitute cartoons." The third factor is no less important, if more difficult to assess. Heavily influenced by the writings of Vasari and other sixteenth-century *disegno* theorists, the history of collecting drawings during and since the Renaissance has been a process of editing and revision in the pursuit of aesthetic excellence. (As is well known, Vasari was himself a prominent collector of drawings.[158]) The consequence of this revisionist approach has been to view Italian Renaissance drawings, almost exclusively, as creative masterpieces rather than as functional tools – a tendency still lingering today in the modern tradition of connoisseurship.

The attractively finished, large-scale drawings that we call "cartoons" today were not necessarily all drawings actually used in the working process.[159] Moreover, such drawings may not necessarily have been typical of most fifteenth- and sixteenth-century workshop practice. Here, the procedure of "substitute cartoons" must have skewed at least some of the balance in the surviving evidence (see Chapter Eight). Undoubtedly, many cartoons were relatively *"ben finiti"* to provide a guide when the final execution in paint or another medium was to be delegated partly or entirely (see Chapter Eleven). Still other such *"ben finiti cartoni"* probably functioned as demonstration pieces for the patron's approval. A large portion of the cartoons actually produced in the Renaissance and Baroque, however, must have been relatively schematic in appearance.

Functional Cartoons

To refine our observations regarding the physical appearance of cartoons, we may return to Leonardo's *Isabella d'Este* cartoon (Plate IV), from around 1500.[160] Although the pricking of the design's outlines is probably not autograph, as discussed in Chapter Three, much of the exquisite drawing certainly is. For instance, small traces of left-handed hatching (most evident in parallel strokes, which generally course from upper left to lower right) sporadically interrupt the delicate *sfumato* of the forms. Moreover, the translucent layers of smoothly stumped, soft charcoal or leadpoint, where delicate lead white chalk highlights and a subtle, searching leadpoint underdrawing further define the formal structure, create in this drawing a virtual equivalent of Leonardo's oil painting technique with its infinite, diaphanous glazes. A layer of bone-colored chalk preparation further unifies the texture of both the ground and the drawing on top. Delicately stumped reddish chalk accents the flesh areas; yellow defines the ribbon below the neckline.

By the High Renaissance, as we have seen, changes had apparently occurred in both the function and appearance of cartoons. Yet to illustrate this change visually, we may compare Leonardo's *Isabella d'Este* (Plate IV) with a cartoon in Windsor, depicting a similar portrait of a woman in profile, by a late fifteenth-century artist (Fig. 234).[161] The comparison of these two pricked cartoons stresses the profound difference which must have existed between the *"ben finito cartone,"* favored as a demonstration piece during the High Renaissance, and the coarse, full-scale outline cartoon, with little or no interior modeling, probably typical in many Quattrocento and Cinquecento workshops. The Windsor cartoon is drawn only in pen and brown ink outlines, almost mechanically so, over minimal traces of leadpoint or charcoal underdrawing. The pricked outlines are rubbed with black pouncing dust; on top of all layers of drawing but underneath the pouncing dust, it is squared in pen and lighter brown ink. More importantly, however, this outline cartoon was long grouped with Leonardo's sheets in the Windsor Royal Collection. The cartoon's watermark is identical to that found in a drawing, also in Windsor, that dates from the 1510s and that is by Francesco Melzi, Leonardo's pupil and heir.[162] The Windsor outline cartoon can thus probably be connected to Leonardo's *bottega* and may exemplify one of the master's precepts in the exercise of portraiture (see Chapters Three and Four). A great number of such cartoons must have merely served to transfer the overall design onto the *intonaco* or panel.

The coarse, purely functional quality of many fifteenth- and sixteenth-century cartoons may be deduced from various types of evidence.[163] A large sur-

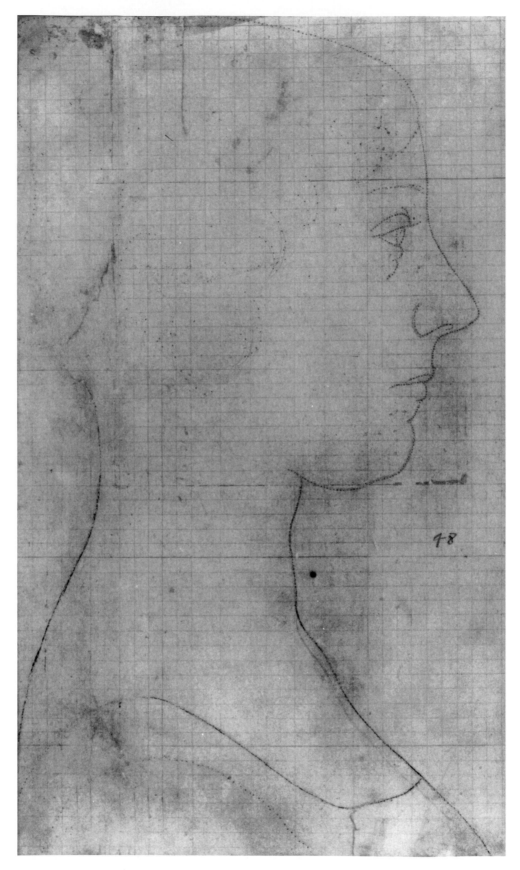

Figure 234. Artist in Leonardo's workshop, outline cartoon for a Portrait of a Woman in Profile (CBC 351; Royal Library inv. 12808, Windsor Castle). The drawing is squared in pen and ink and its pricked outlines are rubbed with black pouncing dust.

viving corpus of *sinopie* from this period portray forms with bold, summary, sketchy strokes, rather than with carefully detailed rendering. Such *sinopie* can offer a reliable indication of the degree of finish of some early cartoons, as they were the traditional underdrawings of frescos before the widespread use of cartoons for figural compositions.[164] Correggio prepared fairly crude outline *sinopie* for his *Coronation of the Virgin* in 1522, detached from the partly destroyed apse of S. Giovanni Evangelista (Biblioteca Palatina, Parma),[165] and for his frescoed dome at Parma Cathedral in 1526–30, as is now evident in a detached fragment depicting the Virgin's steeply foreshortened head (Galleria Nazionale, Parma).[166] Also, the combined evidence of small-sized *giornate* and *spolvero* marks found on the surface of many frescos from the mid–fifteenth century onward suggests that the process of design transfer alone would have been extremely damaging to cartoons; this increases the possibility that such cartoons were often simply functional rather than attractively finished.[167]

A very small number of functional, late Quattrocento and Cinquecento cartoons actually survive, of which the fragment by Michelangelo in Haarlem (see Fig. 236), to be discussed later, is an example.[168] Other examples are the drawing either by Luca Signorelli or his workshop for the lower half of the *Crucifixion* fresco on the right wall of the oratory church of S. Crescenziano from 1507 to 1523 in Morra (see Fig. 252),[169] as well as the cartoon fragments by Francisco de Urbino for the ceiling and lunettes of the prior's lower cell in the Monastery of El Escorial from about 1581 (Fig. 65; CBC 316–317).[170] A further, curious group of sixty-seven outline cartoons (Musée du Louvre, Paris) portray entire figures and cropped body parts; these relate to Correggio's *Assumption of the Virgin,* frescoed in 1526–30 on the dome of Parma Cathedral.[171] But, as is all too often true of schematic outline drawings, it is difficult to establish whether the Louvre "Correggio" cartoons are autograph, rather than tracings. Be that as it may, functional outline cartoons must have usually either perished during the working process or been discarded soon after their use. They would have held little appeal to drawing collectors. Luca Signorelli – to name a late-fifteenth-century artist working brilliantly with the media of charcoal and chalk – also produced accomplished *"ben finiti cartoni."* The same is true of Correggio (Plate IX), an extraordinary master of such broad point media in the sixteenth century. We may also recall Lorenzo di Credi's functional cartoon and *"ben finito cartone"* for altarpieces (Figs. 29, 91, 219).

Michelangelo's Cartoon for *Haman*

For practical reasons alone, not all cartoons produced in the Renaissance could be *"ben finiti."* For instance, as Michelangelo frescoed the Sistine Ceiling from east to west, his *giornate* for the *historie* became fewer and larger, the scale of his figures increased, and his methods of cartoon transfer became less precise. In painting, Michelangelo followed the *spolvero* outlines relatively carefully but often disregarded those from stylus-incised cartoons, treating them only as general guidelines.[172] As we shall see, in the *Separation of Light from Darkness,* frescoed last and in only one *giornata* (Plate XI, fig. 300), the cartoon incisions on the plaster render the figure of God handless, with a straying left arm, as well as with a hairless cranium, narrower bodily contours, and smaller facial features than finally painted. Thus, Michelangelo's cartoons clearly must have also become increasingly rough and schematic.

Textual and further visual evidence help document this summary character of Michelangelo's working cartoons in the late parts of the ceiling. Although written nearly twenty years after the completion of the commission, a letter on 11 April 1531, by Battista Figiovanni to Michelangelo, suggests that a cartoon, no more finished than a *schizzo,* might satisfy a possible patron – the Archbishop of Capua, Nicola Schomberg.[173]

A sheet of drawings (Teylers Museum, Haarlem) provides visual confirmation.[174] The recto contains the famous studies in red chalk for the figure of Haman in the *Punishment of Haman,* the southwest pendentive fresco in the Sistine Ceiling and the second-to-last pendentive to be painted (Fig. 235). Reconstructed, the extremely schematic drawing on the verso of the Haarlem sheet represents a sharply foreshortened head (Fig. 236), which is typical of such other foreshortened heads in Michelangelo's *oeuvre,* as, for instance, Haman and Jonah in the Sistine Ceiling, or the Madonna in the *Doni Tondo.*[175] This large, relatively coarse outline design – really no more than a *schizzo* in charcoal – is an unused full-scale cartoon for the face of Haman.[176] It was obviously later discarded, for in the actual fresco Michelangelo decided to depict part of Haman's face covered by a violently foreshortened hand, and the drawing's outlines are neither pricked nor incised.[177] The drawing and the detail in the fresco correspond exactly in both measurements and continuity of design, as can be verified by placing a full-scale transparency of the Haarlem drawing on the actual fresco of Haman (Figs. 237–38).[178] Although a relatively small fragment, the Haarlem drawing is the only surviving cartoon for the Sistine Ceiling.

The recto and verso of the Haarlem sheet demonstrate that Michelangelo developed the different kinds of working drawings for a particular portion of the ceiling almost consecutively.[179] As the recto of the sheet indicates, and as Vasari's description vividly attests, the final pose of Haman, and particularly the foreshortened hand at his face, was among the most difficult in the Sistine Ceiling to visualize and paint, not least because of the concave surface of the pendentive: "Haman; the figure which he portrayed in extraordinary foreshortening . . . and that arm which thrusts forward not as if painted but as if it were alive . . . a figure among the difficult and beautiful ones, most beautiful and most difficult."[180] In order to depict Haman's pose in the cartoon, Michelangelo must have drawn the full face in charcoal to ensure its correct recession in space, later possibly excising the part of the face covered by the figure's left hand.[181] Despite the vicissitudes of survival,[182] an inordinately high number of preparatory drawings exist for the *Punishment of Haman,* indeed the greatest number associated with any scene of the Sistine Ceiling.[183]

In the frescoed pendentive of the *Punishment of Haman* (Plate XII), the methods of cartoon transfer attest to the efficient resolution of a problematic design, whose foreground compositional elements had clearly been much rehearsed on paper. Michelangelo first painted the fictive frame, stylus-incising its shell and acorn motif. Then he painted the scene, broadly speaking, in three vertical bands from right to left.[184] *Spolvero* marks appear on the right half of the scene, populated by the comparatively small figures of Ahasuerus and his attendants in the background, as well as by the closely knit figures of the two onlookers in front, possibly Mordecai and Esther. Extremely detailed stylus incisions *(incisioni indirette)* describe the monumental nude body of Haman pushed violently to the foreground, in the central band of the composition. Michelangelo painted Haman comparatively slowly, in four *giornate,* adhering precisely to the cartoon incisions. The profusion of cartoon nail holes around the

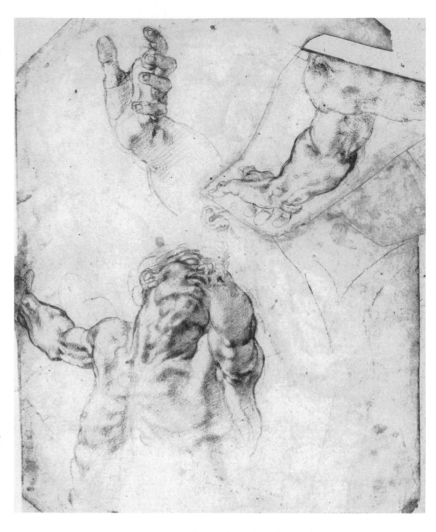

Figure 235. Michelangelo, studies for the figure of Haman *(Teylers Museum A 16 recto, Haarlem).*

figure's head, arms, and hands, an area done in a single, small *giornata,* attests to the difficulty of holding in place and transferring the cartoon for Haman onto the concave surface. Only summary stylus incisions appear on the minor figures in the left background, frescoed second-to-last and in a single *giornata.*

We can therefore establish that Michelangelo turned to more economic means of production in the later *pontata* of the Sistine Ceiling, not only in his actual painting technique but also in some of his design practices, probably as the result of his time constraints, lack of assistants, and increasing confidence in fresco painting. He rejected the type of *"ben finito cartone"* familiar to us from his cartoon fragment for the *Crucifixion of St. Peter* (Fig. 3) or his *Virgin and Child with Saints* (Figs. 34, 229) in favor of bold, schematic, outline cartoons

Figure 236. Michelangelo, unused outline drawing in full scale for the face of Haman *(Teylers Museum A 16 verso, Haarlem).*

more or less concurrently during the Italian Renaissance, as was often true of *sinopie*. On the one hand, as evidenced by Michelangelo's *Haman* (Figs. 236–37), there were coarse outline cartoons, which were primarily working drawings, for no purpose other than transfer. On the other hand, as exemplified by Michelangelo's later *Crucifixion of St. Peter* (Fig. 3), there were carefully drawn and highly finished cartoons – *"ben finiti cartoni,"* to borrow Armenini's phrase. These were often transferred by the intermediary means of "substitute cartoons," to be discussed in Chapter Eight. The new aesthetic value of cartoons in the High Renaissance made them collectible works of art in and of themselves.[185] Cinquecento and Seicento inventories are rich with such possessions. By contrast, the Haarlem cartoon – whose schematic appearance and cropping could have hardly appealed to a collector – seems to have survived because of the beautifully rendered red chalk studies of Haman on the recto (Figs. 235–36). It was surely schematic working cartoons, rather than *"ben finiti cartoni,"* that Michelangelo burned to edit his *oeuvre* for posterity. As Vasari's famous passage states, "shortly before he died, he burned a great number of drawings [*disegni*], sketches [*schizzi*], and cartoons [*cartoni*] made by his own hand, thus no one would see the toil that he endured and the ways in which he tested his intellect, so as not to appear anything but perfect."[186] Chapter One considered other documented instances of the great artist's willful destruction of drawings and cartoons. These corroborate the veracity of Vasari's statements. As records of the gestation of a work of art, drawings offer a rare glimpse into the private world of the creative act, where the purpose of drawing is, however, normally practical rather than aesthetic. That rough working cartoons were probably destroyed and that in their place so many *"ben finiti cartoni"* survive may have largely obscured our understanding of the functions of cartoons and, more importantly, the pragmatic working practices of Italian Renaissance artists.

such as the recently identified Haarlem drawing for Haman (Fig. 236). Superficially, his working cartoons for the late parts of the Sistine Ceiling probably reverted to the outline cartoons traditional in many Quattrocento and Cinquecento workshops. As Michelangelo no longer delegated assignments to workshop assistants, he could develop his drawings and cartoons in a self-assured shorthand and paint from such abbreviated drawings.

Conclusions

In sum, we may, therefore, broadly conclude that probably two general traditions of cartoon making existed

Figure 237. (right) Approximate reconstruction of the unused full-scale drawing for Haman with respect to the frescoed figure.

Figure 238. (below) Detail of Michelangelo, The Punishment of Haman, *fresco (Sistine Ceiling, Vatican Palace).*

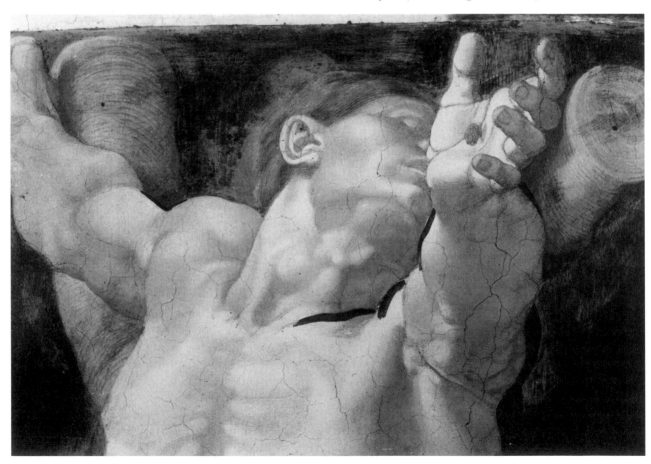

THE "SUBSTITUTE CARTOON"

The "Substitute Cartoon" and the Tradition of the *"Ben Finito Cartone"*

In discussing cartoons, ornament patterns, and mechanically traced copies, we have inevitably and repeatedly encountered the practice that often accompanied their transfer as a protective measure: "substitute cartoons." Much of the evidence about "substitute cartoons" is fragmentary, and conclusions remain speculative. But in order to visualize this very real, yet elusive, practice a summary of the textual and visual evidence is necessary.

The tradition of the *"ben finito cartone,"* developing from the 1460s onward (Plate II)[1] and culminating during the Cinquecento, seems to have largely conditioned the parallel practice of "substitute cartoons." (This procedure has continued to be used by artisans well into modern times.) We may hypothesize that the gradual emergence of the tradition of the *"ben finito cartone"* probably began to require also the integration of "substitute cartoons" as a practice. That a gradual application of "substitute cartoons" indeed occurred – first in a small fragmentary form between the 1460s and 1490s and then in a large, comprehensive form from about 1500 onward – would help explain the following problems in the cartoon's history. First, no cartoons survive for the earliest murals painted from cartoons, those dating between the 1430s and the early 1480s. Only *spolvero* marks or stylus incisions *(incisioni indirette)* on the mural surface can establish that cartoons were used to paint them. Second, the earliest large-scale cartoons to survive, though in fragments only, portray the human head. Dating from around 1469 to the late 1490s, the great majority of these cartoon fragments are for panel paintings. And third, surviving examples of large and relatively complete compositional cartoons are of a later date still, only from about 1500 onward. As proposed in Chapter Seven,

functional outline cartoons may have been traditional during the Quattrocento; the cartoon fragments depicting highly rendered heads may mark the beginnings of the *"ben finito cartone"* tradition. From an economic standpoint, the development of "substitute cartoons" as a practice must have depended on that of the Central-Italian paper industry during the fifteenth and sixteenth centuries.[2] The greater availability of paper in the late Trecento and during the first half of the Quattrocento increased the opportunities for exploratory drawing on paper, culminating first in the use of full-scale cartoons for stained-glass windows and then for murals. Yet, as the surviving textual and visual evidence suggests – and such evidence is fragmentary – "substitute cartoons," much like *"ben finiti cartoni,"* were generally a luxury rather than an absolute necessity of workshop practice.

Broadly speaking, the procedure of "substitute cartoons" could be viewed as the attempt by Renaissance artists and artisans to reconcile the realities of workshop practice with the ideal of *disegno* that regarded beautifully rendered drawings, particularly *"ben finiti cartoni,"* as increasingly important for the creative process.[3] Therefore, if many cartoons served a strictly utilitarian design function for much of the fifteenth century, it may be argued that they often acquired a predominantly aesthetic design function by the sixteenth century, whereby surface finish was crucially emphasized. This change in function, which is perhaps better described as an enrichment of function, may have increasingly required the use of "substitute cartoons." Thus, the utilitarian design function served by cartoons throughout much of the Quattrocento could be displaced onto "substitute cartoons."

The visual and textual evidence suggests that the tradition of "substitute cartoons" was both old and relatively widespread among artists, artisans, and copyists.[4]

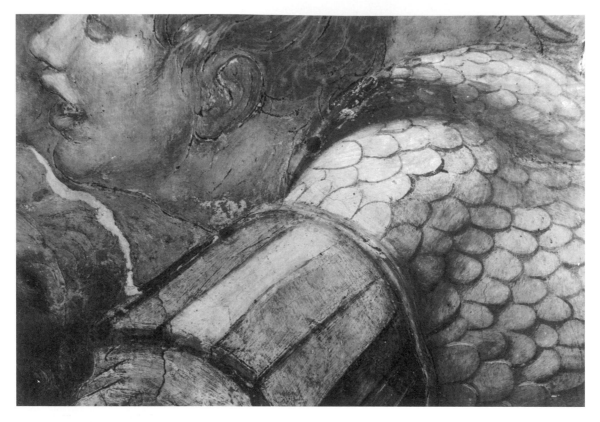

Figure 239. Detail in raking light of workshop of Raphael, The Battle of Ostia, *fresco (*Stanza dell'Incendio, *Vatican Palace), showing crude, deeply excavated stylus incisions through the cartoons.*

It was not only a means of design preservation but also of replication.

Destructive Working Procedures

It must here be emphasized just how much the working process damaged cartoons, particularly the techniques of design transfer it encompassed. As we have seen, cartoons were normally cut into pieces to be more manageable for mural painting. At the moment of transfer, cartoons for frescos were laid against the moist plaster. (In *a secco* murals the *imprimatura* [priming or ground preparation] was usually quite dry.) In easel paintings with the media of tempera or oil, the injury to cartoons was considerably less, since they were generally not cut up (see Chapter Two), and contact with the dry *imprimatura* was relatively harmless. But during the actual process of transfer – for paintings in all media – if the outlines of a design were incised with a sharp point, this often sliced the paper. In recommending the procedure of stylus-tracing cartoons onto the fresh *intonaco ("ricalcare"),* Andrea Pozzo specifically

cautioned that it be done gently *("legermente").*[5] The *intonaco* of the *Battle of Ostia* (Fig. 239), from 1515 to 1517, exhibits deeply gouged but schematic incisions and raised ridges of excess plaster. This vividly attests to the fact that Raphael's assistants transferred the cartoon swiftly and lethally.[6] The same is true of one of the earliest murals documenting the *calco* technique: a St. Jerome with an unidentified female saint (S. Domenico, Pistoia), from the 1460s to 1470s, by an artist in the circle of Andrea Verrocchio.[7] Later, the modified *calco* technique of smudging the verso of a sheet of paper with charcoal or chalk before tracing the outlines with the stylus would alleviate this problem (see Chapter One). Of course, this method was useless in fresco, for it would have not only soiled the moist plaster, but the unset surface would have been too yielding for a carbon or chalk line to be transferred.

Although less destructive, the technique of pouncing the pricked outlines of a design on paper or parchment also inflicted damage (see Chapter Two). Acisclo Antonio Palomino's *Museo pictórico y escala óptica* (Madrid, 1715–24) calls the actual process of pouncing with charcoal dust *"ensuciar"* (to dirty).[8] As a number of extant

drawings and manuscripts can confirm, pouncing dust was frequently rubbed heavy-handedly, leaving disfiguring gray or black smudges. We are not sufficiently aware of this type of damage, precisely because so few extant pricked designs exhibit evidence of actually having been rubbed with pouncing dust. The common practices of pouncing a design from the verso and/or using "substitute cartoons" were attempts to minimize this damage. Moreover, repeated pouncing to reproduce compositions manifold must have proved especially deleterious, which explains the reason why Palomino recommended the use of "substitute cartoons" to make copies by means of *spolvero* (see Chapter Three).

Textual Evidence

Considering the labor and expense required to produce *"ben finiti cartoni,"* particularly for large compositions, artists must have worried about damage to the drawings during the working process. Leonardo stated in his memorandum in *Madrid Codex II,* that when he began painting, on 6 June 1505, in the Council Hall of the Palazzo Vecchio, a great storm with torrential rains broke out and the cartoon became unstuck *("il cartone sistracio").*[9] Letters and payment records from 1523 to 1529 reveal that Giovanni Francesco Capoferri da Lovere and his wood craftsmen worked from tracings of Lorenzo Lotto's cartoons to produce the wood *intarsie* for the choir of S. Maria Maggiore in Bergamo, in order to spare the precious original drawings from damage. Giovanni Battista Armenini's *De' veri precetti della pittura* (Ravenna, 1586) suggests that in painting most of the damage to cartoons occurred at the moment of their transfer. Visually documented since at least the 1460s to 1470s, the *calco* technique was by the time of Armenini's treatise the usual and quick method of cartoon transfer; *spolvero* was considered a more time-consuming and archaic method.[10] Nevertheless, Armenini prescribed the use of *spolvero* "substitute cartoons" to spare *"ben finiti cartoni"* from the destruction of the working process. This is our single most important source. Although we briefly noted it in Chapter One, regarding Michelangelo's Naples cartoon fragment for the *Crucifixion of St. Peter* (Fig. 3), the nuances of its content shed light on the reconstruction proposed below, and we may therefore quote the passage again: "But then to save cartoons unharmed, needing afterward to trace the [cartoons'] outlines onto the surface on which one is working, the best way is to prick their outlines with a needle, having placed another cartoon underneath, which

becomes pricked like the one placed on top, [and which] serves later to pounce over and over where one desires to paint, and especially on plaster. . . ."[11] As Armenini reasoned, by using a pricked "substitute cartoon" to pounce the design onto the working surface, the painter could save the undamaged cartoon, the *"ben finito cartone,"* to use as a guide in painting. Armenini's passage on "substitute cartoons," like others in his treatise, does not restrict the practice to fresco painting, and, thus, in principle, for example, it does not exclude Leonardo's various techniques of mural painting. In fact, "substitute cartoons" were widely applied in other media besides painting – embroidery, ceramics, *intarsia,* and tapestry, as discussed below. In describing the use of *spolvero* "substitute cartoons," Armenini may have recalled the practices of Raphael's workshop. He was especially familiar with the design methods of Giulio Romano (whom he could have known personally), as well as of Polidoro da Caravaggio, and Perino del Vaga, writing about them with great admiration.[12]

The principal reason for Armenini's recommendation to use "substitute cartoons" lay in the fact that he, like Vasari before him, had viewed cartoons as the highest achievement of *disegno.* The Venetian Fra Francesco Bisagno repeated Armenini's passage verbatim in his *Trattato della pittura* (Venice, 1642), which indicates the continuity of the practice into the Seicento.[13] Catherine Perrot's *Traité de la Miniature* (Paris, 1625) notes that "to preserve your drawing or print, it is necessary to sew onto your print or drawing two sheets of paper of the same size before you prick it, because you will go over one of these papers with the pouncing bag."[14]

Apparently, one of these pricked "substitute cartoons" was pounced onto the vellum of the miniature to be painted, while the other was used as a trial piece before actually drawing and painting on the vellum.[15] Later, Charles Germain Saint-Aubin's *L'Art du Brodeur* (Paris, 1770) would describe "substitute cartoons" for embroideries as follows: "when these drawings have been approved, he [the embroidery designer] traces them [the carefully drawn designs] onto oiled [translucent] paper, lining this paper with another paper which is called *grand-raisin,* and has them pricked simultaneously."[16]

Vasari's introduction to the second edition of the *Vite* (Florence, 1568) and Raffaele Borghini's *Il Riposo* (Florence, 1584) mention an analogous procedure for panel paintings in oil: stylus-traced rather than pricked and pounced "substitute cartoons."[17] According to Vasari's and Borghini's methods, a blank sheet whose verso was smudged with charcoal was placed between the cartoon and the surface onto which the design was

to be transferred. Then the outlines of the drawn cartoon were traced with the stylus. The middle sheet in this procedure is the precise ancestor to modern "carbon paper." Such later treatises as Claude Boutet's on miniature painting (Paris, 1676) and its anonymous English translation (London, 1752), as well as Abraham Bosse's tract on etching and engraving (Paris, 1645), speak of similarly stylus-incised substitutes.[18]

Vasari's justification for "substitute cartoons" to paint panels foreshadows Armenini's: "because in doing this, one does not destroy the cartoon."[19] The exalted praise by both theorists of *"ben finiti cartoni"* gains practical credence when we consider their endorsement of "substitute cartoons." The reason why Vasari omitted the passage on stylus-incised "substitute cartoons" altogether in the 1550 edition of the *Vite* is mysterious. In the absence of any references, we can also only guess whether Vasari and Borghini thought "substitute cartoons" useful for frescos.

The lower ranks of artisans and copyists elicit further reasons for "substitute cartoon" use. The practice could function as an effective shortcut to manifold replication. Saint-Aubin explained that embroidery designers would produce multiple replicas of a particular pattern to assist in delegating labor: "one often pricks four or five pieces of paper at one time; these prickings help make the [copies of the] designs which one gives to the different ateliers [for embroidering]."[20] In *El museo pictórico y escala óptica* (Madrid, 1715–24), Acisclo Antonio Palomino recommended the technique of interleafing a blank sheet underneath the design being pricked to produce a copy, a "substitute cartoon" the artisan used in turn to pounce onto the final working surface (see Chapter Three). All such means minimized the damage inflicted on the original.

Visual Evidence

The written sources can help us reconstruct the physical appearance of "substitute cartoons" more or less precisely. As can be deduced, "substitute cartoons" were blank sheets of paper, placed underneath the *"ben finito cartone"* (or any other drawing, print, or pattern to be transferred), that were either pricked or stylus-incised simultaneously with the design on top. These were a record of mechanically transferred outlines and thus only depicted either pricked outlines or stylus incisions. They were not, strictly speaking, duplicates, since the paper was blank, as Armenini's passage quoted above confirms.[21] Palomino elaborated on pouncing pricked copies, the principle being identical to that of the

pricked "substitute cartoon": ". . . and afterward one pricks it [the design] onto another, *clean* paper, so that that one serves to pounce."[22] Borghini's direction about stylus-traced "substitute cartoons" is also unmistakable on this point: "and between the cartoon and the painting, [place] a *white* sheet in the same size and blackened with charcoal on that side, which one places on the gessoed priming."[23] Later, Bosse would apply the essence of Borghini's advice to the art of print making.[24]

The descriptions in the treatises by Armenini, Borghini, Vasari, and Bisagno, especially, imply that large "substitute cartoons," like *"ben finiti cartoni,"* were assembled by gluing multiple sheets of paper. In Michelangelo's Naples cartoon for the *Crucifixion of St. Peter* (figs. 8–9), the small, extant piece of the "substitute cartoon" – the patch with the pricked but undrawn design of the nude male pelvis – exhibits portions of at least two (possibly three) structural joins of paper, suggesting that the "substitute cartoon" originally consisted of *fogli reali* glued in a manner similar to the *"ben finito cartone."*[25] Some of the larger pricked "substitute cartoons" for the Escorial embroideries, to be discussed below, are also on glued sheets of paper. The procedure for transferring "substitute cartoons" onto the working surface, particularly onto the moist *intonaco* of a fresco (about which Armenini remained silent), could not have differed from that for drawn cartoons, as described in Chapter Two.[26]

Paintings and drawings can exhibit a variety of archaeological evidence that may demonstrate the probable use of "substitute cartoons" to transfer their design.[27]

The origins of "substitute cartoons" may be traced as far back as the mid–tenth century, as is documented by at least one pattern on paper from the *"Caves of the Thousand Buddhas"* at Dunhuang (China), in which the pricked, but undrawn outlines represent a seated Buddha figure.[28] As part of the Buddhist design tradition, Buddha figures were replicated almost endlessly. The side of the sheet exhibiting crisp holes (the recto) is also that rubbed with *tuhong,* the local red earth-powder in Dunhuang used for pouncing. Toward the center, on the top and bottom borders, this "substitute cartoon" has two short lines that served as centering marks, and at some point, an artist began to connect the holes on the wings with black paint, and those of the halo with pink. In the West, great numbers of pricked "substitute cartoons" for the decorative arts help us document the practice in relative detail, but the extant visual evidence for its use in painting is extremely fragmentary.

Exactly when "substitute cartoons" entered the workshop practice of Italian painters is not clear: they must have been useful early on in the painting of orna-

ment. By at least 1485–90, as discussed in Chapter Six, Domenico Ghirlandaio and his *équipe* of assistants employed a "substitute cartoon" to transfer the pricked, nearly life-size Chatsworth portrait cartoon onto the fresco surface (Figs. 214–15).[29] The crucial archaeological evidence emerges from a comparison of the fresco surface to the cartoon. On the plaster there are soft, plump stylus incisions made through the paper of a cartoon *(incisioni indirette)* in the area around the woman's left shoulder and breasts, whereas on the Chatsworth drawing the corresponding outlines are pricked, as are all of the cartoon's other outlines.[30] As pointed out, the rest of the woman's figure in the fresco is entirely stylus-incised, suggesting that Ghirlandaio's "substitute cartoon" was partial, only used for the area of her head. An actual example of such a fragmentary "substitute cartoon" is found on a sheet of studies with unrelated pricked outlines by Don Bartolomeo della Gatta from around 1485–1500 (CBC 108).[31] The date for this sheet can be established by the fact that the later study of a foreshortened head on the recto served for one of the apostles in the artist's altarpiece of the *Assumption of the Virgin* (S. Domenico, Cortona). A more mysterious example of a "substitute cartoon" fragment survives on a sheet of pen studies by Raphael in Oxford.[32] On the recto, this sheet portrays a group of four young warriors, in a style that is typical of Raphael's Florentine or early Roman pen drawings (c. 1504–9), and on the verso there are nude and detail studies, including a large, pricked outline-drawing of a foreshortened head in a nearly profile view (Figs. 240–41).[33] The character of the perforations prove that the pricking on the Oxford sheet was done from the recto (rather than from the verso), for it has crisply shaped holes and is rubbed heavily with black pouncing dust.[34]

Evidence of a more comprehensive use of "substitute cartoons" is unfortunately less conclusive. Raphael and his *bottega* probably applied the practice in parts for the *School of Athens* (*Stanza della Segnatura,* Vatican Palace), frescoed in 1510–12. This is suggested by the fact that the outlines on the monumental cartoon (Pinacoteca Ambrosiana, Milan; Fig. 41) are pricked,[35] while the fresco surface reveals complex combinations of *spolvero,* as well as direct and indirect stylus incisions.[36] Thus, the outlines of the *"ben finito cartone"* were apparently pricked onto a "substitute cartoon," whose outlines in turn were then transferred in sections, and by various means, onto the painting surface. That Raphael's *"ben finito cartone"* in Milan shows little sign of having been cut into silhouetted pieces corresponding to the sutures of individual *giornate* or groups of *giornate* would seem to point further to the use of "substitute cartoons" (see

Chapter Two).[37] The structural joins from the paper assembly are generally undisturbed, as is true of many Renaissance and Baroque cartoons.[38] In the case of the *School of Athens* fresco, the insertion on new *intonaco* of the figure of Heraclitus demonstrates that Raphael at times made major changes after the completion of the *"ben finito cartone"* and the initial execution in fresco.[39] Comparisons of the *School of Athens* cartoon, to the fresco as painted, reveal a multitude of other less significant modifications in the final composition, some of which document the preparation of revised, partial cartoons, which are now lost.[40]

We can reasonably speculate that Michelangelo also used "substitute cartoons" for the early *"historie"* of *Genesis* in the Sistine Ceiling, frescoed in 1508–10.[41] Yet, it is clear from the cleaning of the ceiling that, as Michelangelo worked from east to west on the *historie,* he gradually became more economical in his painting practices, abandoning *spolvero* in favor of *calco* in the interest of more rapid execution, and probably also dispensing with the preparation of *"ben finiti cartoni,"* which required transfer by means of "substitute cartoons."[42] As we have seen, the production of cartoons and "substitute cartoons" was a time-consuming, relatively expensive process, not least due to the cost of paper and its assembly. Firm evidence of Michelangelo's use of "substitute cartoons" dates from about three decades later: the small piece with a perforated design of a nude male pelvis glued as a patch onto the Naples cartoon fragment for the *Crucifixion of St. Peter* (Figs. 8, 9), which is among the rare examples of "substitute cartoons" securely related to an actual painting.[43] As mentioned, this fragment exhibits portions of at least two (possibly three) structural joins of paper, which suggests a relatively comprehensive "substitute cartoon." As we have also seen, the area in Michelangelo's Pauline Chapel fresco that corresponds to the Naples *"ben finito cartone"* is composed of ten crudely joined *giornate,* and the joins of the cartoon's paper, still intact in their form of regular rectangles, do not show evidence that the cartoon was cut for transfer (Figs. 3–5).[44] The cartoon in the British Museum (Figs. 34, 229), which Michelangelo drew in the 1550s to help Ascanio Condivi paint an altarpiece (Casa Buonarroti, Florence), was probably also transferred onto the panel by means of a "substitute cartoon," but stylus-incised in the manner described by Vasari and Borghini.[45] A "substitute cartoon," comprised of sheets with versos blackened with charcoal or chalk dust, would have allowed Condivi to indent the outlines of Michelangelo's cartoon slightly and bluntly, for as is true of modern-day "carbon paper," an outline could

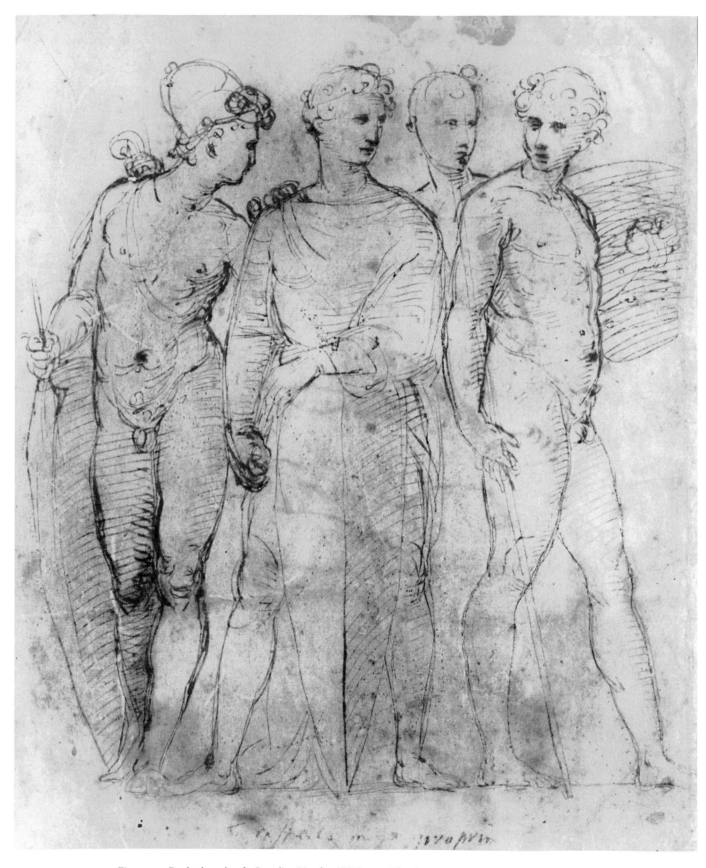

Figure 240. Raphael, studies for Standing Youths *(CBC 251; Ashmolean Museum inv. P II 523 recto, Oxford), with unrelated pricked outlines rubbed with black pouncing dust. A copyist outlined this pricked design with pen and brown ink on the verso of the sheet.*

Figure 241. Approximate reconstruction of the unrelated pricked outlines on Raphael's Ashmolean sheet, a "substitute cartoon."

be conveyed onto another surface with minimal pressure on the original cartoon on top. The surface of Michelangelo's British Museum cartoon is extremely abraded, and the drawn outlines, which are repeatedly reinforced, have a rigidity of stroke that, though not showing a noticeable indentation, could well be the result of this procedure.[46] The earliest "substitute cartoons," however, and probably Michelangelo's own – judging from the proportion of *spolvero* relative to *calco* in his frescos – must have been closer to Armenini's description than to Vasari's and Borghini's. More complete evidence regarding the practice emerges from the decorative arts.

The Decorative Arts

A large corpus of extant sixteenth-century examples confirms the practice of pricked "substitute cartoons"

for embroidery, which is also discussed in Saint-Aubin's *L'Art du Brodeur* (1770). Three albums of designs exist for the embroidered liturgical vestments at the Monastery of San Lorenzo de El Escorial (see Appendix Three). Two albums contain highly finished drawings with pricked and unpricked outlines, most of which were apparently produced between 1587 and 1589 by two eminent local artists, Miguel Barroso and Diego López de Escuriaz, as well as by a team of less skilled, anonymous artists (Fig. 242; CBC 8–13, 158–71, 367–405). Individual sheets of drawings pertaining to the same project are now scattered in the collections at the Musée des Beaux-Arts of Orleans, the National Galleries of Scotland (Edinburgh), the Pierpont Morgan Library (New York), and periodically turn up in the art market. Although exhibiting noticeable differences in the quality of execution, the drawings are identical in medium: pen and brown ink, brush and brown washes, over traces of black chalk underdrawing, on *"carta azzurra"* (blue paper), now often discolored to a gray-green hue. None of the designs is rubbed with pouncing dust. (It is clear from preliminary research on the paper trade, at least in Italy, that *"carta azzurra"* was more expensive than many uncolored papers.[47]) A third volume in the Library of El Escorial contains fifty-two pages glued with ninety-four pricked but undrawn designs. These sheets with pricked but undrawn outlines were the "substitute cartoons" employed by the artisans to produce the Escorial embroideries. The Escorial "substitute cartoons" are all on white paper, but with little to see in them, for as we can also deduce from Armenini's description, "substitute cartoons" have no drawing. Frequently, their designs are more intelligible from their versos (Fig. 243), rather than from their rectos (the side from which the pricking was done). The Escorial "substitute cartoons" are in the same size as the *"ben finiti cartoni,"* recording exactly their pricked outlines hole-by-hole, and are usually rubbed heavily with pouncing dust, which in photographs appears as a faint gray tone. Appendix Three presents a correspondence between the Escorial album of "substitute cartoons" and the *"ben finiti cartoni"* in the other two Escorial albums, as well as those scattered in other European and American collections. The division of labor in this commission was relatively complex, but it can be followed

with surprising precision through the extant payment documents.[48] From the existence of the Escorial "substitute cartoons" album, we can extrapolate that embroiderers often did not use the carefully drawn designs for the destructive process of transfer onto the cloth. The practice of "substitute cartoons" for embroidery, as is fully documented in the relatively late instance of the Escorial commission, helps explain the reason why earlier pricked Renaissance drawings for embroidery survived the working process.

No treatise on the production of ceramics mentions the *spolvero* technique, including Cipriano Piccolpasso's *Li Tre libri dell'arte del vasaio* (MS., 1556–59), the foremost text on the subject.[49] But the technique was clearly part of the workshop practices of ceramicists, as suggested by the large archive of papers and designs, from around 1620 to 1900, owned by the potters of Castelli.[50] Of the 113 pricked drawings, prints, and sheets in this archive, it can be established that 59 seem to be "substitute cartoons": sheets with pricked outlines, but undrawn designs, many rubbed with pouncing dust. In a number of cases both the original design – a drawing or a print – and the resulting "substitute cartoon" survive, and the "substitute cartoon" rather than the original design is heavily rubbed with pouncing dust, at times from both recto and verso.

Domenico Beccafumi's *Intarsia* Cartoons

Among the monumental examples of projects carried out by artisans that probably required "substitute cartoons" are Domenico Beccafumi's large cartoons at the Pinacoteca Nazionale, Siena (CBC 16–17), preparatory for pavements of inlaid marble *(intarsia)*. Seven of these extant cartoons depict scenes from the life of Moses and were commissioned by the *operai* of Siena Cathedral for the interior pavement that is still in situ near the crossing of the building (Figs. 32–33); the related documents date between 1519 and 1531.[51] The execution of an eighth cartoon for *intarsia,* probably for a marble tomb slab, but of unknown patronage, is weaker

Figure 242. Attributed to Miguel Barroso, pricked cartoon for Christ and Nicodemus Discussing the Sacrament of Baptism (CBC 384; National Galleries of Scotland inv. D 1788, Edinburgh). The extant embroidered cope is in the Monastery of S. Lorenzo de El Escorial.

than that of the *Moses* cartoons.[52] Domenico Beccafumi (1486–1551) belonged to the generation of Tuscan painters who stylus-traced, rather than pounced, cartoons for transfer onto the painting surface. A relatively large corpus of stylus-incised drawings[53] and the surface of many of his paintings throughout the city of Siena attest to this design practice: the triptych of the *Holy Trinity* (Pinacoteca Nazionale), as well as the frescos in the Cappella del Manto (Spedale di S. Maria della Scala), those in Siena Cathedral, and those in the Oratory of S. Bernardino.[54] Finally, besides the *intarsie* cartoons just mentioned, there are no extant pricked drawings securely attributed to Beccafumi.

Clearly, more needs to be known about how such designs could have been transferred in the medium of *intarsia*. Although the introduction to Vasari's *Vite* (Florence, 1550 and 1568) states that cartoons were necessary in designing *intarsia* pavements, it does not specify how they were transferred.[55] Both *spolvero* and *calco*

Figure 243. Detail of the verso of a pricked "substitute cartoon," The Parable of the Blind Leading the Blind,
for one of the Escorial embroideries (Library inv. 28-I-2, fol. 33, Monastery of S. Lorenzo de El Escorial).

must have been used, the latter probably by blackening
with charcoal or chalk the verso of the cartoon itself,
or by using a "carbon copy." As we may remember,
Vasari recommended *spolvero* cartoons for the *sgraffito*
decoration of palace façades, no doubt because it
involved the manifold replication of ornamental
motifs,[56] and he repeatedly prescribed plain *calco* to
transfer cartoons for frescos or mosaics, as well as the
modified "carbon copy" method for easel paintings.[57]
According to Vasari's description of *intarsia* pavements,
the artist himself reworked with the brush and black
pigment, in *"tratteggio"* (hatching) and *"proffilo"* (out-
line), the design transferred from the cartoons onto the
marble. The rest of the labor was left to the artisans, the
"scultori," or carvers, who cut and/or incised the mar-
ble pieces with chisels. Areas of intermediate shadows
were inlaid with darker marble, while the darkest shad-
ows were carved out and the hollows filled in with a
mixture of black pitch, asphalt, and earth.[58]

In view of this working procedure, and the repeated
adjustments of the marble slabs that were probably nec-
essary, we can reasonably infer that Beccafumi's cartoons

were pricked for transfer onto "substitute cartoons."
These, in turn, could either be pounced or incised with
the stylus onto the marble by means of the "carbon
copy" method. Beccafumi's cartoons do not appear to be
rubbed with pouncing dust, but their abraded state of
preservation prevents definitive conclusions. The joins of
their paper structure are intact. The relatively large pay-
ment of 84 lire to Beccafumi on 27 June 1524, for one of
the nonextant cartoons portraying the hexagonal scene
of *King Ahab and Elijah,* emphasizes that it is "for his toil
[fadighe] in having designed and painted *[disegniate e
dipente]."*[59] All the cartoons are carefully finished with
pen and ink, brush and wash, over extensive charcoal
underdrawings. An emphatic handling of these com-
bined media was crucial in articulating the powerful
"rilievo" of the figures and overall readability of the
designs. Particularly because the production of the mar-
ble inlay was to be delegated to various laborers (known
by name), precautions must have been taken to prevent
damage to the cartoons.[60] The *Opera del Duomo* paid
Beccafumi handsomely for the cartoons and their subse-
quent history suggests that they were much esteemed.[61]

Summary of the Documents about Leonardo's *Anghiari* Cartoon

It is usually agreed that Leonardo's mural of the *Battle of Anghiari* in *"La Gran'Sala del Consiglio"* of the Palazzo Vecchio in Florence was intended to be of the same size as Michelangelo's *Battle of Cascina*.[62] Thus, the unusually large quantity of paper and the enormous amount of flour, bought for the preparation of Leonardo's *Anghiari* cartoon, have remained among the puzzling facts in the literature on the commission. They can be explained in terms of the "substitute cartoons" practice. Although reconstructions of the area of the murals have varied greatly, the quantity of paper for Leonardo's cartoon seems to be roughly double the area of his mural as plausibly proposed by Johannes Wilde and others.[63] That both Leonardo and Michelangelo used cartoon paper of Bolognese origin and in the *reale* size helps us interpret precisely the data from the documents.

A payment record in February 1504 to the *cartolaio* Giovandomenico di Filippo establishes the quantity (1 *"lisima"* and 18 *"quaderni"*) and price, as well as the *"quadratura"* and *"apianatura"* of Leonardo's cartoon paper.[64] According to the Bolognese statutes governing the production of paper, a *lisima* or *risma* (ream) was comprised of 20 *quaderni*, while a *quaderno* (quire) was comprised of 25 sheets (see Chapter Two). The 1504 payment record to Leonardo's *cartolaio* quotes two different prices: 12 soldi per *quaderno* for those constituting the *lisima,* and 11 soldi per *quaderno* for the 18 sold loosely. This difference of price is by no means a transcription error, for the payment record in April 1505 to Lorenzo Peri states that the three *quaderni* in the Bolognese *reale* size, given to Leonardo, were at 11 soldi the *quaderno*.[65] Thus, at this later date, although the suppliers of paper were different, loose *quaderni* of *fogli reali* continued to be sold at 11 soldi each. Based on the February 1504 payment record, it can be suggested that the price difference per *quaderno* between the *lisima* and the *quaderni* being sold loosely, that is, a higher unit price for the *quaderni* that constituted the *lisima,* most probably indicates a difference of quality. The evidence of the second purchase of paper over a year later, in April 1505, should not be discounted, because the entry states *"per la pictura"* rather than *"per il cartone,"* for it is wholly consistent with the record of payment for cartoon paper in February 1504. The total number of *fogli reali,* at 11 soldi per *quaderno,* would thus be 525. By comparison, a nearly identical amount of paper would probably be of a higher quality: 500 sheets at 12 soldi. According to this hypothesis, the total number of sheets in the *reale*

size intended for Leonardo's cartoon, regardless of price difference, should then be revised to 1,025 sheets, or 41 *quaderni* in the *reale* size. This alone totals about 272 to 286 square meters of paper.[66] A comparison to the payment records regarding Michelangelo's preparation of the *Cascina* cartoon reveals that he bought slightly less than half as much paper in the *reale* size, only a total of 425 sheets, that is, 17 *quaderni*.[67] This amounts to almost 113 to 119 square meters of paper.[68] But at 10 soldi per *quaderno,* Michelangelo also paid 10 percent less than Leonardo's cheaper grade of *reale* size paper.

If, as these documents might suggest, Leonardo had planned from the start to use comprehensive "substitute cartoons" for the *Battle of Anghiari,* it would roughly diminish by one-half the amount of paper purchased for the drawn cartoon; the rest would have been used in the "substitute cartoons." Such an amount begins to square with both the reconstruction proposals for the area of the murals and with Michelangelo's purchase of cartoon paper. The hypothesis might also account for the different prices of the paper: the expensive paper was intended for the *"ben finito cartone,"* the cheaper grade for the "substitute cartoon." Thus, it is no coincidence that the total amounts of paper in the two different prices are nearly identical. Leonardo had probably bought the entire amount of expensive paper for the *"ben finito cartone"* by February 1504, over a year before he began painting, but the amount of cheaper paper intended for the "substitute cartoon" was a more difficult amount for him to predict well in advance of painting. This would explain the supplement of more than a year later: the additional order of 3 *quaderni* in April 1505, just before he began painting by early June, as stated in the memorandum of *Madrid Codex II*. Payment records also for April 1505 show purchases for priming and painting ingredients, as well as salaries for Leonardo's assistants and day laborers. Of some importance, the purchase record of paper in April 1505 states that the paper is *"per la pictura"* not *"per il cartone,"* which had thus far been the usual reference in the payment records about both projects. As is suggested by Armenini's beginning sentence in his paragraph on "substitute cartoons" – "But then to save cartoons unharmed, needing afterward to trace the [cartoons'] outlines onto the surface on which one is working" – "substitute cartoons" were considered part of the painting process, not of the drawing process. The hypothesis also helps explain the document describing the enormous quantity of flour Leonardo bought from the baker Giovanni di Landino on 30 June 1504, which was delivered in two install-

ments: to glue further parts of Leonardo's *Anghiari* cartoon (*"rinpastare"*; see Chapter Two).[69] Thus, finally, our hypothesis that Leonardo was intending to use a *"ben finito cartone"* and an equally comprehensive "substitute cartoon" helps solve the otherwise implausible scenario that over a year after beginning, Leonardo was still buying paper to draw the cartoon, despite his huge initial purchase of paper and as if he had misjudged the size of his mural.

The *Battle of Anghiari* appears to be an early, if not the first, use of comprehensive "substitute cartoons" in the High Renaissance. No other corpus of surviving documents about cartoons offers the opportunity for a comparatively systematic analysis of paper quantities and types, prices, materials, and manual labor, and no extant visual evidence regarding the Council Hall commission can confirm our reading of the documents. Nevertheless, the practice of "substitute cartoons," a deliberate protective measure, would fit well with both Leonardo's circumspect attitude toward painting and the developments of theory and practice that shaped the cartoon's history in the High and Late Renaissance. The critical praise of the *Anghiari* cartoon, recorded in the Cinquecento written sources, attests to an extraordinary mastery of drawing.

Yet the *Anghiari* cartoon was valuable to the patron from a legal, contractual point of view. It is evident in the revised contractual document of 4 May 1504, between Leonardo and the Signoria, that from a legal standpoint, Leonardo's *Anghiari* cartoon, a valuable commodity, was the patron's security.[70] The first of the draconian clauses in this document clearly states that in case of a breach of contract, the cartoon became automatically the property of the Florentine Republic, for the cartoon had been produced at the Signoria's expense.[71] The final clause is no less telling. It explicitly seeks to protect Leonardo against the possibility of the Signoria commissioning any other painter to execute the mural from Leonardo's cartoon, once the cartoon was complete: that is, without Leonardo's express consent. It thus admits to the possibility that the actual execution of the mural could be delegated.[72] Despite the expenditure of materials and labor, therefore, the use of "substitute cartoons" for the *Battle of Anghiari* was a succinctly practical solution.

Conclusions

The practice of "substitute cartoons" in the decorative arts appears to have arisen in cases where the roles of designer and manufacturer were divided: a group of artisans translating carefully finished drawings commissioned from an artist or a group of artisans availing themselves of already existing designs. Division of labor, as well as availability of labor, may have enabled a comprehensive application of the practice in many sixteenth-century mural decorations, for which *"ben finiti cartoni"* were prepared. We may recall that in the *Anghiari* documents the designation of Leonardo's assistants, "Raffaello d'Antonio di Biagio" and "Ferrando Spagnuolo," as *"dipintori"* suggests their status as skilled painters in their own right, though perhaps not matriculated in the guild.[73] And they appear to have been paid accordingly, for Raffaello d'Antonio seems to have collected a daily wage of 20 soldi – more even than the well-paid *cartolai* who helped assemble Michelangelo's cartoon.[74] Tommaso di Giovanni Masini, who ground colors, was paid in turn as Ferrando Spagnuolo's *"garzone"* (assistant), with a lump sum; neither person's wage rate is specified.[75] This suggests a neat pyramid of delegated labor – Leonardo at the top, then the *"dipintori,"* then the *"garzoni."* Ample evidence exists of Italian Renaissance artists painting (or otherwise utilizing) compositions from other artists' cartoons. We may recall that when the Brescian painter Lattanzio Gambara married the daughter of his teacher Girolamo Romanino, at the time the leading painter of Brescia, the dowry included "some pricked cartoons" (*"alcuni spolveri"*).[76] Vasari told in the *Vita* of Jacopo Pontormo that Pontormo painted a *Noli Me Tangere,* as well as a *Venus and Cupid,* after Michelangelo's cartoons, which, to judge from both the extant copies, as well as the biographer's description, must have been *"ben finiti";* the Michelangelo correspondence seems to confirm the validity of Vasari's claim.[77] We shall return to other examples in Chapter Eleven.

The practice of "substitute cartoons" appears to have coincided with the moment of greatest graphic refinement in the history of the drawn cartoon: the ideal of the *"ben finito cartone,"* explored in Chapter Seven. But although we can reasonably conclude that many *"ben finiti cartoni,"* as well as other types of finished drawings, were probably transferred onto the working surface by the intermediary means of "substitute cartoons," sufficient exceptions should remind us to be cautious. For Armenini's parting sentence in his description of "substitute cartoons" is noteworthy: "However, very few pay heed to this, and trace the first [cartoon], that which one retains as a guide in painting with colors...."[78]

Brilliantly drawn in charcoal with lead white chalk highlights, Giulio Romano's large *"ben finito cartone"*

293

fragment in the Pinacoteca Ambrosiana, Milan (CBC 204) is instructive in this respect.[79] It was intended for the *Battle of Constantine at the Milvian Bridge* (*Sala di Costantino*, Vatican Palace), frescoed around 1520–21, soon after Raphael's death. An analysis of the paper assembly in Giulio's cartoon fragment suggests that it must have been used on the *intonaco*. As pointed out in Chapter Two, the portion of the fresco that corresponds to the Milan cartoon fragment was painted with relatively thick pigmentation, and in large *giornate* – a measure of skill and self-assured rapidity. It is also carefully and entirely pounced. The outlines of Giulio's *"ben finito cartone"* fragment are pricked, and the painted outlines in the fresco follow the *spolvero* precisely. The cartoon fragment exhibits two types of paper joins. Most are structural, that is, rectangular, regular, and overlapping, but a few have sharply irregular contours and are without paper overlaps. Some of these latter joins, and, more importantly, the entire irregularly cropped upper border of the cartoon, correspond to the general disposition of *giornate* in this part of the fresco, suggesting that the cartoon must have been cut during the working process, and reassembled later.

Two of the cartoons by Agostino Carracci for the ceiling of the *"Galleria Farnese"* (Palazzo Farnese, Rome), frescoed in 1597–1600, offer another important opportunity for comparison in this respect.[80] The large cartoons (National Gallery, London) are executed in an identical medium: charcoal, highlighted with lead white chalk, on numerous, glued *"carte azzurre,"* produced in the paper mills of Fabriano.[81] But the outlines of the cartoon portraying *Cephalus Carried off by Aurora in her Chariot,* are stylus-incised, and this cartoon has joins of the two types we have been discussing: those from the original assembly and those from the transfer process, which broadly correspond to the eight, rapidly painted *giornate* on the fresco surface and closely follow the contours of the figures. In the pendant cartoon, portraying a woman carried off by a seagod (the so-called *"Glaucus and Scylla"*), the outlines are pricked. That cartoon has only structural joins from the original assembly, and the corresponding fresco surface, comprised of seventeen *giornate,* suggests that, by comparison to the *Cephalus and Aurora,* the scene was painted laboriously and probably much earlier in the program. Although the precise reason for the choices of cartoon transfer methods remains unclear, the division of labor at the moment of painting must have played a role. In the frescoed ceiling, the cartoon transfer methods alternate between *spolvero* and *calco,* but *calco* predominates, as was usual for this time.[82] It is entirely likely that the

pricked cartoon was transferred onto a "substitute cartoon," which would explain its intact paper assembly.

Baroque painters certainly continued the practice, as Fra Francesco Bisagno's treatise of 1642 attests, in repeating Giovanni Battista Armenini's passages at length. One extant example is a large cartoon fragment by Domenichino representing a flying *putto* (CBC 58), drawn in charcoal and with stylus-incised outlines.[83] This cartoon consists of four glued sheets of paper and contains unrelated, undrawn pricked outlines, suggesting that it is a "substitute cartoon" fragment that Domenichino reused to draw the large cartoon of the *putto.* The pricking was done from the recto, as attested by the crispness of the outlines and the clean edge of the paper pushed downward by the needle around the holes. The *putto* in the drawn part of the cartoon served for the fresco of *Truth Disclosed by Time* (Palazzo Costaguti, Rome), from about 1622.

Finally, Raphael's *"ben finiti cartoni"* for the Sistine Chapel tapestries (Plate VII, Fig. 244) illustrate in a nutshell the complexity of the practice that we have here attempted to reconstruct.[84] Only seven cartoons are extant from the series commissioned by Pope Leo X around 1514 and completed in 1516; the tapestries were woven in Brussels between 1517 and 1521 in the atelier of Pieter van Aelst (also called Pierre d'Enghien).[85] The cartoons are painted broadly and thickly with the brush and colored gouache (mineral pigments bound with animal glue), on a charcoal underdrawing that is visible with infrared light. They are sturdily built with a regular, rectilinear paper assembly, largely devoid of *quaderni* creases. Glued in an upright orientation, the sheets measure about 420–30 by 285–90 mm. This is almost exactly the size of a *reale* sheet cut in half (also the approximate size of a *"rezzuta"* or *"comune"* sheet; see Chapter Two). Curiously, the outlines of the Sistine Chapel tapestry cartoons are pricked. The *spolvero* technique was, of course, not part of the weaving process, for tapestry designs are woven simultaneously with the cloth support.[86] (No pouncing dust is apparent.) Analysis of the cartoons' structure leaves little doubt that there are two general types of paper joins: one series from the original assembly of the cartoons' paper (with overlaps), done before painting, and another series that run in vertical strips ranging between 410 mm. and 660 mm. in width.[87] The presence of this second group of joins establishes definitively that the cartoons were cut into strips for weaving. (The anomalous *Miraculous Draught of the Fishes* exhibits also *giornate*like slicing of the paper.) We can therefore reasonably suppose that

Figure 244. Detail of Raphael and workshop, cartoon for Christ's Charge to Peter *(CBC 266 B; Victoria and Albert Museum, London), pricked by a copyist. The corresponding tapestry, woven for the Sistine Chapel, is in the Vatican Museums.*

Figure 245. Detail of Tommaso Vincidor and Flemish artist (attributed), unpricked "copy cartoon" in exact scale after Raphael's Christ's Charge to Peter *(Musée Condé inv. Peinture 40 C, Chantilly).*

the pricking was done to produce "substitute cartoons." These "substitute cartoons," however, were not made for the original weaving procedure. Instead, they served to produce copies of Raphael's cartoons, which were, in turn, used by various artisans to weave some of the plentiful tapestry copies that survive.[88] "Copy cartoons" in exact scale after Raphael's Sistine Chapel tapestry cartoons are also extant (Fig. 245).[89]

Throughout the era of the monumental cartoon in the Renaissance and Baroque, the "substitute cartoon" would clearly bridge the creative and reproductive processes of design.

THE ART OF *DISEGNARE*

Design Transfer Techniques in the Tradition of Exploratory Drawing

Concurrently with the ideal of *disegno* that regarded beautifully rendered drawings, particularly *"ben finiti cartoni,"* as increasingly significant for the creative act, came a more deliberate approach to the preliminary design of the *historia*. However, we have seen just how closely allied the processes of "invention" and "replication" of images could be during the fifteenth and sixteenth centuries, from the work by great artists to that of modest artisans, to that of fraudulent copyists. The *spolvero* technique could indeed enable not only the multiple reproduction and transfer of patterns and cartoons onto the working surface but also the development of preliminary studies from one sheet of paper onto another.[1] As is well known, Italian art theorists from Leon Battista Alberti onward would reserve their highest praise for the originality of an *"inventione."*[2] Yet how the notions of "originality" and "invention" were understood, especially during the Renaissance, needs a further refinement of context. The gradual development of engraving and woodcut as reproductive print media during the second half of the Quattrocento would generally transform their meaning, as would the use of time-saving, semimechanical means of design transfer.

At least sixty-one of Raphael's creative drawings bear outlines either pricked for transfer or drawn on top of *spolvero* marks (CBC 223–77), if we were to include the seven extant Sistine Chapel tapestry cartoons (Victoria and Albert Museum, London). This number translates into approximately a sixth of the artist's corpus of figural drawings, as it is currently defined in the literature. The studies are executed either in the full scale of the final work or considerably

smaller, and they span the master's entire, though short, career. If at times presenting complexities far exceeding the scope of this book, such a corpus of drawings nevertheless demonstrates that Raphael followed a highly systematic process of preliminary design, one that must have largely evolved from his training in Pietro Perugino's workshop and the established traditions of design replication in Umbria and the Marches. Yet on the whole, if all extant preliminary drawings from the Italian Renaissance were to be considered, we could confidently conclude that the vast majority of artists developed their most creative types of preliminary drawings freehand, based on their *"giudizio dell'occhio."* Here, Raphael was also no exception. After all, techniques of design transfer could hardly substitute for the *idea* (in the Platonic sense of inspiration) in the process of *"inventione."* Sketches of all types – *"schizzi,"* or *"primi pensieri,"* to borrow Filippo Baldinucci's term in 1681 for initial sketches – were always executed freehand, as were usually the figural studies after nature that followed. Techniques of design transfer facilitated the process of refinement, variation, and exact reproduction for synthetic types of drawings: drawings of motifs, figures, or *historie* whose design had reached a relatively advanced stage of development. It is this narrower aspect of Italian Renaissance practice that concerns us here.

Not surprisingly, the evidence from the written sources is again extremely fragmentary[3] and does not hint at the fluency with which some artists adopted a variety of pricking and pouncing techniques to elaborate successive drafts. This is a chapter in the history of Italian *disegno* therefore largely told by extant drawings. Only Armenini's *De' veri precetti della pittura* (Ravenna, 1586) offers testimony of any consequence, for it admiringly records the equivalent drawing practice by

members from Raphael's *bottega,* long after the master's death in 1520. To transfer their drawings effortlessly from one sheet of paper onto another for further elaboration or reproduction, Giulio Romano, Polidoro da Caravaggio, and Perino del Vaga employed a *calco* method (much like that of modern-day "carbon copies"), whereby the verso of the paper was smudged with charcoal or chalk before tracing the drawing with a stylus, or any other pointed implement.[4] Such stylus-incised drawings by Giulio and his contemporaries are still extant and can verify Armenini's report, for their versos are still blackened from rubbed charcoal or chalk.[5] One of Federico Barocci's polished, small-scale composition drafts in black chalk and oil paint for the Senigallia *Entombment,* from 1579 to 1582, can document this *calco* technique into Armenini's day.[6]

Such fluency of design could have hardly been possible, however, without the pioneering precedents of this practice, as developed with pricking and pouncing techniques.

Problematic State of the Visual Evidence

The application of the *spolvero* technique to develop preliminary drawings from one sheet onto another may have emerged as a practice more or less contemporaneously with that of cartoons for murals – if not by the 1440s, then soon afterward. This function, however, could have also developed much later in the fifteenth century, for the earliest drawings executed on *spolvero* marks date only from the 1480s to 1490s. Hypotheses on this matter hinge upon a much larger, not entirely resolved issue – the role of exploratory drawing during the fifteenth century – and, therefore, a refined chronology at this point of research does not seem feasible.[7] As is well recognized in the literature, there are many more surviving examples of exploratory drawings from the later Quattrocento than from the Trecento to the mid-Quattrocento. Various types of exploratory drawings have undoubtedly perished, both because of the relative fragility of paper and parchment and because of the extent to which artists drew on other surfaces: on the actual walls and floors of their houses, workshops, and other premises; on the thin, prepared wood tablets that could be erased and reused (with which master artists taught the skill of drawing to apprentices); and, especially, on the surfaces of the final works.[8] Accomplished exploratory underdrawings can often be seen below the crumbling pigments or unfinished designs of illuminated manuscripts on parchment.[9] In the case of detached murals, the *sinopie* on the layer of the *arriccio* frequently reveal similarly free underdrawings, as do the wood panels of paintings and the cloth supports of certain unfinished or worn embroideries.[10] Thus, at an early period when so much of the preliminary design process unfolded directly on the working surface, rather than in drawings on paper, the *spolvero* technique may have played a narrow role, serving solely to replicate or transfer designs during the final stage of a project. As is often pointed out, the phases of preliminary drawing on paper were probably not strongly differentiated until the later fifteenth century.

Nonetheless, the fact that artists relied on *spolvero* and pricking techniques for the purpose of exploratory drawing bears direct weight on our understanding of Italian Renaissance cartoons.

Some late Quattrocento and early Cinquecento artists drew full-scale drafts of compositions at times, both before and after the stage of preparing "final" cartoons. (Raphael's practice of cartoons and "substitute cartoons" already hints at the complexity of the full-scale design process in the stages of revision and transfer onto the final working surface.) Precisely because the pricked outlines of small-scale drawings, however, often resulted from attempts at either replicating them or elaborating further drafts, cautious interpretation is necessary, even in cases where both the final work and the extant corresponding drawings prove to be of identical scale.

This is true of Pietro Perugino's large silverpoint drawing portraying Apollo and a seated figure who may be either Marsyas or Daphnis (Fig. 246).[11] Perugino's delicately drawn, but obviously unfinished, exploratory study dates from 1480 to 1490. A number of its contours are softly incised: Apollo's legs, the seated figure's right leg, and the rock on the left, above the seated figure's head. Moreover, the outlines on the upper right part of Apollo's cranium are finely pricked, the holes being nearly imperceptible. The rest of the outlines exhibit no apparent signs of transfer, but infrared reflectography examination reveals comprehensive *spolvero* marks in the underdrawing on the painted panel (Musée du Louvre, Paris), for which the drawing was clearly a study (Fig. 247).[12] Since the designs of the figures in the drawing and the panel correspond,[13] we can glean that Perugino produced intermediary drawings, which, however, have been lost. The general appearance of such lost drawings must have been disturbingly mechanical, as can be surmised from a rare extant drawing of *Christ and the Samaritan Woman* (Fig. 248), from 1500 to 1505, probably by Perugino or a close associate, and preparatory for an extant *predella* panel (Art Insti-

tute of Chicago). It is drawn on top of *spolvero,* reworked freehand with black chalk, and then blackened quite unattractively with chalk for light stylus-indentation transfer.[14]

We can, therefore, doubt that Raphael's vigorously drawn, though incomplete, pen and ink study for a *St. George and the Dragon* (Fig. 249) functioned as the "final" cartoon.[15] The composition probably dates around 1503–4. Although the outlines of the main design in the drawing are pricked, those of the rocks in the background and the animal skull are not. The dimensions and main design in the sheet agree with those of the painted panel (Musée du Louvre, Paris), which, along with another panel of *St. Michael,* also in the Louvre, formed part of a small diptych.[16] In the *St. George* drawing, the landscape setting, the broken pieces of the lance, and the figure of the princess – all apparent in the final composition – are still absent. Moreover, as a point of reference, we may compare this study to Raphael's later version of *St. George and the Dragon* (Fig. 56). As discussed in Chapter Two, that cartoon corresponds exactly with the painted panel in Washington (Fig. 57), from 1505 or so. The composition of the later *St. George* drawing – a final cartoon – has reached a fully complete state, and the handling of the pen and ink is so precise that it seems nearly lifeless. A similar uniformity of finish is true of other pricked cartoons for small paintings, produced by Umbrian artists around the turn of the century. Such examples also exhibit rubbed black pouncing dust, attesting to their use.[17]

That semimechanical methods of design transfer served to produce both copies and exploratory drawings vastly complicates our understanding of Renaissance practice. By the end of the fifteenth century, *"ben finiti disegni"* were created in both traditions. The distinction between copy and creative drawing can be ambiguous, as we can plainly see from a group of highly rendered wash drawings done from *spolvero* underdrawings, related to the work of Andrea Mantegna. The Munich and Berlin drawings are somewhat

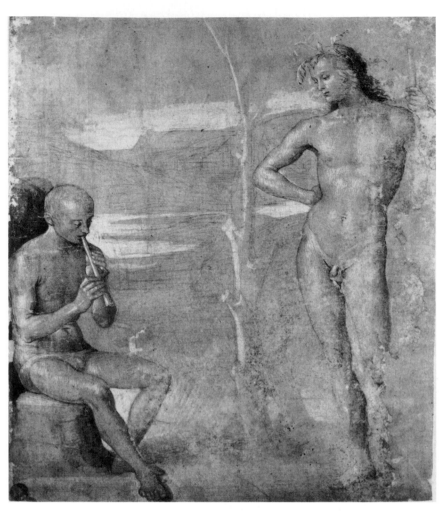

Figure 246. Pietro Perugino, full-scale study for the "Contest of Apollo" (CBC 328; Gallerie dell'Accademia inv. 198, Venice), with some pricked and lightly incised outlines.

disfigured by the fact that their paper supports were once cut into pieces that were subsequently heavily restored.[18] They each portray a dancing muse in Mantegna's *Parnassus* (Musée du Louvre, Paris), a canvas painted around 1497 for Isabella d'Este's *Studiolo* at the Palazzo Ducale in Mantua. A third, much less retouched drawing in Washington, *Judith with the Head of Holofernes,* based on a composition that exists in several drawn and painted variants and that is generally contemporary to the *Parnassus* muses, has only recently been shown to be drawn on *spolvero.*[19] It remains to be decided whether these full-scale drawings – and no doubt other examples will turn up – are (a) autograph, exploratory drawings by Mantegna, prepared from the compositional cartoon to refine the chiaroscuro of the design, or (b) merely copies derived

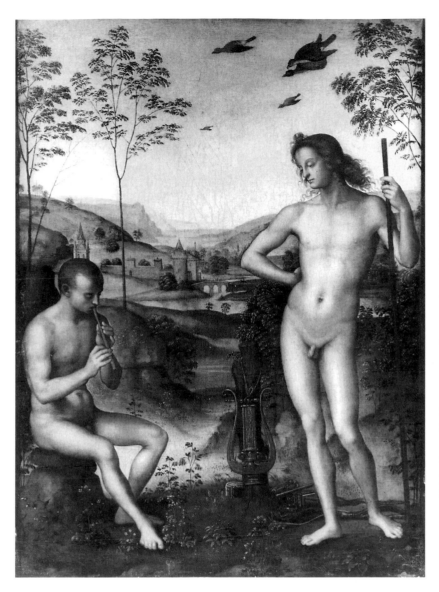

which artists integrated the technique into their creative processes of design remains difficult, if not impossible, to assess. For example, if a mechanically transferred drawing manifests minute changes of design, at what point do we cease to regard it as merely a copy and begin to regard it as a variant of the design leading to further solutions? Artists often developed an *"inventione"* by refining variations on a similar theme. This point is most readily demonstrated in the case of ornament. One of Leonardo's drawings in the *Codex Atlanticus* (VIII, fol. 700 recto, Biblioteca Ambrosiana, Milan; CBC 137) elaborates several alternatives for interlacing stars on the same sheet of studies, and there, a framework of *spolvero* underdrawing offered the artist his point of departure.[22] The same is true of a cruder *cartouche* design with strapwork ornament (Uffizi inv. 6921 A, Florence), from the *bottega* of Bernardo Buontalenti. The final composition, though not identical in all its outlines to the preliminary *spolvero* underdrawing, relies closely on its structure.

Drawings Pricked and Pounced for Further Development onto Other Sheets

Figure 247. Pietro Perugino, "The Contest of Apollo," tempera and oil on panel (Musée du Louvre, Paris), painted from spolvero *underdrawing.*

from Mantegna's lost pricked cartoon, either by the artist himself, a member of his *bottega,* or a later draughtsman.[20] Although compelling arguments have been marshaled in support of the first point of view, there is a greater probability that the drawings are copies.[21] Their enormously labor-intensive chiaroscuro drawing technique with stippling would have actually been redundant, if the drawings were preparatory for paintings, for the process of modeling would have had to be entirely repeated on the final working surface.

Precisely because the reproductive and functional applications of *spolvero* were so inextricably bound – without a clear-cut distinction – the true extent to

The survival of drawings on *spolvero* (evident as dotted charcoal or chalk underdrawing) can verify that at least some examples from the vast corpus of small and large-scale drawings with pricked outlines must have been pounced for transfer onto other sheets of paper for the further development of their design. In only very few cases, however, do both the original designs and their derivations survive, to offer a firm basis for documenting this particular practice.[23] The master designs exhibit pricked outlines, while the derivations show the *spolvero* marks resulting from the transfer process. Unfortunately, the archaeological evidence is usually incomplete. For example, we cannot precisely compare the perforated holes on the master designs to the *spolvero* marks on the derivations, because the *spolvero* is too effaced and only too sporadically visible.

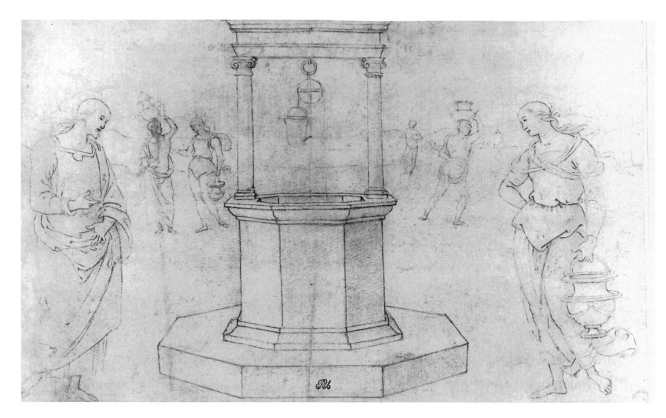

Figure 248. Workshop of Pietro Perugino, cartoon for Christ and the Samaritan Woman *(Ashmolean Museum inv. P II 31, Oxford), drawn from* spolvero *outlines and then lightly incised for further design transfer. A related painting from the* predella *part of an altarpiece is in the Art Institute of Chicago.*

The identification of *spolvero* underdrawings, as a means of production and reproduction in the design of individual motifs or entire compositions, considerably affects our traditional notions of artistic "originality" and "quality" of execution, which are the basis of connoisseurship. In the case of sheets that were barely reworked freehand with charcoal, black chalk, or another medium, the *spolvero* is often evident as interrupted, gray or black powdery outlines (often rubbed), where the individual marks are not discernible as dots. *Spolvero* outlines could, therefore, easily be confused with the tentative, faltering, and awkward freehand lines produced by amateur or unskilled draughtsmen. (We should therefore remember not to judge such semimechanically produced underdrawings with criteria that apply to freehand drawings.) Whether such outlines were produced by the master, his less gifted assistants, or later copyists is intrinsically indistinguishable. Only the ensuing layers of freehand drawing and overall design can reveal the identity of the author's

hand. When drawings executed on *spolvero* outlines are compared with others that are entirely freehand, the difference is immense: chiefly, the former exhibit considerably fewer *pentimenti*. The solution is thus not simply an evaluation of the "superior" or "inferior" hand but of the different processes used by the same hand.

For a variety of complex reasons, drawings on *spolvero* marks can be identified in far fewer cases than drawings with pricked outlines. Perforations from pricking are not easily disguised, particularly because the artist generally produced them during the final stage of work on a drawing and because they permanently and visibly alter the paper support. In great contrast, *spolvero* marks are ephemeral because of their very method of production and their function as underdrawing (see Chapter Two). According to Alessandro Paganino's embroidery patternbook (Venice, c. 1532), artists and artisans could dispose of excess pouncing dust by simply blowing it away.[24] Unlike the *spolvero* marks on a fresco surface, where the subsequent water-based paint layer and the gradual carbonation of the *intonaco* help fix their shape, *spolvero* marks on paper can easily become distorted, erased, or covered by the ensuing layers of freehand drawing.[25] Abrasion of the drawing surface can also damage the evidence of *spolvero,* and artists and restorers often actively tried to

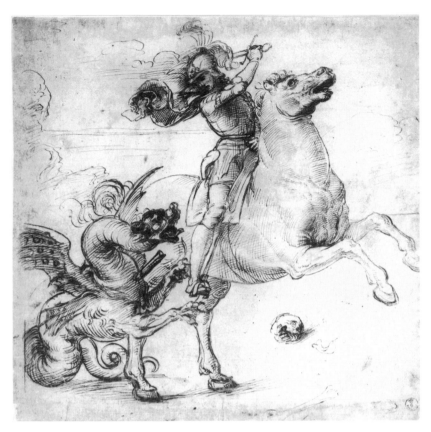

Figure 249. Raphael, full-scale study for St. George and the Dragon *(CBC 234; Gabinetto Disegni e Stampe degli Uffizi inv. 530 E, Florence), with selectively pricked outlines.*

recall Catherine Perrot's recommendation in the *Traité de la Miniature* (Paris, 1625) to erase excess pouncing dust with bread crumbs.[28] Moreover, from Giovanni Battista Armenini's telling description of Giulio Romano's *calchi* (repeated by Fra Francesco Bisagno), it is clear that artists often purposefully erased auxiliary traces of chalk, whether left from the transfer process or not (see Chapter Two). To Giulio, whose numerous extant drawings frequently bear the signs of design transfer methods, it was crucial to simulate the spontaneity of having drawn his *"disegni ben finiti"* without a guide and thus to suggest his dazzling *"facilità"* of invention. Such displays of technical virtuosity gradually became part of the sixteenth-century ideal of *disegno,* but this is precisely the reason why we are so ill-informed regarding the technical means by which that virtuosity was achieved.

Use and Reuse of Drawings in Luca Signorelli's *Bottega*

The extant, pricked figural drawings by Luca Signorelli and his assistants (CBC 287–98) imply a use and reuse of designs that also obscure distinctions between invention and reproduction; many of their sheets even exhibit signs of more than one type of design transfer. An impressive study in charcoal or black chalk of a man standing in a vigorous athletic pose (Fig. 251) is squared on top of the layers of drawing, including the white gouache highlights.[29] This suggests that after the study was transferred by means of pricking – or pouncing, though rubbed pouncing dust is not evident – it was reused on a larger scale by means of the proportional squaring grid. The combination of both pricked outlines and squaring commonly appears in other drawings by Luca and his workshop. In fact, a monumental study in black and red chalk for a standing saint (CBC 289) was squared with two grids of different scale: first underneath with black chalk at 50 mm. intervals and then on top of all layers of drawing with pen and ink at 31 mm. intervals.[30] Moreover, the

"clean" drawings. One verifiable example of the latter may speak for others, where slight damage by overcleaning can remain only a suspicion. In 1913, when Oskar Fischel published the *Circumcision of Christ* (Fig. 250) in his monumental corpus of Raphael's drawings, he noted tentatively that the *all'antica* pedestal on the altar seemed to have traces of *spolvero*.[26] The large, nearly full-size old photograph with which Fischel illustrated the Ashmolean Museum drawing confirms without doubt the presence of *spolvero* dots in this passage, albeit slightly rubbed. The entire composition of the drawing corresponds exactly both in scale and design with the central portion of the scene in the *predella* from the Oddi Altarpiece, the *Coronation of the Virgin* (Pinacoteca Vaticana), painted in 1502–3.[27] Yet today the *spolvero* dots are no longer visible in the Ashmolean sheet (Fig. 250). Its charcoal underdrawing exhibits only faint, hazy, relatively continuous contours.

As noted in Chapter Two, the erasing of *spolvero* also formed part of actual workshop practice: here, we may

Figure 250. Raphael, The Circumcision of Christ *(CBC 226; Ashmolean Museum inv. P II 513, Oxford), partly drawn from* spolvero *outlines.*

outlines of the figure were pricked in at least two, possibly three separate campaigns: at least once with fine, densely spaced holes, and at least another with thicker, less regularly spaced holes. The male saint's figure appears to have been repeatedly recycled in changed contexts, as is also suggested by the variations on his attributes.[31] The spirited rendering of the Louvre drawing establishes Luca's authorship with relative cer-

tainty. But whether the design was reused by the artist, or his assistants, is not clear.

Such techniques of design transfer also had a place in Luca Signorelli's more unfinished studies. In a sheet that was preparatory for four standing apostles (CBC 288), the artist first explored the poses of the figures in the nude and then added their draperies.[32] Only the man on the extreme left is fully clothed. This is clearly a work in progress, and of exciting immediacy, for in contrast to the monumental figures on the left, the two figures on the right are barely sketched. The drawing's syncopated squaring grids, and its pricked outlines sug-

gest the use and reuse of the group. The figures turn up as apostles in the left foreground of the *Assumption of the Virgin* (Museo Diocesano, Cortona), an altarpiece commissioned from Luca in 1519 for the Cathedral of Cortona but that may have been executed almost entirely by the artist's nephew and assistant, Francesco Signorelli.[33] Another of the master's accomplished studies in black chalk, portraying three horsemen (CBC 292), is in a similarly unfinished state, although the outlines of the design are likewise all carefully pricked.[34] The sheet was preparatory for figures seen in the center background landscape of *St. Benedict Welcoming King Totila* in the fresco cycle at the Abbey of Monteoliveto Maggiore, from the late 1490s.

The precise attribution of outline drawings can present notoriously difficult problems of connoisseurship, as we have seen. The complex archaeological evidence on a coarse tracing (CBC 294), which portrays some of the figures in the center of the *Resurrection of the Flesh* fresco at Orvieto Cathedral (1499–1504), can illustrate the scope of experimentation with mechanical design methods in Luca Signorelli's workshop.[35] Another outline drawing either by Luca Signorelli or an assistant, in the Louvre (Fig. 252), cannot possibly be a copy, as is sometimes stated, for the complex archaeological evidence identifies it without doubt as a working drawing, however coarse it may be (it is much more attractive than the "Orvieto" design just mentioned!).[36] The design relates to the lower half of the *Crucifixion* (Oratory Church of S. Crescenziano, Morra), frescoed in 1507–23. The Morra composition recalls those of an earlier *Crucifixion* panel (National Gallery of Art, Washington) and the *Lamentation,* painted for S. Margherita, Cortona (now in the Museo Diocesano).[37] The underdrawing of the Louvre composition draft, though exhibiting comprehensive *spolvero,* has also substantial passages reinforced freehand with black chalk. The outlines are pricked, and the squaring rests on top of all the layers of drawing. Thus, the artist partly relied on a previous drawing whose outlines he pricked and pounced for development onto the Louvre sheet. He altered the composition further with black chalk, then pricked the outlines and pounced them onto another

Figure 251. Luca Signorelli, squared and pricked study for a Standing Man *(CBC 287; Walker Art Gallery inv. 9833, Liverpool).*

surface: faint traces of rubbed pouncing dust are still apparent on the recto. Significantly, although it is of large dimensions and glued on four sheets of paper much like a cartoon, the drawing is in a smaller scale than the

Figure 252. Workshop of Luca Signorelli, squared and pricked composition draft for the lower part of the Crucifixion (CBC 295; Département des Arts Graphiques du Musée du Louvre inv. 1800, Paris), also drawn from spolvero outlines. This scaled design relates to the mural on the right wall at S. Crescenziano, Morra.

fresco; its scale, however, is consistently about one-third that of the fresco. The squaring in black chalk occurs at 32 mm. intervals. The reinforcement in pen and ink may date from after the pricked outlines were transferred by means of spolvero and could constitute further alterations to the design. Moreover, the artist constructed reference marks in black chalk, as well as pen and ink, based on compass work: they resemble intersecting crosses that repeat for dense passages of figural design throughout the composition. These intersecting crosses run corner-to-corner within the squares, so as to establish the basis for a second grid rotated 45 degrees along a diagonal axis.[38] At this point in the history of the Italian Renaissance squared drawing, only a "prospectivo," trained in the rudiments of proportional projection, could put the grid to such systematic use in the calibration of figural design; the authorship of Luca Signorelli should thus not easily be ruled out. As finally painted in the Oratory of S. Crescenziano, the composition for the Crucifixion was

still further adjusted. Moreover, two fragments in the British Museum (Fig. 253; CBC 296 A), relating to the fresco of the Flagellation on the opposite wall of the Oratory at Morra, were also produced by connecting the spolvero underdrawing dot-by-dot and combine uses of other transfer techniques.[39] The full-size cartoons for both the Crucifixion and Flagellation frescos were finally transferred by means of spolvero and, even more extensively, calco, onto the plaster.

Leonardo and the Problem of Scientific Types of Illustrations

Around 1507–10, Leonardo ingeniously applied the spolvero technique to clarify his large, complex anatomical diagrams of the arterial and genito-urinary systems of the female body. Fortunately, both drawings, that with pricked outlines and that with spolvero (Figs. 254–55), are in the Royal Library at Windsor, thus offering a unique opportunity for precise comparison.[40] Leonardo produced the first of the detailed illustrations (Fig. 254) by means of the same shortcut to bilateral symmetry that he used for drawings of ornament, architecture, and perspective.[41] He would prick

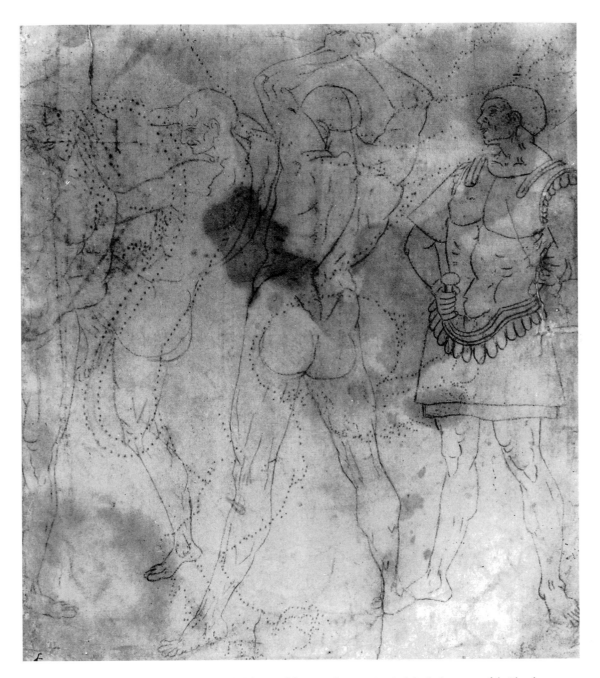

Figure 253. Workshop of Luca Signorelli, lightly incised fragment of composition draft for the lower part of the Flagellation of Christ *(CBC 296 B; British Museum 1895-9-16-604, London), also drawn from* spolvero *outlines and with unrelated pricked outlines. The figural design relates to the mural on the left wall at S. Crescenziano, Morra.*

the outlines of his drawing with two different diameter holes, types (a) and (b). When he folded the sheet vertically through the center, he finely pin-pricked the outlines of the drawing on the left half, as depicted by the chalk underdrawing, onto the right, using type (a), to complete a symmetrical design of the interior organs and blood vessels. Based on this fine type (a) pricking, Leonardo then drew on the right half in pen and ink,

redrawing much of the left half as well. He made the necessary adjustments on the right half, differentiating the organs that are not symmetrically paired and altering the placement of veins and arteries on the left. The latter accounts for unpricked passages. The substantial divergences between pricked and ink outlines – as in the area of the torso and rib cage – establish that Leonardo produced the greater part of the pricking on

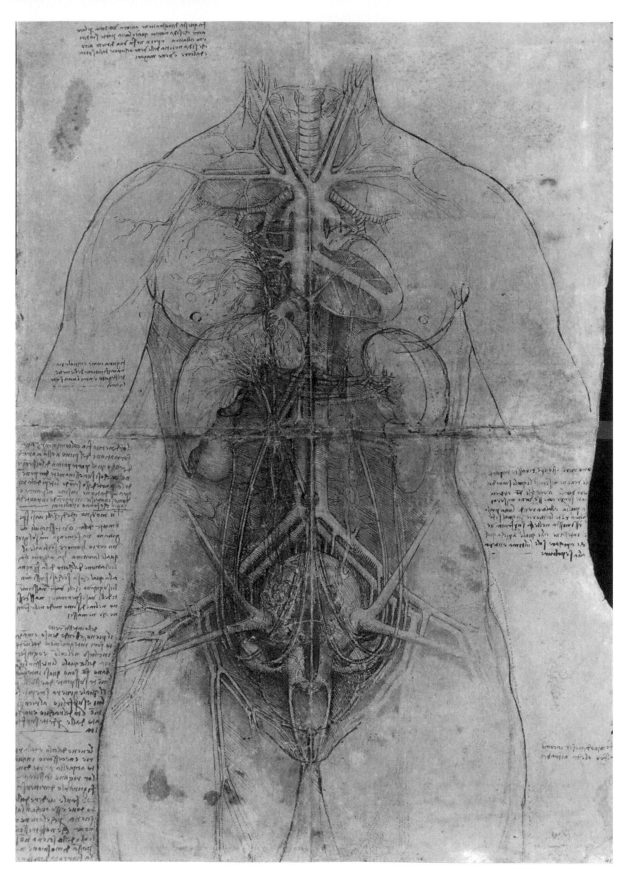

Figure 254. Leonardo, Anatomical Diagram of the Female Body, "The Great Lady of Anatomy" *(CBC 131; Royal Library inv. 12281 recto, Windsor Castle), partly drawn on pricked outlines, obtained by folding the pattern in half, vertically through the center, and pricking from left to right, and repricking of all main outlines.*

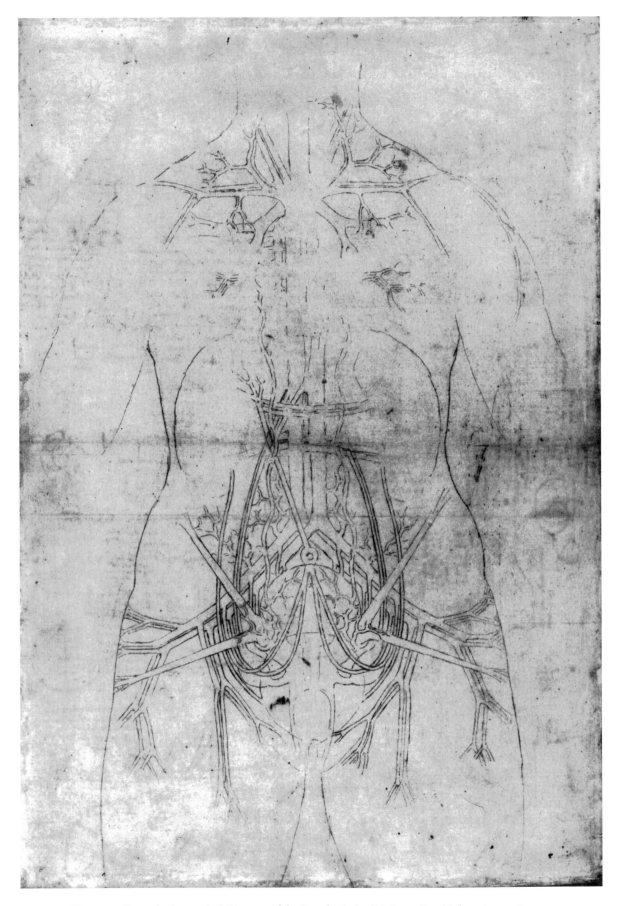

Figure 255. Leonardo, Anatomical Diagram of the Female Body *(CBC 132; Royal Library inv. 12280 verso, Windsor Castle), drawn from* spolvero *outlines.*

both halves prior to developing the drawing in ink. The pen and ink draft of the design required yet further clarification, both because of the intricacy of the resulting pricking and because of the density of the medium that Leonardo employed to draw. (On the yellow-brown washed paper, the artist had first explored the general contours of the anatomical forms with preliminary traces of black chalk, and possibly slight traces of red chalk; he had then outlined forms with pen and ink, also modeling them with brush and wash.) He therefore pricked the general body and rib cage outlines with a thicker point, type (b), to pounce the entire design onto another sheet (Fig. 255).[42] The pricked sheet still exhibits the evidence of having been rubbed with black pouncing dust, especially noticeable on the torso outlines. On the pounced derivation (Fig. 255), the faint *spolvero* outlines are visible in most parts of the design under the ensuing, heavy-handed pen and ink reworking. They remain fairly intact, though rubbed, near the right shoulder and armpit, on portions of the right half of the waistline and along the left torso and rib cage contours. The dotted outlines resulted from pouncing the pricked anatomical drawing (Fig. 254) along the outlines with type (b) holes on that sheet. The sheet drawn from the *spolvero* outlines (Fig. 255) is also, at least in part, an autograph design by Leonardo, for here we must take into account both its means of production and its role in the design process of the anatomical illustration.[43] If somewhat inchoate in form and abraded in surface, the diagram nevertheless clearly conveys the disposition of the woman's arteries and organs.

The surprisingly concrete case of the Windsor anatomical drawings provides a context for other examples of Leonardo's use of *spolvero,* where the physical evidence is more fragmentary. As is suggested by infrared reflectography, Leonardo apparently relied on preliminary *spolvero* outlines to draw his famous *Proportions of the Human Body According to Vitruvius* (the "Vitruvian Man," Fig. 256), which may be dated around 1490 and which may have been intended for a woodcut; a similar figure illustrates Fra Giocondo's edition of Vitruvius (Venice, 1511).[44] For the Venice drawing, the technique offered Leonardo an especially practical shortcut, since he needed to fit the man's figure within the measured stylus construction of circle and square. The artist must have previously worked out the numerous proportional adjustments for the figure in several drafts before finally drawing the man's outlines in ink in the Venice sheet and rendering his form carefully with parallel hatching within the geometric

framework. The general use of mechanical means of design transfer would gradually become part of the tradition of anatomical illustration. A few pages representing the proportions of the human head and body in the much-debated *Codex Huygens* (Pierpont Morgan Library, New York), probably drawn by Carlo Urbino in the 1560s to 1570s after Leonardo's designs, exhibit the evidence of transfer by means of the *calco* method.[45]

The same is true of other forms of didactic illustration. The *spolvero* underdrawing in two schematic outline designs of *icosahedra* in the *Codex Atlanticus* (VIII, fols. 707–8 recto; CBC 141–42) is evident with the plain eye. Here, the technique served to refine and accurately reproduce the foreshortening of the forms.[46] Though probably later copies by a pupil rather than originals by Leonardo, the *icosahedra* in the *Codex Atlanticus* resemble Fra Luca Pacioli's woodcuts in *De Divina proportione* (based on Leonardo's drawings), the manuscripts of which were probably drafted in 1496–98 in Milan and were expanded for the 1509 publication in Venice.

Leonardo also used the technique for more animated exploratory studies, as in the variations on the design of interlacing stars in the *Codex Atlanticus* (VIII, fol. 700 recto; CBC 137), discussed in Chapter Five. Executed entirely in black chalk over *spolvero,* these interlace designs may relate to the *"Sala delle Asse"* (Castello Sforzesco, Milan), decorated around 1498. Another page in the *Codex Atlanticus* (VIII, fol. 704 iv; CBC 139), possibly from as early as the 1480s, to judge from Leonardo's writing on the recto, contains small *spolvero* outlines portraying a human figure with an animal.[47] (The rubbed condition of the sheet, however, does not permit a precise identification of the subject.) For unknown reasons, the artist did not rework the *spolvero* freehand, leaving it entirely untouched as fuzzy, rubbed dots. Other sheets in the *Codex Atlanticus* may exhibit *spolvero* underdrawings as well, although evidence of the technique seems less conclusive.[48]

The application of the *spolvero* technique in Leonardo's beautiful drawings of maps of the Arno River, from around 1503–4, is reminiscent of his practice in anatomical illustration. One of the maps of the river and its valley with a proposed route for a canal (Fig. 257) is rendered atmospherically in a technique combining pen and ink, brush and wash, over black chalk: only the main outlines of the winding river and its arteries are finely pricked.[49] Rubbed *spolvero,* but not directly obtained from extant pricked drawings, are evident in two further maps, one of which is delicately finished in color.[50]

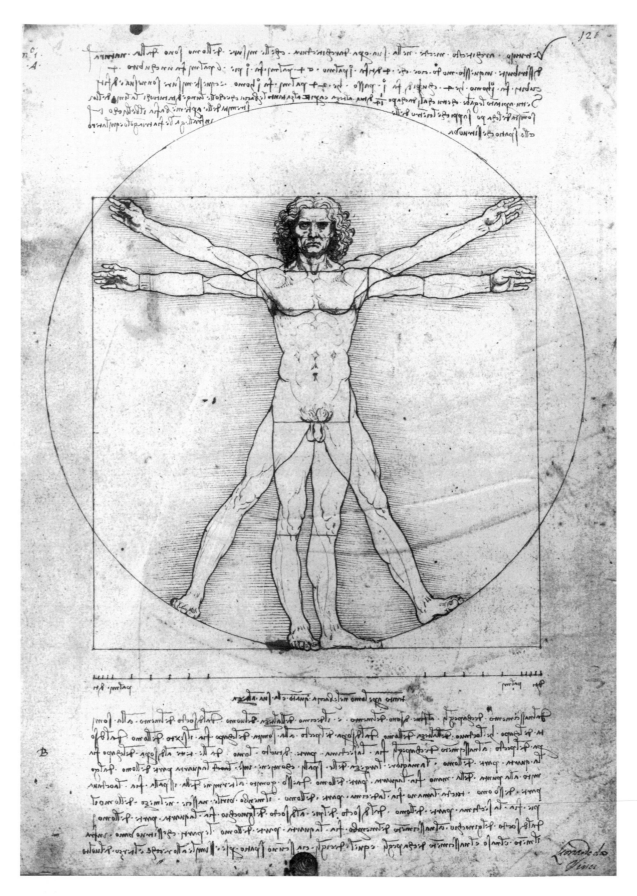

Figure 256. Leonardo, The Proportions of the Human Body According to Vitruvius *(Gallerie dell'Accademia inv. 228, Venice), drawn from* spolvero *outlines.*

Raphael's *Massacre of the Innocents*

If many of Leonardo's illustrations appear to have served a didactic, scientific purpose, our remaining case studies of *spolvero* production exemplify an application in the purely artistic context of designing an *historia*. Most significant of these, especially for the implications regarding Raphael's workshop practice, are the two studies, in the British Museum and in Windsor, for the *Massacre of the Innocents* (Figs. 258–60), executed in 1509–11.[51] Marcantonio Raimondi engraved this *historia* in two versions, "with the fir tree" and "without the fir tree" motif in the background (Fig. 261).[52] Although the majority of masterpieces painted by Raphael in Rome at the height of his career would remain behind closed doors, accessible only to a few of his contemporaries, his inventions, reproduced and disseminated in the prints by Marcantonio, Agostino Veneziano, Ugo da Carpi, Marco Dente "da Ravenna," Giulio Bonasone, and others cemented the master's great fame as a *disegnatore*.[53] As is usually agreed, Raphael probably developed the monumental composition for the *Massacre of the Innocents* almost contemporaneously with that for the *Judgment of Solomon,* frescoed on the ceiling of the *Stanza della Segnatura* (Vatican Palace).[54]

Raphael may not have necessarily designed the *Massacre of the Innocents* expressly for Marcantonio to engrave. Yet it is nevertheless worthy of our notice that the pricked centering and horizon lines in the British Museum sheet are calibrated with respect to the plate of the engravings and that the details in the British Museum and Windsor preliminary studies correspond identically in scale, and nearly so in design, with both versions of the print, as well as with the composition drawing that is now often regarded as the autograph *modello* for the print (Szépmüvészeti Múzeum, Budapest).[55] Infrared reflectography reveals *spolvero* marks in the underdrawing of the severely abraded Budapest *modello*.[56] The vigor and assurance with which Raphael drew the pen and ink composition draft in the British Museum (Figs. 258–59) – boldly cross-hatched, partly corrected in red chalk on the right, and with little traces of overall exploratory underdrawing – suggest that the sheet represents an early synthesis of key elements that he had previously developed in separate detail studies.[57]

Yet the British Museum composition (Figs. 258–59) is itself clearly a design in progress, one in which drawn and pricked outlines frequently diverge. Following the recommendation in Leon Battista Alberti's painting

Figure 257. Leonardo, pricked study for a Map of the Arno Valley with a Proposed Route for a Canal *(Royal Library inv. 12279, Windsor Castle).*

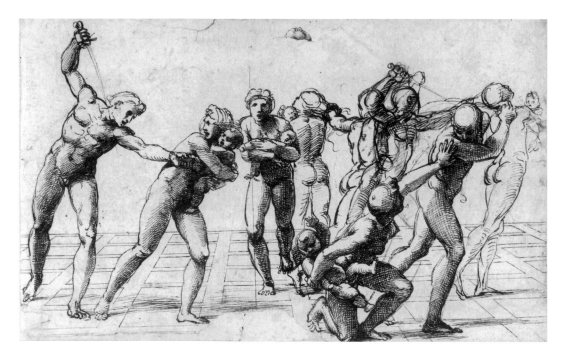

Figure 258. Raphael, pricked study for the Massacre of the Innocents *(CBC 257; British Museum 1860-4-14-446, London).*

Figure 259. Detail of Raphael, pricked study for the Massacre of the Innocents, *with reworking by the artist in red chalk.*

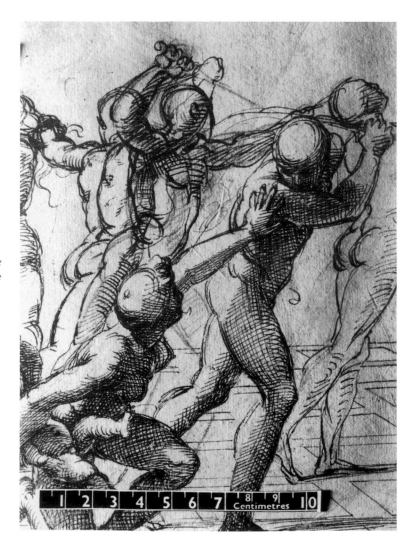

311

treatise (MS., 1435–36), Raphael drew all the figures in the nude, leaving them in different degrees of finish. He then pricked the design for transfer, and afterward, corrected the grouping on the right by adding in red chalk – as a sketchy afterthought – the figures of a sword-wielding executioner and fleeing mother with child (Fig. 259). These are the only main figures in the narrative whose outlines the artist left unpricked. In the upper center of the sheet, he also introduced a small study of a dead child's head, which he also left unpricked and which would reappear in the bottom center of Marcantonio's engraved composition. Raphael drew the receding *quadratura* of the pavement, which unifies space and figures into a three-dimensional whole, over a directly incised perspective construction, ruled with the stylus. This setting would also remain unpricked. The artist then centered the composition by means of horizontal and vertical pricked lines, precisely perpendicular to the borders of the sheet, onto the subsequent working surface. Almost certainly, this surface was the Windsor study (Fig. 260), drawn in red chalk on the basis of black chalk *spolvero* underdrawing. The main purpose of the Windsor sheet was to integrate the subtle chiaroscuro and the gradually increasing cast of characters in the narrative. The elements that Raphael left unpricked in the British Museum drawing disappeared from the Windsor sheet – the sketchy figures of the executioner and the mother with child, the pavement, and the dead child's head on the top. Here, the artist clothed the female figures, though the extant *spolvero* underdrawing on the sheet still depicts them nude, as in the British Museum draft. He added, freehand, five further figures in the background. The monumental forms of the mother and child, commanding the left foreground in the British Museum draft, remained only an undeveloped *spolvero* outline in the Windsor draft. Not only was her design too rehearsed to need repetition – she was the subject of individual studies in red chalk (Albertina inv. IV.188 verso, Vienna) – but her anchoring presence, unlike that of the Apollonian soldier immediately to her left, was not necessary for the further elaboration of the background figures.

Girolamo Genga's *S. Agostino Altarpiece*

In designing the altarpiece for S. Agostino in Cesena, which depicts the unusual subject of the Dispute on the Immaculate Conception, Girolamo Genga's method closely resembled that of Raphael in his Roman period (Figs. 262–64).[58] This monumental

"*sacra conversazione*" (Fig. 264), painted between 1513 and 1518, teems with figures tightly, if gracelessly, packed around the Madonna's stepped throne. Genga and the younger Raphael, both natives of Urbino and trained in Perugino's workshop (perhaps contemporaneously), may have occasionally shared a professional relationship, of which there remains only scanty evidence. Between 1506 and 1510, Genga was also Luca Signorelli's assistant; Genga may have met Signorelli at Urbino as early as 1494.[59] Both the composition draft in the British Museum with pricked outlines (Fig. 262) and its *spolvero* derivation in the Louvre (Fig. 263) are in red chalk, and both drawings depict the figures entirely nude, except for an occasional attribute.[60] Such nudity is also found in Raphael's pricked composition draft for the lower left portion of the *Disputa* fresco in the *Stanza della Segnatura* (CBC 250),[61] in his pricked composition draft for the *Massacre of the Innocents* (Figs. 258–59), as well as in Signorelli's pricked study for the apostles in the *Assumption of the Virgin* at Cortona Cathedral (CBC 288).[62] Similarly, the heads of Genga's figures frequently appear to be bald. Genga's British Museum draft (Fig. 262) represents an already precise synthesis of the final composition but is unevenly finished, as might be expected of a working drawing in progress. The figures on the left half have slightly modeled forms, whereas those on the right appear in outline only. The drawing, which is also squared with the stylus and rubbed with pouncing dust, is chiefly concerned with the linear component of the design. Its slight underdrawing in black chalk almost seems mechanically traced. Identical in design and scale, the Louvre draft (Fig. 263) is the more refined drawing, for it explores gradations of chiaroscuro approaching Raphael's in subtlety. (The treatment of light would ultimately be among the few successful elements in Genga's S. Agostino altarpiece.) The dots from the *spolvero* outlines in the Louvre drawing can be discerned precisely only in such small passages as the spine of the seated bishop saint on the extreme left, the torso of the seated bishop saint on the extreme right, and the left leg of the *putto* who sits in the left foreground. Genga first modified this underdrawing freehand with black chalk, before working up the composition with red chalk.

Andrea del Sarto's *Adoration of the Magi*

Andrea del Sarto's composition drafts for an *Adoration of the Magi* from about 1522, in the Louvre and in the Uffizi (CBC 284–85), present a more complex case, for

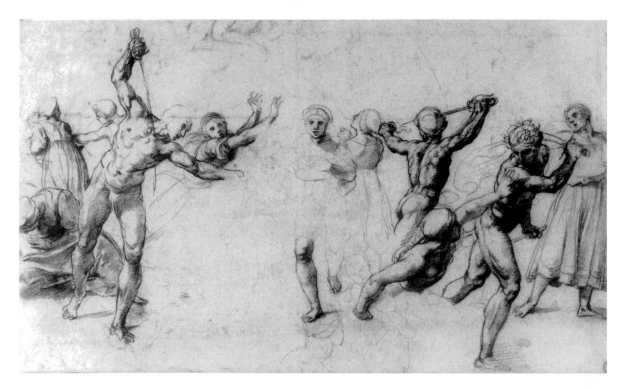

Figure 260. Raphael, study for the Massacre of the Innocents *(CBC 258; Royal Library inv. 12737, Windsor Castle), drawn from spolvero outlines.*

Figure 261. Marcantonio Raimondi after Raphael, The Massacre of the Innocents, *engraving "with the fir tree" (first version), state II (Bartsch XIV.19.18, Metropolitan Museum of Art, Gift of Felix M. Warburg and his Family, 1941; 41.1.27, New York).*

Figure 262. Girolamo Genga, pricked composition draft for the Enthroned Virgin and Child with Saints,
"The Dispute on the Immaculate Conception" *(CBC 109; British Museum 1866-7-14-7, London).*

the relationship between the drawings is indirect: trans-
fer by *spolvero* from one sheet to the other seems to
have involved at least one intermediary study, which no
longer survives. The project for which the sheets were
intended is not known. A rich variety of archaeological
evidence attests to the functional, experimental charac-

ter of the Louvre draft (CBC 284): the dense red chalk
drawing over traces of black chalk, the preliminary sty-
lus underdrawing and stylus construction, the closely
pinpricked outlines on the figures, and, finally, the
squaring in red chalk.[63] The artist prepared the Uffizi
drawing (CBC 285) in a denser medium still, of ink,

Figure 263. Girolamo Genga, composition draft for the Enthroned Virgin and Child with Saints, "The Dispute on the Immaculate Conception" (CBC 110; Département des Arts Graphiques du Musée du Louvre inv. 3117, Paris), drawn from spolvero outlines.

Figure 264. Girolamo Genga, The Enthroned Virgin and Child with Saints, "The Dispute on the Immaculate Conception," oil on panel (Pinacoteca di Brera, Milan).

wash, and white gouache highlights, somewhat messily combined, over traces of stylus and freehand black chalk underdrawing.[64] He also squared the Uffizi composition, but only partially, along the architecture. In the Uffizi sheet, *spolvero* marks are visible in various details of the figures, albeit sporadically, but throughout the background and the architecture.[65] We can thus safely conclude that Andrea drew the entire composition of this thickly pigmented drawing on the basis of *spolvero*, lightly editing the outlines with the stylus. Yet the Uffizi drawing was most probably not pounced directly from the pricked sheet in the Louvre: although the scale of the figures is identical in both drafts, that of the architecture in the Louvre sheet is larger.[66] At least one intermediary drawing must have therefore existed, which received the pouncing dust from the pricked outlines in the Louvre sheet.[67] As these drawings can indicate, the chain of transfer by pricking and pouncing from one sheet onto another was surprisingly complex.

Drawings on *Spolvero* by Artisanlike Masters

Most small-scale drawings with pricked outlines exhibit perforations that are minute (with diameters the size of a needle or pin), closely spaced, and precisely aligned with respect to the drawn outlines. The pricking on such examples usually extends to all details of the composition. When drawings with pricked outlines appear to be unevenly finished, with relatively important elements of the composition less developed than others, we can hypothesize that they were pounced onto another sheet for further elaboration. This, as we have seen, is true of the pricked composition drafts by Raphael, Girolamo Genga, and Andrea del Sarto. The state of relative unfinish in drawings can provide some (though not always an entirely reliable) indication of their place in a design sequence. Even pricked drawings that would seem to be fairly complete were sometimes pounced onto another sheet for further reproduction or variation. This practice seems to have been especially prevalent in designs for embroidery.

A little-known composition on *spolvero*, portraying *Zacharias at the Door of the Temple* (Fig. 265), suggests that the pricked original from which it derived must have already been entirely worked out in all its details.[68] The design is inked with dry, perfectly even contours over the *spolvero* underdrawing and is probably a later, full-scale *ricordo* produced from Antonio Pollaiuolo's original pricked cartoon for the set of extant embroidered vestments on the life of St. John the Baptist (Museo dell'

Figure 265. *Copyist after Antonio Pollaiuolo,* Zacharias at the Door of the Temple *(Gabinetto Disegni e Stampe degli Uffizi inv. 98 F, Florence), drawn from* spolvero *outlines. The embroidery after Pollaiuolo's cartoon of this subject is in the Museo dell'Opera del Duomo, Florence.*

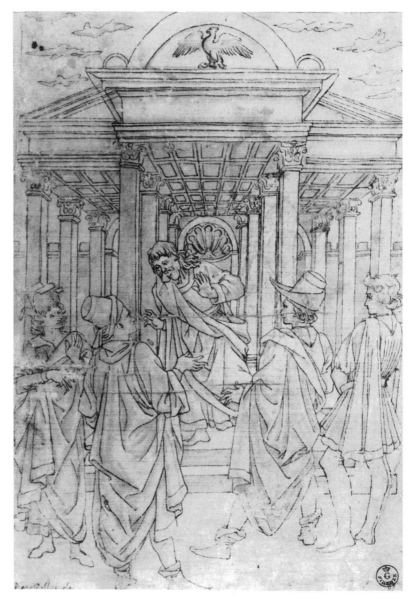

Opera del Duomo, Florence). (The designs for twenty-seven embroideries were commissioned by the *Arte della Mercanzia* from Antonio Pollaiuolo, and the final products were to be used on the feast day of Florence's patron saint in the Baptistry; their execution by seven different embroiderers is recorded in detailed commission and payment entries, starting on 5 August 1466 and lasting into the 1480s.)

Dating from the 1480s to 1490s, Bartolomeo di Giovanni's study for a *Baptism of Christ* (Fig. 266) offers a more creative example of the use of *spolvero* underdrawing.[69] Its composition reflects Andrea Verrocchio's and Leonardo's *Baptism of Christ,* the famous altarpiece painted in the early 1470s for S. Salvi (Galleria degli Uffizi, Florence). The Berlin drawing of the *Baptism* (Fig. 266) exhibits densely spaced *spolvero* dots that depict a minutely developed design, although the chiaroscuro drawing over it would remain partly incomplete. The artist drew the composition over the *spolvero,* first with black chalk and then both with pen and ink and brush and wash, highlighting the forms with white gouache. In inking the drawing, he followed almost exactly the *spolvero* outlines, especially in the figure of Christ, the group of angels on the left, the water of the river, the receding landscape, the figure of God the Father, and the group of flying *putti.* Even the frame of the composition, a modified trefoil, is outlined in both *spolvero* and ink. Significantly, however, there are also passages where drawing and *spolvero* do not agree. Here, the *spolvero* appears as a type of *pentimento* – clearly visible, for example, on the tip of the rock to the left of Christ's shoulder. More substantial changes exist as well: the *spolvero* portrays St. John's right arm higher and straighter, and the foliage of the bushes to the right of the saint's head fuller than these details were finally drawn. Such changes of design establish the function of the Berlin sheet as an exploratory drawing, albeit of a synthetic type, rather than as a copy. Apart from its *spolvero* outlines, this drawing of the *Baptism* looks much like any of Bartolomeo di Giovanni's or Raffaellino del Garbo's numerous finished drawings with finely pricked outlines – drawings often classified as embroidery cartoons.[70]

Closely comparable in style to the Berlin sheet is Bartolomeo di Giovanni's partly pricked study for a composition of the *Trinity* (CBC 117); the iconographic motif is ubiquitous in small Florentine painted panels from the late fifteenth century.[71] Some of Bartolomeo's panels exhibit substantial freehand underdrawings, rather than evidence of cartoons *(spolvero* or *calco);* at least one of these paintings produced from

freehand underdrawings is closely related in composition, though not in size, to the pricked Oxford *Trinity* drawing – a lunette on a painted frame (Metropolitan Museum of Art, New York).[72] Especially the case of the Berlin sheet of the *Baptism of Christ* suggests the probability that Bartolomeo often pricked small-scale drawings onto other sheets of paper for further development or variation of the designs, rather than for transfer onto the final working surface.

Revealing significantly more complex archaeological evidence, Raffaellino del Garbo's pricked finished small drawing of the *Virgin Appearing to St. Bernard* (Fig. 267) recalls in its figural arrangement his master Filippino Lippi's altarpiece in the Badia of Florence, from 1485 to 1486.[73] Tellingly, Raffaellino's composition is also underdrawn with *spolvero.* The subsequent layers of dense drawing medium, especially the freehand reworking with black chalk (evident on the lower parts of the right angel), greatly obscured this *spolvero* underdrawing. Nevertheless, the tiny carbon dots are still visible on the folds of the Virgin's mantle, on the back outlines of the figure of St. Bernard, as well as on his bench and *scriptorium.* Here, the *spolvero* technique served to piece together the various elements of the composition, much like the parts of the *Coronation of the Virgin* (Fig. 109), discussed in Chapter Three. Similar evidence of mass production is also apparent in a crude drawing of the *Annunciation* (CBC 98).[74] There, the multiple parallel pricked outlines framing the composition and defining the halos of the figures, together with the heavy presence of rubbed black pouncing dust, suggest multiple repetitions by Raffaellino's workshop. In the British Museum *Virgin Appearing to St. Bernard* (Fig. 267), the pricked rounded framing outlines on the lower two corners of the sheet suggest that Raffaellino's design may have been intended for the back field of an embroidered cope. The sheet is also jaggedly cut down the center and about groups of figures (with no overlaps), much like a *giornata* in a fresco: in all likelihood, this was the dismemberment of the design accompanying the working procedures of embroiderers.[75] In fact, the crossing detail on an extant fragment from an embroidered chasuble (Collegiata of S. Martino, Pietrasanta) follows closely the design found in Raffaellino del Garbo's pricked drawing of an angel for the *Annunciation* (CBC 94), from 1500 to 1524, in the Metropolitan Museum of Art, New York.[76] But attentive comparisons repeatedly demonstrate that the position of the angel's arms, the angle of his wings, the configuration of his collar, and the drapery folds are very different;

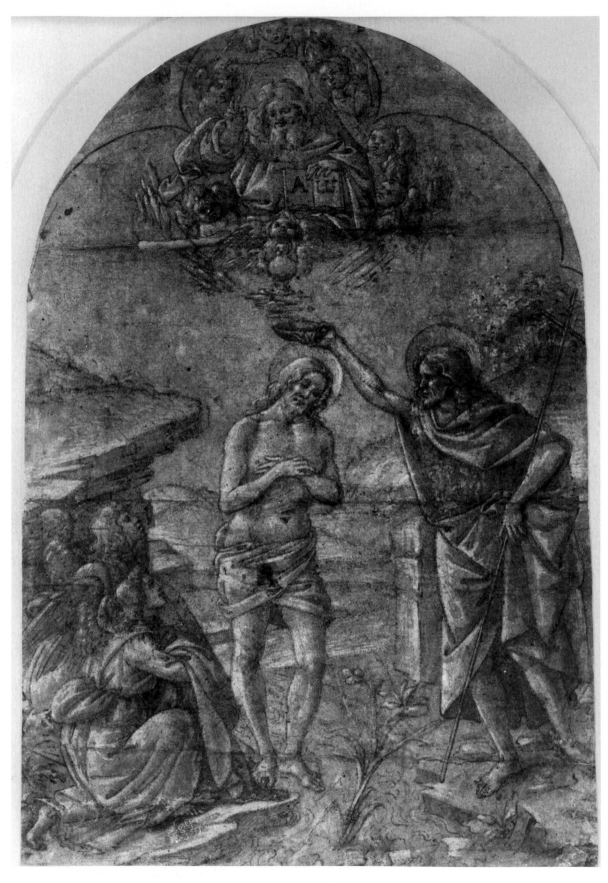

Figure 266. Here attributed to Bartolomeo di Giovanni, The Baptism of Christ *(CBC 123; Kupferstichkabi-nett inv. KdZ 5044, Staatliche Museen, Berlin), drawn from* spolvero *outlines.*

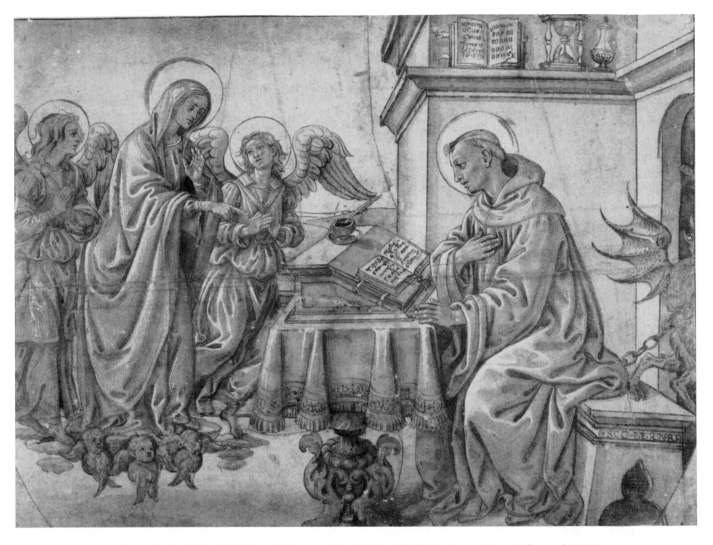

Figure 267. *Raffaellino del Garbo, pricked cartoon for embroidery,* The Virgin Appearing to St. Bernard *(CBC 67; British Museum 1860-6-16-114, London), drawn from* spolvero *outlines, and rubbed with pouncing dust.*

thus, the relationship between embroidery and draw-ing is indirect. Lost intermediary drawings, pricked and pounced for transfer from one sheet onto another, probably bridged in the modification and replication of many such images. As we have seen, the use of the *spolvero* technique facilitated endless variations.

Giovan Francesco Penni's *Modello* for Raphael's *St. Paul Preaching in Athens*

Particularly during the last decade of his life, as his career in Rome reached an unprecedented pace of pro-ductivity, Raphael sought an efficient division of labor within the process of preliminary design, quite apart from that already occurring at the moment of execu-tion in paint. As his extant drawings from 1510 to 1520 can clarify, however, Raphael alone continued to invent his designs. Rapid composition sketches are always and unmistakably by his hand; to a great extent the same is true of his various types of life studies.[77] But the task of producing finished, synthetic types of drawings – com-position drafts following life studies, as well as the refinement of *modelli* and sometimes the enlargement of the design to cartoon scale – often fell upon Raphael's assistants, primarily Giovan Francesco Penni "Il Fattore" and the gifted young Giulio Romano.[78] Raphael's drawings for the *Massacre of the Innocents* (Figs. 258–60) suggest two general conclusions, which must remain hypothetical, however, considering the fragmentary state of the surviving evidence. (Even the corpus of drawings by as revered and collected a *disegnatore* as Raphael has

glaring lacunae.[79]) First, Raphael and his workshop used mechanical means of design transfer as labor-saving devices, in order to generate synthetic drawings at a relatively advanced stage in the design process, often after having developed both initial composition sketches and detail studies of figures.[80] Second, once the artist achieved this synthesis, he often continued to develop successive drawings on a similar scale to the finished composition, to ensure precision of design. If the final composition was of monumental size, like the *Disputa* fresco from 1509 to 1510 (*Stanza della Segnatura,* Vatican Palace), Raphael and his *bottega* probably drew the synthetic composition drafts in as consistent a scale as was possible. This appears to be the function of the pricked Frankfurt drawing (CBC 250), which synthesized individual studies after the nude model.[81] The sheet onto which the pricked *Disputa* composition draft was pounced, however, does not survive.

To visualize the resulting drawing type on *spolvero,*

we may turn to the *modello* by Giovan Francesco Penni, for Raphael's composition of *St. Paul Preaching in Athens* (Fig. 268; Plate VII), one of the Sistine Chapel tapestry cartoons from 1514 to 1516.[82] In great contrast to the lively immediacy of the Frankfurt *Disputa* draft, the *modello* in the Louvre has deeply graded, though fairly static chiaroscuro, rendered in pen and ink, with brush-applied wash and white gouache highlights. The point of Penni's *modello* was to summarize the composition, however, rather than to explore it. The sheet exhibits all the signs of a fully developed working drawing, for it combines at the layer of its preparatory underdrawing both freehand black chalk and *spolvero* outlines, stylus ruling, squaring grids, perspective construction, and scaling. This *modello* incorporates the

Figure 268. Giovan Francesco Penni "Il Fattore" after Raphael, modello for St. Paul Preaching in Athens *(CBC 194; Département des Arts Graphiques du Musée du Louvre inv. 3884 recto, Paris), drawn from* spolvero *outlines.*

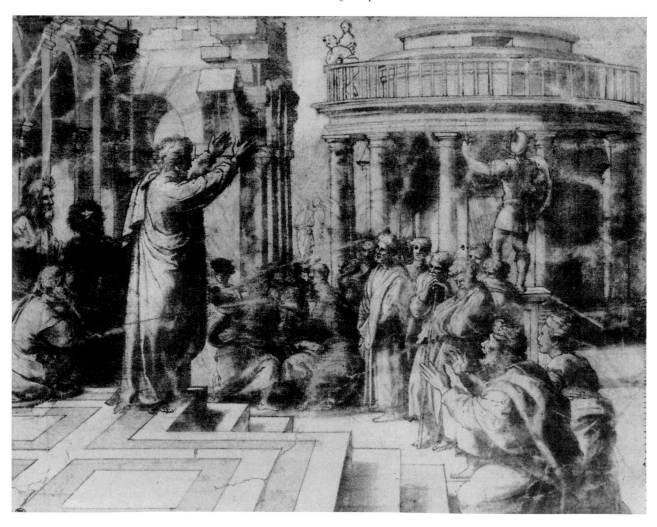

solution for the figures that Raphael explored in an animated red chalk study in the Uffizi, drafted in a similar scale,[83] and for which Raphael's *garzoni* clearly posed as models. Penni drew the composition in the Louvre *modello* on top of a squaring grid with 14 mm. intervals in black chalk, now faded and readily visible only in areas where the drawing is least developed. He cropped the composition about 12 mm. on the right, outlining the final border with pen and ink, which better agrees with the composition of the tapestry cartoon.[84] Toward the bottom of the left and right ink borders, Penni dotted the intervals for the stylus-ruled lines that establish the perspective construction of the pavement. Along the original outer right border, he had pricked holes at intervals of 14 mm., that is, the scale of the squaring, and he pricked a further scale with compass points along the upper pen and ink border, toward the right corner. The artist drew the steps on which St. Paul stands from a smaller system of stylus-ruled horizontals, parallels at intervals of 7 mm. (half the height of the squaring grid), also part of the perspective construction for the composition.

Areas of *spolvero* underdrawing are sporadically visible throughout the *modello,* not just in the architecture, where the layers of drawing are less dense than in the figures. The *spolvero* dots are often a type of *pentimento;* the subsequent freehand drawing either avoids them or corrects them. Between the two buildings in the background, in the space defined by the right profile of the unbuilt *loggia* and the left profile of the *tempietto,* the faint traces of *spolvero* depict an arcade set in a landscape. Some *spolvero* dots emerge also from underneath the layer of white gouache on the figures, as on the cloak of the man standing cross-armed below the idol. Penni must have relied on a detailed pricked drawing by Raphael, to judge from the evidence of the fine *spolvero* outlines. This design must have already been a *fait accompli* in most of its details, before Penni fully rendered it on the Louvre *modello.* Since the *modello* served solely as a guide in drawing the cartoon (Plate VII), its quality of execution was of little significance beyond a basic degree of competence.[85]

Raphael's "Auxiliary Cartoons" and the Tradition of Monumental Studies Drawn on *Spolvero*

At this juncture, we can accept that Raphael and his workshop also transferred designs of monumental scale from one draft onto another, to achieve further refine-

ments or variations of design. Exemplifying this practice are the exquisitely drawn, so-called "auxiliary cartoons" by Raphael and Giulio Romano (Figs. 269–70, 274–76).[86] In his pioneering article of 1937, Oskar Fischel first coined the term "auxiliary cartoon" to designate the great master's relatively finished, full-scale life studies of the head, and sometimes the hands, of a figure, drawn in charcoal or black chalk over *spolvero* outlines.[87] These drawings cannot be considered "cartoons" in the full meaning of the term, as they did not serve the purpose of actual design transfer onto the final working surface.[88] Although nearly life-size, these sheets clearly form part of the larger class of drawings executed on *spolvero* marks that we have been discussing.

The roots in late Quattrocento practice should be emphasized for this class of large-scale studies on *spolvero* marks, however fragmentary the present state of the visual evidence may still be, because this design type was obviously not restricted to Raphael, as has often been supposed. First and foremost, the tradition of design replication prevalent in Perugino's *bottega* offers an important, concrete source, especially for the style of Raphael's early "auxiliary cartoons" related to the Vatican *Coronation of the Virgin* (Figs. 269–71), as is suggested by a large-scale, pedestrian outline drawing on *spolvero* dots for an angel's figure (Fig. 272).[89] Barely reworked freehand with chalk, the sheet by Perugino's workshop appears to date from the late 1490s to early 1500s. An identical angel turns up on the upper left in a *Madonna and Child with Saints* panel (Corcoran Gallery of Art 26.153, Washington). A more accomplished "connect-the-*spolvero*-dots" approach, however, is evident in a highly finished study from the late 1490s, by Lorenzo di Credi, which portrays a reclining Christ Child.[90] There, the semimechanically produced underdrawing was all but obscured by the subsequent layers of chiaroscuro modeling. Equally explicit, for our purposes, is a large-scale design comprised solely of *spolvero* outlines, of contemporary date, on the verso of a cartoon with finely pricked outlines, by the workshop of Raffaellino del Garbo.[91] In excellent condition, though hardly attractive, this *spolvero* outline design is entirely untouched by freehand drawing and portrays the right hand of a man, surrounded by drapery and clutching the handle of a stick. In sharp contrast to the small *"disegno finito"* of St. Benedict on the recto of the sheet, whose pricked outlines are rubbed with black pouncing dust, the *spolvero* design of the hand on the verso is only slightly less than life-size: it is thus roughly comparable in scale to the "auxiliary cartoons" by Raphael and his workshop.

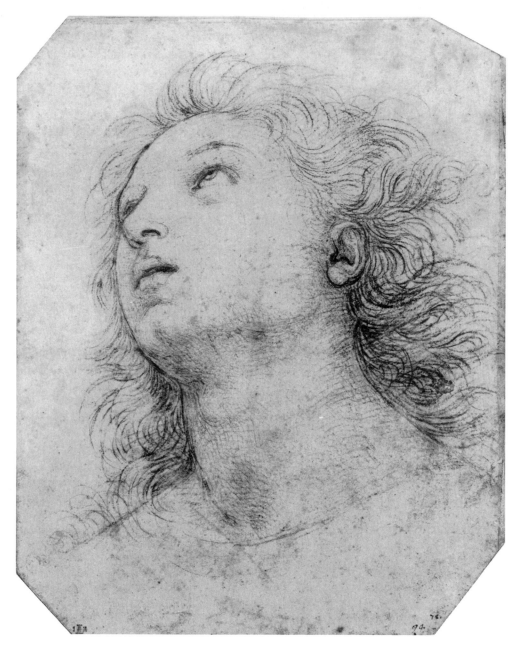

Figure 269. Raphael, Head of St. James *(CBC 229; British Museum 1895-9-15-610 Imperial, London), drawn from* spolvero *outlines.*

Although the recto of a sheet of studies by Fra Bartolomeo can be dated around 1513–15, the verso may well belong in the 1490s or early 1500s. On this verso, a large-scale fragmentary drawing depicts the upper portion of a man's head (Fig. 273).[92] His tall hat recalls the costumes worn in mid-Quattrocento Florence. The function of this mysterious drawing may well turn out to be related to the artist's practice of reconstructing portraits of notable historical figures: the design may be based on a received likeness, possibly pricked from a tracing. Fra Bartolomeo, if he is indeed the author of the drawing, boldly reinforced a number of the *spolvero* outlines freehand with charcoal. Yet the drawing makes a poor impression, precisely because it is mostly unmodeled. In fact, comparable cases of such large-scale, unreinforced *spolvero* outlines also arise in two sheets by Raphael. The first sheet, in Bayonne, contains on its recto the famous initial composition sketch for

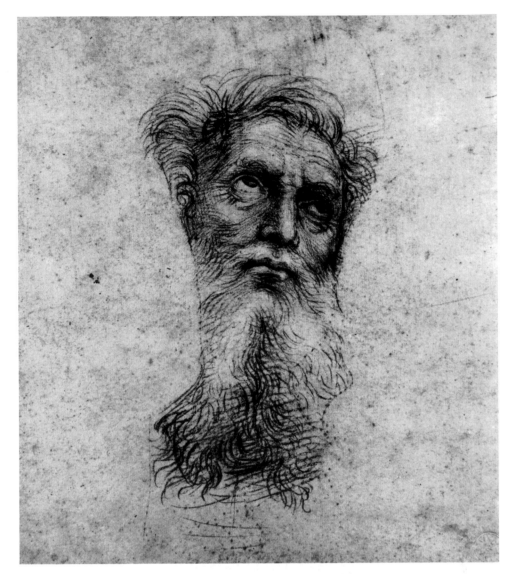

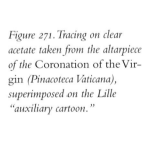

Figure 270. Raphael, Head of an Apostle *(CBC 230; Palais des Beaux-Arts inv. PL 470, Lille), drawn from* spolvero *outlines. The design of the heads of the two neighboring apostles on the left and right in the composition are portrayed only in* spolvero *outlines.*

Figure 271. Tracing on clear acetate taken from the altarpiece of the Coronation of the Virgin *(Pinacoteca Vaticana), superimposed on the Lille "auxiliary cartoon."*

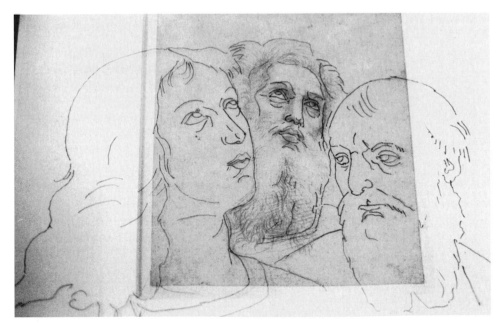

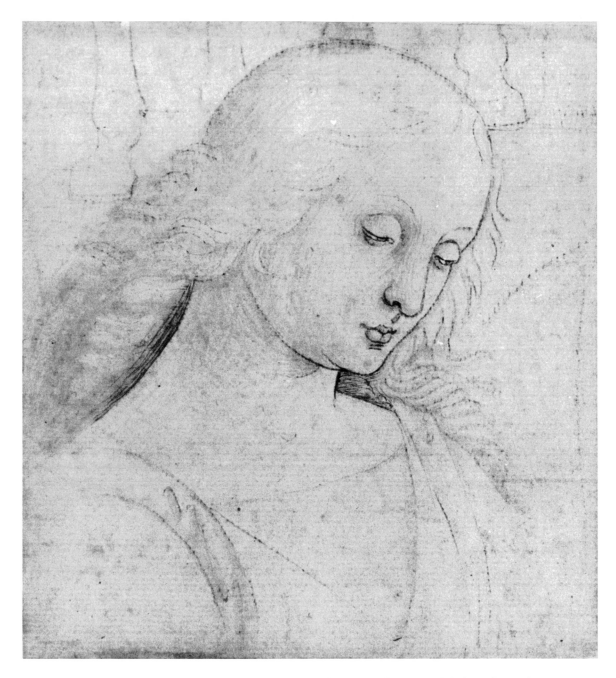

Figure 272. Workshop of Pietro Perugino, Head of an Angel *(Private Collection, London), drawn from* spolvero *outlines.*

the altarpiece of the *Resurrection* (intended for the Chigi Chapel at S. Maria del Popolo, Rome), and on its verso, four studies of male torsos, together with faint, unrelated *spolvero* outlines representing the large-scale, foreshortened *profile perdu* of a woman's head and bust, in stark *contrapposto*.[93] This *spolvero* design is closely comparable to the head of one of the muses in Raphael's *Parnassus* fresco (*Stanza della Segnatura*, Vati-

can Palace), from 1510 to 1511.[94] A superbly beautiful "auxiliary cartoon" for another of the muses in *Parnassus* is extant (CBC 254).[95] A further large-scale *spolvero* design (CBC 268), albeit less identifiable, turns up in a sheet by Raphael in Berlin, underneath his studies in black chalk for the apostles on the lower left of the Monteluce altarpiece of the *Coronation of the Virgin* (Pinacoteca Vaticana), painted after the master's death

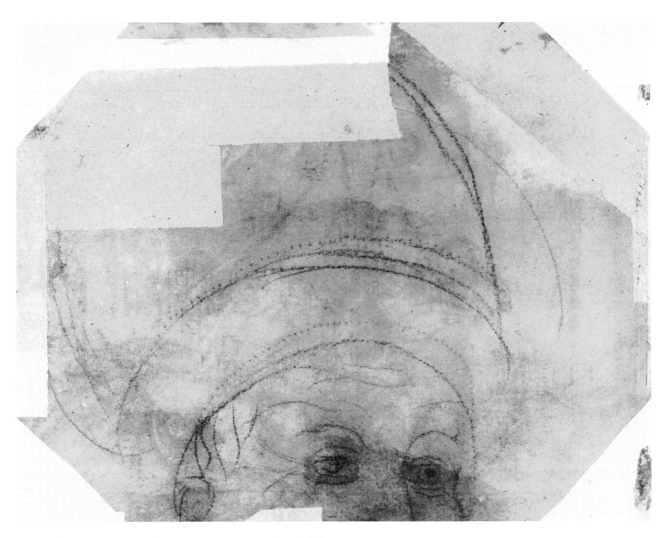

Figure 273. Attributed to Fra Bartolomeo, fragmentary Portrait of a Man (CBC 15; Gabinetto Disegni e Stampe degli Uffizi inv. 467 E verso, Florence), drawn from spolvero outlines.

by Giulio Romano and Giovan Francesco Penni "Il Fattore," probably in 1524–26.[96]

We may rightly judge the designs of the so-called "auxiliary cartoons" by Raphael and Giulio to be infinitely more beautiful than many of the examples that we have been discussing – their treatment of surface is highly refined and the handling of the charcoal or black chalk medium is greatly more spirited. But these are qualities that pertain for the most part to the artists' subsequent manner of drawing freehand, rather than to the stage of semimechanically producing an underdrawing. The so-called "auxiliary cartoons" were all derived from actual pricked, full-scale drafts of compositions, as is established by the presence of detailed and comprehensive *spolvero* throughout, but which, in most cases, is now largely abraded (Fig. 274). Especially in the early Lille drawing (Figs. 270–71), the *spolvero* outlines can be reconstructed to a surprising extent, far beyond the parts that Raphael worked up freehand.[97] Yet in none of the cases for which there are

extant "auxiliary cartoons" do the actual pricked cartoons survive: the Oddi altarpiece of the *Coronation of the Virgin* (Pinacoteca Vaticana), from 1502 to 1503; the fresco of *Parnassus* (*Stanza della Segnatura,* Vatican Palace), from 1510 to 1511; the fresco of the so-called *Coronation of Charlemagne* (*Stanza dell'Incendio,* Vatican Palace), from 1516 to 1517; the altarpiece of the *Transfiguration* (Pinacoteca Vaticana), from 1518 to 1520; and the fresco of the *Allocution of Constantine* (see Figs. 276–77), from 1520 to 1524. We may reasonably hypothesize that the actual pricked cartoons for these compositions were more functional than *"ben finiti,"* hence the need for drawing refined studies from life (see Chapter Seven). It is also quite possible that at least in the case of his oil paintings, for which he pre-

325

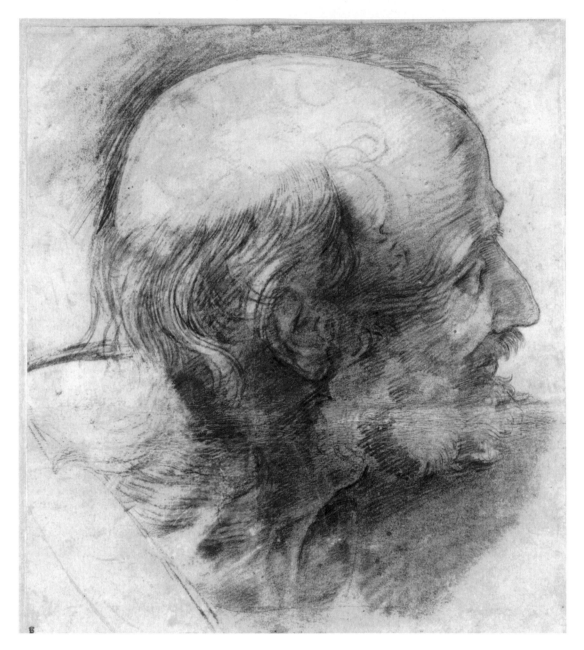

Figure 274. Raphael, Head of St. Andrew *(CBC 274; British Museum 1860-6-16-96, London), drawn from* spolvero *outlines. Locks of hair in undrawn* spolvero *outlines cover the apostle's "bald" cranium, as in the final altarpiece of the* Transfiguration *(Pinacoteca Vaticana).*

ferred a Leonardesque system of modeling, Raphael traced isolated motifs from the underpainting, tracings he then pricked and pounced onto normal drawing paper to clarify the portions of the design that in the underpainting had become obscured under dense layers of chiaroscuro.

Be that as it may, in the full-scale studies on *spolvero* for the *Transfiguration* (Figs. 274–75), the extraordinary monumentality of their chiaroscuro rendering makes them seem a logical extension to the *"ben finito cartone"* tradition of the High Renaissance. Especially the beautiful Ashmolean study for the heads and hands of Sts. John and Peter (Fig. 275) is strikingly more nuanced in its modeling of the flesh areas and hair than the corresponding details as finally painted.[98] Curiously, however, the *spolvero* outlines on the Ashmolean sheet, seen there as discarded *pentimenti,* correspond exactly in design and scale with the painting rather than with the forms as

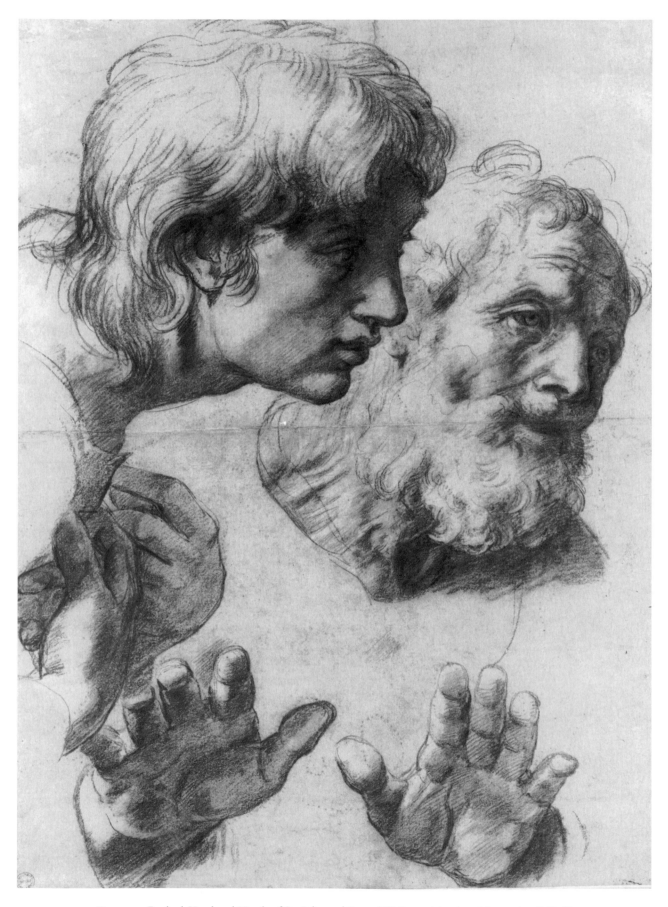

Figure 275. Raphael, Head and Hands of Sts. John and Peter *(CBC 272; Ashmolean Museum inv. P II 568, Oxford), drawn from* spolvero *outlines.*

fully rendered in the Ashmolean drawing.[99] The same is largely true of the other "auxiliary cartoons" for the *Transfiguration* (Fig. 274). Based on such preliminary observations, it is clear that a detailed further consideration of Raphael's "auxiliary cartoons" is necessary, but this can only be accomplished after examination with sophisticated infrared reflectography equipment is done on the panels, in order to clarify the evidence regarding their underdrawings.[100] What remains astonishingly unique about these drawings is the extent to which Raphael would transform a semimechanical method of reproduction into a creative tool for artistic exploration.

By contrast, Giulio Romano's "auxiliary cartoon," a likeness of Giovan Francesco Penni "Il Fattore" (Fig. 276), clearly bridges the function of creative preliminary study and autonomous reproductive portrait.[101] It is in the exact scale as the stylus-incised fresco in the *Sala di Costantino* (Fig. 277), but it also offers the precise design (though not the scale) of the woodcut portrait illustrating the biography of Penni in the 1568 edition of Vasari's *Vite*. The *spolvero* outlines depicting locks of hair in the "auxiliary cartoon," as in the fresco, were reworked freehand in black chalk to depict a turban, as in Vasari's woodcut portrait.

Drawings Drawn on the Basis of Pricking

In discussing copies, ornament patterns, cartoons, and "substitute cartoons," we have seen that artists and artisans often produced multiple versions of a design by stacking several sheets of paper and pricking the outlines of the design placed on top simultaneously through the various layers.[102] By connecting the holes one-by-one, artists used then the preliminary pricked outlines on each of the drafts as the means for the new drawings. A significant early example of this is Antonio Pollaiuolo's study for

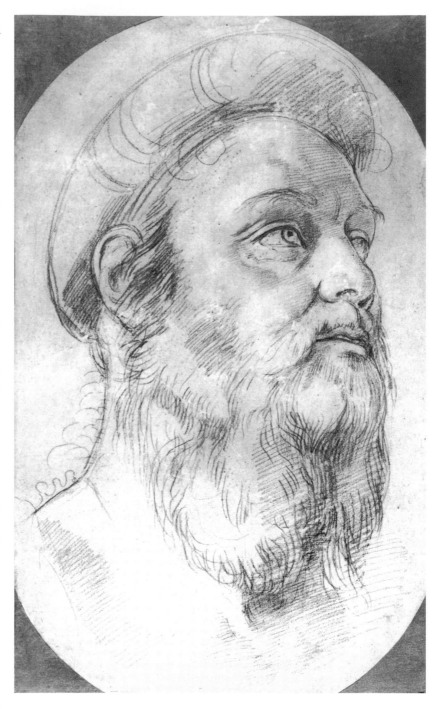

Figure 276. Giulio Romano, Portrait of Giovan Francesco Penni "Il Fattore" *(CBC 206; British Museum 1949-2-12-3 Imperial, London), drawn from* spolvero *outlines.*

an equestrian monument (Fig. 278) in the Metropolitan Museum of Art.[103] The drawing is carefully finished with pen and ink, brush and wash, and dates around 1470–85. The 1568 edition of Vasari's *Vita* of Antonio

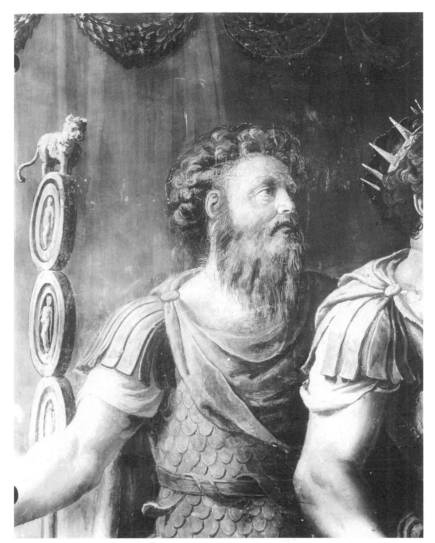

Figure 277. Detail of Giulio Romano and Giovan Francesco Penni "Il Fattore," The Allocution of Constantine, fresco (Sala di Costantino, Vatican Palace).

Pollaiuolo notes that two of the artist's *"disegni"* for the monument of Francesco Sforza, Duke of Milan, formed part of the biographer's *Libro de' disegni*.[104] The sheet in the Metropolitan Museum, as well as the similarly finished, but unpricked, variant (Staatliche Graphische Sammlung, Munich), have traditionally been identified with Vasari's passage.[105] The pricking in the Metropolitan sheet is only partial, done coarsely with large holes, placed far apart. In most passages, the holes are greatly misaligned with respect to the drawing. This evidence suggests that the pricked outlines on Pollaiuolo's sheet served only as a general guideline in drawing.[106] Thus, the Metropolitan Museum sheet was

pricked, as it lay underneath another drawing being pricked. This procedure would account for the entirely unpricked portions of Pollaiuolo's drawing: the horse's right rear leg and genitals, the female allegorical figure representing the city of Verona, and the pedestal on which she reclines. These details were clearly added by the artist after he had finished pricking the outlines of the design: significantly, the details that are unpricked in the Metropolitan Museum drawing are precisely among the details that were modified in the Munich variant. The sizes of the two drawings are close, but not identical, and thus the relationship between the Metropolitan and Munich drawings must be indirect. As we have seen, the technique could offer a substantial shortcut to the variations of motifs in the *inventione*.[107]

Another example of the practice of drawing on preliminary pricked outlines is Luca Signorelli's sheet from the 1490s of a man's profile (Figs. 207–8), the exercise in parallel projection, or "transformation," that was discussed in Chapter Six.[108] As is typical of drawings produced from preliminary pricking, the holes in Signorelli's sheet often do not align with the outlines drawn in pen and ink. The latter have a particularly jagged, scratchy quality and are often traced in parallel strokes.[109] A greatly more complex application of this preliminary pricking technique occurs in a large, later design for a *Flagellation of Christ* (Fig. 279).[110] Of long-debated authorship, the drawing has been attributed to Sebastiano del Piombo, as it evokes the composition of the concave oil mural in the Borgherini Chapel (S. Pietro in Montorio, Rome), painted in 1518–24, which Michelangelo helped design. The Amsterdam sheet is clearly a working drawing, whose purely utilitarian function could easily cause it to be misunderstood as deficient in the "quality" of execution. The artist drew the architectural elements in black chalk, on the basis of pricking and a schematic armature of stylus ruling, then reinforcing the forms with pen and ink. The sheet also exhibits a

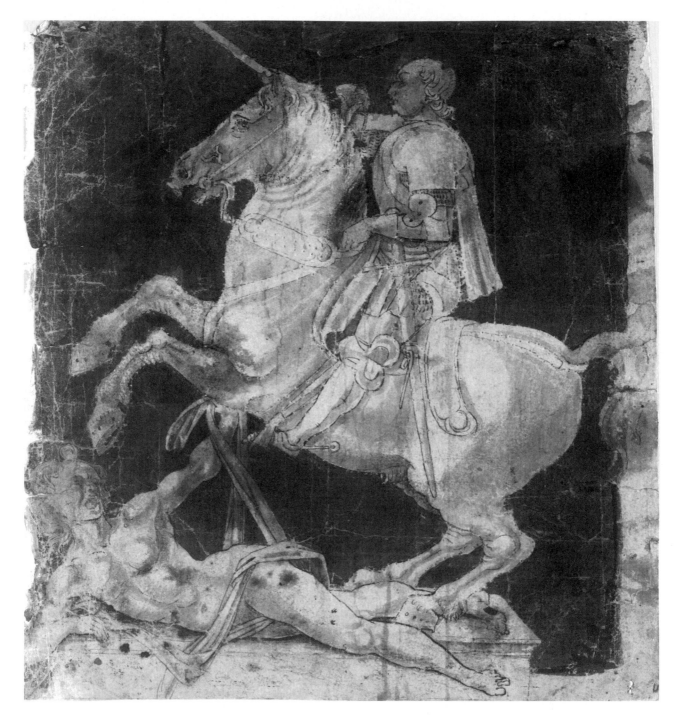

Figure 278. Antonio Pollaiuolo, presumed study for the Sforza Equestrian Monument *(CBC 213; Metropolitan Museum of Art, Robert Lehman Collection, 1975.1.410, New York), drawn from pricked outlines.*

stylus-incised plumbline anchoring the figure of Christ, who is tied to a monumental column. The architectural elements, as well as the figures, are pricked finely, and parts of the design are also rubbed with pouncing dust. The figure of Christ and the column were modeled in black chalk and then reworked densely in pen and ink; finally, the figure of Christ was also squared proportionally with the stylus. By contrast, the figures of the executioners remain as unfinished nets of *pentimenti* in black chalk or ink; at least five exe-

Figure 279. Copyist after Sebastiano del Piombo, The Flagellation of Christ *(CBC 202; Rijksprentenkabinet inv. A 1403, Amsterdam), drawn from pricked outlines.*

cutioners or onlookers are depicted as a series of pricked, but undrawn, unrelated outlines. The artist edited, added, and subtracted figures. This process of drawing and revision, in which the relationships in the scale of the figures and architecture were precisely calibrated with respect to the frame of the composition, probably relates to the production of a print. A similar composition after Michelangelo's design was engraved in 1582 by Adamo "Scultori" (c. 1530–1585); another

version by an anonymous engraver is also known.[111] Significantly, the scale of the figures in both the Amsterdam drawing and Adamo "Scultori"'s engraving seems quite close, despite the differences of motifs.

It is clear that by the High Renaissance, the use of the various semimechanical means of reproduction here discussed had presupposed the development of highly refined types of drawings within the penultimate stages of the design process.

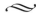

TECHNIQUES OF STYLUS INCISION

To explore further the use of *spolvero* and *calco* cartoons in Renaissance murals, we face at least two problems. First, in reconstructing the functions of stylus tracing or stylus incision *("calco," "calcare," "ricalcare," or "incisione indiretta"),*[1] it is necessary to address the extensive archaeological evidence regarding incision techniques that helps establish our historical ground. Second, photography in raking light, if an indispensable tool for documenting the actual presence of stylus incisions, considerably distorts – certainly flattens, at times even inverts the depth of – the physical evidence on the plaster surface. The same is largely true of drawings incised for transfer. *Caveat lector,* therefore, for the very small selection of illustrations given here serves only as a general guide for the arguments developed below. The mere presence of incisions on a painting surface has frequently been interpreted as a sign of cartoon use, without consideration of the problematic state of the physical evidence. A complete account of stylus-incision techniques, though necessary for the history of Medieval and Renaissance painting, is obviously beyond the scope of this book. The observations that follow are meant to help distinguish the evidence of *calco* from that of other types of incisions, so that we may then better place the functions of *calco* and *spolvero* within the tradition of Italian Renaissance design.

Stylus Incisions before the Quattrocento

Proposals for the origins before the fifteenth century of *calco* as a method of cartoon transfer seem unconvincing.[2] As early examples of this practice, Ugo Procacci drew attention in 1961 to the mural originally in the apse of S. Bartolommeo in Pantano (Pistoia), which he dated about 1260, and to Giovanni da Milano's *Christ the Redeemer* from about 1365–69 in the Rinuccini Chapel (S. Croce, Florence).[3] Leonetto Tintori and Millard Meiss singled out the *Lamentation of Christ,* which they dated 1292–93, in the nave of the Upper Church (S. Francesco, Assisi).[4] With the symposium *Tecnica e stile* in 1986, the issue was again debated, but the handful of examples adduced was the same as that in 1961–62.[5]

Of course, more or less regular incisions appear frequently on the surfaces of both panels and murals from the Duecento and Trecento. Such early incisions, however, seem to have been executed freehand, directly on the painting surface, rather than from cartoons. As in the examples cited above, as well as in two further modest late Duecento murals – a *Virgin and Child with Saint Anne* painted on the left aisle wall (S. Martino, Tarquinia), and the *St. John the Baptist* in the Chapel of S. Tarasio (S. Zaccaria, Venice) – such incisions usually are either selective and angular, or repeatedly intersecting and reinforced. They are also in relatively straight, rather than curving, lines and, above all, seem peculiarly undescriptive of the figures' outlines as finally painted.[6]

The technology of direct incisions *(incisioni dirette)* on the mural surface, both for freehand preliminary sketching and the ruled construction of architecture and geometric shapes, if greatly expanded during the Duecento and Trecento, can be traced continuously in Italy from Antiquity to the twentieth century, albeit with ebbs and flows. In their configuration, such early incision types differ substantially from those found in murals from the late fifteenth century onward that are known to have been painted from cartoons.

For scholars of early Italian drawings, the hypothesis that stylus-traced cartoons emerged during the Duecento presents particular difficulties, as it conflates three assumptions: (1) the regular use of creative, preliminary figural drawings; (2) that these were prepared in full

scale; and (3) that these were drawn on paper or parchment.[7] The evidence is weak, if the history of exploratory drawing is considered as a whole. The present state of research confirms that, before the 1430s to 1440s, artists prepared full-scale drawings directly on the working surface (with rare exceptions, notably in designing stained-glass windows and in painting ornament, as pointed out in Chapters Five and Six).

Moreover, if the hypothesis of Duecento stylus-traced cartoons were to be accepted, a context for the practice would also have to be sought in the history of Italian painting technique, and there lies perhaps the greatest obstacle. It would mean that there is a gap of over 150 years in the archaeological evidence offered by the surfaces of panels and murals from the Duecento to the Quattrocento. As we have seen, the combination of freehand *sinopie* to paint figural scenes and reproductive *spolvero* patterns to paint repetitive ornament was standard until about the 1430s to 1440s (this design approach would also often persist well past the Quattrocento), when the emerging practice of *spolvero* figural cartoons would modify traditional functions. The appearance in murals from the 1460s to 1470s of cartoon incisions *(incisioni indirette),* nearly always combined with passages of *spolvero,* is the earliest firm evidence that we have of artists adopting *calco* to transfer the design of cartoons. As will be discussed in the following chapter, *calco* greatly displaced *spolvero* between 1510 and 1520 as the preferred method of transferring cartoons; although *calco* destroyed drawings more easily, it was considerably less labor-intensive than *spolvero*. If Italian painters had indeed already relied on cartoons and *calco* in the Duecento, why would they have then renounced their technological progress until the later Quattrocento? The refinements of technique and form that Trecento and early Quattrocento painters gradually achieved demonstrate just the opposite. They used not only advanced technologies but also compelling artistic devices.

Finally, considering Cennino Cennini's thorough and amply explicit advice regarding the preparatory process of paintings, his omission from the *Libro dell' arte* of both practices – full-scale drawings on paper or parchment for the painting of figures, and stylus-incision techniques for the general transfer of designs – seriously undermines claims that *calco* cartoons were known from the Duecento onward.[8] The scientific investigation of early Italian panels and murals continues to validate Cennino's *Libro* as a reliable source on painting technique.[9] In fact, no written sources mention stylus-incised cartoons prior to Vasari's introduction to the *Vite* (Florence, 1550 and 1568 editions).

Cennino's *Libro dell'Arte*

Cennino's *Libro* prescribes the use of direct, freehand incisions for various effects.[10] Those techniques go a long way in explaining many of the incision types found in paintings before the mid- to later fifteenth century. To fresco draperies with azurite or ultramarine blue, especially mantles on figures of the Madonna, Cennino recommended that artists "first scratch in the disposition of the folds with some small pointed iron, or with a needle."[11] To achieve highlights on the tops of the knees and to model other projections, "scratch into the pure blue with the point of the brush handle."[12] Numerous panels and murals from the late Duecento onward confirm the technique described in Cennino's treatise, for the draperies on figures frequently exhibit such incisions in their folds, unless obscured by subsequent applications of varnishes and repainting. This type of incision usually occurs in draperies of a highly refractive hue of blue or a dark blue color – the color of the mantle of heaven that the Madonna or Christ traditionally wears. The incisions – whether shallow or deeply excavated and sharp – are often jagged. By gouging these lines through the centers of the folds, the artist simulated a highlighted, sculptural projection on the otherwise flat expanses of color, which could not adequately be shaded pictorially.[13] Late Duecento painters may have gradually developed the practice as a more realistic substitute for the abstract Byzantine technique of highlighting the folds of draperies with striations of gold.[14] The function of incisions of this type is usually clear because the rest of the painting surface either lacks them entirely or exhibits them only in selected areas.[15]

To gild backgrounds and details in panel paintings, Cennino's *Libro* directs, "having drawn in your entire *ancona,* take a small needle mounted on a small stick, and indent over the outlines of the figure around the area which you have to gild, and the ornaments which are to be made for the figures, and certain draperies which are to be made of cloth of gold."[16] This procedure left relatively sharp troughs, which are sometimes deep.[17] The preliminary, direct incisions marking the outlines of the figures and other motifs indicated precisely to the gilder the extent of the area to be covered in gold. Such incisions are at once recognizable in a variety of fourteenth and fifteenth-century panels and murals.[18] This particular gilding technique with direct incision occurs well into the Quattrocento (in provincial outposts even into the early Cinquecento), and often enough in figural details of paintings by artists who employed *spolvero* cartoons. Among the clear

examples we may count the horsemen's armor and saddle decorations in Paolo Uccello's panel of the *Battle of S. Romano* (National Gallery, London), from the 1440s to 1450s; the armor, saddle, and horseshoes in the now nearly obliterated equestrian portrait of Borso d'Este, painted on the south wall of the "*Sala dei Mesi*" (Palazzo Schifanoia, Ferrara) around 1467–69; and the facial outline in Gentile Bellini's panel with the *Portrait of Doge Giovanni Mocenigo* (Museo Correr, Venice), from either 1478–79 or 1480–85.[19] Because, as is sadly evident in the mural cycle at the "*Sala dei Mesi*," the applied metal leaf seems severely abraded and repainted, the technique may not immediately be recognizable for what it is, causing it to be mistaken for the use of cartoon incisions.[20] Here, however, the selectivity of the passages exhibiting such incisions is again a telltale clue.

Other, less significant techniques of incision recommended by Cennino also betray his essentially Medieval approach to design, which was additive and details-oriented rather than compositionally unified. To gild diadems of saints fashioned with tin and without mordant, Cennino urged, "after you have colored the figure in fresco, take a needle and scratch over [the surface], around the outline of the head"; and to model diadems in the lime mortar of the wall, "take a small stick of strong wood, and indent the radiating beams of the diadem."[21] As discussed in Chapter Five, Cennino's *Libro* also explains the *sgraffito* technique – the final step in depicting cloths of gold brocade, for which the repeating designs could first be laid in by pouncing a pricked pattern. In such cases, the regularity of the repeating units, their relatively imprecise siting, and the frequent overlapping or scribbly, reinforced, incised lines show that they were done directly on the working surface.

Neither Theophilus's *De Diversis artibus* (MS., after 1106), nor other early sources, mention equivalents of Cennino's incision techniques.

The Physical Evidence of Incisions

At least in principle, the soft, broad, shallow incisions from stylus-traced cartoons *(incisioni indirette)* can be distinguished with relative ease from direct incisions done without cartoons *(incisioni dirette)*. Even if the artist pressed only lightly on the stylus, direct incisions usually appear scratchy, exhibiting "burr" or ridges of slightly raised ground material, along the sides of the incised trough. If the trough of a direct incision were to be envisioned in section, it would resemble a "V" in shape (Figs. 173–74). By comparison, an indirect incision, or cartoon incision, in section appears like a softer "U"-form, unless the stylus sliced through the paper, tearing it in the process (Fig. 280). The reality, however, is often more complex.[22] When the unset *intonaco* of a fresco is still relatively wet, even direct incisions can register softly, for water tends to inundate the troughs. Gentle troweling over direct incisions can also level their "burr" and soften their imprint.

A detail in Michelangelo's *Prophet Jonah* in the Sistine Ceiling (though too subtle to document in a photograph) offers further reasons for caution. As is established by the *spolvero* dots scattered intermittently about and within the foreshortened figure, it was frescoed from a monumental cartoon. Direct stylus incisions on the folds for the portion of Jonah's draperies beyond his right knee reinforce faint *spolvero* and inflect the folds of the cloth with incisive *"rilievo."* The fictive white marble throne containing the prophet, however, appears to have been projected directly on the *intonaco*. Yet, as is suggested by a detail from the lower right part of Jonah's throne, the ensuing layers of pigment on top (lime white must be laid on thickly) sometimes filled in the troughs of direct incisions, to the point that they might be confused with those done through the intermediary means of a cartoon. Jonah's throne, whose stylus-incised construction of perfectly calibrated angles with a series of unfaltering, intersecting, and at times reinforced stylus-ruled lines, was clearly done directly on the *intonaco;* here, the artist built the planes for the architectural forms in a slightly improvised, exploratory fashion, with more lines than were necessary to define the final forms. Similarly, on the lower left part of Jonah's throne, the troughs of two directly incised, intersecting compass arcs are shallow and soft, as the result of the paint layer on top. Compass work was among the procedures typically done directly on the *intonaco* from Antiquity onward.

Under a variety of physical circumstances, therefore, the appearance of direct incisions can deceptively resemble that of incisions through paper.[23]

Incisions through Paper

To complicate matters further, on the actual surface of cartoons and other types of drawings, incisions from design transfer can also greatly vary in appearance. They can range from imperceptible to clearly visible, depending on the flexibility of the original paper support, the density of the drawing medium, the sharpness of the tracing implement used, the pressure exerted upon it by

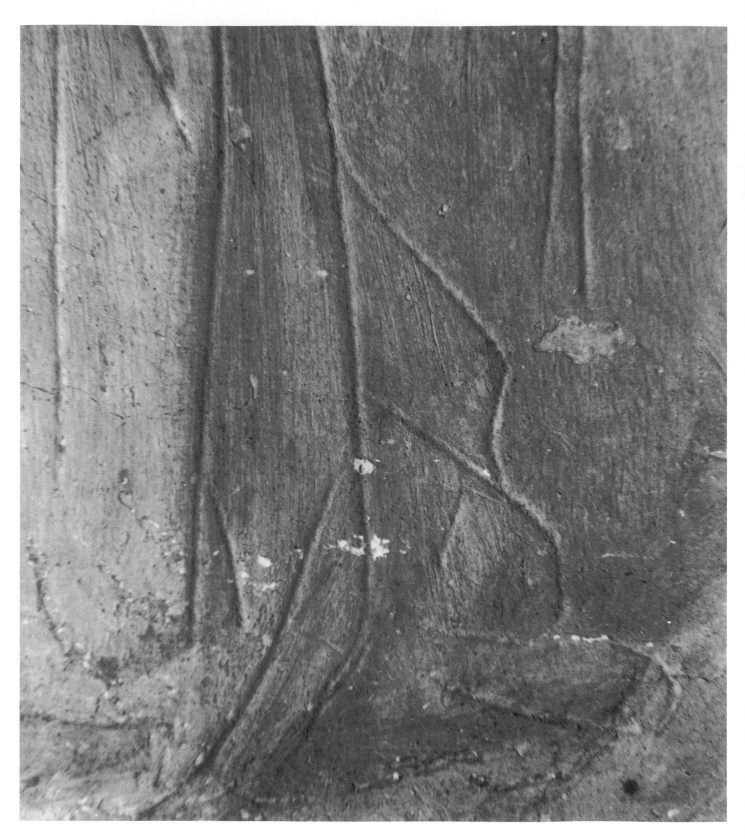

Figure 280. Detail in raking light of Andrea del Sarto, Christian Virtue, *fresco ("Chiostro dello Scalzo," Florence), showing soft stylus incisions from the cartoon.*

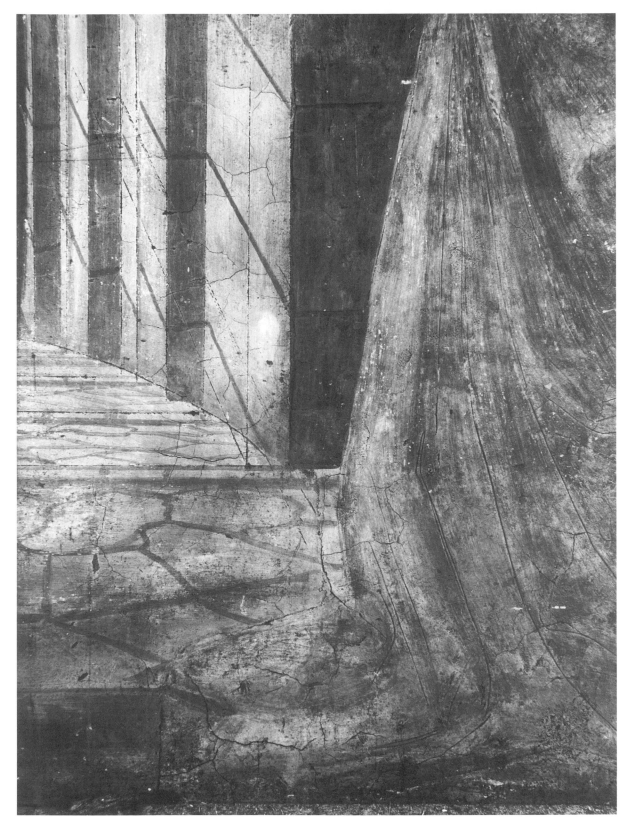

Figure 281. Detail in raking light of Domenico Ghirlandaio, The Visitation, *fresco on the right wall (chancel of S. Maria Novella, Florence). Despite the possible visual ambiguity with respect to the incisions on the drapery folds of the figure on the right, which were obtained through the cartoon, we can deduce that the architectural and perspective lines on the left were all incised directly onto the plaster by means of stylus ruling and cord snapping. A key piece of evidence is the nail holes supplying the reference points for the construction.*

337

the hand, as well as the state of preservation of the drawing and its mount. Most large-scale cartoons have been retouched by old restorers and glued onto secondary supports (e.g., paper, cardboard, panel, or canvas), which has severely flattened incisions and distorted other types of archaeological evidence. Moreover, artists often applied subtle "carbon paper" tracing techniques to transfer cartoons for easel paintings, as is described in Giorgio Vasari's introduction to the *Vite* (Florence, 1550 and 1568 editions) and Raffaele Borghini's *Il Riposo* (Florence, 1584).[24] Giovanni Battista Armenini's *De' veri precetti della pittura* (Ravenna, 1586) alludes to such "carbon" techniques regarding the *"disegni finiti"* by Giulio Romano, Perino del Vaga, and Polidoro da Caravaggio.[25]

As "carbon paper" methods required suprisingly little pressure from the hand, the process of *calcare* could in fact be done with the same chalk used for drawing and may thus appear as reinforced drawn contours (Fig. 221). This procedure also probably explains, for instance, some of the repeatedly reinforced, slightly depressed outlines in Michelangelo's imposing, so-called *"Epifania"* cartoon (Figs. 34, 229), from the 1540s to 1550s.[26] Confirming the practice, Andrea del Sarto's *St. Francis* cartoon (Fig. 59), from around 1517, is harshly incised, but with a fineness of line almost that of a hair's breadth, while the verso reveals an extensive area of charcoal, boldly drawn in curving strokes and rubbed like carbon.[27] Another rare enough instance of a cartoon not glued down, and thus also offering clear evidence, is Sebastiano del Piombo's large head of a bearded man looking upward, from the 1520s to 1530s.[28] Sebastiano's cartoon is broadly rendered in charcoal with sculptural *chiaroscuro* on blue paper, but its verso, unlike Andrea del Sarto's *St. Francis,* is not "carbon" rubbed. The soft indentations along the powerfully drawn contours seem more clearly legible from the verso, appearing slightly raised and without abrasion of the paper; here, the artist probably interleafed a separate "carbon" sheet to perform the *calco.* The stylus incisions in Alessandro Allori's *Descent of Christ to Limbo* (Fig. 61) from the 1530s, though fine, fairly sharp, and slightly jagged, do not noticeably disfigure the delicately rendered drawing surface in black chalk. The stylus incisions, however, have greatly damaged Pellegrino da San Daniele's cartoon for the foreshortened head of a man, from 1500 to 1520, which is closely influenced by Leonardo, Luca Signorelli, and *don* Bartolomeo della Gatta.[29]

Similarly, in Giulio Romano's monumental *Stoning of St. Stephen* (Figs. 230–31), from 1519 to 1521, the fine, schematic incisions – now much flattened and buckled from the mounting onto secondary paper and canvas supports – appear to have greatly abraded the heavy layers of charcoal drawing.[30] Although Giulio prepared this cartoon to paint an altarpiece, commissioned by Giovan Matteo Giberti for S. Stefano (Genoa), still in situ, his full-scale drawing may have also been reused in pieces by other artists. An unexpected reprise of Giulio's composition was frescoed – also stylus-incised – in the Carreto Chapel (S. Maurizio, Milan), by a mid-sixteenth-century follower of Bernardino Luini.[31] Much coarser incisions, still, often sliced the paper in Bernardino Poccetti's cartoon fragments (Fig. 42), from 1582 to 1584, for the *Chiostro Grande* murals (S. Maria Novella, Florence).[32] By comparison, some of Poccetti's small-scale sheets of figural studies seem less damaged, because the artist incised their outlines with less pressure.[33] At times, monumental fresco cartoons exhibit incisions that are fairly scanty, and, although they excavate the paper, they seem relatively soft and round in trough.[34] Artists probably dampened the paper to give the rag fibers greater elasticity.

On the working surface, the process of tracing the outlines of a drawing with a stylus leaves relatively soft, thick incisions, as already described. Like many other such indirect incisions, those in Luca Signorelli's frescos in the *"Cappella Nuova"* (Cappella della Madonna di S. Brizio, Orvieto Cathedral), from 1499 to 1504, may have been done with the back end of the paintbrush. Later descriptions of the *calco* technique described this practice – Karel van Mander *("stelen van penselen")* and Acisclo Antonio Palomino *("pedazo de asta de pincel"),* as discussed in Chapter Two. Signorelli's incisions vary from relatively deep to almost imperceptibly shallow, but they always exhibit a soft, broad (2–3 mm.) trough.

Stylus Ruling, Compass Work, and Cartoons

The process of ruling straight lines with a stylus, as well as that of incising circles and referencing with a pointed compass, has here often been described as direct surface construction.[35] The technology of stylus ruling and pointed-compass work had long formed part of a rich, continuous tradition of mural painting in Italy. From the tombs of the fifth and fourth century B.C. in the Greek colony of Paestum, it can be traced straight through the Renaissance and into the nineteenth century.[36]

Because stylus ruling and compass construction are done directly on the working surface with mechanical instruments, they leave sharp, precise, unfaltering lines with relatively deep ridges (Figs. 173, 281). Perfect pitch and frequent overlappings or intersections readily expose the constructional character of such incisions.

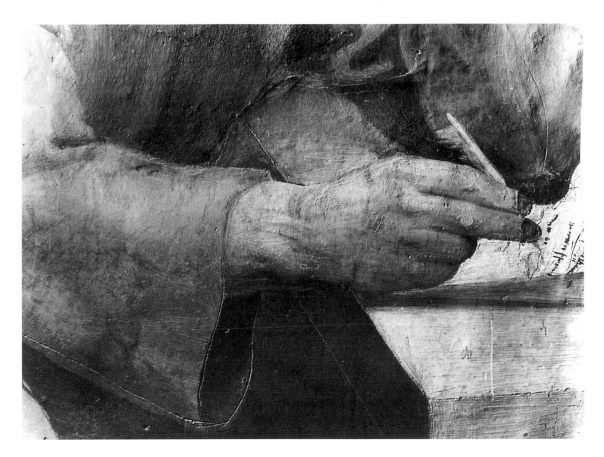

Figure 282. (above) Detail of Heraclitus in *Raphael*, School of Athens, *fresco (*Stanza della Segnatura, *Vatican Palace), a figure omitted from the pricked cartoon (Pinacoteca Ambrosiana, Milan), and painted from a separate cartoon. Some of the jagged, abrasive incisions on the figural parts are the result of direct stylus tracing to reinforce* spolvero *dots that registered too faintly on the plaster.*

Figure 283. (right) Detail of Jacopo Bassano, Moses Receiving the Ten Commandments, *fresco (Chapel of the Rosary, Parish Church of Cartigliano), showing a preliminary sketch, directly incised freehand on the plaster.*

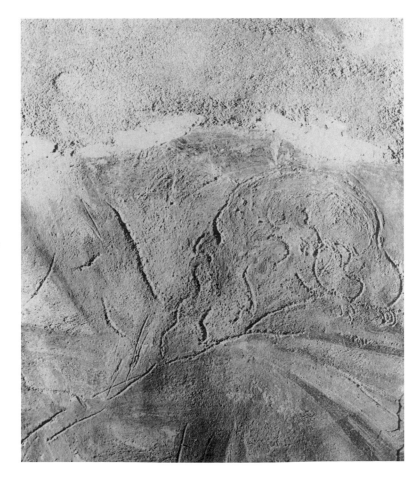

As discussed, direct surface construction is indispensable for perspective and nonrepetitive architectural features.[37] Even when preparing cartoons for the figural parts of *historie,* many Italian mural and easel painters used direct, *alla prima* surface construction for architecture.[38] Painters, more frequently than not, constructed the armatures of stylus-ruled lines for architectural elements before they painted the figures, even in frescos in which the same *giornata* included elements of both.[39] Further, even architecture painted from *spolvero* (or *calco*) was sometimes reinforced with direct stylus ruling or stylus compass to obtain an exact pitch for lines and circles. This is true of selective passages with *spolvero* on the *"all' antica,"* foreshortened temple in the background of Luca Signorelli's *Preaching of the Antichrist,* from 1499 to 1504, at Orvieto Cathedral.

Some of Melozzo da Forlì's mural fragments from the apse of SS. Apostoli (Vatican Museums and Quirinal Palace, Rome), from 1481 to 1483, though comprehensively pounced in the faces and hands of the figures, reveal incisions resulting from cartoon transfer *(incisioni indirette)* on the draperies defining the bodies, and stylus ruling and compass work on the musical instruments held by the angels – the product of direct surface construction.[40] The comprehensive armatures of stylus ruling and compass work are considerably more complex in the so-called *"Coronation of Charlemagne"* (*Stanza dell'Incendio,* Vatican Palace), from 1516 to 1517.[41] In this fresco by Raphael's workshop, there is ample evidence, as well, of *spolvero* on the figures and of *spolvero* dots retraced with the stylus, done directly and crudely on the plaster. Finally, Pellegrino Tibaldi's detached fresco from the Poggi Chapel, *Giovanni Poggi Receiving the News of His Nomination as Cardinal* (S. Giacomo Maggiore, Bologna), painted in 1551–56, offers more subtle data in this regard.[42] As in other scenes in the Poggi Chapel, incisions from transfer, which are usually shallow and relatively broad, appear on the figures and many portions of the framing *trompe–l'oeil* architecture. This attests to the fact that Tibaldi's cartoon detailed the composition of the entire rectangular field. But to correct the architectural lines, the artist retraced some of these by stylus-ruling directly on the *intonaco.* Pitch-straight, the latter type of incision abraded the *intonaco* surface. On the lower left side of the composition, the direct stylus construction for the *podia* of the columns shifts at an angle with respect to the indirect incisions – a perspectival adjustment. On the lower right side of the composition, the stylus ruling runs into the legs of standing figures.

Preliminary Stylus Indications and Cartoons

A third alternative of work is the process of sketching or drawing preliminary lines freehand with the stylus, directly on the working surface, which leaves usually jagged, scribbly, tentative, sometimes reinforced troughs, with relatively built-up "burr." This type of incision could serve as a preliminary guide in drawing or painting, and the overall effect often resembles the freedom of exploratory drawing.[43] This process, too, was known since Antiquity, as attested by the *Tomb of the Diver* of the fifth century B.C. (Museo Civico, Paestum).[44]

As discussed in Chapter Two, muralists frequently reinforced faint *spolvero* outlines with the stylus directly on the *intonaco* (Fig. 282). This practice, in particular, can cause confusion. Such direct incisions, unless rigorously examined (and some cases prove woefully ambiguous!), may be mistaken for *calco,* which, as the present state of research indicates, was beginning to emerge as a technique of design transfer by the 1460s to 1470s.

In great contrast, only preliminary direct incisions – of a rich variety of mark and all closely combined – articulate the figure of Moses in Jacopo Bassano's fresco (Fig. 283), from 1538 to 1540.[45] Some of the indented strokes around the patriarch's face are extremely free, deep, and irregular – not unlike Jacopo's quick pictorial style of drawing with wet chalk on paper.[46] The incisions on the draperies, sleeve, and hand are less descriptive, and are more lightly scribbled on the fresh *intonaco,* with reinforcement lines. Francesco Salviati's mural cycle at the *"Sala dei Fasti Farnesiani"* (Palazzo Farnese, Rome), from 1549 to 1563, exhibits extensive passages of *calco* in the *historie,* but sketchy direct incisions in some of the decorative *rinceaux.*[47] An extraordinary exponent of this *virtuoso* tradition, Caravaggio employed very summary preliminary direct incisions to establish the overall placement of his figures on the canvas.[48] Famous for skipping preliminary drawings on paper entirely, Caravaggio painted directly from the living model and without the aid of cartoons.

SPOLVERO, CALCO, AND THE
TECHNICAL VIRTUOSITY OF FRESCO PAINTING

In concluding, we may seek a context for the developments already described within the larger ideals of artistic prowess emerging from the Quattrocento to the Cinquecento. Admittedly, often enough during this period, figural cartoons were replicated as stock patterns, particularly if designed for artisans or for use by the workshop. This is true, for instance, of the three pricked drawings from a *taccuino* from 1500 to 1520 by the *bottega* of Raffaellino del Garbo (Fig. 109; CBC 79–80), which portray disembodied heads and hands, probably for the use of embroiderers, or of the "biscuit cutter" *spolvero* apparently used for the *Madonna and Child* in the small tabernacle fresco (Figs. 178–79), from the 1430s to 1440s by the prolific Bicci di Lorenzo or a follower. Such examples demonstrate that artists and artisans continued to employ drawings in a patternlike fashion to assemble popular religious imagery. That much of the cartoon's history is intertwined with this crude reproductive function, however, should not obscure its crucial role in the creative process of design for fresco painting. Noting the particular usefulness of cartoons for this medium, Giorgio Vasari aptly concluded in the introduction to the *Vite* (Florence, 1550 and 1568 editions), "but certainly he who hit upon such an invention *[invenzione]* had good imagination *[fantasia]*."[1] That could not be denied of the Quattrocento.

Delegation of Labor

Once the "invention" of cartoons had been made – to recast Vasari's words – its utility would long keep it viable for a variety of reasons. Significant among these, as is already clear from the application of *spolvero* patterns in Trecento ornament painting, cartoons facilitated a greater division of labor between design and execution, for much of the actual preparation of the

mural surface, including the transfer of the design from cartoons, could be entrusted to assistants.[2] We have seen that the memorandum from 6 June 1572 to the Grand Duke Cosimo I de' Medici, submitting the contract and budget for the many types of laborers and collaborators Vasari needed in his vast fresco enterprise at Florence Cathedral, referred specifically to painters who were "cartoon tracers."[3] The capable foreman Vasari hired, the Bolognese painter Lorenzo Sabatini, collected payments for making cartoons between July and September 1572 *("a buon chonto de' chartoni e del servizio in chupola")*.[4] As discussed, Vicente Carducho's *Diálogos de la pintura* (Madrid, 1633) notes that in a painter's workshop it was the *"oficial"* (assistant) who transferred cartoons and prepared the underpainting for the *"maestro"* (master), and much the same is implied by the two painter's assistants conversing in Gian Battista Volpato's dialogue, *Il Modo del tener nel dipinger* (MS., 1670–1700).[5]

In Piero della Francesca's mural cycle on the *Legend of the True Cross* at S. Francesco in Arezzo (finished before 1466), the use of *spolvero* cartoons, particularly, helped unify the areas of painting and preliminary preparation delegated to assistants.[6] In the portion narrating the *Proof of the True Cross,* the orderly *spolvero* dots on St. Helena's hands run consistently 2–3 mm. above the painted outlines. Here, the "pouncer" was most probably not the painter of the figure. Moreover, the dark, painted outlines on some of the women's heads in the background of this scene (Fig. 284) have a bizarre, nearly jagged "connect-the-*spolvero*-dots" quality. Though the upper paint layers may well have been executed by Piero himself, such weak outlining was surely the work of assistants. On the same *pontata,* but on the altar wall, in the *Torture of Judas the Jew,* frescoed by Giovanni da Piamonte (rather than Piero), the cartoon for the man on the extreme left who pulls the

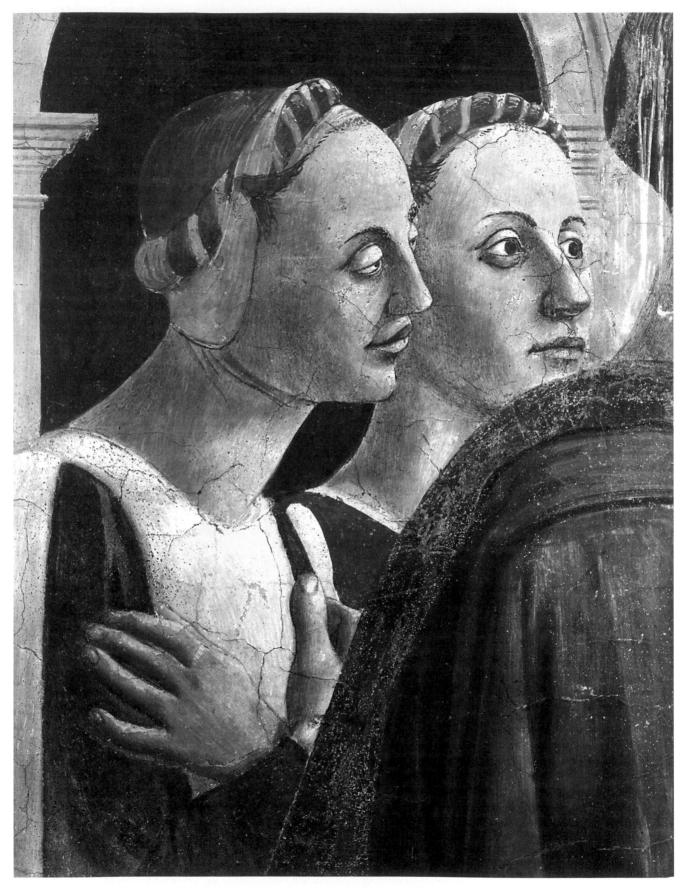

Figure 284. Detail of Piero della Francesca and assistant, The Proof of the True Cross, *mixed mural technique (S. Francesco, Arezzo). These heads reveal an unusually crude outlining of* spolvero *dots with dark paint.*

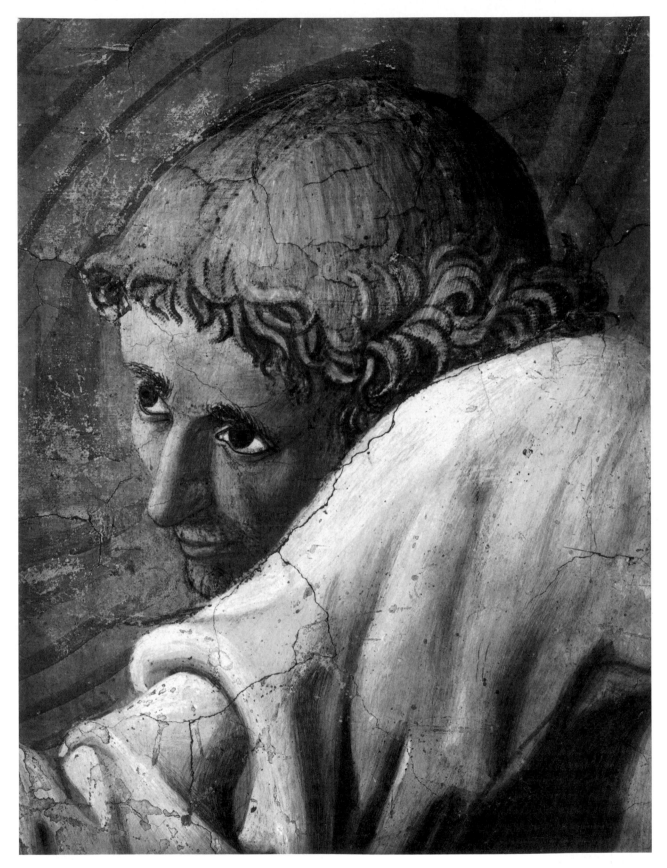

Figure 285. Detail of Giovanni da Piamonte after cartoon by Piero della Francesca, The Burial of the Cross *(S. Francesco, Arezzo), among the very few scenes in the cycle painted entirely in* buon fresco. *The manner of pouncing with fine, tightly spaced* spolvero *dots is distinctive. From the frequently syncopated rows of dots, we can infer that the cartoon slipped, as is especially evident on the stringy locks of hair framing the youth's face.*

343

cord at the well slipped during the process of transfer. Syncopated, double rows of smudged *spolvero* dots outline his hair and face. The same is true of passages in the *Burial of the Cross* (Fig. 285). *Spolvero* cartoons similarly unified the execution of the *"Sala dei Mesi"* murals in Palazzo Schifanoia (Fig. 199), where a team of painters worked between 1467 and 1469, probably under the supervision of Francesco del Cossa.[7]

The written evidence on the delegated labor of execution is no less compelling. Documents from 30 January and 19 June 1465 record that Domenico di Michelino's canvas of *Dante, as Poet of the Divine Comedy* (Florence Cathedral) was to be painted exactly from a *"modello"* given by Alesso Baldovinetti.[8] Dated 1 September 1485, Domenico Ghirlandaio's and his brother David's contract for the fresco cycle on the lives of the Virgin and St. John the Baptist in the chancel *("cappella maggiore")* of S. Maria Novella accepts the involvement of workshop assistants.[9] These frescos exhibit extensive use of the *spolvero* and *calco* techniques

(Figs. 215, 286–88). According to Vasari, Sebastiano Mainardi relied on a cartoon drawn by his brother-in-law, Domenico Ghirlandaio, to fresco the *Virgin Giving the Holy Girdle to St. Thomas* in the Baroncelli Chapel (S. Croce, Florence), from around 1490; in his autobiography, Vasari mentioned that he himself had painted "a Venus and a Leda" in 1540, for Ottaviano de' Medici, from cartoons by Michelangelo.[10] The feeble panel that Ascanio Condivi painted from Michelangelo's poignant cartoon of the *Virgin and Child with Saints* (Fig. 34) is still extant. Not surprisingly, the contract drafted on 29 June 1502, on behalf of Cardinal Francesco de' Todeschini-Piccolomini, for Bernardino Pinturicchio to fresco the Library in Siena Cathedral, states that the painter was "obliged to do all the designs of the *istorie* in his own hand on cartoon and wall *[di sua mano in cartoni et in muro]*; to do the heads in his own hand in fresco, and in *secco* retouch and finish to perfection."[11] Paid for by 27 February 1508, the Piccolomini Library

Figure 286. Domenico Ghirlandaio, The Visitation, *fresco (chancel of S. Maria Novella, Florence).*

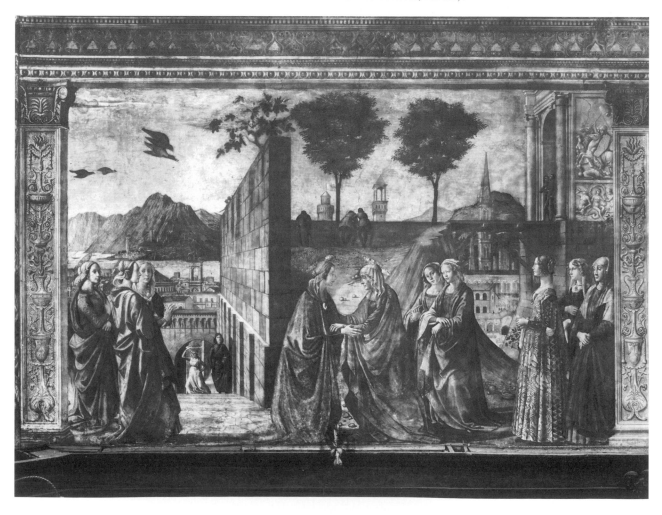

Figure 287. Detail in raking light of Domenico Ghirlandaio, The Visitation, showing the crude cartoon incisions on the foreground figures of the Virgin and St. Elizabeth.

Figure 288. Detail in raking light of Domenico Ghirlandaio, The Visitation, showing the direct construction on the plaster by means of stylus ruling, cord snapping, and pointed compass for the city wall and gate in the left background. Here, the figures were painted alla prima on the plaster.

345

murals, however, in the end demonstrate a greater division of labor than is even allowed for in the contract. This is clear from both the numerous passages of painting showing a diversity of *bottega* helpers at work (with eclectic combinations of *spolvero* and *calco*) and, no less importantly, from Vasari's statements that Raphael designed the *"cartoni"* for Pinturicchio's *"historie,"* words that are partly verifiable by the fact that a *modello*, in all likelihood by Raphael, is extant for the scene with *Eneas Sylvius Piccolomini's Departure to Basel.*[12] The drawing bears handwritten iconographic notes.

In Chapter Eight, we noted the neat pyramid of delegated labor implied by the payment documents from 1503 to 1506 regarding Leonardo's painting of the *Battle of Anghiari* mural, which mention *"dipintori," "garzoni,"* and *"manouali."* About to begin frescoing the Sistine Ceiling, Michelangelo noted in a *"ricordo"* from April 1508 the hiring of five *"garzoni"* to be brought from Florence at twenty gold ducats *"di chamera"* each.[13] Between 11 May and 27 July 1508, the Florentine *"maestro di murare,"* Piero di Jacopo Rosselli stated that he received several sums from both Michelangelo and the master's chief assistant in the early work of the Sistine, Francesco Granacci, for erecting scaffolding and plastering.[14] The *"historia"* closest in date to these documents is the *Flood* (Plate XIII), frescoed painstakingly in twenty-nine or thirty *giornate* from *spolvero* cartoons and showing an actual diversity of artists' hands in its execution.[15] Another clear-cut case of the division of labor between design and execution were Domenico Beccafumi's cartoons from 1524 to 1531 for the production of the marble inlaid pavement in Siena Cathedral (Figs. 32–33), cartoons that were translated to stone independently by various *scarpellini* ("stone cutters"). Vasari's *Vita* of Titian mentions the painter's cartoons for mosaics, yet another craft where the labor of design and execution was divided (no references to cartoons occur in passages about Titian's prowess as a fresco painter).[16] We may also recall Michelangelo Anselmi's ordeal regarding the cartoons for the fresco of the *Coronation of the Virgin* in the apse of S. Maria della Steccata (Parma): despairing letters and an assessment record on 28 January 1543 tell that the artist was finally forced to draw the cartoons directly on the concave painting surface in order to adjust the foreshortenings of his figures.[17] These cartoons were originally to have been drawn by Giulio Romano, who on 14 March 1540 had committed himself to do a small composition drawing in color and render at least the three main figures in cartoon scale, whereas the rest of the work was to be delegated.[18] The acrimonious commission had earlier involved Parmigianino, whom the dishonest *operai* of the Steccata surreptitiously passed over in favor of Giulio.

Calco in the Late Quattrocento and Early Cinquecento

The earliest firmly documented murals that reveal evidence of incisions from cartoons combine at least some passages of *spolvero,* as in Melozzo da Forlì's fragments from the *Ascension* (Pinacoteca Vaticana and Palazzo del Quirinale, Rome), painted originally on the apse of SS. Apostoli around 1481–83.[19] The transition from the traditional technique of *spolvero* to the new one of *calco* occurred between the 1460s to 1470s and the late 1520s. If during these decades the new technique appears especially well represented in Central Italy, examples also abound in the North – for instance, in Lombardy, by Bernardino Luini; in the Veneto, by Francesco Verla, Girolamo Mocetto, and Giovanni Francesco Morone.[20]

The experiments with both *spolvero* and *calco* by the Ghirlandaio *bottega* were pioneering attempts at combining precision of detail with rapid execution. A number of the portrait heads in his early *Funeral of St. Fina* (Collegiata of San Gimignano), from around 1473–75, are carefully frescoed from *spolvero*.[21] More economic in approach is the fresco cycle in the chancel *("cappella maggiore")* of S. Maria Novella in Florence, from 1485 to 1490. There, Ghirlandaio's assistants often pounced cartoons for repetitive ornament patterns, facial features (particularly of portrait heads), and other intricate designs, while stylus-incising areas devoid of detail, such as draperies, which they also painted broadly.[22] The hands of figures were sometimes pounced, sometimes stylus-incised, depending on their complexity of design.[23] Although the precise chronology of the S. Maria Novella cycle is debated, we can generally conclude from the physical evidence that the frescoists loosened their technique considerably as they turned from the left wall to the right wall in the chapel – for instance, on the later right wall, they prepared fewer, larger *giornate* and used *calco* more comprehensively.[24] There, among the vivid signs of such self-assured, economic design technology in the scene of the *Visitation* are the boldly stylus-incised monumental figures in the foreground and the improvised tiny figures in the background, freely painted on top of architectural features and perspective construction incised directly on the plaster (Figs. 286–88).

A different kind of technical proficiency is evident in Luca Signorelli's fresco cycle in the *"Cappella Nuova"*

(Cappella della Madonna di S. Brizio, Orvieto Cathedral), from 1499 to 1504, although complete agreement on its precise chronology of execution is also not forthcoming.[25] From the vault, contracted on 5 April 1499, to the *historie* on the walls of the chapel, contracted nearly a year later on 27 April 1500, the growing mastery of the difficult fresco medium by Luca and his *bottega* assistants generally translates into concrete changes of technique suggesting rapidity of execution. Of the frescos on the vault there are groin compartments which are (1) entirely on *spolvero,* the earlier ones to be painted; (2) partly on *spolvero* and partly on *incisione indiretta;* and (3) entirely on *incisione indiretta,* the later ones to be painted. An exception to these general developments occurs in the compartment immediately to the left of the altar, above the *Crowning of the Elect.* Here, the Signorelli *bottega* inserted the seated figure of the Virgin, amidst the chorus of apostles, clearly a very belated revision of the design: the *intonaco* of her figure lies on top of all adjoining *giornate,* creating an abrupt rise in the fresco surface. Unlike the surrounding figures of apostles in the same compartment (which show *spolvero*), this palimpsest design of the Virgin was stylus-traced from a cartoon; moreover, the style of painting recalls the noticeably freer manner and cooler, more vibrant tonality of Signorelli's later *historie* below. Next to the Virgin's head, the crude process by which the grouping of figures was revised, and her figure as the "Queen of Heaven" was inserted, left as a result an "extra" halo: presumably it belongs to an earlier version of the Virgin's design that was hastily replaced.[26]

The cartoons for all the monumental *historie* on the walls of the chapel were transferred by stylus incision, except for the *spolvero* motifs in the *Preaching of the Antichrist,* already discussed.[27] Much was also painted *alla prima* without cartoons. Most of the repeating ornament patterns, including *grotteschi,* were pounced. Of the *historie,* the *Crowning of the Elect* exhibits a remarkable number of technical slips at the stage of the cartoon. The indirect incisions on a few of the figures of the "elect" show their hair to be limp and straight, but the final painting shows it attractively curly. In the uppermost register, the face of an angel playing the harp also reveals considerable *pentimenti,* including eyes incised 3 mm. lower and 5 mm. more to the right than as painted, and a right facial contour incised about 10 mm. more to the right than as painted, thus creating a much narrower face. The hands and arms of two figures were mistakenly incised but not painted.[28] On the ground level of the scene, toward the left border, there is an "extra" pair of legs (clearly not belonging to an angel or "elect" in the crowd, as we might at first think), both

incised and finally painted. Moreover, the design of the feet on these "stray" legs is abruptly cut off by the vertical suture of a *giornata:* the design continues as a rocky groundline on the adjoing *giornata!* This mistake is quite apparent even to a spectator viewing the fresco from the floor of the chapel.[29] A few of the smaller-scale background figures in the scene were improvised *alla prima,* after the cartoon was transferred: they exhibit no signs of transfer and their execution appears quick, thinly pigmented, and impressionistic.

Other signs of rapid execution, and even oversights in painting, occur throughout the Orvieto fresco cycle. These are usually instances of divergences between stylus-incised and painted outlines – as small as 7 mm. in some of the heads, and sometimes as great as 30–40 mm. in the overall disposition of figures.[30] More noteworthy, however, the head of an onlooker on the right in the *Preaching of the Antichrist* was stylus-incised but never painted. Along the top register of the right half of the altar wall, the right leg of a figure, sketched *alla prima* with brush and brown-mustard color, appears in the space between the figures of two standing angels, whose design bears indirect stylus incisions. This "extra" leg clearly belonged to the figure of yet another angel whose head and body were never completed: not appearing in the cartoon, the figure was added as an afterthought but was then untidily edited out.[31]

Efficiency of Combined Techniques

The combined use of *spolvero* and *calco* to transfer figural cartoons was a common practice not only among the contemporaries of Melozzo da Forlì, Domenico Ghirlandaio, and Luca Signorelli, but also among the artists formed in Raphael's Roman workshop, as is attested by the *"Coronation of Charlemagne"* (Stanza dell' Incendio, Vatican Palace), frescoed in 1516–17, or in Giulio Romano's *"Sala dei Giganti"* (Palazzo Te, Mantua), frescoed in 1530–32.[32] In Andrea del Sarto's monochrome mural cycle on the *Life of St. John the Baptist* (*"Chiostro dello Scalzo,"* Florence), the cartoons for most of the twelve *historie* were stylus-incised, as were those for the allegorical figures of the *Christian Virtues* (Fig. 280).[33] Though commissioned in 1509, the murals were probably begun in 1511 and after several interruptions, finished in 1524; the *Baptism of Christ* (Fig. 289), the first scene to be frescoed, reveals careful *spolvero* throughout.[34] Besides this early scene, and besides the ornamental parts, *spolvero* appears in the scenes painted by Franciabigio from 1518 to 1519, while Andrea was in France: the *Blessing of St. John the Baptist*

by Zacharias and the *Meeting of Christ and St. John the Baptist.*[35] The *Annunciation to Zacharias,* painted in 1522–23 – Andrea returned from France in 1522 – combines both *spolvero* and *calco.*[36] The transition of hands from Andrea del Sarto to Franciabigio, and back to Andrea del Sarto, may well have had something to do with the choice of *spolvero* over *calco* for the later cartoons, for *spolvero* is less destructive and enables a more precise delegation of execution. In the *Imprisonment of St. John the Baptist,* the stylus incisions are remarkably free, frequently diverging from the outlines as finally painted. In a much later example, Annibale and Agostino Carracci's application of both *spolvero* and *calco* to fresco the ceiling of the *"Galleria Farnese"* (Palazzo Farnese, Rome) in 1597–1601 would also be related to the division of labor in the *bottega,* and the extant cartoons for the project bear the evidence of both types of design transfer.[37]

The particular efficiency of *spolvero* to produce copies has already been discussed. It is an advantage that kept the technique viable also in mural painting, not only for ornament but also sometimes for figures. The figural parts of the *Battle of Ostia (Stanza dell' Incendio,* Vatican Palace) from 1515 to 1517, for instance, are entirely stylus-incised, except for one small passage in the right middleground. Here, the Raphael workshop pounced the detail of one horseman but stylus-traced the identical one beside it.[38] Thus, the small pricked cartoon served to repeat the motif, but when it was no longer necessary to preserve the cartoon, it was transferred by the quicker though more destructive method of *calco.*

Not surprisingly, Michelangelo's methods of cartoon transfer in the Sistine Ceiling largely reflect his training in Ghirlandaio's *bottega.* In Michelangelo's *Creation of Adam,* the intricate figures of God the Father and his tightly knit group are carefully pounced, whereas the recumbent, single figure of Adam is stylus-incised (Plate XIV, Figs. 69, 290–91).[39] Here, especially Andrea Pozzo's *Perspectiva Pictorum et architectorum* (Rome, 1693–1700) and Francesco Milizia's *Dizionario* (Bassano, 1797) help explain the combined uses of *spolvero* and *calco* in such frescos. Pozzo's treatise points out that while stylus tracing *("ricalcare")* was the usual and efficient method of cartoon transfer, pouncing *("spolverare"),* was to be employed in *"cose piccole"* (small things).[40] Similarly, Milizia's *Dizionario* specifies that *spolvero* should be utilized if a composition entails numerous figures *("se le figure sono numerose"),* that is, if a composition is complex.[41] This is certainly true of the group around God the Father in Michelangelo's

Creation (Figs. 69, 290–91). As both authors imply, the resulting precision of detail more than compensated for the laboriousness of the *spolvero* technique.

Pozzo's and Milizia's passages also suggest the reason why Michelangelo turned to *calco* in the late *historie* of the Sistine Ceiling, a time-saving device, but retained *spolvero,* for instance, in the complex figures of the prophets and sibyls, which are fitted into the difficult, constraining pictorial fields of the real and fictive architectural framework that already existed[42] and which were painted slowly, in at least ten *giornate* each.[43] A similar reason may be adduced for the use of *spolvero* in the *ignudi,*[44] the pendentive of the *Brazen Serpent* with its knotlike grouping of figures,[45] and other late parts of the ceiling.

As the precision of pictorial notation possible with *spolvero* cannot readily be obtained with the *calco* technique, *calco* can at times prove to be less easily delegated to assistants than *spolvero.*[46] This fact also helps explain the prevalence of *spolvero* in the early *historie* of Michelangelo's Sistine Ceiling, where it is well-known that he employed a team of assistants.[47] In the *Temptation and Fall,* among the last scenes of the first *pontata* Michelangelo painted, the first signs of combined methods of cartoon transfer appear on the *intonaco.* Although most of the scene of the *Temptation and Fall* exhibits *spolvero,* the head of the avenging angel, the last *giornata* painted, bears the blunt, shallow incisions from *calco.*[48] The *Creation of Eve* is still entirely pounced. The moment of transition from the one method to the other seems to have coincided with the drastic reduction of Michelangelo's workshop help.[49] In these last scenes of the first *pontata,* the scale of the figures would become monumental and the number of *giornate* would decrease to only eleven in the *Temptation and Fall* and to three in the *Creation of Eve.*[50] Thus, Michelangelo gradually abandoned *spolvero* cartoons in the interest of more rapid execution.

Creative Reuses of Cartoons

In discussing copies and ornament, we have encountered numerous examples of pricked drawings and prints with telltale physical evidence of multiple design replication: versos rubbed with pouncing dust.[51] Though rare, as we have seen, some Renaissance and Baroque written sources do also mention the flicking over of patterns or cartoons to create mirror images.[52] Bilateral symmetry is an aesthetic goal inherently better served by pricking and pouncing cartoons for transfer,

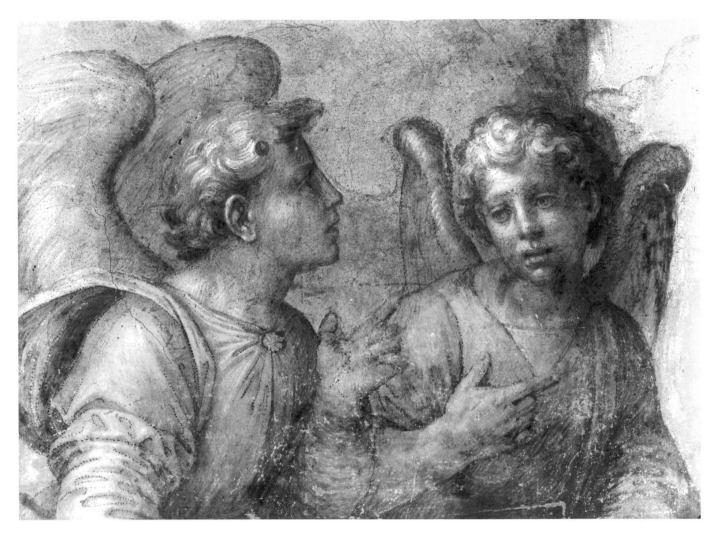

Figure 289. Detail of spolvero in Andrea del Sarto, The Baptism of Christ, mixed mural technique ("Chiostro dello Scalzo").

rather than by stylus-tracing them. From the 1450s to the 1510s, it is clear that Italian artists would exploit the practice of such cartoon reversals as a compositional device.[53] Although paintings from the mid–fifteenth century onward generally attest to this important use and reuse of *spolvero* cartoons, close examination of such cases also reveals unexpected complexities, for the majority of such drawings actually used do not survive and much of the archaeological evidence on the fresco surface is lost.[54] In Michelangelo's Sistine Ceiling, instances of possible cartoon reversal abound in the decorative figural elements that rely heavily on counterpoints of symmetry; provable physical evidence for the practice, however, is only forthcoming regarding the pairs of monochrome *putti* caryatids on the fictive marble thrones flanking the prophets and sibyls.[55] We may remember the demonstrable example of Giulio Romano's repetition of the two ornamental, bilaterally symmetrical hermaphrodites in the *Sala di Costantino* at the Vatican Palace – the one above the allegorical fig-

ure of *Moderatio* and the other above *Aeternitas* (Figs. 89–90). As can be verified not only from the mural surface, but also from the extant cartoon in the Uffizi, Giulio relied on the same drawing to pounce one head and incise the other.

The practice of overtly reversing designs, however, clearly began to collide with the notions of invention, variety, and *disegno* already crystallizing in the late Quattrocento – in Leonardo's words, the *"copia e varietà"* of the *"istoria."* Leonardo's opinion is recorded in the posthumously compiled *Codex Urbinas Latinus* (fols. 44 recto-verso, 106 verso–107 recto).[56] He considered it a mistake for painters to repeat figures, faces, motifs, or movements within the same narrative composition, for exact repetitions of form were not found in Nature. As three-dimensional symmetry gradually

349

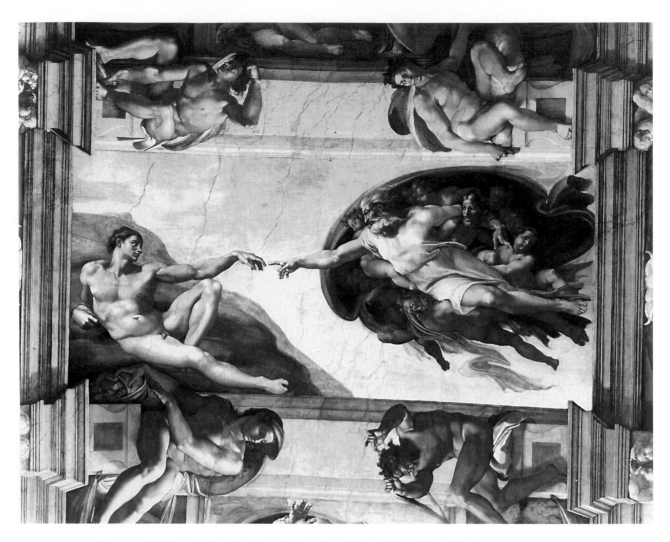

Figure 290. Michelangelo, The Creation of Adam, *fresco (Sistine Ceiling, Vatican Palace).*

Figure 291. Detail of the legs of God the Father in Michelangelo, The Creation of Adam, *painted from* spolvero *cartoons.*

began to replace bilateral symmetry as an aesthetic ideal during the 1510s to 1520s, there were significantly fewer cases of outright cartoon reversals.[57] Nevertheless, as we saw in Chapters Three and Nine, more subtle examples of cartoon and drawing reuse turn up still in plentiful quantity during the Cinquecento, as labor-saving devices within the design process itself.

A related practice may have been a great deal more common than we may now be able to verify – the reuse of parts of cartoons, with isolated pieces of figures. Tantalizing evidence to this general effect has emerged in the case of Luca Signorelli's frescos in the "Cappella Nuova" (Cappella della Madonna di S. Brizio, Orvieto Cathedral), from 1499 to 1504, in which a number of figures have heads with similar dimensions and designs, although their bodies vary greatly in pose.[58] In Correggio's *Assumption of the Virgin* fresco on the dome of Parma Cathedral, executed in 1526–30, designs of entire types of limbs for the adoring angels and saints are repeated manifold.[59] Still more concrete examples of this design reuse practice is found in an actual group of pricked cartoon fragments for figural ornament, attributed to Perino del Vaga and Pellegrino Tibaldi, which served to repeat symmetrical motifs of *putti,* sphynxes, and Antique-style grottesque masks. Unless they designed for artisans or painters of ornament, both Perino and Pellegrino usually employed *calco,* rather than *spolvero* in their mature works. Perino's cartoon of four *putti* flanking an oval (Fig. 292), as well as the three cartoon fragments by Pellegrino of sphynxes and grotesque masks (Figs. 293–94; CBC 305), are drawn on preliminary pricked outlines, which obviously do not relate to the subsequent design of the forms.[60] Of deeply graded chiaroscuro, the four *"ben finiti cartoni"* are executed in a painterly technique, with ink washes and white gouache highlights, applied with the brush, over a charcoal or black chalk underdrawing. In Pellegrino's fragments, possibly intended for the frescoing of a *dado* or *spalliera* in a room, the divergences between pricked and drawn outlines are strikingly great. The pricking here probably served as a general guide both for drawing the many variations of the ornament pattern that were required in frescoing a large space and for transferring the basic design onto the *intonaco*. If greater precision of form was required, however, newly resulting drafts of the pattern would have needed much repricking. Perhaps not coincidentally, Perino's pricked cartoon fragment (Fig. 292) contains both coarse holes and fine holes, probably corresponding to two such separate pricking campaigns. The fine holes are later,

for they are more descriptive and are often found on interior forms; these fine holes were probably used to transfer the design onto the working surface.

A solution similar to that in Perino's and Pellegrino's drawings may have occurred to Michelangelo in designing his full-scale cartoons for the *ignudi* in the Sistine Ceiling (Figs. 66, 290).[61] The *ignudi*'s relatively precise bilateral symmetry, at least in the pair flanking the *Drunkenness of Noah,* has led to the suggestion that they were painted from reversed cartoons.[62] Yet the differences, albeit relatively minor, between the poses of the *ignudi* above the *Prophet Joel* (e.g., the *ignudi* that are intact as a pair) preclude this being simply a case of direct cartoon reversal. Although these two *ignudi* are of identical scale, tracings on clear acetate can demonstrate (if we were to reverse the designs), the many small divergences, displacements, and rotations of the limbs and heads with respect to the torsos, which suggest the use of intermediate, mechanically transferred drawings or tracings, rather than a direct reversal on the fresco surface.[63] The other pair of *ignudi* flanking the *Drunkenness of Noah,* above the *Delphic Sibyl,* is less similar; the *ignudo* damaged in 1797 is known from the engraving by Adamo "Scultori."[64] Moreover, the results from the cleaning of the Sistine Ceiling do not suggest that in designing the poses of the *ignudi,* Michelangelo produced their mirroring counterparts by simply reversing their cartoons and modifying their poses *alla prima* on the *intonaco*.[65] Their painting technique is too precise and laborious for such improvisation. And the number of *giornate,* usually three or four, remains constant.[66] Passages of *spolvero* appear on various portions of the *ignudi*'s anatomies, and black outlines of preliminary underpainting often define the forms conveyed by the *spolvero* marks further. The evidence thus attests to a systematic approach to painting and a deliberate process of preliminary design. Yet Michelangelo probably did seek shortcuts in the design of the *ignudi*'s relative symmetries, as has been hypothesized based on the general correspondences of dimensions.[67] It should be emphasized, however, that the design reversals and alterations of poses must have been practiced in the cartoons, some time before the moment of painting. As the cartoons by Perino and Pellegrino can help us envision, previously used pricked cartoons for the bodies of the *ignudi* may have provided the basis on which Michelangelo elaborated subsequent cartoons, a helpful device in designing symmetrical counterparts on a monumental scale, even if the actual variations had already been explored in small-scale life studies, and even if eventually the symmetries became three-

Figure 292. Attributed to Perino del Vaga, pricked cartoon for a Decorative Motif with Flanking Putti (CBC 321; Gabinetto Disegni e Stampe degli Uffizi inv. 965 E, Florence).

Figure 293. Attributed to Pellegrino Tibaldi, cartoon fragment for a Sphynx (CBC 306 A; Gabinetto Disegni e Stampe degli Uffizi inv. 999E A, Florence). The general forms were drawn from preliminary pricked outlines.

dimensional rather than bilateral. To cite the evidence of a text, as we learn from a letter of 7 February 1526, Lorenzo Lotto would rely on an analogous procedure to produce his cartoons for the complex figural cycle in wood *intarsia* (inlay) at the choir of S. Maria Maggiore, Bergamo. Lotto wrote to ask his patrons that the master wood worker Giovanni Francesco Capoferri da Lovere make tracings on translucent paper *("lucidi")* of Noah, the main figure in the scene of the *Flood* (among the first compositions to be executed), to use as a guide for deriving the scale and proportions of the figures in the scene that would follow.[68]

In the Sistine Ceiling, Michelangelo may have relied on tracing methods and/or partial cartoon reuses for the *historie* of the second *pontata*. For example, roughly from the knee down, God the Father's legs in the *Creation of Adam* are identical mirror images of each other;

they were also painted in a separate *giornata* from the rest of his body. (See Plate XIV, Figs. 290–91.) As finally painted, the equivalent portion of Adam's right leg in the same scene is also identical to God the Father's. Further, as the diagram of cartoon transfer for this scene vividly attests, Michelangelo had inordinate difficulties in producing the correct proportion and scale of Adam's right calf and foot (Plate XIV). The stylus incisions from the cartoon originally depicted his foot smaller by more than a third. In fact, the problem of adjusting the scale of Adam's right lower leg began precisely at his knee. The correspondence of designs and dimensions indicate that all three lower limbs in this scene may have been done from the same cartoon. Thus, we may envision that Michelangelo (or his assistant) pounced the cartoon for God's right leg from the verso to produce God's left leg, and then the artist may

Figure 294. Attributed to Pellegrino Tibaldi, cartoon fragment for a Sphynx (CBC 306 B; Gabinetto Disegni e Stampe degli Uffizi inv. 999 E B, Florence). The general forms were drawn from preliminary pricked outlines.

have conveniently reused the cartoon for God's right leg to help correct the problem of Adam's leg, after the design for this figure had been stylus-traced from the unsatisfactory original cartoon for Adam.[69] The placement of the *giornate* in the scene document that God and his group were painted first, then Adam; the right leg was the last *giornata* of the figure of Adam to be painted (Plate XIV).[70] Similarly, both legs from the knee down in the figure of God the Father, seen in frontal view to the right in the *Creation of the Sun, Moon, and Plants,* are exact mirror images of each other.[71] The lower legs were also the last *giornata* of the figure to be painted. If compared to the other set of three limbs in the *Creation of Adam,* God's lower limbs are close in design and scale, especially if measured in the stylus-incised form rather than the larger outlines of the final painting,[72] and we may wonder, therefore, whether parts of the pricked cartoon for God the Father in the *Creation of Adam* could have been used as a draft to prepare the cartoon for God in the *Creation of the Sun, Moon, and Plants.*[73] Michelangelo probably recycled cartoons – a sensible economic measure, and body parts such as heads, hands, and feet probably helped him gauge the consistency of scale and proportion in his gigantic figures.

The hypothesis regarding Correggio's dome fresco in Parma Cathedral from 1526 to 1530 presupposes a similar reuse of limbs via cartoon fragments, but on a significantly vaster scale.[74] Those conclusions were based on a careful survey of the designs of the figural parts, conducted in the late 1970s under the guidance of the late Eugenio Battisti, with full-scale tracings from the frescos. Apparently, sixty-seven related outline cartoon fragments are extant (Musée du Louvre inv. 5988 to 6002, Paris), of which many portray separate limbs like pieces from a child's cutout doll. But the evidence for this attractive proposal is somewhat compromised by the fact that the "cartoons" may be tracings done by much later artists, either directly from Correggio's frescos or from his cartoons.[75]

Calco and the Ideals of Cinquecento Theorists

In the face of monumental areas to be frescoed, speed of execution became a ruling concern, as well as a matter of pride.[76] Though more destructive, *calco* is a time-saving method of transfer, for with a few sweeping strokes the outlines of a design can be indented permanently on the moist *intonaco.*[77] The method requires self-assurance on the part of the artist, for incisions must be executed relatively quickly. As in Michelangelo's *Creation of the Sun, Moon and Plants* (Fig. 295), the broad, soft incisions from the process of tracing the cartoons are bold, schematic, and fluent. Although the artist usually followed the minute *spolvero* outlines from

Figure 295. Detail in raking light of the angels in Michelangelo, The Creation of the Sun, Moon, and the Plants, *fresco (Sistine Ceiling, Vatican Palace), showing cartoon incisions.*

the cartoons relatively carefully in painting (Figs. 69–70), he often disregarded those from stylus-incised cartoons, treating them only as general guidelines. Michelangelo's approach, however, was by no means exceptional.[78] A remarkable freedom of stroke also characterizes the indirect incisions of numerous murals throughout the sixteenth century and from a variety of regions in Italy.[79]

The ridges from mistaken strokes are readily visible on the *intonaco*. In Michelangelo's *Temptation and Fall* (Sistine Ceiling), the incisions outlining the cranium of the serpent appear much below the one actually painted. In the fresco of the *Dead Christ* (Cenacolo of S. Salvi, Florence), Andrea del Sarto stylus-incised the contours of Christ's legs at times to the left and at times to the right of the painted outlines. Other details in Andrea's frescos reveal similar imprecisions. Divergent incisions with respect to frescoed outlines occur also in Giovanni Antonio Sogliani's *Last Supper,* dated 1536, and *St. Dominic Being Served by Angels* (Large Refectory of S. Marco, Florence). In many murals, such passages are placed much higher than the spectator's eye level, thus the divergences of design are only visible from the restoration scaffoldings and photographs, or when mural fragments are detached and installed in a museum. Sodoma's scenes completing the cycle on the *Life of St. Benedict* (Abbey of Monteoliveto Maggiore), however, stand more or less within reach of the spectator's eye level. There, the considerably misaligned indirect incisions for St. Benedict's hand and left shoulder contour (Fig. 296) are plainly visible, even in normal day light.[80]

That between 1500 and 1520 the *calco* technique began to supersede *spolvero* among painters as the preferred method of cartoon transfer for figural compositions can be demonstrated by a long list of comprehensively stylus-incised murals. Among the highlights, we may note Jacopo Pontormo's *"Madonna of S. Ruffillo"* from around 1514 in the Chapel of St. Luke (SS. Annunziata, Florence), his *Visitation* from 1515–16 in

Figure 296. Detail in raking light of Giovanni Antonio Bazzi "Il Sodoma," St. Benedict Makes a Hatchet Reappear That Had Fallen Into the Lake, fresco (Abbey of Monteoliveto Maggiore), showing displaced cartoon incisions.

the atrium of SS. Annunziata, and his *Annunciation* from 1525 to 1528 in the Capponi Chapel (S. Felicita, Florence); Perino del Vaga's *Justice of Zaleucus* from 1522 to 1523 (Galleria degli Uffizi, Florence); and Agnolo Bronzino's *Miraculous Spring of Moses* from around 1543 in the Chapel of Eleonora di Toledo (Palazzo Vecchio, Florence). The prolific Alessandro Allori, who represents the following generation still, also used the *calco* technique almost exclusively to paint in fresco.[81] Allori's stylus-incised cartoon for a panel of *The Descent*

of Christ to Limbo (Fig. 61) has already been discussed. As we saw in Chapter Three, the *ricordo* about his *Annunciation* fresco from 1589 at S. Jacopo a Ripoli (near Florence), for which he used a *"spolverezzo"* copy of the Virgin from the famous and much venerated Trecento model in SS. Annunziata, refers to a highly unusual circumstance of patronage.[82]

In a century that saw treatise after treatise, by both artists and *dilettanti,* bolstering claims for the nobility of painting, hence its status as a liberal art, the *spolvero* technique – in great contrast to the freedom of mark of *calco* – must have indeed seemed to tie painting and *disegno* to the work of craftspeople. After all, the process of pricking the outlines of a design with a fine point and then pouncing through the holes onto the working surface is laborious and mindlessly mechanical. As extant murals can confirm, except for its application in painting decorative details, the technique of *spolvero* survived mostly in the workshops of artisans and the older generation of painters.[83] That both Michelangelo and Giulio Romano would continue to employ *spolvero* frequently in their complex figural frescos, even in those painted toward the end of their careers, appears as a testimony of their apprenticeships in *botteghe* that developed strong, systematic habits of work, rather than as an entirely representative example of *au courant* fresco technique.[84] As previously discussed, the negative connotations attached to copying and tracing – activities that later writers on art would condemn as signs of unimaginativeness, if not, at times, of fraudulence – largely explain the prejudice against the *spolvero* technique that gradually developed. In this connection, we should recall Vincenzo Giustiniani's famous letter of 1620–30 to Teodoro Amideni (Dirck van Amayden), which stated flatly that painters who employed *spolvero* would rank lowest in his ideal scale of the painter's talents.[85]

"Facilità" and *"Difficultà"*

It is thus understandable that in their discussion of cartoons for fresco and easel painting, Giorgio Vasari's introduction to the *Vite* (Florence, 1550 and 1568) and Raffaele Borghini's *Il Riposo* (Florence, 1584) described not *spolvero,* but *calco.*[86] *Calcare* was like the fluent, spontaneous act of *disegnare* itself. The prowess of Andrea del Sarto as a draughtsman on both paper and the incised plaster of a fresco seems dazzling (Figs. 297–98). The spirited sheet of studies in red chalk, after the nude living model, was preparatory for the apostles on the right in the *Last Supper,* frescoed by Andrea at S.

Salvi in the 1520s.[87] The bold, summary outlines drawn on paper are virtually identical in mark to those traced through the cartoon onto the fresco surface. In this respect, Luca Cambiaso's early work in the 1550s in Genoa would display equivalent verve.[88]

In the act of tracing with the stylus, the artist more or less imitated the rapid motion of the drawing hand. By comparison to the laborious process of pricking and pouncing, *calcare* appears effortless. It is *"facile,"* to use a word of praise that was commonplace in the Cinquecento.

As we have seen, Vasari's *Vite* teem with anecdotes about the technical virtuosity of Renaissance fresco painters, who were often praised for their speed of execution. It is a telling fact, above all, about Vasari's own preoccupations as an artist. If nothing else, for instance, he thought Lorenzo di Bicci (1350–1427) a *"pittor pratico e spedito"* (a practical and fast painter), although in the *Vite* he had actually confused Lorenzo's identity with that of the son, Bicci di Lorenzo (1373–1452). To illustrate his point, Vasari told that after Lorenzo ordered dinner from the *guardiano* at the church where he was hired, just after laying in the *intonaco* to paint a figure, he added, "pour the plates of soup, for I will make this figure, and I will come."[89] The mastery of an enormously difficult, physically challenging medium, that of *buon fresco* – so passionately advocated by Vasari as "being truly the most manly" – had furthered the ideal of the Renaissance artist as *virtuoso,* as *"amatore della difficultà."*[90] Tracing with the stylus – swinging an upraised arm and pressing lightly with the hand around the point to indent a relatively large, slightly resistant surface – requires considerable athletic vigor, as one can discover by actually performing the task during an extended period of time. In a brief passage about stylus-incising designs freehand directly on gilded glass, Cennino's *Libro dell'arte* cautions, "and you will see that you need to have a light hand, and that it should not be tired. . . . And I give you this advice, that the day before the day you want to do this work, you hold your hand to your neck, or in your bosom, so as to get it all unburdened of blood and tiredness."[91]

By the mid–sixteenth century (as art historians have noted in various contexts), the taste for the false paradox disguised in the critical notions of *facilità* and *difficultà* – the task being difficult, but the manner of solving it appearing effortless – had at times become the only yardstick for measuring artistic excellence.[92] Vasari and his contemporaries would repeatedly sum up Michelangelo's genius in such terms.[93] Yet Vasari surely knew that his idol more often relied on *spolvero,* rather

than *calco,* to transfer cartoons. He surely understood, also, the full extent to which earlier Florentine painters had used the *spolvero* technique. He must have encountered the practice often enough, both in his collecting of drawings by early masters and in his remodelings of churches with early frescoed monuments that were thought to be too old-fashioned in the Florence of Grand Duke Cosimo I de' Medici.[94]

In defiance of *disegno* theory, the total omission of preliminary drawings and cartoons in the painting process was at times itself upheld as a sign of artistic prowess.[95] According to Vasari, the young Baldassare Peruzzi proved his mettle when he was able to produce a painting of the *Madonna,* "without so much as a scrap of drawing or cartoon from his master (Maturino)," by making an underdrawing directly on the panel.[96] In the *Vita* of Battista Franco, Vasari also told the famous anecdote regarding the painting competition called by the officials of the Scuola di S. Rocco (Venice).[97] It is repeated in Carlo Ridolfi's *Vita del Tintoretto* (Venice, 1648).[98] While Giuseppe Salviati, Federico Zuccaro, and Paolo Veronese labored diligently to comply with standard practice – that of preparing elaborate demonstration drawings – Jacopo Tintoretto won the judges over by producing the actual painting as his demonstration piece, and with awesome speed. Moreover, Tintoretto's logic appeared unassailable: "Designs *[disegni]* and models *[modelli]* of the work should be such that they do not deceive."[99] In fact, the *topos* gathered force by the seventeenth century. Carlo Malvasia's *Felsina pittrice* (Bologna, 1678) praises Guercino's *"prontezza e facilità"* as a fresco painter – he produced a St. Roch in half a day (!) – and mentions that Guercino, Lorenzo Garbiere, Cesare Baglione, and Lodovico Carracci sometimes frescoed without *"cartoni"* (or *"spolveri"*).[100]

Even for Vasari, who emphasized a considerably more deliberate approach to the art of design and painting than both Venetian and Baroque practitioners, the *spolvero* technique was clearly no longer fundamental, its usefulness being limited to the production of ornament. Indeed, Vasari's workshop assistants only pounced when they needed to replicate patterns of decorative garlands, ribbons, and letters over and over on the *dado,* painted in 1546 in the *"Sala dei Cento Giorni"* (Palazzo della Cancelleria, Rome). The same is true of some of the small women's heads frescoed on the monochrome *dado* decorating the *"Sala del Trionfo della Virtù,"* or *"Sala del Camino,"* begun in 1542 (Casa Vasari, Arezzo). In this regard, we may recall that in the introduction to the *Vite* (Florence, 1550 and 1568), Vasari briefly cited the *spolvero* technique only as a

means of design transfer for *sgraffito* façade decoration.[101] By contrast, he frescoed the *historie* glorifying Pope Paul III's life in the *"Sala dei Cento Giorni"* entirely from stylus-incised cartoons – much as in Vasari's other mural cycles, including the majestic dome of Florence Cathedral and the rooms in Palazzo Vecchio. It gave credence to the artist's boast in his autobiography that he had painted the *sala* in the Palazzo della Cancelleria in a hundred days, hence the *sala's* nickname.[102] The rapidity with which Vasari and his *bottega* completed the project, to comply with his patron Ranuccio Farnese's wishes, prompted another by now famous anecdote. Upon being told how fast Vasari had painted the frescos, Michelangelo stingingly replied, "and it shows."[103] Vasari dutifully expressed contrition, blaming his youthful eagerness to please an impatient patron. He acknowledged his intense efforts in drawing the cartoons himself but regretted that to work faster he had delegated much of the labor of painting to assistants: "It would have been better to do penitence for a hundred months and have made it [all] by my own hand."[104]

"Sconcio" and the Tradition of Illusionistic Fresco Painting

From the late 1420s onward, the attempt to portray the foreshortened human form would often parallel the increasingly complex exploration of pictorial space, as is vividly clear from Masaccio's incised grid of rectangles on the Virgin's figure in the fresco of the *Trinity* (Figs. 171–72). The means of constructing the former were no less deliberate than those of the latter. To the modern observer, a net of converging orthogonals in a fifteenth-century composition conjures almost reflexively the attention with which the artist developed its perspective projection. *Spolvero* marks describing the outlines of a figure should evoke as readily the extensive, careful process of preparatory design leading to these traces on the *intonaco*. As late an example as Michelangelo's *Last Judgment,* frescoed on the altar wall of the Sistine Chapel in 1535–41, provides an informative context. Although the cartoons are lost, a relatively large corpus of extant preliminary drawings by Michelangelo attest to his deliberate study of the extraordinary anatomical effects in the fresco.[105] Approximately 96 percent of a total of 447–50 *giornate* exhibit *spolvero* (Fig. 299), and this despite the fact that by the 1520s *spolvero* was generally considered to be too laborious to compensate for its resulting precision of detail.

Figure 297. Andrea del Sarto, Figure Studies *(Gabinetto Disegni e Stampe degli Uffizi inv. 664 E, Florence).*

Only about 17 *giornate* exhibit *calco* (stylus tracing or *incisione indiretta*).[106]

For Vasari and many of his sixteenth-century contemporaries, *"scorti"* or *"scorci"* (foreshortenings) would remain a more formidable task than any other in painting.[107] Fascinating practical advice regarding the *difficultà* of portraying the foreshortened form abounds in Italian Renaissance and Baroque treatises. Whether such advice was fully practicable is altogether another issue. Piero della Francesca's method of "transformation" has already been discussed. Leon Battista Alberti cited the *"velo"* as an aid to calibrate foreshortenings in drawing, and Leonardo the *"rette"* or *"telaro,"* while Cristoforo Sorte noted that Giulio Romano relied on squared mirrors to develop compositions for illusionistic ceilings, Giorgio Vasari mentioned the use of figural models fashioned of clay, and Benvenuto Cellini the casting of a living model's shadow.[108] Further afield, in *La Pratica della perspettiva* (Venice, 1569), Daniele Barbaro recognized the utility of pricked drawings in the

manner of a *"spolvero"* to project anamorphic designs of the human head onto the painting surface.[109] To all such writers, it was nevertheless self-evident that without an exact means of design reproduction, this research – whether derived from empirical observation, from a semimechanical device, or from a system of measured projection – could not be translated onto a working surface. Indeed, much of it could have proved worthless.

The tradition of illusionistic mural painting could rarely dispense with the application of the semimechanical means of design transfer pioneered by Quattrocento artists, particularly that of figural cartoons. Without doubt, the innovation of such cartoons would sustain this tradition from the Early Renaissance to the Late Baroque, as a survey of design transfer methods in murals can readily confirm.[110] No less importantly, Late Renaissance and Baroque treatise writers vividly affirmed the importance of design transfer techniques for this tradition of illusionistic painting. Here, we may note Egnazio Danti's 1583 commentary to Vignola's treatise on perspective, with its passing reference to drawing cartoons; Pietro Accolti's *Lo Inganno de gl'occhi* (Florence, 1625), with its particular advice on how to

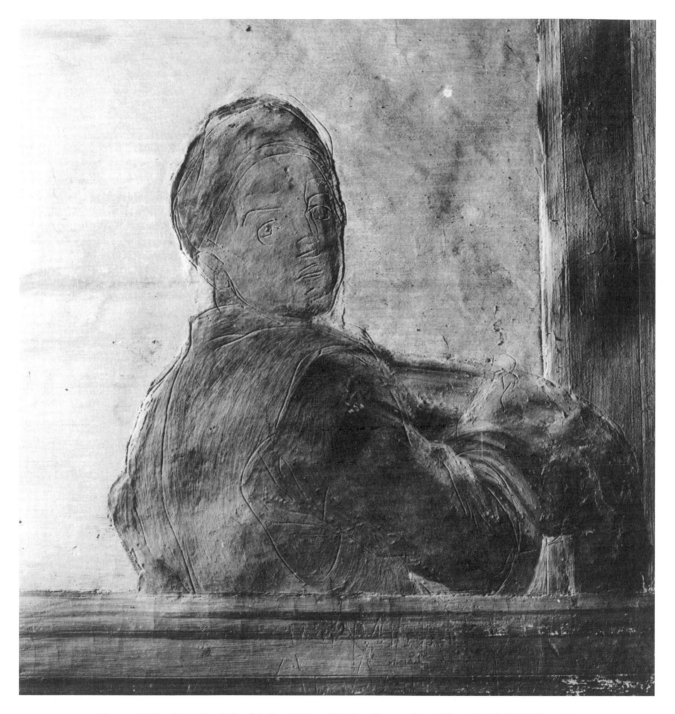

Figure 298. Detail in raking light of Andrea del Sarto, The Last Supper, *fresco (Cenacolo of S. Salvi, Florence).*

execute drawings and cartoons for *"sotto in sù"* compositions on vaults and domes;[111] Andrea Pozzo's *Perspectiva Pictorum* (Rome, 1693–1700), with its "brief instructions on fresco painting," as well as Acisclo Antonio Palomino's *El museo pictórico y escala óptica* (Madrid, 1715–24), with its precise specifications regarding cartoons for flat surfaces, barrel vaults, and

concave, domical surfaces.[112] As we have seen, in fact, Andrea Pozzo rated for his audience the functions of the three methods common in his day: squaring *("graticolare"),* stylus tracing *("ricalcare"),* and pouncing *("spolverare").*[113] Proportional squaring grids served for spaces with too vast or irregular a surface area for which cartoons could not reasonably be prepared.

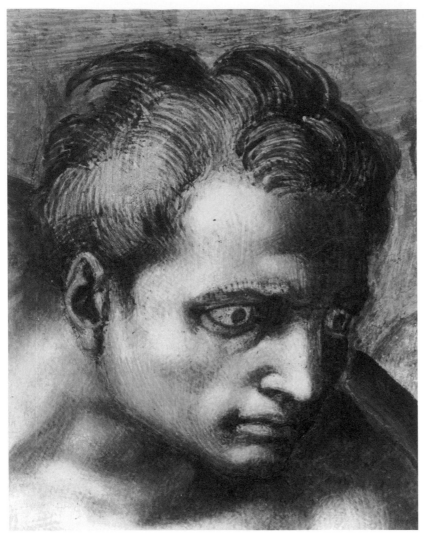

Figure 299. Detail of an angel in the upper left of Michelangelo, The Last Judgment *(Sistine Chapel, Vatican Palace), showing* spolvero *outlines. The meticulous manner of rendering in paint with cross-hatched strokes is typical of foreground figures in this fresco.*

Whereas stylus tracing was the customary and efficient means of cartoon transfer, pouncing was helpful in transferring small, that is, complex details.

Michelangelo's *calco* cartoons for the late *historie* in the Sistine Ceiling were among the early sixteenth-century attempts at using this efficient technique in a comprehensive fashion. Luca Signorelli's monumental wall frescos in the *"Cappella Nuova"* (Cappella della Madonna di S. Brizio, Orvieto Cathedral), from 1499–1504, had constituted among the most daring, extensive applications of stylus-traced cartoons to date.[114] Michelangelo had much admired these frescos, precisely because of the *difficultà* of their compositional elements.[115] Yet, as attested

on the groin vault of the *"Cappella Nuova,"* by both the awkward early transitions from *spolvero* to *calco* and the laborious painting technique of his frescos, Signorelli's had been a hard-won *virtuoso* technique. The same is largely true of Michelangelo's Sistine Ceiling. But if it was in the late parts of the ceiling that Michelangelo came closest to Vasari's ideal of *facilità nel fare,* we do well to remind ourselves that stylus-incised *giornate* represent only 12 percent of the total composing the ceiling, relative to the 52 percent painstakingly pounced.[116]

Although Michelangelo had come to rely increasingly on *calco* to transfer the cartoons for the last half of the Sistine Ceiling, he painted progressively greater parts of his mature frescos from pounced, rather than stylus-incised, cartoons. This comes as a surprise and constitutes, as we have seen, a relatively exceptional chapter in the sixteenth-century history of cartoon transfer. If 55 percent of the total number of *giornate* have *spolvero* in the Sistine Ceiling, the equivalent numbers, based on previously published data, for the other frescos seem significant: apparently, 96 percent for the *Last Judgment,* 99 percent for the *Conversion of St. Paul,* and 100 percent for the *Crucifixion of St. Peter.* This may be explained not only by the partial delegation of labor occurring in the commissions but also by Pozzo's and Milizia's advice regarding complexity of design, especially in compositions with "numerous figures."[117] This also probably meant the production of *"ben finiti cartoni"* rather than schematic, functional cartoons, as Michelangelo clearly must have prepared for some of the *historie* of the last *pontate* in the Sistine Ceiling.[118] Of both Pauline Chapel frescos, only the first *giornata* of the *Conversion of St. Paul* is stylus-incised: the two angels on the top right corner.[119] The total number of *giornate* for the *Conversion of St. Paul* appears to be eighty-five, while that for the *Crucifixion of St. Peter* is probably eighty-seven.[120]

If Michelangelo seems to have used a "substitute cartoon" for his fresco of the *Crucifixion of St. Peter* (and possibly even in the *Conversion of St. Paul*), he surely must have done so also for parts of the *Last Judgment.*

This fresco was painted slowly – the *giornate* are surprisingly small compared to those in the later *pontate* of the Sistine Ceiling – and almost entirely from *spolvero* cartoons. Of approximately 447–50 *giornate,* only seventeen seem to have been painted from stylus-incised cartoons; the cleaning of the fresco has offered an opportunity to refine this data.[121] The composition of the *Last Judgment* was probably divided into at least five separate cartoons: one for each of the two lunettes and, below the lunettes, one for each of the three horizontal bands of figures. The latter must have been further subdivided. Moreover, numerous cartoon nail holes surround small groups of *giornate,* demonstrating that the cartoons actually employed in transferring the design for the *Last Judgment* were probably dismembered.[122]

Finally, and most importantly for our argument, the second edition of Vasari's *Vita* of Michelangelo (Florence, 1568) states that during the visit by Pope Paul III and ten cardinals to view the statues in progress for the tomb of Pope Julius II, particularly the Moses, the dignitaries also admired the cartoons for the *Last Judg-*

ment.[123] It is clear that only *"ben finiti cartoni"* (rather than functional cartoons) could have elicited such high praise. Thus, Vasari's passage, together with the statistics regarding the archaeological evidence on the mural surface of the *Last Judgment,* confirm the great probability that *spolvero* "substitute cartoons" were employed to transfer the design of the *"ben finiti cartoni."*

Whether Michelangelo resorted to "substitute cartoons" or not also raises important issues.[124] For instance, use of the practice points to a relative division of labor in the actual fresco painting process, and a modeling and coloring technique slow, belabored, and exact, rather than free, economic, and energetic. It also helps us establish that the lost cartoons for the *Last Judgment* were probably carefully drawn and highly finished, as is true of the Naples cartoon fragment for the *Crucifixion of St. Peter* (Fig. 3), rather than working drawings, for no other purpose than transfer. As Michelangelo complained toward the end of his life to Vasari of its strenuous physical demands, "fresco painting . . . is not an art for old men."[125]

CONCLUSION

In awesome contrast, therefore, stands the *"facilità"* of execution seen in the *Separation of Light from Darkness,* the last of the *Genesis* scenes on the Sistine Ceiling. Frescoed by Michelangelo at the height of his artistic and athletic powers, nearly thirty years earlier, this *historia* (Plate XI; Fig. 300) offers an example of compelling immediacy, especially because the archaeological evidence on the painting surface can be correlated with a sequence of preliminary drawings. In the so-called *"Oxford Sketchbook,"* in two of the most explicit of the small pen and ink sketches for the figure of God the Father, the artist rendered God open-armed, with a sweeping, searching gesture.[1] He executed the entire *historia,* measuring nearly 3 by 2 meters, in only one day's

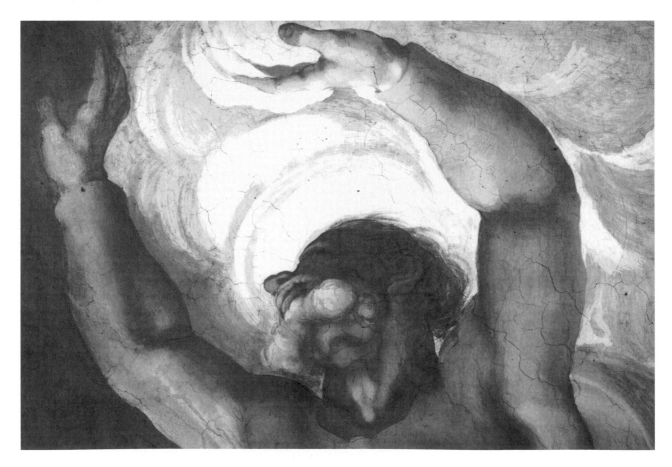

Figure 300. Detail of God the Father in Michelangelo, The Separation of Light from Darkness, *fresco (Sistine Ceiling, Vatican Palace).*

work on the fresco surface. On the plaster, the monumental figure of God reveals incisions establishing that the cartoon Michelangelo employed to transfer the design portrayed his forms only schematically (Plate XI; Fig. 300). Projected illusionistically in a *"sotto in sù"* perspective, the incised design of God is handless, with a straying left arm, a hairless cranium, narrower bodily contours, and smaller facial features than finally painted. It is clear that the cartoon for God's figure did not even depict his hands: many cartoon nail holes are placed close together as *termini* on his right wrist and near his left upper arm (Plate XI).[2] In the fresco, the *pentimento* depicting the straying, cartoon-incised left arm, as well as the left hand incised directly on the plaster, follow closely the design on the small Oxford sheet. As is indicated by the sequence of *giornate* on this portion of the ceiling (Plate XI), Michelangelo painted God the Father after the fictive architecture and figures framing the scene, an order of execution usual in the later campaigns of work on the ceiling, starting with the *Creation of Eve.*

The artist apparently waited until the moment of incising the cartoon onto the *intonaco* to gauge the area available for the gesture of God's arms and redress the resulting awkwardness of design. The number of cartoon nail holes in the passage around God's left upper arm suggests that Michelangelo may have even shifted the cartoon in an effort to modify the figure's position. But shortly after, as the artist boldly put color to plaster, he discarded the gesture developed in the sketches and cartoon. A felicitous adaptation to the exigency of the site, the figure of God as finally painted, with arms and hands nearly closed in a circle, and pushing away the darkness of the universe, soars deep into the heavens with a gesture that signifies the completion and perfection of an *omega.*

It is the kind of spell-binding rapidity of *"idea"* and economy of means that instantly speaks of genius. As in the *Separation of Light from Darkness* in Michelangelo's Sistine, the design process at the cartoon stage can bring us closest to witnessing the artist at work, arguably closer than at any other point in the creation of a masterpiece.

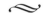

The Sizes of Bolognese Paper as Incised
on the Slab of Stone from the
"Società degli Speziali"

Date: Late Fourteenth century.

Overall dimensions: 748–50 × 1025–27 mm. (borders not actually perpendicular), 35–40 mm. thick.

Medium: Black painted outlines on *"pietra d'Istria."*

In the center of left and right borders, crest of the *"Società degli Speziali"* (mortar and pestle), and on the top, inscribed in Gothic capital letters: QUESTE SIENO LEFORME DEL CHUMUNE DE BOLLO/GNA DECHE GRANDEÇA DENE ESSERE LECHARTE DEBA/BAXE CHE SEFARANO INBOLLOGNA ESSO DESTRETO CH/OME QUI DESOTTO EDIUIXADO:/ IMPERIALLE/ REALLE/ MEÇANE/ REÇUTE.

Provenance: Headquarters of the *"Società degli Speziali;"* Tipografia Merlani, Bologna.[3]

Museo Civico Medievale inv. 1637, Bologna.

Format	Dimensions within carved, black line	Dimensions including carved, black line
"Imperiale"	498 × 726-30 mm.	508–10 × 738–41 mm.
"Reale"	438–40 × 605–06 mm.	448–52 × 615–17 mm.
"Mezzana"	341–44 × 491–94 mm.	350–52 × 501–03 mm.
"Rezzuta"	311–12 × 440–41 mm.	320–21 × 450–51 mm.

Cartoon Transfer Techniques in
Michelangelo's Sistine Ceiling

The following chart (based on Bambach Cappel 1996 a) attempts to break down Michelangelo's *giornate* according to the artist's methods of cartoon transfer, developments more generally discussed in the book. Indirect incision *(incisione indiretta)* identifies the use of stylus-traced cartoons, whereas dotted black chalk underdrawing *(spolvero),* that of cartoons that were pricked and then pounced. In the case of Michelangelo's frescos, the plump, shallow incisions from stylus-traced cartoons are distinguished with relative ease from direct incisions done without cartoons *(incisioni dirette),* which leave deep, craterlike ridges on the plaster. *Spolvero* marks are more difficult to detect. They easily disappeared under the ensuing layers of paint, particularly if the pigment was laid thickly, and under the black outlines of preparatory underpainting with which Michelangelo defined form. *Spolvero* marks are by their very method of production extremely ephemeral.[4] As Leonetto Tintori has demonstrated to me, *spolvero* marks often register only sporadically on the *intonaco* during the process of pouncing, especially if the moisture, consistency, and carbonation of the *intonaco* varies; if the *intonaco* is lightly troweled or lightly incised freehand after pouncing; and if a pricked cartoon or pattern is pounced more than once to replicate a design. Ongoing examination of Italian murals from the Trecento to the Cinquecento demonstrates that this problem regarding the evidence of *spolvero* marks is true of numerous examples.[5] The areas still showing *spolvero* dots on the Sistine Ceiling are without doubt fewer than Michelangelo's actual application of the technique. In the chart, the addition of a second column of numbers, under *"Giornate* with *Spolvero,"* with a "Prob." for "probably," refers to additional *giornate* where *spolvero* was surely used, but where dots are no longer visible, the evidence being that the *giornata* in question was surrounded by *giornate* of figures showing *spolvero.* The estimated numbers of *giornate* with *spolvero* are, for the sake of caution, conservative.

The breakdown of the areas in the Sistine Ceiling under designated "subjects" partly reflects the classification of the graphics stored in the computer archives, which facilitates the process of counting. The *giornate* count for the twelve prophets and sibyls includes the portion of the monumental fictive marble cornice above them, as well as their thrones. The five small *istorie* include their respective *ignudi,* bronze *tondi,* and dividing architectural frames at the top and bottom (thus none must be counted for the four large *istorie*). The *ignudi* (all showing *spolvero*), for instance, account for the fact that *spolvero* is still being recorded in the *Separation of Earth and Water* and the *Separation of Light and Darkness,* although the scenes themselves were entirely stylus-incised. The bronze *tondi* were painted without cartoons. "Sky" refers to the two strips of heavens seen through the fictive architecture at the east end of the *Drunkenness of Noah* and the west end of the *Separation of Light from Darkness.* The four pendentives include their frames, paired bronze nudes (apparently painted without cartoons), *bucrania,* and the corners of the monumental fictive marble cornice above. The one *giornata* given under "architecture," designated with an asterisk (★), is an artificial but inevitable result of the process of counting. It constitutes the remainder of the monumental, fictive marble cornice that frames the central scenes, after counting the prophets, sibyls, and pendentives. The *giornata* occurs between Delphica and Isaiah and is the only separate *giornata* above a spandrel, that is, between a prophet's and sibyl's throne. If this monumental, fictive marble cornice were to be counted as a unit, it totals twenty-five *giornate,* of which at least three have *spolvero* (one *giornata* each above Joel, Isaiah, and Delphica). The fourteen lunettes with the *Ancestors of Christ* do not include the parts of the frames around the windows that

are painted in separate *giornate* and that are not by Michelangelo. The eight spandrels with the *Ancestors of Christ* include their frames, *bucrania,* and pairs of nude bronzes but exclude the fictive marble cornice above them, which is counted with the seers and architecture. The twelve imposts beneath the bottom border of the thrones housing the prophets and sibyls, where *putti* hold tablets identifying the seers, are counted together.

Subject	Giornate with Spolvero Prob.		Giornate with Indirect Incision	Giornate without Cartoon Evidence	Giornate Totals by Subject
Zacharias	9	0	0	5	14
Joel	12	0	0	0	12
Isaiah [1 of the 6 giornate with spolvero also reveals indirect incision]	6	2	2	6	15
Ezekiel	11	0	0	5	16
Daniel	7	2	2	4	15
Jeremiah	3	5	2	7	17
Jonah	6	0	2	5	13
Delphica	9	2	0	1	12
Erithraea	9	1	0	5	15
Cumaea	4	3	2	5	14
Persica [1 of the 3 *giornate* with *spolvero* also reveals indirect incision]	3	5	3	3	13
Libica	5	9	2	4	20
Drunkenness of Noah	23	3	0	5	31
Flood	23	3	0	3	29
Sacrifice of Noah [2 additional *giornate* with indirect incision are by Carnevali]	16	7	0	6	29
Temptation and Fall	8	2	1	2	13
Creation of Eve	12	4	0	6	22
Creation of Adam	6	3	4	3	16
Separation of Earth and Water [2 additional *giornate* with indirect incision are by Carnevali]	11	4	3	8	26
Creation of Sun, Moon, and Plants	0	0	7	0	7
Separation of Light from Darkness	7	5	1	7	20
Sky	0	0	0	2	2

(continued)

Subject	Giornate with Spolvero Prob.		Giornate with Indirect Incision	Giornate without Cartoon Evidence	Giornate Totals by Subject
Architecture★	0	0	0	1	1
David and Goliath	7	3	0	2	12
Judith and Holofernes	3	1	1	9	14
Punishment of Haman	6	1	13	4	24
Brazen Serpent	12	7	6	5	30
Spandrels: Zorobabel, Abiud, Eliachim	3	0	0	5	8
Spandrels: Iosias, Iechonias, Salathiel	2	0	5	1	8
Spandrels: Ozias, Iotham, Achaz	3	0	0	6	9
Spandrels: Ezechias, Manasses, Amon	3	0	0	7	10
Spandrels: Roboam, Abias	0	0	2	9	11
Spandrels: Asa, Iosaphat, Ioram	0	0	1	8	9
Spandrels: Salmon, Booz, Obeth	0	0	7	1	8
Spandrels: Iesse, David, Salomon	0	0	5	4	9
Lunettes: Iacob, Ioseph	0	0	0	4	4
Lunettes: Eleazar, Matham	0	0	0	3	3
Lunettes: Achim, Eliud	0	0	0	5	5
Lunettes: Azor, Sadoch	0	0	0	3	3
Lunettes: Zorobabel, Abiud, Eliachim	0	0	0	3	3
Lunettes: Iosias, Iechonias, Salathiel	0	0	0	3	3
Lunettes: Ozias, Iotham, Achaz	0	0	0	3	3
Lunettes: Ezechias, Manasses, Amon	0	0	0	3	3
Lunettes: Roboam, Abias	0	0	0	1	1
Lunettes: Asa, Iosaphat, Ioram	0	0	0	3	3
Lunettes: Salmon, Booz, Obeth	0	0	0	3	3
Lunettes: Iesse, David, Salomon	0	0	0	3	3
Lunettes: Aminadab	0	0	0	2	2
Lunettes: Naason	0	0	0	3	3
Twelve Putti Holding Tablets below Prophets and Sibyls	12	0	0	16	16
Giornate Totals by Type	**239**	**72**	**71**	**212**	**582**
Percentages by Type (%)	39	12	12	36	100

The Escorial Embroideries:
Concordance of the *"Ben Finiti Cartoni"* and
Their "Substitute Cartoons"

Three albums of designs survive in the Library of the Monastery of San Lorenzo de El Escorial for the embroidered liturgical vestments, commissioned for the monastery and executed in-house from 1587 to 1589 onward. Many of these vestments are still extant. Two albums contain highly finished drawings with pricked and unpricked outlines, but none rubbed with pounce. Album 1, the "large album," (no. 28-I-25) has forty-eight folios, with only one drawing per folio; the last folio, numbered 50, is an engraving by Antonio Salamanca, inscribed in capitals "retrato. de. la. colonna. di. Roma." Folio 39 is missing (it is also annotated on verso of the preceding folio to that numbered 1), or is misnumbered. Folios 1–34, 36, and 38–48 are pricked. Curiously, the unpricked folio 35, depicting *Christ Suffering the Small Child,* probably by Miguel Barroso, corresponds identically to the pricked "substitute cartoon," on folio 19, no. 31 (Album 3, no. 28-I-2). The same is true of the unpricked folio 37, *Entry into Jerusalem,* probably by Barroso, identical to the "substitute cartoon" on folio 10, no. 17 (Album 3, no. 28-I-2). Folio 49, portraying an Old Testament king in bed tormented by demons, is also unpricked (no "substitute cartoon" survives), and the print by Salamanca, folio 50 (last page) is also unpricked. Folios 1, 43–45, are in pen and dark brown ink, brush and grayish brown wash, heightened with white, over traces of black chalk underdrawing, on tan-beige paper. The other drawings are in the same technique as those in the "small album." Album 2, the "small album" (no. 28-II-6) contains fifty-two folios, also with only one drawing per page, and homogeneous in technique – pen and brown ink, brush and brown wash, white heightening, over traces of black chalk underdrawing on blue-gray-green paper. Folios 1–24, 26–52, are pricked. Christ entering the house of the tax collector (folio 25) is unpricked and seems to be by a totally unrelated, cruder hand; it cannot be part of the series of embroideries.

A third, unpublished album (no. 28-I-2) contains fifty-two folios with ninety-four "substitute cartoons." These designs, as well as the outlines framing each of the compositions, are pricked but undrawn, and are all rubbed with black pouncing dust. At least fifty of these "substitute cartoons" correspond exactly in scale, design, and pricking to extant finished drawings in the other two Escorial albums, as well as to single sheets of finished drawings, originally part of the Escorial series but that are now dispersed in other collections. The watermarks recurring in many of these "substitute cartoons" date their thin paper firmly in the second half of the sixteenth century. Of note, each of the "substitute cartoons" was bound in the album from the verso, because this is the side of the design without rubbed pouncing dust and is consequently more legible.

For all three volumes, the lists that follow give the numbering annotated on each folio or drawing.[6] A number of "substitute cartoons" exist in volume 28-I-2 for which no corresponding finished drawing can thus far be identified. In that volume, these are fol. 2, nos. 2–3; fol. 4, no. 5; fol. 8, no. 13; fol. 13, no. 21; fol. 14, no. 22; fol. 18, no. 29; fol. 20, no. 32; fol. 23, no. 38; fol. 24, nos. 40–41; fol. 25, nos. 42–43; fol. 27, no. 47; fol. 28, nos. 48–49; fols. 30, nos. 52–53; fol. 32, nos. 56–57; fol. 33, no. 58; fol. 37, nos. 66–67; fol. 39, no. 70; fol. 40, nos. 72–73; fol. 43, nos. 78–79; fol. 45, nos. 81–82; fol. 48, no. 87; fol. 49, no. 88; and fol. 50, no. 90.

The concordance below lists first the subject (based on the transcribed inscriptions with original orthography, when these exist on the finished drawing), then the "substitute cartoon" in volume 28-I-2, and finally the corresponding finished drawing.

1. *The Angels Reveal the Temple of Jerusalem to the People* (?); fol. 1, no. 1; 28-I-25, f. 40.

2. *The Annunciation to the Shepherds;* fol. 3, no. 4; Angulo and Pérez-Sánchez 1975, Corpus no. 380.

3. *Christ and Nicodemus Discuss the Sacrament of Baptism* ("Xpo y Nicodemus q tratan del baptismo"); fol. 4, no. 6; National Galleries of Scotland inv. D 1788 (Fig. 242) Edinburgh.

4. *Christ Heals the Lame Man* (17. K. junij 1588 M. B. del.); fol. 5, no. 7; 28-I-25, fol. 20.

5. *Christ Heals a Possessed Man* ("Sana xpo aun endemoniado em presencia de su propria . . . 7 K. mart. an. 1588 M.B.D."), fol. 5, no. 8; 28-I-25, fol. 32.

6. *Herod Bids the Magi to Return his Way* ("[. cropped] despide los Reyes y les dice que buel banpor alli . . . [que vuelvan por allí]"); fol. 6, no. 9; 28-II-6, fol. 4.

7. *The Forecast of Herod's Astrologers* ("Como Herodes ayunto los principos de los sacerdotes y letrados de la ley y les mando que buscasen en lases crituras/el lugar donde xpo abia de nacer/Capa del terno principal"); fol. 6, no. 10; 28-II-6, fol. 3.

8. *Christ Resurrects the Son of the Widow* ("El Redentor Resucita al hijo de la viuda"); fol. 7, no. 11; 28-I-25, fol. 28.

9. *Christ Heals the Centurion's Servant* ("El centurion suplica [. . .] le sane su sierbo"; fol. 7, no. 12; 28-I-25, fol. 21. (Repeat of "substitute cartoon" on fol. 33.)

10. *Moses? with Fantastic Animals,* fol. 8, no. 14; 28-I-25, fol. 47.

11. *The Raising of Lazarus;* fol. 9, no. 15; no "substitute cartoon" in identical scale, but a small version is in 28-II-6, fol. 19.

12. *The Transfigured Christ with the Apostles* ("de oro torcido. Christo despues de auerse trasfigurado llega a sus discipulos y les toca con su bendita mano/14 K. Marz. An 1588. M. B. D."); fol. 10, no. 16; 28-I-25, fol. 30.

13. *Christ Enters Jerusalem on Palm Sunday;* fol. 10, no. 17; 28-I-25, fol. 37.

14. *The Adoration of the Magi;* fol. 11, no. 18; Musée du Louvre, Paris (acquired in 1991).

15. *Christ and the Samaritan Woman* ("Conbersion de la samaritana"); fol. 12, no. 19; 28-I-25, fol. 18.

16. *Scene with Plowing;* fol. 12, no. 20; 28-I-25, fol. 45.

17. *The Calling of St. John* ("[. . .] Retirado auna parte dela casa donde fuero las bodas y hablando con sant Juan le dice deje aquellas bodas y le siga"); fol. 15, no. 23; 28-II-6, fol. 15.

18. *The Raising of Lazarus* ("Llega xpo y las dos hermanas al sepulcro Alca xpo los ojos al cielo para/la resurepcion delacaro"); fol. 15, no. 24; 28-II-6, fol. 19.

19. *Christ Receives a Letter from Magdalen and Martha* ("estando xpo en las riueras del rio Jordan llega un hombre y puesta una rodilla en el suelo leda de parte de mA magdalena y marta"); fol. 16, no. 25; 28-II-6, fol. 50.

20. *St. Andrew Presents St. Peter to Christ* ("S. andres trae asu ermano sant pedro y lopone ante la presencia de xpo"); fol. 16, no. 26; 28-II-6, fol. 13.

21. *The Circumcision of Christ* (in large scale); fol. 17, no. 27; possibly Musée des Beaux-Arts inv. 1980 c, Orleans.

22. *Christ Appears to the Sons of Zebedeus* ("Aparesce xpo al benerable zebedeo con sus dos hijos estando remendando sus redes de pescar"); fol. 18, no. 28; 28-I-25, fol. 16.

23. *The Stoning of Christ in the Temple* ("Pudie. Non Juniae A 1588. M.M. Des."); fol. 19, no. 30; 28-I-25, fol. 38.

24. *Christ Suffers the Small Child;* fol. 19, no. 31; 28-I-25, fol. 35, identical in scale and design, but unpricked.

25. *The Sermon of the Mount* ("Xpo Rodeado desus dicipulos y otras gentes les haze un sermon"); fol. 20, no. 33; 28-II-6, fol. 30.

26. *Christ Heals the Man with Dropsy* ("Sana xpo a un hombre ydropico hinchado de vientre y piernas y rostro en cassa/de uno de los fariseos"); fol. 21, no. 34; 28-II-6, fol. 36.

27. *Unidentified Scene,* Christ points to a tree while a man holds an ax to cut a branch; fol. 21, no. 35; 28-II-6, f. 26.

28. *Christ Heals Three Men* ("estando, xpo en un campo, allegan ael tres hombres. Un coxo Un manco/y un paralitico. alosquales sana con su bendicion: tocando a ellos con sus/benditissimas manos"); fol. 22, no. 36; 28-II-6, fol. 37.

29. *Christ Arrives in the House of Mary and Martha* ("recien en su cassa A xpo Las dos hermanas martay maria mostrando mucha/Tristeca por la muerte de su Hermo. Lacaro"); fol. 22, no. 37; 28-II-6, fol. 18.

30. *The Three Magi Arrive in Bethlehem* ("Como llegaron abelen adonde para la estrella"); fol. 23, no. 39; 28-II-6, f. 6.

31. *The Wedding at Cana* ("Las Bodas de a['n' or 'r'] chi te crinos [vinos?]"); fol. 26, no. 44; 28-II-6, fol. 14.

32. *Christ Heals the Man with Dropsy* ("Sana xpo a Un hombre ydropico hinchado de uientre y piernas y rostro en cassa/de uno de los fariseos"); fol. 26, no. 45; 28-II-6, fol. 35.

33. *Unidentified Scene;* fol. 27, no. 46; 28-II-6, fol. 2.

34. *Christ Heals the Blind Man* ("Pone dios sus dedos al honbre [. . .] en los ojos y luego tubo vista"); fol. 29, no. 50; 28-I-25, fol. 34.

35. *The Parable of the Wheat* ("Los Apostoles entran por un sembrado unos cojiendo espigas y otros desgranando y comiendo el Redentor hablando con tres fariseos"); fol. 29, no. 51; 28-I-25, fol. 24.

36. *Christ Heals the Woman with an Issue of Blood* ("una muger puesta de rodillas tocando con sus manos a sus bestiduras de Xpo. queda sana del flujo de sangre"); fol. 31, no. 54; 28-I-25, fol. 27.

37. *Christ Heals the Paralytic Man* ("xpo como sano al paralitico [prostrado/] en la cama"); fol. 31, no. 51; 28-I-25, fol. 19.

38. *The Parable of the Blind Leading the Blind;* fol. 33, no. 59 (Fig. 243); 28-I-25, fol. 42.

39. *The Three Magi Behold the Star of Bethlehem* ("Como salidos de Jesus aun les aparecio laestrella ypor ello hicieron grandes alegrias con sus caballos [Magi]/Esta ques larg serta la ultima baxa dla mano derecha/[illegible on the right border]"); fol. 34, no. 60; 28-II-6, fol. 5.

40. *The Angel Warns the Three Magi* ("Como el angel abiso alos Reyes estando durmiendo queno boluisen por Jesus asen mostrandoles otrocamino/ [illegible on the top to left border]"); fol. 34, no. 61; 28-II-6, fol. 7.

41. *The Pharisees Pay Off the Roman Soldiers Not to Tell of Christ's Resurrection* ("De como los fariseos Pagan Alasguardas. Porque oculten y callen la Resurecion de xpo."), fol. 35, no. 62; 28-II-6, fol. 38.

42. *The Holy Women and St. John after the Resurrection;* fol. 35, no. 63; 28-II-6, fol. 41.

43. *Christ Descends from the Mount with His Three Disciples* ("Desciende xpo del monte acompanado de sus tres discipulos/K. Mart. An. 1588 M.B.D."); fol. 36, no. 64; 28-I-25, fol. 31.

44. *Christ, Martha, and Magdalen* ("Como xpo [cropped]/K. junias 1588. M.B. Des."); fol. 36, no. 65; 28-I-25, fol. 26.

45. *Unidentified Scene;* fol. 38, no. 68; 28-I-25, fol. 10.

46. *Christ with the Apostles* ("pudie l duc. Maias 1588. M. B. Des."); fol. 38, no. 69; 28-I-25, fol. 29.

47. *The Apostles Recognize the Risen Christ as He Parts Bread* ("De como los dicipulos conocieron A xpo en el partir de El pan"); fol. 39, no. 71; 28-II-6, fol. 49.

48. *Christ Appears to the Apostles on the Way to Emmaus* ("como Xpo aprece A los dos discipulos quey ban al castillo de/Emaus/casulla"); fol. 41, no. 74; 28-II-6, fol. 47.

49. *Christ Descends to Limbo* ("Laba xadade Xpo al ynbo./Capa"); fol. 41, no. 75; 28-II-6, fol. 46.

50. *Christ Heals a Woman with a Hunchback* ("sana xpo auna muger. encoruada de toda la espina que apenas podia/alçar el rostro al cielo enpresencia delos fariseos"); fol. 42, no. 76; 28-II-6, fol. 28.

51. *Christ and the Pharisees Dispute about the Tribute to Caesar* ("Dos fariseos, hablan con xpo y le dicen sies Licito, pagar A Cesar/censso. o. no. uno de ellos Le muestra La moneda con la figura de cessar"), fol. 42, no. 77; 28-II-6, fol. 27.

52. *The Mother of the Sons of Zebedeus Pleads with Christ* ("La benerable madre de los hijos zebedos los quales si mendos junto asi/pide al Redentor los siente bno asa tres y el otro a la siniestra"); fol. 44, no. 80; 28-II-6, fol. 20.

53. *The Three Marys and the Apostles Tell of Christ's Resurrection* ("las tres marias con los apostoles quentan dela Resu recion de xpo"), fol. 46, no. 83; 28-II-6, fol. 44.

54. *The Three Marys Meet Two Angels at the Sepulchre* ("llegando las tres marias al sepulcro donde hallan dos angeles"); fol. 46, no. 84; 28-II-6, fol. 42.

55. *Scene of Exorcism* (". . . saca nana ba en pos del Redentor dando vozes rogandole con mucha humildad/a su hija questaen de monjada/M. B. D. S. K. Octubre 1588"), fol. 47, no. 85; 28-II-6, fol. 31.

56. *Unidentified Scene;* fol. 48, no. 86; 28-II-6, fol. 33.

57. *St. John the Baptist Sends his Disciples to Christ* ("Sant Juan enbia a dos desue dicipulos a xpo y hallando le en un campo le dan el glecando de su maestro"), fol. 49, no. 89; 28-I-25, fol. 22.

58. *Christ Heals a Deaf Man* ("sana xpo aun sordo puniendole sus santisimos, dedos en los oydos"); fol. 50, no. 91; 28-II-6, fol. 29.

59. *The Parable of the Good Shepherd* ("para bula del buen pas.or del ebangelio de san Juan .c.10 tres pastores uno ques ta de fendiendo sus/obejas de un lobo: otro quelleba una obeja en los onbros

eltercero ba huyendo aunas chocas"), fol. 51, no. 92; 28-II-6, fol. 34.

60. *The Healing of the Leper* ("el leproso . . . le sana de la lepra fue sano"); fol. 52, no. 93; 28-I-25, fol. 17.

61. *Christ in the Temple Challenged by the Pharisees* ("Estando xpo ensenando en la singna goga [sina-goga] llegados ael algunos fariseos delante [. . .] los quales estando/con un honbre que tenia la mano seca les pregunta si sera lisito hazer bien en sabado cristo le sano/la mano en presencia de todos"); fol. 52, no. 94; 28-I-25, fol. 25.

NOTES

1. Introduction: From Workshop Practice to Design Theory

1. *Codex Urbinas Latinus* facsimile in McMahon 1956, II, fol. 19 recto (cf. Richter, I, 33, § 6; Richter, *Commentary,* I, 103–9; and Farago 1992, 250–51, no. 33): "Dicono quella cognitione essere meccanicha la quale è/partorita dall'es-perientia, e quella esscre scientifica che/nasce et finisse nella mente, e quella essere semimeccani-/cha che nasse dalla scientia et finisse nelle ope-/rationi manuale . . ." For trans., see Leonardo, *On Painting,* 10, and McMahon 1956, I, 11, no. 19.

2. Payments to "Urbino" were as follows: 8 scudi (16 November 1542), 4 scudi (6 December 1542), 4 scudi 54 1/2 (10 August 1545), 7 scudi 40 (29 March 1546). For the documents, see Frey 1909, 150, 155, 157 (nos. 161, 164, 231, and 251); and Baumgart and Biagetti 1934, 69–71. On "Urbino," see Vasari 1966–87, VI (testo), 114: ". . . suo servidore, che lo fece richissimo, et era suo creato." Robert Liebert, *Michelangelo: A Psychoanalytic Study of His Life and Images,* New Haven-London, 1983, 402–4, gives an unconvincing discussion.

3. See Frey 1909, 150–51, particularly document nos. 164, 170 (nos. 157 and 161 seem too imprecisely worded for the purpose of calculating wages).

4. See Frey 1909, 150–57, particularly document nos. 161, 231, and 251.

5. The late Fabrizio Mancinelli and Gianluigi Colalucci kindly facilitated my study of the Pauline frescos from a temporary scaffolding (summer 1992).

6. On the chemistry of fresco painting, see especially Valerio Malaguzzi-Valerj, "Ancient Fresco Technique in the Light of Scientific Examination," *Application of Science in Examination of Works of Art (Proceedings of the Seminar: June 15–19, 1970),* ed. by William J. Young, Boston, 1973, 164–69; Borsook 1980, xxvi; Botticelli 1980, 11–33; Tsuji 1983, 215–22; Mora and Philippot 1984, 10–12; *Tecnica e stile* 1986, I, 131; Ling 1990; *The Conservation of Wall Paintings* 1991; Botticelli 1992; Tintori 1993; and Gianluigi Colalucci in *Dictionary of Art* 1996, XI, 761–64. For helping me clarify the description of the process of carbonation that follows, I am indebted to Paolo Bensi (Professor of the Accademia Ligustica di Belle Arti, Genoa) and Diana Bray (Professor of Chemistry, Fordham University).

7. Although in the past, Cennino Cennini's *Libro dell'arte* has been dated much later (to the early fifteenth century), more recent opinion places the *Libro* in the late 1390s. Cf. Schlosser 1964, 91–92; Mellini 1965, 48; Franco Brunello and Licisco Magagnato in Cennini 1995, v–xxx; *Art in the Making* 1989, 210, 212; Erling Skaug, "Cenniniana: Notes on Cennino Cennini and his Treatise," *AC* (1993), 15–22; and unsigned entry in *Dictionary of Art* 1996, VI, 168–70. Cennino Cennini (c. 1370–1440) adhered closely to Florentine tradition and practice, which were his heritage, but the book was written in the dialect of the Veneto, presumably when Cennino was in Padua. He is cited in two documents in Padua on 13 and 19 August 1398. On the traditional dating of the treatise between 1396 and 1437, see Daniel V. Thompson in Cennini 1932, ix; Bacci and Stoppelli 1979, 566 (ibid., 568–69, Bibliography); and Borsook 1980, xxxviii. For attempts at attributing panels and frescos to Cennino, see Miklòs Boskovits, "Cennino Cennini – pittore nonconformista," *MdKIF,* XVII (1973), 201–22; Boskovits 1975, 129–31; and Boskovits, *Frühe italienische Malerei,* trans. by Erich Schleier, Berlin, 1988, 21–24, no. 11. On apprenticeships, see Thomas 1995, 64–81, 332–34 (with bibliography).

8. Cennini 1995, cap. iv, 6–7 (cf. Cennini 1960, 3, for trans.): "Queste due parti vogliono questo, cioe: sapere tritare, o ver macinare, inconlare, inpannare, ingiessare, radere i giessi e pulirli, rilevare di giesso, mettere di bolo, mettere d'oro, brunire, temperare, campeggiare, spolverare, grattare, granare, o vero chamucciare, ritagliare, colorire, adornare, e'nvernichare, in tavola o vero in chona." For a discussion of such techniques within the social context of the workshop, cf. also Thomas 1995, 149–81.

9. For a full transcription, see Guasti 1857, 144–46, no. 358. Cf. Acidini Luchinat and Dalla Negra 1995, 72; Acidini Luchinat and Danti 1992, 132–39; Cristina Acidini Luchinat, "Vasari's Last Paintings: The Cupola of Florence

Cathedral," *Vasari's Florence* 1998, 238–52, with new transcriptions of further related documents by Philip Jacks (ibid., 248–52).

10. See Carducho 1633, Diálogo Octavo, 133–35, for a long-winded description of cartoons, pouncing, and of the tasks delegated to assistants. For example: "El perito Pintor haze los rasguños, ò esquicios, y estudia cada parte de porsi, que despues lo junta todo en el dibujo, o carton acabado, y compuesto cientificamente. Este, y los demas dibujos entrega al oficial, y el pasa los perfiles . . . ;" discussed in Bambach Cappel 1988, Part 1, I:159–61, II:344–45; and in this book, Chapters One (notes 175–76), and Eleven (note 5). Moreover, cf. comment by the painters' assistants in Giovanni Battista Volpato's *Modo del tener nel dipinger,* the dialogue written in Bassano in 1670–1700 (Merrifield 1849, II, 742–43), discussed and transcribed in Chapter Four, note 2. For other written sources describing this type of delegation of labor, see further, Chapter Eleven.

11. See Baumgart and Biagetti 1934, 45, who arrived at the same conclusion but for different reasons.

12. Vasari 1962, I (testo), 82: ". . . che la pittura, passata una certa età, e massimamente il lavorare in fresco, non è arte da vecchi. . . ."

13. Gallerie Nazionali di Capodimonte inv. 398, Naples. Revised data: 2630 × 1560 mm.; charcoal, possibly highlighted with white chalk on at least nineteen glued sheets of paper. Cf. Steinmann 1925; Wilde 1953, 116; Tolnay 1975–80, III, 48, 384; Bambach 1987; Hirst 1988 b, 128–32, no. 53; Muzii 1988; and Bambach Cappel 1996 a.

14. Armenini 1587, 99–104 (cf. Armenini 1977, 171–75, for trans.). On the 1586 Ravenna edition of this treatise, the first, see Edward J. Olszewski in Armenini 1977, 5–9, 304, 329. The edition cited in this book is that of 1587. On Giovanni Battista Armenini (c. 1525–1609), cf. also Marina Gorreri's introduction to her edition of Armenini's *De' veri precetti della pittura,* Turin, 1988; Robert Williams, "The Vocation of the Artist as Seen by Giovanni Battista Armenini," *Art History,* XVIII (1995), 518–36; and François Quiviger in *Dictionary of Art* 1996, II, 445–46.

15. My translation is somewhat freer than the original text. Armenini 1587, 99 (cf. Armenini 1977, 171, for trans.): "Hora ci resta a trattare dei Cartoni, i quali appresso di noi si tiene essere l'ultimo, et il più perfetto modo di quello che per artificio di dissegno si vede. . . ."

16. For the *giornate,* cf. also Baumgart and Biagetti, 1934, plate L.

17. Vasari 1966–87, I (testo), 118–19, 121, 134 (cf. Vasari 1960, 213–15, 231, for trans.); and Borghini 1584, 173. Note also brief use of the word in Armenini 1587, 104, 113–14, 125 (cf. Armenini 1977, 174, 183, 192–93, for trans.). On these writers' description of *"calco"* or *"calcare"* in relationship to *spolvero,* cf. Bambach Cappel 1988, Part 1, I:103–17, 135–46; II:357–72. On Vasari's *Vite,* see now Rubin 1995. On Borghini's treatise see Sandra Orienti, "Su *il Riposo* di Raffaelle Borghini," *Rivista d'arte,* XXVII (1951–52), 221–26; E. Avanzini, *Il Riposo di Raffaello Borghini e la critica d'arte nel'500,* Milan, 1960; Lewis Einstein, "Conversa-

tion at Villa Riposo," *GBA,* II (1961), 6–20; Schlosser 1964, 349–54, 372–73; Remo Ceserani, "Raffaello Borghini," *Dizionario biografico degli italiani,* Rome, 1970, XII, 677–80; Zygmunt Wazbinski, "Artisti e pubblico nella Firenze del Cinquecento: A Proposito del topos 'cane abbaiante,'" *Paragone,* XXVIII, no. 327, 3–24; and Antonio Natali, "Candidior animus," *Antichità Viva,* XX, (1981), 22–31.

18. See Figures 215, 280, 287, 295, 296, and 298.

19. Cennini 1995, cap. lxvii, 73–74 (cf. Cennini 1960, 42–43, for trans.).

20. For example, note the documents from 24 October 1466 to 6 May 1467 about Alesso Baldovinetti (transcribed in Kennedy 1938, 243), or from 21 October 1447 about Fra Angelico and between 1501 and 1503 about Signorelli (transcribed in Andreani 1996, 426, 436–38, nos. 75, 237, 248).

21. The portrait of the *muratore,* Aniello di Mariotto del Buonis, is also recorded in a counterproof of a drawing by Federico Zuccaro in Palazzo Abatellis, Palermo (vol. A, inv. 15484/43). Done from life, the original study was apparently dated by the artist, 13 March 1576. Cf. Simonetta Prosperi Valenti Rodinò in *Maestri del Disegno nelle Collezioni di Palazzo Abatellis,* exh. cat. ed. by Vincenzo Abbate, Palermo, 1995, 162, no. 38.

22. Cf. Frey 1909, 144 (no. 82), 148 (no. 129), 150 (nos. 161, 164), 155 (no. 231), 157 (no. 251). Cf. Vasari 1966–87, VI (testo), 114: ". . . suo servidore, che lo fece richissimo, et era suo creato."

23. Cf. Frey 1909, 144 (no. 82).

24. Karl Frey has already made this point. See Frey 1909, 144–45 (note 3).

25. I am indebted to the late Fabrizio Mancinelli and Gianluigi Colalucci for the numerous opportunities to study both the Sistine Ceiling and the *Last Judgment* from the restoration scaffolding (1981–94).

26. Of course, hatching had long been a traditional modeling technique in mural painting, often reaching a particularly calligraphic precision during the late fifteenth century. As we can see in the mural cycles on the lives of Christ and Moses, from 1481 to 1483 on the walls of the Sistine Chapel (especially, Perugino's *Childhood of Moses* and *Baptism of Christ,* which because they adjoin Michelangelo's *Last Judgment* offer immediate points of reference), the late Quattrocento manner of hatching was with more orderly, rigid, and less descriptive strokes than Michelangelo's. The earlier manner relied also on a thicker application of pigment, frequently with refinement *a secco.* Similar modeling techniques are found throughout the mural cycles by Domenico Ghirlandaio in the chancel of S. Maria Novella (Florence) and by Luca Signorelli in the Cappella della Madonna di S. Brizio at Orvieto Cathedral. The opportunities for studying the above murals from the scaffoldings erected for their cleaning were offered by the late Fabrizio Mancinelli (Perugino, 1993–94); Giorgio Bonsanti, Cristina Danti (Ghirlandaio, November 1990); and Giusi Testa (Signorelli, 1992–94).

27. Cf. Bambach Cappel 1987, 131–42; Bambach Cappel 1988,

Part 1, I:97–176, II:346–48; and Bambach Cappel 1996 a, 83–102.

28. Armenini 1587, Book II, 104: "Ma à salvarli poi illesi, dovendosi dopo questo calcar i contorni di quello sù l'opere che si lavorano, il miglior modo si è à forarli con vn ago, mettendoci vn altro carton sotto, il qual rimanendo come quello di sopra bucato, serve poi per spolverare di volta in volta per doue si vol dipingere, e massime sù le calce, à benche molti poco di ciò curandosi, calcano il primo, il qual si tien tuttauia per esempio, mentre si fa l'opera con i colori, il che è più commodabile il primo. . . ." Passing allusions to the practice also occur in ibid., 113–14, 120, 125. Cf. also Bambach Cappel 1988, Part 1, I:103–17, 136–47, 163–70, Part 1, II:346; Bambach Cappel 1992 a, 9–30; and Bambach Cappel 1996 a, 83–102.

29. This material was originally published in Bambach Cappel 1987, 131–42, and greatly refined in Bambach Cappel 1996 a, 83–102, as the result of further opportunities offered by Rossana Muzii for studying the Naples cartoon from a ladder, and by the late Fabrizio Mancinelli and Gianluigi Colalucci for studying the Vatican mural from temporary scaffolding. Further revisions are given here, as well as in Chapters Two and Eight. The restoration of Michelangelo's Naples cartoon greatly facilitated an understanding of the cartoon's drawing technique and paper structure (cf. Muzii 1988).

30. See further, Chapter Eight.

31. In the Naples cartoon fragment, there are remnants of perpendicular, structural joins of paper close to the borders of the patch (Bambach Cappel 1996 a, 87; overlooked in my research for the 1987 article). On cartoon joins, see further Chapters Two and Eight. These joins of paper comprising the patch on the Naples cartoon determine the original orientation of the perforated design of the male nude pelvic area. This orientation, as established by the joins of paper, fully corresponds with the detail in the fresco before its repainting with the loincloth. This further supports my original proposal published in 1987 that the design relates to St. Peter. I am indebted to Gianluigi Colalucci for his comments about the painting technique employed for this detail of the mural (observed from temporary scaffolding; summer 1992).

32. See the sheet attributed to Marco Marchetti ("Marco da Faenza"), Louvre inv. 10218, Paris. Data: 282 × 197 mm.; pen and brown ink, brush and brown wash, over black chalk. Cf. Monbeig Goguel 1972, 72, no. 62. Another sheet, attributed to Raffaellino da Reggio and obviously an independent project rather than a copy, borrows this motif of St. Peter's complete nudity, as well as other Michelangelesque elements; Musée des Beaux-Arts inv. 794.1.3054, Rennes. Data: 466 × 302 mm.; pen and brown ink with wash over black chalk, squared in black chalk. Cf. John Gere in Rennes 1990, 118–19, no. 53. These drawings recently came to my attention. For the painting and two prints, see Bambach Cappel 1987, 131–42.

33. On the functions of the Sistine Chapel, see John Shearman, "The Chapel of Sixtus IV: The Fresco Decoration of Sixtus IV: Raphael's Tapestries," in *The Sistine Chapel* 1986,

22–91. On the Pauline Chapel, see Christoph Luitpold Frommel, "Antonio da Sangallos Cappella Paolina. Ein Beitrag zur Baugeschichte des Vatikanischen Palastes," *ZfK*, XXVII (1964), 1–42; Herbert von Einem, *Michelangelo*, Berlin 1973, 165–66; Leo Steinberg, *Michelangelo's Last Paintings*, London, 1975, 15; and William Wallace, "Narrative and Religious Expression in Michelangelo's Pauline Chapel," *Artibus et Historiae*, no. 19 (1989), 107–21.

34. Biagio Biagetti's diagram does record this area in the mural as being repainted, apparently an observation deduced from the condition of the painting surface. Cf. Baumgart and Biagetti 1934.

35. On the "period eye," see Baxandall 1972, 29–108.

36. Here, note especially Svetlana L. Alpers, "*Ekphrasis* and Aesthetic Attitudes in Vasari's *Lives*," *JWCI*, XXIII (1960), 190–215, as well as the following studies, by Giuliano Tanturli, "Le Biografie d'artisti prima del Vasari"; Martino Capucci, "Forme della biografia nel Vasari"; Ettore Merkel, "Giorgio Vasari e gli artisti del Cinquecento a Venezia: Limiti e aporie di un critico moderno"; Giorgio Bonsanti, "Gli Artisti stranieri nelle Vite del Vasari"; and Wolfram Prinz, "I Ragionamenti del Vasari sullo sviluppo e declino delle arti"; all in *Il Vasari storiografo e artista: Atti del congresso internazionale nel IV centenario della morte (Arezzo-Firenze, 2–8 settembre 1974)*, Florence, 1976, 275–98, 299–320, 457–67, 717–34, 857–66; Carlo del Bravo, "Gli Aneddoti su artisti del Quattrocento," *Scritti di storia dell'arte in onore di Roberto Salvini*, ed. by Cristina de Benedictis, Florence 1984, 251–55; Rubin 1995; and Kemp 1997.

37. On Leonardo's *paragone*, see Farago 1992, particularly 32–117 (with discussion of the extensive bibliography on this issue); and Kemp 1997, 27–28, 242–55. Cf. Irma Richter, *Paragone: A Comparison of the Arts by Leonardo da Vinci*, London-New York-Toronto, 1949; Richter, I, 14–101; Carlo Pedretti in Richter, *Commentary*, I, 76–86; Leatrice Mendelsohn, *Paragoni: Benedetto Varchi's Due Lezzioni and Cinquecento Art Theory*, Ann Arbor (Michigan), 1981.

38. *Codex Urbinas Latinus* facsimile in McMahon 1956, II, fol. 20 recto (cf. Farago 1992, 256, no. 35; Richter, I, 91, § 36; Richter, *Commentary*, I, 76–86): "La scultura non é scientia, ma é arte meccanichissima per/che genera sudore, e faticha corporale al suo operatore et'/solo basta a' tale artista le semplici misure de membri e' la/natura delli movimenti é posati, e' cosi in se finisse. . . ." For trans., cf. McMahon 1956, I, 35, no. 49, and Leonardo, *On Painting*, 38.

39. For the pricked and pounced patterns found in the "*Caves of the Thousand Buddhas*," cf. Whitfield and Farrer 1990, 16–17, 88, nos. 70–71; as well as Chapters Two and Five. Bocchi's murals exhibit *spolvero* in the figures and decorative motifs; cf. Gioia Germani, "La Pittura murale italiana del Novecento: Tecniche e materiali," in *Le Pitture murali* 1990, 109, 146 (plate III). For a pricked design by de Morgan, connected with a ruby luster decoration on a dish, see Susan Lambert, *Drawing: Technique and Purpose* (exh. cat., Victoria and Albert Museum), n.p., 1981, 19, no. 36.

40. Beyond the comments in Bambach Cappel 1988, Part 1,

I:248–51, the following may be added. The papers of the Gentili family of potters at Castelli comprise letters, records, *spolveri* patterns and cartoons, "substitute cartoons," dating from the sixteenth to the early twentieth centuries. This large archive is now housed in the J. Paul Getty Center, Los Angeles (no. 880209, GJPA88–A274); I am indebted to Catherine Hess for bringing it to my attention. For Byzantine icons, hundreds of pricked and pounced cartoons survive, together with their corresponding "substitute cartoons," all of which are now dispersed in the collections of the Byzantine and Benaki Museums in Athens and St. Mihalarias in London (see Laskarina Bouras in *From Byzantium to El Greco: Greek Frescoes and Icons,* exh. cat., Royal Academy of Arts, London, 1987, 54–56, 199, nos. 72–73). At Tichelaars Koninklijke Makkumer Aardwerk en Tegelfabriek, Makkum, ceramic tile designers still use pounced patterns *(sponsen).* I am indebted to Ella Schaap for this information. For published examples of *sponsen* from the eighteenth to the twentieth centuries, see J. Pluis, *Kinderspelen op tegels,* Assen, 1979, 49, 50, 68–70, 118, figs. 47b, 48a–d, 69, 78, 82–91, 192; Jan Daniel Van Dam et al., *Dutch Tiles in the Philadelphia Museum of Art* (exh. cat.), Philadelphia, 1984, 34. *Spolvero* occurs on the figures in one of the exterior *sovraporte* murals, which probably dates from the 1960s, in the courtyard of the Palazzo Comunale, housing the Pinacoteca Civica of San Gimignano. Ottocento and Novecento mural painters commonly employed *spolvero* patterns in painting ornament (see Chapters Two and Five). On the use of *spolvero* in modern stage design, I owe the observation to Linda Ballmuth, a practitioner of the art.

41. An easily accessible example is a small tablet frescoed in a sixteenth-century style on *spolvero* dots, in Giulio Romano's *"Sala delle Imprese"* (Palazzo Te, Mantua), commemorating the 1950 restoration of the room. For restorers, the technique is particularly useful in repainting or completing areas of loss in the repetitive ornamental borders or motifs of murals. See Chapter Five, note 6, and Figure 124.

42. See Germani 1990 (as in note 39), 116, 146–47, fig. 6, plates VI, IX.

43. For a summary and discussion, see further, Chapter Ten.

44. For a general chronological outline, see Bambach Cappel 1988, Part 1, I:177–251.

45. See Figures 141, 144, and 145.

46. See Figures 188, 191, 196, 202–4, 215, and 287. The earliest securely documented examples of *calco* as a practice date from the 1470s. Claims for the use of *calco* as early as the thirteenth century have been made. As far as I can judge from the extant evidence, such incisions were most probably done directly on the working surface *(incisioni dirette);* they are not incisions made through the intermediary means of a cartoon on paper *(incisioni indirette).* Chapter Ten summarizes the state of the evidence, for the physical evidence of incisions can admittedly be very complex and ambiguous.

47. For descriptions, cf. Perrot 1625, xiii; Richard Symonds in 1650 (Beal 1984, 294); Boutet 1676, 2–3; and *Art of Painting*

in Miniature 1752, 2–3. The earliest securely documented cases of this practice appear to date from 1500 to 1520. An excellent example is Battista Franco's sheet of drawings of *Roman Telamones in the Egyptian Style* (Metropolitan Museum of Art 1979.62. 2, 3, New York). Data: 382 × 272 mm. (maximum), pen and brown ink, over traces of black chalk, on two glued sheets of buff paper (joined by a restorer, as this was once a single sheet that became separated). Stylus-indented outlines appear only on the left figure. The verso of the sheet corresponding to this left, stylus-incised figure is blackened with chalk for stylus transfer. Cf. Bean 1982, 101, no. 91.

48. See descriptions in Vasari 1966–87, I (testo), 120–21, 134 (cf. Vasari 1960, 214–15, 231, for trans.); Borghini 1584, 170–73; and Armenini 1587, 76–77 (cf. Armenini 1977, 147–48, for trans.). The firmly underpainted outlines were most probably obtained from a cartoon-based underdrawing, transferred by means of the "carbon-copy" method in Fra Bartolomeo's unfinished *Virgin and Child with Saints ("The Signoria Altarpiece"),* oil on panel (Museo S. Marco, Florence). I am indebted to Giorgio Bonsanti for making available to me the dossier and record photography of this panel during restoration by the Opificio delle Pietre Dure e Laboratorio di Restauro, Florence.

49. An example can be seen in the infrared reflectogram assembly of Andrea del Sarto, *The Virgin and Child with Sts. Elizabeth and John ("The Medici Holy Family"),* oil on panel (Galleria degli Uffizi, Florence); Archivio Fotografico, Soprintendenza per i Beni Artistici e Storici, Florence (negative no. 385278). As is most evident on the lower right of the panel, the outlines for the underdrawing of the figures were derived from the "carbon copy" method. Cf. also essays by Ezio Buzzegoli and Diane Kunzelman, "Andrea del Sarto nel restauro" and "Andrea del Sarto in riflettografia," both in Palazzo Pitti 1986, 330–57.

50. See Chapter Seven, notes 24–25, and Figure 221. On these cartoons, cf. Romano 1982, particularly the essay by Franco Mazzini, ibid., 40–58. The modified *calco* method of transfer was, however, not noticed there.

51. See Bambach Cappel 1988, Part 2, II:415–19; and Chapter Three (especially notes 216–25), for a discussion of pricked prints.

52. Armenini 1587, 76–77 (cf. Armenini 1977, 147–48, for trans.).

53. I am indebted to Donatella and Carlo Giantomassi for the opportunity to study these frescos from the scaffolding erected for their cleaning (July 1994). Cf. Giulio Briganti, André Chastel, and Roberto Zapperi with Carlo Giantomassi, *Gli Amori degli dei: Nuove indagini sulla Galleria Farnese,* Rome, 1987, 237, and Finaldi, Harding, and Wallis 1995.

54. Cartoons for the *"Galleria Farnese"* are (1) Annibale Carracci, fragment of the *Triumph of Bacchus and Ariadne* in Galleria Nazionale delle Marche, Urbino; (2) Agostino Carraci, a *Woman Borne off by a Sea God?* (identified by John Rupert Martin as *Glaucus and Scylla*), National Gallery, London; and (3) Agostino Carracci, *Cephalus Carried off by Aurora,* National Gallery, London (see Finaldi,

Harding, and Wallis 1995, and Martin 1965, 257, 259–60, nos. 71, 82, 80). Cartoons for the *"Camerino Farnese"* by Annibale are (1) *Helmsman,* British Museum, London; (2) and (3) fragments of *putto* and siren designs, Royal Library, Windsor (ibid., 240–41, 246, nos. 4, 5, 28).

55. See Chapter Two and Figures 52–53.

56. See Chapter Nine and Figures 272–76.

57. See the unusual example of Raffaellino del Garbo's embroidery cartoon in Chapter Nine and Figure 267.

58. See Chapters Six and Nine and Figures 207, 278–79.

59. Beyond the examples given in Bambach Cappel 1988, Part 1, I:438–41 (Appendix), and Part 2, cat. nos. 348–404, the following may be added. The volume with 94 "substitute cartoons" for the Escorial embroideries (Library of Monastery of S. Lorenzo El Real de El Escorial, no. 28-I-2; see here Appendix Three); the more than 100 pricked patterns, cartoons, and "substitute cartoons" among the papers of the Gentili family of potterers from Castelli (J. Paul Getty Center, Los Angeles, no. 880209, GJPA88–A274); the hundreds of pricked and pounced cartoons for Byzantine icons in the Byzantine and Benaki Museums in Athens and S. Mihalarias in London (see Laskarina Bouras in *From Byzantium to El Greco. Greek Frescoes and Icons,* exh. cat., Royal Academy of Arts, London, 1987, 54–56, 199, nos. 72–73); and about twenty pricked and *spolvero* patterns from the dismembered *Codex Zichy* (Szépmüvészeti Múzeum, Budapest). On the latter codex, see note 122 in this chapter.

60. See CBC 223–77 and especially discussion in Chapter Nine.

61. Bambach Cappel 1988, Part 2, II:113–76.

62. Cf. definitions in Baldinucci 1681, 51, and Tommaseo 1915, III, 267–68. On two occasions even Cennino's use of *"disegno,"* or *"disengnio"* (see Daniel V. Thompson in Cennini 1932 for latter transcription), approaches the more abstract Cinquecento use of the term. See Cennini 1995, cap. xiii, 14–15 (Cennini 1960, 8, for trans.): "Come si de' praticare il disegno con penna," where he wrote: "che ti farà sperto, pratico, e capace di molto disegno entro la testa tua." See also, Cennini 1995, cap. xxx, 29–30 (Cennini 1960, 17, for trans.): "In che modo prima dèi incominciare a disegnare in carta con carbone, e tòr la misura della figura, efermare con stil d'argiento," where he noted that: "Conviene che con intelletto ti guidi; e troverai la verità, guidandoti per questo modo." On Cennino and *disegno,* cf. Boskovits 1973 (as in note 7), 201–22; Boskovits 1975, 172–82; and Bacci and Stoppelli 1979, 566. Gian Lorenzo Mellini, "Rileggendo Cennini – Chiaroscuro e giusto materico," *Critica d'arte,* XI, no. 62 (1964), 43–47, discusses *disegno,* but in very general terms. Alberti's passage dealing with preparatory drawings for paintings is brief but suggestive in Book III of *De Pictura* and its Italian translation. See Alberti 1972, 102:60: "Caeterum cum historiam picturi sumus diutius excogitabimus quonam ordine et quibus modis eam componere pulcherrimum sit. Modulos que in chartis conicientes, tum totam historiam, tum singulas iusdem historiae partes commentabimur, amicosque omnes in ea rea consulemus.

Denique omnia apud nos ita praemeditata esse elaborabimus, ut nihil in opere futurum sit, quod non optime qua id sit parte locandum intelligamus. Quove id certius teneamus, modulos in parallelos dividere iuvabit, ut in publico opere cuncta, veluti ex privatis commentariis ducta, suis sedibus collocentur." Compare Alberti 1950, 112, and translations in Alberti 1966, 96; Alberti 1972, 104:60; Gilbert 1980 a, 74; and Alberti 1991, 94. See further, Chapter Six.

63. Cf. *Scritti d'arte di Federico Zuccaro,* ed. by Detlef Heikamp, Florence, 1961, 221–305; and Bisagno 1642, 14–26. On Zuccaro, see Blunt, 1989, 137–59, and Sergio Rossi, "Idea e accademia: Studio sulle teorie artistiche di Federico Zuccaro, I: Disegno interno e disegno esterno," *Storia dell'arte,* no. 20, (1974), 37–56.

64. Vasari 1966–87, I (testo), 111–19; cf. Vasari 1906, I, 168–74 (cf. Vasari 1960, 205–11, for trans.). Armenini 1587, 90 (cf. Armenini 1977, 146, for trans.); and Lomazzo 1973–74, II, cap. lxv, 415–18. Of the vast secondary literature, cf. Panofsky 1968, 50–97; Carl Goldstein, "Vasari and the Florentine *Accademia del Disegno,"* *ZfK,* XXXVIII (1975), 145–52; Summers 1981, 250–61; Guglielmo De Angelis D'Ossat, *"Disegno e invenzione* nel pensiero e nelle architetture del Vasari," *Il Vasari storiografo e artista: Atti del congresso internazionale nel IV centenario della morte (Arezzo-Firenze, 2–8 settembre 1974),* Florence, 1976, 773–82; Poirier 1976; Wolfgang Kemp, *"Disegno* – Beiträge zur Geschichte des Begriffes zwischen 1547 und 1607," *Marburger Jahrbuch für Kunstwissenschaft,* XIX, 219–40; Karen edis Barzman, "Perception, Knowledge, and the Theory of *Disegno* in Sixteenth-Century Florence," *From Studio to Studiolo* (exh. cat. ed. by Lawrence Feinberg, Allen Memorial Art Museum), Oberlin, 1991, 37–48; and Rubin 1995, 241–48. On Armenini's notions of *disegno,* see Edward J. Olzsewski in Armenini 1977, 39–40, 43–44.

65. See also Benedetto Varchi, *Della Maggioranza e nobilità dell' arti,* in Barocchi 1960, I, 45. For Pontormo's reply, see Jacopo Pontormo, "Al molto magnifico et onorando M. Benedetto Varchi suo osservandissimo . . . ," in ibid., I, 67–69 (for trans., Irma Richter, *Paragone: A Comparison of the Arts by Leonardo da Vinci,* London-New York-Toronto, 1949, 89). A similar view was expressed by the character identified as Michelangelo, who passionately defended *disegno* as the mother of all arts and crafts, in Francisco de Hollanda's *Dialogos em Roma* (English trans. by A. T. G. Bell), London, 1928, 34–37, 38, 68–69.

66. The pioneering studies by Van Os et al. 1978, Galassi 1988–89, Dorigato 1993; and Galassi 1998 have published comprehensive evidence of underdrawings revealed by infrared reflectography examination. This aspect of panel painting technique still awaits further study. On Cima da Conegliano's underdrawings and use of cartoons, cf. Humfrey 1983, 63–67. On the underdrawing techniques used by Carlo and Vittore Crivelli, Bartolomeo Vivarini, Giovanni Bellini, and Bartolomeo Montagna, cf. Galassi 1988–89, 231–54; and Galassi 1998; 49–72, 122–30. For general discussion, see also Ludovico Mucchi, "Caratteri radiografici della pittura di Giorgione," *I Tempi di Giorgione*

(exh. cat.), Florence, 1978, III; Rosand 1982, 19–20; Cocke 1984, 16, 20; Keith Laing and Michael Levey, "The Kingston Lacy *Judgement of Solomon*," *BM,* CXXVIII, (1986), 273–82; David Bull, "Conservation and Treatment," and Joyce Plesters, "Investigation of Materials and Techniques," both essays in *The Feast of the Gods: Conservation, Examination, and Interpretation.* Studies in the History of Art (Monograph Series II), XL (1990), 29–34, and 58–59, respectively. As demonstrated by Laing and Levey, Sebastiano del Piombo used the canvas of the *Judgment of Solomon* (Bankes Collection, Kingston Lacy) as if it were a drawing pad, superimposing three relatively different ideas for the composition over each other.

67. Vasari 1966–87, VI (testo), 156. On Vasari's views of Venetian painting, especially Giorgione and Titian, cf. David Rosand, "Giorgione e il concetto della creazione artistica" *(Giorgione: Atti del convegno internazionale di studi per il 5° centenario della nascita, 29–31 maggio 1978),* Venice, 1979, 135–39; Charles Hope, "The Historians of Venetian Painting," *The Genius of Venice* 1983, 38–40; Rubin 1995, 135–37, 244–48; Jaynie Anderson, *Giorgione: The Painter of "Poetic Beauty,"* London, 1997; Galassi 1998, 85–88, 97 (notes 176–80, with bibliography); and Grand Palais 1993.

68. Nepi Scirè 1983, 80–81, fig. 13. Cf. also Galassi 1998, 129–30.

69. Pointed out to me by Yvonne Szafran (letter, 16 April 1992), who restored the Getty painting. The *spolvero* dots are clearly evident on the group of four figures in the front boat, on the lower left of the composition. Cf. also Dorigato 1993, 77–79, 177–85; and Yvonne Szafran, "Carpaccio's *Hunt in the Lagoon:* a New Perspective," *BM,* CXXXVII (1995), 148–58.

70. Dorigato 1993, 77–79, 177–85.

71. See discussion in Chapter Three.

72. Bambach Cappel 1988, Part 1, I:255–81.

73. Despite excellent studies, more needs to be known about the functions of drawing in the Venetian painter's *bottega.* Degenhart 1937, 225–338, but especially 297–330, argued, for instance, that drawings in north Italy were regarded as works of art in and of themselves, rather than as functional objects in the preparation of works of art, and that artists therefore treated studies that were totally unrelated to each other as if they were unified scenes on the sketchbook page. Oertel 1940, 257, basically agreed with Degenhart on the "unfunctional" character of Venetian draughtsmanship. Tietze and Tietze-Conrat 1944, 4–7, on the other hand, offered a convincing assessment of the functions of drawing in the Venetian *botteghe,* maintaining that drawings played a very important role because they were and remained the backbone of collective activities that united the various members of the shop into one productive order. They emphasized that drawing after the master's drawings, as was surely equally true in Florence, maintained the shop tradition and the common style. The Tietzes were the first to point out that few last wills of Venetian painters failed to provide arrangements concerning the drawings owned by the testator and that drawings were considered the material property of the testator.

Thus, the Tietzes explained the dearth of Venetian drawings as a problem of survival, since drawings had such high use. See also Otto Benesch (with Konrad Oberhuber), *Disegni veneti dell'Albertina di Vienna,* Venice, 1961; W. R. Rearick, *Tiziano e il disegno veneziano del suo tempo,* Florence, 1976; Konrad Oberhuber, *Disegni di Tiziano e della sua cerchia* (exh. cat., Accademia) Venice, 1976, 13–17; James Byam Shaw, "Drawing in Venice," *The Genius of Venice* 1983, 243–45, (though the emphasis of the latter is on the accomplishments of individual draughtsmen rather than on the functions of their drawings); Cocke 1984, 15–30; Grand Palais 1993; Humfrey 1993, 150–57; and Galassi 1998, 48–88. Creighton Gilbert, "Bellini's Drawings" (review of Jacopo Bellini, *The Louvre Album of Drawings* by Bernhard Degenhart and Annegrit Schmitt), *The New Criterion,* IV, (1985), 72–73, has argued that Jacopo's album was a portfolio to show clients samples of his work.

74. See further L. Lazzarini, "Il Colore nei pittori veneziani tra il 1480 e il 1580," *BA* (Supplemento), V (1983), 135–44; Bambach Cappel 1988, Part 1, I:97–149; and Galassi 1998, 61–97. On the distinctions *"colorire," "colorare,"* and *"colorito,"* see Rosand 1982, 15–26. For comments on *disegno* in Paolo Pino's *Dialogo di pittura,* see Barocchi 1960–62, I, 106, 109, 113–14, 119, 122, 126; in Lodovico Dolce's, cf. Roskill 1968, 87, 91, 95, 115, 117, 123, 131, 137, 39, 143, 161, 171, and Barocchi 1960–62, I, 143–206. On the issue of *disegno* versus *colore,* Maurice Poirier has maintained unconvincingly that there was no real controversy since the Venetians also gave *disegno* great importance (Poirier 1976; Poirier, *"Disegno* in Titian: Dolce's Critical Challenge to Michelangelo," *Convegno internazionale di studi: Tiziano e Venezia,* Vicenza, 1980, 249–53). But on this greatly debated issue, see also Cesare Brandi, "Le due *Danae,*" *Atti dei convegni Lincei, 29: Tiziano Vecellio,* Rome, 1977, 21–30; Sidney Freedberg, *"Disegno* versus *colore* in Florentine and Venetian Painting of the Cinquecento," *Florence and Venice: Comparisons and Relations,* Florence (Villa I Tatti Studies, Harvard University Center for Italian Renaissance Studies), 1979–80, II, 309–22 (where this controversy is seen as nothing but the reincarnation of the old dilemma of the *Paragone*); Summers 1981, 250–61; Blunt 1989, 83–85; Kemp 1990, 261–84; Hall 1992, 2; Grand Palais 1993; Claire Pace in *Dictionary of Art* 1996, IX, 6–9 (with bibliography); and Galassi 1998, 73–97. Recent research is showing that there was greater artistic interaction between Venice and Central Italy than Vasari reported in the *Vite.* See, for instance, Creighton Gilbert, "The Usefulness of Comparisons between the Parts and the Set: The Case of the Cappella Paolina," *Actas del Congreso Internacional de Historia del Arte,* III, Granada, 1973, 519–31; Gilbert 1980 b, 36–75; Beverly Louise Brown, "Giorgione, Michelangelo and the *maniera moderna,*" *Renaissance Studies in Honor of Craig Hugh Smyth* (ed. by Fiorella Superbi Gioffredo, Pietro Morselli, and Eve Borsook), Florence, 1985, II, 97–112.

75. Vasari 1966–87, I (testo), 121 (cf. Vasari 1960, 215, for trans.).

76. The lunettes with the *Ancestors of Christ* were painted in

three *giornate* each except for *Iacob, Ioseph* (four), *Achim, Eliud* (five), *Roboam, Abias* (one) and *Aminadab* (two). See Fabrizio Mancinelli, "Die Restaurierung der Lünettenbilder Michelangelos in der Sixtinischen Kapelle," *Kunstchronik*, XXXVI (1983), 121–25; Mancinelli, "The Technique of Michelangelo as a Painter: A Note on the Cleaning of the First Lunettes in the Sistine Chapel," *Apollo*, CXVII (1983), 362–67; Mancinelli 1986 a, especially 241–53; Fabrizio Mancinelli and Gianluigi Colalucci, "Vero colore di Michelangiolo: Le lunette della Cappella Sistina," *Critica d'Arte*, L (1985), 72–89; Gianluigi Colalucci, "Le Lunette di Michelangelo nella Cappella Sistina," *Tecnica e stile* 1986, I, 76–81; Fabrizio Mancinelli and Anna Maria De Strobel, *Le Lunette di Michelangelo nella Cappella Sistina: Cronologia dei lavori della volta e storia dei restauri della Cappella*, Rome, 1992; and *Michelangelo: La Cappella Sistina, Rapporto*, 9–424.

77. See conservation report by Fabrizio Mancinelli and Gianluigi Colalucci in *Monumenti, Musei e Gallerie Pontificie. Bollettino*, IV (1983), 231–46, with discussion of painting technique as well as diagrams of design transfer and direct construction.

78. Ibid., especially 229, 239, 243–45.

79. See Chapter Four and Figure 120.

80. The woodcut here reproduced is from the rare Venice 1600 edition of Cesare Vecellio's patternbook (Biblioteca Marciana, Venice), as published in Ferdinand Ongania, *Raccolta di opere antiche sui disegni dei merletti di Venezia*, Venice, 1875–91. On the various editions of this patternbook, see Lotz 1933, 200–9, 212–16.

81. The *"giudizio dell'occhio"* is further discussed in Chapters Four and Six.

82. Such small-scale squared drawings are usually designated as *"modelli"* in the modern literature on "drawing" and painting technique, but the term *modello* in its meaning of drawing (rather than a sculpture or architecture model or a live model), is not very common or standard in primary sources before the eighteenth century. See Carmen Bambach Cappel in *Dictionary of Art* 1996, XXI, 762–67; Bambach Cappel 1996 a, 86–87; and Bambach Cappel 1990 a, 493–98.

83. It is found on Egyptian *papyri*, wood drawing boards, and stone slabs for relief sculpture from the Old Kingdom (XXVI Dynasty). See objects in the collections of Egyptian art in the British Museum, London (nos. 5601, 144401, 56924), as well as in the Ägyptisches Museum, Staatliche Museen Preussischer Kulturbesitz, Berlin (no. P13558), the latter published in Scheller 1995, 91–93, no. 1.

84. Given in Richter, I, 119, § 20 (cf. Richter, *Commentary*, I, 114–15; Leonardo, *On Painting*, 52, for trans.): "Il pittore che ritrae per pratica e givditio d'ochio, sanza ragione è come lo spechio, che in se imita tutte le a se cōtraposte cose sanza cognitione d'esse." The date 23 April 1490 is written on the verso of this note.

85. Given in Richter, I, 119, § 18 (cf. Richter, *Commentary*, I, 114; Leonardo, *On Painting*, 52, for trans.): "Queste regole fanno · che tu possiedi · uno libero · e bono · giuditio · jnperochè 'l bono · givditio · nascie · dal bene · intēdere ·, e 'l bene intēdere diriua da ragione · tratta da bone ·

regole · le bone regole · sono figliole della · bona speriētia: comvne madre · di tutte le sciētie · e arti...."

86. On Domenichino's cartoons for the ceiling of the Polet Chapel, see CBC 56–57, as well as Spear 1967, 144–58; Spear 1968, 114–16; Richard Spear, "Further Drawings by Domenichino," *MD*, XVII (1979), 245–60; Spear 1982, 182–84; and Bambach Cappel 1988, Part 1, I:245–48. As Spear has convincingly explained, Domenichino may have pricked the outlines of the original cartoon – of which there are three extant fragments (CBC 56 a–c): the head of St. Cecilia at the J. Paul Getty Museum, Los Angeles (formerly, John A. Gere Collection, London); the head of an angel at the Szépművészeti Museum, Budapest; and the other head of an angel at the Pierpont Morgan Library, New York – because Domenichino was not satisfied with the design. This cartoon would have then been pounced onto the complete compositional cartoon that is now at the Louvre (inv. 9082; CBC 57), which is also pricked.

87. Here, the significant examples of Domenichino's Raphaelesque manner of rendering cartoons are the extant cartoon fragments for the *Death of St. Cecilia* on the side wall of the Polet Chapel (Louvre inv. 9080 and 9081, Paris, and Metropolitan Museum of Art 1998.211, New York, the recently discovered, unpublished central section of the composition). On the Louvre fragments, cf. Palazzo Venezia 1996, 489, no. 63, as well as studies by Richard Spear cited earlier.

88. Transcribed in Spear 1982, 341, 345 (but see ibid., 337–46, for context): "Spolvero di S.ta Cecilia con li due Angioli./Un mazzo di Spolveri diversi./ ... calchi di Raffaelle no. 7."

89. Bambach Cappel 1988, Part 1, I:11–176, gives a more detailed analysis of the written sources cited throughout this book.

90. Transcribed in Kennedy 1938, 246: "E addì 28 d'aprile anno detto chonperai sedici quaderni di fogli reali da straccio per soldi 5 el quaderno per fare gli spolverezi de' profeti e altri spolverezi achaggiono in detta volta ... lire 4, soldi 0." On artists' account books, see Thomas 1995, 297–308; and Kemp 1997, 1–78, for context.

91. Transcribed in full in Richter, I, 362, § 628 (cf. Richter, *Commentary*, I, 365–66): "A preparare il legniame per dipi[n]giere su...." See further Bambach Cappel 1988, Part 1, I:91–97.

92. Document is fully transcribed in Buscaroli 1938, 102: "Item uno chartone de nostra Dona e uno san Bastiano e 22 pezi de charta deseniatta teste e altre chose." On Melozzo's use of cartoons, see Chapter Six and Figures 212–13. Other wills and inventories are discussed in Chapter Three.

93. Cf. Vasari 1966–87, I (testo), 118–21, 134 (cf. Vasari 1960, 212–15, 231, for trans.); Borghini 1584, 170–73; Bambach Cappel 1988, Part 1, I:101–17. Of note, Vasari did mention the use of *spolvero* cartoons for *sgraffito* façade decoration, which is entirely based on the repetition of ornament patterns. See Vasari 1966–87, I (testo), 142–43 (cf. Vasari 1960, 243–44, for trans.), and repeated in Vasari's *Vita* of

Andrea di Cosimo Feltrini;Vasari 1966–87, IV (testo), 521. On the general issue of artists' technique in Vasari's *Vite*, cf. Panichi 1991.

94. On Vasari's and Federico Zuccaro's recently cleaned frescos on the dome of Florence Cathedral, which I was fortunate enough to study from the restoration scaffolding (fall 1993, spring 1994), see Acidini Luchinat and Dalla Negra 1995, especially 113–36 (figs. 8, 22, 24, 26–27); as well as Acidini Luchinat and Danti 1992, 132–39. *Spolvero* appears only on the decorative garlands and letters of the *dado* of the *"Sala dei Cento Giorni"* (Palazzo della Cancelleria, Rome); the *historie* in this fresco cycle were stylus-incised from the cartoons. All the rooms in Palazzo Vecchio (Florence) frescoed by Vasari and his collaborators appear to exhibit cartoon stylus incisions.

95. Pozzo 1693–1700, II, *"Breve instruttione per dipingere a fresco,"* unpag., *Settione Sesta-Settima.*

96. Ibid., unpag.: ". . . perche non sempre trovaranno persone pratiche che lor voglia instruire tanto per minuto . . ." On Pozzo as a treatise writer and fresco painter, cf. also Kerber 1971; De Luca 1992, 27–31; Griseri 1994, 483–92; Maurizio De Luca, "Gli Affreschi della Galleria del Gesù a Roma" and Werner Oechslin, "Pozzo e il suo trattato," both essays in *Andrea Pozzo,* ed. by Alberta Battisti, Milan-Trento, 1996, 145–59, 189–213; as well as De Feo and Martinelli 1996. On Palomino, see Antonio Bonet Correa, *Iglesias madrileñas del siglo XVII,* Madrid, 1961; Francisco José Leon Tello and Maria Merced Virginia Sanz Sanz, *La teoría española en la pintura en el siglo XVIII: El tratado de Palomino,* Madrid, 1979; Juan Antonio Gaya Nuño, *Vida de Acisclo Antonio Palomino, el historiador, el pintor . . . ,* Córdoba, 1981; Calvo Serraller 1981; Gross 1984, 9–27; Veliz 1986, 141–89, 211–16; José Miguel Moran Turina, "En defensa de la pintura: Irala y Palomino," *Goya,* no. 190 (1986), 202–7; and Sanz 1990, 93–116.

97. Bambach Cappel 1988, Part 1, I:97–176.

98. Ibid., Part 2, II:120–73.

99. See Chapter Three, on the practices of Venetian *"madonnieri."*

100. Because of their fragile paper support, drawings were all too often ravaged during the working process and discarded after their use; many of the sheets possibly surviving must have also become damaged, and they further disappeared with the passing of time.

101. Vasari 1962, I (testo), 117: "innanzi che morissi di poco, abruciò gran numero di disegni, schizzi e cartoni fatti di man sua, acciò nessuno vedessi le fatiche durate da lui et i modi di tentare l'ingegno suo, per non apparire se non perfetto." Cf. Bambach Cappel 1996 a, 98–99.

102. Cf. Hirst 1988, 17–19, and Perrig 1991, 1–4, 119–20.

103. Michelangelo, *Carteggio,* I, 318: "E' dichono avere arsii tutti que' chartoni, ma non chredo di tutti. . . ." Cf. Hirst 1988, 17; Perrig 1991, 1; and Bambach Cappel 1996 a, 99 (note 147).

104. See letters transcribed in Frey 1923–30, II, 82, 901–2 (no. CDXLIX); and inventory of Michelangelo's possessions, 29 February 1564, transcribed in Gotti 1875, II, 149–54. Cf. Hirst 1988 a, 18–19; Alison Wright, "The *Fortuna* of

the Drawings," in Hirst 1988 b, 159–64; Perrig 1991, 1, 119; and Bambach Cappel 1996 a, 96–99.

105. See Hirst 1988, 17–19, who considered these acts as Michelangelo's measure of self-protection against plagiarism, and Perrig 1991, 1–4, who has reviewed the explanations.

106. Cf. ibid., 1–4.

107. Chapters Three and Nine explore these painters' use of *spolvero* to compose narrative designs.

108. Cf. Bambach Cappel 1996 a, 83–102.

109. See Plate IV, Figures 71, 154–55, 254–57. Cf. also Bambach Cappel 1988, Part 1, I:90–97, Part 2, I:165–201, nos. 128–50; Bambach Cappel 1990 b, 129–31; and Bambach Cappel 1991 a, 72–98.

110. Cf. Frey 1909, 128–36, nos. 153–244, and Beltrami 1919, 81–137, nos. 130–216. Many of these documents are discussed in Bambach 1999 b.

111. *Contra* hypothesis in Galassi 1988–89, 190–91. I am indebted to Maurizio Seracini (Editech, Florence) for allowing me to study his infrared reflectograms of this painting.

112. Infrared reflectograms of these two paintings are also in the archive of Maurizio Seracini (Editech, Florence).

113. See further Kemp 1992, and on the question of authenticity and date, see ibid., 13–23.

114. On these two painted portraits, see Martin Kemp in *Circa 1492,* 270–72, nos. 169–70; Brown 1998, 101–21; as well as Fabjan and Marani 1998. On the technical examinations that revealed *spolvero,* cf. Eric Gibson, "Leonardo's *Ginevra de' Benci,"* Apollo, CXXXIII (1991), 161–65, David Bull, "Two Portraits by Leonardo: *Ginevra de' Benci* and the *Lady with an Ermine,"* Artibus et Historiae, XIII (1992), 67–83; David Bull in Fabjan and Marani 1998, 83–90. I am indebted to David Alan Brown for his help with my research on these paintings and for providing infrared reflectograms of the *Ginevra*. See section on portraits in Chapter Three.

115. See Chapter Three, notes 142–43.

116. I am indebted to Pietro C. Marani for informative visits to the restoration scaffolding of Leonardo's *Last Supper* (November 1996; September 1997). On Leonardo's mural painting technique, see H. Travers Newton, "Leonardo Da Vinci as Mural Painter: Some Observations on his Materials and Working Methods," *AL,* no. 66 (1983), 71–88; Brambilla Barcilon 1984, 97; Roberto Cecchi and Germano Mulazzani, *Il Cenacolo di Leonardo da Vinci: Guida alla lettura del dipinto e storia dei restauri,* Florence, 1985; Carlo Bertelli, "Leonardo e l'*Ultima Cena* (ca. 1495–97)," *Tecnica e stile* 1986, 31–41; and Matteini and Moles 1986, 34–41.

117. Brambilla Barcilon 1984, 97.

118. Ibid., 96, and Brambilla Barcilon 1990, 35–86, especially 47–53.

119. Cf. Costantino Baroni, "Tracce pittoriche leonardesche recuperate al Castello Sforzesco di Milano," *Rendiconti dell' Istituto Lombardo di scienze e lettere,* LXXXVIII (1955), 1–12; Joseph Gantner, *Leonardos Visionen von der Sintflut und vom Untergang der Welt,* Bern, 1958, 133–36; J. Gantner,

"Les fragments récemment découverts d'une fresque de Léonard de Vinci au Chateau de Milan," *GBA,* LIII (1959), 27–34; Mario Pomilio and Angela Ottino della Chiesa, *L'Opera completa di Leonardo pittore (Classici dell'arte, XII),* Milan, 1967, 99–100, no. 24; Volker Hoffmann, "Leonardos Ausmalung der Sala delle Asse im Castello Sforzesco," *MdKIF,* XVI (1972), 51–62; Carlo Pedretti, *Leonardo: A Study in Chronology and Style,* London, 1973, 76–77; Marco Rosci, "La Sala delle Aste," *Leonardo: La Pittura,* Florence, 1977, 115–25; Pedretti 1981, 96, 291, 296–303; Kemp, 1989, 181–89; Pietro Marani, "Leonardo e le 'colonne ad tronchoso': Tracce di un programma iconologico per Ludovico il Moro," *Raccolta Vinciana,* XXI (1982), 101–20; Dawson Kiang, "Gasparo Visconti's *Pasitea* and the Sala delle Asse," *ALV,* II (1989), 101–9; Bambach Cappel 1991 a, 72–80; and Marani 1992, 141–52.

120. Here, see further Bambach 1997 b, 21–28, for a discussion of the painting practice of Filippino Lippi, who was Leonardo's close contemporary and who, by contrast, learned the painting practice of Fra Filippo Lippi and Sandro Botticelli.

121. Bambach Cappel 1991 a, 72–98. This practice has turned out to be more widespread in the Cinquecento than I originally thought when writing my article on Leonardo, Tagliente, and Dürer, and my conclusions are here, therefore, revised.

122. The dismembered parts from the *Codex Zichy* (dating between 1489 and 1536), now in the drawings collection at the Szépművészeti Múzeum, Budapest, were brought to my attention by Lórand Zentai in the summer of 1992. These drawn patterns are of highly uneven quality and are much less known than the famous portion of the codex in the Erwin Szabo Public Library, Budapest. Cf. Margherita Azzi Visentini, "Riflessioni su un inedito trattato di architettura: Il Codice Zichy della Biblioteca Communale di Budapest," *Arte Veneta,* XXIX (1975), 139–45, and Carolyn Kolb, "The Francesco di Giorgio Material in the *Zichy Codex,*" *Journal of the Society of Architectural Historians,* XLVII (1988), 132–59. For our purposes, three patterns (inv. 1915.24, 1915.43, and 1915.55) show the "pricking onto the folded sheet" practice. On the other examples of this practice here cited, see Bambach Cappel 1991 a, 80–81 (and notes 53–57).

123. For example, in the architecture projects by Bernardo Buontalenti and in the *grotteschi* drawings by the followers of Luca Cambiaso working in the Monastery of S. Lorenzo de El Escorial; see further, Chapter Five.

124. See Figures 54, 156, and discussion in Chapter Five.

125. Tagliente 1530, unpag., fols. 27 verso–28 recto. The full text of this patternbook is transcribed in Bambach Cappel 1991 a, 95–98. On this author and his patternbook, cf. further ibid., 72–98; Levey 1983, 10 (note 20); Esther Potter in Stanley Morison, *Splendour of Ornament . . . Specimens Selected from the "Essempio di recammi, the First Italian Manual of Decoration . . . ,"* London, 1968, 27–68; Sander 1942, III, 1122, nos. 6450–54; and Lotz 1933, 112–16, nos. 64 a–e.

126. Impressions of the complete set of six engravings after Leonardo exist only in the Biblioteca Ambrosiana, Milan.

See further Hind 1938–48, V, 83–86, 93–95, nos. 19–24, VI, plates 626–28, Bambach Cappel 1991 a, 72–98 (and note 2), on their function; and Ambrosiana 1998, 140–41, no. 59.

127. For instance, in the *Journey of Moses,* frescoed in 1481–83 on the south wall of the Sistine Chapel by Pietro Perugino, with the assistance of Bernardino Pinturicchio and Bartolomeo della Gatta, the pigments were layered thickly, with substantial *a secco* application. On the right portion of the composition, the incisions reinforcing the folds of the draperies (the lavender gown of the woman on the right and the blue mantle on the woman who is to her left) were probably freehand, direct incisions correcting *spolvero* outlines, rather than the result of cartoon stylus-tracing. Yet these incisions appear shallow, because their troughs are filled in by the thickness of the applied paint. Traces of *spolvero* are apparent only in small passages, in one or two figures of this densely peopled scene, which measures about 3.4 by 5.4 meters (cf. Scarpellini 1984, 78, no. 32). I am indebted to the late Fabrizio Mancinelli for providing the opportunity of studying this mural from the restoration scaffolding (January–March 1994).

128. See discussion of Paolo Uccello's mural surfaces in Chapter Six and Figure 181. In fact, in the fragile tabernacle mural of a *Madonna and Child* (Casa di Raffaello Santi, Urbino), painted largely *a secco,* the *spolvero* dots are visible only by means of infrared reflectography, and only on the foreshortened fingers of the Madonna's right hand. See particularly conservation report by Maurizio Seracini (Editech, Florence), published in Palazzo Ducale Urbino 1983, 217–19, under no. 47. On Giovanni Santi, cf. Joannides 1987, 55–61, as well as Varese 1994, 256–57, where the attribution to Raphael of this *Madonna* is debated.

129. This is sadly true of Raphael's *"Mackintosh Madonna"* (National Gallery, London), for which the cartoon is extant (Fig. 97; British Museum 1894-7-21-1, London; CBC 255), discussed in Chapter Two. On eighteenth- and nineteenth-century restoration practices, see the fascinating studies by Alessandro Conti, *Storia del Restauro e della conservazione delle opere d'arte,* Milan, n.d. (Electa, 1973?), 98–207, and Paolo Bensi, "I Restauri dell'Ottocento: Distruzione e documentazione," *Problemi del restauro in Italia (Atti del Convegno Nazionale, Roma, 3–6 novembre 1986),* Udine, 1988, 239–46.

130. This is especially true of Domenico Veneziano's main fragment from the Canto de' Carnesecchi tabernacle (National Gallery, London), discussed in Chapter Six.

131. On the methods of detaching frescos, cf. Leonetto Tintori, "Methods Used in Italy for Detaching Murals," *Recent Advances in Conservation: Contribution to the I.I.C. Rome Conference,* London, 1963, 37–41; Tintori, "Scientific Assistance in the Practice of Mural Conservation in Italy," *Application of Science in Examination of Works of Art (Proceedings of the Seminar: June 15–19, 1970),* ed. by William J. Young, Boston, 1973, 154–63; Metropolitan Museum of Art 1968, 30–44; Botticelli 1980, 77–89; Borsook 1983, 60–62; Orianna Baracchi Giovanardi, "Il Modenese Antonio Boccolari e l'arte di 'strappare' gli affreschi dal muro,"

Atti e Memorie della Deputazione di Storia Patria per le Antiche Provincie Modenesi, VI (1984), 1–22; Mora and Philippot 1984, 245–81; Castel Sant'Angelo 1989; and Botticelli 1992. Additionally, see glossary of terms in *Tecnica e stile* 1986, I, 133, and *MD*, XXX (1992), 3–4, under *"stacco"* and *"strappo."* For an eyewitness account of an early detachment by *strappo*, see also Campani 1910, 203–10.

132. On this *strappo*, cf. Redig de Campos 1984, 28 (note 1), and Fabrizio Mancinelli in Vatican 1984, 194–95, no. 71.

133. The two cartoon fragments with angels' heads are Louvre inv. 3852 and 3853, Paris. Cf. Oberhuber 1972, 87, nos. 400–1; Catherine Monbeig Goguel in Grand Palais 1983, 258–60, nos. 83, 84; and Louvre 1992, 230–32, nos. 314, 316. The horse's head is Ashmolean Museum inv. P II 556, Oxford. Cf. Parker 1972, 300, no. 556; Oberhuber 1972, 87, no. 402; and Gere 1987, 102, no. 23. See Chapter Seven, note 152, for data.

134. For a particularly important contribution to this topic, see Galassi 1988–89; the papers in *The Princeton Raphael Symposium* 1990; and Galassi 1998.

135. Most unusually, some of the *spolvero* dots are visible with the unassisted eye on the red and white tunics of the angels in Piero della Francesca's *Baptism of Christ* (National Gallery, London), on the white turban worn by a flagellant in Piero's *Flagellation of Christ* (Galleria Nazionale delle Marche, Palazzo Ducale, Urbino), and on the face of a young man portrayed by Lorenzo Costa (see Fig. 100).

136. Of the vast literature on infrared reflectography, note especially J. R. J. van Asperen De Boer: *Infrared Reflectography: A Contribution to the Examination of Earlier European Painting* (Ph. D. Dissertation, University of Amsterdam), Amsterdam, 1970, which is the pioneering study; van Asperen De Boer, "A Note on the Use of an Improved Infrared Vidicon for Reflectography of Paintings," *Studies in Conservation*, XIX (1974), 97–99; Ainsworth 1982, 161–67; E. Bosshard, "Die Unterzeichnung der Gemälde von Nicklaus Manuel Deutsch," *Maltechnik 3/Restauro*, July 1983, 158–68; J. R. J. van Asperen De Boer, "Infrared Reflectography of Paintings: Principles, Development and Applications," *International Symposium on the Conservation and Restoration of Cultural Property: Conservation and Restoration of Mural Paintings*, Tokyo, 1985, II, 167–72; A. Burmester and K. Renger, "Neue Ansätze zur technischen Erforschung von Handzeichnungen: Untersuchungen der 'Münchner Rembrandt-Fälschungen,' im nahen Infrarot," *Maltechnik 3/Restauro*, July 1986, 9–34; Maryan W. Ainsworth and Molly Faries, "Northern Renaissance Paintings: the Discovery of Invention," *Saint Louis Art Museum Bulletin*, n.s., I (1986); Galassi 1988–89, 126–41; Maryan W. Ainsworth, "Renaissance Drawings and Underdrawings: A Proposed Method of Study," *MD*, XXVII (1989), 5–38; Ainsworth 1990, 173–86; J. R. J. Van Asperen De Boer, "Current Techniques in the Scientific Examination of Paintings," *The Princeton Raphael Symposium* 1990, 3–6; Jeffrey Jennings, "Infrared Visibility of Underdrawing Techniques and Media," in Université Catholique de Louvain (Institut Supérieur d'Archéologie et Histoire de l'Art), *Le Dessin sous-jacent dans la peinture: Colloque IX,* ed. by R. Van Schoute and H. Verougstraete-Marcq, Louvain-La-Neuve, 1993, 241–52; Maria Clelia Galassi, "La tecnica pittorica dei primitivi fiaminghi," *Pittura fiaminga in Liguria, secoli XIV–XVII,* ed. by Piero Boccardo and Clario di Fabio, Genoa, 1997, 127–49; Bambach 1997 b, 21–28; Maryan W. Ainsworth, *Gerard David: Purity of Vision in an Age of Transition,* New York, 1998; and Galassi 1998. Also note the proceedings of the regularly ongoing symposia by the Université Catholique de Louvain (Institut Supérieur d'Archéologie et Histoire de l'Art), *Le Dessin sous-jacent et la technologie de la peinture: Colloques I–XI: Infrarouge et autres techniques d'examen,* Louvain-La-Neuve, 1987–97. Colloques VI and VII (1987, 1989) provide bibliographies.

137. Other informative infrared reflectograms are illustrated in Figures 95, 96, and 123.

138. Galassi 1988–89; Dorigato 1993; Bambach 1997 b; and Galassi 1998. For infrared reflectograms of Trecento panels, see the exhibition *Art in the Making* 1989, 81, 86, 88–89, 97, 119, 142. For infrared photographs, see ibid., 132–134, 148, 176–77.

139. J. R. J. van Asperen de Boer, "Current Techniques of Examination," *The Princeton Raphael Symposium* 1990, 5.

140. See Chapters Two, Three, and Five.

141. See results on Leonardo's *"Vitruvian Man"* (Fig. 256; Gallerie dell'Accademia, Venice) from around 1490, discussed further in Chapter Nine; and Spezzani 1992, 179–86. Note also evidence of *spolvero* in some of the pages of the so-called *"Libretto Veneziano"* (Fig. 108; Gallerie dell'Accademia, Venice; CBC Appendix 31), attributed to the circle of Raphael, discussed further in Chapter Three, and Ferino Pagden 1984, 61–62, 78, 101–2 (nos. 14, 22 verso, 34 recto and verso), Appendix, figs. 40–41, 63, 90–91. Infrared reflectography examination of various drawings in the Gabinetto Disegni e Stampe degli Uffizi has been in progress in recent years, conducted by Maurizio Seracini (Editech, Florence).

142. An example are the results of infrared photography and reflectography for Sandro Botticelli's paintings in the Galleria degli Uffizi, Florence – the *Primavera* (c. 1478), the *Birth of Venus* (after 1482), the *Annunciation* (c. 1490), and the *Coronation of the Virgin* (c. 1490) where no *spolvero* has come to light. Cf. Enzo Buzzegoli and Diane Kunzelman, "La Nascita di Venere in riflettografia I.R."; "*L'Annunciazione* in riflettografia I.R.," *Gli Uffizi. Studi e ricerche, 4: La Nascita di Venere e l'Annunciazione del Botticelli restaurate,* Florence, 1987, 63–73; Umberto Baldini, *La Primavera del Botticelli: Storia di un quadro e di un restauro,* Milan, 1984; Galassi 1988–89, 154–64; and Galassi 1998, 111–13. Here, infrared radiation probably has not effectively penetrated the layers of paint, for it only shows occasional *pentimenti* in the outlines, and may thus not have absorbed all types of preliminary underdrawing. The same seems true of Michelangelo's *Entombment* from about 1500 (National Gallery, London) and the Doni *tondo* of the *Holy Family* from 1503 to 1506 (Galleria degli Uffizi). On the painting technique of the young Michelangelo, see Hirst and Dunkerton 1994.

143. Preliminary conclusions about Raphael's painting and drawing of the *"The Knight's Dream"* were presented in Plesters 1990 a, 16–18. The results from a more recent infrared reflectography examination of the painting, published in *Giotto to Dürer* 1991, 169–70, 370–71, and with which I entirely agree, have sharply modified Joyce Plesters's observations.

144. On Raphael's cartoon for *"The Knight's Dream,"* see Chapter Three (and note 98).

145. These are the *predella* panel of the *Agony in the Garden* from 1501–1503 (Metropolitan Museum of Art, New York) and its drawing in the Pierpont Morgan Library (New York; CBC 224); the *St. George and the Dragon* from 1503 to 1504 (Musée du Louvre, Paris) and its drawing in the Uffizi (see Chapter Nine and Fig. 249; CBC 234); as well as the *St. Catherine of Alexandria* from 1506 to 1508 (National Gallery, London) and its cartoon in the Louvre (Plate VI; CBC 249). I am indebted to Everett Fahy, Maryan W. Ainsworth, and Keith Christiansen for the opportunity to study the Metropolitan Museum of Art *Agony in the Garden* panel with infrared reflectography (summer 1990). On the Louvre *St. George* panel, cf. "Raphaël étudié au laboratoire," Grand Palais 1983, 415–16 (*spolvero* marks were not reported, although the painting has been surveyed only with infrared photography, and further examination is necessary); on the Uffizi pricked drawing (inv. 530 E), cf. Petrioli Tofani 1986, 237–38, *sub numero.* Still another case may be offered by the *"Belle Jardinière"* (Louvre) from 1507 to 1508 and its cartoon in the National Gallery of Art (Washington; Fig. 58; CBC 245). No *spolvero* is reported in the painting (cf. "Raphaël étudié au laboratoire," Grand Palais 1983, 419), but it has been studied only with infrared photography. On the National Gallery *St. Catherine* panel, cf. Plesters 1990 a, 25–26, and Dunkerton and Penny 1993. At that time, the *St. Catherine* panel had only been examined with infrared photography.

146. Surprisingly, much of the underdrawing on panels by Raphael can be seen close up with the unassisted eye. A small possibility exists that here the cartoons may have been transferred by means of "substitute cartoons," which in turn were stylus-traced rather than pounced onto the panel. Raphael and his workshop did just this in the case of the *School of Athens* cartoon and fresco (see Chapters Seven and Eight; and Bambach Cappel 1992 a, 9–30). But on the surface of the small panels, the procedure may have left too subtle a line to distinguish precisely its character. The evidence from infrared reflectography is in this respect inconclusive.

147. A significant case in point is Michelangelo's Sistine Ceiling; see Bambach Cappel 1996 a, 83–102; and in this book, Chapters Five and Six, and Appendix Two. Regarding the problems of evidence in earlier frescos, see also Bambach 1996 b, 143–66. Great lacunae in the *spolvero* are everywhere evident on the mural surface of Piero della Francesca's mural cycle of the *Legend of the True Cross* (S. Francesco, Arezzo), visible from the restoration scaffolding and now being documented in the computer archives at the restoration site. I am indebted to Giorgio Bonsanti, Anna Maria Maetzke, Cristina Danti, and Silvano Lazzari for the repeated opportunities to visit the restoration scaffolding at S. Francesco over the years.

148. The etymology of the word in Italian, French, English, Spanish, and German is further discussed in Bambach Cappel 1988, Part 1, I:18–30, 40–56.

149. Daniel V. Thompson, *The Materials and Techniques of Medieval Painting,* New York, 1956, 29, and E. Johnston, *Writing and Illuminating, and Lettering,* London, 1932, 174–75, where recipes for making pouncing dust are also included.

150. Cennini 1995, cap. x, 11–13 (cf. Cennini 1960, 6–7, for trans.).

151. Giovanni Battista Palatino, *Libro . . . Nelqual s'insegna à scriuere ogni sorte de lettera, Antica, & Moderna . . . ,* Rome, 1540; and Juan de Yciar, *Arte Subtilissima, por la qual se enseña a escrivir perfectamente . . . ,* Saragossa, 1550. Both small manuals are unpaginated; see their epilogues, which provide recipes. On some of these Cinquecento writing manuals, see Bambach Cappel 1991 a and b, 72–106.

152. Cennini 1995, cap. iv, 6–7; cap. x, 11–13; cap. cxli, 143–44; cap. cxliii, 145–46 (cf. Cennini 1960, 3, 6–7, 86–89, for trans.), and discussion in Bambach Cappel 1988, Part 1, I:65–83.

153. Cf. ibid., 11–56.

154. Cennini 1995, cap. x, 11–13 (cf. Cennini 1960, 6–7, for trans.). See also Bambach Cappel 1988, Part 1, I:67–68 (note 27).

155. Bambach Cappel 1988, Part 1, I:11–56, with bibliography of primary sources.

156. Accademia della Crusca 1612, 837–38: *"Spolverezzo/ Spolvero/Spolverizzare . . . Ridurre in polvere. Lat. impuluerum redigere. M.V.6.54. . . . Termine di pittura, vale recauar con lo spolvero, che é vn foglio bucherato con ispilletto, nel qualle è il disegno, che si ricaua, facendo per que' buchi passarui polvere di carbone, o di gesso, legata in vn cencio che si chiama lo spolverezzo. . . ."* Cf. Bambach Cappel 1988, Part 1, I:41–43 (and note 65).

157. Baldinucci 1681, 155. Recent critical assessment of Baldinucci's *Vocabolario* has been relatively negative. See Goldberg 1988 and Silvia Parodi's critical essay in the facsimile edition of Baldinucci's *Vocabolario,* Florence, n.d. [1976?], iii–xxxiii.

158. Armenini 1587, 102–3 (cf. Bambach Cappel 1988, Part 1, I:16, 139–40): *". . . per abbreuiar la fatica nelle ombre voglio si dia da quella banda per doue te vanno con un spoluero che sia pieno ò di carbon pesto, o ver di poluere di Lapis nero, col quale si vien battendo leggiermente è sù quello si batte, e spoluera quel luogo per doue le ombre vi vanno più scure, & ciò sia fatto in modo che vi rimanga sotto un letto tale, che si vegga piu che mezzo apparere ombregiato, & indi su quelle ombre poi si vadia leggiermente tratteggiando, o con punte di Carboni o sia de Lapis nero. . . ."*

159. Cennini 1995, cap. iv, 6–7; cap. x, 11–13; cap. cxli, 143–44; cap. cxliii, 145–46 (cf. Cennini 1960, 3, 6–7, 86–89, for trans.); Vasari 1966–87, I (testo), 142 (cf. Vasari 1960, 243, for trans.); Armenini 1587, 102–4 (cf. Armenini 1977, 173–74, for trans.); and Pozzo 1693–1700, II, unpag., under

"Settione Settima," "Ricalcare." Cf. further Tommaseo 1915, VI, 1127, under "spolverare"; and Bambach Cappel 1988, Part 1, I:65–176.

160. Note passages transcribed in Richter, I, 260, 319, §§ 523, 628 (cf. Richter, Commentary, I, 333, 365–66). See also Codex Urbinas Latinus facsimile in McMahon 1956, II, fols. 41 recto and verso (McMahon 1956, I, no. 558, for trans.). Cf. Tommaseo 1915, VI, 1127–28, under "spolverizzare"/"spolverezzare."

161. Paganino c. 1532, unpaginated, Proemio, "Alessandro Paganino al lettore"; Accademia della Crusca, Vocabolario . . . , Venice, 1612, 837–38; and Baldinucci 1681, 30, 155.

162. Tagliente 1530, unpag., fol. 28 recto (transcribed in Bambach Cappel 1991 a, 98), and Ostaus 1567, unpag., Proemio (cf. Bambach Cappel 1988, Part 1, I:120–34).

163. Benvenuto Cellini, Dell'Oreficeria, chap. XIII, 102–3: ". . . perchè universalmente si sa per ognuno."

164. As Vasari described it, sgraffito was a technique of decoration usually applied on façades of buildings. It consisted of scratching (or etching) a design with an iron tool through a very thin superimposed layer of white lime of travertine to reveal a layer underneath of dark gray mortar. It is thus, properly speaking, not painting. Cf. Vasari 1966–87, I (testo), 142–43 (cf. Vasari 1960, 243–44, for trans.). The application of spolvero for sgraffito façade decoration is repeated by Vasari in the Vita of Andrea di Cosimo Feltrini; Vasari 1966–87, IV (testo), 521: ". . . voleva sopra alcuni cartoni, spolverandogli sopra l'intonaco. . . .") On this method of façade decoration, see further Günther and Christel Thiem, Toskanische Fassaden-Dekoration in Sgraffito und Fresko 14. bis 17. Jahrhundert, Munich, 1964, 18–21.

165. On this aspect, see Levey 1983, 6.

166. Paganino c. 1532, unpag., fol. 2 recto. For the context of Paganino's manual and the use of artisan patternbooks to teach drawing practices, cf. Bambach Cappel 1988, Part 1, I:121–28; and Bambach Cappel 1991 a, 81–87 (and note 66, for bibliography). The dating of Paganino's book is only approximate. See further Lotz 1933, 133–38, nos. 70–73; Sander 1942, III, 1119–20, nos. 6432–36; and Nuovo 1990, 193–95, nos. 90–93.

167. Paganino c. 1532, Proemio, "Alessandro Paganino al Letore," unpag., fols. 3 recto and verso. The order in which Paganino described the four methods of design transfer does not correspond to that of the four scenes illustrating each method in the woodcut. In the text, the order is (1) spolvero technique, (2) tracing with light from a window, (3) tracing with light from a candle, and (4) careful freehand copy pointing with the hand for guidance.

168. Tagliente 1530, unpag., title page and verso; transcribed in Bambach Cappel 1991 a, 95–96, but see 72–98, with further bibliography in notes.

169. Cf. ibid., 72–94; Anne Jacobson Schutte, "Teaching Adults to Read in Sixteenth-Century Venice: Giovanni Antonio Tagliente's Libro maistrevole," Sixteenth Century Journal, XVII (1986), 5–8; and Levey 1983.

170. A reconstruction of Tagliente's relationship to Leonardo, Pacioli, and Dürer is attempted in Bambach Cappel 1991 a, 81–87.

171. On Alessandro Paganino, cf. Nuovo 1990 and review by Giorgio Montechi in La Bibliofilia, XCIII (1991), 99 102.

172. On Cesare Vecellio, cf. Venturi 1901–40, IX, Part VII, 85–91; Thieme-Becker, XXXIV, 157; L. Alpago Novello, Gli Incisori bellunesi, Venice, 1939–40; Giuseppe Fiocco, "Note su Cesare Vecellio," Lettere ed arti, Venice, 1946; Francesco Valcanover, Le Venti tavole del soffitto di S. M. Assunta di Lentiai di Cesare Vecellio, Belluno, 1956; Mauro Lucco, Cesare Vecellio: Arte del '600 nel Bellunese, Padua, 1981; and Sergio Claut in Dictionary of Art 1996, XXXII, 107.

173. In documents "Urbino," already middle-aged, is called "servitore" and "garzone" (cf. Frey 1909, 144, 148, 150, 155, 157, nos. 82, 129, 161, 164, 231, and 251); and in Vasari's Vita of Michelangelo, ". . . suo servidore, che lo fece richissimo, et era suo creato" (Vasari 1966–87, VI (testo), 114). On the division of labor in the workshop, compare chiefly Wackernagel 1938, 315–45 (1980, 308–36); V. Egbert, The Medieval Artist at Work, Princeton, 1967; Thomas 1975; Cole 1983; Art in the Making 1989, 9–11, 214; Palazzo Strozzi 1992; and Thomas 1995. Jean Cadogan's study of the copious payment documents regarding the lost frescos from the 1490s for Pisa Cathedral by the Ghirlandaio workshop sheds light on the division of menial labor among workers – the preparation of plaster, grinding of bricks, transportation of water, and grinding of colors. Regarding the delegation of labor in the actual painting of the frescos, however, conclusions are not forthcoming from the documents; cf. Cadogan 1996, 91–94. I am indebted to Everett Fahy, Lisa Venturini, and Virginia Budny for sharing transcriptions of the Pisa Ghirlandaio documents.

174. For the document, see Guasti 1857, 144–46, no. 358. Cf. discussion in Acidini Luchinat and Dalla Negra 1995, 72–75; Acidini Luchinat and Danti 1992, 132–39; Cristina Acidini Luchinat, "Vasari's Last Paintings: The Cupola of Florence Cathedral," Vasari's Florence 1998, 238–52, with new transcriptions of further related documents by Philip Jacks (ibid., 248–52).

175. For citations, see note 10.

176. On Carducho, cf. Mary Crawford Volk, Vicencio Carducho and Seventeenth-Century Castilian Painting (The Garland Series of Outstanding Dissertations in the Fine Arts), New York and London, 1977; F. Sricchia Santoro in Dizionario biografico degli italiani, Rome, 1977, XX, 45–47; Mary Crawford Volk, "Addenda: the Madrid Academy," AB, LXI (1979), 627; Calvo Serraller 1981; Gross 1984, 9–27; Pérez Sánchez 1986, 140–41; Zygmunt Wazbinski, "Los diálogos de la pintura de Vicente Carducho: El manifiesto del academismo español y su origen," Archivo Español del Arte, LXVI (1990), 435–47; and Sanz 1990, 93–116. I am indebted to Lisa Banner for stimulating discussions and for pointing out some of these sources.

177. Saint-Aubin 1770 (cf. Saint-Aubin 1983, 75, for trans.), 39 (facsimile): "Ce sont ordinairement les enfants ou apprentifs qui piquent les dessins: il ne faut que de la patience & routine."

178. Cf. Venturini 1994, 23–39, on Francesco Botticini's forma-

179. Cennini 1995, cap. i, 4–5; cap. lxvii, 78 (cf. Cennini 1960, 2, 46, for trans.). See transcription of Leonardo's note from Paris MS. A (fol. 108 recto) given in Richter, I, 305, § 495 (cf. Richter, *Commentary,* I, 328), and *Codex Urbinas Latinus* facsimile in McMahon 1956, II, fol. 31 recto-verso (McMahon 1956, I, no. 60).

180. Archivio di Stato, Florence, *Arte dei medici e speziali,* 2, fol. 46 verso. On the guild, cf. Edgcumbe Staley, *The Guilds of Florence,* London, 1906, 236–73; Ciasca 1927; Mather 1948, 20–65; Margaret Haines, "Una Ricostruzione dei perduti libri di matricole dell'arte dei medici e speziali a Firenze dal 1353 al 1408," *Rivista d'Arte,* XL (1989), 173–207; L. Indrio, "Firenze nel Quattrocento: divisione e organizzazione del lavoro nelle botteghe," *Ricerche di Storia dell'Arte,* XXXVIII (1989), 61–70. On artists' apprenticeships, cf. Wackernagel 1981, 328–37; Anna Padoa Rizzo, "Giovanni Antonio Sogliani garzone di Lorenzo di Credi," *Rivista d'Arte,* XXXIX (1987), 457–59; Padoa Rizzo 1989; Bernacchioni 1992, 23–33; Anna Padoa Rizzo, "La Bottega come luogo di formazione," Palazzo Strozzi 1992, 53–60; Thomas 1995, 64–81, 332–34; Shell 1995; and Franco Franceschi, "Note sulle corporazioni fiorentine in età laurenziana," *La Toscana al tempo di Lorenzo il Magnifico* 1996, III, 1343–61. On the education of Florentine and Bolognese artists in the Cinquecento, cf. Carl Goldstein, "Vasari and the Florentine *Accademia del Disegno,*" *ZfK,* XXXVIII (1975), 145–52; Sergio Rossi and Maurizio Calvesi, *Dalle Botteghe alle accademie: Realtà sociale e teorie artistiche a Firenze dal XIV al XVI secolo,* Milan, 1980; Dempsey 1980, 552–69; and Karen edis Barzman, "The Florentine *Accademia del Disegno:* Liberal Education and the Renaissance Artist, *Academies of Art Between Renaissance and Romanticism: Leids Kunsthistorisch Jaarboek,* V–VI (1986–87), 14–32.

181. Cennini 1995, cap. civ, 109–10 (cf. Cennini 1960, 64–65, for trans.). Cf. also Thomas 1995, 65–66.

182. Cennini 1995, cap. cxlii, 144–45, but context provided in ibid., 143–44 (cf. Cennini 1960, 86–88, for trans.): "Anche ti dico, se vuogli insegnare ai putti o ver fanciulli a mettere d'oro, fa' lor mettere d'ariento, acciò che ne piglino qualche pratica; perché è men danno." Regarding tooling techniques and the division of labor, cf. Mojmir S. Frinta, "Observations on the Trecento and Quattrocento Workshop," *The Artist's Workshop: Studies in the History of Art, 38,* Center for Advanced Study in the Visual Arts, Symposium Papers XXII, National Gallery of Art, Washington, 1993, 19–34, and Skaug 1994.

183. Document is transcribed in Paul Oskar Kristeller, *Andrea Mantegna,* Berlin and Leipzig, 1902, 514, no. 1. Cf. Vasari 1966–87, III (testo), 547–48; and Wackernagel 1981, 329. On the use of *spolvero* cartoons by these artists, see further, Chapter Six.

184. Vasari 1966–87, V (testo), 347.

185. The information recurs in Vasari's biographies of Piero, Lazzaro Vasari, and Signorelli; see Vasari 1966–87, III (testo), 266, 293–97, 633–35. Cf. Creighton E. Gilbert, *Change in Piero della Francesca,* Glückstadt-New York, 1968, 66 (note 23); Mario Salmi, "Arezzo nella prima e nella seconda edizione delle *Vite,*" *Il Vasari storiografo e artista* (Atti del congresso internazionale nel IV centenario della morte, Arezzo-Florence, 1974), Florence, 1976, 109–26; Gloria Kury, *The Early Work of Luca Signorelli: 1465–1490,* New York-London, 1978, 36–73, 303–15; Kanter 1989, foreword, unpag.; Laurence B. Kanter, "Luca Signorelli, Piero della Francesca, and Pietro Perugino," *Studi di storia dell'arte,* Florence, 1990, 95–11; David Franklin, "An Unrecorded Commission for Piero della Francesca in Arezzo," *BM,* CXXXIII (1991), 193–94; Frank Dabell, "New Documents for the History and Patronage of the Compagnia della SS. Trinità in Arezzo," *AC,* LXXIX (1991), 412–17; and Bambach Cappel 1994, 17–43. In the *Summa de Arithmetica . . .* (Venice, 1494), fol. 2 recto, Fra Luca Pacioli cited Signorelli as "del n[ost]ro Maestro Pietro degno discipulo."

186. Cadogan 1993, 30–31, and Cadogan 1996, 89–90. Regarding Michelangelo's apprenticeship, see account in Vasari 1962, I (testo), 6–7, for the *ricordo* of the contract between Lodovico Buonarroti and Domenico and David Ghirlandaio, which according to Vasari was dated 1 April 1488. Vasari published the *ricordo* only in the 1568 edition of the *Vite.* See further ibid., II (commento), 70–74; and Charles de Tolnay, *The Youth of Michelangelo,* Princeton, 1943, 14–17, 51–52.

187. On the documented presence of assistants in the Ghirlandaio *bottega,* see especially Lisa Venturini in Palazzo Strozzi 1992, 109–13, 125–29, and Cadogan 1996, 89–96.

188. For the complex documentary evidence regarding the personality of Bartolomeo di Giovanni, cf. Fahy 1976; Pons 1990, 115–28; and Cadogan 1996, 89–91.

189. See discussions by Alessandro Cecchi and Carmen C. Bambach in Metropolitan Museum of Art 1997, 37–44, 338–39, 348–49, no. 116.

190. Vasari 1966–87, IV (testo), 341–43, where Andrea's birth date is incorrectly given as 1478, however. For discussion and context regarding Andrea del Sarto's training, note Shearman 1965 a; Wackernagel 1981, 328–37; Peter Burke, *The Italian Renaissance: Culture and Society in Italy,* Princeton, 1986, 51–52; and Alessandro Cecchi, "Profili di amici e committenti," Palazzo Pitti 1986, 42–58.

191. Frey 1892, 108: "Andrea del Sarto Fiorentino, pittore, dicepolo di Raffaellino del Garbo excellente, opero assaj e fece di molti dicepoli." Cf. discussion of this fact in Shearman 1965 a, I, 21–22.

192. See here also Bambach Cappel 1991 a, 72–98 (and especially 81, note 55).

193. The subject of Andrea del Sarto's ties to the artisanal class in Florence was explored by Alessandro Cecchi in Palazzo Pitti 1986, 42–58, with a guide to the archival evidence.

194. Vasari 1966–87, V (testo), 157–58 (cf. Golzio 1971, 197). For suggestive discussions of Vasari's story about Raphael's beginnings, see Luisa Becherucci, "Il Vasari e gl'inizi di Raffaello," *Il Vasari storiografo e artista: Atti del congresso inter-*

nazionale nel IV centenario della morte, Florence, 1976, 179–95; Jones and Penny 1983, 4–5; Becherucci 1987, 345–49; Ciardi Duprè Dal Poggetto 1987, 33–54; Joannides 1987, 55–61; Varese 1994; and Rubin 1995, 376–90.

195. See note 128.

196. Cf. *Art in the Making* 1989, 9, and Goldthwaite 1980, 201, 322.

197. Cennini 1995, cap. lxii, 64–69 (Cennini 1960, 36–39, for trans.), and Thomas 1995, 149.

198. Vasari 1966–87, III (testo), 568–69; kindly brought to my attention by Everett Fahy. See also Carmen C. Bambach in Metropolitan Museum of Art 1997, 292–95, under no. 91. Gaetano Milanesi attempted to identify this artist with Simone Caccialupi, born in 1476 and documented as working in Arezzo in 1516 (Vasari 1906, III, 477, note 1). On the bad reputation of copying practices, see Chapters Three and Four.

199. The terms *"garzoni," "factori,"* and *"discepoli"* are specifically employed to designate members of a master artisan's *bottega* in the 1556 ammendment to the statutes of the *"Arte dei medici, speziali e merciai"* (Archivio di Stato di Firenze, *Arte dei medici e speziali*, 2, fol. 222 recto-verso). On *"fattore"* and *"fattorino,"* cf. Tommaseo 1915, III, 709–10; and Battaglia 1961, V, 735–37. See also discussion of such terms in Thomas 1995, 81–88, based on the evidence of Neri di Bicci's *Ricordanze,* between 1453 and 1475.

200. Chapters Three, Four, and Nine attempt to place the traditions of copying and design reproduction within this broad context.

201. On the cartoon fragment (Louvre inv. 3853, Paris), without the present observation, cf. Catherine Monbeig Goguel in Grand Palais 1983, 260, no. 84, and Louvre 1992, 232, no. 316. I am indebted to Catherine Monbeig Goguel for the opportunity to study this drawing in the paper conservation laboratory of the Musée du Louvre (Paris), as well as for her suggestion of Mariette's name as the restorer of the drawing. The provenance can be established, with any certainty, only as far back as W. Young Ottley and Thomas Lawrence, as noted in Grand Palais 1983, 192–94, no. 28. On Mariette, see the fundamental studies by Roseline Bacou, *Le Cabinet d'un Grand Amateur P. J. Mariette,* (exh. cat., Musée du Louvre), Paris, 1967, and *The Famous Italian Drawings from the Mariette Collection at the Louvre in Paris,* Milan, 1981, as well as Simonetta Prosperi Valenti Rodinò, "Le lettere del Mariette a Giovanni Gaetano Bottari nella Biblioteca Corsiniana," *Paragone,* XXIX (1978), 35–62; Max Harald, "Pierre-Jean Mariette und Dresden," *Dresdener Kunstblätter,* XXIII (1979), 77–87; and Marie-Thérèse Mandroux-Franca, "La collection d'estampes du roi Jean V de Portugal: une relecture des notes manuscrites de Pierre-Jean Mariette," *Revue de l'Art,* no. 73 (1986), 49–56.

202. In Raphael's *Mackintosh Madonna* cartoon (CBC 255; see Fig. 97), a similar, though much less extensive "reconstructed" pricked outline occurs on that part of the Virgin's sleeve, which was redrawn on a strip, added to extend the composition's original left border.

203. The pricked holes on the mount of the small *Annunciation* cartoon are very slightly larger than those of the drawing within. On the small cartoon (Louvre inv. 3860, Paris), cf. Catherine Monbeig Goguel in Grand Palais 1983, 192, no. 28; and Louvre 1992, 25–28, no. 18. I am indebted to Catherine Monbeig Goguel for her comments on this mount. On the subject of collectors' mounts, see her article "Le dessin encadré," *Revue de l'Art,* LXXVI (1987), 25–31, as well as Dominique Le Marois, "Les Montages de dessins au XVIIIe siècle: L'Example de Mariette," *Bulletin de la Société de l'histoire de l'art français* (1982), 87–96.

204. There are no residues of rubbed pouncing dust in these portions.

205. On the technique of *sgraffito* decoration, see note 164. In defining the words designating the technique of "pouncing" (and its various cognates) in European languages, dictionaries from the seventeenth to the nineteenth century would often list the various types of artisans who employed the technique, for such texts aimed at a more comprehensive and encyclopedic view of practices than art or craft treatises. For a discussion of such dictionary sources, see Bambach Cappel 1988, Part 1, I:11–56, 298–99. Calligraphers or writing masters, as we have seen, can be entirely ruled out as users of pouncing for drawing transfer, although they are listed in Ephraim Chambers's dictionary under a muddled definition of the technique (Chambers 1728, II, 852).

206. See Chapter Three and Figures 17, 112–13.

2. Processes, Materials, Tools, and Labor

Eve Borsook, Steven Trent Cappel, Creighton E. Gilbert, and Maryan W. Ainsworth were especially generous in helping me clarify the description of the evidence that follows.

1. See, for instance, Cennini 1995, cap. lxvii, 79; cap. lxxii, 84 (cf. Cennini 1960, 47, 50, for trans.).

2. Vasari 1966–87, I (testo), 119–20 (cf. Vasari 1960, 214, for trans.): ". . . cosa fastidiosa e difficile a darsi ad intendere, non voglio io parlare altrimenti." See similar comment in Borghini 1584, 141.

3. Transcribed in Richter I, 305, § 491 (cf. Richter, *Commentary,* I, 328): "Noi conosciamo chiaramēte che la vista è delle veloci operationi che sia, . . ." See *Codex Urbinas Latinus* facsimile in McMahon 1956, II, fols. 31 recto-verso (Leonardo, *On Painting,* 197, and McMahon 1956, I, no. 60, for trans.).

4. Cennini 1995, cap. cxli, 143–44 (cf. Cennini 1960, 86–87, for trans.). But compare transcription by Daniel V. Thompson in Cennini 1932, 84, which gives the term as *"spolverizzi."*

5. Document transcribed in Kennedy 1938, 246.

6. Tagliente 1530 (unpag.), fols. 27 verso–28 recto; Barbaro 1569, fols. 159–60; Accademia della Crusca 1612; 837–38; and Giovanni Torriano, *Vocabolario Italiano e Inglese: A Dictionary of Italian and English, Formerly Compiled by John Florio . . . ,* London, 1659 (unpag.), under *"spolverio."* Cf.

Bambach Cappel 1991 a, 98; Bambach Cappel 1988, Part 1, I:46–47, 117–31; and etymology for *"spolvero"* given in Tommaseo, VI, 1128.

7. Cf. Baldinucci 1681, 30 (under *"Cartoni"*), 155 (under *"Spoluerizzare"* and *"Spoluero"*).

8. Cennini 1995, cap. cxli, 144 (cf. Cennini 1960, 86–87, for trans.); and Paganino c. 1532, *Proemio, "Alessandro Paganino al Letore,"* unpag., fols. 3 recto and verso. Cf. Bambach Cappel 1988, Part 1, I:16–17, 40–56; as well as etymology for *"spolverizzo"* given in Tommaseo, VI, 1128.

9. See Sergio Samek Ludovici, "Filippo Baldinucci," *Dizionario biografico degli italiani,* Rome, 1963, V, 495–98; Schlosser 1964, 468, 615, 624; Silvia Parodi's critical essay in the facsimile edition of Baldinucci's *Vocabolario,* Florence, n.d. [1976?], iii–xxxiii; and Goldberg 1988.

10. See Anna Matteoli, "Filippo Baldinucci disegnatore," *MdKIF,* XXXII (1988), 353–438, and, more generally, Charles McCorquodale, "Aspects of Florentine Baroque Painting," *Apollo,* C (1974), 198–209.

11. See Roseline Bacou and Jacob Bean, *Dessins florentins de la collection Baldinucci* (exh. cat.; Musée du Louvre), Paris, 1958; "Baldinuccis System des Sammelns und Klassifizierens von Zeichnungen," in Degenhart and Schmitt 1968, I, 640–45; Paola Barocchi, "Il Collezionismo del Cardinale Leopoldo e la storiografia del Baldinucci," in Gabinetto Disegni e Stampe degli Uffizi, *Omaggio a Leopoldo de' Medici, Parte I: Disegni* (exh. cat.), Florence, 1976, 14–25; Wolfram Prinz, *Die Sammlung der Selbstbildnisse in den Uffizien: Geschichte der Sammlung,* (*Italienische Forschungen: Kunsthistorisches Institut in Florenz,* Dritte Folge, Band V), Berlin, 1971, I; and Catherine Monbeig Goguel and C. Lauriol, "Giovanni Bilivert: Itinéraire à travers les dessins du Louvre," *Paragone,* no. 353 (1979), 3–48. The cataloguing data by Filippo Baldinucci for drawings now in the Gabinetto Disegni e Stampe degli Uffizi (Florence) are integrated in Petrioli Tofani 1986, 1987, and 1991 a.

12. Evidence of Cardinal Leopoldo's collection of drawings, gained from Baldinucci's manuscript of a *Registro de' disegni* (12 June 1673) and from his published *Lista de' nomi de' pittori di mano de' quali si hanno disegni* (1 August 1675) suggests that the cardinal's collection had increased from 4,292 sheets to 8,143 sheets in just two years. Many of these drawings were attributed to Quattrocento and Cinquecento masters; 100 drawings were attributed to Raphael alone in 1675. In all likelihood some of the pricked and stylus-traced drawings at the Uffizi today can be identified as part of this original collection, which was so familiar to Baldinucci. See Paola Barocchi, "Il *Registro de' disegni degli Uffizi* di Filippo Baldinucci," *Scritti di storia dell'arte in onore di Ugo Procacci,* ed. by Maria Grazia Ciardi Dupré Dal Poggetto and Paolo Dal Poggetto, Milan, 1977, II, 571–78.

13. On Baldinucci's sources, see especially Silvia Parodi's critical essay in the facsimile edition of Baldinucci's *Vocabolario,* Florence, n.d. [1976?], iii–xxxiii.

14. Baldinucci 1681, ix–x; pointed out in Goldberg 1988, 112, and discussed by Silvia Parodi in her critical essay in the facsimile edition of Baldinucci's *Vocabolario,* Florence, n.d. [1976?], iii–xxxiii.

15. In addition to this use of the term *"spolvero,"* the Italian art-historical literature has often applied the term also to identify a pricked cartoon. For the purpose at hand, such interchangeability of terms is imprecise, for our vocabulary must permit us to differentiate clearly between pricked outlines and outlines composed of dotted underdrawing (or pounce marks). Moreover, not all pricked designs are necessarily final "cartoons." As already suggested (and this will be more evident here, as well as in the following chapters), drawings were frequently pounced for transfer onto other sheets of paper for further elaboration of the composition or for the purpose of copying their design. On these problems, see further Bambach Cappel 1988, Part 1, I:3–4, 11–56, and *Tecnica e stile* 1986, I, 66–67 (discussion), 131–33, under *"cartone spolvero"* and *"cartone a calco."*

16. Cennini 1995, cap. cxli, 144 (cf. Cennini 1960, 86–87, for trans.). The transcription by Daniel V. Thompson in Cennini 1932, 84, gives the term as *"spolverizzi."*

17. Cf. Cennini 1995, cap. x, 11 (cf. Cennini 1960, 6–7, for trans.), and comments by Franco Brunello in Cennini 1995, 11–12 (note 1), and by Daniel V. Thompson in Cennini 1960, 6–7 (note 1).

18. Then, however, Daniel V. Thompson in Cennini 1960, 87 (note 2), translated *"carta"* in the text as meaning parchment rather than paper, which seems arguable in view of the passage quoted immediately above. On the preparation of parchment, see Cennini 1995, cap. x–xvii, 11–20 (cf. Cennini 1960, 6–11, for trans.). On drawing surfaces in the Trecento and early Quattrocento, see Meder 1923, 164–82; Degenhart and Schmitt 1968, I-1, xl; Ames-Lewis 1981, 19–33; Ames-Lewis and Wright 1983, 43–49; Elen 1995, 32–36; and studies in Regni and Tordello 1996 (by Silvio Curto, pp. 71–77; Gerhard Banik, pp. 71–91; and Giuseppe Calabro, pp. 101–7). See also Landau and Parshall 1994, "Paper: The Printmaker's Ground," 15–21; and Bambach 1999 b.

19. See Perrot 1625, xiv; Boutet 1676, 7, and *Art of Painting in Miniature* 1752, 4. Cf. Beal 1984, 190–91, on G. A. Canini's practices in the mid-Seicento, as recorded by Richard Symonds.

20. See, for instance, Archivio di Stato, Florence, *Arte dei medici e speziali,* 2, fols. 193 verso, 214 recto, 220 recto.

21. Cf. Ciasca 1927, 695–704; and Davidsohn 1977–78, VI, 29.

22. For 1314 statutes, see Archivio di Stato, Florence, *Arte dei medici e speziali* (Latin), 1, fol. 30 verso. For 1349 statutes, see *Arte dei medici e speziali* (Italian), 2, fols. 50 verso–51 recto; 3 (Latin), fols. lvii verso–lviii recto. Cf. Ciasca 1921 and 1927 and Davidsohn 1977–78, VI, 27–30, 310–12. Some of these aspects of the *cartolaio's* trade are discussed in Bambach 1999 b.

23. See Hans Sachs's *Eygentliche Beschreibung aller Stände auff Erden, Hoher und Nidriger, Geistlicher und Weltlicher, Aller Künsten, Handwercken . . .* (Frankfurt, 1568); Hartmann Schopper's *Panoplia Omnium . . . artium* (Frankfurt, 1568); Georg Andreas Boeckler's *Theatrum Machinarum novum exhibens opera molaria et aquatica constructum industria*

(Cologne, 1662; here, fig. 27); and Joseph Jerome de Lalande's *Art de faire le papier* (Paris, 1761). Sachs's *Eygentliche Beschreibung* contains the earliest portrayal of a papermaker at work, a woodcut by Jost Amman that was also repeated in Schopper's *Panoplia* (cf. Dard Hunter, *The Literature of Papermaking,* 13–19; Landau and Parshall 1994, 15–17, fig. 4).

24. Gasparinetti 1956, 45–47; and Bambach 1999 b. On the sizes of paper, see O. Valls i Subirà, "Les formats du papier et la pierre de Bologna," *IPH Information,* no. 9/2 (1975), 26–30, and J. P. Gumbert, "The Sizes of Manuscripts. Some Statistics and Notes," *Hellinga Festschrift / Feestbundel / Mélanges,* Amsterdam 1980, 277–88; and Gumbert, "Sizes and Formats," *Ancient and Medieval Book Materials and Techniques* (Acts of Conference held in Erice, 1992), Vatican, 1993, I, 227–63. On reams and quires, cf. also Henk Voorn, *Old Ream Wrappers: An Essay on Early Ream Wrappers of Antiquarian Interest,* North Hills, Penn., 1969, 11–17, and Elen 1995, 33–41, 144–46 (notes 70–78).

25. See Archivio di Stato, Florence, *Arte dei medici, speziali e merciai,* 2, fols. 193 verso (for the year 1436), 214 recto (for the year 1556), 220 recto; and *Diario della Stamperia Ripoli* (Biblioteca Nazionale of Florence, MS. Magl. Cl. X, 143), published with imprecise transcription in Emilia Nesi, *Il Diario della Stamperia Ripoli,* Florence, 1903. On Florentine account books see, for instance, Dard Hunter, *The Literature of Papermaking 1390–1800,* Ohio, 1925, 12, Giuseppe Sergio Martini, "La Bottega di un cartolaio fiorentino . . ." *Bibliofilia,* LVIII (1956), especially 45–77; and Kemp 1997, 32–78. A further study of such records is being prepared by Paul Gehl.

26. Documents transcribed in Frey 1909, 129, 133, 134 (nos. 161, 164, 193, 198, 219); Beltrami 1919, 84, 100 (nos. 137, 165); and Isermeyer 1963, 114–15, 118, 122 (nos. III, VI–VII, XI). See also Chapter Eight. The complex problems presented by these documents are explained, in light of new research on the paper trade in Florence and Bologna, in Bambach 1999 b.

27. Gasparinetti 1956, 45–47, and Bambach 1999 b.

28. Cf. Gasparinetti 1956, 45–47; Bambach 1999 b; and further, Chapter Eight.

29. Bambach 1999 b.

30. See Finaldi, Harding, and Wallis 1995, on the chemical treatment of the paper in the cartoons by Agostino Carracci at the National Gallery, London. The overall brown discoloration of the paper was chemically reversed to recuperate the original blue hue.

31. On metalpoint drawing techniques, see Bambach 1997 b, especially 23–25. For recipes of ground preparation for parchment and paper, see Cennini 1995, cap. xvii–xxii, 19–24 (cf. Cennini 1960, 9–12, for trans.).

32. Examples are Leonardo's *Virgin and Child with Sts. Anne and John the Baptist* (Plate V) and Raphael's *"La Belle Jardinière"* (Figure 58). On Leonardo's cartoon, see further Harding, Braham, Wyld, and Burnstock 1989, 4–27. My observations on Raphael's cartoon are based on the unpublished conservation report by Shelley Fletcher (Chief Paper Conservator of the National Gallery of Art,

Washington), from 1 September 1986. Similarly, the *Isabella d'Este* by Leonardo (Plate IV) is prepared with a delicate layer of lead white, evident with the plain eye; my thanks to Catherine Monbeig Goguel for offering the opportunity to examine this cartoon out of its glass in the paper conservation laboratory of the Musée du Louvre, Paris (July 1991).

33. This "browning" of originally blue paper is typically found in cartoons by Federico Barocci, the Carracci, and Domenichino. The original blue hue of the paper can be recuperated with chemical treatment (Finaldi, Harding, and Wallace 1995).

34. For Leonardo, see passage in Paris MS. A, fol. 104 recto, transcribed in Richter, I, 321, § 531 (cf. Richter, *Commentary,* I, 335), and *Codex Urbinas Latinus* facsimile in McMahon 1956, II, fols. 38 recto and verso (McMahon 1956, I, no. 83). See also Nunes 1615, fols. 70 verso–72 recto; Carducho 1979, 385–86; Palomino 1947, 518–19; and Saint-Aubin 1770, 5 (cf. Saint-Aubin 1983, 20, for trans.).

35. Although of extremely low-quality execution, examples include an unpublished small-scale pen and dark brown ink, pricked tracing on brown oiled paper, 232 × 142 mm., which was based on a copy of a copy of Leonardo's *Virgin of the Rocks* composition (Département des Arts Graphiques inv. 2342, Musée du Louvre, Paris), as well as a group of 100 French eighteenth-century pricked embroidery patterns (Cooper-Hewitt Museum nos. 1931-93-77 through 1931-93-176, New York), discussed in Bambach Cappel 1988, Part 1, I:249–50. Regarding Lorenzo Lotto's design of cartoons for the wood *intarsie* in the choir of S. Maria Maggiore, Bergamo, references to large quantities of *"papér sutil"* (tracing paper), together with mentions of various other kinds of paper *("papér gros," "papér da stamegnia," "papér cancelerescho," "papér reame")* turn up in the accounts of March–April 1525, December 1525–April 1526, and November 1526–January 1527. Cf. Cortesi Bosco 1987, II, 89, 90, 92. Lorenzo Lotto's letter of 7 February 1526 (ibid., II, 8), requesting a *"lucido"* from Giovanni Francesco Capoferri da Lovere, the master wood craftsman, tends to confirm that tracings on translucent paper were being routinely used in this project to generate and duplicate the designs of the cartoons. Neither Lotto's cartoons nor the tracings of them survive.

36. Cennini 1995, cap. xxiii–xxvi, 24–26 (cf. Cennini 1960), 13–14, for trans. Recipes for making tracing paper or parchment are fairly common in Late Medieval treatises; see the fifteenth-century *Straßburg Manuscript* (Straßburg Staatsbibliothek MS. A.VI. 19; translated from the old German by V. and R. Borradaile, . . . *A Medieval Painter's Handbook,* London, 1968, 62–65) and Jehan Alcherius, *De Diversis coloribus in sequenti tractatu . . .* (1398–1411), included in Jehan Le Begue's fifteenth-century recipes (Merrifield 1849, I, 292–95).

37. Borghini 1584, 144–46.

38. On the bad reputation of tracing techniques, see further, Chapter Four.

39. On this aspect of the term *"cartone,"* see Tsuji 1983, 156, and Bambach Cappel 1988, Part 1, I:11–30. Leonardo gave

a recipe for making stiff paper, cardboard, which he called *"cartone"* (Paris MS. F, fol. 56 recto; Richter, I, 360 § 617, cf. Richter, *Commentary,* I, 361–62) but did not state a purpose for this thick paper. Although this fact introduces an element of complexity into the problem, it should be apparent from the fact that many early sources speak of paper yielding to the stylus, when the full-scale drawing was transferred to the *intonaco,* that such *cartoni* were made of relatively thin paper.

40. See Baldinucci 1681, 30 (under *"Cartoni"*); Accademia della Crusca, *Vocabolario degli Accademici della Crusca,* Venice, 1680, 160; and Palomino 1947, 1147.

41. Bambach Cappel 1988, Part 1, I:18–30. Vasari also used the term *"cartonetti"* (to indicate presumably a "cartoon" of small size, in a letter to Cosimo de' Medici on 22 May 1564. See transcription in Frey 1923–30, II, 82, no. CDXLIX: "Che delle cose dell arte non a auto altro che duo cartonetti, dj uno braccio luno, djsegnati, sendo vechio, assai ragioneuolmente, e quali serba per V.E. I., dolendogli non auere altro, poi che lui stesso in duo volte abruscio ogni cosa. . . ." Cf. also Wilde 1959, 370–77.

42. Vasari 1966–87, I (testo), 121 (cf. Vasari 1960, 215, for trans.).

43. I am indebted to Eric Harding for informative discussions regarding the restoration of this cartoon, on which see further Harding, Braham, Wyld, and Burnstock 1989, 4–27. There, figs. 13, 14, plates 2, 3 show details of the area of impact before, during, and after restoration, whereas fig. 9 reproduces in actual size a betaradiograph of a small paper sample obtained from the corner of the Virgin's mantle, close to the center of the cartoon's left border. The laid lines of the paper are visible as a series of closely spaced diagonals coursing vertically at a slight angle from lower left to upper right, whereas the chain lines (which are perpendicular to the laid lines) run more or less horizontally and are widely spaced. On betaradiography techniques, see *Les Relevés de filigranes* 1996, 25–42.

44. On methods of documenting watermarks, cf. Jane Roberts, *A Dictionary of Michelangelo's Watermarks,* Milan, 1988; Elen 1995, 35–36, 144 (and note 68); Monbeig Goguel 1996, 227–33; and *Les Relevés de filigranes* 1996. For preliminary observations on watermarks in cartoons, cf. Bambach Cappel 1992 a, 9–30; Finaldi, Harding, and Wallis 1995; and Chantilly 1997, 78–80, 161–67.

45. This watermark has gone unrecorded in the literature. Cf. Briquet, I, 52, no. 746, *"arbalete."*

46. See documents in Ettlinger 1978, 142–45, 160, nos. 12 and 31.

47. Briquet, I, 52, no. 746, is in type closest to that found in a *"consiglio generale"* of public reforms written between 1469 and 1473 in Lucca, a minor Tuscan center for paper manufacture from the 1420s onward. It also resembles watermarks found in documents in Bologna (c. 1472), Venice (c. 1472–75), Naples (c. 1475), Rome (1469–92), and Florence (1501–3).

48. I am indebted to Peter Day for the photograph of this watermark. It is 66 mm. high and of more regular form than Briquet, I, 180, no. 2375, *"balance,"* appearing in documents from 1400 to 1414 (Siena, Draguignan, Ghistelles, Ghent, Delft, and Perpignan). On the use of transmitted light to record watermarks, see Monbeig Goguel 1996, 227–33; and *Les Relevés de filigranes* 1996, 18–24.

49. See further, Chapters Six and Eight. For the evidence of Ghirlandaio's use of "substitute cartoons," see Bambach Cappel 1996 a, 85–86. Watermarks continue to be found in other pricked cartoons, as more cartoons are detached from the mounts onto which they were frequently glued. See Bambach Cappel 1992 a, 9–30; Finaldi, Harding, and Wallis 1995; and Chantilly 1997, 161–67.

50. A continued search for the Chatsworth watermark will probably reinforce the 1485–90 date of the drawing. Briquet's example has hitherto been documented earliest in a non-cartoon paper from Siena in 1400 and latest from Holland in 1414. The usual lifespan of a watermark is now agreed to be about fifteen years before and after the identified example.

51. The sheet in the center has dimensions closest to a *foglio reale,* 422 × 455 mm.

52. The watermark, which is only on one of the sheets of Lorenzo's cartoon, resembles most that in Lombard documents from about 1473 to 1475 in Briquet, II, 366–67, nos. 6372–73, *"fleur."*

53. Briquet, II, no. 5918. I am indebted to Margaret M. Grasselli, Shelley Fletcher, Ann Eggert, and the Department of Paintings Conservation at the National Gallery of Art, Washington, for facilitating this research (1995–96). Curiously, the watermarks came to light during the reflectography examination of the cartoon with the Platinum Silicide Infrared camera; the images picked up with the Vidicon camera were considerably less precise.

54. Although a thorough investigation of watermarks in Raphael's drawings is yet to be done, it is worthy of some note, that the same watermark type recurs in a *modello* drawing for *St. George and the Dragon* (National Gallery of Art, Washington) and the Uffizi *modello* for the main figural group in the Borghese *Entombment* (Fig. 198), both also key projects from Raphael's Florentine period (c. 1504–1508). The watermark on the Washington *modello* was brought to my attention by Shelley Fletcher.

55. The watermarks on Fra Bartolomeo's cartoon are extremely close to Briquet, II, 309, no. 5202, a type that appears in documents from Pistoia (1441), Bologna (1450), and Lucca (1451–52).

56. Compare discussions in Mather 1948, 20–65; A. Chiappelli, "Case e botteghe di antichi artefici di Firenze," *Arte del Rinascimento,* Rome, 1925; Thomas 1975, 19–81; Alessandro Guidotti, "Botteghe e produzione artistica nella Firenze del Tre e del Quattrocento," *Lorenzo Ghiberti. Materia e Ragionamenti,* Florence, 1978, 267–68; Nikias Speliakos Clark, *Artists' Homes in Sixteenth-Century Italy* (Ph.D. dissertation, Johns Hopkins University), Baltimore, 1980; Wackernagel 1981, 308–10; Carl 1987, 373–91; Padoa Rizzo 1989; Annamaria Bernacchioni, "Documenti e precisazioni sull'attività tarda di Domenico di Michelino: La sua bottega di Via delle Terme," *Antichità Viva,* XXIX

(1990), 5–14; Cecilia Frosinini, "Gli Esordi del Maestro di Signa: Dalla Bottega di Bicci di Lorenzo alle prime opere autonome," *Antichità Viva,* XXIX (1990), 21; Anna Padoa Rizzo, "L'Ultima bottega di Cosimo Rosselli," *Bollettino dell'Accademia degli Euteleti di San Miniato,* LVIII (1991), 31–39; *Giotto to Dürer* 1991, 140–41, 395–96; Bernacchioni 1992, 23–34; Annamaria Bernacchioni, "Botteghe di artisti e artigiani nel XV secolo," *Gli Antichi chiassi fra Ponte Vecchio e Santa Trinita,* ed. by G. Trotta, Florence, 1992, 209–13; Anna Padoa Rizzo, Nicoletta Pons, and Lisa Venturini in Palazzo Strozzi 1992, 53–59, 93–124; Anabel Thomas, "Neri di Bicci, Francesco Botticini and the Augustinians," *AC,* no. 754 (1993), 26; Thomas 1995, 45–62; and Shell 1995.

57. See documents transcribed in Frey 1909, 129–30 (nos. 158, 161, 164–65, 167, 170); Beltrami 1919, 81–82, 84–85 (nos. 130, 132, 134, 136–37); Isermeyer 1963, 112–15 (nos. I–III); and Bambach 1999 b.

58. See document transcribed in Beltrami 1919, 81 (no. 130); neither in Frey 1909 nor Isermeyer 1963. A record of payment on 28 February 1504, the same date as Leonardo's first purchase of paper, states that the ceiling of this apartment was being mended and that an exit was being built connecting Leonardo's room with the *Sala* housing the cartoon. See Frey 1909, 130 (no. 167); Beltrami 1919, 84–85 (no. 137); and Bambach 1999 b.

59. Acidini Luchinat and Dalla Negra 1995, 81, and Acidini Luchinat and Danti 1992, 132–39.

60. On S. Onofrio, see Paatz, III, 459–62. On the dates for the commission of the *Cascina* cartoon, see Morozzi 1988–89, 320–24; and Hirst 1991, 762. Throughout the period of work on the *Cascina* cartoon, Michelangelo may have resided in the paternal family house on Via Ghibellina, not far from S. Onofrio.

61. Armenini 1587, 100–101 (cf. Bisagno 1642, 81–88, and Armenini 1977, 172, for trans.): ". . . prima si misura l'altezza, & larghezza di quel luogo, dove si ha da far l'opera. . . ."

62. Cennini 1995, cap. clxxi, 181–82 (cf. Cennini 1960, 111, for trans.).

63. According to the Bolognese marble slab, the legal dimensions for the *foglio imperiale* can actually range from 498 × 726 mm. to 510 × 741 mm. See Appendix One.

64. The documents are collected in Frey 1909, 129–34 (nos. 161–219), and cf. Beltrami 1919, 81–129 (nos. 130–204), for Leonardo material. As Christian Adolf Isermeyer rightly pointed out, Frey's anthology contains transcription errors (see Isermeyer 1963, 83–130). These documents are discussed in greater detail in Bambach 1999 b.

65. In Leonardo's case, there is a record of payment on 30 April 1505 to Lorenzo Peri for 3 "quaderni dj fogli Bolognesi reali." In Michelangelo's case, the record of payment on 31 October 1504 to Bartholomeo di Sandro cites 14 "quadronj di foglij reali Bolognese." See Frey 1909, 133, 134 (nos. 193, 219).

66. See transcriptions of Baldovinetti document in Kennedy 1938, 246, and Vasari document in Guasti 1857, 146.

67. Document is transcribed in *Beccafumi e il suo tempo* 1990, 686.

68. Uffizi inv. 6508 F verso, Florence. Data: 270 × 141 mm. maximum sheet. Cf. Janet Cox-Rearick, *The Drawings of Pontormo . . . ,* Cambridge, 1964, I, 342–43, no. 380 (and note 40), with bibliography. Regarding the work by Capoferri on the wood *intarsie* at S. Maria Maggiore in Bergamo, the records of payment for paper purchases in the *"Liber Fabrice Chori"* are transcribed in Cortesi Bosco 1987, II, 84–92.

69. Harding, Braham, Wyld, and Burnstock 1989, 9, fig. 7.

70. See document transcribed in Frey 1909, 129 (no. 161), and Beltrami 1919, 84 (no. 137). In this sense *quadratura* does not mean a grid of squares, as Christian Adolf Isermeyer already correctly deduced; cf. Isermeyer 1963, 114–15 (no. III).

71. Vasari 1966–87, I (testo), 119 (cf. Vasari 1966, 213, for trans.); Armenini 1587, 101 (cf. Armenini 1977, 172, for trans.); Borghini 1584, 140–41; Bisagno 1642, 81–88; and Baldinucci 1681, 30 (under *Cartoni*). See also definition of *Squadrare,* ibid., 156.

72. This is true, for instance, of the joins of the paper in Leonardo's National Gallery cartoon (Plate V), Raphael's pricked cartoon for *"La Belle Jardinière"* (Fig. 58), and Michelangelo's pricked cartoon for the *Crucifixion of St. Peter* (Fig. 3).

73. I am indebted to Sheila O'Connell and Nicholas Turner for their help regarding my examination of this cartoon (summer 1989). For a proposal regarding the transfer of Michelangelo's cartoon onto the panel, see Bambach Cappel 1990 a, 493–98, and Bambach Cappel 1996 a, 90–91 (notes 69–73).

74. With time the paper often tore along the spine of such creases. It is important to distinguish between an original join of paper and one caused by the restoration of such a tear, resulting from wear.

75. Rossana Muzii offered me repeated opportunities to examine the Naples cartoon. See Bambach Cappel 1987, 131–42; Muzii 1988; Muzii 1993; and Bambach Cappel 1996 a, 83–102. Until a view of the verso was possible, I, like others, had misjudged, on the recto, the vertical creases through the center of the sheets which appeared to be edges. The same error has often been repeated in the actual count of paper for other large cartoons.

76. Definitive conclusions regarding this physical evidence, however, cannot be given because of the fragile condition of Poccetti's cartoon fragments. They are seriously damaged and restored. The presence of numerous creases, tears, and stains, as well as cockling and buckling of the original paper, much of it resulting from the fact that the cartoon fragments were glued onto a secondary paper support as well as a medium-weave canvas, obscure structural joins and *quaderni* creases. My diagrams are therefore only approximate.

77. See document transcribed in Frey 1909, 129 (no. 161), and Beltrami 1919, 84 (no. 137).

78. The total sum actually paid to the *cartolaio* was 26 lire 10 soldi; see note 70, and cf. Isermeyer 1963, 114–15 (no. III). My figures are different from Isermeyer's, as he calculated prices at 12 soldi 11 denari, rather than as actually stated in

the document: "A Giouandomenico di Filippo cartolaio y 26 sol. 10 per una lisima et quadernj 18 di fogli reali a sol. 12 et sol. 11 el quaderno . . . et per quadratura et apianatura di decti fogli. . . ." Isermeyer thought "sol. 11" was a transcription error for "den. 11" (a point to be discussed further in Chapter Eight). Cf. Bambach 1999 b.

79. See Frey 1909, 133 (nos. 193, 194, and 198).

80. See ibid., 133 (no. 194), and Isermeyer 1963, 118 (no.VI).

81. See Frey 1909, 133 (no. 202), and Isermeyer 1963, 119 (no. VIII).

82. For wages in the Florentine construction industry, see further Goldthwaite 1980, 317–42. Tables of average daily wages of unskilled and skilled workers are given in ibid., Appendix 3, 435–39, which I here cite. In 1502, the average daily wage of an unskilled laborer was 9.0 soldi; from 1503 to 1505, it was 8.7 soldi. In 1502, the average daily wage of a skilled laborer was 14.2 soldi; in 1503, it was 14.3 soldi. No further, representative data exists for skilled labor until the year 1516, when the average was 17.3 soldi.

83. See Frey 1909, 134 (nos. 212, 213), and Beltrami 1919, 99 (no. 165), which is less accurate.

84. See Frey 1909, 134–35 (nos. 220, 222, 223, 230, 237), and Beltrami 1919, 99–100 (no. 165).

85. See Frey 1909, 134–35 (nos. 220, 222, 223, 230). Here, Beltrami 1919 is not reliable.

86. This wage rate is mentioned in Frey 1909, 134 (no. 222), not in Beltrami 1919. The earlier daily wage rate given in Frey 1909, 134 (no. 220); Beltrami 1919, 100 (no. 165) as 2 soldi, is a mistake.

87. See Frey 1909, 135 (no. 230), and Beltrami 1919, 100 (no. 165). Another "color grinder," Lorenzo del Faina, is mentioned along with Tommaso di Giovanni on 31 December 1505, although a specific reference to Leonardo's mural is not given. See Frey 1909, 135 (no. 237).

88. Vasari 1966–87, I (testo), 119 (cf. Vasari 1960, 213, for trans.); Borghini 1584, 140; Armenini 1587, 101 (cf. Armenini 1977, 172, for trans.); and Bisagno 1642, 81–88. Vasari's document for Florence Cathedral dome frescos, ". . . et farine per far paste," is transcribed in Guasti 1857, 146.

89. Cennini 1995, cap. cv, 111; cap. clxxi, 181–82 (cf. Cennini 1960, 65, 111, for trans.).

90. See document in Frey 1909, 132, no. 177; Beltrami 1919, 91, no. 145; and Isermeyer 1963, 118 (no.V).

91. See Frey 1909, 129, no. 165, and Beltrami 1919, 85, no. 137. The precise configuration of this lining is unclear, for no treatises refer to cloth linings. However, many extant Renaissance and Baroque cartoons have them, and perhaps old restorers borrowed the practice of lining cartoons with cloth from the actual working procedures of artists.

92. Vasari 1966–87, I (testo), 119 (cf. Vasari 1960, 213, for trans.): "e si tirano al muro con l'incollarli a torno duo dita verso il muro con la medesima pasta, . . ." See Armenini 1587, 101 (cf. Armenini 1977, 172, for trans.).

93. Palomino 1947, 545.

94. Vasari 1966, I (testo), 119 (cf. Vasari 1960, 213, for trans.): "e si bagnano spruzzandovi dentro per tutto acqua fresca, e così molli si tirano acciò nel seccarsi vengano a distendere il molle delle grinze. . . ." The statement may be at the root of the misconception sometimes found in the secondary literature that cartoons were wetted to facilitate transfer. The wetting of cartoons occured *before* they were drawn, although, undoubtedly, at the time of transfer the paper support of cartoons softened when it came into contact with the moist *intonaco*. Cf., for instance, description of cartoon in Armenini 1587, 101 (cf. Armenini 1977, 172, for trans.), as well as Borghini 1584, 140 (both discussed below); also Baldinucci (1809), II, 114–15; Pozzo 1693–1700, II, *"Breve instruttione per dipingere a fresco,"* unpag. ("Settione Quinta *Disegnare,"* "Settione Sesta *Graticolare,"* "Settione Settima *Ricalcare"*), and Milizia 1827, II, 231.

95. Borghini 1584, 140, and Armenini 1587, 101 (cf. Armenini 1977, 172, for trans.).

96. An example of this practice of wetting to blend smoothly the joins is found in Federico Barocci's *Madonna and Child on Clouds* (Uffizi inv. 1786 E, Florence). Data: 1217 × 893 mm.; charcoal, with laboriously pricked outlines, on nine thin *fogli reali,* exhibiting deckled borders and overlapping joins 12–16, 22–26 mm. wide. This cartoon is skillfully constructed – the sheets of paper are glued in a vertical orientation, in rows of three each, with *"quaderni"* creases aligning horizontally. Many Seicento cartoons exhibit a construction of sheets with similarly deckled borders that appear to have been wetted to achieve a uniformity of drawing surface; cf. Bambach 1998.

97. See transcription in Richter I, 324, § 537 (cf. Richter, *Commentary,* I, 335): "Del modo di ritrare figure per istorie . . ."; and *Codex Urbinas Latinus* facsimile in McMahon 1956, II, fols. 134 recto-verso (McMahon 1956, I, no. 500).

98. Royal Library inv. 12339, Windsor. On the drawing, without the present observations, cf. Giovanna Nepi Sciré in *Leonardo & Venezia* 1992, 270, no. 33; Popham 1994, 143, no. 201; and Clayton 1996, 68–75, no. 35.

99. Vasari 1966–87, IV (testo), 32–33.

100. See documents transcribed in Frey 1909, 129–32 (nos. 166–67, 169, 172), and Beltrami 1919, 85 (no. 137), with an incomplete listing. Regarding the record of payment on 30 August 1504 (Frey 1909, 132, no. 181; Beltrami 1919, 92, no. 146), it is not entirely clear whether the scaffolding that is referred to is still that in the *Sala del Papa* or that being begun in the Council Hall of Palazzo Vecchio (I suspect the latter is intended). After this date, the payments refer more clearly to the scaffolding in the Council Hall. The problem of Leonardo's scaffoldings will be discussed further in a book-length study on the *Battle of Anghiari* and *Battle of Cascina* cartoons.

101. My translation above of the complex, original text is relatively free in order to render its sense. See Danti 1583, 87: ". . . Auuertiscasi in oltre, che nel fare li cartoni per le facciate di simili sale è commodissima cosa il fargli in terra nel pauimento, per non hauere à salire sopra i ponti, & potere con i fili tirare tutte le linee che ci bisognono, come l'esperienza piu volte m'ha mostrato: & simile diciamo nel fare i cartoni delle volte, & delle soffite ancora."

102. Palomino 1947, 545.

103. See discussion and transcriptions of documents in Testi

1922, 142–58, 277–80 (nos. xix, xx), and Ferrari and Belluzzi 1992, II, 1002. Cf. Popham 1957, 8.

104. See document in Testi 1922, 268–69 (no. vii), as well as letters by Giulio, Parmigianino, Anselmi, and the *ufficiali* of the Steccata, dating from 15 March to 11 June 1540, as transcribed in Ferrari and Belluzzi 1992, II, 835–47. Cf. Hartt 1958, I, 247–50.

105. See Vasari 1962, I (testo), 51, and Bambach Cappel 1996 a, 96–97.

106. See further diagrams of archaeological evidence in *Michelangelo: La Cappella Sistina, Rapporto.* A similar technical difficulty characterizes the pounced figure of the *Prophet Jonah,* whose illusionism also astonished Michelangelo's contemporaries. By contrast, in numerous other less illusionistic parts of the Sistine Ceiling, Michelangelo would take great liberties in painting, often ignoring cartoon-transferred outlines.

107. Note especially Vasari 1966–87, I (testo), 119 (cf. Vasari 1960, 213, for trans.), but also Armenini 1587, 99–104 (cf. Armenini 1977, 170–74, for trans.). See also Pozzo 1693–1700, *"Breve instruttione per dipingere a fresco,"* unpag.: ". . . un altro disegno in carta quanto grande è l'opera [cartone], acciò si possa attaccare al luogo per veder da lontano gli errori, se ve ne fossero, per corregerli."

108. Vasari 1966, I (testo), 119 (Vasari 1960, 213, for trans.): "una canna lunga che abbia in cima un carbone . . ." Cf. Borghini 1584, 140. Regarding the method of underdrawing for panel paintings, note Cennini 1995, cap. cxxii, 126 (cf. Cennini 1960, 75, for trans.): "Ma vuolsi legare il carbone a una cannuccia o ver bacchetta, acciò che stia di lungi dalla figura."

109. See Chapter One, section on the Renaissance meaning of "pouncing." Armenini 1587, 102–3 (cf. Armenini 1977, 173): "Per abbreviar la fattica nelli ombre voglio si dia da quella banda per dove te vanno con un spolvero che sia pieno o di carbon pesto, o ver di polvere di Lapis nero, col quale si vien battendo leggiermente è sù quello si batte, e spolvera quel luogo per dove le ombre vi vanno piu scure, et cio sia fatto in modo che vi rimanga sotto un letto tale, che si vegga piu che mezzo appare ombregiato, et indi su quelle ombre poi si vadia leggiermente trattegiando, o con punte di Carboni o sia de Lapis nero. . . ." See further Bambach Cappel 1988, Part 1, I:16, 139–40.

110. Here, see discussion in Bambach 1997 a, 69–70.

111. For Andrea Verrocchio's *Head of an Angel* (Uffizi inv. 130 E, Florence), cf. Petrioli Tofani 1986, 57, *sub numero;* Lucia Monaci Moran in Uffizi 1992, 174, no. 8.3; and Butterfield 1997, 185.

112. For Leonardo's grotesque man's head (Christ Church inv. 0033, Oxford), cf. Byam Shaw 1976, 38, no. 19; Kemp and Roberts 1989, 91, no. 34; and Popham 1995, 134, no. 146. See Vasari 1966–87, IV (testo), 24: " . . . e parimenti quella di *Scaramuccia capitano de' Zingani."*

113. For Raphael's *God the Father* fragment (Louvre inv. 3868, Paris), cf. Catherine Monbeig Goguel in Grand Palais 1983, 246–47, no. 73; Louvre 1992, 123, no. 136; and Bambach Cappel 1992 a 19–24, 26, 28–29. For his *putto* frag-

ment (British Museum inv. Pp. 1–76, Paris), cf. Pouncey and Gere 1962, 25, no. 28, as well as Gere and Turner 1983, 138, no. 111.

114. The *Portrait of Pope Leo X* is Devonshire Collection inv. 38, Chatsworth. Data: 337 × 268 mm. (irregularly cut); mounted on another sheet, 480 × 299 mm.; charcoal, highlighted with white chalk. Cf. Fischel 1934–35, 484–86; Hartt 1958, 51; Shearman 1972, 61; Oberhuber 1972, 199–200, no. 482; Gere and Turner 1983, 226–29, no. 183; Sylvia Ferino Pagden in Mantua 1989, 258; and Jaffé 1994, II, 86, no. 202. The *Head of a Bearded Man* is Louvre inv. 3570, Paris. Data: 304 × 334 mm.; charcoal, highlighted with white chalk, on four glued sheets of blue paper; sheets with deckled edges and about 17 mm. overlapping joins. The connection of this head to the apostle in Francesco Torbido's dome frescos in Verona Cathedral is, in my opinion, not convincing. Cf. Hartt 1958, no. 247.

115. Here, see especially Raphael's *School of Athens* (Figs. 39–40, 228), from 1510 to 1512, and Giulio's *Stoning of St. Stephen* (Figs. 230–31), from 1519 to 1521.

116. Armenini 1587, 101–2 (cf. Armenini 1977, 172–73, for trans.): ". . . & indi sopra di esso vi si misura, & se li batte la grata sottilmente col numero de' quadri, che prima egli havea fatto sopra il dissegno picciolo, che vorrà imitar, & qui vi si comincia a riportar con molta avertenza, & destrezza tutto ciò che in quel loro dissegno si vede essere."

117. For Perugino's *Head of St. Joseph of Arimathea* (Christ Church inv. 0122, Oxford), cf. Byam Shaw 1976, 34, no. 8, as well as Ames-Lewis and Wright 1983, 298, no. 68.

118. See transcription of Leonardo's note in Richter, I, 317–18, § 523 (cf. Richter, *Commentary,* I, 333).

119. On the three cartoons by Fra Bartolomeo discussed above (*St. Mary Magdalen, St. Catherine of Siena,* and *St. Peter;* Uffizi inv. 1777 E, 1778 E, and 1782 E, Florence), cf. Petrioli Tofani 1987, 730–33, *sub numero.*

120. For Poccetti's cartoons (Uffizi inv. 1788 E and 1789 E, Florence), cf. ibid., 736–37, *sub numero.* For examples of cord snapping on murals, see Figures 136, 137, 172, 288, as well as Zanardi and Frugoni 1996, 26, figs. 5–8, and Borsook 1980, xl, fig. 20.

121. Armenini 1587, 101–2 (cf. Armenini 1977, 172–73, for trans.): "Ma perche ci sono di quelli, che dicono esser male l'usar questa grata, & cosi allegano friuole ragioni, con dir che essi perdono assai di quel loro dissegno il qual si possiede del far grande col giudicio solo. . . ."

122. Vasari 1966–87, I (testo), 119 (cf. Vasari 1960, 213–14, for trans.).

123. Chapter Four will explore this topic further, as Renaissance and Baroque treatise writers often ranked methods of design transfer qualitatively.

124. On the drawing media used for monumental cartoons, see Vasari 1966–87, I (testo), 119, as well as Borghini 1584, 144–46, and Armenini 1587, 101–3 (cf. Armenini 1977, 172–73, for trans.). Cf. also Watrous 1957, 91–146, as well as Meder and Ames 1978, I, 80–89, 159, with an illustration of a nineteenth-century steaming kettle to apply fixatives.

125. Cf. Cennini 1995, cap. xxxiii–xxxiv, 32–34 (cf. Cennini

1960, 19–20, for trans.); Gian Paolo Lomazzo's *Trattato dell'arte della pittura* (1584), cap. iv (Lomazzo 1973–74, II, 169); and Dionysius of Fourna 1974, 5.

126. See document transcribed in Guasti 1857, 146. On the memorandum for Vasari's frescos in the dome of Florence Cathedral, see Chapter One, note 9. The payment documents for the frescos from the 1490s by the Ghirlandaio workshop in Pisa Cathedral frequently refer to willow-wood charcoal, which may well have been intended for the cartoons, although this is not explicitly stated; cf. Cadogan 1996, 92. I am indebted to Everett Fahy, Lisa Venturini, and Virginia Budny for sharing with me partial transcriptions of these documents.

127. Cf. Armenini 1587, 99–104 (especially 103; cf. Armenini 1977, 171–74), and Borghini 1584, 140–41. Vasari's budget for the dome frescos in Forence Cathedral is transcribed in Guasti 1857, 146.

128. On the history of chalk drawing in Early Renaissance Italy, see further Ames-Lewis 1981 a, 53–59, and Van Cleave 1994, 231–43.

129. Ecole des Beaux-Arts inv. 109, Paris. Data: 214 × 273 mm.; charcoal and white chalk, two vertical parallel lines in red chalk (51 mm. apart), on two glued sheets of light brown paper, with 21 mm. join overlaps. Cf. Popham 1952, 6–10.

130. Uffizi inv. 7697 Santarelli verso, Florence. Revised data: 570 × 415 mm.; (verso) charcoal, traces of white chalk highlights; partly pricked. The attribution of this cartoon to Michelangelo Anselmi is due to Philip Pouncey. Cf. Anna Forlani Tempesti in *Disegni italiani della Collezione Santarelli: Sec. XV–XVIII* (exh. cat., Gabinetto Disegni e Stampe degli Uffizi), Florence, 1967, 48–49, no. 35, and Julien Stock and David Scrase, *Philip Pouncey: The Achievement of a Connoisseur; Italian Old Master Drawings* (exh. cat., Fitzwilliam Museum Cambridge), London, 1985, no. 4. The types for the young female saint on the left and the kneeling monastic saint in the center (Fig. 48) are identical to those of *Sts. Flavia and Placidus*, frescoed on the apse of the left transept at S. Giovanni Evangelista (dated 1521; Parma), which establishes the cartoon's date in the early 1520s. On Anselmi's early work at S. Giovanni Evangelista, as well as on his interactions with Correggio and Parmigianino at this point, cf. Popham 1957, 108–10, and Augusta Ghidiglia Quintavalle, *Michelangelo Anselmi*, 2nd ed. Parma, 1960, 22–25, 76–77.

131. Uffizi inv. 1784 E, Florence. Data: 1063 × 1300 mm.; charcoal and black chalk, highlighted with white chalk, on multiple glued sheets of light brown paper. Cf. Petrioli Tofani 1987, 733–34, *sub numero,* and Emiliani 1995, II, 217–29. See also Federico Barocci's *Christ Taking Leave from His Mother* (Fig. 232), preparatory for a panel left unfinished at the artist's death in 1612 (Fig. 233). Uffizi inv. 1785 E. Data: 1866 × 1615 mm.; charcoal and black chalk, white chalk, traces of red chalk on twenty glued sheets of light brown paper. Cf. Petrioli Tofani 1987, 734, *sub numero,* and Emiliani 1995, II, 413–19.

132. Examples of such oil sketches are Metropolitan Museum of Art nos. 1976.87.1 and 1976.87.2, New York (Bean 1982, 32–34, nos. 20, 21). On Barocci's working proce-

dures, cf. Pillsbury and Richards 1975; Bauer 1978, 45–57; Bauer 1986, 355–57; and Emiliani 1995.

133. The Art Institute of Chicago no. 1922.5406. Data: 294 × 239 mm.; charcoal and black chalk, highlighted with white, on tan paper. Cf. McCullagh and Giles 1997, 15–17, no. 15, and Emiliani 1995, I, 61–69.

134. Metropolitan Museum of Art 1995.306, New York. Data: 718 × 408 mm.; brush with gray and brown washes, over charcoal, originally on three glued sheets of paper. Here, just as a point of reference for the Seicento technique, we may cite two monumental stylus-incised cartoon fragments, attributed to Carlo Cignani, that are virtually monochromatic paintings in wash and *gouache* over charcoal, preparatory for frescos dating from the 1670s and from 1685 to 1700 (Metropolitan Museum of Art 66.14, New York, and Uffizi inv. 1773 E, Florence). See Bambach 1998, on this and other such painterly cartoons by Carlo Cignani and Marcantonio Franceschini.

135. See ink recipes in Theophilus 1986, 34–35, and Dionysius of Fourna 1974, 11. Surprisingly, none is given in Cennino's *Libro dell'arte*. On fine point drawing media, cf. Watrous 1957, 3–88; Meder and Ames 1978, I, 30–75; and Bambach 1997 b, 21–28.

136. See Figures 14, 17, 56, 224–26, 249, 258, and 267.

137. Cennini 1995, cap. xv–xxii, xxxi–xxxii, 15–24, 30–32 (cf. Cennini 1960, 9–12, 17–19, for trans.).

138. Giovanni Antonio Sogliani's life study of an apostle (CBC 299; Institut Neerlandais, Byam Shaw 23 recto, Paris), is among the exceptions. In the context of exploratory drawing, draughtsmen generally used design transfer techniques to synthesize the various aspects of a composition from drawing to drawing, and here precision of outline was better served by the traditional media of small-scale drawing. The very few extant pricked and pounced drawings in red chalk are negligible in a corpus of well over 400 drawings (see Bambach Cappel 1988, Part II). These are, moreover, nearly all intermediate compositional drafts: Raphael's *Massacre of the Innocents* on *spolvero* marks (Fig. 260; Royal Library inv. 12737, Windsor; CBC 258); Girolamo Genga's two sheets for the Cesena Altarpiece, one with pricked outlines (Fig. 262; British Museum 1866-4-14-7; CBC 109) and the other with *spolvero* (Fig. 263; Louvre inv. 3117, Paris; CBC 110); Perino del Vaga's *Adoration of the Christ Child* (Albertina inv. 522, S. R. 618, Vienna; CBC 322); and Andrea del Sarto's *Adoration of the Magi* (Louvre inv. 1688, Paris; CBC 284). On some of these drawings, see further, Chapter Nine. On the development of red chalk as a medium, cf. Piera Giovanna Tordello, "La matita rossa nella pratica del disegno: Considerazioni sulle sperimentazioni preliminari del medium attraverso le fonti antichi," in Regni and Tordello 1996, 187–207.

139. Staedelsches Kunstinstitut inv. 455, Frankfurt. Data: 402 × 243 mm.; red chalk over stylus underdrawing. Cf. Malke 1980, 142, no. 69. The Frankfurt cartoon closely corresponds in design to a painting by Rimpatta (whereabouts unknown), illustrated in Andreina Ugolini, "Per Antonio Rimpatta," *Paragone,* nos. 47–48 (1994), 11–25, plate 29, where the cartoon went unnoticed.

140. On Luca Signorelli's pricked cartoon of a standing male saint (Louvre inv. 1796, Paris), see Chapter Nine, note 30.

141. On some of the linguistic complexities, however, see Bambach Cappel 1988, Part 1, I:52–53 (and note 122).

142. Paganino c. 1532, *Proemio, "Alessandro Paganino al Letore,"* unpag., fols. 3 recto and verso: "piglia uno ago sottile e va forendo tutto lorlo del disegno, facendo che il buco sia poco distante luno da laltro."

143. Cennini 1995, cap. cxli, 143–44. Daniel V. Thompson renders the term as "carefully," in Cennino 1960, 86–87, for trans.

144. Saint-Aubin 1770, 39 (cf. Saint-Aubin 1983, 75, for trans.)

145. Cennini 1995, cap. cxli, 143–44 (cf. Cennino 1960, 86–87, for trans.): "tenendo sotto la carta una tela o panno; o vòi forare in su 'n un'asse d'albero o ver di tiglio; questo è migliore che la tela." This was also probably the general practice employed from the late Duecento to the Cinquecento in cutting parchment or paper stencils.

146. Paganino c. 1532, *Proemio, "Alessandro Paganino al Letore,"* unpag., fols. 3 recto and verso: "un panno di lana fina: e quando fusse novo te rai disopra el riverso: e questo perche lago non intri tropo a basso perche sarebbe il buco troppo grande."

147. Saint-Aubin 1770, 39 (cf. Saint-Aubin 1983, 75, for trans.).

148. Paganino c. 1532, *Proemio, "Alessandro Paganino al Letore,"* unpag., fols. 3 recto and verso: "E avertissi che quando tu forerai che basti solamente la ponta de lago passi."

149. Metropolitan Museum of Art, Robert Lehman Collection, 1975.1.410 and 1975.1.409, New York. On Pollaiuolo's presumed study for the Sforza equestrian monument, cf. Forlani Tempesti 1991, 197–202, no. 69. An attribution to Francesco Botticini of no. 1975.1.409 seems now more convincing than one to Alesso Baldovinetti and is based on the similarity of figural type to the extant preparatory study in pen and ink for the figure of Christ (Berenson no. 591 C) in the Palmieri Altarpiece in the National Gallery, London. I am indebted to Lisa Venturini (conversation, 16 August 1996), who published the drawing as Botticini (?) in Venturini 1994, fig. 38. On the Palmieri Altarpiece, documented to have been painted for S. Pier Maggiore (Florence) between 1475 and 77, see Venturini, 112–13, no. 35, and Rolf Bagemihl, "Francesco Botticini's Palmieri Altar-Piece," *BM*, CXXXVIII (1996), 308–14. The issue of authorship for the Lehman Collection drawing is not at all certain, but the proposal of Botticini seems to have first been made by James Byam Shaw. Compare further Kenneth Clark, "Italian Drawings at Burlington House," *BM*, LVI (1930), 176, plate B (Andrea del Castagno); Popham 1931, no. 35, plate XXX A (Antonio Pollaiuolo); James Byam Shaw, "Francesco Botticini," *Old Master Drawings*, IX, no. 36 (1935), 59 (note 1); James Byam Shaw and Karl T. Parker, *Oppenheimer Sales Catalogue,* London, 1936, no. 38 (Francesco Botticini); Kennedy 1938, 151–52 (Alesso Baldovinetti); Berenson 1938 and 1961, II, 69, no. 669B, III, fig. 70 (Raffaele dei Carli after Andrea del Castagno); Bean and Stampfle 1965, no. 7, 22 (Raffaellino del Garbo); Szabo 1983, no. 13 (Antonio del Pollaiuolo); and Forlani Tempesti 1991, 192–97, no. 68

(Alesso Baldovinetti?), but where Byam Shaw's attribution to Botticini goes virtually undiscussed and the connection to the Palmieri Altarpiece unnoticed.

150. For these photographs and an important session of study, I am indebted to Margaret Lawson, paper conservator at the Metropolitan Museum of Art, New York (summer 1990).

151. In fact, in Pollaiuolo's *Head of Faith* (Plate II), a portion about 20 mm. long in the outline defining the crown of the woman's head was left entirely unpricked.

152. Perrot 1625, xiv: ". . . il faut piquer les principaux traits de votre estempe ou dessin. . . ."

153. This is plain, for instance, in the numerous drawings by Bartolomeo di Giovanni (CBC 115–25), Raffaellino del Garbo (CBC 65–107), and their workshops.

154. On "substitute cartoons," cf. Chapter Eight, as well as Bambach Cappel 1992 a, 9–30; Henry 1993, 612–19; Finaldi, Harding, and Wallis 1995; and Bambach Cappel 1996 a, 83–102.

155. Paganino c. 1532, *Proemio, "Alessandro Paganino al Letore,"* unpag., fols. 3 recto and verso: "E fatto che tu harai el foro: piglierai una pietra pomice dolze, e spianerala a guisa di tavoletta: dipoi piglia el disegno preforato: e rivoltato sotto sopra pche lago nel forare la carta fa uno relevo della banda di essa onde con ditta pomice la menerai dolcemente sopra essp perforato infin tanto che la pomice hara consumata quella carta superflua."

156. I am indebted to Leonetto Tintori for his demonstrations of the effects of repeatedly pouncing the same design onto fresh *intonaco* (summer 1992).

157. As a matter of course, painters sanded their panels and canvases with pumice, as did engravers their metal plates, and this may represent a common origin of the practice among embroiderers and draughtsmen.

158. Cennini 1995, cap. cxli, 143–44 (cf. Cennino 1960, 86–87, for trans.).

159. Cennini 1995, cap. cxxiv, cxli, clxxii, 128–29, 143–44, 183 (cf. Cennini 1933, 76, 86, 87, 113, for trans.).

160. Accademia della Crusca 1612, 837–38; and Baldinucci 1681, 155.

161. Tagliente 1530, unpag., fols. 27 verso–28 recto (also transcribed in Bambach Cappel 1991 a, 98); Paganino c. 1532, *Proemio, "Alessandro Paganino al Letore,"* unpag., fols. 3 recto and verso; Ostaus 1567, *"Alli saggi et giuditiosi lettori,* unpag., fol. 3 verso"; Palomino 1947, 78, 486–87, 518–19, 1159; Diderot and d'Alembert 1751–65, XIII, 14. Catherine Perrot's *Traité de la Miniature* (1625) characterizes the pricking tool as a "fine, strong needle," mounted on a rounded wood handle. See Perrot 1625, xiv: ". . . avec une pointe d'aiguille fort fine, que l'on emmanche dans un morceau de bois de fusin que l'on arondit." Charles Germain de Saint-Aubin's *L'Art du Brodeur* (1770) illustrates two examples of pricking instruments, calls them *"perçoirs,"* and gives a definition. See further Saint-Aubin 1770, 39 (cf. Saint-Aubin 1983, 75 for trans.).

162. See illustration of metalpoints in Watrous 1957, 11.

163. Baldinucci 1681, 30 (under *Cartoni*): ". . . forano minutamente i dintorni di essi cartoni . . . ;" Pozzo 1693–1700, II, unpag.: ". . . far spessi, e minuti fori."

164. Vasari 1966–87, I (testo), 121, 134: "... punta di ferro overo d'avorio o legno duro" (cf. Vasari 1960, 215, 231, for trans.). My quotation is from Vasari's description of easel painting. In that of fresco painting, he mentioned only *"un ferro."*

165. Borghini 1584, 144–45, 171: "... stecchetto d'avorio, ò di scopa, ò d'altro legno netto."

166. Sandrart 1675, Part I, 64–65: "... mit einem spitzigen Pfriem oder Eisen."

167. Baldinucci 1681, 30 (under *Cartoni*): "... stilo d'avorio o di legno duro."

168. Pozzo 1693–1700, II, Settione settima *"Ricalcare,"* unpag.: "... punta di ferro;" and Samuel van Hoogstraeten, *Inleyding Tot de Hooge Schoole der Schilderkonst . . . ,* Rotterdam, 1678, 335–36: "... met een punticj yzer te werk...."

169. Van Mander 1973, 254; and Palomino 1947, 580.

170. The perforations in Andrea Verrocchio's drawing of the *Head of an Angel* from 1470 to 1480 (Fig. 44) are slightly rhombic. The large perforations in Antonio Pollaiuolo's drawing for the *Sforza Equestrian Monument* from 1470 to 1485 (Figs. 53, 278), limited to the horse and rider only, are incised open circles that often do not completely penetrate the paper. These works by artists known to have been practicing sculptors reflect the choice of pricking tools – probably fairly thick oblong burins or chisels in the first two cases, and a circular gouge in the last.

171. Smith 1730, 2. As with stylus transfer in a *calco* method, the quill was used to trace the outlines of a design on paper, whose verso was rubbed with red chalk.

172. See D. Saff and D. Sacilotto, *Printmaking: History and Process,* New York, 1978, 104–5, 120–21, 133–34.

173. Instances from the Ottocento are the *dado* and borders of the *Sala del Risorgimento* in the Palazzo Pubblico (Siena), in the chapels around the choir of the Basilica of *"Il Santo"* (Padua), and in the south transept of S. Maria presso S. Satiro (Milan).

174. On these issues of ornament design, see further, Chapter Five.

175. Paganino c. 1532, *Proemio, "Alessandro Paganino al Letore,"* unpag., fol. 3 recto and verso: "... e dipoi lo mena sopra esso perforato in fin a tanto che rimanghi el disegno sopra ditto panno o tela che sia...."

176. Saint-Aubin 1770, 35 (cf. Saint-Aubin 1983, 69, for trans.), under *"doux."*

177. See Figure 151, which is also probably representative of the level of execution of underdrawings in other ornamental painting of the period.

178. For the most recent findings on Pisanello's mural painting technique, see the studies by Maria Elisa Avagnina and Aldo Cicinelli in Castelvecchio 1996, 465–85. In Luca Signorelli's mural cycle in the cloister of the Abbey of Monteoliveto Maggiore, begun about 1497–98 and narrating episodes from the *Life of St. Benedict,* a pricked pattern, slipping considerably downward, left sloppy, syncopated rows of *spolvero* dots on a fictive marble pilaster painted *all'antica* with *grotteschi.* On the cleaning and painting technique in this mural cycle, see Danti, Giovannoni, Matteini, and Moles 1987, 10–16.

179. Andrea del Sarto's mural cycle is more fully discussed in Chapter Eleven (and notes 33–36).

180. Here again, I am indebted to Leonetto Tintori for his demonstrations.

181. On this particular technique, see further Bambach Cappel 1991 a, 72–98, as well as Chapter Five.

182. See discussion in Chapter Five.

183. Paganino c. 1532, *Proemio, "Alessandro Paganino al Letore,"* unpag., fols. 3 recto and verso: "e di poi piglia la tua tela o panno di seta, o panno di lana: quello che tu voi disegnare: distendelo sopra una tavola e conficca quello: e dipoi piglia il disegno forato e pollo sopra ditto pano . . . ;" and illustration in ibid., fol. 2 recto.

184. Saint-Aubin 1770, 6 (cf. Saint-Aubin 1983, 20, for trans.), and Boutet 1676, 3, which recommends pinning designs to be stylus-incised *(calquer).*

185. Cennini 1995, cap. xxiii, 24 (cf. Cennini 1960, 13, for trans.). Piero della Francesca's *De Prospectiva pingendi,* written before 1482, recommends the use of wax to attach the different drafts on paper for a perspective exercise of "transformation" (Piero, *De Prospectiva pingendi,* 190–91). According to Alexander Browne, warm wax could fasten designs being stylus-incised onto the engraver's plate; see *Ars Pictoria, or an Academy Treating of Drawing, Painting, Limning, Etching,* London, 1675, 101, under the "art of etching."

186. Vasari 1966–87, I (testo), 121, 134 (cf. Vasari 1960, 215, 231, for trans.), and Borghini 1584, 140–46, 172–74.

187. Vasari 1966–87, I (testo), 134 (cf. Vasari 1960, 231, for trans.): "... Apuntati poi con chiodi piccoli...."

188. Raphael first established these plumblines by tracing intersecting arcs with the compass and then by connecting the points by ruling with the stylus, directly on the paper.

189. Another case by Filippino Lippi is discussed and illustrated by Carmen C. Bambach in Metropolitan Museum of Art 1997, 335–37, nos. 110–11.

190. On the examination of this panel with infrared reflectography, see Christensen 1986, 48–50, and Brown 1983, 149–51.

191. To provide a point of reference, the *St. George* panel in the National Gallery of Art, Washington, measures 280 × 220 mm., whereas the Uffizi cartoon's dimensions are 261 × 214 mm. I am indebted to Annamaria Petrioli Tofani for allowing me to check the correspondences of design between cartoon and painting on 12 July 1991. To prevent even the possibility of damage to the fragile painting surface of Raphael's Washington panel of *St. George,* the tracing on transparent acetate was obtained from a full-scale photograph (kindly provided by David Alan Brown) that was rigorously checked for accuracy against the original.

192. The outlines of the saddle girth are also displaced 3 mm. to the right. The dragon's wing and tail are painted 2 mm. to the right, and its left rear leg is displaced about 4 mm. to the lower right.

193. This was true, even if they were transferred by the intermediary means of a "substitute cartoon." Here, note Vasari's and Borghini's description of stylus-incised substitute cartoons for oil paintings on canvas or panel: Vasari

1966–87, I (testo), 134 (cf. Vasari 1966, 231, for trans.), and Borghini 1584, 173–74.

194. National Gallery of Art 1986.33.1, Washington. Revised data: 938 × 670 mm., charcoal (with some black chalk reinforcements, highlighted with lead white chalk *("gesso da sarti");* outlines pricked and rubbed with black pouncing dust. I am indebted to Margaret M. Grasselli, Shelley Fletcher, and Ann Eggert for offering me the opportunity to study this cartoon in the paper conservation laboratory of the Gallery (winter 1995). It was possible for us to prepare a diagram on clear acetate (in full scale) to record the structural paper assembly and the creases from the spines of the *quaderni,* as well as the location of the recurring watermarks, of the pricked plumblines, and of the compass work that was needed for centering the cartoon onto the panel. The visual effect of superimposing this diagram onto the cartoon's image is too faint for photographic reproduction. A full infrared reflectogram assembly of the cartoon was prepared by Elizabeth Walmsley.

195. In the case of the *"Belle Jardinière"* cartoon in Washington, microphotography and infrared reflectography can help us clarify the layering of the charcoal medium (and traces of black chalk), for this highly finished drawing exhibits much surface abrasion. Whereas the drawn charcoal and chalk leave slightly depressed marks coursing across the laid lines of the paper, the pouncing dust fairly floats on the uppermost surface of the drawing. The layer of rubbed pouncing dust seems sufficiently dense to suggest that Raphael (or a member of his *bottega*) may have pounced the composition more than once to replicate it.

196. The evidence on the Washington cartoon includes a pricked horizon line and plumbline, a pair of directly incised compass arcs, and a drawn but unpricked horizontal axis line connecting the incised compass marks, which emerges only with infrared reflectography.

197. Uffizi inv. 6449 F, Florence. Data: 813 × 376 mm. max.; charcoal, on three glued sheets. On this cartoon, attributed to Andrea del Sarto by Annamaria Petrioli Tofani, cf. Palazzo Pitti 1986, 228, no. 25; on the altarpiece of the *Dispute of the Trinity* in Palazzo Pitti, cf. ibid., 115–17, no. XIII.

198. The *"Medici Holy Family"* (Galleria degli Uffizi, Florence), from 1527 to 1529, was mentioned in Chapter One, note 49. Other altarpieces by Andrea del Sarto revealing such evidence with infrared reflectography are the contemporary *"Pala di Gambassi"* and the *"Pietà di Luco"* (Palazzo Pitti, Florence), from c. 1524; the *"Pala di Vallombrosa"* (Palazzo Pitti), from c. 1528; and the *"Pala di Poppi"* (Palazzo Pitti), begun by the artist in 1529–30. See Ezio Buzzegoli and Diane Kunzelman, "Andrea del Sarto nel restauro," and "Andrea del Sarto in riflettografia," *Palazzo Pitti 1986,* 330–57. For catalogue entries on these paintings, see further ibid., 91–93, 129–31, 134–36, 144–48, 163–69, nos. xvii, xix, xxii, xxviii, xxix.

199. Uffizi inv. 1787 E, Florence. The oil painting on panel in the Galleria Colonna, Rome, measures 1650 × 1270 mm. On Allori's cartoon and painting, see Petrioli Tofani 1986,

735–36, *sub numero,* and Lecchini Giovannoni 1991, 243, no. 59 (where it is imprecisely called a *"cartonetto").*

200. A similarly numbered squaring system was used by Giovanni Angelo Canini, recorded in a diagram and described by Richard Symonds in 1650. See Beal 1984, 245.

201. See Chapter One, note 12, for reference.

202. Cennini 1995, cap. lxvii, clxxv, 73, 192–93 (cf. Cennini 1960, 42, 120, for trans.), and Milizia 1827, II, 231.

203. Vasari 1966–87, I (testo), 129 (cf. Vasari 1960, 222, for trans.): ". . . per essere egli veramente il più virile . . . ;" and Lomazzo 1973–74, I, cap. xxi, 302–3, 304: ". . . Ma il lavorare a fresco è quello che porta il pregio e con cui i più grandi pittori si sono acquistate tutti i suoi vanti et i suoi onori. . . . Ma per esprimer tutte queste cose con prontezza d'ingegno e velocità di mano, bisogna che 'l buon pittore s'appigli alla maniera del lavorare a fresco. . . ."

204. Lomazzo 1973–74, I, cap. xxi, 303: ". . . e questi modi di lavorare, eccetto il fresco, sono propriamente da giovani effeminati, massime quello de l'oglio. . . ." Note also admiring quotation recorded by Richard Symonds in 1650, transcribed in Beal 1984, 259.

205. Cf. Rosemary Mayer (in collaboration with Julia Ballerini and Richard Milazzo), *Pontormo's Diary,* New York and London, 1979, 112–13 (with trans.): ". . . mercoledì ebi uno intonico sì faticoso che io non penso che gl[i] abia a far bene, che sono tucto le poppe come si vede la cometitura. . . ." This passage, I think, refers to the problem of making the transitional sutures between *giornate* smooth. Cf. Roberto Fedi, *Edizione integrale in facsimile del "Diario" di Jacopo da Pontormo (Manoscritto magliabechiano VIII 1490 della Biblioteca Nazionale Centrale di Firenze),* Rome, 1996, 2 vols.

206. Vasari 1966–87, I (testo), 128–30 (cf. Vasari 1966, 221–22, for trans.): "Questo si lavora su la calce che sia fresca, né si lascia mai sino a che sia finito quanto per quel giorno si vuole lavorare, perché allungando punto il dipingerla, fa la calce una certa crosterella pel caldo, pel freddo, pel vento e pe' ghiacci, che muffa e macchia tutto il lavoro. E per questo vuole essere continovamente bagnato il muro che si dipigne, et i colori che vi si adoperano tutti di terre e non di miniere et il bianco di trevertino cotto. Vuole ancora una mano dèstra, resoluta e veloce, ma sopratutto un giudizio saldo et intero, perché i colori, mentre che il muro è molle, mostrano una cosa in un modo, che poi secco non è più quella." See also Cennini 1995, cap. lxvii, 73–80 (cf. Cennini 1960, 42–47, for trans.); Borghini 1584, Book II, 170–71; and Armenini 1587, 112–14 (cf. Armenini 1977, 182–83, for trans.).

207. Vasari 1966–87, II (testo), 278.

208. Palomino 1724, Book VII, Chapter IV:iii, 100–1: "Modo de assentar el primer carton . . . ," "Modo de estarcir el cartón, y recortar la tarea . . . ," "Lo que se ha de hazer en quitando el cartón de la tarea. . . ." Cf. also ibid., Book VI, Chapter V:ii, 76–77, on cartoons for "pintura a el temple."

209. Vasari 1966–87, I (testo), 120–21 (cf. Vasari 1960, 214–15, for trans.), and Borghini 1584, 170–71.

210. Armenini 1587, 104 (cf. Armenini 1977, 174, for trans.), and Bisagno 1642, 87–88.

211. See further Chapter Eight. The process of transferring "substitute cartoons" onto the painting surface is reconstructed in Bambach Cappel 1996 a, 87–91.

212. Cennini 1995, cap. lxvii, 73–77 (cf. Cennini 1960, 42–44, for trans.).

213. Cf. Chapter Six, notes 104–7.

214. Pozzo 1693–1700, II, unpag., "Settione Sesta, *Graticolare* . . . nella parete arricciata: Ciò fatto scioglierà il Pittore quel numero di graticole, che potrà dipingere in un giorno, & ordinarà, che sia diligentemente intonacato, ripigliando sopra la nuova intonacatura la graticolatione, che fù coperta. . . ."

215. Vasari 1966–87, I (testo) 121 (cf. Vasari 1960, 215, for trans.); Borghini 1584, 170–71; Sandrart 1675, Part I, 64–65; and Palomino 1724, Book VII, Chap. IV:iii, 100–1. Cf. Bambach Cappel 1992 a, 9–30, and Bambach Cappel 1996 a, 83–94. It should be pointed out in this regard that there is no proof for the unreasonable observation, persistent sometimes in the secondary literature, that in order to transfer cartoons, the individual sheets of paper could be unglued and then transferred onto the *intonaco,* which would seem impractical and which is not documented in the primary sources (cf. Meder and Ames 1978, I, 404 (note 23), 405 (note 47). A reading in this context of the term *rimpastare,* appearing in the documents about the *Battle of Anghiari* cartoon, is in my opinion incorrect.

216. See Figures 193–94 and further discussion in Chapter Six.

217. Vasari 1966–87, I (testo), 121 (cf. Vasari 1960, 215, for trans.): "ogni giorno nella commettitura se ne taglia un pezzo e si calca sul muro . . ."

218. Sandrart 1675, Part I, 64–65: ". . . so schneidet man ein Stück oder Figur ab just soviel als man selbigen Tag zu verrichten ihm vorgennommen. . . ." See Roberto Salvini, "L'eredità del Vasari storiografo in Germania: Joachim von Sandrart," *Il Vasari storiografo e artista* (*Atti del congresso internazionale nel IV centenario della morte,* Arezzo-Florence, 1974), Florence, 1976, 759–71, and Bambach Cappel 1988, Part 1, I:154–55, for further discussion.

219. Cf. Bambach Cappel 1992 a, 20, 29.

220. For the *giornate* in the *Disputa,* see Redig de Campos 1984, "Schema-zeichnungen zu den Tagewerken," unpaginated.

221. J. Paul Getty Museum inv. 82.GB.107, Los Angeles. Revised data: 320 × 318 mm. (maximum, silhouetted); charcoal, highlighted with white, on two glued pieces of brownish paper (join non-structural); vertical *quaderno* crease; outlines finely pricked. Cf. Hirst 1981, 60 (note 50), plate 87; *The Genius of Venice* 1983, 282, under no. D59; and Goldner 1988, 114, no. 46. The methods of cartoon transfer on the fresco surface seem mixed (and remain to be clarified by a formal conservation report). The much darkened oil mural of the *Flagellation* below in the Borgherini Chapel exhibits *calco* and direct incision.

222. Gallerie Nazionali di Capodimonte inv. 86653, Naples. Approximate data: 1380 × 1440 mm. (maximum); charcoal, highlighted with white chalk, on at least eighteen glued sheets of paper; outlines relatively coarsely pricked and apparently rubbed with pouncing dust. Unfortunately the technical data was not refined, as might have been expected, during the recent restoration of this cartoon. Cf. Oberhuber 1972, 98, no. 411; Joannides 1983, 219, no. 344; Knab, Mitsch, and Oberhuber 1983, 603, no. 488; and Muzii 1993, 14–17 (illustrated in color), 23.

223. Based on various types of physical evidence found on the fresco surface of Raphael's *Fire in the Borgo,* painted in 1514–17 in the *Stanza dell'Incendio,* it has been proposed that the cartoon the artist and his assistants employed must have been cut into pieces during the process of transfer. See Nesselrath 1992, 41–52. Unfortunately, the huge cartoon no longer survives to confirm this hypothesis.

224. Palomino 1724, Book VII, Chapter IV: iii, 100–1.

225. Ibid.

226. I am indebted to Eve Borsook for pointing out the reference to *"scarpate."*

227. Palomino 1724, Book VII, Chapter IV:iii, 100–1.

228. A monumental cartoon fragment portraying the upper part of a woman's figure in a pronounced *"sotto in sù"* perspective, is also cropped in the highly irregular shape of a *giornata* (Uffizi inv. 1773 E, Florence). Data: 8650 × 8180 mm.; monochromatic painting in brush with white, cream, and brown gouaches, over charcoal; outlines sharply stylus-incised for transfer; on five sheets of low-grade, soft paper *("carta da straccio")* of undeterminable size, and with joins of various widths (8–12 mm. and 52 mm. overlaps of paper.) Cf. Petrioli Tofani 1986, 728, *sub numero,* with an attribution to Correggio (?); and Bambach 1998, with an attribution to Carlo Cignani. This *giornata*-cropped cartoon exhibits at least nineteen probable cartoon nail holes; the holes have a relatively large diameter (about 3 mm.) and follow the silhouette of the figure. Some holes, however, lie also in the interior, generally aligning with the top outline of the woman's foreshortened bust line. The nail holes appear as soft inverted craters in the *"carta da straccio"* of the cartoon (a few of these were insensitively mended and flattened by old restorers) and the gouache pigment enters the crevices. On the concave surface of a dome, numerous nails would be required to attach the cut cartoon pieces for painting, which would explain the great number of such holes in the Uffizi fragment. (As described above, an analogous situation arises in Michelangelo's foreshortened figure of *Haman,* frescoed on the southwest pendentive of the Sistine Ceiling.) The figure is in a scale about three times life-size, and, in design, it closely resembles the Virgin in Carlo Cignani's greatly damaged *Assumption* on the dome of the "Cappella S. Maria del Fuoco" in Forlì Cathedral, frescoed in 1685–1700, obviously indebted to Correggio's frescos on the dome of Parma Cathedral in 1526–30.

229. The function of the holes found in the Sistine Ceiling has long been identified with cartoon nail holes. See discussion in Biagetti 1936, 207–10; Biagetti 1939, 231–39; Camesasca 1972, 95; Mancinelli 1988a, 17–18; and Bambach Cappel 1996 a, 88 (and note 46), 98 (and note 148).

230. See Figures 236–37, and discussion in Chapter Seven. Cf. Bambach 1983, 661–65, and Bambach 1996 a, 83–102.

231. Mayer (as in note 205), 156–57: ". . . venerdì si rimurò

tucte quelle buche di sul coro di quella prima stor[ia]." Cf. ibid., 158–59, for another mention of holes being replastered, though these may not have been cartoon nail holes.

232. Cf. Bambach Cappel 1992 a, 9–30; Henry 1993, 612–19; Finaldi, Harding, and Wallis 1995; and Bambach Cappel 1996 a, 83–102; as well as Chapter Eight.

233. Cf. Plesters 1990 b, 112–13; Bambach Cappel 1992 a, 14, 20, 27–32 (notes 29–32); and Finaldi, Harding, and Wallis 1995.

234. Pinacoteca Ambrosiana inv. 114 (489 a), Milan. It has been unfortunately impossible to illustrate this cartoon, which has usually been incorrectly published as having stylus-incised outlines. Revised data: 807 × 2496 mm. (max., irreg. shape, mounted on secondary support); charcoal, partially stumped, highlighted lead white chalk, outlines pricked, on eighteen glued sheets of paper, glued onto secondary support. The sizes of the sheets of paper are usually about 420 × 290 mm. Cf. Hartt 1958 (repr. New York, 1981), 289, no. 36; Dussler 1971, 88; Oberhuber 1972, 29, 204, no. 487; Tsuji 1983, 159; Quednau 1979, 109, 366, 370–71, 594, no. 361; Joannides 1983, 244, no. 443; Bambach Cappel 1988, Part 2, II:280–81, no. 204; Sylvia Ferino Pagden, "Giulio Romano pittore e disegnatore a Roma," Mantua 1989, 83–86; and Bambach Cappel 1992 a, 14, 28 (notes 31–32).

235. Biblioteca, Monasterio de El Escorial. Cf. Pérez Sánchez 1975, 61–63, nos. 253–94; Pérez Sánchez 1986, 144–46; and Bambach Cappel 1996 a, 85 (note 16).

236. Not surprisingly, the *sinopie* corresponding to Bernardino Poccetti's cartoons (Uffizi inv. 1788 E and 1789 E, Florence), render the designs for the figures with extremely schematic outlines. See Opificio delle Pietre Dure e Laboratorio di Restauro di Firenze, negative nos. 153550 and 153551. The much-damaged Uffizi cartoons are squared with black chalk and ink and mounted onto canvas. Cf. Petrioli Tofani 1987, 736–37, and Bambach Cappel 1992 a, 27–28 (note 29).

237. A diagram of the *giornate* for the *Battle of Constantine* does not exist, but with Enrico Guidi's indispensable help, it was possible for me to determine the general disposition of *giornate* in this part of the fresco. The area of the *Ambrosiana* cartoon corresponds to approximately ten relatively large *giornate* in the fresco. The later reassembly and gluing of the cartoon onto its secondary support was presumably done by an early collector. I am indebted to the late Fabrizio Mancinelli and to Arnold Nesselrath for building a temporary scaffolding from which I was able to study the fresco surface (July 1991).

238. See Vasari 1966–87, I (testo), 121 (cf. Vasari 1960, 215, for trans.): "Questo pezzo del cartone si mette in quel luogo dove s'ha a fare la figura e si contrassegna, perchè l'altro dì che si voglia rimettere un altro pezzo si riconosca il suo luogo appunto e non possa nascere errore . . . ," and Palomino 1724, Book VII, Chapter IV: iii, 100: "Assentado, pues este primer cartón . . . , y fixado con sus tachuelas, se estarcira con la mazorquilla de carbón molido; y tambien se ha de golpear con ella por toda la orilla, para cortar despues la tarea por aquella señal, y que sirva de registro,

para ajustar por ella la del dia siguiente; y asi de los demas. . . . Hecho esto se quitará el cartón, y se recortará toda la orilla de la tarea."

239. On the dome frescos in Florence Cathedral, cartoon nails and cartoon marks have been identified; see Acidini Luchinat and Danti 1992, 132–39, and Acidini Luchinat and Dalla Negra 1995, 117 (figs. 6, 7). There, a mark on the plaster, consisting of three short dashes in red pigment, has been interpreted as a Roman numeral corresponding to a numbering on the cartoon pieces. This hypothesis remains unverifiable, as none of the cartoons are extant, but that these red dashes are a deliberate number does not seem entirely convincing, and, to judge from extant, scaled *modelli* drawings (or Alessandro Allori's cartoon of *Christ's Descent to Limbo,* Uffizi inv. 1787 E, Florence), the numbering was usually done with arabic numerals.

240. See Archivio Fotografico, Soprintendenza per i Beni Artistici e Storici, Florence, negative no. 310607, where the sideways "V" mark appears near the horse's snout.

241. For such reference marks, see Pier Giorgio Pasini, "La Sinopia dell'affresco riminese di Piero della Francesca," *Piero della Francesca tra arte e scienza* 1996, 138 (fig. 6); Henry 1996, 263 (for Signorelli); Borsook 1994, 103–6; and Bambach Cappel 1996 a, 11 (fig. 9, for Michelangelo); as well as Redig de Campos 1984, plates 41, 42, 57 (for Raphael). Additionally, Eve Borsook has noted the compass-incised crosses along the cornice in Masaccio's *Trinity* (S. Maria Novella, Florence); cf. Leonetto Tintori's diagram published in Borsook 1980, 61 (fig. 7).

242. In cases when the outlines of cartoons were being transferred by *calco,* as Vasari described, the referencing may have consisted of directly incising around the borders of the particular cartoon piece with the stylus, as it lay on the *intonaco,* in a manner analogous to the pounced referencing described by Palomino (see note 238).

243. See material on the *Stanza dell'Incendio* published in Nesselrath 1992, 31–60, particularly 45, 51, fig. 21.

244. Cf. comment and illustration in *Michelangelo e la Sistina* 1990, 70.

245. Nesselrath 1992, 41 (fig. 12), 45, 51 (fig. 21). As Arnold Nesselrath has pointed out, the marks occur on the coffered arch framing the scene of the *Fire in the Borgo,* along the top and sides, and are exactly tangential to the joins for the *giornate* of the scene. Two of these three marks are also "V"-shaped; the other consists of two parallel dashes. These marks, however, were drawn in red chalk, rather than incised into the *intonaco,* because the frame had been painted earlier by Pietro Perugino and his workshop, and thus its *intonaco* preceded that of the scene.

246. Vasari 1962, I (testo), 38–41.

247. On Michelangelo's assistants for the Sistine Ceiling, cf. Michelangelo, *Carteggio,* I, 110, 375–78; as well as Biagetti 1936, 199–220; Wallace 1987, 203–16; Mancinelli 1988 b, 538–41; and Mancinelli 1990, 55–59.

248. See also comments in Nesselrath 1992, 45, 51 (fig. 21), on Raphael's *Fire of the Borgo.*

249. The upper mark is partly cropped by the upper border of the cartoon. The function of these centering marks on the

cartoon was discussed in Bambach Cappel 1987, 132, 140–41; Muzii 1988, 14, fig. 3; and Bambach Cappel 1996 a, 88–89, figs. 9–11. What follows supplements that discussion.

250. Saint-Aubin 1770, 40 (cf. Saint-Aubin 1983, for trans.).

251. Further discussed and illustrated in Bambach Cappel 1996 a, 89–90, 356, fig. 11.

252. See ibid., for more detailed discussion. For the lower right centering mark of the Naples cartoon, I could only identify in the general area of the fresco surface two replastered and repainted holes, of approximately 20 mm. and 10 mm. in diameter, as well as a deep, partly damaged, probable cartoon nail hole of approximately 5 mm. in diameter. I am indebted to the late Fabrizio Mancinelli, Gianluigi Colalucci, and Piergiorgio Bonetti for the opportunity of doing this comparative research from a temporary scaffolding. Directly incised marks of similar configuration, though more deeply excavated, appear on the fresco surfaces of the *Expulsion of Heliodorus,* the *Liberation of St. Peter,* and the *Battle of Ostia,* painted by Raphael and his workshop in the Vatican *stanze.* For the marks in the *Expulsion of Heliodorus* and the *Liberation of St. Peter,* see photographs in Redig De Campos 1984. In plate 41, notice the area toward the upper left corner and on the left border near the center. In plate 42, notice the area toward the upper right corner. In plate 57, notice the area immediately above the head and shoulder of the soldier who shields himself from the light. The marks on the *Battle of Ostia* were brought to my attention and discussed by Arnold Nesselrath and Enrico Guidi, during one of my visits to the scaffolding erected for the fresco's cleaning (1990–91). Similar parallel dashes in red chalk occur on the right half of the framing arch for the *Fire of the Borgo* (Nesselrath 1992, 51, fig. 21). Pounced, upright centering crosses, in the form of those drawn and pricked in the Naples cartoon, may come to light when the much-repainted *Crucifixion of St. Peter* fresco is cleaned. The possibility of finding them on the fresco surface remains limited, however, considering the discouraging fact that even the *spolvero* outlines on many of the thickly painted figures are only sporadically visible, for *spolvero* marks are extremely ephemeral. The disparities of survival are unfortunately such for Italian Renaissance drawings relative to paintings that it proves difficult to assemble a corpus of cartoons and corresponding murals exhibiting reference marks for comparison. The opportunity offered by Michelangelo's *Crucifixion of St. Peter* appears to be unique, despite the obvious problems that this case may raise.

253. But, as can be gauged from the painting of the *"Mackintosh Madonna"* (National Gallery, London), the British Museum cartoon has been cropped probably by at least 41 mm. on the left border and by at least 61 mm. along the right border, which places the plumbline in the cartoon at the center of the composition as painted. The plumbline in the cartoon touches the Virgin's left eye tangentially. Then, toward the left and right borders of the cartoon, there are two incised compass marks at about 344 to 346 mm. from the top border. They are thus located 20 mm. higher than the midpoints of the cartoon's present left and right borders, but, yet again with respect to the painting, the marks occur precisely at the midpoints of the corresponding borders in the painted composition. (Italian Renaissance artists commonly used such compass arcs to establish perpendicular lines in their drawings.)

254. Unfortunately, Raphael's heavily restored painting of the *"Mackintosh Madonna"* was transferred from its original panel support to canvas in 1729–86, as a means of stabilizing its deteriorating condition (Gould 1975, 218–20, no. 2069). This damaging procedure not only affected the adhesion of the pigment layer but also obliterated the underdrawing. Thus, for corroborative physical evidence, we must turn to other paintings by Raphael from this general moment in his career. Infrared photography of the panel portraying *St. Catherine of Alexandria* (also in the National Gallery, London), from 1506 to 1508, reveals a plumbline passing the corner of the saint's left eye, and X-radiography reveals a horizonline and the intersecting compass arcs for its construction in the area of her left elbow, the precise configurations found in the *"Mackintosh Madonna"* cartoon. Cf. Dunkerton and Penny 1993, figs. 8, 10; I am indebted to the authors of this important study for sharing their views regarding Raphael's workshop practices. The comparison to the *"Mackintosh Madonna"* cartoon has gone unnoticed. The highly finished cartoon relating to the *St. Catherine* (Plate VI), which differs in important details of the composition, does not exhibit equivalent reference marks; the precise role this cartoon played vis-à-vis the painting is not entirely clear (cf. Dunkerton and Penny 1993, 9–13). On the cartoon (Louvre inv. 3871, Paris), cf. Catherine Monbeig Goguel in Grand Palais 1983, 231–33, no. 62; and Louvre 1992, 86–87, no. 77. Infrared reflectography demonstrates both the plumbline and horizonline in the *"Aldobrandini Madonna"* (or *"Garvagh Madonna,"* National Gallery, London), from 1509 to 1511, to be placed similarly to those in the *St. Catherine* panel and the *"Mackintosh Madonna"* cartoon (cf. Dunkerton and Penny 1993, 10–11). In my opinion, the mechanical-looking quality of most of the lines revealed with infrared reflectography in the underdrawing of the *"Aldobrandini Madonna"* suggests the use of a *calco* cartoon; the presence of both a plumbline and a horizonline tends to confirm that a cartoon was used. Moreover, the overall schematic quality of the underdrawing in this painting surely contrasts, rather than compares, with the free and much-reinforced underdrawing of the *"Madonna dei Garofani"* (Alnwick Castle, Northumberland; on loan to the National Gallery, London; analyzed and discussed in Penny 1992, 67–81). In all three cases, the plumblines and horizonlines intersect.

255. See *"The Knight's Dream"* (Fig. 14), the two sheets depicting *St. George and the Dragon* (Figs. 56, 249), and the *Massacre of the Innocents* (Fig. 259).

256. See the two sheets depicting partial studies for the *Lamentation* (Figs. 78–79, and CBC 241).

257. Uffizi inv. 539 E, Florence. This is Sylvia Ferino Pagden's convincing suggestion in Florence 1984, 356–58, no. 44.

258. British Museum, Department of Oriental Antiquities no.

1919.1–1.073 [2] [ch.xli.004]), London. Cf. Whitfield 1983, II, plate 80, with commentary.

259. See Chapters Five and Nine, Figures 154, 155, 254, and also Bambach Cappel 1991 a, 72–98.

260. Szépmüvészeti Múzeum *(Codex Zichy)* inv. 1915.24, 1915.43, and 1915.55, Budapest. Cf. Chapter I, note 106. Lóránd Zentai kindly brought this codex to my attention.

261. In the J. Paul Getty Center, Los Angeles (inv. 880209, GJPA88-A274), see no. F 196, but also note F179, F 192, and F195. Catherine Hess kindly brought these drawings to my attention.

262. Baldinucci 1681, 155: "...e chiamano spolvero lo strumento che adoperano per introdurre la polvere, che e un panni-cello rado fatto in foggia di bottone, e ripieno di essa...."

263. Apparently, Sir Aurel Stein discovered what he thought to be pouncing bag from the eighth or ninth century A.D., of Chinese–Tibetan origin at Mirān Fort. It consisted of a felt pad sewn around the borders and filled with charcoal dust. See Aurel Stein, *Serindia: Detailed Report of Explo-rations in Central Asia and Westernmost China,* Oxford, 1921, I, 484, II, 892, and reported in Rutherford J. Gettens and George L. Stout, *Painting Materials: A Short Encyclopaedia,* New York, 1942, 304, under "pounce bag."

264. Cennini 1995, cap. cxli, 143–44 (cf. Cennini 1960, 86–87, for trans.): "...polvere di carbone leghato in pezuola"; and Armenini 1587, 102–3 (cf. Armenini 1977, 173, for trans.): "...un spolvero che sia pieno o di carbon pesto, o ver di polvere di Lapis negro," although this reference does not occur in a description of pouncing for design transfer, but in that on the shortcut to rendering *chiaroscuro.* See also Accademia della Crusca 1612, 837–38: "...polvere di car-bone;" Perrot 1625, xiv: "La Ponce se fait de charbon bien sec reduit en poudre...;" Baldinucci 1681, 155: "...brace polverizzata;" Pozzo 1693–1700, II, unpag.: "...carbone spolverizato legato in un straccio;" Palomino 1947, 518: "...cenizas cernidas;" and Saint-Aubin 1770, 39 (cf. Saint-Aubin 1983, 75, for trans.): "...charbon de bois blanc, rapé & bien tamisé.... la lie de vin bien brulée." Note further Richard Symonds's eyewitness account of Italian practices in the 1650s, as transcribed in Beal 1984, 294.

265. Paganino c. 1532, *Proemio, "Alessandro Paganino al Letore,"* unpag., fols. 3 recto and verso: "E poi piglierai uno poco di carbone di Salice e pollo in uno strazzo di panno di lino sottile usato: e legalo in esso e pestalo con una pietra."

266. Perrot 1625, xiv; Boutet 1676, 7; and *Art of Painting in Miniature* 1752, 4.

267. Cennini 1995, cap. cxv, cxvii, cxxi, cxxxiv, cliii, clxii, clxxiii, 119, 122, 125, 135, 158–59, 170, 185 (cf. Cennini 1960, 70, 72, 74, 80, 97, 103, 115, for trans.).

268. Cennini 1995, cap. cxlii, 144 (cf. Cennini 1960, 87, for trans.): "S' egli è drappo bianco, spolvera con polvere di carbone legato in pezzuola; se 'l drappo è nero, spolvera con biacca, legata la polvera in pezzuola; et sic de singulis."

269. Cf. Accademia della Crusca 1612, 837–38; Baldinucci 1681, 30, 155; Palomino 1947, 486–87, 518; M. L. Avocat (Lacombe), *Dictionnaire portatif des Beaux-Arts, ou abrégé de ce qui concerne l'Architecture, la Sculpture, la Peinture, la Gravure...,* Paris, 1752, 514; Diderot and d'Alembert

1751–65, XIII, 14, 26; Saint-Aubin 1770, 39, under *"pon-cette"* (cf. Saint-Aubin 1983, 75, for trans.); and Baretti 1771, I, unpag., under *"spolverezzo."*

270. Accademia della Crusca 1612, 837–38 (repeated verbatim in Baldinucci 1681, 30, 155): "polvere di carbone, o di gesso"; as well as Palomino 1947, 518: "yeso en polvo..."; Paganino c. 1532, *Proemio, "Alessandro Paganino al Letore,"* unpag., fols. 3 recto and verso: "pietre pomice dolce"; and Saint-Aubin 1770, 39 (cf. Saint-Aubin 1983, 75, for trans.): "chaux vive bien pulvérisée...."

271. In addition to black chalk pouncing dust, the paper of a few pricked drawings attributed to Raffaellino del Garbo (CBC 70, 78–81, 83, 87) and Bartolomeo di Giovanni (CBC 106, 124) is also rubbed with pink-red chalk, which rather than ground preparation may be pouncing dust (see Chapter Three, as the combination of pouncing dusts might be evidence of reuse).

272. See British Museum, Department of Oriental Antiquities nos. 1919-1-1-073(1).Ch.Xli.004; 1919-1-1-073(2).Ch.Xli.004; and 1919-1-1-072.Ch.0015, London. These patterns are discussed in Chapter Five. Cf. also Whitfield 1983, com-mentary to plates 78–80, and Whitfield and Farrar 1990, 12–17, 88, nos. 70–71.

273. Saint-Aubin 1770, 39 (cf. Saint-Aubin 1983, 75, for trans.).

274. Armenini recommended these procedures in stumping areas of modeling. See Armenini 1587, 57, 103 (cf. Armenini 1977, 126–27, 174, for trans.).

275. Yale University Art Gallery inv. 1961.65.50, New Haven; illustrated in my Ph. D. thesis (fig. 158), as well as in Haverkamp Begemann and Logan 1970, 362, no. A 265. *Spolvero* marks, in the form of dotted charcoal under-drawing, are visible in the less densely worked-up pas-sages of the composition – for example, in the podium of a column in the background. This establishes that the *Adoration* sheet received pouncing dust from another drawing, whose outlines were pricked, but apparently the charcoal *spolvero* registered too faintly on our sheet with the *Adoration.* The artist, therefore, thought it nec-essary to brush the pricked outlines of the original design with brown-black ink, which, in turn, left a more indelible dotted ink underdrawing on our sheet. Thus, the artist used the pricked original design much like a cut stencil, over which he "painted" ink with the brush. In some areas, the dots look almost as if they were out-lined with the ink, their centers remaining nearly blank. In running down the tiny craters of the perforations on the pricked original design, the liquid ink settled unevenly on the surface of our sheet with the *Adoration* that lay underneath.

276. Cf. John Gere, *Drawings by Raphael and his Circle,* exh. cat., Pierpont Morgan Library, New York, 1987. Perhaps the assertion stems from a misreading of the recommenda-tions by Alessandro Paganino (c. 1532, *Proemio, "Alessandro Paganino al Letore,"* unpag., fol. 3 recto and verso) and Charles Germain Saint-Aubin (1770, 39; Saint-Aubin 1983, 75, for trans.) that, after having pounced a design, the artisan should blow the excess pounce away from the working surface.

277. See Figures 70, 202, 284, 285, and Palomino 1947, 579.

278. I am indebted to the late Fabrizio Mancinelli for the opportunities in 1993–94 of studying these early frescos from the restoration scaffolding erected for the cleaning of Michelangelo's *Last Judgment*. On the 1980–83 cleaning of the late Quattrocento cycle of popes on the upper register of the walls of the Sistine Chapel, see Fabrizio Mancinelli's report in *Monumenti Musei e Gallerie Pontificie: Bollettino*, IX (1989), 386–411.

279. The evidence in both monuments is accessible at eye level.

280. Pozzo 1693–1700, II, unpag., see *"Settione Settima,"* "Ricalcare. . . . Che sia atto a lasciar le sue orme meno sensibile. . . ."

281. Here, the dark gray shadows of the fictive marble niches housing the Quattrocento cycle of popes, frescoed on the upper register of the walls of the Sistine Chapel, offer again a case in point.

282. On modeling techniques with color, see especially Hall 1992.

283. I am indebted to Virginia Bonito for the information on Raphael's *Isaiah,* where the evidence is also visible with strong binoculars and a lamp. The late Fabrizio Mancinelli, as well as Arnold Nesselrath, offered repeated opportunities for examining the Vatican *stanze* murals by Raphael and his workshop from temporary and restoration scaffoldings (1990–95). Rosalia Varoli kindly allowed me to study repeatedly the *Loggia di Psiche* from the restoration scaffolding (1993–94). Access to the restoration scaffolding for the frescos in S. Maria della Pace was provided by Maria Pia d'Orazio (June 1994).

284. Instances occur throughout Michelangelo's Sistine Ceiling. Other examples of such corrections, incised directly on the plaster, occur in Pellegrino Tibaldi's mural scene on the right niche of the Poggi Chapel (S. Giacomo Maggiore, Bologna).

285. On fixatives, see Meder and Ames 1978, I, 159, and Glossary (unpag.).

286. Transcribed in full in Richter, I, 362, § 628 (with trans.; cf. Richter, *Commentary,* I, 365–66): "A preparare il legniame per dipi[n]giere su. . . ." See Bambach Cappel 1988, Part 1, I:91–97.

287. Richter, I, 362, § 628 (with trans.; cf. Richter, *Commentary,* I, 365–66): "E poi spolverezza e proffila il tuo disegnio sottilme[n]te e dà di sopra l'imprimitura di 30 parti di uerde rame e vna di uerderame e 2 di giallo." In this particular portion of the passage, I have taken the liberty of completing Leonardo's information. Leonardo gave succinct directions about pouncing the cartoon, for by the 1490s, his audience would have already been familiar with this process. I translate *"sottilmente"* as "thinly" rather than "finely," because the layers of underdrawing and underpainting in Leonardo's own panels appear to be quite transparent.

288. Palomino 1947, 78. Cf. Paganino c. 1532, *Proemio, "Alessandro Paganino al Letore,"* unpag., fols. 3 recto and verso.

289. Paganino c. 1532, *Proemio, "Alessandro Paganino al Letore,"* unpag., fols. 3 recto and verso: ". . . e poi piglia uno poco di Goma e polla in uno scudellino di acqua: e tanto la lassi stare entro che sia disfatta: e di poi piglia biach macinata tanto che basti a far il corpo: e polla in quella acqua. . . ."

290. Cennini 1995, cap. xxxi, 30–32 (cf. Cennini 1960, 17–18, for trans.).

291. Vasari 1966–87, I (testo), 134 (cf. Vasari 1960, 230–31): "gesso da sarti bianco."

292. Cf. J. R. J. van Asperen de Boer, "Current Techniques of Examination," *The Princeton Raphael Symposium* 1990, 5.

293. Ibid.

294. Paganino c. 1532, *Proemio, "Alessandro Paganino al Letore,"* unpag., fols. 3 recto and verso: ". . . di poi leverai il perforo, e con la bocha soffierai pian piano: infino a tanto che sia andata via quella polvere superflua. . . ."

295. Saint-Aubin 1770, 5 (cf. Saint-Aubin 1983, 20, for trans.): ". . . si elle [la ponçure] étoit un peu brouillée ou trop chargée de charbon, il faudroit souffler légérement dessus à mesure qu'on dessine, pour en chasser le superflu. . . ." This part of the process was called *"ordonner."*

296. Borghini 1584, Book II, 146: "E perche dette linee non sono molto stabili, e nel dipignerui sopra facilmente si ca(n)cellano, sarà bene andarle ritrouando con matita."

297. See Armenini 1587, 76 (cf. Armenini 1977, 147–48, for trans.), and, for context, Bambach Cappel 1988, Part 1, I:137–47, II:395–419.

298. Perrot 1625, xiv–xv: "Après que l'on a poncé, il faut tirer à la pointe d'argent tous les traits qui sont marquez sur votre velin une mie de pain, pour empêcher que votre velin ne soit noirci par cette poudre de charbon."

299. Cf. Cennini 1995, cap. xii, 14 (Cennini 1960, 8, for trans.); Palomino 1947, 518–19 *("migajón de pan");* and Smith 1730, 1–2, on the "Light *Italian* Way of Painting."

300. Cennini 1995, cap. cxxii, 126 (cf. Cennini 1960, 75, for trans.): ". . . staendo la figura bene, abbi la detta penna, e va' a poco a poco fregandola su per lo disegno, tanto che squasi dimetta giù il disegno; non tanto però, che tu non intenda bene i tuoi fatti."

301. Cennini 1995, cap. cxxii, 126 (Cennini 1960, 75, for trans.): "Poi abbi un mazzetto delle dette penne, e spazza per tutto 'l disegno del carbone."

302. Paganino c. 1532, *Proemio, "Alessandro Paganino al Letore,"* unpag., fols. 3 recto and verso.

303. Palomino 1724, Book VII, chap. IV:iii, 100: "[carton] aviendolo de estarcir, y ensuciar con el polvo de carbon."

304. Vasari 1966–87, I (testo), 134 (cf. Vasari 1960, 231, for trans.); and Borghini 1584, Book II, 175–76.

3. Traditions of Copying

1. Baldinucci 1681, 85, under *lucidare:* ". . . senza la fatica dell'immitargli a forza del giudizio dell'occhio, e vbbidienza della mano. . . ." On Baldinucci's knowledge of drawings, see Chapter Two, notes 7–14.

2. Alexander 1989, 61–72, and Alexander 1992, 47–51. On Medieval copying traditions, see also Scheller 1995, 34–77, and Elen 1995.

3. Alexander 1989, 61–72.

4. This proposal was first made in Miner 1968, 93–102, and

it was discussed at length in Bambach Cappel 1988, Part 1, I:183–202 (with earlier bibliography). Cf. also Alexander 1992, 50, 162 (notes 90–97), and Scheller 1995, 70–77.

5. The figures in question represent St. Denis (Bib. Nat. MS. lat. 11751, fol. 59 recto, Paris), which is the design that has partly pricked outlines, and St. Germain (Bib. Nat. MS. lat. 12610, fol. 40 verso). Cf. further Miner 1968, 93–102, and Bambach Cappel 1988, Part 1, I:185–88 (and especially notes 20, 21). Examples of pricked motifs on paper or parchment, without the additional supporting evidence provided by textual sources or *spolvero* underdrawings, do not alone constitute proof of the technique's originality as an early workshop practice.

6. This was kindly confirmed also by Patricia Stirnemann (letter on 21 April 1988). See further Bambach Cappel 1988, Part 1, I:185–90.

7. An updated list of examples includes the following (cf. Bambach Cappel 1988, Part 1, I:183–99): an eleventh-century psalter in the Bibliothèque Nationale, Paris (MS. lat. 11751, fol. 59 recto); a twelfth-century English *Life of St. Edmund* in the Pierpont Morgan Library, New York (MS. M. 736); an early twelfth-century bestiary in the British Library, London (Add. MS. 11283); a twelfth- or thirteenth-century *Confessions of St. Augustine* in Beinecke Rare Book Library of Yale University, New Haven (Marston 157); a thirteenth-century *Apocalypse* in John Rylands University Library, Manchester (MS. Latin 8); as well as thirteenth-century English bestiaries in Harvard College Library, Cambridge (MS. Typ 101 H), in the University Library, Aberdeen (MS. 24), in the Bodleian Library, Oxford (MS. Ashmole 1511), and in the Fitzwilliam Museum, Cambridge (MS. 379). Further examples are a fourteenth-century bestiary in the Bibliothèque Royale, Brussels (MS. 8340); an early-fourteenth-century Bible in the Bibliothèque de l'Arsenal, Paris (MS. 588); a fourteenth-century English book of hours and psalter in the British Library, London (MS. Harley 6563); a three-volume set, from the fourteenth-century, of Nicholas of Lyra's *Postils* in the Bibliothèque Nationale, Paris (MS. lat. 360, lat. 402, lat. 489); a fourteenth-century anthropomorphic alphabet in the Biblioteca Civica, Bergamo (Cod. D VII, 14), a loose page from an aviary in the J. Paul Getty Museum, Los Angeles; a fourteenth-century Venetian *Oedipus Legend* in the Biblioteca Marciana, Venice (MS. ital. VI 7 6023); a late-fourteenth-century Paduan edition of Petrarch, *De Viris illustribus* in the Bibliothèque Nationale, Paris (MS. lat. 6069); a Tuscan bestiary from c. 1400 at the Bibliothèque Nationale, Paris (MS. Ital. 450); a mid-fifteenth-century *Speculum* from Cologne in the British Library (MS. Add. 38119); a fifteenth-century Icelandic modelbook in the Arnamagnean Institute, Copenhagen (MS. AM. 673a, 4); a prayerbook by the "Master of Catherine of Cleves" from c. 1438 in the Meermanno-Westreenianum Museum, The Hague (MS. 10, E1); and Ulrich von Pottenstein's *Buch der natürlichen Wahrheit* from c. 1430 in the Bayerische Staatsbibliothek, Munich (Cgm 254). In fact, this corpus appears negligible relative to the corpus of drawings from the Quattrocento

onward that can document the *spolvero* technique and that if counted individually might number well over 1,000 drawings. For this list, I am indebted to Peter Kidd, Patricia Stirnemann, and Alexander 1992, 162 (note 94). See also Scheller 1995, for updated cataloguing data on some of these examples.

8. For instance, whoever pricked the few historiated motifs and initials in the Pierpont Morgan Library *Life of St. Edmund* (New York), or the figures in the Biblioteca Marciana *Oedipus Legend* (Venice), or the bird in the Getty bestiary (Los Angeles), did so with little artisanal knowledge of the *spolvero* technique. The pricking needle penetrated several underlying pages at once, marring many other pages of painted motifs with unrelated prickings. This simple error could be avoided by following the advice of Cennino Cennini, Alessandro Paganino, and others, which specified the placement of a buffer beneath the design being pricked (see Chapter Two).

9. Pierre Dumon, *L'Alphabet gothique de Marie dit de Bourgogne, reproduction du codex Bruxellensis II 845,* [Brussels], 1972, 2–8; Musée du Louvre, *Ornamenistes du XVe au XVIIIe siècle: Gravures et dessins* (exh. cat.; Collection Eduard de Rothschild), Paris, 1987, 61–62, no. 80, and Bambach Cappel 1988, Part 1, I:201–2 (and notes 67–71).

10. For instance, the technique is mentioned in neither Cennino's *Libro dell'arte* (late 1390s, other than regarding "*spolverezzi*"), nor in the German *Straßburg Manuscript* (fourteenth to fifteenth century), nor in the Italian *De Arte illuminandi* (fifteenth century), nor in the German *Göttingen Modelbook* (mid–fifteenth century).

11. Alberti 1972, 53:94–96; Alberti 1950, 103–4. Cf. translations in Alberti 1966, 90–93; Alberti 1972, 53:95–97; Gilbert 1980 a, 70–71; and Alberti 1991, 88. See, moreover, Leonardo's notes as transcribed in Richter, I, 308–12, §§ 500, 506, 508 (cf. Richter, *Commentary,* I, 328–29); and in *Codex Urbinas Latinus* facsimile in McMahon 1956, II, fol. 32 verso–38 recto (McMahon 1956, I, nos. 76, 92–93, 95). Of the vast secondary literature, note especially Kemp 1977, 347–98, and Summers 1981, 103–43 *("l'alta fantasia"),* 279–82, 532–34 ("imitation").

12. On the "creative" use of copies, cf. also Haverkamp-Begemann 1988, 13–92, nos. 1–22, as well as essays by Richard Spear, Beverly Louise Brown, and Jeffrey Muller in *Retaining the Original: Multiple, Originals, Copies, and Reproductions* (Center for Advanced Study in the Visual Arts, Symposium Papers VII), National Gallery of Art, Washington, 1989, 97–99, 111–24, 141–49.

13. Here, note especially Ames-Lewis 1981 a; Ames-Lewis 1981 b; Ames-Lewis 1987; Lisa Venturini, "Modelli fortunati e produzione di serie," and "'Copie' da dipinti illustri," in Palazzo Strozzi 1992, 147–70; and Wiemers 1996. The issue of design reproduction and copies in prints around Raphael is no less noteworthy, see Landau and Parshall 1994, 131–43, with a rich discussion.

14. Richter, I, 303, § 485 (cf. Richter, *Commentary,* I, 326): "Il pictore debbe prima · suefare · la mano col ritrarre · disegni · di mano di bō maestro . . .;" and *Codex Urbinas Latinus* facsimile in McMahon 1956, II, fol. 34 recto (McMa-

hon 1956, I, no. 61). Cf. Cennini 1995, cap. xxvii–xxviii, 27–28 (cf. Cennini 1960, 14–15, for trans.).

15. Here, my translation is deliberately free to capture the spirit of the text. See Vasari 1966–87, III (testo), 538: "... Sono alcuni disegni di sua mano nel nostro libro fatti con molta pacienza e grandissimo giudizio, in fra i quelli sono alcune teste di femina con bell'arie et acconciature di capegli, quali per la sua bellezza Lionardo da Vinci sempre imitò...."

16. On Vasari as a collector of drawings and his *Libro de' disegni,* cf. Otto Kurz, "Giorgio Vasari's *Libro de'disegni,*" Parts 1 and 2, *Old Master Drawings,* XII (1937), Part 1 (June), 1–15, Part 2 (Dec.), 32–44; Ragghianti Collobi 1974; Licia Ragghianti Collobi, "Ancora sul Libro de'disegni di Giorgio Vasari," *Critica d'Arte,* XII (1976), 44–48; Licia Ragghianti Collobi, "Aggiunte per il Libro de'disegni del Vasari," *Critica d'Arte,* XLII (1977), 154–56; Licia Ragghianti Collobi, "Vasari Collezionista," *Critica d'Arte,* L (1985), 84–85; Wohl 1986, 537–68; and George R. Goldner in Metropolitan Museum of Art 1997, 99–101, 111–17, 298–306.

17. The date of Ser Piero da Vinci's move to Florence is posited on the basis of the *portata del catasto* filed in 1469 by Ser Piero and Francesco di Antonio da Vinci, Ser Piero's brother. Cf. Nino Smiraglia Scognamiglio, *Ricerche e documenti sulla giovinezza di Leonardo da Vinci (1452–1482),* Naples, 1900, 25–29, 134–36, doc. nos. V–VII; Beltrami 1919, 2–3, doc. nos. 3–4; and Brown 1998, 1–73.

18. Cf. further Smiraglia Scognamiglio 1900 (as in note 17), 144, doc. no. XV; Beltrami 1919, 3, doc. no. 5; and Wackernagel 1981, 300. On artists' *"matricole,"* see Chapter One (note 180), as well as Mather 1948, 20–65, where it is pointed out that membership in the *"compagnia"* often meant previous membership in the guild. This subject requires much further research.

19. This is posited on the basis of the famous *"tamburazioni"* accusing Leonardo of sodomy on 9 April and 7 June 1476, documents that refer to Leonardo as *"sta con* Andrea del Verrocchio" and *"manet cum* Andrea del Verrocchio." Cf. Smiraglia Scognamiglio 1900 (as in note 17), 145, doc. nos. XVI, XVII; Beltrami 1919, 4–5, doc. nos. 8, 9; Valentiner 1930, 43–89; and Brown 1998, 123–45.

20. Verrocchio's drawing, Louvre inv. RF 2 recto, Paris. Data: 158 × 209 mm.; pen and brown ink. Cf. Adorno 1991, 154, 269–70; Antonio Natali in Uffizi 1992, 132–33, no. 6.5 (illustrated in color); Wiemers 1996, 137–39; and Butterfield 1997, 15, 185, 253. Leonardo's drawing, Royal Library inv. 12562, Windsor. Data: 205 × 152 mm.; charcoal partly reworked in pen and brown ink. Cf. Clark and Pedretti 1968, III, 291, no. 12562 recto; Kemp and Roberts 1989, 86, no. 29 (illustrated in color); and Popham 1994, 140, no. 181.

21. See, for example, the sheet portraying three sketches for a child with a lamb (J. Paul Getty Museum 8-6.GG.725 recto, Los Angeles). Data: 203 × 138 mm.; black chalk and pen and brown ink. Cf. George R. Goldner, "Acquisitions 1986," *J. Paul Getty Museum Journal,* XV (1987), 202–3, no. 84, as well as Goldner and Hendrix 1992, 64–67, no. 22.

22. Among the relevant examples in these pages is Metropolitan Museum of Art 1972.118.252, New York. Data: 274 ×

198 mm.; pen and brown ink, over leadpoint or black chalk, on buff laid paper washed red-pink. Cf. Georg Gronau, "Über das sogenannte Skizzenbuch des Verrocchio," *Jahrbuch der Königlich Preussischen Kunstsammlungen,* XVII (1896), 65–72; Popham and Pouncey 1950, I, no. 56; Bean 1982, 93–94, no. 82; Ames-Lewis and Wright 1983, 140–43, no. 25; and Chantilly 1997.

23. This translation is quoted from Gilbert 1980 a, 156. The passage is from the sermons on the psalm *Quam bonus,* first published in Florence in 1493 (cf. passage given in Prato edition, 1846, 489).

24. On Vasari's notions of *disegno* and Michelangelo, see Rubin 1995, 244–46. Regarding Michelangelo's apprenticeship, see document discovered and transcribed by Jean Cadogan (Cadogan 1993, 30–31; Cadogan 1996, 89–96). Cf. Vasari 1962, I (testo), 6–7, II (commento), 70–74, for the *ricordo* of the contract between Lodovico Buonarroti and Domenico and David Ghirlandaio. Cf. Charles de Tolnay, *The Youth of Michelangelo,* Princeton, 1943, 14–17, 51–52, and revision in Cadogan 1993, 30–31. On Ghirlandaio's working methods, cf. Rosenauer 1969, 59–85; Rosenauer 1972, 187–196; Ames-Lewis 1981 b, 49–62; Cadogan 1983 a, 274–290; Cadogan 1983 b, 27–62; Cadogan 1984, 159–72; Cadogan 1987, 63–75; and Cadogan 1994, 63–72; as well as Chapters Six, Seven, and Eleven.

25. Vasari 1962, I (testo), 9: "... Contrafece ancora carte di mano di varii maestri vechi, tanto simili che non si conoscevano...."

26. *Codex Urbinas Latinus* facsimile in McMahon 1956, II, fol. 39 verso (McMahon 1956, I, 51, no. 77): "Dico alli pittori che mai nessuno debbe imittare la maniera de l'altro perche sarà detto nipote è non figliolo della Natura in quanto al'arte...." Cf. trans. in Leonardo, *On Painting,* 193–94.

27. Transcription in Richter, I, 371–72, § 660 (cf. Richter, *Commentary,* I, 371): "perchè tutti imitavano le fatte pitture ... e così di secolo i[n] secolo I[n] secolo a[n]do declina[n]do I[n]sino...." Cf. trans. in Leonardo, *On Painting,* 193.

28. Leonardo's opinion is recorded in the posthumously compiled *Codex Urbinas Latinus* (fols. 44 recto-verso, 106 verso–107 recto). *Codex Urbinas Latinus* facsimile in McMahon 1956, II, fol. 44 recto-verso (McMahon 1956, I, no. 86): "Sommo diffetto, e ne maestri li quali usano replicare li medesimi moti nelle medesime storie vicini l'uno a l'altro e similmente le bellezze de visi elsere sempre una medesima le quali in Natura mai si trova essere replicate in modo che se tutte le bellezze d'equale eccellentia ritornassin[o] vive esse sarebon maggiore numero di populo che quello ch'al nostro seculo si trova e si come in esso seculo nesuno precisamente si somiglia il medesimo interverebbe nelle dette bellezze...." Ibid., II, fols. 106 verso–107 recto (McMahon 1956, I, no. 384): "D'attitudine, e mouimenti e loro membra/Non sia replicato li mededesimi (sic) mouimenti in una medesima figura, che le sua membra, o' mani, o' dita, ne ancora si replichi le medesime attitudini in una storia e' se la storia fusse gran-

dissima com' e' un zuffo od ucisione di soldati doue non e' nel dare seno tre, modi cio' è una punta un reiverso e' un fendente ma in questo caso tu te hai a' ingegnare. . . ." See also ibid., II, fol. 44 recto (McMahon 1956, I, no. 274): "Del difetto che hanno li maestri a' replichare le medessi [m]e attitudini de uolti; Sommo diffetto, é ne maestri li quali usano li medessime moti nelle medesime storie uicine l'uno a l'altro e similmente le bellezze de uisi essere sempre una medesima le quali in Natura mai si trova." Cf. partial translations in Leonardo, *On Painting,* 204, 220.

29. Louvre inv. 2347, Paris (not in CBC). Data: 136 × 115 mm. maximum (silhouetted sheet; mounted onto secondary paper support, 168 × 141 mm.), metalpoint, reworked with pen and brush and brown ink wash, highlighted with white *gouache,* on brownish blue prepared paper; outlines selectively pricked and rubbed with pouncing dust. The height of the child's head is 121 mm. Cf. Berenson 1938, II, no. 1067; Nathan 1990, 21; Kemp 1992, 75, no. 19; and Jaffé 1994, IV, 167.

30. Devonshire Collection inv. 308/14.22, Chatsworth (not in CBC). Unfortunately, I have not been able to study this sheet recently and thus rely on the technical data published in Nathan 1990, 20–25; Kemp 1992, 77, no. 20; and Jaffé 1994, IV, 167, no. 881: 297 × 220 mm. maximum sheet, silverpoint on prepared paper.

31. As rightly proposed by Johannes Nathan (1990, 25–26), Boltraffio may have derived his copy by holding Leonardo's drawing against the light and tracing it. This method of tracing is described in Alessandro Paganino's embroidery patternbook. See Paganino c. 1532, *Proemio, "Alessandro Paganino al Letore,"* unpag., fols. 3 recto and verso.

32. See transcription in Richter, II, 363–64, § 1458 (cf. Richter, *Commentary,* II, 349–50).

33. Louvre inv. RF 5635, Paris (not in CBC; apparently unpublished). Data: 430 × 253 mm. maximum (silhouetted sheet, mounted onto secondary paper support), metalpoint, reinforced with brush and brown ink wash, highlighted with white gouache, on blue-gray prepared paper; outlines pricked. Dominique Cordellier kindly brought this unusual drawing to my attention (March 1997).

34. For a discussion, bibliography, and illustration of this fresco in color, see Marco Carminati, *Cesare da Sesto. 1477–1523,* Milan and Rome, 1994, 154–58. The Louvre drawing inv. RF 5635, originally from the Vallardi collection, and its correspondence to the fresco has gone hitherto unnoticed.

35. Documents are transcribed in Dalli Regoli 1966, 90–93.

36. Uffizi inv. 192 F, Florence (not in CBC). Data: 192 × 267 mm. maximum (corners cropped), pen and dark brown ink, brush and brown wash, with cream *gouache* highlights, over finely outlined *spolvero* underdrawing. The latter is especially evident on the ear, eyebrows, and hands of the child. Drawn with very fine, short, intermeshed, parallel strokes of the pen, this highly finished drawing was probably a much used *exemplum* in Credi's workshop, as it approximates in design the infant Christ in a number of extant panels.

37. Uffizi inv. 14507 F, Florence. Revised data: 172 × 132 mm.;

leadpoint, charcoal, highlighted by slightly abrading the ground preparation, possibly over *spolvero* underdrawing, on off-white paper prepared beige; selectively pricked outlines, rubbed with black pouncing dust on upper part of drawing. Bernard Berenson first unconvincingly published the Uffizi sheet as "Alunno di Benozzo" (a fictitious master now identified with Benozzo's sons, Francesco or Alesso; see Chapter Six, note 239), but changed his mind to "Lorenzo di Credi." Cf. Berenson 1938, II, 264, no. 1892; and Berenson 1961, 442, no. 1892. Degenhart and Schmitt 1968, 497, I-2, fig. 683, published the sheet as "Nachfolge Gozzolis." With much reason, Gigetta Dalli Regoli has retained the attribution to Lorenzo di Credi or workshop. See Dalli Regoli 1966, 105, no. 11.

38. The connection of the drawing (Uffizi inv. 14507 F, Florence) to the panel in the Galleria dell'Accademia (Venice) has gone unnoticed. On the Venice painting, with the attribution to the "Master of S. Spirito," see Fahy 1976, 194; and Cecilia Filippini in Palazzo Strozzi 1992, 122–23, no. 3.8. The *oeuvre* of the so-called "Master of S. Spirito" has convincingly been identified by Anna Padoa Rizzo with that by Donnino and Agnolo di Domenico del Mazziere on the basis of documents. See Padoa Rizzo 1988, 125–68; Padoa Rizzo 1991 b, 53–63; Anna Padoa Rizzo in Palazzo Strozzi 1992, 114–15, "I del Mazziere;" as well as Monbeig Goguel 1994, 111–29, all studies with further bibliography. In my opinion, however, two facts are not sufficiently emphasized in the literature, as it presently stands: (1) the impact of Lorenzo di Credi on the "Master of S. Spirito" (evident from a number of sensibly attributed drawings and paintings in the circle of Lorenzo di Credi, as published in Dalli Regoli 1966), which thus requires some explanation, and (2) the overlapping *oeuvre* of the so-called "Tommaso," another follower of Lorenzo di Credi, which is yet to be more clearly distinguished in some aspects from that of the "Master of S. Spirito." See further, note 39. On the enormous corpus of painted replicas in Lorenzo di Credi's workshop, see Dalli Regoli 1966 and Anabel Humphreys, "Credi, Tommaso, and a York Tondo," *City of York Art Gallery Preview,* 1969, 787–91.

39. An excellent summary of the attribution history of the Munich panel is given in Rolf Kutzen, *Alte Pinakothek München: Katalog V. Italienische Malerei,* Munich, 1975, 58–59. Cf. discussion in Brown 1998, 126–36. The similarity of the infant's type in this panel and that in our drawing (Uffizi inv. 14507 F, Florence; CBC 47) offers a further and important reason why the connections of the "Master of S. Spirito" (the Del Mazziere) to the Lorenzo di Credi workshop cannot be dismissed.

40. Related small-scale drawings are in the Musée Bonnat inv. 1236, Bayonne; Uffizi inv. 1197 E, Florence; and Louvre inv. 1792, Paris (Dalli Regoli 1966, 102–3, nos. 3, 5, 7, figs. 4, 6, 8). Related paintings are the *Madonna and Child* in the Cleveland Museum of Art; (reversed design) *Madonna and Child with Infant St. John* in the Staatliche Kunstsammlungen, Dresden (Dalli Regoli 1966, 103–4, nos. 8, 9, figs. 11, 14, 18, 19, 21). On Lorenzo's *Madonna* cartoons, see also

note 110 (in this chapter), and Chapter Seven, notes 116, 130–32, as well as Petrioli Tofani 1986, 214–15, no. 476 E, and Petrioli Tofani 1987, 728, no. 1772 E.

41. Transcription in Richter, I, 321, § 531 (cf. Richter, *Commentary*, I, 335): "Del modo del bene i[n]parare a me[n]te. . . ." Cf. *Codex Urbinas Latinus* facsimile in McMahon 1956, II, fol. 37 verso (McMahon 1956, I, no. 66), and trans. in Leonardo, *On Painting*, 206.

42. See Leonardo's note in *Codex Atlanticus*, fol. 119 verso a, transcribed in Richter, I, 119, § 20 (cf. Richter, *Commentary*, I, 115): "Il pittore che ritrae per pratica e givditio d'o-chio, sanza ragione è come lo spechio, che in sé imita tutte le a sé cōtraposte cose sanza cognitione d'esse." Cf. trans. in Leonardo, *On Painting*, 52. See also note from 1490–92 in Paris MS. A (fol. 104 recto), describing a method for tracing an object or a landscape onto glass; transcribed in Richter, I, 317, § 523 (cf. Richter, *Commentary*, I, 333): "Del modo del ritrarre uno sito corretto. . . ."; cf. *Codex Urbinas Latinus* facsimile in McMahon 1956, II, fol. 41 recto and verso, (McMahon 1956, no. 66; Pedretti 1964, 181, no. 90). Regarding this passage, cf. also further Nunes 1615, fols. 70 verso–72 verso, and Veliz 1986, 16–18, since this treatise writer may have had access to Leonardo's notes (beyond what was compiled in the *Codex Urbinas Latinus*), directly or indirectly. On "*giudizio dell'occhio*," see the classic study, Summers 1981, 368–79, to which we should add the evidence from Leonardo's notes and Cinquecento craftsmen's treatises (discussed in Chapter Four).

43. After Leonardo's death in 1519, presumably his pupil, Francesco Melzi, compiled the anthology of his notes in the *Codex Urbinas Latinus* 1270 (Biblioteca Apostolica Vaticana); Leonardo's *Trattato della Pittura* published by Raphael Trichet Dufresne in Paris in 1651, with illustrations by Nicolas Poussin, was based on versions of the Vatican codex.

44. I have much abbreviated the long critical passage that follows. Vasari 1966–87, III (testo), 608: "Aveva Pietro tanto lavorato e tanto gli abondava sempre da lavorare, che e' metteva in opera bene spesso le medessime cose; et era talmente la dottrina dell'arte sua ridotta a maniera, ch'e' faceva a tutte le figure un' aria medesima. . . ." Cf. also discussion in Hiller 1997 a, 223–30, and Hiller 1997 b, 227–38.

45. Vasari 1966–87, III (testo), 610: "Ai quali Pietro rispondeva: 'Io ho messo in opera le figure altre volte lodate da voi e che vi sono infinitamente piaciute: se ora vi dispiacciono e non le lodate, che ne posso?" On Perugino as a painter and draughtsman, cf. Sylvia Ferino Pagden, "A Master Painter and his Pupils," *Oxford Art Journal*, no. 3 (1979), 9–14; Ferino Pagden 1983; Scarpellini 1984; Ferino Pagden 1984; Ferino Pagden 1987, 77–102; Bambach Cappel 1988, Part 2, II:451–61, nos. 323–34; Hiller 1995; Hiller 1997 a; and Hiller 1997 b.

46. See further Hiller 1997 a, 226–28, and diagrams (plates 116a–118b).

47. Vasari 1966–87, III (testo), 599.

48. Christ Church inv. 0122, Oxford. Revised data: 270 × 250 mm.; black chalk, on three glued sheets of paper; pricked outlines appear to be rubbed with black pouncing dust. Cf. Fischel 1917, II:107, no. 42, and Byam Shaw 1976, 34, no. 8.

49. A similar vertical axis of alignment occurs also in Perugino's cartoon from around 1500, portraying a seated bishop saint (Kupferstichkabinett inv. KdZ 5070, Berlin). The design of this cartoon in Berlin recalls that of both a stained-glass window formerly at S. Francesco de' Conventuali in Colle di Val d'Elsa and a larger-scale painted panel of *St. Augustine with Members of the Confraternity of Perugia* (Carnegie Museum of Art, Pittsburgh, Pennsylvania). Cf. Fischel 1917, I: 24, II:27, 99, no. 26, with a reconstruction in Abb. 21; Scarpellini 1984, under no. 119; and Altcappenberg 1995, 176–78, no. 109.

50. For Perugino's oil painting technique in the S. Chiara altarpiece, see especially Hall 1992, 85–91.

51. Further pricked studies by Raphael for the "*Borghese Entombment*" are Ashmolean inv. P II 525 verso and P II 532, Oxford (CBC 241, 242). Cf. Parker 1972, 272–73, 278–79, nos. 525 and 532.

52. Infrared reflectography examination of three of Pietro Perugino's panels comprising the altarpiece originally painted for the Certosa of Pavia (National Gallery, London) offers further evidence of Perugino's repetitions of design. Cf. Davies 1986, 403–7, no. 288; as well as David Bomford and Nicholas Turner, "Perugino's Underdrawing in the *Virgin and Child Adored by an Angel* from the Certosa di Pavia Altarpiece," *Perugino, Lippi e la Bottega di San Marco alla Certosa di Pavia, 1495–1511* (exh. cat., Pinacoteca di Brera, Milan), Florence, 1986). This altarpiece was commissioned by Ludovico Sforza (*"Il Moro"*) from Perugino and Filippino Lippi in 1496; still incomplete in 1499, it was finished by Mariotto Albertinelli around 1511. *Spolvero* marks are visible only in Perugino's central panel, *The Adoration of the Christ Child* – specifically, in the angel who stands on the left in the top register of the composition, and in the larger-scale angel who holds the Christ Child in the foreground (cf. ibid., 54). These are only supporting figures in the composition. Attendant figures of angels are among the typical designs that the artist repeated from composition to composition, and he may have thus used *spolvero* cartoons to abbreviate the labor of painting them. Moreover, variations on the motif of the Virgin in this panel can be related to a great number of compositions by artists under Perugino's influence. For instance, see the partly autograph panels of the *Adoration of the Christ Child* at the Palazzo Pitti, Florence, and at the Museo Cà d'Oro, Venice. Further echoes of the Madonna in the National Gallery panel from the Certosa di Pavia altarpiece appear also in the following works: workshop of Pietro Perugino and Bernardino Pinturicchio, pricked cartoon for the *Adoration of the Christ Child* (British Museum 1895-9-15-594, London; CBC 331.1); workshop of Pietro Perugino, *The Adoration of the Christ Child* mural (Museo di S. Francesco, Montefalco); and Raphael or Bernardino Pinturicchio, pricked cartoon for the *Adoration of the Christ Child on a Saddle* (Ashmolean Museum inv. P II 40, Oxford; CBC 223). An analysis of the under-

drawing types in Perugino's three National Gallery panels reveals that it is highly improbable that a single large cartoon existed for the entire composition. The underdrawings in the other parts of Perugino's National Gallery panels for the Certosa of Pavia altarpiece appear all to be freehand, although this cannot be ascertained beyond doubt, given the physical limitations of infrared reflectography (see Chapter One). For other cases of cartoon reuse by Perugino, see Hiller 1997 a, 223–30; and Hiller 1997 b, 227–38.

53. Louvre inv. 4370, Paris. Revised data: 250 × 185 mm. maximum; point of brush with brown ink and wash, highlighted with white gouache, over metalpoint and black chalk, paper prepared ochre; pricked outlines probably rubbed with black pouncing dust. Cf. Fischel 1917, II:107, no. 41; and Louvre 1983, 9, no. 1. Closest in design to the Louvre cartoon are Perugino's painted *Madonna and Child* panels in the Staedelsches Kunstinstitut, Frankfurt; Musée du Louvre, Paris; and Kunsthistorisches Museum, Vienna (illustrated in Hiller 1997 b, 227–29, figs. 1–3).

54. Uffizi inv. 410 E (fragments A–D), Florence. Revised data: (A) 298 × 221 mm. Christ, (B) 168 × 223 mm. St. John, (C) 239 × 182 mm. St. Peter, (D) 228 × 210 mm. St. James; black chalk, partly reworked with pen and brown ink, on multiple glued sheets of paper; pricked outlines rubbed with black pouncing dust. Cf. Fischel 1917, II:219, no. 138; Ferino Pagden 1982, 65–67, no. 39; and Petrioli Tofani 1986, 183–84, *sub numero*. On this artist, see Fausta Gualdi Sabatini, *Giovanni di Pietro detto lo Spagna,* Spoleto, 1984, with new data on his birth and death dates (ibid., 365, 95, document nos. 1, 50).

55. Cf. Davies 1986, 495–96, no. 1032.

56. Cf. Ferino Pagden 1982, 66. A further reprise of Perugino's *Agony in the Garden* is in the Palazzo Pitti (Florence).

57. Cf. Ferino Pagden 1982, 65–67, no. 39, and Gualdi Sabatini (as in note 54), 304–5, nos. 80–83.

58. Cf. Davies 1986, 496–97, no. 1812.

59. Cf. Vasari 1966–87, III (testo), 613, and Ferino Pagden 1982, 67.

60. Here, see further Vasari 1966–87, III (testo), 611–14.

61. Cf. Glasser 1977; Thomas 1995, 101–48; O'Malley 1994, 100–27, 156–64; O'Malley 1996, 692; Welch 1997, 103–29; and Kemp 1997, 32–78.

62. Cf. Baxandall 1972, 20; Glasser 1977, 64–71; Fabrizio Mancinelli in Vatican 1984, 286–96, no. 108; O'Malley 1994, 156–64; Thomas 1995, 137–40, 245; and O'Malley 1996, 692.

63. This point is rightly made in O'Malley 1994, 156; and O'Malley 1996, 692.

64. See "Lo Spagna"'s contract transcribed in Glasser 1977, 66: ". . . facere picturam de auro cum coloribus et aliis rebus ad speciem et similitudinem tabulae factae in Ecclesia Sancti Jeronymi de Narne," dated 12 September 1507.

65. Beltrami 1919, 65, no. 106.

66. Ibid., 65–67, no. 107. The phrase *"fano retrati"* has traditionally been interpreted as "making copies" (cf. Kemp 1989, 215). The sense of this passage is admittedly difficult, and the phrase may well refer to copies being made of Leonardo's famous cartoon depicting the *Virgin and Child with St. Anne and a Lamb.*

67. These documents are transcribed in Sironi 1981. Cf. discussions in William S. Cannell, "Leonardo da Vinci – *The Virgin of the Rocks.* A Reconsideration of the Documents and a New Interpretation," *GBA,* CIV (1984), 99–108; Kemp 1981, 93–97; Martin Kemp, "Clark's Leonardo," in Clark 1988, 30–31; Thomas 1995, 220–22; and Kemp 1997, 44–45.

68. Transcription in Sironi 1981, 23–24, doc. VII. Cf. also Kemp 1997, 45.

69. Some of the numerous extant variants of the composition of the *Virgin of the Rocks* are reproduced in Angela Ottino della Chiesa, *L'Opera completa di Leonardo pittore,* Milan, 1967, 93–96, nos. 15–16. See further, Chapter One, on Leonardo's inconstant use of cartoons for easel paintings, which were not portraits.

70. This letter is quoted in P. Beroqui, *Tiziano en el Museo del Prado,* Madrid, 1946, 122, and Shearman 1992 a, 7 (note 10). The clearest evidence in a Spanish source for the meaning of *"patrón"* as pricked cartoon is Francisco Pacheco, *Arte de la pintura, su antigüedad, y grandezas* (MS. 1638, published in Sevilla, 1649; Pacheco 1956, II, 52–3): ". . . antes de debuxar lo que se ha de pintar o de *estarcir* [to pounce] el patrón que se hubiere hecho para el efecto, que es lo mas seguro. . . . Después de *estarcido* [pounced] o debuxado. . . ." (Italics are mine for emphasis.) For other references and discussion, see Bambach Cappel 1988, Part I, I:161–64. On the Latin root of the word *"patron,"* cf. Du Cange, VI, 220–21, *sub voce.*

71. Cf. *Tecnica e stile* 1986, II, plates 183–88; Bambach Cappel 1988, Part I, I:278; and contributions by Giovanna Nepi Scirè, Francesco Valcanover, Ettore Merkel, and Paolo Spezzani et al. in *Titian Prince of Painters* 1990, 109–30, 135–40 (nos. 1a and b), 154–55 (no. 6), 202 (no. 20), 337–400. The only cartoons by Titian referred to in Vasari's *Vita* of the artist are for mosaic; see Vasari 1966–87, VI (testo), 173.

72. Archivio di Stato, Florence, under Chiesa di S. Jacopo a Ripoli, *Libro di Ricordanze Segnato D, no. 116,* fol. 1 on the left, as transcribed by Daniela Mignani Galli in Bemporad 1977, 23 (note 15): "Inoltre nel medesimo anno 1589, dalla parte destra del detto altare, nella facciata della detta chiesa di drento dove era il crocifisso sopranominato, si fece dipignere di sua propria mano l'eccellente pittore maestro Alessandro Allori, detto il Bronzino; e la Madonna esatta in cui lo spolverezzo della nunziata qui di Firenze, la quale è tanto celebre e nominata, langelo eal quanto di verso da quello e massimamente nel vestito: tutto laltro ornamento e di pintura intorno alla nuntiata eallangelo insino in terra, lo fece Cesare Veli." Cf. ibid., 23, for discussion. I am greatly indebted to Anna Padoa Rizzo and Lisa Venturini for bringing to my attention this document, which has gone unnoticed in the literature on Allori. They point out that only very small traces of this fresco decoration are still extant. On Allori's habitual use of *calco* to transfer cartoons for fresco painting, see further, Chapter Eleven.

73. Both of these documents are quoted in Nicole Reynaud,

"Un peintre français cartonnier de tapisseries au XVe siè-cle: Henri de Vulcop," *Revue de l'Art,* no. 22 (1973), 7–21 (21, note 46). Cf. Scheller 1995, 74 (note 209). On the ety-mology and meaning of *"patron,"* cf. Diderot and d'Alem-bert 1751–65, XII, 185, *sub voce;* Du Cange, VI, 220–21, *sub voce;* and Zanardi and Frugoni 1996, 32–38, 56 (notes 41–59); on that of *"poncis,"* cf. Bambach Cappel 1988, Part 1, I:44–45, with further bibliography.

74. Document transcribed in Rosso del Brenna 1976, 390: ". . . Papeles de dibujos, llamanse espulburio. Ytem, veinte y dos pedaços de papeles de dibujos que se llaman espul-varos por que estan picados con alfileres para echar polbo para pintar, son tocantes a las obras de Su Magd. pusieronse a nombre quinto." For a rare pricked drawing by "Il Bergamasco," albeit in small scale, see his *Christ in the Temple* (British Museum 1989-7-22-45, London; unpublished). Data: 302 × 199 mm., pen and brown ink, brush and brown wash, over black chalk, squared in red chalk, glued onto secondary paper support.

75. Carlo Ridolfi, *Le Maraviglie dell'arte.* I, Venice, 1648, I, 275: ". . . Ritiratosi à Brescia d'anni 18. si pose di nuouo in pratica col Romanino, da cui ottene vna figliuola in moglie, ricevendo in dotte alcuni spolueri, e la rinontia delle pitture delle case assegnategli dal comune. . . ." On Romanino's fresco technique, cf. Chini 1988, and Nova 1994.

76. Note, for instance, the fresco in the Church of S. Stefano (Vimercate), dated 1566. See Germano Mulazzani, "An Unpublished Fresco by Lattanzio Gambara," *BM,* CXXX (1988), 28–31, figs. 26, 32, 34, and 37.

77. Pacheco 1956, II, 76–77. On this treatise, cf. Calvo Ser-raller 1981; Gross 1984, 9–27; and Sanz 1990, 93–116.

78. Michelangelo, *Carteggio,* III, 380–81: ". . . Sappiatte che di quello chartone n'arò a fare 3 de le Lede . . . ," and discus-sion in Chapter Seven.

79. Hirst and Dunkerton 1994, 83–133, with further bibliog-raphy.

80. Cennini 1995, cap. xxiii, 24 (cf. Cennini 1960, 13, for trans.): "per ritrarre una testa o una figura o una mezza figura. . . ."

81. Of the corpus of pricked and pounced drawings that I previously gathered for my Ph.D. thesis (Bambach Cappel 1988), all too many appear to relate to the production of copies, rather than to functional steps in the creative process. Such data serve as a cautionary reminder of the *spolvero* technique's actual role in Renaissance workshop practice, for artists of the first rank and drones incapable of *"inventione"* relied on it.

82. See techniques of copying described in Nunes 1615, fols. 61 v–72 v, and Veliz 1986, 16–18.

83. See further Chapters One and Eight.

84. Pozzo 1693–1700, II, unpaginated, Settione Settima, *"Ricalcare:* Stabilita che sieno i contorni del disegno in carta grande, come habbiamo detto, si sopraporrà sopra l'intonaco, che per la sua freschezza sarà atto a ricevere ogni impressione: & allora con una punta di ferro andarete legermente premendo i contorni. Ne disegni di cose pic-cole basterà fare uno spolvero, che si fà con far spessi, e

minuti fori ne'contorni con sopra porvi carbone spolver-izato legato in un straccio, che sia atto a lasciar le sue orme meno sensibile. Cio da'Pittori si chiama spolverare." Cf. Bambach Cappel 1988, Part 1, I:149–52, II:365.

85. Milizia 1827, II, 231 (first ed. Bassano, 1797): *"Cartoni. . . .* Sull'intonaco ancora molle si puo con una punta delin-eare il contorno delle figure, seguendo esatamente la estremita del cartone ritagliato. Se le figure sono numerose, si descrivano con fori nel cartone tutti i con-torni della composizione, ed applicato il cartone al muro, vi si fa passar sopra un sacchetto di polvere minutissima di carbone, la quale attraversando i fori lascia sull'intonaco la traccia che seguire deve il pittore." Cf. Bambach Cappel 1988, Part 1, I:25–26.

86. See Boutet 1676, 6, and its translation, *Art of Painting in Miniature* 1752, 4. Cf. further Bambach Cappel 1988, Part 1, I:171–72 (notes 328–29), II:331–32.

87. Kemp 1990, 180, 353 (note 28).

88. Here, note also the practices by G. A. Canini as recorded by Richard Symonds in Beal 1984, 199–200. It was possible to counterproof ink drawings, but this was more compli-cated. Cf. Meder and Ames 1978, 399–400, 406 (note 72).

89. Palomino 1724, Book VI, Chapter V:ii, 76–77: "Y esto de los cartones es muy preciso, quando se han de repetir las cosas a el lado contrario, o a el revés; porque estando picado el cartón, en bolviéndole, y estarciéndole, se halla hecho sin trabajo." My translation is freer than the original text, and my rendition of *"a el lado contrario"* as "on the other side" is based on the fact that surely Palomino did not mean his phrase to be redundant with that following, *"o a el revés."*

90. Hübner 1762, 431, in description of pouncing [under *"cal-quer"*]: "Wenn man an statt, dass man also ein Stueck ueberfahret, den Riss ueber alle Umrisse mit den *Points* nach und nach piquiret, und sie hierauf mit Kohlstaub rei-bet, so heisset solches *poncer* oder *polliren,* und die Risse, welche auf der gleichen Art piquiert sind, nennet man *poncis,* und solche dienen zur Befertigung der *gleichen Wer-cke mehr als einmahl."* (Italics are mine.)

91. Armenini 1587, 78 (cf. Armenini 1977, 149, for trans.).

92. Cennini 1995, cap. cxlii, 144 (cf. Cennini 1960, 87, for trans.): "Fa' i tuoi modani, che rispondano bene ad ongni faccia. . . ." Note that the term is transcribed as *"spolver-izzi"* by Daniel V. Thompson in Cennini 1932, 84. Cf. Bambach Cappel 1988, Part 1, II:367–70.

93. Paganino c. 1532, *Proemio, "Alessandro Paganino al Letore,"* unpag., fol. 3 recto and verso.

94. Saint-Aubin 1770 (cf. Saint-Aubin 1983, 35, for trans.), under *"poncer sur le doux."*

95. The Metropolitan Museum of Art, Robert Lehman Col-lection, 1975.1.409, New York. On the problematic attri-bution, see Chapter Two, note 149. I am indebted to Mar-garet Lawson and Laurence B. Kanter for the opportunity to study this drawing in the paper conservation laboratory of the Metropolitan Museum of Art.

96. A number of pricked drawings attributed to Bartolomeo di Giovanni and Raffaellino del Garbo also exhibit such alternative halo designs, but rarely are both alternatives pricked as in the "Botticini" drawing.

97. Uffizi inv. 10 E recto, Florence. Revised data: 252 × 141 mm.; pen and brown ink, brush and brown wash, over traces of black chalk. Cf. Uffizi 1986, 35, no. 19; and Petrioli Tofani 1986, 5, *sub numero* (as Agnolo Gaddi). The process of printing the image would have suitably returned the design to its original orientation, with the figure's correct, right-handed gesture of blessing.

98. Formerly National Gallery inv. 213 A, now British Museum 1994-5-14-57, London. Revised data: 183 × 215 mm.; pen and brown ink, over traces of black chalk underdrawing (and possibly stylus); pricked outlines and pricked plumbline lightly rubbed with charcoal pouncing dust from the recto (evident only as a faint, even gray tone), and also heavily rubbed with black chalk pouncing dust from the verso. The evidence on the verso of the sheet became visible when the drawing was removed from its secondary paper support. I am indebted to Nicholas Penny and Eric Harding for inviting me to study this drawing with microscopic magnification in the conservation laboratory of the National Gallery, London (3 June 1993). Cf. Gere and Turner 1983, 35, no. 15; Joannides 1983, 141, no. 31; and Knab, Mitsch, and Oberhuber 1983, 564–65, no. 93.

99. Uffizi inv. 16356 F, Florence. Cf. Ferino Pagden 1982, 131, no. 80. For other examples of pricked drawings attributed to this artist, see CBC 340–43.

100. A telling example, in this respect, is a small drawing by Francesco d'Ubertino "Il Bacchiacca" (CBC 309), which reveals Perugino's influence; Uffizi inv. 1926 F, Florence. Data: 231 × 111 mm.; black chalk. The outlines of the small standing satyr and the goat he carries on his shoulders are pricked. Those of the lightly outlined rocks in the background, however, as well as those comprising the stylus-constructed, oval frame, drawn in gray ink, are not pricked. These are the elements that lend Bacchiacca's motif a specific context. The verso of Bacchiacca's sheet is heavily rubbed with black pouncing dust, the recto only slightly so. Moreover, a copyist attempted to connect some of the pricked holes – one by one, with a dark brown ink – from the verso.

101. Biblioteca Apostolica Vaticana, *Codex Capponi 237,* fol. 20 recto. Cf. Vatican 1984, 296–99, nos. 109–12. Raphael's composition is best exemplified in a drawing (Ashmolean Museum inv. P II 565, Oxford). Cf. Parker 1972, 307–8, no. 565.

102. The engravings are Bartsch XV.189.9, and Bartsch XIV.64.56.

103. See further, Chapter Six. Cf. also Creighton E. Gilbert, *Change in Piero della Francesca,* Locust Valley, 1968, 72; Summers 1977, 59–88; Borsook 1980, 96; and Battisti 1992, I, 54–55, 136, 279 (figs. 75–76, 87, 200); II, 441–77, 528–30, nos. A.7, A.18.

104. Borsook 1980, and oral communication by Eve Borsook (summer 1994).

105. Max Seidel gave detailed and convincing proof of this. See Seidel 1984, 181–256 (especially 226, 239, plates 68–70, for corresponding outlines). Other examples of reuse, however, are put forth more tentatively and with no comparisons of measurements. The suggestion that Signorelli reused the hands of saints in the Bichi Chapel altarpiece (Gemäldegalerie, Berlin) for figures in the *Sacra Conversazione* (Pinacoteca Civica, Volterra) is unconvincing (ibid., 234–35). Also, whether the man to the right in the *Pan* (destroyed; formerly, Kaiser Friedrich Museum, Berlin) and the *St. Jerome* in the Bichi Chapel altarpiece wing (Gemäldegalerie, Berlin) were partly painted from the same cartoon, but in reverse, is difficult to substantiate in view of the disappearance of the *Pan.* On Signorelli's reuse of cartoons in the fresco cyle at Orvieto Cathedral, see Henry 1996, 253–70, although there the reuse of cartoons is considerably freer and is very much a tool for creative design. See further Chapters Nine and Eleven.

106. On this project, cf. Oberhuber 1972, and Quednau 1979. On the Raphael workshop, cf. Dollmayr 1895, 230–63; Marabottini 1969; Oberhuber 1972, 25–50; and John Shearman in Vatican 1984, 258–63.

107. Uffizi inv. 5548 Horne, Florence. Revised data: 246 × 201 mm., stumped charcoal, highlighted with white chalk; outlines pricked and rubbed with black pouncing dust, as well as lightly stylus-incised. Oskar Fischel first proposed the hypothesis of cartoon reversal. Cf. Fischel 1934–35, 484–86; Oberhuber 1972, 198, no. 481c; Sylvia Ferino in Palazzo Pitti 1984, 350–51, no. 40; and Sylvia Ferino in Mantua 1989, 257.

108. Cf. Sylvia Ferino Pagden's observation in Palazzo Pitti 1984, 350, no. 40. The cartoon is glued onto a secondary mount, and its verso is unviewable.

109. I am indebted to the late Fabrizio Mancinelli, as well as to Arnold Nesselrath, for the opportunities to study the wall paintings in the *Sala di Costantino* from temporary scaffolding and for making it possible to make these tracings on clear acetate. Annamaria Petrioli Tofani then kindly permitted me to verify the correspondences of design on the Uffizi cartoon (summer 1990).

110. The coarser of Lorenzo di Credi's cartoons (Fig. 91; Uffizi inv. 1772 E; CBC 50) was preparatory for the central group of the enthroned Madonna and Child in the altarpiece, originally painted for the Church of S. Maria delle Grazie in Pistoia and now in the Museo Civico, Pistoia (Fig. 92). Its design, however, also resembles a *Madonna* formerly in the Schlessisches Museum, Breslau, and the *Madonna* in S. Agata, Florence. We can therefore suppose that the more finely executed of Lorenzo's cartoons (Fig. 29; Uffizi inv. 476 E; CBC 49) served similar purposes: (1) as a preparatory study for an altarpiece, and (2) as means of design reproduction in the painting of workshop replicas. On the two cartoons, see also Chapters Two and Seven (notes 116–18 with technical data), as well as Dalli Regoli 1966, 175, nos. 162–63, with illustrations of the related paintings (figs. 218, 222); Petrioli Tofani 1986, 214–15, *sub numero;* and Petrioli Tofani 1987, 728, *sub numero* (without technical evidence).

111. Giulio Romano's cartoon, Albertina inv. 307 (SR 374, R 93), Vienna. Revised data: 322 × 364 mm.; pen and brown ink, brush and brown wash, over black chalk. Cf. Hartt 1958, 251, 307, no. 352, and Birke and Kertesz 1992–97, I, 176.

112. See further Romano 1982.

113. On the organization of painting as a practice in Venice, see Eva Tietze-Conrat, "An Unpublished Madonna by Giovanni Bellini and the Problem of Replicas in his Shop," *GBA*, XXXIII (1948), 379–82; Hans Tietze, "Meister und Werkstätte in der Renaissancemalerei Venedigs," *Alte und Neue Kunst*, I (1952), 89–98; Michelangelo Muraro, "The Statutes of the Venetian *Arti* and the Mosaics of the Mascoli Chapel," *AB*, XLIII (1961), 263–74; Felton Gibbons, "Practices in Giovanni Bellini's Workshop," *Pantheon*, XXIII (1965), 146–54; Elena Favaro, *L'Arte dei pittori in Venezia e i suoi statuti*, Florence, 1975; Rosand 1982, 1–15, "The Historical Situation of Art in Venice," as well as "The Social Situation of the Artist"; Humfrey 1983, 61–69, section 9, on Cima da Conegliano's workshop; Humfrey 1993, 57–160; and Humfrey 1995.

114. The statistic about the paintings is pointed out in *Giotto to Dürer* 1991, 108, that on the gesso reliefs in Thomas 1995, 92. On Neri's *Ricordanze*, see further Thomas 1995 (especially 59–61, 287–89). On this popular imagery, see Ronald G. Kecks, *Madonna und Kind: Das häusliche Andachtsbild im Florenz des 15. Jahrhunderts*, Berlin, 1988.

115. *Giotto to Dürer* 1991, 108.

116. Thomas 1995, 92.

117. Verspreide Rijkscollecties inv. NK 1924, The Hague. Van Os et al. 1978, 131–35, no. 31, especially figs. 75, 77; and Galassi 1998, 118. Another example of probable *spolvero* use occurs in Squarcione's *Madonna and Child* (Gemäldegalerie, Berlin); Galassi 1998, 117–18, no. 20. Though not mentioned in the technical examination of Van Os et al. 1978, Carlo Crivelli's *St. Ambrose* in The Hague (Dienst Verspreide Rijkscollecties inv. no. NK 1573) also shows what may be dots from *spolvero* beneath the underdrawing; they seem especially apparent around the eye area (cf. ibid., 65–68, no.11, especially fig. 43). *The Madonna and Child with St. Anne and St. John the Baptist* attributed to Giovanni Bellini (Galleria Nazionale delle Marche, Palazzo Ducale, Urbino) may also have been based on a *spolvero* cartoon. Surprisingly, *spolvero* marks can be discerned in the radiograph published by Soprintendenza alle Gallerie e Opere d'Arte d'Urbino, *Mostra di opere d'arte restaurate* (exh. cat., Palazzo Ducale), Urbino, 1968, 68, though the authors did not note this.

118. Chiara Rigoni in *Restituzioni 1991: Quattordici opere restaurate: Catalogo della Mostra* (exh. cat., Palazzo Leoni Montanari, Vicenza), Banca Cattolica del Veneto, 1991, 27–29. I am indebted to Maria Clelia Galassi for pointing out this example.

119. Cf. Meder and Ames 1978, I, 393; Eva Tietze-Conrat (as in note 113); and Galassi 1988–89, 238–52.

120. Examples are two panels from about 1465–70 and 1475–80, respectively; Rijksmuseum inv. A 3287 and A 3379, Amsterdam. See Van Os et al. 1978, 29–34, no. 2 (especially figs. 20–22), and ibid., 35–39, no. 3 (especially figs. 24–26), as well as Galassi 1988–89, 250–52, figs. 164–67. Another such Bellini workshop piece with *spolvero* is Dienst Verspreide Rijkscollecties inv. NK 3384, The Hague. See Van Os et al. 1978, 45–49, no. 6 (especially figs.

31–33), as well as Galassi 1988–89, 252, figs. 168–69. Yet another example is by Pasqualino Veneziano, from the early 1490s, Bonnefantenmuseum inv. 622, Maastricht. See Van Os et al. 1978, 123–27, no. 29 (especially figs. 69–70).

121. Humfrey 1983, 66. Examples are the *Virgin and Child*, possibly by Anton Maria da Carpi (Walters Art Gallery, Baltimore), and Cima's *Madonna* (De Young Museum, San Francisco), ibid., nos. 4 (plate 112a), 131 (plate 111); the *Virgin and Child with a Bishop Saint*, possibly by Filippo da Verona (Accademia, Carrara), and the group in Cima's *Virgin and Child with Sts. Michael and Andrew* (Galleria Nazionale, Parma), ibid., nos. 119 (plate 61), 210 (plate 192a); and Cima's Madonna group (Kunstmuseum, Düsseldorf) and that at the Petit Palais (Avignon), ibid., nos. 45 (plate 18), 3 (plate 19b). Peter Humfrey suggested, tellingly, that it does not seem as if a single assistant was responsible for a whole series of variants after a particular design, as was the case in Giovanni Bellini's shop. Rather, variants appear to have been executed over a period of many years and by whoever was available in the shop. Note also the great number of variants of Cima's *Virgin and Child*, the matrix design being that in the Johnson Collection (Philadelphia Museum of Art): ibid., no. 122 (plate 2), no. 168 (plate 3a), no. 111 (plate 3b), no. 75 (plate 3c), no. 78 (plate 4a), no. 171 (plate 4b), no. 174 (plate 4c), no. 169 (plate 5a), no. 172 (plate 5b), no. 170 (plate 5c), and no. 173 (plate 5d). These may turn out to have also corresponding measurements, if it is ever possible to verify them.

122. Private collection, France. Data: 163 × 114 mm., pen and brown ink, brush and brown wash, highlighted with white gouache, on blue paper; outlines pricked and rubbed with pouncing dust. I am indebted to Annamaria Edelstein, Richard Berman, and Bruno de Bayser for bringing this drawing to my attention. In composition, though not in style, the sheet recalls the small panel by Francesco Zaganelli in the Musée Condé, Chantilly (inv. 22).

123. The fresco comes from the former Ospedale di Orbatello, Via della Pergola. Cf. Lisa Venturini in Palazzo Strozzi 1992, 215–16, no. 8.4 a (with previous bibliography).

124. On Mainardi, cf. Fahy 1976, 215–19, and Venturini 1994–95, 123–83, as well as other studies by Lisa Venturini in *Kermes: Arte e tecnica del restauro*, no. 15 (1988), 41–48, in *Paragone*, no. 23 (487) 1990, 67–76, and in Palazzo Strozzi 1992, 109–13.

125. Cf. Fahy 1976, 215–19; Lisa Venturini, "Modelli fortunati e produzione in serie," Palazzo Strozzi 1992, 150–51 (illustrated in figs. 5–8), 162–63, no. 5.6; and Thomas 1995, 233–35. I am indebted to Lisa Venturini, who discussed with me the problem of the sixteen variant compositions and who pointed out that a further variant in a private collection (examined with infrared reflectography in the Paintings Department, Harvard University Art Museums) was found to have *spolvero*.

126. Cf. McKillop 1974, 129–30, 169, nos. 7 and 36. To my knowledge, infrared reflectography has not been conducted on the panels.

127. Obviously prolific painters of *Madonna and Child* compositions who did not use *spolvero* cartoons to produce them

are Fra Filippo Lippi (c. 1406–69), Andrea Mantegna (c. 1431–1506), Giovanni Bellini (1430s–1516), Sandro Botticelli (c. 1445–1510), Neroccio dei Landi (1447–1500), Matteo di Giovanni (1452–95), Filippino Lippi (1457/8–1504); Raffaellino del Garbo (c. 1466/70–after 1527); Francesco Raibolini "Il Francia" (doc. 1482–1517/18), and Francesco d'Ubertino "Il Bacchiacca" (1495–1557). For these artists, the examples examined with infrared reflectography were all drawn from the collection of the Metropolitan Museum of Art; it was conducted by Maryan W. Ainsworth, whose expertise and generosity have been invaluable for this project. Everett Fahy and Keith Christiansen kindly made many arrangements on my behalf and have patiently supported this research. See further, Chapter Six.

128. On the *Madonne* in Washington, cf. Brown 1983 and Christensen 1986, 47–54; on those in the Palazzo Pitti and Uffizi, cf. Palazzo Pitti 1984, 238–68, and Marco Chiarini, "Paintings by Raphael in the Palazzo Pitti, Florence," *The Princeton Raphael Symposium* 1990, 79–83, figs. 98–101, 249–74; and on the *"Madonna in the Meadow,"* cf. Wolfgang Prohaska, "The Restoration and Scientific Examination of Raphael's *Madonna in the Meadow,*" *The Princeton Raphael Symposium* 1990, 57–64.

129. On the conservation of the painting, cf. von Sonnenburg 1983, 12–14, and von Sonnenburg 1990, 65–78, figs. 77–97, 237–48. The discovery, and recovery, of the eight flying *putti,* which Raphael originally painted in the upper register, necessitate a dramatic rereading of the painting's composition. Although the infrared reflectograms were published as evidence that Raphael used a *calco* or stylus-incision technique (the "carbon paper" method), it seems to me that dots from *spolvero* are evident on the children's figures in the reflectogram details. The sometimes faltering, dark outlines seen in such details are the strokes connecting the *spolvero* dots, which explains the traced appearance of the outlines. I am indebted to Hubert von Sonnenburg for having made available to me a large selection of these infrared reflectograms.

130. Cf. Dunkerton and Penny 1993, 7–21; as well as Penny 1992, 67–81.

131. Chapters Nine and Eleven will evaluate further the advantages and disadvantages of such technique in the context of design variations. The following drawings, stylus-incised for transfer, sometimes included in the Raphael corpus should in my opinion be excluded as autograph: Uffizi inv. 1775 E, Florence (which I think is a counter-proof taken from the oil painting on panel of the *"Small Cowper Madonna,"* National Gallery, Washington), and British Museum 1868-8-8-3180 (which is probably Parmese, rather than Roman – close to Correggio, Parmigianino, or Anselmi). Raphael's frescos beginning with the *School of Athens,* invariably show evidence of stylus incisions, frequently combined with *spolvero.*

132. Cf. remarks in Fredericksen 1990, 99–109, Hiller 1997 b, and Hiller 1998.

133. Ashmolean Museum inv. P II 520, Oxford. Revised data: 275 × 228 mm.; pen and brown ink, brush and brown wash, with traces of white gouache highlights, over traces of charcoal or black chalk; squared with stylus at approximately 23 mm. intervals; pricked outlines rubbed with pouncing dust. Cf. Parker 1972, 268–69, no. 520; Joannides 1983, 170, no. 154; Knab, Mitsch, and Oberhuber 1983, 578, no. 242 (illustrated).

134. Regarding the panel in the Museo del Prado, Madrid (dated 1507), see Maria del Carmen Garrido, "Consideraciones técnicas sobre las pinturas de Rafael del Museo del Prado," *Rafael en España* (exh. cat. Museo del Prado, Madrid), Madrid, 1985, 87–95, with an excellent summary of the technical evidence. Although not noticed as such, *spolvero* dots (distorted by the overpainted outlines) are clearly discernible in Garrido's figures 10 and 11, showing infrared reflectogram details of St. Joseph and the Virgin. It should be emphasized that the presence of *spolvero* underdrawing always gives any drawn or painted outlines done on top a telltale broken-up appearance. On the panel in the Musée des Beaux-Arts, Angers see Jean-Pierre Cuzin in Grand Palais 1983, 114–117, no. 18. At a symposium organized by Nicholas Penny in the Ashmolean Museum, Oxford (30 June 1989), "From Cartoon to Painting: Raphael and his Contemporaries," it was possible for me and others to study the Lee Collection panel at length, vis-à-vis the Ashmolean cartoon. I would reject an attribution to Raphael himself, on the grounds of quality, although this is, of course, partly a subjective decision. Cf. Jürg Meyer zur Capellen, "Raffaels *Heilige Familie mit dem Lamm,*" *Pantheon,* XLVII (1989), 98–113; and Jürgen M. Lehman, *The Holy Family with the Lamb of 1504: The Original and its Variants,* (exh. cat., Museum Fridericiarum, Kassel), Landshut, 1995 (both studies with color illustrations of the Prado and Lee paintings).

135. Cf. Meyer zur Capellen (as in note 134), 104–6, figs. 7, 8, and 9.

136. Cf. ibid., 108. But, as pointed out in Chapter One, infrared reflectography as a scientific means of investigating underdrawing does have limitations. There do appear to be signs of *spolvero* underdrawing in the Prado panel (see note 134).

137. This is clearly visible in ibid., 98–113, figs. 6–8.

138. British Museum 1894-7-21-1, London. Revised data: 708 × 533 mm. maximum (including a strip 45 mm. wide added on the left by an early restorer); charcoal, reinforced with black chalk, traces of lead-white chalk highlighting, on two glued sheets of paper. Cf. Pouncey and Gere 1962, 22, 26, and Gere and Turner 1983, 145–46, no. 119. It is not entirely clear whether the stylus incisions are from design transfer, for they may also be the result of the artist's attempts at clarifying the repeatedly reinforced outlines drawn in charcoal and black chalk. The drawing has heavily rendered chiaroscuro. I have changed my mind regarding these incisions and now think it probable that they are the result of design transfer; cf. Bambach Cappel 1988, Part 2, II:352, no. 255, and Bambach Cappel 1992 a, 29 (notes 42, 45).

139. Ferino Pagden 1986, 93–107. Later copyists also relied on Raphael's *"Mackintosh Madonna,"* as attested by the apparently full-scale painted copy, attributed to Sassoferrato, now in the Galleria Borghese (inv. 382), Rome.

140. Grand Palais 1983, 223–25, nos. 54–55, with bibliography.

141. On Marcantonio's prints after Raphael, cf. Shoemaker and Brown 1981; Rome 1985; and Landau and Parshall 1994, 120–43, also with discussion of Agostino Veneziano and Marco Dente.

142. On the duration of sittings for a painted portrait, see Campbell 1990, 164–66. The attempts to amuse "Mona Lisa del Giocondo" with song, lute, and jest, while she sat for Leonardo to paint her famed portrait, "over which he loitered four years," are the stuff of fabricated legend in Giorgio Vasari's *Vite*. See Vasari 1966–87, IV (testo), 30–31.

143. Palomino 1947, 518–19: "Esta practica, o industria, cuando es util para casos precisos (como retratos, que se repiten, o alguna cosa exquisita, que se ha de copiar puntual, y repetir varias veces). . . ."

144. On Leonardo's use and nonuse of cartoons, see Chapters One, Five, and Seven.

145. Cf. Chapter One (note 114); and preliminary observations about the role of *spolvero* for portraiture in Bambach Cappel 1988, Part 1, I:166, 287–92. Taubert 1975, 394, and Koller 1982, 177, based their points on findings of *spolvero* in a limited number of Northern panels. For a general discussion of portrait replicas and portrait drawings, see Campbell 1990, 61–62, 182–90, 215. Although Lorne Campbell's book did not consider the role of mechanical means of reproduction in the making and copying of portraits, the chapters about portrait methods and functions offer a thought-provoking context for the discussion that follows (see ibid., 159–225).

146. Cf. Michel Laclotte, "Le portrait de Sigismond Malatesta par Piero della Francesca," *Revue de l'art* (1978), 255–66, and Bertelli 1992, 210, no. 14. A further copy is in the Museo della Fondazione Horne, Florence; see Archivio Fotografico negative no. 147835, Soprintendenza per i Beni Artistici e Storici di Firenze.

147. Ornella Casazza, "Al di là dell'imagine," *Gli Uffizi. Studi e Ricerche, 5: I Pittori della Brancacci agli Uffizi*, Florence, 1988, 96 (both paintings are uncritically attributed to Filippino Lippi).

148. Cf. Bambach Cappel 1988, Part 1, I:287–95. For examples of other pricked portrait drawings, see CBC 113, 129, 346, 351, 366; for portrait drawings on *spolvero* marks, see CBC 206, 267. Of note, a small Spanish drawing, a *Portrait of a Spanish Prince or King on Horseback* (Metropolitan Museum of Art 80.3.504, New York), attributed to Claudio Coello (1642–1693), offers some evidence of such design replication to confirm the gist of Palomino's comment. This highly finished portrait drawing resembles Diego de Velázquez's painted portraits in style. Data: 187 × 163 mm.; pen and brown ink, brush and brown wash, over black chalk; only the outlines of the royal figure and his saddle are pricked (the reusable parts of the composition). I am indebted to Lisa Banner for bringing this drawing to my attention.

149. The Bellini drawing is Kupferstichkabinett inv. KdZ 5170, Berlin. Revised data: 232 × 194 mm.; charcoal or black chalk; outlines finely and densely pin-pricked, but not rubbed with pouncing dust; watermark close to Briquet 2554. Cf. Altcappenberg 1995, 69–71, no. 4; and Bambach 1999 a. On Costa's panel, cf. Philip Pouncey, "A Portrait by Lorenzo Costa in the Berlin Gallery," *Berliner Museen, Berichte aus den Staatl. Museen Preussischer Kulturbesitz*, XXI (1971–73), 93–95; and Taubert 1975, 394.

150. Cf. Palomino 1724, Book VII, cap. Iv, iii:100; and Armenini 1587, 104 (cf. Armenini 1977, 174, for trans.).

151. This was already pointed out in Pouncey (as in note 149), 93–95.

152. The *spolvero* underdrawing in the Palazzo Pitti panel is recorded in infrared reflectograms by Maurizio Seracini (Editech, Florence). The ancient provenance of both versions of the portrait may further support the supposition, the Pitti panel having belonged to the Medici family and the Boston version having been in the Inghirami family house in Volterra until 1898. A third version, probably executed in the seventeenth century, is in Palazzo Inghirami, Volterra. Cf. Penny and Jones 1983, 159; De Vecchi 1987, 111, nos. 112–13; and Giovanni Battistini, "Raphael's Portrait of Fedra Inghirami," *BM*, CXXXVIII (1996), 541–45.

153. Among the Northern European portrait paintings on *spolvero* are *Louis de Quarre and his Wife* by the "Master of the Embroidered Foliage" (Palais des Beaux-Arts, Lille), *The Portrait of a Man* by Hans Burgkmair the Elder (Palazzo Pitti, Florence) from about 1506, and *Desiderius Erasmus* by Hans Holbein the Younger (Metropolitan Museum of Art, New York) from 1523 to 1529. See Taubert 1975, 392, no 13, for comment that the left eye and lips show *spolvero* in Burckmair's panel. For Holbein, see Ainsworth 1990, 173–86. Micheline Comblen-Sonkes has discussed the presence of *spolvero* marks also in the anonymous portrait of *Philippe le Bon and Marie de Buorgogne* (Chateaux de Gaasbeck) and *Portrait of Woman* in the style of Michel Sittow (Musée du Louvre, Paris). See her essay, "Le Dessin mécanique chez les primitifs flamandes," *Université Catholique de Louvain, Le Dessin sous-jacent dans la peinture, Colloque I*, Louvain-La-Neuve, 1979, 44–45.

154. I am indebted to Maryan W. Ainsworth for sharing her research on Holbein. Cf. also Ainsworth 1990, 173–86; and Bambach Cappel 1988, Part 1, I:287–95.

155. Examination with infrared reflectography has revealed fine *spolvero* underdrawing in Holbein's *Portrait of Sir Thomas More* (Frick Collection, New York), from around 1527; Ainsworth 1990, 175–77. But the *spolvero* dots do not relate precisely to the pricked holes of the extant full-scale drawing in Windsor, which is delicately drawn and nearly life-size (ibid., 177). See Royal Library inv. 12268 P3, Windsor. Data: 397 × 299 mm.; black, brown, red, and yellow chalks (watermark, Briquet 1827); inscribed near upper left corner in tarnished gold over red: "Tho: Moor Ld Chancelour." Cf. Karl T. Parker, *The Drawings of Hans Holbein in the Collection of Her Majesty The Queen at Windsor Castle* (with an appendix to the catalogue by Susan Foister), London and New York, 1983, 36, 60, no. 3; Roy Strong, *Studies in British Art: Holbein and Henry VIII*, New Haven and London, 1970; Pierre Vaisse and Hans Werner Grohn, *Tout l'oeuvre peint de Holbein le jeune*, Milan-Paris, 1971, 95, no. 45g; *Holbein and the Court of Henry VIII* (exh.

cat.; Queen's Gallery, Buckingham Palace), London, 1978–79, 25–27, no. 1; Susan Foister, *Drawings by Holbein from the Royal Library, Windsor Castle,* New York, 1983, no. 3, 22, figs. 49, 50; Jane Roberts, *Drawings by Holbein from the Court of Henry VIII* (exh. cat.; Museum of Fine Arts, Houston), London, 1987, 24, 34, no. 3; and Ainsworth 1990, 177. The gaze of the eyes and the position of the hands were altered between the full-scale pricked drawing and the pounced underdrawing in the painting. The relationship between the drawing portraying Sir Thomas More and the Frick Collection painting was not considered direct until the X-ray examination of the painting was executed (cf. Susan Foister in Parker, *Drawings of Hans Holbein,* 154). Previously, the drawing was thought to be connected to the figure of Sir Thomas More in the lost *More Family Group Portrait,* now only known through a pen and brown ink preparatory composition drawing by Holbein (Kupferstichkabinett der Öffentlichen Kunstsammlung, Basel) and through copies after Holbein's painting, the best being the oil painting by Rowland Lockey in Mostell Priory. On the *More Family Group Portrait,* see Paul Ganz, *The Paintings of Hans Holbein,* Oxford-New York, 1950, 276–84; nos. 175–76; on the copies after the *Group Portrait,* see also Parker, *Drawings of Hans Holbein,* 35. With the results of the technical analysis, the other drawn portrait of *Sir Thomas More* at Windsor, which is unpricked, seems to emerge as closer to the lost *Family Portrait* and less close to the Frick painting. See Royal Library inv. 12225. Data: 376 × 255 mm.; black and colored chalks with watercolor and metalpoint; inscribed in pen and ink: "Sier Thomas Mooer," on the upper border (watermark, Briquet 12863). Holbein's extant Windsor pricked drawing and the New York painting thus clearly shared a common original – the Windsor drawing may have been pricked for transfer onto another sheet of paper to copy it, or to develop the design further or differently, or to produce a "substitute cartoon." Cf. Ainsworth 1990 and Bambach Cappel 1988, Part 1, I:291. Drawings were replicated as much as other works of art, and this is probably the reason why drawings, or rather designs, are still extant today despite the odds of survival faced by works of art on paper. The unpricked Windsor portrait drawing of *Sir Thomas More* (Royal Library inv. 12225) is different from the pricked portrait (Royal Library inv. 12268 P3) in small details such as the hair, cap, and eye structure. But infrared reflectography may reveal *spolvero* underdrawing in Royal Library inv. 12225, thus documenting the use of *spolvero* for close derivation and variation. The similarities between the two drawings are clear when they are compared. The use of intermediary drawings would account for the differences between the Windsor sheet and the New York panel. A number of unpricked portrait drawings by Holbein have turned out to be in the same scale as known paintings, not all of which are autograph (Roberts, *Drawings of Holbein,* 24). Also, two monumental pricked cartoons by Holbein served as elaborate patterns for royal likenesses: a large fragment with the portrait figures of Kings Henry VII and Henry VIII (National Por-

trait Gallery, London), which shows the original cuts in the shape of *giornate* and which was preparatory for the destroyed mural from 1537 in the Privy-Council Chamber of Whitehall Palace, and the controversial group portrait depicting *Henry VIII and the Barber Surgeons* (Barber's Company, London), discovered under layers of later repainting. No further pricked drawings by Holbein have come to light; see the studies by Karl T. Parker, Susan Foister, and Jane Roberts cited above. Holbein's mural in Whitehall Palace was destroyed by a fire in 1698; the extant cartoon fragment in the National Portrait Gallery portrays part of the left half of the composition of the mural. On the lost mural at Whitehall and the portrait cartoon, see Paul Ganz, *The Paintings of Hans Holbein,* Oxford-New York, 1950, 289–90; Pierre Vaisse and Hans Werner Grohn, *Tout l'oeuvre peint de Holbein le jeune,* Milan-Paris, 1971, 105, no. 108; and Roy Strong, *Studies in British Art: Holbein and Henry VIII,* New Haven-London, 1970, 37–54, 81 (Appendix). The cartoon at the Royal College of Surgeons of England, probably dating from 1537 to 1541, was mounted on canvas, and the ensuing layers of pigment obscured the perforations on the outlines; cf. Roy Strong, "Holbein's cartoon for the Barber-Surgeons Group Rediscovered – a Preliminary Report," *BM,* CV (1963), 4–14; Ganz, *Hans Holbein,* 290, no. 181; Strong, *Studies in British Art,* 37; Vaisse and Grohn, *Holbein,* 108–9, no. 137; and *Holbein and the Court of Henry VIII* (exh. cat.; Queen's Gallery, Buckingham Palace), London, 1978–79, 9.

156. See further, Chapter Eleven, and photographic survey in Orvieto 1996. I am indebted to Giusi Testa, Carla Bertorello, Lucia Tito, and the *cantiere* at the *"Cappella Nuova,"* Orvieto Cathedral, for generously facilitating my research during my repeated visits to the scaffolding erected for cleaning and restoration of the frescos (1992–94).

157. The passage in Vasari 1966–87, III (testo), 637, is extremely general about the identity of the portraits Signorelli painted in the Orvieto cycle: ". . . Ritrasse Luca nella sopradetta opera molti amici suoi e se stesso: Niccolò, Paulo e Vitelozzo Vitelli, Giovan Paulo et Orazio Baglioni, et altri che non si sanno i nomi. . . ." Fra Angelico is not mentioned among those portrayed.

158. See *Orvieto 1996.* Fra Angelico's own painting practice did not include the use of *spolvero* cartoons to paint figures. See discussion in Chapters Five and Six (note 229). This is further attested by the two vault compartments that Fra Angelico and his workshop assistants (including Benozzo Gozzoli) painted at Orvieto.

159. Teylers Museum A 21, Haarlem. Revised data: 294 × 219 mm. (maximum; corners cropped); black chalk over preliminary stylus underdrawing; outlines carefully pricked, but apparently not rubbed with pouncing dust; watermark similar to Briquet 5922–24. Cf. Carel van Tuyll, *Master Drawings from the Teylers Museum* (exh. cat., Pierpont Morgan Library, New York), New York, 1989, 32, no. 5.

160. Thanks to Mother Germaine Dèjan, it was possible for me to examine this fresco from a ladder (2 February

1994). Executed in a separate *giornata,* the portion with "Michelangelo"'s head is thickly painted *a secco,* with much flaking paint and salt deposits. The parts portraying "Michelangelo"'s body are shallowly stylus-incised from a cartoon, especially evident on his pink-red mantle. Large portions of the plaster have been detached and consolidated.

161. Varese 1989, 173–87. On Borso d'Este as a patron, cf. Charles Michael Rosenberg, *Art in Ferrara during the Reign of Borso d'Este (1450–1471)* (Ph.D. Dissertation, University of Michigan), Ann Arbor, 1974; Thomas Tuohy, *Artistic Patronage and Princely Magnificence: Studies in Domestic Expenditure at the Court of Ferrara: 1451–1505* (Ph.D. Dissertation, Warburg Institute, University of London), London, 1982; Stefania Macioce, "'La Borsiade' di Tito Vespasiano Strozzi e la Sala dei Mesi di Palazzo Schifanoia," *Annuario dell'Istituto di Storia dell'Arte,* II (1982–83), 3–13; Kristin Lippincott, "The Iconography of the *'Salone dei Mesi'* and the Study of Latin Grammar in Fifteenth-Century Ferrara," *Corte di Ferrara e il suo mecenatismo, 1441–1598,* ed. by Lene Waage and Daniela Quarta, Modena, 1990, 93–109; Charles Michael Rosenberg, "Arte e politica alle corti di Leonello e Borso d'Este," *Muse e il principe, arte di corte nel Rinascimento padano: Saggi,* Modena, 1991, 39–52; Werner Gundersheimer, "Clarity and Ambiguity in Renaissance Gesture: The Case of Borso d'Este," *Journal of Medieval and Renaissance Studies,* XXIII (1993), 1–17; Luciano Cheles, "Tipologia dei ritratti nella fascia inferiore del ciclo dei Mesi di Palazzo Schifanoia," *Rittratto e la memoria: Materiali. 2,* ed. by Augusto Gentili, Philippe Morel, and Claudia Cieri Via, Roma, 1993, 75–112; and Hollingsworth 1994, 202–9. I am indebted to Steven Trent Cappel for his patient help with the analysis of the mural surface in this cycle.

162. See Figure 199 and Chapter Six, note 167, on the dating and bibliography. Cf. Charles M. Rosenberg, "Francesco del Cossa's Letter Reconsidered," *Musei Ferraresi, Bollettino Annuale,* V–VI (1975–76), 11–15, and Joseph Manca, "Francesco del Cossa's *Call for Justice,*" *Source,* XII (1993), 12–15. There is no evidence of *calco* or *incisioni indirette* (*contra* Varese 1989, 189). The incisions on the mural surface were all the result of direct construction (*incisioni indirette*). See Chapter Ten on such distinctions.

163. For portrait type (A), a figure seen standing in three-quarter view, the variations are as follows. On the right side of the *March* scene, Borso's hands are down, his head appears in profile. On the right side of the *April* scene, Borso's hands are in a slightly raised position, his head is shown in three-quarter view. In the center of the *July* scene, Borso's legs are spindlier, his head is in three-quarter view, his right hand holds a glove.

164. For portrait type (B), a figure seen standing in profile, the variations are as follows. On the left side of the *June* scene, Borso faces left. On the right side of the *August* scene, Borso faces right. On the left of the *September* scene, Borso faces right. Cf. Varese 1989, plates 5 a–c, 6 a–d.

165. For portrait type (C), a figure seen in profile and on horseback, the noticeable variations are as follows. On the

right side of the *September* scene, Borso faces right. On the center of the *August* scene, Borso faces left. On the right of the *July* scene, Borso faces left. On the right half of the *June* scene, Borso faces left. On the right of the *March* scene, Borso faces left. On the center of the *February* scene, Borso faces left (almost entirely destroyed, only a ghost of the pigment layer remains). Additionally, differences of design also emerge in the angle of view for the various anatomical parts of the horses. See Varese 1989, plates 5 a–c, 6 a–d.

166. For portrait type (D), a figure on horseback, seen in frontal three-quarter view foreshortening, the variations are as follows. On the left side of the *April* scene, Borso faces right. On the right side of the *May* scene, Borso faces right.

167. Cf. also Chapter Eight.

168. Cf. Vasari 1966–87, III (testo), 27; Travers Newton 1983, 86–87; and Carlo Bertelli in *Tecnica e stile* 1986, I, 40, and II, plate 83, for a photograph of *spolvero* marks. The identity of the two sons who are portrayed with Ludovico Sforza "Il Moro" and his wife, Beatrice d'Este, in the *Crucifixion* mural has been much debated. Like a number of scholars, I believe that the pair of children depicted here, as well as identically in the *"Pala Sforzesca"* (discussed later), is the legitimate progeny of Ludovico, because of the dynastic character of his artistic enterprises. Vasari identified the boys in the *Crucifixion* mural as Massimiliano and Francesco, born in 1493 and 1495 respectively to Beatrice. Since these portraits were added later (Leonardo was at work on the *Last Supper* until 1497/98), the date 1495 on the frescoed part by Montorfano is not difficult to reconcile with the ages of the boys. Born in 1491, Cesare was Ludovico's illegitimate son by his mistress, Cecilia Gallerani, and can most probably be ruled out. In arguing for an attribution of the Sforza portrait heads to Leonardo himself, Marani 1989, 90, no. 17, rightly referred to the 1568 edition of Vasari's *Vite* (Vasari visited the refectory of S. Maria delle Grazie in 1566) and to Lomazzo's *Trattato dell'arte della pittura* of 1584.

169. I am indebted to Pietro C. Marani for discussing this detail with me in front of the mural surface (November 1996).

170. The subject of this portrait has also been identified as Cesare Sforza, illegitimate son of Ludovico "Il Moro" by Cecilia Gallerani, an unconvincing suggestion. Biblioteca Ambrosiana inv. Cod. 290 F. inf. 13, Milan. Revised data: 205 × 156 mm. (maximum sheet). Cf. Marinoni and Cogliati Arano 1982, 93, 141, no. 48, Coleman 1984, 42–43, no. 13; and Ambrosiana 1998, 106–7, no. 44.

171. Giulio Bora observed that the red chalk dust was visible before the drawing's restoration; oral communication (20 July 1986).

172. It should be noted that only the precise date of the commission of the *"Pala Sforzesca"* is documented, not the date of its completion. On the altarpiece, cf. Pietro C. Marani, *Leonardo e i Leonardeschi a Brera,* Florence, 1987, 75–80, no. 3; Fabjan and Marani 1998, 31–71; Giovanni Romano, Maria Teresa Binaghi, and Domenico Collura, "Il Maestro della Pala Sforzesca," *Quaderni di Brera,* Flo-

rence, 1978, no. 4, 7–23; Pietro C. Marani, *Pinacoteca di Brera: Scuole lombarde e piemontese 1300–1535,* Milan, 1988, 325–30; and Laura Baini, "Le Commissioni dinastiche: La Pala per Sant" Ambrogio ad Nemus," *Ludovicus Dux: L'Immagine del potere,* ed. by Luisa Giordano, Vigevano, 1995, 158–67. I am indebted to Rossana Sacchi for lively discussions on the *"Pala Sforzesca"* and for pointing out some of this literature. On the mural, see note 168. On the issue of patronage in the Sforza court in Milan, cf. Gary Ianziti, "Patronage and the Production of History: The Case of Quattrocento Milan," *Patronage, Art, and Society in Renaissance Italy,* ed. by F. W. Kent and Patricia Simons, Canberra-Oxford, 1987, 299–313; Evelyn Welch, "The Process of Sforza Patronage," *Renaissance Studies,* 3 (1989), 370–86; Hollingsworth 1994, 162–80; and Evelyn Welch, *Art and Authority in Renaissance Milan,* New Haven and London, 1995.

173. Louvre inv. M. I. 753, Paris. Revised data: 360 × 460 mm. The attribution history and bibliography are given in Roseline Bacou and Françoise Viatte, *Dessins du Louvre. Ecole italienne,* Paris, 1968, no. 14; Bambach 1996 a, 84, note 9; and Marani 1989, 100, no. 19. Cf. further, discussion in Chapter Seven, notes 160–62; Bambach Cappel 1988, Part 2, I:167–68, no. 129; Campbell 1990, 84; and Popham 1995, 48–49, 138–39, no. 172. Carlo Pedretti has already suggested that the Louvre drawing may have been pricked to pounce it onto another cartoon to generate copies (essay "Leonardo dopo a Milano" in *Leonardo e il Leonardismo* 1983, 45). The observations below about the physical evidence in the cartoon modify aspects of my previous argument, although its substance remains the same. I am greatly indebted to Catherine Monbeig Goguel for the opportunity to study this cartoon, out of its frame, in the paper conservation laboratory of the Musée du Louvre (July 1991). On Isabella d'Este as patron and collector, see Vienna 1994.

174. See Chapter Seven, for a further discussion of this cartoon's drawing technique.

175. Vasari 1966–87, IV (testo), 24: ". . . e parimenti quella di Scaramuccia capitano de' Zingani."

176. Such contrasts in pricking style are particularly noticeable in Andrea Verrocchio's *Head of a Young Woman* (Plate III). As both Leonardo's *"Scaramuccia"* (Fig. 45) and Verrocchio's cartoon are in the drawings collections of Christ Church, Oxford, they can be compared side-by-side with particular precision and immediacy.

177. A control group of cartoons showing spirited diversities of pricking style includes Lorenzo di Credi's two *Enthroned Madonnas* (Figs. 29, 92, 219), Raphael's *"Belle Jardinière"* (Fig. 58), his *School of Athens* (Figs. 40–41), and *"Mackintosh Madonna"* (Fig. 97), Giulio Romano's *Head of a Hermaphrodite* (Fig. 89), Domenico Beccafumi's *Moses* scenes (Fig. 32), and Michelangelo's *Crucifixion of St. Peter* (Fig. 3).

178. This is true of the upturned, scalloped edge of Isabella's veil beyond her forehead on the right, as well as of her right sleeve and hand and the rear outline of her head; it is also true of the profile outlines of her chin, neck, and bosom. The bow on her left shoulder appears in a slightly

more gracefully pricked outline, as do the gatherings of cloth on her right shoulder; here, the drawing seems to have again completely vanished.

179. Clark 1988, 159. Arthur E. Popham also thought that little of Leonardo's own hand was evident in the cartoon (Popham 1995, 48). The analysis given above is an attempt to reconcile the problems of quality of execution with those of attribution.

180. See transcription in Beltrami 1919, 65, no. 106, and discussion in Campbell 1990, 62.

181. Ibid., 62, 84, 140, 185–90, and Vienna 1994, 86–118.

182. These copies are in the Galleria degli Uffizi (Florence), Staatliche Graphische Sammlung (Munich), Ashmolean Museum (Oxford), and British Museum (London). Cf. Popham and Poucey 1950, 72, no. 118; Parker 1972, 13, no. 19; *Leonardo e il Leonardismo* 1983, 126, figs. 256–59; and Popham 1995, 48.

183. This was particularly true of Venetian and Northern European practice (Bambach Cappel 1988, Part 1, I:251–97).

184. For the phrase about the refined drawing technique of Michelangelo's lost cartoon of the *Venus and Cupid,* see Vasari 1966–87, VI (testo), 113. The work that Pontormo executed after Michelangelo's lost cartoon is often identified with the oil painting on panel in the Galleria degli Uffizi, Florence (inv. P 1258). The only securely autograph drawing by Michelangelo for the *Venus and Cupid* project is British Museum 1859-6-25-553 recto, London, a small sketch. Data: 85 × 125 mm.; pen and brown ink. Cf. Wilde 1953, 93, no. 56; and Tolnay 1975–80, II, 87–88, no. 302 recto. Although executed for Bartolomeo Bettini, Michelangelo's cartoon and Jacopo's painting were taken over by Alessandro de' Medici. See further, Chapter Seven, notes 39–40.

185. Gallerie Nazionali di Capodimonte inv. 86654, Naples. Data: 1310 × 1840 mm.; charcoal, on nineteen sheets of paper, glued onto secondary paper support and canvas. In my opinion, this cartoon cannot possibly be autograph, as has sometimes been maintained. It was in the collection of Fulvio Orsini (listed in the inventory drawn up at his death, 31 January 1600); Nolhac 1884, 427. Cf. Wilde 1953, 93, under no. 56; Tolnay 1975–80, II, 87–88, under no. 302; and Muzii 1993, 22–35.

186. British Museum 1926-4-12-1, London. Data: 725 × 587 mm.; charcoal and black chalk, on six sheets of paper. See Pouncey and Gere 1962, 40–41, no. 51.

187. Uffizi inv. 1774 E, Florence; lost during World War II. Recorded data: 770 × 730 mm.; black chalk, highlighted with white. See Petrioli Tofani 1987, 728–29, *sub numero.*

188. Uffizi inv. 1776 E, Florence (data in text above). Cf. Petrioli Tofani 1987, 729–30, *sub numero.*

189. On the painting, cf. Hartt 1958, I, 54, no.6; Paul Joannides, "The Early Easel Paintings of Giulio Romano," *Paragone Arte,* no. 425 (1985), 17–46, especially 37–38; and Sylvia Ferino's entry in Mantua 1989, 269. None of these sources mention the Uffizi "copy cartoon."

190. On the painted copy, see Lo Bianco, *Aspetti dell'arte a Roma prima e dopo Raffaello,* Rome, 1984, 94–96, no. 31.

191. A control group of cartoons by Giulio Romano includes, for instance, the pricked and stylus-incised fragment of a

hermaphrodite's head (Fig. 89; discussed earlier), the pricked *Battle of Constantine* (CBC 204; discussed in Chapter Two), as well as the stylus-incised *Moderatio* (Louvre inv. 4301, Paris). Data: 1780 × 1140 mm.; charcoal and black chalk, stylus-incised outlines, on multiple, glued sheets of paper. Cf. Oberhuber 1972, 198, no. 481 d). We may also add the stylus-incised *Stoning of St. Stephen* (Figs. 230–31; Pinacoteca Vaticana inv. 753). Data: 4190 × 2800 mm.; charcoal, reinforced in parts with black chalk, on multiple sheets of glued paper. Cf. Pierluigi De Vecchi in Vatican 1984, 311–14, no. 118; Sylvia Ferino in Mantua 1989, 258. Also in this group is the much debated stylus-incised *Portrait of Pope Leo X* (Plate VIII; Devonshire Collection inv. 38, Chatsworth; data and bibliography in Chapter Two, note 114). Recent opinion on the attribution of the Chatsworth cartoon has wavered between Giulio and Raphael. I agree with Oskar Fischel, Frederick Hartt, and Konrad Oberhuber in attributing the drawing without reservation to Giulio.

192. See Plates II, III, Figures 44, 76, 80, 212, 214, 222–23, and discussion in Chapters Six, Seven, and Eight.

193. Francisco Pacheco generally advised this in his *Arte de la pintura* (Sevilla, 1649). Cf. Pacheco 1956, II, 2–5, 27, 52–53, 76–77; and Bambach Cappel 1988, Part 1, I:161–62 (note 296).

194. Kupferstichkabinett inv. KdZ 5129 recto and verso, Berlin. Revised data: 272 × 200 mm.; brush and brown wash, highlighted with white gouache, and black chalk, on olive-green prepared paper. Cf. Fischel 1917, II:83, no. 4, and Altcappenberg 1995, 136–38, no. 97. On this artist, cf. Filippo Todini et al., *Niccolò di Liberatore detto l'Alunno*, Foligno, 1987, and Elvio Lunghi (ed.), *Niccolò Alunno in Umbria: Guida alle opere di Niccolò Liberatore detto l'Alunno nelle chiese e nei musei della regione*, Assisi, 1993.

195. The processional banner from Arcevia (Pinacoteca Nazionale, Bologna) is dated 1482, whereas that for the Confraternity of S. Antonio Abate in Deruta is probably contemporary. The altarpiece in Nocera Umbra is dated 1483. Cf. Altcappenberg 1995, 136–38, 231–32, nos. 96–97, and Dreyer 1979, 27–28, under no. 13.

196. The drawing portraying the profile portrait of a youth, on what is now considered the recto of the Berlin sheet, existed before the St. Francis–Christ on the verso; on the recto, the craters left by the perforations raise and interrupt considerably the ink strokes by breaking through the prepared ground.

197. This general observation first appeared in Fischel 1917, I:4, II:11, 83, plate 1.

198. Perhaps the artist cropped the sheet at the same time – the abruptness of the upper left and lower borders is noteworthy – to preserve the head as a useful stock pattern.

199. Kupferstichkabinett inv. KdZ 5107, Berlin. Revised data: 239 × 148 mm.; brush and brown washes, highlighted with white gouache, on orange-brown prepared paper. Cf. Fischel 1917, II:83, no. 3, and Altcappenberg 1995, 231–32, no. 96.

200. See Vittoria Garibaldi in Galleria Nazionale dell'Umbria 1994, 228–29, no. 51.

201. Uffizi inv. 1314 F, Florence. Revised data: 246 × 126 mm.; pen and brush with dark and light brown ink, wash, highlighted with pink, red, and white gouache, over metalpoint on olive prepared paper. Cf. Fischel 1917, II:201, no. 108, and Ferino Pagden 1982, 83–84, no. 52. The stance of the female figure in the Uffizi sheet echoes that of the monumental attendant standing on the extreme left foreground in the *Journey of Moses*, the mural painted in 1481–83 on the south wall of the Sistine Chapel by Pietro Perugino with the assistance of Bernardino Pinturicchio and Bartolomeo della Gatta. The figure type in the Uffizi sheet recalls more precisely – because of their similar scale – that of an elegant attendant standing on the extreme left of the *Birth of the Virgin*, in the *predella* for the altarpiece of S. Maria Nuova in Fano, signed and dated 1497. On the Sistine Chapel mural, see further Scarpellini 1984, 78–79, no. 32; on the Fano *predella*, see Palazzo Ducale Urbino 1983, 208–16, no. 45, and Scarpellini 1984, 92–93, no. 73. The *predella* of the Fano altarpiece has often been attributed to the young Raphael, in my view unreasonably, as he would have been about fourteen years of age. Moreover, the conception of the perspective (as well as its techniques of direct construction with stylus ruling and compass) and quality of execution of this part of the *predella* seem, in my view, fully consistent with those of the main panel. Yet if we compare the drawing on the Uffizi sheet to the securely autograph, vibrantly energetic pen-and-ink figure studies by Perugino from this period, we can see clearly that it is less a searching preparatory study than a record of an already highly synthesized formula. In the Uffizi sheet, the understanding of the figure is decorative rather than structural, and the handling of the painterly drawing medium seems relatively inert. An analogous though freer use of the brush emerges in one of the small striding female figures painted in the middle distance of the *Journey of Moses*: she is even portrayed in a scale close to that of the figure in the Uffizi sheet, without resembling her in design.

202. Gallerie dell'Accademia, Venice (CBC Appendix 31). On the *"Libretto Veneziano,"* cf. Fischel 1917, II:157–87, no. 96; Ferino Pagden 1982, 157–64; Ferino Pagden 1984, 13–25; Louvre 1992, 8–9; and Elen 1995, 274–77, no. 43.

203. The above folio numbers refer to the reconstruction proposed in Ferino Pagden 1984. See ibid., 61–2, 78, 101–2, nos. 14 (inv. 55), 22 verso (inv. 88), 34 recto and verso (inv. 84), and Appendix, 168, 174, 182, figs. 40–1, 63, 90–91, for infrared photographs showing *spolvero*.

204. Ibid., 75–76.

205. Ashmolean Museum inv. P II 512, Oxford. Data: 89 × 62 mm.; pen and brown ink, over stylus and black chalk underdrawing. Cf. Parker 1972, 262, no. 512.

206. Cf. Ferino Pagden 1984, 20–24, where it is maintained that most of the drawings in the *"Libretto"* have prototypes in the early work of Raphael and that the copies may be relatively direct. The fragmented but orderly disposition of the motifs on the page and the relatively mechanical appearance of the drawings suggest that they may have been pounced from pricked copies. The role of pouncing in the production of copies raises problems that,

in the particular case of no. 14 recto (fol. 15), are not easily solved. Assuming these are direct copies of Raphael, the fact that all four heads are nearly in the same scale seems an implausible coincidence unless all the heads derive from the same drawing project by the master. Because the mechanical copy method of pouncing allowed not only relative precision in the process of copying but also the possibility of multiple copies, it seems difficult nonetheless to establish beyond doubt how direct the pouncing relationship between Raphael's originals and the copies in the *"Libretto"* are. Note that the passages in the *Codex Urbinas Latinus* and in Nunes's and Palomino's treatises suggest at least one intervening step linked by the use of pouncing in the production of copies (see Chapter Four). There is also a slight possibility that each head on no. 14 recto of the *"Libretto Veneziano"* was pounced individually from different drawings.

207. Cf. Vasari 1966–87, IV (testo), 118–19; and Carmen C. Bambach in Metropolitan Museum of Art 1997, 338–39. See further Alessandro Cecchi and Carmen C. Bambach in Metropolitan Museum of Art 1997, 40–43, 338–39, 348–49 (no. 116), for examples of Raffaellino's designs for embroidery. In the literature, too many such finely pricked drawings are assumed to be related to embroidery without sufficient documentation. As we shall see later on, there is little technical difference between a pricked drawing for a *predella* or an embroidery.

208. Istituto Nazionale per la Grafica inv. FC 130466, Rome. Revised data: 112 × 146 mm. Cf. Beltrame Quattrocchi 1979, 42, no. 23b. On the S. Salvi altarpiece, see Vasari 1966–87, IV (testo), 118, and Carpaneto 1971, II, 14–15.

209. Istituto Nazionale per la Grafica inv. FC 131755 and FC 131756, Rome. Revised data: 61 × 53 mm. and 61 × 57 mm., respectively. Cf. Beltrame Quattrocchi 1979, 42–43, nos. 23c, d.

210. Istituto Nazionale per la Grafica inv. FC 130454 and FC 130456, Rome. Revised data: 225 × 113 mm. and 219 × 121 mm., respectively. Cf. Beltrame Quattrocchi 1979, 40–41, nos. 22a, b. The companion pieces are Palais des Beaux-Arts inv. PL 264 and PL 265, Lille. Revised data: 215 × 105 mm. and 220 × 100 mm., respectively. Cf. Berenson 1961, 121, nos. 633–34.

211. Among the words that seem legible on the right of the diagram are the names of saints, *"Paolo"* and *"Sº Cristofano,"* possibly referring to the figures portrayed on the recto of the pricked Rome cartoons; whether *". . . rtalo . . ."* on the upper left refers to the Lille *St. Bartholomew* is, however, more speculative.

212. For example, in the *St. Christopher,* his staff is pricked on the bottom as lacking a small branch stump, and on the top as having a long, delicate swirl as a *terminus.* Moreover, numerous outlines in the folds and hem of the Christ Child's robe diverge consistently about 1–2 mm. between pricking and ink drawing.

213. As we have seen, another of Raffaellino's patterns in Rome, the small head of a youth (CBC 79), possibly for an angel, also exhibits rubbed pouncing dust on the recto and, very heavily, on the verso. There, a member of Raf-

faellino's *bottega* or a later draughtsman began to connect some of the pricked holes on the verso with pen and dark brown ink, betraying his interest in reusing the reversed image of the tiny head. In the case of a kneeling angel, facing left and holding a spherical object (CBC 96), it is clear that the artist pounced the drawing from the recto and verso to produce the motif's symmetrical counterpart. There, the blackened verso confirms the procedure. See Teylers Museum inv. A52, Haarlem. Revised data: 216 × 189 mm. Cf. Meijer and Tuyll 1983, 28–29, no. 4. The attribution of this highly accomplished drawing is, however, problematic. The attribution to Raffaellino is, in my opinion, not as certain as it has been proposed in the literature.

214. On this problematic *codex,* see Chapter One, note 122.

215. Laskarina Bouras in *From Byzantium to El Greco: Greek Frescoes and Icons,* exh. cat., Royal Academy of Arts, London, 1987, 54–56, 199, nos. 72–73.

216. On the history of printmaking in the Quattrocento, see Landau and Parshall 1994, especially 103–68.

217. See further, Chapter Six.

218. Cf. Landau and Parshall 1994, 21–28.

219. Among the pricked impressions of early engravings in the Chicago Art Institute are Jacopo Francia's *Venus and Cupid* (Hind V.234.16) and Benedetto Montagna's *St. George* (Hind V.117.9). I am indebted to Suzanne Boorsch for bringing these examples to my attention.

220. Metropolitan Museum of Art 18.65.3, New York. I am indebted to Suzanne Boorsch for bringing this print to my attention, published in *Mantegna* 1992, 313–14, no. 93.

221. Suzanne Boorsch (ibid., 313–16, nos. 93–94) proposed the tantalizing possibility that it was Giovanni Antonio da Brescia who pricked this engraving to produce his own copy: the relatively exact engraved copy by the printmaker varies precisely in the details that were left unpricked in the original.

222. Examples of drawings pricked for such a purpose are those possibly by Raphael for scenes on the right border of Marcantonio Raimondi's engraving of the *Quos Ego* (Devonshire Collection inv. 727 A and 727 B, Chatsworth; CBC 259, 260), which have versos heavily blackened with pouncing dust. See further discussion in Bambach Cappel 1988, Part 1, II: 415–19.

223. The treatises by Bosse, Browne, Lairesse, Hidalgo, Palomino, and Milizia recommend *calco* for direct design transfer to the plate. See Abraham Bosse, *De la manière de graver à l'eauforte et au burin,* Paris, 1745, 19–20, "manière de s'apprêter pour dessiner, contretirer ou calquer son dessein sur la planche"; the methods described are plain stylus tracing, as well as rubbing the verso of drawings with red chalk before incising the outlines with the stylus, and counterproofing. Cf. Alexander Browne, *Ars Pictoria, or: An Academy Treating of Drawing, Painting, Limning, Etching,* London, 1676, 101; Lairesse 1778, 488; José Garcia Hidalgo, *Principios para estudiar el arte de la pintura* (1691; as transcribed in Sánchez Cantón 1923–47, III, 123–4), which cites Jacques Callot's method of engraving and etching ("... y se calca el dibujo ...") and two methods involving blackening the verso of the design before tracing it with a

hard point; Palomino 1947, 748–49, which describes a complicated method of transfer; and Milizia (1827), II, 189, under *"calcare,"* which notes this as being useful to engravers. Vasari 1966–87, I (testo), 170–1, is silent on drawings for engravings and woodcuts. Meder and Ames 1978, I, 398, noted that printmakers sometimes laid straw paper on the drawing to be transferred, tracing the contours heavily with a stylus, and that the resulting ridges on the verso of the straw paper were rubbed with red chalk or powdered graphite. This was in turn transferred by rubbing on the other side of the straw paper with a bookbinder's paper folder, which was a flattened baton made of bone or ivory. See further discussion in Bambach Cappel 1988, Part 1, I:149–72, II:415–19. For a typical example, see Lodovico Carracci's stylus-indented pen and ink drawing, the *Virgin and Child with Angels* (British Museum 1895-9-15-686, London), from the late 1590s or early 1600s. It served for the artist's own print and is in reverse orientation. See British Museum 1996, 92, no. 43. Two large, coarse sixteenth-century counterproofs of woodcuts – portraits of Martin Luther and Katharina Bora, after Lucas Cranach the Elder's famous paintings – though produced by a German rather than an Italian artist – can further illustrate how semiskilled artists and artisans appropriated revered compositions. Kupferstichkabinett inv. 4794 and 4795, Berlin. Cf. Bambach Cappel 1988, Part 2, I:8–9. I am indebted to Lutz Malke for bringing these prints to my attention. The outlines of both woodcut portraits are pricked and reinforced with black and red chalk, and the versos are blackened with pouncing dust. Thus, the copyist first counterproofed the two prints, possibly with a glass in the manner described for portraits by Felipe Nunes in the *Arte poetica* (1615). See Nunes 1615, fols. 70 verso–71 recto (cf. Veliz 1986, 17–18, for trans.). The copyist then pricked the outlines of the design, including the date 1528, which is reversed on both prints, to reverse the design of the counterproofs. Last, the copyist pounced the sheets from the verso to obtain the correct and original orientation of the designs on the secondary surface, which may have been a panel or canvas for painting.

224. Victoria and Albert Museum pressmark 87.C.110, London, fols. 13 verso, 14 recto, 16 verso, and 18 recto. On this special case, see further Bambach Cappel 1991 b, 99–106, illustrated as figs. 3–5. Although neither Tagliente's birth nor death dates are known, he probably lived between c. 1465 and c. 1527. Cf. Esther Potter in Stanley Morison et al., *Splendour of Ornament . . . Specimens Selected from the "Essempio di recammi, the First Italian Manual of Decoration . . . ,"* London, 1968, 27–68; and Bambach Cappel 1991 a, 72–85.

225. On knotwork and interlacing ornament, see ibid., 72–98. None of the pricked motifs are rubbed with pouncing dust, which is relatively odd. It suggests the possibility that the copyist used "substitute cartoons," or that the copyist pricked the letters for an anamorphic projection, resembling one of Leonardo's experiments with cut-out letter stencils; Bambach Cappel 1991 b, 99–106. There are also similarly selectively pricked letters and motifs in a copy of another sixteenth-century calligraphy manual, Sigismondo Fanti's *Theorica e Pratica* (Newberry Library, Wing ZW14.F213, Chicago), as pointed out to me by Lisa Pon.

226. Thus, the relative difficulty of establishing when a design was pricked can to an extent be surmounted by establishing who pricked the design and should thus not be adduced to disqualify the validity of the evidence provided by pricked designs in a reconstruction of pouncing as a technique of design transfer. Such an attempt was made by Taubert 1975, 387–90, and Degenhart 1950, 108 (note 21).

227. Uffizi inv. 7697 Santarelli verso, Florence. For data and bibliography, see Chapter Two, note 130. The recto of the drawing contains small-scale studies for prophets, sibyls, and angels in red chalk; they clearly preceded the verso. This example, however, contrasts with more frequent cases of selective pricking, whereby the pricked motif is a relatively complete unit, despite belonging to a larger whole.

228. Uffizi inv. 538 E, Florence. Revised data: 288 × 298 mm.; pen and medium brown ink, over black chalk and stylus underdrawing; squared with two grids. Cf. Joannides 1983, 58–59, 166, nos. 13, 137; Knab, Mitsch, and Oberhuber 1983, 575, no. 202; Palazzo Pitti 1984, 300–2, no. 11; Ames-Lewis 1986, 59, fig. 66; and Petrioli Tofani 1986, 241–42.

229. Similarly, of Fra Bartolomeo's entire sketch, the *Offering to Venus* (CBC 14), only some outlines in the small figure of the goddess were pricked, and this with an extremely fine pin or needle. Uffizi inv. 1269 E, Florence. Revised data: 205 × 282 mm.; black chalk. Cf. Fischer 1986, 146–47, and Petrioli Tofani 1987, 528–29, *sub numero.* This sheet does not show the evidence as clearly as it once did. The tiny craters, left on the sheet's verso by pricking the paper, were flattened, and it appears now as if the holes do not entirely perforate the paper. Although the project to which the drawing relates is not known, it is clear that it represents a compositional draft at a relatively preliminary stage, before the study of individual figures and the subsequent step of the *modello.* Fra Bartolomeo used the black chalk medium with great vigor and freedom to render this dynamic scene. His copyist, however, could only awkwardly interpret with the fine pricking implement a design that was largely tonal and full of reinforcement lines. A consideration of Fra Bartolomeo's working habits tends to confirm that the drawing was pricked by a copyist. If in his early career, Fra Bartolomeo employed the *spolvero* technique, only a few possible examples by him and his circle survive: a large-scale design of a head drawn on top of *spolvero* marks (Fig. 273); a group of pricked, small-scale drawings attributed to his early business partner, Mariotto Albertinelli (CBC 1–3); and two relatively large pricked cartoons attributed to Fra Paolino (CBC 192–93), one of the *frate's* followers. Moreover, as a group, Fra Bartolomeo's paintings and drawings suggest that he preferred the more efficient technique of design transfer, *calco* (stylus tracing), rather than *spolvero.* Cf. Bambach Cappel 1988, Part 1, I:230–31 (and note 151), as well as the cartoons discussed above in Chapter Two. It is fairly certain that by 1515, the probable date of the *Venus* drawing, Fra Bartolomeo relied

on the technique of *calco* (stylus tracing) nearly exclusively, like many of his predecessors who had begun applying it from the 1460s and 1470s onward.

230. Formerly in the collection of Duke Roberto Ferretti. Data: 230 × 163 mm.; black chalk, highlighted with white gouache (recto); red chalk, in places over stylus; partly pricked for transfer (head on right) and rubbed with black pouncing dust on the reverse of this pricked design. See DeGrazia 1984, 150–51, no. 40, and David McTavish, *Italian Drawings from the Collection of Duke Roberto Ferretti,* exh. cat., Art Gallery of Ontario, Musée des Beaux-Arts de l'Ontario, Toronto, Canada, 1986, 24–25.

231. On the Albertina drawing, inv. 2615 (SL 45, B355), Vienna, see Birke 1991, 67, no. 73, and Birke and Kertesz 1992–97, III, 1470, no. 2615.

232. The study of the *putto*'s bust apparently elaborates, on a larger scale, a detail found in the sketchy composition of frolicking *putti* on the left of the verso, which Parmigianino had quickly developed in red chalk from a fluent preliminary stylus underdrawing. The *putto*'s head, however, does not exactly fit any head in the composition. The perforations are not as fine as might be expected, but, as is true of scores of other pricked drawings, they are closely spaced in the face and are gradually less dense further away from it, as in the locks of hair on the cranium.

233. The pricking approximates the subtle *sfumato* forms clumsily with lines. The pricked outlines distort the subtle design in such a way that the facial features are slightly deformed, as in the exaggerated arch of the *putto*'s right eyebrow. The *sfumato* in the drawing implies that here the eyebrow's outline should almost be straight, if in fact slightly curving upward, to accommodate the slight rotation of the head in space, when it is seen foreshortened from a high viewpoint. Moreover, the area around the tip of the nose where it disappears into its shadow is arbitrarily pricked, and the ear becomes a series of lost loops. On the *putto*'s right shoulder are meaninglessly pricked holes, whereas none appear on the left shoulder. As is especially clear in the shoulder area, the pricking (and lack thereof) serves no real purpose, for it does not develop further the design of the *putto*'s implied body. In fact, the tiny sequence of about four holes toward the inside of the *putto*'s right shoulder is downright nonsensical. If the holes indeed outline the separation between his right arm and torso, and one wonders what other purpose might explain their presence, this is an anatomically false detail, even in a slightly foreshortened three-quarter view of the torso.

234. Uffizi inv. 743 E, Florence. Cf. Freedberg 1950, 66, fig. 43; Popham 1971, I, 65, no. 71, II, plate 212; DeGrazia 1984, 158, no. 44; and Petrioli Tofani 1986, 324–25.

235. Cf. DeGrazia 1984, 158, no. 44.

236. See Bartsch XVIII. 300. 46 (as copy by Guido Reni; now recognized as Parmigianino's first version) and Bartsch XVI. 8.5 (now recognized as Parmigianino's second version). There are at least two states of the first and second versions of the etchings; their sequence is discussed in Landau and Parshall 1994, 268–70. Cf. Oberhuber 1963, 36, and Popham 1971, I, 14–15.

237. The fine pricking on the left study compares to that found in some other North-Italian sheets: for instance, by Giulio Campagnola (CBC 39); by Gian Francesco or Giovanni Caroto (CBC 42); by Alessandro Turchi, called "Orbetto" (CBC 307); and by Jacopo Bassano (CBC 218). In Parmigianino's sheet, it is, however, the unpricked head on the right study that resembles the prints more closely, and the border of the sheet crops the head in a manner similar to that in the prints.

238. This point is rightly made in DeGrazia 1984, 158, no. 44.

239. See further Popham 1971 and the insightful review by Philip Pouncey, "Popham's Parmigianino Corpus," *MD,* XIV (1976), 172–76.

240. See description of Giulio Romano's *calchi* in Armenini 1587, 76–77 (cf. Armenini 1977, 147–48, for trans.). A total of only five pricked drawings by Parmigianino survive, and at least two of these were probably not pricked by him. For four of these pricked drawings, see CBC 181–85. A fifth in a private collection, which I have not been able to study, came to my attention belatedly in Pouncey (see note 239), 172–76 (illustrated).

241. Here, a study by Jacopo Bassano (CBC 218), also for a figure, but whose head only is finely pricked, provides a good analogy.

242. Cf. especially Popham 1971, I, 29–32, and DeGrazia 1984, 141–44, on the early *fortuna critica* of his drawings.

243. Vasari 1966–87, IV (testo), 536: "... lo spirito del qual Raffaello si diceva poi esser passato nel corpo di Francesco." Cf. David McTavish, "Vasari and Parmigianino," *Giorgio Vasari: Tra decorazione ambientale e storiografia artistica. Convegno di Studi,* ed. by G. C. Garfagnini, Florence, 1985, 135–44, and Rubin 1995, 128–29.

244. To the above examples, we may add a list of yet other drawings with small, selectively pricked motifs, which were probably pricked by copyists: the three seated soldiers portrayed in the foreground and in the center of the right border of the *Resurrection,* a compositional draft for an altarpiece attributed to a follower of Perugino and Luca Signorelli (CBC 350); the two cannons in a military scene portraying soldiers with flintlocks and pikes by a gun battery, attributed to an anonymous Brescian artist (CBC 356); the profile of Diana's face in Jacopo Bassano's full-length study of the seated goddess (CBC 218); the head of a bearded man appearing on the extreme left of an anonymous copy from the School of Fontainebleau (CBC 349); as well as the horse's right rear leg in Lodovico Cigoli's study for the *Equestrian Monument to Henry IV* (CBC 41). These are all carefully finished drawings. In some cases, the way in which the pricked outlines interpret the drawn passages of chiaroscuro is especially awkward, as if the "prickers" were unfamiliar with the underlying structure of the forms. This, together with the selective pricking of motifs in the drawings, suggests that they were probably pricked by someone other than their draughtsmen. Neither Jacopo Bassano, nor Lodovico Cigoli, nor members of the School of Fontainebleau (besides Niccolò dell'Abate, occasionally), are known to have been "pouncers"; their drawings and

paintings exhibit, in fact, ample evidence of the *calco* technique.

245. See CBC 45, 157, 189, 216, 345, and 186.

246. The latter is a point repeatedly made in Perrig 1991.

247. Vasari 1962, I (testo), 117–19.

248. The autograph sheet is Ashmolean Museum inv. P II 319, Oxford. Data: 272 × 395 mm.; red chalk over black chalk and stylus underdrawing. Cf. Parker 1972, 159, no. 319; and Tolnay 1975–80, II, 85, no. 297 recto. The pricked copy is British Museum 1946-7-13-365, London. Revised data: 270 × 395 mm.; red chalk over stylus underdrawing. Cf. Wilde 1953, 125, no. 90.

249. *Codex Resta*, Biblioteca Ambrosiana inv. F.261.inf.29, Milan. Cf. Bora 1976, 27, no. 29.

250. Cf. Ruggeri 1969, 18, no. MF 183 (illustrated). I have not been able to study this drawing firsthand.

251. On Ugo da Carpi's *chiaroscuro* woodcut (Bartsch XII.46.27), see especially Oberhuber 1972, 122–23, and more generally on his woodcuts after Raphael, see Landau and Parshall 1994, 150–54. A selection of the reproductive prints after Raphael's *Death of Ananias* is illustrated and catalogued in Rome 1985, 131–32. The dimensions of the sheet with the drawing are reportedly 294 × 404 mm.; the image in Ugo da Carpi's chiaroscuro woodcut measures 252 × 392 mm.

4. The Censure of Copying Practices

1. Cf. *Scritti d'arte di Federico Zuccaro,* ed. by Detlef Heikamp, Florence, 1961, 221–305, and Bisagno 1642, 14–26. On Zuccaro, see Blunt, 1989, 137–59, and Sergio Rossi, "Idea e accademia: Studio sulle teorie artistiche di Federico Zuccaro, I: Disegno interno e disegno esterno," *Storia dell'arte,* no. 20, (1974), 37–56.

2. Volpato in Merrifield 1849, II, 742–43: "Se tratono di pittura non scriverano di queste materie che non s'apartengono ne a l'arte ne agli artefici che saria cosa indecente; che le nostre operationi sono vili e mecaniche, ne vi entra altro artificio che un lavorar di mani." Importantly, the other interlocutor – the elder, experienced painter's assistant, whose name is designated only as "F" – replies, "non hano avuto questa prudenza di separar le cose, è bene che il pittor le conosca e sapia, per potersi far bene servire et ordinare a chi toca tale operatione, e per conoscer le cose fate, se sono perfette, come anco il conoscer li buoni colori, ma non sono tenuti a fabricarli." Although in this ambiguous exchange it is not entirely clear to whom the pronoun "they" refers, the implication seems to be that it broadly classifies the "high status" practitioners of painting – both the *"padroni"* (master painters) employing the assistants having the dialogue as well as such writers on painting as Giovanni Battista Armenini and Raffaele Borghini, mentioned above in the dialogue. The interlocutor "F" tells Silvio that probably his *"padrone"* owns the treatises by Armenini (*De' veri precetti della pittura,* Ravenna, 1586) and Borghini (*Il Riposo,* Florence, 1584), which he should borrow to read.

3. On the Venetian dialogues, see summary in Blunt 1989, 82–85.

4. On the *"velo,"* cf. Volpato in Merrifield 1849, II, 736. Here, note as well discussion of various Italian copying practices in the 1650s, as recorded by Richard Symonds (transcription in Beal 1984, 294–95).

5. See Chapter Three, and Palomino 1947, 518–19: "Esta práctica, o industria, cuando es útil para casos precisos (como retratos, que se repiten, o alguna cosa exquisita, que se ha de copiar puntual, y repetir varias veces) es dañosa, para los que desean aprovechar; y así deben de huir de ella cuanto sea posible, porque con esto se entorpece la práctica del dibujo, y siempre es lo mejor la cuadrícula, y aun sin ella, en cosas de poca substancia."

6. Alberti's statement about his discovery of the veil was first noted in H. Janitschek, *Leon Battista Albertis kleinere kunsttheoretische Schriften (Quellenschriften für Kunstgeschichte,* XI), Vienna, 1877, 237. The following discussion is based on Alberti 1972, 31:67–68, 32:68–70 (cf. Alberti 1950, 82–85). See further, translations in Alberti 1966, 68, 121 (and note 26); Alberti 1972, 31: 67–69; 32:69–70; and Alberti 1991, 65–67.

7. Vasari 1966–87, III (testo), 286.

8. Translation from Alberti 1972, 32:69. For the Latin, see ibid., 32:69: "Nec eos audiam qui dicunt minime conducere pictorem his rebus assuefieri, quae etsi maximum ad pingendum adiumentum afferant, tamen huiusmodi sunt ut absque illis vix quicquam per se artifex possit. Non enim a pictore, ni fallor, infinitum laborem exposcimus, sed picturam expectamus eam quae maxime prominens et datis corporibus persimilis videatur. Quam rem quidem non satis intelligo quonam pacto unuam sine veli adminiculo possit quispiam vel mediocriter assequi." Note 6, above, gives comparative textual references.

9. What follows is based on the text transcribed in Richter, I, 317–18, § 523 (cf. Richter, *Commentary,* I, 333).

10. Uffizi 201 E, Florence. Revised data: 222 × 139 mm.; pen with gold-brown and dark brown ink, over charcoal or black chalk, forms both highlighted and corrected with brush and white *gouache,* on paper rubbed lightly with reddish chalk; only general body outlines and leaning version of her head pin-pricked; design of figure squared twice (in black chalk, or charcoal, or leadpoint?), both underneath and on top of all layers of drawing. Cf. Petrioli Tofani 1986, 88–89, and Caterina Caneva in Uffizi 1992, 272–74, no. 14.3. A large-scale copy of this drawing is in the Ashmolean Museum, Oxford (inv. P II 117 verso). Data: 342 × 231 mm.; pen and brown ink, brush and brown wash, over leadpoint or charcoal, on buff paper lightly rubbed with reddish chalk.

11. The sheet of studies for *St. Bartholomew* by Fra Bartolomeo, Uffizi inv. 227 E (1141 E), Florence. Data: 278 × 187 mm.; red chalk, over leadpoint or charcoal and stylus; squared in leadpoint, with plumbline at center in red chalk. The study by Pontormo for the *Archangel,* Uffizi inv. 6653 F, Florence. Data: 392 × 216 mm.; black chalk, brush with brown and gray wash, over stylus underdrawing and traces of red chalk; squared with stylus, with emphatically indented plumbline at center. Cf. Annamaria Petrioli Tofani and Graham Smith, *Sixteenth-Century Tus-*

can Drawings from the Uffizi (exh. cat., Detroit Institute of Arts), New York and Oxford, 1988, 2–5, 48–49, nos. 1, 21 (with bibliography). Because such drawings are squared, they are usually (and automatically) considered in the literature to have been enlarged for transfer. Although such enlargement is true in many cases, Leonardo's passage provides important evidence for us to consider the explanation given earlier.

12. See Campi in Zaist 1774, 103–6, and discussion in *I Campi e la cultura artistica cremonese del Cinquecento* (exh. cat., S. Maria della Pietà and Museo Civico, Cremona), Milan, 1986, 328, no. 3.13. Cf. further Gian Paolo Lomazzo's *Trattato dell'arte della pittura* (1580), cap. xv (Lomazzo 1973–74, II, 277–79, 291).

13. See Chapter Three and transcription given in Richter, I, 317, § 523 (cf. Richter, *Commentary*, I, 333): "Del modo del ritrarre uno sito corretto. . . ." Cf. *Codex Urbinas Latinus* facsimile in McMahon 1956, II, fol. 41 recto and verso (McMahon 1956, no. 66; Pedretti 1964, 181, no. 90). Cf. also further Nunes 1615, fols. 70 verso–72 verso, and Veliz 1986, 16–18. This Portuguese treatise writer may have had access to Leonardo's notes (beyond what was compiled in the *Codex Urbinas Latinus*), directly or indirectly.

14. Cf. Lomazzo 1973–74, II, 277–79, 291; Volpato in Merrifield 1849, II, 736–38; and Baldinucci 1681, 134. Kim Veltman identified a small sketch by Leonardo (*Codex Atlanticus,* fol. 259 recto, Biblioteca Ambrosiana, Milan), datable c. 1515, as an instrument resembling a pantograph. See Kim Veltman in collaboration with Kenneth Keele, *Studies on Leonardo, I: Linear Perspective and the Visual Dimensions of Science and Art,* Munich, 1986, 112, fig. 181. Christopher Scheiner, however, is formally credited with the invention of the pantograph, which is described in his *Pantographice, seu ars delineandi* (Rome, 1631). Cf. Meder and Ames 1978, I, 158, and Kemp 1990, 180, 353 (and note 28).

15. Ostaus 1567, unpag., *proemio,* fol. 3 verso. On the editions of Ostaus's patternbook, cf. Lotz 1933, 172–3, nos. 96 a–c.

16. Cf. Campi in Zaist 1774, 103–6, and further Chapters One and Five.

17. See further, Chapter One.

18. Pozzo 1693–1700, II, unpag.: "Settione Sesta, *Graticolare/* Quando si hanno à dipinger luoghi grandi, come Chiese, Sale, ò Volte storte, & irregolari, nelli quali ò non si posson far carte così grandi, ò non si posson distendere, è necessario servirsi della graticolatione, la quale è molto utile per trasferir dal piccolo in grande. La graticolatione prospettica è altresì necessaria particolarmente nelle Volte, ò altri luoghi irregolari, per far comparire retta, piana, ò dritta un'Architettura in prospettiva. . . ."

19. Doni 1549, fol. 9 recto: ". . . Perche la fa pigra la pratica della mano, et molto inganna, o ritarda il vero giudicio dell'occhio. . . ."

20. Leonardo's note (*Codex Atlanticus,* fol. 76 recto, Biblioteca Ambrosiana, Milan), as transcribed in Richter, I, 119, § 20 (cf. Richter, *Commentary,* I, 115): ". . . Il pittore che ritrae per pratica e givditio d'ochio, sanza ragione è come lo spechio, che in se imita tutte le a sè cōtraposte cose sanza cognitione d'esse." Cf. trans. in Leonardo, *On Painting,* 52.

See Baldinucci 1681, 85, under *"lucidare":* ". . . senza la fatica dell'immitargli a forza del giudizio dell'occhio, e vbbidienza della mano. . . ." Cf. also further Summers 1981, 368, 352–79.

21. On Anton Francesco Doni, cf. C. Ricottini Marsili-Libelli, *Anton Francesco Doni: Scrittore e stampatore,* Florence, 1960; Andrée Hayum, "Michelangelo's *Doni Tondo:* Holy Family and Family Myth," *Studies in Iconography,* VII–VIII (1981–82), 209–51; and A. Longo in *Dizionario biografico degli italiani,* Rome, 1992, XLI, 158–67. On the *Doni tondo,* see recently, Hirst and Dunkerton 1994 and Antonio Natali in *L'Officina della Maniera* (exh. cat., Galleria degli Uffizi, Florence), Florence, 1996, 140–41, no. 34.

22. Vasari 1966–87, VI (testo), 109: ". . . bisognava avere le seste negli occhi e non in mano, perché le mani operano e l'occhio giudica. . . ." Cf. Blunt, 75, 58–81, and Summers 1981, 373, 352–79.

23. See further Vasari 1966–87, III (testo), 492.

24. The classic study is Panofsky 1968, but it does not encompass the world of the craftsman.

25. Tagliente 1530, unpag., fol. 27 recto and verso (transcribed in Bambach Cappel 1991 a, 98, but see ibid., 72–98, for context): "Et similmente con tal regola, & misura col sesto in mano, ouer col sesto/dell'occhio uostro acuto, potrete fabricare, & ordire ogni qualita de groppi/in tal magistero per far frisi, tondi, quadri, & d'ogn'altra sorte che potra accascar leggiadramente al bisogno uostro. . . ."

26. Armenini 1587, 101–2 (cf. Armenini 1977, 172–73, for trans.): "Ma perche ci sono di quelli, che dicono esser male l'usar questa grata, & cosi allegano friuole ragioni, con dir che essi perdono assai di quel loro dissegno il qual si possiede del far grande col giudicio solo. . . ."

27. According to Armenini, Jacopo Tintoretto skimped on preliminary drawings and cartoons. See Armenini 1587, 116 (cf. Armenini 1977, 184, for trans.).

28. Cf. Armenini 1587, 100–2 (cf. Armenini 1977, 171–73, for trans.), and Perrig 1991, 55, 134 (note 194). Although I agree with the general substance of Perrig's brief point, for the sake of precision, it must be stated that Michelangelo heads the list as a model "cartoonist" in the beginning of Armenini's section on cartoons (Armenini 1587, 100) but is significantly omitted in that on page 102. Further, as we have seen in Chapter Two, the absence of squaring in Michelangelo's cartoon fragment for the *Crucifixion of St. Peter* is not as rare in a sixteenth-century cartoon, as Perrig implies.

29. Vasari 1966–87, I (testo), 119 (cf. Vasari 1960, 213–14, for trans.).

30. Borghini 1584, 140–41.

31. On Michelangelo and *"il giudizio dell'occhio,"* see further Summers 1981, 353–63. Michael Hirst (1988 a) rightly pointed out that there are apparently no autograph squared drawings by Michelangelo. Cf. also discussion in Perrig 1991, 55–56, 134 (note 194).

32. Milizia 1827, II, 189: "Chi calca senza saper disegnare, trascrive una lingua straniera, che gli è insignificante. E impossibile che non vi commetta mille errori. Ondi il calcare non è buono a niente, ed è poco utile a chi sa. Giova

soltanto per ispedetezza degli incisori, che sappiano pero il disegno. Dunque pochissimi dovranno calcare."

33. Baldinucci 1681, 85: ". . . invenzioni tutte, che da chi sa poco, si adoperano con poco frutto; perchè le più squisite minutezze de' dintorni, nelle quali consiste la perfezzione del disegno, con tali istrumenti non si pigliano mai in modo, che bene stieno. Dico da chi sa poco; perchè possono gli eccellenti Artefici valersene con vtilità, pigliando dal lucido il dintorno d'vn certo tutto, e poi riducendo le parti con maestra mano a statto perfetto. . . ."

34. Bauer 1986, 355–57. Cf. Richard Symonds's descriptions of tracing practices prevalent among Italian artists in the 1650s (transcribed in Beal 1984, 294).

35. Leonardo's note is transcribed in Richter, I, 317, § 523 (cf. Richter, *Commentary*, I, 333): "Del modo del ritrarre uno sito corretto . . ."; *Codex Urbinas Latinus* facsimile in McMahon 1956, II, fol. 41 recto and verso (McMahon 1956, no. 66; Pedretti 1964, 181, no. 90). See Nunes 1615, fols. 70 verso–72 recto (cf. Veliz 1986, 16–18, for trans.), as well as Carducho 1979, 385–86.

36. Transcription in Richter, I, 317, § 523 (cf. Richter, *Commentary*, I, 333): "Del modo del ritrarre uno sito corretto/Abbi uno vetro gra[n]de come uno mezzo foglio regale e quello · ferma bene dina[n]zi ali occhi tua, cioè tra l'ochio e la cosa che tu vuoi ritrare · e dipoi ti poni lontano col ochio · al detto · vetro 2/3 di braccio, e ferma la testa con vno strume[n]to i[n] modo no[n] possi · mouere pu[n]to la testa; dipoi serra o ti copri uno ochio · e col penello o co[n] lapis a matita macinata seg[n]ia i[n] sul vetro cio che di là appare, e poi lucida co[n] la carta dal uetro e spolverizzala sopra bona carta e dipi[n]gila, se ti piace, vsando bene poi la prospettiva aerea." See also *Codex Urbinas Latinus* facsimile in McMahon 1956, II, fol. 41 recto and verso (McMahon 1956, no. 66, and Pedretti 1964, 181, no. 90).

37. Nunes 1615, fols. 70 verso–72 verso (cf. Veliz 1986, 17–18, for trans.).

38. As translated in Willi Kurth, *The Complete Woodcuts of Albrecht Dürer*, New York (Dover reprint), 1963, 40: ". . . Solchs ist gut allen denen, die jemand wollen abconterfeien und die ihrer Sache nicht gewis sind."

39. Saint-Aubin 1770, 5 (cf. Saint-Aubin 1983, 20, for trans.). A group of about 100 late-eighteenth-century French tracings (Cooper-Hewitt Museum, New York) probably illustrate that procedure, as they are drawn on translucent oiled paper and for the most part exhibit pricked outlines. These are nos. 1906-21-242, 1906-21-247, and 1931-93-77 through 1931-93-176 (CBC Appendix 22). Most of these pricked patterns are exceedingly repetitive, mechanical, and of low quality. An exception is no. 1906-21-242, which depicts an elegant floral embroidery design for a left front pocket of a waistcoat and which is in watercolor and colored gouaches on laid buff paper. No. 1906-21-242 is also a floral design for the pocket of a waistcoat but is extremely awkward in comparison. The latter is in pen and brown ink over black chalk undrawing on medium-tan laid paper. Both drawings date between 1780 and 1790 and have their versos blackened with pounce. No. 1906-

21-247 has its recto blackened as well, suggesting that it was turned to obtain the requisite mirror images of the waistcoat pockets. Depicting generic floral and *chinoiserie* motifs, nos. 1931-93-77 to 1931-93-176 are of poor execution and date between 1780 and 1800. They are drawn on oiled (relatively transparent) ocher paper, and most patterns are blackened from the black pounce rubbed on their surfaces. Some show the vertical and horizontal creases used to complete the symmetrical patterns. On this technique, see Chapter Five. On Leonardo's knot patterns and Giovanni Antonio Tagliente's embroidery patternbook (first published in Venice in 1527), see Bambach Cappel 1991 a, 72–98. In the case of the Cooper-Hewitt drawings, the preliminary design, which was traced from yet another source, was lightly scratched on the surface of the paper with a needle or pin, in a manner similar to that used in stylus underdrawing. Then the design was, most commonly, drawn with brush and white gouache, or with brush and brownish black ink. Last, the outlines of the patterns were pricked closely and finely, like most early embroidery drawings.

40. Cf. Carducho 1979, 385–86; Palomino 1947, 518–19; and Italian practices current in the 1650s, as recorded by Richard Symonds (transcribed in Beal 1984, 198–202, 294–95).

41. The design obtained with lake pigment then needed to be reversed so as to have the final image in the same orientation as the original being copied. To accomplish this, the design on the tracing paper could be counterproofed, or pricked and pounced from the verso, or stylus-incised from the verso.

42. Medieval painters, like provincial painters of the Renaissance and later centuries, understood their profession as a craft rather than as an art. To them, the distinction between "invention" and "copy" was not important, as it would not generally be for craftspeople until the formation of the so-called "Aesthetic" movement toward the mid-nineteenth century.

43. Volpato in Merrifield 1849, II, 735: ". . . che a questi bisognerebbe troncar le mani in pena di tal delitto, volendo guastar gioje cosi rare potendo in miglior modo conseguire il loro intento, . . ." Cf. also practices of G. A. Canini as recorded by Richard Symonds (transcribed in Beal 1984, 198–201).

44. These passages recommend various methods of tracing but do not mention the *spolvero* technique there. Cf. Cennini 1995, cap. xxiii–xxvi, 24–26 (cf. Cennini 1960, 13–14, for trans.); Borghini 1584, 144–46; and Dionysius of Fourna 1974, 5. The descriptions of tracing in the treatises by Theophilus and Dionysius of Fourna are imprecisely discussed in Nimmo and Olivetti 1985–86, 399–411.

45. Transcription in Frey 1923–30, I, 189, no. LXXXIX: ". . . et infiniti pittori, che non han disegno, come hanno à fare vn quadro, se è da eccellente maestro dipinto, lucidando i contorni, e (è) lo contrafanno di colorito si simile à quello, che molti ingannati si sono; che da per essi non hauendo disegno, far non lo potriano, nascendo questo dalla difficultà dell'arte."

46. Vasari 1966–87, I (testo), 142–43 (cf. Vasari 1960, 243–44, for trans.). The application of *spolvero* for *sgraffito* façade decoration is repeated by Vasari in the *Vita* of Andrea di Cosimo Feltrini; Vasari 1966–87, IV (testo), 521: ". . . voleva sopra alcuni cartoni, spolverandogli sopra l'intonaco. . . ." See further, Chapter One, note 164.

47. Accolti 1625, 18, cap. xvi: ". . . (che cosa sia dilucidare, è molto noto fra Pittori). . . ."

48. Transcription in Samek Ludovici 1956, 37–42. (Creighton E. Gilbert kindly brought this source to my attention.) Giustiniani's undated letter was published in Rome in 1675 and has been dated by art historians anywhere between 1620 and 22 February 1631. Cf. ibid., 89–92; Walter Friedlaender, *Caravaggio Studies,* Princeton, 1955, 76–78; Francis Haskell, *Patrons and Painters,* London, 1963, 94 (note 3); and Howard Hibbard, *Caravaggio,* New York, 1983, 161–62, 345–46.

49. Transcription in Samek Ludovici 1956, 37: "Il primo modo è con spolveri, li quali si possono colorire secondo il genio del pittore, o di chi ordina l'opera. Secondo, il copiare da altre pitture, il che si può fare in molti modi: o con la prima, e semplice veduta, o con più lunga osservazione, o con graticolazioni, o con dilucidazione. . . ."

50. Volpato in Merrifield 1849, II, 736: ". . . e questa la facio ancor io, benchè non son pittore, che in ciò non vi entra artificio di pittura, ma è una pura operazione nostra. . . ."

51. Ibid., 738: "Prima per levarti il fastidio di queste faccende non essendo. . . ."

52. Ibid., 738.

53. Cf. *Nicholas Hilliard's "A Treatise Concerning the Arte of Limning" and Edward Norgate's "A More Compendious Discourse Concerning ye Art of Limning,"* ed. by R. K. R. Thornton, Edinburgh, 1981, and *Nicholas Hilliard's "Art of Limning,"* ed. and comment. by Arthur F. Kinney and Linda Bradley Salamon, Boston, 1983. Cf. Jim Murrell, "The Craft of the Miniaturist," *The English Miniature,* ed. by John Murdoch, Jim Murrell, Patrick Noon, and Roy Strong, New Haven and London, 1981, 1–24.

54. Importantly, the title of the 1752 English translation is *The Art of Painting in Miniature: Teaching the Speedy and Perfect Acquisition of the Art without a Master.*

55. The discussion that follows is based on Boutet 1676, 1–10.

56. Cf. Perrot 1625, xiv–xv, and also Smith 1730, 1, for similar advice to use oiled paper to trace paintings and prints with a porcupine's quill (!) rather than a stylus.

57. Boutet 1676, 6.

5. The Splendors of Ornament

I am indebted to Martin Kemp, Eve Borsook, Steven Trent Cappel, Joel Herschman, and Beatrice Rehl for their helpful comments regarding the classification of ornament patterns here discussed.

1. Cf. Bambach 1996 b, 143–66. For Alberti's passage, see Alberti 1972, 60:102, and Alberti 1950, 111 (cf. translations in Alberti 1966, 72; Alberti 1972, 60:103; and Alberti 1991, 93).

2. See further Cennini 1995, cap. lxvii, lxxii, cxxii, 73–80, 85, 126–28 (cf. Cennini 1960, 42–47, 50–52, 75–76, for trans.), and Bambach Cappel 1996 b, 143–66. The various problematic hypotheses on the supposed origins of figural cartoons in paintings before the Quattrocento are discussed in Chapter Six, notes 2, 320–23, as well as in Chapter Ten. On underdrawings for early Italian panel paintings, see Galassi 1989, 29–33; *Art in the Making* 1989, 19–21, 72–97, 112–23, 129–34, 176–77; Galassi et al. 1991; *Giotto to Dürer* 1991, 164–74; and Galassi 1998, 13–22, 91–102. Infrared reflectograms and infrared photographs showing the typical aqueous, freehand preliminary underdrawings found in late Duecento and Trecento panel paintings are reproduced in *Art in the Making* 1989, figs. 57–59, 90–94, 126–28; as well as in *Giotto to Dürer* 1990, figs. 217–20. On *sinopie* underdrawings for early Italian murals, see, for instance, Procacci 1961, 9, fig. iii, plate 21; Tintori and Meiss 1962, 11–13; Eve Borsook, *Gli Affreschi di Montesiepi: Con annotazioni techniche di Leonetto Tintori,* Florence, 1969; Leonetto Tintori and Eve Borsook, *Giotto: The Peruzzi Chapel,* New York, 1965; Baldini 1977, I, 43–44; Spiazza 1978; Antonino Caleca, Gaetano Nencini, Giovanna Piancastelli, *Pisa: Museo delle Sinopie del Camposanto Monumentale,* Pisa, 1979; Borsook 1980, xxxvi; Hannah Kiel, "Das Sinopienmuseum im Camposanto am Dom zu Pisa," *Pantheon,* XXXIX (1981), 127–28; Borsook 1983, 163–73; Barbara Dodge, "The Role of the *Sinopia* in the Traini Cycle in the Camposanto, Pisa," *La Pittura nel XIV e XV secolo: Il Contributo dell'analisi tecnica alla storia dell'arte, Atti del XXIV Congresso Internazionale di Storia dell'Arte (1979),* Bologna, 1983, 189–210; Mora and Philippot 1984, 138–40; Borsook 1985, 127–36; *Tecnica e stile* 1986, I, 59–66; Bambach Cappel 1988, Part 1, I:82, 227–28, II:429–35; Alessandro Tomei and Serena Romano in Castel Sant'Angelo 1989, 227–37; and *Le Pitture murali 1990.* A number of exhibitions of detached murals and *sinopie* have elucidated this aspect of early technique. See, for instance, Muraro 1960; Metropolitan Museum of Art 1968; Meiss 1970; Umberto Baldini and Paolo Dal Poggetto, *Firenze restaura: Il Laboratorio nel suo quarantennio* (exh. cat., Fortezza da Basso), Florence, 1972; Grossetto 1981 (Parts I and II); and Castel Sant'Angelo 1989. For bibliography, see Paolo Bensi, "La Pellicola pittorica nella pittura murale in Italia: Materiale e tecniche esecutive dall'Alto Medioevo al XIX secolo," 73–102; and Anna Mieli Pacifici, "Il Restauro delle pitture murali nella letteratura italiana e straniera: 1975–89," 329–71, both studies in *Le Pitture murali,* Florence, 1990.

3. On some of these problems, see Leonetto Tintori, "Scientific Assistance in the Practice of Mural Conservation in Italy," *Application of Science in Examination of Works of Art (Proceedings of the Seminar: June 15–19, 1970),* ed. by William J. Young, Boston, 1973, 154–63; Botticelli 1980, 11–32; as well as studies by Andreas Arnold, Konrad Zehnder, and Mauro Matteini in *The Conservation of Wall Paintings* 1991, 103–47, and by Vinicio Furlan and Enzo Ferroni in *Piero ad Arezzo* 1993, 105–7, 219–31.

4. On various methods of waterproofing a wall for painting, see Cennini 1995, cap. clxxv–clxxvii, 192–95 (cf. Cennini 1960, 119–22, for trans.).

5. For general studies on the problem of *intonaci*, see papers in *Intonaci, colore e coloriture nell'edilizia storica. Atti del convegno di studi Roma, 25–27 ottobre 1984* (supplement to no. 35–36, *BA*, Rome, published 1987); papers in *L'intonaco: storia, cultura e tecnologia. Atti del Convegno di studi Bressanone, 24–27 giugno 1985*, Padua, 1985; as well as Giovanna Alessandrini et al. in *Le Pitture murali* 1990, 29–38.

6. This fact first became clear to me in examining the mural cycles in the Upper Church (S. Francesco, Assisi). It was confirmed over and over again, as I compared *spolvero* marks in (1) relatively obvious passages of original Trecento painting, (2) completely or partly repainted areas of losses or other damage in such early murals, and (3) in documented mid- to late Ottocento mural cycles. There appears to be no literature on this subject, and it has hitherto not been identified as a problem. Among further examples of nineteenth-century "restoration *spolvero*," are the various ornamental designs in the *"Sala della Pace"* and the *"Sala della Maestà"* (Palazzo Pubblico, Siena), which house the major masterpieces of early Sienese painting; the beaded stringcourse on the *basamento* of the Bardi-Bardi di Vernio Chapel decorated by Maso di Banco and his followers around 1340 (S. Croce, Florence); the *intrado* of the entrance door of the Oratory of S. Giorgio (Padua) frescoed by Altichiero and his followers in 1380–84; the *imprese* and decoration painted on the walls of the second-floor *loggia* and rooms in the Palazzo del Bargello (Florence); as well as the restored piece on the lower right in the St. Catherine fresco on the right aisle of S. Miniato al Monte (Florence), here illustrated as Figure 124. I am less certain about a number of passages in the so-called *"Cappella del Priore"* (Palazzo Pubblico, Siena). This problem requires further investigation. As I inquired among my colleagues in the fields of art history and conservation, Adriana Gaggi (in charge of the *cantiere* for the restoration of the chancel murals in Orvieto Cathedral, where we located isolated examples of the practice) noted that to reconstruct areas of losses in decorative designs, some modern restorers, in fact, still use *"spolvero* patterns." These consist of tracings on clear acetate or translucent paper, taken from remaining original parts of the designs, which are then pricked and pounced in the traditional manner onto the surface to be repainted. Dott.ssa Gaggi informed me that this practice was used, for instance, in the recent restoration of the murals in Spoleto by Filippo Lippi and others (conversation, 25 June 1992). Moreover, in Giulio Romano's *"Sala delle Imprese"* (Palazzo Te, Mantua), a small tablet is frescoed in sixteenth-century style on a window sill with the inscribed date "1950," to commemorate the room's restoration. Finally, in Ottocento mural decoration, the *spolvero* technique was also used for repeating ornament in the traditional Medieval and Renaissance manner. Among other examples, notice the pilasters of S. Giacomo degli Spagnoli (Rome), the *dado* of the *"Sala dell'Immacolata"* frescoed in 1858 by Francesco Podesta in the Vatican Palace, the *dados* on the radiating chapels of the Basilica of S. Antonio (Padua), the *dado* ornament in the *"Sala del Risorgimento"* or *"Sala Vittorio Emmanuele"* from around 1890 (Palazzo Pubblico, Siena), and the right transept in S. Maria presso S. Satiro (Milan).

7. Surprisingly, this evidence went unnoticed as an issue in the published report accompanying the most recent cleaning of the mural cycle in the Upper Church (S. Francesco, Assisi). Cf. Zanardi and Frugoni 1996. My examinations were done before the damaging earthquakes of September 1997.

8. The original modillions were elaborately constructed by stylus ruling directly on the *intonaco*, probably by means of some mitering device. On the mitering device, cf. Edgerton 1991, 59. See discussion of early fictive modillion cornices and other illusionistic architectural details later in this chapter.

9. The state of the question is discussed in Smart 1971, 3–45; Belting 1977, 87–105; Silvestro Nessi, *La Basilica di S. Francesco in Assisi e la sua documentazione storica*, Assisi, 1982; Edgerton 1991, 56 (and note 19); and Zanardi and Frugoni 1996.

10. Uffizi inv. 291 E, Florence. Revised data: 262 × 391 mm.; pen and brown ink on buff paper; unrelated outlines pricked from verso; and traces of rubbed black pouncing dust. Cf. Petrioli Tofani 1986, 128–29, *sub numero;* and Andrea DeMarchi in Uffizi 1992, 158–59, no. 7.11, though without the present observations on technique.

11. On this fresco cycle, see discussion in Chapter Six. Artur Rosenauer viewed the Uffizi design as possibly being a "substitute cartoon." Cf. Rosenauer 1986, I, 27, and Bambach Cappel 1988, Part 1, II:313, Part 2, I:149–50, no. 114. Yet the argument that the sheet is a reused "substitute cartoon" does not take into account the important fact that the design of the *all'antica* molding was pricked from the verso of the sheet, not the recto. Notice the raised craters of paper along the perforations. The drawing of the egg and dart molding may appear on this verso, in which case the sheet would not qualify as a "substitute cartoon," as others and I previously proposed.

12. The Uffizi sheet is presently glued onto a mount, which makes the pricked design on the verso unviewable.

13. Such decoration is found as well on the much repainted *intrados* of the door and window in the *"Sala dei Gigli"* (Palazzo Vecchio, Florence), frescoed in 1482–84 largely by the Ghirlandaio workshop with elaborate civic imagery.

14. The size of the sheet is smaller by about 5 cm. in both height and width than the *rezzuta* size of Bolognese paper (the smallest size sold according to the city's statutes), but it is larger than one-half the *imperiale*. Clearly, the paper has been trimmed. The pricking, however, stops substantially before the perimeters of the sheet. Also, the original size of the paper pattern could not have been vastly larger; no signs of glued borders appear, although the present mounting of the sheet does not permit firm conclusions.

15. This might help explain why, in the Uffizi drawing, the pattern for the molding is at a more final stage of design than that for the scene of the *Visitation*. For the *giornate*, cf. Danti 1990, 39–52; Danti and Ruffa 1990, 29–48; and Danti 1996, 141–49.

16. In my opinion, the drawing on the recto of the sheet has

been overcleaned; the traces of pouncing dust on the recto (clearly visible with magnification) are no longer as evident as they once must have been. (As discussed in Chapter Two, pouncing dust is extremely ephemeral.) When the sheet is held against the light, it appears to be rubbed with pouncing dust also from the verso; this shows through as dark areas on the recto. The blackened craters of the perforations further attest to the fact that the design was actually pounced. The procedure here described may be compared to that for the pseudomeander frieze painted with a *spolvero* pattern in Masaccio's *Trinity;* the *spolvero* marks are still evident on the fresco (Polzer 1971, 22, plate 5).

17. In fact, both drawings and written sources confirm that craftspeople frequently stacked multiple sheets of paper underneath a pattern, pricking through the outlines of the pattern to replicate it. See further, Chapter Eight, on "substitute cartoons." Charles Germain de Saint-Aubin's *L'Art du Brodeur* (1770) explains that embroidery designers produced such replicas of patterns in order to facilitate the delegation of labor. Saint-Aubin 1770, 5, 39 (cf. Saint-Aubin 1983, 75, for trans.), for definitions of *piquer* and pricked patterns for embroidery: ". . . On pique souvent quatre ou cinque papiers ensemble; ces percés servent à faire les dessins marqués qu'on donne dans les différents atteliers. . . . Quand ces dessins ont été agréés, il les calque (a) au papier huilé (b), double ce papier d'un autre qu'on nomme *grand-raisin,* & les fait piquer ensemble." An equivalent practice must have existed from very early on for the painting of ornament, the execution of which, at least for large mural cycles, was most often entrusted to different assistants within the workshop. The general principle of production resembled that of pricked "substitute cartoons" for figural compositions, as described in Giovanni Battista Armenini's *De' veri precetti della pittura* (1586). Among the early Italian users of that practice was Ghirlandaio himself.

18. Another little-known sheet with a drawing of a *Standing Soldier* contains a fragment of an unrelated pricked ornament pattern depicting concentric circles, and is associated with the Ghirlandaio *bottega;* Nationalmuseum inv. 110/1863, Stockholm (not in CBC). Data: 244 × 163 mm. maximum sheet, pen and dark brown ink over traces of black chalk. Surviving *spolvero* patterns for decorative arts of later periods show how little practices changed among artisans and establish their purely functional appearance. The decorative patterns comprising the *Codex Zichy* (Szépmüvészeti Múzeum, Budapest), the eighteenth-century embroidery *"poncifs"* in the Cooper-Hewitt Museum, New York (inv. 1906-21-242; 1906-21-247; 1931-93-77 through 1931-93-176), the *"sponsen"* for ceramic tile and faience designs in Dutch archives (see Pluis 1979, 49–50, 68–73; Lunsingh Scheuerleer 1984, 17, 179; and Van Dam et al. 1984, 34), and the designs for ceramics from the Gentili Family Archive in the J. Paul Getty Center, Los Angeles (inv. 880209, GJPA88-A274), still have traces of rubbed pouncing dust, often on rectos and versos, attesting to their replication over and over. Such functional, mechanical-looking designs, of generally poor draughts-

manship, help us envision the probable appearance of *spolvero* patterns used in the workshops of painters from the mid-Trecento onward. I am indebted to Lórand Zentai, Ella Schaap, and Catherine Hess, for bringing some of this material to my attention.

19. The conclusions and research on Chinese pouncing here presented drastically revise Bambach Cappel 1988, Part 1, I:179 (note 5), 188–89 (note 28). I am indebted to Cary Liu, Anne Farrar, and Sheila O'Connell for their assistance with some of the material that follows. Three patterns of seated Buddha figures are relevant (Department of Oriental Antiquities, British Museum, London). They are all on papers exhibiting large vegetable fibers, but of different textures. Data for inv. 1919-1-1-073 (1): 342 × 282 mm.; recto brush and black/gray ink, verso brush and black/gray ink, pricked from verso, rubbed on verso with blackish pouncing dust. Data for inv. 1919-1-1-073 (2). Ch.Xli.004: 560 × 380 mm. maximum; pricked outlines but with no drawing except for small areas of wings outlined with brush and black paint, halo outlined with pink (a "substitute cartoon" type), rubbed with pale reddish-ocher pouncing dust, vertical centering marks with brush and black. Data for inv. 1919-1-1-072. Ch.0015: 790 × 1410 mm. maximum; pricked outlines obtained by folding sheet along the center (left half pricked from verso, right half pricked from recto), partly drawn with brush and black/gray gouache, rubbed with dark brown pouncing dust, on eight glued sheets of paper (assembled like a Renaissance cartoon), glued onto secondary paper support. Cf. Whitfield 1983, figs. 138 a and b, 139, plates 78, 79; and Whitfield and Farrar 1990, 12–17, 88, nos. 70–71. For a general context of the practice, though imprecise, cf. Eiichi Matsumoto, *Tonkōga no kenkyū* (research on Dunhuang paintings), Tokyo, 1937, 2 vols.; Matsumoto, "The Modelling of Buddhist Images by the Use of Molds," *Bijutsu Kenkyu,* no. 156 (1950), 1–15 (with summary in English); Matsumoto, "Findings on Dunhuang Paintings," *Bukkyō Geijutsu,* 1956, 66–70; Tseng Yu-ho Ecke, "A Reconsideration of "Ch'Uan-Mo-I-Hsieh," The Sixth Principle of Hsieh Ho," *Proceedings of the International Symposium on Chinese Painting, National Palace Museum,* Taipei, 1972.

20. Whitfield and Farrar 1990, 14–15.

21. Cf. Tsien Tsuen-Hsuin, "Paper and Printing," in J. Needham, *Science and Civilization,* Cambridge-London-New York, 1985, 145–47 (pointed out by Cary Liu).

22. By the eighth or ninth century A.D., the term *"fen pen"* took on the more general meaning of "draft sketch." Cf. Tseng Yu-ho Ecke, "A Reconsideration of "Ch'uan-Mo-I-Hsieh," The Sixth Principle of Hsie Ho," *Proceedings of the International Symposium on Chinese Painting,* Taipei National Palace Museum, 1972, 313–23, 324–38 (discussion). I am indebted to Cary Liu, who undertook a search on my behalf of the Chinese literature on pouncing and of the etymological root of the term *"fen pen"* (letters of 7 February and 1 April 1991). On Chinese pouncing, cf. further E. Matsumoto, "'Kata' ni yoru zōzō" ("The Modelling of Buddist Images by the Use of Molds"), *Bijutsu*

Kenkyu, no. 156 (1950), 1–15 (with summary in English); Whitfield 1983, II, unpag. commentary to plates 78–80, figs. 138 a, b, 139; as well as Whitfield and Farrar 1990, 88, nos. 70–71.

23. Bambach Cappel 1988, Part 1, I:11–56.

24. My point can be supported by comparing an Italian fourteenth-century woven silk at the Metropolitan Museum of Art, New York (12.55.1) inspired by a Chinese pattern (Fig. 128), to an actual thirteenth- or fourteenth-century Central Asian, probably Chinese, woven compound silk also at the Metropolitan Museum of Art (1973.269), which could not be illustrated herein. See color photograph and discussion in James C. Y. Watt et al., *When Silk was Gold: Central Asian and Chinese Textiles* (exh. cat., Metropolitan Museum of Art, New York, and Cleveland Museum of Art), New York, 1997, 148–50, no. 39. The general history of this topic is covered in Antonio Santangelo, *The Development of Italian Textile Design from the 12th to the 18th Century*, London, 1964; Klesse 1967; G. Giargiolli, *L'Arte della seta in Firenze, trattato del secolo XV*, Florence, 1968; Ann E. Wardwell, "The Stylistic Development of 14th and 15th Century Italian Silk Design," *Aachener Kunstblatter*, no. 47 (1976–77), 177–226; Tietzel 1984, 50–75; Hills 1987, 95–114; Lisa Monnas, "The Artists and the Weavers: The Design of Woven Silks in Italy 1350–1550," *Apollo*, CXV (1987), 416–24; and Monnas 1990, 39–58.

25. Here, further research is clearly necessary.

26. The classic study is Klesse 1967. Cf. also Hills 1987, 95–114; Monnas 1990, 39–58; and Paola Frattaroli, "Gli Ornati tessili nelle opere di Pisanello," in Castelvecchio 1996, 453–64.

27. For the classification of textile patterns in paintings, cf. Klesse 1967, and Monnas 1990, 39–58. For the classification of actual textile patterns, see Tietzel 1984, especially 24–107. On punchmarks, cf. Mojmir S. Frinta, "On the Punched Decoration in Medieval Panel Painting and Manuscript Illumination," *Conservation and Restoration of Pictorial Art*, ed. by Norman Brommelle and Perry Smith, London, 1976, 54–60; Erling Skaug, "Punchmarks – What are They Worth? Problems in Tuscan Workshop Interrelationships in the Mid-Fourteenth Century: The Ovile Master and Giovanni da Milano," *La Pittura nel XIV e XV Secolo: Il Contributo dell'Analisi Tecnica alla Storia dell'Arte*, Bologna, 1983, 253–82; as well as Skaug 1994.

28. The list of relevant patternbooks is as follows. Edition is as consulted by author; first editions are as recorded in Lotz 1933. Giovanni Antonio Tagliente, *Esemplario nuovo che insegna a le Donne a cuscire, a raccamare, et a disegnare a ciascuno: Et anchora e di grande utilita ad ogni Artista, per esser il disegno a ogniuno necessario*, Venice, 1527 (Lotz 1933, 112–16; Bambach Cappel 1991 a, 72–98); Nicolo d'Aristotile Zoppino, *Essemplario di lavori . . .* Venice, 1530 (Lotz 1933, 117–18, first ed. 1529); Giovanni Andrea Valvassore, *Opera nuova universale intitulata Corona di racammi . . .* Venice, 1546 (Lotz 1933, 119–23, first ed. 1530); Alessandro Paganino, *De rechami p elquale se impara in diversi modi lordine e il modo de recamare, cosa nõ mai piu fatta ne stata mostrata, el quale modo*

se insegna al lettore voltando la carta: *Opera Nova, . . .* Venice, c. 1532 (Lotz 1933, 133–38; Bambach Cappel 1991 a, 81–83); Nicolo d'Aristotile Zoppino, *Gli Universali de i belli recami antiche . . .* Venice, 1537 (Lotz 1933, 145); Matthio Pagano [Domenico Sera], *Opera nova composta per Domenico Sera . . .* Venice, 1546 (Lotz 1933, 130–33, first ed. 1543); Matthio Pagano, *L'honesto essemplario del vertuoso desiderio che havanno di nobil ingengno . . .* Venice, 1545 (Lotz 1933, 146–52); Giovanni Ostaus, *La vera perfettione del disegno di varie sorti di ricami et di cucire punti a fogliami, punti tagliati*, Venice 1567 (Lotz 1933, 172–75, first ed. 1557); Vittorio Serena, *Opera nova di ricami . . .* Venice, 1564 (Lotz 1933, 180–81); Federico Vinciolo, *Les singuliers et nouveaux pourtraicts, du seigneur Federic de Vinciolo venitien . . .* Paris, 1606 (Lotz 1933, 185–90, first ed. 1587); Cesare Vecellio, *Corona delle nobili et virtuose donne*, Venice, 1591 (Lotz 1933, 200–9, 212–16), Giacomo Franco, *Nuova inventione de diverse mostre cosi di punto in aere . . . ,* Venice, 1596 (Lotz 1933, 230); Isabetta Catanea Parasole, *Pretiosa gemma delle virtuose donne . . .* Venice, 1600 (Lotz 1933, 233–34, first ed. 1598); Matteo Florimi, *Fiori di ricami nuovamente posti in luce . . .* Siena, 1604 (repr. by Ulrico Hoepli, Milan, 1921); Lucretia Romana, *Ornamento nobile per ogni gentil matrona . . .* Venice, 1620 (not in Lotz 1933). Many of these abundantly reprinted books also often repeated previously published patterns from Italian and German sources; originality of subject matter was obviously seldom a consideration. See further Bambach Cappel 1988, Part 1, I:121–35, and Bambach Cappel 1991 a, 72–98.

29. Cf. Klesse 1967. Confirmation of another type will emerge from our discussion, later on, concerning a shortcut used in the depiction of bilaterally symmetrical designs. That identical practice occurs in one of the three tenth-century Chinese pricked patterns now in the British Museum, as well as in five drawings by Leonardo (CBC 131, 138, 143, 148, 149), and, verbally, in Giovanni Antonio Tagliente's embroidery patternbook, first published in Venice in 1527. See Tagliente 1530, unpag., fols. 27 verso–28 recto (transcribed in Bambach Cappel 1991 a, 98). On this practice, see further ibid., 72–98. Leonardo's drawings date his earliest use of the shortcut during his first Milanese period (1482/83–1499), but abundant later examples of the practice attest to its eventually widespread dissemination in Europe.

30. Cennini 1995, cap. cxli 143–44 (cf. Cennini 1960, 86–87, for trans.). But note transcription of the term as *"spolverizzi"* by Daniel V. Thompson in Cennini 1932, 84.

31. Beyond the citations discussed in this section, see also the following, which have been little noticed in the literature: Cennini 1995, cap. cxlii, 144 (cf. Cennini 1960, 86–87, for trans.): "Avendo spolverezzato il tuo drappo, abbi uno stiletto di schopa, o di lengnio forte, o d'osso; punzio, come stile proprio da disegnare, dall' un de' lati; dall' altro, pianetto da grattare"; Cennini 1995, cap. cxliii, 145–46 (cf. Cennini 1960, 89, for trans.): "Ad idem. Campeggia i vestiri la figura, di quel colore che vòi aombrala. Togli poi un pennello di varo sottile, ed i mordenti. Spolverato che hai, secondo vuoi fare i drappi e lacci, lavora di mordenti,

40–53, 58) was reluctant to accept such a transmission of paper patterns. Her conclusions regarding this problem were based on the sporadic comparisons of internal measurements in the case of selective designs. This method of investigation seems imprecise, for it largely overlooks the variations of design that the step of tooling the designs introduced in the *sgraffito* process. Analysis of the *sgraffito* process, particularly its archaeological evidence on panels, suggests that selective internal measurements of a few motifs' dimensions do not really help establish whether designs correspond or not. The possibilities for error are great, especially in the case of textile designs that are inherently similar to each other. We can obtain greater precision by using tracings on clear acetate, from the paintings, of comprehensive portions of the patterns. Some of the discrepancies Monnas noted can be explained by the fact that the paper patterns for the motif most probably portrayed only a quarter of the repeat as painted in the panels; see earlier discussion. Needless to say, the problems of reconstruction grow more complex, because the actual drawings or patterns on paper/parchment no longer survive; in my opinion, we have not yet sufficiently taken into account the implications of this fact. As we shall continue to see during the course of this book, complex tracing practices from one drawing onto another were frequently part of the Renaissance process of design; in the absence of drawings, we can only guess at similar intricacies in the Late Medieval process of design.

58. The pattern is catalogued in Klesse 1967, 329–31, under no. 264, with a list of examples.

59. Nardo's *Enthroned Madonna* (Klesse 1967, 330, no. 264 d), formerly in the New York Historical Society, is now in the Brooklyn Museum (inv. 1995.2), New York.

60. The motif also recurs in paintings attributed to Niccolò di Pietro Gerini, Agnolo Gaddi, and Lorenzo Monaco; cf. Monnas 1990, 49 (note 20).

61. This fact is correctly taken into account in the reconstruction provided in *Art in the Making* 1989, 131–33, 135, plates 117–18.

62. The authors of *Art in the Making* 1989, 131–33, suggested that Nardo di Cione's workshop probably used the alternative practice of stylus incision for the transfer of the textile patterns in the *Trinity with St. Romuald and St. John the Evangelist* (Galleria dell'Accademia, Florence). I have examined the detail in question, the area of painted cloth on the lower right corner of St. John the Evangelist where the column base of the frame was removed. In my opinion, the type of incision visible there was done freehand, directly on the painting surface *(incisione diretta)*; it is most definitely not the type of incision done through the paper of a pattern or cartoon *(incisione indiretta)*. The imprecise distinction between both general types of incisions has posed a serious problem in the literature on painting technique; see further, Chapter Ten. Moreover, that the detail to which the authors alluded does not exhibit *spolvero* marks is hardly surprising; this fact should not be adduced as conclusive evidence, in view of our discussion in Chapter Two on the ephemeral nature of *spolvero*

marks, as well as of what is said about the *sgraffito* technique in the paragraphs that follow.

63. I am indebted to the following persons who facilitated my research on these paintings and who enabled me to make tracings on acetate of the textile patterns with the assistance of the conservators on their staff: Alessandro Cecchi, Stefano Francolini, Franca Falletti, Everett Fahy, Andrea Bayer, Mario Celesia, Richard Gallerani, Cesare Bucci, Giustimi Giuliano (July–August 1991); Nicholas Penny and Jill Dunkerton (June 1993).

64. The process of pouncing itself could lead to imprecisions; patterns could accidentally slip or slide, causing syncopated *spolvero* outlines, as we see in Antonio Pisanello's frieze of banners, or the *grotteschi* by Andrea del Sarto and Giulio Romano. See Figures 54–55, 151.

65. Here, compare the later design practice for embroidery described in Saint-Aubin 1770, 5, 39 (cf. Saint-Aubin 1983, 75, for trans.), with definitions of *"piquer"* and pricked patterns for embroidery.

66. Cf. *Art in the Making* 1989, 130–33.

67. I am indebted to Maryan W. Ainsworth and Jeffrey Jennings for advice, as well as for scanning with infrared reflectography the brocade patterns on the cloth of honor depicted in Nardo di Cione's *Enthroned Madonna and Child with Saints* (formerly in the New York Historical Society, now Brooklyn Museum inv. 1995.2, New York), when it was on loan to the Metropolitan Museum of Art. We selected areas where the gilding was worn.

68. Infrared reflectography reveals *spolvero* dots underlying the brocade patterns on the cloth of honor in the *Coronation of the Virgin* from 1438 to 1440, by the German "Master of the Albrechtsaltar" (Museum of Klosterneuburg). Cf. Taubert 1975, 391, no. 1, and Manfred Koller, "Der Albrechtmeister und Conrad Laib," *Österreichische Zeitschrift für Kunst und Denkmalpflege,* XXVII, 1973, 44, plate 48. In fact, nearly all the early examples of *spolvero* in German painting occur in the portrayal of textile patterns. The continuity of this practice is remarkable, for examples date as late as the 1520s (cf. Taubert 1975, 391–93, nos. 2–12, 14–17), and even the 1540s in Switzerland (ibid., 394, no. 18). See also Konrad Riemann, "Maltechnische Untersuchungen an Gemälden von Lucas Cranach D. A.," *Bildende Kunst,* 1980, 115–18, 151–52, for additional examples of this practice in the paintings of Lucas Cranach the Elder, but the examples and method of analysis are treated very imprecisely. These results are in keeping with the narrow role of design replication that the *spolvero* technique would play in Northern Europe.

69. On the building of the Castelvecchio in Verona, see Renzo Chiarelli and Licisco Magagnato, *Castelvecchio e le Arche Scaligiere,* Florence, 1969. I am indebted to Giorgio Marini for facilitating my research on this fresco cycle.

70. As is clear despite the large lacunae in the decoration, the design of the murals in this room from floor to ceiling – the fictive tapestry on the *dado,* the fictive Islamic-style tile work on the main body of the wall, and the *spalliera* punctuated with *imprese* and foliage – originally repeated identically along all four walls. These murals lay under-

neath later decoration. At the entrance to the room (on the right wall), the *dado* exhibits heavy *martellinatura* (hammering of the surface) from the attempt to lay over fresh plaster in preparation for subsequent frescoing. On the tapestry motif at Assisi, see Klesse 1967, 38–54; Belting 1977, 107–12; and Benton 1983, 74–137.

71. At the Castelvecchio in Verona, the muralists underpainted the main outlines of the top horizontal green band and red tapestry rod with thin, water-based, brick-red pigment. Curiously, additional ocher *spolvero* dots are also sporadically apparent. A slightly off-white hue, the nude *intonaco* provided the ground color for the cloth of the tapestry. Based on the extensive carbon *spolvero* underdrawing, the folds of the cloth were then freely sketched with the brush and final thick blue/dark-green pigment. At times, the muralists carefully refined the design of the folds in the process of painting, at others they negligently misshaped its features.

72. Performed by Maurizio Seracini (Editech, Florence).

73. Cf. Ornella Casazza, "Al di là dell'immagine," *Gli Uffizi: Studi e ricerche*, 5: *I Pittori della Brancacci agli Uffizi*, Florence, 1988, 96, 98, fig. 17 (with an erroneous reading of stippled painted dots on eyelashes as *spolvero* in the *Tribute Money*). For discussion of *spolvero* in the decorative borders of this fresco cycle, see later in the text and note 131.

74. Cf. Carl Strehlke's thorough entry in *Painting in Renaissance Siena* 1988, no. 42, 254–57. It should be noted that the incisions on the folds of the Virgin's and the emperor's garments were done directly on the *intonaco*, without the intermediary means of a cartoon *(incisioni dirette)*. The roots for the particular practice of incising folds in draperies lie in the late Duecento to early Trecento, as the technique of *chrysography* was gradually abandoned. On the problems of distinguishing between cartoon incisions and direct incisions, see further Chapter Ten.

75. Cf. Klesse 1967, 25–33, and Baxandal 1972, 122–23 (with discussion of the phrase *"puro sanza ornato"*).

76. Cf. Klesse 1967, 25–33, and Paola Frattaroli in Castelvecchio 1996, 453–64. On the patronage by the Pellegrini family of Pisanello's murals at S. Anastasia, see studies by Tiziana Franco, Hans-Joachim Eberhardt, Gian Maria Varanini, and Paola Marini in Castelvecchio 1996, 139–50, 165–84, 232–37 (nos. 26–27). On the patronage of Ghirlandaio's frescos in the *cappella maggiore* at S. Maria Novella, see Simons 1987, 221–50, and Hatfield 1996, 112–17. On Carpaccio's *Scuola di S. Orsola*, see Brown 1988, 20, 22, 279–82.

77. The diagnostic survey of the *"Madonna del Parto"* was conducted by Maurizio Seracini (Editech, Florence). At this point in time, a number of textile patterns that were complex but that did not require modeling were also painted from form-positive/form-negative stencils: the telltale evidence for this practice emerges in the extremely even application of the paint layer, as well as in the buildup of the paint layer at the edges of the patterns. Separate cut stencils were used, for instance, for the floral brocade pattern on the stiff, somewhat graceless light-brown mantle that king Solomon wears in Piero's *Meeting of the Queen of Sheba and King Solomon,* part of the mural cycle on the *Legend of the True Cross* (S. Francesco, Arezzo), finished before 1466, even though the figures themselves are based on *spolvero* cartoons. The application of cut stencils also occurs in the fictive brocade curtain flanking Benozzo Gozzoli's *Martyrdom of St. Sebastian,* part of the mural cycle on the entrance wall of the Collegiata of San Gimignano. Presumably this frescoed curtain is to be dated around 1466 (Benozzo's *Martyrdom of St. Sebastian* is dated 18 January 1466; cf. Ahl 1996, 141–48. Two polychromed wood sculptures of saints stand now in front of these fictive curtains.

78. I am indebted to Giorgio Bonsanti, Cristina Danti, Fabrizio Bandini, and Jonathan Nelson for the opportunity to study these frescos from the scaffolding, erected for their cleaning (November 1990).

79. See Figures 182, 184, 190, 192, 194; and Chapter Six. Importantly, the earliest comprehensive study of the *sinopia,* Oertel 1940, 270–303, acknowledges the influence of mosaic design upon the technique of early Renaissance fresco painters. Cf. also Procacci 1961, 13, with excellent technical and photographic records of *sinopie;* Baldini 1977, 43–47; Borsook 1980, xxiv; Ames-Lewis 1981 a, 23–33, with an evaluation of *sinopia* as drawing; Mora and Philippot 1984, especially 138–40; as well as exhibitions of detached frescos and *sinopie:* Metropolitan Museum of Art 1968; Umberto Baldini and Paolo Dal Poggetto in *Firenze restaurata,* Florence, 1972. See also in this chapter, note 2.

80. The discussion that follows is based on Cennini 1995, cap. lxvii, 73–80 (cf. Cennini 1960, 42–45, for trans.).

81. "Poi fa' prima i tuo' fregi, o altre cose che voglia fare d'attorno."

82. Among the examples are the detached *sinopie* fragments from the mural cycle in the Upper Church at S. Francesco, Assisi.

83. It was not possible to illustrate the archaeological evidence on the Arena Chapel discussed, for the argument would require a number of photographs in order to do it justice. Fortunately, much of the evidence is extremely accessible, as it is within the viewer's eye level. The undocumented date for the Arena Chapel murals can be established circumstantially. The building of the chapel began late in 1302. It was consecrated in 1305, and by 1306 some of Giotto's scenes were being copied. On the chronology and documents, cf. James Stubblebine, *Giotto: The Arena Chapel Frescoes,* New York, 1969, 103–11; Claudio Bellinati, "La Cappella di Giotto all'Arena e le miniature dell'antifonario 'Giottesco' della Cattedrale (1306)," in *Da Giotto al Mantegna,* Milan, 1974, 23–30; and Bruce Cole, *Giotto and Florentine Painting 1280–1375,* New York, 1976, 63–67, 182. On the illusionistic ornamental framework of the chapel, cf. Isermeyer 1937, 4–18. On the painting technique, cf. Borsook 1980, 7–14, and Anna Maria Spizzi, "Giotto a Padova," *Studi sullo stato di conservazione della Cappella degli Scrovegni in Padova* (supplement, *Bollettino d'Arte,* 2 Serie Speciale, Rome, 1982), 13–58. Diagnostic analyses of the murals' state of preservation are given in the latter volume, in articles by Domenico Artioli, Maurizio Marabelli,

Costantino Meucci, Guido Biscontin, Silvio Diana, Vasco Fassina, Ottavio Vittori, Giorgio Accardo, Dario Camuffo, Patrizia Schenal, Claudio Bettini, Giuseppe Carruba, Michela Monte Sila, Paolo Mandrioli, et al. Bonsanti 1985 offers useful large-scale photographs.

84. The reddish underpaint is especially visible in passages of ultramarine blue, which, because it was by necessity applied *a secco,* has flaked off.

85. Cf. also Bonsanti 1985, plates 62–63, 90, 94, 104, 113–15.

86. Cennini 1995, cap. lxxxvii, 95–96 (cf. Cennini 1960, 56–57, for trans.): "Poi fa' una riga lunga, diritta e gentile, la quale dall' uno de' tagli sia smussatta, che non s'accosti al muro: ché fregandovi o andando su col penello e col colore non ti imbratterà niente; e lavorrai quelle cornicette con gran piacere e diletto; e per lo simile, base, colonne, capitelli, frontispizi, fioroni, civori, e tutta l'arte della mazzonarìa, che è un bel membro dell' arte nostra e vuolsi fare con gran diletto."

87. I was fortunate enough to study repeatedly the mural and mosaic decorations of the *Sancta Sanctorum* (building complex of S. Giovanni in Laterano, Rome) while the restoration was in progress, thanks to the late Fabrizio Mancinelli and Bruno Zanardi (1993–94). The problem of the various types of design technology used in the mural cycles at S. Francesco (Assisi) and S. Croce (Florence) deserves painstaking investigation from restoration scaffoldings. Cf. photographic surveys in Previtali 1974, figs. 64, 90, 213, 217, 303, 361, 415, plates XV, XXIV, XIX, XXX, XXXVI, XLVIII, LVI–LVII, LXII–LXIV, LXVIII, LXXIV, LXXVI, LXXXVI, XCIX, C–CI; Bonsanti 1985, plates 16, 23, 44, 117, 130, 133, 146–47, 164; as well as Zanardi and Frugoni 1996. For a typological discussion of the fictive ornamental borders in the Bardi and Peruzzi Chapels, cf. Isermeyer 1937, 19–26.

88. See the illustrated survey in Andrea Emiliani et al., *Gli Affreschi trecenteschi da Santa Chiara in Ravenna,* Ravenna, 1995.

89. This is demonstrated in the Villa of Poppaea (Oplontis) by the so-called "Second Style" murals and column decorations or in the upper Catacombs of S. Gennaro (Naples) by a ceiling design from the sixth-century A.D. with incised compass work imitating *opus sectile.*

90. Cf. Borsook 1980, xxxv, 23–27.

91. On the problems of design, attribution, and iconography of this chapel, see G. L. Mellini, *Altichiero e Jacopo Avanzi,* Turin, 1965; Francesca Flores d' Arcais, "Presenza di Giotto al Santo: La Decorazione della cappella di San Giacomo: La decorazione della cappella di San Giorgio," *Le Pitture al Santo di Padova,* Vicenza, 1984; 15–42; Mary D. Edwards, "The Chapel of S. Felice in Padua as *"Gesamtkunstwerk,"* *Journal of the Society of Architectural Historians,* XLVII (1988), 160–76; and Daniele Benati, *Jacopo Avanzi,* Bologna, 1992 (without the present observations on design technology).

92. I have found *spolvero* on the fictive lattice design that appears on the *intrado* of the main entrance; here the *intonaco* changes at about 63–64 inches (159–161 cm) from the floor. There is therefore some restoration. Such careful and meticulously precise repetitions of both small decora-

tive motifs and large architectural structures appear in the frescos that the use of *spolvero* patterns seems like a foregone conclusion.

93. The *spolvero* is most evident on the left border for the scene of the *Dormition of the Virgin.* On this cycle, cf. Francesca Flores d'Arcais, "Jacopo da Verona e la decorazione della cappella di San Michele in Padova," *Arte Veneta* (1973), 9–24; Davide Banzato and Franca Pellegrini, *Da Giotto al Tardogotico: Dipinti dei Musei Civici di Padova del Trecento e della prima metà del Quattrocento* (exh. cat., Musei Civici agli Eremitani, Padua), Rome, 1989, 81–83, nos. 56–60, with extensive bibliography.

94. Traces of *spolvero* can be found on all the walls, but the best preserved passages occur on the two entrance walls.

95. For an Etruscan example, albeit a simple red and white checkerboard pattern, see the *Tomb of the Lioness,* from c. 520 B.C., in Tarquinia. For Roman examples, see the columns in the Villa of Poppaea at Oplontis.

96. On the fictive ornamental borders by the circle of Orcagna, cf. Isermeyer 1937, 59–66. On Florentine painting during the second half of the Trecento, cf. Offner 1927; Offner; Boskovits 1975; and Fremantle 1975.

97. On this fresco fragment, cf. Becherucci 1983, 167–68, no. 11, with bibliography.

98. On this fresco also, cf. ibid., 174–75, no. 32.

99. Examples are the shoddy borders framing the niche within which stands a St. Catherine of Alexandria by a painter close to Nardo di Cione, on the raised choir of S. Miniato al Monte (Florence), along the right wall of the nave, close to the stairs, or those by an anonymous artist on the altar wall immediately to the left of the apse in the same church.

100. On stylus-incision techniques, see Chapter Ten.

101. In less attentive hands, direct construction could produce unsatisfactory results of another kind. In the Rinuccini Chapel (S. Croce, Florence), the border of lozenges, triangles, and blue-green hexagons that connects the square panels we have been discussing offers an example, although, there, we are dealing with portions largely frescoed by Ottocento restorers, no doubt attempting to reconstruct the Trecento practices in the decorative program. For the portion running horizontally above the *dado* on the altar wall, painted entirely in *buon fresco,* the muralist stylus-ruled a long lattice of diagonals, directly on the *intonaco.* Yet before he began to fresco this border, he changed his mind, substantially reducing the border's length. The large, incised *pentimenti* are visible in raking light.

102. Gombrich 1984, 7–16, 95–148.

103. Ibid., 95–101.

104. See bibliography on Cennino in Chapter One, note 7.

105. Surviving examples of the use of *spolvero* patterns in Veronese fourteenth-century murals probably reflect contemporary practice in Venice. See earlier discussion on the use of *spolvero* patterns in the frescoed room at the Castelvecchio in Verona (Figs. 134–35), as well as in the ornamental border of the murals by Jacopo da Verona, originally in the Oratory of S. Michele (detached, and now in the Museo Civico agli Eremitani, Padua).

106. Cennini 1995, cap. cv, 63 (cf. Cennini 1960, 65, for trans.): "Alchuna volta ci e di bisognio per inchollar charte per fare istrafori." Cf. Armenini 1587, 211 (cf. Armenini 1977, 290, for trans.), for mention of *strafori* in the autobiographical passage dealing with Armenini's visit to view a young Milanese artist's fresco, which he disliked greatly: "alquale egli avea dato fine poco tempo era con stampe, e strafori, e messovi di molto oro fino in pi luoghi. . . ."

107. See Figures 138, 157; and notes 54, 55.

108. On these Antique roots and their influence on art and architecture, see, for instance: Belting 1977, 107–42; Benton 1983; Benton 1989, 37–52; Trachtenberg 1991, 22–37; and Edgerton 1991, 47–87.

109. For an attractive hypothesis regarding this concordance, see Trachtenberg 1991, 22–37.

110. Cf. further Kern 1912, 42–44; Isermeyer 1937; Belting 1977, 107–42; Benton 1983; Benton 1989, 37–52; Edgerton 1991, 47–79; and Bambach Cappel 1996 b, 143–66.

111. The problem of the illusionistic cornice as a framing element has been studied more thoroughly in the Upper Church of S. Francesco, Assisi, than anywhere else. Cf. Kern 1912, 39–65; Isermeyer 1937; Belting 1977, 107–54; 214–22; Benton 1983, 158–80; Benton 1989, 37–52; Edgerton 1991, 47–87; and Bambach Cappel 1996 b, 151–53. Note also more general discussion in Bunim 1945. Trachtenberg 1997, 149–243 ("Trecento Framing and Grounding: Urbanism in Theory and the Arts") offers a rich context for the discussion that follows.

112. Cf. Borsook 1980, xxxiv–xxxv, and Bambach Cappel 1996 b, 150–51. On Orcagna's documented career, cf. also Anna Padoa Rizzo, "Per Andrea Orcagna Pittore," *Annali della Scuola Normale Superiore di Pisa*, XI (1981), 835–93; Kathleen Giles Arthur, "A New Document on Andrea Orcagna in 1345," *MdKIF*, XXXII (1988), 521–24; and Gert Kreytenberg, "Orcagnas Fresken im Hauptchor von Santa Maria Novella und deren Fragmente," *Studi di Storia dell'arte*, V–VI (1994–95), 9–40.

113. Vasari 1966–87, III (testo), 481: ". . . Era per avventura in S. Maria Novella, convento de' Frati Predicatori, la cappella maggiore dipinta già da Andrea Orgagna, la quale, per essere stato mal coperto il tetto della volta, era in più parti guasta da l'acqua. . . ." For photographs recording the gradual discovery of the Orcagna murals depicting prophets, still in situ, see photograph archive in Ufficio Belle Arti del Comune, Florence, negative nos. 27–67 (copies in the Archivio Fotografico, Soprintendenza per i Beni Artistici e Storici, Florence). Photographs record the superimposition of Ghirlandaio's vault decoration with fictive moldings and brackets onto that by Orcagna, also as a change in the topography of the plaster (Archivio Fotografico, Soprintendenza per i Beni Artistici e Storici, Florence, negative no. 67535).

114. For the archaeological evidence on Andrea da Firenze's vault in the *Cappellone* at S. Maria Novella, see Archivio Fotografico Soprintendenza, Florence, negative nos. 111516–111518, 118549, as well as record photography in the Archivio Fotografico of the Opificio delle Pietre Dure Laboratori di Restauro, Florence.

115. Here, I am particularly indebted to Leonetto Tintori's actual demonstration of the processes of pouncing and painting on an *intonaco* surface (June 1992).

116. The disposition of the narrative on the right wall is discussed in an informative way in Lavin 1990, 74–78.

117. On this cycle see Freuler 1994, 50–104, with bibliography.

118. See further Vasari 1966–87, II (testo), 253–56. The attribution of this cycle presents one of the most debated problems of early Sienese Painting. Cf. Gordon Moran, "Is the Name Barna an incorrect transcription of the Name Bartolo," *Paragone*, no. 311 (1976), 76–80; Borsook 1980, 43–46; Miklòs Boskovits, "Il Gotico senese rivisitato: Proposte e commenti su una mostra," *AC*, no. 698 (1983), 264–65; essays and entries by Giovanni Previtali, Giovanna Damiani, and Luciano Bellosi in *Simone Martini e "Chompagni,"* exh. cat. edited by Alessandro Bagnoli and Luciano Bellosi (Pinacoteca Nazionale, Siena), Firenze, 1985, 29–31, 82–85 (no. 10), 94–101 (no. 15); Gaudenz Freuler, "Lippo Memmi's New Testament Cycle in the Collegiata in San Gimignano," *AC*, LXXIV (1986), 93–102 (especially 98, 102, and notes 32–33); Antonio Caleca, "Quel che resta del cosidetto Barna," *Simone Martini: Atti del Convegno, Siena, 27–29 Marzo, 1985,* ed. by Luciano Bellosi, Florence, 1988, 183–85; and Freuler 1994, 57–62.

119. There are considerable amounts of repainting in these borders. A portion that is relatively intact occurs on the vertical border separating *The Mocking of Christ* from the *Carrying of the Cross*.

120. Toward the entrance of the Collegiata of San Gimignano, on the walls above the arcade of the nave, *spolvero* dots outline also two illusionistic marble columns (this is easily visible with strong binoculars). With their twisting shafts and Corinthian capitals, they are exact repetitions of each other across space.

121. See also Metropolitan Museum of Art 1968, 78–83, nos. 10–11 (with bibliography); and Offner, Section IV, vol. 1.

122. Richard Offner dated these frescos after 1368 (Section IV, vol. 1, 43). Cf. Becherucci 1983, 165–66, no. 5, for bibliography.

123. The *spolvero* on the upper reaches of these frames is clearly evident with binoculars. See also photographic details published in Offner, Section IV, vol. 1, plates III (7–8, 25).

124. Cf. also Isermeyer 1937, 63–66 (on the fictive ornamental borders); Paatz, III, 720–22 (on the building); Borsook 1980, 48–54 (on the painting technique); and Offner, Section IV, vols. 6, 7 (Part 1 by Johannes Tripps, 1996).

125. In the *"Cappellone degli Spagnoli,"* Additional areas of *spolvero* appear sporadically on the quatrefoils with arabesques centered within the fictive cosmatesque panels on the corner piers of the chapel, and on the fictive inlay borders ornamenting the *intrados* of the two windows along the entrance wall. As these latter passages do have extensive areas of repainting, the *spolvero* may have been the result of later "restorations." On the phenomenon of "restoration" *spolvero*, see further discussion on S. Francesco, Assisi, earlier (especially note 7), and what follows later.

126. In the Collegiata of San Gimignano, this vault fragment is

now on the exterior of the church, along the left nave wall, as the result of a building modification.

127. Cf. Adelaide Cirillo Mastrocinque, "Leonardo da Besozzo e Sergianni Caracciolo in S. Giovanni a Carbonara," *Napoli Nobilissima,* XVII/2, 41–49; Fausta Navarro, "La Pittura a Napoli e nel Meridione nel Quattrocento," *La Pittura in Italia. Il Quattrocento,* Milan, 1986, II, 446–77; Pierluigi Leone De Castris, "Il 'Maestro dei Penna' uno e due altri problemi di pittura primo quattrocentesca a Napoli," *Scritti di storia dell'arte in onore di Raffaello Causa,* Naples, 1988, 52–65; and De Castris, "Italia meridionale," *Pittura murale duecento–quattrocento,* 246–50.

128. I am indebted to Marcello Chemiri for his advice regarding our examination of some of these scenes. The attribution of this mural cycle has been problematic. See Marco Chiarini, "Il Maestro del chiostro degli Aranci: 'Giovanni Consalvo' portoghese," *Proporzioni,* IV (1963), 1–24; Metropolitan Museum of Art 1968, 150–55, nos. 37–40; Ernesto Sestan, Maurilio Adriani, and Alessandro Guidotti, *La Badia Fiorentina,* Florence, 1982; Giuliana Carbi, "Nomi fiorentini per il Chiostro degli Aranci," *Arte in Friuli-Arte in Trieste,* VII (1984), 39–51; and Giovanna Ragionieri in Bellosi 1992, 73–76, no. 5. This fresco cycle is the subject of a forthcoming Ph.D. thesis by Anne Leader, The Institute of Fine Arts, New York University. On the cloister, cf. also Paatz, I, 264–318, and Hood 1993, 129–37.

129. Cf. Metropolitan Museum of Art 1968, 151.

130. The occurrence of *spolvero* was first listed in Oertel 1940, 312 (note 161).

131. Cf. Borsook 1980, 63–67. On these cleaned frescoes, see Umberto Baldini, "Nuovi affreschi nella Cappella Brancacci: Masaccio e Masolino," *Critica d'Arte,* IL (1984), 65–72; Baldini, "Restauro della Cappella Brancacci. Primi risultati, *Critica d'Arte,* LI (1986), 65–68; Baldini and Casazza 1990; Casazza and P. Cassinelli Lazzeri, *La Cappella Brancacci: Conservazione e restauro nei documenti della grafica antica,* Modena, 1989; Keith Christiansen, "Some Observations on the Brancacci Frescoes after their Cleaning," *BM,* CXXXIII (1991), 4–20; and Paul Joannides, "Masaccio's Brancacci Chapel: Restoration and Revelation," *Apollo,* CXXXIII (1991), 26–32. See also above notes 72–73, for discussion about the *spolverezzo* pattern on the tunic of a male figure in Masolino's *Raising of Tabitha.*

132. On the mural cycle in S. Miniato, cf. Pope-Hennessy 1969, 142–44; Padoa Rizzo 1991 a, 92–105, no. 15; and Borsi 1992, 325–27. The occurrence of *spolvero* here was first listed in Oertel 1940, 312 (note 161).

133. Cf. Aldo Cicinelli, "Nuove indagini e risultati per la Sala del Pisanello a Mantova," in Castelvecchio 1996, 479–85, and Giovanni Paccagnini, "Il Ciclo cavalleresco del Pisanello alla corte dei Gonzaga: Tecnica e stile nel ciclo murale," *Studies in Late Medieval and Renaissance Painting in Honor of Millard Meiss,* New York, 1977, I, 213, II (fig. 22). On the *sinopie* for the cycle, see Joanna Woods-Marsden, "The *Sinopia* as Preparatory Drawing: The Evolution of Pisanello's Tournament Scene," *MD,* V (1983–85), 175–91.

134. I am indebted to Giorgio Bonsanti, Cristina Danti, and Anna Maria Maetzke for the repeated opportunities to study the vault frescos from the restoration scaffolding.

135. Cf. Keith Christiansen in Mantegna 1992, 73–74, fig. 34. It should be clarified that *spolvero* is visible only on the capital. In my opinion, it is doubtful that Mantegna painted the entire architectural background from *spolvero,* as Christiansen has supposed. Examination of the panel's surface reveals that there is extensive, direct stylus construction throughout the architecture.

136. Scholars have traditionally thought that most of the drawings assembled in the *"Codex Escurialensis"* originated in Domenico Ghirlandaio's *bottega.* Recently, however, Fabio Benzi has suggested that Baccio Pontelli, the Florentine architect born in 1449 and active in Rome from 1481–82 onward, was most probably the chief author of this compilation, based on an exhaustive analysis of drawing style and graphological character of the inscriptions, as well as on a detailed classification of the codicological evidence. I am indebted to dott. Benzi for sharing his article in manuscript, "Baccio Pontelli a Roma e il *Codex Escurialensis,"* to be published in *Le Arti a Roma all'Epoca di Sisto IV* (October 1997). Cf. Hermann Egger, *Codex Escurialensis: Ein Skizzenbuch aus der Werkstatt Domenico Ghirlandaios,* Vienna 1906; Nicole Dacos, "Ghirlandaio et l'antique," *Bulletin de l'Institut Historique Belge de Rome,* no. XXXIV (1962); Shearman 1977, 107–46; and Arnold Nesselrath, "Il Codice Escurialense," *Ghirlandaio* 1996, 175–98, with an unconvincing attempt to link part of this codex to the *bottega* of Filippino Lippi.

137. Cf. Nicole Dacos, *La Découverte de la Domus Aurea et la formation des grottesques à la Renaissance,* London-Leiden, 1969. On Roman mural painting technique, see Ling 1990, 198–211, 233–34.

138. Ling 1990, 82–85, notes the irregularities in Roman mural ornament, painted freehand.

139. Besides the *grotteschi* on Domenico Ghirlandaio's fictive pilasters dividing the scenes at S. Maria Novella (Florence), consider those in Pietro Perugino's *Collegio del Cambio* (Perugia); Luca Signorelli's cloister in the Abbey of Monte Oliveto Maggiore or in the *dado* of the *"Cappella Nuova"* (Capella della Madonna di S. Brizio, Orvieto Cathedral); the pilasters of the nave in S. Maria in Trastevere (Rome); Bernardino Pinturicchio's Borgia Apartments (Vatican Palace), ceiling in Palazzo Colonna (Rome), and Bufalini Chapel (S. Maria in Aracoeli, Rome); the fictive pilasters of the *Sala di Galatea* (Villa Farnesina, Rome); the fictive pilasters of Andrea del Sarto's *Chiostro dello Scalzo* (Florence) possibly painted with the collaboration of Andrea di Cosimo Feltrini; the wall and the *intrados* of the windows in the *Sala di Costantino* (Vatican Palace); the borders by the workshop of Giulio Romano for the paintings in the Chapel of St. Longinus (S. Andrea, Mantua); the framing elements of gallery after gallery in the Cinquecento wings of the Palazzo Ducale (Mantua); the *intrado* for the apse immediately to the left of the entrance in the Arian Baptistery (Ravenna); the entire *Sala delle Carte Geografiche* (Vatican Palace); and the murals

from the 1580s by the workshop of Bernardino Poccetti in a gallery of Palazzo Vecchio (Florence).

140. For *grotteschi* drawings relating to the Escorial fresco decorations, see CBC 31–35, as well as Angulo and Pérez Sánchez 1975–77, 88, nos. 505–9. A large group of *grotteschi* drawings in pen and brown ink is in the Metropolitan Museum of Art, nos. 52.570.314 to 52.570.335, New York. Cf. Nicole Dacos, "Giulio Aquili, Andrés de Melgar, et leurs grotesques," *Dialoghi di Storia dell'Arte*, no. 4/5 (1997), 24–33. Among these patterns at the Metropolitan Museum of Art, a pricked example is 52.570.329. For a fresco with *spolvero* from Augsburg, see illustration in Mora and Philippot 1984, plate 101.

141. On the use of *spolvero* cartoons for *sgraffito* decoration, see Vasari 1966–87, I (testo), 142–43 (cf. Vasari 1960, 243–44, for trans.). The application of *spolvero* for *sgraffito* façade decoration is repeated by Vasari in the *Vita* of Andrea di Cosimo Feltrini (Vasari 1966–87, IV (testo), 521: ". . . voleva sopra alcuni cartoni, spolverandogli sopra l'intonaco . . ."). As we have seen in Chapter Four, the tension between practices common among artists and artisans may have led to Vasari's bias against the *spolvero* technique; see also discussions in Bambach Cappel 1988, Part 1, I:97–176, II:357–58. On Vasari as a writer on painting technique, see Procacci 1976, 35–64, and Panichi 1991.

142. For examples of *spolvero* in the decorative parts of Ottocento murals, see note 6.

143. I am indebted to Leonetto Tintori for his demonstration of this principle, during sessions on pouncing, stylus incising, and fresco painting (summer 1992).

144. What follows is a revised condensation of Bambach Cappel 1991 a, 72–98.

145. My translation is abbreviated. See Tagliente 1530, fols. 27 verso–28 recto (transcribed in Bambach Cappel 1991 a, 98): "Oltre a queste sopra dimostrate cose io ui dichiaro gentilissimi, &/splendidissime Madōne, & a uoi saggi, & prestanti lettori, che essen-/do riceuuta, & da uoi compressa la scienza del far di groppi, secon-/do li precetti da me dati, dico che accadendoui uoler fare un friso, o tondo, o/quadro, uogliate compartire su la charta la grandezza che uorrete, et piega-/te la charta in piu parti che potrete, piegarla di uero si puo per/meta, per quarto, li frisi, li quadri, & li tondi possono esser piegati in otto parti, & con/li precetti da uoi imparati, & regola, farete il uostro compartimento secon-/do l'opera che uorrete fare con li quadri grandi, & piccoli, incrociati, ca-/ualcando disotto, & disopra, col stile di piombo, & ben poi, & giustamen-/te tirati con la penna, & poi con lo ago puntati, & habbiate a notare, che/su la piegatura della carta farete mezzo quadro, ouer altro mezzo dise-/gno che uorrete, perche quādo aprirete la carta uerra essare intiero, cosi/allhora dapoi puntati con lo ago, come ho detto, farete il spoluero in quella/parte di charta piegata, & puntato che hauerete, aprirete la charta, doue/trouerete lopera grande, & ben misurata, ben compartita, & giusta, & con/quel spoluero potrete spoluereggiar, in qualunque luogo uorrete, o per cu-/scir, o per raccamar, o per depinger, secondo il pieno disio di uostra uolunta . . ."

146. A large example, a group of five Buddhas, produced by this shortcut survives among the treasures discovered by Sir Aurel Stein at the *"Caves of the Thousand Buddhas"* in Dunhuang. The large pattern is on an area comprised of six glued sheets of paper; British Museum, Department of Oriental Antiquities, inv. 1919.1–1.072 [Ch. 00159], London. Cf. Whitfield 1983, II, fig. 138 a, b, plate 78; and Whitfield and Farrar 1990, 88, no. 70, for bibliography.

147. Charles Germain de Saint-Aubin's *L'Art du Brodeur* (Paris, 1770) offers an equivalent shortcut, although it involves counterproofing rather than pricking. See Saint-Aubin 1770, 33, under *"calquer"* (cf. Saint-Aubin 1983, 66, for trans.).

148. The eight examples are CBC 131–32, 137–38, 140, 143, 148–49. See Bambach Cappel 1988, Part 1, II:323–30, Part 2, I:171–200, and Bambach Cappel 1991 a, 77–81.

149. See also *moreschi* patterns on fol. xxxii recto in Francisque Pellegrin's *La Fleur de la Science de Pourtraicture*, Paris, 1530; on fol. 4 verso in Hierosme de Gormont's *Livre de Moresques*, Paris, 1546; and on the lower left of fol. 3 in Balthazar Sylvius's *Variarvm Protractionvm*, Paris, 1554.

150. Biblioteca Ambrosiana, Milan, *Codex Atlanticus*, VIII, fol. 701 recto. Data: 222 × 220 mm.; pen and dark brown ink over traces of black chalk on buff paper; pricked outlines. Cf. Calvi 1925, 130; Carlo Pedretti, *Leonardo: A Study in Chronology and Style*, London, 1973, 77; Pedretti 1979, II, 79; Marinoni 1979–80, VIII, 275; Pedretti 1981, 298–308; and Bambach Cappel 1991 a, 76 (and note 36).

151. The verso of this sheet, which contains no drawing, documents clearly how the drawing on the recto was pricked. We may compare the difference between (a) the raised, diffused, and torn small craters left from the perforation process on the left half of the sheet relative to (b) the crisp, sunken holes on the right half. This criterion also applies to the other drawings discussed here. It is also possible to read this design in a position whereby top and bottom of the sheet are reversed, in which case the design would have been drawn and pricked from left to right.

152. On the left half of the sheet, the slight corrections in brown ink occurring 2–5 mm. to the right of the pricked outlines may have been done as a guide, anticipating some of the design problems that would result on the new drawing on *spolvero*.

153. Biblioteca Ambrosiana, Milan, *Codex Atlanticus*, VIII, fol. 700 recto. Data: 327 × 272 mm.; black chalk over black *spolvero* marks, stylus underdrawing (as well as traces of red chalk underdrawing?), and compass work, on buff paper. I think that the concentric compass work and the rounding of the design along its borders suggests that this was probably a design for a pavement composed either of *intarsia* or ceramic tiles. For an explanation of tile patterns similar to Leonardo's, see Albrecht Dürer, *The Painter's Manual* [1525], facsimile ed. with trans. and comment. by Walter Strauss, New York, 1977, 151–53, 157–69. Dürer did not mention Leonardo's method of pouncing. The original design was presumably based upon (a) small six-pointed stars and (b) large twelve-pointed stars alternating according to an "a-a-b-a-a-b" rhythm, which was syncopated on the following

and preceding rows. The artist explored several alternative solutions, by drawing in fairly heavy strokes of black chalk over the *spolvero* marks; the subsequent freehand reworking in chalk largely obscures the *spolvero* underdrawing, which is best appreciated in the few stars left untouched. Leonardo further improvised on many of the *spolvero* outlines of the stars, first scratching his solution with the stylus, and then drawing with pen and ink. The large twelve-pointed star toward the center of the upper row, whose shape originally derived from a six-pointed star, is in a similar scale as the pricked star (Fig. 154). Leonardo then inflected the outlines of this twelve-pointed star on the upper row into a polygonal rather than round shape, while completing those of the twelve-pointed star in the center of the left border as a roundish interlocking design. He interconnected the outlines of the twelve-pointed star in the center of the lower row to turn the star's heart into a dodecagon. On Leonardo's drawing, cf. Pedretti 1979, II, 79; Marinoni 1979–80, VIII, 275; Pedretti 1981, 298–303; Bambach Cappel 1990, 125–27, no. 13; and Bambach Cappel 1991 a, 78 (and note 40).

154. Biblioteca Ambrosiana, Milan, *Codex Atlanticus*, X, fol. 851 recto [310 verso-b]; Figure 155; CBC 149. Data: 282 × 237 mm.; pen and brown ink over stylus ruling and traces of black chalk on buff paper, and contains compass marks. *Codex Atlanticus,* X, fol. 850 recto [310 recto-b]; CBC 148. Data: 335 × 293; pen and brown ink over black chalk, and is only drawn on the right half of the sheet, except for the pen and ink horizontals carried from the right. The remains of the vertical crease through the center, almost imperceptible from the recto, are more obvious from the verso. For both sheets, but without notice of their technique, cf. Richter, II, 47–48, plate C, no. 1; Anna Maria Brizio, "Bramante e Leonardo alla corte di Lodovico il Moro," *Studi Bramanteschi. Atti del Congresso Internazionale,* Rome, 1974, 6–8, plate III, figs. 5, 6 (fol. 851 recto); Calvi 1925, 130; Luca Beltrami, "Leonardo da Vinci negli studi per il tiburio della cattedrale di Milano," Milan, 1903 (repr., *Luca Beltrami e il Duomo di Milano,* Milan, 1964), 357–86; Luigi Firpo, *Leonardo architetto e urbanista,* Turin, 1963, 21–30, 24–25; Frances Fergusson, "Leonardo da Vinci and the Tiburio of Milan Cathedral," *Architectura,* VII (1977), 175–92, figs. 3, 12; Kemp 1989, 107–9; Pedretti 1981, 36–47, figs. 38, 39; Pedretti 1979, II, 145; Marinoni 1979–80, X, 49; Augusto Marinoni and Luisa Cogliati Arano, *Leonardo all'Ambrosiana . . .* (exh. cat.), Milan, 1982, 74, no. 65 (fol. 850 recto); Richard Schofield, "Amadeo, Bramante and Leonardo and the *tiburio* of Milan Cathedral," *ALV,* II (1989), especially 77–82, fig. 5 (fol. 850 recto); and Bambach Cappel 1991 a, 79 (and notes 41–46). On the *tiburio,* see Carlo Ferrari da Passano and Ernesto Brivio, "Contributo allo studio del tiburio del Duomo di Milano," *AL,* XII (1967), 3–36; Kemp 1989, 107–9; and Ambrosiana 1998, 31–33, no. 3.

155. I agree with Carlo Pedretti and Frances Fergusson regarding the *tiburio* drawings in the *Codex Atlanticus,* that Leonardo produced fol. 850 recto (CBC 148) after fol. 851 recto (fig. 155; CBC 149), also because of the method by which both sheets were drawn. Fol. 851 recto was most probably developed from scratch, as indicated by the analogous situation in Raphael's figural compositional drawings (on which, see Bambach Cappel 1988, Part 1, II:396–421, Part 2, II, cat. nos. 223–77). The slight pen and ink marks, lines, and sketches on the left half of fol. 851 recto were probably done before the outlines of the drawing were set in final form and pricked, as they are only sketchy approximations to symmetry and were not pricked with the rest of the design. Although the outlines of the drawing on the right half of fol. 850 recto are pricked finely, they often differ from those drawn in pen and ink. By comparison, the pricked and drawn outlines generally do correspond precisely on the right half of fol. 851 recto. On fol. 850 recto, the outlines depicting the buttress, its masonry, and the arch to the extreme right are not pricked. Both sheets differ considerably in this passage. On fol. 850 recto, the pricked outline that should correspond to the top diagonal support, buttressing the thrust of the inner pointed arch near the top, runs much above the drawn upper outline. The pricking in this passage corresponds to the equivalent portion in fol. 851 recto, but other passages with pricked outlines in both sheets do not. Furthermore, in fol. 850 recto, the inner outline of the innermost pointed arch is pricked nearly 2 or 3 mm. to the left of the drawing on the right half. These discrepancies on fol. 850 recto, between pricking and drawing, would seem to indicate that the design on the right half was drawn in pen and ink, after the pricking and not before it, as is usually the case, unless the original black chalk underdrawing, now nearly vanished, corresponded more closely to the pricking. I think this less probable. For Leonardo's application of this pricking technique for bilaterally symmetrical designs in anatomical illustrations, see Chapter Nine.

156. Biblioteca Ambrosiana, Milan, *Codex Atlanticus,* VIII, fol. 706 recto (CBC 140). Data: 480 × 177; pen and medium brown ink over a fine net of stylus ruling and traces of black chalk (red chalk used to complete only the outlines of the object) on buff paper. The verticals and diagonals are finely and closely pricked, probably directly against a ruler, for they seem perfectly straight. In the water wheel itself the pricking, though done with a very fine point, has holes far apart from each other. Because the sheet is now mounted sideways, the process of drawing and pricking from right to left is not obvious. Note the presence of a horizontal crease through the center and that the positions and sizes of the pricked, undrawn diagonals and vertical bases, as well as the plotted points within the wheel itself, mirror each other. This technique is thus no different from that found in autograph sheets. Perhaps because the drawing seems so obviously plotted rather than drawn, Carlo Pedretti has questioned whether the drawing is autograph. Its utilitarian nature makes a judgment difficult, though I am inclined to accept it on the evidence of function rather than quality of execution. The blunt red chalk outlines only restate what is obvious in the pen and ink drawing; Melzi was probably responsible for this part of the drawing. The sheet could be grouped

with Leonardo's autograph sketches for water wheels from 1497 and 1517–18, though the earlier date seems more probable in my opinion. Cf. Pedretti 1979, II, 82; Marinoni 1979–80, VIII, 285–86; Augusto Marinoni and Maria Meneguzzo, *Leonardo da Vinci: Disegni,* Verona, 1981, 166–67, fig. 91; as well as Bambach Cappel 1991 a, 80 (and note 51), fig. 24.

157. Biblioteca Ambrosiana, Milan, *Codex Atlanticus,* VIII, fol. 710 ii recto (CBC 143). Data: 375 × 154 mm.; pen, medium brown, and dark brown ink over traces of black chalk on beige paper; heavily rubbed with black pouncing dust, especially on the right half of both recto and verso. The drawing was begun on the right half and pricked and pounced onto the left, but the entire design may have been later pounced again from the recto for further transfer onto a secondary support. Cf. Pedretti 1979, II, 83; Marinoni 1979–80, VIII, 287–88; Marinoni and Meneguzzo (as in note 156), 168–69, fig. 92; Marinoni and Cogliati Arano 1982, 64, no. 55; Bambach Cappel 1991 a, 80 (and note 52), fig. 25; and Ambrosiana 1998, 37–38, under no. 5.

158. Such drawings attributed to Paolo Uccello and his circle are Uffizi inv. 1756 A, 1757 A, and 1758 A, Florence, although their precise authorship is not certain. Cf. Alessandro Parronchi, "Paolo o Piero?," *Studi su la dolce prospettiva,* Milan, 1964, 533–48; Degenhart and Schmitt 1968, I-2, 402–6, nos. 312–17; Pope-Hennessy 1969, 155–56; Uffizi 1978, 68–71, nos. 76–78; Martin Kemp in *Circa 1492,* 241–42, nos. 139–40; Paolo Galluzzi in Uffizi 1992, 205, no. 9.24; and Borsi 1992, 158–62. On Piero della Francesca's methods, cf. Bambach Cappel 1994, 17–43; Bambach Cappel 1996 b, 143–66; as well as Chapter Six, on exercises of "transformation."

159. Illustrated and discussed in Bambach Cappel 1991 a, 81, fig. 27. See also Daniele Barbaro, *La Pratica della perspettiva . . . ,* Venice (Camillo and Rutilio Borgoniere), 1569, fols. 124–28, for further explanations and other illustrations of *mazzocchi.* Cf. Leonardo's design of a water wheel on *Codex Atlanticus,* fol. 849 verso [310 verso-a], dating from about 1517–18, and which renders only one half of the form; cf. Pedretti 1979, II, 145.

160. Cipriano di Michele Piccolpasso, *Li Tre libri dell' arte del vasaio* (Victoria and Albert Museum MS. L 7446–1861, London), Book III, fol. 70 verso, as well as fols. 69 verso and 71 recto, for other designs of plates decorated with interlaces. Facsimile ed. and trans. by Ronald Lightbown and Alan Caiger Smith, *The Three Books of the Potter's Art,* London, 1980, 2 vols. (introductory essays with bibliography, I, xi–xl, and II, xi–xxiv).

161. See Juan de Alcega, *Libro de Geometria, pratica, y traça: El qual trata de lo tocante al oficio de Sastre . . . ,* Madrid, 1589, fol. 13: "Iubon de seda con manga abierta. + bbb /tt/ B5"; see also fols. 14–75, for other patterns requiring folding. This is illustrated and discussed further in Bambach Cappel 1991 a, 80–81, fig. 28. Alcega's is one of the earliest tailors' patternbooks; it is relatively rare (New York Hispanic Society Library; Victoria and Albert Museum, London; and Metropolitan Museum of Art 41.7, New York). The

first edition of 1580 is apparently unique (Library of Palacio de Oriente, Madrid). A facsimile of the 1589 edition was published by Jean Pain, Cecilia Bainton, and J. L. Nevinson, Carlton (Bedford), 1979, with translation, notes, and bibliography.

162. British Museum 1928-4-17-5, London. Data: 394 × 449 mm.; pen and brown ink, over black chalk. Cf. Pouncey and Gere 1962, I, 67–69, no. 89. Related drawings for the project are Nottingham Art Museum inv. 91–138 (which I have not seen firsthand; illustrated in A. F. Kendrick, *The Collector,* XI [1930], 218); Victoria and Albert Museum inv. E 4586–1910, London, 397 × 530 mm. (Hartt 1958, fig. 156, Ward-Jackson 1979, 72–75, no. 151); Collection of the Pouncey Family, London, 414 × 949 mm.; and Devonshire Collection inv. 107, Chatsworth, 353 × 378 mm. These drawings are also catalogued by Nello Forti Grazzini in Mantua 1989, 475–77, except for the example in Nottingham. For various reproductive prints relating to Raphael's Roman themes on the *"giochi di putti,"* see illustrated selection in Rome 1985, 258–60, 826–32.

163. On the tapestries, see Guy Delmarcel and Clifford M. Brown, "Les jeux d'enfants, tapisseries italiennes et flammandes pour les Gonzague," *RACAR: Revue d'art canadienne/Canadian Art Review,* XV/2 (1988), 109–21 (figs. 79–82); and Mantua 1989, 474–77. On Nicholas Karcher and his brother Giovanni, see Candace Adelson in *Dictionary of Art* 1996, XVII, 812.

164. See note 162.

165. See Delmarcel and Brown (as in note 163), 109–21, figs. 89–92.

166. Cf., for instance, summary in Hartt 1958, 159–60, 320, no. 144, and transcriptions in Ferrari and Belluzzi 1992, I, 492–96.

167. Cf. Bambach Cappel 1991 a, 81, note 57. Buontalenti's designs for a jewelry casket, a corbel for a palace, and an elevation for Florence Cathedral (Uffizi inv. 635 Orn., 6777 A, and 2447 A, Florence) are discussed in Andrew Morrough, *Disegni di architetti fiorentini 1540–1640* (exh. cat., Gabinetto Disegni e Stampe degli Uffizi), Florence 1985, 141–44, 149–51, 155, nos. 73, 77, 81. Ida Maria Botto first identified this method of production by Buontalenti and exhibited a large corpus of such drawings (*Mostra di disegni di Bernardo Buontalenti 1531–1608* [exh. cat., Gabinetto Disegni e Stampe degli Uffizi], Florence, 1968, nos. 2, 14, 28, 30, 32, 31, 38, 51, 71, 77, 82, 83, 84, 87, 90, 93, 98; also illustrated). Cf. Amelio Fara, *Bernardo Buontalenti,* Milan, 1995, 283–307, nos. 159–255.

168. See CBC 31–35, as well as Bambach Cappel 1991 a, 81 (note 57). Cf. also Angulo and Pérez Sánchez 1975, 88, nos. 508–9, but without discussion of this technique.

169. Cf. Paatz, I, 533–34, 563–65; Ugo Procacci, "Il Primo ricordo di Giovanni da Milano a Firenze," *Arte antica e moderna,* nos. 13–16 (1961), 49–66; Boskovits 1966, 17–20, 37–38; and Cavadini 1980, 72–87. On Giovanni da Milano, the "Master of the Rinuccini Chapel," and the conception of the illusionistic decoration in this chapel, cf. Isermeyer 1937, 67, and Bambach Cappel 1996 b, 151–52.

170. On the "Master of the Rinuccini Chapel," cf. Offner 1927, 109–26; Luciano Bellosi, "Due note per la pittura fiorentina del secondo Trecento," *MdKIF,* XVII (1973), 179–94; and Boskovits 1975, 56–58, 212–13 (notes 57–60), 357–59.

171. The presence of *spolvero* in the decorative elements of the Rinuccini Chapel was mentioned in Borsook 1983, xxxv, and Borsook 1985, 63.

172. In the Rinuccini Chapel, the *spolvero* is most evident in the decoration of the north wall. In the area of the *dado,* the mural surfaces of the other walls are in very poor condition (as well as largely repainted); *spolvero* marks are thus for the most part not visible.

173. Cennini 1995, cap. cv, 111 (cf. Cennini 1960, 65, for trans.).

174. I have not been able to ascertain whether the columns separating the pairs of scenes on the second register are pounced, but they probably are, as must be the rest of the ornamental motifs in the chapel whose forms are rendered in *chiaroscuro* or with internal detail.

175. This congruence of narrative and composition, however, is slightly disrupted in the south wall. See detailed discussion in Lavin 1990, 90–92, and diagram 21.

176. The reader may be reminded that although the fresco decoration on the altar wall of the Rinuccini Chapel is largely nineteenth-century restoration, it was based on the archaeological remains of the late Trecento decoration. The approach of orienting the fictive modillioned cornices along the real architecture of a room is fairly typical, as can be verified in the great intact parts of the *"Sala di Balìa"* fresco cycle (Palazzo Pubblico, Siena), by Spinello Aretino and his son, Parri Spinelli.

177. Cf. Kern 1912, 39–65; Isermeyer 1937; Belting 1977, 107–42; Benton 1983; Benton 1989, 37–52; and Edgerton 1991, 47–87. For the background on Medieval optics and perspective, see Bunim 1940; Federici Vescovini 1965; Aiken 1986; Kemp 1990; and Trachtenberg 1997, 223–43.

178. For the discussion of the mitering device, cf. Edgerton 1991, 59–60.

179. At S. Miniato al Monte (Florence), in the murals in the southeast corner of the interior (Fig. 161), below the fictive tabernacles with saints, which will be discussed shortly, the "focus modillion" – to borrow Samuel Edgerton's term for this type of center unit (Edgerton 1991) – and its neighboring units were constructed *alla prima,* while the rest of the modillions and the cornice were produced serially with *spolvero* patterns.

180. On the *spolvero* in the *"Sala di Balìa"* at the Palazzo Pubblico in Siena, cf. preliminary observations Bambach Cappel 1996 b, 150–52, fig. 8, and for that in the sacristy of S. Miniato al Monte in Florence, cf. Borsook 1980, xxxv. On Spinello's use of illusionistic borders in the fresco cycle at S. Miniato, cf. Isermeyer 1937, 79–80.

181. On the extant monumental drawings related to the cathedrals of Orvieto, Siena, and Florence (as well as for further examples of the design type), see Degenhart and Schmitt 1968, I-1, 27–31, 88–102, 120–23, nos. 11–12, 37–42, 54, with bibliography and references to documents. Note mentions of such drawings in the archives of the Orvieto Cathedral works, as *"ghavantone."*

182. Here, the main and lateral plumblines used to center each tabernacle unit, with its flanking slender colonnettes, were first stylus-ruled directly on the plaster, and the main arch within was marked with compass arcs. The fluting of the flanking colonnettes is bilaterally symmetrical, and was also directly stylus-incised. *Spolvero* was used to paint the fine details of each unit: the "curls" above the pediments, the tiny *rinceaux,* and the lobed profiles of the tracery. Thus, the overall design approach here is not as unified as in such later examples as the Chiesa del Tau, described earlier. The archaeological evidence in the *"Cappellone degli Spagnoli"* became clear to me during attentive examination of the upper parts of the mural cycle with binoculars at high magnification (February, 1994); a visit to the movable scaffolding erected for its cleaning was not possible, despite repeated attempts.

183. For record photography documenting the recovery of these frescos underneath layers of white plaster, see Opificio delle Pietre Dure e Laboratorio di Restauro, Florence, negative nos. 130342–132007. (I am indebted to Giorgio Bonsanti for making this material available.) On the mural cycles at Chiesa del Tau, cf. Richard Offner, *Niccolò di Tommaso,* New York, 1924 (reprinted from *Art in America,* December 1924); Offner 1927, 109–26; Boskovits 1975, 35–36; and Enzo Carli, *Gli Affreschi del Tau a Pistoia,* Florence, 1977. The occurrence of *spolvero* was first passingly listed in Oertel 1940, 312 (note 161). Cf. Bambach Cappel 1996 b, 152.

184. Here, my analysis of the painting technique is largely the result of reconstruction, because the pigment layer has suffered great losses and is substantially abraded. Although the left part of the entrance wall exhibits the most intact areas of *spolvero* in the detailing of the niches, the technique can be verified for many scattered passages on the adjoining long wall.

185. Cf. Bambach Cappel 1996 b, 152–53. On the issue of attribution, cf. Boskovits 1975, 59–62, 213–15 (and notes 66–73), 417–20, and Gurrieri 1988, 209. On Pietro Nelli, see Luciano Bellosi, "Due note per la pittura fiorentina di secondo Trecento," *MdKIF,* XVII (1973), 179–94.

186. In Agnolo Gaddi's frescos in the chancel of S. Croce, Florence, the design of the fictive tabernacles is replicated eighteen times in a frontal view, three times in an oblique view facing left, and three times in an oblique view facing right. On Agnolo Gaddi's use of illusionistic borders in the fresco cycles in the choir of S. Croce (Florence) and *"Cappella del Sacro Cingolo"* (Prato Cathedral), cf. Isermeyer 1937, 69–74, 77–79.

187. Here, the evidence of *spolvero* was passingly mentioned in Oertel 1940, 312 (note 161), and Borsook 1980, xxxvi. See further Bambach 1996 b, 153 (and note 22); and Archivio Fotografico, Soprintendenza per i Beni Artistici e Storici, Florence, negative no. 85142. On Starnina's murals in the Chapel of S. Girolamo, see Ugo Procacci, "Gherardo Starnina," *Rivista d'Arte,* XV (1933), 151–90; Procacci, "Relazione dei lavori eseguiti nella chiesa del Carmine di Firenze per la ricerca di antichi affreschi," *BA,* XXVII (1933–34), 327–34; and Boskovits 1975, 157–58, 255 (note

301). I am indebted to Stefano Francolini and Marcello Chemiri for the opportunity to study these mural fragments in the restoration studio at S. Maria del Carmine (summer 1990). By contrast, the fresco fragments attributed to Starnina in the Museo of the Collegiata at Empoli reveal that the entire quatrefoil structure was painted from crassly ruled *incisioni dirette,* as the designs are relatively simple.

188. The *spolvero* is evident in the upper left of a record photograph in the Opificio delle Pietre Dure e Laboratorio di Restauro, Florence, negative no. 85151. On Lippo d'Andrea, see especially Ugo Procacci, "Lettera a Roberto Salvini con vecchi ricordi e con alcune notizie di Lippo d'Andrea," *Scritti di storia dell'arte in onore di Roberto Salvini,* Florence, 1984, 215–28.

189. See Figures 171, 173–74. Cf. Bambach 1996 b, 143–66. Of the vast bibliography on Masaccio's *Trinity,* cf. Polzer 1971, 18–59; Borsook 1980, 58–63; Aiken 1986, 156–259; Field, Lunardi, and Settle 1989; Danti, Lunardi, and Tintori 1990, 251–68; Kemp 1990, 16–21; and Aiken 1995, 171–87.

190. I am indebted to the late Fabrizio Mancinelli, Arnold Nesselrath, Enrico Guidi, and Claudio Rossi De Gasperis, for the repeated visits to the restoration scaffoldings in the Vatican *stanze.*

191. See Leonetto Tintori, "Note sulla 'Trinità' affrescata da Masaccio nella chiesa di Santa Maria Novella in Firenze, III: Gli ultimi interventi di restauro," *Le Pitture murali* 1990, 262; Polzer 1971, 22; and Borsook 1980, 59, note *spolvero* only on the pseudomeander.

192. Cf. Borsook 1980, 82, 79–84; and Anna Padoa Rizzo, *La Cappella dell'Assunta nel Duomo di Prato,* Prato, 1997 (115–24, on the fresco technique). The authorship of this mural cycle presents a complex problem. Cf. Pope-Hennessy 1969, 163–64; Wohl 1980, 170–72; Padoa Rizzo 1991 a, 43–57, no. 4; Borsi 1992, 299–302, no. 10; and Alessandro Angelini in Bellosi 1992, 64–67, no. 3.

193. Borsook 1980, 82, 84.

194. It was not possible for me to obtain an up-to-date photograph of this detail. Cf. Bambach Cappel 1996 a, 95 (and note 118). I am indebted to Giusi Testa, Carla Bertorello, and Lucia Tito for the numerous visits to the restoration scaffolding in 1992–94.

195. Cf. Lake 1984/85, 62–65; Giordana Mariani Canova, "Problematiche cronologiche," *Paris Bordon e il suo tempo (Atti del convegno internazionale di studi),* Treviso, 28–30 ottobre 1985, Treviso, 1987, 137–57; and Bambach Cappel 1988, Part 1, I:275, II:315–21. For the attribution history of the Walters *David and Bathsheba,* see Federico Zeri, *Italian Paintings in the Walters Art Gallery,* Baltimore, 1976, II, 397–98. On the *Annunciation* in Caen, see *Paris Bordone* (exh. cat., Palazzo dei Trecento, Treviso), Milan, 1984, 90–91, no. 24; and Sylvie Béguin, "Paris Bordon en France," *Paris Bordon e il suo tempo: Atti del convegno internazionale di studi,* Treviso, 28–30 ottobre 1985, Treviso, 1987, 18–19.

196. Cf. Lake 1984/85, 62–65 (and note 6). This author reported that the *spolvero* marks in the *David and Bathsheba* were revealed only when numerous cross sections of the paint layers were prepared, infrared reflectography examination being apparently ineffective. Only the architectural background exhibits *spolvero.* The figure of Bathsheba and the foreground of the picture apparently were painted either *alla prima* or on the basis of freehand underdrawing. The artist pounced the pattern onto the thick initial white lead ground layer on the canvas, and then over the *spolvero* particles he brushed on another layer of lead white, which was thin enough to leave the *spolvero* marks visible. See Armenini 1587, 119–20, 124–25 (cf. Armenini 1977, 188, 192, for trans.), for recipes on the priming of canvases. One of these includes a method similar to that of Paris Bordone. Gian Battista Volpato's recommendations on the subject, however, suggest that Paris's method with gesso was not always desirable; see *Modo da tener nel dipingere* (MS. in Merrifield 1849, II, 728–32). *Spolvero* marks have not emerged in infrared reflectography examination of the *Annunciation* (Lake 1984/85, 65, note 5). The selectivity of the motif and its repetition in both paintings help us infer the use of the *spolvero* technique for pattern replication.

197. The surface decoration on many of the architectural details of the Caen *Annunciation* seems denser. The *chiaroscuro* contrasts are less intense in the architecture, the forms are seen through a mist, and the lighting appears considerably more diffused. The diagonal stairs on the extreme right in the background are prominently developed in the Baltimore *David and Bathsheba,* whereas in the Caen *Annunciation* the equivalent detail seems to disappear behind the columns. The pavement in the second courtyard is boldly outlined in the *David and Bathsheba,* whereas the corresponding articulation in the *Annunciation* is much subtler.

198. Susan Lake's reconstruction seems much too contrived (Lake 1984/85, 64–65). That the major architectural elements in both paintings appear shifted, led Lake to think that Paris Bordone used a pricked drawing of the architectural background that was in at least two separate parts: one would have included the foreground columns and arches, whereas the other would have contained the background architectural elements. These would have been shifted relative to each other to make the proper adjustments. Though this is possible, it seems overly complicated and would have tampered dangerously with the principles of one-point perspective construction.

199. For Paris Bordone's drawing style, see Treviso exh. cat., 1984, 90, 96, and W. R. Rearick, "The Drawings of Paris Bordone," *Paris Bordon e il suo tempo (Atti del convegno internazionale di studi), Treviso, 28–30 ottobre 1985,* Treviso, 1987, 47–63. A very free black chalk drawing on *carta azzurra,* depicting the Virgin Annunciate for the Caen painting (Louvre inv. 11902, Paris), exemplifies the artist's mature painterly style of drawing. It would have been far removed from the precise and linear appearance that the *spolvero* pattern with the architectural background must have had. Additionally, note the *Bathsheba* at the Hamburg Kunsthalle (inv. 744), signed and dated 1552, in which the figure is identical to the nude in the Walters painting but reversed. Two black chalk drawings on *carta azzurra,* which

are preparatory to the nude Bathsheba in the Hamburg painting (Uffizi inv. 1804 F and 1805 F, Florence) also evidence the free style of Paris's mature period.

200. There is also a possibility, however minimal, that either the *Annunciation* or the *David and Bathsheba* may have been cropped along one of its borders at some unknown date. This could account for some of the differences in the architectural backgrounds, especially along the left and upper borders. Creighton E. Gilbert has suggested yet another possibility: that one drawing of the size of that depicted in the painting of the *Annunciation* was pounced in two successive moments to expand the architecture with added bays.

201. The fact that the major changes occur at the end bays of the design is telling, because these are the easiest to omit in the actual process of pouncing. If unwanted pouncing dust accidentally sprinkled onto the painting surface, it could easily be erased. On erasing and the ephemeral nature of *spolvero* marks, see Chapter Two.

202. Cf. *Tutte l'opere d'architettura et prospettiva di Sebastiano Serlio Bolognese,* Venice, 1619, especially Book III, 111–12 (Poggioreale in Naples) and Book VII, 37, 41, 43, 65, 85, 101, 109, and Daniele da Barbaro's *La Prattica della perspettiva,* Venice, 1569. It must be clarified, however, that none of the published illustrations provides a direct precedent. Cf. Giordana Mariani Canova, *Paris Bordone,* Venice 1964, 117, and Loredana Olivato, "Paris Bordon e Sebastiano Serlio: Nuove riflessioni," *Paris Bordon e il suo tempo (Atti del convegno internazionale di studi), Treviso, 28–30 ottobre 1985,* Treviso, 1987, 33–40.

203. Barbaro 1569, 159, had mentioned *spolvero* in passing when describing a method of anamorphic design to paint on panel, which leads to the assumption that the practice was familiar to his reader. (No such reference is found in Serlio). We may wonder whether indeed Paris Bordone was the inventor of the *concetto* for this architectural design or whether he borrowed it from another source. It is doubtful that Paris, or other painters from his generation (and region), would have pounced compositional cartoons merely to transfer designs of compositions. The obvious choice would have been the *calco* or stylus-tracing technique. On pouncing in Venice and the Veneto, relative to Central-Italian practice, see Bambach Cappel 1988, Part 1, I: 251–81. Paris's practice probably indicates a much wider phenomenon in Renaissance painting.

204. Cf. also Bambach Cappel 1996 b, 143–66.

205. Of an immense literature on the Medieval roots of Renaissance optics and perspective, cf. especially Kern 1912, 39–65; Bunim 1945; Klein 1961, 211–30; Federici Vescovini 1965; Aiken 1986; Kemp 1990; and Trachtenberg 1997, 232–43.

6. Toward a Scientific Design Technology in the Quattrocento

1. As translated by Martin Kemp and Margaret Walker in *Leonardo, On Painting,* 193. See Richter, I, 372, § 661 (cf. Richter, *Commentary,* I, 372): "Come la prima pittura fu sol d'una linia, la quale circu[n]daua l o(m)bra dell'omo, fatta dal sole ne' mvri."

2. Cf. Bambach Cappel 1996 b, 143–66. The origin of the cartoon as a practice to paint the human figure has stimulated a lively debate in the literature on Italian drawing and painting technique. I am here primarily concerned with the innovative design function of figural cartoons. I have preferred a conservative position regarding a proposed date of their origin, based on the presence of archaeological evidence. The earliest frescos with figures on *spolvero* are Paolo Uccello's figure of God the Father in the *Creation of Adam ("Chiostro Verde,"* S. Maria Novella, Florence), Domenico Veneziano's Canto de' Carnesecchi fresco fragments (National Gallery, London), and the *Madonna and Child* shrine (Museo dell'Opera S. Croce, Florence), from the *bottega* of Bicci di Lorenzo, or a follower, works that may well be dated in the 1430s. It is significant and all too telling, in my opinion, that *spolvero* or *incisioni indirette* are absent from scores of murals that may be dated as late as the 1450s. Cf. Procacci 1961, 9, fig. iii, plate 21; Tintori and Meiss 1962, 11–13; Baldini 1977, I, 43–44; Borsook 1980, xxxvi; Borsook 1983, 163–73; Borsook 1985, 127–36; *Tecnica e stile* 1986, I, 59–66; and Bambach Cappel 1988, Part 1, I, 82, 227–28, II, 429–35. Arguments for the cartoon's origin in the Duecento (based on the selective presence of stylus incisions on a few murals), seem in my opinion unconvincing, for such early incisions are almost certainly the result of relatively common late Duecento and Trecento methods of direct preliminary work on the painting surface *(incisioni dirette),* rather than of cartoon transfer *(incisioni indirette).* The practice of stylus-incising cartoons *(incisione indiretta* or *calco)* cannot be corroborated with any degree of certainty before the 1460s–1470s, and thus the early history of the cartoon seems entirely that of the *spolvero* technique. On these problems, see further Chapter Ten, where the evidence of stylus incisions is also analyzed. An attractive, recent hypothesis, which concerns the use of *"sagome"* or *"patroni"* (patterns of body parts) to paint figures in the Duecento and Trecento, has been advanced in Nimmo and Olivetti 1985–86, 399–411, in which the practice is specifically discussed in regard to the authors' findings in the frescos in the Oratorio di S. Silvestro at SS. Quattro Coronati (Rome), as well as in Zanardi and Frugoni 1996, especially 13–15, 24–38, which presents conclusions based on the frescos in the Upper Church of S. Francesco at Assisi and reproduces a convincing group of head types that demomonstrate congruences of design. In my opinion, however, the lack of conclusive evidence in the written sources is problematic: Theophilus and Dionysos of Fourna are much vaguer than suggested by Nimmo and Olivetti, and the references to *"patron"* in the early documents are much more ambiguous than advanced by Zanardi and Frugoni. On the term, cf. Du Cange, VI, 220–21, as well as this chapter, note 125, and Chapter Three, note 73. Moreover, there is also a serious lack of definitive archaeological evidence on the actual mural surfaces (see discussion of such evidence in Chapter Five).

Of one kind or another, we might expect imprints, register marks, or tacky borders along the pigment. Regarding the so-called *sagome* of hands and feet on waxed paper discovered in the *Cappellone di S. Nicola da Tolentino* (ibid., 32, 56, note 46; Angelini in *Tecnica e Stile* 1986, I, 64), Fabio Bisogni has kindly informed me that such cutout paper hands and feet were votive objects (rather than "protocartoons"), as can be established by a series of extant documents. See further Fabio Bisogni, "Gli Inizi dell'iconografia di Nicola da Tolentino e gli affreschi del Cappellone," *San Nicola, Tolentino, le Marche: Contributi e ricerche sul processo (a. 1325) per la canonizzazione di San Nicola da Tolentino. Convegno internazionale di studi (4–7 settembre 1985),* Tolentino, c. 1987, 283–82. The proposal by John Shearman that Giovanni da Milano and his workshop applied figural cartoons as early as 1369 to paint the wood vault of the *"cappella magna"* in the Vatican Palace remains unverifiable, as the monument no longer stands, and is, in any case, based exclusively on the interpretation of complex and ambiguous documents. Cf. Shearman 1992 a, 5–8, and summary of discussion at the conclusion of this chapter. The physical evidence found thus far in extant murals of the Trecento contradicts that hypothesis. Instead, the pioneering research by Eve Borsook (1980, 1983, and 1985) should be acknowledged. Her chronology regarding the development of the cartoon remains presciently accurate today. On the development of the cartoon during the Quattrocento, cf. Oertel 1940, Degenhart and Schmitt 1968, I-1, xxxvii–xxxxix; Ames-Lewis 1981, 23–32, 53, 157–159, 189; Bambach Cappel 1988, especially Part 1, I:203–36, II, 337–72; and Bambach Cappel 1996 b, 143–66.

3. For a schematic summary of this argument, see also ibid., 143–66. Cf. Klein 1961, 211–30.

4. On these dates, see Cecil Grayson in Alberti 1972, 3–17, and Martin Kemp's introduction in Alberti 1991, 17–18. On Alberti's notion of the *"historia,"* see Jack Matthew Greenstein, *"Historia" in Leon Battista Alberti's* On Painting *and in Andrea Mantegna's* Circumcision of Christ, Ph.D. Dissertation, University of Pennsylvania, Philadelphia, 1986 (UMI Microfilms, Ann Arbor 1991).

5. On ornament, cf. Alberti 1950, 102; Alberti 1966, 85–85; Alberti 1972, 49:92–93; and Alberti 1991, 85–86; as well as Joseph Rykwert et al., *Leon Battista Alberti. On the Art of Building in Ten Books,* Cambridge and London, 1989, Book ix, 291–94.

6. The term given in the Latin manuscript is *"circumscriptione,"* that in the Italian *"circonscrictione."* For the relevant passages on "circumscription" and the "veil," see Alberti 1972, 31:67–68, 32:68–70 (cf. Alberti 1950, 82–85), and translations in Alberti 1966, 68, 121 (and note 26); Alberti 1972, 31:67–69; 32:69–70; and Alberti 1991, 65–67. In his biography of Alberti, Vasari confirmed the claim; Vasari 1966–87, III (testo), 286.

7. Alberti 1972, 57:100 (cf. Alberti 1950, 108–9): "Sed cavendum ne, quod plerique faciunt ea minimis tabellis pingamus. Grandibus enim imaginibus te velim assuefacias, quae quidem quam proxime magnitudine ad id quod ipse velis efficere, accedant." Cf. translations in Alberti 1966, 94; Alberti 1972, 57:101; and Alberti 1991, 91–92.

8. Latin text in Alberti 1972, 57:100: "Nam in parvis simulacris maxima vitia maxime latent, in magna effigie etiam minimi errores conspicui sunt." Cf. Italian text in Alberti 1950, 108–9: "Ma guarda non fare come molti quali inparano disegniare in picciole tavolelle; voglio te exerciti disegniando cose grandi, quasi pari al ripresentare la grandezza di quello chettu disegni, però che nei piccioli disegni facile s'asconde ogni gran vitio, nei grandi molto bene i minimi vitii si veggono." Cf. translations in Alberti 1966, 94; Alberti 1972, 57:101; and Alberti 1991, 91–92.

9. Alberti 1972, 40:78 (cf. Alberti 1950, 91): "Primum enim quod in historia voluptatem afferat est ipsa copia et varietas rerum. Ut enim in cibis atque in musica semper nova et exuberantia cum caeteras fortassis ob causas tum nimirum eam ob causam delectant quod ab vetustis et consuetis differant, sic in omni re animus varietate et copia admodum delectatur." Cf. translations in Alberti 1966, 95–96; Alberti 1972, 40:79; and Alberti 1991, 75. See further Creighton E. Gilbert, "Antique Frameworks for Renaissance Art Theory: Alberti and Pino," *Marsyas,* III (1943–45), 87–106; Martin Gosebruch, *"Varietà* bei Leon Battista Alberti und der wissenschaftliche Renaissancebegriff," *ZfK,* XX (1957), 229–38; Gosebruch, "Ghiberti und der Begriff von *'copia e varietà'* aus Albertis Maltraktat," *Lorenzo Ghiberti nel suo tempo. Atti del convegno internazionale di studi,* Florence, 1978, 269–82; and Martin Kemp in Alberti 1991, 17–25.

10. Alberti 1972, 60:103 (cf. Alberti 1950, 111): "Sed cum sit summum pictoris opus historia, in qua quidem omnis rerum copia et elegantia adesse debet, curandum est ut non modo hominem, verum et equum et canem et alia animantia et res omnes visu dignissimas pulchre pingere, quoad per ingenium id liceat, discamus, quo varietas et copia reum, sine quibus nulla laudatur historia, in nostris rebus minime desideretur." Cf. translations in Alberti 1966, 95; Alberti 1972, 60:103; and Alberti 1991, 93.

11. My translated quotation is abridged; see Cennini 1995, cap. xxviii, 28 (cf. Cennini 1960, 15, for trans.): "Come, sopra I maestri, tu dèi ritrarre sempre del naturale con continuo uxo. Attendi, che la più perfetta guida che possa avere e migliore timone si è la trionfal porta del ritrarre de naturale. E questo avanza tutti gli altri essempi."

12. Uffizi inv. 9 E, Florence. Data: 212 × 333 mm.; pen and brown ink, brush and brown wash, on parchment. Cf. Degenhart and Schmitt 1968, I-1, 110, no. 47; and Fiora Bellini in Uffizi 1978, 4–5, no. 2. Several further copies of this project exist: Albertina inv. 4S.R6, Vienna; Musée Condé inv. F.R.I.1, Chantilly; and Pierpont Morgan Library inv. I.1.B, New York.

13. Istituto Nazionale per la Grafica inv. FN 2834–FN 2863, Rome. Data: each sheet is about 134 × 95 mm.; point of brush with gray-brown wash, highlighted in white gouache, over metalpoint, on light-tan prepared paper. On this modelbook, see Degenhart and Schmitt 1968, I-1, 262, no. 4; Enrichetta Beltrame Quattrocchi et al., *Grandi Disegni del Gabinetto Nazionale delle Stampe di Roma,*

Milan, 1980, 73–74, 98 (note 2), 101 (note 14), no. 1 a; Elen 1995, 188–90, no. 12; and Scheller 1995, 292–97.

14. Latin text in Alberti 1972, 61: 102: "Modulosque in chartis conicientes, tum totam historiam, tum singulas eiusdem historiae partes commentabimur, amicosque omnes in ea re consulemus." See Italian text in Alberti 1950, 112: ". . . et faremo nostri concepti et modelli di tutta la storia et di ciascuna sua parte prima et chiameremo tutti li amici a consigliarci sopra adciò." Cf. translations in Alberti 1972, 61:103, and Alberti 1991, 94.

15. For different points of view on the traditions of copying and modelbooks in relationship to the origins of exploratory drawing, cf. Wiemers 1996; Scheller 1995; Ames-Lewis 1987, 1–11; Ulrike Jenni, "The Phenomena of Change in the Modelbook Tradition around 1400," *Drawings Defined* 1987, 35–47; Ames-Lewis 1981 a; Otto Pacht, "Der Weg von der zeichnerischen Buchillustration zur eigenständigen Zeichnung," *Wiener Jahrbuch für Kunst Geschichte,* XXIV (1971), 178–84; Degenhart and Schmitt 1968, I-1, xix–xxv; Scheller 1963; Degenhart 1950, 93–158; and Oertel 1940, 217–314.

16. Musée des Beaux-Arts inv. 794.1.2501, Rennes. Data: 288 × 204 mm.; pen and brown ink. The attribution history of this drawing is discussed by Patrick Ramade in Rennes, 1990, 14–17, no. 2, with bibliography. See also Joachim Poeschke, "Donatello als Zeichner," *Studien zur Künstlerzeichnung. Klaus Schwager zum 65. Geburtstag,* ed. by Stefan Kummer and Georg Satzinger, Stuttgart, 1990, 20 ff.

17. On the three *arriccio* fragments with charcoal drawings detached in 1966 from the Pazzi Chapel, cf. Becherucci 1983, 176, no. 33. Attributions to Donatello and Domenico Veneziano have been suggested.

18. Here, cf. Ames-Lewis 1981a, 17.

19. Alberti 1972, 61:102–4 (cf. Alberti 1950, 112): "Denique omnia apud nos ita praemeditata esse elaborabimus, ut nihil in opere futurum sit, quod non optime qua id sit parte locandum intelligamus. Quove id certius teneamus, modulos in parallelos dividere iuvabit, ut in publico opere cuncta, veluti ex privatis commentariis ducta, suis sedibus collocentur." Cf. translations in Alberti 1972, 61:102–5, and Alberti 1991, 94.

20. Note especially Martin Kemp's introduction and important diagrams in Alberti 1991, 13–14, 37–71. The Italian manuscript is less complete.

21. Antonio di Tuccio Manetti, *The Life of Brunelleschi,* introduced and commented by Howard Saalman, translated by Catherine Enggass, University Park (Penn.), 1970, 53 (no. 360), 132 (note 34). In this regard, note also especially the discussion of Late Medieval and Early Renaissance surveying theory and optical theory in Trachtenberg 1997, 223–43.

22. Cf. Alberti 1972, 1–24:36–59, 31–33:67–70, and Alberti 1950, 55–75, 82–85. Cf. further translations in Alberti 1966, 68, 121 (and note 26); Alberti 1972, 1–24:37–59; 31–33: 67–70; and Alberti 1991, 37–59, 65–67.

23. This fact is well known in the literature as the result of the pioneering studies by Robert Oertel (1934, 31–240, and 1940, 217–314). Cf. further Polzer 1971, 18–59; Bor-

sook 1980, 58–63; Aiken 1986, 156–259; Field, Lunardi, and Settle 1989; Florian Huber, *Das Trinitätsfresko von Masaccio und Filippo Brunelleschi in Santa Maria Novella zu Florenz,* Munich, 1990; Danti, Lunardi, and Tintori 1990, 251–68; Kemp 1990, 16–21; and Aiken 1995, 171–87. Jane Aiken's proposal that knowledge of astrolabic construction techniques guided Masaccio's perspective construction is difficult to reconcile with the archaeological evidence of direct incisions that is extant on the mural surface. Among the conclusive telltale signs of such a procedure would have been the incised construction of a series of tangential circles, evidence that is entirely absent.

24. Cf. Polzer 1971, 43, and Aiken 1986, 179–86.

25. Cf. Polzer 1971, 43.

26. The grid was not entirely snapped with ropes; *pace* Polzer 1971, 41. See Leonetto Tintori, "Note sulla '*Trinità*' affrescata da Masaccio nella chiesa di Santa Maria Novella in Firenze, III: Gli ultimi interventi di restauro," *Le Pitture murali* 1990, 261–68, as well as thorough, complementary photographic documentation in deposit at the Archivio Fotografico of the Soprintendenza per Beni Artistici e Storici, Florence, and Opificio delle Pietre Dure e Laboratorio di Restauro, Florence. Additionally, the photograph of the Virgin's face, published in Paolo Volponi and Luciano Berti, *L'Opera completa di Masaccio,* Milan, 1968, plate XXX, shows clearly that most of the lines were ruled with the stylus, directly on the plaster.

27. For important record photography of Masaccio's *Trinity,* see Opificio delle Pietre Dure e Laboratorio di Restauro, Florence, negative nos. 66437–98371. (I am indebted to Giorgio Bonsanti for making this material available.) In 1860–61, Masaccio's *Trinity* was uncovered underneath Vasari's altarpiece and tabernacle of 1570 dedicated to the Rosary. Cf. Roberto Lunardi, "La Ristrutturazione vasariana di S. Maria Novella: I Documenti ritrovati," *Memorie Domenicane,* n.s. XIX (1988), 403–19, as well as Danti, Lunardi, and Tintori 1990, 247–67. The fresco was then detached by *stacco,* which destroyed the thin *arriccio,* and was transferred from its original site in the north aisle of S. Maria Novella; it was only properly relocated in 1952. Cf. Volponi and Berti (as in note 26), 97–99; Polzer 1971, 18; Borsook 1980, 59–62 (and note 42); as well as Danti, Lunardi, and Tintori 1990, 247–68. Technical exploration of the original site, undertaken between 1950 and 1951 during the discovery of the composition's much-damaged lower portion depicting the open sarcophagus with a skeleton, revealed that Masaccio had painted the *Trinity* on top of two previously existing frescos, though no *sinopia* emerged in this lower portion (see OPD negative no. 69719).

28. On the *Hawkwood* drawing (Uffizi inv. 31 F, Florence), cf. Degenhart and Schmitt 1968, I-2, 383–86, no. 302; Uffizi 1978, 71–72, no. 79; Petrioli Tofani 1991, 16–17, *sub numero;* Padoa Rizzo 1991 a, 62; Lucia Monaci Moran in Uffizi 1992, 170–71, no. 8.1; and Borsi 1992, 304–7. Data: 460 × 332; brush with copper resinate and vermillion wash, highlighted with white gouache, over metalpoint; squared with stylus. On the *Hawkwood* mural, cf. Pope-Hennessy

1969, 140–41; Borsook 1980, 74–79; Eve Borsook, "L'*Hawkwood* d'Uccello et la *Vie de Fabius Maximus* de Plutarque: Evolution d'un projet de cénotaphe," *Revue de l'Art,* LV (1982), 44–51; Padoa Rizzo 1991 a, 62–63, no. 7; Borsi 1992, 112–14, 151–53, 204–6, 304–7 (no. 12); Dittelbach 1993, 101–10; and Scalini 1995, 95–106.

29. The portions of the drawing with the rider and the base are now on separate pieces of paper, which were reglued to form a unit. This has syncopated the squares from the original grid. The cutting of the paper and the shifting of the rider with respect to the base (causing the displacement of the original grid) may well have been done by Paolo Uccello himself in an effort to rework the design of the monument, for the extant documents about the commission record that the *operai* of Florence Cathedral obliged him to remake the mural (this is the subject of Eve Borsook's present research).

30. Cf. Degenhart and Schmitt 1968, I-3, 383–86, and Borsook 1980, 77, 79 (note 55). These incisions are also readily visible with strong binoculars.

31. I have been unable to find any possible evidence of *spolvero* marks in the extensive photographic documentation of the mural, and none is recorded in the literature. As Eve Borsook has discussed, the mural has suffered disastrous restorations (Borsook 1980, 77). For the sake of caution, the use of cartoons cannot entirely be ruled out, until the mural is examined in laboratory conditions.

32. Cf. further Borsook 1980, 82, and Metropolitan Museum of Art 1968, 144–47, nos. 34–35. On the conservation of these frescos, see Giuseppe Rossi, "Il Restauro degli affreschi attribuiti a Paolo Uccello nella Cappella dell'Assunta del Duomo di Prato," *Le Pitture murali* 1990, 293–96; and Anna Padoa Rizzo, *La Cappella dell'Assunta nel Duomo di Prato,* Prato, 1997, 115–24. On the problems of attribution, cf. Pope-Hennessy 1969, 163–64; Wohl 1980, 170–72; Padoa Rizzo 1991 a, 43–57, no. 4; Bellosi 1990, 21; Angelo Angelini in Bellosi 1992, 64–67, no. 3; and Borsi 1992, 299–302, no. 10.

33. On this point, compare Chapter Five and Kemp 1990, 18–21.

34. Cf. Polzer 1971, 58–59.

35. A fundamental confusion regarding cartoon incisions *(incisioni indirette)* and direct incisions *(incisioni dirette)* marrs the otherwise useful conclusions in Polzer 1971. See Chapter Ten, on the problems of distinguishing cartoon stylus incisions *(incisioni indirette)* from direct incisions *(incisioni dirette).*

36. Cf. analyses in Field, Lunardi, and Settle 1989, as well as Kemp 1990, 18–21. Note also Aiken 1986, 156–259, and Aiken 1995, 171–87, although her points about astrolabic construction are not really supported by the archaeological evidence on the mural surface.

37. See note 2, as well as Chapter Ten. Here, we may recall the attractive hypothesis regarding the use of *"sagome"* (models or tracings of figure parts) for the murals in the Upper Church of S. Francesco at Assisi and at the Oratorio di S. Silvestro at SS. Quattro Coronati in Rome. However, in my opinion, the gaps in the visual evidence make this a largely speculative proposal, for we still do not actually know just how the *"sagome"* were applied, nor do we have any telling archaeological remains on the painting surface of their use (tacky borders in the paint or register marks). See the important studies by Zanardi and Frugoni 1996, 32–58, as well as Nimmo and Olivetti 1985–86, 399–411, for tantalizing demonstrations of the visual evidence, but with a problematic reading of the early textual sources (documents and treatises).

38. Galleria degli Uffizi inv. 459, Florence. On the altarpiece, cf. Luisa Marcucci, "Del polittico di Ognissanti di Giovanni da Milano," *Antichità Viva,* no. 4 (1962), 11–19; Boskovits 1966, 28–30, 38–39; Mina Gregori, "Giovanni da Milano: Storia di un polittico," *Paragone,* no. 265 (1972), 4–23; and Cavadini 1980, 62–67, with a reconstruction. On such frames, see Von Teuffel 1979, 21–65.

39. It must be remembered that in comparing overlays with tracings of the motif of God the Father in the painting, we can only compare outlines as painted not as underdrawn. It has not been possible for me to study the roundels with infrared reflectography. I am indebted to Alessandro Cecchi for his help with my technical research (summer 1991).

40. The disposition of the lead transoms in the S. Croce windows varies slightly as the result of restorations. Cf. Becherucci 1983, 172, no. 20, for bibliography. These window designs (often dated around 1325–30) have also been unconvincingly attributed to Giotto; see Miklòs Boskovits, "Una Vetrata e un frammento d'affresco di Giotto nel Museo di S. Croce," *Sritti di storia dell'arte in onore di Federico Zeri,* Milan, 1984, 39–45. On the various campaigns of stained-glass window decoration in S. Croce, see Van Straelen 1938, 9–23. On techniques of production, cf. A. Lane, "Florentine Painted Glass and the Practice of Design," *BM,* XCI (1949), 43–48; Renée Burnam, *The Stained Glass Windows of the Oratory of Orsanmichele in Florence,* Ph.D. Thesis, Syracuse University, 1988; Burnam 1988, 77–93; and Martin 1996, 118–40. The Trecento stained-glass windows at S. Croce are the subject of a forthcoming Ph.D. Thesis by Nancy Thompson. The deliberations and payment documents for the late Trecento and early Quattrocento stained-glass windows in Florence Cathedral sometimes mention *"disegni,"* though not the word *"cartoni."* See, for instance, Poggi 1909, 92, 98, 103–5, nos. 480 (Agnolo Gaddi, on 23 December 1395), 517 (Nicola Pieri, on 23 December 1404), nos. 549–50, 553 (Fra Bernardino, on 4, 13 April 1424 and 1 March 1425).

41. On the dating and documents regarding the chapel, cf. Eugene Müntz, *Les Arts à la Cour des Papes . . . ,* Paris, 1878–82, 112–27, and Pope-Hennessy 1974, 212–14.

42. The *spolvero* is most visible on the cherub head at the entrance wall of the chapel. Additionally, notice the *spolvero* on other ornamental parts such as the monumental tabernacles (see Chapter Five, Fig. 163). Cleaned in 1994–96, these murals have also been restored extensively in the past, cf. Biagio Biagetti's report in *Atti della Pontificia Accademia Romana di Archeologia: Rendiconti,* III (1924–25),

485–95; Dioclecio Redig de Campos's report in *Atti della Pontificia Accademia Romana di Archeologia: Rendiconti,* XXIII–XXIV (1947–49), 385–88, XXVII (1952–54), 400–2, but without notice of *spolvero.* See further discussion of Fra Angelico's frescos in notes 227–28.

43. See payment record from 23 May 1447 transcribed in Ahl 1996, 275–76, under Doc. 4, and Pope-Hennessy 1974, 213.

44. See section on cartoon practice and nonpractice between the 1450s and the 1490s in this chapter, and cf. conservation reports on the Chapel of Nicholas V (cited above in note 42). Another example of the use of *spolvero* patterns for ornament by Fra Angelico occurs on the *rinceaux* framing the fresco of the *Crucifixion* in the *"Sala Capitolare"* (Convent of S. Marco), especially intact on the right.

45. See Chapter Three, note 117.

46. This tabernacle was detached by Dino Dini in 1955; cf. *Le Pitture murali* 1990, 308 (list by A. Felici, L. Lucioli, A. Popple, "Catalogazione ragionata di affreschi staccati in Firenze nel periodo 1945–1980," under *"Tabernacoli,"* where it is unconvincingly said to be fourteenth-century). The small S. Croce shrine has apparently otherwise escaped mention in the literature.

47. For stylistic comparison, note the following paintings by Bicci: (1) frescoed tabernacle of the *Madonna and Child with Sts. Paul, Jerome, and Donor,* on Via dei Serragli and Via S. Monaca, Florence, dated 1427 [Bernard Berenson, *Italian Pictures of the Renaissance. Florentine School,* I, no. 501; Fremantle 1975, 475, plate 987]; (2) frescoed lunette of the *Madonna and Child with Saints* on Porta S. Giorgio, Florence [ibid., plate 988]; (3) triptych in the Pinacoteca Nazionale, Siena, dated 1430 [ibid., plate 989]. On Bicci di Lorenzo, see further ibid., 471–82, especially 471–72. An attribution of this shrine to the "Maestro di Signa," Bicci's close follower is also a possibility (for comparisons, see studies by Cecilia Frosinini cited in note 50). A further possibility is Ventura di Moro (who may or may not be the "Pseudo-Ambrogio di Baldese"). For this master's only firmly attributed work, a small signed panel of the *Madonna and Child* (Siena, Pinacoteca Nazionale), see Pietro Torriti, *La Pinacoteca Nazionale di Siena: I dipinti dal XII al XV secolo,* Genoa, 1981, 410, no. 389. On the "Pseudo-Ambrogio di Baldese," see Freemantle 1975, 417–24. I am indebted to Laurence B. Kanter, who brought to my attention some of these additional stylistic comparisons relevant for the S. Croce shrine: (1) the polyptychs of the *Madonna and Child Enthroned with Angels and Saints* in the Galleria dell'Accademia, Florence; in the Church of S. Pietro at Cedda, near Poggibonsi; and in a private collection (Fremantle 1975, 419, plates 856, 862, 867); (2) The single panels of the *Madonna and Child* in the Worcester Art Museum, Worcester (Mass.); in the Museo Civico, Pistoia; in the Collection of Marchese Bagneri, Florence; and in the Museum of Fine Arts, Boston (ibid., plates 859–60, 864, 868, 871); as well as those whose present whereabouts are unknown (ibid., plates 863, 870, 866); (3) the polyptych of the *Madonna and Child with Angels and Saints* in the Yale University Art Gallery, New Haven (R. Offner, *Italian Primitives at Yale University,*

New Haven, 1927, 19–20, fig. 11, as follower of Agnolo Gaddi).

48. As is not uncommon in murals, especially those which are painted thickly and/or are retouched *a secco,* the *spolvero* marks appear and disappear from sight, being only sporadically visible, especially in the figure of the Madonna, who wears a light-blue mantle painted for the most part *a secco.* On the problems regarding the identification of *spolvero* in murals, see Appendix Two, note 3. In the case of the S. Croce shrine, raking light helps identify the extent of this pouncing and helps verify the lack of pounce marks in the rest of the shrine.

49. Vasari 1966–87, II (testo), 315–18. Cf. *Giotto to Dürer* 1991, 108, as well as Thomas 1995 (especially 59–61, 287–89).

50. On the Bicci family, see especially studies by Cecilia Frosinini: "Il Passaggio di gestione in una bottega pittorica fiorentina del primo Rinascimento: Lorenzo di Bicci e Bicci di Lorenzo," *Antichità Viva,* XXV (1986), 5–15; "Il passaggio di gestione in una bottega pittorica fiorentina del primo '400: Bicci di Lorenzo e Neri di Bicci," *Antichità Viva,* XXVI (1987), 5–14; and "Gli Esordi del Maestro di Signa: Dalla Bottega di Bicci di Lorenzo alle prime opere autonome," *Antichità Viva,* XXIX (1990), 18–25; as well as Giovanni Poggi, "Gentile da Fabriano e Bicci di Lorenzo," *Rivista d'Arte,* V (1907), 85–89; Barbara Buhler Walsh, *The Fresco Painting of Bicci di Lorenzo,* Ph.D. Dissertation, Indiana University, 1979 (UMI Microfilm); Walsh, "Infrared Photography and Bicci di Lorenzo: A Comparison of *Sinopia* Drawings and Underdrawings," *La Pittura nel XIV e XV secolo: Il Contributo dell'analisi tecnica alla storia dell'arte,* ed. by Henk van Os and J.R.J. van Asperen de Boer, Bologna, 1983, 373–94; Walsh, "Two Early Bicci di Lorenzo Annunciations," *Antichità Viva,* XX (1981), 7–13; as well as Thomas 1975 and 1995.

51. For discussion and transcription of relevant document, see Wohl 1980, 202, 342 (document "C").

52. I am indebted to Giorgio Bonsanti, Anna Maria Maetzke, Cristina Danti, and Silvano Lazzari for the numerous opportunities to study the vault from the restoration scaffolding. On Bicci's vault, cf. also summaries in Borsook 1980, 91–102, and Bertelli 1992, 22–24, 186–88.

53. Cf. also Frank Dabell, "Antonio d'Anghiari e gli inizi di Piero della Francesca," *Paragone,* XXXV (1984), 73–94; Banker 1993, 16–21; and Thomas 1995, 267–70.

54. Cf. Oertel 1940, 312 (note 161). The *spolvero* on the corbels is most visible in the photograph published in Padoa Rizzo 1991 a, 104–5. On the problems of dating and authorship of this mural cycle, see Pope-Hennessy 1969, 142–44; Padoa Rizzo 1991 a, 92–105; and Borsi 1992, 122–25, 325–27, no. 24. There is no *spolvero* on the much-damaged lunette fresco of the *Madonna and Child* from the houses of the Del Beccuto family (Museo S. Marco, inv. dep. com. n. 192), attributed to the young Uccello. For bibliography and attribution history, see further Padoa Rizzo 1991 a, 26–27, no. 1, and Borsi 1992, 287, no. 1.

55. On the attribution of the murals in the Chapel of the *"Assunta"* at Prato Cathedral, cf. Pope-Hennessy 1969, 163–64; Wohl 1980, 170–72; Padoa Rizzo 1991 a, 43–57,

no. 4; Alessandro Angelini in Bellosi 1992, 64–67, no. 3; Borsi 1992, 299–302, no. 10; and Anna Padoa Rizzo, *La Cappella dell'Assunta nel Duomo di Prato,* Prato, 1997, 115–24.

56. Of the vast bibliography on this cycle, see Pope-Hennessy 1969, 139–40; Padoa Rizzo 1991 a, 10–14, 28–34; and Borsi 1992, 106–11, 178–87, 290–93, no. 4. Alessandro Angelini in Bellosi 1990, 75–77, attempted to attribute the figure of God the Father to Dello Delli, on the basis of Vasari's ambiguous description in the *Vita* of Dello, which does not seem justified. Cf. Vasari 1966–87, III (testo), 39–41.

57. There have also been attempts to date this mural in the mid-1440s. Cf. discussion in Pope-Hennessy 1969, 140. On the state of the question regarding Paolo Uccello's training with Ghiberti, see Padoa Rizzo 1991 a, 6–7.

58. I am indebted to Stefano Francolini and Fiorenza Scalia, as well as the *"padre guardiano"* of S. Maria Novella, for the opportunity to study this mural from a tall ladder (summer 1990). On the medium and painting technique, cf. Borsook 1980, 72–73, and Borsi 1992, 292. The mural was detached by means of *strappo* and restored in 1938–42; it was conserved again by Leonetto Tintori in 1954–57 and in 1966. Stratigraphic analyses of the pigment layers in this mural cycle are sorely needed for further conclusions on the medium.

59. For mentions of the technique in Uccello's *Vita,* see Vasari 1966–87, III (testo), 64–69. Cf. also Pope-Hennessy 1969, 140–41, and more recently, Dittelbach 1993, 98–119, and Scalini 1995, 96–97. Document transcribed in Giovanni Poggi, "Paolo Uccello e l'orologio di S. Maria del Fiore," *Miscellanea di storia dell'arte in onore di Igino Benvenuto Supino,* Florence, 1933, 323–36.

60. The identification of the dots as *spolvero* marks was first proposed by Mario Salmi, *Paolo Uccello, Andrea del Castagno, Domenico Veneziano,* Paris, 1937, 110, plates III–VII. It was endorsed by Procacci 1961, 46 (note 8), 65, and Alessandro Parronchi, "Paolo Uccello segnalato per la prospettiva e animali," *Michelangelo,* no. 34 (1981), 131. Among the refutations are Oertel 1940, 303 (note 147), and E. M. L. Wakayama, "Per la datazione delle storie di Noè di Paolo Uccello: Un ipotesi di lettura," *AL,* LXI, no. 1 (1982), 93–106. The controversy is mentioned with no conclusive opinion in Pope-Hennessy 1969, 140, 147 (where the terms *"sinopia"* and "cartoon" are confused, however, as if they were interchangeable); Borsook 1980, 72–73, 74 (note 32); and Borsi 1992, 292.

61. In the past, I, like others who lacked the opportunity of examining the mural surface firsthand, doubted that these dots could be *spolvero* marks (cf. Bambach Cappel 1988, Part 1, I:222, note 127).

62. The situation is comparable to that in better preserved murals. The fictive marble cornice surmounting the *dado* of the Rinuccini Chapel (S. Croce, Florence) can serve as a point of reference for observations on Paolo Uccello's figure of God the Father. Cf. Chapter Five. Like the *"Chiostro Verde"* mural cycle, the fictive cornice in the Rinuccini Chapel is fairly monochromatic and has substantial passages *a secco.* As we may remember, the "Rinuc-

cini Master" painted the entire fictive molding, including the acanthus leaves, modillions, and horizontal lines, from *spolvero* patterns that he repeated and reversed throughout the three walls of the chapel. Especially in the horizontal lines on the north wall (the most intact and the least repainted by restorers), one can see the haphazard way in which the *spolvero* appears and disappears in portions that must have been continuously painted from patterns. This is, however, a much more typical occurrence in Late Medieval and Renaissance murals than we may at first think. *Spolvero* marks can be surprisingly difficult to detect, for they easily disappeared under preparatory underpainted outlines and ensuing layers of paint, particularly if the pigment was laid thickly. Moreover, because of their very means of productions, *spolvero* marks are extremely ephemeral. Cf. Chapter Two. As Leonetto Tintori has demonstrated to me, *spolvero* dots can often register only sporadically on the *intonaco* during the process of pouncing, especially if the moisture and consistency of the *intonaco* varies, if the *intonaco* is lightly troweled after pouncing, or if a pricked cartoon or pattern is pounced more than once. Further factors affecting the legibility of *spolvero* marks are the condition of the mural surface (especially if executed or retouched *a secco*), the density of the layers of pigment applied on top, and the relative wetness or dryness of the *intonaco* at the time of pouncing. See further, Appendix Two, note 3, for a list of murals exhibiting such problems.

63. *Spolvero* may also be present on the upper left part of God's draperies and in the group of animals in the *Creation* scene on the extreme left of the lunette, but unfortunately the ladder that I was allowed to use was not sufficiently tall or firm for verification.

64. On Ghiberti as Paolo Uccello's teacher, cf. Mario Salmi, "Lorenzo Ghiberti e la pittura," *Scritti di storia dell'arte in onore di Lionello Venturi,* Rome, 1956, I, 223–37; Pope-Hennessy 1969, 1–2; James Beck, "Uccello's Apprenticeship with Ghiberti," *BM,* CXXIII (1980), 837; and Borsi 1992, 17–18.

65. Albertina inv. 24409, R 8, Vienna. Data: 215 × 166 mm.; pen and brown ink. Cf. Degenhart and Schmitt 1968, I-2, no. 191; Birke 1991, 20, no. 9; and Birke and Kertesz 1992–97, IV, 2386. This study has also been attributed, unconvincingly in my opinion, to Masolino by Luciano Bellosi, "A Proposito del disegno dell'Albertina (dal Ghiberti a Masolino)," *Lorenzo Ghiberti nel suo tempo. Atti del convegno internazionale di studi (Firenze 18–21 ottobre 1978),* Florence, 1980, 135–46.

66. Neither Gentile da Fabriano nor Pisanello are known to have been "pouncers" in the context of figural design. On the complex and much debated reconstruction of this modelbook (a so-called *"taccuino di viaggio"*), cf. Maria Fossi Todorow, "Un Taccuino di viaggi del Pisanello e della sua bottega," *Scritti in onore di Mario Salmi,* Rome, 1962, II, 133–61; Degenhart and Schmitt 1968, I-1, 234–45, nos. 125–35, Exkurs II, 639–44, I-3, plates 173–78; Ames-Lewis 1981, 71–76; Elen 1995, 197–201; and Scheller 1995, 341–56, nos. 33, 34.

67. On this monument, see Paul Joannides, *Masaccio and Masolino: A Complete Catalogue,* London, 1993, 399–413, no. 22, with previous bibliography.

68. I am indebted to Claudio Strinati and Bruno Zanardi for the opportunities to study this mural cycle from the restoration scaffolding (April 1994).

69. See Archivio Fotografico, Soprintendenza per i Beni Artistici e Storici, Florence, negative nos. 97554 (for a general view) and 104652 (for a detail). On this *sinopia,* cf. also Borsook 1980, 71–74, and Borsi 1992, 172–75.

70. Uffizi inv. 1302 F, Florence. Revised Data: 237 × 266 mm.; metalpoint, pen and dark brown ink, brush and brown wash, highlighted with white gouache, over traces of charcoal or black chalk, stylus ruling, and stylus underdrawing, on brown-green prepared paper; incised compass work. Cf. W. Boeck, "Drawings by Paolo Uccello," *Old Master Drawings,* VIII (1933–34), 1; G. Pudelko, "Der Meister der Anbetung in Karlsruhe, ein Schuler Paolo Uccellos," *Festschrift zum 70: Geburtstag von Adolph Goldschmidt,* Berlin, 1935, 128; Mario Salmi, *Paolo Uccello, Andrea del Castagno, Domenico Veneziano,* Rome, 1936, 112 (Milan, 1938 edition, 152); Berenson 1938, II, 358, no. 2778C, III, plate 68; W. Boeck, *Paolo Uccello,* Berlin, 1939, 78; G. Pudelko, "Paolo Uccello," in Thieme-Becker, XXXIII, Leipzig, 1939, 525; Degenhart 1949, 51, no. 34, plate 34; E. Micheletti in *Mostra di quattro maestri del primo Rinascimento* (exh. cat., Palazzo Strozzi), Florence, 1954, 70, no. 31; Grassi 1956, 63; Grassi 1960, 23, 152–53; Berenson 1961, I, 44, II, 605, no. 2778C; Alessandro Parronchi, *Studi su la dolce prospettiva,* Milan, 1964, 538; Luciano Berti, *Paolo Uccello: I Maestri del colore,* Milan, 1964, fig. 2; Degenhart and Schmitt 1968, I-2, 405–6, no. 315, I-4; Pope-Hennessy 1969, 174–75, fig. xxxix; Lucia Tongiorgio Tomasi, *L'Opera completa di Paolo Uccello,* Milan, 1971, 100; Alessandro Parroncchi, *Paolo Uccello,* Bologna, 1974, 80; Fiora Bellini in Uffizi 1978, 67–68, no. 75; and Borsi 1992, 176.

71. The pose of the running angel is significantly more vigorous in the Uffizi drawing than that of the angel seen in the mural portraying the *Expulsion from Paradise* in the "Chiostro Verde," by a close follower of Paolo Uccello.

72. My most recent examination of the sheet has demonstrated that this pricking is *underneath* the olive ground. It is not clear, as I had thought previously, following Degenhart's and Schmitt's suggestion, that it must have been pricked from the verso. It is possible that the design was also on the sheet's recto but that it was later covered with ground preparation to draw the angel. For a reconstruction of the hand, cf. Degenhart and Schmitt 1968, I-2, 405–6, no. 315, fig. 538, I-4, plate 284 b; and Bambach Cappel 1988, Part 2, II:433, no. 313. The stylized design of the hand, apparently that of a woman, resembles that of the Madonna in the panel attributed to Paolo Uccello, or a close follower (Gemäldegalerie, Bodemuseum inv. 1470, Berlin). On these points, cf. also Fiora Bellini in Uffizi 1978, 73–74, no. 80.

73. Regrettably, this fragile sheet is glued onto a paper mount, and the verso is thus unvieweable for verification. But in raking light and under magnification, the perforations appear as small raised, cratered mounts, covered with

gouache color. This pricked design must have therefore preceded that of the angel's figure.

74. The style of construction is generally comparable to that of the *coppe* and *mazzocchi* traditionally attributed to Paolo Uccello, such as Uffizi inv. 1756 A, 1757 A, and 1758 A, Florence. These drawings are always accepted as autograph. See Chapter Five, note 158, for bibliography.

75. See further, Chapter Nine. Draughtsmen often pricked and pounced the outlines of fairly polished designs of isolated motifs and figures, as well as of entire compositions, for further development from one sheet onto another, making successive drafts. Although the earliest extant examples are from the 1490s, it is entirely probable that the practice was already known by the mid-Quattrocento.

76. See Plate I and Figures 195–96, 205.

77. National Gallery inv. 766 and 767, London. The main fragment of the *Enthroned Madonna and Child with God the Father* is inv. 1215. The *spolvero* has gone unnoticed. I am greatly indebted to Nicholas Penny for offering me the opportunity to study these mural fragments from a ladder and in raking light. For discussion and summary of literature on this tabernacle, cf. Davies 1986, 170–71, *sub numeri;* and Wohl 1980, 114–17, no. 1 (support for inv. 766 and 767 incorrectly given as canvas). In 1851–52, the heads of the two saints, whose figures on the thicknesses of the wall of the tabernacle flanked the *Enthroned Madonna and Child with God the Father* in the main arched field, were detached by means of a thick *stacco* and transferred onto tile; this probably greatly halted the deterioration of the *intonaco* surface, and, consequently, of the paint layers. Cf. Davies 1986, 170, nos. 766 and 767; and Wohl 1980, 115–16. The monumental central portion portraying the *Enthroned Madonna,* then already seriously deteriorated, was transferred by means of *strappo* onto canvas with less fortunate results. Cf. Wohl 1980, 114–17, and Davies 1986, 170. Wohl speaks of a "squared cartoon" for the main composition of the *Madonna,* but I find no confirmation of cartoon use in the evidence extant on the painting surface. (The direct stylus-ruled construction is for architectural elements.) In each case, the fragments on tile comprise the *giornata* of the saint's head with a generous border of the adjoining *giornate.*

78. No doubt, however, the paint dots by the restorers followed the original disposition of *spolvero* marks.

79. I am indebted to Nicholas Penny for offering me the opportunity of also studying this fragment from a tall ladder, with raking light. The surface layer of this main portion of the tabernacle was so flattened and molded against the weave of the canvas support, when the fresco was transferred – the damage to the pigment layer so severe – that even the perspectival armature of direct stylus ruling for the throne and its architectural detailing is barely visible here; incisions from stylus ruling ordinarily appear deeply excavated in intact contemporary murals and panels. Likewise the sutures of the *giornate* have been completely effaced. Martin Davies (1986, 170–71, no. 1215) catalogued the medium of this fragment as fresco. The Virgin's dress is adorned with brocade *sgraffito* patterns

(incised finely, shallowly, and scratchily), much like the well-preserved ones in the *Virgin and Child* in the Berenson Collection at Villa I Tatti, Florence. At least this area of the design must have been based on pounced patterns, as in Cennino's famous description of *"spolverezzi"* in the *Libro dell'arte* (see Chapter Five). Moreover, the original surface of the Virgin's and God the Father's ultramarine blue mantle most probably also had directly stylus-incised folds to create the illusion of depth, as ultramarine blue could not really be deeply modeled in *chiaroscuro*. Cennino's *Libro dell'arte* describes this practice as well, which is found in Domenico Veneziano's *oeuvre* as early as in his *Virgin and Child* in the National Museum, Bucharest. This common technique was used from the late Duecento to at least the early Cinquecento (see Chapter Ten, on stylus-incison techniques). The *cosmati* work bands outlining the fictive white marble throne appear to be painted freehand, without a stylus grid (see Chapter Five).

80. Vasari 1966–87, III (testo), 358.

81. For summary of arguments, cf. Wohl 1980, 114–17, no. 1, and Keith Christiansen in *Dictionary of Art* 1996, IX, 98.

82. On Masaccio's influence, see especially Andrea De Marchi in Bellosi 1990, 65.

83. On this fresco and its original site, cf. Marcia Hall, "The Tramezzo in S. Croce, Florence, and Domenico Veneziano's Fresco," *BM*, CXII (1970), 797–99; Hall, "The Tramezzo in S. Croce, Florence, Reconstructed," *AB*, LVI (1974), 325–41; Wohl 1980, 22–23, 77–79, 134–37; Borsook 1980, 90–91; Becherucci 1983, 170, no. 15; Andrea De Marchi and Luciano Bellosi in Bellosi 1990, 56–57 (no. 5), 68; and Bambach Cappel 1996 b, 155–56. The dimensions given for the fresco are: 200 × 80 cm. (Wohl 1980, 134), and 194 × 108 cm. (Borsook 1980, 90). A date in the early 1450s was suggested by Hellmut Wohl, and Andrea De Marchi and Luciano Bellosi preferred one in 1452–59, close to Niccolò Cavalcanti's commission of the *predella* by Giovanni di Francesco, added to the base of Donatello's *Annunciation*.

84. Cf. Wohl 1980, 134–35 (fig. 23); and Borsook 1980, 90–91.

85. The dimensions are given in note 83. For the *giornate*, cf. Wohl 1980, 136, and Borsook 1980, 91. We may note, for the purposes of comparison, that Michelangelo frescoed the much larger *"sotto in sù"* scene of the *Separation of Light from Darkness* in the Sistine Ceiling, in 1508–12, extremely quickly, from a stylus-incised cartoon and in only one *giornata* (Plate XI). The dimensions of Michelangelo's fresco are 180 by 260 cm. (Salvini 1976, 73). For the diagram showing the disposition of the *giornate*, cf. Plate XI, and further *Michelangelo: La Cappella Sistina, Rapporto.*

86. On the *giornate*, see note 85. Unfortunately, it was not possible for me to locate an existing *giornate* diagram for this fresco or to produce one from the fresco surface.

87. I have greatly changed my mind regarding this issue as the result of studying both the unified spatial conception of the composition and the disposition of the *giornate* in Domenico's fresco (cf. Bambach Cappel 1988, Part 1, I:214). If Domenico had used separate cartoons for each figure, it would have proved highly cumbersome to adjust the separate cartoon fragments for each figure (and cut for *giornate*) in painting such an inextricably intertwined design.

88. The *spolvero* technique was rarely applied solely in the design of landscape. Even in compositional cartoons for paintings that include background landscapes, the portrayal of the landscapes is frequently omitted in the actual drawings, and if the drawings include background landscapes, their outlines are pricked extremely cursorily.

89. Leonetto Tintori's actual demonstrations of fresco painting have brought this fact to my attention.

90. The hypothetical presence of a *sinopia* for the *Sts. John the Baptist and Francis* may no longer be verifiable. This often transferred fresco was first detached in 1566 by a *stacco* method, with a good deal of the plaster from the wall on which it was painted, when Vasari dismantled the *tramezzo* in S. Croce, during his remodeling of the church. Cf. further Hall 1970; Wohl 1980, 134–35; and Borsook, 90–91.

91. In the *sinopia* for the *Marriage of the Virgin* at S. Egidio (Museo Andrea del Castagno at the Refectory of S. Apollonia, Florence), Domenico Veneziano first ruled the verticals, horizontals, and orthogonals of the setting in perspective with reddish watery *sinopia* pigment, over traces of *carboncino*. He then brushed onto the extremely rough surface of the *arriccio* the relatively schematic, outline drawing of the Virgin's nude figure, also over a slight preliminary sketch in *carboncino*. (On this *sinopia*, cf. Wohl 1980, 205–7.) Other painters of this period made similar preliminary projections of a composition's perspective onto the *sinopia*: Piero della Francesca for *Sigismondo Malatesta Before St. Sigismund* ("Tempio Malatestiano," Rimini), and Paolo Uccello for the *Nativity* (S. Martino alla Scala, Florence) and for the *Drunkenness of Noah* in the "Chiostro Verde" (S. Maria Novella, Florence). The *sinopia* for Paolo Uccello's *Drunkenness of Noah* was destroyed but is recorded in an old photograph (see note 116, below). A synthesis of the perspectival and figural composition occurs in the *sinopie* for the Benedictine cloister of S. Miniato al Monte (Florence), if indeed Paolo Uccello was the author of those murals, as seems now very probable.

92. As Seicento and Settecento theorists would recognize, at a time when more efficient methods of design transfer existed, *spolvero* was especially effective in duplicating the outlines of small or intricate compositions (see further, Chapter Eleven). Andrea Pozzo would later note that, although *"ricalcare"* (stylus tracing) was the usual and efficient method of cartoon transfer, the *spolvero* technique was to be employed for small-scale passages. See Pozzo 1693–1700, II, unpaginated, Settione Settima, "Ricalcare: Stabilita che sieno i contorni del disegno in carta grande, come habbiamo detto, si sopraporrà sopra l'intonaco, che per la sua freschezza sarà atto a ricevere ogni impressione: & allora con una punta di ferro andarete legermente premendo i contorni. Ne disegni di cose piccole basterà fare uno spolvero, che si fà con far spessi, e minuti fori ne' contorni con sopra porvi carbone spolverizato legato in un straccio, che sia atto a lasciar le sue orme meno sensibile. Cio da' Pittori si chiama spolverare." Similarly, in defining the term *"cartoni,"* Francesco Milizia's *Dizionario delle belle*

arti del disegno (first edition, Bassano, 1797) would specify that *spolvero* should be used if a composition entails numerous figures. See Milizia 1827, II, 231: "Cartoni . . . Sull'intonaco ancora molle si puo con una punta delineare il contorno delle figure, seguendo esatamente la estremita del cartone ritagliato. Se le figure sono numerose, si descrivano con fori nel cartone tutti i contorni della composizione, ed applicato il cartone al muro, vi si fa passar sopra un sacchetto di polvere minutissima di carbone, la quale attraversando i fori lascia sull'intonaco la traccia che seguire deve il pittore." Cf. discussion in Bambach Cappel 1988, Part 1, I:25–26, 149–52, II:365.

93. Some of the points that follow on Andrea del Castagno were proposed in a synthetic manner in my paper given in 1992 and published in 1996 regarding the origin of the cartoon vis-à-vis the role of the *sinopia*. Cf. discussion in Bambach Cappel 1996 b, 143–66, and Wiemers 1996, 31–58.

94. On the problems of dating, cf. Horster 1980, 34–35, 181–82; Wohl 1980, 152–53; and Spencer 1991, 56–61. On the functions of this *sinopia*, cf. Wiemers 1996, 42–44.

95. The extent of the evidence of *spolvero* on this fresco is recorded in a full-scale diagram by Leonetto Tintori, done in 1973 during the restoration (Archivio Fotografico, Soprintendenza per i Beni Artistici e Storici, Florence, negative no. 216096).

96. Cf. Borsook 1980, xlv.

97. The treatise is by the little-known Portuguese Felipe Nunes (1575–1615), the *Arte poetica, e da pintura,* published in Lisbon in 1615; see Nunes 1615, fols. 61 recto–62 recto (cf. Veliz 1986, 8, for trans.). His advice was meant to be compelling, for, to save time, many mural painters of Nunes's time skimped on the design process, omitting cartoons altogether and prefering instead to work from proportionally squared drawings.

98. Heinrich Wölfflin, *Kunstgeschichtliche Begriffe* (1915), 5th ed., Munich, 1943; *Principles of Art History,* trans. by M. Hottinger, London, 1932. The primary concern with luminous color effects is apparent, for instance, in Fra Angelico's non-cartoon-executed murals in the cells of the convent of S. Marco (Florence), from 1441 to 1450, although there we find variations in painting practice; in the Chapel of Nicholas V (Vatican Palace), from 1447 to 1450; and in the vault of the *"Cappella Nuova"* or Cappella della Madonna di S. Brizio (Orvieto Cathedral), from 1447 to 1457. Light and color are also crucial compositional elements in Titian's murals on the walls of the *Scuola del Santo* (Padua), from around 1511, done without cartoons. If articulated diversely, the concern with light and color figures nevertheless prominently also in Florentine mural painting at the end of the sixteenth century: reliance on *sinopie,* and omission of cartoons, was then frequent.

99. An example of such *martellinatura* (plaster keyed up with a hammer) is found in Niccolò di Pietro Gerini's detached *sinopia* for an *Enthroned Madonna and Child with Saints* (Museo dell'Opera S. Croce, Florence), on which cf. Becherucci 1983, 171–72, no. 18. For other examples of *sinopie* exhibiting *martellinatura,* see Pistoiese Master of the

mid-Duecento, *Crucifixion* (S. Domenico, Pistoia); Lapo da Firenze, *Madonna and Child with Saints* (Pistoia Cathedral); "Master of the Fogg *Pietà*" (or "Master of Figline"), *St. Onophrius Cycle* (S. Ambrogio, Florence); on which cf. Metropolitan Museum of Art 1968, 50–55, 90–93, nos. 1, 2, 14.

100. A useful exercise, in this regard, is for us to compare a detail of St. Jerome's foot in the *sinopia* for the *Vision of St. Jerome,* where the *arriccio* is quite rough, with the feet of the foreground apostles in the *sinopia* for the *Entombment,* executed on a considerably flatter surface, for both works are readily accessible in the Museo Andrea del Castagno (Refectory of S. Apollonia, Florence).

101. This extreme view was put forth by Schulz 1969 and Hartt 1969. See also the following who have discussed the problems presented by the *sinopia* but who have not doubted Castagno's authorship: Meiss 1967; Passavant 1969; Meiss 1970; Wohl 1980, 152–53; Borsook, letter in *BM,* CXI (1969), 303–4; Borsook 1980, 90 (note 22); Horster 1980, 34–35; and Ames-Lewis 1981, 19. A parallel case of a *sinopia* presenting a markedly different solution from a mural as finally executed is found already in Ambrogio Lorenzetti's *Annunciation* from the late 1330s to early 1340s in the Oratory of S. Galgano, Montesiepi. On this scene, see Millard Meiss in Metropolitan Museum of Art 1968, 64–71, nos. 5 and 6 (with bibliography and technical notes); Schulz 1969, 51; as well as Borsook 1980.

102. Cf. Borsook 1980, xlvi.

103. On Corboli, cf. Horster 1980, 34, and Spencer 1991, 6, 56–61.

104. Here, my discussion of the S. Apollonia *sinopie* is limited to essential conclusions and object-based data, because they have been treated at length in Borsook 1980, xlvi–xlvii, 87–90, and Wiemers 1996, 33–41, 45–57.

105. Cf. Schulz 1969, 52; Oertel 1963, II, 148–49; Meiss 1970, 151; Borsook 1980, xlix, 88, 90; Mora and Philippot 1984, 146.

106. Cf., for instance, Procacci 1960, 68; Baldini 1969, 146; Borsook 1980, 88; and Wiemers 1996, 45–48.

107. Here, I generally follow Robert Oertel and Eve Borsook (Robert Oertel, "Perspective and Imagination," *The Renaissance and Mannerism: Studies in Western Art: Acts of the Twentieth International Congress of the History of Art,* Princeton, 1963, II, 148–49, and Borsook 1980, 88, 90, note 19). Although it is usually recognized that the *giornate* for the *Resurrection* were plotted on the *sinopia,* it has escaped mention that the same is true of the *Crucifixion* and *Entombment,* only there the *giornate* outlines drawn in *carboncino* have nearly vanished.

108. These points are rightly made in Borsook 1980, xlvi.

109. On Uccello's monochrome technique in this cycle, cf. ibid., 71–74, and Dittelbach 1993, 111–19.

110. Vasari 1966–87, III (testo), 66–68. For a general discussion of this portion of the *"Chiostro Verde"* cycle, cf. Pope-Hennessy 1969, 145–48; Padoa Rizzo 1991 a, 28–42, no. 3; and Borsi 1992, 322–25, no. 23.

111. See also excellent notes on their condition and technique in Borsook 1980, 72–74.

112. Cf. Eugenio Battisti in *La Prospettiva rinascimentale* and in

Kemp 1990, 38–40. Vasari criticized the inconsistencies of perspective, especially in the composition of the *Drunkenness* (Vasari 1966–87, III (testo), 67): "Fece quivi parimenti in prospettiva una botte che gira per ogni lato, cosa tenuta molto bella, e così una pergola piena d'uva, i cui legnami di piane squadrate vanno diminuendo al punto; ma ingannossi, perché il diminuire del piano di sotto, dove posano i piedi le figure, va con le linee della pergola, e la botte non va con le medesime linee che sfuggano: onde mi sono maravigliato assai che un tanto accurato e diligente facesse un errore così notabile."

113. Vasari 1966–87, III (testo), 67. On Vasari's *Vita* of Paolo Uccello, see Rubin 1995, 347–48.

114. On the problems of dating the S. Martino della Scala project, cf. further Pope-Hennessy 1969, 154–55; Padoa Rizzo 1991 a, 90–91, no. 14; and Borsi 1992, 313–14, no. 15.

115. On the *"Chiostro Verde"* murals, cf. Pope-Hennessy 1969, 139–40, 145–48; Padoa Rizzo 1991 a, 28–42, no. 3; and Borsi 1992, 290–93, 322–25, nos. 4, 23. On the S. Miniato murals, cf. Pope-Hennessy 1969, 142–44; Padoa Rizzo 1991 a, 92–105, no. 15; and Borsi 1992, 325–27, no. 24.

116. For a record photograph, see Archivio Fotografico, Soprintendenza per i Beni Artistici e Storici, Florence, negative no. 114113. On the destroyed *sinopie*, cf. Campani 1910, 203–10; Procacci 1961, 40, figs. liii, liv; and Borsook 1980, xlv–xlvi (fig. 21), 72–74. I have relied on Campani's account to supplement my observations on the technique of these murals, though the use of cartoons went there unnoticed.

117. I am indebted to Stefano Francolini and Fiorenza Scalia, as well as the *"padre guardiano"* of S. Maria Novella, for the opportunity to study this mural from a tall ladder (Summer 1990).

118. Cf. Procacci 1961, 233, and Pope-Hennessy 1969, 154–55.

119. Cf. further Campani 1910, 204, 210; Borsook 1980, 72, 74 (note 27); and Borsi 1992, 323–24, under no. 23.

120. At the *"Chiostro Verde,"* in the group of figures in the *Sacrifice of Noah, spolvero* marks are most readily visible in the eyebrows of the woman on the left; the left hand of the man in the center; the rows of quilting on the hat, forehead outline (though smeared), and lower nose and mouth area of the woman on the right. In the group of figures in the *Drunkenness, spolvero* marks are most readily visible along Ham's profile, eye and mouth areas, ear, as well as parts of the hem of his robe; more dots are evident in Shem's left eye area. These areas of painting and *spolvero* are original: cf. Campani 1910, plate 1, showing the mural in its stripped, unrestored state, and plate 2, showing the restoration and inpainting done in 1909. Cf. Oertel 1940, 303 (note 146); Borsook 1980, 73, 74 (note 35); and Borsi 1992, 323, where the possible presence of *spolvero* on two heads in the *Sacrifice of Noah* is reported, based on the evidence in photographs. My examination of the murals from a tall ladder in the summer of 1990 could confirm these observations.

121. See the biographies of Dello Delli and Paolo Uccello in Vasari 1966–87, III (testo), 41, 67. Moreover, the woodcut profile portrait of Dello in the 1568 edition of Vasari's *Vita*

of the artist looks like this turbanned figure in the *Drunkenness of Noah,* but in reverse (a design was reversed in the process of printing).

122. Cf. Pope-Hennessy 1969, 145–47, and Borsi 1992, 322–25.

123. Vasari 1966–87, III (testo), 68.

124. Ibid., III (testo), 70.

125. Adolfo Venturi, "Cosma Tura gennant Cosmé: 1432 bis 1495," *Jahrbuch der königlich Preussischen Kunstsammlungen,* IX (1888), 1–33, with transcriptions of noteworthy documents on pp. 6 (note 4), 7 (notes 1, 2), 10 (note 4), 24 (note 4), 28 (notes 3, 4). The *Memoriale* T of 1457, fol. 87, here cited reads: "Gregorio de gasparino cartolaro de avere per folgi [fogli] 6 de carte reale ebe gusme depintore per fare et depinzere devixe per desegno de fare bancali de m° Levino m° razi." Further documents of this type are transcribed in Thomas Tuohy, *Herculean Ferrara: Ercole d'Este, 1471–1505, and the Invention of a Ducal Capital,* Cambridge and New York, 1996, 402 (doc. 5, "*cartone* designado cum una festa al'antiqua toca de aquarelle lunga br. 5 e larga br 1/2 che fo facto per patrone per li Maistri da li Racci del prefato n.S. per agrandire uno altro patrone d'aparamento da leto, posto a spesa a. c. 112 £1–0–0 d."), 402–3 (doc. 6), 406–7 (doc. 8), 407 (doc. 10), 408 (doc. 12). See also discussion and selection of documents by Nello Forti Grazzini, *Arazzi a Ferrara* (alternative title *L'Arazzo ferrarese*), Milan, 1982, 29–59 (especially 48–49, notes 103–115, on Cosmè Tura). The present state of research suggests that in his paintings Cosmè Tura was not usually a "cartoonist." On his underdrawing techniques for paintings, cf. Jill Dunkerton et al., "The Unmasking of Tura's *Allegorical Figure:* A Painting and its Concealed Image," *NGTB,* II (1987), 5–35; David Scrase, "Cosimo Tura: *The Crucifixion with the Virgin and Saint John,"* *Bulletin of the Hamilton Kerr Institute,* I (1988), 69–71; Galassi 1988–89, 215–30; and Galassi 1998.

126. Cf. further Chapter Eleven. Between 1400 and 1430, Lorenzo Ghiberti and Donatello spurred the revival of figural bronze sculpture as a monumental art form. Full-scale, three-dimensional models in clay, tow, or plaster, if not actually necessary for carving stone, were indispensable for the bronze casting process, regardless of the sculpture's size. See Bruno Bearzi, "La Tecnica fusoria di Donatello," *Donatello e il suo tempo: Atti dell'VIII Convegno Internazionale di Studi sul Rinascimento,* Florence, 1968, 97–105. On bronze casting techniques, see also essays on Verrocchio's *Christ and St. Thomas* by Massimo Leoni, Niccolò Ammannati, Gian Piero Bernardini, and others in Metropolitan Museum of Art 1992, 83–125; as well as Butterfield 1997. Sometimes sculptors lacked the knowledge and skill to cast their own sculptures; while Lorenzo Ghiberti was a masterful practitioner, Benvenuto Cellini spoke harshly about the imperfect casting of some of Donatello's sculptures. In the medium of terracotta, whose revival Ghiberti and Donatello also led during this period, the manifold and nearly exact reproduction of a number of half-length *Madonnas* was no doubt aided by the intermediary use of models. See Richard Krautheimer, "Terracotta Madonnas," *Studies in Early Christian, Medieval, and*

Renaissance Art, Princeton, 1969, 315–22; Laura Martini, "La Rinascita della terracotta," *Lorenzo Ghiberti: Materia e ragionamenti,* exh. cat. ed. by Luciano Bellosi, Museo dell'Accademia and Museo di S. Marco, Florence, 1978, 208–24; and Ulrich Middeldorf, "Some Florentine Painted Madonna Reliefs," *Collaboration in Italian Renaissance Art,* ed. by John T. Paoletti and Wendy Stedman Sheard, New Haven and London, 1978, 77–90.

127. For example, cf. Meder 1923, 522 (Meder and Ames 1978, I, 392); Oertel 1940, 273–74; Degenhart and Schmitt 1968, I-I, xxii–xxiii, xxxvii; Ames-Lewis 1981 a, 28–29; Borsook 1980, xliv; Borsook 1985, 128; and Bambach Cappel 1988, Part 1, I:209–11. See transcriptions of documents on the decoration of the sacristies in Florence Cathedral, in Poggi 1988, 1–35, nos. 1454–1610, for evidence on wood *intarsia* (but the word *"cartone"* does not turn up.)

128. On the practices for stained-glass production, see note 40. For the documents pertaining to the stained-glass windows of Florence Cathedral, see transcriptions in Poggi 1909, 85–171, nos. 450–886; and for discussion, see *Lorenzo Ghiberti: Materia e ragionamento,* exh. cat. by Luciano Bellosi, Museo dell'Accademia and Museo di S. Marco, Florence, 1978, 236–57, 581–84.

129. Andrea del Castagno's intervention in the Mascoli Chapel (Basilica of S. Marco, Venice) is not documented but has generally been accepted on the basis of style. His presence in Venice in the 1440s is documented. Cf. André Chastel, "La mosaique à Venise et à Florence au XVe siècle," *Arte Veneta,* VIII (1954), 122; Hartt 1959, 225–34; Michelangelo Muraro, "The Statutes of the Venetian *Arti* and the Mosaics of the Mascoli Chapel," *AB,* XLIII (1961), 263–74; Debra Pincus, *The Arco Foscari: The Building of a Triumphal Gateway in Fifteenth-Century Venice,* New York, 1976, 93–95; Ettore Merkel, "Un Problema di metodo: La *Dormitio Virginis* dei Mascoli," *Arte Veneta,* XXVII (1973), 65–80; Horster 1980, 18–20; Lightbown 1986, 93–94; Brown 1989, 106–7; and Spencer 1991, 95–102. Cf. also Pope-Hennessy 1969, 159–60, for a summary of proposals regarding Paolo Uccello's intervention in these mosaics, following a suggestion first made by Roberto Longhi in 1926.

130. See document transcribed in Poggi 1909, 145, no. 762 *("designi"),* and Horster 1980, 204, no. 1. On the problem of the *vetrai,* cf. ibid., lxxxviii, and Van Straelen 1938, 89–90.

131. The letter is mentioned in the deliberation transcribed in Poggi 1909, 147, no. 773. Paolo Ucello's destroyed mosaic is partly recorded in Gentile Bellini's *Procession* in the Piazza S. Marco (Gallerie dell'Accademia, Venice), signed and dated 1496.

132. See documents transcribed in ibid., 143, 144, 145; nos. 750 *("designum"),* 754 *("designati"),* 761 *("designi").* Cf. Van Straelen 1938, 86–88.

133. The relevant documents are Poggi 1909, 144–45, nos. 754, 757–58, 762. Cf. also Padoa Rizzi 1991 a, 82, no. 12, and Borsi 1992, 319–21, nos. 20–21.

134. See especially Alesso Baldovinetti's *Ricordi* and payment documents transcribed in Kennedy 1938, 236, 239, 241, 244–46, 249–51, nos. I–II, VI, X, XIV–XVI.

135. Based on the description in Anton Francesco Doni's *Disegno* (Venice, 1549) and the introduction to Giorgio Vasari's *Vite* (Florence, 1550 and 1568), it is indeed tempting to correlate the cutting of cartoons according to *giornate* of production in a mosaic with that that was normal in the painting of a fresco. See Doni 1549, fols. 23 recto and verso, and Vasari 1966–87, I (testo), 147–51 (cf. Vasari 1960, 255, for trans.). However, neither Cennino, whose remarks in the *Libro dell'arte* (MS., late 1390s) are admittedly fragmentary, nor Antonio Filarete in the *Trattato dell'architettura* (MS., c. 1464), who claimed to have written from first-hand observation, refer to the use of cartoons in their descriptions of mosaic design and execution. Cf. Cennini 1995, cap. clxxii, 182–85 (cf. Cennini 1960, 114–15, for trans.); Filarete 1972, II, 670–72; Spencer 1965, I, 312–13; and Filarete 1890, 645–49. By the Cinquecento, the production of cartoons was of course relatively standard in designing most decorative arts, as it was in painting. Extant examples and Vasari's introduction to the *Vite* both attest to it. Yet, with the exception of stained glass, it is difficult to ascertain whether the practice of cartoons in other media preceded that in painting.

136. Theophilus 1986, xvii: "De Componendis Fenestris" ("How to Construct Windows"), 47–48.

137. Cennini 1995, cap. clxxi, 181–82 (cf. Cennini 1960, 111–12, for trans.).

138. Cennini 1995, cap. clxxi, 181 (cf. Cennini 1960, 111, for trans.): ". . . el ti verrà colla misura della sua finestra, larghezza e lunghezza; tu torrai tanti fogli di carta incollati insieme quanto ti farà per bisognio alla tua finestra; e disegnerai la tua figura prima con carbone, poi fermerai con inchiostro, aombrata la tua figura compiutamente, sì come disegni in tavola. Poi il tuo maestro de' vetri toglie questo disegno e spianalo in su desco, o tavola, grande e piano; e secondo che colorire vuole i vestimenti della figura, così di parte in parte va tagliando i suo' vetri. . . ." Cennino's description further establishes just how far painters in the 1390s and early 1400s remained from the notion of drawing a full-scale composition for a painting on a surface other than that of the final work.

139. On the interaction of artists and craftsmen in the production of stained-glass windows, cf. note 40, as well as Poggi 1909, lxxviii–xciii; Marchini 1956, 10–12, 40–54; Van Straelen 1938; Degenhart and Schmitt 1968, I-I, xxiii; Burnam 1988, 77–93; and Martin 1996, 118–40. However, contrary to what is widely stated in the literature, the documents about the stained-glass windows for Florence Cathedral refer to *"disegni,"* rather than *"cartoni."* See transcriptions in Poggi 1909: Agnolo Gaddi's colored designs or drawings on 6 August 1394 (87, no. 456); Ghiberti's drawings on 4–13 April 1424 (103–4, nos. 549–50), 30 December 1433 (136–37, no. 717), 20 April 1434 (114, no. 605), 25 August 1434 (138, no. 722), 19 March 1435 (138, no. 723), 32 October 1436 (116, no. 615), 8 November–29 December 1440 (124, nos. 647–48), 5 January 1442 (127, no. 658), 10–28 February 1442 (129, nos. 660–63), 12 May 1442 (129, no. 667), 14 June 1442 (130, no. 671), 6–31 July 1442 (131, nos. 674, 677), 24 November 1442 (132, no. 685), 10

December 1442 (132, no. 686); Donatello's payment and competition against Ghiberti on 14–20 April 1434 (137, nos. 719–20), 25 August 1434 (138, no. 722), 7 December 1435 (139, no. 727). For the documents relevant to the windows by Andrea del Castagno and Paolo Uccello, see notes 131, 133–34, above. There are records dated 29 November and 2 December 1448 from the accounts of the works at Orvieto Cathedral recording Benozzo Gozzoli's design for a stained-glass window, which Don Francesco Baroni was to execute; see document in Ahl 1996, 272, no. 103. Alesso Baldovinetti made a design for the window *("disegniata")* in the Gianfigliazzi Chapel at S. Trinita (Florence) on 14 February 1466; see *Ricordi* transcribed in Kennedy 1938, 236.

140. Louvre inv. 1152, Paris. Revised data: 251 × 281 mm.; pen and brown ink, sheet glued onto secondary paper support; unrelated outlines pricked from the verso, and holes blackened with pouncing dust.

141. Degenhart and Schmitt 1968, I-2, 567, no. 269.

142. Eve Borsook first made this point. Cf. further Borsook 1980, xliv, 91; Wohl 1980, 17–20, 200–9; and Bambach Cappel 1996 b, 145 (and note 2).

143. There may have even been Medici interests behind the S. Egidio mural project in the Quattrocento, as the Medici and Portinari were close friends. See Francis Ames-Lewis, "Domenico Veneziano and the Medici," *JdBM,* XXI (1979), 67–90; Roberto Bartalini in Bellosi 1990, 168; and Spencer 1991, 81–84. On the chapel, see also further Odoardo Hillyer Giglioli, "Le Pitture di Andrea del Castagno e di Alesso Baldovinetti per la chiesa di Sant' Egidio," *Rivista d'Arte,* III (1905), 206–8; Kennedy 1938, 97–98; Paatz, IV, 1–64 (especially 23–26); Wohl 1980, 17, 200–1; and Wackernagel 1981, 303.

144. For discussion and documents, see Wohl 1980, 201–6, 341–43.

145. On Bicci's presence at S. Egidio, cf. studies by Barbara Buhler Walsh (cited in note 50, above), as well as Paatz, IV, 1–64 (23–26), and Wohl 1980, 200–1, 342.

146. This is proposed in ibid., 202.

147. Ibid., 18–20, 201–6.

148. See discussion and document transcribed in ibid., 17–21, 201, 341.

149. Cf. Lavin et al. 1984, 8 (on the date), 28, 72 (on the use of *spolvero* cartoons). Note the *spolvero* in the following photographic details: the oculus depicting the *Castellum Sismundum ariminense* (ibid., 28, fig. 16), the hand of St. Sigismund (plate 129), and the dog's eye (plate 145). Cf. Bertelli 1992, 67–75, with *spolvero* details illustrated in color.

150. On Andrea's three frescos at S. Egidio, cf. further Giglioli (as in note 143), 206–8; Wohl 1980, 205; Horster 1980, 188–89; and Spencer 1991, 81–84.

151. Vasari 1966–87, III (testo), 360.

152. The Villa Carducci fragments are in deposit at the Soprintendenza per i Beni Artistici e Storici, Florence. A number of these fresco fragments are presently on view in the Galleria degli Uffizi. For their history, rediscovery in 1847, and detachment in 1851 by Giovanni Rizzoli, cf. Alessandro Conti, *I Dintorni di Firenze. Arte, storia, paesag-*

gio, Florence, 1983, 135; Giovanna Ragionieri in Bellosi 1990, 144–45, no. 25; and Alessandro Cecchi in Bellosi 1992, 121–25. Further fragments of the decoration on the left wall of the *salone* came to light in 1948–49. Cf. also J. M. Dunn, "Andrea del Castagno e i Carducci: Documenti vecchi e nuovi riguardanti la Villa Carducci in Firenze," *Archivio Storico Italiano,* CXLVII (1989), 251–76, and Spencer 1991, 32–42.

153. The Benedictine nuns of S. Apollonia observed a strict *clausura.* The monastery was not secularized until 1860. See further Paatz, I, 211–25, and Borsook 1980, 87.

154. For Baldovinetti's mention of his work for Andrea del Castagno, see transcription in Giovanni Poggi, *I Ricordi di Alesso Baldovinetti,* Florence, 1909, 8. On Baldovinetti's training and artistic contacts, see Kennedy 1938 and Roberto Bartalini in Bellosi 1990, 159–63. On his intervention at S. Egidio, see Giglioli (as in note 143), 206–8; Wohl 1971, 635–41; Wohl 1980, 203–5; and Giulietta Chelazzi Dini in Bellosi 1992, 77–80.

155. On the use of *spolvero* cartoons in the Chapel of the Cardinal of Portugal, see Borsook 1980, 107–8.

156. See document transcribed in Kennedy 1938, 246.

157. Cf. ibid., 218; Wohl 1980, 200–1; and Roberto Bartalini in Bellosi 1990, 168.

158. The *sinopia* and two of the mural fragments have usually been installed in the Museo Andrea del Castagno (Cenacolo S. Apollonia), whereas the rest of the fragments are in deposit in the Soprintenza per i Beni Storici e Artistici, Florence. See Wohl 1980, 200.

159. Cf. Wohl 1980, 204–5; Roberto Bartalini in Bellosi 1990, 168–69, no. 30, and Giulietta Chelazzi Dini in Bellosi 1992, 77–80.

160. An especially telling example is the tiny figure of St. Julian, praying within an oratory, in the distant background of Andrea del Castagno's *St. Julian* (SS. Annunziata, Florence), frescoed around 1454–55. Both the foreground and background compositional elements in Andrea's scene are thoroughly pounced.

161. The pricked drawings attributed to Paolo Uccello are Uffizi inv. 14502 F and 1302 F (Plate I and Fig. 185). Cf. Degenhart and Schmitt 1968, I-2, 395, 405–6, nos. 309 and 315; Uffizi 1978, 67–68, 73–74, nos. 75 and 80; Bambach Cappel 1988, Part 2, II:430–34, nos. 312 and 313; and Roberta Bartoli in Uffizi 1992, 70, no. 2.26.

162. On these murals, cf. Horster 1980, 18–21, 171–74; Wohl 1980, 174–75; and Spencer 1991, 7–8, 87–95. I have not found *spolvero* on the *Crucifixion* at S. Maria Nuova. When technical examination of Venetian murals was conducted in connection with the Fondazione Cini exhibition of 1960, no evidence of *spolvero* was reported in the Chapel of S. Tarasio. Cf. Muraro 1960, 79–83, nos. 41–48; Hartt 1959, Part I:158–87, Part II:225–36. I have only been able to study the S. Tarasio murals with strong binoculars. *Spolvero* is not evident in any photographic details. It will be important to verify the mural surface for pouncing, when it is cleaned again.

163. Though finished before 1466, the actual dates of Piero's work in S. Francesco remain much disputed. For summary

449

164. On the latter mural cycle, see Ranieri Varese, "Metodo di lavoro: Progetto e repliche," in Varese 1989, 173–87.

165. Alberti 1972, 31:67–68, 32: 68–70 (cf. Alberti 1950, 82–85), and translations in Alberti 1966, 68, 121 (and note 26); Alberti 1972, 31:67–69; 32:69–70; and Alberti 1991, 65–67.

166. Vasari 1966–87, I (testo), 125–28 (cf. Vasari 1960, 206–7, for trans.).

167. Cf. Chapter Three, note 162. A point of departure for a consideration of the authorship of these murals is provided by Francesco del Cossa's letter of 25 March 1470. Cf. Charles M. Rosenberg, "Francesco del Cossa's Letter Reconsidered," *Musei Ferraresi, Bollettino Annuale,* V–VI (1975–76), 11–15; Kristen Lippincott, "Gli affreschi del *'Salone dei Mesi'* e il problema dell'attribuzione," in Varese 1989, 111–39; and Daniele Benati in *Pittura murale quattrocento,* 105–14. *Spolvero* cartoons were used throughout the *"Sala dei Mesi."* Contrary to Ranieri Varese's imprecise claims (Varese 1989, 189), all the stylus incisions on the mural surfaces appear to be direct (*incisioni dirette; none* from cartoons) and are usually of two types: (a) ruling and compass for the construction of architectural features; or (b) freehand for cutting the reserves in the application of gilding with metal leaf.

168. For a summary of the evidence regarding Alberti's and Piero's respective sojourns in Ferrara, see Bertelli 1992, 16–17, 47 (notes 71–73).

169. On Piero's treatise, cf. Constantin Winterberg, *Pictor Burgensis de Prospectiva pingendi,* Straßburg, 1899, 2 vols; Degenhart and Schmitt 1968, I-2, 522–27, nos. 513–14; Clark 1969, 71–73; *Albrecht Dürer 1471–1971* (exh. cat., Germanisches Nationalmuseum), Nuremberg, 1971, 344, no. 628; Margaret Daly Davis, *Piero della Francesca's Mathematical Treatises: The 'Trattato d'abaco' and 'Libellus de quinque corporibus regularibus,'* Ravenna, 1977, 1–20; Piero, *De Prospectiva pingendi;* James Elkins, "Piero della Francesca and the Renaissance Proof of Linear Perspective," *AB,* LXIX (1987), 220–30 (with an incorrect interpretation of Piero's "proof"); A. Jahnsen, *Perspektivregeln und Bildgestaltung bei Piero della Francesca,* Munich, 1990, 9–35, 137 (note 1); Kemp 1990, 30–35; Martin Kemp in *Circa 1492,* 242–43, no. 141; Bertelli 1992, 38–39, 151–58; Bambach Cappel 1994; Bambach Cappel 1996 b; as well as the important articles by J. V. Field, Cecil Grayson, Paola Manni, Nicoletta Maraschio, and Francesco Di Teodoro in *Piero della Francesca tra arti e scienza* 1996.

170. Creighton E. Gilbert has aptly and succinctly translated Piero's term *"commensuratio"* as "calibration." Cf. Gilbert 1980 a, 91, and Martin Kemp's entry on Piero's *De Prospectiva* in *Circa 1492,* 242–43, no. 141. An important, if more intuitive, application of Piero's principles, as illustrated on fol. 71 recto of his *De Prospectiva,* emerges in the figure of Shem (?) in Paolo Uccello's *Drunkenness of Noah* at the *"Chiostro Verde"* (S. Maria Novella). Noah's son stands in the center and toward the rear of the hut in Paolo's scene; his head is seen frontally, but slightly *"sotto in sù."*

171. See Biblioteca Palatina di Parma, MS. Parm. 1576, 91 folios; and Biblioteca Ambrosiana, Cod. Ambr. C 307 inf., 115 folios. The Latin manuscript in the Ambrosiana contains corrections in Piero's hand. Another version in the *volgare,* with a number of additions in Piero's hand, was recently discovered in the Biblioteca Comunale "Panizzi" di Reggio Emilia, MS., Cod. Reggiano A 41/2. Cf. Cecil Grayson, "L' Edizione Critica: Progetto e Problemi," and Paola Manni, "Sulle coloriture linguistiche del *De Prospectiva pingendi,"* both studies in *Piero della Francesca tra arte e scienza* 1996, 197–206, 207–21, respectively.

172. Martin Kemp in *Circa 1492,* 242.

173. I follow the English translation of these terms given in Creighton E. Gilbert's partial translation of Piero's treatise. Cf. further Gilbert 1980a, 91–92, and Clark 1969, 71.

174. Cf. Piero, *De Prospectiva pingendi,* 173–201; Bambach Cappel 1994; Bambach Cappel 1996 b; and J. V. Field, "Piero della Francesca as Practical Mathematician: The Painter as Teacher," *Piero della Francesca tra arte e scienza* 1996, 331–54. Contrary to what is sometimes thought, the numbers inscribed on Piero's diagrams lack mathematical meaning; they are not ratios or fractions. They merely record sequentially the physical placement of the various points of measurement, axis per axis, three dimensionally around the head. Other types of notation might have served the purpose equally well. On the exercise of "transformation," or proportional foreshortening according to Piero's system, cf. also Gian Paolo Lomazzo's *Trattato dell'arte della pittura* (1584), cap. xvi (Lomazzo 1973–74, II, 280–82).

175. These steps are illustrated on folios 59 verso and 61 recto of the Parma manuscript. Cf. Piero, *De Prospectiva pingendi,* plates xxxvi–xxxvii, and Bambach Cappel 1994, figs. 8, 9.

176. The arduous process of transcription is shown on folios 63 verso and 65 recto of the Parma manuscript. Cf. Piero, *De Prospectiva pingendi,* plate xxxviii, and Bambach Cappel 1994, figs. 10A, 10B.

177. See illustration on folio 65 recto of the Parma manuscript. Cf. Piero, *De Prospectiva pingendi,* plate xxxviii; Bambach Cappel 1994, 17–43; and Bambach Cappel 1996 b, 143–66.

178. This is shown on folio 66 verso of the Parma manuscript. Cf. Piero, *De Prospectiva pingendi,* plate xxxix.

179. On such issues, cf. studies by Kirsti Andersen, Marie Françoise Clergeau, Margaret Daly Davis, Francesco Di Teodoro, J. V. Field, Menso Folkerts, Thomas Frangenberg, Enrico Gamba, Vico Montebelli, and Geoffrey Smedley in *Piero della Francesca tra arte e scienza* 1996, 65–436; as well as Bambach Cappel 1996 b, 143–66; Bambach Cappel 1994, 17–43; Kemp 1990, 7–162; and Kim Veltman (with Kenneth Keele), *Studies on Leonardo da Vinci, I: Linear Perspective and the Visual Dimensions of Science and Art,* Munich, 1986, 170–201.

180. Uffizi inv. 1756 A, 1757A, and 1758 A, Florence. However, doubts exist about the traditional attribution of these sheets to Paolo Uccello. See further, Chapter Five, note 158, for bibliography.

181. Martin Kemp in *Circa 1492,* 241–42, nos. 139–40.

182. For Leonardo's drawing, see Biblioteca Reale inv. 15574 D.C. and 15776 D.C., Turin. Data: 197 × 277 (maximum; two sheets of disparate height joined together); pen and

brown ink over stylus. Cf. Carlo Pedretti, *Disegni di Leonardo da Vinci e della sua scuola alla Biblioteca Reale di Torino* (exh. cat., Royal Library, Turin), Florence, 1975, 12–14, no. 4; Martin Kemp in *Circa 1492,* 279, no. 178; and Giovanna Nepi Sciré in *Leonardo & Venezia* 1992, 226, nos. 16 and 17. On Pacioli, Piero, Leonardo and the problem of facial proportion, cf. Bambach Cappel 1994, 17–43, and Margaret Daly Davis, "Pacioli, Piero, Leonardo: Tra 'prospettiva' e 'proporzionalità' nella *Divina Proportione,*" *Piero della Francesca tra arte e scienza* 1996, 355–61.

183. For a fuller discussion, see Bambach Cappel 1994, 17–43, and Bambach Cappel 1996 b, 143–66.

184. For instance, in the Parma manuscript of Piero's *De Prospectiva,* light traces of slightly divergent, freehand, exploratory leadpoint underdrawing are evident in most of the "transformed" heads. On folio 69 recto of the Parma manuscript, Piero discarded a version of the upturned head in profile, lightly drawn in black chalk or leadpoint and containing its pin-pricked nodal points, because of its problematic alignment. Cf. Piero, *De Prospectiva pingendi,* plate xl. In an area only slightly below this initial draft, Piero repeated the head, oriented more precisely, and completed it with pen and ink outlines.

185. We may speculate whether Piero della Francesca employed clay models also to study foreshortened figures, as later painters would do, in light of the statement in Vasari 1966–87, III (testo), 264–65: "Usò assai Piero di far modelli di terra, et a quelli metter sopra panni molli con infinità di pieghe per ritrarli e servirsene. . . ." On this practice, see further Chapter Seven, notes 96, 97.

186. Literally, "suo caro qua[n]to fratello." Cf. Clark 1969, 27–28, and Bruna Ciati, "Cultura e società nel secondo quattrocento attraverso l'opera ad intarsio di Lorenzo e Cristoforo da Lendinara," *La Prospettiva rinascimentale . . .* 1980, 202 (and note 4). On the Lendinara brothers, see also ibid., 201–14; Pier Luigi Bagatin, *L'Arte dei Canozi Lendinaresi,* 2nd ed., Trieste, 1990; Bruna Ciati, *Il Significato dell'opera ad intarsio nella cultura e nella società del secondo Quattrocento attraverso l'opera dei fratelli Lendinara (tesi di laurea,* Università degli studi di Milano), 1974–75; and Arturo Carlo Quintavalle, *Cristoforo da Lendinara,* Parma, 1959.

187. Here see further Bambach Cappel 1996 b, 143–66. Cf. argument in Klein 1961, 211–30.

188. Cf. Degenhart and Schmitt 1968, 525, and Kemp 1990, 34. See exploration of this problem by Marie Françoise Clergeau, "Le traité *De Prospectiva pingendi* et la peinture de Piero: Quel lien?," in *Piero della Francesca tra arte e scienza* 1996, 65–76, and by Bambach Cappel 1996 b, 143–66. In comparing the sculptural, pounced head of Piero's *Hercules* (Isabella Stewart Gardner Museum, Boston), probably from the 1460s, with the pen and ink drawing on fol. 66 verso of the *De Prospectiva* in the Parma manuscript, we can see that the alignments of facial features within the slightly foreshortened heads are mapped identically. The measured, frontal view of the head on folio 61 recto of Piero's *De Prospectiva* is closely comparable with the head of the pelt-clad woman with braided hair in his *Death of Adam* (S. Francesco, Arezzo), or the

head of Christ in his *Resurrection* (Museo Civico, Sansepolcro), both details painted from *spolvero.* Many other comparisons between the means of construction illustrated in the diagrams of Piero's treatise and the sequences of foreshortening in the heads portrayed with *spolvero* in his S. Francesco murals suggest the painstaking procedure.

189. Unfortunately, and despite repeated attempts, it was not possible for me to obtain the necessary archaeological photographs to illustrate my discussion of constructed architectural details in Piero's murals at S. Francesco in Arezzo.

190. I am indebted to Giorgio Bonsanti, Anna Maria Maetzke, Cristina Danti, and Silvano Lazzari, for offering a number of opportunities to study Piero's mural cycle from the restoration scaffolding. Cf. summary in Borsook 1980, 97–105; Moriondo Lenzini 1989; Centauro 1990, and Bertelli 1992, 188. Giovanni da Piamonte and Lorentino d'Andrea are usually thought to have been Piero's assistants in the mural cycle at S. Francesco, Arezzo; see further Chapter Eleven, note 6, for further bibliography on these artists. The hand of a third assistant has sometimes been identified in the *Death of Adam.* Technical research by Leonetto Tintori and Giuseppe Centauro suggests that only Giovanni da Piamonte – who executed the two middle tier scenes on the altar wall – used a traditional fresco technique in the mural cycle at S. Francesco.

191. On the painting technique of this cycle, cf. especially Borsook 1980, 91–105; Moriondo Lenzini 1989; and Centauro 1990. On Piero's *sinopia* at S. Francesco in Rimini, see Pier Giorgio Pasini, "La Sinopia dell'affresco riminese di Piero della Francesca," *Piero della Francesca tra arte e scienza* 1996, 131–42.

192. Piero similarly outlined the view of the castle in the *oculus* from a separate *spolvero* pattern, in the right frame of the Sigismondo Malatesta fresco at S. Francesco ("*Tempio Malatestiano,*" Rimini). The *spolvero* in the *oculus* at Rimini is clear in the color illustration in Bertelli 1992, 75 (plate 62).

193. On Piero's remarkable treatment of light, see Martin Kemp, "New Light on Old Theories: Piero's Studies of the Transmission of Light," *Piero della Francesca tra arte e scienza* 1996, 33–45.

194. On Piero's perspectival projection of capitals, see Joao Basto, "The Composite Capitals in Piero della Francesca's *Flagellation,*" *Piero della Francesca tra arte e scienza* 1996, 77–94.

195. Cf. Borsook 1980, 95–98; Moriondo Lenzini 1989; and Centauro 1990.

196. Cf. Borsook 1980, 94–97, and Borsook 1985, 128–29. On the recent conservation of Piero's murals, see Moriondo Lenzini 1989; Centauro 1990; and Anna Maria Maetzke, "Interventi conservativi per il *Ciclo della Leggenda della Vera Croce* e della *Madonna del Parto,*" *Piero tra arte scienza* 1996.

197. For comprehensive diagrams detailing this evidence, see Silvano Lazzari in Moriondo Lenzini 1989, 259–66, figs. 340–47. Whether the impressions are indeed the result of applying wet wads of cloth to the *intonaco* to prolong its freshness is, in my opinion, not as clear as has been suggested. Perhaps the impressions are evidence of the chain lines and laid lines from the rag-paper cartoons.

198. Cf. diagrams by Silvano Lazzari in Moriondo Lenzini 1989, 260–62, and diagrams of *giornate* by Leonetto Tintori in Borsook 1980, 96, fig. 12.

199. Cf. Borsook 1980, 97; Moriondo Lenzini 1989; Centauro 1990; Bertelli 1992, 188; Paolo Bensi, "Osservazioni sulla tecnica pittorica dei dipinti murali di Piero della Francesca," *Piero della Francesca ad Arezzo* 1993, 239–46; Giorgio Bonsanti, "Restauri in corso: Problemi aperti," and Paolo Bensi, "Il Ruolo di Piero della Francesca nello sviluppo della tecnica pittorica nel Quattrocento," both studies in *Piero della Francesca tra arte e scienza* 1996, 113–21, 167–81, respectively. I am indebted to Eve Borsook, Silvano Lazzari, and Paolo Bensi for illuminating discussions on the sources of Piero's colors during my visits to the restoration scaffolding in the fall of 1996.

200. Here, see especially demonstrations in Battisti 1992, I, 136, figs. 75–76, 87; II, 441–77. Cf. also Creighton E. Gilbert, *Change in Piero della Francesca,* Locust Valley, 1968, 72; Summers 1977, 59–88; and Borsook 1980, 96. The discussions in Chapters Three and Eleven, on cartoon reversals, repetitions, variations, and copies, offers a context for this aspect of Piero's practice at S. Francesco in Arezzo.

201. Cf. Gilbert (as in note 200), 72, and Borsook 1980, 96.

202. Cf. Clark 1969, 46; Battisti 1992; Borsook 1980, 96; Gilbert 1980 b, 38; and Borsook 1985, 128.

203. Cf. diagrams by Silvano Lazzari in Moriondo Lenzini 1989, 260–62, and diagrams of *giornate* by Leonetto Tintori in Borsook 1980, 96, fig. 12.

204. Uffizi inv. 14502 F, Florence. Revised data: 305 × 342 mm. (maximum); metalpoint, reinforced with pen and brown ink, highlighted with white gouache, over stylus underdrawing, on green prepared paper; stylus-ruled vertical lines. Cf. Degenhart and Schmitt 1968, I-2, 394–95, no. 309, figs. 526–27, I-4, plate 281 c; Uffizi 1978, 67–68, 73–74, nos. 75 and 80; Bambach Cappel 1988, Part 2, II:430–34, nos. 312 and 313; Roberta Bartoli in Uffizi 1992, 70, no. 2.26; and Bambach Cappel 1996 b, 157–63 (notes 51–53). The present hypothesis, however, modifies drastically the way in which Uccello's sheet has been previously regarded (including in my Ph.D. dissertation of 1988). Degenhart's and Schmitt's thorough cataloguing of this sheet's medium and technique provided an important stimulus for my research on the drawing.

205. This design of the nude is reconstructed in Degenhart and Schmitt 1968, I-2, 394, fig. 526. As we have seen from our discussion of Uffizi inv. 1302 F, Florence (Fig. 185 above), this reuse of a sheet for several layers of studies was typical of Paolo Uccello.

206. The intervals of these stylus-ruled vertical lines range between 10–16 mm. and 22–35 mm.; the reconstruction of these lines offered in Figure 205 (cf. Plate I) is not as precise in its details as one may wish, because of the extremely fragile condition of Uccello's drawing. There are numerous abrasions, splintered creases (not to be confused with stylus ruling), and small losses throughout the original paper, glued now onto paper supports and retouched. These problems of condition may obscure some of the evidence that might add to our interpreta-

tion. The drawing shows signs of having been stored in a rolled-up form at some point in the past. Moreover, toward the left and right borders, the original paper support separated into strips, which have been joined. The stylus ruling of lines weakens any paper support, often causing it to crack and separate, as do pricked outlines or any other types of incised outlines. Therefore, we can confidently interpret each of these nonoverlapping joins closest to the left and right borders of the sheet as having originally been a stylus-ruled line. In Figure 205, the latter two lines appear reinforced by interrupted lines.

207. A lack of consistency characterizes also the projections of *mazzocchi* and *coppe* in drawings usually attributed to Paolo Uccello (Uffizi inv. 1756 A, 1757 A, and 1758 A, Florence). See Chapter Five, note 158, on the problem of their attribution.

208. Here, I am indebted to Martin Kemp for his review of the evidence (letter, 22 December 1994).

209. Royal Library inv. 12321, Windsor. Data: 211 × 159 mm.; metalpoint on blue prepared paper. The vertical proportion lines in Leonardo's study are drawn in metalpoint. For the most part, these lines are emphatic. In some passages, however, the lines are tentatively sketched. Cf. Bambach Cappel 1996 b, 161–62 (and note 53); Martin Kemp, "Leonardo's Drawings for 'Il Cavallo di bronzo del Duca Francesco': the Programme of Research," *Leonardo da Vinci's Sforza Monument Horse: the Art and the Engineering,* ed. by Diane Cole Ahl (Acts of Symposium held at Lafayette College and Lehigh University, 1990), Lehigh University Press, 1995; Kemp and Roberts 1989, 99, no. 40; and Clark and Pedretti 1968, I, 23–24, *sub numero.*

210. Cf. Bambach Cappel 1996 b, 161–63. Mario Scalini imprecisely proposed that Uccello used a perspective box and paper models *("sagome")* to visualize the foreshortening of the horses in the *Hawkwood* cenotaph and the *Battle of S. Romano* panels, without explaining how the method would have actually worked. The problem of parallel projection or "transformation" is not at all considered. Cf. Scalini 1995, 95–106.

211. A firsthand examination of the painstaking construction technique found in the figural drawings for Piero's *De Prospectiva,* shows that for any practical application such drawings would have required precise methods of design transfer. On the drawing technique of Piero's treatise, cf. Degenhart and Schmitt 1968, I-2, 522–27, nos. 513–14; Bambach Cappel 1994, 17–43; Bambach Cappel 1996 b, 143–66; and Francesco Di Teodoro, "Per una filologia del disegno geometrico," *Piero della Francesca tra arte e scienza* 1996, 239–52. Tracing and other such semimechanical methods could reduce the complexity of construction and ensure exactitude of design.

212. Metropolitan Museum of Art, Robert Lehman Collection, 1975.1.420, New York. Revised data: 295 × 245 mm. (maximum sheet); pen and brown ink, charcoal, highlighted with white chalk, over traces of stylus underdrawing, stylus construction marks, and pricked outlines; glued onto secondary paper support. Cf. Berenson 1938, II, 335, no. 2509G; Berenson 1961, II, 564, no. 2509G; Bambach Cappel 1988, Part 2,

II:404–5, no. 293; Forlani Tempesti 1991, 207–10, no. 71; Bambach Cappel 1994, 17–43; and Bambach Cappel 1996 b, 161.

213. A fuller account of the technical evidence in Signorelli's drawing is given in Bambach Cappel 1994, 17–43.

214. As examination with the microscope confirms, the layer of charcoal and white highlights were added after the ink drawing was complete. The process of drawing on preliminary pricked outlines is further discussed in Chapter Nine. I am indebted to Margaret Lawson, paper conservator at the Metropolitan Museum of Art, for helping me with the technical research (summer 1991).

215. The stylus construction appears to be underneath the layer of charcoal drawing, but on top of the layer of ink drawing.

216. The stylus-ruled lines begin close to the top border of the sheet and stop at the tip of the man's chin. The last horizontal line is tangential both to the chin and to two wide, overlapping arcs incised with the compass and constructed close to the profile on the left.

217. The plumbline is exactly perpendicular to the horizontals and has pin pricks that mark the intervals for the stylus-ruled horizontals. Additional areas of dense, sporadic pricking along this plumbline suggest that the plumbline also derived from the parent design.

218. Cf. further Piero della Francesca, *De Prospectiva pingendi*, 173–201; Bambach Cappel 1994; and Bambach Cappel 1996 b, 157–63.

219. With respect to the profile, the frontal view appeared either to the right, as in Piero's illustrations in *De Prospectiva*, or to the left, as in the drawing by Leonardo or a follower (Royal Library inv. 12605 recto, Windsor). See Bambach Cappel 1994, 36–38, figs. 17–20. The letter marks on the ear of the figure are of an entirely different type from the marks appearing in the red chalk studies by Michelangelo for the *Libyan Sibyl* (Metropolitan Museum of Art 24.197.2, New York). Cf. Bean 1982, 137–39, no. 131, and Hirst 1988 b, 42–43, no. 16.

220. Cf. Chapter Five, especially note 17. Craftspeople, and probably painters of ornament, frequently stacked multiple sheets of paper underneath a pattern and pricked through the outlines of the pattern, to replicate it. See Saint-Aubin 1770, 5: "Quand ces dessins ont été agréés, il les calque (a) au papier huilé (b), double ce papier d'un autre qu'on nomme *grand-raisin,* & les fait piquer ensemble." Cf. also ibid., 39, definition of *"piquer"*: "On pique souvent quatre ou cinq papiers ensemble; ces percés servent à faire les dessins marqués qu'on donne dans les différents atteliers." Although the purpose here was multiple replication, the general principle of production was like that of pricked "substitute cartoons."

221. Cf. Bambach Cappel 1994, 17–43 (with earlier bibliography), and Bambach Cappel 1996 b, 143–66. On the evidence in paintings, see Margarita Moriondo Lenzini, "Piero e Signorelli," *Nel Raggio di Piero: La Pittura dell' Italia centrale nell'età di Piero della Francesca*, ed. by Luciano Berti, Venice, 1992, 97–107.

222. For another illustration of this point, we may compare the structural similarities underlying one of the diagrams on fol. 71 recto in the Parma manuscript of Piero's *De Prospectiva* with Signorelli's stylus-incised cartoon for the foreshortened head of a devil, produced at the time of the Orvieto frescos in 1499–1504. National Gallery of Art inv. 1991.8.1a, Washington. Data: 217 × 173 mm.; charcoal; stylus-incised. On Signorelli's drawing, cf. Berenson 1938, II, 334, no. 2509 F; Berenson 1961, II, 564, no. 2509 F; and *Woodner Collection, Master Drawings* (exh. cat., Metropolitan Museum of Art), New York, 1990, 28–29, no. 5. The illustration in Piero's *De Prospectiva* can also be compared to Signorelli's pricked cartoon fragment for the foreshortened head of St. John the Baptist (Nationalmuseum inv. 9/1863, Stockholm; CBC 290) in his *Perugia Altarpiece,* signed and dated 1484.

223. For the relevant document on Baldovinetti's collaboration with Andrea del Castagno, as well as for discussion of his relationship with Domenico Veneziano and use of *spolvero* in the Chapel of the Cardinal of Portugal, see notes 154–57.

224. See document transcribed in Kennedy 1938, 246.

225. *Spolvero* seems also apparent in photographs of Lorentino's murals in the chapel dedicated to St. Anthony of Padua (S. Francesco, Arezzo), dated 1480, but I have not been able to confirm this. On Lorentino, see further Chapter Eleven, note 6, as well as Angelandreina Rorro, *Lorentino d'Arezzo: Discepolo di Piero della Francesca,* Rome 1996, 26–27, 32–35, 40–41, nos. 9 (with note of *spolvero*), 14–15 (without note of *spolvero,* but fairly visible at eye level), 19.

226. In the fresco of the *Virgin Handing the Girdle to St. Thomas* (S. Niccolò Oltrarno, Florence), the date MCCCCL painted on the sarcophagus appears to have been added by an old restorer. On the patronage of the fresco and sacristy, cf. Italo Moretti, *La Chiesa di San Niccolò Oltrarno,* Florence, 1972–73, 78–79 (and plates 43–45), with an attribution to Alesso Baldovinetti; and Jane Immler Lawson in *San Niccolò Oltrarno: La Chiesa, una famiglia di antiquari,* Florence, 1982, I, 73–75, no. 19, with an attribution to an anonymous Florentine painter from the second half of the fifteenth century. Both studies review the thorny question of authorship. For a thorough discussion regarding the documents, iconographic program, and technique for this mural, see further Borsook 1980, 113–15, with an attribution to "follower of Andrea del Castagno." An attribution to the young Domenico Ghirlandaio is again favored by Andrea De Marchi and Lisa Venturini. The dramatic restoration of the fresco after the Flood of 1966 is recorded in the Archivio Fotografico, Soprintendenza per i Beni Artistici e Storici, Florence (negative nos. 126591–126597, 126664–126668, 127048). On the church, cf. also Paatz, IV, 258–86. I am indebted to Grazia Badino for facilitating my examination of the mural and relaying the most recent attribution opinions.

227. Cf. Dino Dini and Giorgio Bonsanti, "Fra Angelico e gli affreschi nel Convento di San Marco (ca. 1441–50)," *Tecnica e stile,* 1986, 17–24.

228. Cf. note 42 above, as well as Metropolitan Museum of Art 1968, 128–33, nos. 26–29. Sporadic *spolvero* dots appear on the decorative parts of the Chapel of Nicholas V at the Vat-

ican Palace (as discussed earlier), and on the *rinceaux* borders of the great *Crucifixion* fresco in S. Marco. Faint, scattered *spolvero* dots are also visible on the figure of *Christ the Judge* on the vault of the *"Cappella Nuova"* (Cappella della Madonna di S. Brizio, Orvieto Cathedral). See Bertorello 1996 a, 335–36, with excellent color illustrations. In my opinion, however, this figure of Christ was probably largely frescoed by Benozzo Gozzoli (rather than Fra Angelico; the difference in the handling of the brush was amply evident close up from the restoration scaffolding), on whose use of *spolvero*, see Bambach Cappel 1996 b, 147 (note 9), as well as comments, later. A similar opinion about the execution of this figure is expressed in Ahl 1996, 38–40. On Fra Angelico's contract for the Orvieto vault frescos on 14 June 1447 (which stipulates payment to Benozzo, who is named as his collaborator, and to two assistants), as well as the payment records to Benozzo, see transcriptions in Ahl 1996, 276, Docs. 5–7. I am indebted to Giusi Testa, Carla Bertorello, and Lucia Tito for the numerous opportunities to study these vault frescos from the restoration scaffolding in the summer of 1992 and spring of 1994.

229. On this issue and on stylus-traced cartoons, see Chapter Ten and Bambach Cappel 1988, Part 1, I:212, II:357–72, 429–36.

230. Cf. Eve Borsook, "Fra Filippo Lippi and the Murals for Prato Cathedral," and Leonetto Tintori, "Conservazione, tecnica e restauro degli affreschi," both articles in *MdKIF,* XIX (1975), 1–148, 149–80, as well as Borsook 1980, 104.

231. Giordana Benazzi and Paolo Virilli, *Filippo Lippi nel Duomo di Spoleto, 1467–1469: Notizie dopo il restauro,* Spoleto (1990), 13–17. *Spolvero* was only used for ornamental motifs.

232. These panels are the *Portrait of a Woman and Man in Profile* (Metropolitan Museum of Art 89.15.19, New York), the *Madonna and Child with Angels* (49.7.9), and the *St. Lawrence Enthroned with Saints and Donors* (35.31.1 A). Cf. Zeri and Gardner 1971, 8–11, 60–64, without this technical information, and Carmen C. Bambach in Metropolitan Museum of Art 1997, 26, 28. In the *Madonna and Child with Angels* and the *St. Lawrence Enthroned with Saints and Donors,* especially, the thin overlayers of pigment often barely cover the dense, feathery freehand hatching. I am indebted to Everett Fahy, Keith Christiansen, Maryan W. Ainsworth, and Jeffrey Jennings for arranging this examination with infrared reflectography.

233. Jeffrey Ruda, *Fra Filippo Lippi: Life and Work with a Complete Catalogue,* London 1993, 453–54, 468–70, nos. 55, 61, 63 (illustrated).

234. See also photographs published in Acidini Luchinat 1992 and Acidini Luchinat 1993, as well as discussion in Bambach Cappel 1996 b, 147 (and note 9). I am indebted to Michael Wiemers for pointing out the exceptional examples and for sharing his observations regarding Benozzo's painting technique (letter, 22 September 1991). On Benozzo's design technique, see Wiemers 1996, 79–117.

235. In the *"Cappella dei Magi"* mural cycle at the Palazzo Medici, however, conclusions regarding the use and nonuse of *spolvero* cartoons must remain tentative, because Benozzo's pigment layers are sufficiently thick to have possibly obscured the relevant evidence.

236. For Benozzo's traditional *sinopia* technique, cf. Borsook 1980, 111; Rossana Caterina Proto Pisani and Anna Padoa Rizzo, *Gli affreschi di Benozzo Gozzoli a Castelfiorentino (1484–1490),* Florence, 1987; Padoa Rizzo 1992; Wiemers 1996, 79–117; and Ahl 1996, 135–55, 157–93, 202–23.

237. As presently installed in the Museo delle Sinopie in Pisa, the detached *sinopie* for Benozzo's Camposanto mural cycle offer opportunities for especially precise comparisons. The *sinopia* of the *Sacrifice of Abraham* includes small, preliminary *carboncino* figural sketches along with the schematic full-scale design of the scene in *carboncino* and ocher pigments, executed on relatively rough *arriccio.* The *sinopia* of the *Annunciation,* as well as the detail of Abraham and Eliezer in that of the *Wedding of Isaac and Rebecca,* have precisely rendered chiaroscuro in ocher washes over *carboncino* on very smooth *arriccio.* The relatively refined surface finish here almost approximates that of a cartoon on paper. Yet beyond the fully realized monumental group of Abraham and Eliezer in the foreground, the *Wedding of Isaac and Rebecca* comprises only barely outlined forms, and the basic orthogonals for the architecture are carelessly snapped.

238. These panels are the *St. Peter and Simon Magus, the Conversion of St. Paul, St. Zenobius Resurrecting a Dead Child,* and *Totila before St. Benedict* (Metropolitan Museum of Art 15.106.1–4, New York). They probably once formed the *predella* for the *Alessandri Altarpiece.* See Zeri and Gardner 1971, 8–11. I am indebted to Everett Fahy, Keith Christiansen, Maryan W. Ainsworth, and Jeffrey Jennings for having arranged this examination with infrared reflectography.

239. For a pricked drawing, see, for instance, Uffizi inv. 63 E, Florence (CBC 352, as anonymous). Revised data: 174 × 150 mm.; black chalk, reworked in pen and black ink. Cf. Berenson 1938, II, 263, no. 1865; Berenson 1961, II, 440, no. 1875; Degenhart and Schmitt 1968, I-2, 498, fig. 700; and Petrioli Tofani 1986, 30–31, *sub numero.* The verso of this sheet is now viewable and establishes that perhaps the black-ink drawing on the recto is a reworking, because the pricking on the verso shows the design to be finer and more subtle. The identification of the *"Alunno di Benozzo,"* with documents in Pistoia on Benozzo's sons, is due to Anna Padoa Rizzo. See Padoa Rizzo 1989, 5–30; Padoa Rizzo 1992, 151–52; Annamaria Bernachioni in Palazzo Strozzi 1992, 88–89, no. 2.23; and Ahl 1996, 190–97. The *"Alunno di Benozzo"* is probably Alesso.

240. Uffizi inv. 1117 E, Florence. Revised data: 257 × 205 mm.; pen and brown ink, brush and brown wash, over traces of leadpoint (?) underdrawing. Cf. Uffizi 1986, 36–37, no. 21, and Petrioli Tofani 1987, 471, *sub numero.* Fra Filippo Lippi, who was Pesellino's chief influence, may have also been one of Pesellino's teachers. On 10 September 1455 the Company of Priests of the Trinity of Pistoia commissioned Pesellino to paint an altarpiece for their church, the *Trinity with Saints* (National Gallery, London; Davies 1986, 414–19). The artist left it half-finished at his death on

29 July 1457, and it was completed only in 1460 in Fra Filippo's *bottega*. On 10 July 1457, days before Pesellino died, the spokesman priest for the patrons, Pero di ser Landi, asked an opinion regarding the altarpiece's cost from Fra Filippo and, more importantly, Domenico Veneziano, who presumably knew the plight of the dying artist. Stylistic analysis of Pesellino's paintings demonstrates that by the 1450s he had emulated aspects of Domenico Veneziano's conception of space and volume, as well as color, light, and figural typology.

241. Metropolitan Museum of Art 50.145.30, New York (Zeri and Gardner 1971, 92–93). The total dimensions of the panel, including the added strips, are 264 × 238 mm.; those of the painted surface are 226 × 203 mm. The Uffizi sheet measures 257 × 205 mm. I am indebted to Everett Fahy, Keith Christiansen, Maryan W. Ainsworth, and Jeffrey Jennings for arranging this examination with infrared reflectography.

242. Uffizi inv. 10 E, Florence. Revised data: 252 × 141 mm.; pen and brown ink, brush and brown wash, over traces of black chalk; pricked outlines heavily rubbed with black pouncing dust from the verso, partly and lightly so from the recto. Cf. Uffizi 1986, 35, no. 19, and Petrioli Tofani 1986, 5, *sub numero*.

243. For what follows on Filarete's treatise, compare Oettlingen in Filarete 1890, Book XXIV, 741; Heydenreich in McMahon 1956, I, xxv; Schlosser 1964, 129–38; Spencer 1965, I, introduction; Luisa Cogliati Arano, "Due codici corvini: Il Filarete marciano e l'epitalamio di Volterra," *AL,* LII (1979), 53–62; and Marco Rossi, "I Contributi del Filarete e dei Solari alla ricerca di una soluzione per il tiburio del Duomo di Milano," *AL,* LX (1981), 15–23. As one instance of Filarete's derivativeness, among others, note his passage on the use of the net in drawing, which is directly based on Alberti's painting treatise (cf. Filarete 1972, II, 677, and Spencer 1965, I, 315).

244. This document is transcribed in Ettlinger 1978, 142: ". . . deliberaverunt quod virtus caritatis videlicet figura et imago caritatis que est picta seu designata in pariete seggii sex consiliorum dicte universitatis in sala magna terrena. . . ." On Piero Pollaiuolo's drawing on the back of the panel of *Charity* and on his pricked cartoon for the *Head of Faith* (Plate II), cf. Berenson 1938, II, 272, no. 1952; Ettlinger 1978, 142–45, 160, nos. 12 and 31; Bambach Cappel 1988, Part 2, II:295, no. 217; Lucia Monaci Moran in Uffizi 1992, 172, no. 8.2; and Wiemers 1996, 131–36.

245. Uffizi inv. 14506 F, Florence. Revised data: 211 × 182 mm.; charcoal, reworked with red chalk; watermark closest to Briquet 746. Cf. preceding note for literature.

246. This is pointed out in Paris MS. A, fol. 1 recto and 104 recto (Ash. MS. I, fol. 24 recto). See Richter 1970, I, §§ 628 and 523, and Richter, *Commentary,* I, 365–66, 333, *sub numero*. The first description, "A preparare il legniame per dipingiere su," is not included in the *Treatise on Painting,* and the second, "Del modo del ritrarre uno sito coretto," is in *Codex Urbinas Latinus 1270,* fol. 41 recto–verso (see facsimile in McMahon 1956, II, under fol., and no. 66). On this aspect of Leonardo's work, see Bambach Cappel

1990 b, 129–31; Bambach Cappel 1991 a, 72–98; and Bambach Cappel 1991 b, 99–106.

247. Cf. Clark 1990, 11–14, and Stefano Tumidei in Forlì 1994, 19–81. Melozzo's beginnings as an artist remain a mystery; he is recorded in Forlì in 1460, 1461, and 1464 (documents given in Buscaroli 1938, 14–30). The assumption that Piero may have influenced Melozzo already during the 1450s, while in Ferrara, though attractive, seems highly speculative. A previous generation of scholarship often maintained that Piero was in fact Melozzo's teacher: Schmarsow 1886, 312–18, even suggested that Melozzo assisted Piero in painting a prophet appearing in one of the lunettes in the mural cycle at S. Francesco, Arezzo.

248. Cf. Clark 1990, 11–14. An *ante quem* date for Melozzo's presence in Urbino is based on Giovanni Santi's mention of the artist in the *Cronaca Rimata* (1478); see also Buscaroli 1938, 27.

249. For instance, Giovanni Santi's *Cronaca Rimata* (1478) and Leone Cobelli's *Chronache della Città di Forlì* (1498), as well as Fra Luca Pacioli's *Summa de Arithmetica* (1494) and *De Divina Proportione* (1509). For Giovanni Santi's *Cronaca Rimata* ("Non lassando Melozo a me si caro/Che in prospettiva ha steso tanto il paso") and Leone Cobelli's *Cronache della Città di Forlì* (". . . Lo quale Melocio è da Forlivio, et è uno solenno maistro in prospectiva e in ongni altra coa della dipentura fondato, peritissimo . . ."), see Buscaroli 1938, 121–22, 127–28. For Fra Luca Pacioli's *Summa de Arithmetica* and *De Divina Proportione,* see ibid., 133–140. On Melozzo's *fortuna critica,* cf. also brief comments in Clark 1990, 11–12, 77–79 (notes 3, 4, 9, 18–19).

250. An anthology of sources on Melozzo from the Quattrocento to the Ottocento is given in Buscaroli 1938, 115–216. As is well known, Vasari gave only a confused account of Melozzo (incorporated into the *Vita* of Benozzo Gozzoli), much corrected in the 1568 edition). See Vasari 1966–87, III (testo), 379–80.

251. The passage in Sebastiano Serlio's *Libro* IV is given in Buscaroli 1938, 144. I follow Nicholas Clark's dating of the Loreto mural cycle (Clark 1990, 49). On this project, see ibid., 43–59.

252. British Museum 1895-9-15-591, London. Data: 389 × 261 mm.; black chalk. The British Museum sheet has also repeatedly been attributed to Giovanni Bellini – in my view, quite unconvincingly – following the opinion in Popham and Pouncey 1950, 10–11, no. 16. Cf. discussions in Eberhard Ruhmer, "Melozzo as Zeichner," *Festschrift Ulrich Middeldorf,* ed. by Antje Kosegarten and Peter Tigler, Berlin, 1968, 201–5; Bambach Cappel 1988, Part 2, I:253–54; Clark 1990, 70–71, 94 (and notes 47–50); Stefano Tumidei in Forlì 1994, 23; and British Museum 1996, 28–29, no. 6.

253. *Contra* Clark 1990, 71.

254. See full transcription in Buscaroli 1938, 102: ". . . Item uno chartone de nostra Dona e uno san Bastiano e 22 pezi de charta deseniatta tteste e altre chose."

255. Cf. Clark 1990, 61–71, and report by Fabrizio Mancinelli and Gianluigi Colalucci in *Monumenti, Musei e Gallerie Pontificie: Bollettino,* IV (1983), 111–12.

256. On the commission, see Clark 1990, 61–71. On the

destruction of the apse, cf. Agostino Taja, *Descrizione del Palazzo Apostolico Vaticano,* Rome, 1750, 360–61. The mural fragment in the Palazzo del Quirinale (Rome) is exhibited in the great staircase. The Madrid fragment (Museo del Prado inv. 2843) has been called a forgery in Stefano Tumidei, "Un falso Melozzo: L'angelo musicante," *Prospettiva,* no. 51 (1988), 64–67.

257. Clark 1990, 65, 93 (and notes 26–34).

258. See conservation report, with discussion of painting technique, by Fabrizio Mancinelli and Gianluigi Colalucci in *Monumenti, Musei e Gallerie Pontificie: Bollettino,* IV (1983), 111–22.

259. Cf. Chapter Five, on the ornament. On the possibility that the *Sixtus IV* represents the second of two group portraits painted on the same site, cf. Jose Ruysschaert, "Platina et l'amenagement des locaux de la Vaticane sous Sixtus IV (1471–1481)," *Bartolomeo Sacchi "Il Platina" (Medioevo e Umanesimo, LXII),* Padua, 1985, 145–52; Ruysschaert, "Les trois étapes de l'aménagement de la Bibliothèque Vaticane de 1471 à 1481," *Un Pontificato ed una Citta: Sisto IV (1471–1484),* ed. by M. Miglio, F. Niutta, D. Quaglioni and C. Ranieri, Vatican, 1986, 103–14; Ruyschaert, "La Bibliothèque Vaticane dans les dix premières années du pontificat de Sixte IV," *Archivum historiae pontificiae,* XXIV (1986), 71–90; and Clark 1990, 21–41, 85–86 (Addendum).

260. Vasari 1966–87, III (testo), 379, ". . . e particolarmente mise molto studio e diligenza in fare gli scorti. . . ."

261. Vasari 1966–87, III (testo), 476–78.

262. See Figures 215, 281, 286–88. For the transcription of the Tornabuoni contract, see Milanesi 1901, 134–36, and Davies 1908, 170–72 (cf. Chambers 1970, 173–75, for trans.). On the commission of this chapel, cf. Vasari 1966–87, III (testo), 481–90; Simons 1987, 221–50; and Hatfield 1996, 112–17. For the quotations from the *Vite,* see Vasari 1966–87, III (testo), 490: ". . . cosa bellissima, grande, garbata . . . ;" "per la pratica e pulitezza del mannegiargli [colori] nel muro e per il poco essere stati ritocchi a secco."

263. See ibid., 491.

264. Exhibiting extensive *spolvero,* the fresco in the sacristy built by the Quaratesi family (S. Niccolò Oltrarno, Florence) has often been attributed to the young Domenico Ghirlandaio. See note 226. The figures in the lunette and main scene in the fresco in the Vespucci Chapel at the church of Ognissanti (Florence), among his earliest works and datable 1470–72 (cf. Vasari 1966–87, I (testo), 476), also reveal scattered *spolvero.* For a report on the use of *spolvero* and incised cartoons in the Sassetti Chapel at S. Trinita (Florence), see Borsook 1980, 119. Note also Giorgio Bonsanti, "Il Restauro dell'*Ultima Cena* di San Marco," in *Ghirlandaio* 1996, 109–11. Regarding such evidence in the cycle in S. Maria Novella, cf. Danti 1990, 39–52; Ruffa 1990, 53–58; Danti and Ruffa 1990, 29–48; and Danti 1996, 141–49. Furthermore, Jean Cadogan's various studies on Domenico Ghirlandaio have already explored some of these aspects: cf. Cadogan 1983 a, 274–90; Cadogan 1983 b, 27–62; Cadogan 1984, 159–72; Cadogan 1987, 63–75; Cadogan 1993, 30–31; Cadogan 1994, 63–72; and Cadogan 1996, 89–96. Here, therefore, I limit my discussion to the

new physical evidence supporting the general points being argued in this chapter. On Domenico Ghirlandaio's drawing technique, compare also Wiemers 1996, 185–228.

265. Devonshire Collection inv. 885, Chatsworth. Data: 365 × 220 mm.; charcoal or soft black chalk; watermark close to Briquet 2375 (Fig. 28). Cf. Berenson 1938, 1961, II, no. 866; Cadogan 1983 a, 279–80; Cadogan 1984, 160; Cadogan 1987, 75 (and note 24); Bambach Cappel 1988, Part 2, I:147–49, no. 113; Caterina Caneva in Uffizi 1992, 100–1, no. 4.6; Cadogan 1994, 63–72; Jaffé 1994, I, 63, no. 29; Bambach Cappel 1996 a, 85–86 (and notes 19–22); as well as Wiemers 1996, 219–21. The Chatsworth cartoon is discussed in Chapters Two, Seven, Eight, and Eleven. The woman's head is that of the attendant standing in the foreground, to the extreme left of the composition; the clothed, female figural study on the verso and the faint head study relate to the attendant, standing third from the left in the same group.

266. Vasari 1966–87, III (testo), 485.

267. Rather, judging from the somewhat static quality of the execution in the Chatsworth portrait cartoon, to draw it, Domenico Ghirlandaio probably relied on the intermediary means of a smaller-scale preliminary study from life. An example of the latter is the animated portrait in metalpoint with white gouache highlights of an old woman (Royal Library inv. 12804, Windsor), which relates to an immediately neighboring figure in the fresco.

268. See further, Chapter Eight. I am indebted to Giorgio Bonsanti, Cristina Danti, Fabrizio Bandini, and Jonathan Nelson for arranging my study of the fresco cycle in the *"cappella maggiore"* at S. Maria Novella – this scene in particular – from the scaffolding erected for its cleaning (November 1990), as well as consultation of the photographic records in the Archivio Fotografico of the Opificio delle Pietre Dure e Laboratorio di Restauro, Florence. Cf. *Tecnica e stile* 1986, II, plates 66 and 67; Danti 1990, 44–48 (this study, however, egregiously misreads *incisioni dirette* for incisions from cartoon transfer); Ruffa 1990, 53–58; Cadogan 1994, 63–72; Danti 1996, 141–49; and Bambach Cappel 1996 a, 83–86. Regarding our points above, it should also be noted that, in fact, in the Chatsworth portrait cartoon, the seam of the woman's bodice down the chest area sloppily syncopates into two pricked, nearly parallel lines; these do not align with the drawn outline. Recall that the technique of stylus-incising the outlines of a cartoon *(calco* or *incisione indiretta)* was quicker but more destructive than pricking and pouncing them, but that *spolvero* enabled minute detailing. The hypothesis that Ghirlandaio used a "substitute cartoon" to transfer the outlines of the Chatsworth drawing was first formulated on the basis of the drawing's excellent condition, by Eve Borsook and Artur Rosenauer. Cf. Borsook 1980, l, 119; Artur Rosenauer, "Zum Stil der frühen Werke Domenico Ghirlandaio's," Vienna, 1965, 59 (unpublished Ph.D. dissertation, as cited by Borsook); Rosenauer 1986, I, 27–29; Cadogan 1984, 160; and Cadogan 1987, 75 (note 24). For other drawings by Ghirlandaio possibly documenting the procedure of "substitute cartoons," cf. discus-

269. sion in Bambach Cappel 1988, Part 1, II:312–13; Part 2, I:147–50, nos. 112, 114; Rosenauer 1965, 58; and Danti 1990, 48–50. Regarding Uffizi inv. 291 E, Florence, the sheet of studies for the *Visitation* that is also part of the S. Maria Novella cycle, see Chapter Five, notes 10–16.

269. On these problems, see further Bambach Cappel 1996 a, 99–101; and Appendix Two.

270. Indeed, this is often true of Ghirlandaio's fresco cycles. See Chapter Eleven.

271. This aspect of portraiture is discussed in Chapter Three.

272. Istituto Nazionale per la Grafica inv. F.C. 130522, Rome. Revised data: 232 × 197 mm.; recto, charcoal and black chalk, with background reworked in brush and brown wash; verso, black chalk. On the debated attribution, compare G. Mancini, *Vita di L. Signorelli,* Florence, 1903, 236; Venturi 1901–40, VII, Part 2, 440; Thieme-Becker, 1920, XIII, 246; Van Marle 1923–38, XIII, 385–86; Popham 1930, no. 101, fig. LXXXVa; Berenson 1938, II, 260, no. 1861; R. Langton Douglas, *Piero di Cosimo,* Chicago, 1946, plate LVII; L. Bianchi, *Het Este Manierism in Italie 1500–1540* (exh. cat.), Amsterdam, 1954, no. 3; Pietro Morselli, "Ragioni di un pittore fiorentino: Piero di Cosimo," *L'Arte* (LVII), 1958, 73; Berenson 1961, I, plate LII, II, 434, no. 1861, III, plate 44, fig. 357; H. Ost, *Leonardo-Studien,* Berlin-New York, 1975, 61–2 (and note 227); Beltrame Quattrocchi 1979, 28–9, no. 9, fig. 11; and Bambach Cappel 1987, 138–39, 142 (notes 46–47).

273. On the painting, see Anna Maria Maetzke in *Nel raggio di Piero: La Pittura nell'Italia centrale nell'età di Piero della Francesca,* ed. by Luciano Berti, Venice, 1992, 140–41, no. 23, and, more generally on this artist, her essay "Don Bartolomeo della Gatta abate di San Clemente in Arezzo miniatore architetto pittore e musico," in ibid., 125–41.

274. The pricking represents the head and shoulders of a youth in three-quarter view, facing left. The perforations and the verso are severely stained ocher, indicating corrosion of some type, a feature also present in Domenico Ghirlandaio's Chatsworth cartoon, though to a lesser extent. The pricked head outline resembles some of the designs found in the small decorative *tondi* with busts frescoed by Luca Signorelli and his workshop on the ribs of the Cappella della Madonna di S. Brizio (Orvieto Cathedral), in 1499–1500.

275. See Plate III, Figures 44, 76, 80, 220, 221. Among the examples are another cartoon by Ghirlandaio (CBC 112), as well as the cartoons by Andrea Verrocchio (CBC 336–38), Biagio d'Antonio (CBC 318), Pietro Perugino (CBC 325, 327), and Luca Signorelli (CBC 290). See further Bambach Cappel 1988, Part 1, I:223–24; Part 2, II, 147–49, 295, 400–1, 443–44, 453–54, 463–65. The pricked cartoon in charcoal attributed to Ghirlandaio, which depicts a bearded head (Uffizi inv. 263 Santarelli, Florence; CBC 112), was discovered by Philip Pouncey. It has often been connected with the *Pietà* fresco of around 1470–72 in the Vespucci Chapel at the Church of Ognissanti (Florence). Cf. Pouncey 1964, 285; Cadogan 1983 a, 274–78; Cadogan 1987, 69–70, 75 (note 18); Bambach Cappel 1988, Part 1, I:223, Part 2, II:147, no. 112; and Uffizi 1993, 3, no. 1. Jean Cadogan has proposed that this cartoon

relates to one of the figures in the sketchy *sinopia* but that the figure was discarded in the final composition of the fresco. To me, the relationship between drawing, *sinopia,* and fresco seems too problematic to permit definitive conclusions. There are undeniable similarities of design, but these seem part of Ghirlandaio's general figural vocabulary. More probably, the painting for which the Uffizi drawing was prepared remains to be identified.

276. Cf. Glasser 1977; O'Malley 1995; and Kemp 1997.

277. Cf. Glasser 1977, 120; Thomas 1995, 258; and Lisa Venturini, "Un ipotesi per la *Pala del Palco* di Domenico e David Ghirlandaio," *La Toscana al tempo di Lorenzo il Magnifico* 1996, I, 297–304, in which the altarpiece is identified with the destroyed altarpiece, formerly in the Kaiser Friedrich Museum, Berlin.

278. See documents transcribed in Andreani 1996, 431–32, 434, nos. 183, 219–20. Perugino's contract states: "Item quod teneatur et sic promisit pingere manu propria omnes figuras fiendas in dictis voltis, et maxime facies et omnia figurarum, omnium a medio figura supra." Signorelli's contract states: "Item quod teneatur dictus magister Lucas et sic promisit pingere manu propria omnes figuras fiendas in dictis voltis, et maxime facies et omnia membra figurarum omnium a medio figure sopra." Cf. further Baxandall 1972, 23; Kanter 1989, 10–22; and Thomas 1995, 258. For different interpretations of *"sua mano"* clauses in artists' contracts, cf. Glasser 1977; O'Malley 1994, 70–74; and Kemp 1997, 32–78.

279. See documents transcribed in Andreani 1996, 435, nos. 226–27, and Kanter 1989, 22.

280. See further, Chapter Eleven. Cf. Piero Misciatelli, *La Libreria Piccolomini nel Duomo di Siena,* Siena, 1924 (?), 37–39 (documents); Chambers 1971, 27; and Corrado Ricci, *Pintoricchio . . . ,* Paris, 1903, 176–225.

281. Verrocchio's *Head of an Angel* cartoon (Fig. 44; Uffizi inv. 130 E, Florence) includes portions of the wings on the upper left and lower right. Conservation treatment in March 1996 of Perugino's *Head of St. Joseph of Arimathea* cartoon (Fig. 76; Christ Church inv. 0122, Oxford) reveals that it had another related cartoon fragment glued as a patch (pointed out to me by Lucy Whitaker). This small fragment must have been from the same cartoon as the St. Joseph, to judge from the identical drawing technique, and portrays drapery folds. It was used by an old restorer to complete, and back up, the upper left portion of St Joseph's head.

282. Uffizi inv. 1254 E, Florence. Revised data: 228 × 211 mm.; pen and brown ink, brush with brown wash and white gouache, over stylus and charcoal underdrawing; outlines pricked and rubbed with pouncing dust. Roberta Bartoli in Palazzo Strozzi 1992, 73–74, 87, nos. 2.5, 2.21, first noted the exact correspondence of design to the *tondo* in the Chigi-Saracini Collection is noted, based on tracings on acetate. Cf. Wiemers 1996, 114.

283. See *Vita* of Verrocchio in Vasari 1966–87, III (testo), 538; passage transcribed in Chapter Three, note 15.

284. Cf. discussion in Galassi 1988–89, 203–14; and Galassi 1998, 49–60, 117–18.

285. See Chapter Five, for the discussion of the anonymous mural decoration in the trapezoidal room at the Castelvecchio in Verona (Figs. 134–35), and the mural cycle in the Oratory of S. Michele in Padua, by Jacopo da Verona, dated 1397.

286. See Chapter Three (and notes 117–18).

287. For an interpretation of the document, as it relates to Piero della Francesca's "transformation" of the human head, see Bambach Cappel 1994, 40–41. On apprenticeship contracts in Central Italy, see Thomas 1995, 64–88.

288. As translated in Gilbert 1980 a, 34. Original document transcribed in Creighton E. Gilbert, *L'Arte del Quattrocento nelle testimonianze coeve, Florence-Vienna,* 1988, 60: "zoè le raxon d'un piano lineato ben segondo el mio modo e meter figure sul dicto piano una in zà l'altra in là in diversi luoghi del dicto piano e metere masarizie, zoè chariega, bancha, chasa, e darge intendere queste chose sul dicto piano e insegnare intendere una testa d'omo in schurzo per figura de isometria, zoè d'un quadro perfecto con el soto quadro in scorzo e insegnare le raxon de un corpo nudo mexurado de driedo e denanzi e metere ochi, naxo, bocha, rechie in una testa d'omo ai so luoghi mexuradi e darge intendere tute queste cose a parte a parte. . . ."

289. I am indebted to Martin Kemp for his help in clarifying the meaning of Squarcione's terms (letter, 22 December 1994). Cf. Gilbert 1980 a, 34, which translates the phrase defining isometria as "by isometric rendering, that is, of a perfect square underneath in forehortening. . . ."

290. As transcribed in Enzo Rigoni, *L'Arte rinascimentale in Padova: Studi e documenti,* Padua, 1970, 15–16, doc. V. On Squarcione, see Keith V. Shaw and Teresa M. Boccia-Shaw, "Mantegna's Pre-1448 Years Reexamined: The S. Sofia Inscription," *AB,* LXXI (1989), 52–56; Keith Christiansen in Mantegna 1992, 94–99, 111; and Eve Lincoln, "Mantegna's Culture of Line," *Art History,* XVI (1993), 37–40, 56.

291. For pricked drawings by Andrea Mantegna's circle, see (CBC 178–80): Albertina inv. 24020, SC. V. 23, Vienna; British Museum 1895-9-15-783, London; and Royal Library inv. 12802, Windsor. For drawings done on *spolvero* by Mantegna's circle (not in CBC), see Staatliche Graphische Sammlung inv. 3066, Munich; Kupferstichkabinett inv. KdZ 5058, Berlin; and National Gallery of Art no. 1939.1.178, Washington. For a pricked print around Mantegna's *oeuvre,* see Figures 112–13. For discussion, cf. Bambach 1999 a.

292. Keith Christiansen in Mantegna 1992, 121–23, no. 6 (with bibliography).

293. Cf. Galassi 1988–89, 203–14, and Keith Christiansen in Mantegna 1992, 126–29, no. 8. The evidence is less conclusive in other paintings by Mantegna. Cf. Galassi 1998, 118–20, nos. 22–23.

294. The paintings (Galleria degli Uffizi, Florence) were assembled as a triptych in 1827 but may not have originally been components of a single project. The wood panel of the *Adoration* is shallowly concave, a probable perspectival device. See Keith Christiansen's essay, "Some Observations on Mantegna's Painting Technique," in Mantegna 1992, 72–75. The author's interpretation of the underdrawing in Mantegna's figure of St. Giustina, which forms part of the *St. Luke Altarpiece* (Pinacoteca Brera, Milan), as deriving from a cartoon is conjectural. There is insufficient visual evidence in the infrared reflectogram to arrive at this conclusion; in fact, a case can equally be made for this underdrawing having been produced freehand.

295. On the underdrawings of Quattrocento easel paintings, see especially *Giotto to Dürer* 1991, 164–74, 396–97 (with bibliography), Galassi 1988–89, and Galassi 1998. My informal survey of results published in recent catalogues of museum collections of Italian Renaissance paintings, as well as of studies published in the paintings conservation literature, suggests this. Moreover, of a selection of thirty-eight Italian, non-Venetian panel paintings in the Metropolitan Museum of Art (itself narrowed down to examples that could possibly be painted from *spolvero* underdrawings), only one panel, Pesellino's *Madonna Enthroned with Saints* (inv. 50.145.30), actually exhibits a small part with pouncing, which is visible with infrared reflectography. I am indebted to Everett Fahy, Keith Christiansen, Maryan W. Ainsworth, and Jeffrey Jennings for conducting this infrared reflectography examination on my behalf in the summers of 1990 and 1996. A group of Venetian paintings at the Metropolitan Museum had also been previously examined by Keith Christiansen and Maryan W. Ainsworth, with no discoveries of *spolvero.*

296. See Chapter One (and notes 136–46).

297. See Martin Kemp and Ann Massing, "Paolo Uccello's Hunt in the Forest," *BM,* CXXXIII (1991), 164–78, especially 169–75. For bibliography, see Chistopher Lloyd, *A Catalogue of the Earlier Italian Paintings in the Ashmolean Museum, Oxford,* Oxford, 1977, 172–75, no. A72; Padoa Rizzo 1991 a, 124–27, no. 23; and Borsi 1992, 338–40, no. 34.

298. Examples are Paolo Uccello's three panels of the *Battle of S. Romano* in the Galleria degli Uffizi, Florence; the National Gallery, London; and the Musée du Louvre, Paris; as well as the *predella* panel portraying the *Profanation of the Host* (Galleria Nazionale delle Marche, Palazzo Ducale, Urbino). Cf. also Kemp 1990, 38–39.

299. See Kemp and Massing (as in note 297), 169.

300. Cf. Meiss and Tintori 1962, 13, 36 (note 20); Wohl 1980, 133; and Galassi 1988–89, 144. I am indebted to Maria Clelia Galassi and David Alan Brown for this information.

301. Infrared reflectography examination was conducted by Maria Clelia Galassi in April 1997, thanks to Fiorella Superbi Gioffredo and Patricia Rubin. Cf. now Galassi 1998, 105–6, no. 9.

302. Maria Clelia Galassi has reported that *spolvero* is present. Cf. Galassi 1988–89, 144–46; *contra* entry by Giulietta Chelazzi Dini in Bellosi 1992, 94–107, no. 11.

303. See full transcription in Richter, I, 362, § 628 (cf. Richter, *Commentary,* I, 365–66): "A preparare il legniame per dipi[n]giere su . . . ," and Bambach Cappel 1988, Part I, I:91–97.

304. See Chapters One and Three.

305. See Chapter Three.

306. I am indebted to George Bisacca for an instructive discussion on this subject. Cf. *Art in the Making* 1989, 27–30.

307. Cf. Cennini 1995, cap. cxvi–cxxi, 121–25 (cf. Cennini 1960, 69–76, for trans.), and Vasari 1966–87, I (testo), 130–32.

308. Cf. also Chapter Seven; Vasari 1966–87, I (testo), 132–37; Sir Charles Lock Eastlake, *Methods and Materials of Painting of the Great Schools and Masters* (Dover reprint), New York, 1960, I, 269–368, II, 78–124; and Bambach 1997 b, 21–28.

309. Eastlake (as in note 308), II, 95.

310. Vasari 1966–87, I (testo), 132–34 (cf. Vasari 1960, 230–32, for trans.).

311. My translation is quoted from Ludwig Heydenreich, *Leonardo: The Last Supper,* New York, 1974, 16. Original text is transcribed in Beltrami 1919, 45–46, doc. no. 79: "Soleva anco spesso et io più volte l'ho veduto e considerato, andare la matina a buon' hora a montar su 'l ponte, perchè il Cenacolo è alquanto da terra alto: soleva (dico) dal nascente Sole sino all'imbrunita sera non levarsi mai il pennello di mano, ma scordatosi il mangiare et il bere, di continovo dipingere. Se ne sarebbe poi stato dui, tre e quattro dì, che non v'aerebbe messo mano, e tuttavia dimorava talhora una o due ore al giorno e solamente contemplava, considerava et essaminando tra sè, le sue figure giudicava. L'ho anche veduto (secondo che il capriccio o ghiribizzo lo toccava) partirsi da mezzogiorno, quando il Sole è in Leone, da Corte vecchia ove quel stupendo Cavallo di terra compneva, venirsene dritto a le Gratie: et asceso sul ponte pigliar il pennello, et una o due pennellate dar ad una di quelle figure e di subito partirse et andarc altrove."

312. I am indebted to Pietro C. Marani for informative visits to the restoration scaffolding at Leonardo's *Last Supper.* On the painting technique, cf. Brambilla Barcillon 1984 and analyses of the lunettes by Antonietta Gallone and Hermann Kühn in Brambilla Barcillon 1990, 80–83.

313. See further, Bambach 1999 b, and Chapter Eight, for a discussion of the *Battle of Anghiari* cartoon documents.

314. Examples are the *Baptism* from the 1450s (National Gallery, London), the *Flagellation* from 1458–66 (Galleria Nazionale delle Marche, Palazzo Ducale, Urbino), the *Montefeltro Altarpiece* from 1472–74 (Pinacoteca Brera, Milan), the *Polyptych of St. Anthony* probably from the late 1470s (Galleria Nazionale dell'Umbria, Perugia), as well as the *Triumph of Federigo da Montefeltro* and *Triumph of Battista Sforza* on the versos of the famous Urbino diptych from after 1474 (Galleria degli Uffizi, Florence). Cf. Galassi 1988–89, 146–49; Marilyn Aronberg Lavin, *Piero della Francesca: The Flagellation,* 2nd ed., Chicago, 1990, 19; *Giotto to Dürer* 1991, 169, 286, no. 27; Bertelli 1992, 182, 212, 224; and Maurizio Seracini, "Ricerche diagnostiche," *Piero e Urbino: Piero e le corti rinascimentali,* ed. by Paolo Dal Poggetto, Venice, 1992, 448–73. More recently, see Vittoria Garibaldi, "Anticipazione sul restauro del *Polittico di S. Antonio,*" and Paolo Bensi, "Il ruolo di Piero della Francesca nello sviluppo della tecnica pittorica del Quattrocento," both studies in *Piero della Francesca tra arte e scienza* 1996, 123–30, and 167–81, respectively. In the *Triumph of Battista Sforza,* the *spolvero* outlines depict the tiny figures in the triumphal car in the nude.

315. Cf. Chapters Seven and Eleven.

316. See document transcribed in Kennedy 1938, 246.

317. Cf. Borsook 1980, xliv; Borsook 1983, 63; and Israels 1998, 436–44. I have not been able to examine these frescoed figures, but *spolvero* marks are visible in Enzo Carli, *Sassetta e il Maestro dell'Osservanza,* Milan, 1957, no. 132, plates 80–81.

318. John Pope-Hennessy, *Sassetta,* London, 1939, 120–23 (documents, 139–42); and Israels 1998, 436–44.

319. See document transcribed in Pope-Hennessy, 141 (note 62): "... già fatto et finito a perfectione quasi tutto il disegno in carta...." Note further Israels 1998, 438–44, with newly discovered documents dating from 1453–57 that describe the cartoon (the terms used for it, however, are "designum magnum" and "disengnio grande in pezi").

320. Shearman 1992, 5–8. The *"cappella magna"* was the building upon whose foundations and walls Pope Sixtus IV rebuilt the Sistine Chapel.

321. Ibid., 6. I am indebted to Joel Herschman for his help in interpreting these documents.

322. See Chapter Five. Additionally, the term *"figuratione evangeliatarum"* more probably refers to figures of evangelists, the word *"patrones"* designating patterns that relate only generally to their portrayal. In his treatise, published in 1649, Francisco Pacheco used the term *"patrón"* (common in Latin, French, and Spanish, though not in Italian) to describe cartoons or patterns that were meant to be pricked for transfer by pouncing (cf. Du Cange, VI, 220–21, *sub voce;* Pacheco 1956, II, 2–5, 27, 52–53, 76–77; and Bambach Cappel 1988, Part 1, I:161–62). Therefore, the wording of the documents regarding Giovanni da Milano's ceiling for the *"cappella magna"* might well encompass in their meaning the large fictive architectural structures surrounding the figures of the evangelists, as is seen, for example, in the case of the saints within the pounced tabernacles in Gherardo Starnina's Chapel of S. Girolamo (S. Maria del Carmine, Florence) and in Fra Angelico's Chapel of Nicholas V (Vatican Palace). See Figures 162–63. The *spolvero* canopies enveloping the freehand-painted saints in Gherardo Starnina's five detached fresco fragments from the Chapel of S. Girolamo stand each about five to six feet tall (151–182 cm.), as do the fictive choir stalls by Niccolò di Tommaso in Chiesa del Tau (Pistoia). The tabernacles sheltering the freehand-painted saints by the anonymous masters at S. Miniato al Monte (Florence) seem each almost six feet tall (182 cm.), and the same seems true of those by Agnolo Gaddi in the *cappella maggiore* (S. Croce, Florence). Much of the paper mentioned in the Vatican documents may have been used for duplicating patterns via "substitute cartoon" procedures (cf. *Anghiari* documents analyzed in Chapter Eight). The Bolognese statutes of 1349 regulating the paper trade and the marble slab in the Museo Civico Medievale, Bologna (discussed in Chapter Two; Appendix One), help establish our data regarding the formats and sizes of paper. The evidence of *spolvero* that has thus far emerged in extant murals suggests that Giovanni da Milano and his circle used the technique only in painting ornament. We may

further recall the long, pounced *dado* decoration and the monumental fictive *spolvero* columns dividing the free-hand-painted figural scenes in the Rinuccini Chapel (S. Croce, Florence), frescos begun by Giovanni in 1365–69 and finished by the "Master of the Rinuccini Chapel."

323. This is clear from Cennino's description of both mural and panel painting techniques, as well as from the ongoing scientific examination of contemporary paintings. See further, Chapter Five (and note 2), for bibliography.

7. The Ideal of the *"Ben finito Cartone"* in the Cinquecento

1. *La Vita di Benvenuto Cellini scritta da lui medesimo,* ed. by Brunone Bianchi, Florence, 1903, 23: "Sebbene il divino Michelagnolo fece la gran cappella di papa Iulio [the Sistine Chapel] da poi, non arrivò mai a questo segno. . . ."

2. On the lost cartoon of the *Virgin and Child with St. Anne,* see especially studies by Jack Wasserman (1969, 122–31; 1970, 194–210; and 1971, 312–25), who rightly pointed out that Vasari did not identify the cartoon with the SS. Annunziata altarpiece and that Vasari wrote that Leonardo never began to work on the SS. Annunziata altarpiece. Nelson 1997, 84–94, has discussed the documents about Filippino Lippi and Perugino to support the hypothesis that Leonardo's cartoon was not destined for an altarpiece in the SS. Annunziata. Cf. Pedretti 1968, 22–28; Daniel Arasse, *Note sur le Sainte Anne,* Paris, 1982; Marani 1989, 103–5, no. 20 (under the *"Burlington House"* cartoon); Martin Clayton, "Studi per Sant' Anna," *Leonardo & Venezia* 1992, 242; and Popham 1995, 49–51. Martin Kemp has also rightly objected to the traditional view that Leonardo's lost *"St. Anne"* cartoon was intended for the high altar of the SS. Annunziata, because of the inconsistency arising from Vasari's explanation that when Leonardo returned to Florence, Filippino Lippi generously withdrew from the commission for an altarpiece in SS. Annunziata, and none of the subjects in Filippino's contracted altarpiece appear to correspond with the theme of Leonardo's cartoon (Kemp 1989, 220–26; and letter on 22 December 1994). It should be emphasized, however, that Filippino Lippi's contract of 15 September 1503 states that the subject on the rear of the altarpiece was still to be determined – specified are a *Deposition of Christ from the Cross* for the front, and six smaller panels of saints for the sides. (Filippino died on 20 April 1504, leaving the *Deposition* only probably half finished; Perugino and his workshop completed this panel, as well as an *Assumption of the Virgin,* and the six saints. Cf. Vasari's tale in the life of Perugino; Vasari 1966–87, III [testo], 609.) Possibly an *Assumption of the Virgin* was always intended for the rear (to judge from the fact that Perugino painted one), but this is not stated in Filippino's contract. But for the sake of caution, the small possibility that a *"St. Anne"* subject for this altarpiece may have been planned at some point should not be entirely ruled out. An even-handed summary of Filippino's SS. Annunziata commission is given in Nelson 1992, 239–55, and

Nelson 1997, 84–94, with new documents. The inscription on the verso of a Leonardesque drawing of the *Virgin and Child with St. Anne* (private collection, Switzerland) "Leonardo alla Nuntiata," may simply refer to the fact that Leonardo drew the composition of this subject when living in his rented quarters at SS. Annunziata (see Carlo Pedretti in *Leonardo dopo Milano: La Madonna dei fusi,* exh. cat. by Alessandro Vezzosi, Florence 1982, 18, no.21). A book on the Servite order published in 1589 by Fra Michele Poccianti attributed the design of the frame for the SS. Annunziata altarpiece to Leonardo (*Vite de' sette Beati fiorentini fondatori del Santo Ordine de' Servi con uno epilogo di tutte le Chiese, Monasteri, Luoghi pii e Compagnie della città di Firenze,* Florence, 1589; see most recently Nelson 1992, 247, note 11). The Milanese–French provenance of a *"St. Anne"* cartoon by Leonardo also complicates matters. The undated letter by Padre Sebastiano Resta (who died in 1696) to Giovanni Pietro Bellori, stated that Louis XII, king of France, commissioned a cartoon portraying St. Anne from Leonardo, before 1500, when the artist was in Milan in the service of Lodovico Sforza *"Il Moro";* in Resta's time this cartoon was in the collection of the counts of Arconati in Milan (see transcription in G. Bottari and S. Ticozzi, *Raccolta di Lettere nella pittura, scultura ed architettura scritte da' più celebri personaggi dei secoli XV, XVI e XVII,* Milan, 1822–25, III, 481; Wasserman 1971, 312–25; and Marani 1989, 103). Gian Paolo Lomazzo's *Trattato dell'arte della pittura* (Milan, 1584), cap. xvii, notes: "et ora si trova in Milano appresso Aurelio Lovino . . . ;" Lomazzo 1973–74, II, 150. Brescianino's lost painting in Berlin (Bodmer 1931, 61) probably corresponds with the cartoon described in Fra Pietro da Novellara's letter; the *"St. Anne"* cartoon described in Vasari's *Vite* may be yet another version, but see the alternative idea that is proposed in the text above.

3. Vasari 1962, I (testo), 118: "e Messer Bindo Altoviti, al quale donò il cartone della Cappella dove Noè inebriato è schernito da un de'figliuoli e ricoperto le vergogne dagli altri dua." Cf. Bambach Cappel 1988, Part 1, I:106 (note 138); Hirst 1988, 105; Bambach Cappel 1990, 497; Perrig 1991, 2; and Bambach Cappel 1996 a, 91.

4. Vasari 1962, I (testo), 68: "A Firenze è ritornato poi il cartone della Leda [owned by Antonio Mini], che l'ha Bernardo Vecchieti, e così 4 pezzi di cartoni della Cappella di Ignudi e Profeti, condotti da Benvenuto Cellini scultore, oggi appresso agli eredi di Girolamo degli Albizzi." Cf. Bambach Cappel 1988, Part 1, I:106 (note 138), 107 (note 141); Perrig 1991, 2; and Bambach Cappel 1996 a, 91.

5. Vasari 1966–87, VI (testo), 110.

6. See studies cited in note 2, as well as Vasari 1966–87, IV (testo), 29.

7. Italics are mine for emphasis of phrasing still awaiting further interpretation; my translation attempts to be as literal as the original text. Cf. transcription in Beltrami 1919, 65 (no. 107): "Ha facto solo dopoi che è ad Firenci uno schizo in uno cartone: finge uno Christo bambino de età cerca uno anno che uscendo quasi de bracci ad la

mamma, piglia uno agnello et pare che lo stringa. La mamma quasi levandose de grembo ad S.ta Anna, piglia el bambino per spiccarlo da lo agnellino [animale immolatile] che significa la Passione. Santa Anna alquanto levandose da sedere, pare che voglia ritenere la figliola che non spicca el bambino da lo agnellino, che forsi vole figurare la Chiesa che non vorrebe fussi impedita la passione di Christo. Et sono queste figure grande al natural, ma stano in piccolo cartone, perchè tutte o sedeno o stano curve et una sta a elquanto dinanci ad l'altra verso la man sinistra: e questo schizo ancora non è finito."

Cf. Chapter Three, notes 65–66 and translation in Leonardo, *On Painting*, 273.

8. The phrase *"uno schizo in uno cartone"* should be read within the context of similar references to cartoons from this period. See Michelangelo, *Carteggio*, III, 301, letter on 11 April 1531: ". . . se vi paressi fare uno *schizzo di carbone o giesso in sul cartone* d' un fogl[i]o reale e mandarli intanto. . . ." Note further the descriptions of the ten *"cartoni"* listed in the inventory of Michelangelo's possessions at his death in 1564, transcribed in Gotti 1875, II, 151: ". . . Un altro *cartone con tre schizzi di figure piccole.* . . . Un altro cartone grando, dove sono designate et *schizzate* tre figure grande et dui putti [traditionally thought to be a reference to the *"Epifania"* cartoon in the British Museum, which contains sketchy figures in its background]. . . . Un altro cartone grando dove è designato et *schizzato* una figura grande e sola . . ." (italics are mine). Notice that this inventory also mentions both architectural and figural *"cartoni"* that lack the modifying term *"schizzo," "schizzato,"* or similar derivatives. Seen in this context, the phrase in Isabella d'Este's request of *"uno altro schizo del retracto nostro"* from Leonardo in her letter of 27 March 1501 to Fra Pietro Novellara, does not rule out that she could have received a cartoon: for example, the portrait cartoon of Isabella now in the Musée du Louvre, Paris (transcribed in Beltrami 1919, 65, no. 106). On such complex problems of terminology, still awaiting further study, see preliminary observations in Bambach 1990 a, 493–98; Bambach Cappel 1992 b, 172–73; and Bambach Cappel 1996 a, 96 (and note 125).

9. Here, we should keep in mind the significant situation offered by Leonardo's sheet of quick pen and ink studies with wash for the *"Madonna and Child with a Cat"* (British Museum 1856-6-21-1 recto and verso, London), from the late 1470s, which demonstrates that the great artist reversed the design orientation of compositions back and forth as part of the process of exploration.

10. Vasari 1966–87, IV (testo), 29–30.

11. On Isabella d'Este as patron and collector, see Vienna 1994, as well as Chapter Three, note 173.

12. See Beltrami 1919, loc. cit.: ". . . ma per quanto me occorre, la vita di Leonardo è varia et indeterminata sorte, sì che pare vivere a giornata . . . Altro non ha facto, se non dui suoi garzoni fano retrati, et lui a le volte in alcuno mette mano: dà opra forte ad la geometria, impacientissimo al pennello. . . ."

13. For bibliography, see studies cited in note 2, as well as

Martin Kemp's introduction in Clark 1988, 32–34, and Kemp 1992, 54, no. 9.

14. National Gallery inv. 6337, London. Data: 1415 × 1046 mm.; charcoal (and some black chalk), highlighted with lead white chalk, on eight glued sheets of paper. Sir Kenneth Clark's discussion of this cartoon remains among the most compelling ever written (Clark 1988, 164–67). Cf. Wasserman 1969, 1970, and 1971; Barbara Hochstetler Meyer, "Louis XII, Leonardo and the 'Burlington House Cartoon," *GBA*, LXXXVI (1975), 105–9;" Patricia Leighten, "Leonardo's Burlington House Cartoon," *Rutgers Art Review*, II (1981), 31–42; Marani 1989, 103–5, no. 20; *Giotto to Dürer* 1991, 378–79, no. 66; and Popham 1995, 48–50, 139, nos. 176–79. For technical data on this cartoon, see Harding, Braham, Wyld, and Burnstock 1989, 4–27.

15. See Chris Fischer, "Ghirlandaio and the Origins of Cross-Hatching," in *Florentine Drawing at the Time of Lorenzo the Magnificent* 1994, 245–53.

16. See transcription in Richter, I, 306, § 492 (cf. Richter, *Commentary*, I, 328): "Come si debe prima inparare la dilige[n]za che la presta · pratica. Quando tu disegniatore vorrai fare bono · e vtile studio · vsa nel tuo disegniare fare adagio · e gividicare i[n]fra i lumi quali e qua[n]ti te[n]ghino il primo grado di chiarezza, e similme[n]te i[n]fra l' onbre quali sieno quelle che sono più scure · che l'altre e in che modo si unischano i[n]sieme · e le qua[n]tità, paragonare l'una coll'altra · , i liniame[n]ti · a che parte si dirizzino, e nelle linie qua[n]ta parte d'esse torcie per vno o altro verso, e dove più o meno evide[n]ti e se sia larga o sottile, ed in ultimo · che le tue o[n]bre e lumi sieno uniti sa[n]za tratti o segni, a uso di fumo: E qua[n]do · tu avrai fatto la mano · 'l gividitio a questa dilige[n]za · verati fatto più presto · che tu no[n] te ne avederai."

This often neglected passage sums up the innovations of drawing technique of the late Quattrocento. Cf. *Codex Urbinas Latinus* facsimile in McMahon 1956, II, fol. 37 recto (McMahon 1956, I, no. 63). See also comments on Leonardo's *sfumato* in Gian Paolo Lomazzo's *Trattato dell'arte della pittura* . . . (Milan, 1584); Lomazzo 1973–74, II, 170.

17. Vasari 1966–87, IV (testo), 29: "Non pure fece meravigliare tutti gl' artefici, ma finita ch' ella fù, nella stanza durarono due giorni d' andare a vederla gl' uomini e le donne, i giovani et i vecchi, come si va a le feste solenni, per veder le meraviglie di Lionardo."

18. Another example of the impact of Leonardo's lost *"St. Anne"* cartoon emerges in a smaller Florentine cartoon of the *Madonna and Child with St. John the Baptist* (CBC 300), probably by Giovanni Battista Sogliani, Uffizi inv. 592 E. Revised data: 305 × 344 mm. (maximum), charcoal, brush, and transparent layers of brown wash, highlighted with cream-color chalk, on two sheets of paper; outlines of figures only pricked, with a noticeable divergence of pricking in the Christ Child's belly and legs (resulting from the artist's corrections of the design in the wash reworking).

19. The technical data on Raphael's pricked cartoon for *"La*

Belle Jardinière" (National Gallery of Art, Washington) is discussed in Chapter Two (and notes 194–96).

20. Here, the relevant examples by Fra Bartolomeo are his stylus-incised cartoon for a *Kneeling St. Mary Magdalen* (Fig. 36; Uffizi inv. 1777 E, Florence), whose figure corresponds to that in the altarpiece in the Pinacoteca, Lucca; his stylus-incised cartoon for the *Virgin and St. Joseph Adoring the Christ Child* (Fig. 37; Uffizi inv. 1779 E), for which the corresponding oil painting on panel is in the Museo Poldi Pezzoli, Milan; his stylus-incised (?) cartoon for a *Standing Sts. Jerome and John the Evangelist* (Uffizi inv. 1780 E), not precisely connected to an extant painting; as well as his stylus-incised (?) cartoon for a *Standing St. Peter* (Uffizi inv. 1782 E), for which the corresponding oil painting on panel is in the Pinacoteca Vaticana.

21. Victoria and Albert Museum inv. Dyce 222, London. Revised data: 168 × 139 (maximum); charcoal; pricked outlines rubbed with pouncing dust. The traditional attribution of the Victoria and Albert Museum cartoon, to Marco d'Oggiono (Ward-Jackson 1979, 100–1, no. 211; CBC 55), is also maintained in my Ph.D. thesis. Although by no means exactly, this cartoon relates to a panel in the National Gallery, London (Davies 1986, 343, no. 1149), attributed to Marco d'Oggiono. My present attribution of the Victoria and Albert cartoon to Giampetrino is based on stylistic comparisons to this master's paintings in the Pinacoteca di Brera, Milan.

22. Pinacoteca di Brera, Reg. Cron. 969, inv. gen. 290, Milan. Revised data: 555 × 420; charcoal, highlighted with lead white chalk, squared in black chalk, on several glued sheets of light-tan paper; outlines pricked and apparently rubbed with black pouncing dust; lined with Japanese paper and framed. A closely related painting on panel is in the Museo Poldi Pezzoli, Milan, of which further versions exist. Cf. Sandra di Sicoli in *Disegni Lombardi del cinque e seicento Della Pinacoteca di Brera e dell'Arcivescovado di Milano,* exh. cat. by Daniele Pescarmona, Pinacoteca di Brera, Milan, 1986, 34–36, no. 3. Another example by Solario is his half-length stylus-incised cartoon and corresponding oil on panel painting of *Christ with a Lamb,* both of which are in the Pinacoteca di Brera (Reg. Cron. 1228, inv. Gen. 284; ibid., 32–35, no. 2).

23. Staatliche Graphische Sammlung inv. 1907:198, Munich. Data: 907 × 691 mm. (maximum); charcoal and some black chalk, highlighted with lead white chalk, on four glued sheets of paper (smaller than *fogli reali*), now discolored to a brown hue, with 9–17 mm. overlapping joins; outlines lightly incised for transfer; mounted onto canvas, cardboard, and plywood; drawing surface extremely creased, abraded, retouched, varnished, and showing numerous losses. I am indebted to the late Richard Harprath for his assistance in my examination of this cartoon.

24. On these cartoons in the Accademia Albertina, Turin, see Romano 1982, particularly the essay by Franco Mazzini, ibid., 40–58. Exceptionally among the Turin group of cartoons, Gaudenzio Ferrari's *Madonna and Child* (Romano 1982, no. 5) is pricked. Yet on close examination a great

number of the other cartoons reveal incisions, evident in raking light, but which are flattened. (All of these monumental drawings were mounted by early restorers onto secondary paper and canvas supports.) Among the faintly stylus-incised cartoons are Gaudenzio Ferrari's *St. Gaudenzius* (ibid., no. 2), *St Anthony of Padua* (no. 4), and *Madonna and Child* (no. 6); Gerolamo Giovenone's *St. Protasius* and *St. Gervasius* (nos. 10, 11); Bernardino Lanino's *Madonna and Child* (no. 18), *Christ Displaying the Holy Blood* (no. 20), and *Madonna and Child with Saints and Donors* (no. 21); Giuseppe Giovenone the Younger's *Madonna and Child with Angels* (no. 35), *St. Eusebius with Donor* (no. 39), and *Assumption* (no. 43); as well as Bernardino Campi's *Nativity* (no. 51). This suggests the probability that a modified *calco* (or "carbon copy") method was used to transfer the designs onto the working surface. In other cases, the artists may have used a sharply pointed piece of chalk to go over the outlines for transfer. This appears to be true of Gaudenzio Ferrari's *Sts. Agabius and Paul* (no. 1, see note 25), his *Lamentation over the Dead Christ* (no. 3; see note 25, and Fig. 221); of Bernardino Lanino's *Adoration of the Magi* (no. 19), his *Lamentation* (no. 22), *Adoration of Shepherds* (no. 24); as well as of Giuseppe Giovenone the Younger's *Calvary* (no. 42), his *St. Marguerite* (no. 46), and *St. Augustine* (no. 50). The above evidence of design transfer went unnoticed in Romano 1982. I am indebted to Giuseppe Dardanello and Rossana Sacchi for bringing this collection of cartoons to my attention. To the Turin group of cartoons by Bernardino Lanino, we may add the large, lightly stylus-incised example in charcoal, an *Adoration of the Shepherds* (Pinacoteca di Brera Reg. Cron. 871, inv. 267, Milan); cf. Pescarmona (as in note 22), 51–52, no. 9.

25. Numerous cases of correspondences between the cartoons in the Accademia Albertina, Turin, and their various painted versions are admirably discussed and illustrated in Giovanni Romano's 1982 catalogue. Gaudenzio Ferrari, cartoon for the *Lamentation over the Dead Christ* (Fig. 221) is Accademia Albertina inv. 323, Turin. Data: 1085 × 990 mm. (maximum); with beautifully stumped charcoal (with some black chalk), highlighted with lead white chalk; on six glued sheets of paper, with outlines lightly reworked with pointed black chalk and incised for transfer; mounted onto canvas. Note also the example of Gaudenzio's cartoon for *Sts. Agabius and Paul* (Accademia Albertina inv. 302). Data: 1535 × 775 mm. (maximum); also with beautifully stumped charcoal (with some black chalk), highlighted with lead white chalk, on twelve glued sheets of paper, with outlines retraced with pointed black chalk for the design's transfer. The latter cartoon was preparatory for a side of an extant altarpiece by Gaudenzio in the church of S. Gaudenzio, Novara. Cf. Romano 1982, 72, 76, nos. 1, 3.

26. *La Vita di Benvenuto Cellini scritta da lui medesimo,* ed. by B. Bianchi, Florence, 1903, 23: "Stetteno questi dua cartoni [the *Anghiari* and *Cascina* cartoons], uno in nel palazzo de' Medici, ed uno alla sala del papa. In mentre che *gli stetteno in piè* [this difficult phrase, I think, refers to the cartoon's display, rather than ruination], furno la scuola del mondo."

27. Vasari 1966–87, IV (testo), 32–33: ". . . cosa che eccellentissima e di gran magisterio fu tenuta. . . . Né si può esprimere il disegno che Lionardo fece. . . ."
28. Vasari 1966–87, VI (testo), 24–25: ". . . tutti coloro che su quel cartone studiarono e tal cosa disegnarono, come poi si seguitò molti anni in Fiorenza per forestieri e per terrazzani, diventarono persone in tale arte ecc[ellenti]. . . ."
29. Ibid., 24. Here, see also comments on Michelangelo's cartoon drawing manner in Bambach 1997a, 69–70.
30. Vasari 1966–87, VI (testo), 24–25.
31. Cf. Michelangelo, Carteggio, I, 70: ". . . l'aportatore di questa sarà uno giovine spagnuolo, il quale viene chostà per imparare a dipignere, e àmmi richiesto che io gli facci vedere el mio chartone che io chominciai alla Sala; però fa' che.ctu gli facci aver le chiave a ogni modo, e.sse tu puoi aiutarlo di niente, fallo per mio amore, perché è buono giovane." Above, I quote translation in E. H. Ramsden, The Letters of Michelangelo, Stanford, 1963, I, 45, no. 42. See further letters from and to Michelangelo – on 29 July and 2 September 1508; Michelangelo, Carteggio, I, 75–76, 83–84. Regarding Berruguete, see also Ana Avila, "Repercusión de la Batalla de Cascina en la pintura española del primer renacimiento," Goya, no. 190 (1986), 194–201.
32. See Bambach Cappel 1988, Part 1, I:11–176, and selection of treatises in Barocchi 1960–62, 3 vols.
33. Lomazzo 1973–74, I, 304; II, 170, 171, 173.
34. Michel Angelo Biondo, "Von der hochedlen Malerei," intro., trans., and comment. by Albert Ilg, Quellenschriften für Kunstgeschichte und Kunsttechnik des Mittelalters und der Renaissance, Vienna, 1873, V, especially 40–41.
35. Cf. Lancillotti 1509; Doni 1549; and Sorte in Barocchi 1960–62, I, 277–301. See Bambach Cappel 1988, Part 1, I:97–117, and selection of treatises in Barocchi 1960–62, 3 vols.
36. I quote translation in Ramsden (as in note 31), I, 148, no. 157. For the full text, see Michelangelo, Carteggio, III, 7–9.
37. See Michelangelo, Carteggio, IV, 396–98, and note 4 above, for further explanation.
38. Michelangelo, Carteggio, III, 380–81: ". . . Sappiate che di quello chartone n'arò a fare 3 de le Lede." On the Leda cartoon given to Antonio Mini, cf. Vasari 1966–87, VI (testo), 113.
39. Cf. Michelangelo, Carteggio, III, 340–41 (letter, 26 December 1531); ibid., IV, 396–97 (letter, 27 February 1532); and Chapter Three, notes 184–85.
40. Cf. Vasari 1966–87, VI (testo), 113. On the Venus and Cupid, Bartolomeo Bettini as a patron, and friend of Benedetto Varchi, see Leatrice Mendelsohn, Paragoni: Benedetto Varchi's "Due Lezioni" and Cinquecento Art Theory, Ann Arbor, 1982; Jonathan Nelson, "Dante Portraits in Sixteenth–Century Florence," GBA, 1992, 59–77 (and note 62); and Muzii 1993.
41. Michelangelo, Carteggio, III, 338.
42. Ibid., III, 301: ". . . se vi paressi fare uno schizzo di carbone o giesso in sul cartone d'un fogl[i]o reale e mandarli intanto . . .;" as well as Vasari's very general definitions of drawing types – "schizzo," "disegno," and "cartone" – in the

introduction to the Vite; Vasari 1966–87, I (testo), 117–21. See further Bambach Cappel 1990 a, 497–98, for discussion of terms designating drawing types in Michelangelo's correspondence.
43. Michelangelo, Carteggio, IV, 90–91: ". . . un pezzo di quei cartoni che solete donare fino al fuoco, acciò che io in vita me lo goda et in morte lo porti con esso meco nel sepolcro?"
44. See letter transcribed in Golzio 1971, 62–63.
45. Ibid., 74–75.
46. Ibid., 74.
47. Ibid., 76–77.
48. Ibid., 75.
49. Ibid., 169.
50. The revised contractual document of May 1504 for Leonardo's Battle of Anghiari cartoon is analyzed in Chapter Eight (and see there note 70 for full citations). The patron's role, the use of cartoons, and the commission of replicas are discussed in Chapter Three. A number of Quattrocento and Cinquecento artists' contracts allude to cartoons, as mentioned in Chapters Six and Eleven. For the contractual purpose of cartoons in the Seicento, see Bambach 1998, 154–80.
51. Lorenzo Lotto's contract with the members of the confraternity of St. Lucy of Jesi states: ". . . facere et pingere unam anconam in tabula cum figuris prout et sicut aparet designatum per designum per ipsum magistrum Laurentium in cartone factum existens penes supradictos confraternales, bonorum colorum et legalis auri ita et taliter quod sit melioris conditionis et pulchritudinis tabula scole Icshu de eadem civitate Esii." See transcription in Giovanni Annibaldi, "Documenti d'archivio sull'allogazione a Lorenzo Lotto della pala d'altare della Santa Lucia di Jesi," Notizie da Palazzo Albani Urbino, IX (1980) 143–52 (especially p. 149); and O'Malley 1994, 163. The contractual function of the cartoon, however, is overlooked in both studies. On Lorenzo Lotto's extant St. Lucy altarpiece and its three predella scenes (Pinacoteca Civica, Jesi), cf. especially Paolo Dal Poggetto and Pietro Zampetti, Lorenzo Lotto nelle Marche: Il Suo tempo, il suo influsso (exh. cat., Chiesa del Gesù, Chiesa di S. Francesco alle Scale, Loggia dei Mercanti, Ancona), Florence, 1981, 317–21; and Peter Humphrey in Lorenzo Lotto: Rediscovered Master of the Renaissance (exh. cat. by David Alan Brown, Peter Humphrey, and Mauro Lucco; National Gallery of Art, Washington), Washington, New Haven, and London, 1997, 178–81, nos. 34–36. On the function of Agnolo Bronzino's S. Lorenzo cartoons as demonstration drawings for discussion between patron and artist, see letter from Cosimo I de' Medici to Francesco Seriacopi (di Ser Iacopo), 11 February 1564 (1565, modern reckoning): "Da Ms. Tommaso de' Medici avrete inteso l'arrivo delle due tavole di pittura fatte Bronzino e il disegno che per la vostra del 8 ci scrivete delle due storie di San Lorenzo da dipingersi in quelle due facciate della chiesa. Sarà secondo l'animo nostro però abbiamo scritto a Bronzino che intanto cominci a farne i disegni e ce li facci vedere sue cartoni affinchè ce ne possiamo interamente risolvere . . ."

Archivio di Stato, Florence, Mediceo del Principato 220, fol 79; from the *Documentary Sources for the Arts and Humanities in the Medici Granducal Archive, 1537–1743 (The Medici Archive Project, Inc.)*, directed by Edward Goldberg, database entry 4024. For the references to *"disegni," "modelli," "lucidi,"* and *"cartoni"* in Lorenzo Lotto's letters regarding the production of the wood *intarsia* (inlay) of the choir in S. Maria Maggiore, Bergamo, see Cortesi Bosco 1987, II, 7–26, especially nos. 3, 4, 6–7, 11, 17–18, 23, 30, 32, 33, 35, 38. On the working procedures of the wood craftsmen for the choir of S. Maria Maggiore, see ibid., I, 196–201. On contractual drawings, see bibliography given in Chapter Three, notes 61–63; as well as Salvatore Settis, "Artisti e committenti fra Quattro e Cinquecento," *Storia d'Italia: Annali 4: Intelletuali e potere,* Turin, 1981, 701–61. The problem of Italian Renaissance contractual types of drawings is the subject of a forthcoming Ph.D. dissertation by Allegra Pesenti.

52. See Philip Jacks's transcription of this contract in *Vasari's Florence* 1998, 251: "E in caso che in questo mezzo il Cavaliere Giorgio Vasari mancasse di vita, tutti i disegni, modelli, et cartoni et fatiche attenenti a questa opera che il detto havesse fatto vuole che si dieno subito a detto M. Lorenzo Sabatini et lui sia obligato con buona gratia di loro Alt. seguitare detta cupola fino al fine con la medesima autorità che ha il Cavaliere Giorgio Vasari di presente pagandosi l'opera a lire 5, 14, 8 il braccio. Et mancando detto M. L[oren]zo si possa chiamare uno altro in luogo suo. Et caso che il detto M. L[oren]zo mancasse di vita, il Cavaliere Giorgio Vasari ne trovi un altro nel medesimo modi. Et in caso anche che vivendo M. L[oren]zo non facendo quanto promette per questa opera di studii, fatiche, sollecitudine, et diligentia si possa mettere altri in luogo suo." A memorandum of 6 June 1572 to Cosimo de' Medici, drawn up by Tommaso de' Medici on behalf of Vasari, already listed Vasari's requirements of labor to fresco the dome of Florence Cathedral. Among the required workers were plasterers; a foreman; three skilled fresco painters; painters of draperies, backgrounds, and makers of wax models; as well as painters of ornament, clouds, and filler who could also trace cartoons. Cf. Guasti 1857, 144–46, no. 358.

53. Alberti 1972, 62:104 (cf. Alberti 1950, 113): "Ergo moderata diligentia rebus adhibenda est, amicique consulendi sunt, quin et in ipso opere exequendo omnes passim spectarores recipiendi et audiendi sunt. Pictoris enim opus multitudini gratum futurum est. . . . Nostros ergo pictores palam et audire saepius et rogare omnes quid sentiant volo, quandquidem id cum ad caeteras res tum ad gratiam pictori aucupandam valet." Cf. translations in Alberti 1972, 62:105, and Alberti 1991, 95.

54. Fully transcribed in Richter, I, 322, § 532 (cf. Richter, *Commentary,* I, 335): "Come il pittore debbe esser vago d'udire nel fare dell' opera sua givditio d'ogni omo. . . ." See *Codex Urbinas Latinus* facsimile in McMahon 1956, II, fol. 38 recto-verso. Cf. translations in McMahon 1956, I, no. 83, and Leonardo, *On Painting,* 203.

55. On the development of Italian oil painting, see Del Serra 1985, 4–16; *Giotto to Dürer* 1991, 197–204, 398 (for bibliography on particular case studies); Hall 1992, 47–115; and Dunkerton and Roy 1996, 21–32.

56. On the date for the probable early use of oil painting in Venice and Northern Italy, see *Giotto to Dürer* 1991, 197–200.

57. Of the vast literature on Leonardo's *chiaroscuro,* see the classic studies by Shearman 1962, 13–47; Weil-Garris Posner 1974; Farago 1992, 94–114; and Farago 1994, 306–9, 318–25.

58. See Alberti 1972, 31:67–68, 32:68–70 (cf. Alberti 1950, 82–85): "In hac vero circumscriptione illud praecipue servandum censeo, ut ea fiat lineis quam tenuissimis atque admodum visum fugientibus." See translations in Alberti 1966, 68, 121 (and note 26); Alberti 1972, 31:67–69; 32:69–70; and Alberti 1991, 65–67.

59. See *Codex Urbinas Latinus* facsimile in MacMahon 1956, II, fol. 46 recto-verso (McMahon 1956, I, 75, no. 156): "Fugi li profili cio e' termini/espediti delle cose./Non fare li termini delle tue figure d'altro colore che del pro-/prio campo che con esse termina cioe che non facia profili/oscuri infra'l campo ella figura tua." Cf. Leonardo, *On Painting,* 210 (for trans.), and discussion in Farago 1992, 110–14, on Leonardo's "Principles of the Science of Painting: Treatment of Boundaries."

60. See Vasari 1966–87, III (testo), 354–55. Cf. further Vasari's *Vita* of Raphael (Vasari 1966–87, IV (testo), 205): ". . . maniera del Perugino . . . minuta, secca e di poco dissegno . . ."; *Vita* of Pordenone (ibid., IV (testo), 425): ". . . la maniera del Bellini, la quale era crudetta, tagliente e secca . . ."; or *Vita* of Titian (ibid., VI (testo), 155): ". . . E perché in quel tempo Gianbellino e gli altri pittori di quel paese, per non avere studio di cose antiche, usavano molto, anzi non altro, che ritrarre qualunche cosa facevano dal vivo, ma con maniera secca, cruda e stenta, imparò anco Tiziano per allora quel modo. . . ."

61. Here, see the masterful study by Martin Kemp, "New Light on Old Theories: Piero's Studies of the Transmission of Light," *Piero della Francesca tra arte e scienza* 1996, 33–45.

62. An early history of drawing is outlined in Ames-Lewis 1981 a, 35–62.

63. On this technique, see Bambach 1997 b, 21–28.

64. Examples by Ghirlandaio are the head of a pensive mature woman (Royal Library inv. 12804, Windsor), preparatory for one of the attendants in the left foreground of the *Birth of the Virgin* fresco at S. Maria Novella; or the dead old man with rhinophasy (Nationalmuseum inv. 1863/1, Stockholm), serving for the posthumous portrait panel in the Musée du Louvre (Paris). On these drawings see Uffizi 1992, 100–4, nos. 4.7, 4.8.

65. Of these brush drawings on linen, the masterful example is by Leonardo (Louvre inv. 2235, Paris), which was probably preparatory for the panel of the *Annunciation* (Galleria degli Uffizi, Florence). On the attribution problems of this group of drawings, cf. Cadogan 1983 b, 27–62; Louvre 1989, 74–77, nos. 16, 17; Christiansen 1990, 572–73; and Brown 1998, 79–82.

66. For a specialized study on the technical possibilities of black chalk, see Van Cleave 1994, 231–43.

67. In my opinion, there should be little doubt that this reworking in red chalk in Piero Pollaiuolo's Uffizi cartoon is original, for it is subtly integrated into the overall tonal effect of the rendering.

68. On Ghirlandaio's Chatsworth cartoon, see Chapters Two and Six (note 265), and on Fra Bartolomeo's cartoon (Uffizi inv. 1779 E, Florence), cf. Fischer 1986, 66–68, no. 27; Petrioli Tofani 1987, 731, *sub numero;* and Lucia Monaci Moran in Uffizi 1992, 176–77, no. 8.5

69. Raphael's cartoon of *Jousting Children on Boars,* Musée Condé inv. LA30621, Chantilly. Revised data: 525 × 1250 mm.; charcoal and black chalk, over heavy, comprehensive preliminary stylus underdrawing, on twelve glued pieces of paper; outlines pricked except in small details of foliage; glued onto secondary paper support, and numerous losses made up. Cf. Joannides 1983, 140, no. 29; Knab, Mitsch, and Oberhuber 1983, 563, no. 82; and Grand Palais 1983, 178–79, under no. 13.

70. See Figures 76, 81, and 212.

71. For instance, not a shred remains of any of Verrocchio's monumental cartoons mentioned by Vasari in Verrocchio's *Vita;* Vasari 1966–87, III (testo), 538. For discussions of Verrocchio as a draughtsman and painter, cf. Cadogan 1983 b, 27–62; Cadogan 1983c, 367–400; Wiemers 1996, 137–57; Butterfield 1997, 184–98; and Brown 1998, 23–45.

72. Cf. Carl Frey, *Il Codice Magliabechiano . . . ,* Berlin, 1892, 89; and Vasari 1966–87, III (testo), 539. On the Uffizi painting of the *Baptism of Christ,* cf. Passavant 1959, 58–87; Adorno 1991, 96–105; and Brown 1998, 26–34, 123–45, 167–74 (with new technical evidence).

73. On this altarpiece, cf. Passavant 1959, 29–57; Dalli Regoli 1966, 111–14, no. 30; Davies 1986, 553–54; Luciano Bellosi in Bellosi 1990, 177–78; Adorno 1991, 191–213; Gigetta Dalli Regoli in Palazzo Strozzi 1992, 52, no. 1.5; and Brown 1998, 151–55. On its recent cleaning, see Franca Faletti, "Il Restauro della Madonna di Piazza: Nuove imagini per un vecchio problema," *I Medici, Il Verrocchio e Pistoia: Storia e restauro di due capolavori nella Cattedrale di S. Zeno,* Livorno, 1996, 75–83, with report on examination with infrared reflectography (pointed out to me by Lisa Venturini). Franca Faletti's reading of the infrared reflectograms as showing *spolvero* in this altarpiece is extremely unconvincing, except for the illustration of *spolvero* on the urn, which repeats twice on the parapet (fig. 112). See Brown 1998, on the painting careers of Verrocchio and the young Leonardo.

74. Vasari 1966–87, IV (testo), 300.

75. British Museum 1895-9-15-785, London. Data: 325 × 276 mm.; black chalk. Cf. Popham and Pouncey 1950, no. 258; Wiemers 1996, 140–42; British Museum 1996, 30–31, no. 7; Butterfield 1997, 185–86; and Brown 1998, 126–27.

76. Christ Church inv. 0005, Oxford. Revised data: 411 × 327 mm.; charcoal, partly reinforced in pen and brush with brown ink and wash, outlines pricked. This cartoon was drawn on a single sheet of paper, as is now clear after the verso was detached from the mount in March 1996; my thanks to Lucy Whitaker for this information. Compare Byam Shaw 1976, 36, no. 15; Ames-Lewis and Wright 1983, 310–13, no. 72; Cadogan 1983c, 375; Adorno 1991, 269; Caterina Caneva in Uffizi 1992, 110–11; Wiemers 1996, 144–47; and Butterfield 1997, 184–93.

77. Gemäldegalerie inv. 104 A, Berlin. On this painting, cf. Passavant 1959, 95–102; Bellosi 1990, 179; and Brown 1998, 37–43. This figural type of the woman in the Christ Church cartoon (Plate III) is also extremely close in design to the winged female figure on the lower right of Verrocchio's carved monument to Cardinal Forteguerri at Pistoia Cathedral, probably contracted in 1481 to 1483 (kindly pointed out to me by David Alan Brown).

78. This passage is transcribed in note 16 above.

79. See transcription in note 16 above.

80. Kupferstichkabinett inv. KdZ 5095, Berlin. Revised data: 184 × 158 mm.; charcoal, highlighted with white chalk, pricked outlines (recto); charcoal (verso). The style and technique of the fragmentary angel's head drawing on the verso of the sheet recalls the monumental Madonna's head in the British Museum (inv. 1895-9-15-785), connected with the *Pistoia Altarpiece.* Compare discussion in Passavant 1969, 50, no. D.7; Cadogan 1983 c, 373–79 (and note 32); Adorno 1991, 262–63; Altcappenberg 1995, 141–43, no. 159; Wiemers 1996, 148–50; and Butterfield 1997, 185–90.

81. See transcription in Richter, I, 315, § 515 (cf. Richter, *Commentary,* I, 331): "Come debe essere alto il lume da ritrare di naturale. . . ." Cf. *Codex Urbinas Latinus* facsimile in McMahon 1956, II, fol. 40 recto (McMahon 1956, I, no. 129). See translation in Leonardo, *On Painting,* 214.

82. In this drawing, the white chalk on areas of highlight is probably a later retouching; on the forehead it attempts to hide *pentimenti.*

83. On the pricking implement used in this cartoon, see Chapter Two.

84. Uffizi inv. 130 E, Florence. Revised data: 209 × 180 mm.; black chalk, reinforced with pen and brown ink; pricked outlines apparently rubbed with pouncing dust. Cf. Cadogan 1983 c, 373–74; Petrioli Tofani 1986, 57, *sub numero;* Adorno 1991, 264; Lucia Monaci Moran in Uffizi 1992, 174, no. 8.3; Butterfield 1997, 185–86; and Brown 1998, 30.

85. I am indebted to Nicholas Penny (National Gallery, London) and to Annamaria Petrioli Tofani (Gabinetto Disegni e Stampe degli Uffizi, Florence) for facilitating my comparison of the designs of the cartoon and the *Tobias and the Angel* painting from tracings on acetate in 1993 and 1994. On the *Tobias* painting, cf. Davies 1986, 555–57, no. 781, *Giotto to Dürer* 1991, 314–15, no. 39; and Brown 1998, 47–57 (with an attribution of the *Tobias* figure on the right of the composition to the young Leonardo). The smaller scale of the angel in the S. Salvi *Baptism of Christ* is rightly reported in Brown 1998, 30.

86. Royal Library inv. 12551, Windsor. Data: 190 × 149 mm.; charcoal. On the drawing, cf. Kemp and Roberts 1989, 88, no. 31; Popham 1994, 137, no. 165; and Clayton 1996, 56–59, no. 30.

87. Here, for instance, see Paris MS. C, fols. 4 verso and 5 recto, from c. 1490–92. Data: 328 × 460 mm.; pen and brown ink; illustrated and discussed in Kemp and Roberts 1989, 178–79, no. 100.

88. Here, for instance, see Paris MS. A (BN 2038), fols. 13 verso and 14 verso, from c. 1492. Data: 240 × 380 mm.; pen and brown ink, brush and brown-gray wash, over stylus; illustrated and discussed in Kemp and Roberts 1989, 182, no. 102.

89. The relevant diagrams in Paris MS C and A, cited in notes 87 and 88, could unfortunately not be illustrated.

90. Now detached, the *Last Judgment* fresco was commissioned from Fra Bartolomeo by Gerozzo Dini to decorate the *Chiostro delle Ossa* in the Hospital of S. Maria Nuova (Palazzo Pitti 1996, 160–80). On the drawings for this project, see further Fischer 1990, 25–26, 43–73.

91. See Plates VI, VIII, IX, and Figures 34, 37, 40–42, 45, 49, 51, 59, 220–21, and 228–33.

92. Armenini 1587, 100–103 (cf. Armenini 1977, 171–73, for trans.).

93. Armenini 1587, 103 (cf. Armenini 1977, 173–74, for trans., though imprecise).

94. See notes 24 and 25. Cf. Romano 1982, 144–235, nos. 18–45.

95. See transcriptions of Paris MS. G (fol. 25 recto) and MS. A (fol. 107 verso) in Richter, I, 303, 306, §§ 482, 492 (cf. Richter, *Commentary,* I, 326, 328): "Notitia del giovane disposto alla pictura . . .;" "Come si debe inparare la dilige[n]za che la presta · pratica. . . ." See *Codex Urbinas Latinus* facsimile in McMahon 1956, II, fols. 31 verso, 37 recto (McMahon 1956, I, nos. 63, 64).

96. Vasari 1966–87, I (testo), 117–20 (cf. Vasari 1960, 212–15, for trans.). See further the passage on three-dimensional models for studying foreshortenings, described in Gian Paolo Lomazzo's *Trattato dell'arte della pittura* (Milan, 1584), cap. II; Lomazzo 1973–74, II, 221–22.

97. This approach thus showed "the whole to be most beautiful and highly finished *[maggiormente finito]*; Vasari 1966–87, I (testo), 120 (cf. Vasari 1960, 215, for trans.).

98. Armenini 1587, 99–104 (102, for the list of artists cited above); cf. Armenini 1977, 170–75, for trans.

99. My translation here is free, to capture the overall spirit of the passage. See Vasari 1966–87, I (testo), 119 (cf. Vasari 1960, 213–14, for trans.).

100. Armenini 1587, 99–100 (cf. Armenini 1977, 170–72, for trans.): "l'ultimo, et il più perfetto modo di quello che per artificio di dissegno si vede. . . ."

101. Of the immense literature on the issue of *"finito"* and *"non finito,"* cf. Luigi Grassi, "I Concetti di schizzo, abbozzo, macchia, 'non finito' e la costruzione dell'opera d'arte," *Studi in onore di Pietro Silva,* Florence, 1957, 100 ff.; Barocchi 1958, 221–35; Juergen Schulz, "Michelangelo's Unfinished Works," *AB,* LVII (1975), 366–73; Roland Le Mollé, *Georges Vasari et le vocabulaire de la critique d'art dans les "Vite,"* Grenoble, 1988, 43–60 (with the point about surface finish); Alessandro Conti, "Pittura e immagine in Guido Reni: Dalle opere 'non-perfette' al tempo pittore," *Prospettiva,* no. 52 (1988), 25–31; Augusto Gentili, "Tiziano e il non finito," *Venezia Cinquecento. (Tiziano: Contesti e problemi),* II (1992), 93–127; Luba Freedman, *Titian's Independent Self-Portraits* (L. S. Olschki pocket library of studies in art), Florence, 1990; Nicholas Penny, "'Non-Finito' in Italian Fif-

teenth-Century Bronze Sculpture," *Antologia di Belle Arti (Studi sulla scultura in onore di Andrew S. Ciechanowiecki),* nos. 48–51 (1994), 11–15; Paula Carabell, "'Finito' and 'Non-Finito' in Titian's Last Paintings," *Res,* no. 28 (1995), 78–93. Cast 1991, 676, rightly notes that in the *Lezioni* posthumously published in 1590, Benedetto Varchi employed the adjective *"finito"* to indicate the state of perfection a design may have reached.

102. In this regard, cf. also Timothy Clifford and J. V. Mallet, "Battista Franco as a Designer of Maiolica," *BM,* CXVIII (1976), 387–410; and Arnold Nesselrath, "Carlo Maratti's Designs for the Piatti di S. Giovanni," *MD,* XVII (1979), 417–26.

103. Cf. Vasari 1966–87, IV (testo), 115–20. Here see Alessandro Cecchi, "Filippino [Lippi] and his Circle, Designers for the Decorative Arts," in Metropolitan Museum of Art 1997, 37–44, and Carmen C. Bambach in the same exh. cat., 338–39, 348–49, no. 116.

104. The pricked cartoons attributed to Andrea del Sarto for the embroidered altar frontal *("palliotto")* commissioned by Cardinal Silvio di Rosado Passerini (illustrated in Monti 1981, plates 245–50) are: (1) *St. Mark,* Palais des Beaux–Arts inv. PL 253, Lille. Revised data: 153 mm. diameter; pen and brown ink, brush and brown wash, highlighted with white gouache, over traces of black chalk, on medium brown (probably oiled) paper; pricked outlines of figure and pricked circular framing outline seem rubbed with black pouncing dust. (2) *St. Luke,* Istituto Nazionale per la Grafica inv. 130467, Rome. Revised data: 158 mm. diameter; same medium as above, visibly rubbed with black pouncing dust, but paper is tan color. (3) *St. Matthew* (facing right, in reversed orientation with respect to the embroidery) was recently discovered in the art market, Christie's New York sale, 28 January 1999, lot 48. Data: 164 mm. diameter; medium as above, but paper is off-white and the ink seems to have seeped in, much as is often true of oiled tracing paper. Unpricked, full-scale drawings for this altar frontal are: (4) *St. John The Evangelist,* Uffizi inv. 14421 F, Florence. Revised data: 153 mm. diameter; same medium as above, but on brown (probably oiled) paper; severely damaged. (5) *St. Matthew* (facing left, in the same orientation with respect to the embroidery), Uffizi inv. 14422 F. Revised data: 145–53 mm. diameter; same medium and condition as above. In my opinion, all of the above drawings are autograph. The disparate states of finish and handling in these drawings are a reflection of their highly functional character and of their reliance on the semimechanical transfer techniques that were necessary in designs for embroidery (see examples discussed in Chapters Three and Nine). The complex circumstances of the Passerini embroideries' commission and the functions of the drawings can be reconstructed from the piecemeal discussions in Freedberg 1963, 136–39; Shearman 1965, II, 151, 249–50, 355, 383, 400, no. 60, document 92 (plates 253–56, some mislabeled and reversed); Monti 1981, 168 (note 169); Louvre 1986, 56–57, no 34: Palazzo Pitti 1986, 246–47, nos. 39–41; Bambach Cappel 1988, Part 2, II: 387–91, nos. 282–83; Alessandro Cecchi and Antonio

Natali, *Andrea del Sarto,* Florence 1989, 104, no. 48; Alessandro Cecchi, "Filippino [Lippi] and his Circle, Designers for the Decorative Arts," Metropolitan Museum of Art 1997, 41–44; Carmen C. Bambach in Metropolitan Museum of Art 1997, 338–39; and Christie's New York sale, 28 January 1999 catalogue, lot 48. Future research on the Passerini embroideries should take into account that, as Alessandro Cecchi discovered in 1997 on the basis of a new document, Raffaellino del Garbo was still alive in April 1527, and, therefore "it is more probable that Raffaellino obtained the commission after 1521 and had time to finish it, calling on Andrea del Sarto from the very beginning to provide certain drawings." Passerini was created a cardinal in 1517 by Pope Leo X, his childhood friend; Leo named Passerini bishop of Cortona (his native town) on 21 November 1521. The deed of gift of the embroidered vestments from Passerini and his mother Margherita to the Cathedral of Cortona is dated 2 November 1526, which provides the *terminus ante quem* for the commission of the embroideries and the cartoons. In my opinion, Raffaellino may well have had the lion's share of responsibility in this commission. See Chapter One, notes 191–93, on the fact that Andrea del Sarto was most probably Raffaellino del Garbo's pupil (as suggested first by John Shearman). Both artists followed similar procedures of pricking, pouncing, and tracing techniques, and both had close ties to the artisanal class of embroiderers and garment workers. Regarding the production of embroideries, see also the rare series of six small cartoons by the Lombard artist Bonifacio Bembo (CBC 21), Perino del Vaga's cartoons for the embroidered copes commissioned by Pope Paul III (CBC 324), and the large group of cartoons commissioned by King Philip II of Spain for the various embroidered vestments in the Monastery of El Escorial (CBC 8–13, 158–171, 367–405).

105. Fogg Art Museum inv. 1994.138, Cambridge, Mass. (not in CBC). Data: 177 × 460 mm.; pen and brown ink, brush and brown wash, over black chalk, pricked outlines, lightly rubbed with pouncing dust. See Giulio Bora in *I Campi e la cultura artistica cremonese del Cinquecento* (exh. cat., S. Maria della Pietà and Museo Civico, Cremona), Milan, 1986, no. 2.6.9.

106. See Emmanuelle Brugerolles, *Les dessins de la collection Armand-Valton: La donnation d'un grand collectionneur du XIXe siècle à l'Ecole des Beaux-Arts,* exh. cat., Ecole des Beaux-Arts, Paris, 1981, 2–5, no. 1, with illustrations of the drawings and enamels.

107. On the Sistine Chapel tapestries, see Shearman 1972; Fermor 1996; and Fermor and Derbyshire 1998, 236–50. On those of the *"Scuola Nuova,"* see Vatican 1984, 326–32, nos. 124 a–c.

108. Cf. Chapter Eight, notes 51–60.

109. Here, cf. comments in Bambach Cappel 1997 a, 69–70.

110. On the National Gallery cartoon, cf. Harding, Braham, Wyld, and Burnstock 1989. I am indebted to Nicholas Penny, Eric Harding, Martin Wyld, and Francis Ames-Lewis for the opportunity of studying this cartoon in the conservation laboratory in April 1989.

111. In the sheet of studies for the *"Madonna of the Cat,"* Leonardo first drew the composition on the verso, and then, by holding the sheet against a light source, he traced the forms onto the other face of the paper (now considered the recto), adding shadows in thin layers of wash. British Museum 1856-6-21-1, London. Data: 132 × 95 mm.; pen and ink, brush and brown wash. Cf. Popham and Pouncey 1950, no. 97; Kemp and Roberts 1989, 54, no. 6; and Popham 1994, nos. 9 A and B.

112. *Codex Urbinas Latinus* facsimile in McMahon 1956, II, fols. 61 verso–62 recto (McMahon 1956, I, no. 262): "O tu, componitore delle istorie, non membrificare con terminati lineamenti le membrificazioni d'esse istorie, chè t'interverrà come a molti e vari pittori intervenir suole, i quali vogliono che ogni minimo segno di carbone sia valido. Adunque, pittore, componi grossamente le membra delle tue figure, e attendi prima ai movimenti appropriati agli accidenti mentali degli animali compositori dell'istoria che alla bellezza e bontà delle loro membra. Perchè tu hai a intendere che, se tal componimento inculto ti riuscerà appropriato alla sua intenzione, tanto maggiormente satisfarà, essendo poi ornato della perfezione appropriata a tutte le sue parti." Cf. trans. in Leonardo, *On Painting,* 222. See related passage in Paris MS. A (fol. 88 verso) given in Richter, I, 340, § 579 (cf. Richter, *Commentary,* I, 343).

113. The outlines of Leonardo's National Gallery cartoon are not pricked for pouncing, but if shallow stylus incisions were once present, these may have been flattened when the cartoon was glued onto the canvas support, all but disappearing with old restorations. For instance, the vestigial creases on the sheets of paper formed by the *quaderni's* spines, still visible today in the structure of numerous Renaissance and Baroque cartoons, are no longer evident in the National Gallery cartoon with certainty.

114. This is a point also rightly made in *Giotto to Dürer* 1991, 378, no. 66.

115. Alberti 1972, 62:104 (cf. Alberti 1950, 113): "Siquidem non paucis in rebus ipsa diligentia grata non minus est quam omne ingenium. Sed vitanda est superflua illa, ut ia loquar, superstitio eorum qui, dum omni vitio sua penitus carere et nimis polita esse volunt, prius contritum opus vetustate efficiunt quam absolutum sit. Protogenem soliti erant vituperare antiqui pictores quod nesciret manum a tavola amovere. Merito id quidem, nam conari sane oportet ut pro ingenii viribus quantum sat sit diligentia rebus adhibeatur, sed in omni re plus velle quam vel possis vel deceat, pertinacis est non diligentis. Ergo moderata diligentia rebus adhibenda est. . . ." Cf. translations in Alberti 1972, 62:105, and Alberti 1991, 95, trans.

116. See Vasari 1966–87, IV (testo), 299, 301, 303, on the commendable *"diligenza"* and *"pulitezza"* of Lorenzo di Credi's drawings which imitated Leonardo, on the *"molta diligenza"* of Lorenzo's altarpiece for S. Agostino in Montepulciano, on the *"maggiore studio e diligenza"* of his altarpiece for the chapel in Cestello, and on the anecdote about Lorenzo's abhorrence of dust in his workshop. According to Vasari, such obsessive working habits regarding the art of

painting were destructive, "... *estrema diligenza non è forse più lodevole punto che sia una strema negligenza....*"

117. Casa Buonarroti inv. 71 F, Florence. Data: 541 × 396 mm.; charcoal, red chalk, white chalk, reinforced in pen and brush with ink; on two glued sheets of paper. Cf. Hirst 1988 b, 88–89, no. 36. On the *"finito"* and *"non-finito"* in Michelangelo, recall especially Barocchi 1958, 221–35.

118. My translation of this contorted passage is somewhat freer than that of the original text. See Vasari 1966–87, VI (testo), 57: "... *ancora che non siano finite le parti sue, si conosce, nell'essere rimasta abozzata e gradinata, nella imperfezione della bozza la perfezzione dell'opera.*" See also note 101 above, for bibliography on the *"non finito"* of Michelangelo.

119. Compare here Condivi's and Vasari's accounts in their biographies of Michelangelo. See further Bambach 1997 a, 69–70.

120. Cf. also ibid., 69–70. For further data on Michelangelo's *Crucifixion of St. Peter* cartoon, see Chapter One; for that on Raphael's *School of Athens* cartoon, see Chapters Two and Eight (notes 35–40).

121. Golzio 1971, 76–77.

122. Shearman 1972, 2–3, with transcription of documents in notes 9–10.

123. Vasari 1966–87, IV (testo), 201–2.

124. Ibid., 201–2, 332.

125. Cf. also discussion in Jones and Penny 1983, 146–47; Fermor 1996; and Fermor and Derbyshire 1998, 236–50. On the delegation of labor regarding the preliminary drawings, cf. Shearman 1972, 91–137; Oberhuber 1972, 123–40; and Harprath 1986, 124–26.

126. See further, Chapter Nine.

127. Cf. comments in Shearman 1972, 209–12; Oberhuber 1972, 123–40; Plesters 1990 b, 123–24; Fermor 1996; Henry 1997; as well as Fermor and Derbyshire 1998.

128. Vasari 1966–87, I (testo), 117–21. On Vasari's own model of drawing, cf. Florian Härb, "Modes and Models in Vasari's Early Drawing Oeuvre," *Vasari's Florence* 1998, 83–110. Vasari's model of design, however, seems extremely schematic, and the extent to which his model represents late Quattrocento practice is not certain. See note 141.

129. See Leonardo, Paris MS. A, fols. 8 verso, 22 verso (transcribed in Richter, I, §§ 508, 579), and *Codex Urbinas Latinus,* fols. 34 recto, 35 verso, 61 verso–62 recto (McMahon 1956, I, nos. 257, 76, 261). On Leonardo's method of design, see the classic study by Ernst Gombrich, "Leonardo's Method of Working Out Compositions," *Norm and Form: Studies in the Art of the Renaissance,* London, 1966, 58–63. Gombrich assumed Leonardo's design process to be much less nuanced than is proposed here.

130. On these cartoons, cf. also Dalli Regoli 1966, 175, nos. 162–63; Petrioli Tofani 1986, 214–15, 728 (without technical evidence that follows).

131. Uffizi inv. 1772 E, Florence. Revised data: 1150 × 645 mm.; charcoal or black chalk (and reworked later in the same medium), probably with some white chalk or gouache highlighting originally, on nine sheets of off-white paper (now considerably darkened), glued onto

wood support. The manner of drawing of the figures' contours suggests the possibility that these were the result of tracing, possibly by means of the technique of *lucido:* the paper is fairly thin and discolored, as if originally treated with oil. The maximum dimensions for the two largest sheets comprising the cartoon are: 417 × 294 mm. and 380 × 290 mm., hence closest to a *rezzuta* format (one-half a *foglio reale*). The paper overlaps of the structural joins range between 12 and 19 mm.

132. Uffizi inv. 476 E, Florence. Revised data: 780 × 449 mm.; charcoal or soft black chalk, on three glued sheets of paper, with reinforcement strips on verso. Further technical evidence for this cartoon is discussed in Chapter Two (and notes 51–52).

133. Vasari 1966–87, I (testo), 133. Leonardo's sheets of pen and ink sketches for the *Battle of Anghiari* exemplify the extemporaneous and abstract quality of this drawing type. Four such compositional sketches are extant: Gallerie dell' Accademia inv. nos. 214, 215, 215A, 216, Venice, as well as British Museum inv. 1854-5-13-17, London. See Giovanna Nepi Sciré in *Leonardo & Venezia* 1992, 256–68, nos. 28–32, with previous bibliography.

134. Vasari saw *"schizzi"* as the immediate product of the *"furor del artefice."* See Vasari, I (testo), 117.

135. See transcription given in Richter, I, 340, § 579 (cf. Richter, *Commentary,* I, 343): *"il bozzare delle storie sia pronto; e'l me[m]brificare · no[n] sia troppo finito, sia co[n]tenuto · solamente a siti d'esse me[m]bra ..."* See *Codex Urbinas Latinus* facsimile in McMahon 1956, II, fol. 34 recto (McMahon 1956, no. 257). For trans., see Leonardo, *On Painting,* 225. Cf. also note in Paris MS. A (fol. 107 verso) transcribed in Richter, I, 338, § 571 (cf. Richter, *Commentary,* I, 340): "Del modo dello i[m]parare bene a co[m]porre insieme le figure nelle storie," on stains; *Codex Urbinas Latinus* facsimile in McMahon 1956, fols. 33 verso–34 recto, 58 verso–59 recto (McMahon 1956, nos. 93, 258). See Leonardo, *On Painting,* 225, 199, for trans., respectively.

136. See Vasari 1966–87, I (testo), 117–18, and Leonardo's notes in *Codex Atlanticus,* fol. 199 verso a, Paris MS. A fols. 107 verso, 108 recto. These are transcribed in Richter, I, 304–6, §§ 490, 491, 492 (cf. Richter, *Commentary,* I, 327–28). Note further *Codex Urbinas Latinus* facsimile in McMahon 1956, II, fols. 31 recto–verso, 37 recto (McMahon, nos. 60, 64, 63). Although in the strict context of Renaissance draughtsmanship the term *"disegno"* means literally "drawing," Vasari and his contemporaries understood it less generically. See further, Chapter One; Carmen Bambach Cappel in *Dictionary of Art* 1996, XXI, 762–67; Bambach Cappel 1996 a, 86–87; and Bambach Cappel 1990 a, 493–98.

137. Vasari 1966–87, I (testo), 118. I have rearranged slightly the order of Vasari's terms to conform with the modern, more systematic convention of cataloguing drawings.

138. Leonardo's two *"disegni"* after real draperies arranged on a clay figure, one executed with silverpoint on prepared paper (Istituto Nazionale per la Grafica inv. F.C. 125770, Rome), from about 1473–78, the other with brush, gouache, and wash on bluish gray linen (British Museum

1895-9-15-489, London) are both characteristic of a late Quattrocento drawing type. But, in their media and form, they illustrate the contrast between Quattrocento delicate modeling and High Renaissance full-rounded monumentality. See M. C. Isola et al., *I Grandi disegni italiani dal Gabinetto Nazionale delle Stampe di Roma,* Milan, [1980], no. 8, and Popham and Pouncey 1950, 56–57, no. 95, plate LXXXIX. On the topic, cf. Cadogan 1983 b, 27–62; Louvre 1989, 74–77, nos. 16, 17; Christiansen 1990, 572–73; and Brown 1998, 79–82. Michelangelo's three *"disegni"* in black chalk for the bathers in the *Battle of Cascina* (Teylers Museum inv. A18 recto and A19 recto, Haarlem; Albertina inv. 123, R157, Vienna) exemplify the type of carefully rendered study after the living nude model *("dal vivo"),* increasingly favored during the High Renaissance. Cf. Hirst 1988 a, 65–67; Hirst 1988 b, 22–23, no. 7; *Michelangelo: The Genius of the Sculptor at Work* (exh. cat., Montreal Museum of Fine Arts), 1992, 350–51, no. 81. Regarding life studies, see Leonardo's notes transcribed in Richter, I, 264, 308–10, 314–15, 338, 346, §§ 368, 497, 502–3, 514–15, 571, 596 (cf. Richter, *Commentary,* I, 274–75, 328–32, 340–41, 351), and McMahon 1956, nos. 361, 373–74.

139. See Gallerie dell'Accademia inv. 230, Venice; British Museum 1875-6-12-17 recto and verso, London, and Louvre inv. R.F. 460, Paris. Cf. Virginia Budny, "The Sequence of Leonardo's Sketches for the Virgin and Child with St. Anne and St. John the Baptist," *AB,* LXV (1983), 34–50, and Martin Clayton in *Leonardo & Venezia,* 242–48, nos. 22–24, with previous bibliography.

140. See, however, Leonardo's scaled study for the cartoon of the *Virgin and Child with Sts. Anne and John the Baptist,* "The Burlington House Cartoon" (British Museum 1875-6-12-17, London), with studies of other motifs, below the main composition. In this sheet, the proportional scale that is noted with tiny dots along the bottom edge of the main composition refers to the final scale of the cartoon.

141. On *"modello"* drawings see Bambach Cappel 1992 b, 172–73, and Carmen Bambach Cappel in *Dictionary of Art* 1996, XXI, 762–67. Yet Vasari's description of *"disegni"* – the intermediate group of drawings – where the theorist paid greater attention to the diversity of their medium than to the diversity of their function, appears extremely schematic, particularly if compared to the actual sequences of design that extant High Renaissance drawings reveal. The variety of *disegni* in Raphael's *oeuvre* alone attests to a highly systematic approach, though one that may not have necessarily been typical of most Central-Italian artists in the High Renaissance. Vasari's description of *disegni* therefore seems purposefully flexible. The most concrete test cases for reconstruction are provided by the extant, relatively complete sequences of design in Raphael's *oeuvre:* preliminary drawings for the Florentine *Madonne* (c. 1504–8), the Borghese *Entombment* (signed and dated 1507), the Sistine Chapel tapestry cartoons (c. 1516–18), and the Vatican *stanze* (c. 1508–20). The artist gradually developed the compositional idea from a first sketch to the greatest possible degree of elaboration, often through partial compositional studies and studies after the model,

and synthesized the idea at various stages in comprehensive drafts. If the idea did not prove satisfactory, the artist discarded it, and began the process anew with another idea, back at the stage of a sketch. Cf. Shearman 1965 b, 158–80; Oberhuber 1962 b, 116–49; Oberhuber 1972, especially, 20–24; and Ames-Lewis 1986. Albeit with considerable gaps of sequence, Domenico Ghirlandaio's drawings suggest a similar compositional approach. Cf. Rosenauer 1969, 59–85; Rosenauer 1972, 187–96; Ames-Lewis 1981 b, 49–62; Cadogan 1983 a, 274–90; Cadogan 1983 b, 27–62; Cadogan 1984, 159–72; Cadogan 1987, 63–75; Cadogan 1994, 63–72; and Chris Fischer, "Ghirlandaio and the Origins of Cross-Hatching," *Florentine Drawing at the Time of Lorenzo the Magnificent* 1994, 245–53. The approach is also apparent in Michelangelo's preliminary drawings, cf. Bernadine Barnes, "A Lost *Modello* for Michelangelo's *Last Judgment,*" *MD,* XXVI, 1988, 239–48. Raphael's detailed pen and ink drawing (CBC 250; Städelsches Kunstinstitut inv. 379, Frankfurt), with pricked outlines and heavily rubbed with pouncing dust, portrays the figures intended for the lower left foreground of the *Disputa* in the nude, and in a much smaller scale than that of the final fresco. Revised Data: 282 × 415 mm.; pen and medium brown ink, over black chalk and stylus underdrawing. Two plumblines originate in the upper and lower borders; outlines pricked finely and heavily rubbed with black pouncing dust. Cf. Fischel 1913–41, no. 269; Forlani Tempesti 1968, 375; Dussler 1971, 72; Malke 1980, no. 76; Oberhuber 1982 b (notes 39 and 54); Oberhuber 1983, 13, 21; Joannides 1983, 72–73, nos. 20, 184, cat. no. 205; Knab, Mitsch and Oberhuber 1983, 582, no. 290; Albertina 1983, 80–81, under no. 24; and Ames-Lewis 1986, 78–82. The Frankfurt drawing greatly modifies the arrangement in two earlier *disegni,* Musée Condé inv. Fr.VIII.45, Chantilly (Ames-Lewis 1986, 76–78); and British Museum 1900-8-24-108, London (Gere and Turner 1983, 114–15, no. 88). The Frankfurt drawing also represents the synthesis of individual studies after the nude, living model (British Museum 1948-11-18-39), and exquisite sheets of individual drapery studies (Ashmolean Museum inv. P II 543, 544, and 545, Oxford). Finally, the brush and wash *modello* for this portion of the composition (Albertina inv. V.224, Vienna) streamlines the figural arrangement and fully articulates the dramatic chiaroscuro of the composition, which the separate drapery studies in the Ashmolean already anticipate. The figures in the carefully rendered *disegni* contrast markedly with the unmodeled, loopy, and puppetlike ones in the sole surviving *schizzo* for the *Disputa* (Resta 45/2, Biblioteca Ambrosiana, Milan), which portrays the upper register of the composition. Cf. discussion in Ames-Lewis 1986, 73–92.

142. Vasari, I (testo), 118–21.

143. On Alberti's passage, see Chapter Six. See further Leonardo's note in Paris MS. A (fol. 94 verso) transcribed in Richter, I, 322, § 533 (cf. Richter, *Commentary,* I, 335): "Come · nelle cose · piccole no[n] s'inte[n]de · li errori · come nelle gra[n]di"; and Armenini 1587, 102.

144. Given in full in Richter, I, 362, § 628 (cf. Richter, *Com-*

mentary, I, 365–66): "A preparare il legniame per dipi[n]giere su. . . ." See further Bambach Cappel 1988, Part 1, I:91–97.

145. See also Vasari's description of Perino del Vaga's cartoon for the *Martyrdom of the Ten Thousand* in 1522–23; Vasari 1966–87, V (testo), 129: ". . . Aveva Perino disegnato questo cartone in sul foglio bianco, sfumato e tratteggiato, lasciando i lumi della propria carta, e condotto tutto con una diligenza mirabile. . . ." On this commission, see Wolk-Simon 1992, 70–72.

146. On the damage incurred by cartoons during the working process, see Chapters Two and Eight.

147. On the underdrawing and underpainting techniques of the late Quattrocento and early Cinquecento, cf. Galassi 1988–89; Bambach 1997 b, 21–28; and Galassi 1998. The origins of the oil sketch as a design type would also affect the preparation of easel paintings in the Cinquecento, as pointed out by Bauer 1975 and Bauer 1978, 45–57.

148. Palomino 1947, 580.

149. Bambach Cappel 1988, Part 1, I:105–6.

150. Vasari 1966–87, IV (testo), 20: ". . . La quale opera altrimenti non si fece, onde il cartone è oggi in Fiorenza nella felice casa del magnifico Ottaviano de' Medici, donatogli non ha molto dal zio di Lionardo."

151. Vasari 1966–87, IV (testo), 183: ". . . E fù questa opera [the fresco of the *Expulsion of Heliodorus*] tanto stupenda in tutte le parti, che anco i cartoni sono tenuti in grandissima venerazione. . . ."

152. The two angels' head cartoons are Louvre inv. 3852, 3853, Paris. Data: 277 × 342 mm., 267 × 327 mm.; charcoal, traces of highlighting with leadwhite chalk; reworked by restorers. Cf. Catherine Monbeig Goguel in Grand Palais 1983, 258–60, nos. 83, 84; and Louvre 1992, 230–32, nos. 314, 316. The horse's head is Ashmolean inv. P II 556, Oxford. Data: 681 × 527 mm.; charcoal, highlighted with leadwhite chalk, on several glued sheets of paper; reworked by restorers. Cf. Parker 1972, 300, no. 556, and Gere 1987, 102, no. 23.

153. Vasari 1966–87, I (testo), 27, 68, 118, and Bambach Cappel 1996 a, 91. Bindo Altoviti had the *Drunkenness of Noah* cartoon. Tommaso Cavalieri had, among others, his cartoon portrait. Grand Duke Cosimo I de' Medici obtained cartoons from Leonardo Buonarroti. Michelangelo apparently gave Antonio Mini a great number of cartoons. Bernardo Vecchietti had the *Leda* cartoon. The heirs of Girolamo Albizzi had four pieces of cartoons for the Sistine Chapel. Uberto Strozzi had some remaining pieces of the *Battle of Cascina* cartoon in his house in Mantua.

154. This subject awaits further study. A basis is provided by the fact that cartoons appear to have been bequeathable property, whether left behind by the artists who made them or by the later collectors who acquired them (see Chapter Three). Noteworthy mentions of cartoons occur in the following inventories:

1. MELOZZO DA FORLÌ'S POSSESSIONS, 18 MAY 1493 (BUSCAROLI 1938, 102).

2. GIOVANNI BATTISTA CASTELLO *"Il Bergamasco"*'S POSSESSIONS, 6 JUNE 1569 (ROSSO DEL BRENNA 1976, 390).

3. FULVIO ORSINI'S COLLECTION, 1600 (NOLHAC 1884, 433–34).

4. THE COLLECTION OF FRANCESCO RASPANTINO, DOMENICHINO'S ASSISTANT AND ARTISTIC HEIR, 1664 (SPEAR 1982, 337–46).

5. THE *guardarobba* AND PALACE OF THE FARNESE DUKE OF PARMA, 7 MAY 1697 (*Le Gallerie nazionali italiane: Notizie e documenti,* ROME, 1905, V, 274–75).

6. DEPOSIT OF RAPHAEL'S *School of Athens* CARTOON IN THE LIBRARY OF CARDINAL FEDERICO BORROMEO, 1 JULY 1610 (OBERHUBER AND VITALI 1972, 77–97).

Additionally, numerous cartoons, especially for tapestries, are mentioned in the papers of the Barberini family. See Marilyn Aronberg Lavin, *Seventeenth-Century Barberini Documents and Inventories of Art,* New York, 1975.

155. Armenini 1587, 100 (cf. Armenini 1977, 170–1, for trans.).

156. Vasari 1966–87, V (testo), 241. Cf. Hirst 1988 a, 19–20.

157. Hirst 1988 a, 19–20.

158. See Chapter Three, note 16, for bibliography.

159. For rendered cartoons, see, for instance, CBC 145, 188, 204, 225, 245, 249, 252–53, 256, 261–63, 265, 300–1, 303, 327, 336–38.

160. Louvre inv. M.L. 753, Paris. Cf. Chapter Three, note 173, for data and bibliography. The recto of the design may have been transferred by means of a "substitute cartoon," for the recto does not appear to be rubbed with pouncing dust. A conclusion is, however, not possible, considering the substantial reworking of the recto's drawing with chalks. The verso of the *Isabella d'Este* cartoon is not glued onto a mount, which proves instructive (see Chapter Three). Curiously, this cartoon is rubbed heavily with black pouncing dust from the verso. See Bambach Cappel 1988, Part 2, II:167–168, cat. no. 129; Vienna 1994, 70–74; and Bambach Cappel 1996 a, 84 (and note 9), with a selection of the extensive bibliography. I am indebted to Catherine Monbeig Goguel for the opportunity to study this cartoon, out of its frame, in the paper conservation laboratory of the Musée du Louvre, Paris (July 1991).

161. Royal Library inv. 12808, Windsor. Revised data: 364 × 209 mm.; traces of leadpoint (or charcoal or black chalk), with reinforcements in pen and medium brown ink; outlines pricked from the recto, and probably pounced also from the verso. The sheet is squared in pen and light brown ink at intervals of 50–60 mm. on top of all layers of drawing; there is also a series of parallel, vertical lines at intervals of 60 mm. The sheet was detached from its secondary paper mount in 1979. I am grateful to Martin

Clayton for providing the opportunity to examine this drawing in laboratory conditions. The mechanical character of the Windsor outline drawing makes its attribution extremely problematic. As has been observed, the drawing appears to have been owned by Francesco Melzi, and was numbered "48" perhaps by Pompeo Leoni; it was long grouped with the Windsor Leonardos. Cf. Woldemar von Seidlitz, "I Disegni di Leonardo da Vinci a Windsor," *L'Arte,* XIV (1911), 269–89, no. 223; Popham and Wilde, 1949, 178, no. 32; Clark and Pedretti 1968, I, 187, no. 12808; Keele and Pedretti 1979, II, 814; Carlo Pedretti, "La 'Graticola' del Lamo e i valori simbolici delle forme urbane nel rinascimento," *Centri Storici di Grandi Agglomerati Urbani,* ed. by Corrado Maltese, Comité International d'Histoire de l'Art, IX, Bologna, 1979, 68, 73 (n. 4); Pedretti, "L'Altro Leonardo," *Fra Rinascimento. Manierismo e Realtà: Scritti di storia dell'arte in memoria di Anna Maria Brizio,* Florence, 1984, 17–30, plates 8, 10; Bambach Cappel 1988, Part 2, II:480, no. 351; Bambach Cappel 1994, 17–20; and Bambach Cappel 1996 a, 84 (and note 10).

162. Royal Library inv. 12393, Windsor; as Martin Clayton pointed out to me in conversation (May 1993).

163. Here, note further the studies by Massimo Baldi, Elio Rodio, and Martina Ingendaay on Correggio's use and reuse of cartoons in the dome frescos of Parma Cathedral (reported in Schianchi and Battisti 1981, 46–49, 76–78). Cf. also Ingendaay 1983, 186–88. On fifteenth-century cartoons and cartoon use, note the pioneering work by Eve Borsook: Borsook 1980, xliv–li, 72–73, 88–89, 96–97, 124–26; Borsook 1985, 127–36; and Borsook 1983, 163–73; also note Oertel 1940, 217–314; Degenhart and Schmitt 1968, I-1, xxxvii–xxxxix; and Ames-Lewis 1981 a, 23–32, 53, 157–59, 189. The hypothesis regarding the probable mechanical appearance of fifteenth-century cartoons was explored in Bambach Cappel 1988, especially Part 1, I:214–19; and Bambach Cappel 1996 a, 83–102.

164. Of course, as research continues to demonstrate, the emergence of cartoons slightly before the mid–fifteenth century would modify and at times displace the usefulness of traditional *sinopie.*

165. Illustrated and discussed in Procacci 1961, 69–70, plate 70; Popham 1957, plate XXVII; and Ekserdjian 1997, 108–121, 114, fig. 121 (color).

166. See Ekserdjian 1997, 250, fig. 253 (color).

167. We may also recall the physical evidence on the fresco of the *Birth of the Virgin* (S. Maria Novella, Florence), which establishes that Domenico Ghirlandaio's Chatsworth portrait cartoon (Figs. 214–15) was transferred by means of a partial "substitute cartoon." As previously discussed, the woman's figure below the head is entirely stylus-incised (*incisioni indirette*) in the fresco, and in a comprehensive fashion at that. This excludes the possibility that Domenico's "substitute cartoon" extended beyond the area of the head and suggests that the cartoon used for her body was not rendered as carefully as is the Chatsworth cartoon. Thus, the cartoon stylus-incised on the fresco surface may actually have been a relatively coarse drawing with the head in the form of the "substitute cartoon"

being pasted on or transferred separately. Moreover, as noted, on the fresco surface, the area of the woman's hands exhibits relatively sloppy stylus incisions (*incisioni indirette*). As is true of Ghirlandaio's Virgin and St. Elizabeth in the scene of the *Visitation* on the opposite wall of the chancel or *"cappella maggiore"* (Figs. 286–87), the bodies and hands of many nonportrait figures throughout the cycle are especially coarsely incised.

168. Cf. Bambach 1983, 661–65, and Bambach Cappel 1996 a, 83–102. A stunningly similar brevity of drawing is shared by both Correggio's *sinopia* fragment of the foreshortened Madonna's head at Parma Cathedral (now detached and in the Pinacoteca Nazionale, Parma; see Ekserdjian 1997, 250, fig. 253 in color) and Michelangelo's discarded cartoon fragment portraying the foreshortened head of Haman (Teylers Museum inv. A 16 verso, Haarlem; Figure 236).

169. Louvre inv. 1800, Paris. Cf. Berenson 1938, II, 335, no. 2509 H-8; Berenson 1961, II, 566–67, no. 2509 H-8, fig. 104; Bambach Cappel 1988, Part 2, II:407–9, no. 295; and Bambach Cappel 1996 a, 84–85 (and note 15). This large, mechanical-looking drawing is, however, in a smaller scale than the fresco – a scale that is approximately, but consistently, 1:3. This drawing cannot be a copy, for the material evidence identifies it without doubt as a working drawing (see further, Chapter Nine).

170. Library, Monasterio de San Lorenzo de El Escorial (inventoried according to Angulo and Pérez Sánchez's *Corpus* nos.). On these unattractive cartoons by Francesco da Urbino (Francisco de Urbino), see further Angulo and Pérez Sánchez 1975, 61–63, nos. 253–94; Alfonso Pérez Sánchez, *Historia del dibujo en España de la edad media a Goya,* Madrid, 1986, 144–46; and Bambach Cappel 1988, Part 2, II:436–43, cat. nos. 315–17.

171. Louvre inv. 5988 to 6002, Paris. See Ingendaay 1981, 76–78; and Ingendaay 1983, 185–88. Arthur Ewart Popham firmly dismissed these outline cartoons as tracings from the frescos dating from the Seicento or Settecento; cf. Popham 1957, 6 (note 1); as has Ekserdjian 1997, 260. I have not been able to see most of these cartoons, as they are rolled up and inaccessible in the paintings storage of the Musée du Louvre. Thanks to Françoise Viatte, Catherine Monbeig Goguel, and Catherine Legrand, it was possible to unroll four of the enormous fragments. These are, without doubt, later full-scale copies executed in red chalk or crayon, but see further discussion in Chapter Eleven (and notes 74–75).

172. See Figures 69, 70, 291, and 300. Cf. Colalucci 1990, 72; Colalucci 1994, 77–82; *Michelangelo: La Cappella Sistina, Rapporto;* Borsook 1994, 103–6; and Bambach Cappel 1996 a, 83–102.

173. Cf. Michelangelo, *Carteggio,* III, 301: ". . . se vi paressi fare uno schizzo di carbone o giesso in sul cartone d'un fogl[i]o reale e mandarli intanto . . ."; and Bambach Cappel 1996 a, 95–97, on the context for this phrase. The patron was probably Alfonso d'Avalos, Marchese del Vasto, who was being represented by the Archbishop of Capua, Nicola Schomberg; the cartoon in question must have

been the *"Noli Me Tangere,"* which Pontormo later painted. Cf. Bambach Cappel 1990 a, 497–98, on the terminology of drawing types in Michelangelo's correspondence, and Vasari's general definition of drawing types in the introduction to the *Vite;* Vasari 1966–87, I (testo), 117–21.

174. Teylers Museum inv. A 16, Haarlem. Revised data: 252 × 205 mm.; (verso) charcoal, large foreshortened head; red chalk, small figure study; black chalk, traced through design of Haman from recto; (recto) red chalk. Cf. Bambach Cappel 1996, 96–99; Bambach 1983, 661–65; and Tolnay 1975–80, I, 120–21, no. 164 verso.

175. Cf. Bambach 1983, 663 (fig. 4); and Bambach Cappel 1996 a (figs. 18–19; unfortunately, reversed by the publisher). The reconstruction drawing here illustrated is based on a full-scale tracing of the figure of Haman in the fresco.

176. Cf. Bambach 1983, 664; and Bambach Cappel 1996 a, 95–96.

177. Cf. Bambach 1983, 664–65, and Bambach Cappel 1996 a, 95–96, on the hypothetical working process.

178. I am indebted to the late Fabrizio Mancinelli for having provided the opportunity to verify the correspondence of the design and scale on the restoration scaffolding of the Sistine Chapel. We placed a full-scale transparency of the Haarlem drawing on the actual fresco of Haman (29 March 1990). See Bambach Cappel 1996 a, 96–97.

179. This sheet of drawings can confirm Michael Hirst's general hypothesis that Michelangelo postponed making refined preliminary drawings until the moment of actual execution. As he has pointed out, this seems true of the Sistine Ceiling, as well as of sculptural and architectural projects. See Hirst 1988 a, 25.

180. Some of the vague antecedents in Vasari's text are smoothened in my translation. See Vasari 1962, I (testo), 51: "... Aman; la quale figura fu da lui in scorto straordinariamente condotta ... e quel braccio che viene innanzi non dipinti ma vivi e rilevati in fuori ... figura certamente, fra le dificili e belle, bellissima e dificilissima."

181. Cf. Bambach Cappel 1996 a, 96. I do not think that the unusual cropping of the drawing along its left border is accidental. The detailed preliminary chalk studies for the figure of Haman fail to show the dramatic placement of his left hand upon his face seen in the fresco. Thus, Michelangelo probably did not solve the problem until the cartoon stage. He possibly developed Haman's left hand independently from his face, a device seen also in some of the small-scale red chalk studies for Haman in which parts of the figure are studied separately, and then adjusted this hand to produce the forceful cropping of the face. Changes to the cartoon probably could not be done by simply pasting additional paper on top. This would have made the cartoon's paper too thick to incise with the stylus, in the detailed fashion seen in the fresco surface. Hence, the excision of the unused part of the face was probably necessary.

182. An illuminating discussion on the survival of Michelangelo's drawings is given in Hirst 1988 a, 16–21.

183. On a proposed sequence for the preparatory drawings for the *Punishment of Haman,* see Bambach Cappel 1996 a, 96–98 (and notes 135–37). Cf. Wilde 1953, 24–27, nos. 12–14; and Tolnay 1975–80, I, 118–21, nos. 159 recto, 162–65 recto.

184. The bottom tip of the scene in the pendentive was painted last. *Cf. Michelangelo: La Cappella Sistina, Rapporto* and Bambach Cappel 1996 a, 97.

185. The new aesthetic appearance of the *"ben finito cartone"* may have been partly a response to the demands of the patron, as I have attempted to demonstrate in the case of Leonardo's cartoon for the *Battle of Anghiari* (discussed in Chapter Eight).

186. Vasari 1962, I (testo), 117: "... innanzi che morissi di poco, abruciò gran numero di disegni, schizzi e cartoni fatti di man sua, acciò nessuno vedessi le fatiche durate da lui et i modi di tentare l'ingegno suo, per non apparire se non perfetto." Cf. Bambach Cappel 1996 a, 100–99.

8. The "Substitute Cartoon"

1. As noted, Piero Pollaiuolo's *"ben finito cartone"* of the foreshortened head of *Faith* (Plate II) is among the earliest examples in this tradition, and the first document about the *Arte della Mercanzia* commission of the *Virtues,* to which the cartoon of *Faith* relates, dates from 18 August 1469. Documents are transcribed in Ettlinger 1978, 142–45, 160 (nos. 12 and 31).

2. See further Bambach 1999 b. Art historians have scarcely paid attention to this rich, though complex field. Landau and Parshall 1994, 15–21, 374–77, have related the discussion to the production of prints in Renaissance Europe (with helpful bibliography in the notes to the text). Of the vast bibliography on the history of Italian paper, see particularly G. L. Masetti Zannini, "Produzione e commercio della carta in documenti notarili romani del Cinquecento," extract from *Bollettino dell'Istituto di Patologia del Libro "Alfonso Gallo,"* XXX (1971), *fascicoli* 3–4; R. Sabbatini, "La produzione della carta dal XIII al XVI secolo: strutture, tecniche, maestri cartai," *Tecnica e società nell' Italia dei secoli XII–XVI,* Pistoia, 1987, 37–57; and L. Avrin, *Scribes, Script and Books: The Book Arts from Antiquity to the Renaissance,* Chicago-London, 1991, 288–94. Note also the acts of the conference held on 15–20 April 1991, organized by the Istituto Internazionale di Storia Economica "F. Datini" Prato, *Produzione e commercio della carta e del libro secc. XIII–XVIII,* Florence, 1992.

3. See further Bambach Cappel 1988, Part 1, II:83–149. Of a vast literature, note the following contributions regarding theory and practice: Procacci 1976, 35–64; Wolk-Simon 1992, 61–82; and Nova 1992, 83–100.

4. Because of descriptions in primary sources (on which, see later), I have advocated for this drawing type the use of the term "substitute cartoon," rather than "duplicate cartoon," as it is sometimes named in the literature. "Substitute cartoon" translates Joseph Meder's term *"Ersatzkarton,"* the first modern recognition of this drawing type. Visual and textual evidence, emerging since Meder's book, reinforces the correctness of his term. On the "substitute cartoon," cf.

Meder 1923, 530 (Meder and Ames 1978, I, 395); Tolnay 1972, 23; Oberhuber and Vitali 1972, 9–10; Oberhuber 1972, 22; Borsook 1980, li; Borsook 1985, 130–1; *Tecnica e stile* 1986, I, 131; Bambach Cappel 1987, 131–47; Bambach Cappel 1988, Part 1, I:101–17, 135–47, II:346–56; Danti 1990, 48; Bambach Cappel 1992 a, 9–30; Henry 1993, 612–19; Finaldi, Harding, and Wallis 1995, 6, 18 (note 10); Henry 1996, 253–70; Danti 1996, 141–49; Bambach Cappel 1996 a, 83–102; and Bambach 1999 b.

5. Pozzo 1693–1700, II, unpag., "Settione settima, ricalcare . . . con una punta di ferro andarete legermente premendo i contorni. . . ."

6. I am indebted to the late Fabrizio Mancinelli, Arnold Nesselrath, and Enrico Guidi for the opportunity to study this fresco from the scaffolding erected for the fresco's cleaning (summer 1992).

7. Here, the *intonaco* had already largely set before the cartoon was transferred and the pigment layer added. The detailed incisions, deeply excavated and a great deal more descriptive than in the *Battle of Ostia,* must have destroyed the cartoon during the transfer process. On this fresco, cf. Umberto Baldini in Metropolitan Museum of Art 1968, 164–66; Bellosi 1990, 179; Adorno 1991, 256–57; Bellosi 1992, 134–38, no. 18; and Butterfield 1997, 193, 197.

8. Palomino 1724, Book VII, chapter IV:iii, 100: "[cartón] aviéndolo de estarcir, y *ensuciar* con el polvo de carbón. . . ." Cf. also texts given here in notes 20, 28, and 29. Recall also discussion in Chapter Two.

9. Transcription is as given by Carlo Pedretti in Richter, *Commentary,* I, 382, *sub numero* 669: "(In venerdj dj gugno/aore 13)//Addj 6 dj gugno ^ 1505 ^ invenerdj altocho/delle 13 ore comjcaj acolorire in/palazo · nel qual pūto del posare il/penelo si guasto il tēpo essono abā/cho richiedendo li omjnj aragone il/cartone sistracco lacqua siuerso eru/pesi il uaso dellacqua chessi portaua/esubito si guasto il tenpo eppi-ove/insino assere acqua grādjssima/cstette il tenpo come notte." This passage has been variously interpreted. Cf., for instance, Pedretti 1968, 53–58 (with discussion of the previous bibliography); Kemp 1989, 238; and Giovanna Nepi Sciré in *Leonardo & Venezia* 1992, 257.

10. On the letters and account book regarding Lorenzo Lotto's cartoons and the production of the wood *intarsie* in the choir of S. Maria Maggiore, Bergamo, cf. Cortesi Bosco 1987, II. See Chapter Eleven. The appendix of Andrea Pozzo's treatise (*Perspectiva Pictorum et architectorum,* Rome, 1693–1700), the "Breve instruttione per dipingere a fresco," can clarify for us the merits of *calco* relative to *spolvero* in transfering cartoons.

11. Armenini 1587, Book II, 104 (cf. Armenini 1977, 174, for trans.): ". . . Ma à salvarli poi illesi, dovendosi dopo questo calcar i contorni di quello sù l'opere che si lavorano, il miglior modo si è à forarli con vn ago, mettendoci vn altro carton sotto, il qual rimanendo come quello di sopra bucato, serve poi per spolverare di volta in volta per doue si vol dipingere, e massime sù le calce, à benche molti poco di ciò curandosi, calcano il primo, il qual si tien tuttauia per esempio, mentre si fa l'opera con i colori, il che è più commodabile il primo. . . ." Passing allusions to the prac-

tice also occur in Armenini 1587, 113–14, 120, 125. See discussion in Bambach Cappel 1988, Part 1, I:103–17, 136–47, 163–70; I:2, 346.

12. See Armenini 1587, 76–77 (cf. Armenini 1977, 147–48, for trans.), on the *calchi* by Giulio Romano, Polidoro da Caravaggio, and Perino del Vaga; further discussed in Bambach Cappel 1988, Part 1, I:138, 239–40, II:398–99. Edward J. Olszewski has drawn attention to Armenini's respect for and knowledge of the Raphael school (in Armenini 1977, 60).

13. Bisagno 1642, 87–88. The contents of Bisagno's chapters XI and XII on cartoons, cartoon transfer, and fresco painting are identical to Armenini's treatise.

14. Perrot 1625, xiv: ". . . Pour conserver votre dessein ou estampe, il faut coudre à votre estempe ou dessein, deux papiers de même grandeur avant que le piquer, parce que vous passerez votre ponce sur l'un de ces papiers. . . ."

15. Ibid., xiv: ". . . & votre dessein ou estempe vous servira pour corriger les fautes qui seroient faites sur votre velin, pour les traits ni être pas entierèment. . . ."

16. Saint-Aubin 1770, 5 (cf. Saint-Aubin 1983, 20, for trans.): ". . . Quand ces dessins ont été agréés, il les calque (a) au papier huilé (b), double ce papier d'un autre qu'on nomme *grand-raisin,* & les fait piquer ensemble."

17. Vasari 1966–87, I (testo), chap. XXI, 134 (cf. Vasari 1960, 231, for trans.): ". . . Dopo, distesa detta mestica o colore per tutta la tavola, si metta sopra essa il cartone che averai fatto con le figure e invenzioni a tuo modo, e sotto questo cartone se ne metta un altro tinto da un lato di nero, cioè da quella parte che va sopra la mestica. Appuntati poi con chiodi piccoli l'uno e l'altro, piglia una punta di ferro overo d'avorio o legno duro e va' sopra i proffili del cartone segnando sicuramente, perché così facendo non si guasta il cartone, e nella tavola o quadro vengono benissimo proffilate tutte le figure e quello che è nel cartone sopra la tavola." See Borghini 1584, Book II, 173: "Poi sopra questo quadro appicherete il vostro cartone, e fra il cartone, & il quadro un foglio bianco della medesima grandezza tinto di poluere di carboni da quella parte, che si possa sopra l'ingessato, & andate calcando sopra i lineamenti, come altre volte ho detto, e vi verrà il vostro disegno sul quadro, & il cartone vi rimarra saluo, e poscia potrete à vostro piacere andar dipignendo co'colori. . . ." Cf. Bambach Cappel 1988, Part 1, I:103–17, II:346.

18. Boutet 1676, 2, under *Calquer:* ". . . il en faudra noircir le dessous, ou un *autre papier* avec du crayon noir . . . ;" cf. also *The Art of Painting in Miniature* 1752, 2. Moreover, note Bosse 1745, 57: ". . . mettant entre deux *un papier blanc* dont le côté qui regarde le cuivre est rougi avec de la sanguine. . . ." See further L. Avocat [Lacombe], *Dictionnaire portatif des Beaux-Arts, ou abrégé de ce qui concerne l'Architecture, Sculpture, la Peinture, la Gravure, la Poésie & la Musique,* Paris, 1752, 121–22, under "calquer: ". . . que le papier rougi ou nourci, qu'on met *entre* le Dessin & le Papier, le Velin . . ." (italics are mine).

19. Vasari 1966–87, I (testo), 134 (cf. Vasari 1960, 231, for trans.): ". . . perché così facendo non si guasta il cartone. . . ."

20. See definition of *"piquer"* in Saint-Aubin 1770, 39 (cf.

Saint-Aubin 1983, 75, for trans.): ". . . On pique souvent quatre ou cinque papiers ensemble; ces percés servent à faire les dessins marqués qu'on donne dans les différents atteliers."

21. It was not necessary that the "substitute cartoon" be also drawn with charcoal, chalk, or pen, for the carefully rendered original cartoon provided such a guide. We may speculate that artists drew on a "substitute cartoon" if they intended to draw a revised cartoon for a composition. In such a case, the subsequent drawing, done upon the basis of preexisting pricking or incision, became another full-scale draft, but one itself requiring transfer. See Bambach Cappel 1987, 131–42; Bambach Cappel 1988, Part 2, I:255–56, no. 188; Bambach Cappel 1992 a, 9–30; and Bambach Cappel 1996 a, 87–88.

22. Palomino 1724, Book V, chapter VIII:ii, 58: ". . . y después lo pican sobre otro papel *limpio,* para que este sirva para estarcir . . ." (italics are mine.)

23. Borghini 1584, book II, 173: ". . . Poi sopra questo quadro appicherete il vostro cartone, e fra il cartone, & il quadro un foglio *bianco* della medesima grandezza tinto di poluere di carboni da quella parte, che si possa sopra l'ingessato, & andate calcando sopra i lineamenti, come altre volte ho detto, e vi verrà il vostro disegno sul quadro, & il cartone vi rimarra saluo, e poscia potrete à vostro piacere andar dipingendo co'colori . . ." (italics are mine.) Cf. Bambach Cappel 1988, Part 1, I:113–17, II:346.

24. Bosse 1745, 57: ". . . mettant entre deux *un papier blanc* dont le côté qui regarde le ciuvre est rougi avec de la sanguine . . ." (italics are mine).

25. Cf. Bambach Cappel 1996 a, 87 (and notes 38–39). The remnants of these perpendicular joins of paper, which I previously overlooked (Bambach Cappel 1987), determine the original orientation of the perforated design of the male nude pelvic area. This orientation, as established by the joins of paper, fully corresponds with the detail in the fresco before its repainting with the loincloth. This further supports my original proposal published in 1987 that the design relates to St. Peter.

26. On the transfer of "substitute cartoons" to the *intonaco,* see Bambach Cappel 1996 a, 88–89.

27. We may rely on the following ordered set of general criteria for the examination of this archaeological evidence. The more criteria a particular object meets, the more firmly we can establish the use of the practice. First, we may consider drawings with pricked outlines, in relatively good condition, but which do not appear to be rubbed with pouncing dust. Here, it cannot be overlooked, however, that the presence of pouncing dust is not always easily discerned if the surface of a drawing is heavily abraded or stained from wear. Moreover, as noted in Chapter Two, rubbed pouncing dust is inherently ephemeral and can easily be erased. Artists and artisans could also lightly touch a design with the pouncing bag, leaving little or no trace of the process. Early restorers of drawings often cleaned the offensive presence of pouncing dust. Second, we may attempt to identify sheets with pricked but undrawn outlines. There is an abundant corpus of Italian Renaissance

drawings with unrelated prickings. A group of such possible "substitute cartoons" – sheets with unrelated pricked outlines and that lack corresponding drawings – is discussed and catalogued in Bambach Cappel 1988, Part 2, I:91–92, 142–44, 200–1, II:274–75, 401–2, 404–5, 470–71, nos. 58, 108, 150, 199, 291, 293, and 343. Connections to identifiable paintings (or other works of art) are, however, not forthcoming, and the paper was later reused for drawing. Sheets that are possible "substitute cartoons" can easily be confused with those in which a sheet apparently shows an unrelated pricked design but whose pricking can be demonstrated to have been done from the sheet's verso, the verso being unviewable because the sheet is glued onto a mount. Such sheets may thus not exemplify the practice of "substitute cartoons," for the prickings may correspond to drawings on the unviewable versos. Note, for example, *ibid.,* Part 2, I:59–61, 92–94, 98–99, 149–50, 231–32, II:473–75, nos. 28, 59, 63, 114, 177, and 347. The distinction between these two types of sheets has become clearer to me since the writing of my Ph.D. thesis, in which I classified both types as part of the same group. Particularly no. 114 reflects my revised interpretation; nos. 312–13 (Part 2, II:430–34) may be omitted entirely from consideration in this context, for the unrelated prickings definitely lie between layers of ground preparation. In these cases, the presence of rubbed pouncing dust is one of the only ways to separate "substitute cartoons" from accidental prickings, when a sheet inadvertently lay underneath another being pricked. The third criterion relies on the identification of relatively large cartoons, connected with murals comprised of several *giornate,* but in which the joins of the cartoon's paper are in their rectilinear, undisturbed structural state. Finally, there are paintings for which there exist relatively finished cartoons with pricked outlines, but in which the painting surface exhibits stylus-incised outlines *(incisioni indirette).*

28. British Museum, Department of Oriental Antiquities, inv. 1919-1-1-073 (2), London. Data: 560 × 380 mm. Cf. Whitfield and Farrar 1990, 88, nos. 71–72, on the Chinese stencils from the *"Caves of the Thousand Buddhas"* at Dunhuang, but this particular example is not catalogued there.

29. See Chapter Six, note 268, and Bambach Cappel 1996 a, 85–86 (and notes 19–23).

30. See Chapter Six, note 265, for technical data.

31. See Chapter Six, note 272, for technical data.

32. Ashmolean Museum inv. P II 523, Oxford. Data: 271 × 216 mm.; (recto) pen and light brown ink; (verso) pen and light brown ink, dark brown ink, black chalk; unrelated pricked outline design of a head. For a diversity of opinions, cf. Fischel 1913–41, II, 112–13, no. 87; Parker 1972, II, 271–72, no. 523; Gere and Turner 1983, 67, no. 46; Joannides 1983, 154, nos. 88 recto and verso; Knab, Mitsch, and Oberhuber 1983, 571, no. 165 (recto), 572, no. 173 (verso); Bambach Cappel 1988 Part 1, I:350–52, Part 2, II:344–345, no. 251, plates. 85–87; Bambach Cappel 1992 a, 9–30; Henry 1993, 612–19; and Henry 1996, 253–70.

33. It is not clear whether this mysterious pricked head relates to (1) a figure in a lost composition by Raphael; (2) a figure

on the lower right, leaning over the parapet in Raphael's *Disputa* fresco in the *Stanza della Segnatura* (Vatican Palace), from about 1509–10; or (3) a figure in Luca Signorelli's fresco of the *Resurrection of the Flesh* (Orvieto Cathedral), from 1499–1504. In my opinion, attempts at relating the pricked outlines on this sheet, which has an autograph drawing by Raphael on the recto (precisely datable to 1504–6, I think), to the *oeuvre* of any artist other than Raphael, presuppose a traffic in drawings from *bottega* to *bottega* that does not seem quite probable (pace Henry 1993, 1996). I proposed the possible relationship of this pricked outline design of a head to the *Disputa* in Bambach Cappel 1992 a, 9–30. Although the connection to the *Disputa* may be doubted, the Ashmolean pricked design could well relate to another work by Raphael. Cf. Henry 1993, 612–19, and Henry 1996, 253–70, on the tantalizing, although problematic, connection to Signorelli's work. The hypothesis by Tom Henry still begs the question of why a pricked design by Signorelli could have gotten onto a sheet of drawings that is clearly by Raphael. His articles illustrate the superimposition of a tracing on acetate with the pricked holes from the Ashmolean drawing by Raphael over the stylus-incised, partly repainted detail in the fresco by Signorelli. We should keep in mind, however, that with this method of illustration Signorelli's fresco is given a greater precision of outline than it actually has, if we study it without the overlaid acetate tracing.

34. The rigid and mechanical character of the ink line on the verso suggests that a later draughtsman-restorer attempted to connect the holes to reconstruct the image; a number of holes were left unconnected, and the color of the ink is dark brown, rather than golden brown, as in the autograph studies on the recto.

35. See Figure 30. Pinacoteca Ambrosiana inv. 126, Milan. Data: 2850 × 8040 mm. (maximum); charcoal, partly reworked with black chalk, partially stumped, over traces of stylus underdrawing, stylus ruling, ruled lines in red chalk, and squaring in charcoal or black chalk, outlines pricked, on many glued sheets of paper (195 sheets according to Tsuji 1979, 159; 210 sheets according to Oberhuber 1983, 33). Cf. Luca Beltrami, *Il Cartone di Raffaello Sanzio per la Scuola d'Atene in Vaticano*, Milan, 1920; Fischel 1913–44, VII, nos. 313–44; Dussler 1971, 73–74; Oberhuber and Vitali 1972, 9–10; Oberhuber 1972, 22; Tsuji 1979, 159; Joannides 1983, 82, 191, plate 25, no. 234; Oberhuber 1983; Knab, Mitsch, and Oberhuber 1983, 589, no. 362; Ames-Lewis 1986, 99–100; Matthias Winner, "L'Autoritratto di Raffaello e la misura per il nostro occhio: Appunti sulla costruzione prospettica della Scuola d'Atene," *Tecnica e stile* 1986, I, 83–94; Bambach Cappel 1987, 134, 141; Bambach Cappel 1988, Part 1, I:229–30, II:348–49; Part 2, II:353–54, no. 256; and Bambach Cappel 1992 a, 9–30. It was not possible for me to conduct a refined analysis of the archaeological evidence in the Ambrosiana cartoon, despite numerous attempts, because the Pinacoteca–Biblioteca Ambrosiana was closed from 1988 until late 1997, for building renovation.

36. See Figures 30, 31, 39–41, 228, and 282. As the result of the most recent cleaning, it is clear that the archaeological evidence on the fresco surface of Raphael's *School of Athens* is far more complex than has been assumed. Further, detailed documentation is sorely needed. From my preliminary observation, and contrary to what has been sometimes stated, there are indeed extensive passages of *spolvero* within some figures (which are pricked in the Ambrosiana cartoon) – for instance, in the lower right quadrant, on the full head of blond hair of the kneeling youth beholding Euclid on the left. Above him, the Leonardesque figure in profile, bears *incisioni dirette* on the hair, probably a reinforcement of faint *spolvero* dots. The figure immediately above Euclid, whose face is seen in shadow, bears a very general *incisione diretta* facial outline. The youth's upturned head, at the same level as Euclid's head to the left, bears more detailed, but very crude, *incisioni dirette* on the facial features. In my opinion, there is thus a good possibility that greater portions of the cartoon for the fresco were transferred by means of *spolvero*, which was then reinforced with *incisioni dirette*, than has thus far been suggested (cf. Oberhuber and Vitali 1972). The general correspondences of ruled outlines in the Ambrosiana cartoon to the stylus-constructed architecture in the fresco, at the levels of the figures, also need our attentive refinement. The unfortunate – missed – opportunity of having had the Ambrosiana cartoon available for consultation at the same time that the fresco was being cleaned, impeded my archaeological research. I am deeply indebted to the late Fabrizio Mancinelli, Arnold Nesselrath, and Enrico Guidi for having arranged my visits to the scaffolding erected for the cleaning of the *School of Athens* fresco (March–August 1994).

37. For the *giornate*, see Redig De Campos 1984, unpag.

38. See Figure 30. In my demonstration of this point, I refer, for the reader's convenience, to the excellent reproductions of the cartoon in Oberhuber and Vitali 1972, and for the *giornate* to the diagram published by Redig de Campos 1984. Plate 2 (cf., for details of paper seams, plates 3–18), "*primo settore del cartone*," is equivalent to approximately 13 *giornate* in the fresco, excluding the architectural frame around the door. Plate 19 (cf. for details, plates 20–33), "*secondo settore del cartone*," is equivalent to 16 *giornate*, including Heraclitus who does not appear in the cartoon. Plate 34 (cf. for details, plates 35–46), "*terzo settore del cartone*," is equivalent to 10 *giornate*. Plate 47 (cf. for details, plates 48 to 70), "*quarto settore del cartone*," is equivalent to 16 possible *giornate* (includes 2 *giornate* seams that are not certain). Redig De Campos's diagram of *giornate* can be slightly modified, as the result of new data from the recent cleaning of the fresco.

39. Redig de Campos 1984, 16–17. In the fresco, the broadly painted figure of Heraclitus, which, as is well known, does not appear in the Ambrosiana cartoon and whose two *giornate* are a palimpsest on the *intonaco*, shows *spolvero* from a cartoon on his hands around his knees. The rest of his figure, however, like many others in this composition, was stylus-incised directly on the plaster and indirectly through cartoon paper. The combined evidence in the Heraclitus of both *spolvero* and *calco* – that is, alternating, destructive means of transfer – suggests that the design of this figure,

added after the fresco had been executed, derives from a now lost cartoon, also indicating that this cartoon was probably not transferred by means of a "substitute cartoon." The lost cartoon for Heraclitus may have been more of a functional outline drawing than a highly rendered drawing in the manner of the Ambrosiana cartoon. I am indebted to the late Fabrizio Mancinelli, as well as to Arnold Nesselrath, and Enrico Guidi for arranging my study of the fresco.

40. See further Bambach Cappel 1992 a, 9–30. Comparison of the fresco of the *School of Athens* to the Ambrosiana cartoon regarding the two figures completing the right border of the composition – the presumed portraits of Raphael and Sodoma that are only very faintly and partly sketched out in the cartoon – suggests that they were not entirely improvised. Deoclecio Redig de Campos first noted that their faces, necks, and parts of their shoulders were stylus-incised directly on the *intonaco* without the intermediary means of a cartoon. Cf. Dioclecio Redig De Campos, "Notizie intorno all'autoritratto di Raffaello nella Scuola d'Atene," *Rendiconti della Pontificia Accademia di Archeologia,* XXVIII (1955–56), 251–57, figs. 1–3; De Campos 1984, 18, plate 20. The incisions form *pentimenti* and webs of intersecting, sketchlike reinforcement lines. These reinforcement lines appear lightly scribbled and do not correspond precisely to the painting. The stylus left multiple, slight crater-like ridges on the plaster. These faces were thus ultimately painted *alla prima,* probably from smaller-scale drawings. Yet, in the fresco, Sodoma's body and robes in the large *giornata* below that which includes his and Raphael's heads were stylus-incised from a cartoon. Here the incisions are scanty, unilineal, and broad, like most incisions on other figures in the fresco (see further, Chapter Ten). Additionally, as Konrad Oberhuber and Lamberto Vitali have pointed out, in the Ambrosiana cartoon some of the sketchy, fragmentary outlines defining Sodoma's head are pricked, though those of Raphael's are not. Cf. Oberhuber and Vitali 1972, 22, plates 47, 68, and Oberhuber 1983, 43. For the figure of Sodoma, there must have existed a drawn cartoon, albeit fragmentary, for it may have either lacked a head or depicted another head, later discarded, and possibly a "substitute cartoon." This would explain the otherwise conflicting physical evidence.

41. Michelangelo's use of "substitute cartoons" in the Sistine Ceiling is discussed in detail in Bambach Cappel 1996 a, 83–102. Use of the practice probably explains the reason why Michelangelo could make a present to Bindo Altoviti of the presumably intact cartoon for the *Drunkenness of Noah,* the second *historia* to be painted, as recorded in Vasari's *Vite,* and the reason why the heirs of Girolamo Albizzi could own four pieces of cartoons for the Sistine *ignudi* and *prophets,* said to have been brought back from France by Benvenuto Cellini. See Vasari 1962, I (testo), 118: "... e Messer Bindo Altoviti, al quale donò il cartone della Cappella dove Noè inebriato è schernito da un de'figliuoli e ricoperto le vergogne dagli altri dua." Ibid., 68: "... A Firenze è ritornato poi il cartone della Leda, che l'ha Bernardo Vecchieti, e così 4 pezzi di cartoni della Cappella

di Ignudi e Profeti, condotti da Benvenuto Cellini scultore, oggi appresso agli eredi di Girolamo degli Albizzi." That Vasari reconstructed a kind of provenance for the Sistine Ceiling cartoons, suggests that these *"ben finiti cartoni"* must have been among the master's most admired and collectible drawings. Vasari also recorded the owners of cartoons drawn by other famous artists. On this issue in Vasari's *Vite,* cf. Bambach Cappel 1988, Part 1, I:103–8 (and notes 138, 141).

42. As Michelangelo's *giornate* for the Sistine Ceiling scenes became fewer and larger, and the scale of his figures increased, his methods of cartoon transfer became less precise. As suggested in Chapter Seven, Michelangelo's cartoons may have become increasingly rough and schematic, evolving into functional outline cartoons rather than *"ben finiti cartoni."* As this transition occurred, which may be generally gauged by the transition from *spolvero* to *calco,* "substitute cartoons" were no longer necessary. The use of "substitute cartoons" may have indeed ended with the last scenes painted during the first *pontata,* the *Temptation and Fall,* in which the first signs of combined methods of cartoon transfer appear on the *intonaco,* and the *Creation of Eve.* Although most of the scene of the *Temptation and Fall* is pounced, the head of the avenging angel, the last *giornata* painted, bears the schematic, shallow incisions from a stylus-traced cartoon. The *Creation of Eve* is still entirely pounced. This moment of transition must have coincided with the drastic reduction of Michelangelo's workshop help. In these last scenes of the first *pontata,* the scale of the figures becomes monumental and the number of *giornate* decreases to only eleven in the *Temptation and Fall* and three in the *Creation of Eve.* Cf. discussion in Mancinelli 1988a, 12–14; Mancinelli 1988 b, 540–41; Mancinelli 1990, 57; and Bambach Cappel 1996 a, 91–97. On Michelangelo's workshop assistance in the Sistine, see Biagetti 1936, 199–220; Wallace 1987, 203–16; Mancinelli 1988 b, 538–41, 551; Mancinelli 1990, 55–59; and Bambach Cappel 1996 a, 83–102. The two figures with stylus-incised outlines in the *Sacrifice of Noah* can clearly be ruled out as evidence, for they were repainted on new *intonaco* by Domenico Carnevali in the 1570s. Cf. Gianluigi Colalucci and Anna Maria De Strobel in *Michelangelo e la Cappella Sistina* 1990, 97–100, 280.

43. Bambach Cappel 1987, 131–42 (with previous bibliography), and Bambach Cappel 1996 a, 87–90. On the cartoon, cf. Tolnay 1975–80, III, 48, 384 r; Muzii 1988; and Hirst 1988 b, 128–32, no. 53.

44. For the *giornate,* cf. Baumgart and Biagetti 1934, plate L, and Bambach Cappel 1996 a, 87–88 (and notes 34–40).

45. That the outlines of Michelangelo's British Museum cartoon are apparently neither incised nor pricked is usually noted with some consternation in the literature. Cf. also Steinmann 1925, 2–16; Wilde 1953, 114–16, no. 75; Tolnay 1975–80, III, 52–53, no. 389; Hirst 1988 a, 75–77; Bambach Cappel 1990 a, 497; and Bambach Cappel 1996 a, 90–91 (and notes 71–73). The written sources help provide further clues, for the early history of this cartoon is exceptionally well documented (Wilde 1953, 114–16, no. 75). Like the Naples cartoon fragment, the so-called *"Epifania"* cartoon

entered the collection of Fulvio Orsini: each is already recorded as *"corniciato di noce"* in the Orsini inventory of 1600 (Nolhac 1884, 433). The framing of both cartoons required backing onto secondary supports. As is visible today in the *"Epifania"* cartoon, as well as in the Naples cartoon fragment before conservation, the process of gluing caused the creasing and subsequent buckling of the cartoon's paper when it adapted to the secondary support. The *"Epifania"* cartoon is mounted on wood (Wilde 1953, 114–16, no 75). The Naples cartoon fragment is lined with canvas (Muzii 1988, 14, fig. 3). The backing would have diminished much of the evidence of cartoon transfer by stylus incision, especially if the incisions were shallow, but certainly not the evidence of pricking, as is true of the Naples cartoon fragment. Despite such exceptional cases as Michelangelo's Pauline frescoes, the date of the *"Epifania"* cartoon, soon after 1550, would suggest a greater likelihood that the drawing was traced rather than pricked (on the problem, see Chapter Eleven). Vasari's account of Condivi as one of Michelangelo's pupils in the second edition, "e pestò parecchi anni intorno a una tavola, che Michelagnolo gli aveva dato un cartone; . . ." referring to Michelangelo's *"Epifania"* cartoon and Condivi's panel painting, establishes the biographer's knowledge of the medium and support of this painting. See Vasari 1962, I (testo), 120. The cartoon's subject is often identified as *"Epifania,"* but for a convincing proposal, see Gombrich 1986, 171–78.

46. This seems true especially of the contours of the two children's heads and of the raised arms of the child on the lower right. That Condivi blackened the verso of the cartoon itself can be discounted because it would have damaged the drawing.

47. See Bambach 1999 b. The 1389 statutes of Bologna list prices per *"risima"* for three different grades of *"cartas reales,"* prices that remain identical in the 1454 statutes: *"fina"* at 5 Bolognese lire 10 soldi, *"azura"* (spelled *"açura"* in 1454; i.e., blue paper) at 4 Bolognese lire, and *"a strazo"* (spelled *"a straço"* in 1454; i.e., paper made of coarse rags) at 2 Bolognese lire 10 soldi.

48. Cf. Junquera 1963, II, 551–78. Miguel Barroso was paid 748 *reales* for eleven of the Escorial embroidery designs (cf. Fray Julián Zarco Cuevas, *Pintores españoles en San Lorenzo el Real de El Escorial,* Madrid, 1931, 65–66, 147–48; Junquera 1963, II, 578). Diego López de Escuriaz and Navarrete El Mudo were also on the payroll between 1587 and 1589 (cf. Junquera 1963, II, 578, with the qualification that the actual documents have not been found). A more complete bibliography on this project is given in Appendix Three, note 6.

49. Victoria and Albert Museum MS. L 7446–1861, London. See Chapter Five, note 160.

50. The J. Paul Getty Center inv. 880209, GJPA88-A274, Los Angeles. I am indebted to Catherine Hess for bringing this archive to my attention; she will publish its contents in detail.

51. On the pavements, see Vasari's *Vita* of Beccafumi, which was included only in the 1568 edition; Vasari 1966–87, V (testo), 173–74, although without mention of the cartoons. Cf. Marco Collareta, "'Pittura commessa di bianco e nero.'

Beccafumi nel pavimento del Duomo di Siena," *Beccafumi e il suo tempo* 1990, 652–76; 504–8, nos. 175–76 (cartoons); 686–87 (documents).

52. Cf. Sanminiatelli 1967, 164–65, no. 119, and Torriti 1981, 173, no. 429.

53. For a sampling, see *Beccafumi e il suo tempo* 1990, cat. nos. 120–21, 123, 127, 129–30, 147, 151, 155.

54. See photographs in Torriti 1981, 146 (no. 423, plate 164); and Giulio Briganti, *L'opera completa del Beccafumi,* Milan, 1977, plates VI, XIII.

55. Vasari 1966–87, I (testo), 153–55 (cf. Vasari 1960, 258–60, for trans.).

56. Vasari 1966–87, I (testo), 142–43 (cf. Vasari 1960, 243–44, for trans.), and repeated in Vasari's *Vita* of Andrea di Cosimo Feltrini; Vasari 1966–87, IV (testo), 521.

57. Vasari 1966–87, I (testo), 120–21, 134, 147–51 (cf. Vasari 1960, 215, 231, 255–56, for trans.) The author treated inlaid pavements as a type of mosaic: Vasari 1966–87, I (testo), 152–55 (cf. Vasari 1960, 258–60, for trans.).

58. Vasari 1966–87, I (testo), 152–55 (cf. Vasari 1960, 258–60, for trans.). Cf. also discussion of materials and process from extant documents in Gail Schwarz Aronow, *A Documentary History of the Pavement Decoration in Siena Cathedral, 1362 through 1506* (Ph.D. Dissertation, Columbia University), New York, 1985 (UMI Microfilms, 1989).

59. See document transcribed in *Beccafumi e il suo tempo* 1990, 686, no. 111.

60. Payment records between 18 March 1530 and 8 August 1531 name the *"scalpellini"* (marble carvers): Giovanni d'Antonio, Bernardo di Giacomo, and Piero Gallo. See *Beccafumi e il suo tempo* 1990, 687, nos. 114, 118–19, and 120.

61. The early provenance of Beccafumi's cartoons is well documented, their first owner having been Giovan Battista Sozzini, who sold them in 1565 to Tiburzio Spannocchi (discussed in Torriti 1981, 162).

62. The following summary is based on greatly more detailed research on the cartoon documents for Leonardo's *Battle of Anghiari* and Michelangelo's *Battle of Cascina,* published in Bambach 1999 b.

63. Cf. Johannes Wilde, "The Hall of the Great Council of Florence," *JWCI,* VII (1944), 65–81; Wilde, Michelangelo and Leonardo," *BM,* XIV (1953), 65–77; Charles de Tolnay, *The Youth of Michelangelo,* Princeton, 1947, 216; H. Travers Newton, and John R. Spencer, "On the Location of Leonardo's *Battle of Anghiari,*" *AB,* LXIV (1982), 45–53; Kemp 1989, 234–45. What follows below is a drastic rereading of the documents, in contrast to Isermeyer 1963, 83–130.

64. See document transcribed in Frey 1909, 129 (no. 161): "y [lire] 26 sol. 10 per una lisima et quaderni diciotto 18 di fogli reali a sol. 12 et sol. 11 el quaderno, ebbe Lionardo da Vincio per fare el cartone alla sala, et per quadratura et apianatura di decti fogli, . . ." Cf. Beltrami 1919, 84 (no. 137), and Isermeyer 1963, 114 (Dok. III).

65. See document transcribed in Frey 1909, 134 (no. 219): "A rede di Lorenzo Perj cartolaj . . . et per tre quaderni di foglj Bolognesi reali per la pictura, datj a Lionardo da Vinci, a sol. 11 el quaderno. . . ." Cf. Beltrami 1919, 100 (no. 165); and Isermeyer 1963, 122 (Dok. XI).

66. Here, my figures reflect the variation of dimensions for the *reale* size, as incised on the marble slab at the Museo Civico Medievale, Bologna (Appendix One), but I do not take into account the variable, though minor, dimensions from the overlapping of joins or square cropping *(quadratura)* necessary for assembly, which represent small, but much too speculative, numbers.

67. See documents transcribed in Frey 1909, 133 (nos. 193, 198); on 31 October 1504: "A Bartholomeo di sandro cartolaio y VII per 14 quadronj di foglij reali Bolognesi per il cartone di Michelangelo . . . y 7 sol."; on 31 December 1504: "A Bartholomeo di Saluadore del Fontana cartolaio per 3 quaderni di fogli, auti per fornire il cartone, che fa Michelangelo dipintore, a sol. 10 el quaderno: in tutto . . . y 1 sol. 10." Cf. Isermeyer 1963, 118 (Dok.VI,VII).

68. Norms for my reconstruction are as qualified in note 66.

69. See document transcribed in Frey 1909, 132 (no. 177): "A Giovannj di Landino fornaio y VII sol.V per libre 88 di farina stacciata biancha, data a Lionardo da Vinci in dua uolte, et rinpastare el cartone: in tutto. . . . y 7 sol. 5." Cf. Beltrami 1919, 91 (no. 145), and Isermeyer 1963, 118 (Dok.V).

70. See document transcribed in Frey 1909, 130–31 (no. 175). Cf. Beltrami 1919, 87–89, (no. 140); and Isermeyer 1963, 116–17 (Dok. IV). Other noteworthy examples of cartoons serving the purpose of contractual drawings are discussed in Chapter Seven (and notes 50–53).

71. See document transcribed in Frey 1909, 131 (no. 175): ". . . et debba detto Lionardo quel tanto del cartone fussi facto rilasciarlo a detti magnifici Signori libero, et che fra detto tempo, che detto Lionardo si obligha havere fornito il disegnio di detto cartone."

72. Ibid.: ". . . allora son contenti detti magnifici Signori non potere tal cartone cosi disegnato et fornito alloghare a dipignere a uno altro ne alienarlo in alcuno modo da detto Lionardo sanza expresso consenso suo. . . ." A similar point is made in Glasser 1977, 149.

73. See documents transcribed in Frey 1909, 134–35 (nos. 220, 222, 223, 230, and 237). Cf. Beltrami 1919, 100 (no. 165).

74. See document transcribed in Frey 1909, 134 (no. 222), not in Beltrami 1919.

75. See document transcribed in Frey 1909, 135 (no. 230). Cf. Beltrami 1919, 100 (no. 165).

76. Ridolfi 1648, I, Part I, 260 (cited also in Meder and Ames 1978, I, 395): "Ritiratosi à Brescia d'anni 18. si pose di nuouo à pratica col Romanino, da cui ottene vna figliuola in moglie, riceuendo in dotte alcuni spolueri."

77. Vasari 1966–87, V (testo), 326. On the copies of the *Venus and Cupid* cartoon, cf. Mauro Natale, *Peintures italiennes du XIVe au XVIIIe siècle,* Geneva, 1979, 92; John Shearman, *The Early Italian Pictures in the Collection of Her Majesty The Queen,* Cambridge, 1963, 277; and Muzii 1993.

78. Armenini 1587, Book II, 104 (cf. Armenini 1977, 174, for trans.).

79. See Chapter Two, note 234, for bibliography. Unfortunately, this cartoon could not be illustrated.

80. National Gallery inv. nos. 147 and 148, London. On the cartoons, see Chapter One, notes 53–54. Especially relevant here is the discussion in Finaldi, Harding, and Wallis 1995,

5–10 (with diagrams of the *giornate* on the frescos and the structural assembly of the cartoons).

81. Ibid., 12–15, with discussion of the Fabriano "M" watermark that recurs on several sheets of the cartoons' paper.

82. I am indebted to Donatella and Carlo Giantomassi for the opportunity to study these frescos from the scaffolding erected for their cleaning (July 1994). Cf. Giulio Briganti, André Chastel, and Roberto Zapperi with Carlo Giantomassi, *Gli Amori degli dei: Nuove indagini sulla 'Galleria Farnese,'* Rome, 1987, 237.

83. Christ Church inv. 1381, Oxford. Cf. Byam Shaw 1976, I, 258, no. 983. For a discussion of other cartoons by Domenichino, see Chapter One, notes 86–88.

84. On the technique of the Sistine tapestry cartoons, cf. Shearman 1972, 209–12; Plesters 1990 b, 111–24; Fermor 1996; Henry 1997; as well as Fermor and Derbyshire 1998, 236–50. On their process of preliminary design, see Oberhuber 1972, 122–40, nos. 438–52a.

85. On the dates and weavers, see further Shearman 1972, 138, and Fermor 1996.

86. On the working procedures, cf. especially Guy Del Marcel, "L'auteur ou les auteurs en tapisseries: Quelques reflexions critiques," *Dessin sous-jacent dans la peinture: Colloque IV,* ed. by R. Van Schoute and Dominique Hollanders-Favart, Louvain-La-Neuve, 1983, 43–48; Fermor 1996, 45–64; Henry 1997; as well as Fermor and Derbyshire 1998, 236–50.

87. Cf. Shearman 1972, 139, 209; Plesters 1990 b, 112–13; Fermor 1996, 56–58; as well as Fermor and Derbyshire 1998, 236–50.

88. Cf. Shearman 1972, 140–64, and Tom Campbell, "School of Raphael Tapestries in the Collection of Henry VIII," *BM,* CXXXVIII (1996), 69–78.

89. See the three fragments for *Christ's Charge to Peter* in the Musée Condé inv. Peinture 40 A, 40 B, and 40 C, Chantilly. Data for the fragment here illustrated (Fig. 245): 620 × 760 mm.; pen and brown ink, brush and watercolor, highlighted with white gouache, on four glued sheets of paper. The watermark, an embellished Gothic "P" (not in Briquet), appears mainly on late-fifteenth-century and early-sixteenth-century paper from the Low Countries. Cf. Chantilly 1997, 78–80, 161–67, no. 17.

9. The Art of *Disegnare*

1. See here Chapter Six, on Paolo Uccello. This practice probably explains the reason why the artist pricked the outlines of his study for the figure of a running angel (Fig. 185; CBC 313; Uffizi inv. 1302 F) and that for a soldier riding a horse (Plate I; CBC 312; Uffizi inv. 14502 F), from the 1440s to 1460s. Portrayed in daring *sotto in sù* foreshortening, the motif of the horseman on the latter sheet may have been part of a proto-"transformation" sequence: the pose thus probably required the kinds of perspectival adjustments that could be clarified in further drafts of the design.

2. See Chapters Three and Four.

3. Semimechanical methods of transfer were too well known

to merit explanation or encouragement. And more than any others, techniques used to develop preliminary drawings would have been acquired from firsthand experience, for drawing was among the earliest skills learned during the course of an apprenticeship (see Chapter Three). As a result, we have only passing allusions within the context of more unusual practices: for example, the note from 1490 to 1492 in Paris MS. A (fol. 104 recto; Richter, I, 317, §523; Richter, *Commentary*, I, 333), in which Leonardo described a method for tracing an object or a landscape onto glass, or the passage on the *spolvero* reproduction of bilaterally symmetrical ornament in Giovanni Antonio Tagliente's embroidery patternbook (Venice, 1527). See Tagliente 1530, unpag., fols. 27 verso–28 recto (transcribed in Bambach Cappel 1991 a, 98), for a description of how a design, drawn and pricked onto a folded sheet of paper, could be transferred onto any working surface by pouncing the pricked outlines. Cf. discussion in Chapters One, Five; and Bambach Cappel 1991 a, 72–98. Leonardo, in fact, had earlier employed the *spolvero* technique described by Tagliente in drawings from the 1490s to 1510s, in order to devise symmetrical designs of ornament, architecture, geometric figures, and anatomy (see Chapter Five).

4. Armenini 1587, 76–77 (cf. Armenini 1977, 147–48, for trans.).

5. An example of a large, fairly finished drawing by Giulio Romano with stylus-incised outlines is the *Brazen Serpent* (Louvre inv. 3593, Paris). Data: 396 × 344 mm.; pen and brown ink, brush and brown wash, over traces of black chalk. Other examples are Louvre inv. 3453 and 3492. A *"disegno finito"* by Giulio, probably based on the *calco* method described by Armenini, is Louvre inv. 3550. Data: 246 × 256 mm.; pen and brown ink, brush and brown wash, highlighted with white gouache over mechanical-looking "carbon" underdrawing. Although the drawing surface is very abraded and blackened in tone, it is possible to discern below the brownish layers of ink and wash medium underdrawn lines that are highly unvarying in width and hue, as well as extremely even in both pressure and weight on the paper. Such lines seem to be the result of *calco* transfer.

6. The J. Paul Getty Museum 85.GG.26, Los Angeles. Data: 477 × 356 mm.; black chalk and oil paint on oiled paper. Cf. Goldner and Hendrix 1988, 24–25, no. 3. Barocci drew his composition onto slightly oiled paper on the basis of black, mechanically traced outlines from another draft. These traced lines are only evident in the portion of the drawing the artist left unfinished: the arms and hands of the female figure kneeling in the lower right foreground.

7. On this issue, compare Degenhart 1949; Oertel 1940, 217–314; Degenhart 1950, 93–158; Degenhart and Schmitt 1968 I-1, xix–xxv; Otto Pächt, "Der Weg von der zeichnerischen Buchillustration zur eigenständigen Zeichnung," *Wiener Jahrbuch für Kunst Geschichte*, XXIV (1971), 178–84; Ames-Lewis 1981 a; Ames-Lewis 1987, 1–11; Ulrike Jenni, "The Phenomena of Change in the Modelbook Tradition around 1400," *Drawings Defined* 1987, 35–47; Scheller 1995; and Wiemers 1996.

8. On drawing surfaces, see Chapter Two. Cf. Ames-Lewis 1981 a, 19–34, and Ames-Lewis and Wright 1983, 43–49.

9. Cf. Alexander 1992; Christopher De Hamel, *Medieval Craftsmen: Scribes and Illuminators (British Museum Series)*, London, 1992; and, for examples, Laurence B. Kanter in Metropolitan Museum of Art 1994, 272–83, nos. 35–37.

10. On embroideries, cf. Garzelli 1973; M. Daniela Lunghi, "Tessuti rinascimentali delle civiche collezioni tessili," *Bollettino dei Musei Genovesi*, nos. 28–30 (1988), 69–83, with technical notes; Paolo Peri, *Bordi figurati del rinascimento* (exh. cat., Museo Nazionale del Bargello), Florence, 1990; and Kay Staniland, *Medieval Craftsmen: Embroiderers (British Museum Series)*, London, 1991.

11. Gallerie dell'Accademia inv. 198, Venice. Revised data: 322 × 265 mm.; silverpoint, pen and gray-brown ink, brush and brown wash, highlighted with white gouache, on salmon-pink prepared paper; outlines partly stylus-incised; scattered pinpricked holes. My Ph.D. thesis mistakenly notes that Perugino's drawing was executed on *spolvero* marks. This resulted from my misreading of ambiguously labeled infrared reflectograms pertaining to the Louvre panel rather than to the drawing (Ferino Pagden 1987, 142–43, 197, no. 54, figs. 145 and 146). Cf. Fischel 1917, II:103, no. 39; and Bambach Cappel 1988, Part 1, I:224–25, 252–53, 407; Part 2, II:454, no. 328. Conversations with Sylvia Ferino Pagden proved invaluable for my research on this sheet (summer of 1990 and 1992). I am also indebted to Giovanna Nepi Scirè and Annalisa Perrini for facilitating my research.

12. Ferino Pagden 1984, 142, 197, figs. 145, 146.

13. Ibid.

14. Ashmolean inv. P II 31, Oxford (not in CBC). Data: 232 × 375 mm.; black chalk over traces of *spolvero* underdrawing; stylus-ruled construction on the foreshortened, octagonal well; lightly stylus-incised outlines on the figures for transfer; heavily rubbed with black chalk dust on the recto (and verso, according to Parker; the drawing is now glued onto mount), the latter being evidence of repeated use. The *spolvero* underdrawing is evident with magnification, especially on the upper part of Christ's figure and portions of the well. Cf. Parker 1972, 20–21, no. 31. On the small Chicago panel, see Christopher Lloyd, *Italian Paintings Before 1600 in the Art Institute of Chicago*, Princeton, New Jersey, 1993, 195, and Joseph Antenucci Becherer et al., *Pietro Perugino. Master of the Italian Renaissance*, exh. cat., Grand Rapids Art Museum, Grand Rapids, 1997, 127–37.

15. Uffizi inv. 530 E, Florence. Revised data: 266 × 268 mm.; pen and brown ink over traces of leadpoint or black chalk; most outlines pricked; rubbed selectively with black pouncing dust. Cf. Ferino Pagden 1982, 100–1, no. 59; Sylvia Ferino Pagden in Palazzo Pitti 1984, 296–97, no. 9; and Petrioli Tofani 1986, 237–38, and *sub numero*.

16. I am indebted to Jean Habert for providing a tracing on clear acetate from the Louvre painting for comparison with the Uffizi drawing, and to Anna Maria Petrioli Tofani for enabling this research.

17. Among the examples by Umbrian artists are Perugino's *Adoration of the Shepherds* (British Museum 1895-9-15-594,

London; CBC 333.1), fairly closely related to a panel in the Yale University Art Gallery. Revised data: 396 × 284 mm.; point of brush and brown ink, over leadpoint or black chalk underdrawing; stylus-ruling and stylus-incised compass construction. Cf. Popham and Pouncey 1950, 117–18, no. 192. Raphael's *Adoration of the Christ Child Atop the Saddle* (Ashmolean Museum inv. P II 40, Oxford; CBC 223), preliminary for a *predella* panel formerly in the Conestabile Collection. Revised data: 183 × 262 mm.; pen and brown ink over traces of stylus and leadpoint or black chalk underdrawing. Cf. Parker 1972, 25–26, no. 40, and Gere and Turner 1983, 26–27, no. 7. Raphael's *"The Knight's Dream"* (Figs. 14–15; British Museum 1994-5-14-57, formerly National Gallery inv. 213 A, London; CBC 231), preparatory for the panel in the National Gallery, London. Revised data: 183 × 215 mm.; pen and brown ink over black chalk and traces of stylus underdrawing; pricked outlines rubbed with black pouncing dust from recto and verso. Cf. Gere and Turner 1983, 34–35, no. 15; Knab, Mitsch, and Oberhuber 1983, 564–65, no. 93; and Joannides 1983, 141, no. 31.

18. Staatliche Graphische Sammlung inv. 3066, Munich (not in CBC). Data: 527 × 261 mm.; pen and brown ink, brush and brown wash, highlighted with white gouache, over *spolvero* and traces of freehand black chalk underdrawing, on brownish paper. Kupferstichkabinett inv. KdZ 5058, Berlin (not in CBC). Data: 456 × 312 mm. (maximum made-up sheet); pen and black ink, brush with brown and blue-gray wash, highlighted with white gouache, over *spolvero* and freehand black chalk underdrawing, on brownish paper. Cf. Mantegna 1992, 431–32, no. 137; Alt-cappenberg 1995, 62–63 (where it is reported that pace Mantegna 1992, the Berlin sheet also exhibits *spolvero*); Wiemers 1996, 176–79; and Bambach 1999 a (both drawings are illustrated).

19. National Gallery of Art 1939.1.178, Washington (not in CBC). Data: 236 × 198 mm. (maximum); pen and dark brown ink (or black) ink outlines, over brush and brown wash, highlighted with white gouache, with some modeling of shadows in charcoal (or black chalk), over finely dotted *spolvero* underdrawing, on paper washed brown, mounted onto linen secondary support. A few contours on the figures and the background along Judith's right side are reworked with green-black ink. Cf. Bambach 1999 a (illustrated). I am indebted to Margaret Morgan Grasselli and Gregory Jecmen for their assistance with my research.

20. Mantegna's creative design process is examined at length in Wiemers 1996, 158–82.

21. For the full argument see Bambach 1999 a.

22. See discussion in Chapter Five (and note 153) above.

23. Of the five extant cases known thus far, one clearly exemplifies the use of the technique for the purpose of producing a copy: the pricked "Gothic" *Alphabet of Marie de Bourgogne* (Musée du Louvre, Paris), from around 1480, and its mid-sixteenth-century *spolvero* copy (Bibliothèque Royale, Brussels). See further discussion in Chapter Three (and note 9). Albeit with varying degrees of creativity, the rest of the examples, to be discussed below, are by

Leonardo, Raphael, Girolamo Genga, and Andrea del Sarto. These illustrate the application of the technique in the process of preliminary design.

24. Paganino c. 1532, *Proemio, "Alessandro Paganino al Letore,"* unpag., fols. 3 recto and verso. On the ephemeral nature of *spolvero* underdrawing in fresco painting, see Palomino 1724, Book VII, chapter IV:iv, 101. Cf. Bambach Cappel 1988, Part II, I:1–2; Bambach Cappel 1990, 129–31; Bambach Cappel 1996 a, 99–101; and Bambach Cappel 1996 b, 149–57.

25. Artists sometimes left *spolvero* underdrawing untouched, as the earliest variant of a design, presumably treating them with fixatives. Relatively little is known, however, about drawing fixatives. See Meder and Ames 1978, I, 159, and glossary (unpag.).

26. Ashmolean Museum inv. P II 513, Oxford. Revised data: 199 × 199 mm.; pen and medium brown ink, over traces of stylus, *spolvero,* and freehand charcoal underdrawing. Cf. Fischel 1913–41, I, 54, plate 30, and fig. 47; Parker 1972, 262–63, no. 513; and Gere and Turner 1983, 46–47, no. 27.

27. Thanks to the late Fabrizio Mancinelli, as well as to Arnold Nesselrath, Enrico Guidi, Nicholas Penny, and Catherine Whistler, it was possible for me to overlay a tracing on clear acetate from the painting in the Pina-coteca Vaticana onto the Ashmolean Museum drawing to verify this correspondence. This possibility had already been suggested in the literature on the drawing.

28. Perrot 1625, xiv–xv.

29. Walker Art Gallery inv. 9833, Liverpool. Revised data: 410 × 215 mm.; charcoal or black chalk, highlighted with white gouache; squared in charcoal or black chalk. The point about the squaring was made in Ames-Lewis and Wright 1980, 90–91, no. 13.

30. Louvre inv. 1796, Paris. Revised data: 464 × 257 mm.; black and red chalk over charcoal, highlighted with white gouache; squared in both black chalk and pen and brown ink. Cf. Berenson 1961, II, 565, no. 2509H, and Bacou 1974, no. 1.

31. There are also numerous areas of pricking that do not correspond to the design as drawn, suggesting that the sheet was greatly reworked on separate occasions; it may have even been drawn on the basis of preexisting pricked outlines. Importantly, the figure of the saint bears different attributes, portrayed only as a series of confused, superimposed pricked outline designs; these pricked outlines are only slightly more intelligible from the verso of the sheet. The saint's crossed hands seem to hold across his chest the open book and two keys identifying St. Peter, as well as the knife identifying St. Bartholomew. Below the robe's hemline emerges possibly a third attribute, a staff.

32. British Museum 1885-5-9-40, London. Revised data: 399 × 256 mm.; charcoal or black chalk on three glued pieces of paper; parts of the left figure highlighted with white gouache; squared in charcoal or black chalk; horizontal parallel lines in red chalk. Cf. Popham and Pouncey 1950, 150–51, no. 242.

33. Kanter 1992, 415–19.

34. British Museum 1860-6-16-93, London. Revised data:

340 × 270 mm. (maximum sheet); charcoal or black chalk. Cf. Popham and Pouncey 1950, 147–48, no. 237.

35. British Museum 1946-7-13-220, London. In favor of the sheet's authenticity, not all the figures in the drawing appear in the fresco. The drawing, in fact, may help document the arduous means by which Luca Signorelli generated the *concetto* for this part of the composition. The evidence of transfer methods on this sheet is probably the most complex and varied of all drawings associated with Signorelli here discussed. Revised data: 286 × 413 mm.; pen and dark brown ink; outlines of the figure third from the right, the column, and the stairs at the man's feet are corrected in red chalk. All types of transfer on this sheet were the result of transfer from drawings in other sheets; the British Museum sheet was thus the recipient rather than the generator of transfer. Transfer methods: (A) the outlines on the two figures third and fourth from the right are pricked from the recto. (B) On this right part of the sheet there are also unrelated pricked outlines of a slightly larger-scaled male nude pricked from the verso; it seems to be a partial repetition of the figure fourth from the left border. (C) The outlines of the female figure in the foreground immediately to the left of the major vertical crease (she stands sixth from the left) are traced with a stylus. (A) The pricked outlines on the figures third and fourth from the right were without doubt drawn on the basis of preexisting pricking, for the drawing and pricked outlines diverge greatly. The red chalk correction on the third figure from the right is pricked as are the corrections in red on the stairs. (B) The unrelated pricked outlines on the right, done from the verso, were produced by folding the sheet and pricking through the paper (see also Chapter Five). Though the pricked but undrawn design is probably that of the figure appearing fourth from the left in the British Museum drawing, the pricking came from elsewhere, for this drawn figure is unpricked. (C) The stylus indentations evident on the female figure to the left of the crease were also obtained from another drawing (cf. *calco* method as described in Armenini 1587, 76–77; Armenini 1977, 147–48, for trans.). The rest of the figures on the left half of the sheet may have also been derived by this method. There is a possibility that the severe oil stains visible througout the sheet were the result of an attempt at producing *"carta lucida."* There is some rubbed pouncing dust on the right half of the composition. Problems of condition relevant to an analysis of the sheet's function are as follows: the drawing is glued onto secondary support, severely abraded, severely stained with oil throughout; major vertical crease on the first third of the sheet from the right, other minor creases. Cf. Popham and Pouncey 1950, 153, no. 248.

36. Louvre inv. 1800, Paris. Revised data: 530 × 830 mm. Cf. Berenson 1961, II, 566–67, no. 2509H-8; Bambach Cappel 1988, Part 2, II:407–9, no. 295; and Bambach Cappel 1996 a, 85 (and note 15). This large, mechanical-looking drawing is, however, in a smaller scale than the fresco – a scale that is approximately, but consistently, 1:3. This drawing cannot be a copy, for the material evidence identifies it

without doubt as a working drawing. It was drawn in black chalk on top of an underdrawing of *spolvero*. Though it is probably autograph, the reinforcement in pen and ink may date after its second transfer by pouncing and could constitute further alterations to the design. Centering marks done with the compass, in the form of intersecting arcs, are repeated in pairs or trios throughout the sheet. The drawing, which, as pointed out, is not in the same scale as the fresco, was squared in black chalk at 32 mm. intervals. Its outlines were then pricked finely and rubbed partly with pouncing dust for transfer onto another sheet of paper to develop its design further; the changes between the drawing and fresco confirm this. Thus, because this functional drawing was used in the relatively preliminary stages of design, rather than in the transfer process to the fresco surface, it was probably spared from certain ruination. On the frescos in S. Crescenziano, cf. Mario Salmi, "Luca Signorelli a Morra," *Rivista d'arte,* XXVI (1950), 131–47, and Kanter 1989, 200–206. The quality of execution in these frescos, better revealed by their recent cleaning, is, in my opinion, worthy of being considered largely autograph.

37. On these paintings, see further Kanter 1989, 131–33, 119–23.

38. These crosses, running corner to corner, within the squares, also appear in Luca Signorelli's drawing of the *Adoration of the Magi* (British Museum 1895-9-15-602, London).

39. British Museum 1895-9-16-603 and 1895-9-16-604, London. The connection to the Morra *Flagellation* was rightly pointed out in Popham and Pouncey 1950, 152–53, nos. 246, 247, but overlooked in my Ph.D. thesis. Revised data: fragment (A) *Three Male Figures: Two Nude and One Partially Dressed as a Soldier,* 324 × 235 mm.; fragment (B) *Four Male Figures: A Nude Christ, Two Nude Flagellants and a Clothed Centurion,* 324 × 281 mm.; (A) black chalk; (B) black chalk with reinforcements in pen and dark brown ink; both over black chalk *spolvero* underdrawing (they were pounced from other pricked drawings); both also exhibiting *calco,* as their outlines are shallowly indented for transfer onto other sheets. Additionally, both sheets have unrelated designs pricked from the verso: (A) a portion of an *impresa* with a cardinal's hat (?); (B) a portion of a gryphon. The drawings were part of the same relatively large-scale composition draft, and the sheets were either reused purposefully for the designs appearing pricked from the verso, or the sheets accidentally lay underneath others being pricked. This is no longer verifiable as the sheets are glued onto secondary paper support. The large yellowish brown stains on both sheets look like oil (probably an attempt to make *"carta lucida"* for tracing).

40. Royal Library inv. 12281 recto, Windsor. Revised data: 478 × 333 mm.; pen and medium brown ink, brush and brown wash, over black chalk (and possibly slight traces of red chalk), on paper washed yellowish brown; pricked outlines rubbed with pouncing dust. The recent literature on the drawing has recognized the general means of production. Cf. Popham 1995, 155, no. 247; C. O. Malley and J. B.

Saunders, *Leonardo da Vinci on the Human Body*, New York, 1952, 456, no. 202; Clark and Pedretti 1968, I, 7–8, *sub numero; Anatomical Drawings from the Royal Collection* (exh. cat.; Royal Academy of Arts), London, 1977, 22–23, nos. 2A, 2B; Keele and Pedretti 1978–80, no. 122 recto; Carlo Pedretti, "Leonardo dopo Milano," in *Leonardo e il Leonardismo a Napoli e a Roma* (exh. cat., Palazzo Venezia, Rome – Gallerie Nazionali di Capodimonte), Florence, 1983, 45, 80–81; Kemp and Roberts 1989, 114–15, no. 52; and Bambach Cappel 1991a, 79–80 (and note 47). Royal Library inv. 12280 verso, Windsor. Revised data: 490 × 325 mm.; pen and medium brown ink over black *spolvero* marks. Cf. Malley and Saunders, op. cit., 458, no. 203; Clark and Pedretti 1968, I, 6–7, *sub numero;* Royal Academy of Arts exh. cat., op. cit., 22–23, nos. 2A, 2B; Keele and Pedretti 1978–80, no. 121 verso; Pedretti, "Leonardo dopo Milano," 45; and Bambach Cappel 1991 a, 80 (and note 49).

41. See also description in Giovanni Antonio Tagliente's embroidery patternbook; Tagliente 1530, unpag., fols. 27 verso–28 recto (transcribed in Bambach Cappel 1991 a, 98).

42. Leonardo may have possibly pricked passages in Royal Library inv. 12281 recto, Windsor, a third time: the heart on the right half of the sheet is pricked from the recto but with fine type (a) holes.

43. Cf. Bambach Cappel 1990 b, 125–27, and Bambach Cappel 1991a, 79–80 (notes 48–49).

44. Gallerie dell'Accademia inv. 228, Venice (not in CBC). Data: 344 × 245 mm.; pen and dark brown ink, traces of brush and brown wash, over *spolvero,* as well as stylus and compass construction. This fact was rightly and cautiously noted in Spezzani 1992, 183 (figs. 23, 25), 185, as the result of infrared reflectography examination. The use of the *spolvero* technique for the production of its underdrawing goes a long way to explain the self-assured manner with which Leonardo traced the contours of the figure in pen and ink. On the drawing, cf. also Giovanna Nepi Sciré in *Leonardo & Venezia* 1992, 216–17, no. 12 (without notice of the *spolvero* technique), and Popham 1995, 61–62, 146, no. 215.

45. In the *Codex Huygens* (according to Panofsky's numbering, New York), note especially drawings nos. 8 (verso blackened for transfer), 13 (underdrawing below the pen and ink design is comprised of carbon-derived outlines from *calco*), 27, and 28. On the controversial authorship of the *Codex Huygens,* cf. Erwin Panofsky, *The Codex Huygens and Leonardo da Vinci's Art Theory. The Pierpont Morgan Library Codex M.A. 1139,* London, 1940; Irma Richter, review of Panofsky 1940, *AB,* XXIII (1941), 335–38; Pedretti 1964, 104–5, 263–64; Byam Shaw 1976, I, 291–92, nos. 1149–50; Giulio Bora, "Note cremonesi, II: L'Eredità di Camillo e i Campi," *Paragone,* no. 327 (1977), 54–88, especially 70, 87 (note 69); Richter, *Commentary,* I, ix–x, 48–75; Giulio Bora, "La Prospettiva della figura umana: Gli scurti nella teoria e nella pratica lombarda del Cinquecento," *La Prospettiva rinascimentale: Codificazioni e trasgressioni,* ed. by Marisa Dalai Emiliani, Florence, 1980, I, 295–317; Ugo Ruggeri, "Disegni di Oxford," *Critica d'arte,* XLII (1977), 98–118;

Ruggeri, "Carlo Urbino e il Codice Huygens," *Critica d'arte,* XLIII (1978), 154–56, 167–76; Silvio Marinelli, "The Author of the *Codex Huygens,*" *JWCI,* XLIV (1981), 214–20; Peter Meller, "Quello che Leonardo non ha scritto sulla figura umana: Dall'Uomo di Vitruvio alla Leda," *AL,* LXVII (1983), 117–33; S. Braunfels-Esche, "Aspekte der Bewegung: Umrisse von Leonardos Proportions- und Bewegungslehre," *Leonardo da Vinci: Anatomie, Physiognomik, Proportion und Bewegung,* Cologne, 1984, I, 84–117; Frank Zöllner, "Leonardo, Agrippa and the Codex Huygens," *JWCI,* XLVIII (1985), 229–34; and Zöllner, "Die Bedeutung von *Codex Huygens* und *Codex Urbinas* für die Proportions- und Bewegungsstudien Leonardos da Vinci," *ZfK,* LII (1989), 334–52.

46. Bambach Cappel 1990 b, 131, nos. 15, 16.

47. Ibid., 131, no. 14.

48. Ibid., 129–31.

49. Royal Library inv. 12279, Windsor (not in CBC). Data: 335 × 482 mm.; pen and brush with brown ink and wash, over charcoal chalk; pricked outlines rubbed with black pouncing dust. Cf. Clayton 1996, 101–2, no. 55, for excellent discussion of topography.

50. Royal Library inv. 12685 and 12678, Windsor (not in CBC). Data: (A) 240 × 367 mm.; pen and brown ink, brush and brown wash, over traces of *spolvero* and freehand charcoal underdrawing; (B) pen and brown ink, brush and brown, green, and blue wash over traces of *spolvero* and freehand black chalk underdrawing (here, the tiny *spolvero* dots are only sporadically evident, toward the center of the sheet). Cf. Clayton 1996, 101–5, nos. 54, 57.

51. British Museum 1860-4-14-446, London. Revised data: 231 × 376 mm. (max.); pen and dark brown ink, with two figures worked in red chalk, over stylus and compass construction especially in the pavement; pricked outlines with traces of rubbed black pouncing dust, horizon lines and centering lines. Windsor, Royal Library inv. 12737. Revised data: 246 × 410 mm.; red chalk over black *spolvero* and stylus underdrawing. Cf. Pouncey and Gere 1962, 18–19, no. 21; Joannides 1983, 204, nos. 287, 288 recto; Knab, Mitsch and Oberhuber 1983, 587, nos. 340–41; Gere and Turner 1983, 148–50, nos. 122–23; and Ames-Lewis 1986, 4–9; and Gere 1987, 90–94, no. 19.

52. The engraving "with the fir tree" is Bartsch XIV.19.18, and that "without the fir tree" is Bartsch XIV.21.20. Cf. Pouncey and Gere 1962, 18–19, no. 21; Oberhuber 1972, 24; Pogany Balas 1972, 25–40; Shoemaker and Brown 1981; Emison 1984, 257–67; Rome 1985, 173–74, nos. VI.1–VI.7; Zentai 1991, 27–106; Landau and Parshall 1994, 120–35.

53. See selection of prints published in Rome 1985.

54. In fact, a discarded sheet of preparatory studies in pen and ink for the fresco (Albertina inv. IV.189 verso, Vienna) repeats the Apollonian figure of the executioner seen in the extreme left foreground in the prints, but in a scale that is almost a third larger.

55. Szépmüvészeti Múzeum inv. 2195, Budapest (not in CBC), a *modello* not unanimously accepted as autograph. Data: 261 × 399 mm.; pen and brown ink, with traces of

white gouache highlights, over *spolvero* and traces of stylus underdrawing. Under magnification, a layer of black pouncing dust is evident throughout the drawing surface. Both the means of production and the fragile, abraded condition of the drawing surface should be taken into account in judging the quality of this sheet. The correspondence of design between the British Museum sheet and the impression "with the fir tree" is in fact perfect; the divergences of design between drawing and the impression "without the fir tree" are at most 2 mm. apart. I am indebted to Innis Howe Shoemaker, who offered valuable advice, and to Faith Zieske for the opportunity to make a tracing on clear acetate from the composition of Marcantonio's two engravings at the Philadelphia Museum of Art. Thanks to Sheila O'Connell and Lóránd Zentai it was possible for me to study the correspondences of design and scale, by placing these tracings on the British Museum and Budapest drawings.

56. I am indebted to Lóránd Zentai and his staff for having conducted this examination and making the infrared reflectograms available to me for study (letter, 29 September 1992).

57. In reconstructing the sequence of design for the composition, it is therefore tempting to place a sheet of figural studies for the group in the left foreground (Albertina inv. IV.188 verso, Vienna), before the British Museum draft, rather than after it, as is sometimes proposed. Cf. Pouncey and Gere 1962, 18–19, no. 21; Gere and Turner 1983, 148–50, nos. 122–23; Ames-Lewis 1986, 5–8; and Gere 1987, 90–94. In the Albertina sheet (inv. IV.188 verso), Raphael relied on the same model to explore the dynamic poses for both the sword-wielding soldier and the fleeing mother. Raphael had not yet recast the features of the woman's face, here almost caricaturesque and improvised from memory, into the noble profile of the grieving Roman matron in the final version of the composition, which first appears in the British Museum draft (1860-4-14-446). In the Albertina sheet, the axial rotations of the poses are exploratory. The scale of the bodies and their parts, which varies a great deal as Raphael drew them from left to right, is considerably larger. By comparison, the same figures in the British Museum draft more closely resemble the final composition and, more importantly, are in identical scale.

58. On this altarpiece, cf. Alessandro Morandotti, "Gerolamo Genga negli anni della pala di Sant'Agostino a Cesena," *Studi di Storia dell'Arte,* IV (1993–94), 275–90; and Walter Fontana, *Scoperte e studi sul Genga pittore* (Accademia Raffaello: Università degli Studi Urbino), Urbino, 1981, 96–102.

59. Cf. Vasari 1966–87, V (testo), 347, Kanter 1989; and Sabine Eiche in *Dictionary of Art 1996*, XII, 277–79.

60. British Museum 1866-7-14-7, London. Revised data: 328 × 299 mm. (arched shape); red chalk over black chalk underdrawing (partly also on *spolvero?*); finely pricked outlines with traces of rubbed black pouncing dust. Cf. Pouncey and Gere 1962, 160, no. 270. Louvre inv. 3117, Paris. Revised data: 272 × 311 mm.; red chalk over black

spolvero and freehand black chalk underdrawing. Cf. Louvre 1983, 12, no. 4.

61. Städelsches Kunstinstitut inv. 379, Frankfurt. See Chapter Seven, note 141, for data.

62. British Museum 1885-5-9-40, London. See note 32 for data.

63. Louvre inv. 1688, Paris. Revised data: 295 × 244 mm.; red chalk over traces of black chalk, stylus underdrawing, and ruling; pricked outlines may not be rubbed with black pouncing dust; squared in black chalk. Cf. Shearman 1965, I: 152, 154, plate 92b; II: 308, 345–46, 375–76; as well as Monti 1965, 167–68, no. 186; Françoise Viatte in *Collections de Louis XIV, dessins, albums, manuscrits* (exh. cat., Orangerie des Tuileries), Paris, 1977–78, under no. 26; *Il Primato del disegno* 1980, under no. 36; Louvre 1986, 54–56, no. 33; and Annamaria Petrioli Tofani in Palazzo Pitti 1986, 244, under no. 38. John Shearman was the first to suggest rightly that the Louvre drawing could not be a copy, as had previously been maintained, because of the evidence of working procedure.

64. Uffizi inv. 634 E, Florence. Revised data: 329 × 265 mm.; pen and brown ink, brush and brown wash, over black *spolvero,* traces of freehand black chalk and constructed stylus underdrawing, highlighted with white gouache; partly squared in black chalk and stylus. See preceding note for literature.

65. John Shearman was the first to notice the *spolvero* marks on the Uffizi sheet and related them to the pricked Louvre sheet. Unlike Shearman, Annamaria Petrioli Tofani (in Palazzo Pitti 1986) maintained that the Louvre sheet followed the Uffizi drawing. The Uffizi drawing does indeed show *spolvero* in the figures: we may notice their slightly effaced presence on the Virgin's head and neck, St. Joseph's waist, the kneeling Magus's head, and the fallen soldier to the extreme right of the stable.

66. See Louvre 1986, 54–56, no. 33, contra Bambach Cappel 1988, Part 2, II:391–93, no. 284. Annamaria Petrioli Tofani (in Palazzo Pitti 1986, 282–83), rightly noted the searching and more masterly quality of the drawing in the Uffizi, especially in the relationship of the figures to the composition. She hesitantly accepted the autograph status of the Louvre drawing, suggesting that the harshness of the drawing may be the result of Andrea del Sarto's effort to copy his own designs. In my opinion, the Louvre sheet seems to record a more exploratory phase of the design process than that in the Uffizi. The apparent absence of pouncing dust on the Louvre sheet may be due to a variety of reasons: first, as we saw in Chapter Two, this type of evidence is ephemeral; second, the surface of the drawing is abraded, and, third, the artist may have used a "substitute cartoon" procedure. The Uffizi drawing is, by comparison, very finished. That the Louvre drawing appears to be blocked out in red chalk and without as much detail (whereas the Uffizi drawing is in denser layers of ink, wash, and white gouache highlighting) would also indicate that it represents an earlier attempt at defining the composition. Thus the sequence of the drawings proposed by John Shearman seems in my opinion most appropriate.

67. This lost intermediary drawing, which the artist further developed on the basis of the *spolvero* underdrawing, would have in turn had its outlines pricked during the final stage of elaboration, to pounce the reworked design onto the Uffizi sheet. The presence of squaring in both drawings, albeit partial in the Uffizi example, may have been an attempt to reconcile the disparate scale of their foreshortened architectural backgrounds.

68. Uffizi inv. 98 F, Florence (not in CBC). Data: 329 × 221 mm.; pen and brown ink, brush and brown wash, over *spolvero*. The latter is evident throughout the composition, underneath the firmly inked, somewhat mechanical-looking contours as dotted chalk underdrawing; watermark close to Briquet no. 9962. Cf. Petrioli Tofani 1991, 45–46, *sub numero*, though without identification of the technique and with an attribution to Piero Pollaiuolo, based on the old pen and brown ink inscription on the lower left of the sheet.

69. Kupferstichkabinett inv. KdZ 5044, Berlin. Data: 268 × 176 mm. (maximum, arched shape); point of brush and brown wash, pen and brown ink, highlighted with white gouache, over *spolvero* underdrawing. Cf. Altcappenberg 1995, 172–73, with an attribution to Raffaellino del Garbo, which does not seem justified.

70. See for such small pricked drawings by Bartolomeo di Giovanni (CBC 115–25) and Raffaellino del Garbo (CBC 65–107).

71. Christ Church inv. 0063, Oxford. Cf. Byam Shaw 1976, 47, no. 46.

72. I am indebted to Everett Fahy, Keith Christiansen, and Maryan W. Ainsworth for arranging examination with infrared reflectography of this painting.

73. British Museum 1860-6-16-114, London. Revised data: 275 × 366 mm.; pen and brown ink, brush and brown wash, highlighted with white gouache, over *spolvero* and freehand black chalk underdrawing on paper tinted with reddish wash; comprehensively pricked outlines rubbed with pouncing dust. Cf. Popham and Pouncey 1950, 44, no. 65.

74. Ashmolean Museum inv. P II 11, Oxford. Cf. Parker 1972, 8, no. 11.

75. Another smaller drawing by Raffaellino (British Museum 1946-7-13-1278, London) cut in such a *"giornata"* shape depicts the single figure of a *"Mater Dolorosa"* in a profile view. The cuts are below her head and about the silhouette of her figure (not in Popham and Pouncey 1950, or CBC). Data: 167 × 136 mm. (maximum of silhouetted figure), pen and dark brown ink, brush and brown wash, highlighted with white gouache, over black chalk; outlines finely pricked and drawing surface heavily rubbed with pouncing dust. A further example of this practice by Raffaellino, but unidentified as such, is British Museum 1860-6-16-45 (CBC 65; Popham and Pouncey 1950, 44, no. 66).

76. Metropolitan Museum of Art 12.56.5a, New York. Revised data: 96 mm. diameter; pen and brown ink, brush and brown wash, highlighted with white gouache, over black chalk, on paper washed brown, outlines of figure and circular border pricked and rubbed with traces of black pouncing dust. Cf. Carmen C. Bambach in Metropolitan Museum of Art 1997, 348–49, no. 116.

77. Cf. Pouncey and Gere 1962; Oberhuber 1972, 21, 22; Gere and Turner 1983; Joannides 1983; Ames-Lewis 1986; and Gere 1987.

78. On Giulio Romano and Giovan Francesco Penni "Il Fattore" as draughtsmen, cf. especially Oberhuber 1972, 26–50, and Mantua 1989.

79. Ames-Lewis 1986, 73.

80. These composition drafts correspond to what Konrad Oberhuber has called *"erstes und zweites Gesamtentwurf."* Cf. Oberhuber 1972, 20–24; and Ames-Lewis 1986, 4–11, 73–82.

81. Städelsches Kunstinstitut inv. 379, Frankfurt. See Chapter Seven, note 141, for data.

82. Louvre inv. 3884 recto, Paris. Revised data: 270 × 401 mm. (sheet), 249 × 321 mm. (final image), right border originally extended 12 mm. further to the right; pen and brown ink, brush and brown wash, highlighted with white gouache, over traces of stylus ruling and compass, freehand black chalk and *spolvero* underdrawing. John Shearman first rightly emphasized the importance of this drawing as a *modello* for the cartoon, for it had often previously been regarded as a copy (Shearman 1972, 106–7, note 57). Here, compare also Joannides 1983, 225, no. 366; Sylvia Ferino Pagden in Palazzo Pitti 1984, 136; Harprath 1986, 125; Ames-Lewis 1986, 134–36; and Louvre 1992, 280, no. 413. Konrad Oberhuber (1972, 139–40, no. 452) considered this drawing a copy produced in Raphael's *bottega,* after a lost drawing by Raphael himself. This opinion was maintained by Catherine Monbeig Goguel in Grand Palais 1983, 309–10, no. 120. On the preliminary drawings for the Sistine tapestries, see Oberhuber 1972, 122–40, nos. 438–52a.

83. Uffizi inv. 540 E, Florence. Data: 278 × 418 mm.; red chalk over stylus underdrawing. Cf. Oberhuber 1972, 137–39, no. 451; Sylvia Ferino Pagden in Palazzo Pitti 1984, 304–5, no. 13; and Ames-Lewis 1986, 133–34.

84. Cf. Shearman 1972, 106. Perhaps, the reason that the *modello*'s composition was cropped on the right was that otherwise the outline of the *tempietto* would have cut an awkward, undramatic profile on the right. The left border of the composition is partially pricked along the bottom portion; the holes are pin-size, but relatively far apart. The outline depicting the back of the figure who is in the lower left foreground (immediately between St. Paul and the left border) is also partly pinpricked, but little else in the composition is.

85. Oskar Fischel's remark that the Louvre drawing was a copy made for Marcantonio's engraving (Bartsch XIV.50.44) is suggestive. The dimensions of Marcantonio's print (266 × 350 mm. image) are fairly close to those of the Louvre sheet (247 × 373 mm.), considering the more inclusive composition of the engraving both in height and width. In fact, based on the evidence of *spolvero* dots on the Louvre sheet, it may well be that the Louvre drawing and Marcantonio's print were based on the same original drawing that had its outlines pricked. This might account for some of the minor differences in detailing between the engraving

and Louvre drawing that John Shearman found disturbing (e.g., the articulation of the masonry loggia, the architectonic massing of the *tempietto* structure, and the more elaborately dressed statue). The copy by the Raphael workshop (Uffizi inv. 1217 E, Florence) may also have been derived from a common pricked original by Raphael, to judge from the measurements (253 × 332 mm.). Frederick Hartt's attribution of the drawing to Giulio Romano is not convincing, both on account of style and the fact that despite his precocious beginnings in Raphael's workshop, by 1515–16, Giulio would have been too young to be entrusted with this *modello*. Sidney Freedberg and Luitpold Dussler thought Uffizi inv. 1217 E to be the original *modello* for the tapestry cartoon, although Konrad Oberhuber has repeatedly stated that the drawing is a copy after the lost *modello* and has rejected an attribution to any of the known hands in Raphael's workshop.

86. The so-called "auxiliary cartoons" by Raphael are Royal Library inv. 4370, Windsor; British Museum 1895-9-15-610 Imperial, London; Palais des Beaux-Arts inv. P. L. 470, Lille; Collection of Mrs. Norman Colville, London; Louvre inv. 3983, Paris; Albertina inv. 242, R. 79, Vienna; ex-Collection of Barbara Piasecka Johnson (ex-Devonshire Collection inv. 66, Chatsworth); Devonshire Collection inv. 67, Chatsworth; Ashmolean Museum inv. P II 568, Oxford; British Museum 1860-6-16-96, London; and British Museum 1895-9-15-634. See CBC 228–30, 254, 267, and 270–77. The "auxiliary cartoon" by Giulio Romano is British Museum 1949-2-12-3 Imperial (CBC 206).

87. Cf. Fischel 1937, 167–68; Oberhuber 1962 b; Pouncey and Gere 1962, 5–6, 33–34, 59, under nos. 5, 37–38, 72; Oberhuber 1972, 20, 70–71; Oberhuber 1978; Gere and Turner 1983, 42, 44, 133, 218–23, under nos. 24–25, 107, 176–80; Borsook 1985; Ames-Lewis 1986, 36–38; Gere 1987, 145–47, no. 38; Bambach Cappel 1988, Part 1, II:373–95; Jaffé 1994, II, 192–95, nos. 320–22; and British Museum 1996, 66–67, no. 27; all studies with further bibliography.

88. Though he did not address this as a problem, Shearman 1983, 22–25 (discussion of the Vatican *Coronation* drawings) also refrained from identifying the full-scale studies of heads drawn on *spolvero* underdrawing as "auxiliary cartoons." Borsook 1985, 121; Ames-Lewis 1986, 36, 154 (note 22); and Bambach Cappel 1988, Part 1, II:373–95, have all remarked on the inadequacy of the term. Cf. definition in *Tecnica e stile* 1986, I, 131, under *"Cartone ausiliario."* Based on the general findings regarding drawings produced from *spolvero* underdrawings discussed earlier, I would advocate describing rather than labeling this type of drawing. However, for the sake of clarity, the label cannot be dropped altogether, hence my use here of quotation marks.

89. Listed as Rudolph Collection, London (courtesy of Courtauld Institute of Art, negative no. 293/20 24). I have not seen this drawing in the original and cannot offer technical data. The photograph of the sheet here reproduced came to my attention, thanks to the extraordinary archives assembled by the late Jacob Bean (Department of Drawings and Prints, Metropolitan Museum of Art, New York). Companions to this sheet in the Rudolph Collection, we may add, are two drawings in black chalk, executed on the basis of *spolvero* outlines, published by Oskar Fischel (who did not know the Rudolph sheet) as productions of Perugino's workshop: a *Head of the Virgin* (Louvre inv. 364, Paris; 281 × 175 mm.) and a *Head of St. Joseph* (Musée Condé, Chantilly; 268 × 207 mm.), which Fischel connected to the altarpiece of the *Marriage of the Virgin* (Musée des Beaux-Arts, Caen), suggesting that they are in full scale. Cf. Fischel 1917, II:219, nos. 139–40, illustrated as Abb. 297–98. Both the Louvre and Musée Condé sheets on *spolvero* underdrawing, bear on their versos studies related to Perugino's murals in the Collegio del Cambio, Perugia, which enables us to propose a date of about 1498–1504 for the three drawings in question.

90. Uffizi inv. 192 F, Florence (not in CBC). See Chapter Three, note 36, for data.

91. Istituto Nazionale per la Grafica inv. 130457 verso, Rome (unpublished; verso of CBC 73). Revised data: 232 × 105 mm.; (recto) point of the brush with brown ink and washes, highlighted with white gouache, over charcoal or black chalk, on ocher washed paper, outlines finely pricked; (verso) *spolvero* dots in charcoal. The *St. Benedict* on the recto of the sheet belongs to the class of *"ben finiti disegni,"* often thought to be cartoons for embroidery by Raffaellino del Garbo and his workshop. The designs on both sides of the sheet are clearly by the same artist, despite the enormous differences in scale, medium, and the freehand, as opposed to mechanical, method of production; this is evident at once when the anatomical types of the figures' hands are compared. On the verso, the *spolvero* marks seem light, somewhat abraded, large, and diffused, probably the result from coarse perforations. At times, they are syncopated in disposition and approach the shape of dashes rather than dots. It is as if the pricked design on top had slipped during the process of pouncing and rubbed the paper lying underneath. I overlooked the design on the verso of this sheet when I wrote my Ph.D. thesis, like Beltrame Quattrocchi (1980, 43, no. 24).

92. Uffizi inv. 467 E verso, Florence. Revised data: 284 × 218 mm.; charcoal, over *spolvero* underdrawing. Cf. Petrioli Tofani 1986, 213–14; and Fischer 1986, 131–33, no. 78. I am indebted to Chris Fischer for repeated discussions of this sheet.

93. Musée Bonnat inv. 1707 verso, Bayonne (not in CBC). Data: 406 × 275 mm.; pen and brown ink over stylus underdrawing; unrelated *spolvero* underdrawing. Cf. Jacob Bean, *Bayonne, Musée Bonnat: Les Dessins italiens de la Collection Bonnat,* Paris, 1960, no. 132; Pouncey and Gere 1962, 29–30, under no. 34; Joannides 1983, 208, no. 304 verso; and Ames-Lewis 1986, 101–4.

94. Arnold Nesselrath convincingly suggested the design's connection to the *Parnassus* fresco (oral communication, June 1989). That this *spolvero* head relates to a female figure in the *Mass of Bolsena* (stated by Joannides 1983, 208, 304 verso) can be ruled out.

95. Collection of Mrs. Norman Colville, London. Data: 305 × 222 mm.; charcoal or black chalk over stylus and *spolvero* underdrawing. Cf. Gere and Turner 1983, 132–33, no. 107;

Knab, Mitsch, and Oberhuber 1983, 591, no. 378; Joannides 1983, 193, no. 245; and Ames-Lewis 1986, 37, 99.

96. Kupferstichkabinett inv. KdZ 5123, Berlin. Revised data: 268 × 221 mm.; charcoal or black chalk, possibly brush and brown wash, over unrelated *spolvero* underdrawing. Cf. Dreyer 1979, no. 19; Knab, Mitsch, and Oberhuber 1983, 619, no. 617; and Joannides 1983, 232, no. 391.

97. Palais des Beaux-Arts inv. P.L. 470, Lille. Revised data: 220 × 193 mm.; charcoal or black chalk over traces of stylus and *spolvero* underdrawing. Cf. Joannides 1983, 144, no. 48; Knab, Mitsch, and Oberhuber 1983, 560, no. 48; and Catherine Monbeig Goguel in Grand Palais 1983, 189–90, no. 25.

98. Ashmolean Museum inv. P II 568, Oxford. Revised data: 498 × 364 mm.; charcoal and black chalk (possibly highlighted with white originally) over *spolvero* underdrawing. Cf. Parker 1972, 310–11; no. 568; Joannides 1983, 128–29, 242, nos. 48, 437; Knab, Mitsch, and Oberhuber 1983, 618, no. 614; and Gere and Turner 1983, 218–19, no. 176.

99. I am indebted to the late Fabrizio Mancinelli, as well as to Nicholas Penny and Catherine Whistler, for offering me the opportunities to verify the correspondences of design between the painting in the Vatican and the drawing in the Ashmolean Museum, Oxford, by superimposing a tracing from the painting on translucent acetate onto the drawing (protected by plexiglas).

100. This has not yet been possible for me to undertake; sadly, the great supporter of this particular project, Fabrizio Mancinelli, passed away in 1994, before further research could be organized. In 1982, a preliminary examination with infrared reflectography was done for the *Transfiguration* by Hubert von Sonnenburg, to whom I am also indebted for informative discussions.

101. British Museum 1949-2-12-3 Imperial, London. Revised data: 393 × 241 mm. (maximum); charcoal or black chalk over *spolvero* outlines. Cf. Pouncey and Gere 1962, 59, no. 72; and Oberhuber 1972, 201–2, no. 484b.

102. This procedure may be envisioned from Charles Germain Saint-Aubin's description of pricked patterns for embroidery in *L'Art du Brodeur,* Paris, 1770, 5: "Quand ces dessins ont été agréés, il les calque (a) au papier huilé (b), double ce papier d'un autre qu'on nomme *grand-raisin,* & les fait piquer ensemble." Cf. also ibid., 39, definition of *piquer:* "On pique souvent quatre ou cinq papiers ensemble; ces percés servent à faire les dessins marqués qu'on donne dans les différents atteliers."

103. Metropolitan Museum of Art, Robert Lehman Collection, 1975.1.410, New York. Revised data: 288 × 255 mm. (maximum); pen and brown ink, brush and light brown wash, over charcoal or faint black chalk underdrawing (visible only with infrared light; examination conducted by Margaret Lawson in January 1991). The background was reworked with dark brown ink, possibly by Giorgio Vasari. Cf. Forlani Tempesti 1991, 197–202, 69.

104. Vasari 1966–87, III (testo), 507: ". . . E si trovò dopo la morte sua il disegno e modello che a Lodovico Sforza egli aveva fatto per la statua a cavallo di Francesco Sforza duca di Milano; il quale disegno è nel nostro libro in due modi:

in uno egli ha sotto Verona, nell'altro egli, tutto armato e sopra un basamento pieno di battaglie, fa saltare il cavallo addosso a uno armato. Ma la cagione perché non mettesse questi disegni in opera non ho già potuto sapere."

105. Staatliche Graphische Sammlung inv. 1908.168, Munich. Data: 208 × 217 mm.; pen and brown ink, brush and brown wash; background reworked in dark brown ink, possibly by Giorgio Vasari. Cf. Degenhart and Schmitt 1967, 71, no. 60; and Forlani Tempesti 1991, 197–202, under no. 69. This drawing should be examined with infrared reflectography to verify whether it has *spolvero* marks underneath the dense layers of drawing.

106. Microscopic enlargement reveals no rubbed pouncing dust; infrared reflectography reveals traces of a summary, outline underdrawing in black chalk used to connect the holes, as well as to prepare the reclining figure of the woman, which is unpricked. I am indebted to Laurence B. Kanter and Margaret Lawson for having this technical examination conducted on my behalf (Winter 1991).

107. Two further drawing fragments of *Battle Scenes* (Uffizi inv. 14531 F and 14532 F, Florence; CBC 215), by an artist in the circle of Antonio Pollaiuolo, may have similarly been drawn on the basis of preliminary coarsely pricked outlines, for they exhibit numerous divergences between drawn and pricked contours. Virtual outline drawings, these are extremely crude designs in appearance. Revised data: (A) 411 × 304 mm.; (B) 290 × 388 mm.; both in pen and brown ink; (B) has a vertical reference line approximately 38 mm. from the right border.

108. Metropolitan Museum of Art, Robert Lehman Collection, 1975.1.420, New York. Cf. Chapter Six, note 212, for revised technical data, as well as Forlani Tempesti 1991, 207–10, no. 71, and Bambach Cappel 1994, 17–43. In Signorelli's drawing, examination with the microscope confirms that the layers of black and white chalk lie on top of the pen and ink outlines and thus were added later.

109. As is true of most such cases, the artist left some holes unconnected; in Signorelli's drawing, this is most noticeable from a microscopic enlargement of the sagging corner of the mouth and in the wrinkles of the jowls. On the top part of the chin, the artist pricked the outline consistently 1 mm. within the ink outline. Large groups of holes, especially on the bottom left quadrant of the sheet, also remained entirely unconnected, forming a pricked but undrawn design. My attempt to reconstruct this design has been unsuccessful. The sporadic placement of the holes in a number of passages makes a visualization of the design problematic. The diameters of the pricked holes in the lower left quadrant often vary considerably in size.

110. Rijksprentenkabinett inv. A 1403, Amsterdam. Revised data: 441 × 351 mm.; pen and brown ink, black chalk; partly squared with two grids, once in stylus and then in pen and ink at 13 mm. intervals; stylus-ruled centering line; pricked outlines. Cf. Berenson 1938, II, 327, no. 2506A (attributed to Sebastiano); Luitpold Dussler, *Sebastiano del Piombo,* Basel, 1942, 185, no. 192 (not Sebastiano); Rodolfo Pallucchini, *Sebastiano Viniziano,* Milan, 1944,

190, plate 41 (not Sebastiano); P. della Pergola, *Galleria Borghese. I dipinti,* Rome, 1959, II, 137, under no. 188; Berenson 1961, no. 2506A (Giovanni Battista Franco ?); and Frerichs 1981, 88, no. 310. See autograph studies by Michelangelo in the British Museum: inv. 1895-9-15-500 is in red chalk over stylus underdrawing, 235 × 236 mm. (Wilde 1953, 27–29, no. 15); and Malcolm Collection inv. 366 is in black chalk, highlighted with white gouache, 275 × 145 mm. Further, note the drawn copy attributed to Giulio Clovio after the final design by Michelangelo in the Windsor Royal Library (Popham and Wilde 1949, no. 451, fig. 100). On the controversy regarding Michelangelo's involvement in the designs for the Borgherini Chapel, cf. Berenson 1938 and 1961; Dussler 1942 and 1959; Wilde 1953; Tolnay 1975–80; and Hirst 1981, 49–65. Berenson saw no hint whatsoever of Michelangelo's influence in this drawing but acknowledged some kinship with Signorelli's fresco of the *Flagellation* in S. Crescenziano, Morra. He expressed doubts about Sebastiano's authorship and unconvincingly attempted to attribute the drawing to Battista Franco. This drawing was rightly omitted from Michael Hirst's monograph on Sebastiano. There are several small-scale painted copies on panel after Sebastiano's *Flagellation,* of which the version in the Villa Borghese seems roughly comparable in scale to our drawing.

111. Bartsch XV.417.2. On the print, see Mario Rotili, Maria Catelli Isola, and Elio Galassi, *Fortuna di Michelangelo nell' incisione* (exh. cat., Museo del Sannio, Benevento, and Gabinetto Nazionale delle Stampe, Rome), Rome, 1965, 81, no. 76.

10. Techniques of Stylus Incision

1. A study of written sources describing the transfer of cartoons establishes that the Italian term *"calcare"* in early treatises means "to trace or incise with the stylus" (Bambach Cappel 1988, Part 1, 1:11–176). The term also encompasses the procedure of rubbing a design's verso with charcoal, chalk, or graphite, in the manner of modern-day "carbon copies." When written sources give a name to the process of "stylus incising," rather than just describing it (as is most frequent), the term is translated as follows: archaic English, "calquing," and "calking"; French, *"calquer"* and *"decalquer";* Spanish, *"recalcar"* and *"calcar."* German authors often borrowed foreign words.

2. Cf. Procacci 1961, 9, fig. iii, plate 21; Borsook 1980, xxxvi; Borsook 1985, 128; *Tecnica e stile* 1986, I, 59–66; Bambach Cappel 1988, Part 1, 1:65–83, 183–236; and Bambach Cappel 1996 b, 143–45.

3. Procacci 1961, 9, 21 figs. ii–iii.

4. Eve Borsook cited their example, but rightly hesitated about their conclusion. Cf. Borsook 1980, xxxvi (note 4), and Tintori and Meiss 1962, 11–13.

5. *Tecnica e stile* 1986, I, 64–66.

6. Produced as an extremely sketchy, preliminary underdrawing, the profuse incisions in the mural of S. Martino (Tarquinia), especially, illustrate an unusually great range of mark. At times, the incisions course the *intonaco* harshly with high plaster "burr," at others, more softly than might be expected. Clearly, among the variables affecting the impression of the stylus on the *intonaco* were not only the hand's pressure exerted upon the tracing implement itself but also the quality of painting surface that received it – the *intonaco*'s moisture content, fineness of ingredients, and smoothness of application. I am indebted to Malcolm Bell for offering the opportunities to study the Medieval churches of Tarquinia, during which the *Virgin and Child with St. Anne* in S. Martino (seemingly unpublished) came to my attention. For the mural in S. Zaccaria, cf. Muraro 1960, 43–44, no. 11, plate 11.

7. On this point, see above Chapters Five, note 2, as well as Chapter Six, notes 2 and 320–23.

8. See descriptions of fresco, *"secco,"* and panel painting techniques in Cennini 1995, cap. lxvii–lxxxvii, cxlv–clv, 73–96, 147–63 (cf. Cennini 1933, 49–64, 91–96, for trans.).

9. See Chapter Five, note 2, for bibliography. The features comprising the cartoons Italian Renaissance painters would employ were indeed already known to Cennino, but as separate components: the use of preliminary drawings to develop painted compositions, the use of *spolvero* to replicate ornament patterns, the use of direct incision techniques to establish outlines, and the use of comprehensive, full-scale drawings to design stained-glass windows. Yet the synthesis of these elements into one drawing type for use in painting panels and murals clearly lay a conceptual leap away.

10. Cennini 1995, 93–94, 108–9, 128 (cf. Cennini 1960, 54–55, 63–64, 76, 85–87, for trans.).

11. Cennini 1995, cap. lxxxiii, 93 (cf. Cennini 1960, 54, for trans.): "... Ma prima gratta la perfezion delle pieghe con qualche punteruolo di ferro, o agugiella." The freehand incisions appearing in a Cypriot thirteenth-century mural and an Austrian fourteenth-century mural (Mora and Philippot 1984, plates 75, 84) were probably done according to this method described by Cennino.

12. Cennini 1995, cap. lxxxiii, 93 (cf. Cennini 1960, 55, for trans.): "... gratta l'azzurro puro con la punta dell' asta del pennello."

13. On the development of highlighting techniques, cf. Hills 1987, 19–28.

14. A telling case is the *Enthroned Madonna and Child* (Pinacoteca Nazionale inv. 18, Siena), by an anonymous follower of Duccio, the "Master of Città di Castello." It is much like other late Duecento and early Trecento Sienese *Madonna and Child* panels hanging in the same room of the Pinacoteca Nazionale in Siena, except that in this case the icon painter attempted to reverse the flattening effect of chrysography by incising the Madonna's ultramarine blue mantle and pink lining, rather than highlighting them with gold. Extensive repaintings have rendered the solution less successful than it originally was.

15. For instance, see detail of the deacon's draperies in Simone Martini's fresco of the *Dream of St. Ambrose* in the Lower Church (S. Francesco, Assisi), illustrated in *Tecnica e stile* 1986, I, 22. Mora and Philippot 1984, plates 75, 84, illus-

trated examples of a Cypriot thirteenth-century mural and an Austrian fourteenth-century mural showing such free-hand incisions on draperies. Note, further, Bartolo di Fredi, *Madonna and Child with Saints* (Galleria Nazionale dell'Umbria, Perugia); Nardo di Cione, *Madonna and Child with Sts. Peter and John the Evangelist* (National Gallery of Art 1939.1.261a-c, Washington); Agnolo Gaddi, *Enthroned Madonna and Child with Saints* (National Gallery of Art 1937.1.4a-c); Luca di Tommè, *Madonna and Child with Sts. Nicholas and Paul* (Los Angeles County Museum 31.22); workshop of Sano di Pietro, *Madonna and Child* (Metropolitan Museum of Art, Robert Lehman Collection, 1975.1.39, New York); Cenni di ser Francesco Cenni, *Crucifixion with the Virgin and St. John* (Pinacoteca, Volterra); Sassetta, *Madonna and Child* (Metropolitan Museum of Art 41.100.20); as well as Giovanni di Paolo, *Madonna and Child with Saints* (Metropolitan Museum of Art 32.100.76). Trecento panels at the Philadelphia Museum of Art with such freehand incisions are Pietro Lorenzetti (attributed), *Madonna and Child with Donor* (main panel of altarpiece, no. 9); Gherardo Starnina (attributed), *The Dormition of the Virgin* (fragment of an altarpiece, no. 13); Agnolo Gaddi (attributed), *Scene from the Legend of St. Sylvester* (*predella* panel, no. 9); Benedetto di Bindo (attributed), *The Virgin of Humility* (left wing of diptych also depicting St. Jerome, no. 153).

16. Cennini 1995, cap. cxxiii, 128; (cf. Cennini 1960, 76, for trans.): "... Disegnato che hai tutta la tua ancona, abbi una agugella mettuda in una asticciuola; e va' grattando su per li contorni della figura in verso i campi che hai a mettere d' oro, e i fregi che sono a fare delle figure, e certi vestiri che si fanno di drappo d'oro."

17. On gilding techniques, see Cennini 1995, cap. cxxxi–cxlii, 132–45 (cf. Cennini 1960, 79–89, for trans.), and *Art in the Making* 1989, 21–26.

18. Numerous examples that clearly show this practice can be adduced. Among the examples at the Metropolitan Museum of Art, New York, are "Master of the Griggs Crucifixion," *Crucifixion* (43.98.5); Taddeo Gaddi, *Enthroned Madonna and Child with Saints* (10.97); Taddeo Gaddi, *St. Julian* (1997.117.1); Agnolo Gaddi workshop, *St. Margaret and the Dragon* (41.190.23); Giovanni da Milano, lunette of the *Madonna and Child with Donors* (07.200); as well as Paolo Uccello (attributed), small tabernacle of the *Crucifixion* (1997.117.9).

19. Regarding Gentile Bellini's *Portrait of Doge Giovanni Mocenigo* (Museo Correr, Venice), see discussion in Dorigato 1993, 34–35, 115–17, no. 3 (fig. 90), with illustration of this technical evidence.

20. The incisions in the *"Sala dei Mesi"* mural cycle at the Palazzo Schifanoia, Ferrara, have previously been confused with those from cartoons (cf. Varese 1989, 189). In this cycle, the direct incisions are of two types: (a) ruling and compass contruction for architectural features, or (b) free-hand for cutting the reserves in the application of gilding with metal leaf.

21. Cennini 1995, cap. ci, cii, 108–9 (cf. Cennini 1960, 63–64, for trans.): "... Ancora se vuoi fare le diademe de' santi senza mordenti, quando hai colorita la figura in fresco, togli una agugella, e gratta su per lo contorno della testa. . . . Poi abbi una stecchetta di legno forte, e va' battendo i razi d'attorno della diadema."

22. I am indebted to Leonetto Tintori for his demonstrations of incision techniques on fresh *intonaco* (summer 1992).

23. Such circumstances most likely explain the soft character of the direct incisions in the thirteenth-century apse mural from S. Bartolommeo in Pantano (Pistoia), singled out by Ugo Procacci in 1961.

24. Vasari 1966–87, I (testo), 118–19, 121, 134 (cf. Vasari 1960, 213–15, 231, for trans.), and Borghini 1584, 173.

25. Armenini 1587, 104, 113–14, 125 (cf. Armenini 1977, 174, 183, 192–93).

26. British Museum 1895-9-15-518, London. Cf. Chapter Two (note 73), Chapter Eight (notes 45–46); as well as Wilde 1953, 114–16, no. 75. Such reinforced contours possibly from transfer are also evident in Fra Bartolomeo's monu-mental, exquisitely drawn *"ben finiti cartoni"* in the Uffizi, and in many of the sixty cartoons by Gaudenzio Ferrari, Bernardino Lanino, and their Piedmontese-Lombard fol-lowers in the Accademia Albertina, Turin.

27. Uffizi inv. 6449 F, Florence. Cf. Chapter Two, note 197.

28. British Museum 1895-9-15-812 recto, London. Data: 380 × 247 mm.; charcoal (with some red chalk on the ear), on blue paper. Cf. Pouncey and Gere 1962, 166, no. 277.

29. Kupferstichkabinett inv. 4255, Berlin. Data: 321 × 236 mm.; brush and brown wash, on light-brown paper. Cf. Altcap-penberg 1995, 80–83, no. 107.

30. Vatican Museums inv. 753. Data: 4190 × 2850 mm. (two fragments mounted onto canvas stretcher); charcoal and black chalk, highlighted with white chalk, on multiple glued sheets of paper. On the Vatican cartoon by Giulio, cf. Pier Luigi De Vecchi in Vatican 1984, 311–14, no. 118. In another cartoon fragment by Giulio, a *Head of a Man Look-ing Down* (British Museum 1854-6-28-81, London), the incisions, however, were probably done either with a nee-dle or extremely fine stylus and barely excavated the paper surface, whereas the drawing's outlines in black chalk are vigorously reinforced. Data: 333 × 220 mm.; charcoal, high-lighted with white chalk, on yellowish brown paper. Cf. Pouncey and Gere 1962, 79, no. 135. Incisions sharper still, though equally fine, are evident in Giulio's small *"disegno finito"* of the *Brazen Serpent* (Louvre inv. 3593, Paris). Data: 396 × 344 mm.; pen and brown ink, brush and brown wash, over traces of black chalk.

31. This fresco is illustrated in color in Giovanni Battista San-nazzaro, *San Maurizio al Monastero Maggiore,* Milan, 1992, 148 (without mention of Giulio's composition).

32. Uffizi inv. 1788 E and 1789 E, Florence. See discussion in Chapter Two, notes 76 and 120.

33. An example is Poccetti's drawing on blue paper in the Vic-toria and Albert Museum (inv. 8640 H, London). Cf. Ward-Jackson 1979, 96, no. 203 (with a tentative attribution to Naldini).

34. A number of fresco cartoons by Carlo Cignani and Mar-cantonio Franceschini, dating from the 1670s to 1700, show such softer incisions (Bambach 1998, 154–80).

35. See Chapters Five and Six.

36. Such direct stylus construction turns up, for example, in the fourth-century-B.C. Etruscan tombs near Vulci and Tarquinia; the so-called First, Second, Third, and Fourth Style wall paintings in Rome, Pompeii, and Ostia; the fifth- and sixth-century-A.D. Catacombs of S. Gennaro in Naples; and the late-thirteenth-century murals in S. Francesco, Assisi. See also especially, the fourth-century-B.C. murals in the *François Tomb,* still partly *in situ* in Tarquinia, as well as of the detached fragments now in the Villa Torlonia, Rome. Note the details of the crucifix and the icon with the Madonna and Child appearing in the *Verification of St. Francis's Stigmata,* part of the nave mural cycle in the Upper Church (S. Francesco, Assisi), as well as the small *tondo* depicting the weeping Madonna below Giotto's polyptych of the *Madonna Enthroned with Saints* (Pinacoteca, Bologna). These are illustrated in Giovanni Previtali, *Giotto e la sua bottega,* Milan, 1974, 59 (fig. 90), 193 (plate xxix), 285 (plate cxii). Cf. Mora and Philippot 1984, plate 64, for a detail of a fresco in a Pompeian house showing incisions on the architectural construction. As they observed, the incisions were probably made as the artists ruled the lines with a *liaculum,* a procedure mentioned by Vitruvius.

37. The practice of direct stylus construction in mural painting has been amply discussed. It is also ubiquitous in panel paintings; see, for instance, Ambrogio Lorenzetti, *Cityscape* (Pinacoteca Nazionale inv. 70, Siena); Giovanni di Paolo, *Presentation in the Temple* (Metropolitan Museum of Art 41.100.4, New York); Bartolomeo di Giovanni Corradini "Fra Carnevale" ("Master of the Barberini Panels"), *Birth of the Virgin* (Metropolitan Museum of Art 35.121); artist near Piero della Francesca and Francesco Laurana, *View of the Ideal City* (Gallerie Nazionali delle Marche, Urbino); Paolo Uccello, *predella* with the *Miracles of the Host* (Gallerie Nazionali delle Marche, Urbino); Sandro Botticelli, *Annunciation* (Metropolitan Museum of Art 1975.1.74); Botticelli, four panels portraying the *Miracles of St. Zenobius* (National Gallery inv. 3918, 3919, London; Metropolitan Museum of Art 11.98; Gemäldegalerie inv. 9, Dresden); Botticelli, *Last Communion of St. Jerome* (Metropolitan Museum of Art 14.40.642).

38. Examples of both types of incisions, from cartoons and from direct construction on the plaster, can be seen in details of Domenico Ghirlandaio chancel frescos at S. Maria Novella (Figs. 281, 287–88), from 1485 to 1490, as well as in Giovanni and Cherubino Alberti's ceiling frescos in the *Sala Clementina* at the Vatican Palace, from 1596 to 1602.

39. This is true, for instance, of the background details in Domenico Ghirlandaio's *Visitation* on the right wall of the chancel (S. Maria Novella, Florence). In Masaccio's *Trinity* at S. Maria Novella, the cord snapping and stylus-ruled outlines for the cross's arms run through Christ's head. In his *St. Peter Healing the Sick with his Shadow* in the Brancacci Chapel (S. Maria del Carmine, Florence), the stylus-ruled horizontal line aligning the supporting posts of a building in the background runs through the red turban of the figure said to be a portrait of Donatello.

40. The stylus incisions resulting from cartoon transfer are well illustrated in *Tecnica e stile* 1986, II, plates 107, 146, 181–82.

41. See selection of photographs in *Tecnica e stile* 1986, II, plates 175–79.

42. On this fresco, cf. Vittoria Romani in National Gallery of Art 1987, 205, no. 77.

43. To differentiate further between such freehand, direct incisions *(incisioni dirette)* and *calco* or cartoon incisions *(incisioni indirette),* we may consider the so-called "portrait of Sodoma" in Raphael's *School of Athens* (Vatican Palace), frescoed around 1510–12. Direct incisions form *pentimenti* and webs of intersecting, sketchlike reinforcement lines on the face, while cartoon incisions are seen most prominently as gently curving lines on the mantle over the left shoulder and chest. See also Bambach Cappel 1992 a, 9–30 (illustrated).

44. There, on the thin layer of its perfectly smooth, white *intonaco,* the artist sketchily incised the outlines of a dancing youth. As finally painted with elegant black outlines, however, the left contour of the youth's right leg shifts about 6 mm. to the right, and his foot is lowered considerably, with less flexion at the instep. These changes communicate the fluid dance movements with compelling immediacy. In another mural from a fourth-century-B.C. tomb in Paestum, the artist crudely improvised the disposition of the volutes for an anthemion crowning the pediment part of the end wall. As incised, the jittery diameters of the supposedly bilaterally symmetrical volutes do not even remotely conform in dimensions: that on the left measures 95 mm., and that on the right 130 mm. The outlines as finally painted in brick-red pigment, however, were considerably refined and the diameters made comparable: 120 mm. on the left, 123 mm. on the right. I am indebted to Gregory Bucher for his help with my examination of these tomb paintings in the Museo Archeologico, Paestum.

45. Cf. Muraro 1960, 116–17, no. 85, plate 85; also excellent photograph in *Tecnica e stile* 1986, II, plate 192. See detail of *rinceaux* sketched freehand in the fresh plaster of Francesco Salviati's *Sala dei Fasti Farnesiani* (Palazzo Farnese, Rome), illustrated in Mora and Philippot 1984, plate 108. There are also earlier precedents for freehand incised underdrawing in mural paintings. See ibid., plate 65, for an illustration of an example occurring in a fresco in the *House of Castor and Pollux* (Pompeii). The incisions are in the form of multiple schematic reinforcement lines and are angular.

46. Note, for example, Jacopo Bassano's study for the *Head of St. Paul* (Albertina inv. 1553; Ven. 72), Vienna. Data: 132 × 132 mm.; black and colored chalks on blue paper. See Beverly Louise Brown and Paola Marini, *Jacopo Bassano c. 1510–1592* (exh. cat., Kimbell Art Museum), Fort Worth (Texas), 1992, 466, no. 85.

47. Illustrated in Mora and Philippot 1984, plate 108. Note the presence of rough intersecting reinforcement lines rather than major single lines, which are usually the signs of cartoon transfer. These reinforcement lines appear lightly scribbled and do not really correspond to the painting.

48. This aspect of Caravaggio's working practice was first recognized in Christiansen 1986, 421–45. On the issues, cf. also Bambach Cappel 1988, Part 1, II:430–34.

11. *Spolvero, Calco,* and the Technical Virtuosity of Fresco Painting

1. Vasari 1966–87, I (testo), 121.

2. On the division of labor, though without discussion of cartoons, cf. also Nicoletta Pons, "Dipinti a più mani," in Palazzo Strozzi 1992, 35–50, and Thomas 1995.

3. This document is transcribed in Guasti 1857, 144–46, no. 358. Cf. Acidini Luchinat and Dalla Negra 1995, 72; Acidini Luchinat and Danti 1992, 132–39; Cristina Acidini Luchinat, "Vasari's Last Paintings: The Cupola of Florence Cathedral," *Vasari's Florence* 1998, 238–52, with new transcriptions of further related documents by Philip Jacks (ibid., 248–52).

4. See discussion and transcriptions in Acidini Luchinat and Dalla Negra 1995, 72–75, as well as Acidini Luchinat and Danti 1992, 132–39.

5. Here, see further Carducho 1633, *Diálogo Octavo,* 133–35, discussed and transcribed above in Chapter One, notes 10, 176, and Volpato in Merrifield 1849, II, 742–43, discussed and transcribed in Chapter Four, note 2.

6. Cf. Bambach Cappel 1996 b, 143–66. Though not documented, Giovanni da Piamonte and Lorentino d'Andrea are usually thought to have been Piero's assistants in this mural cycle. The hand of a third assistant may also be recognizable. See summary of evidence in Borsook 1980, 91–102, and Bertelli 1992, 22, 24, 48 (note 105), 188. On Giovanni da Piamonte, cf. also Luciano Bellosi, "Giovanni di Piamonte e gli affreschi di Piero ad Arezzo," *Prospettiva,* no. 50 (1987), 15–35; Rodolfo Battistini in *La Pittura in Italia: Il Quattrocento,* Milan, 1987, II, 643–44; Bellosi 1990, 171–75; Giovanna Damiani and Antonio Paolucci in *Nel Raggio di Piero: La Pittura nell'Italia centrale nell'età di Piero della Francesca,* ed. by Luciano Berti, Venice, 1992, 67–83, 173–83 repectively. On Lorentino, see ibid., as well as Rodolfo Battistini in *La Pittura in Italia: Il Quattrocento,* II, 667–68, and Angelandreina Rorro, *Lorentino d'Arezzo: Discepolo di Piero della Francesca,* Rome 1996, all studies with earlier bibliography.

7. Cf. Chapters Three, note 161, and Six, note 167. *Spolvero* cartoons were used throughout the *"Sala dei Mesi."* Contrary to Ranieri Varese's imprecise claims (Varese 1989, 189), all the stylus incisions on the mural surfaces appear to be direct (none from cartoons) and are usually of two types: (a) ruling and compass for the construction of architectural features, or (b) freehand for cutting the reserves in the application of gilding with metal leaf.

8. See transcription in Poggi 1988, 142–43, nos. 2132–33.

9. For the transcription of the contract, see Milanesi 1901, 134–36, and Davies 1908, 170–72 (cf. Chambers 1970, 173–75, for trans.). As pointed out by Lisa Venturini in Palazzo Strozzi 1992, 109–13, most extant documents about commissions and records of payment for the Ghirlandaio workshop refer to both brothers, Domenico and David; David often appears in the role of administrator of the *bottega.* On the documented members of the *bottega,* see also Cadogan 1996, 89–96.

10. On Mainardi's use of Domenico Ghirlandaio's cartoon, see Vasari 1966–87, III (testo), 495. On Mainardi, see Fahy 1976, 215–19; Lisa Venturini in Palazzo Strozzi 1992, 109–13, 127–29; Venturini 1992, 41–48; and Venturini 1994–95, 123–83. As Lisa Venturini has pointed out, Mainardi's fresco in the Baroncelli Chapel is, in fact, a composite of various design motifs from Domenico's works: most strikingly, the group of God the Father with Angels in the upper register is a reprise of that in Domenico's fresco of the *Baptism of Christ* in the *"cappella maggiore"* of S. Maria Novella from 1485 to 1490, and the individual motifs may well have been pieced together from Domenico's original cartoon fragments. For the reference in Vasari's autobiography, see Vasari 1966–87, VI (testo), 381.

11. See: "Item: sia tenuto fare tutti li disegni delle istorie di sua mano in cartoni et in muro; fare le teste di sua mano tutte in fresco et in secho ritocchare et finire in fino a la perfectione sua . . ." (Piero Misciatelli, *La Libreria Piccolomini nel Duomo di Siena,* Siena, 1924?, 37–39, for documents). Cf. Gaetano Milanesi, *Documenti per la storia delle arti in Siena,* III, 9–12; Enzo Carli, *Alfonso Landi, Racconto del Duomo di Siena,* Firenze, 1992, 39–44, 112–15 (note 27); Chambers 1971, 27; and Corrado Ricci, *Pintoricchio . . . ,* Paris, 1903, 176–225.

12. Vasari's accounts regarding the extent of Raphael's help with the designs of the Piccolomini Library murals differs; cf. Vasari 1966–87, III (testo), 571–73; IV (testo), 159. The *Vita* of Pinturicchio states: "Ma e ben vero che gli schizzi e i cartoni di tutte le storie che egli vi fece, furono di mano di Raffaello da Urbino, allora giovinetto, il quale era stato suo compagno e condiscepolo appresso al detto Piero. . . ." The *Vita* of Raphael, however, states: "In questo mentre, avendo egli acquistato fama grandissima nel seguito di quella maniera, era stato allogato da Pio Secondo pontefice la libreria del Duomo di Siena al Pinturicchio, il quale, essendo amico di Raffaello e conoscendolo ottimo disegnatore, lo condusse a Siena, dove Raffaello gli fece alcuni dei disegni e cartoni di quell' opera." On the *modello* (Uffizi inv. 520 E, Florence), cf. Knab, Mitsch, and Oberhuber 1983, 558, no. 29, and Petrioli Tofani 1986, 232–33, *sub numero.*

13. Michelangelo, *Ricordi,* 1, no. I.

14. Ibid., 2–3, no. III.

15. Cf. *Michelangelo: La Cappella Sistina, Rapporto* and Bambach Cappel 1996 a, 83–102.

16. Vasari 1966–87, VI (testo), 173. Regarding Titian's fresco technique and omission of cartoons, see further, Chapters One, notes 66–74; Three, notes 70–71; and Six, note 98. On an extant pricked cartoon by Maffeo Verona for a mosaic at S. Marco, executed in 1613–19 by the mosaicist Alvise Gaetano, see Ciro Robotti, "Il Cartone di Maffeo Verona per un'opera musiva della Scuola Marciana," *BA,* LVIII (1973), 214–18.

17. See discussion and transcriptions of documents in Testi 1922, 142–58, 277–80 (nos. xix, xx), and Ferrari and Belluzzi 1992, II, 1002. Cf. Popham 1957, 8.

18. See document in Testi 1922, 268–69 (no. vii), as well as letters by Giulio, Parmigianino, Anselmi, and the *ufficiali* of

the *Steccata,* dating from 15 March to 11 June 1540, as transcribed in Ferrari and Bellluzzi 1992, II, 835–47. Cf. Hartt 1958, I, 247–50.

19. Bambach Cappel 1988, Part 1, II:357–72. On the painting technique of Melozzo's mural fragments of the *Ascension of Christ* from SS. Apostoli, cf. Fabrizio Mancinelli in *Tecnica e stile* 1986, I, 64.

20. See detached frescos in Museo Civico di Castelvecchio inv. 461, 476, 518, and 560, Verona.

21. See Archivio Fotografico Fratelli Alinari negative no. 9570, Florence.

22. I am indebted to Giorgio Bonsanti, Cristina Danti, Fabrizio Bandini, and Jonathan Nelson for the opportunity to study the fresco cycle in the chancel (S. Maria Novella, Florence) from the scaffolding erected for its cleaning (November 1990). Additionally, Giorgio Bonsanti kindly put at my disposal the documentary photographs taken during the restoration, now in the Archivio Fotografico of the Opificio delle Pietre Dure e Laboratorio di Restauro, Florence. Cf. Artur Rosenauer's thesis of 1965, 58–60 (which I have not been able to consult), cited and discussed in Borsook 1980, l–li; Rosenauer 1986, I, 27; Danti and Ruffa 1990, 29–48; Danti 1990, 39–52; Ruffa 1990, 53–58 (diagrams 2–7), also with important findings on the architectural construction of the scenes; Cadogan 1994, 63–72; Danti 1996, 141–49; and Bambach Cappel 1996 a, 83–86, 91, 95. Some of these studies, however, offer imprecise data on the issue of direct incisons and cartoon incisions.

23. In Domenico Ghirlandaio's *Birth of St. John the Baptist* (S. Maria Novella, Florence), for example, *spolvero* outlines peek through small areas where the green pigment on the wall has flaked off the grey-beige *intonaco* and suggest that the recumbent St. Elizabeth originally raised her left hand higher and gesticulated toward the tray that her attendant offers. In the *Birth of the Virgin,* executed more broadly, the stylus incisions frequently diverge from the painted outlines. Ample further evidence can be found in the files of record photography, done for the cleaning of the S. Maria Novella frescos, at the Opificio delle Pietre Dure e Laboratorio di Restauro, Florence (kindly made available to me by Giorgio Bonsanti).

24. Firm, precise conclusions are not possible, however, as the existing graphic documentation of the painting technique in Ghirlandaio's fresco cycle at S. Maria Novella is not as detailed, as has become customary in more recent cleaning and restoration campaigns. For diagrams and interpretation, see Danti 1990; Danti and Ruffa 1990; and Danti 1996.

25. It was unfortunately not possible for me to obtain up-to-date, archaeological photographs of Luca Signorelli's fresco cycle in Orvieto Cathedral, despite repeated attempts. I am indebted to Giusi Testa, Carla Bertorello, and Lucia Tito for the numerous opportunities to study the Orvieto fresco cycle from the restoration scaffolding (summer 1992–summer 1994). See Orvieto 1996, for a photographic survey of the frescos after the cleaning directed by Testa. On issues of their painting technique, cf. Bertorello 1996 a and b, 327–49, 357–85; Henry 1996, 253–70; Bambach Cappel 1996 a, 95 (and notes 118, 119);

Henry 1993, 612–19; and Carla Bertorello, "Restauri antichi e moderni nella Cappella S. Brizio," *Il Duomo d Orvieto,* ed. by Lucio Riccetti, Rome-Bari, 1988, 217–45. A chronology of the frescos is proposed by Laurence B. Kanter in Orvieto 1996, 95–132 (with previous bibliography); Kanter 1983; and Kanter 1989, 1–71. All the documents relevant to the chapel are newly transcribed in Andreani 1996, 416–59. I refrain from adducing the disposition of *giornate,* relative to the *pontate* of scaffolding, as a means of settling the issues of precise chronology, for this seems to me to build on two levels of interpretation, where the evidence seems partly ambiguous.

26. In Signorelli's frescoed vault of the *"Cappella Nuova"* (Cappella della Madonna di S. Brizio, Orvieto Cathedral), already twelve apostles are represented in this compartment, as a counterpart to the figures of prophets on the opposite compartment. Considering the overall iconographic order of the vault, it would be difficult to argue that the "stray" halo belongs to an angel. The telling physical evidence is only partly illustrated in photographs in Orvieto 1996, 101 and 168 (for the extra halo on the right of the Virgin's head), 341 (for the rise in the *intonaco* and incisions). It may well be that this was the earliest compartment of the vault painted by Signorelli, a fact that might explain the need for such a partial design revision.

27. On Fra Angelico's presumed portrait in Signorelli's fresco cycle at Orvieto Cathedral, see Chapter Three (Fig. 101), and on the temple, see Chapter Five.

28. See Henry 1996, 258, for illustrations of the misplaced hands.

29. Also on the lower left portion of Signorelli's scene of the *Crowning of the Elect,* a much less drastic adjustment – visible only from the restoration scaffolding, and one fairly unusual in Italian Renaissance murals – occurs in a small passage of the tonsured figure of one of the "elect," standing directly behind and slightly to the upper right of one of the foreground figures. This figure tilts the broken, aquiline profile of his foreshortened face upward and away from the viewer into the space of the background. Parts of his face, ear, upper-jaw contour, and left hand exhibit sporadic outlines of slightly incised holes, as if the original cartoon had been partly pricked, but not rubbed with pouncing dust. These same contours were retraced with the stylus through the paper, leaving unmistakable, indirect incisions of varying depths on the *intonaco.* All retracing of outlines, even of those that evidence pricking, appears to have been done through the paper. The rest of the monumental figure is incised normally. Luca and his assistants may have thus begun to prick the outlines of the cartoon in the portion with this figure's face and left hand, changed their minds, and incised the contours as in the rest of the fresco. More probably, however, the figure in the cartoon had already been partly pricked as the result of an oversight, before the cartoon for the composition was to be transferred by incision.

30. See especially photographs in Orvieto 1996, 138, 144, 173, 255, 261, 267, 268, 322, 326, 334, 341, 345, for examples of rapidly stylus-incised cartoons.

31. This detail on the altar wall of the *"Cappella Nuova"* (Cappella della Madonna di S. Brizio, Orvieto Cathedral), was pointed out to me by Carla Bertorello during one of my visits to the restoration scaffolding. See further photographs in Orvieto 1996, 258, 340, 345, 347, 348, for preliminary cartoon incisions or red brush underdrawing, never finally painted in color, however, and 262, for the incomplete foot of the figure interrupted by the join of the *giornate.*

32. Cf. Mancinelli 1984, 404–8; Mancinelli 1986 c, 166–67; and Nesselrath 1986, 177. See Nesselrath 1992, 31–60, for further analysis of cartoon use in the *Stanza dell'Incendio* (Vatican Palace). The *spolvero* and *calco* in Giulio Romano's *"Sala dei Giganti"* (Palazzo Te, Mantua) are evident with binoculars and the unassisted eye. Cf. also note 84 below.

33. Cf. Borsook 1980, 127–31, on the painting technique, as well as Paatz, V, 74–89; Freedberg 1963, I, 8–70; and Shearman 1965, I, 52–74, II, 294–307, on the historical context. Stylus incisions from cartoons occur in the *Visitation,* the *Birth of St. John the Baptist,* the *Baptism of the People,* the *Imprisonment of St. John,* the *Feast of Herod,* the *Beheading of St. John Baptist,* and the *Presentation of St. John's Head to Herod,* as well as in the allegorical figures of *Faith* and *Hope.*

34. Cf. Shearman 1965, I, 52–74, II, 294–307, where the earliest scene of the *"Chiostro dello Scalzo"* murals to be painted, the *Baptism of Christ,* is dated around 1511.

35. On these two scenes by Franciabigio, cf. McKillop 1974, 159–63, but without mention of cartoon transfer. Documents are transcribed in ibid., 249–51, nos. 40–52. Cf. discussion in Shearman 1965, I, 52–74.

36. In the *Annunciation to Zacharias* at the *"Chiostro dello Scalzo,"* the incomplete date in Roman numerals on the step below the altar is interpreted as 1523 in Shearman 1965, II, 305, no. 13, and as 1522 in Freedberg 1963, II, 122–23. Some of the old engraved copies cited by John Shearman render the date as 1522.

37. I am indebted to Donatella and Carlo Giantomassi for the opportunity to study these frescos from the scaffolding erected for their cleaning (July 1994). For the bibliography, citation of the relevant extant cartoons by the Carracci, and general discussion see Chapter One, notes 53–54, and Chapter Eight.

38. I am indebted to the late Fabrizio Mancinelli, Arnold Nesselrath, and Enrico Guidi for the opportunity to study this mural from the restoration scaffolding (summer 1992).

39. Cf. *Michelangelo: La Cappella Sistina, Rapporto* and Bambach Cappel 1996 a, 91–101. The diagrams of *giornate* for the Sistine Ceiling show that generally in scenes where the cartoons were transferred by both *spolvero* and *incisione indiretta,* the passages with *spolvero* were painted before those with *incisione indiretta.*

40. Pozzo 1693–1700, "Breve instruttione per dipingere a fresco," II, unpaginated, Settione Settima, *"Ricalcare:* Stabilita che sieno i contorni del disegno in carta grande, come habbiamo detto, si sopraporrà sopra l'intonaco, che per la sua freschezza sarà atto a ricevere ogni impressione: & allora con una punta di ferro andarete legermente premendo i contorni. Ne disegni di cose piccole basterà fare

uno spolvero, che si fà con far spessi, e minuti fori ne'contorni con sopra porvi carbone spolverizato legato in un straccio, che sia atto a lasciar le sue orme meno sensibile. Cio da' Pittori si chiama spolverare." Cf. Bambach Cappel 1988, Part 1, I:149–52, II:365.

41. Milizia 1827, II, 231 (first published in Bassano, 1797): "Cartoni . . . Sull'intonaco ancora molle si può con una punta delineare il contorno delle figure, seguendo esatamente la estremita del cartone ritagliato. Se le figure sono numerose, si descrivano con fori nel cartone tutti i contorni della composizione, ed applicato il cartone al muro, vi si fa passar sopra un sacchetto di polvere minutissima di carbone, la quale attraversando i fori lascia sull'intonaco la traccia che seguire deve il pittore." Cf. Bambach Cappel 1988, Part 1, I:25–26.

42. Cf. *Michelangelo: La Cappella Sistina, Rapporto.* Even the fictive architectural cornice above the Delphic Sibyl, Prophet Joel, and Prophet Isaiah has *spolvero,* which indicates the importance of obtaining a precise fit between figures and architectural framework in the initial bays. From east to west, the placement of the *giornate* for the fictive cornice remains always below that of the *giornate* for the adjacent parts of the decoration. This led Fabrizio Mancinelli, Gianluigi Colalucci, and Kathleen Weil-Garris Brandt to suggest that the architectural framework was painted first (my thanks to them for discussing the problem). Fabrizio Mancinelli proposed the probability that the fictive architecture was developed in detail on the *arriccio;* cf. Biagetti 1936, 207–8, 210, fig. 6. On the architecture, see Charles Robertson, "Bramante, Michelangelo and the Sistine Ceiling," *JWCI,* XLIX (1986), 91–105, as well as in *Michelangelo: La Cappella Sistina, Atti,* the essays by Christoph Luitpold Frommel, "Michelangelo e il sistema architettonico della volta della Cappella Sistina," 135–39, Marisa Dalai Emiliani, "Michelangelo e il sistema prospettico della volta,"145–53; and Charles Robertson, "Riflessioni sulle architetture dipinte della Cappella Sistina," 155–57.

43. For the *giornate,* cf. Colalucci 1990, 70, and *Michelangelo: La Cappella Sistina, Rapporto.* The numbers of *giornate* for the seers are as follows: *Zacharias* (ten); *Joel* (eleven); *Isaiah* (twelve); *Ezekiel* (thirteen); *Daniel* (fourteen); *Jeremiah* (sixteen); *Jonah* (twelve); *Delphica* (eleven); *Erithraea* (twelve); *Cumaea* (twelve); *Persica* (eleven); and *Libica* (nineteen). The numbers include thrones, often painted *in tandem* with the figures, but not the fictive marble cornice on top, a separate unit. The *giornata* depicting *Isaiah*'s right arm and torso shows at once pounce marks and stylus incisions from the cartoon; the same is true of *Persica*'s head. Cf. Appendix Two.

44. For literature, see note 42. The number of *giornate* for the *ignudi,* usually three or four, remains constant from east to west.

45. The scene of the *Brazen Serpent* was painted in nineteen *giornate.* The only part of the cartoon to be stylus-incised is the frame with motifs of shells and acorns, painted after the scene itself. Cf. Appendix Two.

46. The *spolvero* technique separates the process of transfer

into two steps: (1) that of pricking the outlines, and (2) that of actually rubbing the pricked holes with charcoal or chalk dust, the "pouncing" onto the working surface. In fresco painting, where speed is essential, *spolvero* avoids the particularly tense moment of improvising simultaneously on the cartoon and the fresh *intonaco*, as is required with *calco*. Because both the pricking of contours, which could be done at leisure either on the site or in the *bottega,* and the actual process of pouncing take time and require a degree of deliberation, artists are compelled to be disciplined in their working method. Moreover, by ensuring an accurate, continuous reading of the transferred image, *spolvero* diminishes the probability of mistakes, especially in small, intricate passages, because the character of the detailed underdrawing is predetermined.

47. On Michelangelo's assistants in the Sistine, cf. Biagetti 1936, 199–220; Wallace 1987, 203–16 (211, note 1, for bibliography); Mancinelli 1988 b, 538–41, 551; and Mancinelli 1990, 55–59; Mancinelli 1990, 55–59; and Fabrizio Mancinellli, "Il Problema degli aiuti di Michelangelo," *Michelangelo: La Cappella Sistina, Atti,* 107–14.

48. The two figures with stylus-incised outlines in the *Sacrifice of Noah* can be ruled out, for they were repainted on new *intonaco* by Domenico Carnevali in the 1570s. Cf. Gianluigi Colalucci, "Stato di conservazione," 97–100, and Anna Maria De Strobel, "Documenti sui problemi strutturali e sugli interventi di manutenzione e di restauro del Cinquecento," 280, both in *Michelangelo e la Cappella Sistina* 1990, as well as *Michelangelo: La Cappella Sistina, Rapporto,* 227, 246–47.

49. On Michelangelo's assistants in the Sistine, see note 47.

50. Cf. discussion in Mancinelli 1988 a, 12–14; Mancinelli 1988 b, 540–41; Mancinelli 1990, 57; and *Michelangelo: La Cappella Sistina, Rapporto.*

51. See Chapters Three and Five.

52. Here, recall the texts by Cennino, Alessandro Paganino, Francisco Pacheco, Acisclo Antonio Palomino, Johann Hübner, and Charles Germain de Saint-Aubin, transcribed in Chapter Three, notes 89–94.

53. See Figures 88–90, 152, 203–4. On the problem of symmetry and cartoon reversals in Italian Renaissance painting, cf. Summers 1977, 59–88; Borsook 1980 b, 128; Gilbert 1980 b, 36–38 (and note 7), 47–50; Bambach Cappel 1988, Part 1, II:370–72; Battisti 1992 (throughout his text); Gilbert 1994; and Bambach Cappel 1996 a, 92–95.

54. With respect to previous scholars who have discussed the practice of cartoon repetitions and reversals for figures in the fifteenth century, my tendency regarding this issue is admittedly conservative, in view of the fact that we have hardly any extant fresco cartoons from this period and in view of the problems presented by copies and freer variants of design, as discussed in Chapters Three, Six, and Nine

55. The problem of Michelangelo's use of cartoon reversal in the Sistine Ceiling to obtain symmetry has long been mentioned in the literature. Cf., for instance, Biagetti 1936, 211; Camesasca 1972, 95–97; Summers 1977, 73, 84–85 (note 4); Gilbert 1980 b, 47; and Gilbert 1994. However, the technical evidence gathered during the recent cleaning of the ceiling suggests that considerable caution is necessary regarding the issue of cartoon reversal. The cartoons for the pairs of *putti* on thrones east of and including those of *Ezekiel* and *Isaiah* were pounced, whereas the cartoons of *putti* on thrones west of and including those of *Persica* and *Cumaea* were stylus-incised. In the cases of *Erithraea, Persica,* and *Jonah,* especially, cartoon nail holes surround the rectangular spaces occupied by the *putti.* This seems to document further that the monochrome *putti* were drawn on separate cartoons from the seers to facilitate their reversal. In the case of the *putti* holding the tablets identifying the seers, however, as Fabrizio Mancinelli's detailed examination of the problem has suggested, they appear to have been painted without cartoons. The symmetry of the *putti* holding the tablets identifying the seers is developed from the north wall across to the south wall. This precise symmetry is interrupted toward the east end, beginning with *Persica* and *Daniel.* Surprisingly, no *spolvero* marks were found in the pairs of bronze nudes surmounting the pinnacles of each spandrel. These figures would seem to be likely candidates for instances of cartoon reversal (as already noted in Camesasca 1972, 95–97), although the recent cleaning has shown them to be painted in a very fluent technique. As for the repeating *bucrania,* pounce marks were found only in the left horn of the *bucranium* surmounting the pendentive of *David and Goliath.* There are differences of size and design.

56. See passages transcribed in Chapter Three, notes 26–28.

57. Cf. Summers 1977, 59–88, and Bambach Cappel 1996 a, 92–95.

58. Cf. Henry 1996, 253–67. There may be more examples of correspondences of designs and dimensions of heads in this cycle than has been reported.

59. Massimo Baldi and Elio E. Rodio, "Ipotesi sui cartoni: Ripetizioni e misure," in Schianchi and Battisti 1981, 46–49. Unlike in the case of the frescos in Orvieto Cathedral, where I was able to work with tracings from some of the figures, I did not have an opportunity to visit the restoration scaffolding in Parma Cathedral to be able to have an opinion on the subject.

60. Perino del Vaga's cartoon is Uffizi inv. 965 E, Florence. Revised data: 800 × 515 mm.; black chalk, charcoal, brush with gray and brown wash, highlighted with white gouache, with horizontal lines in red chalk (also pricked), on several pieces of irregular, glued, brownish gray paper (originally, *"carta azzurra"*); glued onto secondary paper support. Pellegrino Tibaldi's cartoon fragments are Uffizi inv. 998 E a (unpricked mask; 236 × 190 mm., max.), inv. 998 E b (mask; 247 × 249 mm.); inv. 999 E a (sphynx; 377 × 247 mm., max.), and 999 E b (sphynx; 378 × 264 mm.); all in brush with gray and brown wash, over black chalk and charcoal, highlighted with white gouache, on multiple pieces of glued brown paper (originally, *"carta azzurra"*?); glued onto secondary paper supports. Cf. Petrioli Tofani 1987, 410, 423–24, nos. 965 E, 998 E–999 E, but without the present analysis of function. The lower portion of a small-scale drawing by Pellegrino Tibaldi

(Städelsches Kunstinstitut inv. 554, Frankfurt) shows how the individual design parts seen in Pellegrino's Uffizi cartoon fragments formed an overall decorative program with *ignudi*. Cf. also preliminary proposal in Bambach Cappel 1996 a, 93–94 (note 104).

61. What follows is a revision of Bambach Cappel 1996 a, 83–102.

62. Cf. Camesasca 1972, 92, Gilbert 1980 b, 47–48; and Gilbert 1994.

63. My tracings derived from the computer printout in the Vatican Museum's archive, made accessible to me by the late Fabrizio Mancinelli and Filippo Petrignani.

64. See Bartsch XV.426.36 in *Michelangelo e la Sistina* 1990, 196, no. 76 (with bibliography).

65. Here, see further also the photographic material published in *Michelangelo: La Cappella Sistina, Tavole.*

66. Here, see further the diagrams published in *Michelangelo: La Cappella Sistina, Rapporto,* between pp. 134 and 195.

67. Gilbert 1980 b, 47–48, based on approximate dimensions given in Camesasca 1972, 92–93; repeated in Gilbert 1994.

68. See Cortesi Bosco 1987, II, 8, no. 3: "... Onde che inteso quella, rispondo che a 20 decembre, come fui gionto qui, volsi comenciar el quadro grande che me rechiedeti e trovai haver smarita la misura de le figure più grande che sono fate su l'altro quadro grande del diluvio, onde che senza quella non pote né posso dar minimo principio perché da quelle nasse tuto l'ordine de l'opra. Io scrisse al tempo sopradito al mag.co miser hier.o Passo, per altre mie importancie, anchora questo, che sua ex.tia facesse che m.o Io. Franc.o lucidasse el Noè del quadro grande et subito mi fusse mandata." On shortcuts to producing bilaterally symmetrical drawings, see Bambach Cappel 1991 a, 72–98. On the relatively common habit of developing drawings upon the basis of preexisting pricking, see Bambach Cappel 1988, Part 2, I:21 (with further citation of examples). Still other methods of transfer involving full-scale designs were also used in the Italian Renaissance workshop. For instance, the practice of pouncing parts of large, full-scale cartoons onto other sheets of paper for further development is best known in the case of Raphael's so-called "auxiliary cartoons," on which see Fischel 1937, 167–68; Bambach Cappel 1988, Part 1, II:373–94, Part 2, I:17-a, 19; and Bambach Cappel 1996 a, 94 (and notes 104–6).

69. Cf. Bambach Cappel 1996 a, 92–94. Study of these details as actually painted, as well as tracings (scale 1:4) on clear acetate (to facilitate reversal), depicting the outlines of the three limbs both as transferred from the cartoon and as finally painted, demonstrate the correspondence of design and scale. My tracings derive from the computer printout in the Vatican Museum's archive; there are minor imprecisions of design in the computer record of this portion of the composition.

70. No *spolvero* marks on Adam's right lower leg were reported in the data retrieved during the cleaning; this does not mean that they did not exist. Even figures painted from *spolvero* underdrawing in the ceiling show relatively sporadic areas of dots – for example, parts of the lower legs of the Lord in the same scene or some of the late *ignudi*. Cf. further *Michelangelo: La Cappella Sistina, Rapporto,* 92–93, 275–77, and Bambach Cappel 1996 a, 94 (note 107), 99–101.

71. The method of verification is as described in note 69.

72. In the Sistine Ceiling, there is an increase of scale in the feet from God the Father and Adam in the *Creation of Adam* to God the Father in the *Creation of the Sun, Moon, and Plants.* The relatively small increase may have been the inevitable result of the actual processes of transfer, tracing onto paper, and final execution in paint. The stylus incisions in the legs and feet of the Lord in the *Creation of the Sun, Moon, and Plants,* as in the case of Adam, depicted the limbs much smaller. See further Bambach Cappel 1996 a, 94.

73. On the methods of tracing with transparent paper, *lucidare,* described in primary sources from the twelfth to the eighteenth centuries, cf. Chapters Two, Three, and Four, as well as Meder and Ames 1978, I, 397–99; Degenhart and Schmitt 1968, I-1, xxxvii–xxxix; Beal 1984; Bauer 1986, 355–57; and Bambach Cappel 1988, Part 1, I:30–40 (with further bibliography). Tracings could have been done also with opaque paper held against a light source; note description in Paganino c. 1532, *Proemio, "Alessandro Paganino al Letore,"* unpag., fols. 3 recto and verso.

74. For the proposal, cf. Massimo Baldi and Elio E. Rodio, "Ipotesi sui cartoni: ripetizioni e misure," in Schianchi and Battisti 1981, 46–49. On Correggio's cartoons, cf. Popham 1957, 5–7; Ingendaay 1981, 69–78; Ingendaay 1983, 185–88; and Ekserdjian 1997, 260.

75. Cf. Ingendaay 1981, 76–78; Ingendaay 1983, 185–88; and Ekserdjian 1997, 260. Arthur Ewart Popham firmly dismissed these outline cartoons as tracings from the frescos dating from the Seicento or Settecento; cf. Popham 1957, 6 (note 1), 141.

76. Cf. Bambach Cappel 1988, Part 1, II:357–72; Nova 1992, 83–100; and Bambach Cappel 1996 a, 94–96.

77. I am indebted to Leonetto Tintori for his demonstrations of incision techniques on fresh and set *intonaco.*

78. In the fragments from the *Adoration of the Magi* by a follower of Perugino (Museo Ospedale degli Innocenti, Florence) and in Vincenzo Foppa's *St. John the Baptist* (Museo Castello Sforzesco, Milan), the fine *spolvero* dots minutely describe most elements of the composition. By comparison, Sodoma's indirect incisions in the detached mural fragments from the Compagnia di S. Croce appear selective and unconstrained, as, for instance, in the *Agony in the Garden* and *The Descent of Christ to Limbo* (Pinacoteca Nazionale inv. nos. 401 and 403, Siena). Both of these fragments are photographed in Torriti 1981, 100 (no. 401, plate 103), 103 (no. 403, plate 105).

79. Note, for instance, Girolamo Mocetto's *Continence of Scipio* (Museo Civico di Castelvecchio inv. 476, Verona), Giovanni Francesco Morone's *Virgin and Child with St. Roch* (Gallerie dell'Accademia inv. 735, Venice) and *Virgin and Child with Saints* (Museo Civico di Castelvecchio inv. 560, Verona), Correggio's *Annunciation* and *"Madonna della Scala"* (Pinacoteca Nazionale inv. 758 and 31, Parma), Francesco Longhi's *Galla Placidia during the Tempest* and

Consecration of the Church of S. Giovanni Evangelista (Museo Nazionale, unnumbered, Ravenna), as well as Bernardino Poccetti's scenes from the *Life of St. Antoninus* cycle (S. Marco, Florence).

80. Cf. Borsook 1980, liii, fig. 30, and Alfio del Serra, "Sodoma a Monteoliveto Maggiore (ca. 1505–08), e discussione . . . ," *Tecnica e stile* 1986, I, 59–60, II, plate 107.

81. Examples of stylus-incised frescos by Alessandro Allori include the *Trinity,* dated 1571, from the Chapel of St. Luke (SS. Annunziata, Florence); the fragments from 1575 originally in the Refectory of S. Maria Nuova (Museo Ospedale degli Innocenti, Florence); the cycles in the Gaddi Chapel (S. Maria Novella, Florence) from 1577; the *"Salone of Leo X"* (Medici Villa, Poggio a Caiano), dated 1578–82; as well as the evangelists (S. Maria Nuova) from around 1580. On these frescos by Allori, see Lecchini Giovannoni 1991, 238–40, 241, 248–50, 258, nos. 52, 54, 58, 71, 86, although without mention of cartoons or *incisioni indirette.*

82. See Chapter Three, note 72, for the text of this interesting document, kindly brought to my attention by Anna Padoa Rizzo and Lisa Venturini.

83. Bambach Cappel 1988, Part 1, I:236–51.

84. The fresco of the *Battle of Constantine* (Sala di Costantino, Vatican Palace) is comprehensively pounced. See Bambach Cappel 1992 a, 14, 28 (notes 31–32). *Spolvero* marks appear extensively in the frescos by Giulio and his *bottega* in Mantua – those in the Palazzo Ducale and Palazzo Te. Cf. Giuseppe Basile, "L'Intervento dell'Istituto Centrale del Restauro a Palazzo Te," *Quaderni di Palazzo Tè,* I (1985), 19–22, and Basile, "Il Restauro della volta della Sala di Psiche," *Quaderni di Palazzo Tè,* IV (1988), 49–67 For pricked and pounced drawings by Giulio, see Bambach Cappel 1988, Part 2, II:279–90, nos. 203–11. Giulio's use of cartoons in monumental scale is discussed in Chapters Two, Three, and Eight.

85. Transcribed in Samek Ludovici 1956, 37: "Vincenzo Giustiniani al signor Teodoro Amideni . . . farò alcune distinzioni, e gradi di pittori. . . . Il primo modo è con spolveri" (kindly brought to my attention by Creighton E. Gilbert). Cf. Chapter Four, notes 48–49.

86. Cf. Vasari 1966–87, I (testo), 118–21, 134 (cf. Vasari 1960, 212–15, 231, for trans.), and Borghini 1584, 170–73. Vasari only mentioned the use of *spolvero* cartoons for *sgraffito* façade decoration, which is entirely based on the repetition of ornament patterns. Cf. Vasari 1966–87, I (testo), 142–43 (cf. Vasari 1960, 243–44, for trans.); Vasari's *Vita* of Andrea di Cosimo Feltrini; and Vasari 1966–87, IV (testo), 521. In Italian primary sources from 1500 to the 1790s, the term *"calcare"* meant precisely stylus tracing, not just tracing. The original Italian meaning of the term was preserved fairly accurately in English, French, Spanish, and German translations until the early decades of the eighteenth century. See further Bambach Cappel 1988, Part 1, I: 11–56, 101–17, with bibliography of primary and secondary sources.

87. Uffizi inv. 664 E, Florence, Data: 256 × 363 mm.; red chalk. Cf. Annamaria Petrioli Tofani in Palazzo Pitti 1986, 283–84, no. 69.

88. For example, a detail from Luca Cambiaso's pen drawing, a *Martyrdom of St. Sebastian,* datable around 1555–60, when he painted the altarpiece of saints in S. Maria della Castagna at Quarto dei Mille, may be compared to the detail of a nymph on a spandrel fresco in the *"Salone di Apollo"* at the Palazzo Doria-Spinola, from 1551. Cambiaso's drawing and fresco both share a prismatic rendering of chiaroscuro, as well as a taste for complex effects of anatomical foreshortening. On the *St. Sebastian* drawing, which is in the Suida-Manning Collection (Hartford, Connecticut), see Metropolitan Museum of Art, 1996, 20–21, no. 11. Data: 568 × 421 mm.; pen and brown ink, brush and brown wash, over black chalk. On the fresco, see Magnani 1995, 22–44.

89. Vasari 1966–87, II (testo), 317–18: "Fatte le scodelle, che io faccio questa figura e vengo. . . ."

90. See Vasari 1966–87, I (testo), 128–30; as well as Vasari's letter from 1547 to Benedetto Varchi, as transcribed in Frey 1923–30, I, 185–89, no. LXXXIX. On these critical notions see also, for instance, Robert J. Clements, *Michelangelo's Theory of Art,* New York, 1961, 64–65; Shearman 1967, 21–22; John Shearman "Maniera as an Aesthetic Ideal," *Renaissance Art* (ed. by Creighton E. Gilbert), New York, 1970, 181–221, especially, 195; Baxandall, 1972, 123–24, 141–43, 160–61; and Summers 1981, 60–61, 177–85 (with a review of the primary sources). But these critical notions were not unanimously applied in the Cinquecento. Giovanni Battista Armenini, for one, thought that *facilità* could often get in the way of good art. See Armenini 1587, 70–82 (cf. Armenini 1977, 142–43, for trans.), and Edward J. Olszewski's comments in ibid., 34, 61.

91. Cennini 1995, cap. clxxii, 184 (cf. Cennini 1960, 113, for trans.): ". . . e vuoi vedere s'el ti conviene avere legger mano e che non sia affaticata. . . . E dotti questo consiglio: che 'l dì che vuoi lavorare in la detta opera, tieni il dì dinanzi la mano al collo o vuoi in seno, per averla bene scarica dal sangue e da fatica."

92. Cf. note 90, as well as Barocchi 1958, 221–35; Robert J. Clements, *Michelangelo's Theory of Art,* New York, 1961, 64; Shearman 1967, 15–22; Baxandall 1972, 141; Summers 1981, 179–83; and Rubin 1995, 24–25, 264–73. Roskill 1968, 20, proposed that Dolce's *Dialogo* used the concept of *facilità* in Vasari's sense of the term, primarily as a weapon against Michelangelo to emphasize Raphael's gifts.

93. For instance, see Vasari 1962, I (testo), 116 (cf. Vasari 1966–87, VI (testo), 108): "avendo saputo cavare della difficultà tanto facilmente le cose, che non paion fatte con fatica, quantunque, chi disegna poi le cose sue, la vi si trovi per imitarla." Cf. Summers 1981, 179–83.

94. On Giorgio Vasari as a drawings collector, see Chapter Three, note 16, and on his remodeling of Medicean churches, see Hall 1979.

95. Here, see Vasari 1966–87, I (testo), 117–21 (cf. Vasari 1960, 212–15, for trans.), the influential chapter about preliminary drawing types that discusses the use of cartoons. Although the passages strongly state that for fresco painting cartoons must be employed, it tellingly concedes that "Assai pittori sono che per l'op[e]re a olio sfuggono ciò, ma per il lavoro in fresco non si può sfuggire ch'e' non si

faccia." Moreover, the later chapter on oil painting also openly concedes: ". . . E chi non volesse far cartone, disegni con gesso da sarti bianco sopra la mestica overo con carbone di salcio, perché l'uno e l'altro facilmente si cancella." See Vasari 1966–87, I (testo), 132–34 (cf. Vasari 1960, 230–31, for trans.). Such statements comfirm that painters frequently did not prepare cartoons. Although the omission of the practice is less surprising in easel painting, plenty of evidence suggests its frequent omission also in mural painting, even in *buon fresco,* presumably because detailed *sinopie* were prepared on the *arriccio.* Alternatively, in the passage on fresco painting, Armenini's *De' veri precetti* (Ravenna, 1586) explains that painters should prepare the *intonaco* with great care and then on top should begin to outline the composition with a thin water-based *rossigno* pigment (probably a *sinoper*), which could easily be wiped off in case of errors. To do the red underpainting on the *intonaco,* fresco painters could follow the guide provided by his small drawing on paper, or, if a finished cartoon *("carton finito")* had been made, it could be stylustraced or pounced by means of the previously described practice of a "substitute cartoon." See Armenini 1587, 113–14 (cf. Armenini 1977, 183, for trans.). See also Meder 1923, 523, 526 (Meder and Ames 1978, I, 392–93, for trans.), for examples of Cinquecento and Seicento artists, who according to primary sources, worked without cartoons. On direct preparatory techniques, cf. also Bauer 1975, and Bauer 1978, 45–57.

96. Vasari 1966–87, IV (testo), 316.

97. Ibid., V (testo), 471–72.

98. Antonio Manno, *Vite dei Tintoretto da "Le Maraviglie dell'Arte . . ."descrite dal Cavalier Carlo Ridolfi,* Venice, 1994, 30–31. Cf. Armenini 1587, 116–17, where Tintoretto's practice of omitting preliminary drawings in painting important commissions is more generally mentioned, and in a disapproving tone.

99. Vasari 1966–87, V (testo): ". . . e che i disegni e modelli dell'opera avevano essere a quel modo per non ingannare nessuno." On Tintoretto's direct preparatory approach, see also Bauer 1975 and Bauer 1978, 45–57.

100. See further Carlo Cesare Malvasia, *Felsina Pittrice: Vite de' Pittori Bolognesi . . . ,* Bologna, 1967, I, 254 (Cesare Baglione), 346 (Lodovico Carracci), II, 214 (Lorenzo Garbiere), 216 (Giovanni Battista Fulcini), 258 (Guercino).

101. Cf. Vasari 1966–87, I (testo), 142–43 (cf. Vasari 1960, 243–44, for trans.). The application of *spolvero* for *sgraffito* façade decoration is repeated by Vasari in the *Vita* of Andrea di Cosimo Feltrini (Vasari 1966–87, V (testo), 521: ". . . voleva sopra alcuni cartoni, spolverandogli sopra l'intonaco . . ."). On this method of façade decoration, cf. Chapters One (note 164) and Five (141), as well as Günther and Christel Thiem, *Toskanische Fassaden-Dekoration in Sgraffito und Fresko 14. bis 17. Jahrhundert,* Munich, 1964, 18–21. As described in Chapter Four, the tension between practices common among artists and artisans may have led to Vasari's bias against the *spolvero* technique. See Procacci 1975, 35–64, on Vasari as a writer on painting technique.

102. Vasari 1966–87, VI (testo), 387–88.

103. Ibid.: "e si conosce. . . ." Cf. also Robert J. Clements, "Michelangelo on Effort and Rapidity in Art," *JWCI,* XVII (1954), 301–10.

104. Vasari 1966–87, VI (testo), 388: ". . . io confesso aver fatto errore in metterla poi in mano di garzoni per condurla più presto, come mi bisognò fare, perché meglio sarebbe stato aver penato cento mesi et averla fatta di mia mano."

105. Cf. Wilde 1953, 98–103, nos. 60–63; Bernadine Barnes, "A Lost *Modello* for Michelangelo's Last Judgment," *MD,* XXVI (1988), 239–48; Hirst 1988 a, 30, 38–39, 50–52, 61, 68–69; Hirst 1988 b, 123–27, nos. 51–52; Perrig 1991, 52–55; and Bambach Cappel 1996 a, 98.

106. Ibid., 95–99.

107. Cf. Vasari 1966–87, I (testo), 122–24; Baxandall 1986, 143–45; and Bambach Cappel 1996 b, 164–65.

108. For the relevant passages on "circumscription" and the "veil," see Alberti 1972, 31:67–68, 32: 68–70 (cf. Alberti 1950, 82–85); and translations in Alberti 1966, 68, 121 (and note 26); Alberti 1972, 31: 67–69; 32:69–70; and Alberti 1991, 65–67. For the passages in Leonardo's notes, see Richter, I, 317–18, 359, §§ 523, 615 (cf. Richter, *Commentary,* I, 333, 360), and *Codex Urbinas Latinus* facsimile in McMahon 1956, II, fol. 41 recto-verso (McMahon 1956, I, no. 66). On the other methods and devices, see further Cristoforo Sorte, "Osservazioni nella pittura," in Barocchi 1960–62, I, 298; Vasari 1966–87, I (testo), 122–24; Benvenuto Cellini, *La Vita: I trattati: I discorsi,* ed. by Pietro Scarpellini, Rome, 1967, 562–63. The foundation for this discussion is provided by Kemp 1990, 27–148, 165–220, and, regarding the other secondary literature, see Bauer 1987, 211–19; Bambach Cappel 1991 b, 99–106; and Bambach Cappel 1996 b, 143–66.

109. Barbaro 1569, folios 159–60: "Parte quinta nella quale si espone una bella, & secreta parte di Perspettiva. . . ." See further Bambach Cappel 1991 b, 99–106.

110. Besides the examples already discussed, we may note the presence of *calco* in Correggio's dome of Parma Cathedral from 1526 to 1530; of *spolvero* and, more extensively, *calco* in Giulio Romano's *"Sala dei Giganti"* in the Palazzo Te from 1530–32; of *calco* in Paolo Veronese's *sale* in the Villa Barbaro at Maser, from c. 1561); of *calco* in the ceilings and domes frescoed by Luca Cambiaso and his followers on the *palazzi* and churches of Genoa between 1560 and 1600; of *calco* and squaring grids in Giovanni and Cherubino Alberti's *Apotheosis of St. Clement* in the *"Sala Clementina"* of the Vatican Palace from c. 1596–1602; as well as of *spolvero* and *calco* in Annibale and Agostino Carracci's Galleria Farnese Ceiling, from c. 1597–1601. I am indebted to Donatella and Carlo Giantomassi for the opportunity to study the Carracci frescos in the Palazzo Farnese from the scaffolding erected for their cleaning (July 1994; cf. note 37). On the Alberti's *"Sala Clementina,"* see especially conservation report by Fabrizio Mancinelli and Gianluigi Colalucci in *Monumenti, Musei e Gallerie Pontificie. Bollettino,* IV (1983), 231–46, with discussion of painting technique, as well as diagrams of design transfer and direct construction. These few monuments can stand for scores of others by later masters of illusionistic ceiling

frescos who relied on *calco* cartoons to calibrate the figural parts of their pictorial edifices – Giovanni di Stefano *"Il Lanfranco,"* Giovanni and Giovanni Battista Carlone, Angelo Michele Colonna, Agostino Mitelli, Pietro da Cortona, Carlo Cignani, Giovanni Battista Gaulli *"Il Baciccio,"* Gregorio and Lorenzo De Ferrari, Andrea Pozzo, and Marcantonio Franceschini.

111. Danti 1583, 87, and Accolti 1625, 54–56, *"Del disegnare disotto in su nelle nelle volte,"* Cap. XXXIX.

112. Pozzo 1693–1700, II, *"Breve instruttione per dipingere a fresco,"* unpag., *Settione Sesta-Settima,* and Palomino 1947.

113. Cf. Chapters Three and Four.

114. Bambach Cappel 1996 a, 95 (and notes 118, 119).

115. Vasari 1962, I, 209–10, and Vasari 1906, III, 690.

116. Bambach Cappel 1996 a, 95, 101.

117. Cf. notes 40–41.

118. Cf. Chapter Six.

119. Baumgart and Biagetti 1934, 44–55.

120. Ibid.

121. My data are based on Redig De Campos and Biagetti 1949, I, 105, 114–15, II, plate CXVIII. For a preliminary report of the cleaning and the technical data on the *Last Judgment,* see Mancinelli, Colalucci, and Gabrielli 1991, 219–49.

122. Redig de Campos and Biagetti 1949 first discussed the discovery of an inordinately high number of nail holes in this fresco: at least 152 – others may have been filled during the process of painting and old restorations. I find fully convincing their identification of these holes with the nails used to fasten the pieces of the cartoon to the wall. As I have been able to verify, they are indeed placed relatively closely around small groups of figures, and sometimes paint seems to penetrate slightly into the crevices. These are also among the criteria with which the Vatican conservation team verified the function of the nail holes found in the ceiling.

123. Vasari 1962, I (testo), 72:". . . e veduto i cartoni e disegni che ordinava per la facciata della cappella, che gli parvono stupendi. . . ." Cf. also discussion by Paola Barocchi, ibid., III (commento), 1191–1203 [547, I 72], where the author cites the *"breve"* issued by Pope Paul III (1 September 1535):". . . cumque successive Clemens prefatus, decori et ornamento maioris capelle nostri palatii apostolici Sixtine nuncupate intendens, ad caput et altare maius dicte capelle seu supra illud certas picturas fieri proponens, ipsum Michaelem Angelum ad picturam huiusmodi iuxta designum *cartonum* per ipsum factorum . . ." (italics are mine). Regarding the cartoon for the *Last Judgment,* cf. also Condivi 1553, 58: "Ma egli [Papa Paolo III] stando fermo in tal proposito, un giorno se ne venne a trovarlo a casa, accompagnato da otto o dieci Cardinali: e volle vedere il *cartone* fatto sotto Clemente, per la facciata della Cappella di Sisto; le statue, ch'egli per la sepoltura aveva già fatte, e minutamente ogni cosa . . ." (italics are mine; my thanks to Antonella Bucci for her assistance with the interpretation of these passages). Michael Hirst has advanced a freer reading than I prefer of the phrase "il *cartone* fatto sotto Clemente . . ." in Condivi's *Vita* of

Michelangelo: a reference to a large drawing or *"modello,"* rather than literally to a "cartoon," that is, a drawing in full scale, with a 1:1 scale correspondence to a final design as painted. Cf. Hirst 1988, 80–81. In my opinion, the consistent wording of Vasari's *Vita* and Paul III's *"breve,"* cited above, confirm that the term *"cartone"* should probably be interpreted strictly in its meaning of "cartoon," as this term was used with great precision in Quattrocento and Cinquecento written sources. On issues regarding the Italian Renaissance vocabulary of drawing, cf. further Bambach Cappel 1990 a, 497–98; Michael Hirst, "A Note on the Word *Modello," AB,* LXXIV (1992), 172; and Bambach Cappel 1992 b, 172–73. On the design of the *Last Judgment,* cf. further Bernardine Barnes, "A Lost *Modello* for Michelangelo's *Last Judgment," MD,* XXVI (1988), 239–48; Hirst 1988, 30, 38–39, 50–52, 61, 68–69; Perrig 1991, 52–55; and Bambach Cappel 1996 a, 98.

124. See further Bambach Cappel 1996 a, 83–102.

125. Vasari 1962, I (testo), 82: ". . . che la pittura, passata una certa età, e massimamente il lavorare in fresco, non è arte da vecchi. . . ."

Conclusion and Appendixes

1. See Ashmolean Museum inv. P II 301 recto, Oxford, on the top right and bottom left of the sheet. Cf. Tolnay 1975–80, I, 123, no. 168 recto; Hirst 1986, 214–16; and Hirst 1988 a, 37, plates 53–55. The *"Oxford Sketchbook"* apparently contains six sketches for this figure.

2. As the sequence for the *giornate* indicates, Michelangelo had already painted the architecture and *ignudi* framing the scene, a sequence of execution usual in the second *pontata* starting with the *Creation of Eve,* but opposite to that in the first *pontata* (cf. *Michelangelo: La Cappella Sistina, Rapporto*).

3. Appendix One, Bibliography: Briquet, I, II, introduction, 2–3; A. Gallo, *Il Libro,* Roma, [1942], 53, Martini, 75–76, n. 5; Andrea Federico Gasparinetti, *Documenti inediti sulla fabbricazione della carta nell'Emilia,* Milan, 1963, 13–17; Piccard, 56–58; M. G. Tavoni, *Ricerche sulla carta nel basso medievo,* Università di Bologna, 1970–1971 (unpublished *"tesi di laurea"*); Bruno Breveglieri, *Scritture lapidarie romaniche e gotiche a Bologna,* n. p., 1986, 66–67 and plate XIV; "Il Museo Civico Medievale," ed. by R. Grandi, *Storia illustrata di Bologna,* I, XVII (1987), 338–339; catalogue entry by Bruno Breveglieri in museum object file (manuscript); and Elen 1995, 144–45 (note 70). Charles Moise Briquet first published this slab (reproduced in a wood engraving), listing inaccurate dimensions for each of the sizes, dimensions that have been transmitted without correction in the literature on Italian drawings and prints. The relative thickness of the black carved-out groove that outlines the forms of each paper size is a factor in determining their measurements. The range of dimensions given below reflects the fact that in the slab these outlines are rarely exactly perpendicular with respect to each other. Moreover, dimensions for handmade paper can only be approximate due to imprecision inherent in the papermaking process. (I am indebted to Carla Bernardini, Museo Civico Medievale, for making

available the file concerning this object and for her assistance during my research.)

4. Appendix Two, Bibliography: Bambach Cappel 1988, Part II, I:1–2; Colalucci 1990, 73; Ruffa 1990, 53; Danti and Ruffa 1990; Bambach Cappel 1990, 129–31; *Michelangelo: La Cappella Sistina, Rapporto;* and Bambach Cappel 1996 a. On the ephemeral nature of *spolvero* underdrawing in fresco: Palomino 1724, Book VII, chapter IV:iv, 101. Paganino's embroidery patternbook, Venice, c. 1532 (unpaginated, *Proemio,* "Alessandro Paganino al Letore") tells that excess pounce could be disposed of by simply blowing air over the working surface with one's mouth.

5. Appendix Two, Selective list of mural with passages in which *spolvero* dots are only sporadically visible: the ornamental borders in Andrea Orcagna's fragments from the *Last Judgment* (Museo dell'Opera S. Croce, Florence; Fig. 145); the *dado* on the left wall in the Rinuccini Chapel (S. Croce, Florence; Fig. 158); the architectural niches behind the saints in the fragments by Gherardo Starnina, formerly in the Chapel of S. Girolamo (S. Maria del Carmine, Florence; Fig. 162); the architectural backgrounds for the Virgin martyrs on the lower right wall (Chiesa del Tau, Pistoia; Fig. 160); the fictive cornice surmounting the *"Sala di Balìa"* (Palazzo Pubblico, Siena); Paolo Uccello's *Creation of Adam* (figure of God) and *Sacrifice and Drunkenness of Noah* in the *"Chiostro Verde"* (S. Maria Novella, Florence; Fig. 196); Domenico Veneziano's *Sts. John the Baptist and Francis* (Museo dell'Opera S. Croce, Florence; Fig. 188) and two head fragments from the Canto de' Carnesecchi Tabernacle (National Gallery, London; Fig. 186); the decorative borders below the lunette frescos attributed to Giovanni di Consalvo in the *"Chiostro degli Aranci"* (Badia, Florence; Fig. 150); Andrea del Castagno's *St. Julian* and *Vision of St. Jerome* (SS. Annunziata, Florence; Fig. 191); the figures in all the scenes of Piero della Francesca's cycle of the *True Cross* (S. Francesco, Arezzo); the figures and decoration of the *"Sala dei Mesi"* (Palazzo Schifanoia, Ferrara; Fig. 199); numerous passages in Domenico Ghirlandaio's fresco cycle at the *"cappella maggiore"* (S. Maria Novella, Florence), in which a number of scenes are, however, also partly stylus-incised; the figures on the right side in Raphael's *Disputa* and *Parnassus* in the *Stanza della Segnatura;* extensive portions of Michelangelo's *Last Judgment* (Sistine Chapel, Vatican Palace; Fig. 299), in which some *giornate* are, however, stylus-incised; and particularly the bottom left group of soldiers in Michelangelo's *Crucifixion of St. Peter* (Pauline Chapel, Vatican Palace), corresponding to the Naples cartoon fragment.

6. Appendix Three, Bibliography: Paulina Junquera, "El obrador de bordados de El Escorial," *El Escorial 1563–1963: IV Centenario de la fundación del Monasterio de San Lorenzo El Real,* Madrid, 1963, II, 578–82; Gregorio de Andrés, "Catálogo de la colección de dibujos de la Real Biblioteca de El Escorial," *Archivo Español del Arte,* no. 161 (1968; unpaginated supplement); Angulo and Pérez Sánchez 1975, 67–75; Alfonso Pérez Sánchez, *Historia del dibujo español,* Madrid, 1986, 142–44; Bambach Cappel 1988, Part 1, II:414–15, Part 2, II: 497–532, nos. 367–405; Lizzie Boubli in *Dessins espagnols: Maîtres des XVIe et XVIIe siècles* (exh. cat., Musée du Louvre), Paris, 1991, 60–62, under no. 12 (with other bibliography). The function of the sheets as "substitute cartoons" was first noted in Bambach Cappel 1992, 22–24, 29 (note 52).

For the relevant watermarks, see Oriol Valls I Subirà, *The History of Paper in Spain, XV–XVI Centuries,* Madrid, 1980, 122–68, nos. 147 (c. 1587, grill or ladder with IHS monogram), 231 (c. 1568, grapes), 239 (c. 1543, snake), 123 (c. 1563, amphora), 57 (c. 1595, crescent moon), 79–80 (c. 1495–1584, shield with cross), 196 (c. 1567, hand), and 214–27 (c. 1562–97, pilgrim). While the study of watermarks is often an imprecise science, multiple examples of the above motifs are found in the album of "substitute cartoons" (no. 28–I–2), which can generally confirm the date of the commission and authenticity of the pricked designs. I am indebted to Lizzie Boubli for pointing out this bibliographic source.

BIBLIOGRAPHY OF FREQUENTLY
CITED SOURCES

Abbreviations of Most Frequently Cited Periodicals

AB *The Art Bulletin*
AC *Arte Cristiana*
AL *Arte Lombarda*
ALV *Achademia Leonardi Vinci: Journal of Leonardo Studies and Bibliography of Vinciana*
BA *Bollettino d'Arte*
BM *The Burlington Magazine*
GBA *Gazette des Beaux-Arts*
JdBM *Jahrbuch der Berliner Museen*
JWCI *Journal of the Warburg and Courtauld Institutes*
MD *Master Drawings*
MdKIF *Mitteilungen des Kunsthistorischen Institutes in Florenz*
NGTB *National Gallery Technical Bulletin*
OPDR *OPD Restauro: Quaderni dell'Opificio delle Pietre Dure e Laboratorio di Restauro di Firenze*
ZfK *Zeitschrift für Kunstgeschichte*

Accademia della Crusca 1612
Anonymous. *Vocabolario degli Accademici della Crusca.* Venice, 1612.

Accolti 1625
Accolti, Pietro. *Lo Inganno de gl'occhi.* Florence, 1625.

Acidini Luchinat 1992
Acidini Luchinat, Cristina (ed.). *I Restauri nel Palazzo Medici Riccardi: Rinascimento e barocco.* Cinisello Balsamo and Milan, 1992.

Acidini Luchinat 1993
Benozzo Gozzoli: La Cappella dei Magi. Milan, 1993.

Acidini Luchinat and Dalla Negra 1995
Acidini Luchinat, Cristina, and Riccardo Dalla Negra. *La Cupola di Santa Maria del Fiore: Il Cantiere di restauro, 1980–1995.* Rome, 1995.

Acidini Luchinat and Danti 1992
Acidini Luchinat, Cristina, and Cristina Danti. "Un Aspetto imprevisto nella pittura della Cupola di Santa Maria del Fiore," *OPDR,* no. 4 (1992), 132–39.

Adorno 1991
Adorno, Piero. *Il Verrocchio: Nuove proposte nella civiltà artistica del tempo di Lorenzo Il Magnifico.* Florence, 1991.

Ahl 1996
Ahl, Diane Cole. *Benozzo Gozzoli.* New York and London, 1996.

Aiken 1986
Aiken, Jane Andrews. *Renaissance Perspective: Its Mathematical Source and Sanction.* Ph.D. Dissertation, Harvard University, Cambridge, Mass., 1986 (UMI Microfilms, Ann Arbor, 1986).

Aiken 1995
"The Perspective Construction of Masaccio's *Trinity* Fresco and Medieval Astronomical Graphics," *Artibus et Historiae,* no. 35 (1995), 171–87.

Ainsworth 1982
Ainsworth, Maryan. "Underdrawing in Paintings by Joos van Cleve at the Metropolitan," *Université Catholique de Louvain, Colloque IV pour l'étude du dessin sous-jacent dans la peinture.* Louvain, 1982, 161–67.

Ainsworth 1990
"'Paternes for Phisioneamyes': Holbein's Portraiture Reconsidered," *BM,* 132 (1990), 173–86.

Alberti 1950, 1966, 1972, 1991
Alberti, Leon Battista. *Della Pittura: Edizione Critica,* ed. by Luigi Malle, Florence, 1950. *On Painting* (Italian text), trans. and comment. by John R. Spencer, New Haven and London, 1966 (1st ed., 1956). *"On Painting " and "On Sculpture": The Latin Texts of "De Pictura" and "De Statua,"* ed., trans., comment., and intro. by Cecil Grayson, London, 1972. *On Painting* (Penguin Classics), trans. by Cecil Grayson, intro. and comment. by Martin Kemp, London and New York, 1991.

Albertina 1983
Mitsch, Erwin. *Raphael in der Albertina: Aus Anlass des 500. Geburtstages des Künstlers.* Exh. cat., Graphische Sammlung Albertina, Vienna, 1983.

Alexander 1989
Alexander, Jonathan J. G. "Facsimiles, Copies, and Variations: The Relationship to the Model in Medieval and Renaissance European Illuminated Manuscripts," *Retaining the Original: Multiple Originals, Copies, and Reproductions (Studies in the History of Art, Symposium Series VII),* 20 (1989), 61–72.

Alexander 1992
Medieval Illuminators and Their Methods of Work. New Haven and London, 1992.

Altcappenberg 1995
Altcappenberg, Hein-Thomas Schulze. *Die italienischen Zeichnungen des 14. und 15. Jahrhunderts im Berliner Kupferstichkabinett: Kritischer Katalog.* Berlin, 1995.

Ambrosiana 1998
L'Ambrosiana e Leonardo. Exh. cat. by Pietro C. Marani, Gianfranco Ravassi, Marco Rossi, and Alessandro Rovetta; Biblioteca-Pinacoteca Ambrosiana, Milan; Novara, 1998.

Ames-Lewis 1981 a
Ames-Lewis, Francis. *Drawing in Early Renaissance Italy.* New Haven and London, 1981.

Ames-Lewis 1981 b
"Drapery 'Pattern'-Drawings in Ghirlandaio's Workshop and Ghirlandaio's Early Apprenticeship," *AB,* 63 (1981), 49–62.

Ames-Lewis 1986
The Draftsman Raphael. New Haven and London, 1986.

Ames-Lewis 1987
"Modelbook Drawings and the Florentine Quattrocento Artist," *Art History,* 10 (1987), 1–11.

Ames-Lewis and Wright 1983
Ames-Lewis, Francis, and Joanne Wright. *Drawing in the Italian Renaissance Workshop.* Exh. cat., Victoria and Albert Museum, London, 1983.

Andreani 1996
Andreani, Laura. "La Ricerca di archivio," *Orvieto* 1996, 416–59.

Andrews 1971
Andrews, Keith. *The National Gallery of Scotland: Catalogue of Italian Drawings.* Cambridge, 1971, 2 vols.

Angulo and Pérez Sánchez 1975–77
Angulo, Diego, and Alfonso Pérez Sánchez. *A Corpus of Spanish Drawings, I: Spanish Drawings 1400–1600, II: Spanish Drawings 1600–1650.* London, 1975–77.

Armenini 1587, 1977
Armenini, Giovanni Battista. *De' veri precetti della pittura: Libri tre* (1st ed. Ravenna, 1586), Ravenna, 1587 (reprint of 1587 ed., Hildesheim and New York, 1971). *On The True Precepts of the Art of Painting,* trans., comment., and intro. by Edward J. Olszewski, n.p. (Burt Franklin), 1977.

Art in the Making 1989
Bomford, David, et al. *Art in the Making: Italian Painting before 1400.* Exh. cat., National Gallery, London, 1989.

Art of Painting in Miniature 1752
Anonymous. *The Art of Painting in Miniature: Teaching the Speedy and Perfect Acquisition of that Art without a Master . . . "Translated from the Original French."* London, 1752.

Bacci and Stoppelli 1979
Bacci, Mina, and Pasquale Stoppelli. "Cennino Cennini," *Dizionario biografico degli italiani.* Rome, 1979, XXIII, 565–69.

Bacou 1974
Bacou, Roseline. *Cartons d'artistes du XVe au XIXe siècle.* Exh. cat., Cabinet des Dessins, Musée du Louvre, Paris, 1974.

Bacou 1981
The Famous Italian Drawings from the Mariette Collection at the Louvre in Paris. Milan, 1981.

Bacou and Viatte 1974
Bacou, Roseline, and Françoise Viatte. *Italian Renaissance Drawings from the Musée du Louvre: Roman, Tuscan, and Emilian Schools 1500–1575.* Exh. cat., Metropolitan Museum of Art, New York, 1974.

Baldini 1977
Baldini, Umberto. "Dalla sinopia al cartone," *Studies in Late Medieval and Renaissance Painting in Honor of Millard Meiss,* ed. by Irving Lavin and John Plummer, New York, 1977, I, 43–44.

Baldini and Casazza 1990
Baldini, Umberto, and Ornella Casazza. *La Cappella Brancacci.* Milan, 1990.

Baldinucci 1681
Baldinucci, Filippo. *Vocabolario toscano dell'arte del disegno.* Florence, 1681.

Bambach 1983
Bambach, Carmen C. "A Note on Michelangelo's Cartoon for the Sistine Ceiling: Haman," *AB,* 65 (1983), 661–65.

Bambach 1997 a
"Review of Alexander Perrig, *Michelangelo's Drawings: The Science of Attribution,*" *MD,* 35 (1997), 67–72.

Bambach 1997 b
"Technique and Workshop Practice in Filippino's Drawings," Metropolitan Museum of Art 1997, 21–28.

Bambach 1997 c
"Pontormo: Disegni degli Uffizi," *Renaissance Studies,* 11 (1997), 446–54.

Bambach 1998
"Cartoons by Carlo Cignani and Marcantonio Franceschini," *MD,* 36 (1998), 154–80.

Bambach 1999 a
"Early Italian Drawings in Berlin" (Review of *Die italienischen Zeichnungen des 14. und 15. Jahrhunderts im Berliner Kupferstichkabinett,* by Hein-Thomas Schulze Altcappenberg). *MD,* 37 (Spring 1999), 55–62.

Bambach 1999 b
"The Purchases of Cartoon Paper for Leonardo's *Battle of Anghiari* and Michelangelo's *Battle of Cascina,*" *Villa I Tatti Studies,* The Harvard University Center for Italian Renaissance Studies, Florence, 8 (1999).

Bambach Cappel 1987
Bambach Cappel, Carmen. "Michelangelo's Cartoon for the *Crucifixion of St. Peter* Reconsidered," *MD,* 25 (1987), 131–42.

Bambach Cappel 1988 (abbreviated as CBC in text and illustrations)
The Tradition of Pouncing Drawings in the Italian Renaissance Workshop: Innovation and Derivation. Ph.D. Dissertation, Yale University, New Haven, Conn., 1988 (UMI Microfilms, Ann Arbor, 1990).

Bambach Cappel 1990 a
"Review of Michael Hirst, *Michelangelo and His Drawings,*" *AB,* 72 (1990), 493–98.

Bambach Cappel 1990 b
"Pounced Drawings in the *Codex Atlanticus,*" *ALV,* 3 (1990), 129–31.

Bambach Cappel 1991 a
"Leonardo, Tagliente, Dürer: '*La Scienza del Far di Groppi,*'" *ALV,* 4 (1991), 72–98.

Bambach Cappel 1991 b
"Foreshortened Letters," *ALV,* 4 (1991), 99–106.

Bambach Cappel 1992 a
"A Substitute Cartoon for Raphael's *Disputa,*" *MD,* 30 (1992), 9–30.

Bambach Cappel 1992 b
"Letter to the Editor," *AB,* 74 (1992), 172–73.

Bambach Cappel 1994
"Luca Signorelli, Leonardo, and Piero della Francesca's *De Prospectiva Pingendi,*" *Florentine Drawing at the Time of Lorenzo the Magnificent* 1994, 17–43.

Bambach Cappel 1996 a
"Problemi di tecnica nei cartoni di Michelangelo per la Cappella Sistina," *Michelangelo: La Cappella Sistina, Atti,* 83–102.

Bambach Cappel 1996 b
"Piero della Francesca: The Study of Perspective, and the Development of the Cartoon in the Quattrocento," *Piero della Francesca tra arte e scienza* 1996, 143–66.

Banker 1993
Banker, James. "Piero della Francesca as Assistant to Antonio d'Anghiari in the 1430's," *BM,* 135 (1993), 16–21.

Barbaro 1569
Barbaro, Daniele. *La Pratica della perspettiva* . . . Venice, 1569.

Baretti 1771
Baretti, Joseph. *A Dictionary of the English and Italian Languages.* London, 1771, 2 vols.

Barocchi 1960–62
Barocchi, Paola. *Trattati d'arte del Cinquecento: Fra manierismo e contrariforma.* Bari, 1960–62, 3 vols.

Bartsch
Bartsch, Adam von. *Le Peintre graveur.* Vienna, 1803–21, 21 vols.

Barzman 1986–87
Barzman, Karen-Edis. "The Florentine *Accademia del Disegno:* Liberal Education and the Renaissance Artist," *Leids Kunsthistorisch Jaarboek,* 5–6 (1986–87), 14–32.

Battaglia 1961
Battaglia, Salvatore. *Grande dizionario della lingua italiana.* Turin, 1961, II–X.

Battisti 1992
Battisti, Eugenio. *Piero della Francesca (Nuova edizione riveduta e aggiornata con il coordinamento scientifico di Marisa Dalai Emiliani).* Milan, 1992, 2 vols.

Bauer 1975
Bauer, Linda Freeman. *On the Origins of the Oil Sketch: Form and Function in Cinquecento Preparatory Techniques.* Ph.D. Dissertation, New York University, 1975.

Bauer 1978
"'*Quanto si disegna, si dipinge ancora*': Some Observations on the Development of the Oil Sketch," *Storia dell'Arte,* 32 (1978), 45–57.

Bauer 1986
"A Letter by Barocci and the Tracing of Finished Paintings," *BM,* 128 (1986), 355–57.

Bauer 1987
Bauer, George. "Experimental Shadow–Casting and the Early History of Perspective," *AB,* 69 (1987), 211–19.

Baumgart and Biagetti 1934
Baumgart, Fritz, and Biagio Biagetti. *Gli Affreschi di Michelangelo e di L. Sabbatini e F. Zuccari nella Cappella Paolina in Vaticano.* Vatican City, 1934.

Baxandall 1972
Baxandall, Michael. *Painting and Experience in Fifteenth-Century Italy.* Oxford and New York, 1972; reprint, 1986.

Beal 1984
Beal, Mary. *A Study of Richard Symonds: His Italian Notebooks and their Relevance to Seventeenth-Century Painting Techniques.* New York and London, 1984.

Bean 1960
Bean, Jacob. *Bayonne, Musée Bonnat: Les Dessins italiens de la Collection Bonnat.* Paris, 1960.

Bean 1982
15th and 16th Century Italian Drawings in the Metropolitan Museum of Art. New York, 1982.

Bean and Stampfle 1965
Bean, Jacob, and Felice Stampfle. *Drawings from New York Collections, I: Italian Renaissance.* Exh. cat., Metropolitan Museum of Art and Pierpont Morgan Library, New York; Greenwich, Conn., 1965, 2 vols.

Beccafumi e il suo tempo 1990
Domenico Beccafumi e il suo tempo. Exh. cat., Soprintendenza per i Beni Artistici e Storici di Siena. Milan, 1990.

Becherucci 1983
Becherucci, Luisa. *I Musei di Santa Croce e di Santo Spirito a Firenze.* Milan, 1983.

Becherucci 1987
"Per la formazione di Raffaello," *Studi su Raffaello* 1987, 345–49.

Beck 1973
Beck, James H. *Raphael.* New York, 1973.

Beck 1986
"Introduction," *Raphael before Rome* 1986, 7–12.

Béguin 1986
Béguin, Sylvie. "The *Saint Nicholas of Tolentino* Altarpiece," *Raphael before Rome* 1986, 15–28.

Bellosi 1990
Bellosi, Luciano (ed.). *Pittura di luce: Giovanni Francesco e l'arte fiorentina di metà Quattrocento.* Exh. cat., Casa Buonarroti, Florence; Milan, 1990.

Bellosi 1992
(Ed.). *Una Scuola per Piero: Luce, colore e prospettiva nella formazione fiorentina di Piero della Francesca.* Exh. cat., Galleria degli Uffizi, Florence; Venice, 1992.

Beltrame Quattrocchi 1979
Beltrame Quattrocchi, Enrichetta. *Disegni toscani ed umbri del primo*

rinascimento dalle collezione del Gabinetto Nazionale delle Stampe. Exh. cat., Istituto Nazionale per la Grafica di Roma, Rome, 1979.

Beltrami 1911
Beltrami, Luca. *Bernardino Luini 1512–1532: Materiali di studio.* Milan, 1911.

Beltrami 1919
Documenti e memorie riguardanti la vita e le opere di Leonardo da Vinci. Milan, 1919.

Bemporad 1977
Bemporad, Nello (ed.). *Soprintendenza ai Beni Ambientali e Architettonici di Firenze e Pistoia: La Chiesa di S. Jacopo a Ripoli (Restauro 1974–1976).* Florence, 1977.

Benton 1983
Benton, Janetta Rebold. *Influences of Ancient Roman Wall-Painting on Late Thirteenth-Century Italian Painting: A New Interpretation of the Upper Church of S. Francesco in Assisi.* Ph.D. Dissertation, Brown University, Providence, R.I., 1982 (UMI Microfilms, Ann Arbor, 1983).

Benton 1989
"Perspective and the Spectator's Pattern of Circulation in Assisi and Padua," *Artibus et Historiae,* no. 19 (1989), 37–52.

Berenson 1903, 1938, 1961
Berenson, Bernard. *The Drawings of the Florentine Painters Classified, Criticised and Studied as Documents in the History and Appreciation of Tuscan Art, With a Copious Catalogue Raisonné.* London, 1903, 2 vols. *The Drawings of the Florentine Painters.* 2nd ed., Chicago, 1938, 3 vols. *I Disegni dei pittori fiorentini.* 3rd. ed., trans. by Luisa Vertova Nicolson, Milan, 1961, 3 vols.

Berenson 1968
Italian Pictures from the Renaissance. London, 1968.

Bernacchioni 1992
Bernacchioni, Annamaria. "Le Botteghe di pittura: Luoghi, struttura e attività," Palazzo Strozzi 1992, 23–33.

Bertelli 1965
Bertelli, Carlo. "Il Restauro della Cappella Carafa in S. Maria Sopra Minerva a Roma," *Bollettino dell'Istituto Centrale del Restauro* (Rome), 1965, 145–95.

Bertelli 1986
"Caen and Brera: From Marriage to Divorce," *Raphael before Rome* 1986, 31–34.

Bertelli 1992
Piero della Francesca. Trans. by Edward Farrelly. New Haven and London, 1992.

Bertini 1958
Bertini, Aldo. *I Disegni italiani della Biblioteca Reale di Torino.* Rome, 1958.

Bertorello 1996 a
Bertorello, Carla. "La Tecnica della pittura di Beato Angelico e Luca Signorelli," *Orvieto* 1996, 327–49.

Bertorello 1996 b
"Scheda di restauro," *Orvieto* 1996, 357–85.

Biagetti 1936
Biagetti, Biagio. "La Volta della Cappella Sistina," *Atti della Pontificia Accademia Romana di Archeologia,* 12 (1936), 199–220.

Biagetti 1939
"Pitture murali, Palazzo Vaticano: Cappella Sistina," *Atti della Pontificia Accademia Romana di Archeologia,* 15 (1939), 231–39.

Birke 1991
Birke, Veronika. *Die italienischen Zeichnungen der Albertina: Zur Geschichte der Zeichnung in Italien.* Munich [1991].

Birke and Kertész 1992–97
Birke, Veronika, and Janine Kertész. *Die italienischen Zeichnungen der Albertina: General Verzeichnis.* Vienna, 1992–97, 4 vols.

Bisagno 1642
Bisagno, Fra Francesco. *Trattato della Pittura.* Venice, 1642.

Bober and Rubinstein 1986
Bober, Phyllis Pray, and Ruth Rubinstein. *Renaissance Artists and Antique Sculpture: A Handbook of Sources.* London, 1986.

Bodmer 1931
Bodmer, Heinrich. *Leonardo: Des Meisters Gemälde und Zeichnungen (Klassiker der Kunst).* Stuttgart, 1931.

Bonsanti 1985
Bonsanti, Giorgio. *Giotto.* Intro. by Enzo Carli. Padua, 1985.

Bora 1976
Bora, Giulio. *I Disegni del Codice Resta.* Bologna, 1976.

Bora 1980
I Disegni lombardi e genovesi del Cinquecento. Treviso, 1980.

Borghini 1584
Borghini, Raffaele. *Il Riposo.* Florence, 1584.

Borgo 1970
Borgo, Ludovico. *The Works of Mariotto Albertinelli (Garland Series of Outstanding Dissertations in the Fine Arts).* New York and London, 1970.

Borsi 1992
Borsi, Franco and Stefano. *Paolo Uccello.* Paris, 1992.

Borsook 1975
Borsook, Eve. "Fra Filippo Lippi and the Murals for Prato Cathedral," *MdKIF,* 19 (1975), 1–148.

Borsook 1980
The Mural Painters of Tuscany. (1st ed., London, 1960) Oxford, 1980.

Borsook 1982
"L' *Hawkwood* d' Uccello et la *Vie de Fabius Maximus* de Plutarque: Evolution d'un projet de cenotaph," *Revue de l'Art,* 55 (1982), 44–51.

Borsook 1983
"Effects of Technical Developments on the History of Italian Mural Painting of the Fourteenth and Fifteenth Centuries," *III: La Pittura nel XIV e XV secolo: Il Contributo dell'analisi tecnica alla storia dell'arte. Atti del XXIV congresso internazionale di storia dell'arte.* Bologna, 1983, 163–73.

Borsook 1985
"Technical Innovation and the Development of Raphael's Style in Rome," *RACAR: Revue d'art canadienne/Canadian Art Review: "The Roman Tradition of Wall Decoration,"* 12 (1985), 127–36.

Borsook 1994
"Michelangelo e l'uso dei cartoni nella Cappella Sistina," *Michelangelo: La Cappella Sistina, Atti,* 103–6.

Boskovits 1961
Boskovits, Miklòs. *Giovanni da Milano*. Florence, 1961.

Boskovits 1975
Pittura fiorentina alla vigilia del Rinascimento 1370–1400. Florence, 1975.

Boskovits 1985
The Martelli Collection: Paintings, Drawings, and Miniatures from the XIVth to the XVIIIth Centuries. With collaborations by Marco Bona Castellotti, Marco Chiarini, Everett Fahy, Marina Rotunno, and Luisa Tognoli Bardin. Florence, 1985.

Bosse 1745
Bosse, Abraham. *De la manière de graver à l'eaufort et au burin*. (1st ed., Paris, 1645) Paris, 1745.

Botticelli 1980
Botticelli, Guido. *Tecnica e restauro delle pitture murali (Opificio delle Pietre Dure e Laboratori di Restauro, Firenze)*. Florence, 1980.

Botticelli 1992
Metodologia di restauro delle pitture murali. Florence, 1992.

Botto 1968
Botto, Ida Maria. *Mostra di disegni di Bernardo Buontalenti 1531–1608*. Exh. cat., Gabinetto Disegni e Stampe degli Uffizi, Florence, 1968.

Boutet 1676, 1679
Boutet, Claude. *Traité de mignature: Pour apprendre aisément à peindre sans mâitre: Et le secret de faire les plus belles couleurs*, Paris (Christophe Ballard), 1676. *Ecole de la Mignature: Dans laquelle on peut aisément apprendre à peindre sans Maître . . .*, Lyons (François du Chesne), 1679.

Brambilla Barcilon 1984
Brambilla Barcilon, Pinin. *Il Cenacolo di Leonardo in Santa Maria delle Grazie: Storia, condizioni, problemi (Quaderni del restauro 2)*. Milan, 1984.

Brambilla Barcilon 1990
Le Lunette di Leonardo nel Refettorio delle Grazie (Quaderni del restauro 7). Milan, 1990.

Brera 1986
Ministero per i Beni Culturali e Ambientali, Soprintendenza per i Beni Artistici e Storici di Milano. *Disegni lombardi del cinque e seicento della Pinacoteca di Brera e dell'Arcivescovado di Milano*. Exh. cat., Pinacoteca di Brera, Milan. Florence, 1986.

Brera 1989
Ministero per i Beni Culturali e Ambientali, Soprintendenza per i Beni Artistici e Storici di Milano. *Il Polittico di San Luca di Andrea Mantegna (1453–1454): In occasione del suo restauro*. Exh. cat., ed. by Sandrina Bandera Bistoletti, Pinacoteca di Brera, Milan. Florence, 1989.

Briganti and Baccheschi 1977
Briganti, Giuliano, and Edi Baccheschi. *L'Opera completa del Beccafumi*. Milan, 1977.

Briquet
Briquet, Charles Moise. *Les Filigranes: Dictionnaire historiques des marques du papier*. (1st ed. Paris, 1907) Leipzig, 1924, 4 vols.

British Museum 1983
British Museum. *Italian Drawings from the Lugt Collection, Institut Neerlandais*. Exh. cat., Department of Prints and Drawings, British Museum, London, 1983.

British Museum 1996
Royalton-Kisch, Martin, Hugo Chapman, and Stephen Coppel. *Old Master Drawings from the Malcolm Collection*. Exh. cat., Department of Prints and Drawings, British Museum, London, 1996.

Brown 1983
Brown, David Alan. *Raphael and America*. Exh. cat., National Gallery of Art, Washington, D.C., 1983.

Brown 1986
"Saint George in Raphael's Washington Painting," *Raphael before Rome* 1986, 37–44.

Brown 1987
"Raphael's *Small Cowper Madonna* after Cleaning," *Studi su Raffaello* 1987, 465–72.

Brown 1998
Leonardo Da Vinci: Origins of a Genius. New Haven and London, 1998.

Brown and Landau 1981
Brown, David Alan, and David Landau. "A Counter-Proof Reworked by Perino del Vaga and Other Derivations from a Parmigianino *Holy Family*," *MD*, 19 (1981), 18–22.

Brown 1989
Brown, Patricia Fortini. *Venetian Narrative Painting in the Age of Carpaccio*. New Haven and London, 1989.

Bunim 1940
Bunim, Miriam Schild. *Space in Medieval Painting and the Forerunners of Perspective*. New York, 1940.

Burnam 1988
Burnam, Reneé George. "Medieval Stained Glass Practice in Florence, Italy: The Case of Orsanmichele," *Journal of Glass Studies*, 30 (1988), 77–93.

Burns 1994
Burns, Thea. "Chalk or Pastel?: The Use of Coloured Media in Early Drawings," *Paper Conservator*, 18 (1994), 49–56.

Buscaroli 1938
Buscaroli, Rezio. *Melozzo da Forlì nei documenti, nelle testimonianze dei contemporanei, e nella bibliografia*. Roma, 1938.

Butterfield 1997
Butterfield, Andrew. *The Sculpture of Andrea Verrocchio*. New Haven and London, 1997.

Byam Shaw 1969–70
Byam Shaw, James. *Old Master Drawings from Chatsworth: A Loan Exhibition from the Devonshire Collection*. Exh. cat., International Exhibitions Foundation, Washington, D.C., 1969–70.

Byam Shaw 1976
Drawings by Old Masters at Christ Church, Oxford. Oxford, 1976, 2 vols.

Byam Shaw 1983
The Italian Drawings of the Frits Lugt Collection. Paris, 1983, 3 vols.

Cadogan 1983 a
Cadogan, Jean K. "Reconsidering Some Aspects of Ghirlandaio's Drawings," *AB*, 65 (1983), 274–90.

Cadogan 1983 b
"Linen Drapery Studies by Verrocchio, Leonardo and Ghirlandaio," *ZfK,* 46 (1983), 27–62.

Cadogan 1983 c
"Verrocchio's Drawings Reconsidered," *ZfK,* 46 (1983), 367–400.

Cadogan 1984
"Observations on Ghirlandaio's Method of Composition," *MD,* 22 (1984), 159–72.

Cadogan 1987
"Drawings for Frescoes: Ghirlandaio's Technique," *Drawings Defined* 1987, 63–75.

Cadogan 1993
"Michelangelo in the Workshop of Ghirlandaio," *BM,* 135 (1993), 30–31.

Cadogan 1994
"Domenico Ghirlandaio in Santa Maria Novella: Invention and Execution," *Florentine Drawing at the Time of Lorenzo the Magnificent* 1994, 63–72.

Cadogan 1996
"Sulla bottega del Ghirlandaio," *Ghirlandaio* 1996, 89–96.

Calvi 1925
Calvi, Gerolamo. *I Manoscritti di Leonardo da Vinci dal punto di vista cronologico, storico e biografico.* Bologna, 1925.

Calvo Serraller 1981
Calvo Serraller, Francisco. *La teoría de la pintura en el Siglo de Oro.* Madrid, 1981.

Camesasca 1972
Camesasca, Ettore. *L'Opera completa di Michelangelo pittore.* Milan, 1972.

Campani 1910
Campani, Eugenio G. "Uccello's Story of Noah in the *Chiostro Verde;*" *BM,* 17 (1910), 203–10.

Campbell 1990
Campbell, Lorne. *Renaissance Portraits: European Portrait-Painting in the 14th, 15th and 16th Centuries.* New Haven and London, 1990.

Campbell 1996
Campbell, Thomas. "Pope Leo X's Consistorial 'letto de paramento' and the Boughton House Cartoons," *BM,* 138 (1996), 541–45.

Carducho 1633, 1979
Carducho, Vicente. *Diálogos de la Pintura, su Defensa, Orígen, Esse[n]cia, Definición, Modos y Diferencias.* Madrid, 1633. Ed. by Francisco Calvo Serraller, Madrid, 1979.

Carl 1987
Carl, Doris. "Das Inventar der Werkstatt von Filippino Lippi aus dem Jahre 1504," *MdKIF,* 31 (1987), 373–91.

Carli 1965
Carli, Enzo. *Il Duomo di Orvieto.* Rome, 1965.

Carpaneto 1970
Carpaneto, Maria Grazia. "Raffaellino del Garbo: Parte I," *Antichità Viva: Rassegna d'Arte,* 9 (1970), 3–23.

Carpaneto 1971
"Raffaellino del Garbo: Parte II," *Antichità Viva: Rassegna d'Arte,* 10 (1971), 3–19.

Casazza 1990
Casazza, Ornella. "Al di là dell'immagine," *Gli Uffizi: Studi e ricerche,* 5, Florence, 1990, 92–101.

Cast 1991
Cast, David. "Finishing the Sistine," *AB,* 73 (1991), 669–84.

Castel Sant'Angelo 1989
Fragmenti Picta. Affreschi e mosaici staccati del Medioevo romano. Exh. cat., Museo Nazionale di Castel Sant'Angelo; Rome, 1989.

Castelvecchio 1996
Marini, Paola, et al. *Pisanello.* Exh. cat., Museo Civico di Castelvecchio, Verona; Milan, 1996.

Cavadini 1980
Cavadini, Luigi. *Giovanni da Milano.* Exh. cat., intro. by Mina Gregori, Comune di Valmorea, 1980.

Cazort and Johnston 1982
Cazort, Mimi, and Catherine Johnston. *Bolognese Drawings in North American Collections 1500–1800.* Exh. cat., National Gallery of Canada, Ottawa, 1982.

CBC (see Bambach Cappel 1988)

Ceán Bermúdez 1800
Ceán Bermúdez, Juan Agustín. *Diccionario histórico de los más ilustres profesores de las bellas artes en España.* Madrid, 1800, 6 vols.

Cennini 1932, 1933, 1960, 1995
Cennini, Cennino d'Andrea. *I: Il Libro dell'arte,* ed., comment., and intro. by Daniel V. Thompson, Jr., New Haven, Conn., 1932. *II: The Craftsman's Handbook: The Italian "Il Libro dell'arte,"* trans., comment., and intro. by Daniel V. Thompson, Jr., New Haven, 1933; Dover reprint, New York, 1960. *Il Libro dell'arte,* intro. by Licisco Magagnato, ed. by Franco Brunello (1st ed. Vicenza, 1982); reprint, Vicenza, 1995.

Centauro 1990
Centauro, Giuseppe. *La Basilica di S. Francesco ad Arezzo: Indagine su sette secoli: Dipinti murali di Piero della Francesca.* Milan, 1990.

Chambers 1728
Chambers, Ephraim. *Cyclopaedia: Or an Universal Dictionary of Arts and Sciences; containing the Definitions of the Terms, and Accounts of the things signify'd thereby, in the several Arts, both Liberal and Mechanical and the several Sciences, Human and Divine.* London, 1728, 2 vols.

Chambers 1971
Chambers, David S. *Patrons and Artists in the Italian Renaissance.* Columbia, S.C., 1971.

Chantilly 1997
Cordellier, Dominique, and Bernadette Py (ed.). *Dessins italiens du Musée Condé à Chantilly, II: Raphael et son cercle.* Exh. cat., Musée Condé, Chantilly; Paris, 1997.

Chastel 1987
Chastel, André. "Raffaello e Leonardo," *Studi su Raffaello* 1987, 335–43.

Chiarini 1963
Chiarini, Marco. "Il Maestro del Chiostro degli Aranci: 'Giovanni Consalvo' portoghese," *Proporzioni,* 4 (1963), 1–24.

Chicago 1979
Monbeig Goguel, Catherine. *Roman Drawings of the Sixteenth Century from the Musée du Louvre, Paris.* Exh. cat., Art Institute of Chicago, Chicago, 1979.

Chini 1988
Chini, Ezio. *Girolamo Romanino: Gli Affreschi nella Loggia del Buonconsiglio.* Milan, 1988.

Christensen 1986
Christensen, Carol. "Examination and Treatment of Paintings by Raphael at the National Gallery of Art," *Raphael before Rome* 1986, 47–54.

Christiansen 1986
Christiansen, Keith. "Caravaggio and 'l'esempio davanti del naturale,'" *AB,* 68 (1986), 421–45.

Christiansen 1990
"Leonardo's Drapery Studies," *BM,* 132 (1990), 572–73.

Ciasca 1922
Ciasca, Raffaele. *Statuti dell'arte dei medici e speziali (Fonti per la storia delle corporazioni artigiani del comune di Firenze).* Florence, 1922.

Ciasca 1927
Arte dei medici e speziali nella storia e nel commercio fiorentino dal secolo XII al secolo XV. Florence, 1927.

Ciardi Dupré dal Poggetto 1987
Ciardi Dupré dal Poggetto, Maria Grazia. "Osservazioni sulla formazione di Raffaello, *Studi su Raffaello* 1987, 33–54.

Circa 1492
Levenson, Jay (ed.). *Circa 1492: Art in the Age of Exploration.* Exh. cat., National Gallery of Art, Washington D.C., 1991.

Clark 1969
Clark, Kenneth. *Piero della Francesca.* Ithaca, N.Y., 1969.

Clark 1988
Leonardo da Vinci. (1st ed. Oxford, 1939; 2nd ed., 1959) intro. and ed. by Martin Kemp. London, 1988.

Clark and Pedretti 1968
Clark, Kenneth, and Carlo Pedretti. *The Drawings of Leonardo da Vinci in the Collection of Her Majesty the Queen at Windsor Castle.* London, 1968, 3 vols.

Clark 1990
Clark, Nicholas. *Melozzo da Forlì: Pictor Papalis.* London, 1990.

Clayton 1996
Clayton, Martin. *Leonardo Da Vinci: One Hundred Drawings from the Collection of Her Majesty the Queen.* Exh. cat., Queen's Gallery, Buckingham Palace, London, 1996.

Clayton and Philo 1992
Clayton, Martin, and Ron Philo. *Leonardo da Vinci: The Anatomy of Man: Drawings from the Collection of Her Majesty Queen Elizabeth II.* Exh. cat., Museum of Fine Arts, Houston; Philadelphia Museum of Art; and Museum of Fine Arts, Boston, 1992.

Cocke 1984
Cocke, Richard. *Veronese's Drawings: A Catalogue Raisonné.* London, 1984.

Colalucci 1990
Colalucci, Gianluigi. "Esecuzione pittorica," *Michelangelo e la Sistina* 1990, 69–84.

Colalucci 1994
"La Tipologia dei cartoni e la tecnica esecutiva della volta della Cappella Sistina," *Michelangelo: La Cappella Sistina, Atti,* 77–82.

Cole 1983
Cole, Bruce. *The Renaissance Artist at Work.* New York, 1983.

Coleman 1984
Coleman, Robert. *Renaissance Drawings from the Ambrosiana.* Exh. cat., University of Notre Dame, South Bend, Ind., 1984.

Comanini 1591
Comanini, Gregorio. *Il Figino ovvero del fine della pittura.* Mantua, 1591.

Condivi 1553, 1976
Condivi, Ascanio. *Vita di Michelangelo Buonarroti. . . .* Rome, 1553. *The Life of Michelangelo.* Trans. by Alice S. Wohl, Baton Rouge, La., 1976.

The Conservation of Wall Paintings 1991
Cather, Sharon (ed.). *The Conservation of Wall Paintings (Proceedings of a Symposium Organized by the Courtauld Institute of Art and the Getty Conservation Institute, London July 13–16, 1987).* Singapore, 1991.

Cortesi Bosco 1987
Il Coro intarsiato di Lotto e Capoferri per Santa Maria Maggiore in Bergamo (II: Lettere e documenti). Milan, 1987, 2 vols.

Cox-Rearick 1981
Cox-Rearick, Janet. *The Drawings of Pontormo.* (1st ed. Cambridge, 1964) New York, 1981, 2 vols.

Crowe and Cavalcaselle 1882–85
Crowe, Joseph Archer, and Giovanni Battista Cavalcaselle. *Raphael: His Life and Works.* London, 1882–85, 2 vols.

Cuzin 1983
Cuzin, Jean Pierre. *Raphael et l'art français.* Exh. cat., Galeries Nationales du Grand Palais, Paris, 1983.

Dacos 1969
Dacos, Nicole. *La découverte de la Domus Aurea et la formation des grotesques à la Renaissance.* London, 1969.

Dalli Regoli 1966
Dalli Regoli, Gigetta. *Lorenzo di Credi.* Cremona, 1966.

Danti 1583
Danti, Egnazio. *Le Due regole della prospettiva pratica di Iacomo Barozzi da Vignola.* Rome, 1583.

Danti 1990
Danti, Cristina. "Osservazioni sugli affreschi di Domenico Ghirlandaio nella chiesa di Santa Maria Novella, I: Tecnica esecutiva e organizzazione del lavoro," *Le Pitture murali* 1990, 39–52.

Danti 1996
"Osservazioni sulla tecnica degli affreschi della Cappella Tornabuoni," *Ghirlandaio* 1996, 141–49.

Danti, Giovannoni, Matteini, and Moles 1987
Danti, Cristina, and Sabino Giovannoni, Mauro Matteini, Arcangelo Moles. "Un 'colpo di luce' su Luca Signorelli: Cronaca di un intervento di restauro sulle pitture del Signorelli a Monte Oliveto Maggiore," *OPDR,* no. 2 (1987), 10–16.

Danti, Lunardi, and Tintori 1990
Danti, Cristina, Roberto Lunardi, and Leonetto Tintori. "Note

sulla *Trinità* affrescata da Masaccio nella chiesa di Santa Maria Novella in Firenze," *Le Pitture murali* 1990, 251–68.

Danti and Ruffa 1990
Danti, Cristina, and Giuseppe Ruffa. "Note sugli affreschi di Domenico Ghirlandaio nella chiesa di Santa Maria Novella in Firenze," *OPDR*, no. 2 (1990), 29–48.

Davidsohn 1978–79
Davidsohn, Robert. *Storia di Firenze*. Florence, 1978–79,VI.

Davidson 1966
Davidson, Bernice. *Mostra di disegni di Perino del Vaga e la sua cerchia*. Exh. cat., Gabinetto Disegni e Stampe degli Uffizi, trans. by Francoise Chiarini, Florence, 1966.

Davidson 1969
"'Perino del Vaga e la sua cerchia': Addenda and Corrigenda," *MD*, 12 (1969), 404–9.

Davidson 1976
"The Decoration of the *Sala Regia* under Pope Paul III," *AB*, 58 (1976), 395–423.

Davidson 1990
"The Cope Embroideries Designed for Paul III by Perino del Vaga," *MD*, 28 (1990), 123–41.

Davies 1908
Davies, Gerald. *Ghirlandaio*. London, 1908.

Davies 1986
Davies, Martin. *National Gallery Catalogues: The Earlier Italian Schools*. London, 1986.

De Feo and Martinelli 1996
De Feo,Vittorio, and Vittorio Martinelli. *Andrea Pozzo*. Milan, 1996.

De Vecchi 1986
De Vecchi, Pierluigi. "The *Coronation of the Virgin* in the Vatican Pinacoteca and Raphael's Activity between 1502–1504," *Raphael before Rome* 1986, 73–82.

De Vecchi 1987
The Complete Paintings of Raphael (Penguin Classics). Ed. by Sebastian Wormell. Middlesex and New York, 1987.

Degenhart 1937
Degenhart, Bernhard. "Zur Graphologie der Handzeichnung," *Kunstgeschichtliches Jahrbuch der Bibliotheca Hertziana*, 1 (1937), 225–338.

Degenhart 1949
Italienische Zeichnungen des frühen 15. Jahrhunderts. Basel, 1949.

Degenhart 1950
"Autonome Zeichnungen bei mittelalterlichen Künstlern," *Münchner Jahrbuch der bildenen Kunst*, 1 (1950), 93–158.

Degenhart and Schmitt 1967
Degenhart, Bernhard, and Annegrit Schmitt. *Italienische Zeichnungen 15.–18. Jahrhundert*. Exh. cat., Staatliche Graphische Sammlung München, Munich, 1967.

Degenhart and Schmitt 1968
Corpus der italienischen Zeichnungen 1300–1450, Teil I: Süd- und Mittelitalien. Berlin, 1968, 4 vols.

Degenhart and Schmitt 1980
Corpus der italienischen Zeichnungen 1300–1450, Teil II: Venedig, Addenda zu Süd- und Mittelitalien. Berlin, 1980, 3 vols.

DeGrazia 1984
DeGrazia, Diane. *Correggio and His Legacy: Sixteenth Century Emilian Drawings*. Exh. cat., National Gallery of Art,Washington, D.C., 1984.

De Luca 1992
De Luca, Maurizio. "Gli Affreschi di Andrea Pozzo nella Galleria del Gesù a Roma: Confronto tra pittura e trattatistica," *Kermes*, 5 (1992), 27–31.

Della Chiesa 1956
Della Chiesa, Angela Ottino. *Bernardino Luini*. Novara, 1956.

Del Serra 1985
Del Serra, Alfio. "A Conversation on Painting Techniques," *BM*, 127 (1985), 4–16.

Dempsey 1980
Dempsey, Charles. "Some Observations on the Education of Artists in Florence and Bologna during the Later Sixteenth Century," *AB*, 62 (1980), 552–69.

Dempsey 1986
"Malvasia and the Problem of the Early Raphael and Bologna," *Raphael before Rome* 1986, 57–70.

Le Dessin sous-jacent dans la peinture 1989–97
Université Catholique de Louvain. Institut Supérieur d'Archéologie et d'Histoire de l'Art. *Le Dessin sous-jacent dans la peinture* (Colloques I–XI). Louvain-La-Neuve, 1989–97.

Dictionary of Art 1996
Turner, Jane (ed.). *The Dictionary of Art (Macmillan Publishers Limited)*. London, 1996, 34 vols.

Diderot and d'Alembert 1751–65
Diderot, Denis, and Jean Lerond d'Alembert. *Encyclopedie, ou dictionnaire raisonné des sciences, des arts et des métiers par une société de gens de lettres*. Paris, 1751–65, 17 vols.

Dionysius of Fourna 1974
Dionysius of Fourna. *The Painter's Manual*. Trans. by Paul Hetherington. London, 1974.

Dittelbach 1993
Dittelbach,Thomas. *Das monochrome Wandgemälde: Untersuchungen zum Kolorit des frühen 15. Jahrhunderts in Italien*. Hildesheim, Zurich, and New York, 1993.

Dollmayr 1895
Dollmayr, Heinrich. "Raffaels Werkstätte," *Jahrbuch der kunsthistorischen Sammlungen in Wien*, 16 (1895), 230–363.

Doni 1549
Doni, Anton Francesco. *Disegno: Partito in più ragionamenti, ne quali si tratta della scoltura et pittura . . .* Venice (Gabriel Giolito di Ferrari), 1549.

Dorigato 1993
Dorigato, Atilia. *Carpaccio, Bellini, Tura, Antonello e altri restauri della Pinacoteca del Museo Correr*. Exh. cat., Museo Correr,Venice; Milan, 1993.

Drawings Defined 1987
Drawings Defined. Ed. by Konrad Oberhuber, Walter Strauss, and Tracie Felker. New York, 1987.

Dreyer 1979
Dreyer, Peter. *Kupferstichkabinett Berlin: Italienische Zeichnungen*. Stuttgart and Zurich, 1979.

Du Cange
Du Cange, Charles Du Fresne. *Glossarium mediae et infimae latinitatis . . .* 2nd ed., Niort and London, 1883–87, 7 vols.

Dunkerton and Penny 1993
Dunkerton, Jill, and Nicholas Penny. "The Infra Red Examination of Raphael's *Garvagh Madonna*," *NGTB,* no. 14 (1993), 7–21.

Dunkerton and Roy 1996
Dunkerton, Jill, and Ashok Roy. "The Materials of a Group of Late Fifteenth Century Florentine Panel Painting," *NGTB,* no. 27 (1996), 21–32.

Dussler 1959
Dussler, Luitpold. *Die Zeichnungen des Michelangelos.* Berlin, 1959.

Dussler 1971
 Raphael: A Critical Catalogue of his Pictures, Wall-Paintings, and Tapestries. New York, 1971.

Edgerton 1991
Edgerton, Samuel. *The Heritage of Giotto's Geometry: Art and Science on the Eve of the Scientific Revolution.* Ithaca, 1991.

Ekserdjian 1997
Ekserdjian, David. *Correggio.* New Haven and London, 1997.

Elen 1995
Elen, Albert J. *Italian Late-Medieval and Renaissance Drawing-Books from Giovannino de' Grassi to Palma Giovane: A Codicological Approach.* Leiden, 1995.

Elkins 1987
Elkins, James. "Piero della Francesca and the Renaissance Proof of Linear Perspective," *AB,* 69 (1987), 220–30.

Emison 1984
Emison, Patricia. "Marcantonio's *Massacre of the Innocents*," *Print Quarterly,* 1 (1984), 257–67.

Ettlinger 1978
Ettlinger, Leopold. *Antonio and Piero Pollaiuolo: Complete Edition with a Critical Catalogue.* New York, 1978.

Ettlinger 1986
 "Raphael's Early Patrons," *Raphael before Rome* 1986, 85–90.

Fabjan and Marani 1998
Fabjan, Barbara and Pietro C. Marani. *Leonardo: La Dama con l'ermellino.* Exh. cat., Palazzo del Quirinale, Rome; Pinacoteca di Brera, Milan; and Palazzo Pitti, Florence; Milan, 1998.

Fahy 1976
Fahy, Everett. *Some Followers of Domenico Ghirlandaio (Garland Series of Outstanding Dissertations in the Fine Arts).* New York and London, 1976.

Farago 1991
Farago, Claire. "Leonardo's Color and Chiaroscuro Reconsidered: The Visual Force of Painted Images," *AB,* 73 (1991), 63–88.

Farago 1992
 Leonardo da Vinci's 'Paragone': A Critical Interpretation with a New Edition of the Text in the 'Codex Urbinas.' Leiden, New York, Copenhagen, and Cologne, 1992.

Farago 1994
 "Leonardo's *Battle of Anghiari*: A Study in the Exchange between Theory and Practice," *AB,* 76 (1994), 301–30.

Federici Vescovini 1965
Federici Vescovini, Graziella. *Studi sulla prospettiva medievale.* Turin, 1965.

Feinblatt 1976
Feinblatt, Ebria. *Old Master Drawings from American Collections.* Exh. cat., Los Angeles County Museum of Art, Los Angeles, 1976.

Ferino Pagden 1981
Ferino Pagden, Sylvia. "Raphael's Activity in Perugia as Reflected in a Drawing in the Ashmolean Museum, Oxford," *MdKIF,* 25 (1981), 231–52.

Ferino Pagden 1982
 Disegni umbri del rinascimento, da Perugino a Raffaello. Exh. cat., Gabinetto Disegni e Stampe degli Uffizi, Florence, 1982.

Ferino Pagden 1983
 "Pintoricchio, Perugino or the Young Raphael? A Problem of Connoisseurship," *BM,* 125 (1983), 87–88.

Ferino Pagden 1984
 Gallerie dell'Accademia di Venezia: Catalogo dei disegni antichi: Disegni umbri. Milan, 1984.

Ferino Pagden 1986
 "The Early Raphael and his Umbrian Contemporaries," *Raphael before Rome* 1986, 93–107.

Ferino Pagden 1987
 "Perugino's Use of Drawing: Convention and Invention," *Drawings Defined* 1987, 77–102.

Fermor 1996
Fermor, Sharon. *The Raphael Tapestry Cartoons: Narrative, Decoration, Design.* London, 1996.

Fermor and Derbyshire 1998
Fermor, Sharon and Alan Derbyshire. "The Raphael Tapestry Cartoons Re-Examined," *BM,* 115 (1998), 236–50.

Ferrari 1963
Ferrari, Tonino. "Disegni del Correggio per la Cupola di S. Giovanni Evangelista," *Parma per l'arte,* 13 (1963), 3–30.

Ferrari 1970
Ferrari, Tonino. *Il Segno grafico del Correggio.* Rome, 1970.

Ferrari and Belluzzi 1992
Ferrari, Daniela, and Amedeo Belluzzi. *Giulio Romano: Repertorio di fonti documentarie.* Rome, 1992, 2 vols.

Field, Lunardi, and Settle 1989
Field, Judith, Roberto Lunardi, and Thomas Settle. "The Perspective Scheme of Masaccio's *Trinity* Fresco," *Nuncius: Annali di storia della scienza (Istituto e Museo di Storia della Scienza, Firenze),* 4 (1989), no. 2 (Extract reprinted by Leo S. Olschki, Florence, 1989), 32–118.

Filarete 1890, 1972
Filarete (Antonio Averlino, called "Il Filarete"). "Tractat über die Baukunst nebst seinen Büchern von der Zeichenkunst und den Bauten der Medici," trans., ed., comment., and, intro. by Wolfgang von Oettlingen, *Quellenschriften für Kunstgeschichte und Kunsttechnik des Mittelalters und der Neuzeit (Neue Folge),* Vienna, 1890, 3 vols. *Trattato di Architettura,* ed., comment., and intro. by Liliana Grassi and Anna Maria Finoli, Milan, 1972, 2 vols.

Finaldi, Harding, and Wallis 1995
Finaldi, Gabriele, Eric Harding, and June Wallis. *The Conservation of the Carracci Cartoons in the National Gallery.* London, 1995.

Fischel 1898
Fischel, Oskar. *Raphaels Zeichnungen: Versuch einer Kritich der bisher veroffentlichen Blätter.* Strassburg, 1898.

Fischel 1913
"Raffaels Lehrer," *Jahrbuch der königlich Preuszischen Kunstsammlungen, Berlin,* 34 (1913), 89–96.

Fischel 1913–41
Raffaels Zeichnungen, I: *Erster Teil: Raphaels umbrische Zeit* (1913); II: *Florentiner Eindrücke und Skizzenbücher (1919); III: Florentiner Madonnen (1922); IV: Grablegung und Übergang nach Rom* (1923); V: *Römische Anfänge* (1924); *VI: Die Disputa* (1925); *VII: Die Schule von Athen* (1928); *VIII: Raphaels römische Zeichenkunst* (1941). Berlin, 1913–41, 8 vols.

Fischel 1915
"Raffaels *Heilige Magdalena* im Berliner königlich Kupferstichkabinett," *Jahrbuch der königlich Preuszischen Kunstsammlungen, Berlin,* 36 (1915), 92–96.

Fischel 1917
"Die Zeichnungen der Umbrer," *Jahrbuch der königlich Preuszischen Kunstsammlungen, Berlin,* 38 (1917), 1–72; II (Beiheft), 1–88.

Fischel 1922
"Ein Kartonfragment von Raphael: Zur *Madonna del Duca di Terranuova,*" *Amtliche Berichte der Berliner Museen,* 1–2 (1922), 13–15.

Fischel 1934–35
"Un cartone per il ritratto di Leone X nella Sala di Costantino in Vaticano," *BA,* 28 (1934–35), 484–86.

Fischel 1937
"Raphael's Auxiliary Cartoons," *BM,* 71 (1937), 167–68.

Fischel 1939
"Raphael's Pink Sketchbook," *BM,* 74 (1939), 181–87.

Fischel 1948
Raphael, London, 1948, 2 vols.

Fischer 1986
Fischer, Chris. *Disegni di Fra Bartolommeo e della sua scuola.* Exh. cat., Gabinetto Disegni e Stampe degli Uffizi, Florence, 1986.

Fischer 1990
Fra Bartolommeo: Master of the High Renaissance. Exh. cat., Museum Boymans-Van Beuningen, Rotterdam, 1990.

Florentine Drawing at the Time of Lorenzo the Magnificent 1994
Cropper, Elizabeth (ed.). *Florentine Drawing at the Time of Lorenzo the Magnificent (Papers from a Colloquium Held at the Villa Spelman, Florence, 1992, Series 4).* Bologna, 1994.

Forlani Tempesti 1969
Forlani Tempesti, Anna. "The Drawings," *The Complete Work of Raphael.* (Italian ed., Novara, 1968) New York, 1969, 308–428.

Forlani Tempesti 1970
I Disegni dei maestri: Capolavori del rinascimento: Il Primo cinquecento toscano. Milan, 1970.

Forlani Tempesti 1974
I Grandi disegni italiani degli Uffizi di Firenze. Milan, 1974.

Forlani Tempesti 1991
The Robert Lehman Collection, V: Italian Fifteenth- to Seventeenth-Century Drawings. Princeton and New York, 1991.

Forlì 1994
Foschi, Marina, and Luciana Prati. *Melozzo da Forlì: La Sua città e il suo tempo.* Exh. cat., Palazzo Albertini and Oratorio di S. Sebastiano, Forlì. Milan, 1994.

Fossi Todorow 1966
Fossi Todorow, Maria. *I Disegni del Pisanello e della sua cerchia.* Florence, 1966.

Fredericksen 1990
Fredericksen, Burton. "Raphael and Raphaelesque Paintings in California: Technical Considerations and the Use of Underdrawing in his Pre-Roman Phase," *The Princeton Raphael Symposium* 1990, 99–109.

Freedberg 1963
Freedberg, Sidney J. *Andrea del Sarto.* Cambridge, Mass., 1963, 2 vols.

Freedberg 1971
Painting in Italy 1500–1600 (Pelican History of Art). Harmonsworth, 1971.

Freedberg 1972
Painting of the High Renaissance in Rome and Florence. (1st ed., Cambridge, Mass., 1961) Cambridge, 1972, 2 vols.

Freedberg 1973
"Review of *Parmigianino's Drawings* and *Disegni di Girolamo Bedoli* by A. E. Popham," *AB,* 55 (1973), 148–50.

Fremantle 1975
Fremantle, Richard. *Florentine Gothic Painters from Giotto to Masaccio: A Guide to Painting in and near Florence 1300–1450.* London, 1975.

Frerichs 1971
Frerichs, L. C. J. "Een studie voor Rafaels *Transfiguratie* voor het Rijksprentenkabinet," *Amsterdam Rijksmuseum Bulletin,* 19, no. 4 (1971), 165–72.

Frerichs 1981
Italiaanse tekeningen II de 15 de en 16de eeuw. Exh. cat., Rijksmuseum, Amsterdam, 1981.

Freuler 1986
Freuler, Gaudenz. "Lippo Memmi's New Testament Cycle in the Collegiata in San Gimignano," *AC,* 79 (1986), 93–102.

Freuler 1994
Bartolo di Fredi. Ein Beitrag zur sienesischen Malerei des 14. Jahrhunderts. Disentis, 1994.

Frey 1892
Frey, Karl. *Il Codice Magliabechiano, contenente notizie sopra l'arte degli antichi e quella de' fiorentini da Cimabue a Michelangelo Buonarotti scritte da Anonimo Fiorentino.* Berlin, 1892.

Frey 1909
"Studien zu Michelagniolo Buonarroti und zur Kunst seiner Zeit," *Jahrbuch der königlich Preuszischen Kunstsammlungen, Berlin,* 30 (1909), 103–80.

Frey 1923–30
Der literarische Nachlaβ Giorgio Vasaris. Munich, 1923–30, 2 vols.

Frommel 1967–68
Frommel, Christoph Luitpold. *Baldassare Peruzzi als Maler und Zeichner.* Munich and Vienna, 1967–68.

Frommel 1981
"Eine Darstellung der *Loggien* in Raffaels *Disputa?* Beobachtungen zu Bramantes Erneuerung des Vatikanpalastes in den Jahren 1508/09," *Festschrift für Eduard Trier*. Berlin, 1981, 103–29.

Galassi 1988
Galassi, Maria Clelia. "Appunti per la grafica genovese del Quattrocento: I Disegni contrattuali e il disegno sottostante in Giovanni Mazone: Per una rilettura della *Crocefissione* di Palazzo Bianco," *Bollettino dei Musei Civici Genovesi*, nos. 29–31 (1988), 33–51.

Galassi 1988–89
Il Disegno sottostante nella pittura italiana del Quattrocento: Teoria e prassi in alcuni artisti di area centro-settentrionale. Ph.D. Dissertation, Università degli Studi di Milano, Milan, 1988–89.

Galassi 1998
Il disegno svelato: Progetto e immagine nella pittura italiana del primo Rinascimento. Nuoro, 1998.

Gardner 1979
Gardner, Julian. "Andrea di Bonaiuto and the Chapterhouse Frescoes in Santa Maria Novella," *Art History*, 2 (1979), 107–37.

Garzelli 1973
Garzelli, Annarosa. *Il Ricamo nella attività artistica di Pollaiuolo, Botticelli, Bartolomeo di Giovanni*. Florence, 1973.

Gasparinetti 1956
Gasparinetti, Andrea Federico. "Ein altes Statut von Bologna über die Herstellung und den Handeln von Papier," *Papiergeschichte*, 6 (1956), 45–57.

Gaye 1839–40
Gaye, Giovanni. *Carteggio inedito d'artisti dei secoli XIV, XV, XVI, pubblicato ed illustrato con documenti pure inediti*. (I: 1326–1500 [1839]; II: 1500–1557 [1840]; III: 1501–1672 [1840]. Florence, 1839–40, 3 vols.

The Genius of Venice 1983
The Genius of Venice 1500–1600. Exh. cat., Royal Academy of Arts, London, 1983.

Gere 1966
Gere, John A. *Mostra di disegni degli Zuccari*. Exh. cat., Gabinetto Disegni e Stampe degli Uffizi, Florence, 1966.

Gere 1969
Taddeo Zuccaro: His Development Studied in His Drawings. London, 1969.

Gere 1971
I Disegni dei maestri: Il Manierismo a Roma. Milan, 1971.

Gere and Turner 1983
Gere, John A., and Nicholas Turner. *Drawings by Raphael from the Royal Library, the Ashmolean, the British Museum, Chatsworth and other English Collections*. Exh. cat., British Museum, London, 1983.

Ghirlandaio 1996
Prinz, Wolfram and Max Seidel (eds.). *Domenico Ghirlandaio, 1449–1494. Atti del convegno internazionale, Firenze, 16–18 Ottobre 1994*. Florence, 1996.

Gibbons 1977
Gibbons, Felton. *Catalogue of Drawings in the Art Museum, Princeton University*. Princeton, N.J., 1977, 2 vols.

Gilbert 1946
Gilbert, Creighton E. "Antique Frameworks for Renaissance Art Theory: Alberti and Pino," *Marsyas*, 3 (1946), 87–106.

Gilbert 1965
"A Miracle by Raphael," *North Carolina Museum of Art Bulletin*, 6 (1965), 44–45.

Gilbert 1980 a
Italian Art 1400–1500 (Sources and Documents in the History of Art). Englewood Cliffs, N.J., 1980.

Gilbert 1980 b
"Some Findings on Early Works of Titian," *AB*, 62 (1980), 36–75.

Gilbert 1986
"Signorelli and Young Raphael," *Raphael before Rome* 1986, 109–24.

Gilbert 1994
Michelangelo On and Off the Sistine Ceiling: Selected Essays. New York, 1994.

Giotto to Dürer 1991
Dunkerton, Jill, et al. *Giotto to Dürer: Early Renaissance Painting in the National Gallery*. New Haven and London, 1991.

Glasser 1977
Glasser, Hannelore. *Artists' Contracts of the Early Renaissance (Garland Series of Outstanding Dissertations in the Fine Arts)*. New York and London, 1977.

Goldberg 1988
Goldberg, Edward. *After Vasari, Art and Patronage in Late Medici Florence*. Princeton, 1988.

Goldner 1988
Goldner, George R. *The J. Paul Getty Museum: European Drawings, 1: Catalogue of the Collections*. Malibu, 1988.

Goldner and Hendrix 1992
Goldner, George R., and Lee Hendrix. *The J. Paul Getty Museum: European Drawings, 2: Catalogue of the Collections*. Malibu, 1992.

Goldthwaite 1980
Goldthwaite, Richard A. *The Building of Renaissance Florence: An Economic and Social History*. Baltimore and London, 1980.

Golzio 1971
Golzio, Vincenzo. *Raffaello nei documenti, nelle testimonianze dei contemporanei e nella letteratura del suo secolo*. (1st ed., Vatican City, 1936) London, 1971.

Gombrich 1966
Gombrich, Ernst. "Leonardo's Method of Working Out Compositions," *Norm and Form*, London, 1966, 58–63.

Gombrich 1976
Means and Ends: Reflections on the History of Fresco Painting (Walter Neurath Memorial Lecture). London, 1976.

Gombrich 1984
The Sense of Order: A Study in the Psychology of Decorative Art. 2nd ed., Ithaca, N.Y., 1984.

Gombrich 1986
"Michelangelo's Cartoon in the British Museum," *New Light on Old Masters*, Oxford, 1986, 171–78.

Gotti 1875
Gotti, Aurelio. *Vita di Michelangelo Buonarroti narrata con l'aiuto di nuovi documenti*. Florence, 1875, 2 vols.

Gould 1987
Gould, Cecil. *National Gallery Catalogues: The Sixteenth-Century Italian Schools*. 2nd ed., London, 1987.

Grand Palais 1983
Réunion des musées nationaux. *Hommage à Raphael: Raphael dans les collections françaises*. Exh. cat., Galeries Nationales du Grand Palais, Paris, 1983.

Grand Palais 1993
Le Siècle de Titien: L'age d'or de la peinture à Venise. Exh. cat., Galeries Nationales du Grand Palais, Paris, 1993.

Gregori 1965
Gregori, Mina. *Giovanni da Milano alla Cappella Rinuccini*. Milan, 1965.

Griseri 1994
Griseri, Andreina. "Andrea Pozzo: Unità di strategie, prospettiva e pittura" (Conference, "Vocazione artistica dei religiosi: Caratteri e peculiarità delle opere di artisti appartenenti a ordini e congregazioni religiose"), *AC*, 82 (1994), 483–92.

Gross 1984
Gross, Sally. "A Second Look: Nationalism in Art Treatises from the Golden Age of Spain," *Rutgers Art Review*, 5 (1984), 9–27.

Grosseto I 1981
Soprintendenza per i Beni Artistici e Storici delle Provincie di Siena e Grosseto. *Mostra di opere d'arte restaurate nelle provincie di Siena e Grosseto I*. Exh. cat., Genoa, 1981.

Grosseto II 1981
Mostra di opere d'arte restaurate nelle provincie di Siena e Grosseto II. Exh. cat., Genoa, 1981.

Guasti 1857
Guasti, Cesare. *La Cupola di Santa Maria del Fiore*. Florence, 1857.

Gurrieri 1988
Gurrieri, Francesco, et al. *La Basilica di San Miniato al Monte a Firenze*. Florence, 1988.

Hadeln 1925
Hadeln, Detlev Freiherr von. *Venezianische Zeichnungen des Quattrocento*. Berlin, 1925.

Hall 1979
Hall, Marcia. *Renovation and Counter-Reformation: Vasari and Duke Cosimo in S. Maria Novella and S. Croce, 1565–1577*. Oxford, 1979.

Hall 1992
Color and Meaning: Practice and Theory in Renaissance Painting. Cambridge and New York, 1992.

Hambly 1988
Hambly, Maya. *Drawing Instruments 1580–1980*. London, 1988.

Harding, Braham, Wyld, and Burnstock 1989
Harding, Eric; Allan Braham; Martin Wyld; and Aviva Burnstock. "The Restoration of the Leonardo Cartoon," *NGTB*, 13(1989), 4–27.

Harprath 1977
Harprath, Richard. *Italienische Zeichnungen des 16. Jahrhunderts aus eigenem Besitz*. Exh. cat., Staatliche Graphische Sammlung München, Munich, 1977.

Harprath 1986
"Raffaels Teppiche in der Sixtinischen Kapelle," *Raffaello a Roma* 1986, 117–26.

Hartt 1958
Hartt, Frederick. *Giulio Romano*. New Haven, 1958, 2 vols.

Hartt 1959
"The Earliest Works of Andrea del Castagno," *AB*, 41 (1959), 158–87, 225–36.

Hartt 1971
Michelangelo Drawings. New York, 1971.

Harvard 1955
Harvard College Library. *Illuminated and Calligraphic Manuscripts*. Exh. cat., Cambridge, 1955.

Hatfield 1996
Hatfield, Rab. "Giovanni Tornabuoni, i fratelli Ghirlandaio e la cappella maggiore di Santa Maria Novella," *Ghirlandaio* 1996, 112–17.

Haverkamp-Begemann 1988
Haverkamp-Begemann, Egbert with Carolyn Logan. *Creative Copies: Interpretive Drawings from Michelangelo to Picasso*. Exh. cat., Drawing Center, New York, 1988.

Haverkamp-Begemann and Logan 1970
Haverkamp-Begemann, Egbert, and Anne-Marie S. Logan. *European Drawings and Watercolors in the Yale University Art Gallery: 1500–1900*. New Haven and London, 1970, 2 vols.

Henry 1993
Henry, Tom. "Signorelli, Raphael and a 'Mysterious' Pricked Drawing in Oxford," *BM*, 135 (1993), 612–19.

Henry 1996
"I Cartoni," *Orvieto* 1996, 253–70.

Henry 1997
"Cartoons Restored to View: The Raphael Gallery at the Victoria and Albert Museum, London, Opened October 1996," *Renaissance Studies*, 11 (1997), 441–45.

Herrmann-Fiore 1982
Herrmann-Fiore, Kristina. "'Disegno' and 'Giuditio', Allegorical Drawings by Federico Zuccaro and Cherubino Alberti," *MD*, 20 (1982), 247–56.

Heydenreich 1954
Heydenreich, Ludwig. *Leonardo da Vinci*. New York and Basel, 1954, 2 vols.

Hiller 1995
Hiller von Gaertringen, Rudolf. *Aspekte Raphaelscher Lernerfahrung im Atelier Peruginos. Kartonverwendung und Reproduktivität im Wandel*. Unpublished Ph.D. Dissertation, Eberhard-Karls-Universität Tubingen), Stuttgart, 1995.

Hiller 1997 a
"On Perugino's Re-Uses of Cartoons," *Le Dessin sous-jacent dans la peinture: Colloque XI, 14–16 Sept. 1995*, ed. by Roger van Schoute and Hélène Verougstraete, Louvain-La-Neuve, 1997, 223–30.

Hiller 1997 b
"Eine Madonna mit Kind und Johannesknaben im Staedel," *Staedel Jahrbuch*, 16 (1997), 227–38.

Hiller 1999

Raffaels Lernerfahrung in der Werkstatt Peruginos: Kartonverwendung und Motiveübernahme im Wandel (Kunstwissentschaftliche Studien, Band 73). Munich, 1999.

Hills 1987

Hills, Paul. *The Light of Early Italian Painting*. New Haven and London, 1987.

Hind 1912

Hind, Arthur M. *Marcantonio and Italian Engravers and Etchers of the Sixteenth Century*. New York and London, 1912.

Hind 1938–48

Early Italian Engraving: A Critical Catalogue. London, 1938–48, 7 vols.

Hirst 1981

Hirst, Michael. *Sebastiano del Piombo*. Oxford, 1981.

Hirst 1986 a

"'Il Modo delle attitudine,' Michelangelo's Oxford Sketchbook for the Ceiling," *The Sistine Chapel* 1986, 214–16.

Hirst 1986 b

"I Disegni di Michelangelo per la *Battaglia di Cascina*," *Tecnica e stile* 1986, I, 43–49, 52–58 (discussion).

Hirst 1988 a

Michelangelo and his Drawings. New Haven and London, 1988.

Hirst 1988 b

Michelangelo Draftsman. Exh. cat., National Gallery of Art, Washington, D.C., and Cabinet des Dessins, Musée du Louvre, Paris, Olivetti, n.p., 1988.

Hirst 1991

"Michelangelo in 1505," *BM*, 133 (1991), 760–66.

Hirst and Dunkerton 1994

Hirst, Michael, and Jill Dunkerton. *Making and Meaning: The Young Michelangelo: The Artist in Rome, 1496–1501*. Exh. cat., National Gallery, London, 1994.

Hollingsworth 1994

Hollingsworth, Mary. *Patronage in Renaissance Italy: From 1400 to the Early Sixteenth–Century*. Baltimore, 1994.

Hollingsworth 1996

Patronage in Sixteenth–Century Italy. London, 1996.

Hood 1993

Hood, William. *Fra Angelico at San Marco*. New Haven and London, 1993.

Horster 1980

Horster, Marita. *Andrea del Castagno: Complete Edition with a Critical Catalogue*. Ithaca, N.Y., 1980.

Hübner 1762

Hübner, Johann. *Curieuses und reales Natur-Kunst-Berg-Gewerck- und Handlungs-Lexikon*. (1st ed., Leipzig, 1717) Leipzig, 1762.

Humfrey 1983

Humfrey, Peter. *Cima da Conegliano*. Cambridge, 1983.

Humfrey 1993

The Altarpiece in Renaissance Venice. New Haven and London, 1993.

Humfrey 1995

Painting in Renaissance Venice. New Haven and London, 1995.

Ingendaay 1981

Ingendaay, Martina. "I Cartoni del Correggio ritrovati," in Schianchi and Battisti 1981, 76–78.

Ingendaay 1983

"Disegni preparatori e cartoni," "*La Più bella di tutte*": La Cupola del Correggio nel Duomo di Parma, ed. by Eugenio Riccòmini. Parma, 1983, 185–88.

Isermeyer 1937

Isermeyer, Christian-Adolf. *Rahmengliederung und Bildfolge in der Wandmalerei bei Giotto und den Florentiner Malern des 14. Jahrhunderts (Inaugural-Dissertation zur Erlangung der Doktorwürde einer Hohen Philosophischen Fakultät der Georg-August-Universität zu Göttingen, 1933)*. Würzburg, 1937.

Isermeyer 1963

"Die Arbeiten Leonardos und Michelangelos für den grossen Ratsaal in Florenz . . . ," *Studien zur Toskanischen Kunst: Festschrift für Ludwig Heydenreich*. Munich, 1963, 83–130.

Israels 1998

Israels, Machtelt. "New Documents for Sassetta and Sano di Pietro at the Porta Romana, Siena," *BM*, 140 (1998), 436–44.

Ives and Lehmann-Haupt 1942

Ives, Samuel A., and Hellmut Lehmann-Haupt. *An English 13th Century Bestiary: A New Discovery in the Technique of Medieval Illumination*. New York, 1942.

Jack 1976

Jack, Mary Ann. "The *Accademia del Disegno* in Late Renaissance Florence," *The Sixteenth-Century Journal*, 2 (1976), 3–20.

Jaffé 1994

Jaffé, Michael. *The Devonshire Collection of Italian Drawings, I: Tuscan and Umbrian Schools; II: Roman and Neapolitan Schools; III: Bolognese and Emilian Schools; IV: Venetian and North-Italian Schools*. London, 1994, 4 vols.

Joannides 1983

Joannides, Paul. *The Drawings of Raphael with a Complete Catalogue*. Los Angeles, 1983.

Joannides 1987

"Raphael and Giovanni Santi," *Studi su Raffaello* 1987, 55–61.

Jones and Penny 1983

Jones, Roger, and Nicholas Penny. *Raphael*. New Haven, 1983.

Junquera 1963

Junquera, Paulina. "El obrador de bordados de El Escorial," *El Escorial 1563–1963: IV Centenario de la Fundación del Monasterio de San Lorenzo El Real*, Madrid, 1963, II, 578–82.

Kanter 1983

Kanter, Laurence B. *Orvieto, Cappella di San Brizio: Luca Signorelli*, Florence, 1983.

Kanter 1989

The Late Works of Luca Signorelli and His Followers: 1498–1559. Ph.D. Dissertation, Institute of Fine Arts, New York University, New York, 1989.

Kanter 1992

"Some Documents, a Drawing, and an Altarpiece by Luca Signorelli," *MD*, 30 (1992), 415–19.

Keele and Pedretti 1978–80
Keele, Kenneth, and Carlo Pedretti. *Leonardo da Vinci: Corpus of the Anatomical Studies in the Collection of Her Majesty the Queen at Windsor Castle.* London and New York, 1978–80, 3 vols.

Kemp 1977
Kemp, Martin. "From *'Mimesis'* to *'Fantasia:'* The Quattrocento Vocabulary of Creation, Inspiration and Genius in the Visual Arts," *Viator,* 8 (1977), 347–98.

Kemp 1978
"Science, Non-Science and Nonsense: The Interpretation of Brunelleschi's Perspective," *Art History,* 1 (1978), 134–61.

Kemp 1989
Leonardo Da Vinci: The Marvellous Works of Nature and Man. 2nd ed., London, 1989.

Kemp 1990
The Science of Art: Optical Themes in Western Art from Brunelleschi to Seurat. New Haven and London, 1990.

Kemp 1992
Leonardo da Vinci: The Mystery of the 'Madonna of the Yarnwinder.' Exh. cat., National Gallery of Scotland, Edinburgh; London, 1992.

Kemp 1997
Behind the Picture: Art and Evidence in the Italian Renaissance. New Haven and London, 1997.

Kemp and Roberts 1989
Kemp, Martin, and Jane Roberts, with Philip Steadman. *Leonardo da Vinci.* Exh. cat., Hayward Gallery, London; New Haven and London, 1989.

Kempers 1994
Kempers, Bram. *Painting, Power, and Patronage: The Rise of the Professional Artist in Renaissance Italy.* London, 1994.

Kennedy 1938
Kennedy, Ruth Wedgwood. *Alesso Baldovinetti: A Critical and Historical Study.* New Haven and London, 1938.

Kerber 1971
Kerber, Bernhard. *Andrea Pozzo.* Berlin and New York, 1971.

Kern 1912
Kern, Guido Joseph. "Die Anfänge der zentralperspektivischen Konstruktion in der italienischen Malerei des 14. Jahrhunderts," *MdKIF,* 4 (1912), 39–65.

Klein 1961
Klein, Robert. "Pomponius Gauricus on Perspective," *AB,* 13 (1961), 211–30.

Klein and Zerner 1966
Klein, Robert, and Henri Zerner. *Italian Art 1400–1500 (Sources and Documents in the History of Art).* Englewood Cliffs, N.J., 1966.

Klesse 1967
Klesse, Brigitte. *Seidenstoffe in der italienischen Malerei des 14. Jahrhunderts.* Bern, 1967.

Knab, Mitsch, and Oberhuber 1983
Knab, Eckhart; Erwin Mitsch; and Konrad Oberhuber. *Raphael: Die Zeichnungen.* Stuttgart, 1983.

Knapp 1903
Knapp, Fritz. *Fra Bartolommeo della Porta und die Schule von San Marco.* Halle, 1903.

Knapp 1907
Perugino. Bielefeld and Leipzig, 1907.

Koller 1981
Koller, Manfred. "Die technische Entwicklung und künstlerische Funktion der Unterzeichnung in der europäischen Malerei vom 16. bis zum 18. Jahrhundert," *Université Catholique de Louvain, Le dessin sous-jacent dans la peinture, Colloque IV.* Louvain, 1981, 173–90.

Koller 1991
(Ed.). *Geschichte der Restaurierung in Europa: Akten des internationalen Kongresses 'Restauriergeschichte,' Interlaken, 1989 (Association Suisse de Conservation et Restauration).* Worms, 1991.

Koschatzky, Oberhuber, and Knab 1972
Koschatzky, Walter, Konrad Oberhuber, and Eckhart Knab. *I Grandi disegni italiani dell'Albertina a Vienna.* Milan, 1972.

Krautheimer 1990
Krautheimer, Richard. *Lorenzo Ghiberti.* (1st ed., Princeton, N.J., 1956) Princeton, 1990.

Kurz 1937–38
Kurz, Otto. "Giorgio Vasari's *Libro di Disegni," Old Master Drawings,* 12 (1937–38), 1–15, 32–44.

Lairesse 1701, 1778
Lairesse, Gerard de. *Grondlegginge ter teekenkonst.* Amsterdam, 1701. *The Art of Painting in All Its Branches, Methodically Demonstrated by Discourses and Plates, and Exemplified by Remarks on the Paintings of the Best Masters: And their Perfections and Oversights Laid Open.* Trans. by John Frederick Fritsch, London, 1778.

Lake 1984–85
Lake, Susan F. "A Pounced Design in *David and Bathsheba* by Paris Bordone," *Journal of the Walters Art Gallery,* 42/43 (1984–85), 62–65.

Lambert 1981
Lambert, Susan. *Drawing: Technique and Purpose.* Exh. cat., Victoria and Albert Museum, London, 1981.

Lancillotti 1509
Lancillotti, Francesco. *Trattato di pittura.* Rome, 1509.

Landau and Parshall 1994
Landau, David, and Peter Parshall. *The Renaissance Print, 1470–1550.* New Haven and London, 1994.

Lauts 1943
Lauts, Jan. *Domenico Ghirlandaio.* Vienna, 1943.

Lavin 1990
Lavin, Marilyn Aronberg. *The Place of Narrative: Mural Decoration in Italian Churches, 431–1600.* Chicago and London, 1990.

Lavin et al. 1984
Piero della Francesca a Rimini: L'Affresco nel Tempio Malatestiano. Bologna, 1984.

Lazzeroni 1957
Lazzeroni, Irenio. "Le Sinopie degli affreschi di Masolino nella Cappella della Croce in Santo Stefano degli Agostiniani," *Bollettino Storico Empolese,* 1 (1957), 141–54.

Le Molle 1988
Le Molle, Roland. *Georges Vasari et le vocabulaire de la critique d'art dans les Vites.* Geneva, 1988.

Lecchini Giovannoni 1991
Lecchini Giovannoni, Simona. *Alessandro Allori.* Florence, 1991.

Lehmann-Haupt 1966
Lehmann-Haupt, Hellmut. *Gutenberg and the Master of the Playing Cards*. New Haven, 1966.

Lehmann-Haupt 1972
The Göttingen Model-Book. Columbia, 1972.

Leonardo & Venezia 1992
Leonardo & Venezia. Exh. cat., Palazzo Grassi, Venice; Milan, 1992.

Leonardo e il Leonardismo 1983
Vezzosi, Alessandro (ed.). *Leonardo e il Leonardismo a Napoli e a Roma*. Exh. cat., Palazzo Venezia, Rome; and Museo Nazionale di Capodimonte, Naples; Florence, 1983.

Leonardo, *On Painting*
Leonardo da Vinci. *Leonardo, On Painting: An Anthology of Writings by Leonardo da Vinci with a Selection of Documents Relating to his Career as an Artist*. Ed. by Martin Kemp, trans. by Martin Kemp and Margaret Walker. New Haven and London, 1989.

Levey 1983
Levey, Santina. *Lace: A History*. London, 1983.

Lightbown 1986
Lightbown, Ronald. *Mantegna*. Oxford, Berkeley, and Los Angeles, 1986.

Lille 1967–68
Chatelet, Albert. *Dessins italiens du Musée de Lille*. Exh. cat., Rijksmuseum, Amsterdam; Bibliothèque Royale de Belgique, Brussels; and Palais des Beaux-Arts, Lille, 1967–68.

Lille 1983
Musée des Beaux-Arts de Lille. *Dessins de Raphael du Musée des Beaux-Arts de Lille.* Exh. cat., Palais des Beaux-Arts, Lille, 1983.

Ling 1990
Ling, Roger. *Roman Painting*. Cambridge and New York, 1990.

Lloyd 1977
Lloyd, Christopher. "A Short Footnote to Raphael Studies," *BM*, 119 (1977), 113–14.

Lomazzo 1973–74
Lomazzo, Gian Paolo. *Scritti sulle arti*. Ed., comment., and intro. by Roberto Paolo Ciardi. Florence, 1973–74, 2 vols.

Lotz 1933
Lotz, Arthur. *Bibliographie der Modelbücher: Beschreibendes Verzeichnis der Stick-und Spitzenmusterbücher des 16. und 17. Jahrhunderts*. Leipzig, 1933.

Louvre 1983
Bacou, Roseline. *Autour de Raphael: Dessins et peintures du Musée du Louvre*. Exh. cat., Musée du Louvre, Paris, 1983.

Louvre 1986
Réunion des musées nationaux. *Hommage à Andrea del Sarto*. Exh. cat., Cabinet des Dessins, Musée du Louvre, Paris, 1986.

Louvre 1989
Leonard de Vinci, Draperies. Exh. cat. by Françoise Viatte, Cabinet des Dessins, Musée du Louvre, Paris, 1989.

Louvre 1991
Pérez Sánchez, Alfonso, and Lizzie Boubli. *Dessins espagnols:*

Maîtres des XVIe et XVIIe siècle. Exh. cat., Cabinet des Dessins, Musée du Louvre, Paris, 1991.

Louvre 1992
Cordellier, Dominique, and Bernadette Py. *Musée du Louvre: Cabinet des dessins. Raphael, son atelier, ses copistes (Inventaire général des dessins italiens, V)*. Paris, 1992.

Louvre 1996
Cordellier, Dominique, et al. *Pisanello: Le peintre aux sept vertus*. Exh. cat., Musée du Louvre, Paris, 1996.

Lynch 1962
Lynch, James B. "The History of Raphael's *Saint George* in the Louvre," *GBA*, 59 (1962), 203–12.

MacAndrew 1980
MacAndrew, Hugh. *Ashmolean Museum, Oxford: Catalogue of the Collection of Drawings, Vol. 3: Italian School, Supplement*. Oxford, 1980.

Magnani 1995
Magnani, Lauro. *Luca Cambiaso: Da Genoa all' Escorial*. Genoa, 1995.

Malke 1980
Malke, Lutz. *Italienische Zeichnungen des 15. und 16. Jahrhunderts, aus eigenem Bestanden*. Exh. cat., Städelsches Kunstinstitut, Frankfurt, 1980.

Mancinelli 1979
Mancinelli, Fabrizio. *Primo piano di un capolavoro: La 'Trasfigurazione' di Raffaello*. Vatican City, 1979.

Mancinelli 1984
"Raphael's *Coronation of Charlemagne* and Its Cleaning," *BM*, 126 (1984), 404–10.

Mancinelli 1986 a
"Michelangelo at Work," *The Sistine Chapel* 1986, 218–59.

Mancinelli 1986 b
"The *Coronation of the Virgin* by Raphael," *Raphael before Rome* 1986, 127–36.

Mancinelli 1986 c
"L' *Incoronazione di Francesco I* nella Stanza dell'Incendio di Borgo," *Raffaello a Roma* 1986, 163–72.

Mancinelli 1988 a
"La technique de Michel-Ange et les problèmes de la Chapelle Sixtine. La *Création d'Eve* et le *Péché original*," *Revue de l'Art*, no. 81 (1988), 9–19.

Mancinelli 1988 b
"Il Cantiere di Michelangelo per la volta della Cappella Sistina," *La Pittura in Italia: Il Cinquecento*, Milan, 1988, 538–51.

Mancinelli 1990
"Tecnica di Michelangelo e organizzazione del lavoro," *Michelangelo e la Sistina* 1990, 55–59.

Mancinelli, Colalucci, and Gabrielli 1991
Mancinelli, Fabrizio, Gianluigi Colalucci, and Nazareno Gabrielli. "Rapporto sul *Giudizio*," *Bollettino Monumenti Musei e Gallerie Pontificie*, 11 (1991), 219–49.

Manetti 1970
Manetti, Antonio di Tuccio. *The Life of Brunelleschi*. Trans. by Catherine Enggass, University Park, Penn., 1970.

Mantegna 1992
Martineau, Jane (ed.). *Andrea Mantegna*. Exh. cat., Metropolitan

Museum of Art, New York, and Royal Academy of Arts, London; Milan, London, and New York, 1992.

Mantua 1989
Giulio Romano. Exh. cat., Palazzo Te, Mantua, 1989.

Marabottini 1969
Marabottini, Alessandro. "Raphael and his Workshop," *The Complete Work of Raphael.* New York, 1969, 208–89.

Marani 1989
Marani, Pietro C. *Leonardo: Catalogo completo.* Florence, 1989.

Marani 1992
"Tracce ed elementi Verrocchieschi nella tarda produzione grafica e pittorica di Leonardo," *Verrocchio and Late Quattrocento Italian Sculpture,* ed. by Steven Bule et al., Brigham Young University – Harvard University Center for Italian Renaissance Studies at Villa I Tatti, Florence, 1992, 141–52.

Marchini 1957
Marchini, Giuseppe. *Italian Stained Glass Windows.* New York, 1957.

Marinoni 1979–80
Marinoni, Augusto. *Il Codice Atlantico della Biblioteca Ambrosiana di Milano: Transcrizione diplomatica e critica.* Florence, 1979–80, 12 vols.

Marinoni and Cogliati Arano 1982
Marinoni, Augusto, and Luisa Cogliati Arano. *Leonardo all'Ambrosiana: Il Codice Atlantico: I Disegni di Leonardo e della sua cerchia (Fontes Ambrosiani LXXI).* Exh. cat., Biblioteca Ambrosiana, Milan, 1982.

Martin 1965
Martin, John Rupert. *The Farnese Gallery.* Princeton, N.J., 1965.

Martin 1996
Martin, Frank. "Domenico del Ghirlandaio *delineavit:* Osservazioni sulle vetrate della Cappella Tornabuoni," *Ghirlandaio* 1996, 118–40.

Martindale 1961
Martindale, Andrew. "Luca Signorelli and the Drawings Connected with the Orvieto Frescoes," *BM,* 103 (1961), 216–20.

Mather 1948
Mather, Rufus. "Documents Mostly New Relating to Florentine Painters and Sculptors of the Fifteenth Century," *AB,* 30 (1948), 20–65.

Matteini and Moles 1986
Matteini, Mauro, and Arcangelo Moles. "Il Cenacolo di Leonardo: Considerazioni sulla tecnica pittorica e ulteriori studi analitici sulla preparazione," *OPDR,* no. 1 (1986), 34–41.

McCullagh and Giles 1997
McCullagh, Suzanne Folds, and Laura Giles. *Italian Drawings before 1600 in the Art Institute of Chicago: A Catalogue of the Collection.* Chicago, 1997.

McCulloch 1960
McCulloch, Florence. *Medieval Latin and French Bestiaries.* Chapel Hill, N.C., 1960.

McGrath 1997
McGrath, Thomas. "Color in Italian Renaissance Drawings: Reconciling Theory and Practice in Central Italy and Venice," *Apollo,* 146 (1997), 22–30.

McGrath 1998
"Federico Barocci and the History of *Pastelli* in Central Italy," *Apollo,* 148 (1998), 3–8.

McKillop 1974
McKillop, Susan. *Franciabigio.* Berkeley, Los Angeles, and London, 1974.

McMahon 1956
Leonardo da Vinci: Treatise on Painting (Codex Urbinas Latinus 1270), I: trans., II: facsim. Trans. and annot. by A. Philip McMahon, intro. by Ludwig Heydenreich. Princeton, N.J., 1956, 2 vols.

Meder 1923
Meder, Joseph. *Die Handzeichnung, ihre Technik und Entwicklung.* 2nd ed., Vienna, 1923.

Meder and Ames 1978
Meder, Joseph, and Winslow Ames. *The Mastery of Drawing.* New York, 1978, 2 vols.

Meijer and Tuyll 1983
Meijer, Bert W., and Carel van Tuyll. *Disegni italiani del Teylers Museum Haarlem provenienti dalle collezioni di Cristina di Svezia e dei principi Odescalchi.* Exh. cat., Istituto Nazionale per la Grafica di Roma; and Gabinetto Disegni e Stampe degli Uffizi, Florence, 1983.

Meiss 1970
Meiss, Millard. *The Great Age of Fresco: Discoveries, Recoveries, and Survivals.* New York, 1970.

Mellini 1965
Mellini, Gian Lorenzo. "Studi su Cennino Cennini," *Critica d'arte,* 12 (n.s.), no. 75 (1965), 48–64.

Merrifield 1846
Merrifield, Mary. *The Art of Fresco Painting as Practiced by the Old Italian and Spanish Masters . . .* London, 1846.

Merrifield 1849
Original Treatises, Dating from the XIIth to XVIIIth Centuries, on the Arts of Painting in Oil, Miniature, Mosaic, and on Glass; of Gilding; Dyeing, and the Preparation of Colours and Artificial Gems. London, 1849, 2 vols.

Merrill 1986
Merrill, Ross M. "Examination and Treatment of the *Small Cowper Madonna* by Raphael at the National Gallery of Art," *Raphael before Rome* 1986, 139–47.

Metropolitan Museum of Art 1968
The Great Age of Fresco: Giotto to Pontormo. Exh. cat. by Millard Meiss, Ugo Procacci et al., Metropolitan Museum of Art, New York, 1968.

Metropolitan Museum of Art 1992
Opificio delle Pietre Dure e Laboratorio di Restauro di Firenze and the Metropolitan Museum of Art. *Verrocchio's "Christ and St. Thomas": A Masterpiece of Sculpture from Renaissance Florence.* Exh. cat. ed. by Loretta Dolcini; Palazzo Vecchio, Florence, and Metropolitan Museum of Art, New York, 1992.

Metropolitan Museum of Art 1994
Painting and Illumination in Early Renaissance Florence 1300–1450. Exh. cat. by Laurence B. Kanter, Barbara Drake Boehm, Carl Brandon Strehlke, Gaudenz Freuler, Christa C. Mayer Thurman, and Pia Palladino, Metropolitan Museum of Art, New York, 1994.

Metropolitan Museum of Art 1996

Genoa: Drawings and Prints, 1530–1800. Exh. cat. by Carmen Bambach and Nadine Orenstein, with an essay by William M. Griswold, and with the assistance of Allegra Pesenti; Metropolitan Museum of Art, New York, 1996.

Metropolitan Museum of Art 1997

The Drawings of Filippino Lippi and His Circle. Exh. cat. by George R. Goldner, Carmen C. Bambach, Alessandro Cecchi, William M. Griswold, Jonathan Nelson, Innis Howe Shoemaker, and Elizabeth Barker, Metropolitan Museum of Art, New York, 1997.

Michelangelo e la Sistina 1990

Michelangelo e la Sistina: La Tecnica, il restauro, il mito. Exh. cat., Monumenti, Musei e Gallerie Pontificie, and Biblioteca Apostolica Vaticana, Città del Vaticano; Rome, 1990.

Michelangelo, Carteggio

Il Carteggio di Michelangelo. Ed. by Paola Barocchi and Renzo Ristori, Florence, 1965–83, 5 vols.

Michelangelo, Ricordi

I Ricordi di Michelangelo. Ed. by L. Bardeschi Ciulich and Paola Barocchi, Florence, 1970.

Michelangelo: La Cappella Sistina, Tavole

Mancinelli, Fabrizio, and introduced by Carlo Pietrangeli. *Michelangelo: La Cappella Sistina: Documentazione e interpretazione, I: Tavole: La Volta restaurata*. Rome, 1994.

Michelangelo: La Cappella Sistina, Rapporto

Mancinelli, Fabrizio. *Michelangelo: La Cappella Sistina: Documentazione e interpretazione, II: Rapporto sul restauro della volta*. Rome, 1994.

Michelangelo. La Cappella Sistina, Atti

Weil-Garris Brandt, Kathleen (ed.). *Michelangelo: La Cappella Sistina, III: Atti del convegno internazionale di studi, Roma, marzo, 1990*. Rome, 1994.

Middeldorf 1945

Middeldorf, Ulrich. *Raphael's Drawings*. New York, 1945.

Milanesi 1901

Milanesi, Gaetano. *Nuovi documenti per la storia dell'arte toscana dal XII al XV secolo*. Florence, 1901.

Milizia 1827

Milizia, Francesco. *Dizionario delle belle arti del disegno (Opere complete di Francesco Milizia)*. (1st ed., Bassano, 1797) Bologna, 1827, vols. 2, 3.

Miner 1968

Miner, Dorothy. "More About Medieval Pouncing," *Homage to a Bookman: Essays on Manuscripts, Books and Printing Written for H. P. Kraus on His 60th Birthday Oct. 12, 1967*. Berlin [1968], 87–107.

Monbeig Goguel 1972

Monbeig Goguel, Catherine. *Musée du Louvre, Cabinet des Dessins: Inventaire général des dessins italiens, I: Maîtres toscans nés après 1500, mort avant 1600: Vasari et son temps*. Paris, 1972.

Monbeig Goguel 1987 a

"Le trace invisible des dessins de Raphael: Pour une problématique des techniques graphiques à la Renaissance," *Studi su Raffaello* 1987, 377–89.

Monbeig Goguel 1987 b

"Stylet et trace sous-jacent dans les dessins de Raphael," *Université Catholique de Louvain: Le dessin sous-jacent dans la peinture: Colloque VI*. Louvain-La-Neuve, 1987, 99–101.

Monbeig Goguel 1994

"A propos des dessins du 'Maître de la femme voilée assise du Louvre': Réflexion méthodologique en faveur du 'Maître de Santo Spirito' (Agnolo et/ou Donnino di Domenico del Mazziere?)," *Florentine Drawing at the Time of Lorenzo the Magnificent* 1994, 111–29.

Monbeig Goguel 1996

"L'étude des filigranes au Département des Arts Graphiques," *Regni and Tordella* 1996, 227–33.

Mongan and Sachs 1940

Mongan, Agnes, and Paul J. Sachs. *Drawings in the Fogg Museum of Art*. Cambridge, 1940, 3 vols.

Monnas 1990

Monnas, Lisa. "Silk Textiles in the Paintings of Bernardo Daddi, Andrea di Cione and their Followers," *ZfK* (53), 1990, 39–58.

Monti 1981

Monti, Raffaello. *Andrea del Sarto*. 2nd ed., Milan, 1981.

Mora and Philippot 1984

Mora, Paolo, Laura Mora, and Paul Philippot. *Conservation of Wall Paintings*. Trans. by Elizabeth Schwarzbaum and Harold Plenderleith, London and Boston, 1984.

Moriondo Lenzini 1989

Moriondo Lenzini, Marguerita (ed.). *Indagini diagnostico-conoscitive per la conservazione della Legenda della Vera Croce e della Madonna del Parto*. Florence, 1989.

Morozzi 1988–89

Morozzi, Luisa. "La *Battaglia di Cascina* di Michelangelo. Nuovi ipotesi sulla data di commissione," *Prospettiva*, nos. 53–56 (1988–89), 320–24.

Morrogh 1985

Morrogh, Andrew. *Disegni di architetti fiorentini 1540–1640*. Exh. cat., Gabinetto Disegni e Stampe degli Uffizi. Trans. by Silvia Dinale, Florence, 1985.

Mulazzani 1986

Mulazzani, Germano. "Raphael and Venice: Giovanni Bellini, Dürer, and Bosch," *Raphael before Rome* 1986, 149–53.

Mulinari 1778

Mulinari, Stefano. *Istoria pratica dell'Incominciamento, e Progressi della Pittura o sia Raccolta di Cinquanta Stampe, estratte da ugual Numero di Disegni originali esistenti nella Real Galleria di Firenze*. Florence, 1778.

Munich 1977

Stiftung Ratjen italienische Zeichnungen des 16.-18. Jahrhundert. Exh. cat., Staatliche Graphische Sammlung München, Munich, 1977.

Müntz 1897

Müntz, Eugene. *Les tapisseries de Raphael au Vatican et dans les principaux musées ou collections de l'Europe . . .* Paris, 1897.

Muraro 1960

Muraro, Michelangelo. *Pitture murali nel Veneto e tecnica dell'affresco*. Exh. cat., Fondazione Giorgio Cini, Venice, 1960.

Muraro and Rosand 1976–77

Muraro, Michelangelo, and David Rosand. *Titian and the Venetian Woodcut*. Exh. cat., International Exhibitions Foundation, 1976–77.

Panofsky 1927
Panofsky, Erwin. *Die Perspektive als symbolische Form (Vorträge der Bibliothek Warburg, 1924–25)*. Leipzig and Berlin, 1927, 258–330.

Panofsky 1968
Idea: A Concept in Art Theory. Trans. by Joseph J. S. Peake, Columbia, S.C., 1968.

Parker 1972
Parker, Karl T. *Catalogue of the Collections of Drawings in the Ashmolean Museum, II: The Italian Schools* (Oxford, 1956); reprint, Oxford, 1972, 2 vols.

Passavant 1839–58
Passavant, J. D. *Raffael von Urbino und sein Vater Giovanni Santi*. Leipzig, 1839–58, 3 vols.

Passavant 1860
Raphael d'Urbin et son pere Giovanni Santi. Paris, 1860, 2 vols.

Passavant 1860–64
Le peintre-graveur. Leipzig, 1860–64, 6 vols.

Passavant 1959
Passavant, Günther. *Andrea del Verrocchio als Maler*. Düsseldorf, 1959.

Passavant 1969
Verrocchio: Sculptures, Paintings and Drawings: Complete Edition. London, 1969.

Passavant 1983
"Reflexe nordischer Graphik bei Raffael, Leonardo, Giulio Romano und Michelangelo," *MdKIF*, 27 (1983), 193–222.

Pedretti 1964
Pedretti, Carlo. *Leonardo Da Vinci on Painting: A Lost Book (Libro A)*. Berkeley and Los Angeles, 1964.

Pedretti 1968
"The Burlington House Cartoon," *BM*, 110 (1968), 22–28.

Pedretti 1979
The Codex Atlanticus of Leonardo da Vinci: A Catalogue of its Newly Restored Sheets, n.p. (Johnson Reprint Corporation), 1979, 2 vols.

Pedretti 1981
Leonardo Architetto. 2nd ed., Milan, 1981.

Penny 1992
Penny, Nicholas. "Raphael's *Madonna dei Garofani* Rediscovered," *BM*, 134 (1992), 67–81.

Pérez Sánchez 1986
Pérez Sánchez, Alfonso. *Historia del dibujo en España de la Edad Media a Goya*. Madrid, 1986.

Perier–d'Ieteren 1979
Perier–d'Ieteren, Catheline. "La technique picturale de la peinture flamande du XVe siècle," *Atti del XXIV Congresso internazionale de storia dell'arte: La Pittura nel XIV e XV secolo, III: Il Contributo dell'analisi tecnica alla storia dell'arte*. Bologna, 1979, 13–28.

Pernety 1757
Pernety, Antoine Josephe. *Dictionnaire portatif de peinture, sculpture et gravure . . .* Paris, 1757 (reprint, Geneva, 1972).

Perrig 1991
Perrig, Alexander. *Michelangelo's Drawings: The Science of Attribution*. New Haven and London, 1991.

Petrioli Tofani 1985
Petrioli Tofani, Annamaria. *Andrea del Sarto: Disegni*. Florence, 1985.

Petrioli Tofani 1986
Gabinetto Disegni e Stampe degli Uffizi: Inventario, 1: Disegni esposti. Florence, 1986.

Petrioli Tofani 1987
Gabinetto Disegni e Stampe degli Uffizi: Inventario, 2: Disegni esposti. Florence, 1987.

Petrioli Tofani 1991 a
Gabinetto Disegni e Stampe degli Uffizi: Inventario, 1: Disegni di figura. Florence, 1991.

Petrioli Tofani et al. 1991 b
Petrioli Tofani, Annamaria, et al. *Il Disegno: Forme, tecniche, significativo*. Cinisello Balsamo (Milan), 1991.

Petrucci Nardelli 1996
Franca Petrucci Nardelli. "Il Legatore: Un mestiere fra organizzazione e sfruttamento," Regni and Tordella 1996, 329–32.

Pfeiffer 1975
Pfeiffer, Heinrich. *Zur Ikonographie von Raffaels Disputa: Egidio da Viterbo und die christlich-platonische Konzeption der Stanza della Segnatura (Miscellanea Historiae Pontificae, Università Pontificae, XXXVII)*. Rome, 1975.

Piero, *De Prospectiva pingendi*
Piero della Francesca. *De Prospectiva pingendi*. Ed. by Giustina Nicco-Fasola; with forewd., comment., and biblio. by Eugenio Battisti et al. Florence, 1984.

Piero della Francesca ad Arezzo 1993
Centauro, Giuseppe, and Margherita Moriondo Lenzini. *Piero della Francesca ad Arezzo: Atti del convegno internazionale di studi, Arezzo, 1–10 marzo 1990*. Venice, 1993.

Piero della Francesca tra arte e scienza 1996
Dalai Emiliani, Marisa and Valter Curzi (eds.) *Piero della Francesca tra arte e scienza: Atti del convegno internazionale di studi, Arezzo, 8–11 ottobre 1992; Sansepolcro, 12 ottobre 1992*. Venice, 1996.

Pignatti 1976
Pignatti, Terisio. *Paolo Veronese*. Venice, 1976, 2 vols.

Pignatti 1977
Italian Drawings in Oxford from the Collections of the Ashmolean and Christ Church. Trans. by Barbara Luigia La Penta. Oxford, 1977.

Pillsbury and Richards 1978
Pillsbury, Edmund, and Luise Richards. *The Graphic Art of Federico Barocci: Selected Drawings and Prints*. Exh. cat., Yale University Art Gallery, New Haven, Conn., 1978.

Pittura murale duecento-quattrocento
Gregori, Mina (ed.). *Pittura murale in Italia: Dal tardo duecento ai primi del quattrocento*. Essays by Sandrina Bandera, Daniele Benati, Cristina de Benedictis et al. (Istituto Bancario San Paolo di Torino) Bergamo, 1995.

Pittura murale quattrocento
Gregori, Mina (ed.). *Pittura murale in Italia: Il Quattrocento*. Essays by Maria Cristina Bandera, Daniele Benati, Giovanbattista Benedicente, et al. (Istituto Bancario San Paolo di Torino) Bergamo, 1996.

Le Pitture murali 1990
Opificio delle Pietre Dure e Laboratori di Restauro di Firenze. *Le Pitture murali: Tecniche, problemi, conservazione.* Ed. by Cristina Danti, Mauro Matteini, and Arcangelo Moles. Florence, 1990.

Plesters 1990 a
Plesters, Joyce. "Technical Aspects of Some Paintings by Raphael in the National Gallery," *The Princeton Raphael Symposium* 1990, 15–37.

Plesters 1990 b
"Raphael's Cartoons for the Vatican Tapestries: A Brief Report on the Materials, Technique, and Condition," *The Princeton Raphael Symposium* 1990, 112–13.

Pogany Balas 1972
Pogany Balas, Edith. "L'Influence des gravures de Mantegna sur la composition de Raphael et de Raimondi *Massacre des Innocents,*" *Bulletin du Musée Hongrois des Beaux-Arts,* 39 (1972), 25–40.

Poggi 1909, 1988
Poggi, Giovanni. *Il Duomo di Firenze: Documenti sulla decorazione della chiesa e del campanile tratti dall'archivio dell'opera: Parti I–IX.* Berlin, 1909 (reprint, with notes and commentary by Margaret Haines, Florence, 1988, vol. 1; posthumous vol., *Parti X–XVIII*).

Poirier 1976
Poirier, Maurice. *Studies on the Concepts of Disegno, Invenzione, and Colore in Sixteenth– and Seventeenth–Century Italian Art and Theory* Ph.D. Dissertation, New York University, New York, 1976.

Polzer 1971
Polzer, Joseph. "The Anatomy of Masaccio's *Holy Trinity,*" *JdBM,* 13 (1971), 18–59.

Pons 1990
Pons, Nicoletta. "Precisazioni su tre Bartolomeo di Giovanni, il cartolaio, il sargiaio e il dipintore," *Paragone,* no. 479–81 (1990), 115–28.

Pope-Hennessy 1969
Pope-Hennessy, John. *Paolo Uccello: Complete Edition.* 2nd ed., London, 1969.

Pope-Hennessy 1970
Raphael. New York, 1970.

Pope-Hennessy 1974
Fra Angelico. London, 1974.

Pope-Hennessy 1989
The Portrait in the Renaissance. 2nd printing, Princeton, N.J., 1989.

Popham 1931
Popham, Arthur E. *Italian Drawings Exhibited at the Royal Academy in 1930.* Exh. cat., Royal Academy of Arts, London, 1931.

Popham 1957
Correggio's Drawings. London, 1957.

Popham 1964
"Two Drawings by Parmigianino," *The National Gallery of Canada Bulletin,* 2 (1964), 29–30.

Popham 1969
"Observations on Parmigianino's Designs for Chiaroscuro Woodcuts," *Miscellanea I. Q. van Regteren Altena,* Amsterdam, 1969, 48–51.

Popham 1971
Catalogue of the Drawings of Parmigianino. New Haven and London, 1971, 3 vols.

Popham 1995
The Drawings of Leonardo da Vinci. (1st ed., London, 1946) intro. and ed. by Martin Kemp. London, 1995.

Popham and Fenwick 1965
Popham, Arthur E., and K. M. Fenwick. *National Gallery of Canada: Catalogue of European Drawings.* Toronto, 1965.

Popham and Pouncey 1950
Popham, Arthur E., and Philip Pouncey. *Italian Drawings in the Department of Prints and Drawings in the British Museum: The Fourteenth and Fifteenth Centuries.* London, 1950, 2 vols.

Popham and Wilde 1949
Popham, Arthur E., and Johannes Wilde. *The Italian Drawings at Windsor Castle: The Italian Drawings of the XV and XVI Centuries in the Collection of His Majesty the King at Windsor Castle.* London, 1949.

Pouncey 1964
Pouncey, Philip. "Review of Bernard Berenson, *I Disegni dei pittori fiorentini,*" *MD,* 2 (1964), 278–93.

Pouncey 1976
"Popham's Parmigianino Corpus," *MD,* 14 (1976), 172–76.

Pouncey and Gere 1962
Pouncey, Philip, and John A. Gere. *Italian Drawings in the Department of Prints and Drawings in the British Museum: Raphael and his Circle.* London, 1962, 2 vols.

Pozzo 1693–1700
Pozzo, Andrea. *Perspectiva Pictorum et architectorum,* "Breve instruttione per dipingere a fresco." Rome, 1693–1700, 2 vols.

Previtali 1974
Previtali, Giovanni. *Giotto e la sua bottega.* 2nd ed., Milan, 1974.

The Princeton Raphael Symposium 1990
The Princeton Raphael Symposium: Science in the Service of Art History. Ed. by John Shearman and Marcia Hall. Princeton, N.J., 1990.

Procacci 1961
Procacci, Ugo. *Sinopie e affreschi.* Milan, 1961.

Procacci 1976
"Importanza del Vasari come scrittore di tecnica della pittura," *Il Vasari storiografo e artista (Atti del congresso internazionale nel IV centenario della morte, Arezzo-Florence),* Florence, 1976, 35–64.

Procacci and Guarnieri 1975
Procacci, Ugo and Luciano Guarnieri. *Come nasce un affresco.* Florence, 1975.

Prohaska 1990
Prohaska, Wolfgang. "The Restoration and Scientific Examination of Raphael's *Madonna in the Meadow,*" *The Princeton Raphael Symposium* 1990, 57–64.

Quednau 1979
Quednau, Rolf. *Die 'Sala di Costantino' im Vatikanischen Palast: Zur Dekoration der beiden Medici Päpste Leo X. und Clemens VII.* Hildesheim and New York, 1979.

Raffaello a Roma 1986
Raffaello a Roma: Il Convegno del 1983. Ed. by Christoph Luitpold Frommel and Matthias Winner. Rome, 1986.

Ragghianti 1949–50
Ragghianti, Carlo Ludovico. "Andrea del Sarto a Cortona," *Critica d'arte*, 3 (1949–50), 113–24.

Ragghianti and Dalli Regoli 1975
Ragghianti, Carlo Ludovico, and Gigetta Dalli Regoli. *Firenze, 1470–1480: Disegni dal modello.* Pisa, 1975.

Ragghianti Collobi 1974
Ragghianti Collobi, Licia. *Il Libro di disegni del Vasari.* Florence, 1974, 2 vols.

Raphael Before Rome 1986
Studies in the History of Art XVII: Raphael Before Rome (Center of Advanced Study in the Visual Arts, Symposium Series V, National Gallery of Art). Washington, D.C., 1986.

Rèau 1956–59
Rèau, Louis. *Iconographie de l'art chrétien.* Paris, 1956–59, 6 vols.

Redig de Campos 1984
Redig de Campos, Dioclecio. *Raphaels Fresken in den Stanzen.* Trans. by P. and H. Mohring. Stuttgart, 1984 (Italian editions, 1950, 1965, 1983).

Redig de Campos and Biagetti 1949
Redig de Campos, Dioclecio, and Biagio Biagetti. *Il 'Giudizio Universale' di Michelangelo.* Rome, 1949, 2 vols.

Regni and Tordella 1996
Regni, Marina, and Piera Giovanna Tordella. *Documenti 3: Conservazione dei materiali librari archivistici e grafici.* Turin, 1996.

Les Relevés de filigranes 1996
De La Chapelle, Ariane, and André Le Prat. *Les Relevés de filigranes: Watermark Records: I Rilievi di Filigrane: Atelier de restauration du département des Arts Graphiques, Musée du Louvre: Projet dirigé par Catherine Monbeig Goguel.* Paris, 1996.

Retgeren Altena and Ward-Jackson 1970
Retgeren Altena, I. Q. van, and Peter Ward-Jackson. *Drawings from the Teylers Museum, Haarlem.* Exh. cat., Victoria and Albert Museum, London, 1970.

Richter
Richter, Jean Paul. *The Literary Works of Leonardo da Vinci: Compiled and Edited from the Original Manuscripts . . .* (1st ed., Oxford, 1883; 2nd ed., 1939) London, 1970, 2 vols.

Richter, *Commentary*
Pedretti, Carlo. *The Literary Works of Leonardo da Vinci, Compiled and Edited from the Original Manuscripts by Jean Paul Richter: Commentary.* Oxford, 1977, 2 vols.

Richter 1945
Richter, Irma A. "A Contribution of Raphael's Art: The Drawings for the *Entombment,*" *GBA,* 28 (1945), 335–56.

Roberts 1987
Roberts, Jane. *Italian Master Drawings from the British Royal Collection: Leonardo to Canaletto.* Exh. cat., National Gallery of Art, Washington, D.C.; Fine Arts Museum of San Francisco; and Art Institute of Chicago; London, 1987.

Roettgen 1996
Roettgen, Steffi. *Italian Frescoes: The Early Renaissance, 1400–1470.* Trans. by Russell Stockman, with photography by Antonio Quattrone. New York, London, and Paris, 1996.

Roettgen 1997
Italian Frescoes: The Flowering of the Renaissance, 1470–1510. Trans. by Russell Stockman, with photography by Antonio Quattrone and Fabio Lensini. New York, London, and Paris, 1997.

Romano 1982
Romano, Giovanni. *Gaudenzio Ferrari e la sua scuola: I Cartoni cinquecenteschi dell'Accademia Albertina.* Exh. cat., Accademia Albertina di Belle Arti, Turin, 1982.

Rome 1985
Bernini Pezzini, Grazia. '*Raphael invenit*': *Stampe da Raffaello nelle Collezioni dell'Istituto Nazionale per la Grafica.* Exh. cat., Istituto Nazionale per la Grafica di Roma, Rome, 1985.

Rosand 1982
Rosand, David. *Painting in Cinquecento Venice: Titian, Veronese, Tintoretto.* New Haven and London, 1982.

Rosenauer 1969
Rosenauer, Artur. "Zum Stil der frühen Werke Domenico Ghirlandajos," *Wiener Jahrbuch für Kunstgeschichte,* 12 (1969), 59–85.

Rosenauer 1972
"Ein nicht zur Ausführung gelangter Entwurf Domenico Ghirlandaios für die Cappella Sassetti," *Wiener Jahrbuch für Kunstgeschichte,* 25 (1972), 187–96.

Rosenauer 1986
"Domenico Ghirlandaio e bottega: Organizzazione del lavoro per il ciclo di affreschi a S. Maria Novella (c. 1486–90)," *Tecnica e stile* 1986, I, 25–30.

Rosenberg 1986
Rosenberg, Charles M. "Raphael and the Florentine *Istoria,*" *Raphael before Rome* 1986, 175–87.

Roskill 1968
Roskill, Mark W. *Dolce's 'Aretino' and Venetian Art Theory of the Cinquecento.* New York, 1968.

Rossi 1996
Rossi, Paola. "I Cartoni di Jacopo e Domenico Tintoretto per i mosaici della basilica di San Marco," *Arte Veneta,* no. 48 (1996), 43–55.

Rosso del Brenna 1976
Rosso del Brenna, Giovanna. *Giovanni Battista Castello (I Pittori bergamaschi dal XIII al XIX Secolo: Il Cinquecento, II).* Bergamo, 1976.

Rubin 1991
Rubin, Patricia. "'What Men saw': Vasari's Life of Leonardo da Vinci and the Image of the Renaissance Artist," *Nine Lectures on Leonardo da Vinci,* ed. by Francis Ames-Lewis (Department of History of Art, Birkbeck College), London, 1991, 96–108.

Rubin 1995
Giorgio Vasari: Art and History. New Haven and London, 1995.

Ruffa 1990
Ruffa, Giuseppe. "Osservazioni sugli affreschi di Domenico Ghirlandaio nella chiesa di Santa Maria Novella, II: Censimento delle tecniche di tracciamento del disegno preparatorio," *Le Pitture murali* 1990, 53–58.

Ruggeri 1969
Ruggeri, Ugo. *Corpus Graphicum Bergomense.* 2nd ed., Bergamo, 1969, 2 vols.

Russell 1986
Russell, Francis. "Perugino and the Early Experience of Raphael," *Raphael before Rome* 1986, 189–201.

Saint-Aubin 1770, 1983
De Saint Aubin, Charles Germain. *L'Art du Brodeur*, Paris, 1770. *Art of the Embroiderer*, trans. by Nikki Scheuer and Edward Maeder, Boston, 1983.

Salmon 1673
Salmon, William. *Polygraphice; or, The Arts of Drawing, Engraving, Etching, Limning, Painting, Washing, Varnishing, Gilding, Colouring, Dying, Beautifying and Perfuming.* London, 1673.

Samek Ludovici 1956
Samek Ludovici, Sergio. *Vita del Caravaggio dalle testimonianze del suo tempo.* Milan, 1956.

Sánchez Cantón 1923–41
Sánchez Cantón, Francisco Javier. *Fuentes literarias para la historia del arte español.* Madrid, 1923–41, 5 vols.

San Juan 1985
San Juan, Rose Marie. "The Function of Antique Ornament in Luca Signorelli's Fresco Decoration for the Chapel of San Brizio," *Revue d'art canadienne/Canadian Art Review: "The Roman Tradition of Wall Decoration,"* 12 (1985), 235–42.

Sander 1942, 1969
Sander, Max. *Le livre à figures italien depuis 1467 jusqu'à 1530 . . .* Milan, 1942, 6 vols. (*Supplément . . .* by Carlo Enrico Rava, Milan, 1969).

Sandrart 1675
Sandrart, Joachim von. *L'Academia Todesca della Architectura, Scultura e Pittura: Oder Teutsche Akademie der Edlen Bau- Bild- und Mahleren-Künste . . .* Nuremberg and Frankfurt, 1675.

Sandström 1963
Sandström, Sven. *Levels of Unreality: Studies in Structure and Construction in Italian Mural Painting during the Renaissance.* Uppsala, 1963.

Sanminiatelli 1967
Sanminiatelli, Donato. *Domenico Beccafumi.* Milan, 1967.

Santi 1979
Santi, Francesco. "Il Restauro dell'affresco di Raffaello e del Perugino in San Severo di Perugia," *BA,* 64, no. 1 (1979), 57–64.

Sanz 1990
Sanz, Maria Merced Virginia. "La teoria española de la pintura en los siglos XVI y XVII," *Cuadernos de Arte e Iconografía,* 3 (1990), 93–116.

Scalini 1995
Scalini, Mario. "Il Monumento a Giovanni Acuto ed i modi operativi di Paolo Uccello," *Echi e memoria di un condottiero: Giovanni Acuto (Atti del convegno, Castiglion Fiorentino, 2 Ottobre 1995),* Tavarnelle, 1995, 95–106.

Scarpellini 1984
Scarpellini, Pietro. *Perugino.* Milan, 1984.

Scharf 1950
Scharf, Alfred. *Filippino Lippi.* Vienna, 1950.

Scheller 1963
Scheller, Robert W. *A Survey of Medieval Modelbooks.* Haarlem, 1963.

Scheller 1973
"The Case of the Stolen Raphael Drawings," *MD,* 11 (1973), 119–37.

Scheller 1995
Exemplum: Model-Book Drawings and the Practice of Artistic Transmission in the Middle Ages (ca. 900–ca. 1470). Translated by Michael Hoyle. Amsterdam, 1995.

Schianchi and Battisti 1981
Schianchi, Lucia Fornari and Eugenio Battisti. *Rivedendo Correggio: L'Assunzione del Duomo di Parma: Come si fabbrica un paradiso.* Privately printed by Cassa di Risparmio di Reggio Emilia. Rome, 1981.

Schlosser 1964
Schlosser, Julius. *La Letteratura artistica: Manuale delle fonti della storia dell'arte moderna.* Trans. by Filippo Rossi. Florence and Vienna, 1964.

Schmarsow 1886
Schmarsow, August. *Melozzo da Forlì: Ein Beitrag zur Kunst- und Kulturgeschichte Italiens im XV. Jahrhundert.* Berlin, 1886.

Schmitt 1971
Schmitt, Annegritt. "Römische Antikensammlungen im Spiegel eines Musterbuches der Renaissance," *Münchner Jahrbuch der bildenden Kunst,* 21 (1971), 99–121.

Schulz 1968
Schulz, Juergen. *Venetian Painted Ceilings of the Renaissance.* Berkeley, 1968.

Schulz 1969
Schulz, Juergen and Anne Markham Schulz. "Review of *The Great Age of Fresco* in New York," *BM,* 111 (1969), 51–54.

Seidel 1984
Seidel, Max. "Signorelli um 1490," *JdBM,* 2 (1984), 181–256.

Shearman 1960
Shearman, John. "The 'Chiostro dello Scalzo,'" *MdKIF,* 9 (1960), 207–20.

Shearman 1962
"Leonardo's Colour and Chiaroscuro," *ZfK,* 25 (1962), 13–47.

Shearman 1963
"Maniera as Aesthetic Ideal," *The Renaissance and Mannerism, Studies in Western Art: Acts of the Twentieth International Congress of the History of Art.* Princeton, N.J., 1963, II, 200–20.

Shearman 1964
"Die Loggia der Psyche in der Villa Farnesina und die Probleme der letzten Phase von Raffaels graphischem Stil," *Jahrbuch der kunsthistorischen Sammlungen in Wien,* 60 (1964), 59–100.

Shearman 1965 a
Andrea Del Sarto. Oxford, 1965, 2 vols.

Shearman 1965 b
"Raphael's Unexecuted Projects for the Stanze," *Walter Friedländer, zum 90. Geburtstag.* Berlin, 1965, 158–75.

Shearman 1967
Mannerism. Harmondsworth, 1967 (reprint 1986).

Shearman 1970
"Raphael at the Court of Urbino," *BM,* 112 (1970), 72–78.

Shearman 1971

"The Vatican *Stanze:* Functions and Decoration," *Proceedings of the British Academy,* 57, London, 1971.

Shearman 1972

Raphael's Cartoons in the Collection of Her Majesty the Queen and the Tapestries for the Sistine Chapel. London and New York, 1972.

Shearman 1977

"Raphael, Rome, and the *Codex Escurialensis,*" *MD,* 15 (1977), 107–46.

Shearman 1983

"A Drawing for Raphael's *Saint George,*" *BM,* 125 (1983), 15–25.

Shearman 1992 **a**

"A Note on the Early History of Cartoons," *MD,* 30 (1992), 5–8.

Shearman 1992 **b**

Only Connect . . . Art and the Spectator in the Italian Renaissance. Princeton, N.J., 1992.

Shell 1995

Shell, Janice. *Pittori in bottega: Milano nel Rinascimento.* Turin, 1995.

Shoemaker 1975

Shoemaker, Innis H. *Filippino Lippi as a Draughtsman.* Ph.D. Dissertation, Columbia University, New York, 1975 (UMI Microfilms, Ann Arbor 1975).

Shoemaker and Brown 1981

Shoemaker, Innis H., and Elizabeth Broun. *The Engravings of Marcantonio Raimondi.* Exh. cat., Spencer Museum of Art, University of Kansas; and Ackland Memorial Art Center, University of North Carolina; Lawrence, Kans., 1981.

Simons 1987

Simons, Patricia. "Patronage in the Tornaquinci Chapel, Santa Maria Novella," *Patronage, Art, and Society in Renaissance Italy,* ed. by F. W. Kent and Patricia Simons. Canberra and Oxford, 1987, 221–50.

Sironi 1981

Sironi, Grazioso. *Nuovi documenti riguardanti la 'Vergine delle Rocce' di Leonardo da Vinci.* Milan, 1981.

The Sistine Chapel 1986

The Sistine Chapel: The Art, the History, and the Restoration. New York, 1986.

Skaug 1994

Skaug, Erling. *Punchmarks from Giotto to Fra Angelico: Attribution, Chronology, and Workshop Relationships in Tuscan Panel Painting: With Particular Consideration to Florence, c. 1330–1430.* Oslo, 1994, 2 vols.

Smart 1971

Smart, Alastair. *The Assisi Problem and the Art of Giotto: A Study of the Legend of St. Francis in the Upper Church of San Francesco, Assisi.* Oxford, 1971.

Smith 1730

Smith, Mr. [No first name given]. *A Short and Direct Method of Painting in Watercolors.* London, 1730.

Spear 1967

Spear, Richard. "Some Domenichino Cartoons," *MD,* 5 (1967), 144–58.

Spear 1968

"Preparatory Drawings by Domenichino," *MD,* 6 (1968), 111–131.

Spear 1982

Domenichino. New Haven and London, 1982, 2 vols.

Spencer 1957

Spencer, John R. "*'Ut Rhetorica Pictura':* A Study in Quattrocento Theory of Painting," *Journal of the Warburg and Courtauld Institutes,* 20 (1957), 26–44.

Spencer 1965

Filarete's Treatise on Architecture. New Haven and London, 1965, 2 vols.

Spencer 1991

Andrea del Castagno and his Patrons. Durham, N.C., and London, 1991.

Spezzani 1992

Spezzani, Paolo. "La Riflettografia in infrarosso e i disegni di Leonardo alle Gallerie dell'Accademia di Venezia," *Leonardo & Venezia* 1992, 179–86.

Spiazza 1978

Spiazza, Anna Maria. "Giotto a Padova: Studi sullo stato di conservazione della Cappella degli Scrovegni in Padova," *BA* (ser. 2), 63 (1978, but published as extract in 1982).

Steinmann 1905

Steinmann, Ernst. "Chiaroscuri in den Stanzen Raffaels," *Zeitschrift für bildende Kunst,* 10 (1898–99), 169–78.

Steinmann 1925

"Cartoni di Michelangelo," *BA,* no. 1 (1925), 2–16.

Studi su Raffaello 1987

Studi su Raffaello: Atti del Congresso Internazionale di Studi (Urbino-Firenze, 6–14 Aprile 1984). Ed. by Micaela Sambucco Hamoud and Maria Letizia Strocchi. Urbino, 1987, 2 vols.

Summers 1977

Summers, David. "*'Figure come fratelli':* A Transfiguration of Symmetry in the Renaissance," *The Art Quarterly,* 1 (1977), 59–88.

Summers 1981

Michelangelo and the Language of Art. Princeton, N.J., 1981.

Szabo 1983

Szabo, George. *Masterpieces of Italian Drawing in the Robert Lehman Collection.* New York, 1983.

Tagliente 1530

Tagliente, Giovanni Antonio. *Esempio di raccami: Opera nuova che insegna a le donne a cuscire, a raccammare, & a disegnare a ciascuno: Et la detta opera sara di grande utilita ad ogni Artista . . .* Venice, 1530 (eds. 1527, 1528, 1530, and 1531).

Tatrai 1991

Tatrai, Vilmos (ed.). *Museum of Fine Arts, Budapest: Old Master's Gallery: A Summary Catalogue of Italian, French, Spanish and Greek Paintings.* London and Budapest, 1991.

Taubert 1975

Taubert, Johannes. "Pauspunkte in Tafelbildern des 15. und 16. Jahrhunderts," *Bulletin Institut royal du patrimoine artistique,* 15 (1975), 387–401.

Tecnica e stile 1986
Tecnica e stile: Esempi di pittura murale del rinascimento italiano (Harvard University Center for Italian Renaissance Studies at Villa I Tatti). Ed. by Eve Borsook and Fiorella Superbi Gioffredo. Florence, 1986, 2 vols.

Testi 1922
Testi, Laudedeo. *S. Maria della Steccata*. Florence, 1922.

Theophilus 1986
Theophilus. *The Various Arts: De Diversis Artibus*. Trans. by C. R. Dodwell. Oxford, 1986.

Thieme-Becker
Thieme, Ulrich, and Felix Becker, completed by Hans Vollmer. *Allgemeines Lexikon der bildenden Künstler*. Leipzig, 1907–50, 37 vols.

Thomas 1976
Thomas, Anabel. *Workshop Procedure of Fifteenth-Century Florentine Artists*. Ph.D. Dissertation, Courtauld Institute of Art, London University, London, 1976.

Thomas 1995
The Painter's Practice in Renaissance Tuscany. Cambridge and New York, 1995.

Thomson 1914
Thomson, W. G. *Tapestry Weaving in England from the Earliest Times to the End of the XVIIIth Century*. New York, 1914.

Tietze and Tietze-Conrat 1944
Tietze, Hans, and Eva Tietze-Conrat. *The Drawings of the Venetian Painters in the Fifteenth and Sixteenth Centuries*. New York, 1944, 2 vols.

Tietzel 1984
Tietzel, Brigitte. *Deutsches Textilmuseum Krefeld: Italienische Seidengewebe des 13., 14., und 15. Jahrhunderts*. Cologne, 1984.

Tintori 1993
Tintori, Leonetto. *Nella tecnica della pittura murale: Notizie, campioni, esperimenti*. Prato, 1993.

Tintori and Meiss 1962
Tintori, Leonetto, and Millard Meiss. *The Painting of the Life of St. Francis in Assisi, with Notes on the Arena Chapel*. New York, 1962.

Titian Prince of Painters 1990
Titian Prince of Painters. Exh. cat., National Gallery of Art, Washington, D.C., and Palazzo Ducale, Venice; Washington, D.C., 1990.

Tolnay 1945
Tolnay, Charles de. *Michelangelo: The Sistine Ceiling*. Princeton, N.J., 1945, II (reprint, 1971).

Tolnay 1960
Michelangelo: The Final Period. Princeton, 1960, V (reprint, Princeton, 1971).

Tolnay 1972
History and Technique of Old Master Drawings. New York, 1972.

Tolnay 1975
I Disegni di Michelangelo nelle collezioni italiane. Florence, 1975.

Tolnay 1975–80
Corpus dei disegni di Michelangelo. Novara, 1975–80, 4 vols.

Tommaseo
Tommaseo, Nicolò. *Dizionario della lingua italiana*. Turin, Milan, Naples, Palermo, and Rome, 1915, II–VI.

Torriti 1981
Torriti, Pietro. *La Pinacoteca Nazionale di Siena: I dipinti dal XV al XVIII secolo*. Genoa, 1981.

Tordella 1996
Tordella, Piera Giovanna. "La Matita rossa nella pratica del disegno: Considerazioni sulle sperimentazioni preliminari del medium attraverso le fonti antichi," Regni and Tordella 1996, 187–207.

La Toscana al tempo di Lorenzo il Magnifico 1996
La Toscana al tempo di Lorenzo il Magnifico: Politica, Economia, Cultura, Arte (Convegno di studi, Università di Firenze, Pisa e Siena, 5–8 Novembre 1992). Florence, 1996, 3 vols.

Trachtenberg 1991
Trachtenberg, Marvin. "Gothic/Italian "Gothic:" Toward a Redefinition," *Journal of the Society of Architectural Historians*, 50 (1991), 22–37.

Trachtenberg 1997
Dominion of the Eye: Urbanism, Art, and Power in Early Modern Florence. Cambridge and New York, 1997.

Travers Newton 1983
Travers Newton, H. "Leonardo Da Vinci as Mural Painter: Some Observations on his Materials and Working Methods," *AL*, no. 66 (1983), 71–88.

Tsuji 1983 a
Tsuji, Shigeru. "Il Cartone non era spesso: Il vero significato del cartone da pittura," *III: La Pittura nel XIV e XV secolo: Il Contributo dell'analisi tecnica alla storia dell'arte: Atti del XXIV Congresso Internazionale di Storia dell'Arte*, ed. by Henk van Os and J.R.J. van Asperen De Boer, Bologna, 1983, 151–60.

Tsuji 1983 b
"The Origins of *Buon Fresco*," *ZfK*, 46 (1983), 215–22.

Tumidei 1988
Tumidei, Stefano. "Un falso Melozzo: L' Angelo musicante del Prado," *Prospettiva*, no. 52 (1988), 64–67.

Turner 1983
Turner, Nicholas. "Umbrian Drawings at the Uffizi (Review of Ferino-Pagden 1982)," *BM*, 125 (1983), 118–20.

Turner 1986
Florentine Drawings of the Sixteenth Century. Exh. cat., British Museum, London, 1986.

Uffizi 1967
Disegni italiani della collezione Santarelli sec. XV–XVIII. Exh. cat., Gabinetto Disegni e Stampe degli Uffizi, Florence, 1967.

Uffizi 1978
Bellosi, Luciano and Fiora Bellini. *I Disegni antichi degli Uffizi: I Tempi del Ghiberti*. Exh. cat., Gabinetto Disegni e Stampe degli Uffizi, Florence, 1978.

Uffizi 1986
Angelini, Alessandro, and Luciano Bellosi. *Disegni italiani del tempo di Donatello*. Exh. cat., Gabinetto Disegni e Stampe degli Uffizi, Florence, 1986.

Uffizi 1992
Petrioli Tofani, Annamaria (ed.). *Il Disegno fiorentino del tempo di Lorenzo Il Magnifico*. Exh. cat., Gabinetto Disegni e Stampe degli Uffizi, Florence; Cinisello Balsamo and Milan, 1992.

Uffizi 1993
Chiarini, Marco, Gianvittorio Dillon, and Annamaria Petrioli Tofani. *Philip Pouncey per Gli Uffizi*. Exh. cat., Gabinetto Disegni e Stampe degli Uffizi, Florence, 1993.

Ullmann 1894
Ullmann, Hermann. "Raffaellino del Garbo," *Repertorium für Kunstwissenschaft*, 17 (1894), 90–115.

Valentiner 1930
Valentiner, W. R. "Leonardo as Verrocchio's Co-Worker," *AB*, 12 (1930), 43–89.

Valsassina and Garibaldi 1994
Valsassina, Caterina Bon, and Vittoria Garibaldi. *Galleria Nazionale dell'Umbria: Dipinti, sculture, e ceramiche: Studi e restauri*. Florence, 1994.

Van Buren and Edmunds 1974
Van Buren, Anne, and Sheila Edmunds. "Playing Cards and Manuscripts: Some Widely Disseminated Fifteenth Century Model Sheets," *AB*, 56 (1974), 12–30.

Van Cleave 1994
Van Cleave, Claire. "Tradition and Innovation in the Early History of Black Chalk Drawing," *Florentine Drawing at the Time of Lorenzo the Magnificent* 1994, 231–43.

Van Dam et al. 1984
Van Dam, Jan Daniel, et al. *Dutch Tiles in the Philadelphia Museum of Art*. Exh. cat., Philadelphia Museum of Art, Philadelphia, 1984.

Van Mander 1973
Van Mander, Karel. *Den grondt der edel vry schilder-const*. Ed., comment., and intro. by Hessel Miedema. (1st ed., Haarlem, 1604) Utrecht, 1973, 2 vols.

Van Marle 1923–38
Van Marle, Raimond. *The Development of the Italian Schools of Painting*. The Hague, 1923–38, 19 vols.

Van Os et al 1978
Van Os, Henk W., et al. *The Early Venetian Paintings in Holland*. Trans. by Michael Hoyle. Florence, 1978.

Van Straelen 1938
Van Straelen, Hildegard Conrad. *Studien zur Florentiner Glasmalerei des Trecento and Quattrocento*. Wattenscheid, 1938.

Varese 1989
Varese, Ranieri (ed.). *Atlante di Schifanoia*. Ferrara, 1989.

Varese 1994
Giovanni Santi. Fiesole, 1994.

Vasari 1759, 1906
Vasari, Giorgio. *Le Vite de' piu eccellenti pittori, scultori ed architettori scritte da M. Giorgio Vasari*. Ed., comment., and intro. by G. Bottari, Rome, 1759, 9 vols. *Le Vite de' piu eccellenti pittori, scultori ed architettori scritte da M. Giorgio Vasari*. Ed., comment., and intro. by Gaetano Milanesi, Florence, 1906, 9 vols.

Vasari 1960
Vasari on Technique: Being the Introduction to the Three Arts of Design, Architecture, Sculpture and Painting, Prefixed to the Lives of the Most Excellent Painters, Sculptors and Architects [Florence, 1568]. Trans. by Louisa S. Maclehouse. New York, 1960.

Vasari 1962
Giorgio Vasari: La Vita di Michelangelo nelle redazioni del 1550 e del 1568. Ed. by Paola Barocchi. Milan and Naples, 1962.

Vasari 1966–87
Le Vite de' piu eccellenti pittori, scultori e architettori nelle redazioni del 1550 e 1568. Ed. by Rossana Bettarini, annot. by Paola Barocchi. Florence, 1966–1987, 7 vols.

Vasari's Florence 1998
Jacks, Philip (ed.). *Vasari's Florence: Artists and Literati at the Medicean Court*. Cambridge and New York, 1998.

Vatican 1984
Raffaello in Vaticano. Exh. cat., Monumenti, Musei e Gallerie Pontificie, Città del Vaticano; Milan, 1984.

Vecellio 1591, 1600
Vecellio, Cesare. *Corona delle nobili et virtuose donne . . .* (1st ed., Venice, 1591) Venice, 1600.

Veliz 1986
Veliz, Zahira. *Artists' Techniques in Golden Age Spain: Six Treatises in Translation*. Cambridge, London, and New York, 1986.

Venturi 1901–40
Venturi, Adolfo. *Storia dell'arte italiana*. Milan, 1901–40, 11 vols.

Venturini 1992
Venturini, Lisa. "Tre Tabernacoli di Sebastiano Mainardi," *Kermes*, 15 (1992), 41–48.

Venturini 1994
Francesco Botticini. Florence, 1994.

Venturini 1994–95
"Il Maestro del 1506: La Tarda attività di Bastiano Mainardi," *Studi di Storia dell'Arte*, 5–6 (1994–95), 123–83.

Venturini 1996
"Un' ipotesi per la *Pala del Palco* di Domenico e David Ghirlandaio," *La Toscana al tempo di Lorenzo Il Magnifico: Politica, economia, cultura, arte (Atti del Convegno, Firenze, Pisa, Siena, 5–8 November 1992)*, Pisa, 1996, I, 297–304.

Viatte 1994
Viatte, Françoise. "Verrocchio et Leonardo da Vinci: À propos des têtes idéales," *Florentine Drawing at the Time of Lorenzo the Magnificent* 1994, 45–53.

Vienna 1994
Ferino Pagden, Sylvia. *"La Prima donna del mondo": Isabella d'Este: Fürstin und Mäzenatin der Renaissance*. Exh. cat., Kunsthistorisches Museum Wien, Vienna, 1994.

Volpe 1962
Volpe, Carlo. "Notizia e discussione su Raffaello giovane," *Arte antica e moderna*, 5 (1962), 79–85.

Von Sonnenburg 1983
Sonnenburg, Hubertus von. *Raphael in der Alten Pinakothek*. Exh. cat., Die Alte Pinakothek, Munich, 1983.

Von Sonnenburg 1990
"The Examination of Raphael's Paintings in Munich," *The Princeton Raphael Symposium* 1990, 65–78.

Von Teuffel 1979
Von Teuffel, Christa Gardner. "The Buttressed Altarpiece: A Forgotten Aspect of Tuscan 14th Century Design," *JdBM*, 21 (1979), 21–65.

Wackernagel 1981
Martin, Wackernagel. *The World of the Florentine Artist* (First published as *Der Lebensraum des Künstlers in der florentinischen Renaissance: Aufgaben und Auftraggeber, Werkstatt und Kunstmarkt,* Leipzig, 1938). Trans., intro., and ed. by Alison Luchs. Princeton, 1981.

Wallace 1987
Wallace, William. "Michelangelo's Assistants in the Sistine Chapel," *GBA,* 110 (1987), 203–16.

Ward-Jackson 1979
Ward-Jackson, Peter. *Victoria and Albert Museum Catalogues: Italian Drawings, Volume One: 14th–16th Century.* London, 1979.

Wasserman 1969
Wasserman, Jack. "Michelangelo's *Virgin and Child with St. Anne* at Oxford," *BM,* 111 (1969), 122–31.

Wasserman 1970
"A Rediscovered Cartoon by Leonardo da Vinci," *BM,* 112 (1970), 194–210.

Wasserman 1971
"The Dating and Patronage of Leonardo's Burlington House Cartoon," *AB,* 53 (1971), 312–25.

Watrous 1957
Watrous, James. *The Craft of Old Master Drawings.* Madison, 1957.

Watson 1973
Watson, Law. "Technical Observations on the Frescoes of the Brancacci Chapel," *MdKIF,* 17 (1973), 5–74.

Wauters 1911
Wauters, Emile. *Un carton inconnu de Raphael.* Paris, 1911.

Wazbinski 1978
Wazbinski, Zygmunt. "La Prima mostra dell'Accademia del Disegno a Firenze," *Prospettiva,* 14 (1978), 47–57.

Weil-Garris Posner 1974
Weil-Garris Posner, Kathleen. *Leonardo and Central Italian Art, 1515–1550.* New York, 1974.

Welch 1997
Welch, Evelyn. *Art and Society in Italy, 1350–1500.* Oxford and New York, 1997.

White 1972
White, John. *The Raphael Cartoons.* London, 1972.

White 1981
"Cimabue and Assisi: Working Methods and Art Historical Consequence," *Art History,* 4 (1981), 355–83.

White 1987
The Birth and Rebirth of Pictorial Space. 3rd ed., Cambridge, Mass., 1987.

White 1993
Art and Architecture in Italy 1250–1400 (Pelican History of Art). 3rd ed., New Haven and London, 1993.

Whitfield 1982–83
Whitfield, Roderick. *The Art of Central Asia: The Stein Collection in the British Museum.* London, 1982–83.

Whitfield and Farrar 1990
Whitfield, Roderick, and Anne Farrar. *Caves of the Thousand Buddhas: Chinese Art from the Silk Route.* Exh. cat., British Museum, London [1990].

Wiemers 1996
Wiemers, Michael. *Bildform und Werkgenese: Studien zur zeichnerischen Bildvorbereitung in der italienischen Malerei zwischen 1450 und 1490.* Munich and Berlin, 1996.

Wilde 1953
Wilde, Johannes. *Italian Drawings in the Department of Prints and Drawings in the British Museum. Michelangelo and his Studio.* London, 1953.

Wilde 1959
"'Cartonetti' by Michelangelo," *BM,* 101 (1959), 370–77.

Williams 1997
Williams, Robert. *Art, Theory, and Culture in Sixteenth-Century Italy: From Techne to Metatechne.* Cambridge and New York, 1997.

Wittkower 1963
Wittkower, Rudolf. "The Young Raphael," *Allen Memorial Art Museum Bulletin,* 20 (1963), 150–68.

Wohl 1971
Wohl, Hellmut. "Domenico Veneziano Studies: The Sant'Egidio and Parenti Documents," *BM,* 113 (1971), 635–41.

Wohl 1980
The Paintings of Domenico Veneziano ca. 1410–1461: A Study in Florentine Art of the Early Renaissance. Oxford, 1980.

Wohl 1986
"The Eye of Vasari," *MdKIF,* 30 (1986), 537–68.

Wolk-Simon 1992
Wolk-Simon, Linda. "Fame, *Paragone,* and the Cartoon: The Case of Perino del Vaga," *MD,* 30 (1992), 61–82.

Zaist 1774
Zaist, Giovan Battista Zaist. *Notizie istoriche de' pittori, scultori ed architetti cremonesi* (with the reprinted texts of Alessandro Lamo, *Discorso intorno alla scoltura e pittura;* Bernardino Campi, *Parere sopra la pittura*). Cremona, 1774.

Zanardi and Frugoni 1996
Zanardi, Bruno, and Chiara Frugoni. *Il Cantiere di Giotto: Le Storie di San Francesco ad Assisi.* Intro. by Federico Zeri. Milan, 1996.

Zentai 1978
Zentai, Lórand. "Considerations on Raphael's Compositions of the *Coronation of the Virgin,*" *Actae Historiae Artium,* 24 (1978), 195–99.

Zentai 1979
"Contribution à la période ombrienne de Raphael," *Bulletin du Musée Hongrois des Beaux-Arts,* 53 (1979), 69–79.

Zentai 1991
"Le *Massacre des Innocents.* Remarques sur les compositions de Raphael et de Raimondi," *Bulletin du Musée Hongrois des Beaux-Arts,* 75 (1991), 27–106.

Zeri and Gardner 1971
Zeri, Federico, and Elizabeth Gardner. *Italian Paintings: A Catalogue of the Collection of the Metropolitan Museum of Art: Florentine School.* New York, 1971.

PHOTOGRAPHIC CREDITS

In most cases, the photographs of works of art here published were provided by their owners. Works for which further credit is necessary are as follows:

Alinari/Art Resource, New York: Plates I, VII, VIII, Figures 19, 83, 84, 85, 88, 92, 102, 106, 152, 199, 211, 244, 245, 256.

Author: Figures 9, 13, 38, 43, 54, 55, 65, 126, 131, 136, 168, 205, 208, 237, 241, 243, 271.

Author, based on diagrams kindly given by the late Fabrizio Mancinelli, Monumenti e Gallerie Pontificie, Musei Vaticani: Plates XI–XIV.

Author, based on Fritz Baumgart and Biagio Biagetti, *Gli Affreschi di Michelangelo . . . nella Cappella Paolina in Vaticano,* Città del Vaticano, 1934: Figure 5.

Author, based on Bernhard Degenhart and Annegrit Schmitt, *Corpus der Italienischen Zeichnungen 1300–1450,* Berlin, 1968: Figure 198.

Board of Trustees of the National Museums and Galleries on Merseyside (Walker Art Gallery, Liverpool): Figure 251.

Copyright, The Board of Trustees, The National Gallery of Art, Washington: Figures 22, 57, 58.

Copyright, Her Majesty Queen Elizabeth II: Figures 234, 254, 255, 257, 260.

Copyright, The President and Fellows of Harvard College, Harvard University Art Museums: Figures 129, 225.

Courtesy of Giorgio Bonsanti, Opificio delle Pietre Dure e Laboratorio di Restauro di Firenze: Figures 173, 174, 280, 281, 287, 288.

Courtesy of David Alan Brown, The National Gallery of Art, Washington: Figure 23.

Courtesy of Leonardo Farinelli, Biblioteca Palatina, Parma: Figures 200, 201.

Courtesy of the late Fabrizio Mancinelli, Monumenti e Gallerie Pontificie, Archivio Fotografico, Musei Vaticani: Figures 1, 63.

Courtesy of Margaret Lawson, The Metropolitan Museum of Art, New York: Figures 52, 53.

Courtesy of Carlo Pedretti, University of California at Los Angeles and Giunti Publishing Group, Florence: Figures 154, 155.

Courtesy of Nicholas Penny, The National Gallery, London: Figure 123.

Courtesy of Maurizio Seracini, EDITECH, Florence: Figure 96.

Devonshire Collection, Chatsworth; reproduced by permission of the Chatsworth Settlement Trustees: photograph Courtauld Institute of Art: Figures 72, 214.

Devonshire Collection, Chatsworth; reproduced by permission of the Chatsworth Settlement Trustees: photograph courtesy of Peter Day: Figure 28.

Ente Casa Buonarroti, Florence: Plate X.

Fototeca Berenson, Villa I Tatti, The Harvard University Center for Italian Renaissance Studies, Florence: Figures 30, 40, 41, 130, 133, 202, 203, 204, 228, 283, 284, 285, 296.

By permission of The Governing Body of Christ Church, Oxford: Plate III, Figures 45, 76, 227.

Istituto Centrale per il Restauro, Archivio Fotografico, Rome: Figure 183.

Istituto Nazionale per la Grafica di Roma, Archivio Fotografico: Figures 109, 111, 224.

Gemäldegalerie, Staatliche Museen zu Berlin, Preussischer Kulturbesitz: Figure 100.

Kupferstichkabinett, Staatliche Museen zu Berlin, Preussischer Kulturbesitz, Jörg P. Anders: Figures 99, 107, 122, 223, 266.

Monumenti e Gallerie Pontificie, Musei Vaticani, Archivio Fotografico: Figures 2, 24, 25, 31, 39, 66, 67, 69, 70, 90, 92, 163, 177, 213, 230, 231, 238, 239, 277, 282, 290, 291, 295, 299, 300.

Paolo Nannoni, Florence: Figure 132.

The National Gallery, London; reproduced by courtesy of the Trustees of the National Gallery of London: Front Cover, Plate V, Figures 15, 82, 186, 218.

Nicolò Orsi Battaglini, Florence: Figures 124, 137, 138, 139, 140, 142, 143, 145, 147, 149, 150, 157, 158, 159, 160, 176, 179.

Photograph Courtauld Institute of Art, London: Figure 272.

The Photograph Studio, The Metropolitan Museum of Art, New York: Figures 6, 11, 12, 50, 51, 86, 112, 113, 116, 120, 128, 207, 261, 278.

The Photograph Studio, Philadelphia Museum of Art, Graydon Wood: Figure 35.

Photographie Giraudon, Paris: Figure 233.

Antonio Quattrone, Florence: Back Cover.

Réunion des Musées Nationaux, Agence Photographique: Plates IV, VI, IX, Figures 17, 26, 47, 64, 71, 73, 80, 110, 167, 170, 197, 226, 252, 263, 268, 270.

Schlosser Collection of Papermaking, Miriam and Ira D. Wallach Division of Arts, Prints and Photographs, The New York Public Library, Astor, Lenox and Tilden Foundations: Figure 27.

Soprintendenza per i Beni Artistici e Storici delle Provincie di Firenze e Pistoia: Plates I, II, Figures 10, 16, 18, 20, 21, 29, 36, 37, 42, 44, 48, 49, 56, 59, 60, 61, 62, 75, 77, 81, 87, 89, 91, 95, 101, 105, 114, 115, 118, 121, 125, 141, 144, 146, 153, 161, 162, 164, 165, 169, 171, 172, 175, 178, 180, 181, 184, 185, 187, 188, 189, 190, 191, 192, 193, 194, 195, 196, 206, 209, 210, 211, 215, 216, 217, 219, 232, 249, 265, 273, 286, 289, 292, 293, 294, 297, 298.

Soprintendenza per i Beni Artistici e Storici della Provincia di Mantova: Figure 151.

Soprintendenza per i Beni Artistici e Storici di Milano, Laboratorio Fotoradiografico: Figures 103, 104, 264.

Soprintendenza per i Beni Artistici e Storici di Napoli, Archivio Fotografico: Figures 3, 4, 8, 68, 148.

Soprintendenza per i Beni Artistici e Storici delle Provincie di Siena e Grosseto, Archivio Fotografico: Figures 32, 33.

Soprintendenza per i Beni Artistici e Storici di Torino: Figure 221.

Soprintendenza per i Beni Artistici e Storici di Venezia: Figures 108, 246.

Soprintendenza per i Beni Ambientali Architettonici Artistici e Storici dell'Umbria–Perugia: Figure 98.

Umberto Tomba, Verona: Figures 134, 135.

INDEX

The Index is a guide to persons, works of art, and written works cited in the text. Within each entry, works of art are listed after general topics and publications.